2011

Photographer's Market_®

ArtistsMarketOnline.com Where & How to Sell What You Create

THE ULTIMATE MARKET RESEARCH TOOL FOR PHOTOGRAPHERS

To register your 2011 Photographer's Market book and start your FREE 1-year online subscription, scratch off the block below to reveal your activation code*, then go to www.ArtistsMarketOnline.com. Click on "Sign Up Now" and enter your contact information and activation code. It's that easy!

UPDATED MARKET LISTINGS

EASY-TO-USE SEARCHABLE DATABASE

RECORD KEEPING TOOLS

INDUSTRY NEWS

PROFESSIONAL TIPS AND ADVICE

ArtistsMarketOnline.com Where & How to Sell What You Create

ACTIVATE YOUR FREE ARTISTSMARKETONLINE.COM SUBSCRIPTION TO GET INSTANT ACCESS TO:

- **UPDATED MARKET LISTINGS** Find additional listings that didn't make it into the book, updated contact information, and more. ArtistsMarketOnline.com provides the most comprehensive database of verified markets available anywhere.
- EASY-TO-USE SEARCHABLE DATABASE Looking for a specific magazine or book publisher? Just type in its name or other relevant keywords. Or widen your prospects with the Advanced Search. You can also search for listings that have been recently updated!
- PERSONALIZED TOOLS Store your best-bet markets, and use our popular record-keeping tools to track your submissions. Plus, get new and updated market listings, query reminders, and more – every time you log in!
- **PROFESSIONAL TIPS & ADVICE** From pay rate charts to sample query letters, and from how-to articles to Q&As, we have the resources freelancers need.

YOU'LL GET ALL OF THIS WITH YOUR FREE SUBSCRIPTION TO

ArtistsMarketOnline.com

34TH ANNUAL EDITION

2011 Photographer's Market

MARY BURZLAFF BOSTIC, EDITOR

Cincinnati, Ohio

Publisher and Community Leader, Fine Art Community: Jamie Markle Editorial Director, North Light Books, Fine Art: Pam Wissman Managing Editor, North Light Books, Fine Art: Mona Michael

Artist's Market Online website: www.artistsmarketonline.com Artist's Network website: www.artistsnetwork.com North Light Shop website: www.northlightshop.com

2011 Photographer's Market. Copyright © 2010 by North Light Books. Published by F+W Media, Inc., 4700 East Galbraith Rd., Cincinnati, Ohio 45236. Printed and bound in the United States of America. All rights reserved. No part of this book may be reproduced in any form or by any electronic or mechanical means including information storage and retrieval systems without written permission from the publisher. Reviewers may quote brief passages to be printed in a magazine or newspaper.

Distributed in Canada by Fraser Direct 100 Armstrong Avenue Georgetown, ON, Canada L7G 5S4 Tel: (905) 877-4411

Distributed in the U.K. and Europe by F+W Media International Brunel House, Newton Abbot, Devon, TQ12 4PU, England Tel: (+44) 1626 323200, Fax: (+44) 1626 323319 E-mail: postmaster@davidandcharles.co.uk

Distributed in Australia by Capricorn Link Loder House, 126 George Street Windsor, NSW 2756 Australia Tel: (02) 4577-3555

ISSN: 0147-247X

ISBN-13: 978-1-58297-956-4 ISBN-10: 1-58297-956-1

Cover design by Wendy Dunning Interior Design by Clare Finney Production coordinated by Greg Nock

Attention Booksellers: This is an annual directory of F + W Media, Inc. Return deadline for this edition is December 31, 2011.

Contents

Photo © Kathleen Carr

BUSINESS BASICS

How to Use This Book	
How to Start Selling Your Work	7
Running Your Business	
Submitting Your Work	10
Digital Submission Guidelines	
Using Essential Business Forms	
Charging for Your Work	15
Stock List	17
Figuring Small Business Taxes	20
Self-Promotion	22
Organizing and Labeling Your Images	
Protecting Your Copyright	24

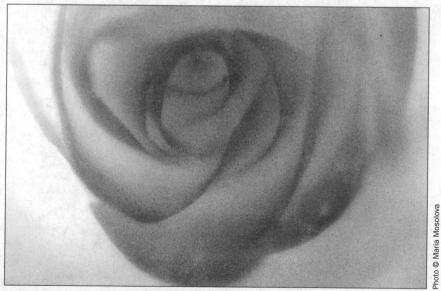

ARTICLES & INTERVIEWS

Find	ing Your Niche by Vik Orenstein	27
Robl	b Siverson Finding Inspiration in Everyday Experiences and the Landscape of the Northern Plains	39
Suza	Capturing the Emotions, Connections, and Stories of Beloved Pets, by Donna Poehner	46
Gen	evieve Russell Sharing and Preserving Stories Through Images, Video, and Audio, by Donna Poehner	52
No F	Place like Home Taking Advantage of Local and Regional Publication Opportunities, by Paul Grecian	58
Net	working With Other Photographers by Vik Orenstein	60

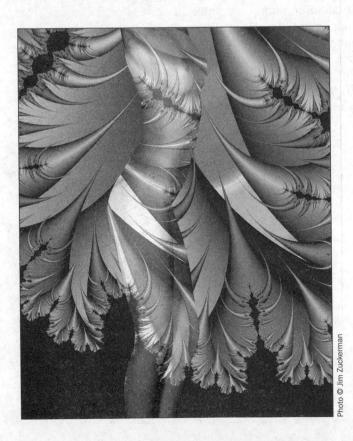

MARKETS

Consumer Publications	65
Newspapers & Newsletters	160
Trade Publications	170
Book Publishers	210
Greeting Cards, Posters, & I Products	
Stock Photo Agencies	251
Advertising, Design, & Relat	
Galleries	341
Art Fairs	405
Contests	448
Photo Representatives	456
Workshops & Photo Tours	467

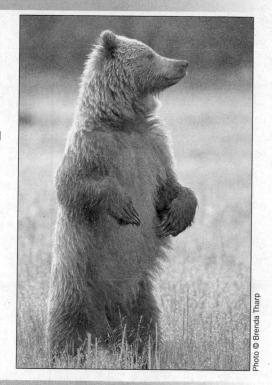

RESOURCES

Stock Photography Portals	493
Portfolio Review Events	494
Grants: State, Provincial, & Regional	495
Professional Organizations	500
Publications	502
Websites	505
Glossary	508
IDEXES	
Geographic Index	514
International Index	528
Subject Index	
General Index	603

From the Editor

No doubt about it, the last couple of years have been tough. Although the "Great Recession" has been difficult for everyone, freelancers have been hit particularly hard. Unfortunately, bringing freelance work back in house is a simple way to tighten a company's budget. So, staying abreast of the latest market trends and developing your business savvy have never been more important. As always, *Photographer's Market* is here to help, and, as *PM's* new editor, I'm excited about joining the effort. In addition to a bunch of new market listings, this edition of *PM* has a great lineup of articles filled with updates on today's best business practices, ideas, and market trends.

One of the best ways to help yourself succeed in a tough economy is to find the right niche for your work. In "Finding Your Niche" (page 27) photographer Vik Orenstein offers advice for finding the area of expertise that suits you best, be it an established area or a new niche completely specific to your work.

Then read on for interviews with three photographers succeeding in very different venues. Robb Siverson (page 39) works in a variety of areas, from commercial aerial photography to artistic landscapes of his home in the Northern Plains. Suzanne Bird (page 46) has found success in the fun, chaotic world of animal lifestyle photography. Genevieve Russell (page 52) has created her own niche, capturing and preserving stories through images, video, and audio.

Sometimes the best way excel in hard times is to stick with what you know. In "No Place Like Home" (page 58) photographer Paul Grecian explains how to find local publishing opportunities in your area. Finally, when times get tough, it helps to have a built-in support group. Check out "Networking With Other Photographers" (page 60) for Orenstein's advice for joining a community of photographers.

I sincerely hope that 2011 looks brighter for everyone, but, in the meantime, take heart, brush up on your business basics, and keep shooting!

Mary Burzlaff Bastic

Mary Burzlaff Bostic photomarket@fwmedia.com www.artistsmarketonline.com

P.S. I'm very excited to announce the launch of our new website **Artist's Market Online**, **which you get FREE for a year with the purchase of this book**. Your free 1-year subscription will provide you with everything *Photographer's Market* has to offer and then some. You'll be able to search listings, track your submissions, exchange ideas and advice with other photographers, and much more. Use the activation code from the front insert to access your free subscription today.

t pages to the control of the contro

How to Use This Book

he first thing you'll notice about most of the listings in this book is the group of symbols that appears before the name of each company. Scanning the listings for symbols can help you quickly locate markets that meet certain criteria. (You'll find a quick-reference key to the symbols on the front and back inside covers of the book.) Here's what each symbol stands for:

- M This photo buyer is new to this edition of the book.
- This photo buyer is located in Canada.
- This photo buyer is located outside the U.S. and Canada.
- A This photo buyer uses only images created on assignment.
- ISI This photo buyer uses only stock images.
- This photo buyer accepts submissions in digital format.
- This photo buyer uses film or other audiovisual media.
- This art fair is a juried event; a juror or committee of jurors views applicants' work and selects those whose work fits within the guidelines of the event.

Complaint Procedure

Important

If you feel you have not been treated fairly by a company listed in *Photographer's Market*, we advise you to take the following steps:

- First, try to contact the listing. Sometimes one phone call, e-mail, or letter can quickly clear up the matter.
- Document all your correspondence with the listing. If you write to us
 with a complaint, provide the details of your submission, the date of
 your first contact with the listing, and the nature of your subsequent
 correspondence.
- We will enter your letter into our files.
- The number and severity of complaints will be considered in our decision whether to delete the listing from the next edition.

PAY SCALE

We asked photo buyers to indicate their general pay scale based on what they typically pay for a single image. Their answers are signified by a series of dollar signs before each listing. Scanning for dollar signs can help you quickly identify which markets pay at the top of the scale. However, not every photo buyer answered this question, so don't mistake a missing dollar sign as an indication of low pay rates. Also keep in mind that many photo buyers are willing to negotiate.

\$ Pays \$1-150

\$\$ \$151-750

\$ \$ \$ Pays \$751-1,500

\$\$\$\$ Pays more than \$1,500

OPENNESS

We also asked photo buyers to indicate their level of openness to freelance photography. Looking for these symbols can help you identify buyers who are willing to work with newcomers, as well as prestigious buyers who only publish top-notch photography.

- Encourages beginning or unpublished photographers to submit work for consideration; publishes new photographers. May pay only in copies or have a low pay rate.
- Accepts outstanding work from beginning and established photographers; expects a high level of professionalism from all photographers who make contact.
- Hard to break into; publishes mostly previously published photographers.
- May pay at the top of the scale. Closed to unsolicited submissions.

SUBHEADS

Each listing is broken down into sections to make it easier to locate specific information. In the first section of each listing you'll find mailing addresses, phone numbers, e-mail and website addresses, and the name of the person you should contact. You'll also find general information about photo buyers, including when their business was established and their publishing philosophy. Each listing will include one or more of the following subheads:

Needs. Here you'll find specific subjects each photo buyer is seeking. (You can find an index of these subjects starting on page 531 to help you narrow your search.) You'll also find the average number of freelance photos a buyer uses each year, which will help you gauge your chances of publication.

Audiovisual Needs. If you create images for media such as filmstrips or overhead transparencies, or you shoot videotape or motion picture film, look here for photo buyers' specific needs in these areas.

Specs. Look here to see in what format the photo buyer prefers to receive accepted images. Many photo buyers will accept both digital and film (slides, transparencies, prints) formats. However, many photo buyers are reporting that they accept digital images only, so make sure you can provide the format the photo buyer requires before you send samples.

Exhibits. This subhead appears only in the Galleries section of the book. Like the Needs subhead, you'll find information here about the specific subjects and types of photography a gallery shows.

Making Contact & Terms. When you're ready to make contact with a photo buyer, look here to find out exactly what they want to see in your submission. You'll also find what the buyer usually pays and what rights they expect in exchange. In the Stock section, this subhead is divided into two parts, Payment & Terms and Making Contact, because this information is often lengthy and complicated.

Frequently Asked Questions

1 How do companies get listed in the book?

No company pays to be included—all listings are free. Every company has to fill out a detailed questionnaire about their photo needs. All questionnaires are screened to make sure the companies meet our requirements. Each year we contact every company in the book and ask them to update their information.

- Why aren't other companies I know about listed in this book?

 We may have sent these companies a questionnaire, but they never returned it. Or if they did return a questionnaire, we may have decided not to include them based on our requirements.
- 3 Some publishers say they accept photos with or without a manuscript. What does that mean?

Essentially, the word manuscript means a written article that will be published by a magazine. Some magazines will only consider publishing your photos if they accompany a written article. Other publishers will consider publishing your photos alone, without a manuscript.

4 I sent a CD with large digital files to a photo buyer who said she wanted to see my work. I have not heard from her, and I am afraid that my photos will be used without my permission and without payment. What should I do?

Do not send large, printable files (300 dpi or larger) unless you are sure the photo buyer is going to use them, and you know what you will be paid for their usage and what rights the photo buyer is requesting. If a photo buyer shows interest in sceing your work in digital format, send small JPEGs at first so they can "review" them—i.e., determine if the subject matter and technical quality of your photos meet their requirements. Until you know for sure that the photo buyer is going to license your photos and you have some kind of agreement, do not send high-resolution files. The exception to this rule would be if you have dealt with the photo buyer before or perhaps know someone who has. Some companies receive a large volume of submissions, so sometimes you must be patient. It's a good idea to give any company listed in this book a call before you submit anything and be sure nothing has changed since we contacted them to gather or update information. This is true whether you submit slides, prints, or digital images.

A company says they want to publish my photographs, but first they will need a fee from me. Is this a standard business practice?

No, it is not a standard business practice. You should never have to pay to have your photos reviewed or to have your photos accepted for publication. If you suspect that a company may not be reputable, do some research before you submit anything or pay their fees. The exception to this rule is contests. It is not unusual for some contests listed in this book to have entry fees (usually minimal—between five and twenty dollars).

Handles. This subhead appears only in the Photo Representatives section. Some reps also represent illustrators, fine artists, stylists, make-up artists, etc., in addition to photographers. The term "handles" refers to the various types of "talent" they represent.

Tips. Look here for advice and information directly from photo buyers in their own words.

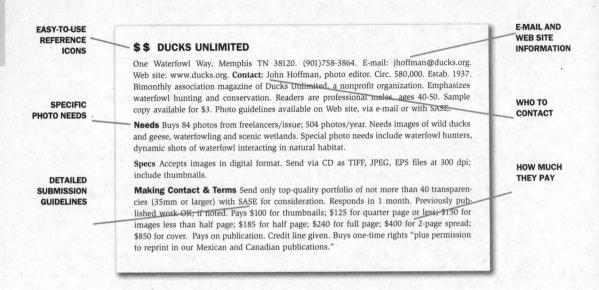

How to Start Selling Your Work

- f this is your first edition of *Photographer's Market*, you're probably feeling a little overwhelmed by all the information in this book. Before you start flipping through the listings, read the 11 steps below to learn how to get the most out of this book and your selling efforts.
- **1. Be honest with yourself.** Are the photographs you make of the same quality as those you see published in magazines and newspapers? If the answer is yes, you may be able to sell your photos.
- **2. Get someone else to be honest with you.** Do you know a professional photographer who would critique your work for you? Other ways to get opinions about your work: join a local camera club or other photo organization; attend a stock seminar led by a professional photographer; attend a regional or national photo conference or a workshop where they offer daily critiques.
 - You'll find workshop and seminar listings beginning on page 467.
 - You'll find a list of photographic organizations on page 500.
 - Check your local camera store for information about camera clubs in your area.
- **3. Get Organized.** Create a list of subjects you have photographed and organize your images into subject groups. Make sure you can quickly find specific images and keep track of any sample images you send out. You can use database software on your home computer to help you keep track of your images. (See page 23 for more information.)

Other Resources:

- Photo Portfolio Success by John Kaplan, Writer's Digest Books.
- Sell and Re-Sell Your Photos by Rohn Engh, Writer's Digest Books.
- The Photographer's Market Guide to Building Your Photography Business by Vik Orenstein, Writer's Digest Books.
- **4. Consider the format.** Are your pictures color snapshots, black-and-white prints, color slides, or digital captures? The format of your work will determine, in part, which markets you can approach. Below are some general guidelines for where you can market various photo formats. Always check the listings in this book for specific format information.
 - **black-and-white prints**—galleries, art fairs, private collectors, literary/art magazines, trade magazines, newspapers, some book publishers
 - color prints—newsletters, very small trade or club magazines
 - ·• large color prints—galleries, art fairs, private collectors
 - color slides (35mm)—most magazines, newspapers, some greeting card and calendar publishers, some book publishers, textbook publishers, stock agencies

- color transparencies (2½×2½ and 4×5)—magazines, book publishers, calendar publishers, ad agencies, stock agencies. Many of these photo buyers have begun to accept only digital photos, especially stock agencies.
- **digital**—newspapers, magazines, stock agencies, ad agencies, book and greeting card publishers. (All listings that accept digital work are marked with a 🖪 symbol.)
- **5. Do you want to sell stock images or accept assignments?** A stock image is any photograph you create on your own and then sell to a publisher. An assignment is a photograph created at the request of a specific buyer. Many of the listings in *Photographer's Market* are interested in both stock and assignment work.
 - ISI Listings that are only interested in stock photography are marked with a symbol.
 - A Listings that are only interested in assignment photography are marked with a symbol.
- **6. Start researching.** Generate a list of the publishers that might buy your images—check the newsstand, go to the library, search the Web, read the listings in this book. Don't forget to look at greeting cards, stationery, calendars, and CD covers. Anything you see with a photograph on it, from a billboard advertisement to a cereal box, is a potential market. See page 6 for instructions about how to read the listings in this book. If you shoot a specific subject, check the Subject Index on page 531 to simplify your search.
- **7. Check the publisher's guidelines.** Do you know exactly how the publisher you choose wants to be approached? Check the listings in this book first. If you don't know the format, subject, and number of images a publisher wants in a submission, you should check their website first. Often, guidelines are posted there. Or you can send a short letter with a self-addressed, stamped envelope (SASE) or e-mail asking those questions. A quick call to the receptionist might also yield the answers.
- **8. Check out the market.** Get in the habit of reading industry magazines. You'll find a list of useful magazines on page 502.
- **9. Prepare yourself.** Before you send your first submission, make sure you know how to respond when a publisher agrees to buy your work.

Pay rates:

Most magazines and newspapers will tell you what they pay, and you can accept or decline. However, you should become familiar with typical pay rates. Ask other photographers what they charge—preferably ones you know well or who are not in direct competition with you. Many will be willing to tell you to prevent you from devaluing the market by undercharging. (See page 15 for more information.)

Other Resources:

- Pricing Photography: The Complete Guide to Assignment and Stock Price, by Michal Heron and David MacTavish, Allworth Press.
- *fotoQuote*, a software package that is updated each year to list typical stock photo and assignment prices, (800)679-0202, www.cradocfotosoftware.com.
- Negotiating Stock Photo Prices, by Jim Pickerell, 110 Frederick Ave., Suite A, Rockville MD 20850, (301)251-0720.

Copyright:

You should always include a copyright notice on any slide, print, or digital image you send out. While you automatically own the copyright to your work the instant it is created, the notice affords extra protection. The proper format for a copyright notice includes the word or symbol for copyright, the date and your name: © 2011 Mary Bostic. To fully protect your copyright and recover damages from infringers, you must register your copyright with the Copyright Office in Washington. (See page 24 for more information.)

Rights:

In most cases, you will not actually be selling your photographs, but rather, the rights to publish them. If a publisher wants to buy your images outright, you will lose the right to resell those images in any form or even display them in your portfolio. Most publishers will buy one-time rights and/or first rights. (See page 25 for more information.)

• Other Resources: Legal Guide for the Visual Artist, by Tad Crawford, Allworth Press.

Contracts:

Formal contract or not, you should always agree to any terms of sale in writing. This could be as simple as sending a follow-up letter restating the agreement and asking for confirmation, once you agree to terms over the phone. You should always keep copies of any correspondence in case of a future dispute or misunderstanding.

- Other Resources: Business and Legal Forms for Photographers, by Tad Crawford, Allworth Press.
- **10. Prepare your submission.** The number one rule when mailing submissions is: "Follow the directions." Always address letters to specific photo buyers. Always include a SASE of sufficient size and with sufficient postage for your work to be safely returned to you. Never send originals when you are first approaching a potential buyer. Try to include something in your submission that the potential buyer can keep on file, such as a tearsheet and your résumé. In fact, photo buyers prefer that you send something they don't have to return to you. Plus, it saves you the time and expense of preparing a SASE. (See page 10 for more information.)
 - Other Resources: Photo Portfolio Success, by John Kaplan, Writer's Digest Books.
- **11.** Continue to promote yourself and your work. After you've made that first sale (and even before), it is important to promote yourself. Success in selling your work depends in part on how well and how often you let photo buyers know what you have to offer. This is known as self-promotion. There are several ways to promote yourself and your work. You can send postcards or other printed material through the mail; send an e-mail with an image and a link to your website if you have one; and upload your images to a website that is dedicated to showcasing your work and your photographic services.

and the first of the second of the first of the second of the second of the second of the second of the second

BUSINESS BASICS

Running Your Business

hotography is an art that requires a host of skills, some which can be learned and some which are innate. To make money from your photography, the one skill you can't do without is business savvy. Thankfully, this skill can be learned. What you'll find on the following pages are the basics of running a photography business. We'll cover:

- Submitting Your Work, page 10
- Digital Submission Guidelines, page 11
- Using Essential Business Forms, page 13
- Charging for Your Work, page 15
- Stock List, page 17
- Figuring Small Business Taxes, page 20
- Self-Promotion, page 22
- Organizing and Labeling Your Images, page 23
- Protecting Your Copyright, page 24

SUBMITTING YOUR WORK

Editors, art directors, and other photo buyers are busy people. Many only spend 10 percent of their work time actually choosing photographs for publication. The rest of their time is spent making and returning phone calls, arranging shoots, coordinating production, and a host of other unglamorous tasks that make publication possible. They want to discover new talent, and you may even have the exact image they're looking for, but if you don't follow a market's submission instructions to the letter, you have little chance of acceptance.

To learn the dos and don'ts of photography submissions, read each market's listing carefully and make sure to send only what they ask for. Don't send prints if they only want slides. Don't send color if they only want black and white. Check their website or send for guidelines whenever they are available to get the most complete and up-to-date submission advice. When in doubt, follow these 10 rules when sending your work to a potential buyer:

- **1. Don't forget your SASE**—Always include a self-addressed, stamped envelope whether you want your submission back or not. Make sure your SASE is big enough, has enough packaging, and has enough postage to ensure the safe return of your work.
- **2. Don't over-package**—Never make a submission difficult to open and file. Don't tape down all the loose corners. Don't send anything too large to fit in a standard file.
- **3. Don't send originals**—Try not to send things you must have back. Never, ever send originals unsolicited.
- **4. Label everything**—Put a label directly on the slide mount or print you are submitting. Include your name, address, and phone number, as well as the name or number of the image. Your slides and prints will almost certainly get separated from your letter.

- **5. Do your research**—Always research the places to which you want to sell your work. Request sample issues of magazines, visit galleries, examine ads, look at websites, etc. Make sure your work is appropriate before you send it out. A blind mailing is a waste of postage and a waste of time for both you and the art buyer.
- **6. Follow directions**—Always request submission guidelines. Include a SASE for reply. Follow *all* the directions exactly, even if you think they're silly.
- **7. Include a business letter**—Always include a cover letter, no more than one page, that lets the potential buyer know you are familiar with their company, what your photography background is (briefly), and where you've sold work before (if it pertains to what you're trying to do now). If you send an e-mail, follow the same protocol as you would for a business cover letter and include the same information.
- **8. Send to a person, not a title**—Send submissions to a specific person at a company. When you address a cover letter to Dear Sir or Madam, it shows you know nothing about the company you want to buy your work.
- **9. Don't forget to follow through**—Follow up major submissions with postcard samples several times a year.
- **10.** Have something to leave behind—If you're lucky enough to score a portfolio review, always have a sample of your work to leave with the art director. Make it small enough to fit in a file but big enough not to get lost. Always include your contact information directly on the leave-behind.

DIGITAL SUBMISSION GUIDELINES

Digital images can come from scanned slides, negatives or prints, or from digital cameras. Today, almost every publisher of photographs will accept digital images. Some still accept "analog" images (slides and prints) as well as digital images, but some accept *only* digital images. And, of course, there are those who still do not accept digital images at all, but their number is decreasing.

Previews

Photo buyers need to see a preview of an image before they can decide if it will fit their needs. In the past, photographers mailed slides or prints to prospective photo buyers so they could review them, determine their quality, and decide whether or not the subject matter was something they could use. Or photographers sent a self-promotion mailer, often a postcard with one or more representative images of their work. Today, preview images can be e-mailed to prospective photo buyers, or they can be viewed on a photographer's website. This eliminates the hassle and expense of sending slides through the mail and wondering if you'll ever get them back.

The important thing about digital preview images is size. They should be no larger than 3 by 5 inches at 72 dpi. E-mailing larger files to someone who just wants a peek at your work could greatly inconvenience them if they have to wait a long time for the files to open or if their e-mail system cannot handle larger files. If photo buyers are interested in using your photographs, they will definitely want a larger, high-resolution file later, but don't overload their systems and their patience in the beginning with large files. Another option is sending a CD with preview images. This is not as efficient as e-mail or a website since the photo buyer has to put the CD in the computer and view the images one by one. If you send a CD, be sure to include a printout of thumbnail images: If the photo buyer does not have time to put the CD in the computer and view the images, she can at least glance at the printed thumbnails. CDs and DVDs are probably best reserved for high-resolution photos you know the photo buyer wants and has requested from you.

Starting a Business

For More Info

To learn more about starting a business:

- Take a course at a local college. Many community colleges offer short-term evening and weekend courses on topics like creating a business plan or finding financial assistance to start a small business.
- Contact the Small Business Administration at (800) 827-5722 or check out their website at www.sba.gov. The U.S. Small Business Administration was created by Congress in 1953 to help America's entrepreneurs form successful small enterprises. Today, SBA's program offices in every state offer financing, training, and advocacy for small firms.
- Contact the Small Business Development Center at (202) 205-6766. The SBDC offers free or low-cost advice, seminars, and workshops for small business owners.
- Read a book. Try Commercial Photography Handbook: Business Techniques for Professional Digital Photographers, by Kirk Tuck (Amhearst Media) or The Business of Studio Photography, by Edward R. Lilley (Allworth Press). The business section of your local library will also have many general books about starting a small business.

Size & quality

Size and quality might be the two most important aspects of your digital submission. If the quality is not there, photo buyers will not be interested in buying your image regardless of its subject matter. Find out what the photo buyer needs. If you scan your slides or prints, make sure your scanning quality is excellent: no dirt, dust, or scratches. If the file size is too small, they will not be able to do much with it either. A resolution of 72 dpi is fine for previews, but if a photo buyer wants to publish your images, they will want larger, high-resolution files. While each photo buyer may have different needs, there are some general guidelines to follow. Often digital images that are destined for print media need to be 300 dpi and the same size as the final, printed image will be (or preferably a little larger). For example, for a full-page photo in a magazine, the digital file might be 8 by 10 inches at 300 dpi. However, always check with the photo buyer who will ultimately be publishing the photo. Many magazines, book publishers, and stock photo agencies post digital submission guidelines on their websites or will provide copies to photographers if they ask. Photo buyers are usually happy to inform photographers of their digital guidelines since they don't want to receive images they won't be able to use due to poor quality.

Note: Many of the listings in this book that accept digital images state the dpi they require for final submissions. They may also state the size they need in terms of megabytes (MB). See subhead "Specs" in each listing.

Formats

When you know that a photo buyer is definitely going to use your photos, you will then need to submit a high-resolution digital file (as opposed to the low-resolution 72-dpi JPEGs used for previews). Photo buyers often ask for digital images to be saved as JPEGs or TIFFs. Again, make sure you know what format they prefer. Some photo buyers will want you to send

them a CD or DVD with the high-resolution images saved on it. Most photo buyers appreciate having a printout of thumbnail images to review in addition to the CD. Some may allow you to e-mail images directly to them, but keep in mind that anything larger than 9 megabytes is usually too large to e-mail. Get the permission of the photo buyer before you attempt to send anything that large via e-mail.

Another option is FTP (file transfer protocol). It allows files to be transferred over the Internet from one computer to another. This option is becoming more prevalent.

Note: Most of the listings in this book that accept digital images state the format they require for final digital submissions. See subhead "Specs" in each listing.

Color space

Another thing you'll need to find out from the photo buyer is what color space they want photos to be saved in. RGB (red, green, blue) is a very common one. You might also encounter CMYK (cyan, magenta, yellow, black). Grayscale is for photos that will be printed without any color (black and white). Again, check with the photo buyer to find out what color space they require.

USING ESSENTIAL BUSINESS FORMS

Using carefully crafted business forms will not only make you look more professional in the eyes of your clients; it will make bills easier to collect while protecting your copyright. Forms from delivery memos to invoices can be created on a home computer with minimal design skills and printed in duplicate at most quick-print centers. When producing detailed contracts, remember that proper wording is imperative. You want to protect your copyright and, at the same time, be fair to clients. Therefore, it's a good idea to have a lawyer examine your forms before using them.

Forms for Photographers

For More Info

To learn more about forms for photographers, try the following:

- EP (Editorial Photographers), www.editorialphoto.com.
- Business and Legal Forms for Photographers, by Tad Crawford (Allworth Press).
- Legal Guide for the Visual Artist, by Tad Crawford (Allworth Press).
- ASMP Professional Business Practices in Photography, (Allworth Press).
- The American Society of Media Photographers offers traveling business seminars that cover issues from forms to pricing to collecting unpaid bills. Write to them at 14 Washington Rd., Suite 502, Princeton Junction NJ 08550, for a schedule of upcoming business seminars, or visit www.asmp.org.
- The Volunteer Lawyers for the Arts, 1 E. 53rd St., 6th Floor, New York NY 10022, (212) 319-2910. The VLA is a nonprofit organization, based in New York City, dedicated to providing all artists, including photographers, with sound legal advice.

The following forms are useful when selling stock photography, as well as when shooting on assignment:

Delivery Memo

This document should be mailed to potential clients along with a cover letter when any submission is made. A delivery memo provides an accurate count of the images that are enclosed, and it provides rules for usage. The front of the form should include a description of the images or assignment, the kind of media in which the images can be used, the price for such usage, and the terms and conditions of paying for that usage. Ask clients to sign and return a copy of this form if they agree to the terms you've spelled out.

Terms & conditions

This form often appears on the back of the delivery memo, but be aware that conditions on the front of a form have more legal weight than those on the back. Your terms and conditions should outline in detail all aspects of usage for an assignment or stock image. Include copyright information, client liability, and a sales agreement. Also be sure to include conditions covering the alteration of your images, transfer of rights, and digital storage. The more specific your terms and conditions are to the individual client, the more legally binding they will be. If you create your forms on your computer, seriously consider altering your standard contract to suit each assignment or other photography sale.

Invoice

This is the form you want to send more than any of the others, because mailing it means you have made a sale. The invoice should provide clients with your mailing address, an explanation of usage, and the amount due. Be sure to include a reasonable due date for payment, usually 30 days. You should also include your business tax identification number or social security number.

Model/Property Releases

Get into the habit of obtaining releases from anyone you photograph. They increase the sales potential for images and can protect you from liability. A model release is a short form, signed by the person(s) in a photo, that allows you to sell the image for commercial purposes. The property release does the same thing for photos of personal property. When photographing children, remember that a parent or guardian must sign before the release is legally binding. In exchange for signed releases, some photographers give their subjects copies of the photos; others pay the models. You may choose the system that works best for you, but keep in mind that a legally binding contract must involve consideration, the exchange of something of value. Once you obtain a release, keep it in a permanent file. (You'll find a sample property release on page 15 and a sample model release on page 16.)

You do not need a release if the image is being sold editorially. However, magazines now require such forms in order to protect themselves, especially when an image is used as a photo illustration instead of as a straight documentary shot. You always need a release for advertising purposes or for purposes of trade and promotion. In works of art, you only need a release if the subject is recognizable. When traveling in a foreign country, it is a good idea to carry releases written in that country's language. To translate releases into a foreign language, check with an embassy or a college language professor.

STOCK LIST

Some market listings in this book ask for a stock list, so it is a good idea to have one on hand. Your stock list should be as detailed and specific as possible. Include all the subjects you have in your photo files, breaking them into logical categories and subcategories. On page

PROPERTY RELEASE

or having the righ	, receipt of which is acknowledged, I being the legal owner of t to permit the taking and use of photographs of certain prop- as
give sentatives the irre all manners, inclu trade, or any other the finished produ therewith.	his/her assigns, licensees, and legal repre- evocable right to use this image in all forms and media and in adding composite or distorted representations, for advertising, r lawful purposes, and I waive any rights to inspect or approve act, including written copy that may be created in connection
Short description	of photographs:
	The second of th
Additional inform	ation:
I am of full age. I	have read this release and fully understand its contents.
Please Print:	
riease riiii.	
Name	

Sample property release

17 is a sample stock list that shows how you might categorize your stock images to create a list that will be easy for photo buyers to skim. This sample list only hints at what a stock list might include. Create a list that reflects your unique collection of images.

CHARGING FOR YOUR WORK

No matter how many books you read about what photos are worth and how much you should charge, no one can set your fees for you. If you let someone try, you'll be setting yourself up for financial ruin. Figuring out what to charge for your work is a complex task that will require a lot of time and effort. But the more time you spend finding out how much you need to charge, the more successful you'll be at targeting your work to the right markets and getting the money you need to keep your business, and your life, going.

Keep in mind that what you charge for an image may be completely different from what a photographer down the street charges. There is nothing wrong with this if you've calculated your prices carefully. Perhaps the photographer works in a basement on old equipment and you have a brand new, state-of-the-art studio. You'd better be charging more. Why the disparity? For one thing, you've got a much higher overhead, the continuing costs of running

MODEL RELEASE

In consideration of \$ receipt of which is acknowle	dged I	· do		
hereby give his/her assigns, licensees, as				
legal representatives the irre- media and in all manners, inc advertising, trade, or any oth spect or approve the finished ated in connection therewith these photographs:	evocable right to use my cluding composite or dist her lawful purposes, and I product, including writt The following name ma	r image in all forms and orted representations, for I waive any rights to inen copy that may be creaty be used in reference to		
My real name, or				
Short description of photographs:				
Additional information:				
Please print:				
Name				
Address				
City	State	Zip code		
Country				
	CONSENT			
(If model is under the age of 1 above and have the legal aut foregoing and waive any righ	thority to execute the abo			
Please print:				
Name				
Address				
City	State	Zip code		
Country				
Signature		arandi a panta a		

TRANSPORTATION

Rainbows

Tornadoes

Tornado Damage

STOCK LIST

LANDMARKS Airplanes and helicopters INSECTS Asia Ants Roads Angkor Wat **Aphids** Country roads Great Wall of China Bees Dirt roads Interstate highways Beetles Europe Two-lane highways Butterflies Big Ben Grasshoppers Eiffel Tower Moths Louvre WEATHER **Termites** Stonehenge Clouds Wasps United States Cumulus Empire State Building Cirrus **PROFESSIONS** Grand Canyon Nimbus Bee Keeper Liberty Bell Stratus Biologist Mt. Rushmore Flooding Firefighter Statue of Liberty Lightning Snow and Blizzards Nurse Police Officer Storm Chasers

Truck Driver

Waitress

Welder

your business. You're also probably delivering a higher-quality product and are more able to meet client requests quickly. So how do you determine just how much you need to charge in order to make ends meet?

Setting your break-even rate

All photographers, before negotiating assignments, should consider their break-even rate—the amount of money they need to make in order to keep their studios open. To arrive at the actual price you'll quote to a client, you should add onto your base rate things like usage, your experience, how quickly you can deliver the image, and what kind of prices the market will bear.

Start by estimating your business expenses. These expenses may include rent (office, studio), gas and electric, insurance (equipment), phone, fax, Internet service, office supplies, postage, stationery, self-promotions/portfolio, photo equipment, computer, staff salaries, taxes. Expenses like film and processing will be charged to your clients.

Next, figure your personal expenses, which will include food, clothing, medical, car and home insurance, gas, repairs and other car expenses, entertainment, retirement savings and investments, etc.

Before you divide your annual expenses by the 365 days in the year, remember you won't be shooting billable assignments every day. A better way to calculate your base fee is by billable weeks. Assume that at least one day a week is going to be spent conducting office business and marketing your work. This amounts to approximately 10 weeks. Add in days for vacation and sick time, perhaps three weeks, and add another week for workshops and seminars. This totals 14 weeks of nonbillable time and 38 billable weeks throughout the year.

Now estimate the number of assignments/sales you expect to complete each week and multiply that number by 38. This will give you a total for your yearly assignments/sales. Finally, divide the total overhead and administrative expenses by the total number of assignments. This will give you an average price per assignment, your break-even or base rate.

As an example, let's say your expenses come to \$65,000 per year (this includes \$35,000 of personal expenses). If you complete two assignments each week for 38 weeks, your average price per assignment must be about \$855. This is what you should charge to break even on each job. But, don't forget, you want to make money.

Establishing usage fees

Too often, photographers shortchange themselves in negotiations because they do not understand how the images in question will be used. Instead, they allow clients to set prices and prefer to accept lower fees rather than lose sales. Unfortunately, those photographers who shortchange themselves are actually bringing down prices throughout the industry. Clients realize if they shop around they can find photographers willing to shoot assignments at very low rates.

There are ways to combat low prices, however. First, educate yourself about a client's line of work. This type of professionalism helps during negotiations because it shows buyers that you are serious about your work. The added knowledge also gives you an advantage when negotiating fees because photographers are not expected to understand a client's profession.

For example, if most of your clients are in the advertising field, acquire advertising rate cards for magazines so you know what a client pays for ad space. You can also find print ad rates in the Standard Rate and Data Service directory at the library. Knowing what a client is willing to pay for ad space and considering the importance of your image to the ad will give you a better idea of what the image is really worth to the client.

Pricing Information

· Where to find more information about pricing:

- Pricing Photography: The Complete Guide to Assignment and Stock Prices, by Michal Heron and David MacTavish (Allworth Press).
- ASMP Professional Business Practices in Photography, (Allworth Press).
- fotoQuote, a software package produced by the Cradoc Corporation, is a customizable, annually updated database of stock photo prices for markets from ad agencies to calendar companies. The software also includes negotiating advice and scripted telephone conversations. Call (800) 679-0202, or visit www.cradocfotosoftware.com for ordering information.
- Stock Photo Price Calculator, a website that suggests fees for advertising, corporate and editorial stock, http://photographersindex.com/stockprice. htm.
- EP (Editorial Photographers), www.editorialphoto.com.

For editorial assignments, fees may be more difficult to negotiate because most magazines have set page rates. They may make exceptions, however, if you have experience or if the assignment is particularly difficult or time-consuming. If a magazine's page rate is still too low to meet your break-even price, consider asking for extra tearsheets and copies of the issue in which your work appears. These pieces can be used in your portfolio and as mailers, and the savings they represent in printing costs may make up for the discrepancy between the page rate and your break-even price.

There are still more ways to negotiate sales. Some clients, such as gift and paper product manufacturers, prefer to pay royalties each time a product is sold. Special markets, such as galleries and stock agencies, typically charge photographers a commission of 20 to 50 percent for displaying or representing their images. In these markets, payment on sales comes from the purchase of prints by gallery patrons, or from fees on the "rental" of photos by clients of stock agencies. Pricing formulas should be developed by looking at your costs and the current price levels in those markets, as well as on the basis of submission fees, commissions, and other administrative costs charged to you.

Bidding for jobs

As you build your business, you will likely encounter another aspect of pricing and negotiating that can be very difficult. Like it or not, clients often ask photographers to supply bids for jobs. In some cases, the bidding process is merely procedural and the assignment will go to the photographer who can best complete it. In other instances, the photographer who submits the lowest bid will earn the job. When asked to submit a bid, it is imperative that you find out which bidding process is being used. Putting together an accurate estimate takes time, and you do not want to waste your efforts if your bid is being sought merely to meet some budget quota.

If you decide to bid on a job, it's important to consider your costs carefully. You do not want to bid too much on projects and repeatedly get turned down, but you also don't want to bid too low and forfeit income. When a potential client calls to ask for a bid, consider these dos and don'ts:

- **1.** Always keep a list of questions by the telephone so you can refer to it when bids are requested. The answers to the questions should give you a solid understanding of the project and help you reach a price estimate.
- **2.** Never quote a price during the initial conversation, even if the caller pushes for a "ballpark figure." An on-the-spot estimate can only hurt you in the negotiating process.
- **3.** Immediately find out what the client intends to do with the photos, and ask who will own copyrights to the images after they are produced. It is important to note that many clients believe if they hire you for a job they'll own all the rights to the images you create. If they insist on buying all rights, make sure the price they pay is worth the complete loss of the images.
- **4.** If it is an annual project, ask who completed the job last time, then contact that photographer to see what he or she charged.
- **5.** Find out who you are bidding against and contact those people to make sure you received the same information about the job. While agreeing to charge the same price is illegal, sharing information about reaching a price is not.
- **6.** Talk to photographers not bidding on the project and ask them what they would charge.
- **7.** Finally, consider all aspects of the shoot, including preparation time, fees for assistants and stylists, rental equipment, and other materials costs. Don't leave anything out.

FIGURING SMALL BUSINESS TAXES

Whether you make occasional sales from your work or you derive your entire income from your photography skills, it's a good idea to consult with a tax professional. If you are just starting out, an accountant can give you solid advice about organizing your financial records. If you are an established professional, an accountant can double-check your system and maybe find a few extra deductions. When consulting with a tax professional, it is best to see someone who is familiar with the needs and concerns of small business people, particularly photographers. You can also conduct your own tax research by contacting the Internal Revenue Service.

Self-employment tax

As a freelancer it's important to be aware of tax rates on self-employment income. All income you receive over \$400 without taxes being taken out by an employer qualifies as self-employment income. Normally, when you are employed by someone else, the employer shares responsibility for the taxes due. However, when you are self-employed, you must pay the entire amount yourself.

Freelancers frequently overlook self-employment taxes and fail to set aside a sufficient amount of money. They also tend to forget state and local taxes. If the volume of your photo sales reaches a point where it becomes a substantial percentage of your income, then you are required to pay estimated tax on a quarterly basis. This requires you to project the amount of money you expect to generate in a three-month period. However burdensome this may be in the short run, it works to your advantage in that you plan for and stay current with the various taxes you are required to pay. Read IRS publication #505 (Tax Withholding and Estimated Tax).

Deductions

Many deductions can be claimed by self-employed photographers. It's in your best interest to be aware of them. Examples of 100-percent-deductible claims include production costs of résumé, business cards and brochures; photographer's rep commissions; membership dues;

Tax Information

To learn more about taxes, contact the IRS. There are free booklets available that provide specific information, such as allowable deductions and tax rate structure:

For More Info

- Tax Guide for Small Businesses, #334
- Travel, Entertainment, Gift, and Car Expenses, #463
- Tax Withholding and Estimated Tax, #505
- Business Expenses, #535
- Accounting Periods and Methods, #538
- Business Use of Your Home, #587

To order any of these booklets, phone the IRS at (800)829-3676. IRS forms and publications, as well as answers to questions and links to help, are available on the Internet at www.irs.gov.

costs of purchasing portfolio materials; education/business-related magazines and books; insurance; and legal and professional services.

Additional deductions can be taken if your office or studio is home-based. The catch here is that your work area must be used only on a professional basis, your office can't double as a family room after hours. The IRS also wants to see evidence that you use the work space on a regular basis via established business hours and proof that you've actively marketed your work. If you can satisfy these criteria, then a percentage of mortgage interests, real estate taxes, rent, maintenance costs, utilities, and homeowner's insurance, plus office furniture and equipment, can be claimed on your tax form at year's end.

In the past, to qualify for a home-office deduction, the space you worked in had to be "the most important, consequential, or influential location" you used to conduct your business. This meant that if you had a separate studio location for shooting but did scheduling, billing and record keeping in your home office, you could not claim a deduction. However, as of 1999, your home office will qualify for a deduction if you "use it exclusively and regularly for administrative or management activities of your trade or business and you have no other fixed location where you conduct substantial administrative or management activities of your trade or business." Read IRS publication #587, Business Use of Your Home, for more details.

If you are working out of your home, keep separate records and bank accounts for personal and business finances, as well as a separate business phone. Since the IRS can audit tax records as far back as seven years, it's vital to keep all paperwork related to your business. This includes invoices, vouchers, expenditures and sales receipts, canceled checks, deposit slips, register tapes, and business ledger entries for this period. The burden of proof will be on you if the IRS questions any deductions claimed. To maintain professional status in the eyes of the IRS, you will need to show a profit for three years out of a five-year period.

Sales tax

Sales taxes are complicated and need special consideration. For instance, if you work in more than one state, use models or work with reps in one or more states, or work in one state and

store equipment in another, you may be required to pay sales tax in each of the states that apply. In particular, if you work with an out-of-state stock photo agency that has clients over a wide geographic area, you should explore your tax liability with a tax professional.

As with all taxes, sales taxes must be reported and paid on a timely basis to avoid audits and/or penalties. In regard to sales tax, you should:

- Always register your business at the tax offices with jurisdiction in your city and state.
- Always charge and collect sales tax on the full amount of the invoice, unless an exemption applies.
- If an exemption applies because of resale, you must provide a copy of the customer's resale certificate. If an exemption applies because of other conditions, such as selling one-time reproduction rights or working for a tax-exempt, nonprofit organization, you must also provide documentation.

SELF-PROMOTION

There are basically three ways to acquaint photo buyers with your work: through the mail, over the Internet, or in person. No one way is better or more effective than another. They each serve an individual function and should be used in concert to increase your visibility and, with a little luck, your sales.

Self-promotion mailers

When you are just starting to get your name out there and want to begin generating assignments and stock sales, it's time to design a self-promotion campaign. This is your chance to do your best, most creative work and package it in an unforgettable way to get the attention of busy photo buyers. Self-promotions traditionally are sample images printed on card stock and sent through the mail to potential clients. If the image you choose is strong and you carefully target your mailing, a traditional self-promotion can work.

But don't be afraid to go out on a limb here. You want to show just how amazing and creative you are, and you want the photo buyer to hang onto your sample for as long as possible. Why not make it impossible to throw away? Instead of a simple postcard, maybe you could send a small, usable notepad with one of your images at the top, or a calendar the photo buyer can hang up and use all year. If you target your mailing carefully, this kind of special promotion needn't be expensive.

If you're worried that a single image can't do justice to your unique style, you have two options. One way to get multiple images in front of photo buyers without sending an overwhelming package is to design a campaign of promotions that builds from a single image to a small group of related photos. Make the images tell a story and indicate that there are more to follow. If you are computer savvy, the other way to showcase a sampling of your work is to point photo buyers to an online portfolio of your best work. Send a single sample that includes your Internet address, and ask buyers to take a look.

Websites

Websites are steadily becoming more important in the photographer's self-promotion repertory. If you have a good collection of digital photographs—whether they have been scanned from film or are from a digital camera—you should consider creating a website to showcase samples of your work, provide information about the type of work you do, and display your contact information. The website does not have to be elaborate or contain every photograph you've ever taken. In fact, it is best if you edit your work very carefully and choose only the best images to display on your website. The benefit of having a website is that it makes it so easy for photo buyers to see your work. You can send e-mails to targeted photo buyers and include a link to your website. Many photo buyers report that this is how they prefer to be contacted. Of course, your URL should also be included on any

Ideas for Great Self-Promotion

For More Info

Where to find ideas for great self-promotion:

- HOW magazine's self-promotion annual (October issue).
- Photo District News, magazine's self-promotion issue (October issue).
- The Photographer's Guide to Marketing & Self-Promotion, by Maria Piscopo (Allworth Press).
- The Business of Photography: Principles and Practices, by Mary Virginia Swanson, available at www.mvswanson.com.

print materials, such as postcards, brochures, your business cards, and stationery. Some photographers even include their URL in their credit line.

Portfolio presentations

Once you've actually made contact with potential buyers and piqued their interest, they'll want to see a larger selection of your work—your portfolio. Once again, there's more than one way to get this sampling of images in front of buyers. Portfolios can be digital—stored on a disk or CD-ROM, or posted on the Internet. They can take the form of a large box or binder and require a special visit and presentation by you. Or they can come in a small binder and be sent through the mail. Whichever way(s) you choose to showcase your best work, you should always have more than one portfolio, and each should be customized for potential clients.

Keep in mind that your portfolios should contain your best work (dupes only). Never put originals in anything that will be out of your hands for more than a few minutes. Also, don't include more than twenty images. If you try to show too many pieces you'll overwhelm the buyer, and any image that is less than your best will detract from the impact of your strongest work. Finally, be sure to show only work a buyer is likely to use. It won't do any good to show a shoe manufacturer your shots of farm animals or a clothing company your food pictures. For more detailed information on the various types of portfolios and how to select which photos to include and which ones to leave out, see *Photo Portfolio Success*, by John Kaplan (Writer's Digest Books).

Do you need a résumé?

Some of the listings in this book say to submit a résumé with samples. If you are a freelancer, a résumé may not always be necessary. Sometimes a stock list or a list of your clients may suffice, and may be all the photo buyer is really looking for. If you do include a résumé, limit the details to your photographic experience and credits. If you are applying for a position teaching photography or for a full-time photography position at a studio, corporation, newspaper, etc., you will need the résumé. Galleries that want to show your work may also want to see a résumé, but, again, confine the details of your life to significant photographic achievements.

ORGANIZING & LABELING YOUR IMAGES

It will be very difficult for you to make sales of your work if you aren't able to locate a particular image in your files when a buyer needs it. It is imperative that you find a

way to organize your images—a way that can adapt to a growing file of images. There are probably as many ways to catalog photographs as there are photographers. However, most photographers begin by placing their photographs into large, general categories such as landscapes, wildlife, countries, cities, etc. They then break these down further into subcategories. If you specialize in a particular subject—birds, for instance—you may want to break the bird category down further into cardinal, eagle, robin, osprey, etc. Find a coding system that works for your particular set of photographs. For example, nature and travel photographer William Manning says, "I might have slide pages for Washington, DC (WDC), Kentucky (KY), or Italy (ITY). I divide my mammal subcategory into African wildlife (AWL), North American wildlife (NAW), zoo animals (ZOO)."

After you figure out a coding system that works for you, find a method for naming your digital files or captioning your slides. Images with complete information often prompt sales: Photo editors appreciate having as much information as possible. Always remember to include your name and copyright symbol © on each image. If you're working with slides, computer software can make this job a lot easier. Programs such as Caption Writer (www. hindsightltd.com); allow photographers to easily create and print labels for their slides.

The computer also makes managing your photo files much easier. Programs such as FotoBiz (www.cradocfotosoftware.com) and StockView (www.hindsightltd.com) are popular with freelance assignment and stock photographers. FotoBiz has an image log and is capable of creating labels. FotoBiz can also track your images and allows you to create documents such as delivery memos, invoices, etc. StockView also tracks your images, has labeling options, and can create business documents.

PROTECTING YOUR COPYRIGHT

There is one major misconception about copyright: Many photographers don't realize that once you create a photo it becomes yours. You (or your heirs) own the copyright, regardless of whether you register it for the duration of your lifetime plus 70 years.

The fact that an image is automatically copyrighted does not mean that it shouldn't be registered. Quite the contrary. You cannot even file a copyright infringement suit until you've registered your work. Also, without timely registration of your images, you can only recover actual damages—money lost as a result of sales by the infringer plus any profits the infringer earned. For example, recovering \$2,000 for an ad sale can be minimal when weighed against the expense of hiring a copyright attorney. Often this deters photographers from filing lawsuits if they haven't registered their work. They know that the attorney's fees will be more than the actual damages recovered, and, therefore, infringers go unpunished.

Registration allows you to recover certain damages to which you otherwise would not be legally entitled. For instance, attorney fees and court costs can be recovered. So too can statutory damages—awards based on how deliberate and harmful the infringement was.

Image Organization & Storage

To learn more about selecting, organizing, labeling and storing images, see:

- · Photo Portfolio Success, by John Kaplan (Writer's Digest Books).
- For More Info

 Sell & Re-Sell Your Photos, by Rohn Engh, 5th edition (Writer's Digest Books).

Statutory damages can run as high as \$100,000. These are the fees that make registration so important.

In order to recover these fees, there are rules regarding registration that you must follow. The rules have to do with the timeliness of your registration in relation to the infringement:

- Unpublished images must be registered before the infringement takes place.
- **Published images** must be registered within three months of the first date of publication or before the infringement began.

The process of registering your work is simple. Visit the United States Copyright Office's website at www.copyright.gov to file electronically. Registration costs \$35, but you can register photographs in large quantities for that fee. For bulk registration, your images must be organized under one title, for example, "The works of John Photographer, 2009–2011." It's still possible to register with paper forms, but this method requires a higher filing fee (\$65). To request paper forms, contact the Library of Congress, Copyright Office–COPUBS, 101 Independence Avenue, SE, Washington, DC 20559-6304, (202) 707-9100, and ask for Form VA (works of visual art).

The copyright notice

Another way to protect your copyright is to mark each image with a copyright notice. This informs everyone reviewing your work that you own the copyright. It may seem basic, but in court this can be very important. In a lawsuit, one avenue of defense for an infringer is "innocent infringement"—basically the "I-didn't-know" argument. By placing a copyright notice on your images, you negate this defense for an infringer.

The copyright notice basically consists of three elements: the symbol, the year of first publication, and the copyright holder's name. Here's an example of a copyright notice for an image published in 2011: © 2011 John Q. Photographer. Instead of the symbol ©, you can use the word "Copyright" or simply "Copr." However, most foreign countries prefer © as a common designation.

Also consider adding the notation "All rights reserved" after your copyright notice. This phrase is not necessary in the U.S. since all rights are automatically reserved, but it is recommended in other parts of the world.

Know your rights

The digital era is making copyright protection more difficult. As this technology grows, more and more clients will want digital versions of your photos. Don't be alarmed, just be careful. Your clients don't want to steal your work. When you negotiate the usage of your work, consider adding a phrase to your contract that limits the rights of buyers who want digital versions of your photos. You might want them to guarantee that images will be removed from their computer files once the work appears in print. You might say it's okay to perform limited digital manipulation, and then specify what can be done. The important thing is to discuss what the client intends to do and spell it out in writing.

It's essential not only to know your rights under the Copyright Law, but also to make sure that every photo buyer you deal with understands them. The following list of typical image rights should help you in your dealings with clients:

- One-time rights. These photos are "leased" or "licensed" on a one-time basis; one fee is paid for one use.
- **First rights.** This is generally the same as purchase of one-time rights, though the photo buyer is paying a bit more for the privilege of being the first to use the image. He may use it only once unless other rights are negotiated.
- **Serial rights.** The photographer has sold the right to use the photo in a periodical. This shouldn't be confused with using the photo in "installments." Most magazines will want to be sure the photo won't be running in a competing publication.

Protecting Your Copyright

How to learn more about protecting your copyright:

- Call the United States Copyright Office at (202)707-3000 or check out their website, www.copyright.gov, for answers to frequently asked questions.
- ASMP (American Society of Media Photographers), www.asmp.org/ tutorials/copyright-overview.html.
- EP (Editorial Photographers), www.editorialphoto.com.
- · Legal Guide for the Visual Artist, by Tad Crawford, Allworth Press.
- SPAR (Society of Photographers and Artists Representatives), www.spar. org.
- Exclusive rights. Exclusive rights guarantee the buyer's exclusive right to use the photo in his particular market or for a particular product. A greeting card company, for example, may purchase these rights to an image with the stipulation that it not be sold to a competing company for a certain time period. The photographer, however, may retain rights to sell the image to other markets. Conditions should always be put in writing to avoid any misunderstandings.
- **Electronic rights.** These rights allow a buyer to place your work on electronic media such as CD-ROMs or websites. Often these rights are requested with print rights.
- **Promotion rights.** Such rights allow a publisher to use a photo for promotion of a publication in which the photo appears. The photographer should be paid for promotional use in addition to the rights first sold to reproduce the image. Another form of this—agency promotion rights—is common among stock photo agencies. Likewise, the terms of this need to be negotiated separately.
- Work for hire. Under the Copyright Act of 1976, section 101, a "work for hire" is defined as: "(1) a work prepared by an employee within the scope of his or her employment; or (2) a work . . . specially ordered or commissioned for use as a contribution to a collective, as part of a motion picture or audiovisual work or as a supplementary work . . . if the parties expressly agree in a written instrument signed by them that the work shall be considered a work made for hire."
- All rights. This involves selling or assigning all rights to a photo for a specified period of
 time. This differs from work for hire, which always means the photographer permanently
 surrenders all rights to a photo and any claims to royalties or other future compensation.
 Terms for all rights—including time period of usage and compensation—should only be
 negotiated and confirmed in a written agreement with the client.

It is understandable for a client not to want a photo to appear in a competitor's ad. Skillful negotiation usually can result in an agreement between the photographer and the client that says the image(s) will not be sold to a competitor, but could be sold to other industries, possibly offering regional exclusivity for a stated time period.

Finding Your Niche

by Vik Orenstein

ere's another paradox, in a field fraught with paradoxes," says wedding/portrait photographer Bob Dale. "You should start out shooting everything. You should be a generalist. That's how you learn. But then you have to narrow it down. The market demands that you choose a specialty."

Says commercial/fine art shooter Leo Kim, "You have to find your own personal style before you can select a niche. You will start out emulating the visual styles of others whose work you admire. But sooner or later, your true self comes out. It has to. Then you will choose your niche accordingly."

In the good old days, when markets were smaller, a photographer used to be able to be a generalist. He could shoot a little tabletop, a little fashion, a little food, a little architecture. He was considered perfectly respectable if he shot a portrait in the morning and a building in the afternoon. But now in order to be successful, he has to specialize. If you're a food photographer, you shoot food. If you're a fashion photographer, you shoot fashion. Period. Nowadays, markets are larger and there's room to support specialty shooters, so if clients suspect that you'll shoot anything, you might seem desperate to them. They are looking for a photographer who feels as passionate about their subject matter as they do.

"I don't want to hire someone who shoots candy and girls," says an architect who often hires photographers to shoot his building projects. "I won't hire anyone who has anything other than architecture in his portfolio."

Says Patrick Fox, "We've been forced to specialize to a ridiculous degree. It's come to the point where you're not just limited to one specialty, you have to shoot one look or one technique within that specialty."

In smaller markets, your neighborhood generalist is probably still respected. But the larger the market you shoot in, the more specialized you'll be forced to be. So when choosing a niche, consider what you like to shoot. Who and what is your lens drawn to?

"You have to shoot selfishly to be successful. Shoot what interests you," advises Doug Beasley.

VIK ORENSTEIN is a photographer, writer, and teacher. She founded KidCapers Portraits in 1988, followed by Tiny Acorn Studio in 1994. In addition to her work creating portraits of children, she has photographed children for such commercial clients as Nikon, Pentax, Microsoft, and 3M. Vik teaches several photography courses at BetterPhoto. com.

Excerpted from *The Photographer's Market Guide to Building Your Photography Business* © 2010 by Vic Orenstein. Used with the kind permission of Writer's Digest Books, an imprint of F+W Media Inc. Visit writersdigestshop.com or call (800)448-0915 to obtain a copy.

An editorial fashion shot for Minnesota Bride Magazine by Lee Stanford.

Jim Miotke, author, photographer, and founder of BetterPhoto.com, agrees, "Follow your bliss, and the prosperity will come. It's an organic process. You learn about yourself as you learn to shoot, and ultimately it all comes together."

The sentiment is shared by Patrick Fox, who adds, "You have to love what you do—this business is too tough and too stressful if you don't."

But don't you have to consider your market, too? What if you want to specialize in baby portraits but you live in a retirement community?

"Then you move," says Patrick.

"You have to create a balance," says Lee Stanford. "You have to weigh your interests against your market and figure them both together when you're deciding on a niche. Because, yes, you'll be miserable if you choose an area you dislike to shoot in, but if you never shoot because there are no clients who need your work, then you'll be miserable, too."

Personally, I like to advise aspiring photographers to "shoot what you shoot"—in other words, to find a niche in the area of specialty in which they shoot for their own pleasure. For instance, I love to travel, and I love architecture, and I love nature. But when I went to Thailand for the very first time in 1994 and immersed myself in awe-inspiring temples and wildlife and landscapes, 70 percent of the images I came home with were of children. In the

A classic example of a shot from the travel niche by Brenda Tharp.

market, in the street, in the airports, at elephant camp, I'd taken more images of kids than of anything else. My travel companion commented, "I'm so glad for you that you're in the right career! But a few more landscape shots would have been nice."

But Jim Miotke advises not to be afraid to pay your dues. "Even Ansel Adams had to shoot portraits," he points out. "Avedon, Warhol, all those guys started out shooting portraits and commercial stuff."

So while you're busy following your bliss (swimsuit models) be realistic about your market (executive portraits). Assist, interview or observe people from different disciplines.

Personally speaking, I love shooting portraits so much I sincerely doubt I'd still be in the business if I had tried to force myself to shoot something else. I have assisted architectural photographers; I shot a little product (not very well) when I was starting out and afraid to say no to any kind of business whatsoever; and I shot actors' and models' head shots for several years. But none of that stoked my passion like portraits, especially portraits of kids and their families and pets. I believe I'd be long gone from the industry had I tried to make myself shoot anything else. It's not that I don't *love* looking at all types of images. I am deeply moved by the amazing nature, travel, photojournalistic, fashion, and other images my colleagues make. But when I shoot, I shoot portraits.

THE OLD NICHES

Certain specialties come to mind when you're thinking about photography. For example, wedding, event, editorial, fashion, commercial, product, food, tabletop, portrait, fine art, and sports. They all have their perks and pitfalls. For example, wedding photography requires the toting around of many pounds of equipment (Stormi Greener's minimum field pack weighs 30 pounds). You also many be forced to go eight or more hours without using a restroom, because in the wedding biz you don't get do overs! All in all, it can be very physically demanding. In contrast, a commercial photographer's clients come to him. So that means minimal equipment hauling, but it also means incurring the fixed overhead of a studio large

An editorial image for The Minneapolis Children's Theater Company by Rob Levine.

An example of a senior portrait by Vik Orenstein. This is an important niche for portrait photographers, because the demand for high-end, creatively rendered portraits of high school graduates is growing.

enough to accommodate large sets and backdrops, and large products (like cars, for instance).

Each niche is demanding in its own way. That's why when choosing a specialty it's important to ask yourself not just "Which area pays the most?" but also "Am I athletic enough to cart my equipment around and am I really that into weddings?" and/or "Do I have the bankroll and the nerve to own a large studio?"

THE NEW NICHES

Digital technology has opened up several new niches, many of which don't require a huge financial commitment. In many businesses, such as real estate, portraiture, e-commerce, retail, and desktop publishing, there is a demand for inexpensive images shot with high-end consumer-grade digital cameras. The drawback is that if you enter this niche, you'll be competing with every other aspiring photographer who has a DSLR.

Another new arena is "lifestyle photography." Lifestyle refers to a style of photography rather than to a specific niche. It describes commercial, portrait, and wedding images that are made to appear candid or

A fine art image created by Kathleen Carr with a DSLR that was converted to infrared, and colored by the photographer.

photojournalistic in execution. "But," says Lee Stanford, "it takes a huge amount of setup to get those candid looking lifestyle shots."

MAKING YOUR OWN NICHE

I've never liked competition. I've always thought that if there were people already doing something, I should do something else. When I opened my first studio, everyone was still generalizing in my regional market. There was no one positioning themselves exclusively as a kid expert or as an exclusive expert of anything, for that matter, because common wisdom still held that if you specialized you'd lose out on a lot of work. But I figured I'd rather have a bigger portion of a small area than a small portion of a large area. Besides, I enjoyed shooting kids and not much else. In calling my studio KidShooters (now called KidCapers) and shooting kids and their families only, I didn't realize I had created a new niche or even that I was positioning myself within my market. I was just trying to do what I loved. I was lucky. It turned out that 1988 was a great year to start a kids' portrait studio. In addition to my portrait clients, national clients who wanted me to shoot their commercial work that involved kids began to call. This was a perk that took me totally by surprise. I got to shoot for Pentax, Nikon, 3M, Hormel, Microsoft, and more. I believe I would never have been considered for these jobs if I hadn't established myself as a shooter who was all kids, all the time.

You can create your own niche, too. Learn as much as you can about the existing ones, and zero in on the things about them you like. For instance, let's say you love pets and you'd like nothing better than to make a living photographing them. But you think, "There isn't a big enough market in my city to draw a large enough client base to support myself doing pet portraits. And who is going to pay me big bucks for a picture of their dog, anyway?"

But wait. Think about this. Sure, it might be difficult to make your living on pet portraits alone. But who else besides pet owners need photos of pets? A little research will reveal that there are breeders in your area who sell puppies and kittens online and need to

Hilary Bullock is a wedding photographer with over 20 years of experience. While she has adapted the best of new technology and creative techniques into her work over the years, her signature style is still classic and distinctive

regularly update their website images as the animals grow. Normally they might take a puppy and place him on their couch and shoot a directflash snapshot. But who's to say you couldn't convince them to hire you to come to their home once a week from the birth of that puppy until its sale and provide gorgeous available-light shots on pretty backdrops? And puppy and kitten images sell really well for stock. So there are two possible buyers for the same images right there. Then consider that perhaps the family who purchases the puppy from the breeder might like to purchase a collage from you. Perhaps six to eight images from the puppy's first weeks of life? (Maybe they'd like to upgrade to a framed piece or add greeting cards or "baby announcements.") Now you have three potential buyers for the same images. While you're at it, research the other professionals who come in contact with these puppies. I can think of pet groomers, trainers, and veterinarians to

start. These folks might also want to show off images of their furry little clients. Or they may appreciate having a trusted photographer to refer their clients to. Now you have four, five, or six potential buyers for the same images, and this is starting to look like a living. And to think you almost didn't even try because you thought your little niche wasn't viable!

HOW TO BE SUCCESSFUL IN MULTIPLE NICHES

You may be a very well-rounded individual who feels passionate about shooting in two or even more different specialties. Or you may find that the market for your chosen specialty is drying up, getting flooded with competitors or simply hasn't turned out to be all it was cracked up to be. How can you get a toehold in a different area without losing the clients in your original field?

Be sneaky! Have different books (portfolios) for each specialty. Have different business cards, letterhead, invoices, and promotional pieces. Keep your studio name noncommittal, like, "Joe's Photography," and not specific, like "Joe's Portraits, Food, Landscape, and Product Studio."

Pay attention to the work you show in your studio. If you're shooting for a portrait client today, have only examples of your portrait work on the walls. Shooting a product? Display only product shots. And don't flap your jaw about your product shots to you portrait clients,

A macro botanical photograph by Maria Mosolova.

or visa versa. If worlds collide and a client finds out about your other specialty, don't deny it, Just say, "Oh sure, didn't you know about that?"

And for goodness sake, don't mix up your clients by being a graphic designer who also shoots, or a photographer who also designs. Since the advent of the digital camera, I've noticed a number of listings in the yellow pages for "Joe's Photography and Design." When a savvy client sees that, she'll probably just conclude (and she might be right) that you're a designer with a camera and not enough to do.

So you have your work cut out for you—to choose a niche that holds both enjoyment and marketability for you. Seems like a tall order. But every successful photographer I interviewed either knew going into the business what they wanted to shoot or found that it all fell into place for them after a little thrashing about.

"Finding your niche is like falling in love," says architectural shooter Karen Melvin. "Once you find it, you know it's right."

BETH WALD: THE DANGLING WOMAN

Beth Wald created a very interesting, highly targeted niche for herself when she became a mountain- and rock-climbing photographer. She literally shoots while dangling from a rope over a 2,000-foot drop.

"It was a great time to start in this niche, because there weren't many other people doing it," she says (and I suspect that might be something of an understatement). "There were other climbers who would carry a snap shooter and take a few snapshots, but when you're climbing you don't want to be carrying a big lens and camera body with you. I was one of the few who would take the time to set up a shot—find the right angle, the right time of day for the light."

Rock and mountain climbing were enjoying new popularity, with more and more magazines and catalogs to sell to.

It's hard enough having to think about lighting, exposure, and composition on a shoot, let alone doing all this while hanging from a rope. I wondered if Beth had ever been in dan-

A wildlife shot by Brenda Tharp.

ger as a consequence of combining her two passions of climbing and photography.

"Yes, I've been in dangerous situations," she says, without hesitation. "Now that I'm established, when I go out on a shoot for a commercial client, I hire a rigger who sets the ropes, and I don't have to worry about that aspect. But in the beginning it was hard to talk clients into budgeting for a rigger, so I was out there alone.

"Once I was in Nepal with a famous French mountain climber, and it was all ice. I use devices to go up the ropes—it's hard to explain to someone who doesn't climb—and these devices would slip on the icy ropes."

What led her into such a refined—and potentially danger-ous—niche?

"Necessity! I wanted to figure out a way to make a living climbing—that was my first passion. Photography became my second. I was just out of college and had decided against a scientific career—I'd studied ecology, plants, botany, because I thought it would be a

great way to be in the mountains, but I discovered that was not the case. Most botanists are only in the field about one month out of the year.

"Now photography has become my first passion, and climbing my second."

She considered whether there is still a place in this narrow niche for newcomers in this unstable economic market. "It's a tough market. But I think it's incredibly important for people to get out there and create great images. There's always a place for talent."

So you need to find yourself a niche—the smaller and more focused, the better. But you also need to be flexible within the parameters of your specialty.

The business and creative models are changing constantly, so you need to be willing to change constantly, too. You must find ways to make great assignments happen. If you wait for them to come to you, you'll be waiting forever. You have to be passionate about the business and apply your creativity to it. Find new ways to get jobs, and get money to finance the jobs.

For instance, I did a shoot in Afghanistan for *Smithsonian Magazine*. The writer and I got together and pitched the story to the magazine. Magazines almost never consider proposals from writer/photographer teams—only from writers. They prefer to assign the photographers themselves. They told me outright that they'd never consider a pitch from a photographer. But we made that job happen. We had to combine several assignments to do it—*Smithsonian* couldn't afford to send us to Afghanistan. So we piggybacked a story for *Sierra Magazine*, and we got a small grant, and it all came together. So I say, "Never say never."

A blend of a botanical and a nude, this image seems to defy categorization. Jim Zuckerman calls this a "fantasy nude."

JIM ZUCKERMAN: A JIM OF ALL TRADES (AND MASTER OF THEM ALL!)

Photographer, author and teacher Jim Zuckerman is an exception (with a capital E) to the common wisdom regarding specializing. Jim doesn't limit himself to any particular market, subject, style or niche. A look at his website reveals images categorized by such varied heads as impressionism, conceptual, fine art, travel fantasies, natural life, and people and cultures—to name just a few. He is equally at ease creating classic straight up nature shots as he is creating images that are digitally manipulated to portray dinosaurs sunbathing or unicorns rearing in front of bolts of lightning.

What's up with this, Jim? I thought we were supposed to specialize?

Most successful photographers do. I don't. I know a photographer who does nothing but shoot diamonds—he flies all over the world to do it. Another one makes tens of thousands of dollars just shooting baby clothes on a white backdrop because his clients like the way he arranges the clothes. But I shoot everything.

Should an aspiring professional photographer specialize or be a generalist? (*Reluctantly*) Probably, he should specialize. Yes.

But you don't. So how, for instance, did you wind up making surrealistic images? Did you know there was a market for this?

No, I didn't. I did this series of images using mannequin heads. I was told not to shoot that, that it would never sell. So I submitted some of them to *OMNI* magazine, and they sold. They bought five covers in seven months. You see, the deal is this. No matter what you shoot, you have to go out and market it. No matter if you specialize or generalize. Constantly! Perpetually! You never stop moving! Before websites, this was harder, because you had to literally go out and see people. I alleviated some of this by sending out proposals via the old-fashioned postal service. Now with e-mail it's even easier. And people go to your website instead of asking for your book.

You sell a lot of stock images. Is it perhaps a little easier to be a generalist in this market than, say, in assignment work?

Yes, I think so. Because when people are buying your work from a stock agency, they're not buying your name or your reputation, they're just buying your image. They don't care if you're a big name or a small name. They don't care where you went to school. They just want that image. That's what makes stock almost a must for new photographers. Because they're on a level playing field with established photographers like you and me.

So do you shoot what sells, or do you sell what you shoot?

I do both. I shoot what I love, but I also ask my editors (at my stock agencies) what they need. Ten years ago an editor told me they needed images of a worker fixing an air conditioner and of a lady being helped out of a limousine. So I said, "Oh, okay." So I went out and I hired models and I rented a limo and I spent a half a day and I shot it. Today, ten years later, these images still sell three to four times a month for \$300 or \$400. That's not bad for a half day's work!

And you didn't even have to market those!

No! That's the other beautiful thing about stock. Your agencies do the marketing for you!

JENNIFER WU: A NICHE FOR ALL SEASONS

Photographer and teacher Jennifer Wu has done a fair share of niche hopping. Now a nature photographer with a subspecialty in amazing images of stars and the night sky, Jennifer started out in photography shooting food and tabletop after majoring in photography in college.

What kinds of food did you shoot?

First, it was gooey desserts. I was eating them for breakfast! Then I got a seafood company, so that was good. I got to eat seafood. Mostly I did the styling myself, but sometimes I worked with a food stylist.

A classic landscape shot by Jennifer Wu (left). Wu has created a highly specialized niche for herself—shooting starry skies (below).

How did you get these clients? Did you market yourself specifically to food companies?

No! These jobs just came to me—they were referred to me by my school—people who were looking for students and former students to shoot for them inexpensively.

Did you like shooting food?

Not really. For me, there was no expression, no life to capture. So then I switched to weddings. In 1993, I shot around forty weddings.

That's a lot of weddings! Did those come as referrals from the school again?

Yes, so of course they were looking for someone inexpensive, as with the food. When I started out, I was shooting a whole wedding for \$300. I knew I should raise my prices, but it was when I went to a wedding fair that it really became real—I saw photographers with booths there who charged thousands of dollars. So over the course of a year I raised my prices until a wedding was \$3,000.

Wow! That's a big increase in such a short time.

Yes. It was hard at first because I felt insecure. But I was tired of working so hard for so little. I lost a couple of prospects when my prices went up but not many.

Then you switched niches again—from weddings to landscape and nature. Why did you make that change?

Because nature is so beautiful!

And you've been successful in your nature niche! Canon features one of your night sky/star images in a brochure! So which niche has been the most rewarding for you?

Oh, nature! Certainly! But the most lucrative is weddings. If someone wants to make a lot of money, I would say, "shoot weddings!"

KATHLEEN CARR: CASUAL FRIDAY MEANS WEAR YOUR HULA SKIRT TO WORK

Kathleen Carr loved photography from the time she was big enough to hold her father's Brownie camera in her hands. Yet she still didn't consider it as a profession until, as an art major in college, she took a fine art photography course—and she was hooked.

Though she worked as a photographer all over the world and even had her first book of photographs published in 1975, it took her until 1990 to really zero in on her true calling.

"Up 'til then I shot everything: events, weddings, births, portraits, dogs, horses, photojournalism, publicity, you name it. But in 1990, I was diagnosed with cancer. That made me take stock of my life. I realized I didn't want to do commercial photography anymore. I just wanted to express my creative vision. I started out with my Polaroid transfers, which galleries picked up and sold very well. I loved the medium so much, I didn't want it to be just a passing fad. I wanted it to be a movement! So I wrote a book about it, and I put on some workshops, and they were packed! I went on to manipulated Polaroids and wrote another book. A year after that one came out, Polaroid stopped making the film. Imagine what that did for book sales!"

Just as she has done with many of her images and various mediums, Kathleen hand colors her art prints. (She works both by hand on the print and on the computer.) These days she is working heavily in digital infrared. Since this is an ethereal, finely textured look that originated with infrared film and regular digital capture can't do it, she has had two digital camera bodies converted to shoot it.

Kathleen now lives in Hawaii full-time and teaches photography online and at her own retreats and workshops, and she also leads photo tours and even swims with dolphins.

"Teaching is also a passion of mine," she says. "Working in cooperation and being of service, and experiencing camaraderie,—that's all a part of creating art for me."

A few of these brave souls forged original niches. A few went into established niches and bent them to their own will. And one, Jim Zuckerman, seems to be the exception to the rule. He shoots in a huge variety of specialties. Whatever niche (or niches) you choose to work in, ultimately your level of satisfaction and your level of success will depend very much on the amount of effort and passion you put into you work. Like most everything else in life, you will get out what you put in.

ARTICLES & INTERVIEWS

Robb Siverson

Finding Inspiration in Everyday Experiences and the Landscape of the Northern Plains

Photo by Cierra Abell

photographic jack-of-all-trades, Robb Siverson might be found shooting digital aerial photography for corporate advertisers, taking traditional large-format photographs of the landscape near his home in Fargo, North Dakota, or working in a local commercial camera store. Although he prefers black-and-white silver halide processes, Siverson is also completely comfortable with digital processes, which he uses for both commercial and color work. He has found that this flexibility has allowed him to eke out a comfortable living and pursue his art photography. Siverson explains, "My commercial photography helps keep the paychecks coming in at a steady pace. I'm not ashamed to work with other forms of photography to make a living."

Born in Grand Forks, North Dakota, Siverson completed his B.A. in photography at Minnesota State University, Moorhead, and has since settled in Fargo, North Dakota. Having spent all of his life in the Northern Plains region of the U.S., he is the first to admit the influence it has had on his work: "The landscape that surrounds me and has surrounded me my entire life is a huge influence on my work. If an artist's everyday surroundings do not inspire him, how can he make good art?" Siverson explains, "In the last two years most of my negatives have been made within an hour of my home. I love the Northern Plains. This is my native landscape, my home." His passion for his subject shows through in his beautiful photographs of his surroundings.

While Siverson says he's still waiting for his first "big break," he continues working, dreaming, and shooting and printing photographs. Here Siverson describes his working process, reveals the ups and downs of being a freelance photographer, and shares his dreams for the future.

When did you know you wanted to be a photographer?

I originally went to college to earn an associate's degree in human resources. Half way through completing my degree, I stumbled across a basic photography class and enrolled the following semester. I was hooked after the first assignment and haven't stopped taking photographs since. My instructor liked my enthusiasm and asked me to be a teacher's assistant the following semester. Before I graduated, I already knew I was going to go back to school to study fine art photography.

How would you describe your photography?

I do such a wide variety of work within the photographic industry that it is hard to describe "my photography." Recently I was interviewed for a photography magazine out of Paris, and the writer indicated in the article that I was a photographic jack-of-all-trades, and I agree that is a good way to describe my work. That said, I truly get the most enjoyment out of

Alone Tree. Siverson describes the day he shot this photo: "I was on a commission shoot in the middle of North Dakota, photographing a hunter's property when I discovered this old tree. It felt like the middle of nowhere at the time. It was negative 22 degrees Fahrenheit that day." You can see more of Siverson's work on his website www. robbsiverson.com.

traditional processing. Whether I am working in my darkroom on straight black-and-white printing or bromide staining, having physical control over my work is something I enjoy. However, I am not immune to the decline in this industry. I have been working part-time in a retail camera store for ten years, so I feel very comfortable behind a digital camera and know that industry as well. I work digitally for both commercial and color work. I am also fortunate enough to have studied fine art photography at a university that taught many alternative, turn-of-the-century processes, some of which I only studied in college, some I still use, and some that I hope to explore more in the future. Photography is an interesting medium to me because of the vast array of processes.

Cypress Trees. Siverson took this photograph in the Everglades. While he was shooting, he discovered a water moccasin next to his tripod. Fortunately, there was a happy ending to this potentially dangerous encounter. Siverson explains, "I moved away slowly without incident."

What are your working methods and how did you develop them?

Since 2004 I've shot most of my personal work with a 4x5 view camera. I personally craft my images from start to finish, using traditional darkroom processing methods. I hand process my negatives and photographs in the darkroom using chemistry and spend countless hours dancing around, dodging and burning, and creating photographs by hand. I then go through the process of spotting and pressing the photographs to prepare them for framing, which I also do myself.

One process that I really enjoy is bromide staining. This is a unique chemical process that creates one-of-a-kind photographs with a painterly quality to them. I apply chemistry

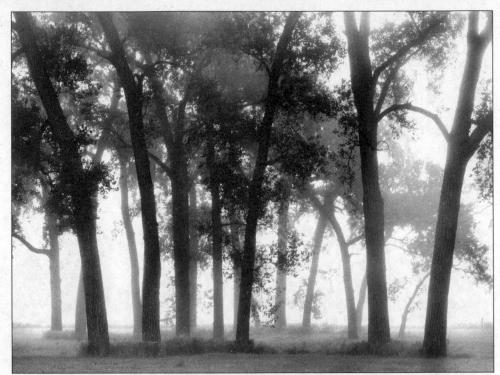

Morning Fog. Sometimes inclement weather can make for happy shooting circumstances. Siverson explains, "I was on assignment for a client and had to pull off the interstate because the morning fog was causing poor visibility. I came across this lovely row of trees and exposed four sheets of film."

to the photograph with a paintbrush and expose the photograph to white light. This adds wonderful hues of color to the black-and-white paper. I have been using this process on multiple projects since 2003. I have found that different brands of paper, such as Kodak, Agfa, and Forte, produce different hues of color. This process is becoming increasingly difficult for me to continue as many of the brands of paper that I use have been discontinued.

Since the discontinuation of the papers I was using for bromide staining, I shifted gears to straight black-and-white silver printing, and I have become very passionate about it. I love the look of well-printed black-and-white silver photographs. They have a wonderful glow.

Lately I've also been working with a variety of alternative photographic processes, including both analog and digital techniques and a combination of the two. For example, I will take a Polaroid but use the negative side instead of the positive (image) side and scan it in wet, digitizing the image. This creates wonderful images with a painterly quality.

What kind of formal training do you have?

In 2004 I received my Bachelor of Arts degree with an emphasis in photography from Minnesota State University, Moorhead. During my studies there, I was introduced to a variety of nineteenth- and twentieth-century photographic processes, including carbon printing, albumen printing, and cyanotypes. These various processes fascinated me and encouraged me to continuously explore and try new processes. Post graduation I studied under photographer Wayne Gudmundson as his darkroom assistant. During this time I assisted on his retrospective exhibit and major book project in collaboration with the Plains Art Museum in Fargo, North Dakota. This opportunity became a continuation of my education. Wayne's willingness to critique my work and teach me tricks of the trade deepened my appreciation

for large-format printing. He helped me see what a quality black-and-white photograph should look like. At the end of the project he said I went from an "OK" printer to a "good" printer; while some may have taken that as an insult, it is truly a great compliment. It is important to always be critical of your own work and strive for improvement.

What do you prefer about traditional film photography?

There is something special about working with traditional large-format film. I tend to slow down and think about what I'm photographing and why. Using this format makes me think the composition through. The slow, at times cumbersome technique is rewarding when it comes together in the darkroom. Working with larger negatives gives me the ability to print larger photographs with wonderful detail and sharpness throughout. I like to get my hands dirty and enjoy the quiet time spent in the darkroom creating photographs.

What's it like to be a traditional film photographer in the digital age?

Exciting and expensive. It seems like every time I order traditional supplies, anything from chemistry, paper, or film, prices continue to increase due to a shrinking demand. It is also a very exciting time in photography as the possibilities are endless, especially when utilizing both analog and traditional techniques together.

What kind of equipment do you use?

I was very fortunate to be able to purchase an entire darkroom setup right before I graduated. A local photographer who was retiring the wet lab and converting to 100-percent digital sold his entire darkroom to me for a song and dance. This enabled me to continue working with the wet-lab process after leaving the university environment. The biggest challenge graduating photography students face is how they will be able to continue traditional processing without access to enlargers and the darkroom supplied by their university. I have to think that this is why a lot of art students turn to using strictly digital techniques upon graduation. And, as this industry continues to "dry up," there aren't a whole lot of choices for community darkrooms to choose from.

While I feel blessed that I was able to find a wet-lab setup for a very reasonable price, my next challenge was to find a place to set it up. I originally set up shop in a rented space that supplied running water and lived in a small apartment a few blocks away. My wife and I have since bought a home in which I converted the basement into a darkroom/studio.

For my commercial photography, I have a wide assortment of digital equipment ranging from digital SLR cameras and lenses, to film scanners, and computer software and hardware. I have a makeshift studio and lighting system that travels with me to a many different locations.

What are your long-term goals?

My ultimate long-term goal is to open a gallery/studio in Montana. Both my wife and I love the mountains and what Montana has to offer. We would like to settle there for the second half of our lives. The gallery/studio would showcase not only my work but also the work of other artists I've met along the way and whose work I really admire. It would be a gallery with a friendly and well-put-together e-commerce website so people could look at the exhibitions and purchase artwork from all over the world. I have been very fortunate to meet many influential artists, who I would be honored to exhibit with, and this would be a way to give back to them by helping promote, sell, and expose their artwork to a wider audience.

What projects are you working on now?

I am currently working on a two-person exhibition that will travel to multiple locations throughout North Dakota. This exhibit will showcase traditional large-format, black-and

Fork in the Road. Sometimes the perfect scene for a shot can surprise you. Siverson explains, "I was on an early morning shoot in unfamiliar territory. When I came around a slight bend in the road, I saw this bridge lit up from the morning sun. The road forked off in two directions, with a wonderful subtle set of tire tracks going straight ahead."

white-photographs. Also, an art director recently hired me to decorate his client's office spaces with artwork, including mural-size photographs of my own. My aerial photography season (July–September) has started, so I will be busy with a mixture of corporate, advertising, and brochure-type work. My daily projects vary widely, which always keeps things interesting. I learned early on that commercial photography is a wonderful way to bring in a steady income and enables me to continue working on my art.

How do you approach new clients and, more generally, how do you promote your work? Do you have an agent or photo rep? Why or why not?

I do not have a photo rep. I have not had that opportunity present itself to me yet. I do, however, promote my work by selling online through my website and by exhibiting in galleries. I have used online stores such as eBay to sell my work in the past, and this helped put more eyes on my art. I also used to travel and showcase at art festivals around the country, but I found out quickly that the "on the road" art festival lifestyle was not for me. The emotional ups and downs of the art festivals was hard on me. Not only are they physically draining, but emotionally draining as well. I would go from one show selling a lot of work and winning an award to not making enough sales to cover one night at the hotel. Lately, I prefer to use the Internet and galleries to promote my art and my commercial work.

Are you able to make a living off the sales of your work?

Not entirely. Making a good living on print sales alone is very hard for most artists. My commercial photography helps keep the paychecks coming in at a steady pace. I'm not ashamed to work with other forms of photography to make a living. This way I am able

to work on my first passion, fine art photography, without the pressure of making a living solely as an artist.

What was your first big break?

After my senior photography exhibition I wanted to continue showing my fine art photography in a gallery setting. Knowing I had to start somewhere, I turned to a local coffee shop. I advertised, promoted, made fliers, got a press publication, and ended up with a large turnout and significant number of sales. I'm not sure if I would call that my "big break"—I'm still waiting for that, but you could call it my first break. It showed me there was interest in what I was doing and that people appreciated my work. Since then I have never stopped trying to show my work and have been fortunate to have a handful of local galleries that continue to exhibit my work on a yearly or bi-yearly basis.

What are the advantages and disadvantages of being a freelancer?

There are a lot of ups and downs in the world of being a photographer and artist. In years past, I've gone months without a paycheck and other times the checks never seem to stop coming in. The financial aspect of working independently can be an emotional roller coaster. A lot of people think freelancers have it easy because we do not have to answer to a boss. In reality there are many weeks I work 60–70 hours, meeting deadlines for commercial clients, exhibiting and creating artwork, or a combination of the two. I may be answering to multiple "bosses" at one time: curators, marketing directors, etc. While I may be in business for myself, I work for my clients.

What's the best piece of career advice you've received and do you have any advice for beginning or struggling photographers?

There are a lot of sacrifices along the way and there is no guarantee of what may transpire from all the hard work you put into your photography. However, no matter what type of photography you create, continuing to do what you love is clearly a form of courage.

ARTICLES & INTERVIEWS

Suzanne Bird

Capturing the Emotions, Connections, and Stories of Beloved Pets

Photo by Miv Fournier • www.mivphotography.com

by Donna Poehner

rban Dog Photog is the clever moniker for the business of Ottawa-based photographer Suzanne Bird, who practices what she calls "animal lifestyle photography." Her goal is to capture the bond between pets and their owners. "Capturing the bond is the backbone of my business. It might sound like a cliché, but it is true to who I am as a photographer and my training. I'm trained to capture emotions, connections, and tell stories," says Bird, who began her photography career as a newspaper photojournalist. She worked at the London Free Press, Kitchener Waterloo Record, and the Ottawa Sun. She has also photographed for magazines, such as Ottawa magazine, Dogs in Canada magazine, and Carleton University Magazine. "My whole business model of capturing pets' personalities relies heavily on my experiences as a photojournalist. Working for newspapers is fast-paced, high-energy. You work on adrenaline, in uncontrolled environments. You learn how to think, create, and execute your skills under pressure of time and deadlines," says Bird.

"I adore animals of all kinds, but I especially love dogs," says Bird. One look at her website will confirm that statement—dogs of all breeds, running with mouths wide open, in funky urban settings, in sunlit meadows, on the beach, on a red sofa, on a wood floor, wearing sweaters their owners have lovingly bought for them. In many of the photos, that bond between animal and human is the focus, and Bird's keen eye for detail adds to the overall quality of the photos.

Her love for and involvement in photography started when Bird was still in school. She photographed for yearbooks and sports teams. She also worked at a photo lab most of the time she was in high school and during summers while she was in college, where she earned a degree in sociology and a diploma in photojournalism.

"I started playing with this business concept in 2003, while on maternity leave with my first child. I started to research the market—successful photographers who were creating stunning editorial images of dogs. There were only a few at that time in the market. Then, in 2006, in the Chinese Year of the Dog, I officially opened up my business. My business model has been to build slowly, allowing myself time to grow effectively, to be at home with my children, and to remain creative and active in my former career role while staying connected with my contacts. Now, in my fourth year of business, I am consistently booking sessions weekly, mainly through word of mouth, with a strong referral system in place. I have a small home-based studio that works for open house events with other vendors, a gallery to hang

Yodah is a hairless Sphynx cat that Bird photographed for a personal project. Bird observes, "Yodah was very curious, and the unique qualities of the hairless cat make for some great images."

samples and a place to meet with clients. It is very country and is a very relaxed setting, as well as being animal friendly. I can also set up a studio area to use seamless backgrounds," says Bird.

Pet portrait sessions can be done at the client's home, at Bird's studio, or in an urban setting, depending on the client's preferences. Parks and farms are also good settings. Above all, Bird wants the animal to feel comfortable in the environment. The sessions are really about who the animal is and how it fits into the family dynamic. Sessions are relaxed so that Bird can capture the natural emotion that goes into making portraits that the family will treasure and keep for years.

During the sales consultation, the client can choose from an array of products for displaying their portraits. "Since the start, I have offered a package that includes a session and an artistic, custom-designed coffee table book. This is still the most popular session with my clients," Bird says. This approach works especially well for Bird because of her photographic style, which lends itself to multiple images that tell a story. Gallery canvas wraps are also popular, and clients often buy multiple images to create a wall grouping for their home. Custom-designed handbags featuring photos from the session are becoming a popular item, as well as a line of museum glass frames. "The most popular items are the canvases and the modern pieces that suit a fun and funky pet photograph," she says.

Even though Bird has found success with her privately commissioned pet portraits, she has not given up on her editorial clients. They are still crucial, making up about 50 percent of her business. She feels that her credentials as a published, professional photographer with images on magazine covers helps reinforce her portrait clients' belief in her ability to create stunning images of their pets.

Bird offers a very special service to her clients, which she calls "Pet Bereavement Photography." She says, "My 'old souls session' came from a need of my clients. Many of

This beautiful Weimaraner puppy relaxes on the couch in Bird's client's home. Bird finds that her clients often unconsciously coordinate their decor with the colors of their pets.

my clients were coming to me with older dogs and wanted to memorialize their bond with them. My ability to tell their story in photos was giving them a way to grieve and heal when the dogs had passed away. One of my clients called it Pet Bereavement Photography, and I thought it was very fitting." It provides a way to keep the beloved pet's spirit alive for the owner. To Bird, it is a celebration of life that captures the honor, nobility, and loyalty of the pet. The sessions can sometimes be emotionally difficult for Bird. She taps into how the owner is feeling: if the owner can be strong, then she can be strong. Many clients order an album of images from the bereavement session so that they have a keepsake— "A piece of their life with that dog," Bird says. Although the animal may be very ill and may only reveal a shadow of its former self, if the pet can give Bird a glimpse of who it was in its more vibrant days, then Bird can capture the images she knows the owner hopes for. Sometimes all it takes is getting out a ball, and that old spark comes back.

On a happier note, Bird offers Pupternity sessions. "Although it is not a top package, we have had some adorable sessions with these pups. They do not stay little that long. Most of my puppy photographs are from my magazine sessions. We typically shoot them at age five to six weeks. After that age, they tend to lose the new pup look, and they start to get more curious and wander more in a session," she says.

"People are still a part of my sessions, but I do end up using them more as props. So the focus is more on the animals, with some interaction from the owner. I will always incorporate families, kids, and teens as well for that wonderful, relaxed family portrait. Many clients comment on how much they enjoyed that day and have great memories of how much fun the session was," Bird says.

Tips for Photographing Pets

"I think having a great knowledge of and affection for animals and an understanding of their traits, antics, and the little things that make them tick are key to a successful session." —Sue Bird

- Understand who the cat, dog, horse is before you shoot. Pre-consult through e-mail or by phone, asking the client questions to give you an idea of who this little personality is.
- Be very cautious with lighting cords and stands. Make sure cords are taped down to the floor and that stands are secured with sand bags.
- Use reflectors to get the catch light in the eyes (if you don't want to or can't use strobes).
- Keep an eye on the stray hairs across the eyes of a hairy-faced dog; a small trim to the hair around the eyes can help this, or use water to slick it to the side.
- Have a good foundation in lighting, problem solving, being able to anticipate situations, and acting fast.
- Be the quiet observer with a bit of producing and directing ability.
- Know your lenses and the moods each one creates; as you are shooting a photo, envision it in a book or on a wall.

"I love design and packaging—as a consumer, it draws me to buy the product. So I like to produce promotions that stay on the person's mind—and on their fridge. I have had clients hire me because they kept my first business card for four years! I do mostly count on word of mouth for advertising, so I need pieces that people will talk about," says Bird. For a Valentine's Day promotion, she created "lil love letters." "It was a unique way to create a product from a standard photo day at a local dog boutique. Instead of a regular 5x7 print, the client received these cool little cards that also worked as a referral discount for the person who received the cards," Bird says.

Another promotion that worked well for her was an open house with other vendors. She says, "I had munchies, drinks, an outdoor fire going. I did it with three other women in business, and we all invited our own clients." To make the clients feel special and to say thank you for coming, the vendors gave away gift bags to the first fifty clients. The bags included their business cards and give-away items from each vendor, including a booking special with Bird and a two-year perPETual calendar featuring her photography. "The day was a great success. I ended up booking sessions from that day, and the buzz of the event was huge," says Bird.

Bird has found that building relationships with other vendors who cater to the same target client as she does has been a win-win situation. "I was very lucky to grab the attention of a local holistic vet who was inspired by my connection to the animals in my photos. Ever since, he has referred me to his clients. A holistic vet offers services that are not considered standard concepts in the industry. So someone who seeks a holistic vet would be the target client that I generally attract. I am very conscious of referring back to the vet as well. I am loyal to the businesses that I have created great relationships with," Bird says.

Bird took this photo for the annual edition of *Dogs in Canada* magazine. Bird works with an assistant on sessions with pups, which she typically photographs at five to six weeks of age.

Bird has also teamed up with three local boutiques in her city. She makes sure to have unique marketing concepts with each boutique to avoid cross promotion problems. For her, three is a manageable number of businesses to partner with so that each store can get more of her attention throughout the year with events and displays—quality vs. quantity. "In return I am heavily marketed by these stores, but it is a genuine referral after forging a great friendship with the owners," she says.

Bird has advice for those just entering the photography market: "Networking is a very important part of this business. Network with other photographers. It is challenging getting into photography today; not every studio wants to become friends with the new photographers in town. So you need to join your local photography group, work on your craft by entering competitions, seek inspiration from photographers in other areas of your country or other countries, and then do something different. Or seek inspiration from a totally different field of photography—food, interiors, advertising."

There is currently an epidemic of imitative photography in the marketplace, Bird believes. "I think if you can find a style that works, you need to stay true to yourself and respect the photographers who have blazed the trails before you. I miss the days when someone would look at an Ansel Adams print, a Henri Cartier Bresson print, or a Sally Mann photo and say, "Oh, wow, I wish I could do that," and respect the photographer's vision, concept, and artistry, and also respect that just because they love the photo does not mean that they can pick up a camera and copy it," she says. Instead, Bird believes, looking at others' work 'should inspire photographers to think harder and make something that is their own.

"You also need to know the industry standards for pricing and your cost of sales," Bird says. "And you need business goals. These are all key elements that are a part of your business. As professional photographers, we are all responsible for this industry, and we need to make sure we are accountable for the information we give our clients and for how we run our businesses. This business is not as easy as picking up a camera and taking a pretty picture; a lot more goes into it. If you are willing to do the hard work to get there, it's the best job to have."

Genevieve Russell

Sharing and Preserving Stories Through Images, Video, and Audio

by Donna Poehner

toryPortrait Media is the brainchild of Santa Fe photographer Genevieve Russell. Her website describes the concept behind her business: "StoryPortrait Media is dedicated to documenting, preserving, and sharing personal and community history through story and images. We work with clients to create beautiful, authentic, and timeless audiovisual portraits that touch the heart and endure through generations."

By combining still images, video, and audio, Russell captures for her clients not only life's traditional milestones, such as weddings, but she also creates mini-documentaries of their family life. For some clients she creates multimedia projects that document a typical day in the life of their family, which involve Russell taking stills, recording video, and conducting audio interviews with the family members. Russell then weaves this altogether into a "story portrait"—a five- to six-minute-long multimedia presentation that the family can enjoy and treasure for years. The families will also often buy albums or fine art prints of their favorite still images from the project.

A story portrait can also focus on one particular person, such as a grandfather who wants to preserve his stories for generations to come. Russell has also created a story portrait for a couple who discovered they were expecting their first child, documenting the process—from their initial excitement to the birth of the child and beyond. So the possibilities for story portraits are just about endless.

But that is just one side of StoryPortrait Media. Organizations, small businesses, and nonprofits also seek out Russell's services. For these clients, the story portraits help the impact of their marketing message by adding an extra dimension to their traditional marketing efforts—that all-important emotional element. Many of these clients put the StoryPortrait to their websites.

Russell has completed projects for a variety of businesses and organizations, including Heart Gallery of New Mexico; Finding Forever Families; Global Green Indigenous Film Festival, The Power of the Image; Jazz of Enchantment—a 25-part series for public radio, profiling top jazz musicians in New Mexico; and Guadalupe Barber and Beauty Shop, which profiles a small, neighborhood business that has been run by the same family for three generations.

StoryPortrait Media also offers photography-only and audio-only services through their VisualPortrait and AudioPortrait packages. Russell also offers a diverse selection of media

platforms: podcasts, web, CDs and DVDs, archival books, albums, and fine-art prints.

Although Russell had been doing documentary photography since her introduction to it in high school, it was a workshop in San Miguel de Allende, Mexico, sponsored by Santa Fe Photographic Workshops, that convinced Russell to incorporate audio and video into her documentary process. In San Miguel, she did a couple documentary photo projects, but when she got home she felt like she'd missed a big part of

Photo by Genevieve Russell • www.storyportraitmedia.com

the story by not getting the full, journalistic details, such as the full names of her subjects and the interesting details of their stories. So, she decided to seek training and education in audio and video to round out her documentary skills. She went to the Center for Documentary Studies at Duke University, where she learned the basics of audio editing, interviewing, and video. She continued to take workshops to round out these skills.

She also met a radio producer, Paul Ingles, who helped her tune in to her sense of hearing. Russell says, "One of my pivotal moments for audio was going to Bosque del Apache, a wildlife preserve in New Mexico, with Paul. When the light wasn't any good, and I wasn't keen to photograph any more, he put a pair of headphones on me. He had a shotgun mike with him and just pointed it up towards the birds. I could hear so many distinct sounds—the flapping of the wings, the birds landing on the water. Sound became as textured as light. When photographing, we're so used to looking that we don't really hear or even listen, even though we may be asking our subjects questions."

StoryPortrait Media has been operating since 2007. As the owner of a nascent business, Russell doesn't have a staff—she basically does everything herself. Her background in web design, graphic design, and photography allows her to do just about everything her clients need, including interviews, image editing, video editing, audio editing. But Russell strongly believes in collaboration. So as her business grows, she brings in subcontractors when necessary—sometimes a sound person, someone to help work the camera so she can connect with subject, or an editor. Then, depending on the project, Russell pieces it all together herself.

Photographer Katie Macaulay recently joined StoryPortrait Media and is going to learn how to do some of the multimedia. Macaulay has been photographing people for many years, specializing in children and families. So far Russell's marketing has mainly been through word of mouth. She joined local networking organizations in Santa Fe started by small business owners, but since she's the only one doing everything in the business, she needed to take a break from it for awhile. Russell believes Macaulay will also be a boon to her efforts to market StoryPortrait Media to families. "She's a mom with two kids and is connected to communities with families and schools," Russell says. The two also plan to teach workshops together.

Russell has also begun a collaboration with Write Choice Network, a social change organization whose clients are nonprofits, NGOs, government entities, and tribes. In this new partnership, Write Choice Network will market StoryPortrait Media to their clients who need visual storytelling. Russell says, "As grant writers, they know the importance of having really compelling images. They need to be able to sell these nonprofits through the heart."

Russell admits that the state of the photography industry today sometimes discourages her. Photographers are pitted against the consumers who think they can do it themselves—especially when it comes to publishing a small book or getting prints made. But StoryPortrait

Photo by Genevieve Russell • www.storyportraitmedia.com

Photo by Genevieve Russell • www.storyportraitmedia.com

Photo by Genevieve Russell • www.storyportraitmedia.com

Media's panoply of product offerings—from still photos to multimedia projects—is something rather new and different, and consumers and businesses may not immediately see the complexity of what she's offering. Russell says, "It's complicated; there are a lot of pieces to put together. We're still in the education process." She belongs to the Association of Personal Historians, and on her business card she lists her title as "personal historian," which prompts people to ask, "What's that?" Russell says, "There are a million photographers. Even saying that you're a documentary photographer doesn't click. But 'personal historian' rings a bell with them. Everyone knows the importance, maybe not of their own story, but of their grandmother's story. I'm trying to get people to see that if they start recording their story right now, they'll have it for future generations. I'm providing a service."

Figuring out pricing for the story portraits can be tricky. "People never realize what goes into it—my time, equipment, what I've put into trying to learn this, and the costs," says Russell. Post-production is often a lengthy process in itself. Sometimes the video is sort of a wash, but the products the clients buy later—albums, fine art prints, gift prints—pay for the video part of the project.

Russell says that sometimes she feels like she's on an emotional roller coaster: "Part of me is really excited. Multimedia storytelling is a growing field that I feel people are looking for. They want that added element of audio and video online that they can share. Part of me feels really optimistic about my business and what I can offer to people." She's also excited by the prospect of doing things for iPhone, iPad, and other digital applications, which represent more avenues for content and distribution.

On the downside, however, Russell admits that it is very difficult to do it all alone. "There's no sponsor like Nikon or Canon giving me equipment. The true costs are hard to bear alone." When planning a self-funded documentary trip to Bali, she reached out to friends in her photo community, borrowing camera lenses and bags to make the trip happen. She says, "It's so necessary for communities to bind together and figure out how to support each other." Russell believes that it's important to have friends you can share or split equipment with, so that you can all keep your dreams alive. "In Santa Fe everybody has many jobs. It's

Photo by Genevieve Russell • www.storyportraitmedia.com

Photo by Genevieve Russell • www.storyportraitmedia.com

Photo by Genevieve Russell • www.storyportraitmedia.com

a juggling act, trying to stay within the art that you love and basically solve problems for different groups of people."

Russell does all of her shooting on location, so she doesn't feel a need for a studio right now. Her garage has been converted into office space. She would like a space for collaboration with other photographers who are working on projects, a place where they could upload, do graphic design, video and audio editing, and teach workshops. This space could also double as a gallery or showcase where clients could come in and see prints displayed on the walls.

In addition to her documentary work, Russell has been an instructor at Santa Fe Photographic Workshops for the past several years, teaching workshops on subjects such as photographing people and a video class for National Geographic. She stopped teaching for awhile because she felt she needed to re-energize her own work, but she'll be teaching again in 2011. She also plans to propose some new classes to teach at Santa Fe Photographic Workshops in the future.

Part of StoryPortrait Media's mission is to seek out projects that celebrate diversity of cultures, beliefs, traditions, and geographic locations. Russell is proud of a couple of projects in particular, Jazz of Enchantment and Los Reyes de Albuquerque, because they fulfill this credo. Both were large projects and included a DVD, a gallery exhibition, and websites that Russell herself designed and put up. She's also pleased that both projects were a result of collaboration with Paul Ingles, the radio producer who first introduced her to the layers and textures of sound at Bosque del Apache. He also wrote the grants to get the funding for the projects, which came from the New Mexico Humanities Council and the Urban Enhancement Trust Fund of the City of Albuquerque. Russell says, "It's amazing that local and statewide funds for arts and humanities are still available.... There are great ideas happening."

ARTICLES & INTERVIEWS

No Place Like Home

Taking Advantage of Local and Regional Publication Opportunities

by Paul Grecian

hether you are an established professional or just starting your photography career, local and regional publication opportunities should be on your radar. There are opportunities for getting published with subjects from your town, county, state, or region. The first place a photographer should look for photographic subjects is outside his front door. At each geographic level, there may be opportunities for a photographer to specialize and become a go-to source for imagery that competing photographers have neither access to nor knowledge about. The easiest niche for a photographer to create is one in which he need not travel far to become an expert. The kinds of subjects that are sought after by local and regional publications include event coverage, historical architecture, travel destinations, areas of natural beauty, and human-interest stories. In fact, most imagery of interest to local publications is also of interest to national publications, which may result in additional opportunities to make sales.

Basic approaches: stock and query

There are basically two ways to approach a potential publishing opportunity with your images. The first way is to build an image library of subjects of local and regional interest and then submit a sample of your work to an editor for consideration. This sample may be a cross-section of subjects to show the diversity of your work and coverage or a selection focusing on a specific theme to demonstrate your ability to fully explore a narrow subject.

The second way to approach an editor is with photos you've taken outside of the geographic range of a publication but which contain similar subject matter. These samples will familiarize the editor with your capabilities, and you won't have to spend any initial effort to make images specific to the local or regional publication's needs. With this form of submission, you may either offer your services for any future assignments from the publication, or query the editor with a feature idea of your own. As a local photographer, you are in the best position to anticipate and develop work that will meet the needs of publications in your geographic area.

With either approach to contacting publications, it is always necessary to provide good notes on where the images were made and what they are about. This information will make an editor's job easier and make it more likely that you will be successful in having your imagery used.

PAUL GRECIAN is a full-time fine-art photographer specializing in nature and travel imagery. From his Bucks County, PA home he has access to wonderful local and regional locations on the East Coast, but he mostly works close to home. His work has appeared in a variety of magazines, calendars, and in corporate projects. Framed prints are available from www.paulgrecianphoto.com and the www.lambertvillearts.com.

Who needs your work?

There are many types of local and regional outlets for your imagery, but it will depend somewhat on where you are located. Publication opportunities will be most abundant if you live in a more highly populated area or one which receives a good deal of tourism. There are magazines that cover cities or towns, counties, states, regions, or natural areas. There is even an organization called the International Regional Magazine Association that deals specifically with regional publications. This organization's mission is to provide information and act as a gathering place for regional publications in order to foster their promotion. To find information about regional publications in your area, visit their website at www. regionalmagazines.org.

Some photographers may find themselves living in an area with multiple magazines covering different levels of their geographic area. As a result, images made locally by these photographers may be used by several different publications. Other than magazines, sources of potential image sales include newspapers, tourist commissions, websites, and brochures put out by specific tourist destinations or even local businesses or organizations needing images for advertisements or websites.

Finding publications

Once you have established a personal stock of quality images, it's time to find out which publications you should submit your images to. There are several ways to go about your discovery process.

An obvious first choice is to use *Photographer's Market*. Finding local publications is easy using the Geographic Index in the back of *Photographer's Market*. This book presents all the relevant information you need to get started. Each listing contains data on the kind of images a publication is seeking, the payment particulars, and perhaps most importantly, the contact person who will review your work. Often the listing will include tips on how to maximize the likelihood of success for your submission.

The Internet is full of potential hits for publications, organizations, and other groups that may want to buy your images of local and regional subjects. Simply searching by location name, venue, or subject terms will certainly garner you a load of listings that may become outlets for selling your work.

Another source for searching out potential regional publications is the brick-and-mortar bookstore. These stores often contain racks of magazines broken into categories including a local/regional section. Here you will find an assortment of titles pertaining to your geographic area and region, allowing you to get a sense of the kinds of imagery they use. Pick up a few titles that look promising so that you can study them carefully, and then contact the editor with a specific proposal. If the publication lists a website, use it to check if submission guidelines are offered online. A publication's website may also offer a listing of previous issues and their contents so that you can get a better idea of the type of imagery they may need. It is also helpful to know what types of feature articles a magazine has published recently in order to determine whether they may be interested in a similar piece. Usually an editor will not be interested in a feature that too closely mirrors a recently published piece. However, you may find that a local/regional publication does a regular seasonal piece for which your work is perfect.

Once you start becoming familiar with the opportunities presented to you by local and regional publications, you will look at your surroundings in a new way.

Networking With Other Photographers

by Vik Orenstein

here are many reasons to join a community of photographers: to network, shoot the breeze, commiserate, compare notes, share technique, battle creative slumps, and to establish and maintain industry standards, to name just a few.

Referrals

One of the biggest ways my colleagues and I help each other is by trading referrals. This is especially important now that many of us have become very specialized. For my portraits, I shoot only black-and-white film and offer only high-end archival pieces. I strictly do black-and-white, sepia or hand-painted portraits of kids, their families, and their pets. No corporate head shots. No events.

Frequently I get calls from clients wanting a service or product outside of my specialty. Requests for weddings, model composites or product shots are common. In the past, I tried to accommodate these requests myself but was often less than happy with the results, preferring ultimately to work only within my limited specialty. So it's a great boon for me to know professionals who I'm proud to refer my clients to. And it's always nice to get a referral from one of my colleagues, of course.

Mentors

Almost every successful photographer I've ever known has credited their success in part to the generosity of a more established shooter who helped them learn the ropes. There's no law that says an old dog has to teach a new dog his tricks. And there can be some risk involved if the protégé turns into an upstart who runs away with part of the mentor's market. So why do it?

"It's for the joy of it," says Jim Miotke.

"It's a natural part of the life cycle," says Jennifer Wu. "You're born, you learn, you teach, you die."

VIK ORENSTEIN is a photographer, writer, and teacher. She founded KidCapers Portraits in 1988, followed by Tiny Acorn Studio in 1994. In addition to her work creating portraits of children, she has photographed children for such commercial clients as Nikon, Pentax, Microsoft, and 3M. Vik teaches several photography courses at BetterPhoto. com.

Excerpted from *The Photographer's Market Guide to Building Your Photography Business* © 2010 by Vic Orenstein. Used with the kind permission of Writer's Digest Books, an imprint of F+W Media Inc. Visit writersdigestshop.com or call (800)448-0915 to obtain a copy.

Professional trades

I've traded shoots and offered and received shoots and prints at a discount from my colleagues. I received a beautiful art print from a nature photographer in exchange for shooting his family. I've done portraits for a wedding photographer in return for shooting my wedding.

Equipment savvy

Whenever I've needed a new piece of equipment, especially when it comes to new technology with which I'm unfamiliar, I ask for the inside scoop from my photographer friends. A commercial shooter taught me everything I needed to know about digital capture, researched the systems from me and helped me choose which one to buy. A fashion shooter taught me how to use strobes, an architectural shooter taught me about hot lights, and a photojournalist taught me that it's okay (and sometimes even desirable) to use mixed light sources.

A senior portrait by Vik Orenstein.

In turn, I've helped some medium-format junkies break their addictions to fine grain and tripods; I've taught a commercial shooter how to get two-year-olds to stand in one spot for a 250th of a second; and I've shared my somewhat paltry knowledge of digital capture with a fellow film lover whose digital knowledge was even more paltry than mine. What goes around really does come around.

Industry standards

American Society of Media Photographers (ASMP) offers a book detailing industry standards for billing, determining usage fees and other practices. The book is invaluable. But ASMP, the society, didn't institute these standards. Individual photographers, the guys in the trenches, created them. Industry standards continue to evolve as technology, the economy, and our markets change. By networking with fellow shooters you can help create the standards.

Classes and seminars

Classes and seminars are good ways to meet other photographers. In addition to picking up some great ideas over the years, I've also met and remained in contact with several photographers this way.

Consulting

If you're going into a new specialty, making the transition to digital or hitting a marketing slump, you may need more than the casual assist that a colleague or a mentor can offer. You may need a hired gun. I've both worked as a consultant for other photographers and hired other photographers to consult for me. It's a way to significantly shorten up your learning curve when you need knowledge and you need it fast.

Internet clubs and discussion groups

Joining an Internet discussion group allows you to network with your brethren from all over the globe. You can put a technical, creative or business question out there and receive

'An editorial image by Stormi Greener.

twenty different (and often excellent) responses from twenty different individuals in a very short time.

Talking shop

Networking with colleagues allows you to check the pulse of the business. You can find out if others are slow or busy and whether they're sensing any new trends or having success with new equipment and technology.

You can also commiserate with those who understand your experiences. I try not to be negative, but sometimes I just need to do a little venting, and having an ear from a person who knows what you're talking about is a wonderful thing.

You can also use the grapevine to find out about studio management software, good vendors and labs, and studio sales where you can pick up used equipment for pennies on the dollar.

You can compare business practices, get the name of a good lawyer or accountant ... you get the idea.

Some shooters are afraid to network for fear of having their clients, ideas, or business practices stolen. And, yes, it does happen. But in my experience, the gains far outweigh the losses when you share your time and expertise with your fellow photographers.

Cross-discipline training

I'm a portrait photographer, but most of what I know about lighting I learned from architectural photographers, and my philosophy of photographing kids comes from a style prevalent among fashion photographers in the early 1980s. One way to develop a distinct visual style is to do things differently from the way your competitors are doing them, and you don't need to roam far afield or be intentionally clever or contrived to create a new look. All you have to do is pick and choose from established traditions in other photographic specialties. Networking makes finding new perspectives easy.

A travel image by Jim Miotke.

How to start

If you've never networked before, it may seem a little daunting. Many of us dislike asking others for their time or knowledge.

- **Be specific.** I'm much more likely to take time out of my schedule to talk to a peer if she's specific about what kind of information she's looking for. For instance, I'm unlikely to go out of my way to meet with someone who just calls up and says, "I'd like to pick your brain about photography." But if someone calls and says, "I'm at the stage in my business where I'm forced to decide whether to scale back or expand my studio space and take on more employees. Since you have experience with this, I was hoping we could meet and discuss the pros and cons."
- **Have something to trade.** If you're looking for marketing ideas, for instance, you might say, "Hey, I have some promotions I've been using with some success, and I was wondering if we might get together and bat some marketing ideas back and forth."
- **Tell them why you chose them.** You're more likely to get results if you tell your colleagues why you chose them to speak with rather than appearing to have picked them out of the phone book. Say, "I've seen your work and I love your use of color, and that's why I'd like to ask you about your creative technique." Or, "I really admire what you've done with your business, and I'd like to hear your ideas on how to sell."
- **Food is love.** It's human nature—we feel more comfortable and relaxed when we break bread with someone than in any other setting. So suggest lunch, or even coffee. And pick up the tab.

Professional associations

As I've mentioned in previous chapters, I highly recommend you join your local chapter of ASMP or Professional Photographers of America or one of any number of other great organizations. You're looking for colleagues to network with. This is a way to find a whole

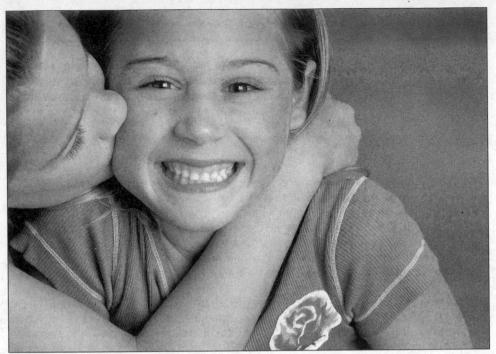

A portrait by Vik Orenstein.

room full of those who are primed and ready to talk shop. And don't just join—go to the meetings!

Your neighbors

In the first years of my career as a photographer I was lucky enough to have my studio in a warehouse building that was also home to tens of other photographers in different disciplines. When I was just starting out, I rented studio space on an as-needed basis from a commercial photographer, and he taught me all about medium-format equipment. All I had to do was go across the hall when I needed to borrow a sync cord (the photographer's equivalent to a cup of sugar). And when a client pulled a fast one on me and brought a reflective product to a shoot that was only supposed to involve kids, I excused myself, went up two flights of stairs and got a quick lighting lesson that allowed me to do the shot unfazed. In turn, I helped a fashion shooter keep an uncooperative four-year-old girl on a white seamless background and get her to pose and laugh. (I stuck a raisin to the bottom of her foot and told her to say "diaper head.") Look around—there are no doubt photographers nearby who would be happy to network with you.

Consumer Publications

esearch is the key to selling any kind of photography. If you want your work to appear in a consumer publication, you're in luck. Magazines are the easiest market to research because they're available on newsstands and at the library and at your doctor's office and . . . you get the picture. So, do your homework. Before you send your query or cover letter and samples, and before you drop off your portfolio on the prescribed day, look at a copy of the magazine. The library is a good place to see sample copies because they're free, and there will be at least a year's worth of back issues right on the shelf.

Once you've read a few issues and feel confident your work is appropriate for a particular magazine, it's time to hit the keyboard. Most first submissions take the form of a query or cover letter and samples. So what kind of letter do you send? That depends on what kind of work you're selling. If you simply want to let an editor know you're available for assignments or have a list of stock images appropriate for the publication, send a cover letter, a short business letter that introduces you and your work and tells the editor why your photos are right for the magazine. If you have an idea for a photo essay or plan to provide the text and photos for an article, you should send a query letter, a 1- to $1\frac{1}{2}$ -page letter explaining your story or essay idea and why you're qualified to shoot it. You can mail your query letter, or you can e-mail it along with a few JPEG samples of your work. Check the listing for the magazine to see how they prefer to be contacted initially. (You'll find a sample query letter on the next page.)

Both kinds of letters can include a brief list of publication credits and any other relevant information about yourself. Both also should include a sample of your work—a tearsheet, a slide or a printed piece, but never an original negative. Be sure your sample photo is of something the magazine might publish. It will be difficult for the editor of a biking magazine to appreciate your skills if you send a sample of your fashion work.

If your letter piques the interest of an editor, she may want to see more. If you live near the editorial office, you might be able to schedule an appointment to show your portfolio in person. Or you can inquire about the drop-off policy—many magazines have a day or two each week when artists can leave their portfolios for art directors to review. If you're in Wichita and the magazine is in New York, you'll have to send your portfolio through the mail. Consider using FedEx or UPS; both have tracking services that can locate your book if it gets waylaid on its journey. If the publication accepts images in a digital format (most do these days), you can send more samples of your work via e-mail or on a CD—whatever the publication prefers. Make sure you ask first. Better yet, if you have a website, you can provide the photo buyer with the link.

To make your search for markets easier, consult the Subject Index on page 531. The index is divided into topics, and markets are listed according to the types of photographs they want to see.

Sample Query Letter

February 6, 2011

You may also include your Web site in your contact information.

Alicia Pope 2984 Hall Avenue Cincinnati, OH 45206 e-mail: amp@shoot.net

Make sure to address letter to the current photo contact. Connie Albright Coastal Life 1234 Main Street Cape Hatteras, NC 27954

Dear Ms. Albright:

Show that you are familiar — with the magazine.

I enjoy reading *Coastal Life*, and I'm always impressed with the originality of the articles and photography. The feature on restored lighthouses in the June 2004 edition was spectacular.

Briefly explain your reason for querying.

I have traveled to many regions along the eastern seaboard and have photographed in several locations along the coast. I have enclosed samples of my work, including 20 slides of lighthouses, sea gulls, sand castles, as well as people enjoying the seaside at all times of the year. I have included vertical shots that would lend themselves to use on the cover. I have also included tearsheets from past assignments with *Nature Photographer*. You may keep the tearsheets on file, but I have enclosed a SASE for the return of the slides when you are done reviewing them.

Enclose copies of relevant work or direct them to your Web site. Never send originals.

If you feel any of these images would be appropriate for an upcoming issue of *Coastal Life*, please contact me by phone or e-mail. If you would like to see more of my coast life images, I will be happy to send more.

Always include a self-addressed, — stamped envelope for the magazine's

reply.

I look forward to hearing from you in the near future.

Sincerely,

Alicia Pope

■ \$ 3 540 RIDER

TMB Publications, P.O. Box 1156, Lake Oswego OR 97035. (503)236-2524. Fax: (503)620-3800. E-mail: dank@aracnet.com. Website: www.540rider.com. Contact: Dan Kesterson, publisher. Quarterly magazine. Emphasizes action sports for youth: snowboarding, skateboarding and other board sports. Features high school teams, results, events, training, "and kids that just like to ride." Sample copy available for 8 × 10 SAE and 75¢ first-class postage. Photo guidelines available by e-mail request or on website.

Needs Buys 10-20 photos from freelancers/issue; 40-80 photos/year. Needs photos of sports. Reviews photos with or without a manuscript. Model/property release preferred. Photo captions preferred.

Specs Accepts images in digital format only. Send via CD as TIFF files at 300 dpi.

Making Contact & Terms Send query via e-mail. Provide self-promotion piece to be kept on file for possible future assignments. Responds only if interested; send nonreturnable samples. Simultaneous submissions OK. Pays \$25 minimum for b&w and color covers and inside photos. Pays on publication. Credit line given. Buys all rights.

Tips "Send an e-mail ahead of time to discuss. Send us stuff that even you don't like, because we just might like it."

■ S ○ A CAPPELLA ZOO

105 Harvard Ave. E., Ste. A1, Seattle WA 98102. (208)705-5070. E-mail: Editor@Acappellazoo.com. Website: www.Acappellazoo.com. Editor: Colin Meldrum. Est. 2008. Circ. 200, print. Covering experimental and magical realist literary works. "A Cappella Zoo invites submissions of memorable prose, poetry, drama, and genre-bending works. We are especially excited about magical realism and works that experiment with technique, form, language, and thought." Reviews photos with or without manuscript. No samples kept on file. Portfolio not required. Credit line given when practical.

Needs Needs alternative process, avant garde, fine art photographs.

Making Contact & Terms E-mail query letter with URL and JPEG samples at 72 dpi.

Tips "Get a feel for the artwork we have featured; images are available online. E-mail both URL and a few samples."

ADVENTURE CYCLIST

P.O. Box 8308, Missoula MT 59807. (406)721-1776, ext. 222. Fax: (406)721-8754. E-mail: mdeme@ adventurecycling.org. Website: www.adventurecycling.org. Editor: Mike Deme. Publication of Adventure Cycling Association. Magazine published 9 times/year. Emphasizes bicycle touring and travel. Sample copy and photo guidelines free with 9 × 12 SAE and 4 first-class stamps. Guidelines also available on website at: www.adventurecycling.org/mag/submissions.cfm.

Needs Cover and inside photos. Model release preferred. Photo captions required.

Making Contact & Terms Query first by e-mail to obtain permission to submit samples or portfolio for review. Responds in 6-9 weeks. Simultaneous submissions and previously published work OK. Payment negotiable. Pays on publication. Credit line given. Buys one-time rights.

AFRICAN AMERICAN GOLFER'S DIGEST

139 Fulton St., Suite 209, New York NY 10038. (212)571-6559. E-mail: debertcook@aol.com. Website: www.africanamericangolfersdigest.com. Managing Editor: Debert Cook. Circ. 20,000. Estab. 2003. Quarterly consumer magazine emphasizes golf lifestyle, health, travel destinations, golfer profiles, golf equipment reviews. Editorial content focuses on the "interests of our market demographic of African Americans and categories of high interest to them-historical, artistic, musical, educational (higher learning), automotive, sports, fashion, entertainment. Sample copy available for \$4.50.

Needs Photos of golf, golfers, automobiles, entertainment, health/fitness/beauty, sports. Interested in lifestyle. Reviews photos with or without a manuscript. Model release required. Captions required: include identification of subjects.

Specs Accepts images in digital format. Send JPEG or GIF files, 4 × 6 inches at 300 dpi. **Making Contact & Terms** Payment negotiated. Credit line given. Buys all rights.

■ ■ S\$ ② AFRICAN PILOT

P.O. Box 30620, Kyalami 1684 South Africa. +27 11 466-8524. Fax: +27 11 466 8496. E-mail: Editor@Africanpilot.co.za. Website: www.wfricanpilot.co.za. Editor: Athol Franz. Est. 2001. Circ. 7,000 online, 6,000 print. "African Pilot is southern Africa's premier monthly aviation magazine. It publishes a high-quality magazine that is well-known and respected within the aviation community of southern Africa. The magazine offers a number of benefits to readers and advertisers, including a weekly e-mail newsletter, annual service guide, pilot training supplement, executive wall calendar and an extensive website that mirrors the paper edition. The magazine offers clean layouts with outstanding photography and reflects editorial professionalism as well as a responsible approach to journalism. The magazine offers a complete and tailored promotional solution for all aviation businesses operating in the African region."

Making Contact & Terms Send e-mail with samples. Samples are kept on file. Portfolio not required. Credit line given.

Tips "African Pilot is an African aviation specific publication and therefore preference is given to articles, illustrations and photographs that have an African theme. The entire magazine is online in exactly the same format as the printed copy for the viewing of our style and quality. Contact me for specific details on our publishing requirements for work to be submitted. Articles together with a selection of about ten thumbnail pictures to be submitted so that a decision can be made on the relevance of the article and what pictures are available to be used to illustrate the article. If we decide to go ahead with the article, we will request high-res images from the portfolio already submitted as thumbnails."

S AFTER FIVE

P.O. Box 492905, Redding CA 96049. (530)402-7440. Fax: (530)303-1528. E-mail: editorial@ after5online.com. Website: www.after5online.com. **Publisher:** Craig Harrington. Monthly tabloid. Emphasizes news, arts and entertainment. Circ. 32,000. Estab. 1986.

Needs Buys 1-2 photos from freelancers/issue; 2-24 photos/year. Needs scenic photos of Northern California. Also wants regional images of wildlife, rural, adventure, automobiles, entertainment, events, health/fitness, hobbies, humor, performing arts, sports, travel. Model release preferred. Photo captions preferred.

Specs Accepts images in digital format. Send via CD, e-mail, Jaz, Zip as TIFF, JPEG, EPS files at 150 dpi.

Making Contact & Terms Provide résumé, business card, brochure, flier or tearsheets to be kept on file for possible future assignments. Responds in 2 weeks. Previously published work OK. Pays \$60 for b&w or color cover; \$20 for b&w or color inside. **Pays on publication.** Credit line given. Buys one-time rights.

Tips "Need photographs of subjects north of Sacramento to Oregon-California border, plus Southern Oregon. Query first."

\$ AIM: AMERICA'S INTERCULTURAL MAGAZINE

P.O. Box 390, Milton WA 98354. E-mail: apiladoone@aol.com; editor@aimmagazine.org. Website: www.aimmagazine.org. **Owner and Founder:** Ruth Apilado. **Editor:** Kathleen Leatham. **Associate Editors:** Ray Leatham and Myron Apilado. Circ. 7,000. Estab. 1974. Quarterly magazine dedicated to promoting racial harmony and peace. *AIM* encourages original works of photography and art. Please limit photos and artwork to no more than 5 items per submission. Readers are high school

and college students, as well as those interested in social change. Sample copy available for \$5 with 9×12 SAE and 6 first-class stamps.

Needs Uses 10 photos/issue; 40 photos/year. Needs "ghetto pictures, pictures of people deserving recognition, etc." Needs photos of "integrated schools with high achievement." Model release required.

Specs Uses b&w prints. Photos and artwork must be submitted in JPEG, TIFF, or PMP format at 300 dpi. Articles, photos, and artwork submitted as hard copy, scanned text, or in any graphical format will not be considered for publication.

Making Contact & Terms Send unsolicited photos by mail for consideration; include SASE. Responds in 1 month. Pays \$25-50 for b&w cover; \$5-10 for b&w inside. Pays on acceptance. Credit line given. Buys one time rights.

Tips Looks for "positive contributions and social and educational development."

\$ ALABAMA LIVING

P.O. Box 244014, Montgomery AL 36124. (334)215-2732. Fax: (334)215-2733. E-mail: mcornelison@ areapower.com. Website: www.alabamaliving.com. Art Director: Michael Cornelison. Circ. 400,000. Estab. 1948. Monthly publication of the Alabama Rural Electric Association. It provides a vital information and education channel between cooperatives and their memberships. Emphasizes culture, lifestyles, history and events. Readers are older males and females living in small towns and suburban areas. Sample copy free with 9×12 SAE and 4 first-class stamps.

Needs Buys 1-3 photos from freelancers/issue; 12-36 photos/year. Needs photos of Alabama specific scenes, particularly seasonal. Special photo needs include vertical scenic cover shots. Photo captions preferred; include place and date.

Specs Accepts images in digital format. Send via CD, Zip as EPS, JPEG files at 400 dpi.

Making Contact & Terms Send query letter with stock list or transparencies ("dupes are fine") in negative sleeves. Keeps samples on file; include SASE for return of material. Responds in 1 month. Simultaneous submissions and previously published work OK "if previously published out-ofstate." Pays \$100 for color cover; \$50 for color inside; \$60-75 for photo/text package. Pays on acceptance. Credit line given. Buys one-time rights for publication and website; negotiable.

N ALARM MAGAZINE

Alarm Press, 222 S. Morgan St., #3E, Chicago IL 60607. E-mail: info@alarmpress.com. Website: www.alarmpress.com. Contact: Art Director.

Making Contact & Terms Art event listings should be e-mailed to artlistings@alarmpress.com.

S\$ ALASKA

301 Arctic Slope Ave., Suite 300, Anchorage AK 99518. (907)272-6070. E-mail: andy.hall@ alaskamagazine.com; tim.woody@alaskamagazine.com. Website: www.alaskamagazine.com. Rebecca Luczycki, senior editor. Assistant Director: Rachel Steer. Monthly magazine. Readers are people interested in Alaska. Sample copy available for \$4. Photo guidelines free with SASE or on website.

Needs Buys 500 photos/year, supplied mainly by freelancers. Photo captions required.

Making Contact & Terms Send carefully edited, captioned submission of 35mm, $2\frac{1}{4} \times 2\frac{1}{4}$ or 4×5 transparencies. Include SASE for return of material. Also accepts images in digital format; check guidelines before submitting. Responds in 1 month. Pays \$50 maximum for b&w photos; \$75-500 for color photos; \$300 maximum/day; \$2,000 maximum/complete job; \$300 maximum/full page; \$500 maximum/cover. Buys limited rights, first North American serial rights and electronic rights.

Tips "Each issue of Alaska features a 4- to 6-page photo feature. We're looking for themes and photos to show the best of Alaska. We want sharp, artistically composed pictures. Cover photo always relates to stories inside the issue."

M ALTERNATIVES JOURNAL

Canadian Environmental Ideas & Action, University of Waterloo, Waterloo ON N2L 3G1, Canada. (519)888-4442. Fax: (519)746-0292. E-mail: mruby@uwaterloo.ca. Website: www. alternativesjournal.ca. **Production Coordinator:** Marcia Ruby. Circ. 5,000. Estab. 1971. Bimonthly magazine. Emphasizes environmental issues. Readers are activists, academics, professionals, policy makers. Sample copy free with 9 × 12 SAE and 2 first-class stamps.

• "Alternatives is a nonprofit organization whose contributors are all volunteer. We are able to give a small honorarium to artists and photographers. This in no way should reflect the value of the work. It symbolizes our thanks for their contribution to Alternatives."

Needs Buys 4-8 photos from freelancers/issue; 48-96 photos/year. Subjects vary widely depending on theme of each issue. "We need action shots of people involved in environmental issues." Check website for upcoming themes. Reviews photos with or without a manuscript. Photo captions preferred; include who, when, where, environmental significance of shot.

Specs Accepts images in digital format. Send via CD, e-mail as JPEG files at 300 dpi.

Making Contact & Terms "E-mail your web address/electronic portfolio." Simultaneous submissions and previously published work OK. Pays on publication. Buys one-time rights; negotiable.

Tips "Alternatives covers Canadian and global environmental issues. Strong action photos or topical environmental issues are needed—preferably with people. We also print animal shots. We look for positive solutions to problems and prefer to illustrate the solutions rather than the problems. Freelancers need a good background understanding of environmental issues. You need to know the significance of your subject before you can powerfully present its visual perspective."

M ■ \$ □ AMC OUTDOORS

Appalachian Mountain Club, 5 Joy St., Boston MA 02108. (617)523-0655. Fax: (617)523-0722. E-mail: amcpublications@outdoors.org. Website: www.outdoors.org. Contact: Photo Editor. Circ. 70,000. Estab. 1908. Magazine published 6 times/year. "Our 94,000 members do more than just read about the outdoors; they get out and play. More than just another regional magazine, AMC Outdoors provides information on hundreds of AMC-sponsored adventure and education programs. With award-winning editorial, advice on Northeast destinations and trip planning, recommendations and reviews of the latest gear, AMC chapter news and more, AMC Outdoors is the primary source of information about the Northeast outdoors for most of our members." Photo guidelines free with SASE.

Needs Buys 6-12 photos from freelancers/issue; 75 photos/year. Needs photos of adventure, environmental, landscapes/scenics, wildlife, health/fitness/beauty, sports, travel. Other specific photo needs: people, including older adults (50 + years), being active outdoors. "We seek powerful outdoor images from the Northeast U.S., or non-location-specific action shots (hiking, skiing, snowshoeing, paddling, cycling, etc.) Our needs vary from issue to issue, based on content, but are often tied to the season."

Specs Uses color prints or 35mm slides. Prefers images in digital format. Send via CD or e-mail as TIFF, JPEG files at 300 dpi. Lower resolution OK for review of digital photos.

Making Contact & Terms Previously published work OK. Pays \$300 (negotiable) for color cover; \$50-100 (negotiable) for color inside. Pays on publication. Credit line given.

Tips "We do not run images from other parts of the U.S. or from outside the U.S. unless the landscape background is 'generic.' Most of our readers live and play in the Northeast, are intimately familiar with the region in which they live, and enjoy seeing the area and activities reflected in living color in the pages of their magazines."

AMERICAN ARCHAEOLOGY

5301 Central NE #902, Albuquerque NM 87108. (505)266-9668. Fax: (505)266-0311. E-mail: tacmag@nm.net. Website: www.americanarchaeology.org. **Art Director:** Vicki Singer. Circ. 25,000. Estab. 1997. Quarterly consumer magazine. Sample copies available.

Specs Uses 35mm, 21/4 × 21/4, 4 × 5 transparencies. Accepts images in digital format. Send via CD at 300 dpi or higher.

Making Contact & Terms Send query letter with résumé, photocopies and tearsheets. Provide résumé, business card, self-promotion piece to be kept on file for possible future assignments. Responds in 2 months to queries. Previously published work OK. Pays \$50 and up for occasional stock images; assigns work by project (pay varies); negotiable. Pays on acceptance. Credit line given. Buys one-time rights.

Tips "Read our magazine. Include accurate and detailed captions."

\$ AMERICAN FITNESS

15250 Ventura Blvd., Suite 200, Sherman Oaks CA 91403. E-mail: americanfitness@afaa.com. Website: www.americanfitness.com. Contact: Meg Jordan, editor. Bimonthly publication of the Aerobics and Fitness Association of America. Emphasizes exercise, fitness, health, sports nutrition, aerobic sports. Readers are fitness professionals, 75% college educated, 66% female, majority between ages 20-45. Sample copy available for \$3.50.

Needs Buys 20-40 photos from freelancers/issue; 120-240 photos/year. Assigns 90% of work. Needs action photography of runners, aerobic classes, swimmers, bicyclists, speedwalkers, inliners, volleyball players, etc. Also needs food choices, babies/children/teens, celebrities, couples, multicultural, families, parents, senior fitness, people enjoying recreation, cities/urban, rural, adventure, entertainment, events, hobbies, humor, performing arts, sports, travel, medicine, product shots/still life, science. Interested in alternative process, fashion/glamour, seasonal. Model release required.

Specs Uses b&w prints; 35mm, 21/4 × 21/4 transparencies. Cover: Color slides, transparencies (2" preferred size) or high-resolution 300 dpi TIFF or PDF files of at least 83/4 × 111/2. Interior/ editorial: Color slides, transparencies or high-resolution 300 dpi TIFF, PDF, or JPEG files; glossy print. Payment is issued post-publication.

Making Contact & Terms Send query letter with samples, list of stock photo subjects; include SASE for return of material. Responds in 2 weeks. Simultaneous submissions and previously published work OK. Pays \$10-35 for b&w or color photo; \$50 for text/photo package. Pays 4-6 weeks after publication. Credit line given. Buys first North American serial rights.

Tips Over-40 sports leagues, youth fitness, family fitness and senior fitness are hot trends. Wants high-quality, professional photos of people participating in high-energy activities—anything that conveys the essence of a fabulous fitness lifestyle. Also accepts highly stylized studio shots to run as lead artwork for feature stories. "Since we don't have a big art budget, freelancers usually submit spin-off projects from their larger photo assignments."

\$\$ AMERICAN FORESTS MAGAZINE

734 15th St. NW, Suite 800, Washington DC 20005. (202)737-1944, ext. 203. Fax: (202)737-2457. E-mail: info@amfor.org. Website: www.americanforests.org. Circ. 25,000. Estab. 1895. Quarterly publication of American Forests. Emphasizes use, enjoyment and management of forests and other natural resources. Readers are "people from all walks of life, from rural to urban settings, whose main common denominator is an abiding love for trees, forests or forestry." Sample copy and photo guidelines free with magazine-sized envelope and 7 first-class stamps.

Needs Buys 32 photos from freelancers/issue; 128 photos/year. Needs woods scenics, wildlife, woods use/management, and urban forestry shots. "Also shots of national champion trees; contact editor for details." Photo captions required; include who, what, where, when and why.

Specs Uses 35mm or larger. Prefers images in digital format. Send link to viewing platform, or send via CD or FTP as TIFF files at 300 dpi.

Making Contact & Terms "We regularly review portfolios from photographers to look for potential images for upcoming issues or to find new photographers to work with." Send query letter with résumé of credits. Include SASE for return of material. Responds in 4 months. Pays \$500 for color cover; \$90-200 for color inside; \$75-100 for b&w inside; \$250-2,000 for text/photo package. Pays

on acceptance. Credit line given. Buys one-time rights and rights for use in online version of magazine.

Tips "Please identify species in tree shots if possible."

\$ THE AMERICAN GARDENER

7931 E. Boulevard Dr., Alexandria VA 22308-1300. (703)768-5700. Fax: (703)768-7533. E-mail: myee@ahs.org. Website: www.ahs.org. Art Director/Managing Editor: Mary Yee. Bimonthly magazine. Sample copy available for \$5. Photo guidelines free with SASE or via e-mail request.

Needs Uses 35-50 photos/issue. Needs photos of plants, gardens, landscapes. Reviews photos with or without a manuscript. Photo captions required; include complete botanical names of plants including genus, species and botanical variety or cultivar.

Specs Prefers color, 35mm slides and larger transparencies or high-res JPEG or TIFF files with a minimum size of 5 × 7 at 300 dpi. Digital images should be submitted on a CD or posted to an online photo gallery.

Making Contact & Terms Send query letter with samples, stock list via mail or e-mail. Photographer will be contacted for portfolio review if interested. Does not keep samples on file; include SASE for return of material. Pays \$350 maximum for color cover; \$80-130 for color inside. Pays on publication. Credit line given. Buys one-time North American and nonexclusive rights.

Tips "Lists of plant species for which photographs are needed are sent out to a selected list of photographers approximately 10 weeks before publication. We currently have about 20 photographers on that list. Most of them have photo libraries representing thousands of species. Before adding photographers to our list, we need to determine both the quality and quantity of their collections. Therefore, we ask all photographers to submit both some samples of their slides (these will be returned immediately if sent with a SASE) and a list indicating the types and number of plants in their collection. After reviewing both, we may decide to add the photographer to our photo call for a trial period of 6 issues (1 year)."

\$ \$ AMERICAN HUNTER

11250 Waples Mill Rd., Fairfax VA 22030. (703)267-1336. Fax: (703)267-3971. E-mail: americanhunter@nrahq.org, wlafever@nrahq.org. Website: www.americanhunter.org. Editor-in-Chief: J. Scott Olmsted. Monthly magazine of the National Rifle Association. Sample copy and photo guidelines free with 9 × 12 SAE.

Needs Uses wildlife shots and hunting action scenes. Photos purchased with or without accompanying manuscript. Seeks general hunting stories on North American and African game. Model release required "for every recognizable human face in a photo." Photo captions preferred. Specs Accepts images in digital format only, no slides. Send via CD as TIFF, GIF, or RAW files at 300 dpi. Vertical format required for cover.

Making Contact & Terms Send material by mail for consideration; include SASE for return of material. Pays \$125-600/image; \$1000 for color cover; \$400-1400 for text/photo package. Pays on publication. Credit line given. Buys one-time rights.

Tips "Most successful photographers maintain a file in our offices so editors can select photos to fill holes when needed. We keep files on most North American big game, small game, waterfowl, upland birds, and some exotics. We need live hunting shots as well as profiles and portraits in all settings. Many times there is not enough time to call photographers for special needs. This practice puts your name in front of the editors more often and increases the chances of sales."

■ S \$ AMERICAN TURF MONTHLY

747 Middle Neck Rd., Suite 103, Great Neck NY 11024. (516)773-4075. Fax: (516)773-2944. E-mail: icorbett@americanturf.com; editor@americanturf.com. Website: www.americanturf.com. Editorin-Chief: James Corbett. Monthly magazine covering Thoroughbred horse racing, especially aimed at horseplayers and handicappers.

Needs Buys 10 photos from freelancers/issue; 120 photos/year. Needs photos of celebrities, racing action, horses, owners, trainers, jockeys. Reviews photos with or without a manuscript. Photo captions preferred; include who, what, where.

Specs Uses glossy color prints. Accepts images in digital format. Send via CD, floppy disk, Zip as TIFF, JPEG files at 300 dpi.

Making Contact & Terms Send query letter with CD, prints. Provide business card to be kept on file for possible future assignments. Responds only if interested; send nonreturnable samples. Pays \$150 minimum for color cover; \$25 minimum for b&w or color inside. Pays on publication. Credit line given. Buys all rights.

Tips "Like horses and horse racing."

ANCHOR NEWS

75 Maritime Dr., Manitowoc WI 54220. (920)684-0218 or (866)724-2356. Fax: (920)684-0219. E-mail: museum@WisconsinMaritime.org, Website: www.wisconsinmaritime.org, Executive Director Norma Bishop. Quarterly publication of the Wisconsin Maritime Museum. Emphasizes Great Lakes maritime history. Readers include learned and lay readers interested in Great Lakes history. Sample copy available for 9 × 12 SAE and \$1 postage. Photo guidelines free with SASE.

Needs Uses 8-10 photos/issue; infrequently supplied by freelance photographers. Needs historic/ nostalgic; personal experience; Great Lakes environmental issues, including aquatic invasive species and other topics of interest to environmental educators; and general interest articles on Great Lakes maritime topics. How-to and technical pieces and model ships and shipbuilding are OK. Special needs include historic photography or photos that show current historic trends of the Great Lakes; photos of waterfront development, bulk carriers, sailors, recreational boating, etc. Model release required. Photo captions required.

Specs Accepts images in digital format. Send via CD, e-mail as JPEG files at 300 dpi minimum. **Making Contact & Terms** Send 4×5 or 8×10 glossy b&w prints by mail for consideration; include SASE for return of material. Simultaneous submissions and previously published work OK. Pays in copies on publication. Credit line given. Buys first North American serial rights.

Tips "Besides historic photographs, I see a growing interest in underwater archaeology, especially on the Great Lakes, and underwater exploration—also on the Great Lakes. Sharp, clear photographs are a must. Our publication deals with a wide variety of subjects; however, we take a historical slant with our publication. Therefore, photos should be related to a historical topic in some respect. Also, there are current trends in Great Lakes shipping. A query is most helpful. This will let the photographer know exactly what we are looking for and will help save a lot of time and wasted effort."

ANIMAL TRAILS

2660 Petersborough St., Herndon VA 20171. E-mail: animaltrails@yahoo.com. Website: animaltrailsmagazine.doodlekit.com. Contact: Shannon Bridget Murphy. Quarterly publication.

Needs Photos of environmental, landscapes/scenics, wildlife, architecture, cities/urban, gardening, interiors/decorating, pets, religious, rural, performing arts, agriculture, product shots/still life—as related to animals. Interested in alternative process, avant garde, documentary, fashion/glamour, fine art, historical/vintage, seasonal. Reviews photos with or without a manuscript. Model/property release preferred.

Specs Uses glossy or matte color and b&w prints.

Making Contact & Terms Send query letter via e-mail or online form at website. Provide résumé, business card, self-promotion piece to be kept on file for possible future assignments. "A photograph or two is requested but not required. Illustrations and artwork are also accepted." Responds within 1 month to queries; 1 week to portfolios. Simultaneous submissions and previously published work OK. Pays on acceptance. Credit line given. Buys one-time rights, first rights; negotiable.

APERTURE

547 W. 27th St., 4th Floor, New York NY 10001. (212)505-5555. E-mail: editorial@aperture.org. Website: www.aperture.org. Managing Editor: Michael Famigehtti. Quarterly. Emphasizes fine-art and contemporary photography, as well as social reportage. Readers include photographers, artists, collectors, writers.

Needs Uses about 60 photos/issue; biannual portfolio review. Model release required. Photo captions required.

Making Contact & Terms Submit portfolio for review in January and July; include SASE for return of material. Responds in 2 months. No payment. Credit line given.

Tips "We are a nonprofit foundation. Do not send portfolios outside of January and July."

\$ APPALACHIAN TRAIL JOURNEYS

P.O. Box 807, Harpers Ferry WV 25425. (304)535-6331. Fax: (304)535-2667. E-mail: sparadis@ appalachiantrail.org. Website: www.appalachiantrail.org. Bimonthly publication of the Appalachian Trail Conservancy. Uses only photos related to the Appalachian Trail. Readers are conservationists, hikers. Photo guidelines available on website.

Needs Buys 4-5 photos from freelancers/issue in addition to 2- to 4-page "Vistas" spread each issue; 50-60 photos/year. Most frequent need is for candids of hikers enjoying the trail. Photo captions and release required.

Specs Accepts high-res digital images (300 dpi). Uses 35mm transparencies.

Making Contact & Terms Send query letter with ideas by mail, e-mail. Duplicate slides preferred over originals for query. Responds in 3 weeks. Simultaneous submissions and previously published work OK. **Pays on publication**. Pays \$300 for cover; variable for inside. Credit line given. Rights negotiable.

\$ AQUARIUM FISH INTERNATIONAL

P.O. Box 6050, Mission Viejo CA 92690. Fax: (949)855-3045. E-mail: aquariumfish@bowtieinc. com. Website: www.fishchannel.com. **Managing Editor:** Patricia Knight. Estab. 1988. Monthly magazine. Emphasizes aquarium fish. Readers are both genders, all ages. Photo guidelines free with SASE, via e-mail or on website.

Needs Buys 30 photos from freelancers/issue; 360 photos/year. Photos of aquariums and fish, freshwater and saltwater; ponds.

Specs Uses 35mm slides, transparencies. Accepts digital images—"but digital image guidelines must be strictly followed for submissions to be considered."

Making Contact & Terms Send slides, transparencies, original prints (no laser printouts) or CDs (no DVDs) by mail for consideration; include SASE for return of material. Pays \$200 for color cover; \$15-150 for color inside. **Pays on publication.** Credit line given. Buys first North American serial rights.

■ ARIZONA WILDLIFE VIEWS

2221 W. Greenway Rd., Phoenix AZ 85053. (602) 789-3224. Fax: (602) 789-3776. E-mail: aww@azgfd.gov. Website: www.azgfd.gov/magazine. Associate Editor: Julie Hammonds. Bimonthly official magazine of the Arizona Game & Fish Department. "Arizona Wildlife Views is a general interest magazine about Arizona wildlife, wildlife management and outdoor recreation (specifically hunting, fishing, wildlife watching, boating and off-highway vehicle recreation). We publish material that conforms to the mission and policies of the Arizona Game and Fish Department. In addition to Arizona wildlife management, topics include habitat issues, outdoor recreation involving wildlife, boating, fishing, hunting, bird-watching, animal observation, off-highway vehicle use, and historical articles about wildlife and wildlife management."

Needs Photos of sports, environmental, landscapes/scenics, wildlife in Arizona. Reviews photos with or without a manuscript. Model release required only if the subject matter is of a delicate or sensitive nature. Captions required.

Specs "We prefer and primarily use professional-quality 35mm and larger color transparencies. Submitted transparencies must be numbered, identified by artist, and an inventory list must accompany each shipment. The highest resolution digital images are occasionally used." Send JPEG or GIF files. See new information for photographers online at website.

Making Contact & Terms Before contacting, please read the appropriate submission guidelines: www.azgfd.gov/i_e/pubs/contributorguidelines.shtml. "Half of the written content of Arizona Wildlife Views magazine is generated by freelance writers and photographers. Payment is made upon publication. We prefer queries by e-mail. Sample copies are available on request. Before contacting us, please read the appropriate submission guidelines on our website." "The magazine does not accept responsibility for any submissions. It is the artist's responsibility to insure his or her work." Pays \$400 for front cover; \$350 for back cover; \$250 for inside half-page or larger; \$150 for inside smaller than half-page. Pays following publication. Credit line given. Buys one-time rights.

Tips "Unsolicited material without proper identification will be returned immediately."

\$ ASTRONOMY

21027 Crossroads Circle, Waukesha WI 53187. Website: www.astronomy.com. Circ. 133,000. Estab. 1973. Monthly magazine. Emphasizes astronomy, science and hobby. Median reader: 52 years old, 86% male. Photo guidelines free with SASE or via website.

Needs Buys 70 photos from freelancers/issue; 840 photos/year. Needs photos of astronomical images. Model/property release preferred. Photo captions required.

Specs "If you are submitting digital images, please send TIFF or JPEG files to us via our FTP site."

Making Contact & Terms Send duplicate images by mail for consideration. Keeps samples on file. Responds in 1 month. Pays on publication. Credit line given.

■ **\$\$ ATLANTA HOMES & LIFESTYLES**

1100 Johnson Ferry Rd. NE, Suite 595, Atlanta GA 30342. (404)252-6670. Fax: (404) 252-6673. E-mail: gchristman@atlantahomesmag.com. Website: www.atlantahomesmag.com. Editor: Clinton Ross Smith. Creative Director: Rachel Cardina. Monthly magazine. Covers residential design (home and garden); food, wine and entertaining; people, lifestyle subjects in the metro Atlanta area. Sample copy available for \$3.95.

Needs Photos of homes (interior/exterior), people, decorating ideas, products, gardens. Model/ property release required. Photo captions preferred.

Specs Accepts images in digital format only.

Making Contact & Terms Contact creative director to review portfolio. Provide résumé, business card, brochure, flier or tearsheets to be kept on file for possible future assignments. Responds in 2 months. Simultaneous submissions and previously published work OK. Pays \$150-750/job. Pays on acceptance. Credit line given. Buys one-time rights.

\$ AUTO RESTORER

3 Borroughs, Irvine CA 92618. (949)855-8822, ext. 3412. Fax: (949)855-3045. E-mail: tkade@ fancypubs.com; editors@mmminc.org. Website: www.autorestorermagazine.com. Editor: Ted Kade. Circ. 60,000. Monthly magazine. Emphasizes restoration of collector cars and trucks. Readers are 98% male, professional/technical/managerial, ages 35-65.

Needs Buys 47 photos from freelancers/issue; 564 photos/year. Needs photos of auto restoration projects and restored cars. Reviews photos with accompanying manuscript only. Model/property release preferred. Photo captions required; include year, make and model of car; identification of people in photo.

Specs Prefers images in high-res digital format. Send via CD at 240 dpi with minimum width of 5 inches. Uses transparencies, mostly 35mm, 21/4 × 21/4.

Making Contact & Terms Submit inquiry and portfolio for review. Provide résumé, business card, brochure, flier or tearsheets to be kept on file for possible future assignments. Responds in 1 month. Simultaneous submissions OK. Pays \$50 for b&w cover; \$35 for b&w inside. **Pays on publication.** Credit line given. Buys first North American serial rights.

Tips Looks for "technically proficient or dramatic photos of various automotive subjects, auto portraits, detail shots, action photos, good angles, composition and lighting. We're also looking for photos to illustrate how-to articles such as how to repair a damaged fender or how to repair a carburetor."

BASEBALL

2660 Petersborough St., Herndon VA 20171. E-mail: shannonaswriter@yahoo.com. Editor: Shannon Murphy. Quarterly magazine covering baseball. Photo guidelines available by e-mail request.

Needs Photos of baseball scenes featuring children and teens; photos of celebrities, couples, multicultural, families, parents, environmental, landscapes/scenics, wildlife, agriculture—as related to the sport of baseball. Interested in alternative process, avant garde, documentary, fine art, historical/vintage, seasonal. Reviews photos with or without a manuscript.

Specs Uses glossy or matte color and b&w prints.

Making Contact & Terms Send query letter via e-mail. "If possible, please do not include photographs in files if they are sent through e-mail. A disk with your photographs is acceptable. If you plan to send a disk, photographs or portfolio, please send an e-mail stating this." Provide résumé, business card, self-promotion piece to be kept on file for possible future assignments. "Photographs sent with CDs are requested but not required. Write to request guidelines for artwork and illustrations." Responds within 1 month to queries; 1 week to portfolios. Simultaneous submissions and previously published work OK. **Pays on acceptance.** Credit line given. Buys one-time, first rights; negotiable.

☑ ■ BC OUTDOORS: HUNTING and SHOOTING

OP Publishing Ltd., 200 West Esplanade, Ste. 500, Vancouver BC V7M 1A4, Canada. (604)606-998-3310. E-mail: production@outdoorgroupmedia.com. Website: www.bcoutdoorsmagazine.com. Editor: Mike Mitchell. Art Director/Production: Paul Bielicki. Biannual magazine emphasizing hunting, RV camping, wildlife and management issues in British Columbia only. Sample copy available for \$4.95 Canadian.

Needs Buys 30-35 photos from freelancers/issue; 60-70 photos/year. "Hunting, canoeing and camping. Family oriented. By far, most photos accompany manuscripts. We are always on the lookout for good covers—wildlife, recreational activities, people in the outdoors—of British Columbia, vertical and square format. Photos with manuscripts must, of course, illustrate the story. There should, as far as possible, be something happening. Photos generally dominate lead spread of each story. They are used in everything from double-page bleeds to thumbnails. Column needs basically supplied in-house." Model/property release preferred. Photo captions or at least full identification required.

Specs Prefers images in digital format. Send via e-mail at 300 dpi.

Making Contact & Terms Send by mail for consideration actual 5×7 or 8×10 color prints; 35mm, $2\frac{1}{4} \times 2\frac{1}{4}$, 4×5 or 8×10 color transparencies; color contact sheet. If color negative, send jumbo prints, then negatives only on request. E-mail high-res electronic images. Send query letter with list of stock photo subjects. Include SASE or IRC. Pays in Canadian currency. Simultaneous submissions not acceptable if competitor. Editor determines payments. **Pays on publication.** Credit line given. Buys one-time rights for inside shots; for covers, "we retain the right for subsequent promotional use."

S THE BEAR DELUXE MAGAZINE

810 SE Belmont, #5, Portland OR 97214. (503)242-1047. E-mail: bear@orlo.org. Website: www.orlo. org. Art Director: Kristen Rogers. Quarterly magazine. "We use the arts to focus on environmental themes." Sample copy available for \$5. Photo guidelines available for SASE.

Needs Buys 10 photos from freelancers/issue; 40 photos/year. Needs photos of environmental, landscapes/scenics, wildlife, adventure, political, Reviews photos with or without a manuscript. Model release required (as needed); property release preferred. Photo captions preferred; include place, year, photographer, names of subjects.

Specs Uses 8 × 10 matte b&w prints. Accepts images in digital format. Send via CD, Zip, or low-res e-mail files.

Making Contact & Terms Send query letter with résumé, slides, prints, photocopies. Portfolio may be dropped off by appointment. Provide résumé, self-promotion piece to be kept on file for possible future assignments. Responds in 6 months to queries; 2 months to portfolios. Only returns materials if appropriate SASE included. Not liable for submitted materials, Simultaneous submissions and previously published work OK as long as it is noted as such. Pays \$200 for b&w cover; \$30-50 for b&w inside. Pays approximately 3 weeks after publication. Credit line given. Buys one-time rights; negotiable.

Tips "Read the magazine. We want unique and unexpected photos, not your traditional nature or landscape stuff."

№ ■ O BELLINGHAM REVIEW

Mail Stop 9053, Western Washington University, Bellingham WA 98225. (360)650-4863. E-mail: Bhreview@wwu.edu, Managing Editor: Christopher Carlson, Estab. 1977, Circ. 1,500, Annual nonprofit magazine. "Literature of palpable quality: poems stories and essays beguiling, they invite us to touch their essence. The Bellingham Review hungers for a kind of writing that nudges the limits of form, or executes traditional forms exquisitely."

Needs Babies/children/teens, couples, multicultural, families, parents, senior citizens, architecture, cities/urban, gardening, pets, rural, disasters, environment, landscapes, wildlife, adventure,

Making Contact & Terms Send an e-mail with sample photographs. Accepts JPEG samples at 72 dpi. Samples not kept on file. Portfolio not required. Pays on publication.

S S BIRD WATCHER'S DIGEST

149 Acme St., P.O. Box 110, Marietta OH 45750. (740)373-5285. Fax: (740)373-8443. E-mail: editor@birdwatchersdigest.com, Website: www.birdwatchersdigest.com, Editor: Bill Thompson III. Bimonthly, digest size. Emphasizes birds and bird watchers. "We use images to augment our magazine's content, so we often look for non-traditional shots of birds, including images capturing unusual behavior or settings. For our species profiles of birds we look for more traditional images: sharp, well-composed portraits of wild birds in their natural habitat." Readers are bird watchers/ birders (backyard and field, veterans and novices). Sample copy available for \$3.99. Photo guidelines available on website.

Needs Buys 25-35 photos from freelancers/issue; 150-210 photos/year. "If you are just starting out, we suggest an initial submission of 20 or fewer images so that we can judge the quality of your work." Needs photos of North American species.

Specs Accepts high-res (300 dpi) digital images via CD or DVD. "We appreciate quality thumbnails to accompany digital images. Our preferred formats for digital images are JPEG or TIFF. Images taken with digital cameras should be created using the highest-quality JPEG setting (usually marked "fine" or "high") on your camera. TIFF images should be saved with LZW compression. Please make all images Mac compatible."

Making Contact & Terms Send query letter with list of stock photo subjects, samples, SASE to Editorial Dept. Responds in 2 months. Work previously published in other bird publications should not be submitted. Pays \$75 for color inside. Credit line given. Buys one-time rights.

Tips "Query with slides or digital images on a CD to be considered for photograph want-list. Send a sample of no more than 20 images for consideration. Sample will be reviewed and responded to in 8 weeks."

■ ■ S S BIRD WATCHING MAGAZINE

Bauer Active, Media House, Lynchwood, Peterborough PE2 6EA, Wales. 01733 468 201. Fax: (44) (733)465-376. Website: www.birdwatching.co.uk. Editor: Dominic Mitchell. Monthly hobby magazine for bird watchers. Sample copy free for SAE with first-class postage/IRC.

Needs Photos of "wild birds photographed in the wild, mainly in action or showing interesting aspects of behavior. Also stunning landscape pictures in birding areas and images of people with binoculars, telescopes, etc." Also considers travel, hobby and gardening shots related to bird watching. Reviews photos with or without a manuscript. Photo captions preferred.

Specs Uses 35mm, 2¼ × 2¼ transparencies. Accepts images in digital format. Send via CD, e-mail as TIFF, EPS, JPEG files at 200 dpi.

Making Contact & Terms Provide résumé, business card, self-promotion piece or tearsheets to be kept on file for possible future assignments. Returns unsolicited material if SASE enclosed. Responds in 1 month. Simultaneous submissions OK. Pays £70-100 for color cover; £15-120 for color inside. Pays on publication. Buys one-time rights.

Tips "All photos are held on file here in the office once they have been selected. They are returned when used or a request for their return is made. Make sure all slides are well labeled; bird, name, date, place taken, photographer's name and address. Send sample of images to show full range of subject and photographic techniques."

☑ ■ A ○ BLACKFLASH

P.O. Box 7381, Station Main, Saskatoon SK S7K 4J3, Canada. (306)374-5115. Fax: (306)665-6568. Website: www.blackflash.ca. Managing Editor: John Shelling. Circ. 1,700. Estab. 1983. Canadian journal of photo-based and electronic arts published 3 times/year.

Needs Looking for lens-based and new media contemporary fine art and electronic arts practitioners." Reviews photos with or without a manuscript.

Specs Accepts images in digital format. Send via CD, Zip, e-mail as TIFF, EPS, BMP, JPEG files at 300 dpi.

Making Contact & Terms Send query letter with résumé, digital images. Does not keep samples on file; will return material with SASE only. Simultaneous submissions OK. Pays when copy has been proofed and edited. Credit line given. Buys one-time rights.

Tips "We need alternative and interesting contemporary photography. Understand our mandate and read our magazine prior to submitting."

■ \$ BLUE RIDGE COUNTRY

P.O. Box 21535, Roanoke VA 24018. (540)989-6138. Fax: (540)989-7603. E-mail: krheinheimer@ leisurepublishing.com. Website: www.blueridgecountry.com. Editor: Kurt Rheinheimer. Bimonthly magazine. Emphasizes outdoor scenics, recreation, travel destinations in 9-state Blue Ridge Mountain region. Photo guidelines available for SASE or on website.

Needs Buys 20-40 photos from freelancers/issue; 100-300 photos/year. Need photos of travel, scenics and wildlife. Seeking more scenics with people in them. Model release preferred. Photo captions required.

Specs Uses 35mm, 21/4 × 21/4, 4 × 5 transparencies. Accepts images in digital format. Send via CD, e-mail, or FTP (contact editor for information) at 300 dpi; low-res images OK for initial review, but accepted images must be high-res.

Making Contact & Terms Send query letter with list of stock photo subjects, samples with caption info and SASE. Responds in 2 months. Pays \$150 for color cover; \$40-150 for color inside. Pays on publication. Credit line given. Buys one-time rights.

\$\$ BOWHUNTER

6385 Flank Dr., Harrisburg PA 17112. (717)695-8083. E-mail: bowhunter_magazine@ intermediaoutdoors.com. Website: www.bowhunter.com. Editor: Dwight Schuh. Publisher: Jeff Waring. Art Director: Mark Olszewski. Published 9 times/year. Emphasizes bow and arrow hunting. Sample copy available for \$2. Submission guidelines free with SASE.

Needs Buys 50-75 photos/year. Wants scenic (showing bowhunting) and wildlife (big and small game of North America) photos. "No cute animal shots or poses. We want informative, entertaining bowhunting adventure, how-to and where-to-go articles." Reviews photos with or without a manuscript.

Specs Digital submissions—300 dpi, RAW, JPEG, or TIFF format; CMYK preferred, provided on CD or DVD named in a simple and logical system with accompanying contact sheet.

Making Contact & Terms Send query letter with samples, SASE. Responds in 2 weeks to queries; 6 weeks to samples. Pays \$50-125 for b&w inside; \$75-300 for color inside; \$600 for cover, "occasionally more if photo warrants it." Pays on acceptance. Credit line given. Buys one-time publication rights.

Tips "Know bowhunting and/or wildlife and study several copies of our magazine before submitting any material. We're looking for better quality, and we're using more color on inside pages. Most purchased photos are of big game animals. Hunting scenes are second. In b&w we look for sharp, realistic light, good contrast. Color must be sharp; early or late light is best. We avoid anything that looks staged; we want natural settings, quality animals. Send only your best, and, if at all possible, let us hold those we indicate interest in. Very little is taken on assignment; most comes from our files or is part of the manuscript package. If your work is in our files, it will probably be used."

BRIARPATCH

2138 McIntyre St., Regina SK S4P 2R7, Canada. (306)525-2949. E-mail: editor@briarpatchmagazine. com. Website: www.briarpatchmagazine.com. Editor: Dave Mitchell. Magazine published 6 times/ year. Emphasizes Canadian and international politics, labor, environment, women, peace. Readers are socially progressive and politically engaged. Sample copy available for \$6 plus shipping.

Needs Buys 5-20 photos from freelancers/issue; 30-120 photos/year. Needs photos of Canadian and international politics, labor, environment, women, peace and personalities. Model/property release preferred. Photo captions preferred; include name of persons in photo.

Specs Minimum 300 dpi color or b&w prints.

Making Contact & Terms Send query letter with samples or link to online portfolio. Do not send slides. Provide résumé, business card, brochure, flier, or tearsheets to be kept on file for possible future assignments. Include SASE for return of material. Responds in 1 month. Simultaneous submissions and previously published work OK. Pays \$20 per published photo; \$100 for cover. Credit line given. Buys one-time rights.

\$ BRIDAL GUIDES MAGAZINE

2660 Petersborough St., Herndon VA 20171. E-mail: BridalGuides@yahoo.com. Editor: Shannon Bridget Murphy. Quarterly. Photo guidelines available by e-mail request.

Needs Buys 12 photos from freelancers/issue; 48-72 photos/year. Photos of babies/children/teens, celebrities, couples, multicultural, families, parents, cities/urban, environmental, landscapes/ scenics, wildlife, architecture, gardening, interiors/decorating, pets, religious, rural, adventure, entertainment, events, food/drink, health/fitness, performing arts, travel, agriculture—as related to weddings. Interested in alternative process, avant garde, documentary, fashion/glamour, fine art, historical/vintage, seasonal. Also wants photos of weddings "and those who make it all happen, both behind and in front of the scene." Reviews photos with or without a manuscript. Model/property release preferred.

Specs Uses glossy or matte color and b&w prints.

Making Contact & Terms Send query letter via e-mail. "If possible, please do not include photographs in files if they are sent through e-mail. A disk with your photographs is acceptable. If you plan to send a disk, photographs or portfolio, please send an e-mail stating this." Provide résumé, business card or self-promotion piece to be kept on file for possible future assignments. "A photograph or two sent with CD is requested but not required. Illustrations and artwork are also accepted." Write to request guidelines for artwork and illustrations. Responds within 1 month to queries; 1 week to portfolios. Simultaneous submissions and previously published work OK. **Pays on acceptance**. Credit line given. Buys one-time rights, first rights; negotiable.

\$ THE BRIDGE BULLETIN

American Contract Bridge League, 6575 Windchase Blvd., Horn Lake MS 38637-1523. (662)253-3156. Fax: (662)253-3187. E-mail: editor@acbl.org, brent.manley@acbl.org. Website: www. acbl.org. Editor: Brent Manley. Circ. 154,000. Estab. 1937. Monthly association magazine for tournament/duplicate bridge players. Sample copies available.

Needs Buys 6-10 photos/year. Reviews photos with or without a manuscript.

Specs Prefers high-res digital images, color only.

Making Contact & Terms Query by phone. Responds only if interested; send nonreturnable samples. Previously published work OK. Pays \$200 or more for suitable work. Pays on publication. Credit line given. Buys all rights.

Tips Photos must relate to bridge. Call first.

\$ CALLIOPE

30 Grove St., Peterborough NH 03458. (603)924-7209. Website: www.cobblestonepub.com/magazine/CAL. Editor: Rosalie Baker. Circ. 13,000. Estab. 1990. Magazine published 9 times/year (May/June, July/August, November/December). Emphasis on non-United States history. Readers are children ages 10-14. "To be considered for publication, photographs must relate to a specific theme. Writers are encouraged to submit available photos with their query or article. We buy one-time use. Our suggested fee range for professional quality photographs follows: ¼ page to full page b&w \$15-100; color \$25-100. Please note that fees for non-professional quality photographs are negotiated. Cover fees are set on an individual basis for one-time use, plus promotional use. All cover images are color. Prices set by museums, societies, stock photography houses, etc., are paid or negotiated. Photographs that are promotional in nature (e.g., from tourist agencies, organizations, special events, etc.) are usually submitted at no charge. If you have photographs pertaining to any upcoming theme, please contact the editor by mail or fax, or send them with your query. You may also send images on speculation." Sample copies available for \$5.95 with 9 × 12 or larger SAE and 5 first-class stamps. Photo guidelines available on website or free with SASE.

Needs Contemporary shots of historical locations, buildings, artifacts, historical reenactments and costumes. Reviews photos with or without accompanying manuscript. Model/property release preferred.

Specs Uses b&w and color prints; 35mm transparencies.

Making Contact & Terms Send query letter with stock photo list. Provide résumé and business card, brochure, flier or tearsheets to be kept on file for possible future assignments. Responds within 5 months. Simultaneous submissions and previously published work OK. Pays \$15-100 for inside; cover (color) photo payment negotiated. **Pays on publication.** Credit line given. Buys one-time rights; negotiable.

Tips "Given our young audience, we like to have pictures that include people, both young and old. Pictures must be dynamic to make history appealing. Submissions must relate to themes in each issue."

🖾 🗏 🕏 🖸 CANADA LUTHERAN

302-393 Portage Ave., Winnipeg MB R3B 3H6, Canada. (204)984-9172. Fax: (204)984-9185. E-mail: tgallop@elcic.ca. Website: www.elcic.ca/clweb. Editorial Director: Trina Gallop. Monthly publication of Evangelical Lutheran Church in Canada. Emphasizes faith/religious content, Lutheran denomination. Readers are members of the Evangelical Lutheran Church in Canada. Sample copy available for \$5 Canadian (includes postage).

Needs Buys 1-2 photos from freelancers/issue; 12-24 photos/year. Photos of people in worship, at work/play, diversity, advocacy, youth/young people, etc. Canadian sources preferred.

Specs Accepts images in digital format. Send via CD, e-mail as JPEG at 300 dpi minimum.

Making Contact & Terms Send sample prints and photo CDs by mail (include SASE for return of material) or send low-res images by e-mail. Payments \$20-75 for a photo, depending on how it is used. Covers claim the greatest return: \$40-75. Feature photos next: \$25-50. News photos: \$20-30. Prices are in Canadian dollars. Pays on publication. Credit line given. Buys one-time rights.

Tips "Give us many photos that show your range. We prefer to keep them on file for at least a year. We have a short-term turnaround and turn to our file on a monthly basis to illustrate articles or cover concepts. Changing technology speeds up the turnaround time considerably when assessing images, yet forces publishers to think farther in advance to be able to achieve promised cost savings. U.S. photographers—send via U.S. mail. We sometimes get wrongly charged duty at the border when shipping via couriers."

S S CANADIAN HOMES & COTTAGES

2650 Meadowvale Blvd., Unit 4, Mississauga ON L5N 6M5, Canada. (905)567-1440. Fax: (905)567-1442. E-mail: schester@homesandcottages.com. Website: www.homesandcottages.com. Managing Editor: Oliver Johnson. Bimonthly. Canada's largest building, renovation and home improvement magazine. Photo guidelines free with SASE.

Needs Photos of landscapes/scenics, architecture, interiors/decorating.

Making Contact & Terms Does not keep samples on file; cannot return material. Responds only if interested; send nonreturnable samples. Pays on acceptance. Credit line given.

🖾 🗏 THE CANADIAN ORGANIC GROWER

323 Chapel St., Ottawa ON K1N 7Z2, Canada. 613-216-0741. Fax: 613-236-0743. E-mail: janet@cog. ca; office@cog.ca; publications@cog.ca. Website: www.cog.ca. Managing Editor: Janet Wallace. Quarterly consumer magazine for organic gardeners, farmers and consumers in Canada. Depends entirely on freelancers.

Needs Photos of gardening, rural, agriculture, organic gardening and farming in Canada. Reviews photos with or without accompanying manuscript. Captions required; include identification of subjects. Try to get pictures of people actively working in their gardens or field. Please indicate who or what is in each photo. List groups of people from left to right and from back row to front row. Try to capture the same person, place or thing from more than one angle as you take pictures. Tell us who the photographer is for the list of credits. With digital photos, we need high-res shots. A good rule-of-thumb is to ensure that the file size of the photo is at least 800kb (preferably 1-3 MB) in size. Deadlines: October 15 for winter issue, January 15 for spring, April 15 for summer, and July 15 for fall.

Specs Accepts images in digital format. Send JPEG or GIF files

Making Contact & Terms Expenses are not reimbursed unless discussed and approved in advance. For each feature article, contributors are paid \$100-200 per article (depending on length, scope and quality). We do not pay for opinion pieces or book reviews. Credit line given. Buys one-time rights. Pays on publication.

Tips Please see website for more guidelines.

E S \$\$ CANOE & KAYAK

P.O. Box 3146, Kirkland WA 98083-3146. (425)827-6363. E-mail: jeff@canoekayak.com. Website: www.canoekayak.com. Editor-in-Chief: Jeff Moag. Circ. 63,000. Estab. 1973. Bimonthly magazine published 6 times a year in March, May, June, July, August, December. Packed with destination reviews and features a different region of North America, paddling techniques, photography from seasoned canoeists, expert reviews of paddle and camping gear. It is the world's largest paddlesports publication. The vast majority of stories are produced by established freelance writers or the *C&K* editorial staff, though "we are open to new story ideas and contributors." Emphasizes a variety of paddle sports, as well as how-to material and articles about equipment. For upscale canoe and kayak enthusiasts at all levels of ability. Also publishes special projects. Sample copy free with 9 × 12 SASE.

Needs Buys 25 photos from freelancers/issue; 150 photos/year. Photos of canoeing, kayaking, ocean touring, canoe sailing, fishing when compatible to the main activity, canoe camping but not rafting. No photos showing disregard for the environment, be it river or land; no photos showing gasoline-powered, multi-hp engines; no photos showing unskilled persons taking extraordinary risks to life, etc. Accompanying manuscripts for "editorial coverage striving for balanced representation of all interests in today's paddling activity. Those interests include paddling adventures (both close to home and far away), camping, fishing, flatwater, whitewater, ocean kayaking, poling, sailing, outdoor photography, how-to projects, instruction and historical perspective. Regular columns feature paddling techniques, conservation topics, safety, interviews, equipment reviews, book/movie reviews, new products and letters from readers." Photos only occasionally purchased without accompanying manuscript. Model release preferred "when potential for litigation." Property release required. Photo captions preferred.

Specs Uses 5×7 , 8×10 glossy b&w prints; 35mm, $2\frac{1}{4} \times 2\frac{1}{4}$, 4×5 transparencies; color transparencies for cover; vertical format preferred. Accepts images in digital format. Send via CD, Zip as TIFF, EPS, JPEG files at 300 dpi.

Making Contact & Terms We never run unsolicited articles. Your best bet is to e-mail us a short, original, and very succinct query about your idea, the photos available to illustrate it, and your writing background/availability. C&K pays \$.50 per published word, on publication. Please read the magazine before sending a query. Your query should demonstrate that you're familiar with the magazine, its editorial focus and tone, and its specific sections. Queries should be tailored to one section of the magazine and sent to the assigning editor for that section. Include SASE for return of material. Responds in 1 month. Simultaneous submissions and previously published work OK, in noncompeting publications. Pays \$500-700 for color cover; \$75-200 for b&w inside; \$75-350 for color inside. Pays on publication. Credit line given. Buys one-time rights, first serial rights and exclusive rights.

Tips "We have a highly specialized subject, and readers don't want just any photo of the activity. We're particularly interested in photos showing paddlers' *faces*; the faces of people having a good time. We're after anything that highlights the paddling activity as a lifestyle and the urge to be outdoors." All photos should be "as natural as possible with authentic subjects. We receive a lot of submissions from photographers to whom canoeing and kayaking are quite novel activities. These photos are often clichéd and uninteresting. So consider the quality of your work carefully before submission if you are not familiar with the sport. We are always in search of fresh ways of looking at our sport. All paddlers must be wearing life vests/PFDs."

\$\$ CARIBBEAN TRAVEL & LIFE

460 N. Orlando Ave., Suite 200, Winter Park FL 32789. (407)571-4704. E-mail: zach.stovall@bonniercorp.com; editor@caribbeantravelmag.com. Website: www.caribbeantravelmag.com. Photo Services: Zach Stovall. Published 9 times/year. Emphasizes travel, culture and recreation in islands of Caribbean, Bahamas and Bermuda. Readers are male and female frequent Caribbean travelers, ages 32-52. Sample copy available for \$4.95. Photo guidelines free with SASE.

Needs Uses about 100 photos/issue; 90% supplied by freelance photographers: 10% assignment and 90% freelance stock. "We combine scenics with people shots. Where applicable, we show interiors, food shots, resorts, water sports, cultural events, shopping and wildlife/underwater shots. We want images that show intimacy between people and place. Provide thorough caption information. Don't submit stock that is mediocre."

Specs Uses 4-color photography.

Making Contact & Terms Query by mail or e-mail with list of stock photo subjects and tearsheets. Responds in 3 weeks. Pays \$1,000 for color cover; \$450/spread; \$325/full + page; \$275/full page; $200/\frac{1}{2}$ + page; $150/\frac{1}{2}$ page; $120/\frac{1}{3}$ page; $90/\frac{1}{4}$ page or less. Pays after publication. Buys one-time rights. Does not pay shipping, research or holding fees.

Tips Seeing trend toward "fewer but larger photos with more impact and drama. We are looking for particularly strong images of color and style, beautiful island scenics and people shots—images that are powerful enough to make the reader want to travel to the region; photos that show people doing things in the destinations we cover; originality in approach, composition, subject matter. Good composition, lighting and creative flair. Images that are evocative of a place, creating story mood. Good use of people. Submit stock photography for specific story needs; if good enough can lead to possible assignments. Let us know exactly what coverage you have on a stock list so we can contact you when certain photo needs arise."

S CAT FANCY

P.O. Box 6050, Mission Vieio CA 92690.(949)855-8822, Fax: (949)855-3045, E-mail: slogan@ bowtieinc.com; query@catfancy.com. Website: www.catchannel.com. Managing Editor: Susan Logan. Estab. 1965. Monthly magazine. Readers are men and women of all ages interested in all aspects of cat ownership. Photo guidelines and needs free with SASE or on website.

Needs Buys 20-30 photos from freelancers/issue; 240-360 photos/year. Wants editorial "lifestyle" shots of cats in beautiful, modern homes; cats with attractive people (infant to middle-age, variety of ethnicities); cat behavior (good and bad, single and in groups); cat and kitten care (grooming, vet visits, feeding, etc.); household shots of CFA- or TICA-registered cats and kittens. Model release required.

Specs Accepts images in digital format. Send via CD as TIFF or JPEG files at 300 dpi minimum; include contact sheet (thumbnails with image names). Also accepts 35mm slides and 21/4 color transparencies; include SASE.

Making Contact & Terms Obtain photo guidelines before submitting photos. Available online at: www.catchannel.com/magazines/catfancy/photo_guidelines.aspx. Pays \$200 maximum for color cover; \$25-200 for inside. Credit line given. Buys first North American serial rights.

Tips "Sharp, focused images only (no prints). Lifestyle focus. Indoor cats preferred. Send SASE for list of specific photo needs."

N 🗏 \$\$ CHARISMA MAGAZINE

600 Rinehart Rd., Lake Mary FL 32746. (407)333-0600. E-mail: joe.deleon@strang.com. Website: www.charismamag.com; www.strang.com. Magazine Design Director: Joe Deleon. Monthly magazine. Emphasizes Christian life. General readership. Sample copy available for \$2.50.

Needs Buys 3-4 photos from freelancers/issue; 36-48 photos/year. Needs editorial photos appropriate for each article. Model release required. Photo captions preferred.

Specs Accepts images in digital format. Send via CD as TIFF, JPEG, EPS files at 300 dpi. Low-res images accepted for sample submissions.

Making Contact & Terms Send unsolicited photos by mail for consideration. Provide brochure, flier or tearsheets to be kept on file for possible future assignments. Simultaneous submissions and previously published work OK. Cannot return material. Responds ASAP. Pays \$650 for color cover; \$150 for b&w inside; \$50-150/hour or \$400-750/day. Pays on publication. Credit line given. Buys all rights; negotiable.

Tips In portfolio or samples, looking for "good color and composition with great technical ability."

\$ \$ CHESAPEAKE BAY MAGAZINE

1819 Bay Ridge Ave., Annapolis MD 21403. (410)263-2662, ext. 15. Fax: (410)267-6924. E-mail: kashley@cbmmag.net. Website: www.cbmmag.net. Art Director: Karen Ashley. Monthly. Emphasizes boating-Chesapeake Bay only. Readers are "people who use Chesapeake Bay for recreation." Sample copy available with SASE.

· Chesapeake Bay is CD-ROM-equipped and does corrections and manipulates photos inhouse.

Needs Buys 27 photos from freelancers/issue; 324 photos/year. Needs photos that are Chesapeake Bay related (must); "vertical powerboat shots are badly needed (color)." Special needs include "vertical 4-color slides showing boats and people on Bay."

Specs Uses 35mm, 21/4 × 21/4, 4 × 5, 8 × 10 transparencies. Accepts images in digital format. Send via CD as TIFF files at 300 dpi, at least 8 × 10 (16 × 10 for spreads). "A proof sheet would be helpful."

Making Contact & Terms Interested in reviewing work from newer, lesser-known photographers. Send query letter with samples or list of stock photo subjects. Responds only if interested. Simultaneous submissions OK. Pays \$400 for color cover; \$75-250 for color stock inside, depending on size; \$200-1,200 for assigned photo package. Pays on publication. Credit line given. Buys onetime rights.

Tips "We prefer Kodachrome over Ektachrome. Looking for boating, bay and water-oriented subject matter. Qualities and abilities include fresh ideas, clarity, exciting angles and true color. We're using larger photos—more double-page spreads. Photos should be able to hold up to that degree of enlargement. When photographing boats on the Bay, keep safety in mind. People hanging off the boat, drinking, women 'perched' on the bow are a no-no! Children must be wearing life jackets on moving boats. We must have IDs for all people in close-up to medium-view images."

S CHESS LIFE

P.O. Box 3967, Crossville TN 38557-3967. (931)787-1234. Fax: (931)787-1200. E-mail: fbutler@ uschess.org. Website: www.uschess.org. Contact: Frankie Butler, art director. Circ. 70,000. Estab. 1939. Monthly publication of the U.S. Chess Federation. Emphasizes news of all major national and international tournaments; includes historical articles, personality profiles, columns of instruction, occasional fiction, humor for the devoted fan of chess. Sample copy and photo guidelines free with SASE or on website.

• "Chess Life underwent a redesign as of the June 2006 issue. Please see current issue for new photographic philosophy."

Needs Uses about 15 photos/issue; 7-8 supplied by freelancers. Needs "news photos from events around the country; shots for personality profiles." Model release preferred. Photo captions preferred.

Specs Accepts prints or high-res digital images. Send digital images as JPEG or TIFF files at 300 dpi—via CD for multiple-image submissions; e-mail for single-shot submission. Contact art director for further details on submission options and specifications.

Making Contact & Terms Query with samples via e-mail (preferred). Responds in 1 month, "depending on when the deadline crunch occurs." Simultaneous submissions and previously published work OK. Pays \$25-100 for b&w inside; cover payment negotiable. Pays on publication. Buys one-time rights; "we occasionally purchase all rights for stock mug shots." Credit line given. Tips Using "more color, and more illustrative photography. The photographer's name, address and date of the shoot should appear on the back of all photos. Also, name of persons in photograph and event should be identified." Looks for "clear images, good composition and contrast with a fresh approach to interest the viewer. Typical 'player sitting at chessboard' photos are not what we want. Increasing emphasis on strong portraits of chess personalities, especially Americans. Tournament photographs of winning players and key games are in high demand."

\$ CHESS LIFE FOR KIDS

P.O. Box 3967, Crossville TN 38557. (732)252-8388. E-mail: gpetersen@uschess.org. Website: www. uschess.org. Editor: Glenn Petersen. Bimonthly association magazine geared for the young reader. age 12 and under, interested in chess; fellow chess players; tournament results; and instruction. Sample copy available with SAE and first-class postage. Photo guidelines available via e-mail.

Needs Photos of babies/children/teens, celebrities, multicultural, families, senior citizens, events, humor. Some aspect of chess must be present: playing, watching, young/old contrast. Reviews photos with or without a manuscript. Property release is required. Captions required.

Specs Accepts images in digital format. Send via Zip or e-mail. Contact Frankie Butler at fbutler@ uschess.org for more information on digital specs. Uses glossy color prints.

Making Contact & Terms E-mail query letter with link to photographer's website. Provide selfpromotion piece to be kept on file. Responds in 1 week to queries and portfolios. Simultaneous submissions and previously published work OK. Pays \$150 minimum/\$300 maximum for color cover. Pays \$35 for color inside. Pays on publication. Credit line given. Rights are negotiable. Will negotiate with a photographer unwilling to sell all rights.

Tips "Read the magazine. What would appeal to your 10-year-old? Be original. We have plenty of people to shoot headshots and award ceremonies. And remember, you're competing against proud parents as well."

CHIRP MAGAZINE

10 Lower Spadina Ave., Suite 400, Toronto ON M5V 2Z2, Canada. (416)340-2700, ext. 318. Fax: (416)340-9769. E-mail: owl@owlkids.com. Website: www.owlkids.com. Circ. 85,000. Published 10 times/year. A discovery magazine for children ages 3-6. Sample copy available for \$4.95 with 9 × 12 SAE and \$1.50 money order to cover postage. Photo guidelines available for SAE or via e-mail.

 Chirp has received Best New Magazine of the Year, Parents' Choice, Canadian Children's Book Centre Choice and Distinguished Achievement awards from the Association of Educational Publishers.

Needs Photo stories, photo puzzles, children ages 5-7, multicultural, environmental, wildlife. adventure, events, hobbies, humor, animals in their natural habitats. Interested in documentary, seasonal. Model/property release required. Photo captions required.

Specs Prefers images in digital format. E-mail as TIFF, JPEG files at 72 dpi; 300 dpi required for publication.

Making Contact & Terms Request photo packages before sending photos for review. Responds in 3 months. Previously published work okay. Credit line given. Buys one-time rights.

■ A S THE CHRONICLE OF THE HORSE

P.O. Box 46, Middleburg VA 20118. (540)687-6341. Fax: (540)687-3937. E-mail: editorial@ chronofhorse.com; tbooker@chronofhorse.com. Website: www.chronofhorse.com. Editor: Tricia Booker. Weekly magazine. Emphasizes English horse sports. Readers range from young to old. "Average reader is a college-educated female, middle-aged, well-off financially." Sample copy available for \$2. Photo guidelines free with SASE or on website.

Needs Buys 10-20 photos from freelancers/issue. Photos from competitive events (horse shows, dressage, steeplechase, etc.) to go with news story or to accompany personality profile. "A few stand-alone. Must be cute, beautiful or newsworthy. Reproduced in black and white." Prefers purchasing photos with accompanying manuscript. Photo captions required with every subject

Specs Uses b&w and color prints, slides (reproduced b&w). Accepts images in digital format at 300 dpi.

Making Contact & Terms Send query letter by mail or e-mail. Responds in 6 weeks. Pays \$30 base rate. Pays on publication. Buys one-time rights. Credit line given. Prefers first North American rights.

Tips "We do not want to see portfolio or samples. Contact us first, preferably by letter; include SASE for reply. Know horse sports."

S CHRONOGRAM

Luminary Publishing, 314 Wall St., Kingston NY 12401. (845)334-8600. Fax: (845)334-8610. E-mail: dperry@chronogram.com. Website: www.chronogram.com. Art Director: David Perry. Circ. 50,000. Estab. 1993. Monthly arts and culture magazine with a focus on green living and progressive community building in the Hudson Valley. Tends to hire regional photographers, or photographers who are showing work regionally. Sample copy available for \$5. Photo guidelines available on website.

Needs Buys 16 photos from regional freelancers/issue; 192 photos/year. Interested in alternative process, avant garde, fashion/glamour, fine art, historical/vintage, artistic representations of anything, "Striking, minimalistic and good! Great covers!" Reviews photos with or without a manuscript. Model/property release preferred. Photo captions required; include title, date, artist, medium.

Specs Prefers images in digital format. Send via CD as TIFF files at 300 dpi or larger at printed size.

Making Contact & Terms Send query letter with résumé and digital images or prints. Provide selfpromotion piece to be kept on file for possible future assignments. Responds only if interested; send nonreturnable samples. Pays \$200 maximum for color inside. Pays 1 month after publication. Credit line given. Buys one-time rights; negotiable.

Tips "Colorful, edgy, great art! See our website—look at the back issues and our covers, and check out back issues and our covers before submitting."

\$ @ CITY LIMITS

Community Service Society of New York, 105 East 22nd Street, Suite 901, New York NY 10010. (212)614-5397. Fax: (212)260-6218. E-mail: editor@citylimits.org; magazine@citylimits.org. Website: www.citylimits.org. "City Limits is an urban policy monthly offering intense journalistic coverage of New York City's low-income and working-class neighborhoods." Sample copy available for 8 × 11 SAE with \$1.50 first-class postage. Photo guidelines available for SASE.

Needs Buys 20 photos from freelancers/issue; 200 photos/year. Assigned portraits, photojournalism, action, ambush regarding stories about people in low-income neighborhoods, government or social service sector, babies/children/teens, families, parents, senior citizens, cities/urban. Interested in documentary. Reviews photos with or without a manuscript. Special photo needs: b&w photo essays about urban issues. Model release required for children.

Specs Uses 5 × 7 and larger b&w prints. Accepts images in digital format. Send via CD, Zip, e-mail as TIFF, EPS, JPEG files at 600 dpi. "Inside photos are black-and-white; cover is 4-color."

Making Contact & Terms Send query letter with samples, tearsheets, self-promotion cards. Provide résumé, business card, self-promotion piece or tearsheets to be kept on file for possible future assignments. Art director will contact photographer for portfolio review if interested. Portfolio should include b&w prints and tearsheets. Keeps samples on file; cannot return material. Responds only if interested; send nonreturnable samples. Simultaneous submissions and previously published work OK. Pays \$100 for color cover; \$50-100 for b&w inside. Pays on publication. Credit line given. Buys rights for use in City Limits in print and online; higher rate given for online use.

Tips "We need good photojournalists who can capture the emotion of a scene. We offer huge pay for great photos."

■ \$\$ ☑ CLEVELAND MAGAZINE

Great Lakes Publishing, 1422 Euclid Ave., #730, Cleveland OH 44115. (216)771-2833. Fax: (216)781-6318. E-mail: miller@clevelandmagazine.com. Website: www.clevelandmagazine.com. Custom Art Director: Kristen Miller. Circ. 40,000. Estab. 1972. Monthly consumer magazine emphasizing Cleveland, Ohio. General interest to upscale audience. Please provide self-promotions, JPEG samples or tearsheets via e-mail or mail to the address below to be kept on file for possible future assignments. We will respond if interested.

Needs Buys an average of 50 photos from freelancers/issue; 600 photos/year. Needs photos of architecture, business concepts, education, entertainment, environmental, events, food/drink, gardening, health/fitness, industry, interiors/decorating, landscapes/scenics, medicine, people (couples, families, local celebrities, multicultural, parents, senior citizens), performing arts, political, product shots/still life, sports, technology, travel, interested in documentary and fashion/ glamour. Model release required for portraits; property release required for individual homes. Photo captions required; include names, date, location, event, phone.

Specs Prefers images in digital format. Send via CD, e-mail as TIFF, JPEG files at 300 dpi. Also uses color and b&w prints.

Making Contact & Terms Provide self-promotion, samples, or tearsheets via e-mail or mail to be kept on file for possible future assignments. Responds only if interested. Pays on publication. Credit line given. Buys one-time publication, electronic and promotional rights.

S S COBBLESTONE

30 Grove St., Suite C, Peterborough NH 03458. (603)924-7209. Fax: (603)924-7380. E-mail: mchorlian@yahoo.com. Website: www.cobblestonepub.com. Editor: Meg Chorlian. Published 9 times/year, September-May. Emphasizes American history; each issue covers a specific theme. Writers are encouraged to submit available photos with their query or article. We buy one-time use. Readers are children ages 9-14, parents, teachers. Sample copy available for \$4.95 and 9 × 12 SAE with 5 first class stamps. Photo guidelines free with SASE. Mail queries to Editorial Dept.

Needs Buys 10-20 photos from freelancers/issue; 90-180 photos/year. Needs photos of children, multicultural, landscapes/scenics, architecture, cities/urban, agriculture, industry, military. Interested in fine art, historical/vintage, reenacters. "We need photographs related to our specific themes (each issue is theme-related) and urge photographers to request our themes list." Model release required. Photo captions preferred.

Specs Uses 8 × 10 glossy prints; 35mm, 21/4 × 21/4 transparencies. Accepts images in digital format. Send via CD, SyQuest, Zip as TIFF files at 300 dpi, saved at 8 × 10 size.

Making Contact & Terms Send query letter with samples or list of stock photo subjects; include SASE for return of material. "Reporting dates depend on how far ahead of the issue the photographer submits photos. We work on issues 6 months ahead of publication." Simultaneous submissions and previously published work OK. Pays on publication. Credit line given. Buys one-time rights. Our suggested fee range for professional quality photographs follows: 1/4 page to full page b&w \$15-100; color \$25-100. Please note that fees for non-professional quality photographs are negotiated. See guidelines on website at: www.cobblestonepub.com/guides cob.html.

Tips "Most photos are of historical subjects, but contemporary color images of, for example, a Civil War battlefield, are great to balance with historical images. However, the amount varies with each monthly theme. Please review our theme list and submit related images."

S COLLECTIBLE AUTOMOBILE

7373 N. Cicero Ave., Lincolnwood IL 60712. (800)595-8484 or (847)676-3470. Fax: (847)676-3671. E-mail: cservice@consumerguide.com. Website: consumerguideauto.howstuffworks.com. Bimonthly magazine. "CA features profiles of collectible automobiles and their designers as well as articles on literature, scale models, and other topics of interest to automotive enthusiasts." Sample copy available for \$8 and $10\frac{1}{2} \times 14$ SAE with \$3.50 first-class postage. Photo guidelines available for #10 SASE.

Needs "We require full photo shoots for any auto photo assignment. This requires 2-3 rolls of 35mm, 2-3 rolls of $2\frac{1}{4} \times 2\frac{1}{4}$, or 4-8 4×5 exposures. Complete exterior views, interior and engine views, and close-up detail shots of the subject vehicle are required."

Specs Uses 35mm, $2\frac{1}{4} \times 2\frac{1}{4}$, 4×5 transparencies. Accepts images in digital format (discuss file parameters with the acquisitions editor).

Making Contact & Terms Send query letter with transparencies and stock list. Provide business card to be kept on file for possible future assignments. Responds only if interested; send nonreturnable samples. Previously published work OK. Pays bonus if image is used as cover photo; \$250-275 plus mileage and film costs for standard auto shoot. **Pays on acceptance**. Photography is credited on an article-by-article basis in an "Acknowledgments" section at the front of the magazine. Buys all intellectual and digital property rights.

Tips "Read our magazine for good examples of the types of backgrounds, shot angles and overall quality that we are looking for."

\$ COLLEGE PREVIEW MAGAZINE

7300 W. 110th St., 7th Fl., Overland Park KS 66210. (913)317-2888. Fax: (913)317-1505. E-mail: info@ cpgcommunications.com; editorial@cpgpublications.com. Website: www.collegepreviewmagazine. com. Circ. 600,000. Quarterly magazine. Emphasizes college and college-bound African-American and Hispanic students. Readers are African-American, Hispanic, ages 16-24. Sample copy free with 9×12 SAE and 4 first-class stamps.

Needs Uses 30 photos/issue. Needs photos of students in class, at work, in interesting careers, on campus. Special photo needs include computers, military, law and law enforcement, business, aerospace and aviation, health care. Model/property release required. Photo captions required; include name, age, location, subject.

Making Contact & Terms Send query letter with résumé of credits. Simultaneous submissions and previously published work OK. Pays \$10-50 for color photos; \$5-25 for b&w inside. **Pays on publication.** Buys first North American serial rights.

■ COMMUNITY OBSERVER

Ann Arbor Observer Co., 201 Catherine St., Ann Arbor MI 48104. (734)769-3175. Fax: (734)769-3375. E-mail: michael@aaobserver.com; editor@arborweb.com. Website: www.washtenawguide.com. Editor: John Hilton. Managing Editor: Michael Betzold. Quarterly consumer magazine. "The Community Observer serves four historic communities facing rapid change. We provide an intelligent, informed perspective on the most important news and events in the communities we cover." Sample copy available for \$2.

Specs Uses contact sheets, negatives, transparencies, prints. Accepts images in digital format; GIF or JPEG files.

Making Contact & Terms Negotiates payment individually. **Pays on publication.** Buys one-time rights.

■ A \$ COMPANY MAGAZINE

1016 16th St. NW, Ste. 400, Washington DC 20036. (800)955-5538. Fax: (773)761-9443. E-mail: editor@companymagazine.org. Website: www.companymagazine.org. Circ. 114,000. Estab. 1983. Quarterly magazine published by the Jesuits (Society of Jesus). Emphasizes Jesuit works/ministries and the people involved in them. Sample copy available for 9×12 SAE.

Needs Photos and photo-stories of Jesuit and allied ministries and projects. Reviews photos with or without manuscript. Photo captions required.

Specs Accepts images in digital format. Send via CD, Zip, e-mail "at screen resolution as long as higher-res is available."

Making Contact & Terms Query with samples; include SASE for return of material. Provide résumé, business card, brochure, flier or tearsheets to be kept on file for possible future assignments. Pays on publication. Credit line given. Buys one-time rights; negotiable.

Tips "Avoid large-group, 'smile at camera' photos. We are interested in people/activity photographs that tell a story about Jesuit ministries."

■ COMPETITOR

Website: www.competitor.com. Circ. 95,000. Monthly consumer magazine covering running, mountain biking, road racing, snowboarding, both alpine and Nordic skiing, kayaking, hiking, climbing, mountaineering, and other individual sports.

Needs Photos of adventure, running, mountain biking, road racing, snowboarding, both alpine and Nordic skiing, kayaking, hiking, climbing, mountaineering, and other individual sports. Interested in lifestyle. Editorial calendar: March: running; April: adventure; May: triathlon; June: climbing/ paddling/mountain biking; July: summer travel; August: organic; September: women; October: gym/fitness; November: snow sports; December: snow sports. Reviews photos with or without a manuscript. Model release required. Captions required; include identification of subjects.

Specs Accepts images in digital format. Send JPEG or TIFF files at 300 dpi minimum.

Making Contact & Terms Payment negotiated. Pays on publication. Credit line given. Buys onetime rights.

Tips "Think fun. Don't be afraid to try something new. We like new."

\$ Ø COMPLETE WOMAN

875 N. Michigan Ave., Suite 3434, Chicago IL 60611-1901. (312)266-8680. E-mail: rolle@ associated pub.com. Website: www.associated pub.com. Art Director: Kourtney McKay. Estab. 1980. Circulation: 300,000. Bimonthly general interest magazine for women. Readers are "females, ages 21-40, from all walks of life."

Needs Uses 50-60 photos/issue; 300 photos/year. High-contrast shots of attractive women, how-to beauty shots, celebrities, couples, health/fitness/beauty, business concepts. Interested in fashion/ glamour. Model release required.

Specs Uses color transparencies (slide and large-format). Accepts images in digital format. Send via CD as TIFF, JPEG files at 300 dpi.

Making Contact & Terms Portfolio may be dropped off and picked up by appointment only. Provide résumé, business card, brochure, flier or tearsheets to be kept on file for possible future assignments. Send color prints and transparencies. "Each print/transparency should have its own protective sleeve. Do not write or make heavy pen impressions on back of prints; identification marks will show through, affecting reproduction." Responds in 1 month. Simultaneous submissions and previously published work OK. Pays \$75-150 for color inside. Pays on publication. Credit line given. Buys one-time rights.

Tips "We use photography that is beautiful and flattering, with good contrast and professional lighting. Models should be attractive, ages 18-28, and sexy. We're always looking for nice couple shots."

CONDE NAST TRAVELLER

4 Times Square, 14th Fl., New York NY 10036. (212)286-2860. Fax: (212)286-5931. E-mail: cntraveller@condenast.co.uk; editorcntraveller@condenast.co.uk. Website: www.cntraveller.com. Contact: Alice Walker. Provides the experienced traveler with an array of diverse travel experiences encompassing art, architecture, fashion, culture, cuisine and shopping. This magazine has very specific needs and contacts a stock agency when seeking photos.

■ S S CONSCIENCE

1436 U St. NW, #301, Washington DC 20009. (202)986-6093. E-mail: conscience@catholicsforchoice. org. Website: www.catholicsforchoice.org. Editor: David Nolan. Quarterly news journal of Catholic opinion. Sample copies available.

Needs Buys up to 25 photos/year. Needs photos of multicultural, religious, Catholic-related news. Reviews photos with or without a manuscript. Model/property release preferred. Photo captions preferred; include title, subject, photographer's name.

Specs Uses glossy color and b&w prints. Accepts high-res digital images. Send as TIFF, JPEC files.

Making Contact & Terms Send query letter with tearsheets. Responds only if interested; send nonreturnable samples. Simultaneous submissions and previously published work OK. Pays \$300 maximum for color cover; \$50 maximum for b&w inside. Pays on publication. Credit line given.

CONTEMPORARY BRIDE MAGAZINE

North East Publishing, Inc., 216 Stelton Rd. Unit D-1, Piscataway NJ 08854. E-mail: gary@ contemporarybride.com. Website: www.contemporarybride.com. Executive Editor: Linda Paris. Publisher: Gary Paris. Biannual bridal magazine with wedding planner; 4-color publication with editorial, calendars, check-off lists and advertisers. Sample copy available for first-class postage.

Needs Needs photos of travel destinations, fashion, bridal events. Reviews photos with accompanying manuscript only. Model/property release preferred. Photo captions preferred; include photo credits.

Specs Accepts images in digital format. Send as high-res files at 300 dpi.

Making Contact & Terms Send query letter with samples. Art director will contact photographer for portfolio review if interested. Provide b&w or color prints, disc. Keeps samples on file; cannot return material. Responds only if interested; send nonreturnable samples. Simultaneous submissions and previously published work OK. Payment negotiable. Buys all rights, electronic rights.

Tips "Digital images preferred with a creative eye for all wedding-related photos. Give us the best presentation."

S S CONTINENTAL NEWSTIME

501 W. Broadway, Plaza A, PMB #265, San Diego CA 92101-3802. (858) 492-8696. E-mail: Continentalnewsservice@yahoo.com. Website: www.continentalnewsservice.com. Editor-in-Chief: Gary P. Salamone. Estab. 1987. Bi-weekly general interest magazine of news and commentary on U.S. national and world news, with travel columns, entertainment features, humor pieces, comic strips, general humor panels, and editorial cartoons. Covers the unreported and under-reported national (U.S.) and international news. Sample copy available for \$4.50 in US and \$6.50 CAN/ foreign.

Needs Buys variable number of photos from freelancers. Needs photos of public figures, U.S. and foreign government officials/cabinet ministers, breaking/unreported/under-reported news. Reviews photos with or without a manuscript. Model/property release required. Photo captions required.

Specs Uses 8×10 color and b&w prints.

Making Contact & Terms Send query letter with résumé, photocopies, tearsheets, stock list. Provide résumé to be kept on file for possible future assignments. Responds only if interested in absence of SASE being received; send nonreturnable samples. Simultaneous submissions OK. Pays \$10 minimum for b&w cover. Pays on publication. Credit line given. Buys one-time rights.

Tips "Read our magazine to develop a better feel for our photo applications/uses and to satisfy our stated photo needs."

CONVERGENCE

CSU Sacramento, 6000 J St., Sacramento CA 95819-6075. E-mail: clinville@csus.edu. Website: www.convergence-journal.com. Managing Editor: Cynthia Linville. Quarterly. Convergence seeks to unify the literary and visual arts and draw new interpretations on the written word by pairing poems and flash fiction with complementary art.

Needs Ethnic/multicultural, experimental, feminist, gay/lesbian.

Making Contact & Terms Send up to 6 JPEGs no larger than 4MB each to clinville@csus.edu with "Convergence" in the subject line. Include full name, preferred e-mail address, and a 75word bio (bios may be edited for length and clarity). A cover letter is not needed. Absolutely no simultaneous or previously published submissions. Acquires electronic rights.

Tips "Work from a series or with a common theme has a greater chance of being accepted. Seasonally-themed work is appreciated (spring and summer for the January deadline, fall and winter for the June deadline)."

\$\$ COUNTRY WOMAN

Reiman Media Group, Inc., 5400 S. 60th St., Greendale WI 53129. E-mail: editors@ countrywomanmagazine.com. Website: www.countrywomanmagazine.com. Managing Editor: Marilyn Kruse. Bimonthly consumer magazine. Supported entirely by subscriptions and accepts no outside advertising. Emphasizes rural life and a special quality of living to which country women can relate; at work or play, in sharing problems, etc. Sample copy available for \$2. Photo guidelines free with SASE.

Needs Uses 75-100 photos/issue; most supplied by readers, rather than freelance photographers. "Covers are usually supplied by professional photographers; they are often seasonal in nature and generally feature a good-looking country woman (mid-range to close up, shown within her business setting or with a hobby, craft or others; static pose or active)." Photos purchased with or without accompanying manuscript. Also interested in unique or well designed country homes and interiors. Some work assigned for interiors. Works 6 months in advance. "No poor-quality color prints, posed photos, etc." Photo captions required.

Specs Prefers color transparencies, all sizes. Accepts images in digital format. Send via lightboxes, CD/DVD with printed thumbnails and caption sheet, or e-mail if first review selection is small (12 or less).

Making Contact & Terms Send material by mail for consideration; include SASE. Provide brochure, calling card, letter of inquiry, price list, résumé and samples to be kept on file for possible future assignments. Responds in 3 months. Previously published work OK. If the material you are submitting has been published previously, we ask that you please let us know. We accept color prints, slides or high-res digital photos. Digital images should be about 4×6 at a minimum resolution of 300 dpi and sent as JPEGs on a CD or via e-mail. We cannot use photos that are printed on an ink-jet printer. After you share a story or photos, please be patient. We receive a lot of mail, and it takes our small staff a while to catch up. We may hold your material for consideration in a future issue without informing you first, but we will let you know if we publish it. If we publish your material, we will send you a complimentary copy of the issue and any payment mentioned in the original solicitation upon publication, or at our normal contributor's rates." Pays \$300-800 for text/photo package depending on quality of photos and number used; \$300 minimum for front cover; \$200 minimum for back cover; \$100-300 for partial page inside, depending on size. No b&w photos used. Pays on acceptance. Buys one-time rights.

Tips Prefers to see "rural scenics, in various seasons; include a variety of country women—from traditional farm and ranch women to the new baby-boomer, rural retiree; slides appropriately simple for use with poems or as accents to inspirational, reflective essays, etc."

\$\$ CRUISING WORLD

55 Hammarlund Way, Middletown RI 02842. (401)845-5122. Fax: (401)845-5180. E-mail: bill. roche@thesailingcompany.com. Website: www.cruisingworld.com. Art Director: William Roche. Circ. 156,000. Estab. 1974. Emphasizes sailboat maintenance, sailing instruction and personal experience. For people interested in cruising under sail. Sample copy free for 9 × 12 SAE.

Needs Buys 25 photos/year. Needs "shots of cruising sailboats and their crews anywhere in the world. Shots of ideal cruising scenes. No identifiable racing shots, please." Also wants exotic images of cruising sailboats, people enjoying sailing, tropical images, different perspectives of sailing, good composition, bright colors. For covers, photos "must be of a cruising sailboat with strong human interest, and can be located anywhere in the world." Prefers vertical format. Allow space at top of photo for insertion of logo. Model release preferred; property release required. Photo captions required; include location, body of water, make and model of boat. See guidelines at www.cruisingworld.com/writer_and_photographer_guidelines.jsp.

Specs Prefers images in digital format via CD. Accepts 35mm color slides.

Making Contact & Terms "Submit original 35mm slides—no duplicates—or digital images. Most of our editorial is supplied by author. We look for good color balance, very sharp focus, the ability to capture sailing, good composition and action. Always looking for cover shots." Responds in 2 months. Pays \$600 for color cover; \$50-300 for color inside. Pays on publication. Credit line given. Buys all rights, but may reassign to photographer after publication; first North American serial rights; or one-time rights.

S CYCLE CALIFORNIA! MAGAZINE

1702-L Meridian Ave., #289, San Jose CA 95125. (888)292-5323. Fax: (408)292-3005. E-mail: bmack@cyclecalifornia.com. Website: www.cyclecalifornia.com. Publisher: Bob Mack. Monthly magazine providing readers with a comprehensive source of bicycling information, emphasizing the bicycling life in Northern California and Northern Nevada; promotes bicycling in all its facets. Sample copy available for 9 × 12 SAE with \$1.39 first-class postage. Photo guidelines available for

Needs Buys 3-5 photos from freelancers/issue; 45 photos/year. Needs photos of recreational bicycling, bicycle racing, triathalons, bicycle touring and adventure racing. Cover photos must be vertical format, color. All cyclists must be wearing a helmet if riding. Reviews photos with or without manuscript. Model release required; property release preferred. Photo captions preferred; include when and where photo is taken; if an event, include name, date and location of event; for nonevent photos, location is important.

Specs High-res TIFF images preferred (2000×3000 pixel minimum). Cover photos are 7×9 .

Making Contact & Terms Send query letter with CD/disk or e-mail. Keeps usable images on file; include SASE for return of material. Responds in 3 weeks. Simultaneous submissions OK. Pays \$125 for color cover; \$50 for inside. Pays on publication.

Tips "We are looking for photographic images that depict the fun of bicycle riding. Your submissions should show people enjoying the sport. Read the magazine to get a feel for what we do. Label images so we can tell what description goes with which image."

S CYCLE WORLD MAGAZINE

1499 Monrovia Ave., Newport Beach CA 92663. (949)720-5300. E-mail: dedwards@hfmus.com; cycleworld@neodata.com. Website: www.cycleworld.com. Vice President/Editor-in-Chief: David Edwards. Vice President/Senior Editor: Paul Dean. Monthly magazine. Circ. 300,000. Readers are active motorcyclists who are "affluent, educated and very perceptive."

Needs Buys 10 photos/issue. Wants "outstanding" photos relating to motorcycling. Prefers to buy photos with manuscripts. For "Slipstream" column, see instructions in a recent issue.

Specs Prefers high-res digital images at 300 dpi or quality 35mm color transparencies.

Making Contact & Terms Send photos for consideration; include SASE for return of material. Responds in 6 weeks. "Cover shots are generally done by the staff or on assignment." Pays \$50-200/photo. Pays on publication. Buys first publication rights.

Tips Editorial contributions are welcomed, but must be guaranteed exclusive to Cycle World. We are not responsible for the return of unsolicited material unless accompanied by a SASE.

■ S S DAKOTA OUTDOORS

P.O. Box 669, Pierre SD 57501. (605)224-7301. Fax: (605)224-9210. E-mail: office@capjournal.com. Website: www.dakotashop.com/do. Editor: Lee Harstad. Managing Editor: Rachel Engbrecht. Circ. 8,000. Estab. 1978. Monthly magazine. Emphasizes hunting and fishing in the Dakotas. Readers are sportsmen interested in hunting and fishing, ages 35-45. Sample copy available for 9 × 12 SAE and 3 first-class stamps. Photo guidelines free with SASE.

Needs Uses 15-20 photos/issue; 8-10 supplied by freelancers. Needs photos of hunting and fishing. Reviews photos with or without a manuscript. Special photo needs include: scenic shots of sportsmen, wildlife, fish. Model/property release required. Photo captions preferred.

Specs Uses 3 × 5 b&w and color prints; 35mm b&w and color transparencies. Accepts images in digital format. Send via Zip, e-mail as EPS, JPEG files.

Making Contact & Terms Send query letter with samples. Keeps samples on file; include SASE for return of material. Responds in 3 weeks. Pays \$20-75 for b&w cover; \$10-50 for b&w inside; payment negotiable. Pays on publication. Credit line given. Usually buys one-time rights; negotiable.

Tips "We want good-quality outdoor shots, good lighting, identifiable faces, etc.—photos shot in the Dakotas. Use some imagination and make your photo help tell a story. Photos with accompanying story are accepted."

DANCE

2660 Petersborough St., Herndon VA 20171. E-mail: shannonaswriter@yahoo.com. Editor: Shannon Murphy. Quarterly publication featuring international dancers.

Needs Performing arts, product shots/still life—as related to international dance for children and teens. Interested in alternative process, avant garde, documentary, fashion/glamour, fine art, historical/vintage, seasonal. Reviews photos with or without a manuscript. Model/property release preferred.

Specs Uses glossy or matte color and b&w prints.

Making Contact & Terms Send query letter via e-mail. Provide résumé, business card, selfpromotion piece to be kept on file for possible future assignments. "Photographs sent along with CDs are requested but not required. Write to request guidelines for artwork and illustrations." Responds within 1 month to queries; 1 week to portfolios. Simultaneous submissions and previously published work OK. Pays on acceptance. Credit line given. Buys one-time rights, first rights; negotiable.

\$ DEER & DEER HUNTING

F+W Media, Inc., 700 E. State St., Iola WI 54990. (715)445-2214. E-mail: dan.schmidt@fwmedia. com. Website: www.deeranddeerhunting.com. Editor: Daniel SchmidtCirc. 200,000. Estab. 1977. Magazine published 9 times/year. Emphasizes white-tailed deer and deer hunting. Readers are "a cross-section of American deer hunters-bow, gun, camera." Sample copy and photo guidelines free with 9 × 12 SAE with 7 first-class stamps. Photo guidelines also available on website.

Needs Buys 20 photos from freelancers/issue; 180 photos/year. Photos of deer in natural settings. Model release preferred. Photo captions preferred.

Specs Accepts images in digital format. Send contact sheet.

Making Contact & Terms Send query letter with résumé of credits and samples. "If we judge your photos as being usable, we like to hold them in our file. Send originals—include SASE if you want them returned." Responds in 2-4 weeks. Pays \$800 for color cover; \$75-250 for color inside; \$50 for b&w inside. Pays net 30 days of publication. Credit line given. Buys one-time rights.

Tips Prefers to see "adequate selection of 35mm color transparencies; action shots of whitetail deer only, as opposed to portraits. We also need photos of deer hunters in action. We are currently using almost all color—very little black & white. Submit a limited number of quality photos rather than a multitude of marginal photos. Include your name on all entries. Cover shots must have room for masthead."

■ S DIGITAL PHOTO

Media House, Lynchwood Petersborough Business Park, Peterborough PE2 6EA, United Kingdom. 44 1733 468 546. Fax: 44 1733 468 387. E-mail: dp@bauerconsumer.co.uk. Monthly consumer magazine. "UK's best-selling photography and imaging magazine."

Needs Stunning, digitally manipulated images of any subject and Photoshop or Elements step-by-step tutorials of any subject. Reviews photos with or without a manuscript. Model/property release preferred. Photo captions preferred.

Specs Accepts images in digital format. Send via CD as PSD, TIFF or JPEG files at 300 dpi, or via e-mail as JPEG.

Making Contact & Terms Send e-mail with résumé, low-res tearsheets, low-res JPEGs. Responds in 1 month to queries. Rates negotiable, but typically 60 GBP per page. Pays on publication. Credit line given. Buys first rights.

Tips "Study the magazine to check the type of images we use, and send a sample of images you think would be suitable. The broader your style, the better for general acceptance, while individual styles appeal to our Gallery section. Step-by-step technique pieces must be formatted to house style, so check magazine before submitting. Supply a contact sheet or thumbnail of all the images supplied in electronic form to make it easier for us to make a quick decision on the work."

N ■ \$\$ Ø DOG FANCY

P.O. Box 6050, Mission Viejo CA 92690. (949)855-8822. Fax: (949)855-3045. E-mail: jschwartze@ bowtieinc.com. Website: www.dogfancy.com. Associate Editor: John Schwartze. Circ. 268,000. Estab. 1970. Monthly magazine. Readers are "men and women of all ages interested in all aspects of dog ownership." Sample copy available for \$5.50. Photo guidelines free with SASE or on website. Needs Three specific breeds featured in each issue. Prefers "photographs that show the various physical and mental attributes of the breed. Include both environmental and action photographs. Dogs must be well groomed and, if purebred, good examples of their breed. By good example, we mean clean, healthy-looking dogs who conform to their breed standard (found at www.akc.org or www.ukcdogs.com). We also need for high-quality, interesting photographs of pure or mixed-breed dogs in canine situations (dogs with veterinarians; dogs eating, drinking, playing, swimming, etc.) for use with feature articles. Shots should have natural, modern background, style and setting, avoiding studio backgrounds. Photographer is responsible for model releases.

Specs Prefers high-res digital images either TIFF or JPEG at least 5 inches at 300 dpi. Can be sent on disk or via FTP site. Instructions for FTP submittal provided upon request. Send CD, DVD, or actual 35mm slides.

Making Contact & Terms Address submission to "Photo Editor." Present a professional package: Disks with photographer's name on it separated by subject with contact sheets and 35mm slides in sleeves with photographer's name and breed of dog. Pays \$300 for color cover; \$25-100 for color inside; \$200 for 4-color centerspreads. Credit line given. Buys first North American print rights and non-exclusive rights to use in electronic media.

Tips "Send a variety of shots. We mainly want to see candid outdoor and action photos of dogs alone and dogs with people. Once we review your images, we will notify you whether we will or will not be adding you to our list of freelance photographers. Poor lighting, focus, and composition in photographs are what make a particular photographer a likely candidate for rejection."

S\$ DOGS IN CANADA

200 Ronson Dr., Suite 401, Etobicoke ON M9W 5Z9, Canada. (416)798-9778. Fax: (416)798-9671. E-mail: photos@dogsincanada.com. Website: www.dogsincanada.com. Editor-in-Chief/Art Director: Kelly Caldwell. Monthly consumer magazine. "Dogs in Canada magazine is a reliable and authoritative source of information about dogs. Our mix of editorial content and photography must satisfy a diverse readership, including breed fanciers and those who simply have a beloved family pet. Photography is of central importance." Sample copy available for \$4.95 and 8 × 10 SAE with postage. Request photo guidelines via e-mail.

Needs Buys 10-30 photos/year. Needs photos from any category as long as there is a dog in the shot. Reviews photos with or without a manuscript. Model/property release preferred. Photo captions preferred; include breed of dog.

Specs Prefers images in digital format. Send via CD as TIFF or ESP files at 300 dpi.

Making Contact & Terms E-mail query letter with link to photographer's website and JPEG samples at 72 dpi. Send query letter with slides, prints. Provide résumé, business card, self-promotion piece to be kept on file for possible future assignments. Responds only if interested; send nonreturnable samples. Considers previously published work. Pays \$80-600 for b&w or color cover; \$50-300 for b&w or color inside. Pays on publication. Credit line given. Buys first rights, electronic rights.

Tips "Well-composed, high-quality photographs are expected. A creative approach catches our eye. Photos that capture a moment in time and the essence of a dog are preferred to a staged portrait."

DOWN BEAT MAGAZINE

102 N. Haven Rd., Elmhurst IL 60126. (630)941-2030. Fax: (630)941-3210. E-mail: editor@downbeat. com; jasonk@downbeat.com. Website: www.downbeat.com. Editor: Jason Koransky. Monthly. Emphasizes jazz musicians. Sample copy available for SASE.

Needs Buys 20 photos from freelancers/issue; 240 photos/year. Needs photos of live music performers/posed musicians/equipment, primarily jazz and blues. Photo captions preferred.

Specs Accepts images in digital format. "Do NOT send unsolicited high-res images via e-mail!" Making Contact & Terms Send 8 × 10 b&w prints; 35mm, 21/4 × 21/4, 4 × 5, 8 × 10 transparencies; b&w or color contact sheets by mail. Unsolicited samples will not be returned unless accompanied by SASE. Provide résumé, business card, brochure, flier or tearsheets to be kept on file for possible future assignments. Responds only when needed. Simultaneous submissions and previously published work OK. Pay rates vary by size. Credit line given. Buys one-time rights.

Tips "We prefer live shots and interesting candids to studio work."

\$ THE DRAKE MAGAZINE

1600 Maple St., Fort Collins CO 80521. (949)218-8642. E-mail: info@drakemag.com. Website: www.drakemag.com. Managing Editor: Tom Bie. Estab. 1998. Quarterly magazine for fly-fishing enthusiasts.

Needs Buys 50 photos from freelancers/issue. Needs creative flyfishing shots. Reviews photos with or without a manuscript.

Specs Uses digital photos; 35mm transparencies.

Making Contact & Terms Send query letter with slides. Provide business card to be kept on file for possible future assignments. Responds in 6 months to queries. Pays \$200 minimum for color cover; \$40 minimum for b&w inside. Pays on publication. Credit line given. Buys one-time rights.

Tips "No 'grip and grins' for fishing photos. Think creative. Show me something new."

\$\$ DUCKS UNLIMITED MAGAZINE

One Waterfowl Way, Memphis TN 38120. (901)758-3864. E-mail: jhoffman@ducks.org. Website: www.ducks.org. Photo Editor: John Hoffman. Bimonthly association magazine of Ducks Unlimited, a nonprofit organization. Emphasizes waterfowl hunting and conservation. Readers are professional males, ages 40-50. Sample copy available for \$3. Photo guidelines available on website, via e-mail or with SASE.

Needs Buys 84 photos from freelancers/issue; 504 photos/year. Needs images of wild ducks and geese, waterfowling and scenic wetlands. Special photo needs include waterfowl hunters, dynamic shots of waterfowl interacting in natural habitat.

Specs Accepts images in digital format. Send via CD as TIFF, JPEG, EPS files at 300 dpi; include thumbnails.

Making Contact & Terms Send only top-quality portfolio of not more than 40 transparencies (35mm or larger) with SASE for consideration. Responds in 1 month. Previously published work OK, if noted. **Pays on publication.** Credit line given. Buys one-time rights "plus permission to reprint in our Mexican and Canadian publications."

■ S \$\$ THE ELKS MAGAZINE

425 W. Diversey Pkwy., Chicago IL 60614-6196. (773)755-4894. E-mail: annai@elks.org, cheryls@elks.org. Website: www.elks.org/elksmag. Editor/Publisher: Cheryl T. Stachura. Magazine published 10 times/year. Mission is to provide news of elks to all 1 million members. "In addition, we have general interest articles. Themes: Americana; history; wholesome, family info; sports; adventure; technology. We do not cover religion, politics, controversial issues." Sample copy free. Needs Buys 10 cover photos/year; mostly from stock photo houses; approximately 20 photos/month for interior use. "Photographs of Elks in action are particularly welcome." Reviews photos with or without a manuscript. Photo captions required; include location.

Specs Accepts high-res digital images.

Making Contact & Terms Send query letter with samples. Does not keep samples on file; include SASE for return of material. Responds in 2 months to queries. Simultaneous submissions OK. Pays \$475 for color cover. **Pays on publication.** Credit line given. Buys one-time rights.

Tips "Artistry and technical excellence are as important as subject matter. We are now purchasing 90 percent of our photographs from photographic stock houses."

2445 McCabe Way, Suite 400, Irvine CA 92614. (949)261-2325. Website: www.entrepreneur.com. **Creative Director:** Megan Roy. Monthly magazine emphasizing business. Readers are existing and aspiring small business owners.

Needs Uses about 40 photos/issue; about 10% supplied by freelance photographers; 80% on assignment; 10% from stock. Needs "people at work, home office, business situations. I want to see colorful shots in all formats and styles." Model/property release preferred. Photo captions required; include names of subjects.

Specs Accepts images in digital format and film. Send via Zip, CD, e-mail as TIFF, EPS, JPEG files at 300 dpi.

Making Contact & Terms All magazine queries should be e-mailed to: queries@entrepreneur.com. Responds in 6 weeks. No phone calls, please. Entrepreneur Media Inc. assumes no responsibility for unsolicited manuscripts or photos. Provide résumé, business card, brochure, flier or tearsheets to be kept on file for possible future assignments. Pays \$2,000 for color cover; \$700 for color inside. **Pays on acceptance.** Credit line given. Buys one-time North American rights; negotiable.

Tips "I am looking for photographers who use the environment creatively; I do not like blank walls for backgrounds. Lighting is also important. I prefer medium-format for most shoots. I think photographers are going back to the basics—a good, clean shot, different angles and bright colors. I also like gelled lighting. I prefer examples of your work—promo cards and tearsheets—along with business cards and résumés."

■ ■ \$ □ EOS MAGAZINE

Robert Scott Publishing, The Old Barn, Ball Lane, Tackley, Kidlington, Oxfordshire 0X5 3AG, United Kingdom. (44)(186)933-1741. Fax: (44)(186)933-1641. E-mail: editorial@eos-magazine.com.

Website: www.eos-magazine.com. Editor: Angela August. Circ. 20,000. Estab. 1993. Quarterly consumer magazine for all users of Canon EOS cameras. Photo guidelines free.

Needs Looking for quality stand-alone images as well as photos showing specific photographic techniques and comparison pictures. All images must be taken with EOS cameras but not necessarily with Canon lenses. Model release preferred. Photo captions required; include technical details of photo equipment and techniques used.

Specs Accepts images in digital format exclusively.

Making Contact & Terms E-mail to request 'Notes for Contributors' (put this in the subject line). You will be e-mailed with further information about how to submit images, current requirements, and rates of payment. Pays on publication. Credit line given. Buys one-time rights.

Tips "We are more likely to use images from photographers who submit a wide selection of topquality images (40-60 images)."

■ \$\$ E/THE ENVIRONMENTAL MAGAZINE

28 Knight St., Norwalk CT 06851. (203)854-5559, ext. 109. E-mail: bbelli@emagazine.com; trudy@ emagazine.com. Website: www.emagazine.com. Managing Editor: Brita Belli. Art Director: Trudy Hodenfield. Nonprofit consumer magazine. Emphasizes environmental issues. Readers are environmental activists, people concerned about the environment. Sample copy available for 9 × 12 SAE and \$5. Photo guidelines free with SASE or via e-mail.

Needs Buys 20 photos from freelancers/issue. Needs photos of threatened landscapes, environmental leaders, people and the environment, pollution, transportation, energy, wildlife and activism. Photo captions required; include location, identities of people in photograph, date, action in photograph.

Specs Accepts images in digital format. Send via CD, Zip, e-mail as TIFF, EPS, JPEG files at 300 dpi and at least 3 × 4 print size.

Making Contact & Terms "The specific focus of E is environmental activism. We are therefore interested in photographs that will enlarge our readers' awareness of the threats to our natural environment. We look for professional slides and photographs that can be easily understood and tell a story. Please do not submit artwork unless accompanying a story and/or pertaining to a specific photographic request. All photographic needs are based on editorial content." Send samples of work to be kept on file. Do not send slides for review. "We prefer non-returnable samples such as tearsheets, promotional pieces, photocopies, etc. Also, include photo stock lists and note areas in which you specialize."

Tips Wants to see "straightforward, journalistic images. Abstract or art photography or landscape photography is not used." In addition, "please do not send manuscripts with photographs. These can be addressed as queries to the managing editor."

S S S EVENT

Douglas College, Box 2503, New Westminster BC V3L 5B2, Canada. (604)527-5293. Fax: (604)527-5095. E-mail: event@douglas.bc.ca. Website: http://event.douglas.bc.ca/. Editor: Elizabeth Bachinsky. Managing Editor: Ian Cockfield. Magazine published every 4 months. Emphasizes literature (short stories, reviews, poetry, creative nonfiction). Sample back issue available for \$9. Current issue is \$12.

Needs Buys approximately 3 photographs/year. "Has featured photographs by Mark Mushet, Lee Hutzulak and Anne de Haas. Assigns 50% of photographs to new and emerging photographers. Uses freelancers mainly for covers. "We look for art that is adaptable to a cover, particularly images that are self-sufficient and don't lead the reader to expect further artwork within the journal."

Making Contact & Terms "Please send photography/artwork (no more than 10 images) to EVENT, along with a self-addressed stamped envelope (Canadian postage or IRCs only) for return of your work. We also accept e-mail submissions of cover art. We recommend that you send low-res versions of your photography/art as small JPEG or PDF attachments. If we are interested, we will request hi-res files. We do not buy the actual piece of art; we only pay for the use of the image." Simultaneous submissions OK. Pays \$150 on publication. Credit line given. Buys one-time rights.

\$ FAMILY MOTOR COACHING

8291 Clough Pike, Cincinnati OH 45244. (513)474-3622. Fax: (513)388-5286. E-mail: rgould@fmca.com; magazine@fmca.com. Website: www.fmca.com. Art Director: Guy Kasselmann. Editor: Robbin Gould. Monthly publication of the Family Motor Coach Association. Emphasizes motor homes. Readers are members of national association of motor home owners. Sample copy available for \$3.99 (\$5 if paying by credit card). Writer's/photographer's guidelines free with SASE or via e-mail.

Needs Buys 55-60 photos from freelancers/issue; 660-720 photos/year. Each issue includes varied subject matter—primarily needs photos depicting motorhome travel, travel with scenic shots, couples, families, senior citizens, hobbies and how-to material. Photos purchased with accompanying manuscript only. Model release preferred. Photo captions required.

Specs Accepts images in digital format. Send via CD as EPS, TIFF files at 300 dpi.

Making Contact & Terms Send query letter with résumé of credits, samples, contact sheets; include SASE for return of material. Responds in 3 months. Pays \$100 for color cover; \$25-100 for b&w and color inside. \$125-500 for text/photo package. **Pays on acceptance.** Credit line given if requested. Prefers first North American rights, but will consider one-time rights on photos *only*.

Tips Photographers are "welcome to submit brochures or copies of their work. We'll keep them in mind should a freelance photography need arise."

\$ | FELLOWSHIP

P.O. Box 271, Nyack NY 10960. (845)358-4601 ext. 42. E-mail: editor@forusa.org. Website: www. forusa.org. Editor: Ethan Vesely-Flad. Publication of the Fellowship of Reconciliation; quarterly magazine. Emphasizes peace-making, social justice, nonviolent social change. Readers are interested in peace, justice, nonviolence and spirituality. Sample copy available for \$7.50.

Needs Buys 1-2 photos from freelancers/issue; 4-10 photos/year. Needs stock photos of people, civil disobedience, demonstrations—Middle East, Latin America, Caribbean, prisons, anti-nuclear, children, gay/lesbian, human rights issues, Asia/Pacific. Captions required.

Making Contact & Terms Provide résumé, business card, brochure, flier or tearsheets to be kept on file for possible future assignments. "Call on specs." Responds in 4-6 weeks. Simultaneous submissions and previously published work OK. Pays \$100 for color cover; \$35 for b&w inside. **Pays on publication.** Credit line given. Buys one-time rights.

Tips "You must want to make a contribution to peace movements. Money is simply token."

S \$ FINESCALE MODELER

21027 Crossroads Circle, P.O. Box 1612, Waukesha WI 53187. Website: www.finescale.com. Circ. 60,000. Magazine published 10 times/year. Emphasizes "how-to information for hobbyists who build non-operating scale models." Readers are "adult and juvenile hobbyists who build non-operating model aircraft, ships, tanks and military vehicles, cars and figures." Photo guidelines free with SASE or on website.

Needs Buys 10 photos from freelancers/issue; 100 photos/year. Needs "in-progress how-to photos illustrating a specific modeling technique; photos of full-size aircraft, cars, trucks, tanks and ships." Model release required. Photo captions required.

Specs Prefers prints and transparencies; will accept digital images if submission guidelines are followed.

Making Contact & Terms Provide résumé, business card, brochure, flier or tearsheets to be kept on file for possible future assignments. "Will sometimes accept previously published work if copyright is clear. **Pays for photos on publication, for text/photo package on acceptance.** Credit line given. Buys all rights.

Tips Looking for "sharp color prints or slides of model aircraft, ships, cars, trucks, tanks, figures and science-fiction subjects. In addition to photographic talent, must have comprehensive knowledge of objects photographed and provide complete caption material. Freelance photographers should provide a catalog stating subject, date, place, format, conditions of sale and desired credit line before attempting to sell us photos. We're most likely to purchase color photos of outstanding models of all types for our regular feature, 'Showcase.'"

■ FLAUNT MAGAZINE

1422 N. Highland Ave., Los Angeles CA 90028. (323)836-1000. E-mail: info@flauntmagazine.com. Website: www.flaunt.com. Creative Director: Jim Turner. Art Director: Todd Tourso. Monthly consumer magazine covering culture, arts, entertainment, literature. "Flaunt features the bold work of emerging photographers, writers, artists and musicians. The quality of the content is mirrored in the sophisticated, interactive format of the magazine, using advanced printing techniques, foldout articles, beautiful papers, and inserts to create a visually stimulating, surprisingly readable and intelligent book that pushes the magazine format into the realm of art object."

Needs Photos of celebrities, architecture, cities/urban, entertainment, performing arts, avant garde, lifestyle. Reviews photos with or without a manuscript. Model release required. Captions required; include identification of subjects.

Specs Accepts images in digital format. Send JPEG or GIF files. Reviews contact sheets, any size transparencies and prints.

Making Contact & Terms E-mail query letter with link to photographer's website. Credit line given. Buys one-time rights.

S S FLY ROD & REEL

P.O. Box 370, Camden ME 04843. (207) 594-9544. Fax: (207) 594-5144. E-mail: editor@flyrodreel.com. Website: www.flyrodreel.com. Editor-in-Chief: Paul Guernsey. Bimonthly magazine. Emphasizes fly-fishing. Readers are primarily fly-fishers ages 30-60. Sample copy and photo guidelines free with SASE; photo guidelines also available via e-mail.

Needs Buys 15-20 photos from freelancers/issue; 90-120 photos/year. Needs "photos of fish, scenics (preferably with anglers in shot), equipment." Photo captions preferred; include location, name of model (if applicable).

Specs Uses 35mm slides; $2\frac{1}{4} \times 2\frac{1}{4}$, 4×5 transparencies.

Making Contact & Terms Send query letter with list of stock photo subjects. Send unsolicited photos by mail for consideration; include SASE for return of material. Provide résumé, business card, brochure, flier or tearsheets to be kept on file for possible future assignments. Responds in 1 month. Pays \$600-800 for color cover photo; \$75 for b&w inside (seldom needed); \$75-200 for color inside. Pays on publication. Credit line given. Buys one-time rights.

Tips "Photos should avoid appearance of being too 'staged.' We look for bright color (especially on covers), and unusual, visually appealing settings. Trout and salmon are preferred for covers. Also looking for saltwater fly-fishing subjects. Ask for guidelines, then send 20 to 40 shots showing breadth of work."

A \$\$ FORTUNE

Rockefeller Center, Time-Life Bldg., 1271 Avenue of the Americas, New York NY 10020-1393. (212)522-8021. Fax: (212)467-1213. E-mail: letters@fortune.com. Website: www.fortune.com. Deputy Picture Editor: Scott Thode. Emphasizes analysis of news in the business world for management personnel.

Making Contact & Terms Picture Editor reviews photographers' portfolios on an overnight drop-off basis. Photos purchased on assignment only. Day rate on assignment (against space rate): \$500; page rate for space: \$400; minimum for b&w or color usage: \$200.

■ ISI \$ ✓ FRANCE MAGAZINE

Archant House, Oriel Rd., Cheltenham, Gloucestershire GL50 1BB, United Kingdom. +44 1242 216001. E-mail: miller.hogg@archant.co.uk; editorial@francemag.com. Website: www.francemag. com. Art Director: Adam Vines. Circ. 40,000. Monthly magazine about France. Readers are male and female, ages 45 and over; people who holiday in France.

Needs Needs photos of France and French subjects: people, places, customs, curiosities, produce, towns, cities, countryside. Photo captions required; include location and as much information as is practical.

Specs Uses 35mm, medium-format transparencies; high-quality digital.

Making Contact & Terms "E-mail in the first instance with list of subjects. Please do not send digital images. We will add you to our photographer list and contact you on an ad-hoc basis for photographic requirements."

S FREEFALL REVIEW

Undead Poets Press, 15735 Kerstyn St., Taylor MI 48180-4891. E-mail: shootanyangle@yahoo.com. Website: www.freefallreview.t35.com. Contact: James Hannibal. "The Freefall Review is a literary magazine showcasing black & white photography inside and color photography on the coverfiction, non-fiction, and poetry. The cover is a horizontal color photo that wraps around to the back cover (please make sure your cover submissions are horizontal and that the right and left half of the photo can stand on their own as well as together, bearing in mind that just the right half of the photo will be on the front)."

Needs "Feature stories written in news style that include topic-related photos have better odds in being published."

Tips "Please carefully review our submission guidelines at our website before submitting."

N 🖪 🖪 🖸 FRESHLY BAKED FICTION

P.O. Box 510232, Saint Louis MO 63151. (314)315-5200. E-mail: Editor@Freshlybakedfiction.com. Website: www.freshlybakedfiction.com. Editor: John Ferguson. Estab. 2009. Circ. 8,000 + monthly. "Freshly Baked Fiction is a non-genre specific publication. We publish short stories, novellas, poetry, art, and more. Our audience is everyone that loves to read. Our website is free to all and updated daily with new fiction and classic works. Freshly Baked Fiction is a place where new and published authors can get opinions and insight from readers and other authors relating to their own work: Taking advantage of technology, we have set out goals on being the new way people read. We will be offering readers a chance to get daily fiction on eBook readers, via RSS, e-mail, iPhone, and other electronic devices that have yet to hit the market."

Needs Style photography: alternative process, avant garde, documentary, erotic, fine art, historical/ vintage, lifestyle and seasonal. Samples not kept on file. Portfolio not required. Credit line given.

Making Contact & Terms Send an e-mail with samples in zipped TIFF, GIF or JPEG format.

Tips "We like to use technology. We look for creative artists and photographers willing to use multiple medias to create work. Also, make sure you send work as attachments. Zipped or unzipped is good. Technology is here to stay so I recommend you learn to use it."

\$ T. MYERS MAGAZINE

15880 Summerlin Rd., Suite 189, Ft. Myers FL 33908. (239)433-3884. Fax: (516)652-6072. E-mail: ftmyers@optonline.net. Website: www.ftmyersmagazine.com. Magazine published every 2 months for southwest Florida, focusing on local and national arts and lifestyle. Ft. Myers Magazine is targeted at successful, educated and active residents of southwest Florida, ages 20-60, as well as guests at the best hotels and resorts on the Gulf Coast. Media columns and features include: books, music, video, films, theater, Internet, software (news, previews, reviews, interviews, profiles). Lifestyle columns and features include: art & design, house & garden, food & drink, sports & recreation, health & fitness, travel & leisure, science & technology (news, previews, reviews, interviews, profiles). Sample copy available for \$3 including postage & handling.

Needs Buys 3-6 photos from freelancers/year. Photos of celebrities, architecture, gardening, interiors/decorating, medicine, product shots/still life, environmental, landscapes/scenics, wildlife, entertainment, events, food and drink, health/fitness/beauty, performing arts, sports, travel. Interested in alternative process, avant garde, documentary, fashion/glamour, fine art, historical/ vintage. Also needs beaches, beach scenes/sunsets over beaches, boating/fishing, palm trees. Reviews photos with or without a manuscript. Model release required. Photo captions preferred; include description of image and photo credit.

Specs Uses 4×5 , 8×10 glossy or matte color and b&w prints; 35mm, 2×2 , 4×5 , 8×10 transparencies ("all are acceptable, but we prefer prints or digital"). Accepts images in digital format. Send via CD or e-mail (preferred) as TIFF, EPS, PICT, JPEG, PDF files (prefers TIFF or JPEG) at 300-600 dpi.

Making Contact & Terms Send query letter via e-mail with digital images and stock list. Responds only if interested; send nonreturnable samples. Simultaneous submissions and previously published work OK. Pays \$100 for b&w or color cover; \$25-100 for b&w or color inside. Pays on publication. Credit line given. Buys one-time rights.

N 🖪 \$ 🗷 GAME & FISH MAGAZINES

E-mail: Ken.Dunwoody@imoutdoors.com. Website: www.gameandfishmag.com. Director: Ken Dunwoody. Publishes 31 different monthly outdoors magazines: Alabama Game & Fish, Arkansas Sportsman, California Game & Fish, Florida Game & Fish, Georgia Sportsman, Great Plains Game & Fish, Illinois Game & Fish, Indiana Game & Fish, Iowa Game & Fish, Kentucky Game & Fish, Louisiana Game & Fish, Michigan Sportsman, Mid-Atlantic Game & Fish, Minnesota Sportsman, Mississippi Game & Fish, Missouri Game & Fish, New England Game & Fish, New York Game & Fish, North Carolina Game & Fish, Ohio Game & Fish, Oklahoma Game & Fish, Pennsylvania Game & Fish, Rocky Mountain Game & Fish, South Carolina Game & Fish, Tennessee Sportsman, Texas Sportsman, Virginia Game & Fish, Washington-Oregon Game & Fish, West Virginia Game & Fish, Wisconsin Sportsman, and North American Whitetail. All magazines (except Whitetail) are for experienced hunters and fishermen and provide information about where, when and how to enjoy the best hunting and fishing in their particular state or region, as well as articles about game and fish management, conservation and environmental issues. Photo guidelines and current needs list free with SASE.

Needs 50% of photos supplied by freelance photographers; 5% assigned. Photos of live game animals/birds in natural environments and hunting scenes; game fish photos and fishing scenes. Photo captions required; include species identification and location. Number slides/prints.

Specs Accepts images in digital format. Send via CD at 300 dpi with output of 8×12 .

Making Contact & Terms Send 5 × 7, 8 × 10 glossy b&w prints or 35mm transparencies (preferably Fujichrome, Kodachrome) with SASE for consideration. Responds in 1 month. Simultaneous submissions not accepted. Pays 60 days prior to publication. Tearsheet provided. Credit line given. Buys one-time rights.

Tips "Send separate CD and proof sheet for each species, with digital submissions. We'll return photos we don't expect to use and hold remainder in-house so they're available for monthly photo selections. Please do not send dupes. Photos will be returned upon publication or at photographer's request."

\$\$ GEORGIA STRAIGHT

1701 W. Broadway, Vancouver BC V6J 1Y3, Canada. (604)730-7000. Fax: (604)730-7010. E-mail: contact@straight.com; photos@straight.com. Website: www.straight.com. Editor: Charlie Smith. Weekly tabloid. Emphasizes entertainment. Readers are generally well-educated people, ages 20-45. Sample copy free with 10×12 SASE.

Needs Buys 3 photos from freelancers/issue; 364 photos/year. Needs photos of entertainment events and personalities. Photo captions essential.

Making Contact & Terms Send query letter with list of stock photo subjects. Provide résumé, business card, brochure, flier or tearsheets to be kept on file for possible future assignments. Responds in 1 month. Simultaneous submissions and previously published work OK. Include SASE for return of material. Pays \$250-300 for cover; \$100-200 for inside. Pays on publication. Credit line given. Buys one-time rights.

Tips "Almost all needs are for in-Vancouver assigned photos, except for high-quality portraits of film stars. We rarely use unsolicited photos, except for Vancouver photos for our content page."

\$ GERMAN LIFE MAGAZINE

1068 National Hwy., LaVale MD 21502. (301)729-6190. Fax: (301)729-1720. E-mail: mslider@ germanlife.com. Website: www.germanlife.com. Editor: Mark Slider. Bimonthly magazine focusing on history, culture, and travel relating to German-speaking Europe and German-American heritage. Sample copy available for \$5.95.

Needs Limited number of photos purchased separate from text articles.

Specs Queries welcome for specs.

Making Contact & Terms Payment varies. Pays on publication. Credit line given. Buys one-time rights.

GHOST TOWN

2660 Petersborough St., Herndon VA 20171. E-mail: shannonsdustytrails@yahoo.com. Editor: Shannon Murphy, Estab. 1998. Quarterly magazine. Photo guidelines available by e-mail request. Needs Buys 12 photos from freelancers/issue; 48-72 photos/year. Needs photos of babies/ children/teens, celebrities, couples, multicultural, families, parents, disasters, environmental, landscapes/scenics, wildlife, architecture, cities/urban, education, gardening, interiors/decorating, pets, religious, rural, adventure, events, food/drink, sports, travel, agriculture, medicine, military, political, product shots/still life, science, technology—as they are related to archaeology and ghost towns. Interested in alternative process, avant garde, documentary, fashion/glamour, fine art, historical/vintage, seasonal. Wants photos of archaeology sites and excavations in progress of American ghost towns. "Would like photographs from ghost towns and western archaeological sites." Reviews photos with or without a manuscript. Model/property release preferred.

Specs Uses glossy or matte color and b&w prints.

Making Contact & Terms Send query letter via e-mail. "If possible, please do not include photographs in files if they are sent through e-mail. A CD sent with your photographs is acceptable." Provide résumé, business card or self-promotion piece to be kept on file for possible future assignments. "Photographs sent with CDs are requested but not required. Illustrations and artwork are also accepted," Responds within 1 month to queries; 1 week to portfolios. Simultaneous submissions and previously published work OK. Pays on acceptance. Credit line given. Buys one-time rights, first rights; negotiable.

A \$ GIRLS LIFE MAGAZINE/GIRLSLIFE.COM

4529 Harford Rd., Baltimore MD 21214. (410)426-9600. Fax: (410)254-0991. E-mail: katiea@girlslife. com. Website: www.girlslife.com. Senior Editor: Katie Abbondanza. Estab. 1994. Bimonthly magazine emphasizing advice, relationships, school, current news issues, entertainment, quizzes, fashion and beauty pertaining to preteen girls. Readers are preteen girls (ages 10-15). Girls' Life accepts unsolicited manuscripts on a speculative basis only. First, send an e-mail or letter query with detailed story ideas. No telephone solicitations, please. Please familiarize yourself with the voice and content of Girls' Life before submitting.

Needs Buys 65 photos from freelancers/issue. Submit seasonal material 3 months in advance.

Specs Uses 5×8 , $8\frac{1}{2} \times 11$ color and b&w prints; 35mm, 4×5 transparencies.

Making Contact & Terms Send query letter with stock list. E-mail queries are responded to within 90 days. Works on assignment only. Keeps samples on file. Responds in 3 weeks. Simultaneous submissions and previously published work OK. Pays on usage. Credit line given.

Tips Guidelines available online at website.

■ \$\$ ☑ GOLF TIPS

12121 Wilshire Blvd., #1200, Los Angeles CA 90025. (310)820-1500. Fax: (310)826-5008. E-mail: editors@golftipsmag.com. Website: www.golftipsmag.com. Art Director: Warren Keating. Circ. 300,000. Estab. 1986. Magazine published 9 times/year. Readers are "hardcore golf enthusiasts." Sample copy free with SASE.

Needs Buys 40 photos from freelancers/issue; 360 photos/year. Photos of golf instruction (usually pre-arranged, on-course), equipment; health/fitness, travel. Interested in alternative process, documentary, fashion/glamour. Reviews photos with accompanying manuscript only. Model/ property release preferred. Photo captions required.

Specs Uses prints; 35mm, $2\frac{1}{4} \times 2\frac{1}{4}$, 4×5 , 8×10 transparencies. Accepts images in digital format. Send via Zip as TIFF files at 300 dpi. Submission guidelines at: www.golftipsmag.com/submissions. html.

Making Contact & Terms Send query letter with résumé of credits. Submit portfolio for review. Cannot return material. Responds in 1 month. Pays \$500-1,000 for b&w or color cover; \$100-300 for b&w inside; \$150-450 for color inside. Pays on publication. Buys one-time rights; negotiable.

🖸 🖪 🔾 GOSPEL HERALD

5 Lankin Blvd., Toronto ON M4J 4W7, Canada. (416)461-7406. E-mail: editorial@gospelherald.org. Website: www.gospelherald.org. Managing Editor: Max Craddock. Co-Editor: Wayne Turner. Circ. 1,300. Estab. 1936. Monthly consumer magazine. Emphasizes Christianity. Readers are primarily members of the Churches of Christ. Sample copy free with SASE.

Needs Uses 2-3 photos/issue. Photos of babies/children/teens, families, parents, landscapes/ scenics, wildlife, seasonal, especially those relating to readership-moral, religious and nature

Specs Uses b&w, any size and any format. Accepts images in digital format. Send via CD, Zip, e-mail as JPEG files.

Making Contact & Terms Send unsolicited photos by mail for consideration. Payment not given, but photographer receives credit line.

Tips "We have never paid for photos. Because of the purpose of our magazine, both photos and stories are accepted on a volunteer basis."

\$ GRAND RAPIDS FAMILY MAGAZINE

Gemini Publications, 549 Ottawa Ave. NW, Suite 201, Grand Rapids MI 49503. (616)459-4545. Fax: (616)459-4800. E-mail: ssommerfeld@geminipub.com. Website: www.grfamily.com. Design/ Production Manager: Scott Sommerfeld. Circ. 30,000. Estab. 1989. Monthly magazine. Readers are West Michigan families. Sample copy available for \$2. Photo guidelines free with SASE.

Needs Buys 20-50 photos from freelancers/issue; 240-600 photos/year. Needs photos of families, children, education, infants, play, etc. Model/property release required. Photo captions preferred; include who, what, where, when.

Making Contact & Terms Send query letter with résumé of credits, stock list. Sometimes keeps samples on file; include SASE for return of material. Responds in 1 month, only if interested. Simultaneous submissions and previously published work OK. Pays \$200 minimum for color cover; \$35-75 for inside. Pays on publication. Credit line given. Buys one-time rights, all rights; negotiable.

Tips "We are not interested in 'clip art' variety photos. We want the honesty of photojournalism; photos that speak to the heart, that tell a story, that add to the story told."

S GRAND RAPIDS MAGAZINE

Gemini Publications, 549 Ottawa Ave. NW, Suite 201, Grand Rapids MI 49503-1444. (616)459-4545. Fax: (616)459-4800. E-mail: ssommerfeld@geminipub.com. Website: www.grmag.com. Design/ Production Manager: Scott Sommerfeld. Monthly magazine. Emphasizes community-related material of metro Grand Rapids area and West Michigan; local action and local people.

Needs Needs photos of animals, nature, scenic, travel, sport, fashion/beauty, photo essay/photo feature, fine art, documentary, human interest, celebrity/personality, humorous, wildlife, vibrant people shots and special effects/experimental. Wants, on a regular basis, West Michigan photo essays and travel-photo essays of any area in Michigan. Model release required. Photo captions required.

Specs Prefers images in digital format. Send via CD at 300 dpi minimum. Also uses 21/4 × 21/4, 4 × 5 color transparencies for cover, vertical format required. "High-quality digital also acceptable."

Making Contact & Terms Send material by mail for consideration; include SASE for return. Provide business card to be kept on file for possible future assignments; "only people on file with us are those we have met and personally reviewed." Arrange a personal interview to show portfolio. Responds in 3 weeks. Pays \$35-100 for color photos; \$100 minimum for cover. Buys one-time rights, exclusive product rights, all rights; negotiable.

Tips "Most photography is by our local freelance photographers, so you should sell us on the unique nature of what you have to offer."

■ A S S GRIT MAGAZINE

1503 SW 42nd St., Topeka KS 66609. (785)274-4300. Fax: (785)274-4305. E-mail: Grit@Grit.com. Website: www.grit.com, Senior Associate Editor: Jean Teller. Estab. 1882. Circ. 230,000. Quarterly publication. "Grit focuses on rural lifestyles, country living and small farming. We are looking for useful, practical information on livestock, gardening, farm equipment, home and yard improvement and related topics."

Needs Buys 24 + photos/year with accompanying stories or articles; 90% from freelancers. Needs, on a regular basis, photos of small-farm livestock, animals, farm labor, gardening, produce and related images. "Be certain pictures are well composed, properly exposed and pin sharp. Must be shot at high resolution (no less than 300 dpi). No cheesecake. No pictures that cannot be shown to any member of the family. No pictures that are out of focus or over- or under-exposed. No ribboncutting, check-passing or hand-shaking pictures. Story subjects include all aspects of the hobby or country lifestyle farm, such as livestock, farm dogs, barn cats, sowing and hoeing, small tractors, fences, etc." Photo captions required. "Any image that stands alone must be accompanied by 50-100 words of meaningful caption information."

Specs Uses 35mm, slides and high-res digital images. Send digital images via CD or e-mail; Zip as JPEG files at 300 dpi. Model and property releases are preferred. Photo captions are required (who, what, when, where, why, how).

Making Contact & Terms Study the magazine. "We use a beautiful country scene for 'Reverie,' the last page in each issue. Take a look at previous issues to get a sense of the sort of shot we're looking for." Send material by mail with SASE for consideration. Responds ASAP. Pay is negotiable up to \$1,000 for color cover; \$35-200 for color inside; \$25-100 for b&w inside. Rarely uses b&w, and only if "irresistibly atmospheric." Pays on publication. Buys shared rights; negotiable.

Tips "This is a relaunch of an old title. You must study the new publication to make sure your submissions are appropriate to Grit's new direction."

\$\$ @ GUIDEPOSTS

16 E. 34th St., 21st Fl., New York NY 10016. (212)251-8124. Fax: (212)684-1311. Website: www. guideposts.org. E-mail: submissions@guidepostsmag.com. Photo Editor: Candice Smilow, photo editor. Circ. 2.6 million. Estab. 1945. Monthly magazine. Emphasizes tested methods for developing courage, strength and positive attitudes through faith in God. Free sample copy and photo guidelines with 6 × 9 SASE.

Needs Uses 90% assignment, 10% stock on a story-by-story basis. Photos are mostly environmental portraiture, editorial reportage. Stock can be scenic, sports, fine art, mixed variety. Model release required.

Specs Uses 35mm, 21/4 × 21/4 transparencies; vertical for cover, horizontal or vertical for inside. Accepts images in digital format. Send via CD at 300 dpi.

Making Contact & Terms Send photos or arrange a personal interview. Responds in 1 month. Simultaneous submissions OK. Pays by job or on a per-photo basis; \$800 minimum for color cover; \$150-400 for color inside; negotiable. Pays on acceptance. Credit line given. Buys one-time rights.

Tips "I'm looking for photographs that show people in their environment; straight portraiture and people interacting. We're trying to appear more contemporary. We want to attract a younger audience and yet maintain a homey feel. For stock—scenics; graphic images in color. Guideposts is an 'inspirational' magazine. NO violence, nudity, sex. No more than 20 images at a time. Write first and ask for a sample issue; this will give you a better idea of what we're looking for."

GUITAR WORLD

149 5th Ave., 9th Fl., New York NY 10010-6987. (646)723-5400, (650)872-1642. Fax: (650)872-1643. E-mail: robert@guitarworld.com. Website: www.guitarworld.com. Photo Editor: Jimmy Hubbard. Consumer magazine for guitar players and enthusiasts.

Needs Buys 20 photos from freelancers/issue; 240 photos/year. Photos of guitarists. Reviews photos with or without a manuscript. Property release preferred. Photo captions preferred.

Specs Uses glossy or matte color and b&w prints; 35mm, 21/4 × 21/4 transparencies. Accepts images in digital format. Send via e-mail as TIFF, EPS, JPEG files at 300 dpi.

Making Contact & Terms Send query letter with slides, prints, photocopies, tearsheets. Keeps samples on file. Responds in 2 weeks to queries. Previously published work OK. Pay rates vary by size. Pays on acceptance. Credit line given. Buys one-time rights.

\$\$ A HADASSAH MAGAZINE

50 W. 58th St., New York NY 10019. (212)451-6284. Fax: (212)451-6257. E-mail: rfyman@hadassah. org. Website: www.hadassah.org. Editorial Assistant: Rachel Fyman. Monthly publication of the Hadassah Women's Zionist Organization of America. Emphasizes Jewish life, Israel. Readers are 85% females who travel and are interested in Jewish affairs, average age 59. Photo guidelines free with SASE.

Needs Uses 10 photos/issue; most supplied by freelancers. Photos of travel, Israel and general Jewish life. Photo captions preferred; include where, when, who and credit line.

Specs Accepts images in digital format. Send via CD as JPEG files at 300 dpi. High-res, digital photos preferred. Pays \$80-\$100/image.

Making Contact & Terms Submit portfolio for review. Send unsolicited photos by mail for consideration. Keeps samples on file; include SASE for return of material. Responds in 3 months. Pays \$450 for color cover; \$125-175 for \(\frac{1}{2} \) page color inside. **Pays on publication.** Credit line given. Buys one-time rights.

Tips "We frequently need travel photos, especially of places of Jewish interest."

M ☑ ■ HAMILTON MAGAZINE

1074 Cooke Blvd., Burlington ON L7t 4A8, Canada. (905)634-8003. Fax: (905)634-8004. E-mail: ksharrow@townmedia.ca, Website: www.hamiltonmagazine.com. Art Director: Kate Sharrow. Estab. 1978. Consumer magazine. "Our mandate: to entertain and inform by spotlighting the best of what our city and region have to offer. We invite readers to take part in a vibrant community by supplying them with authoritative and dynamic coverage of local culture, food, fashion and design."

Needs Photos of cities/urban, entertainment, food/drink, health/fitness/beauty, fashion/glamour, lifestyle. Reviews photos with or without a manuscript. Captions required; include identification of subjects.

Specs Accepts images in digital format. Send JPEG files at 8×10 at 300 dpi. Uses 8×10 prints. Making Contact & Terms Pays on publication. Credit line given.

\$ \$ HARPER'S MAGAZINE

666 Broadway, 11th Floor, New York NY 10012. (212)420-5720. Fax: (212)228-5889. E-mail: alyssa@ harpers.org. Website: www.harpers.org. Assistant Art Director: Alyssa Coppelman. Estab. 1850. Monthly literary magazine. "The nation's oldest continually published magazine providing fiction, satire, political criticism, social criticism, essays."

Needs Buys 8-10 photos from freelancers/issue; 120 photos/year. Needs photos of human rights issues, environmental, political. Interested in alternative process, avant garde, documentary, fine art, historical/vintage. Model/property release preferred.

Specs Uses any format. Accepts images in digital format. Send preferably via e-mail to alyssa@ harpers.org or on CD; TIFF, EPS, JPEG files at 72 dpi.

Making Contact & Terms Send query letter with résumé, slides, prints, photocopies, tearsheets, transparencies. Portfolio may be dropped off last Wednesday of the month. Provide self-promotion piece to be kept on file for possible future assignments. Responds in 1 week. Pays \$200-800 for b&w/color cover; \$250-400 for b&w/color inside. Pays on publication. Credit line given. Buys one-time rights; negotiable.

Tips "Harper's is geared more toward fine art photos or artist's portfolios than to 'traditional' photo usages. For instance, we never do fashion, food, travel (unless it's for political commentary), lifestyles or celebrity profiles. A good understanding of the magazine is crucial for photo submissions. We consider all styles and like experimental or nontraditional work. Please don't confuse us with Harper's Bazaar!"

HEALING LIFESTYLES & SPAS MAGAZINE

E-mail: melissa@healinglifestyles.com; shanon@healinglifestyles.com; editorial@healinglifestyles. com. Website: www.healinglifestyles.com. Art Director: Laura Kayata. Editorial Director: Melissa B. Williams. HL&S has recently moved all publishing efforts online, the print magazine has been dissolved into www.healinglifestyles.com and the brand continues to build and flourish after 14 years in development. HL&S continues it's role as a trusted leading social media platform for the spa/wellness industry, focusing on spas, retreats, therapies, food and beauty geared towards a mostly female audience, offering a more holistic and alternative approach to healthy living. Photo guidelines available for SASE.

Needs Buys 3 photos from freelancers/issue; 6-12 photos/year. Needs photos of multicultural, environmental, landscapes/scenics, adventure, health/fitness/beauty, food, yoga, travel. Reviews photos with or without a manuscript. Model/property release preferred. Photo captions required; include subject, location, etc.

Specs Prefers images in digital format. Send via CD, Zip, e-mail as TIFF, EPS, JPEG files at 300 dpi. Also uses 35mm or large-format transparencies.

Making Contact & Terms Send query letter with résumé, prints, tearsheets. Provide résumé, business card, self-promotion piece to be kept on file for possible future assignments. Responds in 1 month. Responds only if interested; send nonreturnable samples. Simultaneous submissions OK. Pays on assignment. Credit line given. Buys one-time rights.

Tips "We strongly prefer digital submissions, but will accept all formats. We're looking for something other than the typical resort/spa shots—everything from at-home spa treatments to far-off, exotic locations. We're also looking for reliable lifestyle photographers who can shoot yogainspired shots, healthy cuisine, ingredients, and spa modalities in an interesting and enlightening way."

■ A \$\$ ☐ HEARTLAND BOATING

The Waterways Journal, Inc., 319 N. Fourth St., Suite 650, St. Louis MO 63102. (314)241-4310. Fax: (314)241-4207. E-mail: Lbraff@Heartlandboating.com. Website: www.Heartlandboating.com. Contact: John R. Cassady, art director. Est. 1989. Art Director: John R. Cassady. Estab. 1989. Circ. 12,000. Magazine published 8 times/year covering recreational boating on the inland waterways of mid-America, from the Great Lakes south to the Gulf of Mexico and over to the east. "Our writers must have experience with, and a great interest in, boating, particularly in the area described above. Heartland Boating's content is both informative and humorous—describing boating life as the heartland boater knows it. We are boaters and enjoy the outdoor, water-oriented way of life. The content reflects the challenge, joy, and excitement of our way of life afloat. We are devoted. to both power and sailboating enthusiasts throughout middle America; houseboats are included. The focus is on the freshwater inland rivers and lakes of the heartland, primarily the waters of the Arkansas, Tennessee, Cumberland, Ohio, Missouri, Illinois, and Mississippi rivers, the Tennessee-Tombigbee Waterway, the Gulf Intracoastal Waterway, and the lakes along these waterways." Samples kept on file. Portfolio not required. Credit line given.

Needs Hobby or sports photos, primarily boating. Model release is required. Property release is preferred. Photo captions are required; include names and locations. Submission period is only between May 1 and July 1.

Making Contact & Terms Send query letter with samples or postcard sample. No follow-ups.

Tips "Please, please read the magazine first. Go to the website to obtain three free copies. Our rates are low, but we do our best to take care of and promote our contributors. Also, please note that any e-mail submission will be deleted unread. Submissions must come during our window, May 1-July 1, and be hard-copy form only. Remember to include your contact info, all of it! Please make it easy to find you."

HERITAGE RAILWAY MAGAZINE

P.O. Box 43, Horncastle, Lincolnshire LN9 6JR, United Kingdom. (44)(507)529300. Fax: (44) (507)529301. E-mail: robinjones@mortons.co.uk. Website: www.heritagerailway.co.uk. Editor: Mr. Robin Jones. Monthly leisure magazine emphasizing preserved railways; covering heritage steam, diesel and electric trains with over 30 pages of news in each issue.

Needs Interested in railway preservation. Reviews photos with or without a manuscript. Photo captions required.

Specs Uses glossy or matte color and b&w prints; 35mm, $2\frac{1}{4} \times 2\frac{1}{4}$, 4×5 , 8×10 transparencies. No digital images accepted.

Making Contact & Terms Send query letter with slides, prints, transparencies. Query with online contact form. Does not keep samples on file; include SASE for return of material. Responds in 1 month to queries. Simultaneous submissions OK. Buys one-time rights.

Tips "Contributions should be topical, preferably taken in the previous month. Label clearly all submissions and include a SAE.".

■ S S MIGHWAYS

Affinity Group Inc., 2575 Vista Del Mar Dr., Ventura CA 93001-3920. (805)667-4003. Fax: (805)667-4122. E-mail: info@affinitygroup.com; vlaw@affinitygroup.com. Website: www.goodsamclub. com/highways. Editorial Director: Valerie Law. Circ. 975,000. Estab. 1966. Monthly consumer magazine. The official publication of the Good Sam Club. "Your authoritative source for information on issues of concern to all RVers, as well as your link to the RV community." Sample copy free with $8\frac{1}{2} \times 11$ SAE.

Specs Accepts images in digital format. Send via CD or e-mail at 300 dpi.

Making Contact & Terms Editorial director will contact photographer for portfolio review if interested. Pays \$500 for cover; \$75-350 for inside. Buys one-time rights.

S A HOME EDUCATION MAGAZINE

P.O. Box 1083, Tonasket WA 98855. (800)236-3278, (509)486-1351. Fax: (509)486-2753. E-mail: edchief@homeedmag.com; articles@homeedmag.com. Website: www.homeedmag.com. Managing Editor: Helen Hegener. Bimonthly magazine. Emphasizes homeschooling, Readership includes parents, educators, researchers, media, etc.—anyone interested in homeschooling. Sample copy available for \$6.50. Photo guidelines free with SASE or via e-mail.

Needs Number of photos used/issue varies based on availability; 50% supplied by freelance photographers. Photos of babies/children/teens, multicultural, families, parents, senior citizens, education. Special photo needs include homeschool personalities and leaders. Model/property release preferred. Photo captions preferred.

Specs Uses color and b&w prints in normal print size. "Enlargements not necessary." Accepts images in digital format. Send via CD, Zip, e-mail as TIFF files at 300 dpi.

Making Contact & Terms Send unsolicited color and b&w prints by mail with SASE for consideration. Responds in 1 month. Pays \$100 for color cover; \$12.50 for b&w or color inside; \$50-150 for photo/ text package. Pays on publication. Credit line given. Buys first North American serial rights.

Tips In photographer's samples, wants to see "sharp, clear photos of children doing things alone, in groups, or with parents. Know what we're about! We get too many submissions that are simply irrelevant to our publication."

\$\$ HOOF BEATS

750 Michigan Ave., Columbus OH 43215. (614)224-2291. Fax: (614)222-6791. E-mail: nkraft@ ustrotting.com. Website: www.hoofbeatsmagazine.com. Art Director/Production Manager: Gena Gallagher. Executive Editor: Nicole Kraft. Monthly publication of the U.S. Trotting Association. Emphasizes harness racing. Readers are participants in the sport of harness racing. Sample copy free.

Needs Buys 6 photos from freelancers/issue; 72 photos/year. Needs "artistic or striking photos that feature harness horses for covers; other photos on specific horses and drivers by assignment only."

Making Contact & Terms Send query letter with samples; include SASE for return of material. Responds in 3 weeks. Simultaneous submissions OK. Pays \$150 minimum for color cover; \$25-150 for b&w inside; \$50-200 for color inside; freelance assignments negotiable. Pays on publication. Credit line given if requested. Buys one-time rights.

Tips "We look for photos with unique perspective and that display unusual techniques or use of light. Send query letter first. Know the publication and its needs before submitting. Be sure to shoot pictures of harness horses only, not thoroughbred or riding horses. We always need good night racing action or creative photography."

\$\$ In Horizons Magazine

P.O. Box 1091, Bismarck ND 58502. (701)335-4458. Fax: (701)223-4645. E-mail: ndhorizons@ btinet.net. Website: www.ndhorizons.com. Editor: Andrea W. Collin. Estab. 1971. Quality regional magazine. Photos used in magazines, audiovisual, calendars.

Needs Buys 50 photos/year; offers 25 assignments/year. Scenics of North Dakota events, places and people. Also wildlife, cities/urban, rural, adventure, entertainment, events, hobbies, performing arts, travel, agriculture, industry. Interested in historical/vintage, seasonal. Model/property release preferred. Photo captions preferred.

Specs Prefers images in digital format. Send via CD, as TIFF, EPS files at 600 dpi.

Making Contact & Terms Prefers e-mail query letter. Pays by the project, varies (\$300-500); negotiable. Pays on usage. Credit line given. Buys one-time rights; negotiable.

Tips "Know North Dakota events, places. Have strong quality of composition and light."

\$ HORSE ILLUSTRATED

P.O. Box 8237, Lexington KY 40533. (859)260-9800. Fax: (859)260-1154. E-mail: horseillustrated@ bowtieinc.com. Website: www.horseillustrated.com. Editor: Elizabeth Moyer. Readers are "primarily adult horsewomen, ages 18-40, who ride and show mostly for pleasure, and who are very concerned about the well being of their horses. Editorial focus covers all breeds and all riding disciplines." Sample copy available for \$4.50. Photo guidelines free with SASE.

Needs Buys 30-50 photos from freelancers/issue. Needs stock photos of riding and horse care. "Photos must reflect safe, responsible horsekeeping practices. We prefer all riders to wear protective helmets; prefer people to be shown only in action shots (riding, grooming, treating, etc.). We like all riders—especially those jumping—to be wearing protective headgear."

Specs Prefer digital images—high-res JPEGs on a CD with printout of thumbnails.

Making Contact & Terms Send by mail for consideration. Responds in 2 months. Pays \$250 for color cover; \$65-250 for color inside. Credit line given. Buys one-time rights.

Tips "Looks for clear, sharp color shots of horse care and training. Healthy horses, safe riding and care atmosphere is standard in our publication. Send SASE for a list of photography needs, photo guidelines, and to submit work. Photo guidelines are also available on our website."

■ S S HUNGER MOUNTAIN

Vermont College, 36 College St., Montpelier VT 05602. (802)828-8517. E-mail: hungermtn@ vermontcollege.edu. Website: www.hungermtn.org. Managing Editor: Caroline Mercurio. Estab. 2002. Biannual literary magazine. Sample copy available for \$5. Photo guidelines free with SASE. Needs Buys no more than 10 photos/year. Interested in avant garde, documentary, fine art,

seasonal. Reviews photos with or without a manuscript. Specs Accepts slides or website link via e-mail; do not send e-mail attachments.

Making Contact & Terms Send query letter with résumé, slides, prints, tearsheets. Does not keep samples on file; include SASE for return of material. Responds in 3 months to queries and portfolios. Simultaneous submissions OK. Pays \$30-45 for inside photos; cover negotiable. Pays on publication. Credit line given. Buys first rights.

Tips Fine art photography—no journalistic/media work. Particularly interested in b&w. "Keep in mind that we only publish twice per year with a minimal amount of artwork. Considering publication of a special edition of all black-and-white photos. Interested in photography with a literary link."

S S IDEALS MAGAZINE

535 Metroplex Dr., Suite 250, Nashville TN 37211. (615)333-0478, ext. 453. Fax: (615)781-1447. Website: www.idealsbooks.com. Editor: Melinda Rathjen. Magazine published 4 times/year. Emphasizes an idealized, nostalgic look at America through poetry and short prose, using seasonal themes. Average reader has a college degree. Sample copy available for \$4. Photo guidelines free with SASE or available on website.

Needs Buys 30 photos from freelancers/issue; 120 photos/year. Photos of "bright, colorful flowers, scenics, still life, children, pets, home interiors; subject-related shots depending on issue." Model/ property release required. No research fees.

Specs Prefers medium- to large-format transparencies; no 35mm.

Making Contact & Terms Submit tearsheets to be kept on file. No color copies. Will send photo needs list if interested. Do not submit unsolicited photos or transparencies. Keeps samples on file. Simultaneous submissions and previously published work OK. Payment negotiable. Pays on publication. Credit line given. Buys one-time rights.

Tips "We want to see sharp shots. No mood shots, please. No filters. We suggest the photographer study several recent issues of Ideals for a better understanding of our requirements."

IS □ ILLOGICAL MUSE

115 Liberty St., Apt. 1, Buchanan MI 49107-1424. E-mail: illogicalmuseonline@yahoo.com. Website: http://illogicalmuse.blogspot.com. Editor: Amber Rothrock. Estab. 2004. Irregular literary e-zine magazine. Online journal publishing fiction, poetry, reviews, essays and artwork. Photo guidelines available on website.

Needs Photos of babies/children/teens, couples, multicultural, parents, senior citizens, architecture, cities/urban, gardening, pets, religious, rural, agriculture, disasters, environmental, wildlife, hobbies, performing arts. Interested in avant garde, historical/vintage, seasonal. Does not want to see anything pornographic; mild erotica is fine. "I am open to all schools and styles but tend to lean toward the more experimental and avant garde." Reviews photos with or without a manuscript. Model release preferred. Property release preferred. Photo captions preferred.

Specs Accepts images in digital format only. Send JPEG or GIF files via CD or e-mail.

Making Contact & Terms E-mail query letter with link to photographer's website, JPEG samples at 72 dpi. "Send a cover letter with a brief, publishable bio. An exceptionally long list of prior achievements is not necessary. Tell me a little bit about yourself and the work you do." Does not keep samples on file; include SASE for return of material. Responds in 1 month to queries; 6 months to portfolios. Simultaneous submissions and previously published work OK. All rights remain with the photographer. "There are three different ways to submit artwork: 1) attach 6-8 images to an e-mail; 2) send a link to your website; 3) or send a cover letter along with some images on a CD to the snail mail address. I want to make it perfectly clear that I do not pay for material on the website, neither do I look at professional stock photography that is sent via mass e-mail by a middle man."

Tips "Visit the website to see if it appeals to you. It's hard to say what I am specifically looking for as I try to keep an open mind with every submission. Just send your best."

IMMIGRANT ANCESTORS

2660 Petersborough St., Herndon VA 20171. E-mail: immigrantancestors@yahoo.com. Editor: Shannon Bridget Murphy. Quarterly magazine, "Searching for immigrant records." Photo guidelines available by e-mail request.

Needs Buys 12-24 photos/year. Photos of babies/children/teens, multicultural, families, parents, disasters, environmental, landscapes/scenics, wildlife, cities/urban, education, religious, rural, adventure, events, food/drink, sports, travel, agriculture, medicine, military, political, product shots/still life, science, technology—as related to early immigration and those who made its history. Interested in alternative process, avant garde, documentary, fashion/glamour, fine art, historical/vintage, seasonal. Reviews photos with or without manuscript. Model/property release preferred. **Specs** Uses glossy or matte color and b&w prints.

Making Contact & Terms Send query letter via e-mail. "If possible, please do not include photographs in files if they are sent through e-mail. A disk with your photographs is acceptable." Provide résumé, business card or self-promotion piece to be kept on file for possible future assignments. Responds within 1 month to queries; 1 week to portfolios. Simultaneous submissions and previously published work OK. **Pays on acceptance.** Credit line given. Buys one-time rights, first rights; negotiable.

\$\$ INDIANAPOLIS MONTHLY

40 Monument Circle, Suite 100, Indianapolis IN 46204. (317)237-9288. E-mail: dzivan@indymonthly. emmis.com. Website: www.indianapolismonthly.com. Contact: Art Director. Monthly regional magazine. Readers are upscale, well-educated. Circ. 50,000. Sample copy available for \$4.95 and 9×12 SASE.

Needs Buys 10-12 photos from freelancers/issue; 120-144 photos/year. Needs seasonal, human interest, humorous, regional; subjects must be Indiana- or Indianapolis-related. Model release preferred. Photo caption information required.

Specs Glossy prints; transparencies, digital. Send via CD, e-mail as TIFF, EPS, JPEG files at 300 dpi at actual size.

Making Contact & Terms Send query letter with samples, SASE. Responds in 1 month. Previously published work on occasion OK, if different market. Pays \$300-1,200 for color cover; \$75-350 for b&w inside; \$75-350 for color inside. Pays on publication. Credit line given. Buys first North American serial rights.

Tips "Read publication. Send photos similar to those you see published. If you see nothing like what you are considering submitting, it's unlikely we will be interested. We are always interested in photo essay queries if they are Indiana-specific."

\$\$ INSIGHT MAGAZINE

55 W. Oak Ridge Dr., Hagerstown MD 21740-7390. (301)393-4038. Fax: (301)393-4055. E-mail: insight@rhpa.org. Website: www.insightmagazine.org. Weekly Seventh-Day Adventist teen magazine. "We print teens' true stories about God's involvement in their lives. All stories, if illustrated by a photo, must uphold moral and church organization standards while capturing a hip, teen style." Sample copy free.

Needs "Send query letter with photo samples so we can evaluate style." Model/property release required. Photo captions preferred; include who, what, where, when.

Making Contact & Terms Send query letter with samples. Provide résumé, business card, selfpromotion piece or tearsheets to be kept on file for possible future assignments. Responds only if interested; send nonreturnable samples. Simultaneous submissions and previously published work OK. Pays \$200-300 for color cover; \$200-400 for color inside. Pays 30-45 days after receiving invoice and contract. Credit line given. Buys first rights.

■ INSTINCT MAGAZINE

Website: http://instinctmagazine.com, Estab. 1997. Monthly gay men's magazine. "Instinct is geared towards a gay male audience. The slant of the magazine is humor mingled with entertainment, travel, and health and fitness." Sample copies available. Photo guidelines available via website.

Needs Buys 50-75 photos from freelancers/issue; 500-750 photos/year. Needs photos of celebrities, couples, cities/urban, entertainment, health/fitness, humor, travel. Interested in lifestyle, fashion/ glamour. High emphasis on humorous and fashion photography. Reviews photos with or without a manuscript. Model release required; property release preferred. Photo captions preferred.

Specs Uses 8×10 glossy color prints; $2\frac{1}{4} \times 2\frac{1}{4}$ transparencies. Accepts images in digital format. Send via CD, Jaz, Zip as TIFF files at least 300 dpi.

Making Contact & Terms Portfolio may be dropped off every weekday. Provide résumé, business card, self-promotion piece to be kept on file for possible future assignments. Responds in 2 weeks. Simultaneous submissions OK. Payment negotiable. Pays on publication. Credit line given.

Tips "Definitely read the magazine. Keep our editor updated about the progress or any problems with the shoot."

■ \$\$ ☐ IN THE WIND

Paisano Publications, P.O. Box 3000, Agoura Hills CA 91376-3000. (818)889-8740. Fax: (818)889-1252. E-mail: photos@easyriders.net. Website: www.easyriders.com. Editor: Kim Peterson. Quarterly consumer magazine displaying the exhilaration of riding American-made V-twin (primarily Harley-Davidson) street motorcycles, the people who enjoy them, and the fun involved. Motto: "If It's Out There, It's In Here." Photo guidelines free with SASE.

Needs Photos of celebrities, couples, landscapes/scenics, adventure, events, travel. Interested in erotic, historical/vintage. Other specific photo needs: action photos of people (men or women) riding Harley-Davidson motorcycles. "Ideally, with no helmets; full-frame without wheels cropped off on the bikes. No children." Reviews photos with or without a manuscript. Model release required on posed and nude photos.

Specs Uses 4×6 , 5×7 , 8×10 glossy color and/or b&w prints; 35mm transparencies. Accepts images in digital format. Send via CD, e-mail as TIFF, JPEG files at 300 dpi, 5×7 size. 3 Megapixel minimum (2048 × 1536) Resolution: 5×7 , 300 dpi minimum RGB. Acceptable formats: TIFF, Photoshop (PSD), Kodak Photo CDs, JPEG. GIF format is NOT acceptable.

Making Contact & Terms There is an online submission form. Send query letter with slides, prints, transparencies. Does not keep samples on file; include SASE for return of material. Responds in 6 weeks to queries; 3 months to portfolios. Responds only if interested; send nonreturnable samples. Pays \$30-200 for b&w cover; \$30-200 for color cover; \$30-500 for b&w inside; \$30-500 for color inside; inset photos usually not paid extra. Assignment photography for features pays up to \$1,500 for bike and model. **Pays on publication.** Credit line given. Buys all rights; negotiable.

Tips "Get familiar with the magazine. Shoot sharp, in-focus pictures; fresh views and angles of bikes and the biker lifestyle. Send self-addressed, stamped envelopes for return of material. Label each photo with name, address and caption information, i.e., where and when picture was taken."

S THE IOWAN MAGAZINE

The Plaza, 300 Walnut, Ste. 6, Des Moines IA 50309. (515)246-0402. Fax: (515)282-0125. E-mail: editor@iowan.com. Website: www.iowan.com. Art Director: Bobbie Russie. Circ. 22,000. Bimonthly magazine. Emphasizes "Iowa's people, places, events, nature and history." Readers are over age 40, college-educated, middle-to-upper income. Sample copy available for \$4.50 plus shipping/handling; call the Distribution Center toll-free at (877)899-9977. Photo guidelines available on website or via e-mail.

Needs "We print only Iowa-related images from Iowa photographers, illustrators, and artists. Show us Iowa's residents, towns, environmental, landscape/scenics, wildlife, architecture, rural, entertainment, events, performing arts, travel." Interested in Iowa heritage, historical/vintage, seasonal. Accepts unsolicited stock photos related to above. Editorial stock photo needs available on website or via e-mail. Model/property release preferred. Photo captions required.

Specs Digital format preferred on clearly labeled CD/DVD with submission form, printed contact sheet, and image reference. See website for details. Press resolution is 300 dpi at 9X12. Digital materials will not be returned. Uses 35mm, color transparencies, which will be returned following press deadline.

Making Contact & Terms Pays \$50-250 for stock photo one-time use, depending on size printed. **Pays on publication.** Contract rates run \$200-500/day for assigned editorials; **pays within 60 days of receipt of invoice.**

\$\$ JEWISH ACTION

11 Broadway, 14th Fl., New York NY 10004. (212)613-8146. Fax: (212)613-0646. E-mail: carmeln@ou.org; ja@ou.org; kosher@ou.org. Website: www.ou.org/publications/ja. Art Director: Ed Hamway. Quarterly magazine with adult Orthodox Jewish readership. Sample copy available for \$5 or on website.

Needs Buys 30 photos/year. Photos of Jewish lifestyle, landscapes and travel photos of Israel, and occasional photo essays of Jewish life. Reviews photos with or without a manuscript. Model/property release preferred. Photo captions required; include description of activity, where taken, when.

Specs Uses color and b&w prints. Accepts images in digital format. Send CD, Jaz, Zip as TIFF, GIF, JPEG files.

Making Contact & Terms Send query letter with samples, brochure or stock photo list. Keeps samples on file. Responds in 2 months. Simultaneous submissions OK. Pays \$250 maximum for b&w cover; \$400 maximum for color cover; \$100 maximum for b&w inside; \$150 maximum for color inside. **Pays within 6 weeks of publication.** Credit line given. Buys one-time rights.

Tips "Be aware that models must be clothed in keeping with Orthodox laws of modesty. Make sure to include identifying details. Don't send work depicting religion in general. We are specifically Orthodox Jewish."

\$\$ JOURNAL OF ASIAN MARTIAL ARTS

941 Calle Mejia #822, Santa Fe NM 87501. (505)983-1919. Website: www.goviamedia.com. Circ. 10,000. "An indexed, notch-bound quarterly magazine exemplifying the highest standards in writing and graphics available on the subject. Comprehensive, mature and eye-catching. Covers all historical and cultural aspects of Asian martial arts." Sample copy available for \$10. Photo guidelines free with SASE.

Needs Buys 120 photos from freelancers/issue; 480 photos/year. Photos of health/fitness, sports, action shots; technical sequences of martial arts; photos that capture the philosophy and aesthetics of Asian martial traditions. Interested in alternative process, avant garde, digital, documentary, fine art, historical/vintage. Model release preferred for photos taken of subjects not in public demonstration; property release preferred. Photo captions preferred; include short description, photographer's name, year taken.

Specs Uses color and b&w prints; 35mm, $2\frac{1}{4} \times 2\frac{1}{4}$, 4×5 , 8×10 transparencies. Accepts images in digital format. Send via CD, Zip as TIFF files at 300 dpi.

Making Contact & Terms Send query letter with samples, stock list. Provide résumé, business card, self-promotion piece or tearsheets to be kept on file for possible future assignments. Art director will contact photographer for portfolio review if interested. Keeps samples on file. Responds in 2 months. Previously published work OK. Pays \$100-500 for color cover; \$10-100 for b&w inside. Credit line given. Buys first rights and reprint rights.

Tips "Read the journal. We are unlike any other martial arts magazine and would like photography to compliment the text portion, which is sophisticated with the flavor of traditional Asian aesthetics. When submitting work, be well organized and include a SASE."

\$\$ JUVENILE DIABETES RESEARCH FOUNDATION INTERNATIONAL

120 Wall St., New York NY 10005, (800)533-2873, Fax: (212)785-9595, E-mail: info@idrf.org, Website: www.jdrf.org. Editor: Jason Dineen. Estab. 1970. Produces 4-color, 48-page quarterly magazine to deliver research information to a lav audience.

Needs Buys 60 photos/year; offers 20 freelance assignments/year. Photos of babies/children/ teens, families, events, food/drink, health/fitness, medicine, product shots/still life, science. Needs "mostly portraits of people, but always with some environmental aspect." Reviews stock photos. Model release preferred. Photo captions preferred.

Specs Uses $2\frac{1}{4} \times 2\frac{1}{4}$ transparencies. Accepts images in digital format. Send via CD, Zip as TIFF, EPS, JPEG files at 300 dpi.

Making Contact & Terms Send query letter with samples. Provide résumé, business card, brochure, flier or tearsheets to be kept on file for possible future assignments. Cannot return material. Responds as needed. Pays \$500 for color photos; \$500-700 per day. Also pays by the job—payment "depends on how many days, shots, cities, etc." Credit line given. Buys nonexclusive perpetual

Tips Looks for "a style consistent with commercial magazine photography—upbeat, warm, personal, but with a sophisticated edge. Call and ask for samples of our publications before submitting any of your own samples so you will have an idea of what we are looking for in photography. Nonprofit groups have seemingly come to depend more and more on photography to get their messages across. The business seems to be using a variety of freelancers, as opposed to a single in-house photographer."

\$\$ ANSAS! MAGAZINE

100 SW Jackson, Ste. 100, Topeka KS 66612. (785)296-3479. Fax: (785)296-6988. E-mail: ksmagazine@kansascommerce.com. Website: www.kansmag.com. Editor: Jennifer Haugh. Quarterly magazine published by the Travel & Tourism Development Division of the Kansas Department of Commerce. Emphasizes Kansas travel, scenery, arts, recreation and people. Photo guidelines available on website.

Needs Buys 60-80 photos from freelancers/year. Subjects include animal, human interest, nature, seasonal, rural, scenic, sport, travel, wildlife, photo essay/photo feature, all from Kansas. No nudes, still life or fashion photos. Reviews photos with or without a manuscript. Model/property release preferred. Photo captions required; include subject and specific location.

Specs Prefers digital at 300 dpi for 8×10 .

Making Contact & Terms Send material by mail for consideration. Previously published work OK. **Pays on acceptance.** Credit line given. Buys one-time or limited universal rights.

Tips Kansas-oriented material only. Prefers Kansas photographers. "Follow guidelines, submission dates specifically. Shoot a lot of seasonal scenics."

\$ ASHRUS MAGAZINE

P.O. Box 204, Parkville Station, Brooklyn NY 11204. (718)336-8544. Fax: (718)336-8550. E-mail: editorial@kashrusmagazine.com. Website: www.kashrusmagazine.com. Editor: Rabbi Yosef Wikler. Bimonthly. Emphasizes kosher food and food technology, travel (Israel-desirable), catering, weddings, remodeling, humor. Readers are kosher food consumers, vegetarians and food producers. Sample copy available for \$2.

Needs Buys 3-5 photos from freelancers/issue; 18-30 photos/year. Photos of babies/children/teens, environmental, landscapes, interiors, Jewish, rural, food/drink, humor, travel, product shots, technology/computers. Interested in seasonal, nature photos and Jewish holidays. Model release preferred. Photo captions preferred.

Specs Uses $2\frac{1}{4} \times 2\frac{1}{4}$, $3\frac{1}{2} \times 3\frac{1}{2}$ or $7\frac{1}{2} \times 7\frac{1}{2}$ matte b&w and color prints.

Making Contact & Terms Send unsolicited photos by mail with SASE for consideration. Provide business card, brochure, flier or tearsheets to be kept on file for possible future assignments. Responds in 1 week. Simultaneous submissions and previously published work OK. Pays \$40-75 for b&w cover; \$50-100 for color cover; \$25-50 for b&w inside; \$75-200/job; \$50-200 for text for photo package. **Pays part on acceptance, part on publication.** Buys one-time rights, first North American serial rights, all rights; negotiable.

Tips "Seriously in need of new photo sources, but *call first* to see if your work is appropriate before submitting samples."

■ \$ □ KENTUCKY MONTHLY

106-C St. James Court, Frankfort KY 40601-0559. (502)227-0053. Fax: (502)227-5009. E-mail: steve@ kentuckymonthly.com. Website: www.kentuckymonthly.com. Creative Director: Amanda Hervey. Managing Editor: Patty Ranft. Editor: Stephen Vest. Monthly magazine focusing on Kentucky and Kentucky-related stories. Sample copy available for \$4.

Needs Buys 10 photos from freelancers/issue; 120 photos/year. Photos of celebrities, wildlife, entertainment, landscapes. Reviews photos with or without a manuscript. Model release required. Photo captions required.

Specs Uses glossy prints; 35mm transparencies. Accepts images in digital format. Send via CD, e-mail at 300 dpi.

Making Contact & Terms Send query letter. Provide self-promotion piece to be kept on file for possible future assignments. Responds in 1 month. Simultaneous submissions OK. Pays \$25 minimum for inside photos. **Pays the 15th of the following month.** Credit line given. Buys one-time rights.

■ A \$ ✓ KIWANIS MAGAZINE

3636 Woodview Trace, Indianapolis IN 46268. (317)875-8755. Fax: (317)879-0204. E-mail: klittle@ kiwanis.org; kjackson@kiwanis.org. Website: www.kiwanis.org. Editors: Kristian Little and Kasey Jackson. Published 6 times/year. Emphasizes organizational news, plus major features of interest to business and professional men and women involved in community service. Sample copy available for SAE and 5 first-class stamps. Photo guidelines available via website: www.kiwanis.org/magazine/. Look for "magazine submission guidelines" link.

Needs Photos of babies/children/teens, multicultural, families, parents, senior citizens, landscapes/ scenics, education, business concepts, medicine, science, technology/computers. Interested in fine art. Reviews photos with or without manuscript.

Specs Uses 5×7 or 8×10 glossy b&w prints; accepts 35mm but prefers $2\sqrt[3]{4} \times 2\sqrt[3]{4}$ and 4×5 transparencies. Accepts images in digital format. Send via CD, e-mail as TIFF, BMP files.

Making Contact & Terms Send résumé of stock photos. Provide brochure, business card or flier to be kept on file for future assignments. Assigns 95% of work, Pays \$400-1,000 for b&w or color cover; \$75-800 for b&w or color inside. Buys one-time rights.

Tips "We can offer the photographer a lot of freedom to work and worldwide exposure. And perhaps an award or two if the work is good. We are now using more conceptual photos. We also use studio set-up shots for most assignments. When we assign work, we want to know if a photographer can follow a concept into finished photo without on-site direction." In portfolio or samples, wants to see "studio work with flash and natural light."

■ \$\$ ☑ KNOWATLANTA

450 Northridge Parkway, Suite 202, Atlanta GA 30350. (770)650-1102, ext. 129. Fax: (770)650-2848. E-mail: amy@knowatlanta.com, laura@knowatlanta.com. Website: www.knowatlanta.com. Editors: Amy Selby and Laura Newsome. Circ. 48,000. Estab. 1986. Quarterly magazine serving as a relocation guide to the Atlanta metro area with a corporate audience. Photography reflects regional and local material as well as corporate-style imagery.

Needs Buys more than 10 photos from freelancers/issue; more than 40 photos/year. Photos of cities/urban, events, performing arts, business concepts, medicine, technology/computers. Reviews photos with or without a manuscript. Model release required; property release preferred. Photo captions preferred.

Specs Uses 8 × 10 glossy color prints; 35mm, transparencies. Accepts images in digital format. Send via CD, Zip, e-mail as TIFF, EPS, JPEG files at 300 dpi.

Making Contact & Terms Send query letter with photocopies. Provide résumé, business card, selfpromotion piece to be kept on file for possible future assignments. Responds only if interested; send nonreturnable samples. Pays \$600 maximum for color cover; \$300 maximum for color inside. Pavs on publication. Credit line given. Buys first rights.

Tips "Think like our readers. What would they want to know about or see in this magazine? Try to represent the relocated person if using subjects in photography."

S LACROSSE MAGAZINE

113 W. University Pkwy., Baltimore MD 21210. (410)235-6882. Fax: (410)366-6735. E-mail: pkrome@ uslacrosse.org; gferraro@uslacrosse.org. Website: www.uslacrosse.org. Art Director: Gabriella O'Brien. Publication of US Lacrosse. Monthly magazine. Emphasizes sport of lacrosse. Readers are male and female lacrosse enthusiasts of all ages. Sample copy free with general information pack. **Needs** Buys 15-30 photos from freelancers/issue; 120-240 photos/year. Needs lacrosse action shots. Photo captions required; include rosters with numbers for identification.

Specs Accepts images in digital format. Digital photographs should be submitted in the form of original, unedited JPEGs. Suggested captions are welcome. Photographs may be submitted via CD or e-mail. Prints also are accepted and are returned upon request. Photographer credit is published when supplied. Original RAW/NEF files or 300 dpi TIFFs.

Making Contact & Terms Send unsolicited photos by mail with SASE for consideration. Provide résumé, business card, brochure, flier or tearsheets to be kept on file for possible future assignments. Responds in 3 weeks. Simultaneous submissions and previously published work OK. Pays \$250 for color cover; \$75-150 inside. Pays on publication. Credit line given. Buys one-time rights.

\$ LAKELAND BOATING MAGAZINE

727 South Dearborn St. Suite 812, Chicago IL 60605. (312)276-0610. Fax: (312)276-0619. E-mail: bpoplawski@lakelandboating.com. Website: www.lakelandboating.com. Art/Production Manager: Brook Poplawski. Circ. 60,000. Estab. 1945. Monthly magazine. Emphasizes powerboating in the Great Lakes. Readers are affluent professionals, predominantly men over age 35.

Needs Shots of particular Great Lakes ports and waterfront communities. Model release preferred. Photo captions preferred.

Making Contact & Terms Send query letter with list of stock photo subjects. Provide résumé, business card, brochure, flier or tearsheets to be kept on file for possible future assignments. Pays \$25-100 for photos. Pays on publication. Credit line given.

\$ JAKE SUPERIOR MAGAZINE

P.O. Box 16417, 310 E. Superior St. #125, Duluth, MN 55802-3134. (218)722-5002. Fax: (218)722-4096. E-mail: kon@lakesuperior.com; edit@lakesuperior.com. Website: www.lakesuperior.com. Editor: Konnie LeMay. Bimonthly magazine. "Beautiful picture magazine about Lake Superior." Readers are male and female, ages 35-55, highly educated, upper-middle and upper-management level through working. Sample copy available for \$4.95 plus \$5.95 S&H. Photo guidelines free with SASE or via website.

Needs Buys 21 photos from freelancers/issue; 126 photos/year. Also buys photos for calendars and books. Needs photos of landscapes/scenics, travel, wildlife, personalities, boats, underwater—all Lake Superior-related. Photo captions preferred.

Specs Uses 5×7 , 8×10 glossy b&w and color-corrected prints; 35mm, $2\frac{1}{4} \times 2\frac{1}{4}$, 4×5 , 8×10 transparencies. Accepts images in digital format. Send via CD with at least thumbnails on a printout.

Making Contact & Terms Send unsolicited photos by mail with SASE for consideration. Provide résumé, business card, brochure, flier or tearsheets to be kept on file for possible future assignments. Responds in 2 months. Simultaneous submissions OK. Pays \$150 for color cover; \$50 for b&w or color inside. Pays on publication. Credit line given. Buys first North American serial rights; reserves second rights for future use.

Tips "Be aware of the focus of our publication—Lake Superior. Photo features concern only that. Features with text can be related. We are known for our fine color photography and reproduction. It has to be 'tops.' We try to use images large; therefore, detail quality and resolution must be good. We look for unique outlook on subject, not just snapshots. Must communicate emotionally. Some photographers send material we can keep in-house and refer to, and these will often get used."

■ \$ ☐ LIVING FREE

P.O. Box 969, Winnisquam NH 03289. (603)455-7368. E-mail: free@natnh.com. Website: www. natnh.com/lf/mag.html. Editor-in-Chief: Tom Caldwell. Quarterly electronic magazine succeeding Naturist Life International's Online e-zine. Emphasizes nudism. Readers are male and female nudists. Sample copy available on CD for \$10. Photo guidelines free with SASE. We periodically organize naturist photo safaris to shoot nudes in nature.

Needs Buys 36 photos from freelancers/issue; 144 photos/year. Needs photos depicting familyoriented nudist/naturist work, recreational activity and travel. Reviews photos with or without a manuscript. Model release required (including Internet use) for recognizable nude subjects. Photo captions preferred.

Specs Prefers digital images submitted on CD or via e-mail; 8 × 10 glossy color and b&w prints. Making Contact & Terms Send query letter with résumé of credits. Send unsolicited photos by mail or e-mail for consideration; include SASE for return of material. Provide résumé, business card, brochure, flier or tearsheets to be kept on file for possible future assignments. Responds in 2 weeks. Pays \$50 for color cover; \$10-25 for others. Pays on Credit line given. "Prefer to own all rights but sometimes agree to one-time publication rights."

Tips "The ideal photo shows ordinary-looking people of all ages doing everyday activities, in the joy of nudism. We do not want 'cheesecake' glamour images or anything that emphasizes the erotic."

\$\$ IOG HOME LIVING

4125 Lafayette Center Dr., Suite 100, Chantilly VA 20151. (703)222-9411. Fax: (703)222-3209. E-mail: editor@loghomeliving.com; emann@homebuyerpubs.com. Website: www.loghomeliving.com. Art Director: Edie Mann. Circ. 120,000. Estab. 1989. Monthly magazine. Emphasizes planning, building and buying a log home. Sample copy available for \$4. Photo guidelines available on website.

Needs Buys 90 photos from freelancers/issue; 120 photos/year. Needs photos of homes—living room, dining room, kitchen, bedroom, bathroom, exterior, portrait of owners, design/decor-tile sunrooms, furniture, fireplaces, lighting, porch and deck, doors. Close-up shots of details (roof trusses, log stairs, railings, dormers, porches, window/door treatments) are appreciated. Model release required.

Specs Prefers to use digital images or 4 × 5 color transparencies/Kodachrome or Ektachrome color slides; smaller color transparencies and 35mm color prints also acceptable.

Making Contact & Terms Send unsolicited photos by mail for consideration. Keeps samples on file. Responds only if interested. Previously published work OK. Pays \$2,000 maximum for color feature. Cover shot submissions also accepted; fee varies, negotiable. Pays on acceptance. Credit line given. Buys first World-one-time stock serial rights; negotiable.

Tips "Send photos of log homes, both interiors and exteriors."

\$ LOYOLA MAGAZINE

820 N. Michigan Ave., Chicago IL 60611. (312)915-6930. E-mail: abusiek@luc.edu. Website: www. luc.edu/loyolamagazine. Circ. 120,000. Estab. 1971. Loyola University Alumni magazine. Quarterly magazine emphasizing issues related to Loyola University Chicago. Readers are Loyola University Chicago alumni—professionals, ages 22 and up.

Needs Buys 20 photos from freelancers/issue; 60 photos/year. Needs Loyola-related or Loyola alumni related photos only. Model release preferred. Photo captions preferred.

Specs Uses 8×10 b&w and color prints; 35mm, $2\frac{1}{4} \times 2\frac{1}{4}$ transparencies. Accepts high-resolution digital images. Query before submitting.

Making Contact & Terms Best to query by mail before making any submissions. If interested, will ask for résumé, business card, brochure, flier or tearsheets to be kept on file for possible future assignments. Simultaneous submissions and previously published work OK. Pays on acceptance. Credit line given.

Tips "Send us information, but don't call."

№ ■ **S O LULLWATER REVIEW**

Emory University, P.O. Box 122036, Atlanta GA 30322. Fax: (404)727-7367. E-mail: Lullwaterreview@ Yahoo.com. Editor-in-Chief: Arina Korneva. Estab. 1990. Circ. 2,000. "We're a small, student-run literary magazine published out of Emory University in Atlanta, GA with two issues yearly—once in the fall and once in the spring. You can find us in the Index of American Periodical Verse, the American Humanities Index and as a member of the Council of Literary Magazines and Presses. We welcome work that brings a fresh perspective, whether through language or the visual arts."

Needs Architecture, cities/urban, rural, landscapes, wildlife, alternative process, avant garde, fine art and historical/vintage photos.

Making Contact & Terms Send an e-mail with photographs. Samples kept on file. Portfolio should include b&w, color, photographs and finished, original art. Credit line given when appropriate.

Tips "Read our magazine. We welcome work of all different types, and we encourage submissions that bring a fresh or alternative perspective. Submit at least 5 works. We frequently accept 3-5 pieces from a single artist and like to see a selection."

■ \$\$ THE LUTHERAN

8765 W. Higgins Rd., 5th Floor, Chicago IL 60631-4183. (773)380-2540; (800)638-3522, ext. 2540. Fax: (773)380-2751; (773)380-2409. E-mail: michael.watson@thelutheran.org; lutheran@ thelutheran.org. Website: www.thelutheran.org. Art Director: Michael Watson. Monthly publication of Evangelical Lutheran Church in America. "Please send samples of your work that we can keep in our files. Though we prefer to review online portfolios, a small number of slides, prints or tearsheets, a brochure, or even a few photo-copies are acceptable as long as you feel they represent you."

Needs Buys 10-15 photos from freelancers/issue; 120-180 photos/year. Needs current news, mood shots. Subjects include babies/children/teens, couples, multicultural, families, parents, senior citizens, disasters, landscapes/scenics, cities/urban, education, religious. Interested in fine art, seasonal. "We usually assign work with exception of 'Reflections' section." Model release required. Photo captions preferred.

Specs Accepts images in digital format. Send via CD or e-mail as TIFF or JPEG files at 300 dpi. Making Contact & Terms Send query letter with list of stock photo subjects. Online e-mail is available on website. Provide résumé, brochure, flier or tearsheets to be kept on file for possible future assignments. Pays \$300-500 for color cover; \$175-300 for color inside; \$300 for half day; \$600 for full day. Pays on publication. Credit line given. Buys one-time rights; credits the photographer.

Tips Trend toward "more dramatic lighting; careful composition." In portfolio or samples, wants to see "candid shots of people active in church life, preferably Lutheran. Church-only photos have little chance of publication. Submit sharp, well-composed photos with borders for cropping. Send printed or duplicate samples to be kept on file; no originals. If we like your style, we will call you when we have a job in your area."

S\$ SAILING MAGAZINE

125 E. Main St., P.O. Box 249, Port Washington WI 53074. (262)284-3494. Fax: (262)284-7764. E-mail: editorial@sailingmagazine.net. Website: www.sailingmagazine.net. Managing Editor: Greta Schanen, Circ. 50,000. Monthly magazine. Emphasizes sailing. Readers are experienced sailors who race, cruise and daysail on all types of boats: dinghies, large and small mono and multihulls. Sample copy available for 11 × 15 SAE and 9 first-class stamps. Photo guidelines free with SASE.

Needs "We are a large-format journal, with a strong emphasis on top-notch photography backed by creative, insightful writing. Need photos of sailing, both long shots and on-deck. We encourage creativity; send me a sailing photograph I have not seen before." Photo captions required; include boat and people IDs, location, conditions, etc.

Specs Uses 35mm and larger transparencies. Accepts images in digital format. Send via CD as TIFF, JPEG files at 300 dpi. Include printed thumbnails with CD. If photos are also being submitted by e-mail, they should be sent as low-res attachments, and under no circumstances, be embedded in a Microsoft Word document. Only submit photos via e-mail or FTP upon request.

Making Contact & Terms Send query letter with samples; include SASE for return of material. Portfolios may be dropped off by appointment. Send submissions by mail; e-mail samples or portfolios will not be considered. Responds in 3 months. "Tell us of simultaneous submissions; previously published work OK if not with other sailing publications who compete with us." Pays \$250-500 for color cover; \$50-500 for color inside. Pays 30 days after publication.

\$\$ MARLIN

460 N. Orlando Ave., Suite 200, Winter Park FL 32789. (407)628-4802. Fax: (407)628-7061. E-mail: dave.ferrell@bonniercorp.com; editor@marlinmag.com. Website: www.marlinmag.com. Managing Editor: Charlie Levine. Editor: David Ferrell. Estab. 1981. Circ. 45,000 (paid). Published 8 times/year. Emphasizes offshore big game fishing for billfish, tuna and other large pelagics. Readers are 94% male, 75% married, average age 43, very affluent businessmen. Sample copy free with 8 × 10 SASE. Photo guidelines free with SASE or on website.

Needs Buys 45 photos from freelancers/issue; 270 photos/year. Photos of fish/action shots, scenics and how-to. Special photo needs include big game fishing action and scenics (marinas, landmarks, etc.). Model release preferred. Photo captions preferred.

Specs Uses 35mm transparencies. Also accepts high-res images on CD or via FTP.

Making Contact & Terms Contract required. Send unsolicited photos by mail with SASE for consideration. Responds in 1 month. Simultaneous submissions OK with notification. Pays \$1,200 for color cover; \$100-300 for color inside. Pays on publication. Buys first North American rights.

Tips "Send sample material with SASE. No phone call necessary." "Don't hesitate to call editor Dave Ferrel or managing editor Charlie Levine at (407)628-4802 anytime you have any general or specific questions about photo needs, submissions or payment."

■ \$\$ ☐ METROSOURCE MAGAZINE

137 W. 19th St., 2nd Fl., New York NY 10011. (212)691-5127, ext. 814. Fax: (212)741-2978. E-mail: evayner@metrosource.com. Website: www.metrosource.com. Upscale, gay men's luxury lifestyle magazine published 6 times/year. Emphasizes fashion, travel, profiles, interiors, film, art. Sample copies free.

Needs Buys 10-15 photos from freelancers/issue; 50 photos/year. Needs photos of celebrities, architecture, interiors/decorating, adventure, food/drink, health/fitness, travel, product shots/still life. Interested in erotic, fashion/glamour, seasonal. Also needs still life drink shots for spirits section. Reviews photos with or without a manuscript. Model/property release preferred. Photo captions preferred.

Specs Uses 8 × 10 glossy or matte color and b&w prints; 21/4 × 21/4, 4 × 5 transparencies. Prefers images in digital format. Send via CD, Zip, e-mail as TIFF, EPS, JPEG files at 300 dpi.

Making Contact & Terms Send query letter with self-promo cards. "Please call first for portfolio drop-off." Provide self-promotion piece to be kept on file for possible future assignments. Responds only if interested; send nonreturnable samples. Simultaneous submissions and previously published work OK. Pays \$500-800 for cover; \$0-300 for inside. Pays on publication. Credit line given. Buys one-time rights.

Tips "We work with creative established and newly-established photographers. Our budgets vary depending on the importance of story. Have an e-mail address on card so we can see more photos or whole portfolio online."

M 🖪 🖸 MGW NEWSMAGAZINE

1123 21st St., Suite 201, Sacramento CA 95811. (916)441-6397. Fax: (206)339-5864. E-mail: editor@ momguesswhat.com. Website: www.mgwnews.com.

Needs Photo subjects include events, personalities, culture, entertainment, fashion, food, travel. Model release required. Photo captions required.

Specs Accepts images in digital format. Send via CD, e-mail preferred as TIFF, EPS, JPEG, PDF files at 300 dpi.

Making Contact & Terms Arrange a personal interview to show portfolio. Send 8 × 10 glossy color or b&w prints by mail for consideration; include SASE for return of material. Previously published work OK. "Currently only using volunteer/pro bono freelance photographers but will consider all serious inquiries from local professionals." Credit line given.

Tips In portfolios, prefers to see gay/lesbian-related stories, human/civil rights, some "artsy" photos; no nudes or sexually explicit photos. "E-mail is always the best way to contact us." Uses photographers as interns (contact editor for details).

\$ MICHIGAN OUT-OF-DOORS

P.O. Box 30235, Lansing MI 48912. (517)346-1041. Fax: (517)371-1505. E-mail: magazine@mucc. org. Website: www.mucc.org. Circ. 80,000. Estab. 1947. Monthly magazine for people interested in "outdoor recreation, especially hunting and fishing; conservation; environmental affairs." Sample copy available for \$3.50; editorial guidelines free.

Needs Buys 6-12 photos from freelancers/issue; 72-144 photos/year. Needs photos of animals/ wildlife, nature, scenics, sports (hunting, fishing, backpacking, camping, cross-country skiing, other forms of noncompetitive outdoor recreation). Materials must have a Michigan slant. Photo captions preferred.

Making Contact & Terms Send any size glossy b&w prints; 35mm or 21/4 × 21/4 color transparencies; high-definition digital images. Include SASE for return of material. Responds in 1 month. Pays \$175 for cover; \$20 minimum for b&w inside; \$40 for color inside. Credit line given. Buys first North American serial rights.

Tips Submit seasonal material 6 months in advance. Wants to see "new approaches to subject matter."

■ A S MINNESOTA GOLFER

Minnesota Golf Association, 6550 York Ave. S., Suite 211, Edina MN 55435. (952)927-4643 or (800)642-4405. Fax: (952)927-9642. E-mail: editor@mngolf.org; wp@mngolf.org. Website: www. mngolf.org. Editor: W.P. Ryan. Bimonthly association magazine covering Minnesota golf scene. Sample copies available.

Needs Works on assignment only. Buys 25 photos from freelancers/issue; 150 photos/year. Photos of golf, golfers, and golf courses only. Will accept exceptional photography that tells a story or takes specific point of view. Reviews photos with or without manuscript. Model/property release required. Photo captions required; include date, location, names and hometowns of all subjects.

Specs Accepts images in digital format. Send via DVD or CD, e-mail as TIFF files.

Making Contact & Terms Send query letter with digital medium. Portfolios may be dropped off every Monday. Provide business card or self-promotion piece to be kept on file for possible future assignments. Responds only if interested; send nonreturnable samples. Pays on publication. Credit line given. Buys one-time rights. Will negotiate one-time or all rights, depending on needs of the magazine and the MGA.

Tips "We use beautiful golf course photography to promote the game and Minnesota courses to our readers. We expect all submissions to be technically correct in terms of lighting, exposure, and color. We are interested in photos that portray the game and golf courses in new, unexpected ways. For assignments, submit work with invoice and all expenses. For unsolicited work, please include contact, fee, and rights terms submitted with photos; include captions where necessary. Artist agreement available upon request."

M MOTHER JONES

222 Sutter St., Suite 600, San Francisco CA 94108. E-mail: mmurrmann@motherjones.com; query@ motherjones.com. Website: www.motherjones.com. Associate Photo Editor: Mark Murrmann. "Recognized worldwide for publishing groundbreaking work by some of the most talented photographers, Mother Jones is proud to include the likes of Antonin Kratochvil, Eugene Richards, Sebastião Salgado, Lana Šlezić, and Larry Sultan as past contributors. We remain committed to championing the best in photography and are always looking for exceptional photographers with a unique visual style. It's best to give us a URL for a portfolio website. For photoessays, describe the work that you've done or propose to do; and if possible, provide a link to view the project online. We will contact you if we are interested in seeing more work. Or you can mail non-returnable samples or disks to: Mark Murrmann."

Tips Please do not submit original artwork or any samples that will need to be returned. *Mother* Jones cannot be responsible for the return or loss of unsolicited artwork.

MOTORBOATING MAGAZINE

460 North Orlando Ave., Suite 200, Winter Park FL 32789. (407)628-4802. Fax: (407)628-7061. E-mail: editor@yachtingmagazine.com. Website: www.motorboating.com. Art Director: Emilie Whitcomb. Circ. 132,000. Estab. 1907. Monthly magazine addressing the interests of both sail and powerboat owners, with the emphasis on high-end vessels. Includes boating events, boatingrelated products, gear and how-to.

Making Contact & Terms Send query letter with tearsheets. Provide self-promotion piece to be kept on file for possible future assignments. Responds only if interested; send nonreturnable samples. Pays on publication. Buys first rights.

Tips "Read the magazine, and have a presentable portfolio."

■ ■ ISI MOTORING & LEISURE

CSMA Club, Britannia House, 21 Station St., Brighton BN1 4DF, United Kingdom. E-mail: sarah. harvey@csma.uk.com; magazine@csmaclub.co.uk. Website: www.csma.uk.com. Circ. 300,000. In-house magazine of CSMA (Civil Service Motoring Association). Published 10 times/year (double issue July/August and November/December). Covers car reviews, worldwide travel features, lifestyle and leisure, gardening. Sample copy available.

Needs Innovative photos of cars and motorbikes, old and new, to give greater choice than usual stock shots; motoring components (tires, steering wheels, windscreens); car manufacturer logos; UK traffic signs, road markings, general traffic, minor roads and motorways; worldwide travel images; UK villages, towns and cities; families on UK outdoor holidays; caravans, motor homes, camping, picnics sites. Reviews photos with or without manuscript. Photo captions preferred; include location.

Specs Prefers images in digital format. Send JPEG files via e-mail at 300 dpi where possible or 72 dpi at the largest possible image size. Maximum limit per e-mail is 8MB so may need to send images in separate e-mails or compress byte size in Photoshop. Most file formats (EPS, TIFF, PDF, PSD) accepted for PC use. Unable to open Mac files. TIFFs and very large files should be sent on a CD.

Making Contact & Terms Prefers to be contacted via e-mail. Simultaneous submissions and previously published work OK. Payment negotiated with individual photographers and image libraries. Credit line sometimes given if asked. Buys one-time rights.

\$\$ MOUNTAIN LIVING

1777 S. Harrison St., Suite 903, Denver CO 80210. (303)248-2052. Fax: (303)248-2064. E-mail: lshowell@mountainliving.com; hscott2@mountainliving.com. Website: www.mountainliving. com. Art Director: Loneta Showell. Publisher: Holly Scott. Circ. 45,000. Estab. 1994. Bimonthly magazine. Emphasizes shelter, lifestyle.

Needs Buys 10 photos from freelancers/issue; 120 photos/year. Photos of home interiors, architecture. Reviews photos with accompanying manuscript only. Model/property release required. Photo captions preferred.

Specs Prefers images in digital format. Send via CD as TIFF files at 300 dpi. Also uses 35mm, $2\frac{1}{4} \times 2\frac{1}{4}$, 4×5 transparencies.

Making Contact & Terms Submit portfolio for review. Send query letter with stock list. Provide résumé, business card, brochure, flier or tearsheets to be kept on file for possible future assignments. Responds in 6 weeks. Pays \$500-600/day; \$0-600 for color inside. Pays on acceptance. Credit line given. Buys one-time and first North American serial rights as well as rights to use photos on the Mountain Living website and in promotional materials; negotiable.

■ S \$ MUSHING.COM MAGAZINE

P.O. Box 1195, Willow AK 99688. (907)495-2468. E-mail: editor@mushing.com. Website: www. mushing.com. Managing Editor: Greg Sellentin. Circ. 6,000. Estab. 1987. Bimonthly magazine. Readers are dog drivers, mushing enthusiasts, dog lovers, outdoor specialists, innovators, and sled dog history lovers. Sample copy available for \$5 in U.S. Photo guidelines free with SASE or on website at: www.mushing.com/magazine/editorial.php.

Needs Uses 50 photos/issue; most supplied by freelancers. Needs action photos: all-season and wilderness; still and close-up photos: specific focus (sledding, carting, dog care, equipment, etc.). Special photo needs include skijoring, feeding, caring for dogs, summer carting or packing, 1- to 3-dog-sledding, and kids mushing. Model release preferred. Photo captions preferred.

Specs Accepts images in digital format. Send via CD, Zip, e-mail as JPEG files at 300 dpi.

Making Contact & Terms Send unsolicited photos by mail for consideration. Responds in 6 months. Pays \$175 maximum for color cover; \$15-40 for b&w inside; \$40-50 for color inside. Pays \$10 extra for 1 year of electronic use rights online. Pays within 60 days after publication. Credit line given. Buys first serial rights and second reprint rights.

Tips Wants to see work that shows "the total mushing adventure/lifestyle from environment to dog house." To break in, one's work must show "simplicity, balance and harmony. Strive for unique, provocative shots that lure readers and publishers. Send 10-40 images for review. Allow for 2-6 months' review time for at least a screened selection of these."

■ S S MUZZLE BLASTS

P.O. Box 67, Friendship IN 47021. (812)667-5131. Fax: (812)667-5136. E-mail: mblastdop@seidata. com. Website: www.nmlra.org. Director of Publications: Terri Trowbridge. Publication of the National Muzzle Loading Rifle Association. Monthly magazine emphasizing muzzleloading. Sample copy free. Photo guidelines free with SASE.

Needs Interested in muzzleloading, muzzleloading hunting, primitive camping. "Ours is a specialized association magazine. We buy some big-game wildlife photos but are more interested in photos featuring muzzleloaders, hunting, powder horns and accoutrements." Model/property release required. Photo captions preferred.

Specs Accepts images in digital format. Send via e-mail or on a CD in JPEG or TIFF format. Also accepts 3 × 5 color transparencies, quality color and b&w prints; sharply contrasting 35mm color slides are acceptable.

Making Contact & Terms Send query letter with stock list. Keeps samples on file; include SASE for return of material. Responds in 2 weeks. Simultaneous submissions OK. Pays \$300 for color cover; \$25-50 for b&w inside. Pays on publication. Credit line given. Buys one-time rights.

\$ A NA'AMAT WOMAN

350 5th Ave., Suite 4700, New York NY 10018. (212)563-5222. Fax: (212)563-5710. E-mail: judith@ naamat.org, Website: www.naamat.org, Editor: Judith A. Sokoloff. Quarterly organization magazine focusing on issues of concern to contemporary Jewish families and women. Sample copy free with SAE and \$2 first-class postage.

Needs Buys 5-10 photos from freelancers/issue; 50 photos/year. Photos of Jewish themes, Israel, women, babies/children/teens, families, parents, senior citizens, landscapes/scenics, architecture, religious, travel. Interested in documentary, fine art, historical/vintage, seasonal. Reviews photos with or without manuscript. Photo captions preferred.

Specs Uses color and b&w prints. Accepts images in digital format. Contact editor before

Making Contact & Terms Provide résumé, business card, self-promotion piece or tearsheets to be kept on file for possible future assignments. Art director will contact photographer for portfolio review if interested. Keeps samples on file; include SASE for return of material. Responds in 6 weeks. Pays \$250 maximum for cover; \$35-75 for inside. Pays on publication. Credit line given. Buys one-time, first rights.

NATIONAL GEOGRAPHIC

1145 17th St. NW, Washington DC 20036. Website: www.nationalgeographic.com. Deputy Director of Photography: Susan Smith. Director of Photography: David Griffin. Circ. 7 million. Monthly publication of the National Geographic Society.

• This is a premiere market that demands photographic excellence. National Geographic does not accept unsolicited work from freelance photographers. Photography internships and faculty fellowships are available. Contact Susan Smith, deputy director of photography, for application information.

S \$ NATIONAL PARKS MAGAZINE

National Parks Conservation Association, 1300 19th St. NW, Suite 300, Washington DC 20036. (800)628-7275. E-mail: srutherford@npca.org; nyin@npca.org. Website: www.npca.org/magazine. Communications Coordinator: Nicole Yin. Circ. 300,000. Estab. 1919. Quarterly magazine. Emphasizes the preservation of national parks and wildlife. Sample copy available for \$3 and 8½ × 11 or larger SASE. Photo guidelines available on website.

Specs Photographers who are new to National Parks may ONLY submit digitally for an initial review—we prefer links to clean, easily-navigable and searchable websites, or lightboxes with well-captioned images. We DO NOT accept and are not responsible for unsolicited slides, prints, or CDs.

Making Contact & Terms The best way to break in is to send a brief, concise e-mail message to Sarah Rutherford. See guidelines online. Less than 1 percent of our image needs are generated from unsolicited photographs, yet we receive dozens of submissions every week. Photographers are welcome to send postcards or other simple promotional materials that we do not have to return or respond to." Photographers who are regular contributors may submit images in the following forms: digitally, via CD, DVD, or e-mail (as in attachments or a link to a lightbox or FTP site) physically, as slides or prints, via courier mail. Pays within 30 days after publication. Buys onetime rights.

Tips "When searching for photos, we frequently use www.agpix.com to find photographers who fit our needs. If you're interested in breaking into the magazine, we suggest setting up a profile and posting your absolute best parks images there."

\$ ATIVE PEOPLES MAGAZINE

5333 N. 7th St., Suite C-224, Phoenix AZ 85014. (602)265-4855. Fax: (602)265-3113. E-mail: kcoochwytewa@nativepeoples.com. Website: www.nativepeoples.com. Art Director: Kevin Coochwytewa. Bimonthly magazine. "Dedicated to the sensitive portrayal of the arts and lifeways of the Native peoples of the Americas." Photo guidelines free with SASE or on website.

Needs Buys 20-50 photos from freelancers/issue; 120-300 photos/year. Native American lifeways photos (babies/children/teens, celebrities, couples, multicultural, families, parents, senior citizens, events). Also uses photos of entertainment, performing arts, travel. Interested in fine art. Model/ property release preferred. Photo captions preferred; include names, location and circumstances. Uses transparencies, all formats. Accepts images in digital format. Send via CD, Zip, e-mail as TIFF, JPEG, EPS files at 300 dpi.

Making Contact & Terms Submit portfolio for review. Send unsolicited photos by mail for consideration; include SASE for return of material. Responds in 1 month. Pays \$250 for color cover; \$45-150 for color or b&w inside. Pays on publication. Buys one-time rights.

Tips "Send samples, or, if in the area, arrange a visit with the editors."

■ S S NATURE FRIEND

4253 Woodcock Lane, Dayton VA 22821. (540)867-0764. E-mail: photos@naturefriendmagazine. com. Website: www.naturefriendmagazine.com. Editor: Kevin Shank. Monthly children's magazine. Sample copy available for \$5 plus \$2 first-class postage.

Needs Buys 5-10 photos from freelancers/issue; 100 photos/year. Photos of wildlife, wildlife interacting with each other, humorous wildlife, all natural habitat appearance. Reviews photos with or without manuscript. Model/property release preferred. Photo captions preferred.

Specs Prefers images in digital format. Send via CD or DVD as TIFF files at 300 dpi at 8 × 10 size; provide color thumbnails when submitting photos. "Transparencies are handled and stored carefully; however, we do not accept liability for them so discourage submissions of them."

Making Contact & Terms Responds in 1 month to queries; 2 weeks to portfolios. "Label contact prints and digital media with your name, address, and phone number so we can easily know how to contact you if we select your photo for use." "Please send articles rather than queries. We try to respond within 4-6 months." Simultaneous submissions and previously published work OK. Pays \$75 for front cover; \$50 for back cover; \$15-25 for inside photos. Pays on publication. Credit line given. Buys one-time rights.

Tips "We're always looking for photos of wild animals doing something unusual or humorous. Please label every sheet of paper or digital media with name, address and phone number. We may need to contact you on short notice, and you do not want to miss a sale. Also, photos are selected on a monthly basis, after the articles. What this means to a photographer is that photos are secondary to writings and cannot be selected far in advance. High-resolution photos in our files the day we are making selections will stand the greatest chance of being published."

\$ NEW MEXICO MAGAZINE

495 Old Santa Fe Trail, Santa Fe NM 87501. (505)827-7447. Fax: (505)827-6496. E-mail: artdirector@ nmmagazine.com. Website: www.nmmagazine.com. Art Director: Ms. Fabian West. Monthly magazine for affluent people ages 35-65 interested in the Southwest or who have lived in or visited New Mexico. Sample copy available for \$4.95 with 9 × 12 SAE and 3 first-class stamps. Photo guidelines available on website.

Needs Buys 10 photos from freelancers/issue; 120 photos/year. Needs New Mexico photos only landscapes, people, events, architecture, etc. Model release preferred.

Specs Uses 300 dpi digital files with contact sheets (8-12 per page). Photographers must be in photodata. Photo captions required; include who, what, where.

Making Contact & Terms Submit portfolio; include SASE for return of material, or e-mail with web gallery link. Pays \$450/day; \$300 for color or b&w cover; \$60-100 for color or b&w stock. Pays on publication. Credit line given. Buys one-time rights.

Tips "New Mexico Magazine is the official magazine for the state of New Mexico. Photographers should know New Mexico. We are interested in the less common stock of the state. The magazine is editorial driven, and all photos directly relate to a story in the magazine." Cover photos usually relate to the main feature in the magazine.

NEWSWEEK

395 Hudson St., New York NY 10014. (212)445-4000. E-mail: Editors@newsweek.com. Website: www.newsweek.com. Circ. 3,180,000. Newsweek reports the week's developments on the newsfront of the world and the nation through news, commentary and analysis. News is divided into National Affairs; International; Business; Society; Science & Technology; and Arts & Entertainment. Relevant visuals, including photos, accompany most of the articles. Query before submitting.

\$ NORTH AMERICAN WHITETAIL MAGAZINE

2250 Newmarket Pkwy., Suite 110, Marietta GA 3006. (678)-589-2000. Fax: (678) 279-7512. E-mail: ron.sinfelt@imoutdoors.com. Website: www.northamericanwhitetail.com. Photo Editor: Ron Sinfelt. Estab. 1982. Circ. 125,000. Published 7 times/year (July-February) by InterMedia Outdoors. Emphasizes trophy whitetail deer hunting. Sample copy available for \$4. Photo guidelines free with

Needs Buys 5 photos from freelancers/issue; 35 photos/year. Needs photos of large, live whitetail deer, hunter posing with or approaching downed trophy deer, or hunter posing with mounted head. Also uses photos of deer habitats and signs. Model release preferred. Photo captions preferred; include when and where scene was photographed.

Specs Accepts images in digital format. Send via CD at 300 dpi with output of 8 × 12. Also uses 35mm transparencies.

Making Contact & Terms Send query letter with résumé of credits and list of stock photo subjects. Will return unsolicited material in 1 month if accompanied by SASE. Simultaneous submissions not accepted. Pays \$400 for color cover; \$75 for color inside. Tearsheets provided. Pays 60 days prior to publication. Credit line given. Buys one-time rights.

Tips "In samples we look for extremely sharp, well-composed photos of whitetailed deer in natural settings. We also use photos depicting deer hunting scenes. Please study the photos we are using before making submission. We'll return photos we don't expect to use and hold the remainder for potential use. Please do not send dupes. Use an 8 × 10 envelope to ensure sharpness of images, and put name and identifying number on all slides and prints. Photos returned at time of publication or at photographer's request."

\$ NORTH CAROLINA LITERARY REVIEW

East Carolina University, 555 English, Greenville NC 27858-4353. (252)328-1537. Fax: (252)328-4889. E-mail: rodman@ecu.edu. Website: www.nclr.ecu.edu. Art Acquisitions Editor: Diane Rodman. Annual literary magazine with North Carolina focus. NCLR publishes poetry, fiction and nonfiction by and interviews with NC writers, and articles and essays about NC literature, literary history and culture. Photographs must be NC-related. Sample copy available for \$15. Photo guidelines available on website.

Needs Buys 3-6 photos from freelancers/issue. Model/property release preferred. Photo captions preferred.

Specs Accepts images in digital format, 5X7 at 300 dpi. Inquire first; request, submit TIFF, GIF files at 300 dpi to nclrsubmissions@ecu.edu.

Making Contact & Terms Send query letter with website address to show sample of work. If selected, art acquisitions editor will be in touch. Pays \$50-250 for cover; \$5-100 for b&w inside. Pays on publication. Credit line given. Buys first rights.

Tips "Only NC photographers. Look at our publication—1998-present back issues. See our website."

S NORTHERN WOODLANDS

1776 Center Rd., P.O. Box 471, Corinth VT 05039-9900. (802)439-6292; (800)290-5232. Fax: (802)439-6296. E-mail: dave@northernwoodlands.org. Website: www.northernwoodlands.org. Quarterly consumer magazine "created to inspire landowners' sense of stewardship by increasing their awareness of the natural history and the principles of conservation and forestry that are directly related to their land; to encourage loggers, foresters, and purchasers of raw materials to continually raise the standards by which they utilize the forest's resources; to increase the public's awareness and appreciation of the social, economic, and environmental benefits of a working forest; to raise the level of discussion about environmental and natural resource issues; and to educate a new generation of forest stewards." Sample copies available for \$5. Photo guidelines available on website.

Needs Buys 10-50 photos from freelancers/year. Photos of forestry, environmental, landscapes/ scenics, wildlife, rural, adventure, travel, agriculture, science. Interested in historical/vintage, seasonal. Other specific photo needs: vertical format, photos specific to assignments in northern New England and upstate New York. Reviews photos with or without a manuscript. Model release preferred. Photo captions required.

Specs Uses glossy or matte color and b&w prints; 35mm, 21/4 × 21/4 transparencies. Prefers images in digital format. Send via CD, Zip, e-mail as TIFF, EPS files at 300 dpi minimum. No e-mails larger than 10MB.

Making Contact & Terms Send cover photo submissions as either slides or digital photos. Digital photos (less than 1MB each) can be e-mailed. "We can read JPEG, PDF, or TIFF files. If yours is chosen, we will request a higher-resolution image. You may also mail us a CD of your images Provide self-promotion piece to be kept on file for possible future assignments. Responds only if interested; send nonreturnable samples. Previously published work OK. Pays \$150 for color cover; \$25-75 for b&w inside. "We might pay upon receipt or as late as publication." Credit line given. Buys one-time rights. "We will hold your photos until publication of the magazine for which they are being considered, unless you ask otherwise. All materials will be returned by certified mail." **Tips** "Read our magazine or go to our website for samples of the current issue. We're always looking for high-quality cover photos on a seasonal theme. Vertical format for covers is essential. Also, note that our title goes up top, so photos with some blank space up top are best. Please remember that not all good photographs make good covers—we like to have a subject, lots of color, and we don't mind people. Anything covering the woods and people of Vermont, New Hampshire, Maine, northern Massachusetts or northern New York is great. Unusual subjects, and ones we haven't run before (we've run lots of birds, moose, large mammals, and horse-loggers), get our attention. For inside photos we already have stories and are usually looking for regional

to Attn: Cover Photos. Send query letter with slides. We have an online e-mail form available."

\$ NORTHWEST TRAVEL MAGAZINE

photographers willing to shoot a subject theme."

4969 Hwy. 101, Suite 2, Florence OR 97439. (800)348-8401. Fax: (541)997-1124. E-mail: barb@ ohwy.com; Rosemary@nwmags.com. Website: www.northwestmagazines.com. Editor: Rosemary Camozzi. Estab. 1991. Bimonthly consumer magazine emphasizing travel in Oregon, Washington, Idaho, western Montana, and British Columbia, Canada. Sample copy available for \$6. Photo guidelines free with SASE or on website.

Needs Buys 3-5 photos from freelancers/issue; 18-30 photos/year. Wants seasonal scenics. Model release required. Photo captions required; include specific location and description. "Now only accepting digital images. Please include metadata."

Specs Uses 35mm, $2\frac{1}{4} \times 2\frac{1}{4}$, 4×5 positive transparencies. "Do not e-mail images." We recommend acquiring model releases for any photos that include people, but we don't require releases except for photos used on covers or in advertising. Photos must be current, shot within the last five years. Digital photos must be sent on CDs as high resolution (300 dpi) TIFF, JPEG, or EPS files without compression. Images should be $8\frac{1}{2} \times 11\frac{1}{2}$. Include clear, color contact sheets of all images (no more than 8 per page). CDs are not returned. To be considered for calendars, photos must have horizontal formats.

Making Contact & Terms The annual deadline for calendars is August 15. Responds in 1 month. Pays \$425 for color cover; \$100 for calendar usage; \$25-50 for b&w inside; \$25-100 for color inside; \$100-250 for photo/text package. Credit line given. Buys one-time rights. Note: "We do not sign for personal delivery." SASE or return postage required.

Tips "Send slide film that can be enlarged without graininess (50-100 ASA). We don't use color filters. Send 20-40 slides. Protect slides with sleeves put in plastic holders. Don't send in little boxes. We work about 3 months ahead, so send spring images in winter, summer images in spring, etc."

■ A S \$\$ NOTRE DAME MAGAZINE

University of Notre Dame, 538 Grace Hall, Notre Dame IN 46556-5612. E-mail: ndmag@nd.edu. Website: magazine.nd.edu. **Contact:** Art Director. Est. 1972. Circ. 150,000. "We are a university magazine with a scope as broad as that found at a university, but we place our discussion in a moral, ethical, and spiritual context reflecting our Catholic heritage."

Needs 50% freelance written. People, cities, education, architecture, business, science, environmental and landscapes. Model and property releases are required. Photo captions are required.

Making Contact & Terms E-mail (JPEG samples at 72 dpi) or send a postcard sample.

N ■ \$ Ø NOW & THEN

Box 70556 ETSU, 807 University Pkwy., Johnson City TN 37614-1707. (423)439-5348. Fax: (423)439-6340. E-mail: wardenc@etsu.edu. Website: www.etsu.edu/cass. Photo Editor: Charlie Warden. Estab. 1984. Literary magazine published twice/year. Now & Then tells the story of Appalachia, the mountain region that extends from northern Mississippi to southern New York state. The magazine presents a fresh, revealing picture of life in Appalachia, past and present, with engaging articles, personal essays, fiction, poetry and photography. Sample copy available for \$8 plus \$2 shipping. Photo guidelines free with SASE or visit website.

Needs Photos of environmental, landscapes/scenics, architecture, cities/urban, rural, adventure, performing arts, travel, agriculture, political, disasters. Interested in documentary, fine art, historical/vintage. Photographs must relate to theme of issue. Themes are posted on the website or available with guidelines. "We publish photo essays based on the magazine's theme." Reviews photos with or without a manuscript. Model/property release preferred. Photo captions preferred; include where the photo was taken, identify places/people.

Specs Require images in digital format sent as e-mail attachments as JPEG or TIFF files at 300 dpi

Making Contact & Terms Send query letter with résumé, photocopies. Provide self-promotion piece to be kept on file for possible future assignments. Responds only if interested; send nonreturnable samples. Simultaneous submissions OK. Pays \$100 maximum for color cover; \$25 maximum for b&w inside. Pays on publication. Credit line given. Buys one-time rights; negotiable.

Tips "Know what our upcoming themes are. Keep in mind we cover only the Appalachian region. (See the website for a definition of the region)."

■ S \$\$ OCEAN MAGAZINE

P.O. Box 84, Rodanthe NC 27968-0084. (252)256-2296. E-mail: Diane@oceanmagazine.org. Website: www.oceanmagazine.org. Publisher: Diane Buccheri. Estab. 2004. Circ. 40,000. 100% Freelance written. "OCEAN Magazine serves to celebrate and protect the greatest, most comprehensive resource for life on earth, our world's ocean. OCEAN publishes articles, stories, poems, essays, and photography about the ocean-observations, experiences, scientific and environmental discussions—written with fact and feeling, illustrated with images from nature."

Needs People, disasters, environmental, adventure, landscape, wildlife, pets, documentary, sports, travel, fine art, lifestyle and seasonal photographs. Identification of subjects, model releases required. Reviews 3×5 , 4×6 , 5×7 , 8×10 , 10×12 prints, JPEG files. Negotiates payment individually. Buys one-time rights.

Making Contact & Terms E-mail with photographs and samples. Samples kept on file. Portfolio not required.

Tips "Purchase an issue to see what *OCEAN* is all about."

\$\$ Ø OKLAHOMA TODAY

120 N. Robinson, Suite 600, Oklahoma City OK 73102. (405)230-8450. E-mail: liz@oklahomatoday. com. Website: www.oklahomatoday.com. Assistant Editor: Liz Blood. Bimonthly magazine. "We cover all aspects of Oklahoma, from history to people profiles, but we emphasize travel." Readers are "Oklahomans, whether they live in-state or are exiles; studies show them to be above average in education and income." Sample copy available for \$4.95. Photo guidelines free with SASE or on website.

Needs Buys 45 photos from freelancers/issue; 270 photos/year. Needs photos of "Oklahoma subjects only; the greatest number are used to illustrate a specific story on a person, place or thing in the state. We are also interested in stock scenics of the state." Other areas of focus are adventure-sport/travel, reenactment, historical and cultural activities. Model release required. Photo captions required.

Specs Uses 8 × 10 glossy b&w prints; 35mm, 21/4 × 21/4, 4 × 5, 8 × 10 transparencies. Accepts images in digital format. Send via CD or e-mail.

Making Contact & Terms Send query letter with samples; include SASE for return of material. Responds in 2 months. Simultaneous submissions and previously published work OK (on occasion). Pays \$50-150 for b&w photos; \$50-250 for color photos; \$125-1,000/job. Pays on publication. Buys one time rights with a 4-month from publication exclusive, plus right to reproduce photo in promotions for magazine without additional payment with credit line.

Tips To break in, "read the magazine. Subjects are normally activities or scenics (mostly the latter). I would like good composition and very good lighting. I look for photographs that evoke a sense of place, look extraordinary and say something only a good photographer could say about the image. Look at what Ansel Adams and Eliot Porter did and what Muench and others are producing, and send me that kind of quality. We want the best photographs available, and we give them the space and play such quality warrants."

ONBOARD MEDIA

1691 Michigan Ave., Ste. 600, Miami Beach FL 33139-2563. (305)673-0400. Fax: (305)674-9396. E-mail: beth@onboard.com; sirena@onboard.com. Website: www.onboard.com. Co-Art Directors: Beth Wood and Sirena Andras. 90 annual and quarterly publications. Emphasize travel in the Caribbean, Europe, Mexican Riviera, Bahamas, Alaska, Bermuda, Las Vegas. Custom publications reach cruise vacationers and vacation/resort audience. Photo guidelines free with SASE.

Needs Photos of scenics, nature, prominent landmarks based in Caribbean, Mexican Riviera, Bahamas, Alaska, Europe and Las Vegas. Model/property release required. Photo captions required; include where the photo was taken and explain the subject matter. Credit line information requested.

Specs Uses 35mm, $2\frac{1}{4} \times 2\frac{1}{4}$, 4×5 , 8×10 transparencies. Prefers images in digital format RAW data. Send via CD at 300 dpi.

Making Contact & Terms Send query letter with stock list. Provide résumé, business card, brochure, flier or tearsheets to be kept on file for possible future assignments. Keeps samples on file. Responds in 3 weeks. Previously published work OK. Rates negotiable per project. Pays on publication. Credit line given.

\$ ONE

1011 1st Ave., New York NY 10022-4195. (212)826-1480. Fax: (212)838-1344. E-mail: cnewa@cnewa. org, Website: www.cnewa.org, Circ. 90,000. Bimonthly magazine. Official publication of Catholic Near East Welfare Association, "a papal agency for humanitarian and pastoral support." ONE informs Americans about the traditions, faiths, cultures and religious communities of the Middle East, Northeast Africa, India and Eastern Europe. Sample copy and photo guidelines available for 81/2 × 11 SASE.

Needs Freelancers supply 80% of photos. Prefers to work with writer/photographer team. Looking for evocative photos of people-not posed-involved in activities: work, play, worship. Liturgical shots also welcome. Extensive captions required if text is not available.

Making Contact & Terms Send query letter first. "Please do not send an inventory; rather, send a letter explaining your ideas." Include 81/2 × 11 SASE. Responds in 3 weeks; acknowledges receipt of material immediately. Simultaneous submissions and previously published work OK, "but neither is preferred. If previously published, please tell us when and where." Pays \$75-100 for b&w cover; \$150-200 for color cover; \$50-100 for b&w inside; \$75-175 for color inside. Pays on publication. Credit line given. "Credits appear on page 3 with masthead and table of contents." Buys first North American serial rights.

Tips "Stories should weave current lifestyles with issues and needs. Avoid political subjects; stick with ordinary people. Photo essays are welcome. Write requesting sample issue and guidelines, then send query. We rarely use stock photos but have used articles and photos submitted by single photojournalist or writer/photographer team."

\$ OREGON COAST MAGAZINE

4969 Highway 101, Suite 2, Florence OR 97439. (800)348-8401. Fax: (541)997-1124. E-mail: barb@ ohwy.com; Rosemary@nwmags.com. Website: www.northwestmagazines.com. Editor: Rosemary Camozzi. Estab. 1982. Bimonthly magazine. Emphasizes Oregon coast life. Sample copy available for \$6, including postage. Photo guidelines available with SASE or on website.

Needs Buys 3-5 photos from freelancers/issue; 18-30 photos/year. Needs scenics. Especially needs photos of typical subjects—waves, beaches, lighthouses—with a fresh perspective. Needs mostly vertical format. Model release required. Photo captions required; include specific location and description. "Now only accepting digital images."

Specs We recommend acquiring model releases for any photos that include people, but we don't require releases except for photos used on covers or in advertising. Photos must be current, shot within the last five years. Digital photos must be sent on CDs as high resolution (300 dpi) TIFF, JPEG, or EPS files without compression. Images should be 8½ × 11. Include clear, color contact sheets of all images (no more than 8 per page). CDs are not returned. To be considered for calendars, photos must have horizontal formats.

Making Contact & Terms The annual deadline for Calendars is August 15. Responds in 3 months. Pays \$425 for color cover; \$100 for calendar usage; \$25-50 for b&w inside; \$25-100 for color inside; \$100-250 for photo/text package. Credit line given. Buys one-time rights. "Note: We do not sign for personal delivery." SASE or return postage required.

Tips "Send only the very best. Use only slide film that can be enlarged without graininess. Don't use color filters. An appropriate submission would be 20-40 slides. Protect slides with sleeves—put in plastic holders. Don't send in little boxes."

N ■ \$\$ OUTDOOR AMERICA

707 Conservation Ln., Gaithersburg MD 20878. (301)548-0150. E-mail: info@iwla.org. Website: www.iwla.org/oa. Circ. 36,000. Estab. 1922. Published quarterly. Covers conservation topics, from clean air and water to public lands, fisheries and wildlife. Also focuses on outdoor recreation issues and covers conservation-related accomplishments of the League's membership.

Needs Vertical wildlife photos or shots of campers, boaters, anglers, hunters and other traditional outdoor recreationists for cover. Reviews photos with or without a manuscript. Model release required. Photo captions preferred; include date taken, model info, location and species.

Specs Uses 35mm, 6 × 9 transparencies or negatives. Accepts images in digital format. Send via CD, Zip, e-mail as TIFF, EPS, JPEG files at 300 dpi.

Making Contact & Terms "Tearsheets and nonreturnable samples only. Not responsible for return of unsolicited material." Simultaneous submissions and previously published work OK. Pays on acceptance. Credit line given. Buys one-time rights and occasionally web rights.

Tips "We prefer the unusual shot—new perspectives on familiar objects or subjects. We occasionally assign work. Approximately one half of the magazine's photos are from freelance sources."

🖾 🗏 \$\$ 🗵 OUTDOOR CANADA MAGAZINE

25 Sheppard Ave. W., Suite 100, Toronto ON M2N 6S7 Canada. (416)218-3697. Fax: (416)227-8296. E-mail: editorial@outdoorcanada.ca; scheung@outdoorcanada.ca. Website: www.outdoorcanada. ca. Associate Art Director: Sandra Cheung. Art Director: Robert Biron. Circ. 100,000. Estab. 1972. Magazine published 8 times/year." Photographers interested in sending originals should send a small portfolio of 100 (or less) well-edited images. Naturally, we would expect photographers to send images that are in line with the magazine's content (i.e. fishing, hunting, conservation). Label each frame with your name, and provide details such as species of fish or shot location. We usually do not purchase images in advance, but will solicit images from your library when packaging stories or features. We'll return them by Express Post as soon as we can after viewing. We also are happy to accept electronic submissions via e-mail." Photo guidelines free with SASE (or SAE and IRC), via e-mail or on website.

Needs Buys 200-300 photos/year. Needs photos of wildlife; fishing, hunting, ice-fishing; action shots. "Canadian content only." Photo captions required; include identification of fish, bird or animal.

Specs Accepts images in digital format.

Making Contact & Terms "Send a well-edited selection of transparencies with return postage for consideration, E-mail/CD portfolios also accepted." Responds in 1 month. Pays \$500 for cover; \$400 for the special double-page feature image called "Scene," down to \$75 for 1/8 page (all payable in Canadian funds). Pays on invoice. Buys one-time rights.

\$\$ OUTDOOR LIFE MAGAZINE

2 Park Ave., 10th Fl., New York NY 10016. E-mail: olphotos@bonniercorp.com; cherie.cincilla@ time4.com. Website: www.outdoorlife.com. Photo Editor: Cherie Cincilla. Circ. 750,000. Monthly. Emphasizes hunting, fishing and shooting. Readers are "outdoor enthusiasts of all ages." Sample copy "not for individual requests." Photo guidelines available for SASE.

Needs Buys 100 photos from freelancers/issue; 1,000-2,000 photos/year. Needs photos of "all species of wildlife and game fish, especially in action and in natural habitat; how-to and where-to." Interested in historical/vintage hunting and fishing photos. Photo captions preferred.

Specs Prefers 35mm slides. Accepts images in digital format. Send via CD, e-mail as JPEG files at 100 dpi, 3 × 5 size.

Making Contact & Terms Send 35mm or 23/4 × 23/4 transparencies by certified mail with SASE for consideration. Prefers dupes. Responds in 1 month. Pays \$1,000 minimum for color cover; \$100-850 for color inside. Rates are negotiable. Pays on publication. Credit line given. Buys one-time

Tips "Print name and address clearly on each photo to ensure return; send in 8 × 10 plastic sleeves. Multiple subjects encouraged. E-mail examples and list of specific animal species and habitats. All of our images are hunting and fishing related. We are about adventure (hunting & fishing!) and 'how-to!' Query first with SASE; will not accept, view or hold artist's work without first receiving a signed copy of our waiver of liability."

☑ ■ ② OWL MAGAZINE

10 Lower Spadina Ave., Suite 400, Toronto ON M5V 2Z2, Canada. (416)340-2700. Fax: (416)340-9769. E-mail: melissa.kilpatrick@owlkids.com; owl@owlkids.com. Photo Editor: Debbie Yea. Circ. 80,000. Estab. 1976. Published 10 times/year. A discovery magazine for children ages 9-13. Sample copy available for \$4.95 and 9 × 12 SAE with \$1.50 money order for postage. Photo guidelines free with SAE or via e-mail.

Needs Photo stories, photo puzzles, photos of children ages 12-14, extreme weather, wildlife, science, technology, environmental, pop culture, multicultural, events, adventure, hobbies, humor, sports, extreme sports. Interested in documentary, seasonal. Model/property release required. Photo captions required. Will buy story packages.

Specs Accepts images in digital format. E-mail as JPEG files at 72 dpi. "For publication, we require 300 dpi."

Making Contact & Terms Accepts no responsibility for unsolicited material. Previously published work OK. Credit line given. Buys one-time rights.

Tips "Photos should be sharply focused with good lighting, and engaging for kids. We are always on the lookout for humorous, action-packed shots; eye-catching, sports, animals, bloopers, etc. Photos with a 'wow' impact."

S\$ OXYGEN

400 Matheson Blvd W, Mississauga ON L5R 3M1, Canada. (905)507-3545. Fax: (905)507-2372. Website: www.oxygenmag.com. Publisher: Robert Kennedy. Circ. 250,000. Estab. 1997. Monthly magazine. Emphasizes exercise and nutrition for women. Readers are women ages 20-39. Sample copy available for \$5.

Needs Buys 720 photos from freelancers/issue. Needs photos of women weight training and exercising aerobically. Model release required. Photo captions preferred; include names of subjects.

Specs Accepts high-res digital images. Uses 35mm, $2\frac{1}{4} \times 2\frac{1}{4}$ transparencies. Prints occasionally acceptable.

Making Contact & Terms Send unsolicited photos by mail for consideration. Does not keep samples on file; include SASE for return of material. Responds in 3 weeks. Pays \$200-400/hour; \$800-1,500/day; \$500-1,500/job; \$500-2,000 for color cover; \$50-100 for color or b&w inside. Pays on acceptance. Credit line given. Buys all rights.

Tips "We are looking for attractive, fit women working out on step machines, joggers, rowers, treadmills, ellipticals; with free weights; running for fitness; jumping, climbing. Professional pictures only, please. We particularly welcome photos of female celebrities who are into fitness; higher payments are made for these."

■ \$ ■ PACIFIC YACHTING MAGAZINE

200 W. Esplanade, Suite 500, North Vancouver BC V7M 1A4, Canada. (604)998-3310. E-mail: editorial@pacificyachting.com. Website: www.pacificyachting.com. Editor: Dan Miller. Monthly magazine. Emphasizes boating on West Coast. Readers are ages 35-60; boaters, power and sail. Sample copy available for \$6.95 Canadian plus postage.

Needs Buys 75 photos from freelancers/issue; 900 photos/year. Photos of landscapes/scenics, adventure, sports. Interested in historical/vintage, seasonal. "All should be boating related." Reviews photos with accompanying manuscript only. "Always looking for covers; must be shot in British Columbia."

Making Contact & Terms Keeps samples on file. Simultaneous submissions and previously published work OK. Pays \$400 Canadian for color cover. Payment negotiable. Credit line given. Buys one-time rights.

\$ PADDLER MAGAZINE

6409 132nd Ave. NE, Kirkland WA 98033. (425)814-4140. Fax: (425)814-4042. E-mail: editor@ paddlermagazine.com. Website: www.paddlermagazine.com. Art Director: Jason Mohr. Bimonthly magazine. Emphasizes kayaking, rafting, canoeing and sea kayaking. Sample copy available for \$3.50. Photo guidelines free with SASE.

Needs Buys 27-45 photos from freelancers/issue; 162-270 photos/year. Needs photos of scenics and action. Model/property release preferred. Photo captions preferred; include location.

Specs Prefers images in digital format. Send via CD, Zip, e-mail as TIFF, EPS, JPEG files at 300 dpi. Digital submissions should be accompanied by a printed proof sheet. Also accepts 35mm transparencies.

Making Contact & Terms Send query letter with stock list. Send unsolicited photos by mail with SASE for consideration. Keeps samples on file. Responds in 2 months. Buys first North American serial rights; negotiable.

Tips "Send innovative photos of canoeing, kayaking and rafting, and let us keep them on file." See contributor guidelines online at: http://paddlermagazine.com/contributor-guidelines.html or send for them at: Paddlesport Publishing, Inc., 12040 98th Ave. NE, Suite 205, Kirkland WA 98033.

PAKN TREGER

National Yiddish Book Center, 1021 West St., Amherst MA 01002. E-mail: bwolfson@bikher. org. Website: www.yiddishbookcenter.org. Designer: Betsey Wolfson. Circ. 30,000. Estab. 1980. Literary magazine published 3 times/year; focuses on modern and contemporary Jewish and Yiddish culture.

Needs Needs photos of families, parents, senior citizens, education, religious, humor, historical/ vintage, Jewish and Yiddish culture. Reviews photos with or without a manuscript. Captions required; include identification of subjects.

Specs Accepts images in digital format. Send JPEG or GIF files.

Making Contact & Terms Negotiates payment. **Pays on publication.** Credit line given. Buys one-time rights.

\$ PENNSYLVANIA GAME NEWS

2001 Elmerton Ave., Harrisburg PA 17110-9797. (717)787-3745. E-mail: jkosack@state.pa.us. Website: www.pgc.state.pa.us. **Editor:** Joe Kosack. Monthly magazine published by the Pennsylvania Game Commission. Readers are people interested in hunting, wildlife management and conservation in Pennsylvania. Sample copy available for 9 × 12 SASE. Editorial guidelines free.

Needs Considers photos of "any outdoor subject (Pennsylvania locale), except fishing and boating." Reviews photos with accompanying manuscript. Manuscript not required.

Making Contact & Terms The agency expects all photos to be accompanied with a photo credit (e.g. Jake Dingel/PGC Photo). E-mail Joe Kosack with questions about images, the agency's image policy. Send prints or slides. "No negatives, please." Include SASE for return of material. Will accept electronic images via CD only (no e-mail). Will also view photographer's website if available. Responds in 2 months. Pays \$40-300. **Pays on acceptance.**

\$ PENNSYLVANIA MAGAZINE

P.O. Box 755, Camp Hill PA 17011. (717)697-4660. E-mail: pamag@aol.com. Website: www.pamag.com. **Editor:** Matthew K. Holliday. Circ. 30,000. Bimonthly. Emphasizes history, travel and contemporary topics. Readers are 40-70 years old, professional and retired. Samples available upon request. Photo guidelines free with SASE or via e-mail.

Needs Uses about 40 photos/issue; most supplied by freelancers. Needs include travel, wildlife and scenic. All photos must be taken in Pennsylvania. Reviews photos with or without accompanying manuscript. Photo captions required.

Making Contact & Terms Send query letter with samples. Send digital submissions of 5.0 MP or higher (OK on CD with accompanying printout with image file references); 5 × 7 and larger color prints; 35mm and 2½ × 2½ transparencies (duplicates only, in camera or otherwise, no originals) by mail for consideration; include SASE for return of material. Responds in 1 month. Simultaneous submissions and previously published work OK with notification. Pays \$100-150 for color cover; \$35 for color inside; \$50-500 for text/photo package. Credit line given. Buys one-time, first rights or other rights as arranged.

Tips Look at several past issues and review guidelines before submitting.

\$\$ @ PERSIMMON HILL MAGAZINE

1700 NE 63rd St., Oklahoma City OK 73111. (405)478-6404. Fax: (405)478-4714. E-mail: editor@ nationalcowboymuseum.org. Website: www.nationalcowboymuseum.org. Editor: Judy Hilovsky. Quarterly publication of the National Cowboy and Western Heritage Museum. Emphasizes the West, both historical and contemporary views. Has diverse international audience with an interest in preservation of the West. Sample copy available for \$10.50 and 9×12 SAE with 10 first-class stamps. Photo guidelines free with SASE or on website.

 This magazine has received Outstanding Publication honors from the Oklahoma Museums Association, the International Association of Business Communicators, Ad Club and Public Relations Society of America.

Needs Buys 65 photos from freelancers/issue; 260 photos/year. "Photos must pertain to specific articles unless it is a photo essay on the West." Western subjects include celebrities, couples, families, landscapes, wildlife, architecture, interiors/decorating, rural, adventure, entertainment, events, hobbies, travel. Interested in documentary, fine art, historical/vintage, seasonal. Model release required for children's photos. Photo captions required; include location, names of people, action. Proper credit is required if photos are historic.

Specs Accepts images in digital format. Send via CD.

Making Contact & Terms Submit portfolio for review by mail, directly to the editor, or with a personal visit to the editor. Responds in 6 weeks. Pays \$150-500 for color cover; \$100-150 for b&w cover; \$50-150 for color inside; \$25-100 for b&w inside. Credit line given. Buys first North American serial rights.

Tips "Make certain your photographs are high quality and have a story to tell. We are using more contemporary portraits of things that are currently happening in the West and using fewer historical photographs. Work must be high quality, original, innovative. Photographers can best present their work in a portfolio format and should keep in mind that we like to feature photo essays on the West in each issue. Study the magazine to understand its purpose. Show only the work that would be beneficial to us or pertain to the traditional Western subjects we cover."

S \$ PHI DELTA KAPPAN

408 N. Union St., P.O. Box 789, Bloomington IN 47402. E-mail: kappan@pdkintl.org; cbucheri@ pdkintl.org. Website: www.kappanmagazine.org. Contact: Design Director. Produces Kappan magazine and supporting materials. "If you have something that would enhance an article you are submitting, please indicate that when you submit your manuscript. If your manuscript is selected for publication, we will contact you and provide directions for transmitting that material to us." Photos used in magazine, fliers and subscription cards. Photo guidelines available online at: www. pdkintl.org/kappan/write.htm

Needs Uses high-quality royalty-free, model-released stock photos on education topics. Especially interested in photos of educators and students at all levels, depicting a variety of people in different educational settings; teacher-to-teacher interactions with or without students (e.g., teachers' meetings, in-service, professional development settings). Reviews stock photos. Model release required. Photo caption required; include who, what, when, where.

Specs All visual materials should be submitted in high-res digital format, preferably JPEG (300 dpi at a minimum of 2100 × 3000 pixels). When taking photos, use the largest or finest format available. Images should be at least a few MB in size. Secure signed releases from parents before submitting any images of students. In cases where an author is submitting work (photos or artwork) done by another person, obtain that person's written permission and include information crediting that person. Releases should be transmitted to Kappan along with the images. Always include caption information with photos. Uses 8 × 10 b&w and color prints; occasionally uses color. Accepts images in digital format.

Making Contact & Terms Send query letter with list of education-related stock photo subjects before sending samples, or send URL for online portfolio. Provide photocopies, brochure or flier to be kept on file for possible future assignments. Responds in 3 weeks. Credit line and tearsheets given. Buys one-time rights. Payment is for print and electronic use in one issue, which may include distribution of, through third party vendors such as EBSCO, PDFs of articles that include illustrations, photographs, and cartoons. Provides 3 copies of the issue in which the photographs or illustrations appear.

Tips "We will definitely consider purchasing collections of royalty-free, copyright-free, modelreleased stock work if the majority of the photos are relevant."

PHOTOGRAPHER'S FORUM MAGAZINE

813 Reddick St., Santa Barbara CA 93103. (805)963-6425. Fax: (805)965-0496. E-mail: julie@serbin. com. Website: www.pfmagazine.com. Managing Editor: Julie Simpson. Quarterly magazine for the serious student and emerging professional photographer. Includes feature articles on historic and contemporary photographers, interviews, book reviews, workshop listings, new products. (See separate listings for annual photography contests in the Contests section.)

🖸 🖪 🖪 🕏 🕖 PHOTO LIFE

Apex Publications, 185 St. Paul Street, P.O. Box 84, Quebec, QC G1K 3W2, Canada. (800)905-7468. Fax: (800)664-2739. Website: www.photolife.com. Contact: Editor. Magazine published 6 times/ year. Readers are amateur, advanced amateur and professional photographers. Sample copy free with SASE. Photo guidelines available on website. Priority is given to Canadian photographers.

Needs Buys 70 photos from freelancers/issue; 420 photos/year. Needs landscape/wildlife shots, fashion, scenics, b&w images and so on.

Specs Accepts images in digital format. Send via CD at 300 dpi.

Making Contact & Terms Send query letter with résumé of credits, SASE. Pays on publication. Buys first North American serial rights and one-time rights.

Tips "Looking for good writers to cover any subject of interest to the amateur and advanced photographer. Fine art photos should be striking, innovative. General stock and outdoor photos should be presented with a strong technical theme."

S PILOT MAGAZINE

3 The Courtyard, Denmark Street, Wokingham, Berkshire RG40 2AZ, United Kingdom. +44(0)118 989 7246. Fax: +44(0)7834 104843. Circ. 25,048. Estab. 1968. Monthly consumer magazine. Photo guidelines available.

Needs Photos of aviation. Reviews photos with or without a manuscript. Photo captions required.

Specs Uses glossy, color prints; 35mm, $2\frac{1}{4} \times 2\frac{1}{4}$, 4×5 , 8×10 transparencies. Accepts images in digital format. Send via CD, Zip as JPEG files at 300 dpi.

Making Contact & Terms Does not keep samples on file; include SASE for return of material. Previously published work OK. Pays £30 for color inside. **Pays on publication.** Credit line given. Buys one-time rights.

Tips "Read our magazine. Label all photos with name and address. Supply generous captions."

■ S PLANET

P.O. Box 44, Aberystwyth SY23 3ZZ, Wales. (44)(1970)611255. Fax: (44)(1970)611197. E-mail: planet.enquiries@planetmagazine.org.uk. Website: www.planetmagazine.org.uk. Circ. 1,400. Estab. 1970. Bimonthly cultural magazine devoted to Welsh culture, current affairs, the arts, the environment, but set in broader international context. Audience based mostly in Wales.

Needs Photos of environmental, performing arts, sports, agriculture, industry, political, science. Interested in fine art, historical/vintage. Reviews photos with or without manuscript. Model/property release preferred. Photo captions required; include subject, copyright holder.

Specs Uses glossy color and b&w prints; 4 × 5 transparencies. Accepts images in digital format. Send as JPEG files at 300 dpi.

Making Contact & Terms Send query letter with résumé, slides, prints, photocopies. Does not keep samples on file; include SASE for return of material. Simultaneous submissions and previously published work OK. **Pays on publication.** Credit line given. Buys first rights.

Tips "Read the magazine first to get an idea of the kind of areas we cover so incompatible/ unsuitable material is not submitted."

\$\$ ⊌ PLAYBOY

680 N. Lake Shore Dr., Chicago IL 60611. (312)373-2735. Fax: (312)587-9046. Website: www.playboy. com. **Contributing Editor:** Gary Cole. **Photography Director:** Matt Doyle. Monthly magazine and website with daily updates. Pay site: Playboy Cyber Club. This is a premier market that demands photographic excellence. *Playboy* frequently uses freelancers but only those with superior quality work. *Playboy* accepts model submissions from all photographers but copies of model photo ID showing they are at least 18 years of age must be included with submission. Playmate finder's fees are paid. Readers are 75% male, 25% female, ages 18-70; come from all economic, ethnic and regional backgrounds.

Needs Photographic needs focus primarily on glamour/pretty girls with nudity. Also includes still life, fashion, food, personalities, travel.

Specs Raw digital file preferred with a minimum of 40-50MB.

Making Contact & Terms Pay is negotiable depending on job. Finder's fee for a published Playmate is \$500. The modeling fee for a published Playmate is \$25,000. Pays on acceptance. Buys all rights.

Tips "Lighting and attention to detail is most important when photographing women, especially the ability to use strobes indoors. Refer to magazine for style and quality guidelines."

POETS & WRITERS MAGAZINE

90 Broad St., 2100, New York NY 10004. (212)226-3586. Fax: (212)226-3963. E-mail: editor@pw.org. Website: www.pw.org/magazine. Managing Editor: Suzanne Pettypiece. Circ. 60,000. Bimonthly literary trade magazine. "Designed for poets, fiction writers and creative nonfiction writers. We supply our readers with information about the publishing industry, conferences and workshop opportunities, grants and awards available to writers, as well as interviews with contemporary

Needs Photos of contemporary writers: poets, fiction writers, writers of creative nonfiction. Photo captions required.

Specs Digital format.

Making Contact & Terms Provide URL, self-promotion piece or tearsheets to be kept on file for possible future assignments. Managing editor will contact photographer for portfolio review if interested. Pays on publication. Credit line given.

Tips "We seek photographs to accompany articles and profiles. We'd be pleased to have photographers' lists of author photos."

POPULAR PHOTOGRAPHY & IMAGING

1633 Broadway, New York NY 10019. (212)767-6000. E-mail: mleuchter@hfmus.com; popeditor@ hfmus.com. Website: www.popularphotography.com. Managing Editor: Miriam Leuchter. Editorin-Chief: John Owens. Circ. 450,000. Estab. 1937. Monthly magazine. Readers are male and female photographers, amateurs to professionals of all ages. Photo guidelines free with SASE.

Needs "We are primarily interested in articles on new or unusual phases of photography which we have not covered recently or in recent years. We do not want general articles on photography which could just as easily be written by our staff. We reserve the right to rewrite, edit, or revise any material we are interested in publishing."

Making Contact & Terms "Queries should be accompanied by a sampling of how-to pictures (particularly when equipment is to be constructed or a process is involved), or by photographs which support the text. Please send duplicates only; do not send negatives or original slides. We are not responsible for the loss of original work. The sender's name and address should be clearly written on the back of each print, on the mount of each slide, watermarked on digitally sent sample images, and on the first and last pages of all written material, including the accompanying letter. Technical data should accompany all pictures, including the camera used, lens, film (or image format if digital), shutter speed, aperture, lighting, and any other points of special interest on how the picture was made. Material mailed to us should be carefully wrapped or packaged to avoid damage. All submissions must be accompanied by a SASE. The rate of payment depends upon the importance of the feature, quality of the photographs, and our presentation of it. Upon acceptance, fees will be negotiated by the author/photographer and the editors of the magazine. We are unable to accept individual portfolios for review. However, we do welcome samples of your work in the form of promotional mailers, press kits, or tear sheets for our files. These should be sent to the attention of Miriam Leuchter, managing editor, at the above address or via e-mail at mleuchter@ hfmus.com"

Tips The Annual Reader's Picture Contest gives photographers the opportunity to have their work recognized in the largest photo magazine in the world, as well as on PopPhoto.com. See website for submission guidelines, or e-mail acooper@hfmus.com.

• See the magazine's monthly photo contest, Your Best Shot, in the Contests section.

■ \$\$ POZ MAGAZINE

500 5th Ave., Suite 320, New York NY 10110-0303. (212)242-2163. Fax: (212)675-8505. E-mail: editor-in-chief@poz.com; webmaster@poz.com. Website: www.poz.com. Art Director: Michael Halliday, Circ. 100,000. Monthly magazine focusing exclusively on HIV/AIDS news, research and treatment.

Needs Buys 10-25 photos from freelancers/issue; 120-300 photos/year. Reviews photos with or without a manuscript. Model release preferred. Photo captions required.

Specs Prefers online portfolios.

Making Contact & Terms Send query letter with nonreturnable samples. Provide self-promotion piece to be kept on file for possible future assignments. Responds only if interested; send nonreturnable samples. Simultaneous submissions and previously published work OK. Pays \$400-1,000 for color cover; \$100-500 for color inside. Pays on publication. Credit line given.

🖸 🔳 🗟 💲 🔘 PRAIRIE JOURNAL, THE

28 Crowfoot Terrace NW, P.O. Box 68073, Calgary AB T3G 3N8, Canada. E-mail: prairiejournal@ yahoo.com. Website: prairiejournal.org. Literary magazine published twice/year. Features mainly poetry and artwork. Sample copy available for \$6 and 7 × 8½ SAE. Photo guidelines available for SAE and IRC.

Needs Buys 4 photos/year. Needs literary only, artistic.

Specs Uses b&w prints. Accepts images in digital format. Send via e-mail "if your query is successful."

Making Contact & Terms Send query letter with photocopies only (no originals) by mail. Provide self-promotion piece to be kept on file. Responds in 6 months, only if interested; send nonreturnable samples. Pays \$10-50 for b&w cover or inside. Pays on publication. Credit line given. Buys first rights.

Tips "Black & white literary, artistic work preferred; not commercial. We especially like newcomers. Read our publication or check out our website. You need to own copyright for your work and have permission to reproduce it. We are open to subjects that would be suitable for a literary arts magazine containing poetry, fiction, reviews, interviews. We do not commission but choose from your samples."

☑ ■ S S D PRAIRIE MESSENGER

P.O. Box 190, Muenster SK S0K 2Y0, Canada. 1 + 306 682-1772. Fax: 1 + 306 682-5285. E-mail: Pm.canadian@Stpeterspress.ca. Website: www.prairiemessenger.ca. Associate Editor: Maureen Weber. Estab. 1904. Circ. 6,000. 10% Freelance written. Weekly Catholic publication published by the Benedictine Monks of St. Peter's Abbey in Muenster, SK Canada. Has a strong focus on ecumenism, social justice, interfaith relations, aboriginal issues, arts and culture.

Needs People, religious, agriculture, industry, military, environmental, entertainment, performing arts, lifestyle, seasonal photographs. Buys 50 photos/year. "I usually need photos to illustrate columns and occasionally use 'filler' feature photos with captions I either make up or seek quotations for. This means a range of themes is possible, including seasonal, environmental, religious, etc. Also, we carry a weekly poem submitted by freelancers, but I use stock photos to illustrate the poems."

Specs Accepts photos as TIFF or JPEG format.

Making Contact & Terms E-mail with JPEG samples at 72 dpi. Credit line given.

PRINCETON ALUMNI WEEKLY

194 Nassau St., Ste. 38, Princeton NJ 08542. (609)258-4722. Fax: (609)258-2247. E-mail: mnelson@ princeton.edu. Website: www.princeton.edu/paw. Circ. 60,000. Magazine published 15 times/year. Emphasizes Princeton University and higher education. Readers are alumni, faculty, students, staff and friends of Princeton University. Sample copy available for \$2 with 9 × 12 SAE and 2 first-class stamps.

Needs Assigns local and out-of-state photographers and purchases stock. Needs photos of "people, campus scenes; subjects vary greatly with content of each issue."

Making Contact & Terms Arrange a personal interview to show portfolio. Provide sample card to be kept on file for possible future assignments. Payment varies according to usage, size, etc. Pays on publication. Buys one-time rights.

■ **S** THE PROGRESSIVE

409 E. Main St., Madison WI 53703. (608)257-4626. E-mail: nick@progressive.org; editorial@ progressive.org; photos@progressive.org. Website: www.progressive.org. Editor: Matt Rothschild. Managing Editor: Amitabh Pal. Art Director: Nick Jehlen. Circ. 68,000. Estab. 1909. Monthly political magazine. "Grassroots publication from a left perspective, interested in foreign and domestic issues of peace and social justice." Photo guidelines free and on website.

Needs Buys 5-10 photos from freelancers/issue; 50-100 photos/year. Looking for images documenting the human condition and the social/political environments of contemporary society. Special photo needs include "labor activities, environmental issues and political movements." Photo captions required; include name, place, date, credit information.

Specs Accepts low-resolution JPEGs via e-mail.

Making Contact & Terms Send query letter with photocopies; include SASE. Provide stock list to be kept on file for possible future assignments. Art director will contact photographer for portfolio review if interested. Responds once every month. Simultaneous submissions and previously published work OK. Pays \$50-150 for b&w inside. Pays on publication. Credit line given. Buys onetime rights. All material returned with SASE.

Tips "Most of the photos we publish are of political actions. Interesting and well-composed photos of creative actions are the most likely to be published. We also use 2-3 short photo essays on political or social subjects per year." For detailed photo information, see website at www.art. progressive.org.

RACQUETBALL MAGAZINE

1685 W. Uintah, Colorado Springs CO 80904-2906. (719)635-5396. Fax: (719)635-0685. E-mail: jhiser@usra.org. Website: www.usaracquetball.com. Circ. 30,000. Bimonthly magazine of USA Racquetball. Emphasizes racquetball. Sample copy available for \$4.50. Photo guidelines available. Needs Buys 6-12 photos from freelancers/issue; 36-72 photos/year. Needs photos of action racquetball. Model/property release preferred. Photo captions required.

Specs Accepts images in digital format. Send via CD as EPS files at 900 dpi.

Making Contact & Terms Provide résumé, business card, brochure, flier or tearsheets to be kept on file for possible future assignments. Responds in 1 month. Previously published work OK. Pays \$200 for color cover; \$3-5 for b&w inside; \$25-75 for color inside. Pays on publication. Credit line given. Buys all rights; negotiable.

\$\$ ₩ RANGER RICK

11100 Wildlife Center Dr., Reston VA 20190-5362. (703)438-6525. Fax: (703)438-6094. E-mail: mcelhinney@nwf.org. Website: www.nwf.org/rangerrick. Photo Editor: Susan McElhinney. Monthly educational magazine published by the National Wildlife Federation for children ages 8-12. Photo guidelines free with SASE.

Needs Needs photos of children, multicultural, environmental, wildlife, adventure, science.

Specs Uses transparencies or digital capture; dupes or lightboxes OK for first edit.

Making Contact & Terms Send nonreturnable printed samples or website address. Ranger Rick space rates: \$300 (quarter page) to \$1,000 (cover).

Tips "NWF's mission is to inspire Americans to protect wildlife for our children's future. Seeking experienced photographers with substantial publishing history only."

REFORM JUDAISM

633 Third Ave., 7th Floor, New York NY 10017-6778. (212)650-4240. E-mail: rjmagazine@urj.org. Website: www.reformjudaismmag.org. Managing Editor: Joy Weinberg. Quarterly publication of the Union for Reform Judaism. Offers insightful, incisive coverage of the challenges faced by contemporary Jews. Readers are members of Reform congregations in North America. Sample copy available for \$3.50. Photo guidelines available via e-mail or on website.

Needs Buys 3 photos from freelancers/issue; 12 photos/year. Needs photos relating to Jewish life or Jewish issues, Israel, politics. Model release required for children. Photo captions required.

Making Contact & Terms Provide website. Responds in 1 month. Simultaneous submissions and previously published website work OK. Include self-addressed, stamped postcard for response. Pays on publication. Credit line given. Buys one-time rights, first North American serial rights.

Tips Wants to see "excellent photography: artistic, creative, evocative pictures that involve the reader."

REVOLUTIONARY WAR TRACKS

2660 Petersborough St., Herndon VA 20171. E-mail: revolutionarywartracks@yahoo.com. Contact: Shannon Bridget Murphy. Quarterly magazine, "Bringing Revolutionary War history alive for children and teens." Photo guidelines available by e-mail request.

Needs Buys 12-24 photos/year. Needs photos of babies/children/teens, multicultural, families, parents, disasters, environmental, landscapes/scenics, wildlife, cities/urban, education, religious, rural, adventure, events, food/drink, sports, travel, agriculture, medicine, military, political, product shots/still life, science, technology—as related to Revolutionary War history. Interested in alternative process, avant garde, documentary, fashion/glamour, fine art, historical/vintage, seasonal. Reviews photos with or without a manuscript. Model/property release preferred.

Specs Uses glossy or matte color and/or b&w prints.

Making Contact & Terms Send query letter via e-mail. "If possible, please do not include photographs in files if they are sent through e-mail. A disk with your photographs is acceptable." Provide résumé, business card or self-promotion piece to be kept on file for possible future assignments. "Photographs sent with CDs are requested but not required." Responds within 1 month to queries; 1 week to portfolios. Simultaneous submissions and previously published work OK. Pays on acceptance. Credit line given. Buys one-time rights, first rights; negotiable.

RHODE ISLAND MONTHLY

Rhode Island Monthly Communications, Inc., 717 Allens Avenue, Suite 105, Providence RI 02905. (401)649-4800. Fax: (401)649-4885. E-mail: ellen_dessloch@rimonthly.com. Website: www. rimonthly.com. Art Director: Ellen Dessloch, art director. Monthly regional publication for and about Rhode Island.

Needs Buys 15 photos from freelancers/issue; 200 photos/year. "Almost all photos have a local slant: portraits, photo essays, food, lifestyle, home, issues."

Specs Accepts images in digital format.

Making Contact & Terms Portfolio may be dropped off. Provide self-promotion piece to be kept on file for possible future assignments. Will return anything with SASE. Responds in 2 weeks. Pays a month after invoice. Credit line given. Buys one-time rights.

Tips "Freelancers should be familiar with Rhode Island Monthly and should be able to demonstrate their proficiency in the medium before any work is assigned."

ROCKFORD REVIEW

P.O. Box 858, Rockford IL 61105. E-mail: daveconnieross@aol.com. Website: http://writersguild1. tripod.com. Editor: David Ross. Circ. 750. Estab. 1982. Association publication of Rockford Writers' Guild. Published twice/year (summer and winter). Emphasizes poetry and prose of all types. Readers are of all stages and ages who share an interest in quality writing and art. Sample copy available for \$9.

• This publication is literary in nature and publishes very few photographs. However, the photos on the cover tend to be experimental (e.g., solarized images, photograms, etc.).

Needs Uses 1-5 photos/issue; all supplied by freelancers. Needs photos of scenics and personalities. Model/property release preferred. Photo captions preferred; include when and where, and biography.

Specs Uses 8×10 or 5×7 glossy b&w prints.

Making Contact & Terms Send unsolicited photos by mail for consideration. Does not keep samples on file; include SASE for return of material. Responds in 6 weeks. Simultaneous submissions OK. Payment is one copy of magazine, but work is eligible for *Review*'s \$25 Editor's Choice prize. Pays on publication. Credit line given. Buys first North American serial rights.

Tips "Experimental work with a literary magazine in mind will be carefully considered. Avoid the 'news' approach."

■ ⊘ ROLLING STONE

1290 Avenue of the Americas, 2nd Floor, New York NY 10104-0298. (212)484-1616. Fax: (212)484-1290. E-mail: photo@rollingstone.com. Website: www.rollingstone.com. **Photo Editor:** John Gara. Monthly consumer magazine. Emphasizes film, CD reviews, music groups, celebrities, fashion. Readers are young adults interested in news of popular music, politics and culture.

Needs photos of celebrities, political, entertainment, events. Interested in alternative process, avant garde, documentary, fashion/glamour.

Specs Accepts images in digital format. Send as TIFF, JPEG files at 300 dpi.

Making Contact & Terms Portfolio may be dropped off every Wednesday and picked up on Friday afternoon. Provide business card, self-promotion piece to be kept on file for possible future assignments. Responds only if interested; send nonreturnable samples.

Tips "It's not about a photographer's experience, it's about a photographer's talent and eye. Lots of photographers have years of professional experience but their work isn't for us. Others might not have years of experience, but they have this amazing eye."

■ THE ROTARIAN

1560 Sherman Ave., Evanston IL 60201. (847)866-3000. Fax: (847)866-9732. E-mail: lawrende@ rotaryintl.org. Website: www.rotary.org. **Creative Director:** Deborah Lawrence. Circ. 500,000. Estab. 1911. Monthly organization magazine for Rotarian business and professional men and women and their families. "Dedicated to business and professional ethics, community life, and international understanding and goodwill." Sample copy and photo guidelines free with SASE.

Needs Assigns photography to freelancers and staff photographers; Subject varies from studio to location, from environmental portraiture to photojournalism, but there is always a Rotary connection.

Specs Digital images only. Prefers RAW files, but will accept high resolution JPEG.

Making Contact & Terms Send query e-mail, fee schedule and link to online portfolio. Clearly identify your location in the subject of your e-mail. Creative director will contact photographer. No calls please. Keeps e-mail, promotion samples on file. Do not send unsolicited originals. Responds in 3 weeks. Payment negotiable. **Pays on acceptance.** Credit line given. Buys one-time rights; occasionally all rights; negotiable.

■ A \$ □ RUGBY MAGAZINE

11 Martine Ave., 8th Fl., White Plains NV 10606. Fax: (914)831 6201. E-mail: alex@rugbymag.com. Website: www.rugbymag.com. Circ. 10,000. Estab. 1975. Monthly magazine emphasizing rugby matches. Readers are male and female, wealthy, well-educated, ages 16-60.

Needs Uses 20 photos/issue; most supplied by freelancers. Needs rugby action shots. Reviews photos with accompanying manuscript only.

Specs Uses color or b&w prints. Accepts images in digital format. Send as high-res JPEG or TIFF files at 300 dpi.

Making Contact & Terms Send unsolicited photos by mail with SASE for consideration. Provide résumé, business card, brochure, flier or tearsheets to be kept on file for possible future assignments. Simultaneous submissions and previously published work OK. "We only pay when we assign a photographer. Rates are very low, but our magazine is a good place to get some exposure." Pays on publication. Credit line given. Buys one-time rights.

\$ RURAL HERITAGE

P.O. Box 2067, Cedar Rapids IA 52406-2067. (319)362-3027. E-mail: publisher@ruralheritage.com; infor@ruralheritage.com. Website: www.ruralheritage.com. Editor/Publisher: Joe Mischka. Bimonthly journal in support of modern-day farming and logging with draft animals (horses, mules, oxen). Sample copy available for \$8 (\$10 outside the U.S.). Photo guidelines available on website or via e-mail.

Needs "Quality photographs of draft animals working in harness."

Specs "For interior pages we use glossy color prints, high-quality slides, or high-resolution images (300 dpi or greater) shot with a quality digital camera. For covers we use 5×7 glossy color prints, large-format transparencies, or high-resolution images shot with a quality digital camera. Digital images must be original (not resized, cropped, etc.) files from a digital camera; scans unacceptable."

Making Contact & Terms Send query letter with samples. "Please include SASE for the return of your material, and put your name and address on the back of each piece." Pays \$100 for color cover; \$10-25 for b&w inside. Also provides 2 copies of issue in which work appears. Pays on publication.

Tips "Animals usually look better from the side than from the front. We like to see all the animal's body parts, including hooves, ears and tail. For animals in harness, we want to see the entire implement or vehicle. We prefer action shots (plowing, harvesting hay, etc.). Watch out for shadows across animals and people. Please include the name of any human handlers involved, the farm, the town (or county), state, and the animals' names (if possible) and breeds. You'll find current guidelines in the 'Business Office' of our website."

\$ RUSSIAN LIFE MAGAZINE

P.O. Box 567, Montpelier VT 05601. (802)223-4955. E-mail: paulr@russianlife.net; editors@russianlife.com. Website: www.russianlife.net. **Publisher:** Paul Richardson. Estab. 1956. Bimonthly magazine.

Needs Uses 25-35 photos/issue. Offers 10-15 freelance assignments/year. Needs photojournalism related to Russian culture, art and history. Model/property release preferred.

Making Contact & Terms Works with local freelancers only. Send query letter with samples. Send $35 \, \text{mm}$, $2 \, \frac{1}{4} \times 2 \, \frac{1}{4}$, 4×5 , 8×10 transparencies; $35 \, \text{mm}$ film; digital format. Include SASE "or material will not be returned." Responds in 1 month. Pays \$20-50 (color photo with accompanying story), depending on placement in magazine. Pays on publication. Credit line given. Buys one-time and electronic rights.

■ \$\$ ☑ SAIL MAGAZINE

98 N. Washington St., Suite 107, Boston MA 02114. (617)720-8600. Fax: (617)723-0912. E-mail: Peter.Nielsen@sorc.com. Website: www.sailmagazine.com. Circ. 200,000. Estab. 1970. Monthly magazine. Emphasizes all aspects of sailing. Readers are managers and professionals, average age 44. Photo guidelines free with SASE and on website.

Needs Buys 50-100 images/issue. "Particularly interested in photos for cover and 'pure sail' sections. Ideally, these photos would be digital files @300 dpi with a run size of approximately 9×12 for cover, 9×16 for 'pure sail'." Also accepts 35mm transparencies. Vertical cover shots also needed. Photo captions required.

Specs Accepts images in digital format. Send high-resolution JPEG, TIFF and RAW files via CD, DVD or FTP (contact for FTP log-in info). Also accepts all forms of transparencies and prints with negatives.

Making Contact & Terms Send unsolicited 35mm and 21/4 × 21/4 transparencies by mail with SASE for consideration. Pays \$1,000 for color cover; \$50-800 for color inside; also negotiates prices on a per day, per hour and per job basis. Pays on publication. Credit line given. Buys one-time North American rights. Photo shoots commissioned using half- or full-day rates.

■ \$\$ SALT WATER SPORTSMAN

460 N. Orlando Ave., Suite 200, Winter Park FL 32789. (407)628-4802. Fax: (407)628-7601. Website: www.saltwatersportsman.com. Circ. 175,000. Estab. 1939. Monthly magazine. Emphasizes all phases of saltwater sport fishing for the avid beginner-to-professional saltwater angler. "Numberone monthly marine sport fishing magazine in the U.S." Sample copy free with 9 × 12 SAE and 7 first-class stamps. Photo guidelines free.

Needs Buys photos (including covers) without manuscript; 20-30 photos/issue with manuscript. Needs saltwater fishing photos. "Think fishing action, scenery, mood, storytelling close-ups of anglers in action. Make it come alive-and don't bother us with the obviously posed 'dead fish and stupid fisherman' back at the dock." Wants, on a regular basis, cover shots (clean verticals depicting saltwater fishing action). For accompanying manuscript, needs fact/feature articles dealing with marine sport fishing in the U.S., Canada, Caribbean, Central and South America. Emphasis on how-to.

Specs Uses 35mm or $2\frac{1}{4} \times 2\frac{1}{4}$ transparencies; vertical format preferred for covers. Accepts images in digital format. Send via CD, Zip; format as 8-bit, unconverted, 300 dpi, RGB TIFF. A confirming laser or proof of each image must accompany the media. A printed disk directory with each new name written next to each original name must be provided.

Making Contact & Terms Send material by mail for consideration, or query with samples. Provide résumé or tearsheets to be kept on file for possible future assignments. Holds slides for 1 year and will pay as used; include SASE for return of material. Responds in 1 month. Pays \$2,500 maximum for cover; \$100-500 for color inside; \$500 minimum for text-photo package. Pays on acceptance.

Tips "Prefer to see a selection of fishing action and mood; must be sport fishing-oriented. Read the magazine! No horizontal cover slides with suggestions it can be cropped, etc. Don't send Ektachrome. We're using more 'outside' photography-that is, photos not submitted with manuscript package. Take lots of verticals and experiment with lighting."

SANDLAPPER MAGAZINE

Sanlapper Society, Inc., 3007 Millwood Ave., Columbia SC 29205. (803)779-8763 or (803)779-2126. Fax: (803)254-4833. E-mail: elaine@sandlapper.org; elaine@thegillespieagency.com. Website: www.sandlapper.org. Executive Director: Elaine Gillespie. Quarterly magazine. Emphasizes South Carolina topics only.

Needs Uses about 10 photographers/issue. Needs photos of anything related to South Carolina in any style, "as long as they're not in bad taste." Model release preferred. Photo captions required; include places and people.

Specs Uses 8×10 color and b&w prints; 35mm, $2\frac{1}{4} \times 2\frac{1}{4}$, 4×5 , 8×10 transparencies. Accepts images in digital format. Send via CD, Zip as TIFF, JPEG files at 300 dpi. "Do not format exclusively for PC. RGB preferred. Submit low-resolution and high-resolution files, and label them as such. Please call or e-mail Elaine Gillespie with any questions" about digital submissions.

Making Contact & Terms Send query letter with samples. Keeps samples on file; include SASE for return of material. Responds in 1 month. Pays \$100 for color cover; \$50-100 for color inside. Pays 1 month after publication. Credit line given. Buys first rights plus right to reprint.

Tips "We see plenty of beach sunsets, mountain waterfalls, and shore birds. Would like fresh images of people working and playing in the Palmetto state."

\$ SCHOLASTIC MAGAZINES

557 Broadway, New York NY 10012. (212)343-7147. Fax: (212)389-3913. E-mail: sdiamond@ scholastic.com. Website: www.scholastic.com. Executive Director of Photography: Steven Diamond. Publication of magazines varies from weekly to monthly. "We publish 27 titles on topics from current events, science, math, fine art, literature and social studies. Interested in featuring high-quality, well-composed images of students of all ages and all ethnic backgrounds. We publish hundreds of books on all topics, educational programs, Internet products and new media."

Needs Needs photos of various subjects depending upon educational topics planned for academic year. Model release required. Photo captions required. "Images must be interesting, bright and lively!"

Specs Accepts images in digital format. Send via CD, e-mail.

Making Contact & Terms Send query letter with résumé, business card, brochure, flier or tearsheets to be kept on file for possible future assignments. Material cannot be returned. Previously published work OK. Pays on publication.

Tips Especially interested in good photography of all ages of student population. All images must have model/property releases.

SEA

America's Western Boating Magazine, Duncan McIntosh & Co., 17782 Cowan, Suite A, Irvine CA 92614. (949)660-6150. Fax: (949)660-6172. E-mail: editorial@seamag.com. Website: www. seamag.com. Associate Editor/Publisher: Jeff Fleming, Managing Editor: Mike Werling. Monthly magazine. Emphasizes "recreational boating in 13 Western states (including some coverage of Mexico and British Columbia) for owners of recreational power boats." Sample copy and photo guidelines free with 10 × 13 SAE.

Needs Uses about 50-75 photos/issue; most supplied by freelancers; 10% assignment; 75% requested from freelancers, existing photo files, or submitted unsolicited. Needs "people enjoying boating activity (families, parents, senior citizens) and scenic shots (travel, regional); shots that include parts or all of a boat are preferred." Photos should have West Coast angle. Model release required. Photo captions required.

Specs Accepts images in digital format. Send via CD, FTP, e-mail as TIFF, EPS, JPEG files at least 266 dpi. E-mail editorial assistant, Kristal@seamag.com, for FTP instructions.

Making Contact & Terms Send query letter with samples; include SASE for return of material. Responds in 1 month. Pay rate varies according to size published (range is \$50-200 for color). Pays on publication. Credit line given. Buys one-time North American rights and retains reprint rights via print and electronic media.

Tips "We are looking for sharp images with good composition showing pleasure boats in action, and people having fun aboard boats in a West Coast location. Digital shots are preferred; they must be at least 5 inches wide and a minimum of 300 dpi. We also use studio shots of marine products and do personality profiles. Send samples of work with a query letter and a résumé or clips of previously published photos. Sea does not pay for shipping; will hold photos up to 6 weeks."

■ M \$\$ SEATTLE HOMES & LIFESTYLES

Network Communications, Inc., 3240 Eastlake Ave. E., Suite 200, Seattle WA 98102. (206)322-6699. Fax: (206)322-2799. E-mail: swilliams@seattlehomesmag.com. Website: www.seattlehomesmag. com. Art Director: Shawn Williams. Circ. 30,000. Estab. 1996. Magazine published 8 times/year. Emphasizes interior home design, gardens, architecture, lifestyles (food, wine, entertaining). Sample copy available for \$3.95 and SAE.

Needs All work is commissioned specifically for magazine. Buys 35-50 photos from freelancers/ issue; 200 photos/year. Needs photos of architecture, interior design, gardens, food, wine, entertaining. All work is commissioned specifically for magazine. Model release required. Photo captions required. "Do not send photos without querying first."

Specs Accepts images in digital format.

Making Contact & Terms No phone calls please. Send query letter with résumé, photocopies, tearsheets. Provide self-promotion piece to be kept on file for possible future assignments. Responds only if interested; send nonreturnable samples. Payment varies by assignment, \$140-900, depending on number of photos and complexity of project. Pays on acceptance. Credit line given. Buys exclusive, first rights for one year; includes Web usage.

Tips "Assignments contracted to experienced architectural and interior photographers for homedesign and garden features. Photographers must be in Seattle area."

A SEVENTEEN MAGAZINE

300 W 57th St., 17th Fl., New York NY 10019. E-mail: mail@seventeen.com. Website: www. seventeen.com. Seventeen is a young women's fashion and beauty magazine. Tailored to young women in their teens and early 20s, Seventeen covers fashion, beauty, health, fitness, food, cars, college, careers, talent, entertainment, fiction, plus crucial personal and global issues. Photos purchased on assignment only. Query before submitting.

\$ SHARING THE VICTORY

Fellowship of Christian Athletes, 8701 Leeds Rd., Kansas City MO 64129. (816)921-0909. Fax: (816)921-8755. E-mail: stv@fca.org. Website: www.sharingthevictory.com. Managing Editor: Jill Ewert. Estab. 1982. Monthly association magazine featuring stories and testimonials of prominent athletes and coaches in sports who proclaim a relationship with Jesus Christ. Sample copy available for \$1 and 9 × 12 SAE. No photo guidelines available.

Needs Needs photos of sports. "We buy photos of persons being featured in our magazine. We don't buy photos without story being suggested first." Reviews photos with accompanying manuscript only. "All submitted stories must be connected to the FCA Ministry." Model release preferred; property release required. Photo captions preferred.

Specs Uses glossy or matte color prints; 35mm, 21/4 × 21/4 transparencies. Accepts images in digital format. Send via CD, Zip, e-mail as TIFF, JPEG files at 300 dpi.

Making Contact & Terms Contact through e-mail with a list of types of sports photographs in stock. Do not send samples. Simultaneous submissions OK. Pays \$150 maximum for color cover; \$100 maximum for color inside. Pays on publication. Credit line given. Buys one-time rights.

Tips "We would like to increase our supply of photographers who can do contract work."

\$\$ SHOOTING SPORTS USA

NRA, 11250 Waples Mill Rd., Fairfax VA 22030. (703)267-1310. E-mail: shootingsportsusa@nrahq. org. Website: www.nrapublications.org. Editor: Chip Lohman. Monthly publication of the National Rifle Association of America. Emphasizes competitive shooting sports (rifle, pistol and shotgun). Readers range from beginner to high master. Online copies available at www.shootingsportsusa. com. Editorial guidelines free via e-mail.

Needs 15-25 photos from freelancers/issue; 180-300 photos/year. Needs photos of how-to, shooting positions, specific shooters. Quality photos preferred with accompanying manuscript. Model release required. Photo captions preferred.

Specs Accepts images in digital format. Send via CD or e-mail as TIFF files at 300 dpi.

Making Contact & Terms Send query letter with photo and editorial ideas by e-mail. Include SASE. Responds in 1 week. Previously published work OK when cleared with editor. Pays \$150-400 for color cover; \$50-150 for color inside; \$250-500 for photo/text package; amount varies for photos alone. Pays on publication. Credit line given. Buys first North American serial rights.

Tips Looks for "generic photos of shooters shooting, obeying all safety rules and using proper eye protection and hearing protection. If text concerns certain how-to advice, photos are needed to illuminate this. Always query first. We are in search of quality photos to interest both beginning and experienced shooters."

■ Ø SHOTS

P.O. Box 27755, Minneapolis MN 55427-0755. E-mail: shots@shotsmag.com. Website: www. shotsmag.com. **Editor/Publisher:** Russell Joslin. Quarterly fine art photography magazine. "We publish black-and-white fine art photography by photographers with an innate passion for personal, creative work." Sample copy available for \$6.50. Photo guidelines free with SASE or on website.

Needs Fine art photography of all types accepted for consideration (but not bought). Reviews photos with or without a manuscript. Model/property release preferred. Photo captions preferred. **Specs** Uses 8 × 10 b&w prints. Accepts images in digital format. Send via CD as TIFF files at 300 dpi. "See website for further specifications."

Making Contact & Terms Send query letter with prints. There is a \$16 submission fee for nonsubscribers (free for subscribers). Include SASE for return of material. Responds in 3 months. Credit line given. Does not buy photographs/rights.

SIERRA

E-mail: sierra.letters@sierraclub.org.

■ A S SKIPPING STONES

P.O. Box 3939, Eugene OR 97403-0939. (541)342-4956. Fax: On demand. E-mail: Editor@ Skippingstones.org. Website: www.Skippingstones.org. Editor: Arun Toké. Contact: Estab. 1988. Circ 2,000 print. 80% Freelance written. Award-winning multicultural and nature awareness magazine for youth and their parents/educators. Non-commercial and nonprofit. Ecological and ecologically aware magazine. No advertisements. Black and white inside and full color covers. "We promote multicultural awareness, international understanding, nature appreciation, and social responsibility. We suggest authors not make stereotypical generalizations in their articles. We like when authors include their own experiences, or base their articles on their personal immersion experiences in a culture or country." Has featured Xuan Thu Pham, Soma Han, Jon Bush, Zarouhie Abdalian, Elizabeth Zunon and Najah Clemmons.

Needs Buys babies/teens/children, celebrities, multicultural, families, disasters, environmental, landscapes, wildlife, cities, education, gardening, rural, events, health/fitness/beauty, travel, documentary and seasonal. Reviews 4 × 6 prints, low-resolution JPEG files. Captions required.

Making Contact & Terms Send query letter or e-mail with photographs (digital JPEGs at 72 dpi). **Tips** "We consider your work as a labor of love that contributes to the education of youth. We publish photoessays on various cultures and countries/regions of the world in each issue of the magazine to promote international and intercultural (and nature) understanding. Tell us a little bit about yourself, your motivation, goals, and mission."

\$ SKYDIVING

1725 Lexington Ave., DeLand FL 32724. (386)736-4793. Fax: (386)736-9786. E-mail: sue@skydivingmagazine.com; mike@skydivingmagazing.com. Website: www.skydivingmagazine.com. Publisher: Mike Truffer. Editor: Sue Clifton. Parachuting's newsmagazine. Circ. 14,200. Estab. 1979. Monthly magazine. Readers are "sport parachutists worldwide, dealers and equipment manufacturers." Sample copy available for \$3. Photo guidelines free with SASE or on website.

Needs Buys 5 photos from freelancers/issue; 60 photos/year. Selects photos from wire service, photographers who are skydivers and freelancers. Interested in anything related to skydiving—news or any dramatic illustration of an aspect of parachuting. Model release preferred. Photo captions preferred; include who, what, why, when, how.

Specs Digital files are preferred. Send via CD, DVD, FTP, e-mail as JPEG, TIFF files at 300 dpi (minimum). Also accepts prints and transparencies.

Making Contact & Terms Send digital files after reviewing guidelines, or send 5×7 or larger b&w or color prints or 35mm or $2\frac{1}{4} \times 2\frac{1}{4}$ transparencies by mail for consideration. Keeps samples on

file; include SASE for return of material. Responds in 1 month. Pays \$50 for color cover; \$5-25 for b&w inside; \$25-50 for color inside. Pays on publication. Credit line given. Buys all rights.

N SMITHSONIAN MAGAZINE

MRC 513, P.O. Box 37012, Washington DC 20012-7012. (202)633-6090. Fax: (202)633-6095. E-mail: smithsonianmagazine@si.edu. Website: www.smithsonianmagazine.com. Photo Editor: Molly Roberts. Monthly magazine. Smithsonian chronicles the arts, environment, sciences and popular culture of the times for today's well-rounded individuals with diverse, general interests, providing its readers with information and knowledge in an entertaining way. Visit website for photo submission guidelines. Does not accept unsolicited photos or portfolios. Use online submission form. Ouerv before submitting.

SOUTHCOMM PUBLISHING COMPANY, INC.

310 Paper Trail Way, Suite 108, Canton GA 30115. (678)624-1075, ext. 234. Fax: (678)624-1079. E-mail: cwwalker@southcomm.com. Website: www.southcomm.com. Managing Editor: Carolyn Williams-Walker. "We publish approximately 35 publications throughout the year. They are primarily for chambers of commerce throughout the Southeast (Georgia, Tennessee, South Carolina, North Carolina, Alabama, Virginia, Florida). We are expanding to the Northeast (Pennsylvania) and Texas. Our publications are used for tourism, economic development and marketing purposes. We also are a custom publishing company, offering brochures and other types of printed material."

Needs "We are only looking for photographers who can travel to the communities with which we're working as we need shots that are specific to those locations. We will not consider generic stocktype photos. Images are generally for editorial purposes; however, advertising shots sometimes are required." Model/property release preferred. Photo captions required. "Identify people, buildings and as many specifics as possible."

Specs Prefers images in digital format. Send via CD, saved as TIFF, GIF or JPEG files for Mac at no less than 300 dpi. "We prefer digital photography for all our publications."

Making Contact & Terms Send query letter with résumé and photocopies. Keeps samples on file; provide business card. Responds only if interested; send nonreturnable samples. Pays \$40 minimum; \$60 maximum for color inside. Pays a flat rate that ranges between \$400 and \$1,200 for projects. Each has its own specific budget, so rates fluctuate. We pay the same rates for cover images as for interior shots because, at times, images identified for the cover cannot be used as such. They are then used in the interior instead." Pays on acceptance. Credit line given. "Photos that are shot on assignment become the property of SouthComm Publishing Company, Inc. They cannot be released to our clients or another third party. We will purchase one-time rights to use images from photographers should the need arise." Will negotiate with a photographer unwilling to sell all rights.

Tips "We are looking for photographers who enjoy traveling and are highly organized and can communicate well with our clients as well as with us. Digital photographers must turn in contact sheets of all images shot in the community, clearly identifying the subjects."

\$\$ SOUTHERN BOATING

330 N. Andrews Ave., Ft. Lauderdale FL 33301. (954)522-5515. Fax: (954)522-2260. E-mail: jon@ southernboating.com. Website: www.southernboating.com. Art Director: Jon Hernandez. Monthly magazine. Emphasizes "powerboating, sailing, and cruising in the southeastern and Gulf Coast U.S., Bahamas and the Caribbean." Readers are "concentrated in 30-60 age group, mostly male, affluent, very experienced boat owners." Sample copy available for \$7.

Needs Number of photos/issue varies; many supplied by freelancers. Seeks "boating lifestyle" cover shots. Buys stock only. No "assigned covers." Model release required. Photo captions required. Specs Accepts images in digital format. Send via CD or e-mail as JPEG, TIFF files, minimum 4 × 6

at 300 dpi.

Making Contact & Terms Send query letter with list of stock photo subjects, SASE. Response time varies. Simultaneous submissions and previously published work OK. Pays \$300 minimum for color cover; \$70 minimum for color inside; photo/text package negotiable. Pays within 30 days of publication. Credit line given. Buys one-time print and electronic/website rights.

Tips "We want lifestyle shots of saltwater cruising, fishing or just relaxing on the water. Lifestyle or family boating shots are actively sought."

S \$ SPECIALIVING

P.O. Box 1000, Bloomington IL 61702. (309)820-9277; (309)962-2003. E-mail: gareeb@aol.com. Website: www.speciaLiving.com. **Publisher:** Betty Garee. Quarterly consumer magazine for physically disabled people. Emphasizes travel, home modifications, products, info, inspiration. Sample copy available for \$5.

Needs Any events/settings that involve physically disabled people (who use wheelchairs), not developmentally disabled. Reviews photos with or without a manuscript. Model release preferred. Photo captions required.

Specs Uses glossy or matte color and/or b&w prints. Accepts images in digital format. Send via CD, Zip, e-mail as TIFF, JPEG files at 300 dpi.

Making Contact & Terms Send query letter with prints. Online e-mail form available on website. Does not keep samples on file; include SASE for return of material. Responds in 3 weeks. Simultaneous submissions and previously published work OK. Pays \$50 minimum for b&w cover; \$100 maximum for color cover; \$10 minimum for b&w or color inside. Pays on publication. Credit line given. Buys one-time rights.

Tips "Need good-quality photos of someone in a wheelchair involved in an activity. Need caption and where I can contact subject to get story if wanted."

■ \$\$\$ SPORT FISHING

Bonnier Corporation, LLC, 460 N. Orlando Ave., Suite 200, Winter Park FL 32789. (407)628-5662. Fax: (407)628-7061. E-mail: editor@sportfishingmag.com; stephanie.pancratz@bonniercorp.com. Website: www.sportfishingmag.com. Managing Editor: Stephanie Pancratz.

Needs Buys 50% or more photos from freelancers/issue. Needs photos of saltwater fish and fishing—especially good action shots. "Are working more from stock—good opportunities for extra sales on any given assignment." Model release not generally required.

Specs Prefers images in RAW, unaltered/undoctored digital format, especially for the option to run images very large, with accompanying low-res JPEGs for quick review. Original 35mm (or larger) transparencies are accepted for smaller images, but no longer for the cover or two-page spreads. All guidelines, rates, suggestions available on website; click on "Editorial Guidelines" at bottom of home page.

Making Contact & Terms Send query letter with samples. Send unsolicited photos by mail or low resolution digitals by e-mail for consideration. Provide business card, brochure, flier or tearsheets to be kept on file for possible future assignments. Responds in 3 weeks. Pays \$1,000 for cover; \$75-400 for inside. Buys one-time rights unless otherwise agreed upon.

Tips "Sharp focus critical; avoid 'kill' shots of big game fish, sharks; avoid bloody fish in/at the boat. The best guideline is the magazine itself. Know your market. Get used to shooting on, in or under water using the RAW setting of your camera. Most of our needs are found in the magazine. If you have first-rate photos and questions, e-mail us."

S SPORTSCAR

16842 Von Karman Ave., Suite 125, Irvine CA 92606. (949)417-6700. Fax: (949)417-6116. E-mail: sportscar@haymarketworldwide.com. Website: www.sportscarmag.com. **Editor:** Philip Royle. Circ. 50,000. Estab. 1944. Monthly magazine of the Sports Car Club of America. Emphasizes sports car racing and competition activities. Sample copy available for \$4.99.

Needs Uses 75-100 photos/issue; 75% from assignment and 25% from freelance stock. Needs action photos from competitive events, personality portraits and technical photos.

Making Contact & Terms Prefers electronic submissions on CD with query letter. Provide résumé, business card, brochure or flier to be kept on file for possible future assignments. Responds in 1 month. Simultaneous submissions OK. Pays \$250-400 for color cover; \$25-100 for color inside; negotiates all other rates. Pays on publication. Credit line given.

Tips To break in with this or any magazine, "always send only your absolute best work; try to accommodate the specific needs of your clients. Have a relevant subject, strong action, crystal-sharp focus, proper contrast and exposure. We need good candid personality photos of key competitors and officials."

■ \$ ☐ STICKMAN REVIEW

721 Oakwater Ln., Port Orange FL 32128. (386)756-1795. E-mail: art@stickmanreview.com. Website: www.stickmanreview.com. Editor: Anthony Brown. Estab. 2001. Biannual literary magazine publishing fiction, poetry, essays and art for a literary audience. Sample copies available on website.

Needs Buys 1-2 photos from freelancers/issue; 4 photos/year. Interested in alternative process, avant garde, documentary, erotic, fine art. Reviews photos with or without a manuscript.

Specs Accepts images in digital format. Send via e-mail as JPEG, GIF, TIFF, PSD files at 72 dpi (500K maximum).

Making Contact & Terms Contact through e-mail only. Does not keep samples on file; cannot return material. Do not query, just submit the work you would like considered. Responds 2 months to portfolios. Simultaneous submissions OK. Pays \$25-50. Pays on acceptance. Credit line given. Buys electronic rights.

Tips "Please check out the magazine on our website. We are open to anything, so long as its intent is artistic expression."

\$ SUBTERRAIN MAGAZINE

P.O. Box 3008, MPO, Vancouver BC V6B 3X5, Canada. (604)876-8710. Fax: (604)879-2667. E-mail: subter@portal.ca. Website: www.subterrain.ca. Literary magazine published 3 times/year.

Specs Uses color and/or b&w prints.

Making Contact & Terms No unsolicited material. "We are now featuring one artist (illustration or photography) per issue, and are generally soliciting that work."

\$ THE SUN

107 N. Roberson St., Chapel Hill NC 27516. (919)942-5282. Fax: (919)932-3101. E-mail: tim@ thesunmagazine.org. Website: www.thesunmagazine.org. Contact: Art Director. Monthly literary magazine featuring personal essays, interviews, poems, short stories, photos and photo essays. Sample copy available for \$5. Photo guidelines free with SASE or on website.

Needs Buys 10-30 photos/issue; 200-300 photos/year. Needs "slice of life" photographs of people and environments. "We also need photographs that relate to political, spiritual, and social themes. We consider documentary-style images. Most of our photos of people feature unrecognizable individuals, although we do run portraits in specific places, including the cover." Model/property release strongly preferred.

Specs Uses 4 × 5 to 11 × 17 glossy or matte b&w prints. Slides are not accepted, and color photos are discouraged. "We cannot review images via e-mail or website. If you are submitting digital images, please send high-quality digital prints first. If we accept your images for publication, we will request the image files on CD or DVD media (Mac or PC) in uncompressed TIFF grayscale format at 300 dpi or greater."

Making Contact & Terms Send query letter with prints. Portfolio may be dropped off Monday-Friday. Does not keep samples on file; include SASE for return of material. Responds in 3 months. Simultaneous submissions and previously published work OK. "Submit no more than 30 of your best b&w prints. Please do not e-mail images." Pays \$500 for b&w cover; \$100-300 for b&w inside. Pays on publication. Credit line given. Buys one-time rights.

Tips "We're looking for artful and sensitive photographs that aren't overly sentimental. We're open to unusual work. Read the magazine to get a sense of what we're about. Send the best possible prints of your work. Our submission rate is extremely high; please be patient after sending us your work. Send return postage and secure return packaging."

\$\$ SURFING MAGAZINE

E-mail: travis.ferre@sorc.com. Website: www.surfingthemag.com. Contact: Tony Perez, publisher. Circ. 180,000. Monthly magazine. Emphasizes "surfing action and related aspects of beach lifestyle. Travel to new surfing areas covered as well. Average age of readers is 17 with 95% being male. Nearly all drawn to publication due to high-quality, action-packed photographs." Sample copy available for legal-size SAE and 9 first-class stamps. Photo guidelines free with SASE or via e-mail.

Needs Buys an average of 10 photos from freelancers/issue. Needs "in-tight, front-lit surfing action photos, as well as travel-related scenics. Beach lifestyle photos always in demand."

Specs Uses 35mm transparencies. Accepts digital images via CD; contact for digital requirements before submitting digital images.

Making Contact & Terms Pays \$750-1,000 for color cover; \$25-330 for color inside; \$600 for color poster photo. Pays on publication. Credit line given. Buys one-time rights.

Tips Prefers to see "well-exposed, sharp images showing both the ability to capture peak action, as well as beach scenes depicting the surfing lifestyle. Color, lighting, composition and proper film usage are important. Ask for our photo guidelines prior to making any film/camera/lens choices."

\$ TEXAS GARDENER MAGAZINE

P.O. Box 9005, Waco TX 76714-9005. (254)848-9393. Website: www.texasgardener.com. Circ. 25,000. Bimonthly. Emphasizes gardening. Readers are "51% male, 49% female, home gardeners, 98% Texas residents." Sample copy available for \$4.

Needs Buys 18-27 photos from freelancers/issue; 108-162 photos/year. Needs "color photos of gardening activities in Texas." Special needs include "cover photos shot in vertical format. Must be taken in Texas." Photo captions required.

Specs Prefers high-resolution digital images. Send via e-mail as JPEG files at 300 dpi.

Making Contact & Terms Send query letter with samples, SASE. Responds in 3 weeks. Pays \$100-200 for color cover; \$25-100 for color inside. Pays on publication. Credit line given. Buys one-time rights.

Tips "Provide complete information on photos. For example, if you submit a photo of watermelons growing in a garden, we need to know what variety they are and when and where the picture was taken."

\$ \$ TEXAS HIGHWAYS

Texas Dept. of Transportation, P.O. Box 141009, Austin TX 78714. (512)486-5870. Fax: (512)486-5879. E-mail: gsmith@dot.state.tx.us. Website: www.texashighways.com. Photo Editor: J. Griffis Smith. Monthly. "Texas Highways interprets scenic, recreational, historical, cultural and ethnic treasures of the state and preserves the best of Texas heritage. Its purpose is to educate and entertain, to encourage recreational travel to and within the state, and to tell the Texas story to readers around the world." Readers are ages 45 and over (majority); \$24,000 to \$60,000/year salary bracket with a college education. Photo guidelines and online submission form available on website.

Needs Buys 30-60 photos from freelancers/issue; 360-420 photos/year. Needs "travel and scenic photos in Texas only." Special needs include "fall, winter, spring and summer scenic shots and wildflower shots (Texas only)." Photo captions required; include location, names, addresses and other useful information.

Specs "We take only color originals, 35mm or larger transparencies. No negatives or prints." Accepts images in digital format. Prefers camera RAW files with tweaks and captions in sidecar files. Consult guidelines before submitting.

Making Contact & Terms Send query letter with samples, SASE. Provide business card and tearsheets to be kept on file for possible future assignments. Responds in 1 month, Simultaneous submissions OK. Pays \$400 for color cover; \$60-170 for color inside. Pays \$15 extra for electronic usage. Pays on publication. Credit line given. Buys one-time rights.

Tips "Look at our magazine and format. We accept only high-quality, professional-level work no snapshots. Interested in a photographer's ability to edit own material and the breadth of a photographer's work. Look at 3-4 months of the magazine. Query not just for photos but with ideas for new/unusual topics."

\$ I TEXAS MONTHLY

P.O. Box 1569, Austin TX 78767. (512)320-6936. E-mail: lbaldwin@texasmonthly.com. Website: www.texasmonthly.com. Photo Editor: Leslie Baldwin. Texas Monthly is edited for the urban Texas audience and covers the state's politics, sports, business, culture and changing lifestyles. It contains lengthy feature articles, reviews and interviews, and presents critical analysis of popular books, movies and plays.

Needs Uses about 50 photos/issue. Needs photos of celebrities, sports, travel.

Making Contact & Terms Please feel free to submit your photography or illustration portfolio to us. The best way to do this is by e-mailing us a link to your work. If you do not have a website, simply attaching a few images of your work in an e-mail is fine. Send samples or tearsheets. No preference on printed material—b&w or color. Responds only if interested. Keeps samples on file.

Tips "Check our website (www.texasmonthly.com/artguide) for information on sending portfolios."

■ \$ □ THEMA

P.O. Box 8747, Metairie LA 70011-8747. (504)887-1263. E-mail: thema@cox.net. Website: http:// members.cox.net/thema. Editor: Virginia Howard. Estab. 1988. Literary magazine published 3 times/year emphasizing theme-related short stories, poetry and art. Sample copy available for \$10.

Needs Photo must relate to one of *THEMA*'s upcoming themes (indicate the target theme on submission of photo). Upcoming themes (submission deadlines in parenthesis); Your Reality or Mine (March 1, 2011), Wisecracks & Poems (July 1, 2011), Who Keeps It Tidy? (November 1, 2011). Reviews photos with or without a manuscript. Model/property release preferred. Photo captions preferred.

Specs Uses 5 × 7 glossy color and/or b&w prints. Accepts images in digital format. Send via Zip as TIFF files at 200 dpi.

Making Contact & Terms Send query letter with prints, photocopies. Does not keep samples on file; include SASE for return of material. Responds in 1 week to queries; 3 months after deadline to submissions. Simultaneous submissions and previously published work OK. Pays \$25 for cover; \$10 for b&w inside. Pays on acceptance. Credit line given. Buys one-time rights.

Tips "Submit only work that relates to one of *THEMA*'s upcoming themes. Contact by snail mail preferred."

6919 Portwest Dr., Suite 100, Houston TX 77024. (713)626-4234. Fax: (713)626-5852. E-mail: ccantl@ joincca.org. Website: www.joincca.org. Contact: Editor. Circ. 80,000. Estab. 1979. Bimonthly magazine of the Coastal Conservation Association. Emphasizes coastal fishing, conservation issues—exclusively along the Gulf and Atlantic Coasts. Readers are mostly male, ages 25-50, coastal anglers and professionals.

Needs Buys 12-16 photos from freelancers/issue; 72-96 photos/year. Needs photos of only Gulf and Atlantic coastal activity, recreational fishing and coastal scenics/habitat, tight shots of fish (saltwater only). Model/property release preferred. Photo captions not required, but include names, dates, places and specific equipment or other key information.

Making Contact & Terms Send query letter with stock list. Responds in 1 month. Simultaneous submissions and previously published work OK. Pays \$250 for color cover; \$50-200 for color inside; \$300-400 for photo/text package. Pays on publication. Credit line given. Buys one-time rights; negotiable.

Tips Wants to see "fresh twists on old themes—unique lighting, subjects of interest to my readers. Take time to discover new angles for fishing shots. Avoid the usual poses, i.e., 'grip-and-grin.' We see too much of that already."

\$ TIKKUN

2342 Shattack Ave., #1200, Berkeley CA 94704. (510)644-1200. Fax: (510)644-1255. E-mail: magazine@tikkun.org. Website: www.tikkun.org. Managing Editor: Dave Belden. Circ. 25,000. Estab. 1986. "A bimonthly Jewish and interfaith critique of politics, culture and society." Readers are 60% Jewish, professional, middle-class, literary people ages 30-60.

Needs Uses 15 photos/issue; 30% supplied by freelancers. Needs political, social commentary; Middle East and U.S. photos. Reviews photos with or without a manuscript.

Specs Uses b&w and color prints. Accepts images in digital format for Mac.

Making Contact & Terms Response time varies. "Turnaround is 4 months, unless artist specifies other." Previously published work OK. Pays \$50 for b&w inside. Pays on publication. Credit line given. Buys all rights; negotiable.

Tips "Look at our magazine and suggest how your photos can enhance our articles and subject material. Send samples."

O TIME

Time/Life Building, 1271 Avenue of the Americas, New York NY 10020. (212)522-1212. E-mail: letters@time.com. Website: www.time.com. TIME is edited to report and analyze a complete and compelling picture of the world, including national and world affairs, news of business, science, society and the arts, and the people who make the news. Query before submitting.

■ S TIMES OF THE ISLANDS

Lucille Lightbourne #7, Box 234, Providenciales, Turks & Caicos Islands, British West Indies. (649)946-4788. E-mail: timespub@tciway.tc. Website: www.timespub.tc. Editor: Kathy Borsuk. Quarterly magazine focusing on in-depth topics specifically related to Turks & Caicos Islands. Targeted beyond mass tourists to homeowners/investors/developers and others with strong interest in learning about these islands. Sample copy available for \$6. Photo guidelines available on website.

Needs Buys 5 photos from freelancers/issue; 20 photos/year. Needs photos of environmental, landscapes/scenics, wildlife, architecture, adventure, travel. Interested in historical/vintage. Also scuba diving, islands in TCI beyond main island of Providenciales. Reviews photos with or without a manuscript. Photo captions required; include specific location, names of any people.

Specs Prefers images in high resolution digital format. Send via CD or e-mail as JPEG files.

Making Contact & Terms Send query e-mail with photo samples. Provide business card, selfpromotion piece to be kept on file for possible future assignments. Responds in 6 weeks to queries. Simultaneous submissions and previously published work OK. Pays \$100-300 for color cover; \$50-100 for inside. Pays on publication. Credit line given. Buys one-time rights; negotiable.

Tips "Make sure photo is specific to Turks & Caicos and location/subject accurately identified."

S S TOWARD FREEDOM

P.O. Box 468, 300 Maple St. (05401), Burlington VT 05402-0468. E-mail: admin@towardfreedom. com; ben@towardfreedom.com. Website: www.towardfreedom.com. Publisher: Robin Lloyd. A progressive perspective on world events. Online magazine. Back issues available for \$3 each.

Needs Needs photos of environmental, military, political. Reviews photos with or without a manuscript. Photo captions required.

Making Contact & Terms Send query letter with prints, tearsheets, stock list. Does not keep samples on file; include SASE for return of material. Has online e-mail form, Responds in 2 months to queries. Simultaneous submissions and previously published work OK. Pays on publication. Credit line given. Buys one-time rights.

Tips "Must understand *Toward Freedom*'s progressive mission."

N 🗏 🛛 TRACE MAGAZINE

41 Great Jones St., 3rd Floor, New York NY 10012. 212-625-1192. Fax: (212)625-1195. E-mail: editorial@trace212.com. Creative Director: Katie Constans. Consumer publication published 10 times/year, focusing on international transcultural style (a term invented to describe the increasing prevalence of individuals who "transcend their initial culture, in order to explore, examine and infiltrate foreign cultures), mixing music, fashion, lifestyle and art. "The magazine has offices in New York and London, which gather stories for our U.S. and U.K. editions." It has featured photography by Marc Baptiste, Ellen Von Unwerth, Albert Watson and Juergen Teller.

Needs Wants photos of celebrities, music. Interested in fashion/glamour, lifestyle. Model release required.

Specs Accepts images in digital format. Send JPEG or GIF files. Reviews contact sheets, any size transparencies and negatives.

Making Contact & Terms E-mail query letter with link to photographer's website. Credit line given. Payment negotiated. Buys exclusive worldwide first-time periodical rights; worldwide rights to republish or cause the photographs to be republished in any book or periodical anthology, and/or any edition of RACE Inc., and its affiliates; exclusive worldwide rights to use the photographs as part of any electronic and/or computer-based database, newsletter or website containing TRACE Inc. articles.

■ \$ ☑ TRACK & FIELD NEWS

2570 El Camino Real, Suite 480, Mountain View CA 94040. (650)948-8188. Fax: (650)948-9445. E-mail: editorial@trackandfieldnews.com. Website: www.trackandfieldnews.com. Associate Editor (features/photography): Jon Hendershott. Monthly magazine. Emphasizes national and world-class track and field competition and participants at those levels for athletes, coaches, administrators and fans. Sample copy free with 9 × 12 SASE. Photo guidelines free.

Needs Buys 10-15 photos from freelancers/issue; 120-180 photos/year. Wants, on a regular basis, photos of national-class athletes, men and women, preferably in action. "We are always looking for quality pictures of track and field action, as well as offbeat and different feature photos. We also welcome shots from road and cross-country races for both men and women. Any photos may eventually be used to illustrate news stories in T&FN, feature stories in T&FN, or may be used in our other publications (books, technical journals, etc.). Any such editorial use will be paid for, regardless of whether material is used directly in T&FN. About all we don't want to see are pictures taken with someone's Instamatic. No shots of someone's child or grandparent running. Professional work only." Photo captions required; include subject name (last name first), meet date/name.

Specs Images must be in digital format. Send via CD, e-mail; all files at 300 dpi.

Making Contact & Terms Send query letter with samples, SASE. Responds in 10-14 days. Pays \$225 for color cover; \$25 for b&w inside (rarely used); \$50 for color inside (\$100 for full-page interior color; \$175 for interior 4-color poster). Payment is made monthly. Credit line given. Buys one-time rights.

Tips "No photographer is going to get rich via T&FN. We can offer a credit line, nominal payment and, in some cases, credentials to major track and field meets. Also, we can offer the chance for competent photographers to shoot major competitions and competitors up close, as well as being the most highly regarded publication in the track world as a forum to display a photographer's talents."

■ \$\$ ☑ TRAILER BOATS MAGAZINE

20700 Belshaw Ave., Carson CA 90746. (310)537-6322. E-mail: info@trailerboats.com. Website: www.trailerboats.com. Circ. 90,000. Estab. 1971. Distributed 9 times/year. "We are the only magazine devoted exclusively to trailerable boats and related activities" for owners and prospective owners.

Needs Uses 15 photos/issue; 95-100% of freelance photography comes from assignment, 0-5% from stock. Needs how-to trailerable boat, travel (with manuscript). For accompanying manuscripts, needs articles related to trailer boat activities. Photos purchased with or without accompanying manuscript. "Photos must relate to trailer boat activities. No long list of stock photos or subject matter not related to editorial content." Photo captions preferred; include location of travel pictures.

Specs Accepts images in digital format. Send as JPEG files at 300 dpi.

Making Contact & Terms Query or send photos or contact sheet by mail with SASE for consideration. Pays per text/photo package or on a per-photo basis. Pays on acceptance. Credit line given.

Tips "Shoot with imagination and a variety of angles. Don't be afraid to 'set up' a photo that looks natural. Think in terms of complete feature stories: photos and manuscripts.

■ \$\$ TRAIL RUNNER

417 Main St., Unit N, Carbondale CO 81623. (970)704-1442. Fax: (970)963-4965. E-mail: mbenge@ bigstonepub.com; photo@bigstonepub.com. Website: www.trailrunnermag.com. Elinor Fish, managing editor. Contact: Photo Editor. Bimonthly magazine. The nation's only magazine covering all aspects of trail running. Trail Runner regularly features stunning photography of trail running destinations, races, adventures and faces of the sport. Trail Runner is not responsible for unsolicited submissions. Please address all submissions to Photo Editor, and include a SASE for their return. DIGITAL SUBMISSIONS PREFERRED. Please send a low-resolution preview CD and a corresponding high-resolution CD along with hard-copy printout. We do not return CDs unless accompanied by SASE of the proper dimensions and with sufficient postage. CDs do not have a monetary value. Generally, we require a minimum of 6mp for up to 2/3-page, and 10mp for full page and spread use. We prefer unsharpened images. You can e-mail low-resolution samples. We accept original slides (but still prefer digital). Sample copy available for 9 × 12 SAE with \$1.65 postage. Photo guidelines available on website.

Needs Buys 5-10 photos from freelancers/issue; 50-100 photos/year. Needs photos of landscapes/ scenics, adventure, health/fitness, sports, travel. Interested in anything related to running on trails and the outdoors. Reviews photos with or without a manuscript. Model/property release preferred. Photo captions required.

Specs Uses glossy color prints; 35mm transparencies. Accepts images in digital format. Send via CD, e-mail as TIFF files at 600 dpi.

Making Contact & Terms Send query letter via e-mail to photo editor. Contact photo editor for appointment to drop off portfolio. Provide résumé, business card or self-promotion piece to be kept on file for possible future assignments. Responds in 3 weeks. Simultaneous submissions OK. Pays \$500 for color cover; \$50-200 for b&w inside; \$50-250 for color inside; \$350 for spread (color). Pays 30 days from date of publication. Credit line given. Buys one-time rights, first rights; negotiable.

Tips "Read our magazine. Stay away from model shots, or at least those with make-up and spandex clothing. No waving at the camera."

TRAVEL + LEISURE

1120 Avenue of the Americas, 10th Floor, New York NY 10036. (212)382-5600. Website: www. travelandleisure.com. Creative Director: Bernard Scharf. Monthly magazine. Emphasizes travel destinations, resorts, portraits, dining and entertainment.

Needs Does not accept unsolicited photos. Model release required. Photo captions required.

Making Contact & Terms "If mailing a portfolio, include a self-addressed stamped package for its safe return. You may also send it by messenger Monday through Friday between 11 a.m. and 5 p.m. We accept work in book form exclusively—no transparencies, loose prints, nor scans on CD, disk or e-mail. Send photocopies or photo prints, not originals, as we are not responsible for lost or damaged images in unsolicited portfolios. We do not meet with photographers if we haven't seen their book. However, please include a promo card in your portfolio with contact information, so we may get in touch with you if necessary."

🕮 🗏 \$ TRAVELLER MAGAZINE & PUBLISHING

45-49 Brompton Road, London SW3 1DE, United Kingdom. (44)(207)581-6156. Fax: (44)(207)581-8476. E-mail: traveller@and-publishing.co.uk. Website: www.traveller.org.uk. www.traveller@ and-publishing.co.uk. Editor: Amy Sohanpaul. Circ. 25,000. Quarterly. Readers are predominantly male, professional, ages 35 and older. Sample copy available for £4.95.

Needs Uses 75-100 photos/issue; all supplied by freelancers. Needs photos of travel, wildlife, tribes. Reviews photos with or without a manuscript. Photo captions preferred.

Making Contact & Terms Send at least 20 original color slides or b&w prints. Or send at least 20 low-res scans by e-mail or CD (include printout of thumbnails); high-res (300 dpi) scans will be required for final publication. Does not keep samples on file; include SASE for return of material. Responds in 3 months. Pays £150 for color cover; £80 for full page; £50 for other sizes. Pays on publication. Buys one-time rights.

Tips Look at guidelines for contributors on website.

S TRAVELWORLD INTERNATIONAL MAGAZINE

531 Main St., #902, El Segundo CA 90245. (310)836-8712. Fax: (310)836-8769. E-mail: helen@natja. org. Website: www.natja.org, www.travelworldmagazine.com. CEO: Helen Hernandez. Quarterly online magazine of the North American Travel Journalists Association (NATJA). Emphasizes travel, food, wine, and hospitality industries.

Needs Uses photos of food/drink, travel.

Specs Uses color and/or b&w. Prefers images in digital format.

Making Contact & Terms Send query via e-mail.

Tips Only accepts submissions from members.

S TRIUMPH WORLD

P.O. Box 978, Peterborough PE1 9FL, United Kingdom. +44 (0)1959 541444. Fax: +44 (0)1959 541400. E-mail: tw.ed@kelseypb.co.uk. Website: www.triumph-world.co.uk/. Estab. 1995. Bimonthy magazine for enthusiasts and owners of Triumph cars.

Needs Buys 60 photos from freelancers/issue; 360 photos/year. Needs photos of Triumph cars. Reviews photos with or without a manuscript. Photo captions preferred.

Specs Uses color and/or b&w prints; 35mm, 21/4 × 21/4, 4 × 5 transparencies. Accepts images in digital format. Send as JPEG files.

Making Contact & Terms Send query letter with samples, tearsheets. Pays 6 weeks after publication. Credit line given. Buys first rights.

Tips "Be creative—we do not want cars parked on grass or public car parks with white lines coming out from underneath. Make use of great 'American' locations available. Provide full information about where and when subject was photographed."

\$\$ TURKEY & TURKEY HUNTING

F+W Media, Inc., 700 E. State St., Iola WI 54990-0001. (715)445-4612. E-mail: brian.lovett@ fwmedia.com. Website: www.turkeyandturkeyhunting.com. **Editor:** Beth Duris, editor. Circ. 125,000. Estab. 1959. Quarterly magazine. Emphasizes conservation, protection, and restoration of North America's trout and salmon species and the streams and rivers they inhabit. Readers are conservation-minded anglers, primarily male, with an average age of 50. Sample copy available for 9×12 SAE and 4 first-class stamps. Photo guidelines free with SASE.

Needs Buys 150 photos/year. Needs action photos of wild turkeys and hunter interaction scenes. Reviews photos with or without a manuscript.

Specs Uses 35mm transparencies and high-res digital images. "Do not send photos without first contacting the editor."

Making Contact & Terms Send query letter with samples; include SASE for return of material. Responds in 3 months to queries. Pays \$300 minimum for color cover; \$75-200 for color inside. Pays on publication. Credit line given. Buys one-time rights.

\$ TURKEY COUNTRY

P.O. Box 530, Parcel services: 770 Augusta Rd., Edgefield SC 29824. (803)637-3106. Fax: (803)637-0034. E-mail: klee@nwtf.net;bcarey@nwtf.net; mlindler@nwtf.net; turkeycountry@nwtf.net. Website: www.nwtf.org. Editors: Karen Lee and Burt Carey. Photo Editor: Matt Lindler. Circ. 200,000. Estab. 2009. Bimonthly magazine for members of the National Wild Turkey Federation—people interested in conserving the American wild turkey. Sample copy available for \$5 with 9 × 12 SASE. Images may be submitted to accompany specific assignments or on speculation. See photograph submission information and send speculative images to the photo editor at the NWTF shipping address. Photo guidelines free with SASE or on website at www.turkeycountrymagazine. com/contributor_guidelines.html.

Needs Buys at least 100 photos/year. Needs photos of "wildlife, including wild turkeys, upland birds, North American Big Game; wild turkey hunting; wild turkey management techniques (planting food, trapping for relocation, releasing); wild turkey habitat; families, women, children and people with disabilities hunting or enjoying the outdoors." Photo captions required.

Specs Prefers images in digital format from 6mp or higher resolution cameras. Send via CD/DVD at 300 ppi with thumbnail page (see guidelines for more details).

Making Contact & Terms Send copyrighted photos to editor for consideration; include SASE. Responds in 6 weeks. Pays \$800 for cover; \$400 maximum for color inside. We purchase both print rights and for electronic usage on turkeycountrymagazine.com, which includes a digital version of the magazine. Additional usage on the website, other than in the digital magazine, will be negotiated. Pays on publication. Credit line given. Buys one-time rights.

Tips Wants "no poorly posed or restaged shots, no mounted turkeys representing live birds, no domestic animals representing wild animals. Photos of dead animals in a tasteful hunt setting are considered. Contributors must agree to the guidelines before submitting."

TV GUIDE

1211 Avenue of the Americas, 4th Floor, New York NY 10036. (212)852-7500. Fax: (212)852-7470. Website: www.tvguide.com. **Contact:** Photo Editor. TV Guide watches television with an eye for how TV programming affects and reflects society. It looks at the shows and the stars, and covers the medium's impact on news, sports, politics, literature, the arts, science and social issues through reports, profiles, features and commentaries.

Making Contact & Terms Works only with celebrity freelance photographers. "Photos are for one-time publication use. Mail self-promo cards to photo editor at above address. No calls, please."

N B S O UP AND UNDER

The QND Review, P.O. Box 115, Hainesport NJ 08036. (609)953-7568. E-mail: qndpoets@yahoo. com. Website: www.quickanddirtypoets.com. Co-Editor: Kendall A. Bell. Annual literary magazine. "A literary journal with an eclectic mix of poetry: sex, death, politics, IKEA, Mars, food and jug handles, alongside a smorgasbord of other topics covered in such diverse forms as the sonnet, villanelle, haiku and free verse." Sample copy available for \$7 and SAE.

Needs Acquires 8 photos from freelancers/issue; 8 photos/year. Interested in architecture, cities/ urban, rural, landscapes/scenics, avant garde, fine art, historical/vintage. Reviews photos with or without a manuscript.

Specs Uses 8 × 10 or smaller b&w prints. Accepts digital images in Windows format. Send via e-mail as GIF or JPEG files.

Making Contact & Terms Send query letter with prints. Does not keep samples on file; include SASE for return of material. Responds in 2-3 months to queries. Simultaneous submissions OK. Pays 1 copy on publication. Credit line sometimes given, depending on space allowance in the journal. Acquires one-time rights.

Tips "This is predominantly a poetry journal, and we choose photographs to complement the poems, so we prefer unusual, artistic images whether they are landscapes, buildings or art. Include a short (3- to 5-line) bio."

□ \$\$ ② UP HERE

#800-4920 52nd St., Yellowknife NT X1A 3T1, Canada. (867)766-6710. Fax: (867)873-9876. E-mail: kathy@uphere.ca; aaron@uphere.ca. Website: www.uphere.ca. Circ. 100. Estab. 2005. Annual literary magazine. Editor: Jake Kennedy. Circ. 35,000. Estab. 1984. Magazine published 8 times/ year. Emphasizes Canada's North. Readers are educated, affluent men and women ages 30 to 60. Sample copy available for \$7 and SAE.

Needs Buys 18-27 photos from freelancers/issue; 144-216 photos/year. Needs photos of Northern Canada environmental, landscapes/scenics, wildlife, adventure, performing arts. Interested in documentary, seasonal. Purchases photos with or without accompanying manuscript. Photo captions required.

Specs Accepts images in digital format. Send via CD, e-mail. Also uses color transparencies, not prints, labeled with the photographer's name, address, phone number, and caption.

Making Contact & Terms Provide résumé, business card, brochure, flier or tearsheets to be kept on file for possible future assignments. Pays \$350-400 for color cover, up to \$300 for color inside. Pays on publication. Credit line given. Buys one-time rights.

Tips "We are a *people* magazine. We need stories that are uniquely Northern (people, places, etc.). Few scenics as such. We approach local freelancers for given subjects, but routinely complete commissioned photography with images from stock sources. Please let us know about Northern images you have." Wants to see "sharp, clear photos, good color and composition. We always need verticals to consider for the cover, but they usually tie in with an article inside."

\$\$ VERMONT LIFE

One National Life Dr., 6th Floor, Montpelier VT 05620. E-mail: editors@vtlife.com. Website: www. vermontlife.com. Art Director: Jan Lowry Hubbard. Managing Editor: Bill Anderson. Circ. 75,000. Estab. 1946. Quarterly magazine. Emphasizes life in Vermont: its people, traditions, way of life. farming, industry, and the physical beauty of the landscape for "Vermonters, ex-Vermonters, and would-be Vermonters." Sample copy available for \$6 with 9 × 12 SAE. Photo guidelines available for SASE, via e-mail or on website.

Needs Buys 27 photos from freelancers/issue; 108 photos/year. Wants (on a regular basis) scenic views of Vermont, seasonal (winter, spring, summer, autumn) submitted 6 months prior to the actual season, animal, human interest, humorous, nature, landscapes/scenics, wildlife, gardening, sports, photo essay/photo feature, still life, travel. Interested in documentary. "We are using fewer,

larger photos and are especially interested in good shots of wildlife, Vermont scenics." No photos in poor taste, clichés, or photos of places other than Vermont. No manipulated digital images. Model/property release preferred. Photo captions required.

Specs Uses 35mm, 21/4 × 21/4 color transparencies. Accepts images in digital format. See guidelines for specifications at www.vermontlife.com/about vl/guidelines.htm.

Making Contact & Terms Send query letter with SASE or e-mail; no phone queries. Responds in 3 weeks. Simultaneous submissions OK. Pays \$500 minimum for color cover; \$75-250 for b&w or color inside; \$250-800/job. Pays on publication. Credit line given. Buys one-time rights; negotiable.

Tips "Unusual angles and landscapes not shown in previous issues of Vermont Life are appreciated."

\$ WERMONT MAGAZINE

P.O. Box 900, Arlington VT 05259. Website: www.vermontmagazine.com. Editor: Kathleen James. Circ. 50,000. Estab. 1989. Bimonthly magazine. Emphasizes all facets of Vermont culture, business, sports, restaurants, real estate, people, crafts, art, architecture, etc. Readers are people interested in Vermont, including residents, tourists and second home owners. Sample copy available for \$4.95 with 9×12 SAE and 5 first-class stamps. Photo guidelines free with SASE.

Needs Buys 10 photos from freelancers/issue; 60 photos/year. Needs animal/wildlife shots, travel, Vermont scenics, how-to, products and architecture. Special photo needs include Vermont activities such as skiing, ice skating, biking, hiking, etc. Model release preferred. Photo captions required.

Making Contact & Terms Send query letter with résumé of credits, samples, SASE. Send 8 × 10 b&w prints or 35mm or larger transparencies by mail for consideration. Submit portfolio for review. Provide tearsheets to be kept on file for possible future assignments. Responds in 2 months. Previously published work OK, depending on "how it was previously published." Pays \$300 for color cover: \$150 color page rate; \$50-150 for color or b&w inside; \$250/day. Pays on publication. Credit line given. Buys one-time rights and first North American serial rights; negotiable.

Tips In portfolio or samples, wants to see tearsheets of published work and at least 40 35mm transparencies. Explain your areas of expertise. Looking for creative solutions to illustrate regional activities, profiles and lifestyles. "We would like to see more illustrative photography/fine art photography where it applies to the articles and departments we produce."

N @ VERSAL

Postbus 3865, Amsterdam 1054 EJ, The Netherlands. +31 (0)63 433 8875. E-mail: Info@ wordsinhere.com. Website: www.Wordsinhere.com. Editor: Megan M. Garr, editor. Assistant Art Editor: Shayna Schapp. Estab. 2002. Circ. 650. "Versal, published each May by wordsinhere, is the only literary magazine of its kind in the Netherlands and publishes new poetry, prose and art from around the world. Versal and the writers behind it are also at the forefront of a growing translocal European literary scene, which includes exciting communities in Amsterdam, Paris and Berlin. Versal seeks work that is urgent, involved and unexpected."

Making Contact & Terms Submission guidelines online. Samples not kept on file. Portfolio not required. Credit line is given. Work accepted by submission period (September-January).

Tips "After reviewing the journal, if you are interested in what we're doing and would like to get involved, please send a query and CV to Editor Megan Garr at Megan@Wordsinhere.com. Artists submitting to Versal must follow our submission guidelines online and submit during our review period, September to January. Others interested in helping should always send an inquiry with a cover letter and CV. Please do not submit images of artwork via e-mail."

WASHINGTON TRAILS

2019 3rd Ave., Suite 100, Seattle WA 98121-2430. (206)971-9966. E-mail: editor@wta.org. Website: www.wta.org. Editor: Lace Thornberg. Magazine of the Washington Trail's Association, published 6 times/year. Emphasizes "backpacking, hiking, cross-country skiing, all nonmotorized trail use, outdoor equipment and minimum-impact camping techniques." Readers are "people active in outdoor activities, primarily backpacking; residents of the Pacific Northwest, mostly Washington; age group: 9-90; family-oriented; interested in wilderness preservation, trail maintenance." Photo guidelines free with SASE or on website.

Needs Uses 10-15 photos from volunteers/issue; 100-150 photos/year. Needs "wilderness/scenic; people involved in hiking, backpacking, skiing, snowshoeing, wildlife; outdoor equipment photos, all with Pacific Northwest emphasis." Photo captions required.

Making Contact & Terms Send JPEGs by e-mail for consideration. Responds in 1-2 months. Simultaneous submissions and previously published work OK. No payment for photos. A 1-year subscription offered for use of color cover shot. Credit line given.

Tips "Photos must have a Pacific Northwest slant. Photos that meet our cover specifications are always of interest to us. Familiarity with our magazine will greatly aid the photographer in submitting material to us. Contributing to Washington Trails won't help pay your bills, but sharing your photos with other backpackers and skiers has its own rewards."

\$\$ WATERSKI

460 N. Orlando Ave., Suite 200, Winter Park FL 32789. (407)628-4802. Fax: (407)628-7061. E-mail: bill.doster@bonniercorp.com; bill.doster@worldpub.net; russ.moore@bonniercorp.com. Website: www.waterskimag.com. Art Director: Russ Moore. Photo Editor: Bill Doster. Published 8 times/ year. Emphasizes water skiing instruction, lifestyle, competition, travel. Readers are 36-year-old males, average household income \$65,000. Sample copy available for \$2.95. Photo guidelines free with SASE.

Needs Buys 20 photos from freelancers/issue; 160 photos/year. Needs photos of instruction, travel, personality. Model/property release preferred. Photo captions preferred; include person, trick described.

Making Contact & Terms Query with good samples, SASE. Keeps samples on file. Responds within 2 months. Pays \$200-500/day; \$500 for color cover; \$50-75 for b&w inside; \$75-300 for color inside; \$150/color page rate; \$50 75/b&w page rate. Pays on publication. Credit line given. Buys first North American serial rights.

Tlps "Clean, clear, tight images. Plenty of vibrant action, colorful travel scenics and personality. Must be able to shoot action photography. Looking for photographers in other geographic regions for diverse coverage."

🖸 🖪 💲 🖸 WAVELENGTH MAGAZINE

Wild Coast Publishing #6, 10 Commercial St., Nanaimo BC V9R 5G2, Canada. (866)984-6437. Fax: (866)654-1937. E-mail: kayak@wavelengthmagazine.com. Website: www.WaveLengthMagazine. com. Editor: John Kimantas. Quarterly magazine. Emphasizes safe, ecologically sensitive paddling. For sample copy, see downloadable PDF version on website.

Needs Buys 10 photos from freelancers/issue ("usually only from authors"); 60 photos/year. Needs kayaking shots. Photos should have sea kayak in them, Reviews photos with or without a manuscript. Model/property release preferred. Photo captions preferred.

Specs Prefers digital submissions, but only after query. Send as low-res for assessment.

Making Contact & Terms Send query letter. Provide business card or self-promotion piece to be kept on file for possible future assignments. Responds in 2 months to queries. Absolutely no simultaneous submissions or previously published work accepted. Pays \$100-200 for color cover; \$25-50 for inside. Pays on publication. Credit line given. Buys one-time print rights including electronic archive rights.

Tips "Look at free downloadable version on website and include kayak in picture wherever possible. Always need vertical shots for cover!"

\$\$ WOODMEN LIVING

Woodmen Tower, 1700 Farnam St., Omaha NE 68102. (402)342-1890. Fax: (402)271-7269. E-mail: service@woodmen.com. Website: www.woodmen.org. Editor: Billie Jo Foust. Circ. 480,000. Estab.

1890. Quarterly magazine published by Woodmen of the World/Omaha Woodmen Life Insurance Society, Emphasizes American family life. Sample copy and photo guidelines free.

Needs Buys 10-12 photos/year. Needs photos of the following themes: historic, family, insurance, humorous, photo essay/photo feature, human interest and health. Model release required. Photo captions preferred.

Specs Uses 8 × 10 glossy b&w prints on occasion; 35mm, 21/4 × 21/4, 4 × 5 transparencies; for cover: 4 × 5 transparencies, vertical format preferred. Accepts images in digital format. Send high-res scans via CD.

Making Contact & Terms Send material by mail with SASE for consideration. Responds in 1 month. Previously published work OK. Pays \$500-600 for cover; \$250 minimum for color inside. Pays on acceptance. Credit line given on request. Buys one-time rights.

Tips "Submit good, sharp pictures that will reproduce well."

WHISKEY ISLAND MAGAZINE

Department of English, Cleveland State University, Cleveland OH 44115-2214. (216)687-2056. Fax: (216)687-6943. E-mail: whiskeyisland@csuohio.edu. Website: www.csuohio.edu/whiskey_island/. Contact: Editor. Biannual literary magazine publishing extremely contemporary writing. Sample copy available for \$6. Photo guidelines available for SASE.

Needs Uses 10 photos/issue; 20 photos/year. Interested in mixed media, alternative process, avant garde, fine art. Surreal and abstract are welcome. Do not send sentimental images, "rust-belt" scenes, photos of Cleveland, straight landscapes, or anything that can be viewed as "romantic." Model/property release preferred. Photo captions required; include title of work, photographer's name, address, phone number, e-mail, etc.

Specs Accepts images in digital format. Send via e-mail attachment as individual, high-resolution JPEG files. No TIFFs. No disks.

Making Contact & Terms E-mail with sample images. Do not just send your website link. Does not keep samples on file; responds in 3 months. Pays 2 contributor's copies and a 1-year subscription. Credit line given. Include as much contact information as possible.

\$\$ WINE ENTHUSIAST MAGAZINE

333 North Bedford Rd., Mt. Kisco NY 10549. (914)345-8463. E-mail: mturelli@wineenthusiast.net. Website: www.wineenthusiast.com/mag. Art Director: Marco Turelli.

Needs Needs photos of entertainment, food/drink, wine and spirits. Interested in lifestyle. Reviews photos with or without a manuscript.

Specs Accepts images in digital format. Send JPEG or GIF files.

Making Contact & Terms Pays \$135- \$400/photo. Pays on acceptance.

\$\$ WRITER'S DIGEST

F+W Media, Inc., 4700 E. Galbraith Rd., Cincinnati OH 45236. (513)531-2690, ext. 1432. Fax: (513)891-7153. E-mail: writersdig@fwmedia.com. Website: www.writersdigest.com. Editor: Jessica Strawser. Art Director: Jess Boonstra. Monthly consumer magazine. "Our readers write fiction, nonfiction, plays and scripts. They're interested in improving their writing skills and the ability to sell their work, and finding new outlets for their talents." Photo guidelines free with SASE or via e-mail.

Needs Occasionally buys photos from freelancers. Needs photos of education, hobbies, writing life, business concepts, product shots/still life. Other specific photo needs: photographers to shoot authors on location for magazine cover. Model/property release required. Photo captions required; include your copyright notice.

Specs Uses 8 × 10 color and/or digital (resizable) images. Accepts images in digital format if hired. Send via CD as TIFF, EPS, JPEG files at 300 dpi (at hire).

Making Contact & Terms Prefers postal mail submissions to keep on file. Final art may be sent via e-mail. Buys one-time rights. Pays on acceptance: \$500-1,000 for color cover; \$100-800 for color

inside. Responds only if interested; send nonreturnable samples. Credit line given. Buys one-time rights.

Tips "I like having several samples to look at. Online portfolios are great." "Submissions are considered for other Writer's Digest publications as well. For stock photography, please include pricing/sizes of black & white usage if available."

■ \$\$ W YANKEE MAGAZINE

1121 Main St., P.O. Box 520, Dublin NH 03444. (603)563-8111. E-mail: heatherm@yankeepub.com. Website: www.yankeemagazine.com. Photo Editor: Heather Marcus. Art Director: Leonard Loria. Circ. 500,000. Estab. 1935. Monthly magazine. Emphasizes general interest within New England, with national distribution. Readers are of all ages and backgrounds; majority are actually outside of New England. Sample copy available for \$1.95. Photo guidelines free with SASE or on website. "We give assignments to experienced professionals. If you want to work with us, show us a portfolio of your best work. Contact our Photo Editor, Heather Marcus, before sending any photography to our Art Department. Please do not send any unsolicited original photography or artwork."

Needs Buys 56-80 photos from freelancers/issue; 672-960 photos/year. Needs photos of landscapes/ scenics, wildlife, gardening, interiors/decorating. "Always looking for outstanding photo essays or portfolios shot in New England." Model/property release preferred. Photo captions required; include name, locale, pertinent details.

Making Contact & Terms Submit portfolio for review. Keeps samples on file; include SASE for return of material. Responds in 1 month. Simultaneous submissions and previously published work OK. Pays \$800-1,000 for color cover; \$150-700 for color inside. Credit line given. Buys onetime rights; negotiable.

Tips "Submit only top-notch work. Submit the work you love. Prefer to see focused portfolio, even of personal work, over general 'I can do everything' type of books."

\$ YOUTH RUNNER MAGAZINE

P.O. Box 1156, Lake Oswego OR 97035. (503)236-2524. Fax: (503)620-3800. E-mail: dank@ youthrunner.com. Website: www.youthrunner.com. Editor: Dan Kesterson. Ten issues per year, Features track, cross country and road racing for young athletes, ages 8-18. Photo guidelines available on website.

Needs Uses 30-50 photos/issue. Also uses photos on website daily. Needs action shots from track, cross country and indoor meets. Model release preferred; property release required. Photo captions preferred.

Specs Accepts images in digital format only. Send via e-mail or CD.

Making Contact & Terms Send low-res photos via e-mail first or link to gallery for consideration. Responds to e-mail submissions immediately. Simultaneous submissions OK. Pays \$25 minimum. Credit line given. Buys electronic rights, all rights.

MARKETS

Newspapers & Newsletters

hen working with newspapers, always remember that time is of the essence. Newspapers have various deadlines for each of their sections. An interesting feature or news photo has a better chance of getting in the next edition if the subject is timely and has local appeal. Most of the markets in this section are interested in regional coverage. Find publications near you and contact editors to get an understanding of their deadline schedules.

More and more newspapers are accepting submissions in digital format. In fact, most newspapers prefer digital images. However, if you submit to a newspaper that still uses film, ask the editors if they prefer certain types of film or if they want color slides or black-and-white prints. Many smaller newspapers do not have the capability to run color images, so black-and-white prints are preferred. However, color slides and prints can be converted to black and white. Editors who have the option of running color or black-and-white photos often prefer color film because of its versatility.

Although most newspapers rely on staff photographers, some hire freelancers as stringers for certain stories. Act professionally and build an editor's confidence in you by supplying innovative images. For example, don't get caught in the trap of shooting "grip-and-grin" photos when a corporation executive is handing over a check to a nonprofit organization. Turn the scene into an interesting portrait. Capture some spontaneous interaction between the recipient and the donor. By planning ahead you can be creative.

When you receive assignments, think about the image before you snap your first photo. If you are scheduled to meet someone at a specific location, arrive early and scout around. Find a proper setting or locate some props to use in the shoot. Do whatever you can to show the editor you are willing to make that extra effort.

Always try to retain resale rights to shots of major news events. High news value means high resale value, and strong news photos can be resold repeatedly. If you have an image with national appeal, search for larger markets, possibly through the wire services. You also may find buyers among national news magazines such as *Time* or *Newsweek*.

While most newspapers offer low payment for images, they are willing to negotiate if the image will have a major impact. Front-page artwork often sells newspapers, so don't underestimate the worth of your images.

\$\$ AMERICAN SPORTS NETWORK

Box 6100, Rosemead CA 91770. (626)280-0000. Fax: (626)280-0001. Website: www.fitnessamerica. com. Circ. 873,007. Publishes 4 newspapers covering "general collegiate, amateur and professional sports, i.e., football, baseball, basketball, wrestling, boxing, powerlifting and bodybuilding, fitness, health contests, etc." Also publishes special bodybuilder annual calendar, collegiate and professional football pre-season and post-season editions.

Needs Buys 10-80 photos from freelancers/issue for various publications. Needs "sport action, hard-hitting contact, emotion-filled photos." Model release preferred. Photo captions preferred.

Making Contact & Terms Send 8 × 10 glossy b&w prints, 4 × 5 transparencies, video demo reel, or film work by mail for consideration. Include SASE for return of material. Provide résumé, business card, brochure, flier or tearsheets to be kept on file for possible future assignments. Simultaneous submissions and previously published work OK. Negotiates rates by the job and hour. Pays on publication. Buys first North American serial rights.

■ A □ AQUARIUS

1035 Green St., Roswell GA 30075. (770)641-9055. Fax: (770)641-8502. E-mail: felica@aquariusatlanta.com. Website: www.aquarius-atlanta.com. Publisher/Editor: Gloria Parker. Creative Director: Felica Hicks. Monthly newspaper. Emphasizes "New Age, metaphysical, holistic health, alternative religion; environmental audience primarily middle-aged, college-educated, computerliterate, open to exploring new ideas." "Our mission is to publish a newspaper for the purpose of expanding awareness and supporting all those seeking spiritual growth. We are committed to excellence and integrity in an atmosphere of harmony and love." Sample copy available for SASE. **Needs** "We use photos of authors, musicians, and photos that relate to our articles, but we have no budget to pay photographers at this time. We offer byline in paper, website, and copies." Needs photos of New Age and holistic health, celebrities, multicultural, environmental, religious, adventure, entertainment, events, health/fitness, performing arts, travel, medicine, technology, alternative healing processes. Interested in coverage on environmental issues, genetically altered foods, photos of "anything from Sufi Dancers to Zen Masters." Model/property release required. Photo captions required; include photographer's name, subject's name, and description of content.

Specs Uses color and b&w photos. Accepts images in digital format. Send via Zip, e-mail as JPEG files at 300 dpi.

Making Contact & Terms Send query letter with photocopies and/or tearsheets, or e-mail samples with cover letter. Provide résumé, business card or self-promotion piece to be kept on file for possible future assignments. Pays in copies, byline with contact info (phone number, e-mail address published if photographer agrees).

\$ ARCHAEOLOGY

2660 Petersborough St., Herndon VA 20171. E-mail: shannonaswriter@yahoo.com. Contact: Shannon Murphy. Quarterly magazine. Photo guidelines available via e-mail.

Needs Buys 12 photos from freelancers/issue; 48-72 photos/year. Needs photos of disasters, environmental, landscapes/scenics, wildlife, architecture, cities/urban, education, gardening, interiors/decorating, pets, religious, rural, adventure, events, food/drink, sports, travel, agriculture, medicine, military, political, product shots/still life, science, technology—as related to archaeology. Interested in alternative process, avant garde, documentary, fashion/glamour, fine art, historical/ vintage, seasonal. Wants photos of archaeology sites and excavations in progress that are available for children and teens to visit. "Would like photographs of archaeological sites and excavations, artifacts and Paleobiology." Reviews photos with or without a manuscript. Model/property release preferred.

Specs Uses glossy or matte color and/or b&w prints.

Making Contact & Terms Send query letter via e-mail. "If possible, please do not include photographs in files if they are sent through e-mail. A CD with your photographs sent to Archaeology is acceptable." Write to request guidelines for artwork and illustrations. Provide résumé, business card or self-promotion piece to be kept on file for possible future assignments. "A CD with your photographs is requested but not required. Illustrations and artwork are also accepted." Responds within 1 month to queries; 1 week to portfolios. Simultaneous submissions and previously published work OK. Pays on acceptance. Credit line given. Buys one-time rights, first rights; negotiable.

S \$ CAPPER'S

1503 SW 42nd St., Topeka KS 66609-1265. (800)678-4883. Fax: (800)274-4305. E-mail: editor@ cappers.com. Website: www.cappers.com. Editor-in-Chief: K.C. Compton. Bimonthly magazine. Emphasizes small town life, country lifestyle, or "hobby" farm-oriented material. Readership is national. Sample copy available for \$4.

Needs Buys 24 + photos/year with accompanying stories and articles; 90% from freelancers. Needs, on a regular basis, photos of small-farm livestock, animals, farm labor, gardening, produce and related images. "Be certain pictures are well composed, properly exposed and pin sharp. Must be shot at high resolution (no less than 300 dpi). No cheesecake. No pictures that cannot be shown to any member of the family. No pictures that are out of focus or over- or under-exposed. No ribbon-cutting, check-passing or hand-shaking pictures. Story subjects include all aspects of the hobby or country lifestyle farm, such as livestock, farm dogs, barn cats, sowing and hoeing, small tractors, fences, etc." Photo captions required. "Any image that stands alone must be accompanied by 50-100 words of meaningful caption information."

Specs Uses 35mm, high-resolution digital images. Send digital images via e-mail, one at a time, as JPEG files at 300 dpi resolution.

Making Contact & Terms Study the magazine. "We use a beautiful country scene for 'Reverie,' the last page in each issue. Take a look at previous issues to get a sense of the sort of shot we're looking for." Send material by mail with SASE for consideration. Responds ASAP. Pay is negotiable up to \$1,000 for color cover; \$35-\$200 for color inside; \$25-\$100 for b&w inside. Rarely uses b&w, and only if "irresistibly atmospheric." Pays on publication. Buys shared rights; negotiable.

Tips "This is a relaunch of an old title. You must study the new publication to make sure your submissions are appropriate to Capper's new direction."

M ■ A S CATHOLIC SENTINEL

P.O. Box 18030, Portland OR 97218. (503)281-1191 or (800)548-8749. Website: www.sentinel.org. Circ. 8,000. Weekly newspaper. "We are the newspaper for the Catholic community in Oregon." Sample copies available for SASE. Photo guidelines available via e-mail.

Needs Buys 15 photos from freelancers/issue; 800 photos/year. Needs photos of religious and political subjects. Interested in seasonal. Model/property release preferred. Photo captions required; include names of people shown in photos, spelled correctly.

Specs Prefers images in digital format. Send via e-mail or FTP as TIFF or JPEG files at 300 dpi. Also uses 5 × 7 glossy or matte color and b&w prints; 35mm 2 × 2, 4 × 5, 8 × 10 transparencies.

Making Contact & Terms Send query letter with résumé and tearsheets. Portfolio may be dropped off every Thursday. Keeps samples on file. Responds only if interested; send nonreturnable samples. Simultaneous submissions and previously published work OK. Pays on publication or on receipt of photographer's invoice. Credit line given. Buys first rights and electronic rights.

Tips "We use photos to illustrate editorial material, so all photography is on assignment. Basic knowledge of Catholic Church (e.g., don't climb on the altar) is a big plus. Send accurately spelled cutlines. Prefer images in digital format."

N 🔳 💲 CHILDREN'S DEFENSE FUND

25 E St. NW, Washington DC 20001. (800)233-1200. E-mail: cdfinfo@childrensdefense.org. Website: www.childrensdefense.org. Children's advocacy organization.

Needs Buys 20 photos/year. Buys stock and assigns work. Wants to see photos of children of all ages and ethnicity-serious, playful, poor, middle class, school setting, home setting and health setting. Subjects include babies/children/teens, families, education, health/fitness/beauty. Some location work. Domestic photos only. Model/property release required.

Specs Uses b&w and some color prints. Accepts images in digital format. Send via e-mail as TIFF. EPS, JPEG files at 300 dpi or better.

Making Contact & Terms Provide résumé, business card, self-promotion piece or tearsheets to be kept on file for possible future assignments. Keeps photocopy samples on file. Previously published work OK. Pays on usage. Credit line given. Buys one-time rights; occasionally buys all rights.

Tips Looks for "good, clear focus, nice composition, variety of settings and good expressions on faces."

M S THE CHURCH OF ENGLAND NEWSPAPER

14 Great College St., London SW1P 3RX, United Kingdom. (020)7878 1012. E-mail: subs@ churchnewspaper.com. Website: www.churchnewspaper.com. Circ. 12,000. Weekly religious newspaper. Sample copies available.

Needs Buys 2-3 photos from freelancers/issue; 100 photos/year. Needs political photos. Reviews photos with or without a manuscript. Photo captions required.

Specs Uses glossy color prints; 35mm transparencies.

Making Contact & Terms Does not keep samples on file; include SASE for return of material. Responds only if interested; send nonreturnable samples. Pays on publication. Credit line given. Buys one-right rights.

N S THE CLARION-LEDGER

201 S. Congress St., Jackson MS 39201. (601)961-7073. E-mail: ctodd@clarionledger.com. Website: www.clarionledger.com. Circ. 95,000. Daily newspaper. Emphasizes photojournalism: news, sports, features, fashion, food and portraits. Readers are in a very broad age range of 18-70 years, male and female. Sample copies available.

Needs Buys 1-5 photos from freelancers/issue; 365-1,825 photos/year. Needs news, sports, features, portraits, fashion and food photos. Special photo needs include food and fashion. Model release required. Photo captions required.

Specs Uses 8 × 10 matte b&w and/or color prints; 35mm slides/color negatives. Accepts images in digital format. Send via CD, e-mail as JPEG files at 200 dpi.

Making Contact & Terms Provide résumé, business card, brochure, flier or tearsheets to be kept on file for possible future assignments. Pays on publication. Credit line given. Buys one-time or all rights; negotiable.

\$\$ @ EQUIPMENT JOURNAL

Canada's National Equipment Newspaper, 5160 Explorer Dr., Unit 6, Mississauga ON L4W 4T7, Canada. (800)667-8541. E-mail: Editor@Equipmentjournal.com. Website: www.Equipmentjournal. com. Editor: Nathan Medcalf. Estab. 1964. Circ. 23,000. "We are Canada's national heavy equipment newspaper. We focus on the construction, material handling, mining, forestry and onhighway transportation industries."

Needs Reviews 4 × 6 prints. Identification of subjects required. Buys one-time rights. Negotiates payment individually. Responds in 1 week.

Making Contact & Terms Send query letter. Will respond if interested.

A \$ FULTON COUNTY DAILY REPORT

190 Pryor St. SW, Atlanta GA 30303. (404)521-1227. Fax: (404)659-4739. E-mail: ibennitt@alm. com. Website: www.dailyreportonline.com. Art Director: Jason R. Bennitt. Daily newspaper (5 times/week). Emphasizes legal news and business. Readers are male and female professionals,

age 25+, involved in legal field, court system, legislature, etc. Sample copy available for \$2 with $9\frac{3}{4} \times 12\frac{3}{4}$ SAE and 6 first-class stamps.

Needs Buys 1-2 photos from freelancers/issue; 260-520 photos/year. Needs informal environmental photographs of lawyers, judges and others involved in legal news and business. Some real estate, etc. Photo captions preferred; include complete name of subject and date shot, along with other pertinent information. Two or more people should be identified from left to right.

Specs Accepts images in digital format. Send via CD or e-mail as JPEG files at 200-600 dpi.

Making Contact & Terms Submit portfolio for review. Mail or e-mail samples. Keeps samples on file. Simultaneous submissions and previously published work OK. "Freelance work generally done on an assignment-only basis." Pays \$75-100 for color cover; \$50-75 for color inside. Credit line given.

Tips Wants to see ability with "casual, environmental portraiture, people—especially in office settings, urban environment, courtrooms, etc.-and photojournalistic coverage of people in law or courtroom settings." In general, needs "competent, fast freelancers from time to time around the state of Georgia who can be called in at the last minute. We keep a list of them for reference. Good work keeps you on the list." Recommends that "when shooting for FCDR, it's best to avoid law-book-type photos if possible, along with other overused legal clichés."

M A S GRAND RAPIDS BUSINESS JOURNAL

549 Ottawa Ave. NW, Suite 201, Grand Rapids MI 49503. (616)459-4545. Fax: (616)459-4800. E-mail: production@geminipub.com. Website: www.grbj.com. Circ. 6,000. Weekly tabloid. Emphasizes West Michigan business community. Sample copy available for \$1.

Needs Buys 5-10 photos from freelancers/issue; 520 photos/year. Needs photos of local community, manufacturing, world trade, stock market, etc. Model/property release required. Photo captions required.

Making Contact & Terms Send query letter with résumé of credits, stock list. Responds in 1 month. Simultaneous submissions and previously published work OK. Pays on publication. Credit line given. Buys one-time rights and first North American serial rights; negotiable.

6113 State Highway 5, PO Box 121, Palatine Bridge NY 13428, United States. 518-673-3237 or 800-836-2888. Fax: 518-673-3245. E-mail: jcasey@leepub.com. Website: www.hardhat.com. Circ. 60,000. Biweekly trade newspaper for heavy construction. Readership includes owners, managers, senior construction trades. Photo guidelines available via e-mail only.

Needs Buys 12 photos from freelancers/issue; 280 photos/year. Specific photo needs: heavy construction in progress, construction people. Reviews photos with accompanying manuscripts only. Property release preferred. Photo captions required.

Specs "Only hi-res digital photographs." Send via e-mail as JPEG files at 300 dpi.

Making Contact & Terms "E-mail only." Simultaneous submissions OK. Pays on publication. Credit line given. Buys first rights.

Tips "Include caption and brief explanation of what picture is about."

THE LAWYERS WEEKLY

123 Commerce Valley Dr. E., Suite 700, Markham ON L3T 7W8, Canada. (905)479-2665 or (800)668-6481. Fax: (905)479-3758. E-mail: tim.wilbur@lexisnexis.ca. Website: www.thelawyersweekly.ca. Needs Uses 12-20 photos/issue; 5 supplied by freelancers. Needs head shots of lawyers and judges

mentioned in stories, as well as photos of legal events.

Specs Accepts images in digital format. Send as JPEG, TIFF files.

Making Contact & Terms Provide résumé, business card, brochure, flier or tearsheets to be kept on file for possible future assignments. Deadlines: 1- to 2-day turnaround time. Does not keep samples on file; include SASE for return of material. Responds only when interested. Pays on acceptance. Credit line not given.

Tips "We need photographers across Canada to shoot lawyers and judges on an as-needed basis. Send a résumé, and we will keep your name on file. Mostly black-and-white work."

■ A S THE LOG NEWSPAPER

17782 Cowan, Suite A, Irvine CA 92614. (949)660-6150. Fax: (949)660-6172. E-mail: eston@ goboating.com. Website: www.thelog.com.

Needs Buys 15-18 photos from freelancers/issue; 390-468 photos/year. Needs photos of marinerelated, historic sailing vessels, sailing/boating in general. Photo captions required; include location, name and type of boat, owner's name, race description if applicable.

Specs Accepts images in digital format. Send via e-mail as TIFF, EPS, JPEG files at 300 dpi or greater.

Making Contact & Terms Simultaneous submissions and previously published work OK. Pays on publication. Credit line given. Buys all rights; negotiable.

Tips "We want timely and newsworthy photographs! We always need photographs of people enjoying boating, especially power boating. Ninety-five percent of our images are of California subjects."

\$ NATIONAL MASTERS NEWS

P.O. Box 1117, Orangevale CA 95662. (916)989-6667. E-mail: nminfo@nationalmastersnews.com. Website: www.nationalmastersnews.com. Circ. 8,000. Monthly tabloid. Official world and U.S. publication for Masters (ages 30 and over)-track and field, long distance running, and race walking. Sample copy free with 9 × 12 SASE.

Needs Uses 25 photos/issue; 30% assigned and 70% from freelance stock. Needs photos of Masters athletes (men and women over age 30) competing in track and field events, long distance running races or racewalking competitions. Photo captions required.

Making Contact & Terms Send any size matte or glossy b&w prints by mail for consideration; include SASE for return of material. Responds in 1 month. Simultaneous submissions and previously published work OK. Pays on publication. Credit line given. Buys one-time rights.

\$\$ NEW YORK TIMES MAGAZINE

620 Eighth Ave, New York NY 10018. (212)556-7434. E-mail: thearts@nytimes.com. Website: www. nytimes.com. **Photo Editor:** Kathy Ryan. Circ. 1.8 million. Weekly newspaper.

Needs Number of freelance photos purchased varies. Model release required. Photo captions required.

Making Contact & Terms "Please Fed Ex all submissions." Include SASE for return of material. Responds in 1 week. Pays \$345 for full page; \$260 for half page; \$230 for quarter page; \$400/job (day rates); \$750 for color cover. **Pays on acceptance.** Credit line given. Buys one-time rights.

■ THE NEW YORK TIMES ON THE WEB

500 7th Ave., New York NY 10018. E-mail: webeditor@nytimes.com. Website: www.nytimes.com. Circ. 1.3 million. Daily newspaper. "Covers breaking news and general interest." Sample copy available for SAE or on website.

Needs Needs photos of celebrities, architecture, cities/urban, gardening, interiors/decorating, industry, medicine, military, political, product shots/still life, science, technology/computers, disasters, environmental, landscapes/scenics, wildlife, automobiles, entertainment, events, food/ drink, health/fitness/beauty, hobbies, performing arts, sports, travel, alternative process, avant garde, documentary, fashion/glamour, fine art, breaking news. Model release required. Photo captions required.

Specs Accepts images in digital format. Send via CD, e-mail as TIFF, JPEG files.

Making Contact & Terms E-mail query letter with link to photographer's website. Provide business card, self-promotion piece to be kept on file for possible future assignments. Simultaneous submissions OK. Pays on publication. Credit line given. Buys one-time rights and electronic rights.

■ A S TREETPEOPLE'S WEEKLY NEWS

E-mail: sw_n@yahoo.com. **Publisher:** Lon G. Dorsey, Jr. Newspaper. Sample copy no longer available temporarily. Photo guidelines package now required. Photo guidelines package now required. Now free when submitting samples of work. "Seeking help to launch homeless television show and photo gallery."

• *SW News* wishes to establish relationships with professionals interested in homeless issues. "Photographers may be certified by *SWN* by submitting samples of work. Photographers needed in every metropolitan city in U.S."

Needs Wants photos of babies/children/teens, celebrities, couples, multicultural, families, parents, senior citizens, cities/urban, education, pets, religious, rural, events, food/drink, health/fitness, hobbies, humor, political, technology/computers. Interested in alternative process, documentary, fine art, historical/vintage, seasonal. Subjects include: photojournalism on homeless or street people. Model/property release required. "All photos *must* be accompanied by *signed* model releases." Photo captions required.

Specs Accepts images in digital format. Send via CD, e-mail as GIF, JPEG files. Items to be considered for publishing must be in PDF. Write first to gain clearance to publisher.

Making Contact & Terms "Hundreds of photographers are needed to show national state of America's homeless." Send unsolicited photos by mail for consideration with SASE for return. Responds promptly. Pays \$15-450 for cover; \$15-150 for inside. Pays extra for electronic usage (negotiable). Pays on acceptance or publication. Credit line sometimes given. Buys all rights; negotiable.

Tips "In freelancer's samples, wants to see professionalism, clarity of purpose, without sex or negative atmosphere which could harm purpose of paper." The trend is toward "kinder, gentler situations, the 'let's help our fellows' attitude." To break in, "find out what we're about so we don't waste time with exhaustive explanations. We're interested in all homeless situations. Inquiries not answered without SASE. **All persons interested in providing photography should get registered with us.** Now using 'Registered photographers and Interns of *SWNews*' for publishing and upcoming Internet worldwide awards competition. Info regarding competition is outlined in *SWN*'s photo guidelines package. Photographers not registered will not be considered due to the continuous sending of improper materials, inadequate information, wasted hours of screening matter, etc. **If you don't wish to register with us, please don't send anything for consideration.** You'll find that many professional pubs are going this way to reduce the materials management pressures which have increased. We are trying something else new—salespeople who are also photographers. So, if you have a marketing/sales background with a photo kicker, contact us!"

N ■ \$ 2 SUN

1000 American Media Way, Boca Raton FL 33464-1000. Weekly tabloid. Readers are housewives, college students, middle Americans. Sample copy free with extra-large SASE.

Needs Buys 30 photos from freelancers/issue; 1,560 photos/year. Wants varied subjects: prophesies and predictions, amazing sightings (i.e., Jesus, Elvis, angels), stunts, unusual pets, health remedies, offbeat medical, human interest, inventions, spectacular sports action; offbeat pix and stories; and celebrity photos. "Also—we are always in need of interesting, offbeat, humorous stand-alone pics." Model release preferred. Photo captions preferred.

Specs Uses 8 × 10 b&w prints; 35mm transparencies. Accepts images in digital format.

Making Contact & Terms Send query letter with stock list and samples. Responds in 2 weeks. Simultaneous submissions and previously published work OK. Pays on publication. Buys one-time rights.

Tips "We are specifically looking for the unusual, offbeat, freakish true stories and photos. *Nothing* is too far out for consideration. We suggest you send for a sample copy and take it from there."

■ S THE SUNDAY POST

2 Albert Square, Dundee DD1 9QJ, Scotland. (44)(1382)223131. Fax: (44)(1382)201064. E-mail: amorrison@sundaypost.com. Website: www.sundaypost.com. External Content Taster: Alan Morrison. Readership 901,000. Weekly family newspaper.

Needs Needs photos of "UK news and news involving Scots," sports. Other specific needs: exclusive news pictures from the UK, especially Scotland. Reviews photos with accompanying manuscript only. Model/property release preferred. Photo captions required; include contact details, subjects, date. "Save in the caption field of the file info, so they can be viewed on our picture desk system. Mac users should ensure attachments are PC-compatible as we use PCs."

Specs Prefers images in digital format. Send via e-mail as JPEG files. "We need a minimum 5MB file saved at quality level 9/70% or above, ideally at 200 ppi/dpi."

Making Contact & Terms Send query letter with tearsheets, stock list. Does not keep samples on file; include SASE for return of material. Responds in 2 weeks to queries. Simultaneous submissions OK. Pays \$100 (USD) for b&w or color cover; \$100 (USD) for b&w or color inside. Pays on publication. Credit line not given. Buys single use, all editions, one date, worldwide rights; negotiable.

Tips "Offer pictures by e-mail before sending: lo-res only, please—72 ppi, 800 pixels on the widest side; no more than 10 at a time. Make sure the daily papers aren't running the story first and that it's not being covered by the Press Association (PA). We get their pictures on our contracted feed."

N \$ 2 SYRACUSE NEW TIMES

1415 W. Genesee St., Syracuse NY 13204. (315)422-7011. Website: www.syracusenewtimes.com. Circ. 46,000. Weekly newspaper covering alternative arts and entertainment. Sample copy available for 8 × 10 SASE.

Needs Photos of performing arts. Interested in alternative process, fine art, seasonal. Reviews photos with or without a manuscript. Model/property release required. Photo captions required; include names of subjects.

Specs Uses 5×7 b&w prints; 35mm transparencies.

Making Contact & Terms Send query letter with résumé, stock list. Does not keep samples on file; include SASE for return of material. Responds in 6 weeks. Responds only if interested; send nonreturnable samples. Previously published work OK. Pays on publication. Credit line given. Buys one-time rights.

Tips "Realize the editor is busy and responds as promptly as possible."

🛂 🗏 \$\$ TORONTO SUN PUBLISHING

333 King St. E., Toronto ON M5A 3X5, Canada. (416)947-2399. Fax: (416)947-1664. E-mail: jim.thomson@sunmedia.ca. Website: www.torontosun.com. Circ. 180,000. Daily newspaper. Emphasizes sports, news and entertainment. Sample copy free with SASE.

Needs Uses 30-50 photos/issue; occasionally uses freelancers (spot news pics only). Needs photos of Toronto personalities making news out of town. Also disasters, beauty, sports, fashion/glamour. Reviews photos with or without a manuscript. Photo captions preferred.

Specs Accepts images in digital format. Send via CD or e-mail.

Making Contact & Terms Arrange a personal interview to show portfolio. Send any size color prints; 35mm transparencies; press link digital format. Deadline: 11 p.m. daily. Does not keep samples on file. Responds in 1-2 weeks. Simultaneous submissions and previously published work OK. Pays on publication. Credit line given. Buys one-time and other negotiated rights.

Tips "The squeaky wheel gets the grease when it delivers the goods. Don't try to oversell a questionable photo. Return calls promptly."

N \$ VELONEWS

1830 55th St., Boulder CO 80301. (303)440-0601 or (800)811-4210. Fax: (303)444-6788. E-mail: coehring@competitorgroup.com. Website: www.velonews.com. Paid circ. 55,000. Covers road racing, mountain biking and recreational riding. Sample copy free with 9 × 12 SASE.

Needs Uses photos of bicycle racing (road, mountain and track). "Looking for action and feature shots that show the emotion of cycling, not just finish-line photos with the winner's arms in the air." No bicycle touring. Photos purchased with or without accompanying manuscript. Uses news, features, profiles. Photo captions required.

Specs Uses negatives and transparencies.

Making Contact & Terms Send samples of work or tearsheets with assignment proposal. Query first. Pays on publication. Credit line given. Buys one-time rights.

Tips "Photos must be timely."

N 🔳 \$ VENTURA COUNTY REPORTER

Dept. PM, 700 E. Main St., Ventura CA 93001. (805)648-2244. Fax: (805)648-2245. E-mail: artdirector@ vcreporter.com. Website: www.vcreporter.com. Circ. 35,000. Weekly tabloid newspaper.

Needs Uses 12-14 photos/issue; 40-45% supplied by freelancers. "We require locally slanted photos (Ventura County, CA)." Model release required.

Specs Accepts images in digital format. Send via e-mail or CD.

Making Contact & Terms Send sample b&w or color original photos; include SASE for return of material. Simultaneous submissions OK. Pays on publication. Credit line given. Buys one-time rights.

\$ THE WASHINGTON BLADE

529 14th St. NW, Ste. 545, Washington DC 20045. (202)797-7000. Fax: (202)797-2070. E-mail: lbrown@washblade.com; knaff@washblade.com. Website: www.washingtonblade.com. Editor: Kevin Naff. Weekly tabloid for and about the gay community. Readers are gay men and lesbians; moderate- to upper-level income; primarily Washington, DC, metropolitan area. Sample copy free with 9×12 SAE plus 11 first-class stamps.

• The Washington Blade stores images on CD; manipulates size, contrast, etc.-but not content.

Needs Uses about 6-7 photos/issue. Needs "gay-related news, sports, entertainment, events; profiles of gay people in news, sports, entertainment, other fields." Photos purchased with or without accompanying manuscript. Model release preferred. Photo captions preferred,

Specs Accepts images in digital format. Send via e-mail.

Making Contact & Terms Send query letter with résumé of credits. Provide résumé, business card and tearsheets to be kept on file for possible future assignments. Responds in 1 month. Simultaneous submissions and previously published work OK. Pays \$10 fee to go to location, \$15/ photo, \$5/reprint of photo; negotiable. Pays within 30 days of publication. Credit line given. Buys all rights when on assignment, otherwise one-time rights.

Tips "Be timely! Stay up-to-date on what we're covering in the news, and call if you know of a story about to happen in your city that you can cover. Also, be able to provide some basic details for a caption (tell us what's happening, too)." Especially important to "avoid stereotypes."

N 🔳 \$ WATERTOWN PUBLIC OPINION

120 3rd Avenue NW, P.O. Box 10, Watertown SD 57201. (605)886-6901. Fax: (605)886-4280. E-mail: itf@thepublicopinion.com. Website: www.thepublicopinion.com. Circ. 15,000. Daily newspaper. Emphasizes general news of the region; state, national and international news.

Needs Uses up to 8 photos/issue. Reviews photos with or without a manuscript. Model release required. Photo captions required.

Specs Uses b&w or color prints. Accepts images in digital format. Send via CD.

Making Contact & Terms Send unsolicited photos by mail for consideration. Does not keep samples on file; include SASE for return of material, Responds in 1-2 weeks, Simultaneous submissions OK. Pays on publication. Credit line given. Buys one-time rights; negotiable.

☑ ■ \$ ☑ THE WESTERN PRODUCER

P.O. Box 2500, Saskatoon SK S7K 2C4, Canada. (306)665-9629. Fax: (306)933-9536. E-mail: robert.magnell@producer.com. Website: www.producer.com. Circ. 70,000. Weekly newspaper. Emphasizes agriculture and rural living in western Canada. Photo guidelines free with SASE. Needs Buys 5-8 photos from freelancers/issue; 260-416 photos/year. Needs photos of farm families,

environmental, gardening, science, livestock, nature, human interest, scenic, rural, agriculture, day-to-day rural life and small communities. Interested in documentary, Model/property release preferred. Photo captions required; include person's name, location, and description of activity. Specs Accepts images in digital format. Send via CD, Zip, e-mail as TIFF, EPS, PICT files at 300

dpi.

Making Contact & Terms Send material for consideration by mail or e-mail to the attention of the news editor; include SASE for return of material if sending by mail. Previously published work OK, "but let us know." Pays on publication. Credit line given. Buys one-time rights.

Tips Needs current photos of farm and agricultural news. "Don't waste postage on abandoned, derelict farm buildings or sunset photos. We want modern scenes with life in them—people or animals, preferably both." Also seeks items on agriculture, rural western Canada, history and contemporary life in rural western Canada.

MARKETS

Trade Publications

ost trade publications are directed toward the business community in an effort to keep readers abreast of the ever-changing trends and events in their specific professions. For photographers, shooting for these publications can be financially rewarding and can serve as a stepping stone toward acquiring future assignments.

As often happens with this category, the number of trade publications produced increases or decreases as professions develop or deteriorate. In recent years, for example, magazines involving new technology have flourished as the technology continues to grow and change.

Trade publication readers are usually very knowledgeable about their businesses or professions. The editors and photo editors, too, are often experts in their particular fields. So, with both the readers and the publications' staffs, you are dealing with a much more discriminating audience. To be taken seriously, your photos must not be merely technically good pictures, but also should communicate a solid understanding of the subject and reveal greater insights.

In particular, photographers who can communicate their knowledge in both verbal and visual form will often find their work more in demand. If you have such expertise, you may wish to query about submitting a photo/text package that highlights a unique aspect of working in a particular profession or that deals with a current issue of interest to that field.

Many photos purchased by these publications come from stock—both freelance inventories and stock photo agencies. Generally, these publications are more conservative with their freelance budgets and use stock as an economical alternative. For this reason, some listings in this section will advise sending a stock list as an initial method of contact. (See sample stock list on page 17.) Some of the more established publications with larger circulations and advertising bases will sometimes offer assignments as they become familiar with a particular photographer's work. For the most part, though, stock remains the primary means of breaking in and doing business with this market.

■ S S AAP NEWS

141 Northwest Point Blvd., Elk Grove Village IL 60007. (847)434-4755. Fax: (847)434-8000. E-mail: mhayes@aap.org. Website: www.aapnews.org. Art Director/Production Coordinator: Michael Hayes. Estab. 1985. Monthly tabloid newspaper. Publication of American Academy of Pediatrics.

Needs Uses 60 photos/year. Needs photos of babies/children/teens, families, health/fitness, sports, travel, medicine, pediatricians, health care providers—news magazine style. Interested in documentary. Model/property release required as needed. Photo captions required; include names, dates, locations and explanations of situations.

Specs Accepts images in digital format. Send via CD, floppy disk, Jaz, Zip, e-mail as TIFF, EPS, JPEG files at 300 dpi.

Making Contact & Terms Provide résumé, business card or tearsheets to be kept on file (for 1 year) for possible future assignments. Cannot return material. Simultaneous submissions and previously published work OK. Pays \$50-150 for one-time use of photo. Pays on publication. Buys one-time or all rights; negotiable.

Tips "We want great photos of 'real' children in 'real-life' situations; the more diverse the better."

■ \$\$\$\$ ☑ ABA BANKING JOURNAL

Simmons-Boardman Publishing Corp., 345 Hudson St., 12th Floor, New York NY 10014. (212)620-7200. E-mail: bstreeter@sbpub.com. Website: www.ababj.com. Creative Director: Wendy Williams. Art Director: Phil Desiere. Circ. 30,000. Estab. 1909. Monthly magazine. Emphasizes "how to manage a bank better. Bankers read it to find out how to keep up with changes in regulations, lending practices, investments, technology, marketing and what other bankers are doing to increase community standing."

Needs Buys 6 photos/year; freelance photography is 20% assigned, 80% from stock. Personality, and occasionally photos of unusual bank displays or equipment. "We need candid photos of various bankers who are subjects of articles." Photos purchased with accompanying manuscript or on assignment.

Specs Uses 35mm transparencies. Accepts images in digital format. Send via CD, e-mail as CMYK JPEG files at 300 dpi.

Making Contact & Terms Send query letter with samples, postcards; include SASE for return of material. Responds in 1 month. Pays \$400-1,500/photo. **Pays on acceptance**. Credit line given. Buys one-time rights.

Tips "Send postcard. We hire by location, city."

■

Advanstar Communications, 7500 Old Oak Blvd., Cleveland OH 44130. (818)227-4435. Fax: (440)891-2675. E-mail: bchernin@advanstar.com. Website: www.aftermarketbusiness.com. The mission of Aftermarket Business World (formerly Aftermarket Business) involves satisfying the needs of U.S. readers who want to do business here and elsewhere and helping readers in other countries who want to do business with U.S. companies. "Being an electronic publication assures us that we can reach just about anybody, anywhere." New editorial material for Aftermarket Business World will focus on news, trends and analysis about the international automotive aftermarket. The publication features a new column, "Beyond Borders," by Karen Fierst, a well-known and well-traveled global consultant. Fierst's monthly column provides in-depth understanding of countries around the world including the cultural, political, marketing and logistical information that make each country unique. Written for corporate executives and key decision-makers responsible for buying automotive products (parts, accessories, chemicals) and other services sold at retail to consumers and professional installers. It's the oldest continuously published business magazine covering the retail automotive aftermarket and is the only publication dedicated to the specialized needs of this industry." Sample copies available; call (888)527-7008 for rates.

Needs Buys 0-1 photo from freelancers/issue; 12-15 photos/year. Needs photos of automobiles, product shots/still life. "Review our editorial calendar to see what articles are being written. We use lots of conceptual material." Model/property release preferred.

Specs Prefers images in digital format. Send via CD, Zip, e-mail as TIFF, JPEG files at 300 dpi. Also uses 35mm, $2\frac{1}{4} \times 2\frac{1}{4}$ transparencies.

Making Contact & Terms Send query letter with slides, transparencies, stock list. Provide business card or self-promotion piece to be kept on file for possible future assignments. Responds only if interested; send nonreturnable samples. Pay negotiable. Pays on publication. Credit line given. "Corporate policy requires all freelancers to sign a print and online usage contract for stories and photos." Usually buys one-time rights.

Tips "We can't stress enough the importance of knowing our audience. We are not a magazine aimed at car dealers. Our readers are auto parts distributors. Looking through sample copies will show you a lot about what we need. Show us a variety of stock and lots of it. Send only dupes."

■ S \$ AIR LINE PILOT

535 Herndon Pkwy., Box 20172, Box 20172, Herndon VA 22070. (703)481-4460. Fax: (703)464-2114. E-mail: magazine@alpa.org. Website: www.alpa.org. **Publications Manager:** Pete Janhunen. Circ. 72,000. Estab. 1932. Publication of Air Line Pilots Association. 10 issues/year. Emphasizes news and feature stories for airline pilots. Photo guidelines available on website.

Needs Buys 3-4 photos from freelancers/issue; 18-24 photos/year. Needs dramatic 35mm transparencies, prints or high-resolution IBM-compatible images on disk or CD of commercial aircraft, pilots and co-pilots performing work-related activities in or near their aircraft. "Pilots must be ALPA members in good standing. Our editorial staff can verify status." Special needs include dramatic images technically and aesthetically suitable for full-page magazine covers. Especially needs vertical composition scenes. Model release required. Photo captions required; include aircraft type, airline, location of photo/scene, description of action, date, identification of people and which airline they work for. "Our greatest need is for strikingly original cover photographs featuring ALPA flight deck crew members and their airlines in their operating environment. See list of airlines with ALPA Pilots online."

Specs Accepts images in digital format. Uses original 35mm or larger slides; Fuji Velvia 50 film preferred.

Making Contact & Terms Send query letter with samples. Send unsolicited photos by mail with SASE for consideration. "Currently use 2 local outside vendors for assignment photography. Occasionally need professional 'news' photographer for location work. Most freelance work is on speculative basis only." No simultaneous submissions. Pays \$350 for cover (buys all rights); Fees for inside are negotiable (buys one-time rights). **Pays on acceptance**.

Tips In photographer's samples, wants to see "strong composition, poster-like quality and high technical quality. Photos compete with text for space, so they need to be very interesting to be published. Be sure to provide brief but accurate caption information and send only professional-quality work. Cover images should show airline pilots at work or in the airport going to work. For covers, please shoot vertical images. Check website for criteria and requirements. Send samples of slides to be returned upon review. Make appointment to show portfolio."

AMERICAN BAR ASSOCIATION JOURNAL

321 N. Clark St., 15th Floor, Chicago IL 60610. Fax: (312)988-6025. E-mail: releases@abanet. org; abajournal@abanet.org. Website: www.abajournal.com. **Contact:** Sarah Randag. Monthly magazine of the American Bar Association. Emphasizes law and the legal profession. Readers are lawyers. Photo guidelines available.

Needs Buys 45-90 photos from freelancers/issue; 540-1,080 photos/year. Needs vary; mainly shots of lawyers and clients by assignment only.

Specs Prefers digital images sent via CD as TIFF files at 300 dpi.

Making Contact & Terms "Send us your website address to view samples. If samples are good, portfolio will be requested." Cannot return unsolicited material. Payment negotiable. Credit line given. Buys one-time rights.

Tips "NO PHONE CALLS. The ABA Journal does not hire beginners."

\$ AMERICAN BEE JOURNAL

51 S. Second St., Hamilton IL 62341. (217)847-3324. Fax: (217)847-3660. E-mail: editor@ americanbeejournal.com. Website: www.americanbeejournal.com. Editor: Joe B. Graham. Estab. 1861. Monthly trade magazine. Emphasizes beekeeping for hobby and professional beekeepers. Sample copy free with SASE.

Needs Buys 1-2 photos from freelancers/issue; 12-24 photos/year. Needs photos of beekeeping and related topics, beehive products, honey and cooking with honey. Special needs include color photos of seasonal beekeeping scenes. Model release preferred. Photo captions preferred.

Making Contact & Terms Send query e-mail with samples. Send thumbnail samples to e-mail. Send 5 × 7 or 81/2 × 11 color prints by mail for consideration; include SASE for return of material. Responds in 2 weeks. Pays \$75 for color cover; \$25 for color inside. Pays on publication. Credit line given. Buys all rights.

■ **S** AMERICAN POWER BOAT ASSOCIATION

17640 E. Nine Mile Rd., Box 377, Eastpointe MI 48021-0377. (586)773-9700. Fax: (586)773-6490. E-mail: propeller@apba-racing.com. Website: www.apba-racing.com. Publications Editor: Tana Moore, Estab. 1903. Sanctioning body for US power boat racing; monthly magazine. Majority of assignments made on annual basis. Photos used in monthly magazine, brochures, audiovisual presentations, press releases, programs and website.

Needs Needs photos of APBA boat racing—action and candid. Interested in documentary, historical/ vintage. Photo captions or class/driver ID required.

Specs Accepts images in digital format. Send via CD, e-mail as TIFF, EPS, JPEG files at 300 dpi. Making Contact & Terms Initial personal contact preferred. Suggests initial contact by e-mail, letter or phone, possibly to be followed by evaluating samples. Provide business card to be kept on file for possible future assignments. Responds in 2 weeks when needed. Payment varies. Standard is \$25 for color cover; \$15 for interior pages. Credit line given. Buys one-time rights; negotiable. Photo usage must be invoiced by photographer within the month incurred.

Tips Prefers to see selection of shots of power boats in action or pit shots, candids, etc., (all identified). Must show ability to produce clear color action shots of racing events. "Send a few samples with introduction letter, especially if related to boat racing."

\$ ANIMAL SHELTERING

HSUS, 2100 L St. NW, Washington DC 20037. Phone: (301) 258-3008. Fax: (301)721-6468. E-mail: sbrannigan@hsus.org; asm@hsus.org. Website: www.animalsheltering.org. Editor: Carrie Allan. Production/Marketing Manager: Shevaun Brannigan. Bimonthly magazine of The Humane Society of the United States. Emphasizes animal protection. Readers are animal control workers, shelter workers, animal rescuers, volunteers, veterinarians, men and women, all ages. Sample copy

Needs Buys about 2-10 photos from freelancers/issue; 30 photos/year. Needs photos of domestic animals interacting with animal control and shelter workers; animals in shelters, including farm animals and wildlife; general public visiting shelters and adopting animals; humane society work, functions, and equipment. Photo captions preferred.

Specs Accepts color images in digital or print format. Send via CD, Zip, e-mail as TIFF, JPEG files at 300 dpi.

Making Contact & Terms Provide samples of work to be kept on file for possible future use or assignments; include SASE for return of material. Responds in 1 month. Pays \$150 for cover; \$75 for inside. Pays on publication. Credit line given. Buys one-time and electronic rights.

Tips "We almost always need good photos of people working with animals in an animal shelter or in the field. We do not use photos of individual dogs, cats and other companion animals as often as we use photos of people working to protect, rescue or care for dogs, cats and other companion animals. Contact us for upcoming needs."

Aircraft Owners and Pilots Association, 421 Aviation Way, Frederick MD 21701. (301)695-2371. Fax: (301)695-2180. E-mail: pilot@aopa.org; mike.kline@aopa.org. Website: www.aopa.org. **Design Director:** Michael Kline. Circ. 400,000. Estab. 1958. Monthly association magazine. "The world's largest aviation magazine. The audience is primarily pilot and aircraft owners of General Aviation airplanes." Sample copies and photo guidelines available.

Needs Buys 5-25 photos from freelancers/issue; 60-300 photos/year. Needs photos of couples, adventure, travel, industry, technology. Interested in documentary. Reviews photos with or without a manuscript. Model/property release preferred. Photo captions preferred.

Specs Uses images in digital format. Send via CD, DVD as TIFF, EPS, JPEG files at 300 dpi. *AOPA Pilot* prefers original 35mm color transparencies (or larger), although high-quality color enlargements sometimes can be used if they are clear, sharp, and properly exposed. (If prints are accepted, the original negatives should be made available.) Slides should be sharp and properly exposed; slower-speed films (ISO 25 to ISO 100) generally provide the best results. We are not responsible for unsolicited original photographs; send duplicate slides and keep the original until we request it.

Making Contact & Terms Send query letter. Provide self-promotion piece to be kept on file for possible future assignments. Responds only if interested; send nonreturnable samples. Pays \$800-2,000 for color cover; \$200-720 for color inside. **Pays on acceptance.** Credit line given. Buys one-time, all rights; negotiable.

Tips "A knowledge of our subject matter, airplanes, is a plus. Show range of work and not just one image."

\$ APPALOOSA JOURNAL

2720 W. Pullman Rd., Moscow ID 83843. (208)882-5578. Fax: (208)882-8150. E-mail: artdirector@appaloosajournal.com; editor@appaloosajournal.com. Website: www.appaloosajournal.com. Editor: Dana Russell. Circ. 22,000. Estab. 1946. Monthly association magazine. "Appaloosa Journal is the official publication of the Appaloosa Horse Club. We are dedicated to educating and entertaining Appaloosa enthusiasts from around the world." Readers are Appaloosa owners, breeders and trainers, child through adult. Complimentary sample copies available. Photo guidelines free with SASE or online.

Needs Buys 3 photos from freelancers/issue; 36 photos/year. Needs photos for cover, and to accompany features and articles. Specifically wants photographs of high-quality Appaloosa horses, especially in winter scenes. Model release required. Photo captions required.

Specs Uses glossy color prints; 35 mm transparencies; digital images 300 + dpi at 5×7 inches or larger, depending on use.

Making Contact & Terms Send query letter with résumé, slides, prints, or e-mail as PDF or GIF. Keeps samples on file. Responds only if interested; send nonreturnable samples. Simultaneous submissions OK. Pays \$200 for color cover; \$25 minimum for color inside. **Pays on publication**. Credit line given. Buys first rights.

Tips "The Appaloosa Horse Club is a not-for-profit organization. Serious inquiries within specified budget only." In photographer's samples, wants to see "high-quality color photos of world-class, characteristic (coat patterned) Appaloosa horses in appealing, picturesque outdoor environments. Send a letter introducing yourself and briefly explaining your work. If you have inflexible preset fees, be upfront and include that information. Be patient. We are located at the headquarters; although an image might not work for the magazine, it might work for other printed materials.

Work has a better chance of being used if allowed to keep on file. If work must be returned promptly, please specify. Otherwise, we will keep it for other departments' consideration."

\$\$ AOUA MAGAZINE

4130 Lien Rd., Madison WI 53704-3602. (608)249-0186. Fax: (608)249-1153. E-mail: scott@ aguamagazine.com. Website: www.aguamagazine.com. Art Director: Scott Maurer. The Business Publication for Spa & Pool Professionals. Athletic Business Publications, Inc. Monthly magazine. "AQUA serves spa dealers, swimming pool dealers and/or builders, spa/swimming pool maintenance and service, casual furniture/patio dealers, landscape architects/designers and others allied to the spa/swimming pool market. Readers are qualified owners, GM, sales directors, titled personnel." **Needs** Photos of residential swimming pools and/or spas (hot tubs) that show all or part of pool/ spa. "The images may include grills, furniture, gazebos, ponds, water features." Photo captions including architect/builder/designer preferred.

Making Contact & Terms "OK to send promotional literature, and to e-mail contact sheets/ Web gallery or low-resolution samples, but do not send anything that has to be returned (i.e., slides, prints) unless asked for." Simultaneous submissions and previously published work OK, "but should be explained." Pays \$400 for color cover (negotiable); \$200 for color inside. Pays on publication. Credit line given. Buys all rights; negotiable.

Tips Wants to see "visually arresting images, high quality, multiple angles, day/night lighting situations. Photos including people are rarely published."

■ S S ASIAN ENTERPRISE MAGAZINE

Asian Business Ventures, Inc., P.O. Box 1126, Walnut CA 91788. (909)896-2865; (909)319-2306. E-mail: alma.asianent@gmail.com. Website: www.asianenterprise.com. Monthly trade magazine. "Largest Asian American small business focus magazine in U.S." Sample copy available for SAE with first-class postage.

Needs Buys 3-5 photos from freelancers/issue; 36-60 photos/year. Needs photos of multicultural, business concepts, senior citizens, environmental, architecture, cities/urban, education, travel, military, political, technology/computers. Reviews photos with or without a manuscript. Model/ property release required.

Specs Uses 4 × 6 matte b&w prints. Accepts images in digital format. Send via Zip as TIFF, JPEG files at 300-700 dpi.

Making Contact & Terms Send query letter with prints. Provide self-promotion piece to be kept on file for possible future assignments. Responds only if interested; send nonreturnable samples. Simultaneous submissions OK. Pays \$50-200 for color cover; \$25-100 for b&w inside. Pays on publication. Credit line given. Buys one-time rights.

\$\$ ATHLETIC BUSINESS

Athletic Business Publications, Inc., 4130 Lien Rd., Madison WI 53704. (800)722-8764, x119. Fax: (608)249-1153. E-mail: diane@athleticbusiness.com. Website: www.athleticbusiness.com. Art Director: Cathy Liewen. The Leading Resource for Athletic, Fitness & Recreation Professionals. Monthly magazine. Emphasizes athletics, fitness and recreation. Readers are athletic, park and recreational directors and club managers, ages 30-65. Sample copy available for \$8. The magazine can also be viewed digitally at www.athleticbusiness.com. Join us at the 29th annual Athletic Business Conference & Expo Dec. 2-4, 2010, San Diego Convention Center, San Diego, California. Become a fan on Facebook or LinkedIn.

Needs Buys 2-3 photos from freelancers per issue; 24-26 photos/year. Needs photos of college and high school team sports, coaches, athletic equipment, recreational parks, and health club/multisport interiors." Model/property release preferred. Photo captions preferred.

Making Contact & Terms Use online e-mail to contact. "Feel free to send promotional literature, but do not send anything that has to be returned (i.e., slides, prints) unless asked for." Simultaneous submissions and previously published work OK, "but should be explained." Pays \$400 for color cover (negotiable); \$200 for color inside. Pays on publication. Credit line given. Buys all rights; negotiable.

Tips Wants to see "visually arresting images, ability with subject and high quality photography." To break in, "shoot a quality and creative shot (that is part of our market) from more than one angle and at different depths."

S ATHLETIC MANAGEMENT

31 Dutch Mill Rd., Ithaca NY 14850-9785. (607)257-6970. Fax: (607)257-7328. E-mail: art@momentummedia.com. Art Director: Pam Crawford. Editor-in-Chief: Eleanor Frankel. Bimonthly magazine. Emphasizes the management of athletics. Readers are managers of high school and college athletic programs.

Needs Uses 10-20 photos/issue; 50% supplied by freelancers. Needs photos of athletic events and athletic equipment/facility shots; college and high school sports action photos. Model release preferred.

Making Contact & Terms Call art director at (413)253-4726. Previously published work OK. Pays \$600-800 for color cover; \$200-400 for color inside. Pays on publication. Credit line given. Buys first North American serial rights; negotiable.

\$ AUTOMATED BUILDER

1445 Donlon St. #16, Ventura CA 93003. (805)642-9735, 800-344-2537. Fax: (805)642-8820. E-mail: info@automatedbuilder.com. Website: www.automatedbuilder.com. Editor/Publisher: Don Carlson. Monthly. Emphasizes home and apartment construction. Readers are "factory and site builders and dealers of all types of homes, apartments and commercial buildings." Sample copy free with SASE.

Needs Buys 4-8 photos from freelancers/issue; 48-96 photos/year. Needs in-plant and job site construction photos and photos of completed homes and apartments. Reviews photos purchased with accompanying manuscript only. Photo captions required.

Making Contact & Terms "Call to discuss story and photo ideas." Send 3×5 color prints; 35mm or $2\frac{1}{4} \times 2\frac{1}{4}$ transparencies by mail with SASE for consideration. Will consider dramatic, preferably vertical cover photos. Responds in 2 weeks. Pays \$350 for text/photo package; \$150 for cover. Credit line given "if desired." Buys first time reproduction rights.

Tips "Study sample copy. Query editor by phone on story ideas related to industrialized housing industry."

AUTOMOTIVE COOLING JOURNAL

3000 Village Run Road, Suite 103, #221, Wexford PA 15090. (412)847-5747. Fax: (724)934-1036. E-mail: info@narsa.org. Website: www.narsa.org. Estab. 1956. Monthly magazine of the National Automotive Radiator Service Association. Emphasizes cooling system repair, mobile air conditioning service. Readers are mostly male shop owners and employees.

Needs Buys 3-5 photos from freelancers/issue; 36-60 photos/year. Needs shots illustrating service techniques, general interest auto repair emphasizing cooling system and air conditioning service. Model/property release preferred. Photo captions required.

Specs Uses any size glossy prints; 35mm, $2\frac{3}{4} \times 2\frac{3}{4}$, 4×5 , 8×10 transparencies.

Making Contact & Terms Send unsolicited photos by mail with SASE for consideration. Provide résumé, business card, brochure, flier or tearsheets to be kept on file for possible future assignments. Responds in 1 month. Payment negotiable. Pays on publication. Credit line given. Buys one-time rights.

AUTOMOTIVE NEWS

1155 Gratiot Ave., Detroit MI 48207-2997. E-mail: rjohnson@crain.com. Website: www.autonews.com. Managing Editor: Richard Johnson. Crain Communications. Circ. 77,000. Weekly tabloid.

Emphasizes the global automotive industry. Readers are automotive industry executives, including people in manufacturing and retail. Sample copies available.

Needs Buys 5 photos from freelancers/issue; 260 photos/year. Needs photos of automotive executives (environmental portraits), auto plants, new vehicles, auto dealer features. Photo captions required; include identification of individuals and event details.

Specs Uses 8 × 10 color prints; 35mm, 2¼ × 2¼, 4 × 5 transparencies. Accepts images in digital format. Send as JPEG files at 300 dpi (at least 6" wide).

Making Contact & Terms Send unsolicited photos by mail with SASE for consideration. Provide résumé, business card, brochure, flier or tearsheets to be kept on file for possible future assignments. Keeps samples on file. Responds in 2 weeks. Simultaneous submissions and previously published work OK. Pays on publication. Credit line given. Buys one-time rights, possible secondary rights for other Crain publications.

■ \$\$ AVIONICS MAGAZINE

PBI Media, 4 Choke Cherry Rd., 2nd floor, Rockville MD 20854. (301)354-2000. Fax: (301)340-8741. E-mail: bcarey@accessintel.com; efeliz@accessintel.com. Website: www.avionicsmagazine.com. Editor-in-Chief: Bill Carey. Circ. 20,000. Estab. 1976. Monthly magazine. Emphasizes aviation electronics. Readers are avionics and air traffic management engineers, technicians, executives. Sample copy free with 9×12 SASE.

Needs Buys 1-2 photos from freelancers/issue; 12-24 photos/year. Needs photos of travel, business concepts, industry, technology, aviation. Interested in alternative process, avant garde. Reviews photos with or without a manuscript. Photo captions required.

Specs Prefers images in digital format. Send as JPEG files at 300 dpi minimum.

Making Contact & Terms Query by e-mail. Provide résumé, business card, brochure, flier or tearsheets to be kept on file for possible future assignments. Simultaneous submissions OK. Responds in 2 months. Pay varies; negotiable. Pays on acceptance. Credit line given. Rights negotiable.

BARTENDER MAGAZINE

P.O. Box 158, Liberty Corner NJ 07938. (908)766-6006. Website: www.bartender.com. Circ. 150,000. Magazine published 4 times/year. Bartender Magazine serves full-service drinking establishments (full-service means able to serve liquor, beer and wine). "We serve single locations, including individual restaurants, hotels, motels, bars, taverns, lounges and all other full-service on-premises licensees." Sample copy available for \$2.50.

Needs Number of photos/issue varies; number supplied by freelancers varies. Needs photos of liquor-related topics, drinks, bars/bartenders. Reviews photos with or without a manuscript. Model/property release required. Photo captions preferred.

Making Contact & Terms Provide résumé, business card, brochure, flier or tearsheets to be kept on file for possible future assignments; include SASE for return of material. Previously published work OK. Payment negotiable. Pays on publication. Credit line given. Buys all rights; negotiable.

■ \$\$ Ø BEDTIMES

5603-B, W. Friendly Ave., #286, Greensboro NC 27410. (336)727-1889. Fax: (703)683-4503. E-mail: jpalm@sleepproducts.org, Website: www.sleepproducts.org, Editor: Julie Palm. Monthly association magazine; 40% of readership is overseas. Readers are manufacturers and suppliers in bedding industry. Sample copies available.

Needs Needs head shots, events, product shots/still life, conventions, shows, annual meetings. Reviews photos with or without a manuscript. Photo captions required; include correct spelling of name, title, company, return address for photos.

Specs Prefers digital images sent as JPEGs via e-mail. Also accepts glossy prints.

Making Contact & Terms Send query letter with résumé, photocopies. Responds in 3 weeks to queries. Simultaneous submissions and previously published work may be OK—depends on type of assignment. Pays \$1,000 minimum for color cover; \$100-750 for b&w or color inside. Pays on publication. Credit line given. Buys one-time rights; negotiable.

Tips "Like to see variations of standard 'mug shot' so they don't all look like something for a prison line-up. Identify people in the picture. Use interesting angles. We'd like to get contacts from all over the U.S. (near major cities) who are available for occasional assignments."

BEEF TODAY

1550 Northwest Highway, Suite 403, Park Ridge IL 60068. (847)628-3289. E-mail: kwatson@ farmjournal.com. Website: www.agweb.com. Circ. 220,000. Monthly magazine. Emphasizes American agriculture. Readers are active farmers, ranchers or agribusiness people. Sample copy and photo guidelines free with SASE.

Needs Buys 5-10 photos from freelancers/issue; 180-240 photos/year. "We use studio-type portraiture (environmental portraits), technical, details, scenics." Wants photos of environmental, livestock (feeding transporting, worming cattle), landscapes/scenics (from different regions of the U.S.). Model release preferred. Photo captions required.

Specs Accepts images in digital format. Send via CD or e-mail as TIFF, EPS, JPEG files, color RGB only.

Making Contact & Terms Arrange a personal interview to show portfolio. Send query letter with résumé of credits along with business card, brochure, flier or tearsheets to be kept on file for possible future assignments. DO NOT SEND ORIGINALS. Responds in 2 weeks. Simultaneous submissions OK. Payment negotiable. "We pay a cover bonus." **Pays on acceptance**. Credit line given. Buys one-time rights.

Tips In portfolio or samples, likes to see "about 20 slides showing photographer's use of lighting and ability to work with people. Know your intended market. Familiarize yourself with the magazine and keep abreast of how photos are used in the general magazine field."

\$\$ BEVERAGE DYNAMICS

17 High St., 2nd Floor, Norwalk CT 06851. (203)855-8499. Website: www.adamsbevgroup.com. Circ. 67,000. Quarterly. Emphasizes distilled spirits, wine and beer. Readers are retailers (liquor stores, supermarkets, etc.), wholesalers, distillers, vintners, brewers, ad agencies and media.

Needs Uses 5-10 photos/issue. Needs photos of retailers, products, concepts and profiles. Special needs include good retail environments, interesting store settings, special effect photos. Model/property release required. Photo captions required.

Making Contact & Terms Send query letter with samples and list of stock photo subjects. Provide business card to be kept on file for possible future assignments. Keeps samples on file; send nonreturnable samples, slides, tearsheets, etc. Simultaneous submissions OK. Pays on publication. Credit line given. Buys one-time rights or all rights.

Tips "We're looking for good location photographers who can style their own photo shoots or have staff stylists. It also helps if they are resourceful with props."

■ \$ ☐ BIZTIMES MILWAUKEE

BizTimes Media, 126 N. Jefferson St., Suite 403, Milwaukee WI 53202-6120. (414)277-8181. Fax: (414)277-8191. E-mail: shelly.tabor@biztimes.com. Website: www.biztimes.com. Art Director: Shelly Tabor. Biweekly business-to-business publication.

Needs Buys 2-3 photos from freelancers/issue; 200 photos/year. Needs photos of Milwaukee, including cities/urban, business men and women, business concepts. Interested in documentary. **Specs** Uses various sizes of glossy color prints. Accepts images in digital format. Send via CD as TIFF files at 300 dpi.

Making Contact & Terms Provide résumé, business card, self-promotion piece to be kept on file for possible future assignments. Responds only if interested; send nonreturnable samples. Simultaneous submissions and previously published work OK. Pays \$250 maximum for color cover; \$80 maximum for inside. **Pays on acceptance**.

Tips "Readers are owners/managers/CEOs. Cover stories and special reports often need conceptual images and portraits. Clean, modern and cutting edge with good composition. Covers have lots of possibility! Approximate one-week turnaround. Most assignments are for the Milwaukee area."

S S BOXOFFICE MAGAZINE

Boxoffice Media, LLC, 9107 Wilshire Blvd., Suite 450, Beverly Hills CA 90210. (310)858-4500; (310)876-9090. Fax: (310)858-4503. E-mail: amy@boxoffice.com; phil@boxoffice.com. Website: www.boxoffice.com. Editor of Boxoffice.com: Phil Contrino. Editor: Amy Nicholson. Circ. 10,000. Estab. 1920. Monthly trade magazine; the official publication of the National Association of Theater Owners. Sample copy available for \$10.

Needs Photo needs are very specific: "All photos must be of movie theaters and management." Reviews photos with accompanying manuscript only. Photo captions required.

Specs Uses 4×5 , 8×10 glossy color and/or b&w prints; 35mm, $2\frac{1}{4} \times 2\frac{1}{4}$, 4×5 transparencies. Accepts images in digital format. Send via CD, Zip as TIFF files at 300 dpi.

Making Contact & Terms Send query letter with résumé, tearsheets. Does not keep samples on file; cannot return material. Responds in 1 month to queries. Responds only if interested; send nonreturnable samples. Previously published work OK. Pays \$10/printed photo. Pays on publication. Credit line sometimes given. Buys one-time print rights and all electronic rights.

N S S BUSINESS NH MAGAZINE

55 South Commercial St., Manchester NH 03101. (603)626-6354. Fax: (603)626-6359. E-mail: mmowry@businessNHmagazine.com. Website: www.businessnhmagazine.com. Editor: Michael Mowry. Contact: Graphic Designer. Circ. 14,600. Estab. 1984. Monthly magazine. Emphasizes business. Readers are male and female top management, average age 45. Sample copy free with 9×12 SAE and 5 first-class stamps.

Needs Uses 3-6 photos/issue. Needs photos of couples, families, rural, entertainment, food/ drink, health/fitness, performing arts, travel, business concepts, industry, science, technology/ computers. Model/property release preferred. Photo captions required; include names, locations, contact phone number.

Specs Accepts images in digital format. Send via CD, Zip as TIFF, JPEG files at 300 dpi.

Making Contact & Terms Arrange personal interview to show portfolio. Provide résumé, business card, brochure, flier or tearsheets to be kept on file for possible future assignments. Responds in 3 weeks. Pays \$450 for color cover; \$100 for color or b&w inside. Pays on publication. Credit line given. Buys one-time rights. Offers internships for photographers.

Tips Looks for "people in environment shots, interesting lighting, lots of creative interpretations, a definite personal style. If you're just starting out and want excellent statewide exposure to the leading executives in New Hampshire, you should talk to us. Send letter and samples, then arrange for a portfolio showing."

CANADIAN GUERNSEY JOURNAL

5653 Highway 6 N, RR 5, Guelph ON N1H 6J2, Canada. (519)836-2141. Fax: (519)763-6582. E-mail: info@guernseycanada.ca. Website: www.guernseycanada.ca. Administration: Doris Curran. Annual journal of the Canadian Guernsey Association. Emphasizes dairy cattle, purebred and grade guernseys. Readers are dairy farmers and agriculture-related companies. Sample copy available for

Needs Needs photos of guernsey cattle: posed, informal, scenes. Photo captions preferred. Making Contact & Terms Contact through administration office. Keeps samples on file.

\$ CASINO JOURNAL

505 E. Capovilla Ave., Suite 102, Las Vegas NV 89119. (702)794-0718. Fax: (702)794-0799. E-mail: gizickit@bnpmedia.com. Website: www.casinojournal.com. Art Director: Tammy Gizicki. Circ. 35,000. Estab. 1985. Monthly journal. Emphasizes casino operations. Readers are casino executives,

employees and vendors. Sample copy free with 11 × 14 SASE. Ascend Media Gaming Group also publishes IGWB, Slot Manager, and Indian Gaming Business. Each magazine has its own photo

Needs Buys 0-2 photos from freelancers/issue; 12-24 photos/year. Needs photos of gaming tables and slot machines, casinos and portraits of executives. Model release required for gamblers, employees. Photo captions required.

Making Contact & Terms Send query letter with résumé of credits, stock list. Pays on publication. Credit line given. Buys all rights; negotiable.

Tips "Read and study photos in current issues."

CATHOLIC LIBRARY WORLD

100 North St., Suite 224, Pittsfield MA 01201-5109. (413)443-2CLA. Fax: (413)442-2252. E-mail: cla@cathla.org. Website: www.cathla.org/cathlibworld.html. Executive Director: Jean R. Bostley, SSJ. Quarterly magazine of the Catholic Library Association. Emphasizes libraries and librarians (community/school libraries; academic/research librarians; archivists). Readers are librarians who belong to the Catholic Library Association; other subscribers are generally employed in Catholic institutions or academic settings. Sample copy available for \$15.

Needs Uses 2-5 photos/issue. Needs photos of authors of children's books, and librarians who have done something to contribute to the community at large. Special needs include photos of annual conferences. Model release preferred for photos of authors. Photo captions preferred.

Making Contact & Terms Send electronically in high resolution, 450 dpi or greater. Deadlines: January 2, April 1, July 1, October 1. Responds in 2 weeks. Credit line given. Acquires one-time. rights.

\$ CEA ADVISOR

Connecticut Education Association, Capitol Place, Suite 500, 21 Oak St., Hartford CT 06106. (860)525-5641; (800)842-4316. Fax: (860)725-6356; (860)725-6323. E-mail: kathyf@cea.org. Website: www.cea.org. Managing Editor: Michael Lydick. Director of Communications: Kathy Frega. Monthly tabloid. Emphasizes education, Readers are public school teachers. Sample copy free with 6 first-class stamps.

Needs Buys 1-2 photos from freelancers/issue; 12-24 photos/year. Needs "classroom scenes, students, school buildings," Model release preferred. Photo captions preferred.

Making Contact & Terms Send b&w contact sheet by mail for consideration. Provide résumé, business card, brochure, flier or tearsheets to be kept on file for possible future assignments. Cannot return material. Responds in 1 month. Simultaneous submissions and previously published work OK. Pays \$50 for b&w cover; \$25 for b&w inside. Pays on publication. Credit line given. Buys all rights.

■ O CHEF

Talcott Communications, 20 W. Kinzie St., 12th Floor, Chicago IL 60610. (312)849-2220. Fax: (312)849-2174. E-mail: mshea@talcott.com; lgriebeler@talcott.com. Website: www.chefmagazine. com. Managing Editor: Lacey Griebeler. Trade magazine. "We are a food magazine for chefs. Our focus is to help chefs enhance the bottom lines of their businesses through food preparation, presentation, and marketing the menu."

Needs Buys 1-2 photos from freelancers /issue. Needs photos of food/drink. Other specific photo needs: chefs, establishments. Reviews photos with or without a manuscript. Model/property release preferred. Photo caption s preferred.

Specs Prefers images in digital format. Send via CD, Jaz, Zip as TIFF, EPS, JPEG files at 300 dpi minimum, 5×7 .

Making Contact & Terms Send query letter with résumé, photocopies, tearsheets, stock list. Provide business card or self-promotion piece to be kept on file for possible future assignments. Responds in 1 month to queries; 3 months to portfolios. Previously published work OK. Pays on publication. Credit line given. Buys one-time rights (prefers one-time rights to include electronic).

\$ CHILDHOOD EDUCATION

17904 Georgia Ave., Suite 215, Olney MD 20832, (301)570-2111, Fax: (800)423-3563, E-mail: headquarters@acei.org. Website: www.acei.org. Deborah Kravitz. Director of Publications: Anne Bauer. Circ. 15,000. Bimonthly journal of the Association for Childhood Education International. Emphasizes the education of children from infancy through early adolescence. Readers include teachers, administrators, day-care workers, parents, psychologists, student teachers, etc. Sample copy free with 9 × 12 SAE and \$1.44 postage. Photo guidelines free with SASE.

Needs Uses 1 photos/issue; 2-3 supplied by freelance photographers. Uses freelancers mostly for covers. Subject matter includes children, infancy-14 years, in groups or alone, in or out of the classroom, at play, in study groups; boys and girls of all races and in all cities and countries. Wants close-ups of children, unposed. Reviews photos with or without accompanying manuscript. Special needs include photos of minority children; photos of children from different ethnic groups together in one shot; boys and girls together. Model release required.

Specs Accepts images in digital format, 300 dpi.

Making Contact & Terms Send unsolicited photos by e-mail to abauer@acei.org and bherzig@ acei.org. Responds in 1 month. Simultaneous submissions and previously published work are discouraged but negotiable. Pays \$200 for color cover; \$75-100 for b&w inside. Pays on publication. Credit line given. Buys one-time rights.

Tips "Send pictures of unposed children in educational settings, please."

■ \$ M THE CHRONICLE OF PHILANTHROPY

1255 23rd St. NW, 7th Floor, Washington DC 20037. (202)466-1216. Fax: (202)466-2078. E-mail: creative@chronicle.com. Website: http://philanthropy.com. Art Director: Sue LaLumia. 1988. Biweekly tabloid. Readers come from all aspects of the nonprofit world such as charities, foundations and relief agencies such as the Red Cross. Sample copy free.

Needs Buys 10-15 photos from freelancers/issue; 260-390 photos/year. Needs photos of people (profiles) making the news in philanthropy and environmental shots related to person(s)/ organization. Most shots arranged with freelancers are specific. Model release required. Photo caption required.

Specs Accepts images in digital format. Send via CD, Zip,

Making Contact & Terms Arrange a personal interview to show portfolio. Send 35mm, 21/4 × 21/4 transparencies and prints by mail for consideration. Provide résumé, business card, brochure, flier or tearsheets to be kept on file for possible future assignments. Responds in 2 days. Previously published work OK. Pays (color and b&w) \$275 plus expenses/half day; \$450 plus expenses/full day; \$100 for web publication (2-week period). Pays on publication. Buys one-time rights.

S S CIVITAN MAGAZINE

P.O. Box 130744, Birmingham AL 35213-0744. (205)591-8910. E-mail: civitan@civitan.org. Website: www.civitan.org. Circ. 24,000. Estab. 1920. Quarterly publication of Civitan International. Emphasizes work with mental retardation/developmental disabilities. Readers are men and women, college age to retirement, usually managers or owners of businesses. Sample copy free with 9 × 12 SASE and 2 first-class stamps.

Needs Buys 1-2 photos from freelancers/issue; 6-12 photos/year. Always looking for good cover shots (multicultural, travel, scenic and how-to), babies/children/teens, families, religious, disasters, environmental, landscapes/scenics. Model release required. Photo captions preferred.

Specs Accepts images in digital format. Send via CD or e-mail at 300 dpi only.

Making Contact & Terms Send sample of unsolicited 21/4 × 21/4 or 4 × 5 transparencies by mail for consideration. Provide résumé, business card, brochure, flier or tearsheets to be kept on file for possible future assignments. Responds in 1 month. Simultaneous submissions and previously published work OK. Pays \$50-200 for color cover; \$20 for color inside. **Pays on acceptance.** Buys one-time rights.

\$ CLASSICAL SINGER

P.O. Box 1710, Draper UT 84020. (801)254-1025. Fax: (801)254-3139. Website: www.classicalsinger. com. **Contact:** Art Director. Circ. 9,000. Estab. 1988. Glossy monthly trade magazine for classical singers. Sample copy free.

Needs Looking for photos in opera or classical singing. E-mail for calendar and ideas. Photo captions preferred; include where, when, who.

Specs Uses b&w and color prints or high-res digital photos.

Making Contact & Terms Responds in 1 month to queries. Simultaneous submissions and previously published work OK. Pays honorarium plus 10 copies. Pays on publication. Credit line given. Buys one-time rights. Photo may be used in a reprint of an article on paper or website.

Tips "Our publication is expanding rapidly. We want to make insightful photographs a big part of that expansion."

\$ • CLEANING & MAINTENANCE MANAGEMENT MAGAZINE

13 Century Hill Dr., Latham NY 12110. (518)783-1281, ext. 3137. Fax: (518)783-1386. E-mail: rdipaolo@ntpmedia.com. Website: www.cmmonline.com. Senior Editor: Rich Dipaolo. Circ. 38,300. Estab. 1963. Monthly. Emphasizes management of cleaning/custodial/housekeeping operations for commercial buildings, schools, hospitals, shopping malls, airports, etc. Readers are middle- to upper-level managers of in-house cleaning/custodial departments, and managers/owners of contract cleaning companies. Sample copy free (limited) with SASE.

Needs Uses 10-15 photos/issue. Needs photos of cleaning personnel working on carpets, hardwood floors, tile, windows, restrooms, large buildings, etc. Model release preferred. Photo captions required.

Making Contact & Terms Provide résumé, business card, brochure, flier or tearsheets to be kept on file for possible future assignments. "Send query letter with specific ideas for photos related to our field." Responds in 1-2 weeks. Simultaneous submissions and previously published work OK. Pays \$25 for b&w inside. Credit line given. Rights negotiable.

Tips "Query first and shoot what the publication needs."

■ ② COMMERCIAL CARRIER JOURNAL

3200 Rice Mine Rd. NE, Tuscaloosa AL 35406. (800)633-5953. Fax: (205)750-8070. E-mail: avise@ccjmagazine.com; avise@ccjdigital.com. Website: www.ccjmagazine.com. Editorial Director: Avery Vise. Monthly magazine. Emphasizes truck and bus fleet maintenance operations and management.

Needs Spot news (of truck accidents, Teamster activities and highway scenes involving trucks). Photos purchased with or without accompanying manuscript, or on assignment. Model release required. Detailed captions required.

Specs Prefers images in digital format. Send via e-mail as JPEG files at 300 dpi. For covers, uses medium-format transparencies (vertical only).

Making Contact & Terms Does not accept unsolicited photos. Query first; send material by mail with SASE for consideration. Responds in 3 months. Pays on a per-job or per-photo basis. **Pays on acceptance.** Credit line given. Buys all rights.

Tips Needs accompanying features on truck fleets and news features involving trucking companies.

S CONVENIENCE STORE DECISIONS

Two Greenwood Square, Suite 410, 3331 Street Rd., Bensalem PA 19020. (215)246-4555. Fax: (215)245-4060. E-mail: jpetersen@csdecisions.com; jlofstock@csdecisions.com. Website: www.csdecisions.com. Contact: John Lofstock. Publisher: John Petersen. Circ. 41,000. Estab. 1990.

Monthly trade magazine. Convenience Store Decisions is the in-print "Idea Factory" for the convenience store industry. Written for and read by the industry's decision-makers. Sample copies available. "The new and improved CSDecisions.com is the industry's online Idea Factory. The website for the Convenience Store Decisions Group offers a virtual meeting place for retailers and suppliers, including a new community section, our Ask the Experts forum and industry blogs."

Needs Buys 24-36 photos from freelancers/year. Needs photos of food/drink, business concepts, product shots/still life, retail. Convenience stores—transactions, customers, employees. Gasoline/ petroleum outlets-customers pumping gas, etc. Newsworthy photos dealing with convenience stores and gas stations. Reviews photos with or without manuscript. Photo captions preferred.

Specs Uses any print format, but prefers digital images in TIFF, EPS or JPEG format via CD or e-mail at 300 dpi.

Making Contact & Terms Send query letter with photocopies, stock list. Provide business card or self-promotion piece to be kept on file for possible future assignments. Simultaneous submissions and previously published work OK. Pays \$300-800 for color cover; \$100-600 for color inside. Pays on publication. Credit line given. Buys one-time rights, electronic rights; negotiable.

Tips "We have numerous opportunities for spec jobs in various markets across the country. We also have a great need for spot photo/illustration that relates to our audience (convenience store operators and petroleum marketers). We will do a lot of volume with the right photographer. Consider our audience."

65 Germantown Court, Suite 202, Cordova TN 38018. (901)756-8822. E-mail: hgantz@meistermedia. com. Website: www.cotton247.com. Circ. 45,000. Estab. 1999. Monthly trade magazine. Emphasizes "cotton production; for cotton farmers." Sample copies and photo guidelines available.

Needs Photos of agriculture. "Our main photo needs are cover shots of growers. We write cover stories on each issue."

Specs Prefers high-res digital images; send JPEGs at 300 dpi via e-mail or CD. Uses high-quality glossy prints from 35mm.

Making Contact & Terms Send query letter with slides, prints, tearsheets. Pays on acceptance. Credit line given. Buys all rights.

Tips Most photography hired is for cover shots of cotton growers.

\$\$ CROPLIFE

37733 Euclid Ave., Willoughby OH 44094. (440)942-2000. E-mail: pjschrimpf@meistermedia.com. Website: www.croplife.com. Group Editor: Paul Schrimpf. Circ. 24,500. Estab. 1894. Monthly magazine. Serves the agricultural distribution channel delivering fertilizer, chemicals and seed from manufacturer to farmer. Sample copy and photo guidelines free with 9 × 12 SASE.

Needs Buys 6-7 photos/year; 5-30% supplied by freelancers. Needs photos of agricultural chemical and fertilizer application scenes (of commercial-not farmer-applicators), people shots of distribution channel executives and managers. Model release preferred. Photo captions required.

Specs Uses 8 × 10 glossy b&w and color prints; 35mm slides, transparencies.

Making Contact & Terms Send query letter first with résumé of credits. Simultaneous submissions and previously published work OK. Pays on acceptance. Buys one-time rights.

Tips "E-mail is the best way to approach us with your work. Experience and expertise is best."

\$\$ DAIRY TODAY

P.O. Box 958, Mexico MO 65265. (573)581-6387. E-mail: cfinck@farmjournal.com. Website: www.agweb.com. Contact: Charlene Finck. FarmJournal Media. Circ. 50,000. Monthly magazine. Emphasizes American agriculture. Readers are active farmers, ranchers or agribusiness people. Sample copy and photo guidelines free with SASE.

Needs Buys 5-10 photos from freelancers/issue; 60-120 photos/year. "We use studio-type portraiture (environmental portraits), technical, details, scenics." Wants photos of environmental, landscapes/scenics, agriculture, business concepts. Model release preferred. Photo captions required.

Making Contact & Terms Arrange a personal interview to show portfolio. Send query letter with résumé of credits along with business card, brochure, flier or tearsheets to be kept on file for possible future assignments. "Portfolios may be submitted via CD-ROM." DO NOT SEND ORIGINALS. Responds in 2 weeks. Simultaneous submissions OK. Pays \$75-400 for color photo; \$200-400/day. "We pay a cover bonus." **Pays on acceptance.** Credit line given, except in advertorials. Buys one-time rights.

Tips In portfolio or samples, likes to see "about 40 slides showing photographer's use of lighting and ability to work with people. Know your intended market. Familiarize yourself with the magazine and keep abreast of how photos are used in the general magazine field."

A DISPLAY DESIGN IDEAS

1145 Sanctuary Pkwy., Suite 355, Alpharetta GA 30004. (770)569-1540 or (770)291-5510. Fax: (770)569-5105. E-mail: aembrey@ddimagazine.com; jbove@ddimagazine.com. Website: www.ddimagazine.com. Managing Editor/Web Editor: Jessie Bove. Executive Editor: Alison Embrey Medina. Circ. 21,500. Estab. 1988. Monthly magazine. Emphasizes retail design, store planning, visual merchandising. Readers are retail architects, designers and retail executives. Sample copies available.

Needs Buys 7 or fewer photos from freelancers/issue; 84 or fewer photos/year. Needs photos of architecture, mostly interior. Property release preferred.

Specs Prefers digital submissions. Send as TIFF or JPEG files at 300 dpi.

Making Contact & Terms Send query letter with résumé of credits. Provide résumé, business card, brochure, flier or tearsheets to be kept on file for possible future assignments. Responds in 3 weeks. Credit line given. Rights negotiable.

Tips Looks for architectural interiors, ability to work with different lighting. "Send samples (photocopies OK) and résumé."

DM NEWS

17 Battery Place, Suite 1330, New York NY 10004. (212)925-7300; (212)344-0759. Fax: (212)925-8754. E-mail: carol.krol@dmnews.com; news@dmnews.com. Website: www.dmnews.com. Editor-in-Chief: Carol Krol. Company publication for Courtenay Communications Corporation. Weekly newspaper. Emphasizes direct, interactive and database marketing. Readers are decision makers and marketing executives, ages 25-55. Sample copy available for \$2.

Needs Uses 20 photos/issue; 3-5 supplied by freelancers. Needs news head shots, product shots. Reviews photos purchased with accompanying manuscript only. Photo captions required.

Making Contact & Terms Provide résumé, business card, brochure, flier or tearsheets to be kept on file for possible future assignments. Responds in 1-2 weeks. Payment negotiable. **Pays on acceptance.** Buys worldwide rights.

Tips "News and business background are a prerequisite."

A \$ ELECTRICAL APPARATUS

Barks Publications, Inc., 400 N. Michigan Ave., Chicago IL 60611-4198. (312)321-9440. E-mail: edickson@barks.com. Websites: www.barks.com/eacurr.html; www.eamagazine.com. Associate Publisher: Elsie Dickson. Monthly trade magazine. Emphasizes industrial electrical machinery maintenance and repair for the electrical aftermarket. Readers are "persons engaged in the application, maintenance and servicing of industrial and commercial electrical and electronic equipment." Sample copies available.

Needs "Assigned materials only. We welcome innovative industrial photography, but most of our material is staff-prepared." Photos purchased with accompanying manuscript or on assignment. Model release required "when requested." Photo captions preferred.

Making Contact & Terms Send query letter with résumé of credits. Contact sheet or contact sheet with negatives OK; include SASE for return of material. Responds in 3 weeks. Pays \$200 for color. Pays on publication. Credit line given. Buys all rights, but exceptions are occasionally made.

■ \$\$ ☐ EL RESTAURANTE MEXICANO

P.O. Box 2249, Oak Park IL 60303. (708)488-0100. Fax: (708)488-0101. E-mail: brussell@restmex.com. Website: www.restmex.com. Circ. 26,000. Estab. 1997. Bimonthly trade magazine for restaurants that serve Mexican, Tex-Mex, Southwestern and Latin cuisine. Sample copies available.

Needs Buys at least 1 photo from freelancers/issue; at least 6 photos/year. Needs photos of food/ drink. Reviews photos with or without a manuscript.

Specs Uses 35mm transparencies. Accepts images in digital format. Send via e-mail as TIFF, JPEG files of at least 300 dpi.

Making Contact & Terms Send query letter with slides, prints, photocopies, tearsheets, transparencies or stock list. Provide résumé, business card, self-promotion piece to be kept on file for possible future assignments. Responds in 2 months to queries. Previously published work OK. Pays \$450 maximum for color cover; \$125 maximum for color inside. Pays on publication. Credit line given. Buys all rights; negotiable.

Tips "We look for outstanding food photography; the more creatively styled, the better."

ESL TEACHER TODAY

2660 Petersborough St., Herndon VA 20171. E-mail: shannonaswriter@yahoo.com. Contact: Shannon Murphy. Quarterly trade magazine. Photo guidelines available via e-mail.

Needs Buys 12-24 photos/year. Needs photos of babies/children/teens, multicultural, families, parents, disasters, environmental, landscapes/scenics, wildlife, cities/urban, education, religious, rural, adventure, events, food/drink, sports, travel, agriculture, medicine, military, political, product shots/still life, science, technology—as related to teaching ESL (English as a Second Language) around the globe. Interested in alternative process, avant garde, documentary, fashion/glamour, fine art, historical/vintage, seasonal. Reviews photos with or without a manuscript. Model/property release preferred.

Specs Uses glossy or matte color and/or b&w prints.

Making Contact & Terms Send query letter via e-mail. "If possible, please do not include photographs in files if they are sent through e-mail. A disk with your photographs sent to ESL Teacher Today is acceptable." Provide résumé, business card or self-promotion piece to be kept on file for possible future assignments. Responds within 1 month to queries; 1 week to portfolios. Simultaneous submissions and previously published work OK. Pays on acceptance. Credit line given. Buys one-time rights, first rights; negotiable.

S FIRE CHIEF

330 N. Wabash Ave., Suite 2300, Chicago IL 60611. (312)595-1080. Fax: (312)595-0295. E-mail; sundee@firechief.com. Website: www.firechief.com. Art Director: Sundee Koffarnus. Monthly magazine. Focus on fire department management and operations. Readers are primarily fire officers and predominantly chiefs of departments. Sample copy free. Request photo guidelines via e-mail. **Needs** Fire and emergency response, especially leadership themes—if you do not have fire or EMS, please do not contact.

Specs Digital format preferred, filename less than 15 characters. Send via e-mail, CD, Zip as TIFF, EPS files at highest possible resolution.

Making Contact & Terms Send low-resolution JPEGs for consideration along with caption, date, time, and location. Samples are kept on file. Expect confirmation/response within 1 month. Payment 90 days after publication. Buys first serial rights; negotiable.

Tips "As the name Fire Chief implies, we prefer images showing a leading officer (white, yellow, or red helmet) in action—on scene of a fire, disaster, accident/rescue, hazmat, etc. Other subjects: administration, communications, decontamination, dispatch, EMS, foam, heavy rescue, incident command, live fire training, public education, SCBA, water rescue, wildland fire."

■ \$ FIRE ENGINEERING

21-00 Route 208 South, Fairlawn NJ 07410. (973)251-5055. Fax: (973)251-5065. E-mail: roberth@pennwell.com. Website: www.fireengineering.com. Estab. 1877. Training magazine for firefighters. Photo guidelines free.

Needs Uses 400 photos/year. Needs action photos of disasters, firefighting, EMS, public safety, fire investigation and prevention, rescue. Photo captions required; include date, what is happening, location and fire department contact.

Specs Accepts images in digital format. Send via e-mail or mail on CD as JPEG files at 300 dpi minimum.

Making Contact & Terms Send unsolicited photos by mail for consideration. Pays on publication. Credit line given. We retain copyright.

Tips "Firefighters must be doing something. Our focus is on training and learning lessons from photos."

■ \$ FIRE-RESCUE MAGAZINE

525 B St., Suite 1800, P.O. Box 469012, San Diego CA 92101. (800)266-5367. Fax: (619)699-6396. E-mail: s.pieper@elsevier.com; jfoskett@elsevier.com. Website: www.firerescuemagazine.com. **Deputy Editor:** Shannon Pieper. Monthly. Emphasizes techniques, equipment, action stories of fire and rescue incidents. Editorial slant: "Read it today, use it tomorrow." Sample copy free with 9×12 SAE and 7 first-class stamps. Photo guidelines free with SASE.

Needs Uses 20-25 photos/issue; most supplied by freelancers. Needs photos of fires, fire ground scenes, commanders operating at fires, company officers/crews fighting fires, disasters, emergency medical services, rescue scenes, transport, injured victims, equipment and personnel, training, earthquake rescue operations. Special photo needs include strong color shots showing newsworthy rescue operations, including a unique or difficult firefighting, rescue/extrication, treatment, transport, personnel, etc.; b&w showing same. Photo captions required.

Specs Accepts images in digital format. Prefers digital format submitted via e-mail or FTP (http://info.jems.com/ftp/). Send via Zip, e-mail, Jaz, CD as TIFF, EPS, JPEG files at 300 dpi.

Making Contact & Terms Send query letter or e-mail with 5×7 or larger glossy color prints or color contact sheets. Pays \$300 for cover; \$22-137 for color inside; \$27-110 for b&w inside. Pays on publication. Credit line given. Buys one-time rights.

Tips Looks for "photographs that show firefighters in action, using proper techniques and wearing the proper equipment. Submit timely photographs that show the technical aspects of firefighting and rescue. Tight shots/close-ups preferred."

■ S S FOREST LANDOWNER

900 Circle 75 Parkway SE, Ste. 205, Atlanta GA 30339-3075. (800)325-2954; (404)325-2954. Fax: (404)325-2955. E-mail: info@forestlandowners.com. Website: www.forestlandowners.com. Bimonthly magazine of the Forest Landowners Association. Emphasizes forest management and policy issues for private forest landowners. Readers are forest landowners and forest industry consultants; 94% male between the ages of 46 and 55. Sample copy available for \$3 (magazine), \$30 (manual).

Needs Uses 15-25 photos/issue; 3-4 supplied by freelancers. Needs photos of unique or interesting private southern forests. Other subjects: environmental, regional, wildlife, landscapes/scenics. Model/property release preferred. Photo captions preferred.

Specs Accepts images in digital format. Send via CD, Zip, e-mail as TIFF, EPS files at 300 dpi.

Making Contact & Terms Send Zip disk, color prints, negatives or transparencies by mail or e-mail for consideration. Send query letter with stock list. Keeps samples on file. SASE. Responds in 3 weeks. Simultaneous submissions and previously published work OK. Pays \$100-150 for color

cover; \$25-50 for b&w inside; \$35-75 for color inside. Pays on publication. Credit line given. Buys one-time and all rights; negotiable.

Tips "We most often use photos of timber management, seedlings, aerial shots of forests, and unique southern forest landscapes. Mail Zip, CD or slides of sample images. Captions are important."

GEOSYNTHETICS

Industrial Fabrics Association International, 1801 County Road B W., Roseville MN 55113. (651)222-2508 or (800)225-4324. Fax: (651)225-6966. E-mail: generalinfo@ifai.com; rwbygness@ifai.com. Website: www.geosyntheticsmagazine.com. www.ifai.com. Editor: Ron Bygness. Circ. 18,000. Estab. 1983. Association magazine published 6 times/year. Emphasizes geosynthetics in civil engineering applications. Readers are civil engineers, professors and consulting engineers. Sample copies available.

Needs Uses 10-15 photos/issue; various number supplied by freelancers. Needs photos of finished applications using geosynthetics; photos of the application process. Reviews photos with accompanying manuscript only. Model release required. Photo captions required; include project, type of geosynthetics used and location.

Specs Prefers images in high-res digital format.

Making Contact & Terms "Please call before submitting samples!" Keeps samples on file. Responds in 1 month. Simultaneous submissions OK. Credit line given. Buys all rights; negotiable.

S GOVERNMENT TECHNOLOGY

100 Blue Ravine Rd., Folsom CA 95630. (916)932-1300. Fax: (916)932-1470. E-mail: kmartinelli@ erepublic.com. Website: www.govtech.net. Creative Director: Kelli Martinelli. Monthly trade magazine. Emphasizes information technology as it applies to state and local government. Readers are government executives.

Needs Buys 2 photos from freelancers/issue; 20 photos/year. Needs photos of government officials, disasters, environmental, political, technology/computers. Reviews photos with accompanying manuscript only. Model release required; property release preferred. Photo captions required.

Specs Accepts images in digital format only. Send via DVD, CD, Zip, e-mail as TIFF, JPEG files at 300 dpi.

Making Contact & Terms Send query letter with résumé, prints, tearsheets. Provide business card, self-promotion piece to be kept on file for possible future assignments. Responds only if interested; send nonreturnable samples. Simultaneous submissions and previously published work. OK. Payment is dependent upon pre-publication agreement between photographer and Government Technology. Pays on publication. Credit line given. Buys one-time rights, electronic rights.

Tips "View samples of magazines for style, available online at www.govtech.com/gt/magazines."

\$ GRAIN JOURNAL

3065 Pershing Court, Decatur IL 62526. (217)877-9660. Fax: (217)877-6647. E-mail: ed@grainnet. com. Website: www.grainnet.com. Editor: Ed Zdrojewski. Bimonthly trade magazine. Emphasizes grain industry. Readers are "elevator and feed mill managers primarily, as well as suppliers and others in the industry." Sample copy free with SASE (#10 envelope).

Needs Uses about 1-2 photos/issue. "We need photos concerning industry practices and activities. We look for clear, high-quality images without a lot of extraneous material." Photo captions preferred.

Specs Accepts images in digital format minimum 300 dpi resolution. Send via e-mail, floppy disk, Zip.

Making Contact & Terms Send query letter with samples and list of stock photo subjects. Responds in 1 week. Pays \$100 for color cover; \$30 for b&w inside. Pays on publication. Credit line given. Buys all rights; negotiable.

\$ THE GREYHOUND REVIEW

P.O. Box 543, Abilene KS 67410. (785)263-4660. E-mail: nga@ngagreyhounds.com. Website: www. ngagreyhounds.com. Circ. 3,006. Monthly publication of The National Greyhound Association. Emphasizes Greyhound racing and breeding. Readers are Greyhound owners and breeders. Sample copy free with SAE and 11 first-class stamps.

Needs Buys 1 photo from freelancers/issue; 12 photos/year. Needs "anything pertinent to the Greyhound that would be of interest to Greyhound owners." Photo captions required.

Making Contact & Terms Query via e-mail first. After response, send b&w or color prints and contact sheets by mail for consideration. Provide résumé, business card, brochure, flier or tearsheets to be kept on file for possible future assignments. Can return unsolicited material if requested; include SASE for return of material. Responds in 1 month. Simultaneous submissions and previously published work OK. Pays \$85 for color cover; \$25-100 for color inside. Pays on acceptance. Credit line given. Buys one-time and North American rights.

Tips "We look for human-interest or action photos involving Greyhounds. No muzzles, please, unless the Greyhound is actually racing. When submitting photos for our cover, make sure there's plenty of cropping space on all margins around your photo's subject; full breeds on our cover are preferred."

S HEARTH AND HOME

P.O. Box 1288, Laconia NH 03246. (603)528-4285. Fax: (603)527-3404. E-mail: production@ villagewest.com. Contact: Production. Circ. 16,000. Monthly magazine. Emphasizes hearth, barbecue and patio news and industry trends for specialty retailers and manufacturers of solid fuel and gas appliances, barbeque grills, hearth appliances inside and outside and casual furnishings. Sample copy available for \$5.

Needs Buys 3 photos from freelancers/issue; 36 photos/year. Needs "shots of inside and outside fireplace and patio furnishings, gas grills, outdoor room shots emphasizing BBQs, furniture, and outdoor fireplaces. Assignments available for conferences." Model release required. Photo captions preferred.

Specs Accepts digital images with color proof; high-res, 300 dpi preferred.

Making Contact & Terms Contact before submitting material. Responds in 2 weeks. Simultaneous and photocopied submissions OK. Pays \$50-200 for color photos; \$250-1,200/on location job. Pays within 30 days after publication prints. Credit line given. Buys various rights.

Tips "Call first and ask what we need. We're always on the lookout for gorgeous outdoor room material."

\$ HEREFORD WORLD

Hereford Cattle Association, P.O. Box 014059, Kansas City MO 64101. (816)842-3757. Fax: (816)842-6931. E-mail: aha@hereford.org; cvaught@hereford.org. Website: www.hereford.org/ node/268, www.herefordworld.org. Contact: Caryn Vaught, production manager. "We also publish a commercial edition with a circulation of 20,000." Estab. 1947. Monthly (11 issues with 7 glossy issues) association magazine. Emphasizes Hereford cattle for registered breeders, commercial cattle breeders and agribusinessmen in related fields. A tabloid-type issue is produced 4 times—January, February, August and October—and mailed to an additional 20,000 commercial cattlemen.

Needs "Hereford World magazine includes timely articles and editorial columns that provide readers information to help them make sound management and marketing decisions. From basic how-to articles to in-depth reports on cutting-edge technologies, the Hereford World offers its readers a solid package of beef industry information."

Specs Uses b&w and color prints.

Making Contact & Terms Query. Responds in 2 weeks. Pays \$5 for b&w print; \$100 for color print. Pays on publication.

Tips Wants to see "Hereford cattle in quantities, in seasonal and/or scenic settings."

\$\$ @ IEEE SPECTRUM

3 Park Ave., 17th Floor, New York NY 10016. (212)419-7569. Fax: (212)419-7570. E-mail: r.silberman@ ieee.org; g.zorpette@ieee.org. Website: www.spectrum.ieee.org. Photo Editor: Randi Silberman. Circ. 370,000. Monthly magazine of the Institute of Electrical and Electronics Engineers, Inc. (IEEE). Emphasizes electrical and electronics field and high technology for technology innovators, business leaders, and the intellectually curious. Spectrum explores future technology trends and the impact of those trends on society and business. Readers are technology professionals and senior executives worldwide in the high technology sectors of industry, government, and academia. Subscribers include engineering managers and corporate and financial executives, deans and provosts at every major engineering university and college throughout the world; males/females, educated, ages 20-70.

Needs Uses 20-30 photos/issue. Purchases stock photos in following areas: technology, energy, medicine, military, sciences and business concepts. Hires assignment photographers for location shots and portraiture, as well as product shots. Model/property release required. Photo captions required.

Specs Accepts images in digital format. Send via CD as TIFF, JPEG files at 300 dpi.

Making Contact & Terms Provide promos or tearsheets to be kept on file for possible future assignments. Pays \$1,200 for color cover; \$200-600 for inside. Pays on acceptance. Credit line given. Buys one-time rights.

Tips Wants photographers who are consistent, have an ability to shoot color and b&w, display a unique vision, and are receptive to their subjects. "As our subject matter is varied, Spectrum uses a variety of imagemakers."

■ IGA GROCERGRAM

8745 W Higgins Road, Suite 350, Chicago IL 60631. (773)693-5902. E-mail: apage@igainc.com. Website: www.iga.com/igagrocergram.aspx. Communications: Ashley Page. Quarterly magazine of the Independent Grocers Alliance. Emphasizes food industry. Readers are IGA retailers. Sample copy available upon request.

Needs Needs in-store shots, food (appetite appeal). Prefers shots of IGA stores. Model/property release required. Photo captions required.

Specs Accepts images in digital format. Send as TIFF files at 300 dpi.

Making Contact & Terms Send samples by e-mail or link to website for consideration. Provide résumé, business card, brochure, flier or tearsheets to be kept on file for possible future assignments. Keeps samples on file. Responds in 3 weeks. Simultaneous submissions and previously published work OK. Pay negotiable. Pays on acceptance. Credit line given. Buys one-time rights.

\$ ITE JOURNAL

1099 14th St. NW, Suite 300W, Washington DC 20005-3438. (202)289-0222. Fax: (202)289-7722. E-mail: ite_staff@ite.org. Website: www.ite.org. Contact: Managing Editor. Monthly journal of the Institute of Transportation Engineers. Emphasizes surface transportation, including streets, highways and transit. Readers are transportation engineers and professionals.

Needs One photo used for cover illustration per issue. Needs "shots of streets, highways, traffic, transit systems. No airports, airplanes, or bridges." Also considers landscapes, cities, rural, automobiles, travel, industry, technology, historical/vintage. Model release required. Photo captions preferred; include location, name or number of road or highway, and details.

Making Contact & Terms Send query letter with list of stock photo subjects. Send 35mm slides or 21/4 × 21/4 transparencies by mail for consideration. Provide résumé, business card, brochure, flier or tearsheets to be kept on file for possible future assignments. "Send originals; no dupes, please." Simultaneous submissions and previously published work OK. Pays \$200 for color cover. Pays on publication. Credit line given. Buys multiple-use rights.

Tips "Send a package to me in the mail; package should include samples in the form of slides and/ or transparencies."

S JOURNAL OF ADVENTIST EDUCATION

12501 Old Columbia Pike, Silver Spring MD 20904-6600. (301)680-5075. Fax: (301)622-9627. E-mail: rumbleb@gc.adventist.org. Website: http://education.gc.adventist.org/jae. Editor: Beverly J. Robinson-Rumble. Published 5 times/year. Emphasizes procedures, philosophy and subject matter of Christian education. Official professional organ of the Department of Education covering elementary, secondary and higher education for all Seventh-day Adventist educational personnel (worldwide).

Needs Buys 5-15 photos from freelancers/issue; up to 75 photos/year. Needs photos of children/ teens, multicultural, parents, education, religious, health/fitness, technology/computers with people, committees, offices, school photos of teachers, students, parents, activities at all levels, elementary though graduate school. Reviews photos with or without a manuscript. Model release preferred. Photo captions preferred.

Specs Uses mostly digital color images but also accepts color prints; 35mm, 21/4 × 21/4, 4 × 5 transparencies. Send digital photos via Zip, CD-ROM or DVD (preferred); e-mail as TIFF, GIF, JPEG files at 300 dpi. Do not send large numbers of photos as e-mail attachments.

Making Contact & Terms Send query letter with prints, photocopies, transparencies. Provide selfpromotion piece to be kept on file for possible future assignments. Responds in 1 month to queries. Simultaneous submissions and previously published work OK. Pays \$100-350 for color cover; \$50-100 for color inside. Willing to negotiate on electronic usage of photos. Pays on publication. Credit line given. Buys one-time rights for use in magazine and on website.

Tips "Get good-quality people shots-close-ups, verticals especially; use interesting props in classroom shots; include teacher and students together, teachers in groups, parents and teachers, cooperative learning and age-varying, multicultural children. Pay attention to backgrounds (not too busy) and understand the need for high-res photos!"

\$ JOURNAL OF PSYCHOACTIVE DRUGS

856 Stanyan St., San Francisco CA 94117. (415)752-7601. E-mail: hajpdeditor@comcast.net. Website: www.hajpd.com/. Circ. 1,400. Estab. 1967. Quarterly. Emphasizes "psychoactive substances (both legal and illegal)." Readers are "professionals (primarily health) in the drug abuse treatment field."

Needs Uses 1 photo/issue; supplied by freelancers. Needs "full-color abstract, surreal, avant garde or computer graphics."

Making Contact & Terms Send query letter with 4 × 6 color prints or 35mm slides. Online and e-mail submissions are accepted. Include SASE for return of material. Responds in 2 weeks. Simultaneous submissions and previously published work OK. Pays \$50 for color cover. Pays on publication. Credit line given. Buys one-time rights.

\$\$ JUDICATURE

2700 University Ave., Des Moines IA 50311. (773)973-0145. Fax: (773)338-9687. E-mail: drichert@ ajs.org, Website: www.ajs.org, Editor: David Richert. Circ. 5,000. Estab. 1917. Bimonthly publication of the American Judicature Society. Emphasizes courts, administration of justice. Readers are judges, lawyers, professors, citizens interested in improving the administration of justice. Sample copy free with 9×12 SAE and 6 first-class stamps.

Needs Buys 1-2 photos from freelancers/issue; 6-12 photos/year. Needs photos relating to courts, the law. "Actual or posed courtroom shots are always needed." Interested in fine art, historical/ vintage. Model/property release preferred. Photo captions preferred.

Specs Uses b&w and/or color prints. Accepts images in digital format. Send via CD, Zip, e-mail as JPEG files at 600 dpi.

Making Contact & Terms Submit samples via e-mail. Simultaneous submissions and previously published work OK. Pays \$250 for b&w cover; \$350 for color cover; \$125-250 for b&w inside; \$125-300 for color inside. Pays on publication. Credit line given. Buys one-time rights.

\$ LANDSCAPE ARCHITECTURE

636 Eye St. NW, Washington DC 20001. (202)898-2444. Fax: (202)898-1185. E-mail: info@asla.org; cmcgeea@sla.org. Website: www.asla.org. Art Director: Christopher McGee. Monthly magazine of the American Society of Landscape Architects. Emphasizes "landscape architecture, urban design, parks and recreation, architecture, sculpture" for professional planners and designers.

Needs Buys 5-10 photos from freelancers/issue; 50-120 photos/year. Needs photos of landscapeand architecture-related subjects as described above. Special needs include aerial photography and environmental portraits. Model release required. Credit, caption information required.

Making Contact & Terms Send query letter with samples or list of stock photo subjects. Provide brochure, flier or tearsheets to be kept on file for possible future assignments. Response time varies. Previously published work OK. Pays \$300-600/day. Pays on publication. Credit line given. Buys one-time rights.

Tips "We take an editorial approach to photographing our subjects."

M S THE MANITOBA TEACHER

191 Harcourt St., Winnipeg MB R3J 3H2, Canada. (204)888-7961. Fax: (204)831-0877. E-mail: gstephenson@mbteach.org. Website: www.mbteach.org. Editor: George Stephenson. Magazine of The Manitoba Teachers' Society published 7 times/year. Emphasizes education in Manitoba specifically teachers' interests. Readers are teachers and others in education. Sample copy free with 10 × 12 SAE and Canadian stamps.

Needs Buys 3 photos from freelancers/issue; 21 photos/year. Needs action shots of students and teachers in education-related settings. Model release required.

Making Contact & Terms Send 8 × 10 glossy b&w prints by mail for consideration; include SASE for return of material. Submit portfolio for review. Provide résumé, business card, brochure, flier or tearsheets to be kept on file for possible future assignments. Responds in 1 month. Pays \$40/ photo for single use.

Tips "Always submit action shots directly related to major subject matter of publication and interests of readership."

S\$\$ MANUFACTURING AUTOMATION & ADVANCED MANUFACTURING

CLB Media, 240 Edwards St., Aurora ON L4G 3S9, Canada. (905) 713-4378 or (905)727-0077. Fax: (905)727-0017 E-mail: editor@automationmag.com. Website: www.advancedmanufacturing. com. Editor: Mary Del Ciancio. Circ. 17,400. Estab. 1998. Bimonthly trade magazine providing a window on the world of advanced manufacturing. Sample copies available for SAE with first-class

Needs Buys 2 photos from freelancers per issue. Subjects include industry, science and technology. Reviews photos with or without a manuscript. Model release required. Photo captions preferred.

Specs Uses 5 × 7 color prints; 4 × 5 transparencies. "We prefer images in high-resolution digital format. Send as FTP files at a minimum of 300 dpi."

Making Contact & Terms Send query letter with résumé, stock list. Provide self-promotion piece to be kept on file for possible future assignments. Responds only if interested. Simultaneous submissions and previously published work OK. Pays \$200-1,000 for color cover; \$150-1,000 for color inside. Pays 30-45 days after invoice date. Credit line given. Buys one-time rights, electronic rights; negotiable.

Tips "Read our magazine. Put yourself in your clients' shoes. Meet their needs and you will excel. Understand your audience and the editors' needs. Meet deadlines, be reasonable and professional."

\$\$ MARKETING & TECHNOLOGY GROUP

1415 N. Dayton, Chicago IL 60622. (312)274-2216. E-mail: qburns@meatingplace.com. Website: www.marketingandtechnology.com. **VP/Design & Production:** Queenie Burns. Publishes magazines that emphasize meat and poultry processing. Readers are predominantly male, ages 35-65, generally conservative. Sample copy available for \$4.

Needs Buys 1-3 photos from freelancers/issue. Needs photos of food, processing plant tours, product shots, illustrative/conceptual. Model/property release preferred. Photo captions preferred.

Making Contact & Terms Provide résumé, business card, brochure, flier or tearsheets to be kept on file for possible future assignments. Submit portfolio for review. Keeps samples on file. Responds in 1 month. Simultaneous submissions and previously published work OK. Payment negotiable. Pays on publication. Credit line given.

Tips "Work quickly and meet deadlines. Follow directions when given; and when none are given, be creative while using your best judgment."

☑ ■ **☑** MEETINGS & INCENTIVE TRAVEL

1 Mount Pleasant Rd., 7th Floor, Toronto ON M4Y 2Y5, Canada. (416)764-1635. E-mail: lindsey. mrav@mtg.rogers.com. Website: www.meetingscanada.com. **Art Director:** Lindsey Mrav. Rogers Media. Circ. 10,500. Bimonthly trade magazine emphasizing meetings and travel.

Needs Buys 1-5 photos from freelancers/issue; 7-30 photos/year. Needs photos of environmental, landscapes/scenics, cities/urban, interiors/decorating, events, food/drink, travel, business concepts, technology/computers. Reviews photos with or without a manuscript. Model/property release required. Photo captions required; include location and date.

Specs Uses 8 × 12 prints depending on shoot and size of photo in magazine. Accepts images in digital format. Send via CD as TIFF files at 300 dpi.

Making Contact & Terms Contact through rep or send query letter with tearsheets. Portfolio may be dropped off every Tuesday. Provide résumé, business card, self-promotion piece to be kept on file for possible future assignments. Responds only if interested; send nonreturnable samples. Simultaneous submissions and previously published work OK. "Payment depends on many factors." Credit line given. Buys one-time rights.

Tips "Send samples to keep on file."

■ MY FOODSERVICE NEWS

P.O. Box 917, Newark OH 43058. (740)345-5542. Fax: (740)345-5557. E-mail: jim@mymfn. com. Website: www.mymfn.com. **Publisher:** Jim Young. (Formerly Midwest Foodservice News) Bimonthly magazine. "National publication targeting the independent restaurant owner." Each edition contains state and national news, plus articles of local interest, to foster an informative dialogue between foodservice operators, their suppliers and associated businesses." Sample copy available for \$3.95 with \$2 first-class postage.

Specs Accepts images in digital format only. Send via CD, e-mail as JPEG files at 300-800 dpi. **Making Contact & Terms** Send e-mail. Provide self-promotion piece to be kept on file for possible future assignments. Responds only if interested; send nonreturnable samples. Simultaneous submissions OK. Pay is based on experience. Pays on publication. Credit line given. Buys first rights.

N ■ \$\$ NAILPRO

7628 Densmore Ave., Van Nuys CA 91406-2042. (818)782-7328. Fax: (818)782-7450. E-mail: syaggy@creativeage.com. Website: www.nailpro.com. **Executive Editor:** Stephanie Yaggy. Circ. 65,000. Estab. 1990. Monthly magazine published by Creative Age Publications. Emphasizes topics for professional manicurists and nail salon owners. Readers are females of all ages. Sample copy available for \$2 with 9×12 SASE.

Needs Buys 10-12 photos from freelancers/issue; 120-144 photos/year. Needs photos of beautiful nails illustrating all kinds of nail extensions and enhancements; photographs showing process of creating and decorating nails, both natural and artificial. Also needs salon interiors, health/fitness, fashion/glamour. Model release required. Photo captions required; identify people and process if applicable.

Specs Accepts images in digital format. Send via Zip, e-mail as TIFF, EPS files at 300 dpi or better.

Making Contact & Terms Send query letter; responds only if interested. Call for portfolio review. "Art directors are rarely available, but photographers can leave materials and pick up later (or leave nonreturnable samples)." Send color prints; 35mm, 21/4 × 21/4, 4 × 5 transparencies. Keeps samples on file. Responds in 1 month. Previously published work OK. Pays \$500 for color cover; \$50-250 for color inside. Pays on acceptance. Credit line given. Buys one-time rights.

Tips "Talk to the person in charge of choosing art about photo needs for the next issue and try to satisfy that immediate need; that often leads to assignments. Submit samples and portfolios with letter stating specialties or strong points."

S NAILS MAGAZINE

Bobit Publishing, 3520 Challenger St., Torrance CA 90503. (310)533-2537. Fax: (310)533-2507. E-mail: danielle.parisi@bobit.com. Website: www.nailsmag.com. Art Director: Danielle Parisi. Circ. 60,000. Estab. 1982. Monthly trade publication for nail technicians and beauty salon owners. Sample copies available.

Needs Buys up to 10 photos from freelancers/issue. Needs photos of celebrities, buildings, historical/vintage. Other specific photo needs: salon interiors, product shots, celebrity nail photos. Reviews photos with or without a manuscript. Model release required. Photo captions preferred. Specs Uses 35mm transparencies. Accepts images in digital format. Send via CD, Zip as TIFF, EPS files at 266 dpi.

Making Contact & Terms Send query letter with résumé, slides, prints. Keep samples on file. Responds in 1 month on queries. Pays on acceptance. Credit line sometimes given if it's requested. Buys all rights.

\$\$ THE NATIONAL NOTARY

9350 De Soto Ave., Chatsworth CA 91311. (800)876-6827. Website: www.nationalnotary.org. Circ. 300,000 + . Bimonthly association magazine. Emphasizes "Notaries Public and notarization—goal is to impart knowledge, understanding and unity among notaries nationwide and internationally." Readers are employed primarily in the following areas: law, government, finance and real estate. Needs Number of photos purchased varies with each issue. "Photo subject depends on accompanying story/theme; some product shots used." Reviews photos with accompanying manuscript only. Model release required.

Making Contact & Terms Send query letter with samples. Provide business card, tearsheets, résumé or samples to be kept on file for possible future assignments. Prefers to see prints as samples. Cannot return material. Previously published work OK. Pays on publication. Credit line given "with editor's approval of quality." Buys all rights.

Tips "Since photography is often the art of a story, the photographer must understand the story to be able to produce the most useful photographs."

S S NAVAL HISTORY

U.S. Naval Institute, 291 Wood Rd., Annapolis MD 21402. (410)295-1071. Fax: (410)295-1049. E-mail: avoight@usni.org. Website: www.usni.org. Photo Editor: Amy Voight. Bimonthly association publication. Emphasizes Navy, Marine Corps, Coast Guard. Readers are male and female naval officers (enlisted, retirees), civilians. Photo guidelines free with SASE.

Needs Needs 40 photos from freelancers/issue; 240 photos/year. Needs photos of foreign and U.S. Naval, Coast Guard and Marine Corps vessels, industry, military, personnel and aircraft. Interested in historical/vintage. Photo captions required.

Specs Uses 8 × 10 glossy or matte b&w and/or color prints (color preferred); transparencies. Accepts images in digital format. Send via CD, Zip, e-mail as JPEG files at 300 dpi.

Making Contact & Terms "We prefer to receive photo images digitally. We accept cross-platform (must be Mac and PC compatible) CDs with CMYK images at 300 dpi resolution (TIFF or JPEG). If e-mailing an image, send submissions to Photo Editor. We do not return prints or slides unless specified with a SASE, so please do not send original photographs. Payment for any use of photography is based upon a space rate fee of \$25 for inside editorial, \$50 for an article opener, and \$200 for a cover. We negotiate fees with photographers who provide a volume of images for publication in books or as magazine pictorials. We sponsor three annual photo contests." (For additional information, see contest section.) For additional information please contact the Photo Editor. Responds in 1 month. Simultaneous submissions and previously published work OK. Pays on publication. Credit line given. Buys one-time and electronic rights.

■ \$ ⊘ NEWDESIGN MAGAZINE

6A New St., Warwick, Warwickshire CV34 4RX, United Kingdom. +44 (0)1926 408207. E-mail: info@newdesignmagazine.co.uk; tanya@newdesignmagazine.co.uk. Website: www.newdesignmagazine.co.uk. Circ. 5,000. Published 10 times/year. Emphasizes product design for product designers: informative, inspirational. Sample copies available.

Needs Needs photos of product shots/still life, technology. Reviews photos with or without a manuscript.

Specs Uses glossy color prints; 35mm transparencies. Accepts images in digital format. Send via CD as TIFF, JPEG files at 300 dpi.

Making Contact & Terms Send query letter with résumé. Provide self-promotion piece to be kept on file for possible future assignments. Cannot return material. Responds only if interested; send nonreturnable samples. Pays on publication. Credit line given.

NFPA JOURNAL

1 Batterymarch Park, Quincy MA 02169. E-mail: NFPAJournal@nfpa.org. Website: www.nfpa. org. **Art Director**: David Yount. Circ. 85,000. Bimonthly magazine of the National Fire Protection Association. Emphasizes fire and life safety information. Readers are fire professionals, engineers, architects, building code officials, ages 20-65. Sample copy free with 9 × 12 SAE or via e-mail.

Needs Buys 5-7 photos from freelancers/issue; 30-42 photos/year. Needs photos of fires and fire-related incidents. Model release preferred. Photo captions preferred.

Making Contact & Terms Send query letter with list of stock photo subjects. Provide résumé, business card, brochure, flier or tearsheets to be kept on file for possible future assignments. Send color prints and 35mm transparencies in 3-ring slide sleeve with date. Responds in 3 weeks. Payment negotiated. Pays on publication. Credit line given.

Tips "Send cover letter, 35mm color slides, preferably with manuscripts and photo captions."

■ S \$ PEDIATRIC ANNALS

6900 Grove Rd., Thorofare NJ 08086. (856)848-1000. Fax: (856)848-6091. E-mail: editor@ PediatricSuperSite.com. Website: www.pediatricsupersite.com. Monthly journal. Readers are practicing pediatricians. Sample copy free with SASE.

Needs Uses 5-7 photos/issue; primarily stock. Occasionally uses original photos of children in medical settings.

Specs Color photos preferred. Accepts images in digital format. Send as EPS, JPEG files at 300 dpi.

Making Contact & Terms Request editorial calendar for topic suggestions. E-mail query with link(s) to samples. Simultaneous submissions and previously published work OK. Pays varies;

negotiable. Pays on publication. Credit line given. Buys unlimited North American rights including any and all subsidiary forms of publication, such as electronic media and promotional pieces.

\$ PET PRODUCT NEWS

P.O. Box 6050, Mission Viejo CA 92690. (949)855-8822. Fax: (949)855-3045. E-mail: ppneditor@ bowtieinc.com. Website: www.petproductnews.com. Contact: Photo Editor. Monthly tabloid. Emphasizes pets and the pet retail business. Readers are pet store owners and managers. Sample copy available for \$5. Photo guidelines free with SASE or on website.

Needs Buys 16-50 photos from freelancers/issue; 192-600 photos/year. Needs photos of people interacting with pets, retailers interacting with customers and pets, pets doing "pet" things, pet stores and vets examining pets. Also needs wildlife, events, industry, product shots/still life, Interested in seasonal. Reviews photos with or without a manuscript. Model/property release preferred. "Enclose a shipment description with each set of photos detailing the type of animal, name of pet store, names of well-known subjects and any procedures being performed on an animal that are not self-explanatory."

Specs Accepts images in digital format. Send via CD, Zip, e-mail as TIFF, EPS, JPEG files at 300 dpi.

Making Contact & Terms "We cannot assume responsibility for submitted material, but care is taken with all work. Freelancers must include a self-addressed, stamped envelope for returned work." Send sharp 35mm color slides or prints by mail for consideration. Responds in 2 months. Previously published work OK. Pays \$75 for color cover; \$50 for color inside. Pays on publication. Photographer also receives 2 complimentary copies of issue in which their work appears. Credit line given; name and identification of subject must appear on each slide or photo. Buys one-time rights.

Tips Looks for "appropriate subjects, clarity and framing, sensitivity to the subject. No avant garde or special effects. We need clear, straight-forward photography. Definitely no 'staged' photos; keep it natural. Read the magazine before submission. We are a trade publication and need businesslike, but not boring, photos that will add to our subjects."

■ A \$ PILOT GETAWAYS

P.O. Box 550, Glendale CA 91209. (818)241-1890 or (877)745-6849. Fax: (818)241-1895. E-mail: info@pilotgetaways.com. Website: www.pilotgetaways.com. Circ. 25,000. Estab. 1998. Bimonthly magazine focusing on travel by private aircraft. Includes sections on backcountry, bush and mountain flying. Emphasizes private pilot travel-weekend getaways, fly-in dining, bush flying, and complete flying vacations. Readers are mid-life males, affluent.

Needs Uses assignment photos. Needs photos of adventure, travel, product shots/still life. Model release required. Photo captions required.

Specs Accepts medium-format and 35mm slides. Accepts images in digital format. Send via CD as TIFF files at 300 dpi.

Making Contact & Terms Provide résumé, business card or tearsheets to be kept on file for possible future assignments; contact by e-mail. Simultaneous submissions OK. Prefers previously unpublished work. Pays 30 days after publication. Credit line given. Buys all rights; negotiable.

Tips "Exciting, fresh and unusual photos of airplanes used for recreation. Aerial landscapes, fly-in destinations. Outdoor recreation: skiing, hiking, fishing and motor sports. Affluent back-country lifestyles: homes, hangars and private airstrips. Query first. Don't send originals—color copies or low-resolution digital OK for evaluation."

■ S \$\$ ☐ PI MAGAZINE

Professional Investigator Magazine, 4400 Rt. 9 S., Suite 1000, P.O. Box 7198, Freehold NJ 07728. (732)308-3800; (800)836-3088. Fax: (732)308-3314. E-mail: jim@pimagazine.com; graphics@ pimagazine.com. Website: www.pimagazine.com. Publisher: Jimmie Mesis. (Formerly PI Magazine, Journal of Professional Investigators.) Bimonthly trade magazine. "Our audience is 80%

private investigators with the balance law enforcement, insurance investigators, and people with interest in becoming a PI. The magazine features educational articles about the profession. Serious conservative format." Sample copy available for \$7.95 and SAE with \$1.75 first-class postage.

Needs Buys 10 photos from freelancers/issue; 60-100 photos/year. Needs photos of technology/ computers, law/crime. Reviews photos with or without a manuscript. Model/property release required. Photo captions preferred.

Specs Accepts images in digital format. Send via CD, e-mail as TIFF, EPS files at highest dpi.

Making Contact & Terms Query editor first at: editor@pimagazine.com. Or, mail query letter with tearsheets, stock list. Provide résumé, business card, self-promotion piece to be kept on file for possible future assignments. Responds only if interested; send nonreturnable samples. Simultaneous submissions OK. Pays \$200-500 for color cover; \$50-200 for color inside. Pays on publication. Credit line given. Buys all rights; negotiable.

\$\$ PLANNING

205 N. Michigan Ave., 205 N. Michigan Ave, Chicago IL 60603. (312)431-9100. Fax: (312)431-9985. E-mail: slewis@planning.org; rsessions@planning.org. Website: www.planning.org. Editor: Sylvia Lewis. Photo Director: Richard Sessions. Monthly magazine. "We focus on urban and regional planning, reaching most of the nation's professional planners and others interested in the topic." Sample copy and photo guidelines free with 10 × 13 SASE with 4 first-class stamps (do not send cash or checks).

Needs Buys 4-5 photos from freelancers/issue; 60 photos/year. Photos purchased with accompanying manuscript and on assignment. Photo essay/photo feature (architecture, neighborhoods, historic preservation, agriculture); scenic (mountains, wilderness, rivers, oceans, lakes); housing; transportation (cars, railroads, trolleys, highways). "No cheesecake; no sentimental shots of dogs, children, etc. High artistic quality is very important. We publish high-quality nonfiction stories on city planning and land use. Ours is an association magazine but not a house organ, and we use the standard journalistic techniques: interviews, anecdotes, quotes. Topics include energy, the environment, housing, transportation, land use, agriculture, neighborhoods and urban affairs." Photo captions required.

Specs Uses 4-color prints; 35mm, 4 × 5 transparencies. Accepts images in digital format. Send via Zip, CD as TIFF, EPS, JPEG files at 300 dpi and around 5 × 7 in physical size.

Making Contact & Terms Send query letter with samples; include SASE for return of material. Responds in 1 month. Previously published work OK. Pays \$50-100 for b&w photos; \$75-200 for color photos; \$375 maximum for cover; \$200-600 for manuscript. Pays on publication. Credit line given.

Tips "Subject lists are only minimally useful, as are website addresses. How the work looks is of paramount importance. Please don't send original slides or prints with the expectation of them being returned. Your best chance is to send addresses for your website showing samples of your work. As stated above, we no longer keep paper on file. If we like your style we will commission work from you."

\$ PLASTICS NEWS

1725 Merriman Rd., Akron OH 44313. (330)836-9180. Fax: (330)836-2322. E-mail: dloepp@crain. com. Website: www.plasticsnews.com. Managing Editor: Don Loepp. Weekly tabloid. Emphasizes plastics industry business news. Readers are male and female executives of companies that manufacture a broad range of plastics products; suppliers and customers of the plastics processing industry. Sample copy available for \$1.95.

Needs Buys 1-3 photos from freelancers/issue; 52-156 photos/year. Needs photos of technology related to use and manufacturing of plastic products. Model/property release preferred. Photo captions required.

Making Contact & Terms Send unsolicited photos by mail for consideration. Provide résumé, business card, brochure, flier or tearsheets to be kept on file for possible future assignments. Send query letter with stock list. Keeps samples on file; include SASE for return of material. Responds in 2 weeks. Simultaneous submissions and previously published work OK. Pays \$125-175 for color cover; \$100-150 for b&w inside; \$125-175 for color inside. Pays on publication. Credit line given. Buys one-time and all rights.

\$\$\$ PLASTICS TECHNOLOGY

Gardner Publications, 6915 Valley Ave., Cincinnati OH 45244. (513) 527-8800, (800)950-8020. Fax: (646)827-4859. E-mail: sbriggs@gardnerweb.com. Website: www.ptonline.com. Art Director: Sheri Briggs. Circ. 50,000. Estab. 1954. Monthly trade magazine. Sample copy available for firstclass postage.

Needs Buys 1-3 photos from freelancers/issue. Needs photos of agriculture, business concepts. industry, science, technology. Model release required. Photo captions required.

Specs Accepts images in digital format. Send via CD, Zip, e-mail as TIFF, EPS, JPEG files at 300 dpi.

Making Contact & Terms Send query letter with résumé, photocopies, tearsheets. Provide business card, self-promotion piece to be kept on file for possible future assignments. Responds only if interested; send nonreturnable samples. Simultaneous submissions OK. Pays \$1,000-1,300 for color cover; \$300 minimum for color inside. Pays on publication. Credit line given. Buys one-time rights, all rights; negotiable.

\$ POLICE AND SECURITY NEWS

DAYS Communications, Inc., 1208 Juniper St., Quakertown PA 18951. (215)538-1240. Fax: (215)538-1208. E-mail: amenear@policeandsecuritynews.com. Website: www.policeandsecuritynews.com. Associate Publisher: Al Menear. Bimonthly trade journal. "Police and Security News is edited for middle and upper management and top administration. Editorial content is a combination of articles and columns ranging from the latest in technology, innovative managerial concepts, training and industry news in the areas of both public law enforcement and Homeland security." Sample copy free with 13 × 10 SAE and \$2.24 first-class postage.

Needs Buys 2 photos from freelancers/issue; 12 photos/year. Needs photos of law enforcement and security related. Reviews photos with or without a manuscript. Photo captions preferred. **Specs** Uses color and b&w prints.

Making Contact & Terms Provide résumé, business card, self-promotion piece or tearsheets to be kept on file for possible future assignments. Art director will contact photographer for portfolio review if interested. Portfolio should include b&w and/or color prints or tearsheets. Keeps samples on file; include SASE for return of material. Simultaneous submissions and previously published work OK. Pays \$20-40 for color inside. Pays on publication. Credit line given. Buys one-time rights; negotiable.

POLICE MAGAZINE

3520 Challenger St., Torrance CA 90503. (310)533-2400. Fax: (310)533-2507. E-mail: david.griffith@ policemag.com; info@policemag.com. Website: www.policemag.com. Editor: David Griffith. Monthly. Emphasizes law enforcement. Readers are various members of the law enforcement community, especially police officers. Sample copies available. Photo guidelines free via e-mail.

Needs Uses in-house photos and freelance submissions. Needs law enforcement-related photos. Special needs include photos relating to daily police work, crime prevention, international law enforcement, police technology and humor. Model release required; property release preferred. Photo captions preferred.

Specs Uses color photos only. Accepts images in digital format. Send via e-mail or CD; no Zip files.

Making Contact & Terms Send contact sheet or samples by e-mail or mail for consideration. Simultaneous submissions OK. Pay scale available in photographer's guidelines. Pays on publication. Buys all rights.

Tips "Send for our editorial calendar and submit photos based on our projected needs. If we like your work, we'll consider you for future assignments. A photographer we use must grasp the conceptual and the action shots."

■ S \$ □ PROCEEDINGS

U.S. Naval Institute, 291 Wood Rd., Annapolis MD 21402. (410)295-1071. Fax: (410)295-1049. E-mail: avoight@usni.org. Website: www.usni.org. Photo Editor: Amy Voight. Circ. 80,000. Monthly trade magazine dedicated to providing an open forum for national defense. Sample copy available for \$3.95. Photo guidelines free with SASE.

Needs Buys 10 photos from freelancers/issue; 120 photos/year. Needs photos of industry, military, political. Model release preferred. Photo captions required; include time, location, subject matter, service represented—if necessary.

Specs Uses glossy color prints. Accepts images in digital format. Send via CD, Zip as TIFF, JPEG files at 300 dpi.

Making Contact & Terms Send query letter with résumé, prints. Does not keep samples on file; include SASE for return of material. Responds only if interested; send nonreturnable samples. Simultaneous submissions and previously published work OK. Pays \$200 for color cover; \$25-75 for color inside. Pays on publication. Credit line given. Buys one-time and sometimes electronic rights.

Tips "We look for original work. The best place to get a feel for our imagery is to see our magazine or look at our website."

S PRODUCE MERCHANDISING

Vance Publishing Corp., 400 Knightsbridge Pkwy., Lincolnshire IL 60069. (512)906-0733. E-mail: pamelar@produceretailer.com. Website: http://produceretailer.com. Editor: Pamela Riemenschneider. Monthly magazine, e-mail newsletters, and website. Emphasizes the retail end of the fresh produce industry. Readers are male and female executives who oversee produce operations in US and Canadian supermarkets as well as in-store produce department personnel. Sample copies available.

Needs Buys 2-5 photos from freelancers/issue; 24-60 photos/year. Needs in-store shots, environmental portraits for cover photos or display pictures. Photo captions required; include subject's name, job title and company title-all verified and correctly spelled.

Specs Accepts images in digital format. Send via e-mail as TIFF, JPEG files.

Making Contact & Terms E-mail only. Response time "depends on when we will be in a specific photographer's area and have a need." Pays \$500-750 for color cover; \$25-50/color photo. Pays on acceptance. Credit line given. Buys all rights.

Tips "We seek photographers who serve as our on-site 'art director' to ensure capture of creative angles and quality images."

PROFESSIONAL PHOTOGRAPHER

Professional Photographers of America, 229 Peachtree St. NE, Ste. 2200, International Tower, Atlanta GA 30303. (404)522-8600. Fax: (404)614-6406. E-mail: cbishopp@ppa.com. Website: www.ppmag. com. Art Director: Debbie Todd. Director of Publications: Cameron Bishopp. Monthly magazine. Emphasizes professional photography in the fields of portrait, wedding, commercial/advertising, sports, corporate and industrial. Readers include professional photographers and photographic services and educators. Approximately half the circulation is Professional Photographers of America members. Sample copy available for \$5 postpaid.

• PPA members submit material unpaid to promote their photo businesses and obtain recognition. Images sent to *Professional Photographer* should be technically perfect, and photographers should include information about how the photo was produced.

Needs Buys 25-30 photos from freelancers/issue; 300-360 photos/year. "We only accept material as illustration that relates directly to photographic articles showing professional studio, location,

commercial and portrait techniques. A majority are supplied by Professional Photographers of America members." Reviews photos with accompanying manuscript only. "We always need commercial/advertising and industrial success stories; how to sell your photography to major accounts, unusual professional photo assignments. Also, photographer and studio application stories about the profitable use of electronic still imaging for customers and clients." Model release preferred. Photo captions required.

Specs Prefers' images in digital format. Send via CD, e-mail as TIFF, EPS, JPEG files at 72 dpi minimum. Also uses 8 × 10 unmounted glossy b&w and/or color prints; 35mm, 21/4 × 21/4, 4 × 5, 8×10 transparencies.

Making Contact & Terms Send query letter with résumé of credits. "We prefer a story query, or complete manuscript if writer feels subject fits our magazine. Photos will be part of manuscript package." Responds in 2 months. Credit line given.

PUBLIC POWER

1875 Connecticut Ave. NW., Ste. 1200, Washington DC 20009. (202)467-2948; (800)515-2772. Fax: (202)467-2910. E-mail: dblaylock@appanet.org; mrufe@appanet.org; jlabella@appanet. org. Website: www.appanet.org. Editor: Jeanne LaBella. Bimonthly publication of the American Public Power Association. Emphasizes electric power provided by cities, towns and utility districts. Sample copy and photo guidelines free.

Needs "We buy photos on assignment only."

Specs Prefers digital images; call art director (Robert Thomas) at (202)467-2983 to discuss.

Making Contact & Terms Send query letter with samples. Provide résumé, business card, brochure, flier or tearsheets to be kept on file for possible future assignments. Pays on acceptance. Credit line given. Buys one-time rights.

■ \$\$ Ø OSR

4905 Pine Cone Dr., Suite 2, Durham NC 27707. (919)489-1916. Fax: (919)489-4767. E-mail: mavery@journalistic.com. Website: www.qsrmagazine.com. Production Manager: Mitch Avery. Trade magazine directed toward the business aspects of quick-service restaurants (fast food). "Our readership is primarily management level and above, usually franchisors and franchisees. Our goal is to cover the quick-service and fast, casual restaurant industries objectively, offering our readers the latest news and information pertinent to their business." Photo guidelines free.

Needs Buys 10-15 photos/year. Needs corporate identity portraits, images associated with fast food, general food images for feature illustration. Reviews photos with or without a manuscript. Model/property release preferred.

Specs Prefers images in digital format. Send via CD/DVD, Zip as TIFF, EPS files at 300 dpi.

Making Contact & Terms Send query letter with samples, brochure, stock list, tearsheets. Art director will contact photographer for portfolio review if interested. Portfolio should include slides and digital sample files. Keeps samples on file. Responds only if interested; send nonreturnable samples. Simultaneous submissions and previously published work OK. Pay's \$250-500 for color cover; \$250-500 for color inside. Pays on publication. Publisher only interested in acquiring all rights unless otherwise specified.

Tips "Willingness to work with subject and magazine deadlines essential. Willingness to follow artistic guidelines necessary but should be able to rely on one's own eye. Our covers always feature quick-service restaurant executives with some sort of name recognition (i.e., a location shot with signage in the background, use of product props which display company logo)."

N 🗏 \$ 🕢 QUICK FROZEN FOODS INTERNATIONAL ·

2125 Center Ave., Suite 305, Fort Lee NJ 07024-5898. (201)592-7007. Fax: (201)592-7171. E-mail: JohnQFFI@aol.com. Website: www.qffintl.com. Chief Editor/Publisher: John M. Saulnier. Quarterly magazine. Emphasizes retailing, marketing, processing, packaging and distribution of frozen foods around the world. Readers are international executives involved in the frozen food

industry: manufacturers, distributors, retailers, brokers, importers/exporters, warehousemen, etc. Sample copy available for \$20.

Needs Buys 10-25 photos/year. Uses photos of agriculture, plant exterior shots, step-by-step inplant processing shots, photos of retail store frozen food cases, head shots of industry executives, etc. Photo captions required.

Specs Accepts digital images via CD at 300 dpi, CMYK. Also accepts 5×7 glossy b&w and/or color prints.

Making Contact & Terms Send query letter with résumé of credits. Responds in 1 month. Payment negotiable. Pays on publication. Buys all rights but may reassign to photographer after publication.

Tips A file of photographers' names is maintained; if an assignment comes up in an area close to a particular photographer, she/he may be contacted. "When submitting your name, inform us if you are capable of writing a story if needed."

RANGEFINDER

6059 Bristol Pkwy., Ste. 100, Culver City CA 90230. (310)846-4770. Fax: (310)846-5995. E-mail: bhurter@rfpublishing.com; aronck@rfpublishing.com. Website: www.rangefindermag.com. Editor: Bill Hurter. Managing Editor: Abigail Ronck. Circ. 61,000. Estab. 1952. Monthly magazine. Emphasizes topics, developments and products of interest to the professional photographer. Readers are professionals in all phases of photography. Sample copy free with 11 × 14 SAE and 2 first-class stamps. Photo guidelines free with SASE.

Needs Buys very few photos from freelancers/issue. Needs all kinds of photos; almost always run in conjunction with articles. "We prefer photos accompanying 'how-to' or special interest stories from the photographer." No pictorials. Special needs include seasonal cover shots (vertical format only). Model release required; property release preferred. Photo captions preferred.

Making Contact & Terms Send query letter with résumé of credits. Keeps samples on file; include SASE for return of material. Responds in 1 month. Previously published work occasionally OK; give details. Payment varies. Covers submitted gratis. Pays on publication. Credit line given. Buys first North American serial rights; negotiable.

\$ READING TODAY

International Reading Association, 800 Barksdale Rd., P.O. Box 8139, Newark DE 19714-8139. (302)731-1600, ext. 250. Fax: (302)731-1057. E-mail: jmicklos@reading.org. Website: www. reading.org. Editor-in-Chief: John Miklos, Jr.. Bimonthly newspaper of the International Reading Association. Emphasizes reading education. Readers are educators who belong to the International Reading Association. Sample copies available. Photo guidelines free with SASE.

Needs Buys 1 or 2 photos from freelancers/issue; 6-12 photos/year. Needs classroom shots and photos of people of all ages reading in various settings. Reviews photos with or without a manuscript. Model/property release needed. Photo captions preferred; include names (if appropriate) and context of photo.

Specs Uses $3\frac{1}{2} \times 5$ or larger color and b&w prints. Prefers images in digital format. Send via CD, e-mail as JPEG files.

Making Contact & Terms Send query letter with résumé of credits and stock list. Send unsolicited photos by mail or e-mail for consideration; include SASE for return of material. Responds in 1 month. Simultaneous submissions and previously published work OK. Pays \$100 for editorial use. **Pays on acceptance.** Credit line given. Buys one-time rights for print use and rights to post editorially on the IRA website.

■ \$ RECOMMEND MAGAZINE

Worth International Media Group, 5979 NW 151st St., Suite 120, Miami Lakes FL 33014. (305)828-0123; (800)447-0123. Fax: (305)826-6950. E-mail: janet@recommend.com; rick@recommend.

com. Website: www.recommend.com; www.worthit.com. Editor-in-Chief: Rick Shively. Monthly. Emphasizes travel. Readers are travel agents, meeting planners, hoteliers, ad agencies.

Needs Buys 16 photos from freelancers/issue; 192 photos/year. "Our publication divides the world into 7 regions. Every month we use travel destination-oriented photos of animals, cities, resorts and cruise lines; feature all types of travel photography from all over the world." Model/property release required. Photo captions preferred; identification required on every photo.

Specs Accepts images in digital format. Send via CD, Zip as TIFF, EPS files at 300 dpi minimum. "We do not accept 35mm slides or transparencies."

Making Contact & Terms "Contact via e-mail to view sample of photography." Simultaneous submissions and previously published work OK. Pays \$75-150 for color cover; \$50 for front cover less than 80 square inches: \$25-50 for color inside, Pays 30 days after publication. Credit line given. Buys one-time rights.

Tips Prefers to see high-res digital files.

S S REFEREE

P.O. Box 161, Franksville WI 53126. (262)632-8855. Fax: (262)632-5460. E-mail: jstern@referee. com. Website: www.referee.com. Senior Editor: Jeffrey Stern. Monthly magazine. Readers are mostly male, ages 30-50. Sample copy free with 9 × 12 SAE and 5 first-class stamps. Photo guidelines free with SASE.

Needs Buys 37 photos from freelancers/issue; 444 photos/year. Needs action officiating shots all sports. Photo needs are ongoing. Photo captions required; include officials' names and hometowns.

Specs Prefers to use digital files (minimum 300 dpi submitted on CD only-no DVDs) and 35mm slides. Also uses color prints.

Making Contact & Terms Send unsolicited photos by mail for consideration. Responds in 2 weeks. Simultaneous submissions and previously published work OK. Pays \$100 for color cover; \$35 for color inside. Pays on publication. Credit line given. Rights purchased negotiable.

Tips "Prefer photos that bring out the uniqueness of being a sports official. Need photos primarily of officials at or above the high school level in baseball, football, basketball, softball, volleyball and soccer in action. Other sports acceptable, but used less frequently. When at sporting events, take a few shots with the officials in mind, even though you may be on assignment for another reason. Don't be afraid to give it a try. We're receptive, always looking for new freelance contributors. We are constantly looking for pictures of officials/umpires. Our needs in this area have increased. Names and hometowns of officials are required."

■ A \$ @ REGISTERED REP

Penton Media, 249 W. 17th St., 3rd Floor, New York NY 10011. (212)204-4200. E-mail: sean. barrow@penton.com. Website: www.rrmag.com. www.registeredrep.com. Managing Editor: Kristen French. Art Director: Sean Barrow. Monthly magazine. Emphasizes stock brokerage and financial services industries. Magazine is "requested and read by 90% of the nation's top financial advisors."

Needs Uses about 8 photos/issue—3 supplied by freelancers. Needs environmental portraits of financial and brokerage personalities, and conceptual shots of financial ideas—all by assignment only. Model/property release is photographer's responsibility. Photo captions required.

Specs Prefers 100 ISO film or better. Accepts images in digital format. Send via Zip, Jaz as TIFF at 300 dpi.

Making Contact & Terms Provide brochure, flier or tearsheets to be kept on file for possible future assignments. Cannot return material. Due to space limitations, please obtain permission prior to sending digital samples via e-mail. Simultaneous submissions and previously published work OK. Pays \$500-1,500 for cover; \$200-800 for inside. Pays 30 days after publication. Credit line given. Buys one-time rights. Publisher requires signed rights agreement.

Tips "We're always looking for young talent. The focus of our magazine is on design, so talent and professionalism are key."

RELAY MAGAZINE

P.O. Box 10114, 417 E. College Ave., Tallahassee FL 32302-2114. (850)224-3314, ext. 4. Fax: (850)224-2831. E-mail: mfordham@publicpower.com. Website: www.publicpower.com/relay. shtml. Circ. 5,000. Estab. 1957. Quarterly industry magazine of the Florida Municipal Electric Association. Emphasizes energy, electric, utility and telecom industries in Florida. Readers are utility professionals, local elected officials, state and national legislators, and other state power associations.

Needs Number of photos/issue varies; various number supplied by freelancers. Needs photos of electric utilities in Florida (hurricane/storm damage to lines, utility workers, power plants, infrastructure, telecom, etc.); cityscapes of member utility cities. Model/property release preferred. Photo captions required.

Specs Uses 3×5 , 4×6 , 5×7 , 8×10 b&w and/or color prints. Accepts images in digital format. **Making Contact & Terms** Send query letter with description of photo or photocopy. Keeps samples on file. Simultaneous submissions and previously published work OK. Payment negotiable. Rates negotiable. Pays on use. Credit line given. Buys one-time rights, repeated use (stock); negotiable. Tips "Must relate to our industry. Clarity and contrast important. Always query first."

S REMODELING

1 Thomas Circle NW, Suite 600, Washington DC 20005. (202)452-0800. E-mail: ibush@hanleywood. com; rspink@hanleywood.com; salfano@hanleywood.com. Website: www.remodelingmagazine. com. Managing Editor: Ingrid Bush. Publisher: Ron Spink. Circ. 80,000. Published 13 times/ year. "Business magazine for remodeling contractors." Readers are "small contractors involved in residential and commercial remodeling." Sample copy free with 8 × 11 SASE.

Needs Uses 10-15 photos/issue; number supplied by freelancers varies. Needs photos of remodeled residences, both before and after. Reviews photos with "short description of project, including architect's or contractor's name and phone number. We have one regular photo feature: Before and After describes a whole-house remodel. Request editorial calendar to see upcoming design features."

Specs Accepts images in digital format. Send via Zip as TIFF, GIF, JPEG files at 300 dpi.

Making Contact & Terms Provide résumé, business card, brochure, flier or tearsheets to be kept on file for possible future assignments. Responds in 1 month. Pays on acceptance. Credit line given. Buys one-time rights; web rights.

Tips Wants "interior and exterior photos of residences that emphasize the architecture over the furnishings."

\$\$ @ RESTAURANT HOSPITALITY

Penton Media, 1300 E. Ninth St., Cleveland OH 44114. (216)931-9942. Fax: (216)696-0836. E-mail: chris.roberto@penton.com. Website: www.restaurant-hospitality.com. Group Creative Director: Chris Roberto. Editor-in-Chief: Michael Sanson. Monthly magazine. Emphasizes "ideas for fullservice restaurants" including business strategies and industry food trends. Readers are restaurant owners/operators and chefs for full-service independent and chain concepts.

Needs Assignment needs vary; 10-15 photos from freelancers/issue, plus stock; 120 photos/year. Needs "on-location portraits, restaurant interiors and details, and occasional project specific food photos." Special needs include "subject-related photos; query first." Model release preferred. Photo captions preferred.

Specs Accepts images in digital format. Send via FTP, download link or e-mail.

Making Contact & Terms Send postcard samples. Provide business card, samples or tearsheets to be kept on file for possible future assignments. Previously published work OK. Pay varies; negotiable. Cover fees on per project basis. Pays on acceptance. Credit line given. Buys one-time rights plus usage in all media.

Tips "Send a postcard that highlights your work and website. If you mainly shoot in one specific metro area, it's always nice to know what city you're based in-seems that many photographers tastefully use only a web address on a mailer, but sometimes additional info helps."

\$\$ RTOHO: THE MAGAZINE

Association of Progressive Rental Organizations, 1504 Robin Hood Trail, Austin TX 78703. (800)204-2776; (512)794-0095. Fax: (512)794-0097. E-mail: nferguson@rtohq.org. Website: www.rtohq. org. Publications Editor/Art Director: Neil Ferguson. (Formerly Progressive Rentals.) Bimonthly magazine published by the Association of Progressive Rental Organizations. Emphasizes the rentalpurchase industry. Readers are owners and managers of rental-purchase stores in North America, Canada, Great Britain and Australia.

Needs Buys 1-2 photos from freelancers/issue; 6-12 photos/year. Needs "strongly conceptual, cutting-edge photos that relate to editorial articles on business/management issues. Also looking for photographers to capture unique and creative environmental portraits of our members." Model/ property release preferred.

Specs Prefers images in digital format.

Making Contact & Terms Provide brochure, flier or tearsheets to be kept on file for possible future assignments. Simultaneous submissions and previously published work OK. Pays \$200-450/job; \$350-450 for cover; \$200-450 for inside. Pays on publication. Credit line given. Buys one-time and electronic rights.

Tips "Understand the industry and the specific editorial needs of the publication, i.e., don't send beautiful still life photography to a trade association publication."

S S THE SCHOOL ADMINISTRATOR

801 N. Quincy St., Arlington VA 22203. (703)528-0700. E-mail: info@aasa.org. Website: www. aasa.org. Monthly magazine of the American Association of School Administrators. Emphasizes K-12 education. Readers are school district administrators including superintendents, ages 50-60. Sample copy available for \$10.

Needs Uses 8-10 photos/issue. Needs classroom photos (K-12), photos of school principals, superintendents and school board members interacting with parents and students. Model/property release preferred for physically handicapped students. Photo captions required; include name of school, city, state, grade level of students, and general description of classroom activity.

Specs Accepts images in digital format: TIFF, JPEG files at 300 dpi. Send via link to FTP site

Making Contact & Terms "Send a link to your FTP site with photos of children in public school settings, grades K-12. Do not send originals or e-mails of your work or website. Check our website for our editorial calendar. Familiarize yourself with topical nature and format of magazine before submitting work." Work assigned is 3-4 months prior to publication date. Keeps samples on file; include SASE for return of material. Simultaneous submissions and previously published work OK. Pays \$50-75 for inside photos. Credit line given. Buys one-time rights.

Tips "Prefer photos with interesting, animated faces and hand gestures. Always looking for the unusual human connection where the photographer's presence has not made subjects stilted."

SCHOOL TRANSPORTATION NEWS

STN Media Group, STN Magazine, P.O. Box 789, Redondo Beach CA 90277. (310)792-2226. Fax: (310)792-2231. E-mail: ryan@stnonline.com. Website: www.stnonline.com. Editor-in-Chief: Ryan Gray. Monthly trade magazine specializing in school bus and pupil transportation industries in North America. School Transportation News magazine is a source for news and trends affecting the safe and efficient transportation of North American school children and is read both by those who work in the industry and those in related local, state and federal agencies and national associations. Published on an 11-month schedule each year as well as an annual Buyer's Guide and monthly supplements. In addition to our editors and contributors, who scour the industry dayin and day-out for the latest news, STN relies on its readers to submit story ideas they feel would benefit all of our readers.

Needs Needs photos of babies/children/teens, education, automobiles, humor, historical/vintage, photos related to the school transportation community. Reviews photos with or without an accompanying manuscript. Model release required. Photo caption required.

Specs Accepts images in digital format. Send TIFF, EPS or high-density JPEG files at 300 dpi via e-mail to the editors, or mail a disc. Photos should be unedited and uncompressed.

Making Contact & Terms Payment negotiated. Pays on publication. Credit line given. Buys all rights.

Tips Think visual. *STN* is always seeking quality color photographs, regardless of whether they accompany a story or not. Photographs should be clear and depict a scene, event or individual of interest to the school transportation community."

■ \$\$ Ø SCRAP

1615 L St. NW, Suite 600, Washington DC 20036-5664. (202)662-8547. E-mail: kentkiser@scrap. org. Website: www.scrap.org. **Publisher & Editor-in-Chief:** Kent Kiser. Circ. 11,559. Estab. 1988. Bimonthly magazine of the Institute of Scrap Recycling Industries. Emphasizes scrap recycling for owners and managers of recycling operations worldwide. Sample copy available for \$8.

Needs Buys 0-15 photos from freelancers/issue; 15-70 photos/year. Needs operation shots of companies being profiled and studio concept shots. Model release required. Photo captions required.

Specs Accepts images in digital format. Send via CD, Zip, e-mail as TIFF files at 270 dpi.

Making Contact & Terms Provide résumé, business card, brochure, flier or tearsheets to be kept on file for possible future assignments. Previously published work OK. Pays \$800-1,500/day; \$100-400 for b&w inside; \$200-600 for color inside. **Pays on delivery of images.** Credit line given. Rights negotiable.

Tips Photographers must possess "ability to photograph people in corporate atmosphere, as well as industrial operations; ability to work well with executives, as well as laborers. We are always looking for good color photographers to accompany our staff writers on visits to companies being profiled. We try to keep travel costs to a minimum by hiring photographers located in the general vicinity of the profiled company. Other photography (primarily studio work) is usually assigned through freelance art director."

\$ SECURITY DEALER & INTEGRATOR

3 Huntington Quadrangle, Suite 301N, Melville NY 11747. (800)547-7377, ext. 2730. Fax: (847)384-1926. E-mail: deborah.omara@cygnusb2b.com. Website: www.securityinfowatch.com. Editor-in-Chief: Deborah L. O'Mara. Monthly magazine. Emphasizes security subjects. Readers are business owners who install alarm, security, CCTV, home automation and access control systems. Sample copy free with SASE. "SD&I magazine seeks credible, reputable thought leaders to provide timely, original editorial content for our readers-security value-added resellers, integrators, systems designers, central station companies, electrical contractors, consultants and others-on rapidly morphing new communications and signaling technologies, networking, standards, business acumen, project information and other topics to hone new skills and build business. Content must add value to our pages and provide thought-provoking insights on the industry and its future. In most cases content must be vendor-neutral, unless the discussion is on a patented or proprietary technology."

Needs Uses 2-5 photos/issue; none at present supplied by freelance photographers. Needs photos of security-application-equipment. Model release preferred. Photo captions required.

Specs Photos must be JPEG, TIFF or EPS form for any section of the magazine, including product sections (refer to the editorial calendar). We require a 300 dpi image at a minimum 100% size of 2×3 for product submissions. SD&I has a File transfer Protocol (FTP) site to send images over

10MB; visit www.cygnusb2b.com and note the Cygnus Web FTP icon on the bottom of the home page. Or, consult the editor for FTP instructions. See more complete guidelines online at: www. securityinfowatch.com/magazine/sdi/editorialguidelines.

Making Contact & Terms Send b&w and color prints by mail for consideration; include SASE for return of material. Responds "immediately." Simultaneous submissions and/or previously published work OK.

Tips "Do not send originals; send dupes only, and only after discussion with editor."

S SPECIALTY TRAVEL INDEX

Alpine Hansen Publishing, P.O. Box 458, San Anselmo CA 94979. (415)455-1643. Fax: (415)455-1648. E-mail: info@specialtytravel.com. Website: www.specialtytravel.com. Contact: Editor. Biannual trade magazine. Directory of special interest travel. Readers are travel agents. Sample copy available for \$6.

Needs Contact for want list. Buys photo/manuscript packages. Photo captions preferred.

Specs Uses digital images. Send via CD or photographer's website. "No e-mails for photo submissions!"

Making Contact & Terms Send query letter with résumé, stock list and website URL to view samples. Does not keep samples on file; include SASE for return of material. Responds in 2 months to queries. Simultaneous submissions and previously published work OK. Pays \$25/photo. Pays on acceptance. Credit line given.

Tips "We like a combination of scenery and active people. Read our magazine for a sense of what we need."

THE SURGICAL TECHNOLOGIST

6 W. Dry Creek Circle, Suite 200, Littleton CO 80120-8031. (303)694-9130. Fax: (303)694-9169. E-mail: kludwig@ast.org. Website: www.ast.org. Editor/Publisher: Karen Ludwig. Circ. 23,000. Monthly journal of the Association of Surgical Technologists. Emphasizes surgery. Readers are operating room professionals, well educated in surgical procedures, ages 20-60. Sample copy free with 9 × 12 SASE and 5 first-class stamps. Photo guidelines free with SASE.

Needs "surgical, operating room photos that show members of the surgical team in action." Model release required.

Making Contact & Terms Send low-res JPEGs with query via e-mail. Responds in 4 weeks after review by editorial board. Simultaneous submissions and previously published work OK. Payment negotiable. Pays on acceptance. Credit line given. Buys all rights.

\$ I TECHNIQUES

1410 King St., Alexandria VA 22314. (703)683-3111 / 800-826-9972. Fax: (703)683-7424. E-mail: techniques@acteonline.org. Website: www.acteonline.org. Managing Editor: Susan Emeagwali. Circ. 42,000. Estab. 1926. Monthly magazine of the Association for Career and Technical Education. Emphasizes education for work and on-the-job training. Readers are teachers and administrators in high schools and colleges. Sample copy free with 10×13 SASE.

• This publication is now outsourced and offers little opportunity for freelance photography. Needs Buys 1-2 photos from freelancers/issue; 12-24 photos/year. Needs "students in classroom and job training settings; teachers; students in work situations." Model release preferred for children. Photo caption preferred; include location, explanation of situation.

Specs Uses 5×7 color prints; 35mm transparencies.

Making Contact & Terms Send query letter with list of stock photo subjects. Send unsolicited photos by mail for consideration. Provide résumé, business card, brochure, flier or tearsheets to be kept on file for possible future assignments. Responds as needed. Simultaneous submissions and previously published work OK. Pays \$400 minimum for color cover; \$30 minimum for b&w inside; \$50 minimum for color inside; \$500-1,000/job. Pays on publication. Credit line given. Buys onetime rights; sometimes buys all rights; negotiable.

\$\$ TEXAS REALTOR MAGAZINE

P.O. Box 2246, Austin TX 78768. (800)873-9155 (512)370-2286. Fax: (512)370-2390. E-mail: jmathews@texasrealtors.com. Website: www.texasrealtors.com. Art Director: Joel Matthews. Monthly magazine of the Texas Association of Realtors. Emphasizes real estate sales and related industries. Readers are male and female realtors, ages 20-70. Sample copy free with SASE.

Needs Buys 10 photos from freelancers/issue; 120 photos/year. Needs photos of architectural details, business, office management, telesales, real estate sales, commercial real estate, nature. Property release required.

Making Contact & Terms Pays \$75-300/color photo; \$1,500/job. Buys one-time rights; negotiable.

A \$ TEXTILE RENTAL MAGAZINE

1800 Diagonal Rd., Suite 200, Alexandria VA 22314. (877)770-9274. E-mail: info@trsa.org. Website: www.trsa.org. Monthly magazine of the Textile Rental Services Association of America. Emphasizes the linen supply, industrial and commercial textile rental and service industry. Readers are "heads of companies, general managers of facilities, predominantly male; national and international readers." Needs Photos needed on assignment basis only. Model release preferred. Photo captions preferred or required "depending on subject."

Making Contact & Terms "We contact photographers on an as-needed basis from a directory. We also welcome inquiries and submissions." Cannot return material. Previously published work OK, Pays \$350 for color cover plus processing; "depends on the job." Pays on acceptance. Credit line given if requested. Buys all rights.

\$ THOROUGHBRED TIMES

P.O. Box 8237, 2008 Mercer Rd., Lexington KY 40533. (859)260-9800. Fax: (859)260-9800. E-mail: photos@thoroughbredtimes.com, thoroughbredtimes@thoroughbredtimes.com,letters@ thoroughbredtimes.com. Website: www.thoroughbredtimes.com. Circ. 18,000. Estab. 1985. Weekly tabloid news magazine. Emphasizes Thoroughbred breeding and racing. Readers are wide demographic range of industry professionals. Photo guidelines available upon request.

Needs Buys 10-15 photos from freelancers/issue; 520-780 photos/year. Looks for photos "only from desired trade (Thoroughbred breeding and racing)." Needs photos of specific subject features (personality, farm or business). Model release preferred. Photo captions preferred. "File info required."

Making Contact & Terms Provide business card, brochure, flier or tearsheets to be kept on file for possible future assignments. Responds in 1 month. Previously published work OK. Pays \$50 for b&w cover or inside; \$50 for color; \$250/day. Pays on publication. Credit line given. Buys one-time rights.

\$ TOBACCO INTERNATIONAL

Lockwood Publications, Inc., 26 Broadway, Floor 9M, New York NY 10004. (212)391-2060. Fax: (212)827-0945. E-mail: e.leonard@lockwoodpublications.com;info@tobaccoproductsmag.com. Website: www.tobaccointernational.com. Contact: Emerson Leonard, editor. Monthly international business magazine. Emphasizes cigarettes, tobacco products, tobacco machinery, supplies and services. Readers are executives, ages 35-60. Sample copy free with SASE.

Needs Uses 20 photos/issue. "Prefer photos of people smoking, processing or growing tobacco products from all around the world, but any interesting newsworthy photos relevant to subject matter is considered." Model and/or property release preferred.

Making Contact & Terms Send query letter with photocopies, transparencies, slides or prints. Does not keep samples on file; include SASE for return of material. Responds in 3 weeks. Simultaneous submissions OK (not if competing journal). Pays \$50/color photo. Pays on publication. Credit line may be given.

☐ TODAY'S PHOTOGRAPHER

American Image Press, P.O. Box 42, Hamptonville NC 27020-0042. (336)468-1138. Fax: (336)468-1899. Website: www.aipress.com. Editor-in-Chief: Vonda H. Blackburn. Published once a year in print, twice/year on internet. Magazine of the International Freelance Photographers Organization. Emphasizes making money with photography. Readers are 90% male photographers. Sample copy available for 9 × 12 SASE. Photo guidelines free with SASE.

Needs Buys 40 photos from freelancers/issue; 240 photos/year. Model release required. Photo captions preferred. Only buys content from members of IFPO (\$74 membership fee, plus \$7 shipping).

Making Contact & Terms Send 35mm, $2\frac{1}{4} \times 2\frac{1}{4}$, 4×5 , 8×10 b&w and/or color prints or transparencies by mail for consideration; include SASE for return of material. Responds at end of quarter. Simultaneous submissions and previously published work OK. Payment negotiable. Credit line given. Buys one-time rights, per contract.

Tips Wants to see "consistently fine-quality photographs and good captions or other associated information. Present a portfolio that is easy to evaluate—keep it simple and informative. Be aware of deadlines. Submit early."

S TREE CARE INDUSTRY

Tree Care Industry Association, 136 Harvey Rd., Suite 101, Londonderry NH 03053. (603)314-5380. Fax: (603)314-5386. E-mail: staruk@tcia.org. Website: www.treecareindustry.org. Managing Editor: Don Staruk. Circ. 28,500. Estab. 1990. Monthly trade magazine for arborists, landscapers and golf course superintendents interested in professional tree care practices. Sample copy available for \$5.

Needs Buys 3-6 photos/year. Needs photos of environment, landscapes/scenics, gardening. Reviews photos with or without a manuscript.

Specs Uses color prints. Accepts images in digital format. Send via e-mail as TIFF files at 300 dpi. Making Contact & Terms Send query letter with stock list. Does not keep samples on file; include SASE for return of material. Pays \$100 maximum for color cover; \$25 minimum for color inside. Pays on publication. Credit line given. Buys one-time rights and online rights. Tips Query by e-mail.

\$\$ \(\text{VETERINARY ECONOMICS} \)

Advanstar Veterinary Healthcare Communications, 8033 Flint, Lenexa KS 66214. (913)492-4300. Fax: (913)492-4157. E-mail: afulton@advanstar.com. Website: www.dvm360.com. Sr. Art Director: Alison Fulton. Art Director: Melissa Galitz. Monthly trade magazine emphasizing practice management for veterinarians.

Needs Photographers on an "as needed" basis for editorial portraits; must be willing to sign license agreement; 2-3 photo portraits/year. License agreement required. Photo captions preferred.

Specs Prefers images in digital format. Send via FTP, e-mail as JPEG files at 300 dpi.

Making Contact & Terms Send 1 e-mail with sample image less than 1 MB; repeat e-mails are deleted. Does not keep samples on file. Pays on acceptance. Credit line given.

\$ WATER WELL JOURNAL

National Ground Water Association, 601 Dempsey Rd., Westerville OH 43081. (800)551-7379. Fax: (614)898-7786. E-mail: tplumley@ngwa.org. Website: www.ngwa.org. Associate Editor: Mike Price. Director of Publications/Editor: Thad Plumley. Circ. 24,000. Estab. 1947. Monthly association publication. Emphasizes construction of water wells, development of ground water resources and ground water cleanup. Readers are water well drilling contractors, manufacturers, suppliers, and ground water scientists. Sample copy available for \$21 U.S., \$36 foreign.

Needs Buys 1-3 freelance photos/issue plus cover photos; 12-36 photos/year. Needs photos of installations and how-to illustrations. Model release preferred. Photo captions required.

Specs Accepts images in digital format. Send via CD, Jaz, Zip as TIFF files at 300 dpi.

Making Contact & Terms Send query letter with samples. "We'll contact you." Pays \$250 for color cover; \$50 for b&w or color inside; "flat rate for assignment." Pays on publication. Credit line given. Buys all rights.

Tips "E-mail or send written inquiries; we'll reply if interested. Unsolicited materials will not be returned."

\$\$ WINES & VINES

1800 Lincoln Ave., San Rafael CA 94901. (415)453-9700. Fax: (415)453-2517. E-mail: edit@ winesandvines.com. Website: www.winesandvines.com. News and Copy Editor: Jane Firstenfeld. Circ. 5,000. Monthly magazine. Emphasizes winemaking, grape growing, and marketing in North America and internationally for wine industry professionals, including winemakers, grape growers, wine merchants and suppliers.

Needs Wants color cover subjects on a regular basis.

Specs Accepts images in digital format. Send via CD, Zip, e-mail as TIFF, or JPEG files at 400 dpi. **Making Contact & Terms** Prefers e-mail query with link to portfolio; or send material by mail for consideration. Will e-mail if interested in reviewing photographer's portfolio. Provide business card to be kept on file for possible future assignments. Responds in 3 months. Previously published work considered. Pays \$100-350 for color cover, or negotiable ad trade out. Pays on publication. Credit line given. Buys one-time rights.

S WISCONSIN ARCHITECT

321 S. Hamilton St., Madison WI 53703. (608)257-8477. Website: www.aiaw.org. Circ. 3,700. Estab. 1931. Annual magazine of the American Institute of Architects Wisconsin. Emphasizes architecture. Readers are design/construction professionals.

Needs Uses approximately 100 photos/issue. "Photos are almost exclusively supplied by architects who are submitting projects for publication. Of these, approximately 65% are professional photographers hired by the architect."

Making Contact & Terms "Contact us through architects." Keeps samples on file. Responds when interested. Simultaneous submissions and previously published work OK. Pays on publication. Credit line given. Rights negotiable.

WOMAN ENGINEER

445 Broad Hollow Rd., Suite 425, Melville NY 11747. (631)421-9421, ext. 12. Fax: (631)421-1352. E-mail: info@eop.com; llang@eop.com. Website: www.eop.com. Art Director: Laura Lang. Equal Opportunity Publications, Inc. Circ. 16,000. Magazine published 3 times/year. Emphasizes career guidance for women engineers at the college and professional levels. Readers are college-age and professional women in engineering. Sample copy free with 9 × 12 SAE and 6 first-class stamps.

Needs Uses at least 1 photo/issue (cover); planning to use freelance work for covers and possibly editorial; most of the photos are submitted by freelance writers with their articles. Model release preferred. Photo captions required.

Making Contact & Terms Send query letter with list of stock photo subjects, or call to discuss current needs. Responds in 6 weeks. Simultaneous submissions OK. Credit line given. Buys one-time rights. **Tips** "We are looking for strong, sharply focused photos or slides of women engineers. The photo should show a woman engineer at work, but the background should be uncluttered. The photo subject should be dressed and groomed in a professional manner. Cover photo should represent a professional woman engineer at work and convey a positive and professional image. Read our magazine, and find actual women engineers to photograph. We're not against using cover models, but we prefer cover subjects to be women engineers working in the field."

\$\$ WOODSHOP NEWS

Soundings Publications LLC, 10 Bokum Rd., Essex CT 06426. (860)767-8227. Fax: (860)767-0645. E-mail: t.riggio@woodshopnews.com; editorial@woodshopnews.com. Website: www. woodshopnews.com. Editor: Tod Riggio. The news magazine for professional woodworkers. Circ. 60,000. Estab. 1986. Monthly trade magazine (tabloid format) covering all areas of professional woodworking. Sample copies available.

Needs Buys 12 sets of cover photos from freelancers/year. Needs photos of celebrities, architecture, interiors/decorating, industry, product shots/still life. Interested in documentary. "We assign our cover story, which is always a profile of a professional woodworker. These photo shoots are done in the subject's shop and feature working shots, portraits and photos of subject's finished work." Photo captions required; include description of activity contained in shots. "Photo captions will be written in-house based on this information."

Specs Prefers digital photos.

Making Contact & Terms Send query letter with résumé, photocopies, tearsheets. Provide self-promotion piece to be kept on file for possible future assignments. Responds only if interested; send nonreturnable samples. Previously published work OK occasionally. Pays \$600-800 for color cover. Note: "We want a cover photo 'package'—one shot for the cover, others for use inside with the cover story." Pays on acceptance. Credit line given. Buys "perpetual" rights, but will pay a lower fee for one-time rights.

Tips "I need a list of photographers in every geographical region of the country—I never know where our next cover profile will be done, so I need to have options everywhere. Familiarity with woodworking is a definite plus. Listen to our instructions! We have very specific lighting and composition needs, but some photographers ignore instructions in favor of creating 'artsy' photos, which we do not use, or poorly lighted photos, which we cannot use."

■ \$\$ ✓ WORLD TOBACCO

DMG World Media, Westgate House, 120/130 Station Rd., Redhill, Surrey RH1 1ET, United Kingdom. E-mail: anja.helk@konradin.de; stefanie.rossel@konradin.de; william.mcewen@ konradin.de. Website: www.worldtobacco.co.uk. Editors: William McEwen and Anja Helk. Circ. 4,300. Trade magazine. "Focuses on all aspects of the tobacco industry from international trends to national markets, offering news and views on the entire industry from leaf farming to primary and secondary manufacturing, to packaging, distribution and marketing." Sample copies available. Request photo guidelines via e-mail.

Needs Buys 5-10 photos from freelancers/issue; agriculture, product shots/still life. "Anything related to tobacco and smoking. Abstract smoking images considered, as well as international images." Specs Accepts almost all formats. Minimum resolution of 300 dpi at the size to be printed. Prefers

TIFFs to JPEGs, but can accept either.

Making Contact & Terms E-mail query letter with link to photographer's website, JPEG samples at 72 dpi. Provide self-promotion piece to be kept on file for possible future assignments. Pays £200 maximum for cover photo. Pays on acceptance. Credit line given.

Tips "Check the features list on our website."

■ \$ □ WRITERS' JOURNAL

P.O. Box 394, Perham MN 56573. (218)346-7921. E-mail: writersjournal@writersjournal.com. Website: www.writersjournal.com. Publisher: John Ogroske. Estab. 1980. Bimonthly trade magazine. Sample copy available for \$6.

Needs Buys 1 photo from freelancers/issue; 6 photos/year. Needs photos of landscapes/scenics or wildlife; more recently uses photos about reading or writing.

Specs Uses 8 × 10 color prints. "Digital images must be accompanied by a hardcopy printout." Making Contact & Terms Does not keep samples on file; include SASE for return of material. Responds in 2 months. Pays \$50 for color cover. Pays on publication. Credit line given. Buys one time North American rights.

Book Publishers

here are diverse needs for photography in the book publishing industry. Publishers need photos for the obvious (covers, jackets, text illustrations, and promotional materials), but they may also need them for use on CD-ROMs and websites. Generally, though, publishers either buy individual or groups of photos for text illustration, or they publish entire books of photography.

Those in need of text illustration use photos for cover art and interiors of textbooks, travel books, and nonfiction books. For illustration, photographs may be purchased from a stock agency or from a photographer's stock, or the publisher may make assignments. Publishers usually pay for photography used in book illustration or on covers on a per-image or per-project basis. Some pay photographers hourly or day rates, if on an assignment basis. No matter how payment is made, however, the competitive publishing market requires freelancers to remain flexible.

To approach book publishers for illustration jobs, send a cover letter with photographs or slides and a stock photo list with prices, if available. (See sample stock list on page 17.) If you have a website, provide a link to it. If you have published work, tearsheets are very helpful in showing publishers how your work translates to the printed page.

PHOTO BOOKS

Publishers who produce photography books usually publish books with a theme, featuring the work of one or several photographers. It is not always necessary to be well-known to publish your photographs as a book. What you do need, however, is a unique perspective, a salable idea, and quality work.

For entire books, publishers may pay in one lump sum or with an advance plus royalties (a percentage of the book sales). When approaching a publisher for your own book of photographs, query first with a brief letter describing the project, and include sample photographs. If the publisher is interested in seeing the complete proposal, you can send additional information in one of two ways depending on the complexity of the project.

Prints placed in sequence in a protective box, along with an outline, will do for easy-to-describe, straightforward book projects. For more complex projects, you may want to create a book dummy. A dummy is basically a book model with photographs and text arranged as they will appear in finished book form. Book dummies show exactly how a book will look, including the sequence, size, format and layout of photographs and accompanying text. The quality of the dummy is important, but keep in mind that the expense can be prohibitive.

To find the right publisher for your work, first check the Subject Index on page 531 to help narrow your search, then read the appropriate listings carefully. Send for catalogs and guidelines for those publishers that interest you. You may find guidelines on publishers' websites as well. Also, become familiar with your local bookstore or visit the site of an online bookstore such as

Amazon.com. By examining the books already published, you can find those publishers who produce your type of work. Check for both large and small publishers. While smaller firms may not have as much money to spend, they are often more willing to take risks, especially on the work of new photographers. Keep in mind that photo books are expensive to produce and may have a limited market.

ACTION PUBLISHING

P.O. Box 391, Glendale CA 91209. (323)478-1667. Fax: (323)478-1767. Website: www. actionpublishing.com. Subjects include children's books, fiction, nonfiction, art and photography. **Specs** Uses all formats.

Making Contact & Terms Send promo piece. Pays by the project or per photo.

Tips "We use a small number of photos. Promo is kept on file for reference if potential interest. If book proposal, send query letter first with web link to sample photos if available."

ADAMS MEDIA.

F+W Media, Inc., 57 Littlefield St., Avon, MA 02322. (508)427-7116. Fax: (508)427-6790. E-mail: frank.rivera@fwmedia.com. Website: www.adamsmedia.com. Art Director: Frank Rivera. Estab. 1980. Publishes hardcover originals; trade paperback originals and reprints. Types of books include biography, business, gardening, pet care, cookbooks, history, humor, instructional, New Age, nonfiction, reference, self-help and travel. Specializes in business and careers. Recent titles: 1001 Books to Read for Every Mood, Green Christmas, The Bride's Survival Guide. Publishes 260 titles/ year. Book catalog free by request.

Making Contact & Terms Send postcard sample of work. Samples are filed. Art director will contact artist for portfolio review if interested. Portfolio should include tearsheets. Rights purchased vary according to project, but usually buys all rights.

A AERIAL PHOTOGRAPHY SERVICES

2511 S. Tryon St., Charlotte NC 28203. (704)333-5144. Fax: (704)333-4911. Website: www.aps-1. com. Publishes pictorial books, calendars, postcards, etc. Photos used for text illustrations, book covers, souvenirs. Examples of recently published titles: Blue Ridge Parkway Calendar; Great Smoky Mountain Calendar; North Carolina Calendar; North Carolina Outer Banks Calendar—all depicting the seasons of the year. Photo guidelines free with SASE.

Needs Buys 100 photos/year. Wants landscapes/scenics, mostly seasons (fall, winter, spring). Reviews stock photos. Model/property release preferred. Photo captions required; include location.

Specs Uses 5×7 , 8×10 matte color prints; 35mm, $2\frac{1}{4} \times 2\frac{1}{4}$, 4×5 transparencies; C41 120mm film mostly. Accepts images in digital format on CD.

Making Contact & Terms Send unsolicited photos by mail with SASE for consideration. Works with local freelancers on assignment only. Responds in 3 weeks. Simultaneous submissions OK. Payment negotiable. Pays on acceptance. Credit line given. Buys all rights; negotiable.

Tips Looking for "fresh looks; creative, dynamic, crisp images. We use a lot of nature photography, scenics of the Carolinas area including Tennessee and the mountains. We like to have a nice variety of the 4 seasons. We also look for quality chromes good enough for big reproduction. Only submit images that are very sharp and well exposed. For the fastest response time, please limit your submission to only the highest-quality transparencies. Seeing large-format photography the most (120mm-4 × 5). If you would like to submit images on a CD, that is acceptable also."

A \$\$ ALL ABOUT KIDS PUBLISHING

P.O. Box 159, Gilroy CA 95021. (408)429-0393. Website: www.aakp.com. Editor: Linda L. Guevara. Publishes children's books, including picture books and books for young readers.

Needs Uses freelance photographers on assignment only. Model/property release required. **Specs** Uses 35mm transparencies.

Making Contact & Terms Submit portfolio, color samples/copies. Include cover letter, résumé, contact info. Keeps samples on file for possible future assignments; include SASE for return of material. Pays by the project, \$500 minimum or royalty of 5% based on wholesale price.

Tips "Visit out our website for updates and submission guidelines."

■ \$\$ ② ALLYN & BACON PUBLISHERS

75 Arlington St., Suite 300, Boston MA 02116. Website: www.ablongman.com. **Contact:** Find local rep to submit materials via online Rep Locator. Publishes college textbooks. Photos used for text illustrations, book covers. Examples of recently published titles: *Criminal Justice*; *Including Students with Special Needs*; *Social Psychology* (text illustrations and promotional materials).

Needs Offers 1 assignment plus 80 stock projects/year. Needs photos of babies/children/teens, celebrities, couples, multicultural, families, parents, senior citizens, disasters, education, special education, science, technology/computers. Interested in fine art, historical/vintage. Also uses multi-ethnic photos in education, health and fitness, people with disabilities, business, social sciences and good abstracts. Reviews stock photos. Model/property release required.

Specs Uses b&w prints, any format; all transparencies. Accepts images in digital format. Send via CD, Zip, e-mail as TIFF, EPS, PICT, GIF, JPEG files at 72 dpi for review, 300 dpi for use.

Making Contact & Terms See photo and art specifications online.

AMERICAN SCHOOL HEALTH ASSOCIATION

P.O. Box 708, Kent OH 44240. (330)678-1601. Fax: (330)678-4526. E-mail: asha@ashaweb.org. Website: www.ashaweb.org. Publishes professional journals. Photos used for book covers.

Needs Looking for photos of school-age children. Model/property release required. Photo captions preferred; include photographer's full name and address.

Specs Uses 35mm transparencies.

Making Contact & Terms Send query letter with samples. Does not keep samples on file; include SASE for return of material. Responds as soon as possible. Simultaneous submissions and previously published work OK. Payment negotiable. Pays on publication. Credit line given. Buys one-time rights.

MANVIL PRESS

P.O. Box 3008 MPO, Vancouver BC V6B 3X5, Canada. (604)876-8710. Fax: (604)879-2667. E-mail: info@anvilpress.com. **Publisher:** Brian Kaufman.

■ S\$ S APPALACHIAN MOUNTAIN CLUB BOOKS

5 Joy St., Boston MA 02108. (617)523-0655. Fax: (617)523-0722. Website: www.outdoors.org. Publishes hardcovers and trade paperbacks. Photos used for text illustrations, book covers. Examples of recently published titles: *Discover* series, *Best Day Hikes* series, *Trail Guide* series.

Needs Looking for photos of nature, hiking, backpacking, biking, paddling, skiing in the Northeast. Model release required. Photo captions preferred; include location, description of subject, photographer's name and phone number.

Specs Uses print-quality color and gray-scale images.

Making Contact & Terms E-mail light boxes. Art director will contact photographer if interested. Keeps samples on file. Responds only if interested.

M S \$\$\$\$ ₩ BARBOUR PUBLISHING, INC.

1800 Barbour Dr., P.O. Box 719, Urichsville OH 44683. (740)922-6045. E-mail: Aschrock@ Barbourbooks.com. Website: www.Barbourbooks.com. Creative Director: Ashley Schrock. Estab. 1981. Publishes Adventure, humor, juvenile, romance, religious, young adult, coffee table, cooking

and reference books. Specializes in inspirational fiction. "We're an inspirational company—no graphic or provocative images are used. Mostly scenic, non-people imagery/illustration."

Needs Inspirational/traditional. Publishes 364 titles/year.

Tips Portfolio should include b&w, color, finished and original art, and tearsheets. "Provide Samples"

M BEARMANOR MEDIA

P.O. Box 1129, Duncan OK 73534. (580)252-3547. Fax: (814)690-1559. E-mail: Books@Benohmart. com. Publisher: Ben Ohmart, Estab. 2000. Publishes 60 + titles/year. Payment negotiable. Responds only if interested. Catalog available online or free with a 9×12 SASE submission.

Tips "Potential freelancers should be familiar with our catalog, be able to work comfortably and timely with project managers across 12 time zones and be computer savvy. Like many modern publishing companies, different facets of our company are located in different regions from Japan to both US coasts. Potential freelancers must be knowledgeable in the requirements of commercial printing in regards to resolution, colorspace, process printing and contrast levels. Please provide some listing of experience and payment requirements."

S \$\$ BEDFORD/ST. MARTIN'S

175 Fifth Ave., New York NY 10010. (646)307-5151. E-mail: contactus@bedfordstmartins.com. Website: www.bedfordstmartins.com. Publishes college textbooks. Subjects include English, communications, philosophy, music, history. Photos used for text illustrations, promotional materials, book covers. Examples of recently published titles: Stages of Drama, 5th Edition (text illustration, book cover); 12 Plays (book cover); Campbell Media & Cultural 5.

Needs "We use photographs editorially, tied to the subject matter of the book." Needs mostly historical photos. Also wants artistic, abstract, conceptual photos; people-predominantly American; multicultural, cities/urban, education, performing arts, political, product shots/still life, business concepts, technology/computers. Interested in documentary, fine art, historical/vintage. Not interested in photos of children or religious subjects. Also uses product shots for promotional material. Reviews stock photos. Model/property release required.

Specs Prefers images in digital format. Send via CD, Zip as TIFF, EPS, JPEG files at 300 dpi. Also uses 8×10 b&w and/or color prints; 35mm, $2\frac{1}{4} \times 2\frac{1}{4}$, 4×5 transparencies.

Making Contact & Terms Send query letter with nonreturnable samples. Provide résumé, business card, brochure, flier or tearsheets to be kept on file for possible future assignments. Previously published work OK. Pays \$50-1,000 for cover. Credit line always included for covers, never on promo. Buys one-time rights and all rights in every media; depends on project; negotiable.

Tips "We like Web portfolios; we keep postcards, sample sheets on file if we like the style and/or subject matter."

BENTLEY PUBLISHERS

1734 Massachusetts Ave., Cambridge MA 02138. (617)547-4170. Fax: (617)876-9235. E-mail: michael.bentley@bentleypublishers.com. Website: www.bentleypublishers.com. Michael Bentley. Publishes professional, technical, consumer how-to books. Photos used for text illustrations, promotional materials, book covers, dust jackets. Examples of published titles: Porsche: Genesis of Genius; Toyota Prius Repair and Maintenance Manual.

Needs Buys 70-100 photos/year; offers 5-10 freelance assignments/year. Looking for motorsport, automotive technical and engineering photos. Reviews stock photos. Model/property release required. Photo captions required; include date and subject matter.

Specs Uses 8 × 10 transparencies. Accepts images in digital format.

Making Contact & Terms Send query letter with samples. Provide résumé, business card, brochure, flier or tearsheets to be kept on file for possible future assignments. Keeps samples on file; cannot return material. Works on assignment only. Responds in 6 weeks. Simultaneous submissions and previously published work OK. Payment negotiable. Credit line given. Buys electronic and one-time rights.

☑ ■ BOSTON MILLS PRESS

66 Leek Crescent, Richmond Hill ON L4B 1H1, Canada. E-mail: publicity@fireflybooks.com. Website: www.fireflybooks.com/BostonMills. Estab. 1974. Publishes coffee table books, local guide books. Photos used for text illustrations, book covers and dust jackets.

Needs "We're looking for book-length ideas, *not* stock. We pay a royalty on books sold, plus advance."

Specs Prefers images in digital format, but will accept 35mm transparencies.

Making Contact & Terms Send query letter with résumé of credits. Does not keep samples on file; include SAE/IRC for return of material. Simultaneous submissions OK. Payment negotiated with contract. Credit line given.

■ \$\$ BREWERS ASSOCIATION

736 Pearl St., Boulder CO 80302. (888)822-6273 (US and Canada). Fax: (303)447-0816. E-mail: info@brewersassociation.org. Website: www.beertown.org. Publishes beer how-to, cooking with beer, trade, hobby, brewing, beer-related books. Photos used for text illustrations, promotional materials, books, magazines. Examples of published magazines: *Zymurgy* (front cover and inside); *The New Brewer* (front cover and inside). Examples of published book titles: *Sacred & Herbal Healing Beers* (front/back covers and inside); *Standards of Brewing* (front/back covers).

Needs Buys 15-30 photos/year; offers freelance assignments. Needs photos of food/drink, beer, hobbies, humor, agriculture, business, industry, product shots/still life, science. Interested in alternative process, fine art, historical/vintage.

Specs Uses b&w prints; 35mm, $2\frac{1}{4} \times 2\frac{1}{4}$, 4×5 transparencies. Accepts images in digital format. Send via CD, e-mail as TIFF, EPS, JPEG files at 300 dpi.

Making Contact & Terms Send query letter with nonreturnable samples. Provide résumé, business card, brochure, flier or tearsheets to be kept on file for possible future assignments. Simultaneous submissions and previously published work OK. Payment negotiable; all jobs done on a quote basis. Pays by the project: \$700-800 for cover shots; \$300-600 for inside shots. Pays 60 days after receipt of invoice. Preferably buys one-time usage rights; negotiable.

Tips "Send nonreturnable samples for us to keep in our files that depict whatever your specialty is, plus some samples of beer-related objects, equipment, events, people, etc."

■ \$ ☑ CAPSTONE PRESS

151 Good Counsel Dr., Mankato MN 56002. (800)747-4992. Fax: (507)388-1227. E-mail: d.barton@capstonepress.com. Website: www.capstonepress.com. Photo Director: Dede Barton. Publishes juvenile nonfiction and educational books. Subjects include animals, ethnic groups, vehicles, sports, history, scenics. Photos used for text illustrations, promotional materials, book covers. "To see examples of our products, please visit our website." Photo guidelines for projects are available after initial contact or reviewing of photographer's stock list.

Needs Buys about 3,000 photos/year. "Our subject matter varies (usually 100 or more different subjects/year); editorial-type imagery preferable, although always looking for new ways to show an overused subject or title (fresh)." Model/property release preferred. Photo captions preferred; include "basic description; if people of color, state ethnic group; if scenic, state location and date of image."

Specs Uses various sizes of color and/or b&w prints (if historical); 35 mm, $2\frac{1}{4} \times 2\frac{1}{4}$, 4×5 transparencies. Accepts images in digital format for submissions as well as for use. Digital images must be at least 8×10 at 300 dpi for publishing quality (TIFF, EPS or original camera file format preferred).

Making Contact & Terms Send query letter with stock list. Provide résumé, business card, brochure, flier or tearsheets to be kept on file for possible future assignments. Keeps samples on

file. Responds in 6 months. Simultaneous submissions and previously published work OK. Pays \$200 for cover; \$75 for inside. Pays after publication. Credit line given. Looking to buy worldwide all language rights for print and digital rights. Producing internet projects (interactive websites and books); printed books may be bound up into binders.

Tips "Be flexible. Book publishing usually takes at least 6 months. Capstone does not pay holding fees. Be prompt. The first photos in are considered for covers first."

■ A CENTERSTREAM PUBLICATION

P.O. Box 17878, Anaheim CA 92807. (714)779-9390. Fax: (714)779-9390. E-mail: centerstrm@aol. com. Owner: Ron Middlebrook. Publishes music history, biographies, DVDs, music instruction (all instruments). Photos used for text illustrations, book covers. Examples of published titles: Dobro Techniques; History of Leedy Drums; History of National Guitars; Blues Dobro; Jazz Guitar Christmas (book covers).

Needs Reviews stock photos of music. Model release preferred. Photo captions preferred.

Specs Uses color and/or b&w prints; 35mm, $2\frac{1}{4} \times 2\frac{1}{4}$, 4×5 transparencies. Accepts images in digital format. Send via Zip as TIFF files.

Making Contact & Terms Send query letter with samples and stock list. Send unsolicited photos by mail for consideration. Provide résumé, business card, brochure, flier or tearsheets to be kept on file for possible future assignments. Works on assignment only, Responds in 1 month. Simultaneous submissions and previously published work OK. Payment negotiable. Pays on receipt of invoice. Credit line given. Buys all rights.

\$ CHATHAM PRESS

9 Lafavette Ct., Suite E, Old Greenwich CT 06830. (203)622-1010. Fax: (718)359-8568. Editor: Rich Kraham. Publishes New England- and ocean-related topics. Photos used for text illustrations, book covers, art, wall framing.

Needs Buys 25 photos/year; offers 5 freelance assignments/year. Needs photos of architecture, gardening, cities/urban, automobiles, food/drink, health/fitness/beauty, science. Interested in fashion/glamour, fine art, avant garde, documentary, historical/vintage. Model release preferred. Photo captions required.

Specs Uses b&w prints.

Making Contact & Terms Send query letter with samples; include SASE for return of material. Responds in 1 month. Payment negotiable. Credit line given. Buys all rights.

Tips To break in with this firm, "produce superb black-and-white photos. There must be an Ansel Adams-type of appeal that is instantaneous to the viewer."

A \$\$ CLEIS PRESS

P.O. Box 14697, San Francisco CA 94114. (415)575-4700. Fax: (415)575-4705. E-mail: fdelacoste@ cleispress.com. Website: www.cleispress.com. Publishing Coordinator: Kara Wuest. Art Director: Frédérique Delacoste. Estab. 1979. Publishes fiction, nonfiction, trade and gay/lesbian erotica. Photos used for book covers. Examples of recently published titles: Best Gay Erotica 2006; Best Lesbian Erotica 2006; Best Women's Erotica 2006.

Needs Buys 20 photos/year. Reviews stock photos.

Specs Uses color and/or b&w prints; 35mm transparencies.

Making Contact & Terms Ouery via e-mail only. Provide résumé, business card, brochure, flier or tearsheets to be kept on file for possible future assignments. Works with local freelancers on assignment only. Keeps samples on file. Responds in 1 week. Pays \$350/photo for all uses in conjunction with book. Pays on publication.

\$\$ CONARI PRESS

500 Third St., Suite 230, San Francisco CA 94107. E-mail: info@redwheelweiser.com. Website: www.redwheelweiser.com. Publishes hardcover and trade paperback originals and reprints. Subjects include women's studies, psychology, parenting, inspiration, home and relationships (all nonfiction titles). Photos used for text illustrations, book covers, dust jackets.

Needs Buys 5-10 freelance photos /year. Looking for artful photos; subject matter varies. Interested in reviewing stock photos of most anything except high-tech, corporate or industrial images. Model release required. Photo caption s preferred; include photography copyright.

Specs Prefers images in digital format.

Making Contact & Terms Provide résumé, business card, self-promotion piece or tearsheets to be kept on file for possible future assignments. Art director will contact photographer for portfolio review if interested. Portfolio should include prints, tearsheets, slides, transparencies or thumbnails. Keeps samples on file. Simultaneous submissions and previously published work OK. Pays by the project: \$400-1,000 for color cover; rates vary for color inside. Pays on publication. Credit line given on copyright page or back cover.

Tips "Review our website to make sure your work is appropriate."

■ \$\$ ☑ THE COUNTRYMAN PRESS

P.O. Box 748, Woodstock VT 05091. Website: www.countrymanpress.com. Publishes hardcover originals, trade paperback originals and reprints. Subjects include travel, nature, hiking, biking, paddling, cooking, Northeast history, gardening and fishing. Examples of recently published titles: *The King Arthur Flour Baker's Companion* (book cover); *Vermont: An Explorer's Guide* (text illustrations, book cover). Catalog available for $6\frac{3}{4} \times 10\frac{1}{2}$ envelope.

Needs Needs photos of environmental, landscapes/scenics, wildlife, architecture, gardening, rural, sports, travel. Interested in historical/vintage, seasonal. Model/property release preferred. Photo captions preferred; include location, state, season.

Specs Accepts high-res images in digital format. Send via CD, Zip as TIFF files at 350 dpi.

Making Contact & Terms Send query letter to the attention of "Submissions," with résumé, slides, tearsheets, stock list. Provide résumé, business card, self-promotion piece to be kept on file for possible future assignments. Responds in 2 months, only if interested. Simultaneous submissions and previously published work OK. Pays \$100-600 for color cover. Pays on publication. Credit line given. Buys all rights for life of edition (normally 2-7 years); negotiable.

Tips "Our catalog demonstrates the range of our titles and shows our emphasis on travel and the outdoors. Crisp focus, good lighting, and strong contrast are goals worth striving for in each shot. We prefer images that invite rather than challenge the viewer, yet also look for eye-catching content and composition."

■ \$ CRABTREE PUBLISHING COMPANY

PMB 59051, 350 Fifth Ave., 59th Floor, New York NY 10118. (212)496-5040; (800)387-7650. Fax: (800)355-7166. Website: www.crabtreebooks.com. Publishes juvenile nonfiction, library and trade. Subjects include science, cultural events, history, geography (including cultural geography), sports. Photos used for text illustrations, book covers. Examples of recently published titles: *The Mystery of the Bermuda Triangle, Environmental Activist, Paralympic Sports Events, Presidents' Day, Plant Cells, Bomb and Mine Disposal Officers*.

• This publisher also has offices in Canada, United Kingdom and Australia.

Needs Buys 20-50 photos/year. Wants photos of cultural events around the world, animals (exotic and domestic). Model/property release required for children, photos of artwork, etc. Photo captions preferred; include place, name of subject, date photographed, animal behavior.

Specs Uses high-resolution digital files (no JPEG compressed files).

Making Contact & Terms *Does not accept unsolicited photos.* Provide resume, business card, brochure, flier or tearsheets to be kept on file for possible future assignments. Simultaneous submissions and previously published work OK. Pays \$100 for color photos. Pays on publication. Credit line given. Buys non-exclusive, worldwide and electronic rights.

Tips "Since our books are for younger readers, lively photos of children and animals are always excellent." Portfolio should be diverse and encompass several subjects rather than just 1 or 2;

depth of coverage of subject should be intense so that any publishing company could, conceivably, use all or many of a photographer's photos in a book on a particular subject."

■ \$ ☐ THE CREATIVE COMPANY

P.O. Box 227, Mankato MN 56002. (507)388-2117. Fax: (507)388-4797. E-mail: info@ thecreativecompany.us. Website: www.thecreativecompany.com. Photo Researcher: Tricia Kleist. Imprint: Creative Editions Education, Publishes hardcover originals, textbooks for children, Subjects include animals, nature, geography, history, sports (professional and college), science, technology, biographies. Photos used for text illustrations, book covers. Examples of recently published titles: Let's Investigate Wildlife series (text illustrations, book cover); Ovations (biography) series (text illustrations, book cover). Catalog available for 9 × 12 SAE with \$2 first-class postage. Photo guidelines free with SASE.

Needs Buys 2,000 stock photos/year. Needs photos of celebrities, disasters, environmental, landscapes/scenics, wildlife, architecture, cities/urban, gardening, pets, rural, adventure, automobiles, entertainment, health/fitness, hobbies, sports, travel, agriculture, industry, medicine, military, science, technology/computers. Other specific photo needs: NFL, NHL, NBA, Major League Baseball. Photo captions required; include photographer's or agent's name.

Specs Accepts images in digital format for Mac only. Send via CD as JPEG files.

Making Contact & Terms Send query letter with photocopies, tearsheets, stock list. Provide selfpromotion piece to be kept on file for possible future assignments. Responds in 1 month to queries. Simultaneous submissions and previously published work OK. Pays \$100-150 for cover; \$50-150 for inside. Projects with photos and text are considered as well. Pays on publication. Credit line given. Buys one-time rights and foreign publication rights as requested.

Tips "Inquiries must include nonreturnable samples. After establishing policies and terms, we keep photographers on file and contact as needed. All photographers who agree to our policies can be included on our e-mail list for specific, hard-to-find image needs. We rarely use black-and-white or photos of people unless the text requires it. Project proposals must be for a 4-, 6-, or 8-book series for children."

S CREATIVE EDITIONS

P.O. Box 227, Mankato MN 56002. (800)445-6209. E-mail: info@thecreativecompany.us. Website: www.thecreativecompany.us. Publishes hardcover originals. Subjects include photo essays, biography, poetry, stories designed for children. Photos used for text illustrations, book covers, dust jackets. Examples of recently published titles: Little Red Riding Hood (text illustrations, book cover, dust jacket); Poe (text illustrations, book cover, dust jacket). Catalog available.

Needs Looking for photo-illustrated documentaries or gift books. Must include some text. Publishes 5-10 books/year.

Specs Uses any size glossy or matte color and/or b&w prints. Accepts images in digital format for Mac only. Send via CD as JPEG files at 72 dpi minimum (high-res upon request only).

Making Contact & Terms Send query letter with publication credits and project proposal, prints, photocopies, tearsheets of previous publications, stock list for proposed project. Responds in 1 month to queries. Simultaneous submissions and previously published work OK. Advance to be negotiated. Credit line given. Buys world rights for the book; photos remain property of photographer.

Tips "Creative Editions publishes unique books for the book-lover. Emphasis is on aesthetics and quality. Completed manuscripts are more likely to be accepted than preliminary proposals. Please do not send slides or other valuable materials."

\$\$ @ CREATIVE HOMEOWNER

24 Park Way, Upper Saddle River NJ 07458. (201)934-7100, ext. 375. Fax: (201)934-7541. Website: www.creativehomeowner.com. Photo Researcher: Robyn Poplasky. Estab. 1975. Publishes soft cover originals, mass market paperback originals. Photos used for text illustrations, promotional materials, book covers. Creative Homeowner's books and online information are known by consumers for their complete and easy-to-follow instructions, up-to-date information, and extensive use of color photography. Among its best-selling titles are *Decorating with Architectural Trimwork, Wiring, and Landscaping with Stone*. Catalog available. Photo guidelines available via fax.

Needs Buys 1,000 freelance photos/year. Needs photos of architecture, interiors/decorating, some gardening. Other needs include interior and exterior design photography; garden beauty shots. Photo captions required; include photographer credit, designer credit, location, small description, if possible.

Specs Accepts images in digital format. Send via CD as TIFF files at 300 dpi. Transparencies are preferred.

Making Contact & Terms Send query letter with résumé, photocopies, tearsheets, transparencies, stock list. Provide résumé, business card, self-promotion piece to be kept on file for possible future assignments. Responds in 2 weeks to queries. Simultaneous submissions and previously published work OK. Pays \$800 for color cover; \$100-150 for color inside; \$200 for back cover. Pays on publication. Credit line given. Buys one-time rights.

Tips "Be able to pull submissions for fast delivery. Label and document all transparencies for easy in-office tracking and return."

CREATIVE WITH WORDS PUBLICATIONS (CWW)

P.O. Box 223226, Carmel CA 93922. Fax: (831)655-8627. E-mail: geltrich@mbay.net. Website: http://members.tripod.com/CreativeWithWords. Estab. 1975. Publishes poetry and prose anthologies according to set themes. Black & white photos used for text illustrations, book covers. Photo guidelines, theme list and submittal forms free with SASE.

Needs Needs theme-related b&w photos. Currently looking for collages. Model/property release preferred.

Specs Uses any size b&w photos. "We will reduce to fit the page."

Making Contact & Terms Request theme list, then query with photos. Does not keep samples on file; include SASE for return of material. Responds 3 weeks after deadline if submitted for a specific theme. Payment negotiable. Pays on publication. Credit line given. Buys one-time rights.

■ M DOCKERY HOUSE PUBLISHING, INC.

P.O. Box 1237, Lindale TX 75771. (903)882-6900. Fax: (903)882-7607. E-mail: questions@dockerypublishing.com. Website: www.dockerypublishing.com. Publishes customized books and magazines. Subjects include food, travel, healthy living. Photos used for text illustrations, promotional materials, book covers, magazine covers and articles. Examples of recently published titles: *The Magical Taste of Grilling; Total Health and Wellness*.

Needs Looking for lifestyle trends, people, travel, food, luxury goods. Needs vary. Reviews stock photos. Model release preferred.

Specs Uses all sizes and finishes of color and b&w prints; 35mm and digital.

Making Contact & Terms Send query letter with samples. Provide résumé, business card, brochure, flier or tearsheets to be kept on file for possible future assignments. Works on assignment only. Keeps samples on file. Cannot return material. Payment negotiable. Pays net 30 days. Buys all rights; negotiable.

N ■ S \$ DOWN THE SHORE PUBLISHING CORP.

P.O. Box 100, West Creek NJ 08092. (609)978-1233. Fax: (609)597-0422. E-mail: info@down-the-shore.com. Website: www.down-the-shore.com. Publisher: Raymond G. Fisk. Publishes regional calendars; seashore, coastal, and regional books (specific to the mid-Atlantic shore and New Jersey). Photos used for text illustrations, scenic calendars (New Jersey and mid-Atlantic only). Examples of recently published titles: *Great Storms of the Jersey Shore* (text illustrations); *NJ Lighthouse Calendar* (illustrations, cover); *Shore Stories* (text illustrations, dust jacket). Photo guidelines free with SASE or on website.

Needs Buys 30-50 photos/year. Needs scenic coastal shots, photos of beaches and New Jersey lighthouses (New Jersey and mid-Atlantic region). Interested in seasonal. Reviews stock photos. Model release required; property release preferred. Photo captions preferred; specific location identification essential.

Specs "We have a very limited use of prints." Prefers 35mm, $2\frac{1}{4} \times 2\frac{1}{4}$, 4×5 transparencies. Accepts digital submissions via high-resolution files on CD. Refer to guidelines before submitting. Making Contact & Terms Send query letter with stock list. Provide résumé, business card, brochure, flier or tearsheets to be kept on file for possible future requests. Responds in 6 weeks. Previously published work OK. Pays \$100-200 for b&w or color cover; \$10-100 for b&w or color inside. Pays 90 days from publication. Credit line given. Buys one-time or book rights; negotiable.

Tips "We are looking for an honest depiction of familiar scenes from an unfamiliar and imaginative perspective. Images must be specific to our very regional needs. Limit your submissions to your best work. Edit vour work very carefully."

S S S ECW PRESS

2120 Queen St. E., Suite 200, Toronto ON M4E 1E2, Canada. (416)694-3348. Fax: (416)698-9906. E-mail: info@ecwpress.com. Website: www.ecwpress.com. Publisher: Jack David. Publishes hardcover and trade paperback originals. Subjects include entertainment, biography, sports, travel, fiction, poetry. Photos used for text illustrations, book covers, dust jackets. Examples of recently published titles: Living the Dream: The Unofficial Story of Hannah Montana and Miley Cyrus (text illustrations); Finding LOST (text illustrations).

Needs Buys hundreds of freelance photos/year. Looking for color, b&w, fan/backstage, paparazzi, action, original, rarely used. Reviews stock photos. Property release required for entertainment or star shots. Photo captions required; include identification of all people.

Specs Accepts images in digital format. Send via CD as TIFF files at 300 dpi.

Making Contact & Terms "For photo and art submissions, it is best to contact us by e-mail and direct us to your work online. Please also describe what area(s) you specialize in. If you do send us artwork by mail that you wish returned, make sure to include a SASE with sufficient postage (for those outside Canada, include an International Reply Coupon). Since our projects vary in topic, we will keep you on file in case we publish something along the lines of your subject(s)." Pays by the project: \$250-600 for color cover; \$50-125 for color inside. Pays on publication. Credit line given. Buys one-time book rights (all markets).

Tips "We have many projects on the go. Query for projects needing illustrations. Please check our website before querying."

F+W MEDIA

4700 E. Galbraith Rd., Cincinnati OH 45236. (513)531-2690. Website: www.fwmedia.com. Art Directors: Grace Ring, Geoff Raker, Wendy Dunning, Claudean Wheeler. See website for more information on who to contact. Imprints: Writer's Digest Books, HOW Books, Betterway Books, North Light Books, IMPACT Books, Popular Woodworking Books, Memory Makers Books, Adams Media, David & Charles, Krause Publications. Publishes 120 books/year for writers, artists, graphic designers and photographers, plus selected trade (humor, lifestyle, home improvement) titles.

Needs Tries to fill photo needs through stock first, before making assignments.

Making Contact & Terms Send nonreturnable photocopies of printed work to be kept on file. Art director will contact photographer for portfolio review if interested. "Pay rates usually depend on the scope of the project; \$1,000 for a cover is pretty typical." Considers buying second rights (reprint rights) to previously published photos. "We like to know where art was previously published." Finds photographers through word of mouth, submissions, self promotions.

Tips "Don't call. Send appropriate samples we can keep."

\$ FARCOUNTRY PRESS

P.O. Box 5630, Helena MT 59604. (406)444-5109 or (800)821-3874. Fax: (406)443-5480. E-mail: shirley.machonis@farcountrypress.com. Website: www.farcountrypress.com. Senior Designer: Shirley Machonis. Award-winning publisher Farcountry Press specializes in softcover and hardcover color photography books showcasing the nation's cities, states, national parks, and wildlife. Farcountry also publishes several children's series, as well as guidebooks, cookbooks and regional history titles nationwide. The staff produces about 25 books annually; the backlist has grown to more than 300 titles. "Photographer guidelines are available on our website."

Needs Seeking color photography of landscapes (including recreation), cityscapes, and wildlife in the United States.

Specs For digital photo submissions, please send 8- or 16-bit TIFF files (higher preferred), at least 350 dpi or higher, formatted for Macs, RGB profile. All images should be flattened—no channels or layers. Information, including watermarks, should not appear directly on the images. Include either a contact sheet or a folder with low-resolution files for quick editing. Include copyright and caption data. Model releases are required for all images featuring recognizable individuals. Note on the mount or in the metadata that a model release is available. Do not submit images that do not have model releases.

Making Contact & Terms Send query letter with stock list. Unsolicited submissions of photography WILL NOT be accepted and WILL NOT be returned. Simultaneous submissions and previously published work OK.

M I FLASHLIGHT PRESS

527 Empire Blvd., Brooklyn NY 11225. (718)288-3800. Fax: (718)972-6307. E-mail: Editor@ Flashlightpress.com. Website: www.flashlightpress.com. Editor: Shari Greenspan. Estab. 2004.

Needs Previous titles: I Need My Monster; That Cat Can't Stay; I Always, ALWAYS Get My Way; Grandfather's Wrinkles; Grandpa For Sale. Catalog available online. Responds in 1 month.

Making Contact & Terms E-mail with resume and digital images. Submission guidelines available at www.flashlightpress.com/submissionguidelines.html.

Tips "Since I only accept e-mail submissions, I'd love for the sample images to be pasted into the e-mail so I don't have to open multiple files. Include URLs if you have online portfolios."

■ FOCAL PRESS

30 Corporate Dr., Suite 400, Burlington MA 01803. (781)313-4794. Fax: (781)313-4880. E-mail: v.geary@elsevier.com. Website: www.focalpress.com.

Needs "We publish professional reference titles, practical guides and student textbooks in all areas of media and communications technology, including photography and digital imaging. We are always looking for new proposals for book ideas. Send e-mail for proposal guidelines."

Making Contact & Terms Simultaneous submissions and previously published work OK. Buys all rights; negotiable.

■ S \$ FORT ROSS INC.

26 Arthur Place, Yonkers NY 10701. (914)375-6448. E-mail: fortross@optonline.net. Website: www. fortrossinc.com. **Executive Director:** Vladimir Kartsev. Co-publishes hardcover reprints, trade paperback originals; offers photos to East European publishers and advertising agencies. Subjects include romance, science fiction, fantasy. Photos used for book covers.

Needs Buys up to 200 photos/year. Needs photos of couples, "clinches," jewelry, flowers. Interested in alternative process, fashion/glamour. Model release required. Photo captions preferred.

Specs Accepts images in digital format. Send via CD, e-mail as JPEG files.

Making Contact & Terms Send query letter with photocopies. Provide self-promotion piece to be kept on file for possible future assignments. Responds only if interested. Simultaneous submissions

and previously published work OK. Pays \$50-150 for color images, Pays on acceptance. Buys onetime rights.

M FORT ROSS INC. INTERNATIONAL RIGHTS

26 Arthur Pl., Yonkers NY 10701. (914)375-6448. E-mail: Fortross@optonline.net. Website: www. Fortrossinc.com. Executive Director: Dr. Kartsen. Estab. 1992. Publishes more than 500 titles per year, mostly in Russian. Genres include adventure, fantasy, horror, romance, science fiction, biography, history and self-help.

Needs Couples and pets.

Tips We will gladly take a look at your portfolio and buy the secondary rights for works. Looking for images already used on American book covers or images from an original portfolio.

M 🔳 🕖 GRYPHON HOUSE

10770 Columbia Pike, Suite 201, Silver Spring MD 20901. (800)638-0928. Fax: (877)638-7576. Website: www.ghbooks.com. Publishes educational resource materials for teachers and parents of young children. Examples of recently published titles: Great Games for Young Children (text illustrations); Starting With Stories (book cover).

Needs Looking for b&w and color photos of young children (from birth to 6 years.) Reviews stock photos. Model release required.

Specs Uses 5x7 glossy color (cover only) and b&w prints. Accepts images in digital format. Send via CD, Zip, e-mail as TIFF files at 300 dpi.

Making Contact & Terms Send query letter with samples and stock list. Keeps samples on file. Simultaneous submissions OK. Payment negotiable. Pays on receipt of invoice. Credit line given. Buys book rights.

S GUERNICA EDITIONS, INC.

489 Strathmore Blvd., Toronto ON M4C 1N8, Canada. Website: www.guernicaeditions.com. Publishes adult trade (literary). Photos used for book covers. Examples of recently published titles: Barry Callagan: Essays on His Work, edited by Priscila Uppal; Mary Di Michele: Essays on Her Works, edited by Joseph Pivato; Maria Mazziotti: Essays on Her Works, edited by Sean Thomas Doughtery; Mary Melfi: Essays on Her Works, edited by William Anselmi.

Needs Buys varying number of photos/year; "often" assigns work. Needs life events, including characters; houses. Photo captions required.

Specs Uses color and/or b&w prints. Accepts images in digital format. Send via CD, Zip as TIFF, GIF files at 300 dpi minimum.

Making Contact & Terms Send query letter with samples. Does not accept manuscript enquiries by e-mail. Sometimes keeps samples on file. Cannot return material. Responds in 2 weeks. Pays \$150 for cover. Pays on publication. Credit line given. Buys book rights. "Photo rights go to photographers. All we need is the right to reproduce the work."

Tips "Look at what we do. Send some samples. If we like them, we'll write back."

HANCOCK HOUSE PUBLISHERS

1431 Harrison Ave., Blaine WA 98230-5005. (800)938-1114. Fax: (800)983-2262. E-mail: david@ hancockwildlife.org. Website: www.hancockwildlife.org. President: David Hancock. Publishes trade books. Photos used for text illustrations, promotions, book covers. Examples of recently published titles: Meet the Sasquatch by Chris Murhydd (over 500 color images); Alaska in the Wake of the North Star by Loel Schuler; Pheasants of the World (350 color photos).

Needs Needs photos of birds/nature. Reviews stock photos. Model release preferred. Photo captions preferred.

Making Contact & Terms Send query letter with samples, SASE. Responds in 1 month. Simultaneous submissions and previously published work OK. Payment negotiable. Credit line given. Buys nonexclusive rights.

■ § \$\$ → HARPERCOLLINS CHIDREN'S BOOKS / HARPERCOLLINS PUBLISHERS

10 East 53rd, New York NY 10022. (212)207-6901. E-mail: dana.fritts@harpercollins.com (Artists). Website: www.harpercollins.com. **Assistant Designers:** Mischa Rosenberg and Dana Fritts. Publishes hardcover originals and reprints, trade paperback originals and reprints, mass market paperback originals and reprints, and audio books. 500 titles/year.

Needs Babies/children/teens, couples, multicultural, pets, food/drink, fashion, lifestyle. "We would be interested in seeing samples of map illustrations, chapter spots, full page pieces, etc. We are open to half-tone and line art illustrations for our interiors." Negotiates a flat payment fee upon acceptance. Will contact if interested. Catalog available online.

Tips "Be flexible and responsive to comments and corrections. Hold to scheduled due dates for work. Show work that reflects the kinds of projects you *want* to get, be focused on your best technique and showcase the strongest, most successful examples."

■ ☐ HERALD PRESS

616 Walnut Ave., Scottdale PA 15683. (724)887-8500. Fax: (724)887-3111. Website: www.mpn.net. **Contact:** Design director. Photos used for book covers, dust jackets. Examples of published titles: *Saving the Seasons; What IS Iran?; Where Was God on September 11?* (all cover shots).

Needs Buys 5 photos/year; offers occasional freelance assignments. Subject matter varies. Reviews stock photos of people and other subjects including religious, environmental. Model/property release required. Photo captions preferred; include identification information.

Specs Prefers images in digital format. Submit URL or link to web pages or light box.

Making Contact & Terms Send query letter or e-mail with samples. Provide résumé, business card, brochure, flier or tearsheets to be kept on file for possible future assignments. Keeps samples on file. Works on assignment only or selects from file of samples. Simultaneous submissions and previously published work OK. Payment negotiable. **Pays on acceptance.** Credit line given. Buys book rights; negotiable.

Tips "We put your résumé and samples on file. It is best to direct us to your website."

■ \$\$ ☑ HOLT MCDOUGAL

1900 South Batavia Ave., Geneva IL 60134. 800-462-6595. Fax: (888)872-8380. Website: www.hrw. com. **Photo Research Manager:** Jeannie Taylor. Publishes textbooks in multiple formats. Photos are used for text illustrations, promotional materials and book covers.

Needs Uses 6,500 + photos/year. Wants photos that illustrate content for mathematics, sciences, social studies, world languages and language arts. Model/property release preferred. Photo captions required; include scientific explanation, location and/or other detailed information.

Specs Prefers images in digital format. Send via CD or broadband transmission.

Making Contact & Terms Send a query letter with a sample of work (nonreturnable photocopies, tearsheets, printed promos) and a list of subjects in stock. Self-promotion pieces kept on file for future reference. Include promotional website link if available. "Do not call!" Will respond only if interested. Payment negotiable depending on format and number of uses. Credit line given.

Tips "Our book image programs yield an emphasis on rights-managed stock imagery, with a focus on teens and a balanced ethnic mix. Though we commission assignment photography, we maintain an in-house studio with 2 full-time photographers. We are interested in natural-looking, uncluttered photographs labeled with exact descriptions, that are technically correct and include no evidence of liquor, drugs, cigarettes or brand names."

\$\$ HUMAN KINETICS PUBLISHERS

P.O. Box 5076, Champaign IL 61825-5076. E-mail: acquisitions@hkusa.com. Website: www.hkusa.com. Publishes hardcover originals, trade paperback originals, textbooks, online courses and CD-ROMs. Subjects include sports, fitness, physical therapy, sports medicine, nutrition, physical activity.

Photos used for text illustrations, promotional materials, catalogs, magazines, web content, book covers. Examples of recently published titles: Serious Tennis (text illustrations, book cover); Beach Volleyball (text illustrations, book cover). Photo guidelines available via e-mail only.

Needs Buys 2,000 freelance photos/year. Needs photos of babies/children/teens, multicultural, families, education, events, food/drink, health/fitness, performing arts, sports, medicine, military, product shots/still life. All photos purchased must show some sort of sport, physical activity, health and fitness. "Expect ethnic diversity in all content photos." Model release preferred.

Specs Prefers images in digital format. Send via CD, Zip as TIFF, JPEG files at 300 dpi at 9 × 12 inches; will accept 5 × 7 color prints, 35mm transparencies.

Making Contact & Terms Send query letter and URL via e-mail to view samples. Responds only if interested. Simultaneous submissions and previously published work OK. Pays \$250-500 for b&w or color cover; \$75-125 for b&w or color inside. Pays extra for electronic usage of photos. Pays on publication. Credit line given. Buys one-time rights. Prefers world rights, all languages, for one edition; negotiable.

Tips "Go to Borders or Barnes & Noble and look at our books in the sport and fitness section. We want and need peak action, emotion and razor-sharp images for future projects. The pay is below average, but there is opportunity for exposure and steady income to those with patience and access to a variety of sports and physical education settings. We have a high demand for quality shots of youths engaged in physical education classes at all age groups. We place great emphasis on images that display diversity and technical quality. Do not contact us if you charge research or holding fees. Do not contact us for progress reports. Will call if selection is made or return images. Typically, we hold images 4 to 6 months. If you can't live without the images that long, don't contact us. Don't be discouraged if you don't make a sale in the first 6 months. We work with over 200 agencies and photographers. Photographers should check to see if techniques demonstrated in photos are correct with a local authority. Most technical photos and submitted work are rejected on content, not quality."

M HYPERION BOOKS FOR CHILDREN

114 Fifth Ave., New York NY 10011. (914)288-4100. Fax: (212)807-5880. Website: www. hyperionchildrensbooks.com. Design Coordinator: Susan Masry. Publishes children's books, including picture books and books for young readers. Subjects include adventure, animals, history, multicultural, sports. Catalog available for 9 × 12 SAE with 3 first-class stamps.

Needs Needs photos of multicultural subjects.'

Making Contact & Terms Provide résumé, business card, self-promotion piece to be kept on file for possible future assignments. Pays royalties based on retail price of book, or a flat fee.

N 🖪 🛭 🖸 IMMEDIUM

P.O. Box 31846, San Francisco CA 94131. (415)452-8546. Fax: (360)937-6272. E-mail: submissions@ immedium.com Website: www.immedium.com. Submissions Editor: Amy Ma. Estab. 2005. 4 titles/year. Pays on publication, \$1-150. Responds in 3-6 months. Catalog available online. Photo captions and property releases are required. Rights are negotiated and will vary with project.

Needs Babies/Children/Teens, multicultural, families, parents, entertainment, lifestyle. Photos for dust jackets, promotional materials and book covers.

Tips "Look at our catalog, it's colorful and a little edgy. Tailor your submission to our catalog. We need responsive workers."

■ S\$ INNER TRADITIONS/BEAR & COMPANY

1 Park St., Rochester VT 05767. (802)767-3174. Fax: (802)767-3726. E-mail: peris@innertraditions. com. Website: www.innertraditions.com. Art Director: Peri Ann Swan. Estab. 1975. Publishes adult trade and teen self-help. Subjects include New Age, health, self-help, esoteric philosophy. Photos used for text illustrations, book covers. Examples of recently published titles: Tibetan Sacred Dance (cover, interior); Tutankhamun Prophecies (cover); Animal Voices (cover, interior).

Needs Buys 10-50 photos/year; offers 5-10 freelance assignments/year. Needs photos of babies/children/teens, multicultural, families, parents, religious, alternative medicine, environmental, landscapes/scenics. Interested in fine art, historical/vintage. Reviews stock photos. Model/property release required. Photo captions preferred.

Specs Uses 35mm, 4×5 transparencies. Accepts images in digital format. Send via CD, Zip as TIFF, EPS, JPEG files at 300 dpi.

Making Contact & Terms Provide résumé, business card, brochure, flier or tearsheets to be kept on file for possible future assignments. Works with freelancers on assignment only. Simultaneous submissions OK. Pays \$150-600 for color cover; \$50-200 for b&w and color inside. Pays on publication. Credit line given. Buys book rights; negotiable.

■ \$ ☑ KEY CURRICULUM PRESS

1150 65th St., Emeryville CA 94608. (800)995-6284. Fax: (800)541-2442. Website: www.keypress. com. Publishes textbooks, CD-ROMs, software. Subjects include mathematics. Photos used for text illustrations, promotional materials, book covers. Examples of recently published titles: *Discovering Algebra* (text illustrations, promotional materials, book cover); *The Heart of Mathematics* (text illustrations, promotional materials, book cover). Catalog available for first-class postage.

Needs photos of babies/children/teens, couples, multicultural, families, environmental, landscapes/scenics, wildlife, architecture, cities/urban, education, rural, health/fitness/beauty, performing arts, sports, science, technology/computers. Interested in documentary, fine art. Also needs technology with female adults performing professional tasks. Female professionals, not just in office occupations. Model/property release required. Photo captions preferred; include type of technology pictured.

Specs Accepts images in digital format. Send via CD as TIFF, EPS files at 300 dpi (72 dpi for FPOs).

Making Contact & Terms Send query letter with résumé, photocopies, tearsheets, stock list. Provide business card, self-promotion piece to be kept on file for possible future assignments. Responds only if interested, send nonreturnable samples. Simultaneous submissions and previously published work OK. Pays \$250-500 for b&w cover; \$250-1,000 for color cover; by the project, \$250-1,000 for cover shots; \$150-200 for b&w inside; \$150-300 for color inside; by the project, \$100-900 for inside shots. **Pays on acceptance.** Credit line given. Buys all rights to assignment photography.

Tips "Provide website gallery. Call prior to dropping off portfolio."

S LAYLA PRODUCTIONS, INC.

370 E. 76th St., New York NY 10021. (212)879-6984. E-mail: laylaprod@aol.com. **Manager:** Lori Stein. Estab. 1980. Publishes adult trade and how-to gardening. Photos used for text illustrations, book covers. Examples of recently published titles: *Spiritual Gardening* and *American Garden Guides*, 12 volumes (commission or stock, over 4,000 editorial photos).

Needs Buys over 150 photos/year; offers 6 freelance assignments/year. Needs photos of gardening.

Making Contact & Terms Provide résumé, business card, brochure, flier or tearsheets to be kept on file for possible future assignments. Prefers no unsolicited material. Simultaneous submissions and previously published work OK. Pays \$50-300 for color photos; \$50-300 for b&w photos; \$30-75/hour; \$250-500/day. Other methods of pay depend on job, budget and quality needed. Buys all rights.

Tips "We're usually looking for a very specific subject. We do keep all résumés/brochures received on file—but our needs are small, and we don't often use unsolicited material."

■ \$\$ LERNER PUBLISHING GROUP, INC.

241 First Ave. N., Minneapolis MN 55401. (612)332-3344. Fax: (612)332-7615. E-mail: dwallek@ igigraphics.com. Website: www.lernerbooks.com. **Director of Electronic Content and Photo Research:** Dan Wallek. Publishes educational books for grades K-12. Subjects include animals,

biography, history, geography, science, vehicles and sports. Photos used for editorial purposes for text illustrations, promotional materials, book covers. Examples of recently published titles: A Temperate Forest Food Chain-Follow That Food (text illustrations, book cover); Protecting Earth's Water Supply—Saving Our Living Earth (text illustrations, book cover).

Needs Buys more than 6,000 photos/year; occasionally offers assignments. Needs photos of children/teens, celebrities, multicultural, families, disasters, environmental, landscapes/scenics, wildlife, cities/urban, education, pets, rural, hobbies, sports, agriculture, industry, political, science. vehicles, technology/computers. Model/property release preferred when photos are of social issues (e.g., the homeless). Photo captions required; include who, where, what and when,

Specs Prefers images in digital format. Send via FTP, CD, or e-mail as TIFF or JPEG files at 300 dpi.

Making Contact & Terms Send query letter with detailed stock list by mail, fax or e-mail. Provide current editorial use pricing. "No calls, please." Cannot return material. Responds only if interested. Previously published work OK. Pays by the project: \$150-400 for cover; \$50-150 for inside. Pays on receipt of invoice. Credit line given. Licenses images for book based on print-run rights, electronic rights, all language rights, worldwide territory rights.

Tips Prefers crisp, clear images that can be used editorially. "Send in as detailed a stock list as you can (including fees for clearing additional rights), and be willing to negotiate price."

3949 South Racine Ave., Chicago IL 60609-2523. (773)579-4900; (800)933-1800. Website: www.ltp. org. Director: Thomas Fox. Publishes materials that assist parishes, institutions and households in the preparation, celebration and expression of liturgy in Christian life. Photos used for text illustrations, book covers. Examples of recently published titles: Infant Baptism: A Parish Celebration (text illustrations); The Postures of the Assembly During the Eucharistic Prayer (cover); Teaching Christian Children About Judaism (text illustrations).

Needs Buys 50-60 photos/year; offers 1 freelance assignment/year. Needs photos of processions, assemblies with candles in church, African-American Catholic worship, sacramental/ritual moments. Interested in fine art. Model/property release required. Photo captions preferred.

Specs Uses 5 × 7 glossy b&w prints; 35mm transparencies; digital scans.

Making Contact & Terms Arrange personal interview to show portfolio or submit portfolio for review. Send query letter with résumé of credits, samples and stock list. Provide résumé, business card, brochure, flier or tearsheets to be kept on file for possible future assignments. Responds only if interested; send nonreturnable samples. Simultaneous submissions and previously published work OK. Pays \$25-200 for b&w; \$50-225 for color. Pays on publication. Credit line given. Buys one-time rights; negotiable.

Tips "Please realize that we are looking for very specific things—Catholic liturgy-related photos including people of mixed ages, races, socioeconomic backgrounds; post-Vatican II liturgical style; candid photos; photos that are not dated. We are not looking for generic religious photography. We're trying to use more photos, and will if we can get good ones at reasonable rates."

■ S \$ J LUCENT BOOKS

27500 Drake Rd., Farmington Hills MI 48331. E-mail: gale.customerservice@cengage.com. Website: www.gale.com/lucent. Publishes juvenile nonfiction. Subjects include social issues, science/ environment, crime, health/medicine, black history, biographies and histories. Photos used for text illustrations and book covers. Examples of recently published titles: The Death Penalty (text illustrations); Teen Smoking (text illustrations).

Needs Buys hundreds of photos/year, including many historical and biographical images, as well as controversial topics such as euthanasia. Needs celebrities, teens, disasters, environmental, wildlife, education. Interested in documentary, historical/vintage. Reviews stock photos. Model/ property release required; photo captions required.

Specs Uses 5×7 , $8\frac{1}{2} \times 11$ b&w prints. Accepts images in digital format. Send via CD, Zip, e-mail at 300 dpi.

Making Contact & Terms Send query letter with résumé of credits and samples. Provide résumé, business card, brochure, flier or tearsheets to be kept on file for possible future assignments. Keeps samples on file. Will contact if interested. Simultaneous submissions and previously published work OK. Pays \$100-300 for color cover; \$50-100 for inside. Credit lines given on request.

M 🖸 🖪 MAGENTA PUBLISHING FOR THE ARTS

151 Winchester St., Toronto ON M4X 1B5, Canada. E-mail: info@magentafoundation.org. Website: www.magentafoundation.org. Contact: Submissions. Magenta Foundation is Canada's first charitable arts publishing house. "Our prime mandate is to promote the work of contemporary Canadian and international artists through books and exhibitions."

Needs "We are looking for complete bodies of work *only* (80% finished). Please do not send works in progress. We are looking for work in all related arenas of photography."

Making Contact & Terms See website for open submissions and sign up for e-newsletter for alerts.

Tips "Please do not contact the office to inquire about the state of your proposal."

N MAGICAL CHILD

Shades of White, 301 Tenth Ave., Crystal City MO 63019. Estab. 2007. (314)740-0361. E-mail: acquisition@magicalchildbooks.com. Website: www.magicalchildbooks.com. Estab. 2007. Specializes in trade books, fiction. **Art Acquisitions:** Art Director. Publishes 1-3 picture books/year; 1-3 young readers/year; 1-3 middle readers/year. 80% of books by first-time authors. "The Neo-Pagan Earth Religions Community is the fastest growing demographic in the spiritual landscape, and Pagan parents are crying out for books appropriate for the Pagan kids. It is our plan to fill this small but growing need."

■ \$\$\$ ② MCGRAW-HILL

Website: www.mhhe.com. Publishes hardcover originals, textbooks, CD-ROMs. Photos used for book covers.

Needs Buys 20 freelance photos/year. Needs photos of business concepts, industry, technology/computers.

Specs Uses 8×10 glossy prints; 35mm, $2\frac{1}{4} \times 2\frac{1}{4}$, 4×5 transparencies. Accepts images in digital format. Send via CD.

Making Contact & Terms Contact through local sales rep (see website submissions guidelines) or via online form. Provide business card, self-promotion piece to be kept on file for possible future assignments. Responds only if interested. Previously published work OK. Pays \$650-1,000 for b&w cover; \$650-1,500 for color cover. Pays extra for electronic usage of photos. Pays on publication. Credit line given. Buys one-time rights.

MEADOWBROOK PRESS

5451 Smetana Dr., Minnetonka MN 55343. Fax: (952)930-1940. Website: www.meadowbrookpress. com. **Contact:** Art Director. Estab. 1974. "Meadowbrook is a family-oriented press. We specialize in pregnancy, baby care, child care, humorous poetry for children, party planning and children's activities. We are also the number one publisher of baby name books in the country, with eight baby-naming books in print." Publishes trade paperback originals and reprints. 12 titles/year.

Needs Babies/Children/Teens. Receives 1,500 queries/year. No SASE returns. Responds only if interested. Guidelines available online. Book catalog for #10 SASE.

Tips "Send me a new postcard at least every 3 months. I may not be looking for your style this month, but I may be in six months. I receive a pile of them every day, I will not reply until I need your style, but I enjoy looking at every single one, and I will keep them on file for 6 months. Don't worry about showing me 'everything,' just show me what you do best."

■ \$\$ ☑ MILKWEED EDITIONS

1011 Washington Ave. S., Suite 300, Minneapolis MN 55415. Website: www.milkweed.org. Publishes hardcover originals and trade paperback originals. Subjects include literary fiction, literary nonfiction, poetry, children's fiction. Photos used for book covers and dust jackets. Examples of recently published titles: *The Song of Kahunsha*. Catalog available for \$1.50. Photo guidelines available for first-class postage.

Needs Buys 6-8 freelance photos/year. Needs photos of environmental, landscapes/scenics, wildlife, people, stock, art, multicultural.

Specs Uses any size glossy or matte color and/or b&w prints; $2\frac{1}{4} \times 2\frac{1}{4}$, 4×5 transparencies. Accepts images in digital format. Send via CD, Zip, e-mail as TIFF, EPS, JPEG files at 300 dpi.

Making Contact & Terms Send query letter with résumé, business card, self-promotion piece to be kept on file for possible future assignments. Responds only if interested; send nonreturnable samples. Simultaneous submissions OK. Pays \$300-800 for b&w or color cover; by the project, \$800 maximum for cover/inside shots. Credit line given. Buys one-time rights.

\$ MITCHELL LANE PUBLISHERS, INC.

P.O. Box 196, Hockessin DE 19707. (302)234-9426. Fax: (302)234-4742. E-mail: barbaramitchell@mitchelllane.com. Website: www.mitchelllane.com. Publisher: Barbara Mitchell. Publishes hardcover originals for library market. Subjects include biography and other nonfiction for children and young adults. Photos used for text illustrations, book covers. Examples of recently published titles: Meet Our New Student from Nigeria (text illustrations and book cover); A Backyard Flower Garden for Kids (text illustrations, book cover).

Needs Photo captions required.

Specs Accepts images in digital format. Send via CD as TIFF, JPEG files at 300 dpi.

Making Contact & Terms Send query letter with stock list (stock photo agencies only). Does not keep samples on file; cannot return material. Responds only if interested. Pays on publication. Credit line given. Buys one-time rights.

M ■ M \$\$ O MONDIAL

203 W. 107th St., Suite 6C, New York NY 10025. (212)361-2863. Fax: (212)851-3252. E-mail: contact@mondialbooks.com. Website: www.mondialbooks.com. Editor: Andrew Moore. Estab. 1996. Publishes mainstream fiction, romance, history and reference books. Specializes in linguistics. Payment on acceptance.

Needs Landscapes, travel and erotic. Printing rights are negotiated according to project. Illustrations are used for text illustration, promotional materials and book covers. Publishes 20 titles/year. Responds only if interested.

M 🕮 🖪 🛭 🗷 MORPHEUS TALES PUBLISHING

116 Muriel St., London N1 9QU, United Kingdom. E-mail: Morpheustales@Blueyonder.co.uk. Website: www.Morpheustales.com. **Publisher:** Adam Bradley. Estab. 2008. Publishes experimental fiction, fantasy, horror and science fiction.

Needs Publishes 4-6 titles/year. Responds within 30 days. Model and property release are required. Publisher buys first rights, electronic rights, which may vary according to the project.

Tips "Look at magazine and website for style." Portfolio should include b&w, color, finished and original art.

\$ MUSEUM OF NORTHERN ARIZONA

3101 N. Fort Valley Rd., Flagstaff AZ 86001. (928)774-5213. E-mail: publications@mna.mus.az.us. Website: www.musnaz.org. **Photo Archivist:** Tony Marinella. Subjects include biology, geology, archaeology, anthropology and history. Photos used for *Plateau: Land and People of the Colorado Plateau* magazine, published twice/year (May, October).

Needs Buys approximately 80 photos/year. Biology, geology, history, archaeology and anthropology—subjects on the Colorado Plateau. Reviews stock photos. Photo captions preferred; include location, description and context.

Specs Uses 8 × 10 glossy b&w prints; 35mm, 2¼ × 2¼, 4 × 5 and 8 × 10 transparencies. Prefers 2¼ × 2¼ transparencies or larger. Possibly accepts images in digital format. Submit via Zip disk. **Making Contact & Terms** Send query letter with samples, SASE. Responds in 1 month. Simultaneous submissions and previously published work OK. Pays \$55-250/color photo; \$55-250/b&w photo. Credit line given. Buys one-time and all rights; negotiable. Offers internships for photographers. **Tips** Wants to see top-quality, natural history work. To break in, send only pre-edited photos.

M \$\$ MUSIC SALES GROUP

257 Park Ave. S., 20th Floor, New York NY 10010. (212)254-2100. Fax: (212)254-2013. E-mail: de@ musicsales.com. Website: www.musicsales.com. **Production Manager:** Daniel Earley. Publishes instructional music books, song collections and books on music. Photos used for covers and/or interiors. Examples of recently published titles: *Bob Dylan: 100 Songs and Photos; Paul Simon: Surprise; AC/DC: Backtracks*.

Needs Buys 200 photos/year. Model release required on acceptance of photo. Photo captions required.

Specs Uses 8×10 glossy prints; 35mm, 2×2 , 5×7 transparencies. Hi-res digital 3000 x 4000 pixels.

Making Contact & Terms Send query letter first with résumé of credits. Provide business card, brochure, flier or tearsheets to be kept on file for possible future assignments. Responds in 2 months. Simultaneous submissions and previously published work OK. Pays \$75-100 for b&w, \$250-750 for color.

Tips In samples, wants to see "the ability to capture the artist in motion with a sharp eye for framing the shot well. Portraits must reveal what makes the artist unique. We need rock, jazz, classical—onstage and impromptu shots. Please send us an inventory list of available stock photos of musicians. We rarely send photographers on assignment and buy mostly from material on hand." Send business card and tearsheets or prints stamped 'proof' across them. Due to the nature of record releases and concert events, we never know exactly when we may need a photo. We keep photos on permanent file for possible future use."

■ S S NEW LEAF PRESS, INC.

Box 726, Green Forest AR 72638. (800)999-3777. Website: www.nlpg.com. Publishes Christian adult trade, gifts, devotions and homeschool. Photos used for book covers, book interiors and catalogs. Example of recently published title: *The Hand That Paints the Sky*.

Needs Buys 5 freelance photos/year. Needs photos of landscapes, dramatic outdoor scenes, "anything that could have an inspirational theme." Reviews stock photos. Model release required. Photo captions preferred.

Specs Uses 35mm slides and transparencies. Accepts images in digital format. Send via CD, Jaz, Zip, e-mail as TIFF, EPS files at 300 dpi.

Making Contact & Terms Send query letter with copies of samples and list of stock photo subjects. "Not responsible for submitted slides and photos from queries. Please send copies, no originals unless requested." Does not assign work. Responds in 2-3 months. Simultaneous submissions and previously published work OK. Pays \$50-100 for b&w photos; \$100-175 for color photos. Credit line given. Buys one-time and book rights.

Tips "In order to contribute to the company, send color copies of quality, crisp photos. Trend in book publishing is toward much greater use of photography."

■ S \$ NICOLAS-HAYS, INC.

P.O. Box 540206, Lake Worth FL 33454-0206. E-mail: info@nicolashays.com; info@ibispress.net. Website: www.nicolashays.com. Publishes trade paperback originals and reprints. Subjects include

Eastern philosophy, Jungian psychology, New Age how-to. Photos used for book covers. Example of recently published title: Dervish Yoga for Health and Longevity: Samadeva Gestual Euphony-The Seven Major Arkanas (book cover). Catalog available upon request.

Needs Buys 1 freelance photo/year. Needs photos of landscapes/scenics.

Specs Uses color prints; 35mm, $2\frac{1}{4} \times 2\frac{1}{4}$, 4×5 transparencies. Accepts images in digital format. Making Contact & Terms Send query letter with photocopies, tearsheets. Provide self-promotion piece to be kept on file for possible future assignments. Responds only if interested; send nonreturnable samples. Simultaneous submissions and previously published work OK. Pays \$100-200 for color cover. Pays on acceptance. Credit line given. Buys one-time rights.

Tips "We are a small company and do not use many photos. We keep landscapes/seascapes/ skyscapes on hand-images need to be inspirational."

\$ \$ W.W. NORTON AND COMPANY

500 Fifth Ave., New York NY 10110. (212)354-5500. Fax: (212)869-0856. Website: www.wwnorton. com. **Production:** Trish Marks. Photos used for text illustrations, book covers, dust jackets.

Needs Variable. Photo captions preferred.

Specs Accepts images in all formats; digital images at a minimum of 300 dpi for reproduction and archival work.

Making Contact & Terms Send stock list. Do not enclose SASE. Simultaneous submissions and previously published work OK. Responds as needed. Payment negotiable. Credit line given. Buys one-time rights; many images are also used in print and web-based ancillaries; negotiable.

Tips "Competitive pricing and minimal charges for electronic rights are a must."

A \$ @ RICHARD C. OWEN PUBLISHERS, INC.

P.O. Box 585, Katonah NY 10536, (914)232-3903; (800)262-0787; (800)336-5588, Fax: (914)232-3977. E-mail: rcostaff@rcowen.com. Website: www.rcowen.com. Director: Janice Boland. Publishes picture/storybook fiction and nonfiction for 5- to 7-year-olds; author autobiographies for 7- to 10 year-olds; professional books for educators. Photos used for text illustrations, promotional materials, book covers. Examples of recently published titles: Maker of Things (text illustrations, book cover); Springs (text illustrations, book cover).

Needs Number of photos bought annually varies; offers 3-10 freelance assignments/year. Needs unposed people shots and nature photos that suggest storyline. "For children's books, must be child-appealing with rich, bright colors and scenes, no distortions or special effects. For professional books, similar, but often of classroom scenes, including teachers. Nothing posed; should look natural and realistic." Reviews stock photos of children involved with books and classroom activities, ranging from kindergarten to 6th grade. Also wants photos of babies/children/teens, multicultural, families, environmental, landscapes/scenics, wildlife, architecture, cities/urban, pets, adventure, automobiles, sports, travel, science. Interested in documentary. (All must be of interest to children ages 5-9.) Model release required for children and adults. Children (under the age of 21) must have signature of legal guardian. Property release preferred. Photo captions required; include "any information we would need for acknowledgments, including if special permission was needed to use a location."

Specs "For materials that are to be used, we need 35mm mounted transparencies or high-definition color prints. We usually use full-color photos."

Making Contact & Terms Submit copies of samples by mail for review. Provide brochure, flier or tearsheets to be kept on file for possible future assignments; no slides or disks. Include a brief cover letter with name, address and daytime phone number, and indicate Photographer's Market as a source for correspondence. Works with freelancers on assignment only. "For samples, we like to see any size color prints (or color copies)." Keeps samples on file "if appropriate to our needs." Responds in 1 month. Simultaneous submissions OK. Pays \$10-100 for color cover; \$10-100 for color inside; \$250-800 for multiple photo projects. "Each job has its own payment rate and arrangements." Pays on acceptance. Credit line sometimes given, depending on the project. "Photographers' credits

appear in children's books and in professional books, but not in promotional materials for books or company." For children's books, publisher retains ownership, possession and world rights, which apply to first and all subsequent editions of a particular title and to all promotional materials. "After a project, (children's books) photos can be used by photographer for portfolio."

Tips Wants to see "real people in natural, real life situations. No distortion or special effects. Bright, clear images with jewel tones and rich colors. Keep in mind what would appeal to children. Be familiar with what the publishing company has already done. Listen to the needs of the company. Send tearsheets, color photocopies with a mailer. No slides, please."

S PAULIST PRESS

997 Macarthur Blvd., Mahwah NJ 07430. (201)825-7300. Fax: (201)825-8345. E-mail: dcrilly@paulistpress.com. Website: www.paulistpress.com. Project Manager: Donna Crilly. Estab. 1857. Publishes hardcover and trade paperback originals, juvenile and textbooks. Types of books include religion, theology and spirituality including biography. Specializes in academic and pastoral theology. Recent titles include *He Said Yes, Finding Purpose in Narnia* and *Our Daily Bread*. Publishes 90 titles/year; 5% requires freelance illustration; 5% require freelance design. Paulist Press also publishes the general trade imprint HIDDENSPRING.

Needs Works with 5 illustrators and 10 designers/year. Prefers local freelancers particularly for juvenile titles, jacket/cover, and text illustration. Prefers knowledge of QuarkXPress. Works on assignment only. Book design assigns 8 freelance design jobs/year. Jackets/Covers assigns 30 freelance design jobs/year. Pays by the project, \$400-\$800. Text Illustration assigns 5 freelance illustration jobs/year. Pays by the project.

Making Contact & Terms Send query letter with brochure, résumé and tearsheets. Samples are filed. Portfolio review not required. Negotiates rights purchased. Originals are returned at job's completion if requested.

PELICAN PUBLISHING CO.

E-mail: bmcdowell@pelicanpub.com. **Art Director:** Bridget McDowell. Publishes adult trade, how-to, cooking, and art books; also religious inspirational and business motivational. Photos used for book covers. Books have a "high-quality, conservative and detail-oriented" look. Examples of published titles: Brownies to Die For; Abraham Lincoln's Execution.

Needs Buys 8 photos/year; offers 3 freelance assignments/year. Needs photos of cooking/food, business concepts, nature/inspirational. Reviews royalty-free stock photos of people, nature, etc. Model/property release required. Photo captions required. Specs Uses 8×10 glossy color prints; 35mm, 4×5 transparencies. Accepts images in digital format. Send via CD as TIFF files at 300 dpi or higher.

PRAKKEN PUBLICATIONS, INC.

P.O. Box 8623, Ann Arbor MI 48107. (734)975-2800. Fax: (734)975-2787. E-mail: susanne@ techdirections.com; pam@eddigest.com. Website: http://techdirections.com; http://eddigest.com. Pam Moore, managing editor. Art/Design/Production Manager: Sharon K. Miller. Publishes The Education Digest (magazine), Tech Directions (magazine for technology and career/technical educators), text and reference books for technology and career/technical education, and posters. Photos used for text illustrations, promotional materials, book covers, magazine covers and posters. Photo guidelines available at website.

Needs Wants photos of education "in action," especially technology, career/technical education and general education; prominent historical figures, technology/computers, industry. Photo captions required; include scene location, activity.

Specs Uses all media; any size. Accepts images in digital format. Send via CD, Zip as TIFF, EPS, JPEG files at 300 dpi.

Making Contact & Terms Send query letter with samples. Send unsolicited photos by mail for consideration. Keeps samples on file. Payment negotiable. Methods of payment to be arranged. Credit line given. Rights negotiable.

Tips Wants to see "high-quality action shots in tech/career, tech-ed and general education classrooms" when reviewing portfolios. Send inquiry with relevant samples to be kept on file. "We buy very few freelance photographs but would be delighted to see something relevant."

\$ PROSTAR PUBLICATIONS INC.

3 Church Circle, Suite 109, Annapolis MD 21401. (800)481-6277. Fax: (800)487-6277. E-mail: editor@ prostarpublications.com. Website: www.prostarpublications.com. Publishes trade paperback originals (how-to, nonfiction). Subjects include history, nature, travel, nautical. Photos used for book covers. Examples of recently published titles: The Age of Cunard; California's Channel Islands; Pacific Seaweeds. Photo guidelines free with SASE.

Needs Buys less than 100 photos/year; offers very few freelance assignments/year. Reviews stock photos of nautical (sport). Prefers to review photos as part of a manuscript package. Model/ property release required. Photo captions required.

Specs Uses color and/or b&w prints.

Making Contact & Terms Send query letter with stock list or contact to see if accepting submissions. Does not keep samples on file; include SASE for return of material. Responds in 1 month. Simultaneous submissions and previously published work OK. Pays \$10-50 for color or b&w photos. Pays on publication. Credit line given. Buys book rights; negotiable.

🕅 🕮 🖪 💲 🕖 QUARTO PUBLISHING PLC.

+44 020 7700 9000. Fax: +44 020 7253 4437. E-mail: info@quarto.com. Website: www.quarto. com. Publishes nonfiction books on a wide variety of topics including arts, crafts, natural history, home and garden, reference. Photos used for text illustrations, book covers, dust jackets. Examples of recently published titles: The Color Mixing Bible; Garden Birds; The Practical Geologist. Contact for photo guidelines.

Needs Buys 1,000 photos/year. Subjects vary with current projects. Needs photos of multicultural, environmental, wildlife, architecture, gardening, interiors/decorating, pets, religious, adventure, food/drink, health/fitness, hobbies, performing arts, sports, travel, product shots/still life, science, technology/computers. Interested in fashion/glamour, fine art, historical/vintage. Special photo needs include arts, crafts, alternative therapies, New Age, natural history. Model/property release required. Photo captions required; include full details of subject and name of photographer.

Specs Uses all types of prints. Accepts images in digital format. Send via CD, floppy disk, Zip, e-mail as TIFF, EPS, JPEG files at 72 dpi for viewing, 300 dpi for reproduction.

Making Contact & Terms Provide résumé, business card, samples, brochure, flier or tearsheets to be kept on file for future reference. Arrange a personal interview to show portfolio. Simultaneous submissions and previously published work OK. Pays \$30-60 for b&w photos; \$60-100 for color photos. Pays on publication. Credit line given. Buys one-time rights; negotiable.

Tips "Be prepared to negotiate!"

S RIGBY EDUCATION

Specialized Curriculum Group, 181 Ballardvale St., Wilmington MA 01887. (800)289-4490. Fax: (800)289-3994. Website: www.rigby.com. Publishes paperbacks and posters for kindergarten preparation, plus grade school reading curriculum. Photos used for text illustrations, book covers and posters. Examples of recently published titles: Getting Ready and Water Detective.

Needs Will need photos of happy ethnic children ages 5-6 at home, in classroom, with teacher, with pets, in playground, garden, farm, aquarium, restaurant, circus and city environments. Also needs classroom scenes with teacher and kids ages 7, 8 and 9, especially test taking, reading and writing. Also needs teachers in conference with parents, other teachers and administrators. Model releases preferred. Always interested in wild and domestic animals and other nature photos.

Specs Publishes from transparencies, 35mm or larger. Accepts images in digital format at 300 dpi minimum.

Making Contact & Terms "Contact by e-mail OK, but do not include attachments larger than 5 MB. web links will be looked at for stock." Responds only if interested. Send nonreturnable samples and stock lists. Simultaneous submissions and previously published work OK. Pays \$300-700 for color cover; \$130-500 for color inside. Pays on acceptance. Credit given in acknowledgments in front or back of book or in teacher's guide.

\$\$ RUNNING PRESS BOOK PUBLISHERS

2300 Chestnut St., Suite 200, Philadelphia PA 19103. (215)567-5080. Fax: (215)567-4636. E-mail: bill.jones@perseusbooks.com. Website: www.runningpress.com. Contact: Bill Jones, art director. Publishes hardcover originals, trade paperback originals. Subjects include adult and children's fiction and nonfiction; cooking; crafts, lifestyle, kits; miniature editions used for text illustrations, promotional materials, book covers, dust jackets. Examples of recently published titles: Skinny Bitch, Eat What You Love, The Ultimate Book of Sports Movies, The Baseball Hall of Fame, Wine Drinking For Inspired Thinking, The South Park Guide to Life, the Big Lebowski Kit.

Needs Buys a few hundred freelance photos/year and lots of stock images. Needs photos for gift books; photos of wine, food, lifestyle, landscapes/scenics, wildlife, architecture, gardening, rural, hobbies, sports. Model/property release preferred. Photo captions preferred; include exact locations, names of pertinent items or buildings, names and dates for antiques or special items of interest.

Specs Prefers images in digital format. Send via CD/DVD, via FTP/e-mail as TIFF, EPS files at 300

Making Contact & Terms Send URL and provide contact info. Do not send original art or anything that needs to be returned. Responds only if interested. Simultaneous submissions and previously published work OK. Pays \$500-1000 for color cover; \$100-250 for inside. Pays 45 days after receipt of invoice. Credits listed on separate copyright or credit pages. Buys one-time rights.

Tips "Look at our website, www.runningpress.com."

S \$ SCHOLASTIC LIBRARY PUBLISHING

557 Broadway, New York NY 10012. E-mail: info@artandwriting.org. Website: www.scholastic. com. Publishes 7 encyclopedias plus specialty reference sets in print and online versions. Photos used for text illustrations. Examples of published titles: The New Book of Knowledge; Encyclopedia Americana.

Needs Buys 5,000 images/year. Needs excellent-quality editorial photographs of all subjects A-Z and current events worldwide. All images must have clear captions and specific dates and locations, and natural history subjects should carry Latin identification.

Specs Uses 8 × 10 glossy b&w and/or color prints; 35mm, 4 × 5, 8 × 10 (reproduction-quality dupes preferred) transparencies. Accepts images in digital format. Send via photo CD, floppy disk, Zip as JPEG files at requested resolution.

Making Contact & Terms Send query letter, stock lists and printed examples of work. Cannot return unsolicited material and does not send guidelines. Include SASE only if you want material returned. Pricing to be discussed if/when you are contacted to submit images for specific project. Please note, encyclopedias are printed every year, but rights are requested for continuous usage until a major revision of the article in which an image is used (including online images).

Tips "Send subject lists and small selection of samples. Printed samples only, please. In reviewing samples, we consider the quality of the photographs, range of subjects and editorial approach. Keep in touch, but don't overdo it—quarterly e-mails are more than enough for updates on subject matter."

■ S SCHOOL GUIDE PUBLICATIONS

210 North Ave., New Rochelle NY 10801, (800)433-7771, ext. 27. E-mail: mridder@schoolguides. com. Website: www.schoolguides.com. Publishes mass market paperback originals. Photos used for promotional materials, book covers.

Needs Needs photos of college students.

Specs Accepts images in digital format; send via CD, Zip, e-mail as TIFF or JPEG files.

Making Contact & Terms E-mail query letter. Pays on acceptance.

S S STRANG COMMUNICATIONS COMPANY

600 Rinehart Rd., Lake Mary FL 32746. (407)333-0600. Fax: (407)333-7100. Website: www.strang. com. Publishes religious magazines and books for Sunday School and general readership, as well as gift books and children's books. Photos used for text illustrations, promotional materials, book covers, dust jackets. Examples of recently published titles: Charisma Magazine; New Man Magazine; Ministries Today Magazine; Christian Retailing; Vida Cristiana (all editorial, cover).

Needs Buys 75-100 photos/year; offers 75-100 freelance assignments/year. Needs photos of people, environmental portraits, situations. Reviews stock photos. Model/property release preferred for all subjects. Photo captions preferred; include who, what, when, where.

Specs Uses 8×10 prints; 35mm, $2\frac{1}{4} \times 2\frac{1}{4}$, 4×5 transparencies. Accepts images in digital format for Mac (Photoshop). Send via CD, e-mail.

Making Contact & Terms Arrange a personal interview to show portfolio or call and arrange to send portfolio. Send query letter with samples. Provide résumé, business card, brochure, flier or tearsheets to be kept on file for possible future assignments. Works with freelancers on assignment only. Keeps samples on file. Simultaneous submissions and previously published work OK. Pays \$5-75 for b&w photos; \$50-550 for color photos; negotiable with each photographer. Pays on publication and receipt of invoice. Credit line given. Buys one-time, first-time, book, electronic and all rights; negotiable.

TIGHTROPE BOOKS

602 Markham St., Toronto ON M6G 2L8, Canada. (647) 348-4460. Website: www.Tightropebooks. com. Editor: Shirarose Wilensky. Estab. 2005. Publishes fiction, poetry, nonfiction. Publishes hardcover and trade paperback originals.

Needs Publishes 12 titles/year. SASE returned. Responds only if interested. Catalog and guidelines free upon request and online.

TILBURY HOUSE, PUBLISHERS

103 Brunswick Ave., Gardiner ME 04345. (207)582-1899. Fax: (207)582-8227. E-mail: tilbury@ tilburyhouse.com. Website: www.tilburyhouse.com.

Making Contact & Terms Send photocopies of photos/artwork.

N 🖪 🛭 \$\$ TORAH AURA PRODUCTIONS

4423 Fruitland Ave., Los Angeles CA 90058. Owners: Jane Golub and James Golub. Estab. 1981. Jewish educational textbooks. Publishes nonfiction books; history, instructional, textbooks and religious books. Photos used for book covers and text illustrations. Book catalog available online, or free upon request. Guidelines available online. Pays by the product, upon publication. Prefers local freelancers. Buys stock photos and offers assignments. Responds to inquiries only if interested. Buys reprint rights.

Needs Publishes 6-8 titles/year. Artzeinu by Joel Lurie Grishaver; Apples and Oranges by Rabbi David Lieb; Yisrael Sheli by David Singer; Eizehu Gibor: Living Jewish Values by Joel Lurie Grishaver; and many more!

Making Contact & Terms Send a postcard sample.

Tips "Look at our catalog. Often our work is for young children. Abstract and edgy doesn't work that well. Communicate: be clear about your submission."

■ A W TRICYCLE PRESS

2625 Alcatraz Ave., #505, Berkeley CA 94705. E-mail: freelance@tenspeed.com. Website: tenspeed.crownpublishing.com. Imprint of Random House, Inc. Publishes children's books, including board books, picture books, and books for middle readers. Photos used for text illustrations and book covers. Example of recently published titles: *Busy Barnyard* (photography by Stephen Holt).

Needs Needs photos of children, multicultural, wildlife, performing arts, science.

Specs Uses 35mm transparencies; also accepts images in digital format.

Making Contact & Terms Responds only if interested; send nonreturnable samples. Pays royalties of 7¾-8¾ %, based on net receipts.

Tips "Tricycle Press is looking for something outside the mainstream; books that encourage children to look at the world from a different angle. Like its parent company, Ten Speed Press, Tricycle Press is known for its quirky, offbeat books. We publish high-quality trade books."

№ \$\$\$ TYNDALE HOUSE PUBLISHERS

351 Executive Dr., Carol Stream IL 60188. Website: www.tyndale.com. **Art Buyer:** Talinda Iverson. Estab. 1962. Publishes hardcover and trade paperback originals. Subjects include Christian content. Photos used for promotional materials, book covers, dust jackets. Examples of recently published titles: *Inside the Revolution, First Things First*. Photo guidelines free with #10 SASE.

Needs Buys 5-20 freelance photos/year. Needs photos of babies/children/teens, couples, multicultural, families, parents, senior citizens, landscapes/scenics, cities/urban, gardening, religious, rural, adventure, entertainment. Model/property release required.

Specs Accepts hard copy samples only.

Making Contact & Terms Send query letter with prints, tearsheets. Provide self-promotion piece to be kept on file for possible future assignments. Responds only if interested; send nonreturnable samples. Simultaneous submissions OK. Pays by the project; \$200-1,750 for cover; \$100-500 for inside. **Pays on acceptance**. Credit line given.

Tips "We don't have portfolio viewings. Negotiations are different for every project. Have every piece submitted with legible contact information."

VINTAGE BOOKS

1745 Broadway, 20-2, New York NY 10019. E-mail: vintageanchorpublicity@randomhouse.com. Website: www.randomhouse.com. Publishes trade paperback reprints; fiction. Photos used for book covers. Examples of recently published titles: *Selected Stories* by Alice Munro (cover); *The Fight* by Norman Mailer (cover); *Bad Boy* by Thompson (cover).

Needs Buys 100 freelance photos/year. Model/property release required. Photo captions preferred.

Making Contact & Terms Send query letter with samples, stock list. Portfolios may be dropped off every Wednesday. Keeps samples on file. Responds only if interested; send nonreturnable samples. Pays by the project, per use negotiation. Pays on publication. Credit line given. Buys one-time and first North American serial rights.

Tips "Show what you love. Include samples with name, address and phone number."

🖾 🖪 VISITOR'S CHOICE MAGAZINE

102 E. 4th Ave., Vancouver BC V5T 1G2, Canada. (604)608-5180. E-mail: editor@visitorschoice.com. Website: www.visitorschoice.com. Publishes full-color visitor guides for 16 communities and areas of British Columbia. Photos used for text illustrations, book covers, websites. Photo guidelines available via e-mail upon request.

Needs Looking for photos of attractions, mountains, lakes, views, lifestyle, architecture, festivals, people, sports and recreation—specific to British Columbia region. Specifically looking for people/

activity shots. Model release required; property release preferred. Photo captions required—"detailed but brief."

Specs Uses color prints; 35mm transparencies. Prefers images in digital format.

Making Contact & Terms Send query letter or e-mail with samples; include SASE for return of material. Works with Canadian photographers. Keeps digital images on file. Responds in 3 weeks. Previously published work OK. Payment varies with size of photo published. Pays in 30-60 days. Credit line given.

Tips "Please submit photos that are relevant to our needs only. Photos should be specific, clear, artistic, colorful, with good lighting."

■ \$\$ ② VOYAGEUR PRESS

400 First Ave. North, Suite 300, Minneapolis MN 55401. Website: www.voyageurpress.com. Publishes adult trade books, hardcover originals and reprints. Subjects include regional history, nature, popular culture, travel, wildlife, Americana, collectibles, lighthouses, quilts, tractors, barns and farms. Photos used for text illustrations, book covers, dust jackets, calendars. Examples of recently published titles: Legendary Route 66: A Journey Through Time Along America's Mother Road; Illinois Central Railroad; Birds in Love: The Secret Courting & Mating Rituals of Extraordinary Birds; Backroads of New York; How to Raise Cattle; Knitknacks; Much Ado About Knitting; Farmall: The Red Tractor that Revolutionized Farming; Backroads of Ohio; Farmer's Wife Baking Cookbook; John Deere Two-Cylinder Tractor Encyclopedia (text illustrations, book covers, dust jackets). Photo guidelines free with SASE.

 Voyageur Press is an imprint of MBI Publishing Company (see separate listing in this section).

Needs Buys 500 photos/year. Wants photos of wildlife, Americana, environmental, landscapes/scenics, cities/urban, gardening, rural, hobbies, humor, travel, farm equipment, agricultural. Interested in fine art, historical/vintage, seasonal. "Artistic angle is crucial—books often emphasize high-quality photos." Model release required. Photo captions preferred; include location, species, "interesting nuggets," depending on situation.

Making Contact & Terms "Photographic dupes must be of good quality for us to fairly evaluate your photography. We prefer 35mm and large format transparencies; will accept images in digital format for review only; prefers transparencies for production. Send via CD, Zip, e-mail as TIFF, BMP, GIF, JPEG files at 300 dpi." Simultaneous submissions OK. Pays \$300 for cover; \$75-175 for inside. Pays on publication. Credit line given, "but photographer's website will not be listed." Buys all rights; negotiable.

Tips "We are often looking for specific material (crocodile in the Florida Keys; farm scenics in the Midwest; wolf research in Yellowstone), so subject matter is important. However, outstanding color and angles and interesting patterns and perspectives are strongly preferred whenever possible. If you have the capability and stock to put together an entire book, your chances with us are much better. Though we use some freelance material, we publish many more single-photographer works. Include detailed captioning info on the mounts."

S \$ WAVELAND PRESS, INC.

4180 IL Rt. 83, Suite 101, Long Grove IL 60047-9580. (847)634-0081. Fax: (847)634-9501. E-mail: info@waveland.com. Website: www.waveland.com. **Photo Editor:** Jan Weissman. Publishes college-level textbooks and supplements. Photos used for text illustrations, book covers. Examples of recently published titles: *Our Global Environment: A Health Perspective, 6th Edition; Juvenile Justice, 2nd Edition.*

Needs Number of photos purchased varies depending on type of project and subject matter. Subject matter should relate to college disciplines: criminal justice, anthropology, speech/communication, sociology, archaeology, etc. Needs photos of multicultural, disasters, environmental, cities/urban, education, religious, rural, health/fitness, agriculture, political, technology. Interested in fine art, historical/vintage. Model/property release required. Photo captions preferred.

Specs Accepts images in digital format. Send via CD, Zip, e-mail as TIFF, EPS, JPEG files at 300 dpi.

Making Contact & Terms Send query letter with stock list. Provide résumé, business card, brochure, flier or tearsheets to be kept on file for possible future assignments. Simultaneous submissions and previously published work OK. Pays \$100-200 for cover; \$50-100 for inside. Pays on publication. Credit line given. Buys one-time and book rights.

Tips "Mail stock list and price list." See guidelines on website at: www.waveland.com/manusc. htm.

☑ 🖪 🖫 \$ 🔾 WEIGL EDUCATIONAL PUBLISHERS LIMITED

6325-10 St. SE, Calgary AB T2H 2Z9, Canada. (403)233-7747. Fax: (403)233-7769. Website: www.weigl.com. **President and Publisher:** Linda A. Weigl. Publishes textbooks, library and multimedia resources. Subjects include social studies, biography, life skills, environment/science studies, multicultural, language arts, geography. Photos used for text illustrations, book covers. Examples of recently published titles: *Land Mammals* (text illustrations, book cover); *Fossils* (text illustrations, book cover), *Opossums* (text illustrations, book cover); *Eiffel Tower* (text illustrations, book cover).

Needs Buys 2,000 photos/year. Needs photos of social issues and events, politics, celebrities, technology, people gatherings, multicultural, architecture, cities/urban, religious, rural, agriculture, disasters, environment, science, performing arts, life skills, landscape, wildlife, industry, medicine, biography and people doing daily activities, Canadiana, famous landmarks, aboriginal people. Interested in historical/vintage, seasonal. Model/property release required. Photo captions required.

Specs Prefers images in digital format. Send via CD, e-mail, FTP as TIFF files at 300 dpi. Uses 5×7 , 8×10 color prints (b&w for historical only); 35mm, $2\frac{1}{4} \times 2\frac{1}{4}$ transparencies.

Making Contact & Terms Send query letter with stock list. Provide tearsheets to be kept on file for possible future assignments. "Tearsheets or samples that don't have to be returned are best. We get in touch when we actually need photos." Simultaneous submissions and previously published work OK. Pays \$0-250 for color cover; \$0-100 for color inside. Credit line given upon request (photo credits are listed in appendix). Buys one-time, book and all rights; negotiable.

Tips Needs "clear, well-framed shots that don't look posed. Action, expression, multicultural representation are important, but above all, educational value is sought. People must know what they are looking at. Please keep notes on what is taking place, where and when. As an educational publisher, our books use specific examples as well as general illustrations."

N ■ \$\$ WILLOW CREEK PRESS

P.O. Box 147, Minocqua WI54548. (715) 358-7010. Fax: (715) 358-2807. E-mail: joyr@willowcreekpress. com. Website: www.willowcreekpress.com. Art Director: Joy Rasmussen. Publishes hardcover, paperback and trade paperback originals; hardcover and paperback reprints; calendars and greeting cards. Subjects include pets, outdoor sports, gardening, cooking, birding, wildlife. Photos used for text illustrations, promotional materials, book covers, dust jackets, calendars and greeting cards. Examples of recently published titles: *Pug Mugs, Horse Wisdom, How to Work Like a Cat.* Catalog free with #10 SASE. Photo guidelines free with #10 SASE or on website.

Needs Buys 2,000 freelance photos/year. Needs photos of gardening, pets, outdoors, recreation, landscapes/scenics, wildlife. Model/property release required. Photo captions required.

Specs Uses only digital format. Send 300dpi JPEGs and TIFFs.

Making Contact & Terms Send query letter with sample of work. Provide self-promotion piece to be kept on file. Responds only if interested. Simultaneous submissions and previously published work OK. Pays by the project. Pays on publication. Credit line given. Buys one-time rights.

■ S S WILSHIRE BOOK COMPANY

9731 Variel Ave., Chatsworth CA 91311-4315. (818)700-1522. Fax: (818)700-1527. E-mail: mpowers@ mpowers.com. Website: www.mpowers.com. President: Melvin Powers. Publishes trade paperback originals and reprints. Photos used for book covers.

Needs Needs photos of horses. Model release required.

Specs Uses 35mm, 21/4 × 21/4, 4 × 5 transparencies. Accepts images in digital format. Send via floppy disk, e-mail.

Making Contact & Terms Send query letter with slides, prints, transparencies. Portfolio may be dropped off Monday through Friday. Does not keep samples on file; include SASE for return of material. Responds in 6 weeks. Simultaneous submissions and previously published work OK. Pays \$250 for color cover. Pays on acceptance. Credit line given.

\$ WOMEN'S HEALTH GROUP

(212)573-0296. Website: www.rodale.com. Director of Communications: Yelena Nesbit. Publishes hardcover originals and reprints, trade paperback originals and reprints, one-shots. Subjects include healthy, active living for women, including diet, cooking, health, beauty, fitness and lifestyle.

Needs Needs photos of babies/children/teens, couples, multicultural, families, parents, senior citizens, food/drink, health/fitness/beauty, sports, travel, women, Spanish women, intimacy/ sexuality, alternative medicine, herbs, home remedies. Model/property release preferred.

Specs Uses color and/or b&w prints; 35mm, 21/4 × 21/4, 4 × 5 transparencies. Accepts images in digital format. Send via CD, Zip, e-mail as TIFF, EPS, JPEG files at 300 dpi.

Making Contact & Terms Send query letter with résumé, prints, photocopies, tearsheets, stock list. Provide résumé, business card, self-promotion piece to be kept on file for possible future assignments. Responds only if interested; send nonreturnable samples. Simultaneous submissions and previously published work OK. Pays \$600 maximum for b&w cover; \$900 maximum for color cover; \$400 maximum for b&w inside; \$500 maximum for color inside. Pays additional 20% for electronic promotion of book cover and designs for retail of book. Pays on acceptance. Credit line given. Buys one-time rights, electronic rights; negotiable.

Tips "Include your contact information on each item that is submitted."

Greeting Cards, Posters, & Related Products

he greeting card industry takes in more than \$7.5 billion per year—the lion's share through the giants American Greetings and Hallmark Cards. Naturally, these big companies are difficult to break into, but there is plenty of opportunity to license your images to smaller companies.

There are more than 3,000 greeting card companies in the United States, many of which produce low-priced cards that fill a niche in the market, focusing on anything from the cute to the risqué to seasonal topics. A number of listings in this section produce items like calendars, mugs, and posters, as well as greeting cards.

Before approaching greeting card, poster, or calendar companies, it's important to research the industry to see what's being bought and sold. Start by checking out card, gift, and specialty stores that carry greeting cards and posters. Pay attention to the selections of calendars, especially the large seasonal displays during December. Studying what you see on store shelves will give you an idea of what types of photos are marketable.

Greetings etc., published by Edgell Publications, is a trade publication for marketers, publishers, designers, and retailers of greeting cards. The magazine offers industry news and information on trends, new products, and trade shows. Look for the magazine at your library or visit their website: www.greetingsmagazine.com. Also the National Stationery Show (www.nationalstationeryshow.com) is a large trade show held every year in New York City. It is the main event of the greeting card industry.

APPROACHING THE MARKET

After your initial research, query companies you are interested in working with and send a stock photo list. (See sample stock list on page 17.) You can help narrow your search by consulting the Subject Index on page 531. Check the index for companies interested in the subjects you shoot.

Since these companies receive large volumes of submissions, they often appreciate knowing what is available rather than actually receiving samples. This kind of query can lead to future sales even if your stock inventory doesn't meet their immediate needs. Buyers know they can request additional submissions as their needs change. Some listings in this section advise sending quality samples along with your query while others specifically request only a list. As you plan your queries, follow the instructions to establish a good rapport with companies from the start.

Some larger companies have staff photographers for routine assignments but also look for freelance images. Usually, this is in the form of stock, and images are especially desirable if they are of unusual subject matter or remote scenic areas for which assignments—even to staff shooters—would be too costly. Freelancers are usually offered assignments once they have established track records and demonstrated a flair for certain techniques, subject matter, or locations. Smaller companies are more receptive to working with freelancers, though they are less likely to assign work because of smaller budgets for photography.

The pay in this market can be quite lucrative if you provide the right image at the right time for a client in need of it, or if you develop a working relationship with one or a few of the better-paying markets. You should be aware, though, that one reason for higher rates of payment in this market is that these companies may want to buy all rights to images. But with changes in the copyright law, many companies are more willing to negotiate sales that specify all rights for limited time periods or exclusive product rights rather than complete surrender of copyright. Some companies pay royalties, which means you will earn the money over a period of time based on the sales of the product.

■ \$\$ ADVANCED GRAPHICS

466 N. Marshall Way, Layton UT 84041. (801)499-5000 or (800)488-4144. Fax: (801) 499-5001. E-mail: info@advancedgraphics.com. Website: www.advancedgraphics.com. Estab. 1984. Specializes in life-size standups and cardboard displays, decorations and party supplies.

Needs Photos of celebrities (movie and TV stars, entertainers), babies/children/teens, couples, multicultural, families, parents, senior citizens, wildlife. Interested in seasonal, Reviews stock

Specs Uses 4 × 5, 8 × 10 transparencies. Accepts images in digital format. Send via CD, Zip, e-mail.

Making Contact & Terms Send query letter with stock list. Keeps samples on file. Responds in 1 month. Pays \$400 maximum/image; royalties of 7-10%. Simultaneous submissions and previously published work OK. Pays on acceptance. Credit line given. Buys exclusive product rights; negotiable.

Tips "We specialize in publishing life-size standups which are cardboard displays of celebrities. Any pictures we use must show the entire person, head to toe. We must also obtain a license for each image that we use from the celebrity pictured or from that celebrity's estate. The image should be vertical and not too wide."

ART IN MOTION

425-625 Agnes St., New Westminster BC V3M 5Y4, Canada. (604)525-3900 or (800)663-1308. Fax: (604)525-6166 or (877)525-6166. E-mail: bpower@artinmotion.com. Website: www.artinmotion. com. Contact: Artist Relations. Specializes in open-edition reproductions, framing prints, wall decor and licensing.

Needs "We are publishers of fine art reproductions, specializing in the decorative and gallery market. In photography, we often look for alternative techniques such as hand coloring, Polaroid transfer, or any process that gives the photograph a unique look."

Specs Accepts unzipped digital images sent via e-mail as JPEG files at 72 dpi.

Making Contact & Terms Submit portfolio for review. Pays royalties of 10%. Royalties paid monthly. "Art In Motion covers all associated costs to reproduce and promote your artwork."

Tips "Contact us via e-mail, or direct us to your website; also send slides or color copies of your work (all submissions will be returned)."

■ Ø ARTVISIONS™: FINE ART LICENSING

12117 SE 26th St., Bellevue WA 98005-4118. E-mail: nonospam0@gmail.com; zx@avidre. net. Website: www.artvisions.com. President: Neil Miller. Estab. 1993. Licenses "fashionable, decorative fine art photography and high-quality art to the commercial print, décor and puzzle/ game markets."

Needs Handles fine art and photography licensing only.

Making Contact & Terms "See website. Not currently seeking new talent. However, we are always willing to view the work of top-notch established artists and photographers. If you fit this category,

please contact ArtVisions via e-mail and include a link to a website where your art can be seen." Exclusive worldwide representation for licensing is required. Written contract provided.

Tips "To gain an idea of the type of art we license, please view our website. Animals, children, people and pretty places should be generic, rather than readily identifiable (this also prevents potential copyright issues and problems caused by not having personal releases for use of a 'likeness'). We prefer that your original work be in the form of high-resolution TIFF files from a 'pro-quality' digital camera. Note: scans/digital files are not to be interpolated or compressed in any way. We are firmly entrenched in the digital world; if you are not, then we cannot represent you. If you need advice about marketing your art, please visit: www.artistsconsult.com."

■ \$\$ ☑ AVANTI PRESS INC.

6 W. 18 St., 6th Floor, New York NY 10011. (212)414-1025. E-mail: davidlaubach@avantipress.com. Website: www.avantipress.com. Director of Creative Services: David Laubach. Specializes in photographic greeting cards. Photo guidelines free with SASE or on website.

Needs Buys approximately 200 images/year; all are supplied by freelancers. Interested in humorous, narrative, colorful, simple, to-the-point photos of babies, children (4 years old and younger), mature adults, animals (in humorous situations) and exceptional florals. Has specific deadlines for seasonal material. Does NOT want travel, sunsets, landscapes, nudes, high-tech. Reviews stock photos. Model/property release required.

Specs Will work with all mediums and formats. Accepts images in digital format. Send via CD as TIFF, JPEG files.

Making Contact & Terms Request guidelines for submission with SASE or visit website. DO NOT submit original material. Pays on license. Credit line given. Buys 5-year worldwide, exclusive card rights.

■ ② BENTLEY PUBLISHING GROUP

1410 Lesnick Ln., Walnut Creek CA 94597. (925)935-3186 or (800)227-1666. Fax: (925)935-0213. E-mail: info@bentleypublishinggroup.com. Website: www.bentleypublishinggroup.com. Estab. 1986. Publishes posters.

Needs Interested in figurative, architecture, cities, urban, gardening, interiors/decorating, rural, food/drink, travel—b&w, color or hand-tinted photography. Interested in alternative process, avant garde, fine art, historical/vintage. Reviews stock photos and slides. Model/property release required. Include location, date, subject matter or special information.

Specs Mainly uses 16×20 , 22×28 , 18×24 , 24×30 , 24×36 color and/or b&w prints; 4×5 transparencies from high-quality photos. Accepts images in digital format. Send via CD as TIFF or JPEG files.

Making Contact & Terms Submit photos or slides for review; include SASE for return of material. "Do not call." Responds in 6 weeks. Simultaneous submissions and previously published work OK. Pays royalties quarterly based upon sales, 10%.

■ S \$ BLUE SKY PUBLISHING

P.O. Box 19974, Boulder CO 80308. (303)530-4654 or (800)875-9493. Fax: (800)432-6168. E-mail: bspinfo@blueskypublishing.net. Website: www.blueskypublishing.net. Estab. 1989. Specializes in fine art and photographic greeting cards.

Needs Buys 12-24 images/year; all are supplied by freelancers. Interested in Rocky Mountain winter landscapes, dramatic winter scenes featuring wildlife in mountain settings, winter scenes from the Southwest, unique and creative Christmas still life images and scenes that express the warmth and romance of the holidays. Submit seasonal material December-April. Reviews stock photos. Model/property release preferred.

Specs Uses 35mm, 4×5 (preferred) transparencies. Accepts images in digital format.

Making Contact & Terms Submit 24-48 of your best images for review. Provide résumé, business card, self-promotion piece or tearsheets to be kept on file for possible future assignments. "We try

to respond within 1 month, but it could take 2 months." Simultaneous submissions and previously published work OK. Pays on acceptance.

Tips "Due to the volume of calls we receive from photographers, we ask that you refrain from calling regarding the status of your submission. We will contact you within 2 months to request more samples of your work if we are interested. We do not return unsolicited samples."

N ■ A BON ARTIQUE.COM/ART RESOURCES INT., LTD.

129 Glover Ave., Norwalk CT 06850-1311, (203)845-8888, E-mail: info@bonartique.com. Website: www.bonartique.com. Art Coordinator: Brett Bennist. Licensing and design studio specializing in posters and open edition fine art prints.

Needs Buys 50 images/year. Needs artistic/decorative photos (not stock photos) of landscapes/ scenics, wildlife, architecture, cities/urban, gardening, interiors/decorating, rural, adventure, health/fitness, extreme sports. Interested in fine art, cutting edge b&w, sepia photography. Model release required. Photo captions preferred.

Specs Uses high resolution digital files.

Making Contact & Terms Send unsolicited photos by mail with SASE for consideration. Works on assignment only. Responds in 3 months. Simultaneous submissions and previously published work OK. Pays advance against royalties—specific dollar amount is subjective to project. Pays on publication. Credit line given if required. Buys all rights; exclusive reproduction rights.

Tips "Send us new and exciting material; subject matter with universal appeal. Submit color copies, slides, transparencies, actual photos of your work; if we feel the subject matter is relevant to the projects we are currently working on, we'll contact you."

THE BOREALIS PRESS

35 Tenney Hill, Blue Hill ME 04614. (207)667-3700 or (800)669-6845. E-mail: info@borealispress. net. Website: www.borealispress.net. Owner: Mark Baldwin. Specializes in greeting cards, magnets and "other products for thoughtful people." Photo guidelines available for SASE.

Needs Buys more than 100 images/year; 90% are supplied by freelancers. Needs photos of humor, babies/children/teens, couples, families, parents, senior citizens, adventure, events, hobbies, pets/ animals. Interested in documentary, historical/vintage, seasonal. Photos must tell a story. Model/ property release preferred.

Specs Low resolution files are fine for review. Any media OK for finals. Uses 5×7 to 8×10 prints; 35mm, 21/4 × 21/4, 4 × 5, 8 × 10 transparencies. Accepts images in digital format. Send via CD. Send low-resolution files if e-mailing. Send images to art@borealispress.net.

Making Contact & Terms Send query letter with slides (if necessary), prints, photocopies, SASE. Send no originals on initial submissions. Responds in 2 weeks to queries; 3 weeks to portfolios. Previously published work OK. Pays by the project, royalties. Pays on acceptance, receipt of contract.

Tips "Photos should have some sort of story, in the loosest sense. They can be in any form. We do not want multiple submissions to other card companies. Include SASE, and put your name on every image you submit."

S S BRISTOL GIFT CO., INC.

P.O. Box 425, Washingtonville NY 10992. (845)496-2821. Fax: (845)496-2859. E-mail: bristol6@ frontiernet.net. Website: http://bristolgift.net. President: Matthew Ropiecki. Specializes in gifts.

Needs Interested in religious, nature, still life. Submit seasonal material 6 months in advance. Reviews stock photos. Model/property release preferred.

Specs Uses 4×5 , 8×10 color prints; 4×5 transparencies. Accepts images in digital format. Send via CD, floppy disk, Zip, e-mail as TIFF, JPEG files.

Making Contact & Terms Send query letter with samples. Keeps samples on file. Responds in 1 month. Previously published work OK. Pays \$50-200/image. Buys exclusive product rights.

■ \$ □ CENTRIC CORPORATION

6712 Melrose Ave., Los Angeles CA 90038. (323)936-2100. Fax: (323)936-2101. E-mail: centric@juno.com. Website: www.centriccorp.com. **President:** Sammy Okdot. Estab. 1986. Specializes in products that have nostalgic, humorous, thought-provoking images or sayings on them and in the following product categories: T-shirts, watches, pens, clocks, pillows, and drinkware.

Needs Photos of cities' major landmarks, attractions and things for which areas are well-known, and humorous or thought-provoking images. Submit seasonal material 5 months in advance. Reviews stock photos.

Specs Uses 8×12 color and/or b&w prints; 35mm transparencies. Accepts images in digital format. Send via CD as JPEG files.

Making Contact & Terms Submit portfolio for review or query with résumé of credits. Provide résumé, business card, self-promotion piece or tearsheets to be kept on file for possible future assignments. Responds in 2 weeks. Works mainly with local freelancers. Pays by the job; negotiable. **Pays on acceptance.** Rights negotiable.

S COMSTOCK CARDS

600 S. Rock Blvd., Suite 15, Reno NV 89502. (775)856-9400 or (800)326-7825. Fax: (775)856-9406 or (888)266-2610. E-mail: production@comstockcards.com. Website: www.comstockcards.com. Estab. 1986. Specializes in greeting cards, invitations, notepads, games, gift wrap. Photo guidelines free with SASE.

Needs Buys/assigns 30-40 images/year; all are supplied by freelancers. Wants wild, outrageous and shocking adult humor; seductive images of men or women. Definitely does not want to see traditional, sweet, cute, animals or scenics. "If it's appropriate to show your mother, we don't want it!" Frontal nudity in both men and women is OK and now being accepted as long as it is professionally done—no snapshots from home. Submit seasonal material 10 months in advance. Model/property release required. Photo captions preferred.

Specs Uses 5×7 color prints; 35mm, $2\frac{1}{4} \times 2\frac{1}{4}$ color transparencies. Accepts images in digital format.

Making Contact & Terms Send query letter with samples, tearsheets, SASE. Responds in 2 months. Pays on publication. Buys all rights; negotiable.

Tips "Submit with SASE if you want material returned."

M 🖪 🖫 \$\$ 🗵 CONCORD LITHO

92 Old Turnpike Rd., Concord NH 03301. (603)225-3328. Fax: (603)225-6120. E-mail: print@concordlitho.com. Website: www.concordlitho.com. Estab. 1958. Specializes in bookmarks, greeting cards, calendars, postcards, stationary and gift wrap. Photo guidelines free with SASE.

Needs Buys 150 images/year; 50% are supplied by freelancers. Rarely offers assignments. Needs photos of nature, seasonal, domestic animals, dogs and cats, religious, inspirational, florals and scenics. Also considers babies/children, multicultural, families, gardening, rural, business concepts, fine art. Submit seasonal material minimum 6-8 months in advance. Does not want nudes, comedy or humorous—nothing wild or contemporary. Model/property release required for historical/nostalgia, homes and gardens, dogs and cats. Photo captions preferred; include accurate information pertaining to image (location, dates, species, etc.).

Specs Uses 8×10 satin color prints; 35mm, $2\frac{1}{4} \times 2\frac{1}{4}$, 4×5 , 8×10 transparencies. Accepts images in digital format. Send via CD, e-mail as TIFF, EPS, PICT, GIF, JPEG files at 300 dpi (TIFF, EPS, JPEG).

Making Contact & Terms Submit samples/dupes for review along with stock list. Keeps samples/dupes on file. Response time may be as long as 6 months. Simultaneous submissions and previously published work OK. Pays on usage. Credit line sometimes given depending upon client and/or product. Buys one-time rights.

Tips "Send nonreturnable samples/color copies demonstrating skill and creativity, along with a complete-as-possible stock list. No phone calls, please."

CURRENT, INC.

1005 E. Woodmen Rd., Colorado Springs CO 80920. E-mail: info@currentinc.com. Website: www. currentinc.com. Freelance Manager: Dana Grignano. Estab. 1940. Specializes in bookmarks. calendars, decorations, gifts, giftwrap, greeting cards, ornaments, posters, stationery, computer.

Needs Buys at least 50 images/year; all are supplied by freelancers. Needs photos of animal humor, b&w and hand-tinted photos of children. Also needs photos of landscapes/scenics, wildlife, gardening, rural, product shots/still life. Interested in fine art, seasonal. Submit seasonal material 16 months in advance. Model release required.

Specs Uses 35mm, $2\sqrt[3]{4} \times 2\sqrt[3]{4}$, 4×5 , 8×10 transparencies.

Making Contact & Terms Send query letter with photocopies, tearsheets, transparencies, Keeps samples on file. Responds only if interested, send nonreturnable samples. Considers previously published work. Pays \$50-600/image. Pays on acceptance, receipt of invoice. Credit line sometimes given depending upon product type. Buys one-time rights, all rights; negotiable.

Tips "Request and review catalog prior to sending work to see what we look for."

DELJOU ART GROUP

1616 Huber St., Atlanta GA 30318. (404)350-7190 or (800)237.4638. Fax: (404)350-7195. E-mail: info@deljouartgroup.com. Website: www.deljouartgroup.com. Estab. 1980. Specializes in wall decor, fine art.

Needs All images supplied by freelancers. Specializes in artistic images for reproduction for highend art market. Work sold through art galleries as photos or prints. Needs nature photos. Reviews stock photos of graphics, b&w photos. No tourist photos: only high-quality, artistic photos.

Specs Uses color and/or b&w prints; 35mm, 21/4 × 21/4, 4 × 5, 8 × 10 transparencies. Accepts images in digital format. Prefers initial digital submissions via e-mail, but will accept CDs. Final, accepted images must be high-resolution, of at least 300 dpi.

Making Contact & Terms Submit portfolio for review; include SASE for return of material. Also send portfolio via e-mail. Simultaneous submissions and previously published work OK, Pays royalties on sales. Credit line sometimes given depending upon the product. Rights negotiable. Tips "Abstract-looking photographs OK. Hand-colored black & white photographs needed."

DESIGN DESIGN. INC.

P.O. Box 2266, Grand Rapids MI 49501. (616)771-8359. Fax: (616)774-4020. E-mail: susan. birnbaum@designdesign.us. Website: www.designdesign.us. Creative Director: Susan Birnbaum. Specializes in greeting cards and paper-related product development.

Needs Licenses stock images from freelancers and assigns work. Specializes in humorous topics. Submit seasonal material 1 year in advance. Model/property release required.

Specs Uses 35mm transparencies. Accepts images in digital format. Send via Zip.

Making Contact & Terms Submit portfolio for review. Provide résumé, business card, self-promotion piece or tearsheets to be kept on file for possible future assignments. Do not send original work, Pays royalties. Pays upon sales. Credit line given.

DODO GRAPHICS INC.

P.O. Box 585, Plattsburgh NY 12901. (518)561-7294. Fax: (518)561-6720. E-mail: dodographics@ aol.com. Website: www.dodographicsinc.com. President: Frank How. Specializes in posters and framing prints.

Needs Buys 50-100 images/year; 100% are supplied by freelancers. Offers 25-50 assignments/year. Needs all subjects. Submit seasonal material 3 months in advance. Reviews stock photos. Model/ property release preferred. Photo captions preferred.

Specs Uses color and/or b&w prints; 35mm, 4 × 5 transparencies; CD-ROMs.

Making Contact & Terms Submit portfolio for review. Send query letter with samples and stock list or CD-ROMs. Works on assignment only. Keeps samples on file. Responds in 1 month. Simultaneous submissions OK. Payment negotiable. **Pays on acceptance**. Credit line given. Buys all rights; negotiable.

■ S \$\$ GALLANT GREETINGS CORP.

4300 United Parkway, Schiller Park IL 60176. (847)671-6500 or (800)621-4279. Fax: (847)671-5900. E-mail: info@gallantgreetings.com. Website: www.gallantgreetings.com. Estab. 1966. Specializes in greeting cards.

Needs Buys vertical images; all are supplied by freelancers. Needs photos of landscapes/scenics, wildlife, gardening, pets, religious, automobiles, humor, sports, travel, product shots/still life. Interested in alternative process, avant garde, fine art. Submit seasonal material 1 year in advance. Model release required. Photo captions preferred.

Specs Accepts images in digital format. Send via CD, e-mail as TIFF files at 300 dpi. No slides accepted.

Making Contact & Terms Send query letter with photocopies. Provide self-promotion piece to be kept on file for possible future assignments. Send nonreturnable samples. Pays by the project. Buys U.S. greeting card and allied product rights; negotiable.

■ S Ø IMPACT PHOTOGRAPHICS

4961 Windplay Dr., El Dorado Hills CA 95762. (916)939-9333. Website: www.impactphotographics. com. Estab. 1975. Specializes in calendars, postcards, magnets, bookmarks, mugs, CD-ROMs, posters, books for the tourist industry. Photo guidelines and fee schedule free with SASE.

This company sells to specific tourist destinations; their products are not sold nationally. They
need material that will be sold for at least a 5-year period.

Needs Buys stock. Buys 3,000 photos/year. Needs photos of wildlife, scenics, US travel destinations, national parks, theme parks and animals. Submit seasonal material 4-5 months in advance. Model/property release required. Photo captions preferred.

Specs Uses 35mm, $2\frac{1}{4} \times 2\frac{1}{4}$, 4×5 , 8×10 transparencies. Accepts images in digital format. Send via CD, Zip as TIFF, JPEG files at 300 dpi.

Making Contact & Terms "Must have submissions request before submitting samples. No unsolicited submissions." Send query letter with stock list. Provide business card, self-promotion piece or tearsheets to be kept on file for possible future assignments. Simultaneous submissions and previously published work OK. Request fee schedule; rates vary by size. Pays on usage. Credit line and printed samples of work given. Buys one-time and nonexclusive product rights.

\$\$ INTERCONTINENTAL GREETINGS LTD.

38 West 32nd St., Ste. 910, New York NY 10001. (212)683-5830: Fax: (212)779-8564. E-mail: art@ intercontinental-ltd.com. Website: www.intercontinental-ltd.com. Sells reproduction rights of designs to manufacturers of multiple products around the world. Represents artists in 50 different countries. "Our clients specialize in greeting cards, giftware, giftware, calendars, postcards, prints, posters, stationery, paper goods, food tins, playing cards, tabletop, bath and service ware and much more."

Needs Approached by several hundred artists/year. Seeking creative decorative art in traditional and computer media (Photoshop and Illustrator work accepted). Prefers artwork previously made with few or no rights pending. Graphics, sports, occasions (i.e., Christmas, baby, birthday, wedding), humorous, "soft touch," romantic themes, animals. Accepts seasonal/holiday material any time. Prefers artists/designers experienced in greeting cards, paper products, tabletop and giftware.

Making Contact & Terms Send unsolicited CDs or DVDs by mail or low-resolution JPEGs by e-mail. "Please do not send original artwork." Upon request, submit portfolio for review. Provide resume, business card, brochure, flier, or tear sheets to be kept on file for possible future assignments. "Once your art is accepted, we require original color art-Photoshop files on disc (TIFF, 300 dpi). We

will respond only if interested (will send back non-accepted artwork in SASE if provided)." Pays on publication. No credit line given. Offers advance when appropriate. Sells one-time rights and exclusive product rights. Simultaneous submissions and previously published work OK. "Please state reserved rights, if any."

Tips Recommends the annual New York SURTEX and Licensing shows. In photographer's portfolio samples, wants to see "a neat presentation, perhaps thematic in arrangement."

\$\$ ILLSON & ROBERTS

3300 W. Castor St., Santa Anna CA 92704-3908. (714)424-0111. Fax: (714)424-0054. E-mail: shawn@ jillsonroberts.com; sales@jillsonroberts.com. Website: www.jillsonroberts.com. Creative Director: Shawn K. Doll. Specializes in gift wrap, totes, printed tissues, accessories. Photo guidelines free with SASE. Eco-friendly products.

Needs Needs vary. Specializes in everyday and holiday products. Themes include babies, sports, pets, seasonal, weddings. Submit seasonal material 3-6 months in advance.

Making Contact & Terms Submit portfolio for review or query with samples. Provide résumé, business card, self-promotion piece or tearsheets to be kept on file for possible future assignments. The review process can take up to 4 months. Pays average flat fee of \$250 or royalties.

Tips "Please follow our guidelines!"

■ \$\$ MCGAW GRAPHICS, INC.

100 Dutch Hill Rd., Suite 230, Orangeburg NY 10962. (845)353-8600. Fax: (845)353-8907; (800)446-8230. E-mail: katy@mcgawgraphics.com. Website: www.mcgawgraphics.com. Product Development Manager: Katy Murphy. Specializes in posters, framing prints, wall decor.

Needs Licenses 250-300 images/year in a variety of media; 10-15% in photography. Interested in b&w: still life, floral, figurative, landscape; color: landscape, still life, floral. Also considers celebrities, environmental, wildlife, architecture, rural, fine art, historical/vintage. Does not want images that are too esoteric or too commercial. Model/property release required for figures, personalities, images including logos or copyrighted symbols. Photo captions required; include artist's name, title of image, year taken. Not interested in stock photos.

Specs Uses color and/or b&w prints; 35mm, 21/4 × 21/4, 4 × 5, 8 × 10 transparencies. Accepts images in digital format at 300 dpi.

Making Contact & Terms Submit portfolio for review. "Review is typically 2 weeks on portfolio drop-offs. Be certain to leave phone number for pick up." Provide résumé, business card, selfpromotion piece or tearsheets to be kept on file for possible future assignments. "Do not send originals!" Responds in 1 month. Simultaneous submissions and previously published work OK. Pays royalties on sales. Pays quarterly following first sale and production expenses. Credit line given. Buys exclusive product rights for all wall decor.

Tips "Work must be accessible without being too commercial. Our posters/prints are sold to a mass audience worldwide who are buying art prints. Images that relate a story typically do well for us. The photographer should have some sort of unique style or look that separates him from the commercial market. It is important to take a look at our catalog or website before submitting work to get a sense of our aesthetic. You can view the catalog in any poster shop. We do not typically license traditional stock-type images—we are a decorative house appealing to a higher-end market. Send your best work (20-60 examples)."

■ \$\$ MODERNART EDITIONS

165 Chubb Ave., Lyndhurst NJ 07071. (201)842-8500 or (800)760-3058. Fax: (201)842-8546. E-mail: modernarteditions@theartpublishinggroup.com. Website: www.modernarteditions.com. Specializes in posters, wall decor, open edition fine art prints.

Needs Interested in b&w or sepia tone, seasonal, landscapes, seascapes, European scenes, floral still lifes, abstracts, cities, gardening, sports, fine art. Model/property release required.

Specs Uses 8×10 color and/or b&w prints; $2\frac{1}{4} \times 2\frac{1}{4}$, 4×5 transparencies. Accepts images in digital format. Send JPEG files for review via e-mail.

Making Contact & Terms Submit portfolio for review. Keeps samples on file. Include SASE for return of material. Simultaneous submissions OK. Responds within 2 months. Pays on usage. Credit line given. Buys one-time, all and exclusive product rights.

■ NEW YORK GRAPHIC SOCIETY PUBLISHING GROUP

130 Scott Rd., Waterbury CT 06705. (203)847-2000 or (800)677-6947. Fax: (203)757-5526. Website: www.nygs.com. Estab. 1925. Specializes in fine art reproductions, prints, posters, canvases.

Needs Buys 150 images/year; 125 are supplied by freelancers. "Looking for variety of images."

Specs Prefers digital format. Send low-res JPEGs via e-mail; no zip files.

Making Contact & Terms Send query letter with samples to Attn: Artist Submissions. Does not keep samples on file; include SASE for return of material. Responds in 3 months. Payment negotiable. Pays on usage. Credit line given. Buys exclusive product rights. No phone calls.

Tips "Visit website to review artist submission guidelines and to see appropriate types of imagery for publication."

\$ NOVA MEDIA INC.

1724 N. State St., Big Rapids MI 49307-9073. (231)796-4637. E-mail: trund@netonecom.net. Website: www.novamediainc.com; www.culturaldiversitytest.com; www.racialattitudesurvey. com. **Chairman:** Thomas J. Rundquist. Specializes in CD-ROMs, CDs/tapes, games, limited edition plates, posters, school supplies, T-shirts. Photo guidelines free with SASE.

Needs Buys 100 images/year; most are supplied by freelancers. Offers 20 assignments/year. Seeking art fantasy photos. Needs photos of children/teens, celebrities, multicultural, families, landscapes/scenics, education, religious, rural, entertainment, health/fitness/beauty, military, political, technology/computers. Interested in documentary, erotic, fashion/glamour, fine art, historical/vintage. Submit seasonal material 2 months in advance. Reviews stock photos. Model release required. Photo captions preferred.

Specs Uses color and/or b&w prints. Accepts images in digital format. Send via CD.

Making Contact & Terms Send query letter with samples. Accepts e-mail submissions. Responds in 1 month. Keeps samples on file; does not return material. Simultaneous submissions and previously published work OK. Payment negotiable. Pays extra for electronic usage of photos. Pays on usage. Credit line given. Buys electronic rights; negotiable.

Tips "The most effective way to contact us is by e-mail or regular mail. Visit our website."

M OHIO WHOLESALE, INC.

5180 Greenwich Rd., Seville OH 44273. (330)769-1059. Fax: (330)769-1961. E-mail: annev@ohiowholesale.com. Website: www.ohiowholesale.com.

■ ⊘ PAPER PRODUCTS DESIGN

60 Galli Dr., Novato CA 94949. (415)883-1888. Fax: (415)883-1999. E-mail: carol@paperproductsdesign.com. Website: www.paperproductsdesign.com. **President:** Carol Florsheim. Specializes in napkins, plates, candles, porcelain.

Needs Buys 500 images/year; all are supplied by freelancers. Needs photos of babies/children/teens, architecture, gardening, pets, food/drink, humor, travel. Interested in avant garde, fashion/glamour, fine art, historical/vintage, seasonal. Submit seasonal material 6 months in advance. Model release required. Photo captions preferred.

Specs Uses glossy color and/or b&w prints; 35mm, $2\frac{1}{4} \times 2\frac{1}{4}$, 4×5 , 8×10 transparencies. Accepts images in digital format. Send via Zip, e-mail at 350 dpi.

Making Contact & Terms Send query letter with photocopies, tearsheets. Responds in 1 month to queries, only if interested. Simultaneous submissions and previously published work OK.

S\$ PI CREATIVE ART

1180 Caledonia Rd., Toronto ON M6A 2W5, Canada. (416)789-7156. Fax: (416)789-7159. E-mail: dow@pifineart.com. Website: www.picreativeart.com. Creative Director: Darounny (Dow) Marcus. Specializes in posters/prints. Photo guidelines available.

Needs Needs photos of landscapes/scenics, floral, architecture, cities/urban, European, hobbies. Interested in alternative process, avant garde, fine art, historical/vintage. Interesting effects, Polaroids, painterly or hand-tinted submissions welcome. Submit seasonal material 2 months in advance. Model/property release preferred. Photo captions preferred; include date, title, artist,

Specs Accepts images in digital format. Send via CD, Zip, e-mail as low res JPEG files for review. Images of interest will be requested in 300 dpi TIFF files.

Making Contact & Terms Send query letter with résumé, slides, prints, photocopies, tearsheets, transparencies, stock list. Provide business card, self-promotion piece to be kept on file for possible future assignments. Responds in 2 weeks to queries; 5 weeks to portfolios. Simultaneous submissions OK. Pays royalties of 10% minimum. Buys worldwide rights for approximately 4-5 years to publish in poster form.

Tips "Keep all materials in contained unit. Provide easy access to contact information. Provide any information on previously published images. Submit a number of pieces. Develop a theme (we publish in series of 2, 4, 6, etc.). Black & white performs very well. Vintage is also a key genre; sepia great, too. Catalog is published with supplement 2 times/year. We show our images in our ads, supporting materials and website."

PORTFOLIO GRAPHICS, INC.

4680 Kellv Cir., Salt Lake City UT 84117. (801)424-2574. E-mail: info@portfoliographics.com. Website: www.nwgs.com. Creative Director: Kent Barton. Publishes and distributes open edition fine art prints, posters, and canvases as well as images and designs on alternative substrates such as metal, wooden plagues and wall decals.

Needs Buys 100 images/year; nearly all are supplied by freelancers. Seeking creative, fashionable and decorative art for commercial and designer markets. Clients include galleries, designers, poster distributors (worldwide), framers and retailers. For posters, "keep in mind that we need decorative art that can be framed and hung in home or office." Submit seasonal material on an ongoing basis. Reviews stock photos. Photo captions preferred.

Specs Uses prints, transparencies, high-res digital files recommended.

Making Contact & Terms E-mail JPEGs, PDF or website links. Send photos, transparencies, tearsheets or gallery booklets with SASE. Does not keep samples on file; must include SASE for return of material. Art director will contact photographer for portfolio review if interested. Responds in 3 months. Pays royalties of 10% on sales. Semi-annual royalties paid per pieces sold. Credit line given. Buys exclusive product rights license per piece.

Tips "We find artists through galleries, magazines, art exhibits and submissions. We are looking for a variety of artists, styles and subjects that are fresh and unique."

\$\$ RECYCLED PAPER GREETINGS, INC.

111 N. Canal St., Suite 700, Chicago IL 60606-7206. (800)777-9494. Website: www.recycled.com. Estab. 1971. Specializes in greeting cards. Photo guidelines available on website.

Needs Buys 200-400 images/year; all supplied by freelancers. Wants "primarily humorous photos for greeting cards. Unlikely subjects and offbeat themes have the best chance, but we'll consider all types. Text ideas required with all photo submissions." Needs photos of babies/children/teens, landscapes/scenics, wildlife, pets, humor. Interested in alternative process, fine art, historical/ vintage, seasonal. Model release required.

Specs Uses b&w and/or color prints; b&w and/or color contact sheets. "Please do not submit slides, disks, tearsheets or original photos."

Making Contact & Terms Send for artists' guidelines or visit website. Include SASE with submissions for return of material. Responds in up to 2 months. Simultaneous submissions OK. **Pays on acceptance.** Credit line given. Buys card rights.

Tips Prefers to see "up to 10 samples of photographer's best work. Cards are printed in 5×7 format. Please include messages."

N - S \$\$ RIG

500 Paterson Plank Rd., Union City NJ 07087. (201)863-4500. Website: www.rightsinternational.com. Licensing agency specializing in the representation of photographers and artists to manufacturers for licensing purposes. Manufacturers include greeting card, calendar, poster and home furnishing companies.

Needs Needs photos of architecture, entertainment, humor, travel, floral, coastal. "Globally influenced—not specific to one culture. Moody feel." See website for up-to-date needs. Reviews stock photos. Model/property release required.

Specs Uses prints, slides, transparencies. Accepts images in digital format. Send via CD, e-mail as JPEG files.

Making Contact & Terms Submit portfolio for review. Keeps samples on file. Simultaneous submissions and previously published work OK. Payment negotiable. Pays on license deal. Credit line given. Buys exclusive product rights.

B SANTORO GRAPHICS LTD.

Rotunda Point, 11 Hartfield Crescent, Wimbledon, London SW19 3RL, United Kingdom. (44) (208)781-1100. Fax: (44)(208)781-1101. E-mail: submissions@santorographics.com. Website: www. santorographics.com. Contact: Submissions. Specializes in greeting cards, stationery, gift wrap, gifts.

Needs Wants "humorous, cute, retro, nostalgic and unusual pictures of animals, people and situations." Also interested in fine art imagery. "Do not submit seasonal material; we do not print it."

Specs Accepts images in digital format sent via CD or e-mail.

Making Contact & Terms Send query letter/e-mail with CV, photocopies/digital files. Include SASE for return of material. **Pays on receipt of invoice.** Credit line not given. Rights and fees determined by negotiation.

■ \$\$ ☑ SPENCER GIFTS, LLC

6826 Black Horse Pike, Egg Harbor Twp. NJ 08234-4197. (609)645-5526. Fax: (609)645-5797. E-mail: james.stevenson@spencergifts.com. Website: www.spencersonline.com. **Senior Graphic Designer:** James Stevenson. Specializes in packaging design, full-color art, novelty gifts, brochure design, poster design, logo design, promotional P.O.P.

Needs Needs photos of babies/children/teens, couples, party scenes (must have releases), jewelry (gold, sterling silver, body jewelry—earrings, chains, etc.). Interested in fashion/glamour. Model/property release required. Photo captions preferred.

Specs Uses transparencies. Accepts images in digital format. Send via CD, DVD at 300 dpi. Contracts some illustrative artwork. All styles considered.

Making Contact & Terms Send query letter with photocopies. Portfolio may be dropped off any weekday, 9-5. Provide self-promotion piece to be kept on file for possible future assignments. Responds only if interested; send *only* nonreturnable samples. Pays by the project, \$250-850/image. **Pays on receipt of invoice**. Buys all rights; negotiable. Will respond upon need of services.

S S S TELDON

Unit 100 - 12751 Vulcan Way, Richmond BC V6V 1N6, Canada. E-mail: photo@teldon.com. Website: www.teldon.com. Contact: Photo Editor. Publishes high-quality dated and nondated promotional

products, including wall calendars, desk calendars, magnets, newsletters, postcards, etc. Photo guidelines free with SAE (legal size)—waiting list applies.

Needs Buys over 1,000 images/year; 70% are supplied by freelancers. Needs photos of lifestyles (babies/children/teens, couples, multicultural, families, parents, senior citizens, wildlife (North American), architecture (exterior residential homes), gardening, interiors/decorating, adventure, sports, travel (world), motivational, inspirational, landscape/scenic. Reviews stock photos. Model/ property release required for trademarked buildings, residential houses, people. Photo captions required; include complete detailed description of destination, i.e., Robson Square, Vancouver, British Columbia, Canada (month picture taken also helpful).

Specs Uses 35mm, medium- and large-format (horizontal only) transparencies. "We make duplicates of what we think is possible material and return the originals within a given time frame. Originals are recalled once final selection has been made. We do not accept digital submissions at this time."

Making Contact & Terms Send query letter or e-mail. "No submissions accepted unless photo guidelines have been received and reviewed." Include SAE and IRCs for return of material. Responds in 1 month, depending on workload. Simultaneous submissions and previously published work OK. Works with freelancers and stock agencies. Pays \$150 for one-time use, non-negotiable. Pays in September of publication year. Credit line and complementary calendar copies given. Photos used for one-time use in dated products, North American rights, unlimited print runs.

Tips Send horizontal transparencies only; dramatic and colorful nature/scenic/wildlife shots. City shots should be no older than 1 year. "Examine our catalog on our website carefully, and you will see what we are looking for."

M THE GREETINGS FACTORY

P.O. Box 264, Hampton Middlesex TW12 2ZT, United Kingdom. Works with different skill levels. Illustrator and/or Photoshop beneficial but not essential. Seasonal material must be submitted 6 months in advance. All physical samples are returned if SAE is enclosed.

Needs Produces conventional, religious, alternative, alternative humour, inspirational, juvenile and contemporary products. Produces graduation, birthday, congratulations, baby congrats, woman-towoman, wedding/anniversary, get-well/sympathy and everyday cards.

Making Contact & Terms Send a query letter with samples.

■ S S TIDE-MARK PRESS

P.O. Box 20, Windsor CT 06095. (860)683-4499, ext. 107. Fax: (860)683-4055. E-mail: scott@tidemark.com, Website: www.tidemarkpress.com, Acquisitions Editor: Mara Braverman, Specializes in calendars. Photo guidelines available on website.

Needs Buys 1,000 images/year; 800 are supplied by freelancers. Categories: landscapes/scenics, wildlife, architecture, gardening, interiors/decorating, pets, religious, adventure, automobiles, entertainment, events, food/drink, health/fitness, hobbies, humor, performing arts, sports, travel. Interested in fine art, historical/vintage; Native American; African American. Needs "complete calendar concepts that are unique but also have identifiable markets; groups of photos that could work as an entire calendar; ideas and approach must be visually appealing and innovative but also have a definable audience. No general nature or varied subjects without a single theme." Submit seasonal material 18 months in advance. Reviews stock photos. Model release preferred. Photo captions required.

Specs Uses film and digital images. Accepts lo-res images in PDF or JPEG format for initial review; send high-res only on selection.

Making Contact & Terms "Offer specific topic suggestions that reflect specific strengths of your stock." Send e-mail with sample images. Editor will contact photographer for portfolio review if interested. Responds in 3 weeks. Pays \$150-350/color image for single photos; royalties on net sales if entire calendar supplied. Pays on publication or per agreement. Credit line given. Buys one-time rights.

Tips "We tend to be a niche publisher and rely on photographers with strong stock to supply our needs. Check the website, then call or send a query suggesting a specific calendar concept."

■ \$ TRAILS MEDIA GROUP

333 W. State St., Milwaukee WI 53201. Fax: (414) 647-4723. E-mail: mchristiansen@wistrails.com. Website: www.wistrails.com. Specializes in calendars (horizontal and vertical) portraying seasonal scenics. Also publishes regional books and magazines, including *Wisconsin Trails*.

Needs Buys 300 photos/year. Needs photos of nature, landscapes, wildlife and regional (Wisconsin, Michigan, Iowa, Minnesota, Indiana, Illinois) activities. Makes selections in January for calendars, 6 months ahead for magazine issues. Photo captions required.

Specs Uses 35mm, $2\frac{1}{4} \times 2\frac{1}{4}$, 4×5 transparencies. Accepts images in digital format. Send via CD, Zip, Jaz as TIFF, EPS files at 300-1,250 dpi.

Making Contact & Terms Submit material by mail with SASE for consideration. Responds in 1 month. Simultaneous submissions OK "if we are informed, and if there's not a competitive market among them." Previously published work OK. Buys one-time rights.

Tips "Be sure to inform us how you want materials returned and include proper postage. Calendar scenes must be horizontal to fit $8\frac{3}{4} \times 11$ format, but we also want vertical formats for engagement calendars. See our magazine and books and be aware of our type of photography. E-mail for an appointment."

■ A S \$\$ ZITI CARDS

601 S. Sixth St., St. Charles MO 63301. (800)497-5908. Fax: (636)352-2146. E-mail: mail@ziticards.com. Website: www.ziticards.com. **Owner:** Salvatore Ventura. Estab. 2006. Produces greeting cards. Specializes in holiday cards for design businesses. Art guidelines available via e-mail.

Needs Buys 20+ freelance photographs per year. Produces material for greeting cards, mainly Christmas and Thanksgiving. Submit seasonal material at any time. Final art size should be proportional to and at least 5x7 inches. "We purchase exclusive rights for the use of photographs on greeting cards and do not prevent photographers from using images on other non-greeting card items. Photographers retain all copyrights and can end the agreement for any reason." Pays \$50 advance and 5% royalties at the end of the season. Finds freelancers through submissions. Accepts prints, transparencies and digital formats.

Making Contact & Terms E-mail query letter with resume, link and samples or send a query letter with resume slides, prints, tearsheets and/or transparencies. Samples not kept on file, include SASE for return of material.

Tips "Pay attention to details, look at other work that publishers use, follow up on submissions, have good presentations.

\$\$ THE ZOLAN COMPANY, LLC

9947 E. Desert Jewel Dr., Scottsdale AZ 85255. (480)306-5680. E-mail: donaldz798@aol.com. Website: www.zolan.com. **President/Art Director:** Jennifer Zolan. Commercial and fine art business. Photos used for artist reference in oil paintings.

Needs Buys 8-10 images/year; works on assignment; looking for photographs of Farmall tractors, especially model M, C, H, 1066, Farmall Cub, Farmall 1206, f20. John Deere tractors are also needed. Looking for photos of puppies and dogs for paintings. Reviews stock photos.

Specs Uses any size, color and b&w prints. Prefers images in digital format. Send via e-mail, PDF, GIF, JPEG files at 72 dpi for preview.

Making Contact & Terms Request photo guidelines by e-mail. Does not keep samples on file; include SASE for return of material. Responds in 2 months to queries. Pays \$100-500 "depending on the extent of photo shoot." **Pays on acceptance**.

Tips "Call or e-mail before submitting work. We are happy to work with amateur and professional photographers. Will work on assignment shoots with photographers who have access to Farmall tractors. Will also purchase what is in stock if it fits the needs."

MARKETS

Stock Photo Agencies

f you are unfamiliar with how stock agencies work, the concept is easy to understand. Stock agencies house large files of images from contracted photographers and market the photos to potential clients. In exchange for licensing the images, agencies typically extract a 50-percent commission from each use. The photographer receives the other 50 percent.

In recent years, the stock industry has witnessed enormous growth, with agencies popping up worldwide. Many of these agencies, large and small, are listed in this section. However, as more and more agencies compete for sales, there has been a trend toward partnerships among some small to mid-size agencies. Other agencies have been acquired by larger agencies and essentially turned into subsidiaries. Often these subsidiaries are strategically located to cover different portions of the world. Typically, smaller agencies are bought if they have images that fill a need for the parent company. For example, a small agency might specialize in animal photographs and be purchased by a larger agency that needs those images but doesn't want to search for individual wildlife photographers.

The stock industry is extremely competitive, and if you intend to sell stock through an agency, you must know how they work. Below is a checklist that can help you land a contract with an agency.

- Build a solid base of quality images before contacting any agency. If you send an agency 50–100 images, they are going to want more if they're interested. You must have enough quality images in your files to withstand the initial review and get a contract.
- Be prepared to supply new images on a regular basis. Most contracts stipulate that photographers must send additional submissions periodically—perhaps quarterly, monthly, or annually. Unless you are committed to shooting regularly, or unless you have amassed a gigantic collection of images, don't pursue a stock agency.
- Make sure all of your work is properly cataloged and identified with a file number. Start this
 process early so that you're prepared when agencies ask for this information. They'll need to
 know what is contained in each photograph so that the images can be properly keyworded
 on websites.
- Research those agencies that might be interested in your work. Smaller agencies tend to be
 more receptive to newcomers because they need to build their image files. When larger agencies
 seek new photographers, they usually want to see specific subjects in which photographers
 specialize. If you specialize in a certain subject area, be sure to check out our Subject Index on
 page 531, which lists companies according to the types of images they need.
- Conduct reference checks on any agencies you plan to approach to make sure they conduct business in a professional manner. Talk to current clients and other contracted photographers to see if they are happy with the agency. Also, some stock agencies are run by photographers

who market their own work through their own agencies. If you are interested in working with such an agency, be certain that your work will be given fair marketing treatment.

- · Once you've selected a stock agency, contact them via e-mail or whatever means they have stipulated in their listing or on their website. Today, almost all stock agencies have websites and want images submitted in digital format. If the agency accepts slides, write a brief cover letter explaining that you are searching for an agency and that you would like to send some images for review. Wait to hear back from the agency before you send samples. Then send only duplicates for review so that important work won't get lost or damaged. Always include a SASE when sending samples by regular mail. It is best to send images in digital format; some agencies will only accept digital submissions.
- Finally, don't expect sales to roll in the minute a contract is signed. It usually takes a few years before initial sales are made.

SIGNING AN AGREEMENT

There are several points to consider when reviewing stock agency contracts. First, it's common practice among many agencies to charge photographers fees, such as catalog insertion rates or image duping fees. Don't be alarmed and think the agency is trying to cheat you when you see these clauses. Besides, it might be possible to reduce or eliminate these fees through negotiation.

Another important item in most contracts deals with exclusive rights to market your images. Some agencies require exclusivity to sales of images they are marketing for you. In other words, you can't market the same images they have on file. This prevents photographers from undercutting agencies on sales. Such clauses are fair to both sides as long as you can continue marketing images that are not in the agency's files.

An agency also may restrict your rights to sign with another stock agency. Usually such clauses are designed merely to keep you from signing with a competitor. Be certain your contract allows you to work with other agencies. This may mean limiting the area of distribution for each agency. For example, one agency may get to sell your work in the United States, while the other gets Europe. Or it could mean that one agency sells only to commercial clients, while the other handles editorial work. Before you sign any agency contract, make sure you can live with the conditions, including 40/60 fee splits favoring the agency.

Finally, be certain you understand the term limitations of your contract. Some agreements renew automatically with each submission of images. Others renew automatically after a period of time unless you terminate your contract in writing. This might be a problem if you and your agency are at odds for any reason. Make sure you understand the contractual language before signing anything.

REACHING CLIENTS

One thing to keep in mind when looking for a stock agent is how they plan to market your work. A combination of marketing methods seems the best way to attract buyers, and most large stock agencies are moving in that direction by offering catalogs, CDs, and websites.

But don't discount small, specialized agencies. Even if they don't have the marketing muscle of big companies, they do know their clients well and often offer personalized service and deep image files that can't be matched by more general agencies. If you specialize in regional or scientific imagery, you may want to consider a specialized agency.

MICROSTOCK

A relatively new force in the stock photography business is microstock. The term microstock comes from the "micro payments" that these agencies charge their clients-often as little as one dollar (the photographer gets only half of that), depending on the size of the image. Compare that to a traditional stock photo agency, where a rights-managed image could be licensed for hundreds of dollars, depending on the image and its use. Unlike the traditional stock agencies, microstock agencies are more willing to look at work from amateur photographers, and they consider their content "member generated." However, they do not accept all photos or all photographers; images must still be vetted by the microstock site before the photographer can upload his collection and begin selling. Microstock sites are looking for the lifestyle, people, and business images that their traditional counterparts often seek. Unlike most traditional stock agencies, microstock sites offer no rights-managed images; all images are royalty free.

So if photographers stand to make only fifty cents from licensing an image, how are they supposed to make money from this arrangement? The idea is to sell a huge quantity of photos at these low prices. Microstock agencies have tapped into a budget-minded client that the traditional agencies have not normally attracted—the small business, nonprofit organization, and even the individual who could not afford to spend \$300 for a photo for their newsletter or brochure. There is currently a debate in the photography community about the viability of microstock as a business model for stock photographers. Some say it is driving down the value of all photography and making it harder for all photographers to make a living selling their stock photos. While others might agree that it is driving down the value of photography, they say that microstock is here to stay and photographers should find a way to make it work for them or find other revenue streams to counteract any loss of income due to the effects of microstock. Still others feel no pinch from microstock: They feel their clients would never purchase from a microstock site and that they are secure in knowing they can offer their clients something unique.

If you want to see how a microstock site works, see the following websites, which are some of the more prominent microstock sites. You'll find directions on how to open an account and start uploading photos.

- · www.shutterstock.com
- · www.istockphoto.com
- www.bigstockphoto.com
- · www.fotolia.com
- www.dreamstime.com

DIGITAL IMAGING GUIDELINES AND SYSTEMS

The photography industry is in a state of flux as it grapples with the ongoing changes that digital imaging has brought. In an effort to identify and promote digital imaging standards, the Universal Photographic Digital Imaging Guidelines (UPDIG, www.updig.org) were established. The objectives of UPDIG are to:

- Make digital imaging practices more clear and reliable
- Develop an Internet resource for imaging professionals (including photo buyers, photographers, and nonprofit organizations related to the photography industry)
- Demonstrate the creative and economic benefits of the guidelines to clients
- Develop industry guidelines and workflows for various types of image reproduction, including RAW file delivery, batch-converted files, color-managed master files, and CMYK with proofs.

PLUS (Picture Licensing Universal System) is a cooperative, multi-industry initiative designed to define and categorize image usage around the world. It does not address pricing or negotiations, but deals solely with defining licensing language and managing license data so that photographers and those who license photography can work with the same systems and use the same language when licensing images. To learn more about PLUS, visit www.useplus.com

MARKETING YOUR OWN STOCK

If you find the terms of traditional agencies unacceptable, there are alternatives available. Many photographers are turning to the Internet as a way to sell their stock images without an agent and are doing very well. Your other option is to join with other photographers sharing space on the Internet. Check out PhotoSource International at www.photosource.com and www.agpix.com.

If you want to market your own stock, it is not absolutely necessary that you have your own website, but it will help tremendously. Photo buyers often "google" the keyword they're searching for—that is, they use an Internet search engine, keying in the keyword plus "photo." Many photo buyers, from advertising firms to magazines, at one time or another, either have found the big stock agencies too unwieldy to deal with, or they simply did not have exactly what the photo buyer was looking for. Googling can lead a photo buyer straight to your site; be sure you have adequate contact information on your website so the photo buyer can contact you and possibly negotiate the use of your photos.

One of the best ways to get into stock is to sell outtakes from assignments. The use of stock images in advertising, design, and editorial work has risen in the last five years. As the quality of stock images continues to improve, even more creatives will embrace stock as an inexpensive and effective means of incorporating art into their designs. Retaining the rights to your assignment work will provide income even when you are no longer able to work as a photographer.

■ ■ 911 PICTURES

63 Gardiners Ln., East Hampton NY 11937. (631)324-2061. Fax: (631)329-9264. E-mail: 911pix@ optonline.net. Website: www.911pictures.com. Stock agency. Has 3,500 photos in files. Clients include: advertising agencies, public relations firms, audiovisual firms, businesses, book publishers, magazine publishers, calendar companies, insurance companies, public safety training facilities.

Needs Wants photos of disaster services, public safety/emergency services, fire, police, EMS, rescue, hazmat. Interested in documentary.

Specs Accepts images in digital format on CD at minimum 300 dpi, 8" minimum short dimension. Images for review may be sent via e-mail, CD as BMP, GIF, JPEG files at 72 dpi.

Payment & Terms Pays 50% commission for b&w and color photos; 75% for film and videotape. Enforces minimum prices. Offers volume discounts to customers. Works with photographers on contract basis only. Offers nonexclusive contract. Charges any print fee (from negative or slide) or dupe fee (from slide). Statements issued/sale. Payment made/sale. Photographers allowed to review account records in cases of discrepancies only. Offers one-time rights. Informs photographers and allows them to negotiate when client requests all rights. Model release preferred. Photo captions preferred; include photographer's name and a short caption as to what is occurring in photo.

How to Contact Send query letter with résumé, slides, prints, photocopies, tearsheets. "Photographers can also send e-mail with thumbnail (low-resolution) attachments." Does not keep samples on file; include SASE for return of material. Responds only if interested; send nonreturnable samples. Photo guidelines sheet free with SASE.

Tips "Keep in mind that there are hundreds of photographers shooting hundreds of fires, car accidents, rescues, etc., every day. Take the time to edit your own material, so that you are only sending in your best work. We are especially in need of hazmat, police and natural disaster images. At this time 911 Pictures is only soliciting work from those photographers who shoot professionally or who shoot public safety on a regular basis. We are not interested in occasional submissions of one or two images."

ACCENT ALASKA/KEN GRAHAM AGENCY

P.O. Box 272, Girdwood AK 99587. (907)783-2796. Fax: (907)783-3247. E-mail: info@accentalaska. com. Website: www.accentalaska.com. Stock agency. Has 18,000 photos online. Clients include: advertising agencies, public relations firms, audiovisual firms, businesses, book publishers, magazine publishers, newspapers, calendar companies, greeting card companies, postcard publishers, CD-ROM encyclopedias.

Needs Wants modern stock images of Alaska, Antarctica. "Please do not submit material which we already have in our files."

Specs Uses images from digital cameras 10 megapixels or greater; no longer accepting film but will review and select then you return us scanned images with metadata embedded. Send via CD, Zip, e-mail lightbox URL.

Payment & Terms Pays 50% commission. Negotiates fees at industry-standard prices. Works with photographers on contract basis only. Offers nonexclusive contract. Payment made quarterly. "We are a rights managed agency."

How to Contact "See our website contact page. Any material must include SASE for returns," Expects minimum initial submission of 60 images. Prefers online web gallery for initial review. **Tips** "Realize we specialize in Alaska although we do accept images from Antarctica. The bulk of our sales are Alaska-related. We are always interested in seeing submissions of sharp, colorful and professional-quality images with model-released people when applicable. Do not want to see same material repeated in our library."

ACE STOCK LIMITED

10 Clove Lea, Godalming Surrey GU7 3QQ, United Kingdom. (44)(208)944 9944. Fax: (44) (208)944-9940. E-mail: library@acestock.com. Website: www.acestock.com. Estab. 1980. Stock photo agency. Has approximately 500,000 photos on file; over 65,000 online. Clients include: ad agencies, audiovisual firms, businesses, book/encyclopedia publishers, magazine publishers, postcard companies, calendar companies, greeting card companies, design companies, direct mail companies.

Needs Photos of babies/children/teens, couples, multicultural, families, parents, senior citizens, environmental, landscapes/scenics, wildlife, pets, adventure, automobiles, food/drink, health/ fitness, hobbies, humor, sports, travel, business concepts, industry, medicine, product shots/still life, science, technology/computers. Interested in alternative process, avant garde, documentary, fashion/glamour, seasonal.

Specs "Digital submissions only. Quality High. Scanning resolutions for low-res at 72 dpi and highres at 300 dpi with 30MB minimum size. Send via CD-ROM, or e-mail low-res samples."

Payment & Terms Pays 50% commission on net receipts. Average price per image (to clients): \$400. Works with photographers on contract basis only. Offers limited regional exclusivity. Contracts renew automatically for 2 years with each submission. No charges for scanning. Charges \$200/image for catalog insertion. Statements issued quarterly. Payment made quarterly. Photographers permitted to review sales records with 1-month written notice. Offers one-time rights, first rights or mostly nonexclusive rights. Informs photographers when client requests to buy all rights, but agency negotiates for photographer. Model/property release required for people and buildings. Photo captions required; include place, date and function. "Prefer data as IPTC-embedded within Photoshop File Info 'caption' for each scanned image."

How to Contact Send e-mail with low-res attachments or website link or FTP. Alternatively, arrange a personal interview to show portfolio or post 50 sample transparencies. Responds within 1 month. Photo guidelines sheet free with SASE. Online tips sheet for contracted photographers.

Tips Prefers to see "definitive cross-section of your collection that typifies your style and prowess. Must show originality, command of color, composition and general rules of stock photography. All people must be mid-Atlantic to sell in UK. No dupes. Scanning and image manipulation is all done in-house. We market primarily via online search engines and e-mail promos. In addition, we distribute printed catalogs and CD-ROMs."

□ A+E

9 Hochgernstr., Stein D-83371, Germany. (49)8621-61833. Fax: (49)8621-63875. E-mail: apluse@ aol.com. Website: www.apluse.de. Picture library. Has 30,000 photos in files. Clients include newspapers, postcard publishers, book publishers, calendar companies, magazine publishers.

Needs Wants photos of nature/landscapes/scenics, pets, "only your best material."

Specs Uses 35mm, 6 × 6 transparencies. Accepts images in digital format. Send via CD as JPEG files at 100 dpi for referencing purposes only.

Payment & Terms Pays 50% commission. Average price per image (to clients): \$15-100 for b&w photos; \$75-1,000 for color photos. Offers volume discounts to customers. Works with photographers on contract basis only. Offers nonexclusive contract. Subject exclusivity may be negotiated. Statements issued annually. Payment made annually. Photographers allowed to review account records in cases of discrepancies only. Offers one-time rights. Model/property release required. Photo captions must include country, date, name of object (person, town, landmark, etc.)

How to Contact Send query letter with your qualification, description of your equipment, transparencies or CD, stock list. Include SASE for return of material in Europe. Cannot return material outside Europe. Expects minimum initial submission of 100 images with annual submissions of at least 100 images. Responds in 1 month.

Tips "Judge your work critically. Only technically perfect photos will attract a photo editor's attention—sharp focus, high colors, creative views."

AERIAL ARCHIVES

Petaluma Airport, 561 Sky Ranch Dr., Petaluma CA 94954. (415)771-2555. Fax: (707)769-7277. www.aerialarchives.com/contact.htm; herb@aerialarchives.com. Website: aerialarchives.com. Has 100,000 photos in files. Has 2,000 hours of film, video footage. Clients include: advertising agencies, public relations firms, audiovisual firms, businesses, book publishers, magazine publishers, newspapers, calendar companies.

Needs Aerial photography only.

Specs Accepts images in digital format only, unless they are historical. Uses $2\frac{1}{4} \times 2\frac{1}{4}$, 4×5 , 9×9 transparencies; 70mm, 5" and 9 × 9 (aerial film). Other media also accepted.

Payment & Terms Buys photos, film, videotape outright only in special situations where requested by submitting party. Pays on commission basis. Average price per image (to clients): \$325. Enforces minimum prices. Offers volume discounts to customers. Photographers can choose not to sell images on discount terms. Works with photographers on contract basis only. Statements issued quarterly. Payment made monthly. Photographers allowed to review account records in cases of discrepancies only. Offers one-time rights, electronic media rights, agency promotion rights. Informs photographers and allows them to negotiate when client requests all rights. Property release preferred. Photo captions required; include date, location and altitude if available.

How to Contact Send query letter with stock list. Provide résumé, business card, self-promotion piece to be kept on file. Expects minimum initial submission of 100 images with quarterly submissions of at least 50 images. Responds only if interested; send nonreturnable samples. Photo guidelines sheet available via e-mail.

Tips "Supply complete captions with date and location; aerial photography only."

AFLO FOTO AGENCY

Sun Bldg., 8th Floor, 5-13-12, Ginza, Chuo-ku, Tokyo 104-0061, Japan. +81 3-5550-2120. E-mail: support@aflo.com. Website: www.aflo.com. Estab. 1980. Stock agency, picture library and news/ feature syndicate. Member of the Picture Archive Council of America (PACA). Has 1 million photos in files. "We have other offices in Tokyo and Osaka." Clients include: advertising agencies, businesses, public relations firms, book publishers, magazine publishers.

Needs Wants photos of babies/children/teens, celebrities, couples, multicultural, families, parents, senior citizens, disasters, environmental, landscapes/scenics, wildlife, architecture, cities/ urban, education, gardening, interiors/decorating, pets, religious, rural, adventure, automobiles, entertainment, events, food/drink, health/fitness, hobbies, humor, performing arts, sports, travel, agriculture, business concepts, industry, medicine, military, political, product shots/still life, science, technology/computers. Interested in alternative process, avant garde, documentary, erotic, fashion/glamour, fine art, historical/vintage, lifestyle, seasonal.

Specs Uses 35mm, $2\frac{1}{4} \times 2\frac{1}{4}$, 4×5 , 8×10 transparencies. Accepts images in digital format. Send via CD, e-mail as TIFF, JPEG files. When making initial submission via e-mail, files should total less than 3MB.

Payment & Terms Pays commission. Average price per image (to clients): \$195 minimum for b&w photos; \$250 minimum for color photos, film, videotape. Offers volume discounts to customers; terms specified in photographers' contracts. Photographers can choose not to sell images on discount terms. Works with photographers with or without a contract; negotiable. Contract type varies. Statements issued quarterly. Payment made quarterly. Photographers allowed to review account records. Model/property release preferred. Photo captions required.

How to Contact Send query letter with transparencies, stock list. Provide self-promotion piece to be kept on file. Expects minimum initial submission of 100 images with quarterly submissions of at least 25 images. Responds in 2 weeks to samples. Photo guidelines sheet free with SASE. See website ("Photo Submission") for more information or contact support@aflo.com.

AGE FOTOSTOCK

Bretón de los Herreros, 59 bajos B E-28003 Madrid, Spain. (34)91 451 86 00. Fax: (34)91 451 86 01. E-mail: agemadrid@agefotostock.com. Website: www.agefotostock.com. Estab. 1973. Stock agency. Photographers may submit their images to Barcelona directly. Clients include: advertising agencies, businesses, newspapers, postcard publishers, public relations firms, book publishers, calendar companies, audiovisual firms, magazine publishers, greeting card companies. See website for other locations.

Needs "We are a general stock agency and are constantly uploading images onto our website. Therefore, we constantly require creative new photos from all categories."

Specs Accepts all formats. Details available upon request, or see website, "Photographers/ submitting images."

Payment & Terms Pays 50% commission for all formats. Terms specified in photographer's contract. Works with photographers on contract basis only. Offers image exclusivity worldwide. Statements issued monthly. Payment made monthly. Photographers allowed to review account records. Model/property release required. Photo captions required.

How to Contact "Send query letter with résumé and 100 images for selection. Download the photographer's info pack from our website."

AGSTOCKUSA INC.

25315 Arriba Del Mundo Dr., Carmel CA 93923. (831)624-8600. E-mail: edyoung@agstockusa. com. Website: www.agstockusa.com. Stock photo agency. Has 100,000 photos. Clients include: advertising agencies, graphic design firms, businesses, public relations firms, book/encyclopedia publishers, calendar companies, magazine publishers, greeting card companies.

Needs Photos should cover all aspects of agriculture worldwide: fruits, vegetables and grains in various growth stages; studio work, aerials; harvesting, processing, irrigation, insects, weeds, farm life, agricultural equipment, livestock, plant damage and plant disease.

Specs Uses 35mm, $2\frac{1}{4} \times 2\frac{1}{4}$, 4×5 , 6×7 , 6×17 transparencies. Accepts images in digital format. Send as high-res TIFF files.

Payment & Terms Pays 50% commission for color photos. Average price per image (to clients): \$ 100-25,000 for color photos. Works with photographers on contract basis only. Offers nonexclusive contract. Contracts renew automatically with additional submissions for 2 years. Charges 50% website insertion fee. Statements issued monthly. Payment made monthly. Photographers allowed to review account records. Offers unlimited use and buyouts if photographer agrees to sale. Informs photographer when client requests all rights; final decision made by agency. Model/property release preferred. Photo captions required; include location of photo and all technical information (what, why, how, etc.).

How to Contact "Review our website to determine if work meets our standards and requirements." Submit low-res JPEGs on CD for review. Call first. Keeps samples on file; include SASE for return of material. Expects minimum initial submission of 250 images. Responds in 3 weeks. Photo guidelines available on website. Agency newsletter distributed yearly to contributors under contract.

Tips "Build up a good file (quantity and quality) of photos before approaching any agency. A portfolio of 16,000 images is currently displayed on our website. CD-ROM catalog with 7,600 images available to qualified photo buyers."

AKM IMAGES, INC.

109 Bushnell Place, Mooresville NC 28115. (630)416-1847. E-mail: um83@yahoo.com. Website: www.akmimages.com. Stock agency. Has over 80,000 photos in files (and still increasing). Clients include: advertising agencies, book publishers, magazine publishers, newspapers, calendar and greeting card companies, and postcard publishers.

Needs Wants photos of agriculture, city/urban, food/wine, gardening, multicultural, religious, rural, landscape/scenic, bird, wildlife, wildflower, butterfly, insect, cat, dog, farm animals, fishing, outdoor activity, travel and underwater images. "We also need landscape and culture from Asian countries, Nordic countries (Sweden, Norway, Finland), Alaska, Greenland and Iceland." Also need culture about Sami and Lapplander from Nordic countries and Native American.

Specs Uses 35mm transparencies, Accepts images in digital format. Send via CD/DVD of JPEG or TIFF low-res files and high-res files (300 dpi) for Windows XP.

Payment & Terms Pays 48% commission for color photos. Terms specified in photographers' submission guidelines. Works with photographers with a contract. Offers nonexclusive contract. Contracts renew automatically with additional submissions. Offers one-time rights. Model/ property release required. Photo captions required.

How to Contact Send query letter by e-mail with image samples and stock list. Does not keep samples on file. Include SASE for return of material. Expects minimum initial submission of 100 images. Responds in 1 month to samples. Photo submission guidelines free with SASE or via e-mail.

ALASKA STOCK IMAGES

2505 Fairbanks St., Anchorage AK 99503. (907)276-1343. Fax: (907)258-7848. E-mail: info@ alaskastock.com. Website: www.alaskastock.com. Stock photo agency. Member of the Picture Archive Council of America (PACA) and ASMP. Has 500,000 photos in files. Clients include: international and national advertising agencies; businesses; magazines and newspapers; book/ encyclopedia publishers; calendar, postcard and greeting card publishers.

Needs Wants photos of everything related to Alaska, including babies/children/teens. couples. multicultural, families, parents, senior citizens involved in winter activities and outdoor recreation, wildlife, environmental, landscapes/scenics, cities/urban, pets, adventure, travel, industry. Interested in alternative process, avant garde, documentary (images which were or could have been shot in Alaska), historical/vintage, seasonal, Christmas.

Specs Uses 35mm, 2×2 , 4×5 , 6×17 panoramic transparencies. Accepts images in digital format. Send via CD as JPEG files at 72 dpi for review purposes. "Put together a gallery of low-res images on your website and send us the URL, or send via PC-formatted CD as JPEG files no larger than 9 × 12 at 72 dpi for review purposes." Accepted images must be 50MB minimum shot as raw originals.

Payment & Terms Pays 40% commission for color and b&w photos; minimum use fee \$125. No charges for catalog, dupes, etc. Offers volume discounts to customers; inquire about specific terms. Photographers can choose not to sell images on discount terms. Works with photographers on contract basis only. Offers nonexclusive contract; exclusive contract for images in promotions. Contracts renew automatically with additional submissions; nonexclusive for 3 years. Statements issued monthly. Payment made monthly. Photographers allowed to review account records. Offers negotiable rights. Informs photographer and negotiates rights for photographer when client requests all rights. Model/property release preferred for any people and recognizable personal objects (boats, homes, etc.). Photo captions required; include who, what, when, where.

How to Contact Send query letter with samples. Does not keep samples on file; include SASE for return of material. Expects minimum initial submission of 200 images with periodic submissions of 100-200 images 1-4 times/year. Responds in 3 weeks. Photo guidelines free on request. Market tips sheet distributed 2 times/year to those with contracts. "View our guidelines online at www. alaskastock.com/prospectivephotographers.asp."

Tips "E-mailed sample images should be sent in one file, not separate images. For photographers shooting digital images, Alaska Stock assumes that you are shooting RAW format and are able to properly process the RAW image to meet our 50MB minimum standards with acceptable color, contrast and density range."

S AMANAIMAGES INC.

1-13 Kanda-Jimbocho, Chiyoda-ku, Tokyo 101, Japan. (81)(3)3295-1424. Fax: (81)(3)3295-1430. E-mail: planet-info@amanaimages.com; h.sugihara@amanaimages.com. Website: http://amanaimages.com. Stock photo agency. Member of the Picture Archive Council of America (PACA). Has 2,300,000 digital files and continuously growing. Clients include: advertising agencies, public relations firms, businesses, book/encyclopedia publishers, magazine publishers, newspapers, postcard publishers, calendar companies, greeting card companies and TV stations.

Needs Wants photos of babies/children/teens, celebrities, couples, multicultural, families, parents, senior citizens, disasters, environmental, landscapes/scenics, wildlife, architecture, cities/urban, education, gardening, interiors/decorating, pets, religious, rural, adventure, automobiles, entertainment, events, food/drink, health/fitness, hobbies, humor, performing arts, sports, travel, agriculture, business concepts, medicine, military, political, industry, product shots/still life, science, technology/computers. Interested in documentary, erotic, fashion/glamour, fine art, historical/vintage, seasonal.

Specs Digital format by single-lens reflex camera, data size should be larger than 30MB with 8-bit, Adobe RGB, TIFF format. Digital high-res image size: larger than 48MB for CG, 3D, etc. using editing software, e.g. Photoshop or Shade, digital change made by scanning, composed images, collage images.

Payment & Terms Based on agreement.

How to Contact Send 30-50 sample images (shorter side has to be 600 pixel as JPEG file) and your profile by e-mail. "After inspection of your images we may offer you an agreement. Submissions are accepted only after signing the agreement."

AMERICAN MUSEUM OF NATURAL HISTORY LIBRARY, PHOTOGRAPHIC COLLECTION

Library Services, Central Park West at 79th St., New York NY 10024. (212)769-5419. Fax: (212)769-5009. E-mail: speccol@amnh.org. Website: www.amnh.org. Provides services for authors, film and TV producers, general public, government agencies, picture researchers, scholars, students, teachers and publishers.

Needs "We accept only donations with full rights (nonexclusive) to use; we offer visibility through credits." Model release required. Photo captions required.

Payment & Terms Credit line given. Buys all rights.

M AMERICAN STOCK PHOTOGRAPHY

P.O. Box 175, Blue Bell PA 19422. (610)272-4000. Fax: (610)539-9558. E-mail: info@ americanstockphotos.com. Website: www.americanstockphotos.com. Stock photo agency. Has 2 million photos in files. Clients include: advertising agencies, public relations firms, audiovisual firms, businesses, book/encyclopedia publishers, magazine publishers, newspapers, postcard companies, calendar companies, greeting card companies, TV and movie production companies.

• American Stock Photography is a subsidiary of Camerique, which is also listed in this section.

Needs General stock, all categories. Special emphasis on California scenics and lifestyles.

Specs Uses 35mm, $2\frac{1}{4} \times 2\frac{1}{4}$, 4×5 transparencies; b&w contact sheets; b&w negatives.

Payment & Terms Does not buy photos outright. Pays 50% commission off net sale. General price range (to clients): \$100-750. Works with photographers on contract basis only. Offers nonexclusive contract. Contracts renew automatically with additional submissions. Charges 50% for catalog insertion, advertising, CD. Statements issued monthly. Payment made monthly. Photographers allowed to review account records. Offers one-time, electronic and multi-use rights. Informs photographers and allows them to negotiate when client requests all rights.

Model/property release required for people, houses and animals. Photo captions required: include date, location, specific information on image.

How to Contact Contact Camerique Inc., P.O. Box 175, Blue Bell PA 19422. Photo guidelines free with SASE.

🕅 🗐 THE ANCIENT ART & ARCHITECTURE COLLECTION, LTD.

410-420 Rayners Lane, Suite 1, Pinner Middlesex HA5 5DY, United Kingdom. +44 (0)20 8429 3131. Fax: +44 (0)20 8429 4646. E-mail: library@aaacollection.co.uk. Website: www.aaacollection.com. Picture library. Has 250,000 photos in files. Represents C.M. Dixon Collection. Clients include: advertising agencies, book/encyclopedia publishers, magazine publishers, newspapers.

Needs Wants photos of ancient/archaeological site, sculptures, objects, artifacts of historical nature. Interested in fine art, historical/vintage.

Specs Digital images only. JPEG format.

Payment & Terms Pays commission for color photos. Works with photographers on contract basis only. Offers nonexclusive contract. Contracts renew automatically with additional submissions. Statements issued quarterly. Payment made quarterly. Photographers allowed to review account records. Offers one-time rights. Detailed photo captions required.

How to Contact Send query letter with samples, stock list, SASE.

Tips "Material must be suitable for our specialist requirements. We cover historical and archeological periods from 25,000 BC to the 19th century AD, worldwide. All civilizations, cultures, religions, objects and artifacts as well as art may be included. Pictures with tourists, cars, TV aerials, and other modern intrusions not accepted. Send us a submission of CD by mail with a list of other material that may be suitable for us."

ANDES PRESS AGENCY

26 Padbury Ct., Shoreditch, London E2 7EH, United Kingdom. +44 (0)20 7613 5417. Fax: +44 (0)20 7739 3159. E-mail: apa@andespressagency.com. Website: http://andespressagency.com. Picture library and news/feature syndicate. Has 300,000 photos in files. Clients include: magazine publishers, businesses, book publishers, non-governmental charities, newspapers.

Needs Wants photos of multicultural, senior citizens, disasters, environmental, landscapes/ scenics, architecture, cities/urban, education, religious, rural, travel, agriculture, business, industry, political. "We have color and black & white photographs on social, political and economic aspects of Latin America, Africa, Asia and Britain, specializing in contemporary world religions."

Specs Uses 35mm and digital files.

Payment & Terms Works with photographers on contract basis only. Offers nonexclusive contract. Contracts renew with additional submissions. Statements issued bimonthly. Payment made bimonthly. Offers one-time rights. "We never sell all rights; photographer has to negotiate if interested." Model/property release preferred. Photo captions required.

How to Contact Send query via e-mail. Do not send unsolicited images.

Tips "We want to see that the photographer has mastered one subject in depth. Also, we have a market for photo features as well as stock photos. Please write to us first via e-mail."

ANIMALS ANIMALS/EARTH SCENES

17 Railroad Ave., Chatham NY 12037. (518)392-5500. Fax: (800)392-5503. E-mail: info@ animalsanimals.com. Website: www.animalsanimals.com. Member of Picture Archive Council of America (PACA). Has 1.5 million photos in files. Clients include: ad agencies, public relations firms, businesses, audiovisual firms, book publishers, magazine publishers, encyclopedia publishers, newspapers, postcard companies, calendar companies, greeting card companies.

Needs "We are currently not reviewing any new portfolios."

Specs Accepts images in digital and transparency formats.

Payment & Terms Pays 50% commission. Works with photographers on contract basis only. Offers exclusive contract. Photographers allowed to review account records to verify sales figures

"if requested and with proper notice and cause." Statements issued quarterly. Payment made quarterly. Offers one-time rights; other uses negotiable. Informs photographers and allows them to negotiate when client requests all rights. Model release required if used for advertising. Photo captions required; include Latin names ("they must be correct!").

Tips "First, pre-edit your material. Second, know your subject."

M ANTHRO-PHOTO FILE

33 Hurlbut St., Cambridge MA 02138. (617)868-4784. Fax: (617)497-7227. E-mail: cdevore@ anthrophoto.com. Website: www.anthrophoto.com. Has 10,000 photos in files. Clients include: book publishers, magazine publishers.

Needs Wants photos of anthropologists at work.

Specs Uses b&w prints; 35mm transparencies. Accepts images in digital format.

Payment & Terms Pays 50% commission. Average price per image (to clients): \$170 minimum for b&w photos; \$200 minimum for color photos. Offers volume discounts to customers; discount terms negotiable. Works with photographers with contract. Contracts renew automatically. Statements issued annually. Payment made annually. Photographers allowed to review account records. Offers one-time rights. Photo captions required.

How to Contact Send query letter with stock list. Keeps samples on file; include SASE for return of material.

Tips Photographers should e-mail first.

ANT PHOTO LIBRARY

P.O. Box 576, Mornington VIC 3931, Australia. 03 5978 8877. Fax: 03 5978 8411. E-mail: images@ antphoto.com.au. Website: www.antphoto.com.au. Estab. 1982. Has 170,000 photos in files, with 30,000 high-res files online. Clients include: advertising agencies, public relations firms, businesses, book publishers, magazine publishers, newspapers, calendar companies, greeting card companies, postcard publishers.

Needs Wants photos of "flora and fauna of Australia, Asia and Antarctica, and the environments in which they live."

Specs "Use digital camera files supplied as a minimum of 16-bit TIFF files from a minimum of 8-megapixel SLR digital camera. Full specs on our website."

Payment & Terms Offers volume discounts to customers. Discount sales terms not negotiable. Discount sales terms negotiable. Works with photographers on contract basis only. Offers limited regional exclusivity. Statements issued quarterly. Payment made quarterly. Model release required. Photo captions required; include species, common name and scientific name on supplied Excel spreadsheet.

How to Contact Send e-mail with 10 of your best images attached (images must be relevant to our needs). Expects minimum initial submission of 200 images with regular submissions of at least 100 images. Photo guidelines available on website. Market tips sheet "available to all photographers we represent."

Tips "Our clients come to us for images of all common and not-so-common wildlife species from around the world particularly. Good clean shots. Good lighting and very sharp."

■ Ø APPALIGHT

230 Griffith Run Rd., Spencer WV 25276. Phone/fax: (304)927-2978. E-mail: wyro@appalight.com. Website: www.appalight.com. Stock photo agency. Has over 30,000 photos in files. Clients include advertising agencies, public relations firms, businesses, book/encyclopedia publishers, magazine publishers, calendar companies, greeting card companies, graphic designers.

 Currently not accepting submissions. This agency also markets images through the Photo Source Bank.

Needs General subject matter with emphasis on the people, natural history, culture, commerce, flora, fauna, and travel destinations of the Appalachian Mountain region and Eastern Shore of

the United States. Wants photos of West Virginia, babies/children/teens, couples, multicultural, families, parents, senior citizens, disasters, environmental, landscapes, wildlife, cities/urban, education, gardening, pets, religious, rural, adventure, events, health/fitness, hobbies, humor, travel, agriculture, business concepts, industry, medicine, military, political, science, technology/ computers. Interested in documentary, seasonal.

Specs Uses 8 × 10 glossy b&w prints; 35mm, 2¼ × 2¼, 4 × 5 transparencies and digital images.

Payment & Terms Pays 50% commission for b&w or color photos. Works with photographers on nonexclusive contract basis only. Contracts renew automatically for 2-year period with additional submissions. Payment made quarterly. Photographers allowed to review account records during regular business hours or by appointment. Offers one-time rights, electronic media rights. Model release preferred. Photo captions required.

How to Contact AppaLight is not currently accepting submissions.

Tips "We look for a solid blend of top-notch technical quality, style, content and impact. Images that portray metaphors applying to ideas, moods, business endeavors, risk-taking, teamwork and winning are especially desirable."

ARCHIVO CRIOLLO

Ignacio San María, e3-30 y nuñez de vela edificio, Metropoli 6to piso oficina 603, Ecuador. (593 2) 60 38 748. Fax: (593 9) 52 50 615. E-mail: info@archivocriollo.com. Website: www.archivocriollo. com. Administrator: Diana Santander. Estab. 1998. Picture library. Has 20,000 photos in files. Clients include: advertising agencies, businesses, newspapers, postcard publishers, calendar companies, magazine publishers, greeting card companies, travel agencies.

Needs Wants photos of multicultural, environmental, landscapes/scenics, wildlife, architecture, cities/urban, religious, rural, adventure, travel, art and culture, photo production, photo design, press photos. Interested in alternative process, documentary, fine art, historical/vintage.

Specs Uses 35mm transparencies. Accepts images in digital format. Send via CD, Zip, e-mail or FTP as JPEG files at 300 dpi, 11 inches.

Payment & Terms Average price per image (to clients): \$50-150 for color photos; \$450-750 for videotape. Enforces minimum prices. Offers volume discounts to customers; terms specified in photographers' contracts. Photographers can choose not to sell images on discount terms. Works with photographers with or without a contract; negotiable. Offers nonexclusive contract. Charges 50% sales fee. Payment made quarterly. Photographers allowed to review account records. Informs photographers and allows them to negotiate when client requests all rights. Photo captions preferred.

How to Contact Send query letter with stock list. Responds only if interested. Catalog available.

(APL)

Room 2001-4 Progress Commercial Bldg., 9 Irving St., Causeway Bay, Hong Kong. (852)2890-6970. Fax: (852)2881-6979. E-mail: argus@argusphoto.com. Website: www.argusphoto.com. Estab. 1992. Stock photo agency with branches in Beijing and Guangzhou. Has over 1 million searchable photos online. Clients include: advertising agencies, graphic houses, corporations, real estate developers, book and magazine publishers, postcard, greeting card, calendar and paper product manufacturers.

Needs "We are a quality image provider specializes in high-end lifestyle, luxurious interiors/home decor/gardenscape, Asian/oriental and sport images. High quality features on home & garden, travel & leisure, fashion & accessories and celebrities stories are welcome."

Specs Accepts high-quality digital images only. Send 50MB JPEG files at 300 dpi via DVD or website link for review. English captions and keywords are required.

Payment & Terms Pays 50% commission. Average price per image (to clients): US\$100-6,000. Offers volume discounts to customers. Works with photographers on contract basis only. Statements/payment made quarterly. Informs photographers and allows them to negotiate when

client requests all rights. Model/property release may be required. Expects minimum initial submission of 200 images.

ARKRELIGION.COM

57 Burdon Ln., Cheam Surrey SM2 7BY, United Kingdom. E-mail: images@artdirectors.co.uk. Website: www.arkreligion.com. Estab. 2004. Stock agency. Has 100,000 photos on file. Clients include: advertising agencies, businesses, newspapers, postcard publishers, calendar companies, magazine publishers, greeting card companies.

Needs Wants photos of major, minor and alternative religions. This covers all aspects of religion from birth to death.

Specs Prefers digital submissions. Initial submission: 1MB JPEG. High-res requirement: 50MB TIFF. See contributors' page on website for full details. "We require an extremely broad cross-section of images from all religions, from mainstream to alternate, to include ceremonies from birth to death, festivals and important events, peoples—priests, pilgrims, worshipers, artifacts, churches/ temples-interior and exterior, holy books, worship-including inside the home, meals and food and daily rituals. If you are actively involved with your religion, we would be very interested in hearing from you and would particularly like to hear from any Muslim photographers who have undertaken or are intending to undertake the pilgrimage to Makkah."

Payment & Terms Average price per image (to clients): \$65-1,000 for b&w or color photos. Enforces strict minimum prices. Offers volume discounts to customers. Discount sales terms not negotiable. Works with photographers on contract basis only. Offers nonexclusive contract. Statements issued quarterly. Payment made quarterly. Photographers allowed to review account records in cases of discrepancies only. Offers one-time rights, electronic media rights. Model/ property release preferred. Photo captions required; include as much relevant information as possible.

How to Contact Please use the contact page if you have any questions before making a submission. Contact by e-mail. Does not keep samples on file. Expects minimum initial submission of 50 images with periodic submissions of at least 50 images. Photo guidelines available on website. Tips "Fully caption material and follow the full requirements for digital submissions as detailed on the website. Will only accept slides/transparencies where these represent exceptional and/or difficult-to-obtain images."

■ ART DIRECTORS & TRIP PHOTO LIBRARY

57 Burdon Lane, Cheam Surrey SM2 7BY United Kingdom. (44)(208)642-3593. Fax: (44)(208)395-7230. E-mail: images@artdirectors.co.uk. Website: www.artdirectors.co.uk. Estab. 1992. Stock agency. Has 1 million photos in files. Clients include: advertising agencies, businesses, newspapers, postcard publishers, public relations firms, book publishers, calendar companies, magazine publishers, greeting card companies.

Needs Wants photos of babies/children/teens, couples, multicultural, families, parents, senior citizens, disasters, environmental, landscapes/scenics, wildlife, architecture, cities/urban, education, gardening, interiors/decorating, pets, religious, rural, adventure, automobiles, entertainment, events, food/drink, health/fitness, hobbies, humor, performing arts, sports, travel, agriculture, business concepts, industry, medicine, military, political, product shots/still life, science, technology/computers. Interested in alternative process, avant garde, documentary, historical/vintage, seasonal.

Specs Prefers digital submissions. Initial submission: 1MB JPEG. High-res requirement: 50MB TIFF. See contributors' page on website for full details. Uses 35mm, $2\frac{1}{4} \times 2\frac{1}{4}$, 4×5 , 8×10 transparencies.

Payment & Terms Pays 50% commission for b&w or color photos when submitted digitally; pays 40% commission when film is submitted. Average price per image (to clients): \$65-1,000 for b&w or color photos. Enforces strict minimum prices. Offers volume discounts to customers. Discount sales terms not negotiable. Works with photographers on contract basis only. Offers

nonexclusive contract. Statements issued quarterly. Payment made quarterly. Photographers allowed to review account records in cases of discrepancies only. Offers one-time rights, electronic media rights. Model/property release preferred. Photo captions required; include as much relevant information as possible.

How to Contact Contact by e-mail. Does not keep samples on file. Expects minimum initial submission of 50 images with periodic submissions of at least 50 images. Responds in 6 weeks to queries. Photo guidelines available on website.

Tips "Fully caption material and follow the full requirements for digital submissions as detailed on the website. Will only accept slides/transparencies where these represent exceptional and/or difficult-to-obtain images."

ART LICENSING INTERNATIONAL INC.

7350 S. Tamiami Trail, #227, Sarasota FL 34231. (941)966-8912. E-mail: artlicensing@comcast.net. Website: www.artlicensinginc.com. "We represent artists, photographers and creators who wish to establish a licensing program for their work. We are particularly interested in photographic images that we can license internationally particularly for fine art posters, limited edition giclees for interior design projects and home and office decor."

Needs "We prefer concepts that have a unique look or theme and that are distinctive from the generic designs produced in-house by publishers and manufacturers. Images for prints and posters must be in pairs or sets of 4 or more with a regard for trends and color palettes related to the home décor and interior design trends. Nature themes and landscapes are of particular interest."

Payment & Terms "Our general commission rate is 50% with no expenses to the photographer as long as the photographer provides high-resolution digital files at 300 dpi to print 30-36 inches."

How to Contact Send CD/photocopies, e-mail JPEGs or details of your website. Send SASE if you want material returned.

Tips "We require substantial portfolios of work that can generate good incomes or concepts that have wide commercial appeal."

ART RESOURCE

536 Broadway, 5th Floor, New York NY 10012. (212)505-8700. Fax: (212)505-2053. E-mail: requests@ artres.com; rrossman@artres.com. Website: www.artres.com. Stock photo agency specializing in fine arts. Member of the Picture Archive Council of America (PACA). Has access to 3 million photos. Clients include: advertising agencies, public relations firms, audiovisual firms, businesses, book/encyclopedia publishers, magazine publishers, newspapers, postcard publishers, calendar companies, greeting card companies, all other publishing.

Needs Wants photos of painting, sculpture, architecture only.

Specs Digital photos (300 dpi).

Payment & Terms Pays 50% commission. Average price per image (to client): \$185-10,000 for color photos. Negotiates fees below standard minimum prices. Offers volume discounts to customers; terms specified in photographer's contract. Discount sales terms not negotiable. Offers one-time rights, electronic media rights, agency promotion and other negotiated rights. Photo captions required.

How to Contact Send query letter with stock list.

Tips "We represent European fine art archives and museums in the U.S. and Europe but occasionally represent a photographer with a specialty in photographing fine art."

ARTWERKS STOCK PHOTOGRAPHY

5045 Brennan Bend, Idaho Falls ID 83406. (208)523-1545. E-mail: photojournalistjerry@msn. com. Owner: Jerry Sinkovec. Estab. 1984. News/feature syndicate. Has 100,000 photos in files. Clients include: advertising agencies, public relations firms, businesses, book publishers, magazine publishers, calendar companies, postcard publishers.

Needs Wants photos of American Indians, ski action, ballooning, British Isles, Europe, Southwest scenery, disasters, environmental, landscapes/scenics, wildlife, adventure, events, food/drink, hobbies, performing arts, sports, travel, business concepts, industry, product shots/still life, science, technology/computers. Interested in documentary, fine art, historical/vintage, lifestyle.

Specs Uses 8×10 glossy color and/or b&w prints; 35mm, $2\frac{1}{4} \times 2\frac{1}{4}$, 4×5 transparencies. Accepts images in digital format. Send via CD, Zip as JPEG files.

Payment & Terms Pays 50% commission. Average price per image (to clients): \$125-800 for b&w photos; \$150-2,000 for color photos; \$250-5,000 for film and videotape. Negotiates fees below stated minimums depending on number of photos being used. Offers volume discounts to customers; terms not specified in photographers' contracts. Discount sales terms not negotiable. Works with photographers with or without a contract, negotiable. Offers nonexclusive contract, Charges 100% duping fee. Statements issued quarterly. Payment made quarterly. Offers onetime rights. Does not inform photographers or allow them to negotiate when a client requests all rights. Model/property release preferred. Photo captions preferred.

How to Contact Send query letter with brochure, stock list, tearsheets. Provide résumé, business card. Portfolios may be dropped off every Monday. Agency will contact photographer for portfolio review if interested. Portfolio should include slides, tearsheets, transparencies. Works with freelancers on assignment only. Does not keep samples on file; include SASE for return of material. Expects minimum initial submission of 20 images. Responds in 2 weeks.

ASIA IMAGES GROUP

15 Shaw Rd., #08-02, Teo Bldg., 367953, Singapore. (65)6288-2119. Fax: (65)6288-2117. E-mail: info@asiaimagesgroup.com. Website: www.asiapix.com. Stock agency. We specialize in creating, distributing and licensing locally relevant Asian model-released lifestyle and business images. Our image collections reflect the visual trends, styles and issues that are current in Asia. We have three major collections: Asia Images (rights managed); AsiaPix (royalty free); and Picture India (royalty free). Clients include: advertising agencies, corporations, public relations firms, book publishers, calendar companies, magazine publishers.

Needs Wants photos of babies/children/teens, couples, families, parents, senior citizens, health/ fitness/beauty, science, technology. "We are only interested in seeing images about or from

Specs Accepts images in digital format. "We want to see 72-dpi JPEGs for editing and 300-dpi TIFF files for archiving and selling."

Payment & Terms "We have minimum prices that we stick to unless many sales are given to one photographer at the same time. Works with photographers on image-exclusive contract basis only. We need worldwide exclusivity for the images we represent, but photographers are encouraged to work with other agencies with other images. Statements issued monthly. Payment made monthly. Photographers allowed to review account records. Offers one-time rights, electronic media rights. Model and property releases are required for all images."

AURORA PHOTOS

81 West Commercial St., Suite 201, Portland ME 04101. (207)828-8787 x 300. Website: www. auroraphotos.com. Stock agency, news/feature syndicate. Member of the Picture Archive Council of America (PACA). Has 500,000 photos in files. Clients include: advertising agencies, businesses, book publishers, magazine publishers, newspapers, calendar companies, postcard publishers.

Needs Wants photos of babies/children/teens, celebrities, couples, multicultural, families, parents, senior citizens, disasters, environmental, landscapes/scenics, wildlife, architecture, cities/urban, education, rural, adventure, events, sports, travel, agriculture, industry, military, political, science, technology/computers.

Specs Accepts digital submissions only; contact for specs.

Payment & Terms Pays 50% commission for film. Average price per image (to clients): \$225 minimum-\$30,000 maximum. Offers volume discounts to customers. Works with photographers

on image-exclusive contract basis only. Statements issued monthly. Payment made monthly. Photographers allowed to review account records once/year. Offers one-time rights, electronic media rights. Model/property release required. Photo captions required.

How to Contact "We are not accepting new contributors to our rights managed collections at this time. We are accepting inquiries from photographers interested in contributing to our outstanding outdoor adventure and lifestyle royalty-free collection, Open. Aurora's Open Collection combines the user-friendliness of royalty-free licensing with a picture archive that captures the breadth of sports, recreation and outdoor lifestyles. View Aurora's Open collection on IPNstock.com We are exclusively seeking photographers with outstanding, Model Released outdoor sports and lifestyle imagery. If you are interested in having your images reviewed, please send a link to your website portfolio for review to Open at open@auroraphotos.com." Does not keep samples on file; does not return material. Responds in 1 month. Photo guidelines available after initial contact.

Tips "Review our website closely. List area of photo expertise/interest and forward a personal website address where your photos can be found."

■ AUSCAPE INTERNATIONAL

PO Box 1024, Bowral NSW 2576, Australia. (61)(024)885-2245. E-mail: auscape@auscape.com. au. Website: www.auscape.com.au. Has 250,000 photos in files. Clients include: advertising agencies, book publishers, magazine publishers, newspapers, calendar companies, greeting card companies.

Needs Wants photos of environmental, landscapes/scenics, wildlife, pets, health/fitness, medicine, model-released Australian lifestyle.

Specs Uses 35mm, 21/4 × 21/4, 4 × 5, 8 × 10 transparencies. Accepts images in digital format. Send via CD or DVD as TIFF files at 300 dpi.

Payment & Terms Pays 40% commission for color photos. Enforces minimum prices. Offers volume discounts to customers. Works with photographers on contract basis only. Requires exclusive contract. Statements issued quarterly. Payment made quarterly. Photographers allowed to review account records. Charges scan fees for all transparencies scanned inhouse; all scans placed on website. Offers one-time rights. Photo captions required; include scientific names, common names, locations.

How to Contact Does not keep samples on file. Expects minimum initial submission of 200 images with monthly submissions of at least 50 images. Responds in 3 weeks to samples. Photo guidelines sheet free.

Tips "Send only informative, sharp, well-composed pictures. We are a specialist natural history agency and our clients mostly ask for pictures with content rather than empty-but-striking visual impact. There must be passion behind the images and a thorough knowledge of the subject."

AUTHOR PICTURES AT LEBRECHT

3 Bolton Road, London NW8 0RJ, United Kingdom. E-mail: pictures@lebrecht.co.uk. Website: www.authorpictures.co.uk. Picture library has 120,000 high-res images online; thousands more not yet scanned. Clients include: advertising agencies, newspapers, public relations firms, book publishers, calendar companies, magazine publishers, greeting card companies.

Needs Wants photos of authors, writers, historians, plays, playwrights, philosophers, etc.

Specs Accepts images in digital format only.

Payment & Terms Pays 50% commission for b&w or color photos. Offers volume discounts to customers. Works with photographers on contract basis only. Offers limited regional exclusivity. Statements issued quarterly. Offers one-time rights. Informs photographers and allows them to negotiate when a client requests all rights. Photo captions required; include who is in photo, location, date.

How to Contact Send e-mail.

THE BERGMAN COLLECTION

P.O. Box AG, Princeton NJ 08542-0872. (609)921-0749. E-mail: information@pmiprinceton.com. Website: http://pmiprinceton.com. Collection established in the 1930s. Stock agency. Has 20,000 photos in files. Clients include: advertising agencies, book publishers, audiovisual firms, magazine publishers.

Needs "Specializes in medical, technical and scientific stock images of high quality and accuracy."

Specs Uses color and/or b&w prints; 35mm, 2¼ × 2¼ transparencies. Accepts images in digital format. Send via CD, Zip, e-mail as TIFF, BMP, JPEG files.

Payment & Terms Pays on commission basis. Works with photographers on contract basis only. Offers one-time rights. Model/property release required. Photo captions required; must be medically, technically, scientifically accurate.

How to Contact "Do not send unsolicited images. Call, write, fax or e-mail to be added to our database of photographers able to supply, on an as-needed basis, specialized images not already in the collection. Include a description of the field of medicine, technology or science in which you have images. We contact photographers when a specific need arises."

Tips "Our needs are for very specific images that usually will have been taken by specialists in the field as part of their own research or professional practice. A good number of the images placed by The Bergman Collection have come from photographers in our database."

BIBLE LAND PICTURES

P.O. Box 8441, Jerusalem 91084 Israel. (972)(2)566-2167. Fax: (972)(2)566-3451. E-mail: radovan@ netvision.net.il. Website: www.biblelandpictures.com. Picture library. Has 50,000 photos in files. Clients include: book publishers, magazine publishers, newspapers, calendar companies, postcard publishers.

Needs Wants photos of museum objects, archaeological sites. Also multicultural, landscapes/ scenics, architecture, religious, travel. Interested in documentary, fine art, historical/vintage. **Specs** Uses high-res digital system.

Payment & Terms Average price per image (to clients): \$80-700 for b&w, color photos. Offers volume discounts to customers; terms specified in photographers' contracts.

Tips "Our archives contain tens of thousands of color slides covering a wide range of subjects: historical and archaeological sites, aerial and close-up views, museum objects, mosaics, coins, inscriptions, the myriad ethnic and religious groups individually portrayed in their daily activities, colorful ceremonies, etc. Upon request, we accept assignments for in-field photography."

■ BIOLOGICAL PHOTO SERVICE AND TERRAPHOTOGRAPHICS

P.O. Box 490, Moss Beach CA 94038. (650)359-6219. E-mail: bpsterra@pacbell.net. Website: www. agpix.com/biologicalphoto. Stock photo agency. Has 80,000 photos in files. Clients include: ad agencies, businesses, book/encyclopedia publishers, magazine publishers.

Needs All subjects in the pure and applied life and earth sciences. Stock photographers must be scientists. Subject needs include: electron micrographs of all sorts; biotechnology; modern medical imaging; marine and freshwater biology; diverse invertebrates; organisms used in research; tropical biology; and land and water conservation. All aspects of general and pathogenic microbiology, normal human biology, petrology, volcanology, seismology, paleontology, mining, petroleum industry, alternative energy sources, meteorology and the basic medical sciences, including anatomy, histology, medical microbiology, human embryology and human genetics.

Specs Uses 4×5 through 11×14 glossy, high-contrast b&w prints for EM's; 35mm, $2\frac{1}{4} \times 2\frac{1}{4}$, 4×5 , 8 × 10 transparencies. "Dupes acceptable for rare and unusual subjects, but we prefer originals." Welcomes images in digital format as 50-100MB TIFF files.

Payment & Terms Pays 50% commission for b&w and color photos. General price range (for clients): \$75-500, sometimes higher for advertising uses. Works with photographers with or without a contract, but only as an exclusive agency. Photographers may market directly on their own, but not through other agencies or portals. Statements issued quarterly. Payment made quarterly; "one month after end of quarter." Photographers allowed to review account records to verify sales figures "by appointment at any time." Offers only rights-managed uses of all kinds; negotiable. Informs photographers and allows them veto authority when client requests a buyout. Model/property release required for photos used in advertising and other commercial areas. Thorough scientific photo captions required; include complete identification of subject and location.

How to Contact Interested in receiving work from scientific and medical photographers if they have the proper background. Send query letter or e-mail with stock list, résumé of scientific and photographic background; include SASE for return of material. Responds in 2 weeks. Photo guidelines free with query, résumé and SASE. Tips sheet distributed intermittently to stock photographers only. "Nonscientists should not apply."

Tips "When samples are requested, we look for proper exposure, maximum depth of field, adequate visual information and composition, and adequate technical and general information in captions. Digital files should have image information in IPTC and EXIF fields. We avoid excessive overlap among our photographer/scientists. Our three greatest problems with potential photographers are: 1) inadequate captions/metadata; 2) inadequate quantities of fresh and diverse photos; 3) poor sharpness/depth of field/grain/composition in photos."

N BLEND IMAGES

1201 1st Ave. S., Suite 321B, Seattle WA 98134. (888)721-8810 ext. Fax: (206)749-9391. E-mail: rebecca@blendimages.com. Website: www.blendimages.com. Submission and Content Manager: Rebecca LaGuire. Estab. 2005. Stock agency. Clients include: advertising agencies, businesses, public relations firms, magazine publishers. Blend Images represents a "robust, high-quality collection of ethnically diverse lifestyle and business imagery.

Needs Wants photos of babies/children/teens, couples, multicultural, families, parents, senior citizens, business concepts; interested in lifestyle. Photos must be ethnically diverse.

Specs Accepts images in digital format only. Images should be captured using professional-level SLRs of 11 + megapixels, pro digital backs, or high-end scanners that can deliver the required quality. Final media should be 48-52 MB, 24-bit RGB (8 bits per channel), uncompressed TIFF files at 300 dpi. Images should be fully retouched, color-corrected and free from dust, dirt, posterization, artifacing or other flaws. Files should be produced in a color-managed environment with Adobe RGB 1998 as the desired color space.

How to Contact E-mail your photographic background and professional experience, along with 30-50 tightly edited, low-resolution PJEGs in one of the following ways: 1. URL with your personal website. 2. Web photo gallery. (Web galleries can be created using your imaging software. Reference your owner's manual for instructions.) 3. Spring-loaded hot link—a clickable link that provides downloadable JPEGs.

■ THE BRIDGEMAN ART LIBRARY

65 E. 93rd St., New York NY 10128. (212)828-1238. Fax: (212)828-1255. E-mail: newyork@ bridgemanart.com. Website: www.bridgemanart.com. Member of the Picture Archive Council of America (PACA). Has 400,000 photos online, over 1 million offline. Has branch offices in London, Paris and Berlin. Clients include: advertising agencies, public relations firms, audiovisual firms, businesses, book publishers, magazine publishers, newspapers, calendar companies, greeting card companies, postcard publishers.

Needs Interested in fine art, historical photography.

Specs Uses 4×5 , 8×10 transparencies and 50MB + digital files.

Payment & Terms Pays 50% commission for color photos. Enforces minimum prices. Offers volume discounts to customers; terms specified in photographers' contracts. Discount sales terms not negotiable. Works with photographers on contract basis only. Charges 100% duping

fee. Statements issued quarterly. Photographers allowed to review account records. Offers onetime rights, electronic media rights, agency promotion rights.

How to Contact Send query letter with photocopies, stock list. Does not keep samples on file; include SASE for return of material. Expects minimum initial submission of 20 images. Responds only if interested; send nonreturnable samples. Catalog available.

BSIP

34 rue Villiers-de-l'Isle-Adam, 75020 Paris, France. + 33(0)1 43 58 69 87. Fax: + 33(0)1 43 58 62 14. E-mail: international@bsip.com. Website: www.bsip.com. Member of Coordination of European Picture Agencies Press Stock Heritage (CEPIC). Has 200,000 downloadable high-res images online. Clients include: advertising agencies, book publishers, magazine publishers, newspapers.

Needs Wants photos of environmental, food/drink, health/fitness, medicine, science, nature and animals.

Specs Accepts images in digital format only. Send via CD, DVD, FTP as TIFF or JPEG files at 330 dpi, 3630×2420 pixels.

Payment & Terms Offers volume discounts to customers; terms specified in photographers' contracts. Discount sales terms not negotiable. Works with photographers with or without a contract; negotiable. Offers guaranteed subject exclusivity. Contracts renew automatically with additional submissions for 5 years. Statements issued monthly. Payment made monthly. Photographers allowed to review account records. Offers one-time rights, electronic media rights, agency promotion rights. Model release required. Photo captions required.

How to Contact Send query letter. Portfolio may be dropped off every Monday through Friday. Keeps samples on file. Expects minimum initial submission of 50 images with monthly submissions of at least 20 images. Photo guidelines sheet available on website. Catalog free with SASE. Market tips sheet available.

CALIFORNIA VIEWS/MR. PAT HATHAWAY HISTORICAL PHOTO COLLECTION

469 Pacific St., Monterey CA 93940-2702. (831)373-3811. E-mail: hathaway@caviews.com. Website: www.caviews.com. Picture library; historical collection. Has 80,000 b&w images; 10,000 color images in files. Clients include: advertising agencies, public relations firms, audiovisual firms, book/encyclopedia publishers, magazine publishers, museums, postcard companies, calendar companies, television companies, interior decorators, film companies.

Needs Historical photos of California from 1855 to today, including disasters, landscapes/scenics, rural, agricultural, automobiles, travel, military, portraits, John Steinbeck and Edward F. Rickets.

Payment & Terms Payment negotiable. Offers volume discounts to customers.

How to Contact "We accept donations of California photographic material in order to maintain our position as one of California's largest archives. Please do not send unsolicited images." Does not keep samples on file; cannot return material.

🌐 🗏 🕢 CAMERA PRESS LTD.

21 Queen Elizabeth St., London SE1 2PD, United Kingdom. +44 (0)20 7378 1300. Fax: +44 (0)20 7278 5126. E-mail: info@camerapress.com. Website: www.camerapress.com. Quality syndication service and picture library. Clients include: advertising agencies, public relations firms, audiovisual firms, book/encyclopedia publishers, magazine publishers, newspapers, postcard companies, calendar companies, greeting card companies and TV stations. Clients principally press but also advertising, publishers, etc.

· Camera Press sends and receives images via ISDN, FTP, and e-mail. Has a fully operational electronic picture desk to receive/send digital images via modem/ISDN lines, FTP.

Needs Celebrities, world personalities (e.g., politics, sports, entertainment, arts, etc.), news/ documentary, scientific, human interest, humor, women's features, stock.

Specs Accepts images in digital format as TIFF, JPEG files as long as they are a minimum of 300 dpi or 16MB.

Payment & Terms Standard payment term: 50% net commission. Statements issued every 2 months along with payments.

Tips "Camera Press, one of the oldest and most celebrated family-owned picture agencies, celebrated its 60th anniversary in November 2007. We represent some of the top names in the photographic world but also welcome emerging talents and gifted newcomers. We seek quality celebrity images; lively, colorful features which tell a story; and individual portraits of world personalities, both established and up-and-coming. Accurate captions are essential. Remember there is a big worldwide demand for celebrity premieres and openings. Other needs include: scientific development and novelties; beauty, fashion, interiors, food and women's interests; humorous pictures featuring the weird, the wacky and the wonderful."

☑ CAMERIQUE INC. INTERNATIONAL

164 Regency Dr., Eagleville PA 19403. (888)272-4749, (610)272-4000. E-mail: info@camerique. com. Website: www.camerique.com. Representatives in Los Angeles, New York City, Montreal, Tokyo, Calgary, Buenos Aires, Rio de Janerio, Amsterdam, Hamburg, Barcelona, Athens, Rome, Lisbon and Hong Kong. Has 1 million photos in files. Clients include: advertising agencies, public relations firms, audiovisual firms, businesses, book/encyclopedia publishers, magazine publishers, newspapers, postcard companies, calendar companies, greeting card companies.

Needs General stock photos, all categories, Emphasizes people, activities, all seasons, Always needs large-format color scenics from all over the world. No fashion shots.

Specs Accepts digital files only.

Payment & Terms Sometimes buys photos outright; pays \$10-25/photo. Also pays 50-60% commission for b&w or color after sub-agent commissions. General price range (for clients): \$300-500. Works with photographers on contract basis only. Offers nonexclusive contract. Contracts are valid "indefinitely until canceled in writing." Charges 50% catalog insertion fee for advertising, CD and online services. Statements issued monthly. Payment made monthly; within 10 days of end of month. Photographers allowed to review account records. Offers one-time rights, electronic media and multi-rights. Informs photographers and allows them to negotiate when client requests all rights. Model/property release required for people, houses, pets. Photo captions required; include "date, place, technical detail and any descriptive information that would help to market photos."

How to Contact Send query letter with stock list. Send unsolicited photos by mail with SASE for consideration. "Send letter first; we'll send our questionnaire and spec sheet. You must include correct return postage for your material to be returned." Tips sheet distributed periodically to established contributors.

Tips Prefers to see "well-selected, edited color on a variety of subjects. Well-composed, well lit shots, featuring contemporary styles and clothes. Be creative, selective, professional and loyal. Communicate openly and often." Review guidelines on website before submitting.

■ □ □ CAPITAL PICTURES

85 Randolph Ave., London W9 1DL, United Kingdom. (44)(207)286-2212. E-mail: sales@ capitalpictures.com, phil@capitalpictures.com. Website: www.capitalpictures.com. Picture library. Has 500,000 photos on file. Clients include: advertising agencies, book publishers, magazine publishers, newspapers. Specializes in high-quality photographs of famous people (politics, royalty, music, fashion, film and television).

Needs "We have a lot of clients looking for 'picture of the capital.' We need very high-quality images of London, postcard-type images for international sales. Not just large files, but great content; famous landmarks photographed at the best time, from the best angle, creating interesting and evocative images. Try looking on the Internet for pictures of London for some inspiration."

Specs High-quality digital format only. Send via CD or e-mail as JPEG files.

Payment & Terms Pays 50% commission of money received. "We have our own price guide but will negotiate competitive fees for large quantity usage or supply agreements." Offers volume

discounts to customers. Discount sales terms negotiable. Works with photographers with or without a contract; negotiable, whatever is most appropriate. No charges. 50% commission for sales. Statements issued monthly. Payment made monthly. Photographers allowed to review account records. Offers any rights they wish to purchase. Informs photographers and allows them to negotiate when client requests all rights." Photo captions preferred; include date, place, event, name of subject(s).

How to Contact Send query letter with samples. Agency will contact photographer for portfolio review if interested. Keeps samples on file. Expects minimum initial submission of 24 images with monthly submissions of at least 24 images. Responds in 1 month to queries.

CATHOLIC NEWS SERVICE

3211 Fourth St. NE, Washington DC 20017. (202)541-3250. Fax: (202)541-3255. E-mail: cns@ catholicnews.com. Website: www.catholicnews.com. News service transmitting news, features, photos and graphics to Catholic newspapers and religious publishers.

Needs Timely news and feature photos related to the Catholic Church or Catholics, head shots of Catholic newsmakers or politicians, and other religions or religious activities, including those that illustrate spirituality. Also interested in photos of family life, modern lifestyles, teenagers, poverty and active seniors.

Specs Prefers high-quality JPEG files, 8 × 10 at 200 dpi. If sample images are available online, send URL via e-mail, or send samples via CD.

Payment & Terms Pays for unsolicited news or feature photos accepted for one-time editorial use in the CNS photo service. Include full-caption information. Unsolicited photos can be submitted via e-mail for consideration. Some assignments made, mostly in large U.S. cities and abroad, to experienced photojournalists; inquire about assignment terms and rates.

How to Contact Query by mail or e-mail; include samples of work. Calls are fine, but be prepared to follow up with letter and samples.

Tips "See our website for an idea of the type and scope of news covered. No scenic, still life, or composite images."

CHARLTON PHOTOS, INC.

3605 Mountain Dr., Brookfield WI 53045. (262)781-9328. Fax: (262)781-9390. E-mail: jim@ charltonphotos.com. Website: www.charltonphotos.com. Stock photo agency. Has 475,000 photos; 200 hours of video. Clients include: ad agencies, public relations firms, audiovisual firms, businesses, book/encyclopedia publishers, magazine publishers, newspapers, calendar companies.

Needs "We handle photos of agriculture, rural lifestyles and pets."

Specs Uses color photos; digital only. Also uses video.

Payment & Terms Pays 60/40% commission. Average price per image (to clients): \$500-650 for color photos. Offers volume discounts to customers; terms specified in photographers' contracts. Works with photographers on contract basis only. Prefers exclusive contract, but negotiable based on subject matter submitted. Contracts renew automatically with additional submissions for 3 years minimum. Charges duping fee, 50% catalog insertion fee and materials fee. Statements issued monthly. Payment made monthly. Photographers allowed to review account records that relate to their work. Model/property release required for identifiable people and places. Photo captions required; include who, what, when, where.

How to Contact Query by phone before sending any material. Expects initial submission of 1,000 images. Responds in 2 weeks. Photo guidelines free with SASE. Market tips sheet distributed quarterly to contract freelance photographers; free with SASE.

Tips "Provide our agency with images we request by shooting a self-directed assignment each month. Visit our website."

CODY IMAGES

2 Reform St., Beith KA15 2AE, Scotland. (08)(45) 223-5451. E-mail: sam@codyimages.com. Website: www.codyimages.com. Picture library. Has 100,000 photos in files. Clients include: advertising agencies, newspapers, book publishers, calendar companies, audiovisual firms, magazine publishers.

Needs Wants photos of historical and modern aviation and warfare.

Specs Accepts images in digital format.

Payment & Terms Pays commission. Average price per image (to clients): \$80 minimum. Offers volume discounts to customers. Discount sales terms not negotiable. Works with photographers with or without a contract; negotiable. Offers nonexclusive contract. Contracts renew automatically with additional submissions. Statements issued quarterly. Payment made quarterly. Photographers allowed to review account records. Offers one-time rights, electronic media rights. Informs photographers and allows them to negotiate when a client requests all rights. Model/property release preferred. Photo captions preferred.

How to Contact Send e-mail with examples and stock list. Provide résumé, business card, self-promotion piece to be kept on file. Expects minimum initial submission of 1,000 images. Responds in 1 month.

EDUARDO COMESANA AGENCIA DE PRENSA/BANCO FOTOGRÁFICO

Av. Olleros 1850 4to. "F", Buenos Aires C1426CRH, Argentina. (54)(11)4771-9418. E-mail: info@ comesana.com. Website: www.comesana.com. Managing Director: Eduardo Comesaña. Estab. 1977. Stock agency, news/feature syndicate. Has 500,000 photos in files. Clients include: advertising agencies, businesses, newspapers, postcard publishers, book publishers, calendar companies, magazine publishers.

Needs Photos of babies/children/teens, celebrities, couples, families, parents, disasters, environmental, landscapes/scenics, wildlife, education, adventure, entertainment, events, health/ fitness, humor, performing arts, travel, agriculture, business concepts, industry, medicine, political, science, technology/computers. Interested in documentary, fine art, historical/vintage.

Specs Accepts images in JPEG format only, minimum 300 dpi.

Payment & Terms Offers volume discounts to customers; terms specified in photographer's contracts. Photographers can choose not to sell images on discount terms. Works with photographers with or without a contract; negotiable. Offers limited regional exclusivity, Contracts renew automatically with additional submissions. Statements issued quarterly. Payment made quarterly. Photographers allowed to review account records in cases of discrepancies only. Offers one-time rights. Model release preferred; property release required.

How to Contact Send query letter with tearsheets, stock list. Provide self-promotion piece to be kept on file. Expects minimum initial submission of 200 images in low-res files with monthly submissions of at least 200 images. Responds only if interested; send nonreturnable samples.

CORBIS

250 Hudson Street, 4th Floor, New York NY 10013. (212)777-6200. Fax: (212)375-7700. Website: www.corbis.com. Estab. 1991. Stock agency, picture library, news/feature syndicate. Member of the Picture Archive Council of America (PACA). Corbis also has offices in London, Paris, Dusseldorf, Tokyo, Seattle, Chicago and Los Angeles. Clients include: advertising agencies, businesses, newspapers, public relations firms, book publishers, calendar companies, audiovisual firms, magazine publishers, greeting card companies, businesses/corporations, media companies.

How to Contact "Please check 'About Corbis' on our website for current submission information."

M CREATIVE STOCK IMAGES

3 Concorde GateFourth Floor, Toronto ON M3C 3N7, Canada. E-mail: help@crestock.com. Website: www.crestock.com. Estab. 2005. Stock agency. "Crestock is a community-based, royalty-free micro-stock agency. "We maintain a growing, high-quality image archive." Has 150,000 photos in files. Clients include advertising agencies, businesses, newspapers, public relations firms, book publishers, calendar companies, audiovisual firms, magazine publishers.

Needs Wants photos of babies/children/teens, celebrities, couples, multicultural, families, parents, senior citizens, architecture, cities/urban, education, gardening, interiors/decorating, pets, religious, rural, agriculture, business concepts, industry, medicine, military, political, product shots/still life, science, technology/computers, disasters, environmental, landscapes/scenics, wildlife, adventure, automobiles, entertainment, events, food/drink, health/fitness/beauty, hobbies, humor, performing arts, sports, travel. Interested in alternative process, avant garde, documentary, erotic, fashion/glamour, fine art, historical/vintage, seasonal, lifestyle.

Specs Accepts images in digital format. Upload via website as JPEG, EPS, AI, Flash animations. **Payment & Terms** Enforces strict minimum prices. Works with photographers on contract basis only. Nonexclusive contract. Statements issued continually. Payments made on request. Photographers allowed to review account records in cases of discrepancies only. Offers one-time rights, electronic media rights, agency promotion rights. Model/property release required. Captions required.

How to Contact Register at website and submit photos for approval. Catalog available online. **Tips** "Crestock is among the most selective micro-stock agencies, so be prepared for strict quality standards. Make sure your caption and keywording is well thought through."

DDB STOCK PHOTOGRAPHY, LLC

P.O. Box 80155, Baton Rouge LA 70898. (225)763-6235. Fax: (225)763-6894. E-mail: info@ddbstock.com. Website: www.ddbstock.com. Stock photo agency. Member of American Society of Picture Professionals. Rights managed stock only, no RF. Currently represents 105 professional photographers. Has 500,000 original color transparencies and 25,000 black-and-white prints in archive, and 125,000 high-resolution digital images with 45,000 available for download on website. Clients include: text-trade book/encyclopedia publishers, travel industry, museums, ad agencies, audiovisual firms, magazine publishers, CD-ROM publishers and many foreign publishers.

Needs Specializes in picture coverage of Latin America with emphasis on Mexico, Central America, South America and the Caribbean. Needs photos of anthropology/archeology, art, commerce, crafts, secondary and university education, festivals and ritual, geography, history, indigenous people and culture, museums, parks, political figures, religion. Also uses teens 6th-12th grade/young adults college age, couples, multicultural, families, parents, senior citizens, architecture, rural, adventure, entertainment, events, food/drink, restaurants, health/fitness, performing arts, business concepts, industry, science, technology/computers.

Specs Prefers images in TIFF digital format on DVD at 10 megapixels or higher. Prepare digital submissions filling IPTC values. Caption, Copyright, and Keywords per instructions at: www. ddbstock.com/submissionguidelines.html. Accepts uncompressed JPEGs, TIFFs and original 35mm transparencies.

Payment & Terms Pays 40% commission for color photos; 25% on foreign sales through foreign agents. Payment rates: \$50-\$20,000. Average price per image (to clients): \$225. Offers volume discount to customers; terms specified in photographers' contracts. 4-year initial minimum holding period for original transparencies. Payment made quarterly. Does not allow independent audits. "We are a small agency and do not have staff to oversee audits." Offers one-time, print/electronic media, world and all language rights. Model/property release preferred for ad set-up shots. Photo captions required; include location and detailed description. "We have a geographic focus and need specific location info on captions (Geocode latitude/longitude if you carry a GPS unit, and include latitude/longitude in captions)."

How to Contact Interested in receiving work from professional photographers who regularly visit Latin America. Send query letter with brochure, tearsheets, stock list. Expects minimum initial submission of 300 digital images/original transparencies and yearly submissions of at least 500 images. Responds in 6 weeks. Photo guidelines available on website.

Tips "Speak Spanish and spend 1-6 months shooting in Latin America and the Caribbean every year. Follow our needs list closely. Call before leaving on assignment. Shoot digital TIFFs at 12 megapixels or larger. Shoot RAW/NEF/DNG, adjust and convert to TIFF or Fuji professional transparency film if you have not converted to digital. Edit carefully. Eliminate images with focus, framing, excessive grain/noise, or exposure problems. The market is far too competitive for average pictures and amateur photographers. Review guidelines for photographers on our website. Include coverage from at least three Latin American countries or five Caribbean Islands. No one-time vacation shots! Shoot subjects in demand listed on website."

DESIGN CONCEPTIONS (JOEL GORDON PHOTOGRAPHY)

112 Fourth Ave., New York NY 10003. (212)254-1688. E-mail: joel.gordon@verizon.net. Website: www.joelgordon.com. Stock photo agency. Member ASMP, ASPP, SAA. Has 500,000 photos in files. Clients include: book/encyclopedia publishers, magazine publishers, advertising agencies.

Needs "Real people." Also interested in children/teens, couples, families, parents, senior citizens, events, health/fitness, medicine, science, technology/computers. Not interested in photos of nature. Interested in documentary, fine art.

Specs Accepts images in digital format only. Send via CD as JPEG files (low-res for first review) with 1 PTC or meta data info.

Payment & Terms Pays 50% commission for photos. Average price per image (to clients): \$200-250 minimum for b&w and color photos. Enforces minimum prices, Offers volume discounts to customers; terms specified in photographers' contracts. Works with photographers with or without a contract. Offers limited regional exclusivity, nonexclusive. Statements issued monthly. Payment made monthly. Photographers allowed to review account records. Offers one-time electronic media and agency promotion rights. Informs photographer when client requests all rights. Model/property release preferred. Photo captions preferred.

How to Contact Call first to explain range of files. Arrange personal interview to show portfolio or CD. Send query letter with samples.

Tips Looks for "real people doing real, not set-up, things."

■ □ DINODIA PHOTO LIBRARY

13-15 Vithoba Lane, Vithalwadi, Kalbadevi, Bombay 400 002, India. (91)(22)2240-4026. Fax: (91) (22)2240-1675. E-mail: jagdish@dinodia.com. Website: www.dinodia.com. Stock photo agency. Has 500,000 photos in files. Clients include: advertising agencies, public relations firms, audiovisual firms, businesses, book/encyclopedia publishers, magazine publishers, newspapers, postcard companies, calendar companies, greeting card companies.

Needs Wants photos of babies/children/teens, celebrities, couples, multicultural, families, parents, senior citizens, disasters, environment, landscapes/scenics, wildlife, architecture, cities/ urban, education, gardening, interiors/decorating, pets, religious, rural, adventure, automobiles, entertainment, events, food/drink, health/fitness/beauty, hobbies, humor, performing arts, sports, travel, agriculture, business concepts, industry, medicine, military, political, product shots/still life, science, technology/computers. Interested in alternative process, avant garde, documentary, erotic, fashion/glamour, fine art, historical/vintage, seasonal.

Specs "At the moment we are only accepting digital. Initially it is better to send a few nonreturnable printed samples for our review."

Payment & Terms Pays 50% commission for b&w and color photos. General price range (to clients): US \$50-600. Negotiates fees below stated minimum prices. Offers volume discounts to customers; inquire about specific terms. Discount sales terms not negotiable. Works with photographers on contract basis only. Offers limited regional exclusivity; "Prefer exclusive for

India." Contracts renew automatically with additional submissions for 5 years. Statement issued monthly. Payment made monthly. Photographers permitted to review sales figures. Informs photographers and allows them to negotiate when client requests all rights. Offers one-time rights. Model release preferred. Photo captions required.

How to Contact Send query letter with résumé of credits, nonreturnable samples, stock list and SASE. Responds in 1 month. Photo guidelines free with SASE. Dinodia news distributed monthly to contracted photographers.

Tips "We look for style—maybe in color, composition, mood, subject matter, whatever—but the photos should have above-average appeal." Sees trend that "market is saturated with standard documentary-type photos. Buyers are looking more often for stock that appears to have been shot on assignment."

DK STOCK, INC.

3524 78th Street, Ste. 29A, Jackson Heights NY 11372. (866)362-4705. Fax: (678)384-1883. E-mail: david@dkstock.com. Website: www.dkstock.com. "A multicultural stock photo company based in New York City. Prior to launching DK Stock, its founders worked for years in the advertising industry as a creative team specializing in connecting clients to the \$1.6 trillion multicultural market. This market is growing, and DK Stock's goal is to service it with model-released, well composed, professional imagery." Member of the Picture Archive Council of America (PACA). Has 15,000 photos on file. Clients include: advertising agencies, public relations firms, graphic design businesses, book publishers, magazine publishers, newspapers, calendar companies, greeting card companies.

Needs "Looking for contemporary lifestyle images that reflect the black and Hispanic Diaspora." Wants photos of babies/children/teens, celebrities, couples, multicultural, families, parents, senior citizens, education, adventure, entertainment, health/fitness/beauty, hobbies, humor, performing arts, sports, travel, agriculture, business concepts, industry, medicine, military, political, science, technology/computers. Interested in historical/vintage, lifestyle. "Images should include models of Hispanics and/or people of African descent. Images of Caucasian models interacting with black people or Hispanic people can also be submitted. Be creative, selective and current. Visit website to get an idea of the style and range of representative work. E-mail for a current copy of 'needs

Specs Accepts images in digital format. 50MB, 300 dpi.

Payment & Terms Pays 50% commission for b&w or color photos. Average price per image (to clients): \$485. Enforces minimum prices. Offers volume discounts to customers; terms specified in photographers' contracts. Photographers can choose not to sell images on discount terms. Works with photographers on contract basis only. Offers nonexclusive contract. Contracts renew automatically with additional submissions for 5 years. Statements issued monthly. Payment made monthly. Photographers allowed to review account records. Model/property release required. Photo captions not necessary.

How to Contact Send query letter with disc or DVD. Portfolio may be dropped off every Monday-Friday. Does not keep samples on file; include SASE for return of material. Expects minimum initial submission of 50 images with 5 times/year submissions of at least 200 images. Responds in 2 weeks to samples, portfolios. Photo guidelines free with SASE. Catalog free with SASE.

Tips "We love working with talented people. If you have 10 incredible images, let's begin a relationship. Also, we're always looking for new and upcoming talent as well as photographers who can contribute often. There is an increasing demand for lifestyle photos of multicultural people. Our clients are based in the Americas, Europe, Asia and Africa. Be creative, original and technically proficient."

N 🔳 🖸 DRK PHOTO

100 Starlight Way, Sedona AZ 86351. (928)284-9808. E-mail: info@drkphoto.com. Website: www. drkphoto.com. "We handle only the personal best of a select few photographers—not hundreds. This allows us to do a better job aggressively marketing the work of these photographers." Member of Picture Archive Council of America (PACA) and American Society of Picture Professionals (ASPP). Clients include: ad agencies; PR and AV firms; businesses; book, magazine, textbook and encyclopedia publishers; newspapers; postcard, calendar and greeting card companies; branches of the government; and nearly every facet of the publishing industry, both domestic and foreign.

Needs "Especially need marine and underwater coverage." Also interested in S.E.M.s, African, European and Far East wildlife, and good rainforest coverage.

Specs Digital capture, digital scans.

Payment & Terms General price range (to clients): \$100-"into thousands." Works with photographers on contract basis only. Contracts renew automatically. Statements issued quarterly. Payment made quarterly. Offers one-time rights; "other rights negotiable between agency/photographer and client." Model release preferred. Photo captions required.

How to Contact "With the exception of established professional photographers shooting enough volume to support an agency relationship, we are not soliciting open submissions at this time. Those professionals wishing to contact us in regards to representation should query with a brief letter of introduction."

IDENTIFY OF THE PROOF OF THE P

108 Beecroft Rd., Beecroft, New South Wales 2119, Australia. (61)2 9869 0717. E-mail: info@ dwpicture.com.au. Website: www.dwpicture.com.au. Estab. 1997. Has more than 200,000 photos on file and 30,000 online. "Strengths include historical images, marine life, African wildlife, Australia, travel, horticulture, agriculture, people and lifestyles." Clients include: advertising agencies, designers, printers, book publishers, magazine publishers, calendar companies.

Needs Wants photos of babies/children/teens, families, parents, senior citizens, disasters, gardening, pets, rural, health/fitness, travel, industry. Interested in lifestyle.

Specs Accepts images in digital format. Send as low-res JPEG files via CD.

Payment & Terms Average price per image (to clients): \$200 for color photos. Enforces minimum prices. Offers volume discounts to customers. Works with photographers on contract basis only. Statements issued quarterly. Photographers allowed to review account records in cases of discrepancies only. Offers one-time rights. Model release preferred. Photo captions required.

How to Contact Send query letter with images; include SASE if sending by mail. Expects . minimum initial submission of 200 images.

🕮 🗏 E & E PICTURE LIBRARY

1st Floor Reception, Clerks Court, 18-20 Farringdon Lane, London EC1R 3AU, United Kingdom. +44(0)20 7251 7100. Fax: +44 (0)20 7434 0673. E-mail: angela.davies@heritage-images.com. Website: www.heritage-images.com. Estab. 1998. Member of BAPLA (British Association of Picture Libraries and Agencies). Has 250,000+ images on file. Clients include: advertisers/designers, businesses, book publishers, magazine publishers, newspapers, calendar/card companies, merchandising, TV.

Needs Worldwide religion, faith, spiritual images, buildings, clergy, festivals, ceremony, objects, places, food, ritual, monks, nuns, stained glass, carvings, the unusual. Mormons, Shakers, all groups/sects, large or small. Death: burial, funerals, graves, gravediggers, green burial, commemorative. Ancient/heritage/Biblelands/saints/eccentricities/festivals: curiosities, unusual oddities like follies, signs, symbols. Architecture, religious or secular. Manuscripts and illustrations, old and new, linked with any of the subjects above.

Specs Accepts images in digital format. Send via CD, JPEG files in medium-high resolution. Uses 35mm, $2\frac{1}{4} \times 2\frac{1}{4}$, 4×5 transparencies.

Payment & Terms Average price per image (to clients): \$140-200 for color photos. Offers volume discounts to customers. Works with photographers on contract basis for 5 years, offering exclusive/nonexclusive contract renewable automatically with additional submissions. Offers one-time rights. Model release where necessary. Photo captions very important and must be accurate; include what, where, any special features or connections, name, date (if possible), and religion.

How to Contact Send query letter with slides, tearsheets, transparencies/CD. Expects minimum initial submission of 40 images. Photo guidelines sheet and "wants list" available via e-mail.

Tips "Decide on exact subject of image. Get in close and then closer. Exclude all extraneous matter. Fill the frame. Dynamic shots. Interesting angles, light. No shadows or miniscule subject matter far away. Tell us what is important about the picture. No people in shot unless they have a role in the proceedings as in a festival or service, etc."

■ ■ ECOSCENE

Empire Farm, Throop Rd., Templecombe, Somerset BA8 0HR, United Kingdom. (44)(196)337-1700. E-mail: sally@ecoscene.com, pix@ecoscene.com. Website: www.ecoscene.com. Picture library. Has 80,000 photos in files. Clients include: advertising agencies, businesses, book/encyclopedia publishers, magazine publishers, newspapers, Internet, multimedia.

Needs Wants photos of disasters, environmental, energy issues, sustainable development, wildlife, gardening, rural, agriculture, medicine, science, pollution, industry, energy, indigenous peoples.

Specs Accepts digital submissions only. High quality JPEG at 300 dpi, minimum file size when opened of 50MB.

Payment & Terms Pays 55% commission for color photos. Average price per image (to clients): \$70 minimum for color photos. Negotiates fees below stated minimum prices, depending on quantity reproduced by a single client. Offers volume discounts to customers. Discount sales terms not negotiable. Works with photographers on contract basis only. Offers nonexclusive contract. Contracts renew automatically with additional submissions, 4 years minimum. Statements issued quarterly. Payment made quarterly. Offers one-time and electronic media rights. Informs photographers and allows them to negotiate when client requests all rights. Model/property release required. Photo captions required; include location, subject matter, keywords and common and Latin names of wildlife and any behavior shown in pictures.

How to Contact Send e-mail with résumé of credits. Digital submissions only. Keeps samples on file; include SASE for return of material. Expects minimum initial submission of 100 images with annual submissions of at least 100 images. Responds in 2 months. Photo guidelines free with SASE. Market tips sheets distributed quarterly to anybody who requests, and to all contributors.

Tips Photographers should carry out a tight EDT, no fillers and be critical of their own work.

N EMPICS

Pavilion House, 16 Castle Blvd., Nottingham NG7 1FL, United Kingdom. +44(0)1158 447 447. Fax: +44(0)1158 447 448. E-mail: info@empics.com. Website: www.empics.com. Formerly Empics Sports Photo Agency. Picture library. Has over 3 million news, sports and entertainment photos (from around the world, past and present) online. Clients include: advertising agencies, newspapers, public relations firms, book publishers, magazine publishers, web publishers, television broadcasters, sporting bodies, rights holders.

Needs Wants photos of news, sports and entertainment.

Specs Uses glossy or matte color and/or b&w prints; 35mm transparencies. Accepts the majority of images in digital format.

Payment & Terms Negotiates fees below stated minimums. Offers volume discounts to customers. Works with photographers on contract basis only. Rights offered varies.

How to Contact Send query letter or e-mail. Does not keep samples on file; cannot return material.

ENVISION

27 Hoppin Rd., Newport RI 02840. (401)619-1500 or (800)524-8238. E-mail: envision@att.net. Website: www.envision-stock.com. Estab. 1987. Stock photo agency. Member of the Picture Archive Council of America (PACA). Has 200,000 photos in files. Clients include: advertising agencies, public relations firms, businesses, book/encyclopedia publishers, magazine publishers, newspapers, calendar and greeting card companies, graphic design firms.

Needs Professional-quality photos of food, commercial food processing, fine dining, crops. Modelreleased images of people interacting with food and produce in any way.

Specs Accepts images in digital format: 50MB files, 300 dpi.

Payment & Terms Pays 50% commission for b&w and color photos and film. General price range (to clients): \$200-25,000 for b&w photos; \$200-25,000 for color photos. Works with photographers on contract basis only. Statements issued monthly. Payment made monthly. Offers one-time rights; "each sale individually negotiated—usually one-time rights." Model/ property release required. Photo captions required.

How to Contact Present portfolio online or arrange for low-res scans to be reviewed on disk. Regular submissions are mandatory.

Tips "Clients expect the very best in professional-quality material: Photos that are unique, taken with a very individual style. Demands for traditional subjects, but with a different point of view; African- and Hispanic-American lifestyle photos are in great demand. We have a need for modelreleased, professional-quality photos of people with food—eating, cooking, growing, processing, etc."

E ESTOCK PHOTO, LLC

27-28 Thomson Avenue, Ste. 628, Long Island City NY 11101. (800)284-3399. Fax: (212)545-1185. E-mail: submissions@estockphoto.com. Website: www.estockphoto.com. Member of Picture Archive Council of America (PACA). Has over 1 million photos in files. Clients include: ad agencies, public relations and AV firms; businesses; book, magazine and encyclopedia publishers; newspapers, calendar and greeting card companies; textile firms; travel agencies and poster companies.

Needs Wants photos of travel, destination, people, lifestyles, business.

Specs Accepts images in digital format. Requires images to be taken with a minimum 12 megapixel camera. In order to view new work as efficiently as possible, we can only handle images submitted digitally, as follows: 1. If you have a website, or have your images displayed in another forum on the web, please send us your URL. 2. You may e-mail us 50 - 75 of your best images following these guidelines: Images must be in RGB JPEG format; The overall file size of your e-mail cannot exceed 4MB. (Messages exceeding this size will be rejected by our mail server). You may use our form on our website to send us an e-mail.

Payment & Terms Price depends on quality and quantity. Usually pays 50% commission. General price range (to clients): \$125-6,500. Works with photographers on contract basis only. Offers exclusive and limited regional exclusive contracts. Contracts renew automatically for 3 years. Offers to clients "any rights they want to have; payment is calculated accordingly." Statements issued bimonthly and quarterly. Payment made bimonthly and quarterly. Photographers allowed to review account records to verify their sales figures. Offers one-time and electronic media rights. Informs photographers and allows them to negotiate when client requests all rights; some conditions. Model release required; "depends on subject matter." Photo captions preferred.

How to Contact Send query letter with samples—"about 100 is the best way." Send query letter with list of stock photo subjects or submit portfolio for review. Response time depends; often the same day. Photo guidelines free with SASE.

Tips "Photos should show what the photographer is all about. They should show technical competence-photos that are sharp, well-composed, have impact; if color, they should show color."

N EWING GALLOWAY INC.

100 Merrick Rd., Rockville Centre NY 11570. (516)764-8620. Fax: (516)764-1196. Estab. 1920. Stock photo agency. Member of Picture Archive Council of America (PACA), American Society of Media Photographers (ASMP). Has 3 million + photos in files. Clients include: advertising agencies, public relations firms, audiovisual firms, businesses, book/encyclopedia publishers, magazine publishers, newspapers, postcard companies, calendar companies, greeting card companies, religious organizations.

Needs General subject library. Does not carry personalities or news items, Lifestyle shots (model released) are most in demand.

Payment & Terms Average price/per image (to clients): \$400-450. Charges catalog insertion fee. Statements issued monthly. Payment made monthly. Offers one-time rights; also unlimited rights for specific media. Model/property release required. Photo captions required; include location, specific industry, etc.

How to Contact Send query letter with samples. Send unsolicited photos by mail for consideration; must include SASE. Photo guidelines available for SASE. Market tips sheet distributed monthly: SASE.

Tips Wants to see "high quality-sharpness, subjects released, shot only on best days-bright sky and clouds. Medical and educational material is currently in demand. We see a trend toward photography related to health and fitness, high-tech industry and mixed race in business and leisure."

EYE UBIQUITOUS

65 Brighton Rd., Shoreham West Sussex N43 6RE, United Kingdom. +44(0)1273 440113. Fax: +44(0)1273 440116. Website: www.eyeubiquitous.com. Estab. 1988. Picture library. Has 300,000 + photos in files. Clients include: ad agencies, public relations firms, businesses, book/encyclopedia publishers, magazine publishers, newspapers, television companies.

Needs Photos of worldwide social documentary and general stock.

Specs Transparencies and 50 MB files at 300 dpi.

Payment & Terms Offers volume discounts to customers; inquire about specific terms. Discount sales terms not negotiable. Works with photographers on contract basis only. Offers exclusive, limited regional exclusivity and nonexclusive contracts. Contracts renew automatically with additional submissions. Charges to photographers "discussed on an individual basis." Payment made quarterly. Photographers allowed to review account records. Buys one-time, electronic media and agency promotion rights; negotiable. Does not inform photographers or allow them to negotiate when client requests all rights. Model/property release preferred for people, "particularly Americans." Photo captions required; include where, what, why, who.

How to Contact Submit portfolio for review. Works with freelancers only. Keeps samples on file. Include SASE for return. No minimum number of images expected in initial submission, but "the more the better." Responds as time allows. Photo guidelines free with SASE. Catalog free with SASE. Market tips sheet distributed to contributors "when we can"; free with SASE.

Tips "Find out how picture libraries operate. This is the same for all libraries worldwide. Amateurs can be very good photographers but very bad at understanding the industry after reading some irresponsible and misleading articles. Research the library requirements."

III FAMOUS PICTURES & FEATURES AGENCY

13 Harwood Rd., London SW6 4QP, United Kingdom. +44(0)20 7731 9333. Fax: +44(0)20 7731 9330. E-mail: info@famous.uk.com. Website: www.famous.uk.com. Estab. 1985. Picture library, news/feature syndicate. Has more than 500,000 photos on database. Clients include: advertising agencies, book publishers, magazine publishers, newspapers, calendar companies, postcard publishers and poster publishers.

Needs Photos of music, film, TV personalities; international celebrities; live, studio, party shots (paparazzi) with stars of all types.

Specs Prefers images in digital format. Send via FTP or e-mail as JPEG files at 300 dpi or higher. Payment & Terms Offers volume discounts to customers. Photographers can choose not to sell images on discount terms. Works with photographers with or without a contract; contracts available for all photographers. Offers limited regional exclusivity. Statements issued monthly. Payment made monthly. Photographers allowed to review account records. Offers one-time rights. Photo captions preferred.

How to Contact E-mail, phone or write, provide samples. Provide résumé, business card, selfpromotion piece or tearsheets to be kept on file. Agency will contact photographer for portfolio review if interested. Keeps samples in online database. Will return material with SAE/IRC.

Tips "We are solely marketing images via computer networks. Our fully searchable archive of new and old pictures is online. Send details via e-mail for more information. When submitting work, please caption pictures correctly."

M FIRST LIGHT ASSOCIATED PHOTOGRAPHERS

9 Davies Ave., Suite 410, Toronto ON M4M 2A6, Canada. (416)597-8625. Fax: (416)597-2035. E-mail: info@firstlight.com. Website: www.firstlight.com. Stock agency and image partner of Getty Images, represents over 150 photographers and 40 rights-managed and royalty-free collections. Over one million images available online. Clients include: advertising agencies, public relations firms, audiovisual firms, businesses, book/encyclopedia publishers, magazine publishers, newspapers, calendar companies.

Needs Commercial imagery in all categories. Special emphasis on model-released people, lifestyle, conceptual photography and business and Canadian images. "Our broad files require variety of subjects." Sister company WAVE royalty-free also requires environmentally relevant imagery; contact First Light for more information.

Specs "For initial review submission we prefer low-res JPEG files via e-mail; for final submissions we require clean 50MB (minimum) high-res TIFF files."

Payment & Terms Photographer's imagery is represented as rights-managed. 45% commission rate. Works on contract basis only, nonexclusive Statements issued monthly. Payment made monthly. Offers one-time rights. Informs photographers and allows them to negotiate when client requests buy-out. Model releases required. IPTC embedding required for all final files. Photo captions required.

How to Contact Send query letter via e-mail.

Tips "Wants to see tightly edited submissions. Well-produced, non-candid imagery."

THE FLIGHT COLLECTION

4 Craster Court, Oxford Road, Banbury OX16 9AG, United Kingdom. +44(0)1295 278146. E-mail: flight@uniquedimension.com. Website: www.theflightcollection.com. Estab. 1983. Has 1 million + photos in files. Clients include: advertising agencies, public relations firms, audiovisual firms, businesses, book publishers, magazine publishers, newspapers, calendar companies, greeting card companies, postcard publishers.

Needs Photos of aviation.

Specs Accepts all transparency film sizes: Send a sample of 50 for viewing. Accepts images in digital format. Send via CD as TIFF files at 300 dpi.

Payment & Terms Enforces minimum prices. Offers volume discounts to customers. Discount sales terms not negotiable. Works with photographers on contract basis only. Offers nonexclusive contract. Contracts renew automatically with additional submissions, no specific time. Statements issued monthly. Payment made monthly. Offers one-time rights. Model/property release required. Photo captions required; include name, subject, location, date.

How to Contact Send query letter with transparencies or CD. Does not keep samples on file; include SASE for return of material. Expects minimum initial submission of 50 images. Photo guidelines sheet free via e-mail.

Tips "Caption slides/images properly. Provide a list of what's submitted."

■ FOCUS NEW ZEALAND PHOTO LIBRARY LTD.

Box 84-153, Westgate, Auckland 1250, New Zealand. (64)(9)4115416. Fax: (64)(9)4115417. E-mail: photos@focusnzphoto.co.nz. Website: www.focusnzphoto.co.nz. Stock agency. Has 40,000 photos in files. Clients include: advertising agencies, businesses, newspapers, postcard publishers, public relations firms, book publishers, calendar companies, magazine publishers, greeting card companies, electronic graphics.

Needs Photos of babies/children/teens, couples, multicultural, families, parents, senior citizens, environmental, landscapes/scenics, architecture, cities/urban, education, rural, adventure, events, health/fitness/beauty, hobbies, performing arts, sports, travel, agriculture, business concepts, industry, science, technology/computers. Interested in seasonal. Also needs New Zealand, Australian, and South Pacific images.

Specs Uses 35mm, medium-format and up to full-frame panoramic 6 × 17 transparencies. Accepts images in digital format, RGB, TIFF, 300 dpi, A4 minimum.

Payment & Terms Pays 50% commission. Offers volume discounts to customers. Discount sales terms not negotiable. Works with photographers on contract basis only. Offers nonexclusive contract. Statements issued quarterly. Payment made quarterly. Photographers allowed to review account records. Offers one-time, electronic media and agency promotion rights. Model/property release preferred. Photo captions required; include exact location, content, details, releases, date taken.

How to Contact Send query letter. Does not keep samples on file; include SASE for return of material. Expects minimum initial submission of 100 images with yearly submissions of at least 100-200 images. Responds in 3 weeks to samples. Photo guidelines sheet free with SASE or by e-mail. Catalog free on website. Market tips sheet available by mail or e-mail to contributors only.

Tips "Only submit original, well-composed, well-constructed, technically excellent work, fully captioned."

■ FOODPIX

601 N. 34th Street, Seattle WA 98103. (206)925-5000. E-mail: sales@gettyimages.com. Website: www.gettyimages.com. Estab. 1994. Stock agency. Member of the Picture Archive Council of America (PACA). Has 40,000 photos in files. Clients include: advertising agencies, businesses, newspapers, book publishers, calendar companies, design firms, magazine publishers.

Needs Food, beverage and food/lifestyle images.

Specs Accepts analog and digital images. Review and complete the Online Submission Questionnaire on the website before submitting work.

Payment & Terms Enforces minimum prices. Offers volume discounts to customers; terms specified in photographers' contracts. Works with photographers on contract basis only. Offers exclusive contract only. Statements issued monthly. Payment made quarterly. Offers one-time rights. Model/property release required. Photo captions required.

How to Contact Send query e-mail with samples. Expects maximum initial submission of 50 images. Catalog available.

N FOTOAGENT

E-mail: werner@postcardusa.com. Website: www.fotoagent.com. **President:** Werner J. Bertsch. Estab. 1985. Stock photo agency. Has 1.5 million photos in files. Clients include: magazines, advertising agencies, newspapers, publishers.

Needs General worldwide travel, medical and industrial.

Specs Uses digital files only. Upload your files on website.

Payment & Terms Pays 50% commission for b&w or color photos. Average price per image (to clients): \$175 minimum for b&w or color photos. Works with photographers on contract basis only. Offers nonexclusive contract. Contracts renew automatically with each submission for

1 year. Statements issued monthly. Payment made monthly. Photographers allowed to review account records to verify sales figures. Offers one-time rights. Model release required. Photo captions required.

How to Contact Use the "Contact Us" feature on website.

Tips Wants to see "clear, bright colors and graphic style. Looking for photographs with people of all ages with good composition, lighting and color in any material for stock use."

■ FOTO-PRESS TIMMERMANN

Speckweg 34A, Moehrendorf D-91096 Germany. (49)(9131)42801. Fax: (49)(9131)450528. E-mail: info@f-pt.com. Website: www.f-pt.com. Stock photo agency. Has 750,000 photos in files. Clients include: advertising agencies, audiovisual firms, businesses, book/encyclopedia publishers, magazine publishers, newspapers, calendar companies.

Needs Landscapes, countries, travel, tourism, towns, people, business, nature, babies/children/ teens, couples, families, parents, senior citizens, adventure, entertainment, health/fitness/beauty, hobbies, industry, medicine, technology/computers. Interested in erotic, fine art, seasonal, lifestyle.

Specs Uses $2\frac{1}{4} \times 2\frac{1}{4}$, 4×5 , 8×10 transparencies (no prints). Accepts images in digital format. Send via CD, Zip as TIFF files.

Payment & Terms Pays 50% commission for color photos. Works on nonexclusive contract basis (limited regional exclusivity). First period: 3 years; contract automatically renewed for 1 year. Photographers allowed to review account records. Statements issued quarterly. Payment made quarterly. Offers one-time rights. Informs photographers and allows them to negotiate when a client requests to buy all rights. Model/property release preferred. Photo captions required; include state, country, city, subject, etc.

How to Contact Send query letter with stock list. Send unsolicited photos by mail for consideration; include SAE/IRC for return of material. Responds in 1 month.

TOTOSCOPIO

Jaramillo 3894 8° "18", C1430AGJ, Capital Federal, Buenos Aires 1203AAO Argentina. (54) (114)542-3512. Fax: (54)(114)542-3512. E-mail: info@fotoscopio.com. Website: www.fotoscopio. com. Estab. 1999. Latin American stock photo agency. Has 50,000 photos in files. Clients include: advertising agencies, businesses, postcard publishers, book publishers, calendar companies, magazine publishers, greeting card companies.

Needs Photos of Hispanic people, Latin American countries, babies/children/teens, celebrities, couples, multicultural, families, senior citizens, disasters, environmental, landscapes/scenics, wildlife, architecture, cities/urban, interiors/decorating, pets, religious, adventure, automobiles, entertainment, health/fitness/beauty, hobbies, sports, travel, agriculture, business concepts, industry, product shots/still life, technology/computers. Interested in documentary, fine art, historical/vintage.

Specs Uses 35mm, $2\frac{1}{4} \times 2\frac{1}{4}$, 4×5 , 8×10 transparencies. Accepts images in digital format. Send via CD, Zip.

Payment & Terms Average price per image (to clients): \$50-300 for b&w photos; \$50-800 for color photos. Negotiates fees below stated minimums. Offers volume discounts to customers: terms specified in photographer's contracts. Discount sales terms not negotiable. Works with photographers on contract basis only. Offers nonexclusive contract. Contracts renew automatically with additional submissions for 1 year. Statements issued and payment made whenever one yields rights of reproduction of his photography. Photographers allowed to review account records in cases of discrepancies only. Offers one-time and electronic media rights. Model release required; property release preferred. Photo captions preferred.

How to Contact Send query letter with résumé, slides, prints, photocopies, tearsheets, transparencies, stock list. Provide résumé, business card, self-promotion piece to be kept on file. Expects minimum initial submission of 100 images. Responds in 1 month to samples. Photo guidelines sheet free with SASE.

FUNDAMENTAL PHOTOGRAPHS

210 Forsyth St., Suite 2, New York NY 10002. (212)473-5770. Fax: (212)228-5059. E-mail: mail@ fphoto.com. Website: www.fphoto.com. Stock photo agency. Applied for membership into the Picture Archive Council of America (PACA). Has 100,000 photos in files. Searchable online database. Clients include: textbook/encyclopedia publishers, advertising agencies, science magazine publishers, travel guide book publishers, corporate industrial.

Needs Photos of medicine, biology, microbiology, environmental, industry, weather, disasters, science-related business concepts, agriculture, technology/computers, optics, advances in science and industry, green technologies, pollution, physics and chemistry concepts.

Specs Accepts 35mm and all large-format transparencies but digital is strongly preferred. Send digital as RAW or TIFF unedited original files at 300 dpi, 11 × 14 or larger size. Please e-mail mail@ fphoto.com for current submission guidelines.

Payment & Terms Pays 50% commission for color photos. General price range (to clients): \$100-500 for b&w photos; \$150-1,200 for color photos; depends on rights needed. Enforces strict minimum prices. Offers volume discount to customers. Works with photographers on contract basis only. Offers guaranteed subject exclusivity. Contracts renew automatically with additional submissions for 2 or 3 years. Charges \$5/image scanning fee; can increase to \$15 if corrective Photoshop work required. Charges copyright registration fee (optional). Statements issued and payment made quarterly for any sales during previous quarter. Photographers allowed to review account records with written request submitted 2 months in advance. Offers onetime and electronic media rights. Gets photographer's approval when client requests all rights; negotiation conducted by the agency. Model release required. Photo captions required; include date and location.

How to Contact Please send e-mail request for current photo guidelines to: mail@fphoto.com. Contact via e-mail to arrange digital submission. Submit link to web portfolio for review. Send query e-mail with résumé of credits, samples or list of stock photo subjects. Keeps samples on file; include SASE for return of material if sending by post. Expects minimum initial submission of 100 images. E-mail crucial for communicating current photo needs.

Tips "Our primary market is science textbooks. Photographers should research the type of illustration used and tailor submissions to show awareness of saleable material. We are looking for science subjects ranging from nature and rocks to industrials, medicine, chemistry and physics; macro photography, photomicrography, stroboscopic; well-lit still-life shots are desirable. The biggest trend that affects us is the need for images that document new discoveries in sciences and ecology. Please avoid images that appear dated, images with heavy branding, soft focus or poorly lit subjects."

■ GEOSLIDES & GEO AERIAL PHOTOGRAPHY

4 Christian Fields, London SW16 3JZ, United Kingdom. +44(115)981-9418. E-mail: geoslides@geogroup.co.uk. Website: www.geo-group.co.uk. Picture library. Has approximately 100,000 photos in files. Clients include: advertising agencies, public relations firms, audiovisual firms, businesses, book/ encyclopedia publishers, magazine publishers, newspapers, calendar companies, television.

Needs Accent on travel/geography and aerial (oblique) shots. Wants photos of disasters, environmental, landscapes/scenics, wildlife, architecture, rural, adventure, travel, agriculture, industry, medicine, military, political, product shots/still life, science, technology/computers. Interested in documentary, historical/vintage.

Specs High-res digital.

Payment & Terms Pays 50% commission for b&w or color photos. General price range (to clients): \$75-750. Works with photographers with or without a contract; negotiable. Offers nonexclusive contract. Charges mailing costs. Statements issued monthly. Payment made upon

receipt of client's fees. Offers one-time rights and first rights. Does not inform photographers or allow them to negotiate when clients request all rights. Model release required. Photo captions required; include description of location, subject matter and sometimes the date.

How to Contact Send query letter or e-mail with résumé of credits, stock list; include SAE/IRC for return of material. Photo guidelines available for SAE/IRC. No samples until called for.

Tips Looks for "technical perfection, detailed captions, must fit our needs, especially location needs. Increasingly competitive on an international scale, Quality is important, Needs large stocks with frequent renewals." To break in, "build up a comprehensive (i.e., in subject or geographical area) collection of photographs which are well documented."

GETTY IMAGES

601 N. 34th St., Seattle WA 98103. (206)925-5000. Website: www.gettyimages.com. "Getty Images is the world's leading imagery company, creating and distributing the largest and most relevant collection of still and moving images to communication professionals around the globe and supporting their work with asset management services. From news and sports photography to contemporary and archival imagery, Getty Images' products are found each day in newspapers, magazines, advertising, films, television, books and websites. Gettvimages.com is the first place customers turn to search, purchase, download and manage powerful imagery. Seattle-headquartered Getty Images is a global company with customers in more than 100 countries."

How to Contact Visit www.gettyimages.com/contributors

GRANT HEILMAN PHOTOGRAPHY. INC.

506 West Lincoln Ave., Lititz PA 17543. (717)626-0296 or (800)622-2046. E-mail: info@heilmanphoto. com. Website: www.heilmanphoto.com. Estab. 1948. Member of the Picture Archive Council of America (PACA). Has one million photos in files. Now representing Photo Network Stock. Sub agents in Canada, Europe, England, Japan. Clients include: advertising agencies, public relations firms, businesses, book/textbook publishers, magazine publishers, calendar companies, greeting card companies, postcard publishers.

Needs Photos of environmental, landscapes/scenics, wildlife, gardening, pets, rural, agriculture, science, renewable energies and resources, technology/computers. Interested in seasonal.

Specs Uses 35mm, 21/4 × 21/4, 4 × 5 transparencies. Accepts images in digital format. Send via CD, floppy disk, Jaz, Zip, as TIFF, EPS, PICT, JPEG files.

Payment & Terms Pays on commission basis. Enforces minimum prices, Offers volume discounts to customers. Works with photographers on contract basis only. Offers guaranteed subject exclusivity (within files). Contracts renew automatically with additional submissions per contract definition. Charges determined by contract. Statements issued quarterly. Payment made quarterly. Photographers allowed to review account records. Offers one-time rights, electronic media rights, agency promotion rights. Model/property release required. Photo captions required: include all known information.

How to Contact Send query letter with résumé, slides, prints, photocopies, tearsheets, transparencies, stock list. Provide résumé, business card, self-promotion piece to be kept on file. Expects minimum initial submission of 200 images.

Tips "Make a professional presentation."

HUTCHISON PICTURE LIBRARY

65 Brighton Rd., Shoreham-by-Sea, West Sussex BN43 6RE, United Kingdom. E-mail: library@ hutchisonpictures.co.uk. Website: www.hutchisonpictures.co.uk. Stock photo agency, picture library. Has around 500,000 photos in files. Clients include: ad agencies, public relations firms, audiovisual firms, businesses, book/encyclopedia publishers, magazine publishers, newspapers, postcard companies, calendar companies, television and film companies.

Needs "We are a general, documentary library (no news or personalities). We file mainly by country and aim to have coverage of every country in the world. Within each country we cover such subjects

as industry, agriculture, people, customs, urban, landscapes, etc. We have special files on many subjects such as medical (traditional, alternative, hospital, etc.), energy, environmental issues, human relations (relationships, childbirth, young children, etc., but all real people, not models)." We constantly require images of Spain and Spanish-speaking countries. Also interested in babies/ children/teens, couples, multicultural, families, parents, senior citizens, disasters, architecture, education, gardening, interiors/decorating, religious, rural, health/fitness, travel, military, political, science, technology/computers. Interested in documentary, seasonal. "We are a color library."

Specs Uses 35mm transparencies. Accepts images in digital format: 50MB at 300 dpi, cleaned of dust and scratches at 100%, color corrected.

Payment & Terms Pays 40% commission for exclusive; 35% for nonexclusive. Statements issued semiannually. Payment made semiannually. Sends statement with check in June and January. Offers one-time rights. Model release preferred. Photo captions required.

How to Contact Always willing to look at new material or collections. Arrange a personal interview to show portfolio. Send letter with brief description of collection and photographic intentions. Responds in about 2 weeks, depends on backlog of material to be reviewed. "We have letters outlining working practices and lists of particular needs (they change)." Distributes tips sheet to photographers who already have a relationship with the library.

Tips Looks for "collections of reasonable size (rarely less than 1,000 transparencies) and variety; well captioned (or at least well indicated picture subjects; captions can be added to mounts later); sharp pictures, good color, composition; and informative pictures. Prettiness is rarely enough. Our clients want information, whether it is about what a landscape looks like or how people live, etc. The general rule of thumb is that we would consider a collection which has a subject we do not already have coverage of or a detailed and thorough specialist collection. Please do not send any photographs without prior agreement."

■ □ I.C.P. INTERNATIONAL COLOUR PRESS

Piazza Vesuvio 19, Milano 20144, Italy. Milano +390289954751 | Roma +3906452217748 | Torino +3901123413919 | UK +44 2078553279 Fax +3902700567952 |. Fax: (39)(02)48195625. E-mail: icp@icponline.it. Website: www.icponline.it. Stock photo agency. Clients include: advertising agencies, public relations firms, audiovisual firms, businesses, book/encyclopedia publishers, magazine publishers, postcard publishers, calendar companies and greeting card companies.

Specs High-res digital (A3-A4, 300 dpi), keyworded (English and, if possible, Italian).

Payment & Terms Pays 50% commission for color photos. Offers volume discounts to customers; terms specified in photographer's contract. Discount sales terms not negotiable. Contracts renew automatically with additional submissions, for 3 years. Statements issued monthly. Payment made monthly. Photographers permitted to review account records to verify sales figures or deductions. Offers one-time, first and sectorial exclusive rights. Model/property release required. Photo captions required.

How to Contact Arrange a personal interview to show portfolio. Send query letter with samples and stock list. Works on assignment only. No fixed minimum for initial submission. Responds in 3 weeks, if interested.

THE IMAGE FINDERS

2570 Superior Ave., Suite 200, Cleveland OH 44114. (216)781-7729 or (440)413-6104. E-mail: imagefinders@sbcglobal.net. Website: http://agpix.com/theimagefinders. Owner: Jim Baron. Estab. 1988. Stock photo agency. Has 500,000 + photos in files. Clients include: advertising agencies, public relations firms, businesses, book/encyclopedia publishers, magazine publishers, calendar companies, greeting card companies.

Needs General stock agency. Always interested in good Ohio images. Also needs babies/children/ teens, couples, multicultural, families, senior citizens, landscapes/scenics, wildlife, architecture, gardening, pets, automobiles, food/drink, sports, travel, agriculture, business concepts, industry, medicine, political, technology/computers. Interested in fashion/glamour, fine art, seasonal.

Specs Accepts digital images; see guidelines before submitting. Send via CD.

Payment & Terms "This is a small agency and we will, on occasion, go below stated minimum prices." Offers volume discounts to customers; terms specified in photographers' contracts. Works with photographers on contract basis only. Contracts renew automatically with additional submissions for 2 years. Statements issued monthly if requested. Payment made monthly. Photographers allowed to review account records. Offers one-time rights; negotiable depending on what the client needs and will pay for. Informs photographers and allows them to negotiate when client requests all rights. "This is rare for us. I would inform photographer of what the client wants and work with photographer to strike the best deal." Model/property release preferred. Photo captions required; include location, city, state, country, type of plant or

How to Contact Send query letter with stock list or send e-mail with link to your website. Call before you send anything that you want returned. Expects minimum initial submission of 100 images with periodic submission of at least 100-500 images. Photo guidelines free with SASE. Market tips sheet distributed 2-4 times/year to photographers under contract.

Tips Photographers must be willing to build their file of images. "We need more people images, industry, lifestyles, wildlife, travel, etc. Scenics and landscapes must be outstanding to be considered. Call first or e-mail. Submit at least 100 good images. Must have ability to produce more than 100-200 images per year."

■ IMAGES.DE FULFILLMENT

Potsdamer Str. 96D, Berlin 10785, Germany. +49(0)30-2579 28980. Fax: +49(0)30-2579 28999. E-mail: info@images.de. Website: www.images.de. Estab. 1997. News/feature syndicate. Has 50,000 photos in files. Clients include: advertising agencies, newspapers, public relations firms, book publishers, magazine publishers. "Images.de is a service company with 10 years experience on the picture market. We offer fulfillment services to picture agencies, including translation, distribution into Fotofiner and APIS picturemaxx, customer communication, invoicing, media control, cash delivery, and usage control."

Needs Photos of babies/children/teens, couples, multicultural, families, parents, senior citizens, environment, entertainment, events, food/drink, health/fitness, hobbies, travel, agriculture, business concepts, industry, medicine, political, science, technology/computers.

Specs Accepts images in digital format. Send via FTP, CD.

Payment & Terms Pays 50% commission for b&w photos; 50% for color photos. Average price per image (to clients): \$50-1,000 for b&w photos or color photos. Offers volume discounts to customers. Discount sales terms not negotiable. Works with photographers with or without a contract; negotiable. Offers limited regional exclusivity. Statements issued monthly. Payment made monthly. Photographers allowed to review account records in cases of discrepancies only. Offers one-time rights, electronic media rights. Informs photographers and allows them to negotiate when client requests all rights. Model release preferred; property release required. Photo captions required.

How to Contact Send query letter with CD or link to website. Expects minimum initial submission of 100 images.

THE IMAGE WORKS

P.O. Box 443, Woodstock NY 12498. (845)679-8500 or (800)475-8801. Fax: (845)679-0606. E-mail: info@theimageworks.com. Website: www.theimageworks.com. President: Mark Antman. Estab. 1983. Stock photo agency. Member of Picture Archive Council of America (PACA). Has over 1 million photos in files. Clients include: ad agencies, book/encyclopedia publishers, magazine publishers, newspapers, postcard publishers, greeting card companies, documentary video.

Needs "We are always looking for excellent documentary photography. Our prime subjects are people-related subjects like family, education, health care, workplace issues, worldwide historical, technology, fine arts."

Specs All images must be in digital format; contact for digital guidelines. Rarely accepts 35mm, $2\frac{1}{4} \times 2\frac{1}{4}$ transparencies and prints.

Payment & Terms Works with photographers on contract basis only. Offers nonexclusive contract. Statements issued monthly. Payments made monthly. Photographers allowed to review account records to verify sales figures by appointment. Offers one-time, agency promotion and electronic media rights. Informs photographers and allows them to negotiate when clients request all rights. Model release preferred. Photo captions required.

How to Contact Send e-mail with description of stock photo archives. Expects minimum initial submission of 500 images.

Tips "The Image Works was one of the first agencies to market images digitally. All digital images from photographers must be of reproduction quality. When making a new submission to us, be sure to include a variety of images that show your range as a photographer. We also want to see some depth in specialized subject areas. Thorough captions are a must. We will not look at uncaptioned images. Write or call first."

■ S \$ INMAGINE

2650 Fountain View Dr., Ste. 332, Houston TX 77057. 800-810-3888. Fax: 866-234-5310. E-mail: photo@inmagine.com. Stock agency, picture library. Member of the Picture Archive Council of America (PACA). Has 6,000,000 photos in files. Branch offices in USA, Hong Kong, Australia, Malaysia, Thailand, United Arab Emirates, Singapore, Indonesia, and China. Clients include: advertising agencies, businesses, newspapers, public relations firms, magazine publishers.

Needs Photos of babies, children, teens, couples, multicultural, families, parents, education, business concepts, industry, medicine, environmental and landscapes, adventure, entertainment, events, food and drink, health, fitness, beauty, hobbies, sports, travel, fashion/glamour, and lifestyle.

Specs Accepts images in digital format. Submit online via http://submission.inmagine.com or send JPEG files at 300 dpi.

Payment & Terms Pays 50% commission for color photos. Average price per image (to clients): \$100 minimum, maximum negotiable. Negotiates fees below stated minimums. Offers volume discounts to customers, terms specified in photographers' contracts. Works with photographers on a contract basis only. Offers nonexclusive contract. Payments made monthly. Photographers are allowed to view account records in cases of discrepancies only. Offers one-time rights. Model and property release required. Photo caption required.

How to Contact Contact through website. Expects minimum initial submission of 5 images. Responds in 1 week to samples. Photo guidelines available online.

Tips "Complete the steps as outlined in the IRIS submission pages. E-mail us if there are queries. Send only the best of your portfolio for submission, stock-oriented materials only. EXIF should reside in file with keywords and captions."

■ M INTERNATIONAL PHOTO NEWS

2902 29th Way, West Palm Beach FL 33407. (561)683-9090. E-mail: jkravetz1@earthlink.net. News/feature syndicate. Has 50,000 photos in files. Clients include: newspapers, magazines, book publishers. Previous/current clients include: newspapers that need celebrity photos with story.

Needs Wants photos of celebrities, entertainment, events, health/fitness/beauty, performing arts, travel, politics, movies, music and television, at work or play. Interested in avant garde, fashion/glamour.

Specs Accepts images in digital format. Send via CD, Zip, e-mail as TIFF, JPEG files at 300 dpi. Uses 5×7 , 8×10 glossy b&w prints.

Payment & Terms Pays \$10 for b&w photos; \$25 for color photos; 5-10% commission. Average price per image (to clients): \$25-100 for b&w photos; \$50-500 for color photos. Works with photographers on contract basis only. Offers nonexclusive contract. Contracts renew automatically with additional submissions; 1-year renewal. Photographers allowed to review account records.

Statements issued monthly. Payment made monthly. Offers one-time rights. Model/property release preferred. Photo captions required.

How to Contact Send query letter with résumé of credits. Solicits photos by assignment only. Responds in 1 week.

Tips "We use celebrity photographs to coincide with our syndicated columns, Must be approved by the celebrity."

THE IRISH IMAGE COLLECTION

#101, 10464-176 St., Edmonton AB Canada. 780-447-5433. E-mail: kristi@theirishimagecollection. com. Website: www.theirishimagecollection.ie. Office Manager: Kristi Bennell. Stock photo agency and picture library. Has 50,000+ photos in files. Clients include: advertising agencies, public relations firms, businesses, book/encyclopedia publishers, magazine publishers, newspapers and designers.

Needs Consideration is given only to Irish or Irish-connected subjects.

Specs Uses 35mm and all medium-format transparencies.

Payment & Terms Pays 40% commission for color photos. Average price per image (to client): \$85-2,000. Works on contract basis only. Offers exclusive contracts and limited regional exclusivity. Contracts renew automatically with additional submissions. Statements issued quarterly. Payment made quarterly. Photographers allowed to review account records. Offers one-time and electronic media rights. Informs photographer when client requests all rights, but "we take care of negotiations." Model release required. Photo captions required.

How to Contact Send query letter with list of stock photo subjects. Does not return unsolicited material. Expects minimum initial submission of 250 transparencies; 1,000 images annually. "A return shipping fee is required: important that all similars are submitted together. We keep our contributor numbers down and the quantity and quality of submissions high. Send for information first by e-mail."

Tips "Our market is Ireland and the rest of the world. However, our continued sales of Irishoriented pictures need to be kept supplied. Pictures of Irish-Americans in Irish bars, folk singing, Irish dancing, in Ireland or anywhere else would prove to be useful. They would be required to be beautifully lit, carefully composed with attractive, model-released people."

🌐 🖪 THE IRISH PICTURE LIBRARY

69b Heather Rd., Sandyford Industrial Estate, Dublin 18 Ireland. (353)1 295 0799. Fax: (353)1295 0705. E-mail: helpdesk@fatherbrowne.com. Website: www.fatherbrowne.com/ipl. Estab. 1990. Picture library. Has 60,000 + photos in files. Clients include: advertising agencies, businesses, book publishers, magazine publishers, newspapers, calendar companies.

Needs Photos of historic Irish material. Interested in alternative process, fine art, historical/ vintage.

Specs Uses any prints. Accepts images in digital format. Send via CD as TIFF, JPEG files at 400

Payment & Terms Enforces minimum prices. Offers volume discounts to customers. Photographers can choose not to sell images on discount terms. Works with photographers on contract basis only. Statements issued quarterly. Payment made quarterly. Photographers allowed to review account records. Offers one-time rights, electronic media rights. Property release required. Photo captions required.

How to Contact Send query letter with photocopies. Does not keep samples on file; include SAE/IRC for return of material.

ISOPIX

Werkhuizenstraat 7-9 Rue des Ateliers, Brussel-Bruxelles 1080, Belgium. +32 2 420 30 50. Fax: 32 2 420 41 22. E-mail: isopix@isopix.be. Website: www.isopix.be. Estab. 1984. News/feature syndicate. Has 2.5 million photos on website, including press (celebrities, royalty, portraits, news sports, archival), stock (contemporary and creative photography) and royalty-free. Clients include: advertising agencies, public relations firms, businesses, book publishers, magazine publishers, newspapers, calendar companies, postcard publishers.

Needs Photos of teens, celebrities, couples, families, parents, senior citizens, disasters, environmental, landscapes/scenics, wildlife, education, religious, events, food/drink, health/ fitness, hobbies, humor, agriculture, business concepts, industry, medicine, science, technology/ computers. Interested in alternative process, avant garde, documentary, fashion/glamour, fine art, historical/vintage, seasonal.

Specs Accepts images in digital format; JPEG files only.

Payment & Terms Enforces strict minimum prices. Works with photographers with or without a contract; negotiable. Offers limited regional exclusivity. Contracts renew automatically with additional submissions. Statements issued monthly. Payment made monthly. Photographers allowed to review account records in cases of discrepancies only. Model/property release preferred. Photo captions required.

How to Contact Contact through rep. Does not keep samples on file; include SAE/IRC for return of material. Expects minimum initial submission of 1,000 images with quarterly submissions of at least 500 images.

ISRAEL IMAGES

P.O. Box 60, Kammon 20112, Israel. (972)(4)908-2023. Fax: (972)(4)990-5783. E-mail: israel@ israelimages.com. Website: www.israelimages.com. Has 450,000 photos in files. Clients include: advertising agencies, web designers, businesses, book publishers, magazine publishers, newspapers, calendar companies, greeting card and postcard publishers, multimedia producers, schools and universities.

Needs "We are interested in everything about Israel, Judaism (worldwide) and The Holy Land." Specs Uses digital material only, minimum accepted size 2000 × 3000 pixels. Send CD with low-res samples for review. "When accepted, we need TIFF or JPEG files at 300 dpi, RGB, saved at quality '11' in Photoshop."

Payment & Terms Average price per image (to clients): \$50-3,000/picture. Negotiates fees below standard minimum against considerable volume that justifies it. Offers volume discounts to customers. Works with photographers on contract basis only. Offers limited regional exclusivity, nonexclusive contract. Contracts renew automatically with additional submissions. Statements issued quarterly. Payment made quarterly. Photographers allowed to review account records. Offers one-time rights, electronic media rights, agency promotion rights. Informs photographers and allows them to negotiate when a client requests all rights. Model/property release preferred. Photo captions required (what, who, when, where).

How to Contact Send query letter with CD or send low-res by e-mail. Expects minimum initial submission of 100 images. Responds in 2 weeks.

Tips "We strongly encourage everyone to send us images to review. When sending material, a strong edit is a must. We don't like to get 100 pictures with 50 similars. Last, don't overload our e-mail with submissions. Make an e-mail query, or better yet, view our submission guidelines on the website. Good luck and welcome!"

■ ■ JAYTRAVELPHOTOS

7A Napier Rd., Wembley, Middlesex HA0 4UA, United Kingdom. (44)(208)795-3581. Fax: (44) (202)975-4083. E-mail: jaytravelphotos@aol.com. Website: www.jaytravelphotos.com. Stock photo agency and picture library. Has 150,000 photos in files. Clients include: advertising agencies, businesses, book/encyclopedia publishers, magazine publishers, newspapers, postcard publishers, tour operators/travel companies.

Needs Travel and tourism-related images worldwide.

Specs Uses 35mm up to 6 × 7cm original transparencies and digital images (see website for guidelines).

Payment & Terms Pays 50% commission. Average price per image (to clients): \$125-1,000. Enforces minimum prices of \$125, "but negotiable on quantity purchases." Offers volume discounts to customers; inquire about specific terms. Discount sales terms not negotiable. Works with photographers on contract basis only. Offers limited regional exclusivity contract. Statements issued semiannually. Payment made semiannually, within 30 days of payment received from client. Offers one-time and exclusive rights for fixed periods. Does not inform photographers or allow them to negotiate when client requests all rights. Model/property release preferred. Photo captions required; include country, city/location, subject description.

How to Contact Send e-mail with stock list, or call. Expects a minimum initial submission of 300 images with quarterly submissions of at least 100 images. Responds in 3 weeks.

Tips "Study our guidelines on our website on what to submit. If you're planning a photo shoot anywhere, you need to give us an itinerary, with as much detail as possible, so we can brief you on what kind of pictures the library may need."

JEROBOAM

120 27th St., San Francisco CA 94110. (415)821-7098. E-mail: jeroboamster@gmail.com. Has 200,000 b&w photos, 200,000 color slides in files. Clients include: text and trade book, magazine and encyclopedia publishers, editorial (mostly textbooks), greeting cards, and calendars.

Needs "We want people interacting, relating photos, comic, artistic/documentary/photojournalistic images, especially ethnic and handicapped. Images must have excellent print quality—contextually interesting and exciting and artistically stimulating." Wants photos of babies/children/teens, couples, multicultural, families, parents, senior citizens, disasters, environmental, cities/urban, education, gardening, pets, religious, rural, adventure, health/fitness, humor, performing arts, sports, travel, agriculture, industry, medicine, military, political, science, technology/computers. Interested in documentary, historical/vintage, seasonal. Needs shots of school, family, career and other living situations. Child development, growth and therapy, medical situations. No nature or studio shots.

Specs Uses 35mm transparencies.

Payment & Terms Works on consignment only; pays 50% commission. Average price per image (to clients): \$150 minimum for b&w and color photos. Works with photographers without a signed contract. Statements issued monthly, Payment made monthly, Photographers allowed to review account records to verify sales figures. Offers one-time and electronic media rights. Informs photographers and allows them to negotiate when client requests all rights. Model/ property release preferred for people in contexts of special education, sexuality, etc. Photo captions preferred; include "age of subject, location, etc."

How to Contact Call if in the Bay Area; if not, query with samples and list of stock photo subjects; send material by mail for consideration or submit portfolio for review. "Let us know how long you've been shooting." Responds in 2 weeks.

Tips "The Jeroboam photographers have shot professionally a minimum of 5 years, have experienced some success in marketing their talent, and care about their craft excellence and their own creative vision. New trends are toward more intimate, action shots; more ethnic images needed."

I KIMBALL STOCK

1960 Colony St., Mountain View CA 94043. (650)969-0682. Fax: (650)969-0485, (888)562-5522. E-mail: submissions@kimballstock.com. Website: www.kimballstock.com. Has 1 million photos in files. Clients include: advertising agencies, businesses, newspapers, postcard publishers, public relations firms, book publishers, calendar companies, magazine publishers, greeting card companies. "Kimball Stock strives to provide automotive and animal photographers with the best medium possible to sell their images. In addition, we work to give every photographer a safe, reliable, and pleasant experience."

Needs Photos of dogs, cats, lifestyle with cars and domestic animals, landscapes/scenics, wildlife (outside of North America). Interested in seasonal.

Specs Prefers images in digital format, minimum of 12-megapixel digital camera, although 16-megapixel is preferred. Send via e-mail as JPEG files or send CD to mailing address. Uses 35mm, 120mm, 4 × 5 transparencies.

Payment & Terms Pays 50% commission for color photos. Works with photographers with a contract; negotiable. Offers nonexclusive contract. Statements issued quarterly. Payments made quarterly. Photographers allowed to review account records. Offers one-time rights, electronic media rights. Model/property release required. Photo captions required.

How to Contact Send query letter with transparencies, digital files, stock list. Provide self-promotion piece to be kept on file. Expects minimum initial submission of 250 images with quarterly submissions of at least 200 images. Responds only if interested; send nonreturnable samples. Photo guidelines available on website at www.kimballstock.com/submissions.asp.

JOAN KRAMER AND ASSOCIATES, INC.

10490 Wilshire Blvd., Suite 1701, Los Angeles CA 90024. (310)446-1866. Fax: (310)446-1856. E-mail: ekeeeek@earthlink.net. Website: www.home.earthlink.net/~ekeeeek. Member of Picture Archive Council of America (PACA). Has 1 million photos in files. Clients include: ad agencies, magazines, recording companies, photo researchers, book publishers, greeting card companies, promotional companies, AV producers.

Needs "We use any and all subjects! Stock slides must be of professional quality." Subjects on file include travel, cities, personalities, animals, flowers, lifestyles, underwater, scenics, sports and couples.

Specs Uses 8 × 10 glossy b&w prints; any size transparencies.

Payment & Terms Pays 50% commission. Offers all rights. Model release required.

How to Contact Send query letter or call to arrange an appointment. Do not send photos before calling.

B LATITUDE STOCK

14 High St., Goring-on-Thames, Reading Berks RG8 9AR United Kingdom. +44 1491 873011. Fax: +44 1491 875558. E-mail: info@latitudestock.com. Website: www.latitudestock.com. Collections Editor: Stuart Cox. Has over 115,000 photos in files. Clients include: advertising agencies, businesses, newspapers, public relations firms, book publishers, calendar companies, audiovisual firms, magazine publishers, greeting card companies.

Needs Photos of multicultural, environmental, landscapes/scenics, wildlife, architecture, cities/urban, gardening, religious, rural, adventure, events, food/drink, health/fitness/beauty, hobbies, sports, travel.

Specs Uses 35mm and medium-format transparencies. Accepts images in digital format. See website for details.

Payment & Terms Pays on a commission basis. Enforces minimum prices. Offers volume discounts to customers. Works with photographers on contract basis only. Offers exclusive contract only. Statements issued quarterly. Payments made quarterly. Photographers allowed to review account records. Offers one-time rights. Model/property release required. Photo captions required.

How to Contact "Currently accepting submissions from new photographers. Please e-mail first."

LIGHTWAVE PHOTOGRAPHY

170 Lowell St., Arlington MA 02174. (781)354-7747. E-mail: paul@lightwavephoto.com. Website: www.lightwavephoto.com. Has 250,000 photos in files. Clients include: advertising agencies, textbook publishers.

Needs Candid photos of people in school, work and leisure activities, lifestyle.

Specs Uses color transparencies.

Payment & Terms Pays \$210/photo; 50% commission. Works with photographers on contract basis only. Offers nonexclusive contract. Contracts renew automatically each year. Statements issued annually. Payments made "after each usage." Offers one-time rights. Informs photographers and allows them to negotiate when client requests all rights. Model/property release preferred. Photo captions preferred.

How to Contact "Create a small website and send us the URL."

Tips "Photographers should enjoy photographing people in everyday activities. Work should be carefully edited before submission. Shoot constantly and watch what is being published. We are looking for photographers who can photograph daily life with compassion and originality."

Van der Helllaan 6, Arnhem 6824 HT Netherlands. (31)(26)4456713. E-mail: info@lineairfoto.nl. Website: www.lineairfoto.nl. Stock photo agency. Has 100,000 analog photos to digitize in files at this moment and more than 1.4 million downloadable images available through the website. Clients include advertising agencies, public relations firms, book/encyclopedia publishers, magazine publishers, Library specializes in images from Asia, Africa, Latin America, Eastern Europe and nature in all forms on all continents. Member of WEA, a group of international libraries that use the same server to market each other's images, uploading only once.

Needs Photos of disasters, environmental, landscapes/scenics, wildlife, cities/urban, education, religious, adventure, travel, agriculture, business concepts, industry, political, science, technology/ computers. Interested in everything that has to do with the development of countries all over the world, especially in Asia, Africa and Latin America.

Specs Accepts images in digital format only. Send via CD, DVD (or use our FTP) as high-quality JPEG files at 300 dpi, A4 or rather bigger size. "Photo files need to have IPTC information!"

Payment & Terms Pays 50% commission. Average price per image (to clients): \$100-500. Enforces minimum prices. Offers volume discounts to customers; inquire about specific terms. Photographers can choose not to sell images on discount terms. Works with or without a signed contract; negotiable. Offers limited regional exclusivity. Statements issued quarterly. Payments made quarterly. Photographers allowed to review account records. "They can review bills to clients involved," Offers one-time rights. Informs photographers and allows them to negotiate when client requests all rights. Photo captions required; include country, city or region, description of the image.

How to Contact Submit portfolio or e-mail thumbnails (20KB files) for review. There is no minimum for initial submissions. Responds in 3 weeks. Market tips sheet available upon request. View website to see subject matter and 'quality.

Tips "We like to see high-quality pictures in all aspects of photography. So we'd rather see 50 good ones than 500 for us to select the 50 out of. Send contact sheets upon our request. We will mark the selected pictures for you to send as high-res, including the very important IPTC (caption and keywords)."

LONELY PLANET IMAGES

150 Linden St., Oakland CA 94607. (510)893-8555 or (800)275-8555. Fax: (510)625-0306. E-mail: lpi@lonelyplanet.com. Website: www.lonelyplanetimages.com. Stock photo agency. Clients include: advertising agencies, public relations firms, book/encyclopedia publishers, magazine publishers, newspapers, calendar companies, greeting card companies, design firms.

Needs Photos of international travel destinations.

Specs Uses original color transparencies in all formats; digital images from 6-megapixel and higher DSLRs.

Payment & Terms Pays 40-50% commission. Works with photographers on contract basis only. Offers image exclusive contract. Contract renews automatically. Model/property release preferred. Photo captions required.

How to Contact Download submission guidelines from website—click on Photographers tab, then click on Prospective Photographers.

Tips "Photographers must be technically proficient, productive, and show interest and involvement in their work." See website for other locations.

LUCKYPIX

1658 N. Milwaukee, #324, Chicago IL 60647. (773)235-2000. Fax: (773)235-2030. E-mail: info@ luckypix.com. Website: www.luckypix.com. Stock agency. Has 9,000 photos in files (adding constantly). Clients include: advertising agencies, businesses, book publishers, design companies, magazine publishers.

Needs Wants outstanding people/lifestyle images.

Specs 50 + MB TIFFs, 300 dpi, 8-bit files. Photos for review: upload to website or e-mail info@ luckypix.com. Final: CD/DVD as TIFF files.

Payment & Terms 50% commission for net revenues. Enforces minimum prices. Offers exclusivity by image and similars. Contracts renew automatically annually. Statements and payments issued quarterly. Model/property release required.

How to Contact Call or upload sample from website (preferred). Responds in 1 week. See website for guidelines.

Tips "Have fun shooting. Search the archives before deciding what pictures to send."

MASTERFILE

3 Concorde Gate, 4th Fl., Toronto ON M3C 3N7, Canada. (800)387-9010. E-mail: portfolio@ masterfile.com. Website: www.masterfile.com. General stock agency offering rights-managed and royalty-free images. The combined collection exceeds 2.5 million images online. Clients include: major advertising agencies, broadcasters, graphic designers, public relations firms, book and magazine publishers, producers of greeting cards, calendars and packaging.

Specs Accepts images in digital format only, in accordance with submission guidelines.

Payment & Terms Pays photographers 40% royalties of amounts received by Masterfile. Contributor terms outlined in photographer's contract, which is image-exclusive. Photographer sales statements and royalty payments issued monthly.

How to Contact Refer to www.masterfile.com/info/artists/submissions.html for submission guidelines.

Tips "Do not send transparencies or prints as a first-time submission. We also prefer not receiving discs. In order to view new work as efficiently as possible, we can only handle images submitted digitally, as follows: Submission methods: You can show us a sample in two ways: If you have a website, or are listed in a web-based visual directory, please send us your URL. You may e-mail us 20-30 of your best images following these guidelines: Images must be in RGB JPEG format. The overall file size of your e-mail cannot exceed 4MB. (Messages exceeding this size will be rejected by our mail server.)"

MAXX IMAGES

1433 Rupert St., Suite 3A, North Vancouver BC V7J 1G1 Canada. (604)985-2560. Fax: (604)985-2590. E-mail: newsubmissions@maxximages.com. Website: www.maxximages.com. Estab. 1994. Stock agency. Member of the Picture Archive Council of America (PACA). Has 3.2 million images online. Has 350 hours of video footage. Clients include: advertising agencies, public relation firms, audiovisual firms, businesses, book publishers, magazine publishers, newspapers, calendar companies, postcard publishers, video production, graphic design studios.

Needs Photos of people, lifestyle, business, recreation, leisure.

Specs Uses all formats.

How to Contact Send e-mail. Review submission guidelines on website prior to contact.

THE MEDICAL FILE INC.

279 East 44th St., 21st Fl., New York NY 10017. (212)883-0820 or (917)215-6301. E-mail: themedicalfile@gmail.com. Website: www.themedicalfile.com. Estab. 2005. Clients include: advertising agencies, public relations firms, businesses, book/encyclopedia publishers, magazine publishers, postcard companies, calendar companies, greeting card companies.

Needs Photos of any medically related imagery including fitness and food in relation to health

Specs Accepts digital format images only on CD or DVD. Images can be downloaded to FTP site. Payment & Terms Average price per image (for clients): \$250 and up. Works on exclusive and nonexclusive contract basis. Contracts renew automatically with each submission for length of original contract. Payments made quarterly. Offers one-time rights. Informs photographers when clients request all rights or exclusivity. Model release required. Photo captions required.

How to Contact Arrange a personal interview to show portfolio. Submit portfolio for review. Tips sheet distributed as needed to contract photographers only.

Tips Wants to see a cross-section of images for style and subject. "Photographers should not photograph people before getting a model release. The day of the 'grab shot' is over."

■ 🖪 🔜 MEDISCAN

2nd Floor Patman House, 23-27 Electric Parade, George Lane South Woodford, London E18 2LS United Kingdom. +44(0)20 8530 7589. Fax: +44(0)20 8989 7795. E-mail: info@mediscan.co.uk. Website: www.mediscan.co.uk. Estab. 2001. Picture library. Has over 1 million photos and over 2,000 hours of film/video footage on file. Subject matter includes medical personnel and environment, diseases and medical conditions, surgical procedures, microscopic, scientific, ultrasound/CT/MRI scans and x-rays. Online catalog on website. Clients include: advertising and design agencies, business-to business, newspapers, public relations, book and magazine publishers in the health care, medical and science arenas.

Needs Photos of babies/children/teens/senior citizens; health/lifestyle/fitness/beauty; medicine, especially plastic surgery, rare medical conditions; model-released images; science, including microscopic imagery, botanical and natural history.

Specs Accepts negatives; 35mm and medium format transparencies; digital images (make contact before submitting samples).

Payment & Terms Pays up to 50% commission. Statements issued quarterly. Payments made quarterly. Model/property release required, where necessary.

How to Contact E-mail or call.

☑ ■ MEGAPRESS IMAGES

1751 Richardson, Suite 2205, Montreal QC H3K 1G6 Canada. (514)279-9859. Fax: (514)279-9859. E-mail: info@megapress.ca. Website: www.megapress.ca. Estab. 1992. Stock photo agency. Has 500,000 photos in files. Has 2 branch offices. Clients include: book/encyclopedia publishers, magazine publishers, postcard publishers, calendar companies, greeting card companies, advertising agencies.

Needs Photos of people (babies/children/teens, couples, people at work, medical); animals including puppies in studio; industries; celebrities and general stock. Also needs families, parents, senior citizens, disasters, environmental, landscapes/scenics, wildlife, gardening, pets, religious, adventure, automobile, food/drink, health/fitness/beauty, sports, travel, business concepts, still life, science. "Looking only for the latest trends in photography and very high-quality images. A part of our market is Quebec's local French market."

Specs Accepts images in digital format only. Send via CD, floppy disk, Zip as JPEG files at 300 dpi.

Payment & Terms Pays 50% commission for color photos. Average price per image (to client): \$100. Enforces minimum prices. Will not negotiate below \$60. Works with photographers with or without a contract. Statements issued semiannually. Payments made semiannually. Offers one-time rights. Model release required for people and controversial news.

How to Contact Submit link first by e-mail. "If interested, we'll get back to you." Does not keep samples on file; include SAE/IRC for return of material. Expects minimum initial submission of 250 images with periodic submission of at least 1,000 digital pictures per year. Make first contact by e-mail. Accepts digital submissions only.

Tips "Pictures must be very sharp. Work must be consistent. We also like photographers who are specialized in particular subjects. We are always interested in Canadian content. Lots of our clients are based in Canada."

■ ■ MILESTONE MEDIA

19/5 Via Adolfo Wildt, Milan 20131 Italy. (39) (02) 26680702. Fax: (39) (02) 26681126. E-mail: info@ milestonemedia.it. Website: www.milestonemedia.it. Stock and press agency. Member of CEPIC. Has 2 million photos in files and 800,000 images online. Clients include: advertising agencies, newspapers, book publishers, calendar companies, audiovisual firms, magazine publishers, production houses.

Needs Photos of celebrities, people.

Specs Uses high-res digital files. Send via Zip, FTP, e -mail as TIFF, JPEG files.

Payment & Terms Pays 60% commission for color photos. Negotiates fees below stated minimums in cases of volume deals. Offers volume discounts to customers. Photographers can choose not to sell images on discount terms. Works with photographers on contract basis only. Offers exclusive contract only. Contracts renew automatically with additional submissions for 1 year. Statements issued monthly. Photographers allowed to review account records in cases of discrepancies only. Offers one-time rights. Model/property release preferred. Photo captions required; include location, country and any other relevant information.

How to Contact Send query letter with digital files.

MIRA

716 Iron Post Rd., Moorestown NJ 08057. (856)231-0594. E-mail: editing@mira.com. Website: http://library.mira.com/gallery-list. "Mira is the stock photo agency of the Creative Eye, a photographers cooperative. Mira seeks premium rights-protected images and contributors who are committed to building the Mira archive into a first-choice buyer resource. Mira offers a broad and deep online collection where buyers can search, price, purchase and download on a 24/7 basis. Mira sales and research support are also available via phone and e-mail. "Our commitment to customer care is something we take very seriously and is a distinguishing trait." Client industries include: advertising, publishing, corporate, marketing, education.

Needs Mira features premium stock photo images depicting a wide variety of subjects including travel, Americana, business, underwater, food, landscape, cityscapes, lifestyle, education, wildlife, conceptual and adventure sports, among many others.

Specs "We require you to use the enhanced version of the Online Captioning software or to embed your captions and keywords using the Photoshop File Info feature, or an application such as Extensis Portfolio 7 or iView MediaPro 2.6 to embed this info in the IPTC metadata fields. Please read over the Mira Keywording Guidelines (download PDF) before preparing your submission. For additional suggestions on Captioning and Keywording see the Metalogging section of the Controlled Vocabulary site."

How to Contact "E-mail, call or visit our websites to learn more about participation in Mira." **Tips** "Review the submission guidelines completely. Failure to follow the submission guidelines will result in the return of your submission for appropriate corrections."

M PTV (MOTION PICTURE AND TELEVISION PHOTO ARCHIVE)

16735 Saticoy St., Suite 109, Van Nuys CA 91406. (818)997-8292. Fax: (818)997-3998. E-mail: sales@mptyimages.com. Website: www.mptyimages.com. Established over 20 years ago, mpty is a

unique stock photo agency that is passionate about preserving the memory of some of the greatest legends of our time through the art of still photography. We offer one of the largest and continually expanding collections of entertainment photography in the world—images from Hollywood's Golden Age and all the way up to the present day. Our unbelievable collection includes some 1 million celebrity and entertainment-related images taken by more than 60 photographers from around the world. Many of these photographer's are represented exclusively through mpty and can't be found anywhere else. While mptv is located in Los Angeles, our images are used worldwide and can be seen in galleries, magazines, books, advertising, online and in various products.

How to Contact If interested in representation, send e-mail to photographers@mptvimages. com.

■ MUSIC & ARTS PICTURES AT LEBRECHT

3 Bolton Rd., London NW8-0RJ, United Kingdom. E-mail: pictures@lebrecht.co.uk. Website: www. lebrecht.co.uk. Has 120,000 high-res images online; thousands more not yet scanned. Clients include: book publishers, magazine publishers, newspapers, calendar companies, film production companies, greeting card companies, public relations firms, advertising agencies.

Needs Photos of arts personalities, performing arts, instruments, musicians, dance (ballet, contemporary and folk), orchestras, opera, concert halls, jazz, blues, rock, authors, artists, theater, comedy, art and artists. Interested in historical/vintage.

Specs Accepts images in digital format only.

Payment & Terms Pays 50% commission for b&w or color photos. Offers volume discounts to customers. Works with photographers on contract basis only. Offers limited regional exclusivity. Statements issued quarterly. Offers one-time rights. Informs photographers and allows them to negotiate when a client requests all rights. Model release required. Photo captions required; include who is in photo, location, date.

How to Contact Send e-mail.

NOVASTOCK

1306 Matthews Plantation Dr., Matthews NC 28105-2463. (888)894-8622. Fax: (704)841-8181. E-mail: novastock@aol.com. Website: www.painetworks.com/websites/zznskz600.html. Stock agency. Clients include: advertising agencies, businesses, postcard publishers, public relations firms, book publishers, calendar companies, magazine publishers, greeting card companies, and large international network of subagents.

Needs Photos of babies/children/teens, couples, multicultural, families, parents, senior citizens, disasters, environmental, wildlife, rural, adventure, health/fitness, travel, business concepts, military, science, technology/computers. "We need commercial stock subjects such as lifestyles, fitness, business, science, medical, family, etc. We also are looking for unique and unusual imagery. We have one photographer who burns, scratches and paints on his film."

Specs Prefers images in digital format as follows: (1) Original digital camera files. (2) Scanned images in the 30-50MB range. "When sending files for editing, please send small files only. Once we make our picks, you can supply larger files. Final large files should be uncompressed TIFF or JPEG saved at best-quality compression. NEVER sharpen or use contrast and saturation filters. Always flatten layers. Files and disks must be readable on Windows PC."

Payment & Terms Pays 50% commission for b&w and color photos. "We never charge the photographer for any expenses whatsoever." Works with photographers on contract basis only. "We need exclusivity only for images accepted, and similars." Photographer is allowed to market work not represented by Novastock. Statements and payments are made in the month following receipt of income from sales. Informs photographers and discusses with photographer when client requests all rights. Model/property release required. Photo captions required; include who, what and where. "Science and technology need detailed and accurate captions. Model releases must be cross-referenced with the appropriate images."

How to Contact Contact by e-mail or send query letter with digital files, slides, tearsheets, transparencies. Expects minimum initial submission of 100 images. Responds in 1 week to submissions.

Tips "Digital files on CD/DVD are preferred. All images must be labeled with caption (if necessary) and marked with model release information and your name and copyright. We market agency material through more than 50 agencies in our international subagency network. The photographer is permitted to freely market nonsimilar work any way he/she wishes."

OKAPIA KG FRANKFORT

Postfach 645-Röderbergweg 168, Frankfurt 60385 Germany. +49 (0)69 94 34 40 0. Fax: +49 (0)69 49 84 49. E-mail: info@okapia.de. Stock photo agency and picture library. Has 700,000 + photos in files. Clients include: ad agencies, book/encyclopedia publishers, magazine publishers, newspapers, postcard companies, calendar companies, greeting card companies, school book publishers.

Needs Photos of natural history, babies/children/teens, couples, families, parents, senior citizens, gardening, pets, adventure, health/fitness, travel, agriculture, industry, medical, science, technology/computers, general interest.

Specs Uses 35mm, 21/4 × 21/4, 4 × 5 transparencies. Accepts digital images. Send via DVD, CD as JPEG files at 355 dpi.

Payment & Terms Pays 50% commission for color photos. Average price per image (to clients): \$60-120 for color photos. Enforces strict minimum prices. Offers volume discounts to customers. Discount sales terms not negotiable. Works with photographers on contract basis only. Offers nonexclusive contract, limited regional exclusivity and guaranteed subject exclusivity (within files). Contracts renew automatically for 1 year with additional submissions. Charges catalog insertion fee. Statements issued quarterly, semiannually or annually, depending on money photographers earn. Payments made quarterly, semiannually or annually with statement. Photographers allowed to review account records in cases of discrepancies only. Offers onetime, electronic media and agency promotion rights. Does not permit photographers to negotiate when client requests all rights. Model/property release preferred. Photo captions required.

How to Contact Send query letter with slides. Does not keep samples on file; include SASE for return of material. Expects minimum initial submission of 300 slides. Photo guidelines free with SASE. Distributes tips sheet on request semiannually to photographers with statements.

Tips "We need every theme which can be photographed." For best results, "send pictures continuously."

OMNI-PHOTO COMMUNICATIONS

10 E. 23rd St., New York NY 10010. (212)995-0805. Fax: (212)995-0895. E-mail: info@omniphoto. com. Website: www.omniphoto.com. Stock photo and art agency. Has 100,000 photos in files. Clients include: advertising agencies, public relations firms, businesses, book/encyclopedia/ magazine/calendar/greeting card companies.

Needs Wants photos of babies/children/teens, couples, multicultural, families, senior citizens, environmental, wildlife, architecture, cities/urban, religious, rural, entertainment, food/drink, health/fitness, sports, travel, agriculture, industry, medicine.

Specs Accepts images in digital format. High-res 30-50MB JPEGs required for accepted digital

Payment & Terms Pays 50% commission. Works with photographers on contract basis only. Offers limited regional exclusivity. Contracts renew automatically with additional submissions for 4 years. Charges catalog insertion fee. Statements issued with payment on a quarterly basis. Offers one-time rights. Informs photographers and allows them to negotiate when client requests all rights. Model/property release required. Photo captions required.

How to Contact "Send low-res sample JPEGs (approximately 3 × 5) on DVD, CD, or point us to your website portfolio. Only discs with SASE are returned. No e-mail attachments."

Tips "We want spontaneous-looking, professional-quality photos of people interacting with each other. Have carefully thought-out backgrounds, props and composition, commanding use of color. Stock photographers must produce high-quality work at an abundant rate. Self-assignment is very important, as is a willingness to obtain model releases; caption thoroughly and make submissions regularly."

ONASIA

30 Cecil St., Prudential Tower Level 15, 049712, Singapore. (66)2655-4683. Fax: (66)2655-4682. E-mail: info@onasia.com. Website: www.onasia.com. An Asia-specialized agency offering rightsmanaged stock, features and assignment services. Represents over 180 photographers and has over 180,000 high-res images available online and 400,000 photos in files. Offices in Singapore and Bangkok. Clients include: advertising and graphic design agencies, newspapers, magazines, book publishers, calendar and gift card companies.

Needs Model-released Asia-related conceptual, lifestyle and business imagery as well as a broad range of nonreleased editorial imagery including current affairs, historical collections, travel and leisure, economics as well as social and political trends. Please note: "We only accept images from or relating to Asia."

Specs Accepts images in digital format. Send via CD or to our FTP site as 12 × 18 JPEG files at 300 dpi. All files must be retouched to remove dust and dirt. Photo captions required; include dates, location, country and a detailed description of image, including names where possible.

Payment & Terms Pays 50% commission to photographers. Terms specified in photographer contracts. Photographers are required to submit on an image-exclusive basis. Statements issued monthly.

How to Contact E-mail queries with lo-res JPEG samples or a link to photographer's website. Does not keep samples on file; cannot return material. Expects minimum initial submission of 150 images. Photo guidelines available via e-mail.

Tips "Provide a well-edited lo-res portfolio for initial evaluation. Ensure that subsequent submissions are tightly edited, sized to Onasia's specs, retouched and submitted with full captions."

ONREQUEST IMAGES

1415 Western Ave., Suite 300, Seattle WA 98101. (206)774-1555 or (877)202-5025. Fax: (206)774-1291. E-mail: photographer.manager@onrequestimages.com. Website: www.onrequestimages.com. Contact: Director of Photographer Relations. Estab. 2003. Custom image services. Headquartered in Seattle, the company has offices in New York, Chicago, Los Angeles, Denver, Dallas, Philadelphia and San Francisco. Clients include Fortune 1000 corporations.

Needs Photos of babies, multicultural, families, parents, senior citizens, environmental, landscapes/ scenics, architecture, education, interiors/decorating, pets, rural, adventure, food/drink, health/ fitness/beauty, travel, agriculture, business concepts, science, technology/computers. Interested in lifestyle, seasonal.

Specs Accepts images in digital format as TIFF files at 300 dpi. Send via e-mail or upload.

Payment & Terms Offers volume discounts to customers; terms specified in photographers' contracts. Photographers can choose not to sell images on discount terms. Works with photographers on contract basis only. Offers nonexclusive contract; guaranteed subject exclusivity (within files). Statements issued quarterly. Payments made within 45 days. Rights offered depend on contract. Informs photographers and allows them to negotiate when a client requests all rights. Model release/property release required. Captions required.

How to Contact E-mail query letter with link to photographer's website. Provide self-promotion piece to be kept on file. Expects minimum initial submission of 15 images. Photo guidelines sheet available.

Tips "Be honest about what you specialize in."

III OPCÃO BRASIL IMAGENS

Phone: 55 21 2256-9007. E-mail: pesquisa@opcaobrasil.com.br. Website: www.opcaobrasil.com.br. Estab. 1993. Has 600,000 + photos in files. Clients include: advertising agencies, book publishers, magazine publishers, calendar companies, postcard publishers, publishing houses.

Needs Photos of babies/children/teens, couples, families, parents, wildlife, health/fitness, beauty, education, hobbies, sports, industry, medicine. "We need photos of wild animals, mostly from the Brazilian fauna. We are looking for photographers who have images of people who live in tropical countries and must be brunette."

Specs Accepts images in digital format.

Payment & Terms Pays 50% commission for b&w or color photos. Negotiates fees below standard minimum prices only in cases of renting at least 20 images. Offers volume discounts to customers. Works with photographers on contract basis only. Offers limited regional exclusivity. Contracts renew automatically with additional submissions for 3 years. Charges \$200/image for catalog insertion. Statements issued quarterly, Payments made quarterly, Photographers allowed to review account records in cases of discrepancies only. Offers one-time rights, electronic media rights, agency promotion rights. Model release required; property release preferred. Photo captions required.

How to Contact Initial contact should be by e-mail or fax. Explain what kind of material you have. Provide business card, self-promotion piece to be kept on file. "If not interested, we return the samples." Expects minimum initial submission of 500 images with quarterly submissions of at least 300 images.

Tips "We need creative photos presenting the unique look of the photographer on active and healthy people in everyday life at home, at work, etc., showing modern and up-to-date individuals. We are looking for photographers who have images of people with the characteristics of Latin American citizens."

OUT OF THE BLUE

1022 Hancock Ave., Sarasota FL 34232. (941) 966-4042. Fax: (941)296-7345. E-mail: outoftheblue. us@mac.com. Website: www.out-of-the-blue.us. Estab. 2003. President: Michael Woodward. Licensing Manager: Jane Mason. "We are looking for fine art photographic collections, especially evocative landscapes, lakes, nautical, nature, still life, flowers, and tropical categories for canyas reproductions, poster and prints for mass market as well as fine art subjects for interior design office and hotel projects."

Needs i-We require collections, series, or groups of photographic images which are either decorative or have a more sophisticated fine art look." E-mail or CD presentations only.

Payment & Terms "Commission rate is 50% with no expenses to photographers. Photographer needs to provide high-resolution scans at 300 dpi to print at large sizes if we agree to representation." Include short bio.

Tips "Keep aware of current trends in color palettes."

OUTSIDE IMAGERY

4548 Beachcomber Ct., Boulder CO 80301. (303)530-3357. E-mail: John@outsideimagery.com. Website: www.outsideimagery.com. Stock agency. Has 200,000 images in keyword-searchable, online database. Clients include: advertising agencies, businesses, multimedia, greeting card and postcard publishers, book publishers, graphic design firms, magazine publishers.

Needs Photos showing a diversity of people participating in an active and healthy lifestyle in natural and urban settings, plus landscapes and cityscapes. Photos of people enjoying the outdoors. Babies/ children/teens, couples, multicultural, families, senior citizens. Activities and subjects include: recreation, cityscapes, skylines, environmental, landscapes/scenics, wildlife, rural, adventure, health/fitness, sports, travel, wildlife, agriculture, business and technology.

Specs Requires images in high-res digital format. No film. Send low-res files via CD or e-mail in JPEG format at 72 dpi.

Payment & Terms Pays 50% commission for all imagery. Average price per image (to clients): \$150-3,500 for all imagery. Will often work within a buyer's budget. Offers volume discounts to customers. Offers nonexclusive contract. Payments made quarterly. Model release required; property release preferred. Photo captions and keywords required.

How to Contact "First review our website. Then send a query e-mail, and include a stock list or an active link to your website. If you don't hear from us in 3 weeks, send a reminder e-mail."

■ ■ OXFORD SCIENTIFIC (OSF)

2nd Floor Waterside House 9 Woodfield Rd., London W9 2BA United Kingdom. (44)(0) 20 7432 8200. Fax: (44)(0) 20 7432 8201. E-mail: lwheatley@photolibrary.eu. Website: www.osf.co.uk. Stock agency. Stills and footage libraries. Has 350,000 photos, over 2,000 feet of HD, film and video originated footage. Clients include: advertising agencies, design companies, audiovisual firms, book/encyclopedia publishers, magazine publishers, newspapers, merchandising companies, multimedia publishers, film production companies.

Needs Photos and footage of natural history: animals, plants, behavior, close-ups, life-histories, histology, embryology, electron microscopy, scenics, geology, weather, conservation, country practices, ecological techniques, pollution, special-effects, high speed, time-lapse, landscapes, environmental, travel, sports, pets, domestic animals, wildlife, disasters, gardening, rural, agriculture, industry, medicine, science, technology/computers. Interested in seasonal.

Specs Send via CD, e-mail at 72 dpi for initial review; 300 dpi (RGB TIFF files) for final submission. Review guidelines for details.

Payment & Terms Pays 40% commission. Negotiates fees below stated minimums on bulk deals. Average price per image (to clients): \$100-2,000 for b&w and color photos; \$300-4,000 for film or videotape. Offers volume discounts to regular customers; inquire about specific terms. Discount sale terms not negotiable. Works with photographers on contract basis only; needs image exclusivity. Offers image-exclusive contract, limited regional exclusivity, guaranteed subject exclusivity. Contracts renew automatically every 5 years. There is a charge for handling footage. Offers one-time, electronic media and agency promotion rights. Informs photographers and allows them to negotiate when client requests all rights. Model/property release required. Photo captions required; include common name, Latin name, behavior, location and country, magnification where appropriate, if captive, if digitally manipulated. Contact OSF for footage terms.

How to Contact Submission guidelines available on website. Expects minimum initial submission of 100 images with quarterly submissions of at least 100 images. Interested in receiving high-quality, creative, inspiring work from both amateur and professional photographers. Responds in 1 month.

Tips "Contact via e-mail, phone or fax, or visit our website to obtain submission guidelines." Prefers to see "good focus, composition, exposure, rare or unusual natural history subjects and behavioral and action shots, inspiring photography, strong images as well as creative shots. Read photographer's pack from website or e-mail/write to request a pack, giving brief outline of areas covered and specialties and size."

PACIFIC STOCK/PRINTSCAPES.COM

7192 Kalanianaole Highway, Suite G-240, Honolulu HI 96825. (808)394-5100. Fax: (808)394-5200. E-mail: pics@pacificstock.com. Website: www.pacificstock.com. Member of Picture Archive Council of America (PACA). Has 100,000 photos in files; 25,000 digital images online. "Pacific Stock specializes exclusively in imagery from throughout the Pacific, Asia and Hawaii." Clients include: advertising agencies, public relations firms, book/encyclopedia publishers, magazine publishers, postcard companies, calendar companies, greeting card companies. "Printscapes caters to the professional interior design market at our new fine art website, www.printscapes.com."

Needs Photos and fine art of Hawaii, Pacific Islands, and Asia. Subjects for both companies include: people (women, babies/children/teens, couples, multicultural, families, parents, senior citizens), culture, marine science, environmental, landscapes, wildlife, adventure, food/drink, health/fitness, sports, travel, agriculture, business concepts. "We also have an extensive vintage Hawaii file as well as fine art throughout the Pacific Rim."

Specs Accepts images from specialized professional photographers in digital format only. Send via Hard Drive or DVD as 16-bit TIFF files (guidelines on website at www.pacificstock.com/ photographer_guidelines.asp).

Payment & Terms Pays 40% commission for color, b&w photos, or fine art imagery. Average price per image (to clients): \$650. Works with photographers and artists on contract basis only. Statements and payments issued monthly. Contributors allowed to review account records to verify sales figures. Offers one-time or first rights; additional rights with contributor's permission. Informs contributors and allows them to negotiate when client requests all rights. Model/ property release required for all people and certain properties, i.e., homes and boats. Accurate and detailed photo captions required; include: "who, what, where." See submission guidelines for more details.

How to Contact "E-mail or call us after reviewing our website and our photo guidelines." Want lists distributed regularly to represented photographers; free via e-mail to interested photographers.

Tips "Photographer must be able to supply minimum of 500 image files (must be model-released) for initial entry and must make quarterly submissions of fresh material from Hawaii, Pacific and Asia area destinations. Image files must be captioned in File Info (i.e., IPTC headers) according to our submission guidelines. Please contact us to discuss the types of imagery that sell well for us. We are also looking for fine artists whose work is representative of Hawaii and the Pacific Rim. We are interested in working with contributors who work with us and enjoy supplying imagery requested by our valued clients."

PAINET INC.

P.O. Box 171, 29 Skating Pond Rd., Montezuma NM 87731. (701)484-1251. E-mail: painet@ stellarnet.com. Website: www.painetworks.com. Picture library. Has 650,000 digital photos in files. Painet is a stock photo agency that works mainly with advertising agencies, book publishers, photo researchers and graphic designers.

Needs "Anything and everything."

Specs Refer to www.painetworks.com/helppages/submit.htm for information on how to scan and submit images to Painet. The standard contract is also available from this page. View the individual contract and the agency contract by clicking the links online.

Payment & Terms Pays 60% commission (see contract). Works with photographers with or without a contract. Offers nonexclusive contract. Payment made immediately after a sale. Informs photographers and allows them to negotiate when client requests all rights. Provides buyer contact information to photographer by sending photographer copies of the original invoices on all orders of photographer's images.

How to Contact Print out, complete and mail or e-mail a copy of the contract when sending your first submission. Note: upload highest quality JPEGs only. Images should open to 24MB, or more, in a graphics application, such as Photoshop. As of February 22, 2010, due to bandwidth limitations, we no longer can support uploading of RAW or TIFF files. We have also changed our activation time period for new submissions to 1 month in lieu of weekly.

Tips "We have added an online search engine with 650,000 images. We welcome submissions from new photographers, since we add approximately 60,000 images quarterly. Painet markets color and b&w images electronically or by contact with the photographer. Because images and image descriptions are entered into a database from which searches are made, we encourage our photographers to include lengthy descriptions that improve the chances of finding their images during a database search. We prefer descriptions be included in the IPTC (File Info area of Photoshop). Photographers who provide us their e-mail address will receive a biweekly list of current photo requests from buyers. Photographers can then send matching images via e-mail or FTP, and we forward them to the buyer. Painet also hosts photographer's and photo agency websites. See details at www.painetworks.com/helppages/setupPT.htm."

PANORAMIC IMAGES

2302 Main St., Evanston IL 60202. (847)324-7000 or (800)543-5250. Fax: (847)324-7004. E-mail: images@panoramicimages.com. Estab. 1987. Stock photo agency. Member of ASPP, NANPA and IAPP. Clients include: advertising agencies, magazine publishers, newspapers, design firms, graphic designers, corporate art consultants, postcard companies, calendar companies.

Needs Photos of lifestyles, environmental, landscapes/scenics, wildlife, architecture, cities/ urban, gardening, interiors/decorating, rural, adventure, automobiles, health/fitness, sports, travel, business concepts, industry, medicine, military, science, technology/computers. Interested in alternative process, avant garde, documentary, fine art, historical/vintage, seasonal. Works only with panoramic formats (2:1 aspect ratio or greater). Subjects include: cityscapes/skylines, international travel, nature, tabletop, backgrounds, conceptual.

Specs "Transparencies preferred for initial submission. Call for digital submission guidelines or see website."

Payment & Terms Pays 40% commission for photos. Average price per image (to clients): \$600. No charge for scanning, metadata or inclusion on website. Statements issued quarterly. Payments made quarterly. Offers one-time, electronic rights and limited exclusive usage. Model release preferred "and/or property release, if necessary." Photo captions required. Call or see website for submission guidelines before submitting.

How to Contact Send e-mail with stock list or low-res scans/lightbox. Specific want lists created for contributing photographers. Photographer's work is represented on full e-commerce website and distributed worldwide through image distribution partnerships with Cetty Images, National Geographic Society Image Collection, Amana, Digital Vision, etc.

Tips Wants to see "well-exposed chromes or very high-res stitched pans. Panoramic views of wellknown locations nationwide and worldwide. Also, generic beauty panoramics."

TAPILIO

155 Station Rd., Herne Bay, Kent CT6 5QA, United Kingdom. (44)(122)736-0996. E-mail: library@ papiliophotos.com. Website: www.papiliophotos.com. Has 120,000 photos in files. Clients include: advertising agencies, book publishers, magazine publishers, newspapers, calendar companies, greeting card companies, postcard publishers.

Needs Photos of wildlife.

Specs Prefers digital submissions. Uses digital shot in-camera as RAW and converted to TIFF for submission, minimum file size 17MB. See website for further details or contact for a full information sheet about shooting and supplying digital photos.

Payment & Terms Works with photographers on contract basis only. Offers nonexclusive contract. Statements issued quarterly. Payment made quarterly. Offers one-time rights, electronic media rights. Photo captions required; include Latin names and behavioral information and keywords.

How to Contact Send query letter with résumé. Does not keep samples on file. Expects minimum initial submission of 150 images. Responds in 1 month to samples. Returns all unsuitable material with letter. Photo guidelines sheet free with SASE.

Tips "Contact first for information about digital. Send digital submissions on either CD or DVD. Supply full caption listing for all images. Wildlife photography is very competitive. Photographers are advised to send only top-quality images."

PHOTO AGORA

3711 Hidden Meadow Lane, Keezletown VA 22832. (540)269-8283. Fax: (540)269-8283. E-mail: photoagora@aol.com. Website: www.photoagora.com. Stock photo agency. Has over 65,000 photos in files. Clients include: businesses, book/encyclopedia and textbook publishers, magazine publishers, calendar companies.

Needs Photos of families, children, students, Virginia, Africa and other Third World areas, work situations, etc. Also needs babies/children/teens, couples, multicultural, parents, senior citizens, disasters, environmental, landscapes/scenics, wildlife, cities/urban, education, gardening, pets, religious, rural, health/fitness, travel, agriculture, industry, medicine, science, technology/ computers.

Specs Send high-res digital images. Ask for password to download agreement and submission guidelines from website.

Payment & Terms Pays 50% commission for b&w and color photos. Average price per image (to clients): \$40 minimum for b&w photos; \$100 minimum for color photos. Negotiates fees below standard minimum prices. Offers volume discounts to customers; inquire about specific terms. Photographers can choose not to sell images on discount terms. Works with photographers with or without a contract. Offers nonexclusive contract. Payment made quarterly. Photographers allowed to review account records. Offers one-time rights. Informs photographers and allows them to negotiate when client requests all rights. Model/property release preferred. Embedded photo captions required; include location, important dates, scientific names, etc.

How to Contact Call, write or e-mail. No minimum number of images required in initial submission. Responds in 3 weeks. Photo guidelines free with SASE or download from website.

■ PHOTOEDIT

3505 Cadillac Ave., Suite P-101, Costa Mesa CA 92626. (800)860-2098. Fax: (800)804-3707. E-mail: sales@photoeditinc.com. Website: www.photoeditinc.com. Estab. 1987. Stock photo agency. Member of Picture Archive Council of America (PACA). Has 500,000 photos. Clients include: textbook/encyclopedia publishers, magazine publishers.

Needs Photos of people-seniors, babies, couples, adults, teens, children, families, minorities, handicapped—ethnic a plus.

Specs Uses digital images only.

Payment & Terms Pays 50% commission for color photos. Average price per image (to clients): \$200/quarter page, textbook only; other sales higher. Works on contract basis only. Offers nonexclusive contract. Payments and statements issued quarterly; monthly if earnings over \$1,000/month. Photographers are allowed to review account records. Offers one-time rights; limited time use. Consults photographer when client requests all rights. Model release preferred.

How to Contact Submit digital portfolio for review. Once accepted into agency, expects minimum initial submission of 1,000 images with additional submission of 1,000 images/year. Photo guidelines available on website.

Tips In samples, looks for "drama, color, social relevance, inter-relationships, current (not dated material), tight editing. We want photographers who have easy access to models of every ethnicity (not professional models) and who will shoot actively and on spec."

■ THE PHOTOLIBRARY GROUP

Level 11, 54 Miller St., North Sydney, N.S.W. 2090, Australia. (61)(2)9929-8511. Fax: (61)(2)9923-2319. E-mail: creative@photolibrary.com. Website: www.photolibrary.com. Estab. 1967. Stock agency. Has more than 7,000,000 high-res images Online. Clients include: advertising agencies, graphic designers, corporate, newspapers, postcard publishers, public relations firms, book publishers, calendar companies, magazine publishers, greeting card companies, web designers.

 This agency also has an office in the UK at 83-84 Long Acre, London WC2E 9NG. Phone: (44) (207)836-5591. Fax: (44)(207)379-4650; other offices in New Zealand, Singapore, Malaysia, Thailand, Philippines, India, Dubai, USA, Indonesia, Hong Kong, France. Brands in the Photolibrary Group include OSF specializing in the natural world, Garden Picture Library, fresh food, monsoon, Peter Arnold, ticket and index stock.

Needs "Contemporary imagery covering all subjects, especially model-released people in business and real life."

Specs Images must be in digital format.

Payment & Terms Pays 40% commission. Offers volume discounts to customers. Discount sales terms not negotiable. Offers guaranteed subject exclusivity. Statements issued quarterly. Photographers allowed to review account records. Offers one-time rights, electronic media rights, agency promotion rights. Model/property release required. Photo captions required; include date of skylines.

How to Contact See website for information on how to make initial submissions under Contributor tab.

PHOTOLIBRARY GROUP

23 W. 18th St., 3rd Fl., New York NY 10011. (212)929-4644 or (800)690-6979. Fax: (212)633-1914. E-mail: phyllis.giarnese@photolibrary.us.com. Website: www.photolibrary.com. "The Photolibrary Group represents the world's leading stock brands and the finest photographers around the world, to bring memorable, workable content to the creative communities in America, Europe, Asia, and the Pacific. We provide customers with access to over 5 million images and thousands of hours of footage and full composition music. Photolibrary Group was founded in 1967 and, 40 years on, has a global presence with offices in the United Kingdom (London), the USA (New York), Australia (Sydney and Melbourne), Singapore, India, Malaysia, the Philippines, Thailand, New Zealand and the United Arab Emirates. Photolibrary is always on the lookout for new and innovative photographers and footage producers. Due to the highly competitive market for stock imagery, we are very selective about the types of work that we choose to take on. We specialize in high quality, creative imagery primarily orientated to advertising, business-to-business and the editorial and publishing markets. Interested contributors should go to the website and click on the Artists tab for submission information. For additional information regarding our house brands, follow the 'About Us' link."

PHOTOLIFE CORPORATION LTD.

2/F Eton Tower, 8 Hysan Avenue, Causeway Bay, Hong Kong. (852)2808 0012. Fax: (852)2808 0072. E-mail: photo@photolife.com.hk. Website: www.photolife.com.hk. Estab. 1994. Stock photo library. Has over 1.6 million photos in files. Clients include: advertising agencies, newspapers, book publishers, calendar companies, magazine publishers, greeting card companies, corporations, production houses, graphic design firms.

Needs Wants contemporary images of architecture, interiors, garden, infrastructure, concepts, business, finance, sports, lifestyle, nature, travel, animal, marine life, foods, medical.

Specs Accepts images in digital format only. "Use only professional digital cameras (capable of producing 24+MB images) with high-quality interchangeable lenses; or images from high-end scanners producing a file up to 50MB."

Payment & Terms Pays 50% commission for b&w and color photos. Average price per image (to clients): \$105-1,550 for b&w photos; \$105-10,000 for color photos. Offers volume discounts to customers; terms specified in photographers' contracts. Works with photographers on contract basis only. Contract can be initiated with minimum 300 selected images. Quarterly submissions needed. Informs photographers and allows them to negotiate when client requests all rights. Model release required; property release preferred. Photo captions required; include destination

How to Contact E-mail 50 low-res images (1,000 pixels or less), or send CD with 50 images.

Tips "Visit our website. Edit your work tightly. Send images that can keep up with current trends in advertising and print photography."

PHOTO NETWORK

P.O. Box 317, Lititz PA 17543. (717)626-0296 or (800)622-2046. Fax: (717)626-0971. E-mail: info@ heilmanphoto.com. Website: www.heilmanphoto.com. Stock photo agency/library. Member of Picture Archive Council of America (PACA). Has more than 1 million photos in files. Clients include: agribusiness companies, ad agencies, textbook companies, graphic artists, public relations firms, newspapers, corporations, magazine publishers, calendar companies, greeting card companies. Member ASPP, NANPA, AAEA.

• Photo Network is now owned by Grant Heilman Photography.

Needs Photos of agriculture, families, couples, ethnics (all ages), animals, travel and lifestyles. Also wants photos of babies/children/teens, parents, senior citizens, disasters, environmental, wildlife, architecture, cities/urban, education, gardening, interiors/decorating, pets, religious, rural, adventure, automobiles, food/drink, health/fitness/beauty, hobbies, humor, sports, business concepts, industry, medicine, military, political, science, technology/computers. Special subject needs include people over age 55 enjoying life; medical shots (patients and professionals); children and domestic animals.

Specs Uses transparencies and digital format. Send via CD as JPEG files.

Payment & Terms Information available upon request.

How to Contact Send query letter with stock list. Send a sample of 200 images for review; include SASE for return of material. Responds in 1 month.

Tips Wants to see a portfolio "neat and well-organized and including a sampling of photographer's favorite photos." Looks for "clear, sharp focus, strong colors and good composition. We'd rather have many very good photos rather than one great piece of art. Would like to see photographers with a specialty or specialties and have it/them covered thoroughly. You need to supply new photos on a regular basis and be responsive to current trends in photo needs. Contract photographers are supplied with quarterly 'want' lists and information about current trends."

PHOTO RESEARCHERS, INC.

307 Fifth Ave., New York NY 10016. (212)758-3420 or (800)833-9033. E-mail: info@photoresearchers. com. Website: www.photoresearchers.com. Stock agency. Has over 1 million photos and illustrations in files, with 250,000 images in a searchable online database. Clients include: advertising agencies; graphic designers; publishers of textbooks, encyclopedias, trade books, magazines, newspapers, calendars, greeting cards; foreign markets.

Needs Images of all aspects of science, astronomy, medicine, people (especially contemporary shots of teens, couples and seniors). Particularly needs model-released people, European wildlife, up-to-date travel and scientific subjects. Lifestyle images must be no older than 2 years; travel images must be no older than 5 years.

Specs Prefers images in digital format.

Payment & Terms Rarely buys outright; pays 50% commission on stock sales. General price range (to clients): \$150-7,500. Works with photographers on contract basis only. Offers limited regional exclusivity. Contracts renew automatically with additional submissions for 5 years (initial term; 1 year thereafter). Charges \$15 for web placement of transparencies. Photographers allowed to review account records upon reasonable notice during normal business hours. Statements issued monthly, bimonthly or quarterly, depending on volume. Informs photographers and allows them to negotiate when a client requests to buy all rights, but does not allow direct negotiation with customer. Model/property release required for advertising; preferred for editorial. Photo captions required; include who, what, where, when. Indicate model release.

How to Contact See submission guidelines on website.

Tips "We seek the photographer who is highly imaginative or into a specialty (particularly in the scientific or medical fields). We are looking for serious contributors who have many hundreds of images to offer for a first submission and who are able to contribute often."

PHOTO RESOURCE HAWAII

111 Hekili St., #41, Kailua HI 96734. (808) 599-7773. E-mail: prh@photoresourcehawaii.com. Website: www.photoresourcehawaii.com. Stock photo agency. Has e-commerce website with electronic delivery of over 14,000 images. Clients include: ad agencies, audiovisual firms, businesses, book/encyclopedia publishers, magazine publishers, calendar companies, greeting card companies, postcard publishers.

Needs Photos of Hawaii and the South Pacific.

Specs Accepts images online only via website submission in digital format only; 48MB or larger; JPEG files from RAW files preferred.

Payment & Terms Pays 50% commission. Enforces minimum prices. Offers volume discounts to customers. Discount sales terms not negotiable. Works with photographers on contract basis only. Offers nonexclusive contract. Contracts renew automatically with additional submissions. Statements issued monthly. Payments made monthly. Offers royalty-free and rights-managed images. Model/property release preferred. Photo captions and keywording online required.

How to Contact Send query e-mail with samples. Expects minimum initial submission of 100 images with periodic submissions at least 5 times per year. Responds in 2 weeks. Offers photographer retreats in Hawaii to learn how to become a contributor and enjoy a healthy Hawaiian vacation!

PHOTOSOURCE INTERNATIONAL

1910 35th Rd., Osceola WI 54020-5602. (715)248-3800. E-mail: info@photosource.com. Website: www.photosource.com. Newsletter. "We are the meeting place for photographers who want to sell their stock photos, and for editors and art directors who want to buy them. For more than twenty-five years we've been helping photographers and photobuyers from our worldwide connected electronic cottage on our farm in western Wisconsin."

■ SYLVIA PITCHER PHOTO LIBRARY

75 Bristol Rd., Forest Gate, London E7 8HG, United Kingdom. E-mail: SPphotolibrary@aol.com. Website: www.sylviapitcherphotos.com. Picture library. Has 70,000 photos in files. Clients include: book publishers, magazine publishers, design consultants, record and TV companies.

Needs Photos of musicians—blues, country, bluegrass, old time and jazz with views of America that could be used as background to this music. Also, other relevant subject matter such as recording studios, musicians' birth places, clubs, etc. Please see website for a good indication of the library's contents.

Specs Accepts images in digital format.

Payment & Terms Pays 50% commission for b&w and color photos. Average price per image (to clients): \$105-1,000. Negotiates fees below stated minimum for budget CDs or multiple sale. Offers volume discounts to customers; terms specified in photographers' contracts. Photographers can choose not to sell images on discount terms, if specified at time of depositing work in library. Works with photographers with or without contract; negotiable. Offers nonexclusive contract. Contracts renew automatically with additional submissions for 3 years. Statements issued quarterly. Payment made when client's check has cleared. Offers one-time rights. Model/property release preferred. Photo captions required; include artist, place/venue, date taken.

How to Contact Send query letter with CD of approximately 10 low-res sample images and stock list. Provide self-promotion piece to be kept on file. Expects minimum initial submission of 50 high-res images on CD with further submissions when available.

PIX INTERNATIONAL

3600 N. Lake Shore Dr., 612 Fl., Chicago IL 60613, (773)975-0158, E-mail: pixintl@vahoo.com. Website: www.pixintl.com. Stock agency, news/feature syndicate. Has 200,000 photos in files. Clients include: advertising agencies, public relations firms, businesses, book publishers, magazine publishers, newspapers.

Needs Photos of celebrities, entertainment, performing arts.

Specs Accepts images in digital format only. E-mail link to website. "Do not e-mail any images, Do not send any unsolicited digital files. Make contact first to see if we're interested."

Payment & Terms Pays 50% commission for b&w or color photos, film. Average price per image (to clients): \$35 minimum for b&w or color photos; \$75-3,000 for film. Enforces minimum prices. Offers volume discounts to customers; terms specified in photographers' contracts. Discount sales terms not negotiable. Works with photographers with or without a contract; negotiable. Statements issued monthly. Payments made monthly. Photographers allowed to review account records in cases of discrepancies only. Offers one-time rights, Informs photographers and allows them to negotiate when client requests all rights. Model release not required for general editorial. Photo captions required; include who, what, when, where, why.

How to Contact "E-mail us your URL with thumbnail examples of your work that can be clicked for a larger viewable image." Responds in 2 weeks to samples, only if interested.

Tips "We are looking for razor-sharp images that stand up on their own without needing a long caption. Let us know by e-mail what types of photos you have, your experience, and cameras used. We do not take images from the lower-end consumer cameras—digital or film. They just don't look very good in publications. For photographers we do accept, we would only consider high-res 300dpi at 6 × 9 or higher scans submitted on CDR. Please direct us to samples on your website."

🏻 🖪 PLANS, LTD. (PHOTO LIBRARIES AND NEWS SERVICES)

#201 Kamako Bldg., 1-8-9 Ohgi-gaya Kamakura 248-0011 Japan. 81-467-23-2350. Fax: 81-467-23-2351. E-mail: yoshida@plans.jp. Website: www.plans.jp. Was stock agency; now representing JaincoTech Japan as a joint project in scanning, keywording, dustbusting and color correction for photographers in the stock photo market. Has 100,000 photos in files. Clients include: photo agencies, newspapers, book publishers, magazine publishers, advertising agencies.

Needs "We do consulting for photo agencies for the Japanese market."

How to Contact Send query e-mail. Responds only if interested.

T PONKAWONKA

97 King High Ave., Toronto ON M3H 3B3 Canada. (416)638-2475. E-mail: contact@ponkawonka. com. Website: www.ponkawonka.com. Estab. 2002. Stock agency. Has 60,000 + photos in files. Clients include: advertising agencies, businesses, newspapers, public relations firms, book publishers, calendar companies, magazine publishers.

Needs Photos of religious events and holy places. Interested in avant garde, documentary, historical/ vintage. "Interested in images of a religious or spiritual nature. Looking for photos of ritual, places of worship, families, religious leaders, ritual objects, historical, archaeological, anything religious, especially in North America."

Specs Accepts images in digital format. Send via CD or DVD as TIFF or JPEG files.

Payment & Terms Pays 50% commission for any images. Offers volume discounts to customers. Works with photographers on contract basis only. Charges only apply if negatives or transparencies have to be scanned. Statements issued quarterly. Payments made quarterly. Offers one-time rights. Informs photographers and allows them to negotiate when client requests all rights. Model/property release preferred. Photo captions required; include complete description and cutline for editorial images.

How to Contact Send query e-mail. Does not keep samples on file; cannot return material. Expects minimum initial submission of 200 images with annual submissions of at least 100

images. Responds only if interested; send 30-40 low-res samples by e-mail. Photo guidelines available on website.

Tips "We are always looking for good, quality images of religions of the world. We are also looking for photos of people, scenics and holy places of all religions. Send us sample images. First send us an e-mail introducing yourself, and tell us about your work. Let us know how many images you have that fit our niche and what cameras you are using. If it looks promising, we will ask you to e-mail us 30-40 low-res images (72 dpi, no larger than 6 inches on the long side). We will review them and decide if a contract will be offered. Make sure the images are technically and esthetically salable. Images must be well-exposed and a large file size. We are an all-digital agency and expect scans to be high-quality files. Tell us if you are shooting digitally with a professional DSLR or if scanning from negatives with a professional slide scanner."

POSITIVE IMAGES

61 Wingate St., Haverhill MA 01832. (978)556-9366. Fax: (978)556-9448. E-mail: pat@ positiveimagesphoto.com. Website: www.agpix.com/positiveimages. Stock photo agency and fine art gallery. Member of ASPP, GWAA. Clients include advertising agencies, public relations firms, book/encyclopedia publishers, magazine publishers, greeting card and calendar companies, sales/ promotion firms, design firms.

Needs Horticultural images showing technique and lifestyle, photo essays on property-released homes and gardens, travel images from around the globe, classy and funky pet photography, health & nutrition, sensitive and thought-provoking images suitable for high-end greeting cards, calendarquality landscapes, castles, lighthouses, country churches. Model/property releases preferred.

Payment & Terms Pays 50% commission for stock photos; 60% commission for fine art. Average price per image (to clients): \$250. Works with photographers on contract basis only. Offers limited regional exclusivity. Payments made quarterly. Offers one-time and electronic media rights. "We never sell all rights."

How to Contact "Positive Images Stock is accepting limited new collections; however, if your images are unique and well organized digitally, we will be happy to review online after making e-mail contact. Our Gallery 61 will review fine art photography portfolios online as well and will consider exhibiting nonmembers' work."

Tips "Positive Images has taken on more of a boutique approach, limiting our number of photographers so that we can better service them and offer a more in-depth and unique collection to our clients. Gallery 61 is a storefront in a small historic arts district. Our plan is to evolve this into an online gallery as well. We are always in search of new talent, so we welcome anyone with a fresh approach to contact us!"

PURESTOCK

7660 Centurion Pkwy., Jacksonville FL 32256. (904)680-1990 or (800)828-4545. Fax: (904)641-4480. E-mail: yourfriends@superstock.com. Website: www.superstock.com/purestock. "The Purestock royalty-free brand is designed to provide the professional creative community with highquality images at high resolution and very competitive pricing. Purestock offers CDs and singleimage downloads in a wide range of categories including lifestyle, business, education and sports to distributors in over 100 countries. Bold and fresh beyond the usual stock images."

Needs "A variety of categories including lifestyle, business, education, medical, industry, etc."

Specs "Digital files which are capable of being output at 80MB with minimal interpolation. File must be 300 dpi, RGB, TIFF at 8-bit color."

Payment & Terms Statements issued monthly to contracted image providers. Model release required. Photo captions required.

How to Contact Submit a portfolio including a subject-focused collection of 300+ images. Photo guidelines available on website at www.superstock.com/submissions.asp.

Tips "Please review our website to see the style and quality of our imagery before submitting."

M B RAILPHOTOLIBRARY.COM

Newton Harcourt, Leicester, Leicestershire LE8 9FH United Kingdom. (44)(116)259-2068. Website: www.railphotolibrary.com. Estab. 1969. Has 400,000 photos in files relating to railways worldwide. Clients include: advertising agencies, businesses, newspapers, postcard publishers, public relations firms, book publishers, calendar companies, audiovisual firms, magazine publishers, greeting card companies.

Needs Photos of railways.

Specs Uses digital images; glossy b&w prints; 35mm, $2\frac{1}{4} \times 2\frac{1}{4}$ transparencies.

Payment & Terms Buys photos, film or videotape outright depending on subject; negotiable. Pays 50% commission for b&w or color photos. Average price per image (to clients): \$125 maximum for b&w or color photos. Works with photographers with or without a contract; negotiable. Statements issued quarterly. Photographers allowed to review account records in cases of discrepancies only. Photo captions preferred.

How to Contact Send query letter with slides, prints. Portfolio may be dropped off Monday through Saturday. Does not keep samples on file; include SAE/IRC for return of material. Unlimited initial submission.

Tips "Submit well-composed pictures of all aspects of railways worldwide: past, present and future; captioned digital files, prints or slides. We are the world's leading railway picture library, and photographers to the railway industry."

REX USA

1133 Broadway Suite 1626, New York NY 10010. (212) 586-4432. E-mail: requests@rexusa.com. Website: www.rexusa.com. Estab. 1935. Stock photo agency, news/feature syndicate. Affiliated with Rex Features in London. Member of Picture Archive Council of America (PACA). Has 1.5 million photos. Clients include: advertising agencies, public relations firms, audiovisual firms, businesses, book/encyclopedia publishers, magazine publishers, newspapers, postcard companies, calendar companies, greeting card companies, TV, film and record companies.

Needs Primarily editorial material: celebrities, personalities (studio portraits, candid, paparazzi), human interest, news features, movie stills, glamour, historical, geographic, general stock, sports and scientific.

Specs Digital only.

Payment & Terms Pays 50-65% commission; payment varies depending on quality of subject matter and exclusivity. "We obtain highest possible prices, starting at \$100-100,000 for one-time sale." Pays 50% commission for b&w and color photos. Works with or without contract. Offers nonexclusive contract. Statements issued monthly. Payment made monthly. Photographers allowed to review account records. Offers one-time, first and all rights. Informs photographers and allows them to negotiate when client requests all rights. Model release required. Photo captions required.

How to Contact E-mail query letter with samples and list of stock photo subjects.

ROBERTSTOCK / CLASSICSTOCK

4203 Locust St., Philadelphia PA 19104. E-mail: info@robertstock.com. Website: www.robertstock.com, www.classicstock.com. Stock photo agency. Member of the Picture Archive Council of America (PACA). Has 2 different websites: Robertstock offers contemporary rights-managed and royalty-free images; ClassicStock offers retro and vintage images. Clients include: advertising agencies, public relations firms, audiovisual firms, businesses, book/encyclopedia publishers, magazine publishers, newspapers, postcard publishers, calendar companies, greeting card companies.

Needs Uses images on all subjects in depth.

Specs Accepts images in digital format. Send via CD, Zip at 300 dpi, 50MB or higher.

Payment & Terms Pays 45-50% commission. Works with photographers with or without a contract; negotiable. Offers various contracts. Statements issued monthly. Payment made

monthly. Payment sent with statement. Photographers allowed to review account records to verify sales figures "upon advance notice." Offers one-time rights. Informs photographers when client requests all rights. Model release required. Photo captions required.

How to Contact Send query letter. Does not keep samples on file. Expects minimum initial submission of 250 images with quarterly submissions of 250 images. Responds in 1 month. Photo guidelines available.

🏻 🖪 SCIENCE PHOTO LIBRARY, LTD.

327-329 Harrow Rd., London W9 3RB United Kingdom. +44(0)20 7432 1100. Fax: +44(0)20 7286 8668. E-mail: info@sciencephoto.com. Website: www.sciencephoto.com. Stock photo agency. Clients include: book publishers, magazines, newspapers, medical journals, advertising, design, TV and the Web in the U.K. and abroad. "We currently work with agents in over 30 countries. including America, Japan, and in Europe."

Needs Specializes in all aspects of science, medicine and technology.

Specs Digital only via CD/DVD. File sizes at least 38MB with no interpolation. Captions, model, and property releases required.

Payment & Terms Pays 50% commission. Works on contract basis only. Agreement made for 5 years; general continuation is assured unless otherwise advised. Offers exclusivity. Statements issued quarterly. Payments made quarterly. Photographers allowed to review account records to verify sales figures; fully computerized accounts/commission handling system. Model and property release required. Photo captions required. "Detailed captions can also increase sales so please provide us with as much information as possible."

How to Contact "Please complete the inquiry form on our website so that we are better able to advise you on the saleability of your work for our market. You may e-mail us low-res examples of your work. Once you have provided us with information, the editing team will be in contact within 2-3 business weeks. Full photo guidelines available on website."

■ SILVER IMAGE®

4104 NW 70th Terrace, Gainesville FL 32606. (352)373-5771. Fax: (352)374-4074. E-mail: silverimagephotoagency@gmail.com. Website: www.silver-image.com, www.silverimageweddings. com. Stock photo agency and rep for award-winning wedding photojournalists. Assignments in Florida and southern Georgia. Has 150,000 photos in files. Clients include: public relations firms. book/encyclopedia publishers, brides and grooms, magazine publishers, newspapers.

Needs Wants Photos from Florida only: nature, travel, tourism, news, people.

Specs Accepts images in digital format only. Send via CD, FTP, e-mail as JPEG files upon request only. No longer accepting new photographers.

Payment & Terms Pays 50% commission for image licensing fees. Average price per image (to clients): \$150-600. Works with photographers on contract basis only. Offers nonexclusive contract. Payment made monthly. Statements provided when payment is made. Photographers allowed to review account records. Offers one-time rights. Informs photographer and allows them to be involved when client requests all rights. Model release preferred. Photo captions required; include name, year shot, city, state, etc.

How to Contact Send query letter via e-mail only. Do not submit material unless first requested.

Tips "I will review a photographer's work to see if it rounds out our current inventory. Photographers should review our website to get a feel for our needs. We will gladly add a photographer's e-mail address to our online photo requests list."

■ SKYSCAN PHOTOLIBRARY

Oak House, Toddington, Cheltenham, Gloucestershire GL54 5BY United Kingdom. (44)(124)262-1357. Fax: (44)(124)262-1343. E-mail: info@skyscan.co.uk. Website: www.skyscan.co.uk. Picture library. Member of the British Association of Picture Libraries and Agencies (BAPLA) and the

National Association of Aerial Photographic Libraries (NAPLIB), Has more than 450,000 photos in files. Clients include: advertising agencies, public relations firms, businesses, book publishers, magazine publishers, newspapers, calendar companies, postcard publishers.

Needs "Anything aerial! Air-to-ground; aviation; aerial sports. As well as holding images ourselves, we also wish to make contact with holders of other aerial collections worldwide to exchange information."

Specs Uses color and b&w prints; any format transparencies. Accepts images in digital format. Send via CD, e-mail.

Payment & Terms Pays 50% commission for b&w and color photos. Average price per image (to clients): \$100 minimum. Enforces strict minimum prices. Offers volume discounts to customers. Photographers can choose not to sell images on discount terms. Works with photographers with or without a contract; negotiable. Offers guaranteed subject exclusivity (within files); negotiable to suit both parties. Statements issued quarterly. Payment made quarterly. Photographers allowed to review account records in cases of discrepancies only. Offers one-time, electronic media and agency promotion rights. Informs photographers and allows them to negotiate when a client requests all rights. Will inform photographers and act with photographer's agreement. Model/property release preferred for "air-to-ground of famous buildings (some now insist they have copyright to their building)." Photo captions required; include subject matter, date of photography, location, interesting features/notes.

How to Contact Send query letter or e-mail. Provide résumé, business card, self-promotion piece or tearsheets to be kept on file. Agency will contact photographer for portfolio review if interested. Portfolio should include color slides and transparencies. Does not keep samples on file; include SAE for return of material. No minimum submissions. Photo guidelines sheet free with SAE. Catalog free with SAE. Market tips sheet free quarterly to contributors only.

Tips "We have invested heavily in suitable technology and training for in-house scanning, color management, and keywording, which are essential skills in today's market. Contact first by letter or e-mail with résumé of material held and subjects covered."

SOVFOTO/EASTFOTO, INC.

263 W. 20th St. #3, New York NY 10011. (212)727-8170. Fax: (212)727-8228. E-mail: info@sovfoto. com. Website: http://sovfoto.com. Estab. 1935. Stock photo agency. Has 500,000 + photos in files. Clients include: advertising firms, audiovisual firms, book/encyclopedia publishers, magazine publishers, newspapers.

Needs All subjects acceptable as long as they pertain to Russia, Eastern European countries, Central Asian countries or China.

Specs Uses b&w historical; color prints; 35mm transparencies. Accepts images in digital format. Send via CD or DVD as TIFF files.

Payment & Terms Pays 50% commission. Average price per image (to clients): \$150-500 for b&w or color photos for editorial use. Statements issued quarterly. Payment made quarterly. Photographers allowed to review account records to verify sales figures or account for various deductions. Offers one-time print, electronic media, and nonexclusive rights. Model/property release preferred. Photo captions required.

How to Contact Arrange personal interview to show portfolio. Send query letter with samples, stock list. Keeps samples on file. Expects minimum initial submission of 50-100 images.

Tips Looks for "news and general interest photos (color) with human element."

SPORTSLIGHT PHOTO

6 Berkshire Circle, Great Barrington MA 01230. (413)528-8457; (347)819-1503 (mobile). E-mail: rbkanu@yahoo.com. Stock photo agency. Has 500,000 photos in files. Clients include: advertising agencies, public relations firms, corporations, book publishers, magazine publishers, newspapers, postcard companies, calendar companies, greeting card companies, design firms.

Needs "We specialize in every sport in the world. We deal primarily in the recreational sports such as skiing, golf, tennis, running, canoeing, etc., but are expanding into pro sports, and have needs for all pro sports, action and candid close-ups of top athletes. We also handle adventure-travel photos, e.g., rafting in Chile, trekking in Nepal, dogsledding in the Arctic, etc."

Specs Uses 35mm transparencies. Accepts images in digital format. Send via CD. Contact us prior to shipment.

Payment & Terms Pays 50% commission. Average price per image (to clients): \$100-6,000. Contract negotiable. Offers limited regional exclusivity. Contract is of indefinite length until either party (agency or photographer) seeks termination. Charges \$5/image for duping fee; \$3 for catalog and digital CD-ROM insertion promotions. Statements issued quarterly. Payments made quarterly. Photographers allowed to review account records to verify sales figures "when discrepancy occurs." Offers one-time rights; sometimes exclusive rights for a period of time; and other rights, depending on client. Informs photographers and consults with them when client requests all rights. Model release required for corporate and advertising usage. (Obtain releases whenever possible.) Strong need for model-released "pro-type" sports. Photo captions required; include who, what, when, where, why.

How to Contact Interested in receiving work from newer and known photographers. Cannot return unsolicited material. Responds in 2-4 weeks. Photo guidelines free with SASE. See website for more information regarding digital transmission. For review, send JPEG files at 72 dpi via e-mail or CD; or "direct us to your website to review images for consideration."

Tips "We look for a range of sports subjects that shows photographer's grasp of the action, drama, color and intensity of sports, as well as capability of capturing great shots under all conditions in all sports. Want well-edited, perfect exposure and sharpness, good composition and lighting in all photos. Seeking photographers with strong interests in particular sports. Shoot variety of action, singles and groups, youths, male/female—all combinations; plus leisure, relaxing after tennis, lunch on the ski slope, golf's 19th hole, etc. Sports fashions change rapidly, so that is a factor. Art direction of photo shoots is important. Avoid brand names and minor flaws in the look of clothing. Attention to detail is very important. Shoot with concepts/ideas such as teamwork, determination, success, lifestyle, leisure, cooperation in mind. Clients look not only for individual sports but for photos to illustrate a mood or idea. There is a trend toward use of real-life action photos in advertising as opposed to the set-up slick ad look. More unusual shots are being used to express feelings, attitude, etc."

TOM STACK & ASSOCIATES, INC.

154 Tequesta St., Taavernier FL 33070. (305)852-5520. Fax: (305)852-5570. E-mail: tomstack@ earthlink.net. Website: www.tomstackphoto.com. Has 500,000 photos in files. Clients include: advertising agencies, public relations firms, businesses, audiovisual firms, book publishers, magazine publishers, encyclopedia publishers, postcard companies, calendar companies, greeting card companies.

Needs Photos of wildlife, endangered species, marine life, landscapes; foreign geography; photomicrography; scientific research; whales; solar heating; mammals such as weasels, moles, shrews, fisher, marten, etc.; extremely rare endangered wildlife; wildlife behavior photos; lightning and tornadoes; hurricane damage; dramatic and unusual angles and approaches to composition, creative and original photography with impact. Especially needs photos on life science, flora and fauna and photomicrography. No run-of-the-mill travel or vacation shots. Special needs include photos of energy-related topics-solar and wind generators, recycling, nuclear power and coal burning plants, waste disposal and landfills, oil and gas drilling, supertankers, electric cars, geothermal energy.

Specs Only accepts images in digital format. Send sample JPEGs or link to website where your images can be viewed.

Payment & Terms Pays 50% commission. Average price per image (to clients): \$150-200 for color photos; as high as \$7,000. Works with photographers on contract basis only. Contracts

renew automatically with additional submissions for 3 years. Statements issued quarterly, Payments made quarterly. Offers one-time and electronic media rights. Informs photographers and allows them to negotiate when client requests all rights. Model release preferred. Photo captions preferred.

How to Contact E-mail tomstack@earthlink.net

Tips "Strive to be original, creative and take an unusual approach to the commonplace; do it in a different and fresh way. We take on only the best so we can continue to give more effective service."

STILL MEDIA

714 Mission Park Dr., Santa Barbara CA 93105. (805)682-2868. Fax: (805) 682-2659. E-mail: info@ stillmedia.com. Website: www.stillmedia.com. Photojournalism and stock photography agency. Has 500,000 photos in files. Clients include: advertising agencies, public relations firms, businesses, book/encyclopedia publishers, magazine publishers, newspapers, calendar companies.

Needs Reportage, world events, travel, cultures, business, the environment, sports, people, industry.

Specs Accepts images in digital format only. Contact via e-mail.

Payment & Terms Pays 50% commission for color photos. Works with photographers on contract basis only. Offers nonexclusive and guaranteed subject exclusivity contracts. Statements issued quarterly. Payment made quarterly. Photographers allowed to review account records. Offers onetime and electronic media rights. Model/property release preferred. Photo captions required.

STOCK CONNECTION

110 Frederick Ave., Suite A, Rockville MD 20850. (301)251-0720. Fax: (301)309-0941. E-mail: photos@scphotos.com. Website: www.scphotos.com. Stock photo agency. Member of the Picture Archive Council of America (PACA). Has over 200,000 photos in files. Clients include advertising agencies, graphic design firms, magazine and textbook publishers, greeting card companies.

Needs "We handle many subject categories including lifestyles, business, concepts, sports and recreation, travel, landscapes and wildlife. We will help photographers place their images into our extensive network of over 35 distributors throughout the world. We specialize in placing images where photo buyers can find them."

Specs Accepts images in digital format (TIFF or hi-quality JPEG), minimum 50MB uncompressed, 300 dpi, Adobe RGB.

Payment & Terms Pays 65% commission. Average price per image (to client): \$450-500. Works with photographers on contract basis only. Offers non-exclusive contract. Contracts renew automatically with additional submissions. Photographers may cancel contract with 60 days written notice. Charges for keywording average \$3 per image, depending on volume. If photographer provides acceptable scans and keywords, no upload charges apply. Statements issued monthly. Photographers allowed to review account records. Offers rights-managed and royalty-free. Informs photographers when a client requests exclusive rights. Model/property release required. Photo captions required.

How to Contact Please e-mail for submission guidelines. Prefer a minimum of 100 images as an initial submission.

Tips "The key to success in today's market is wide distribution of your images. We offer an extensive network reaching a large variety of buyers all over the world. Increase your sales by increasing your exposure."

■ STOCKFOOD

Tumblingerstr. 32, Munich 80337 Germany. (49)(89)74720222. Fax: (49)(89)7211020. E-mail: petra. thierry@stockfood.com. Website: www.stockfood.com. Estab. 1979. Stock agency, picture library. Member of the Picture Archive Council of America (PACA). Has over 250,000 photos in files. Clients include: advertising agencies, businesses, newspapers, postcard publishers, public relations firms, book publishers, calendar companies, magazine publishers, greeting card companies.

Needs Photos and video clips of food/drink, health/fitness/food, wellness/spa, people eating and drinking, interiors, nice flowers and garden images, eating and drinking outside, table settings.

Specs Uses 21/4 × 21/4, 4 × 5, 8 × 10 transparencies. Accepts only digital format. Send via CD/DVD as TIFF files at 300 dpi, 34MB minimum (12 MIO.PIXL). Submission guidelines on our website.

Payment & Terms Pays 40% commission for rights managed images. Enforces minimum prices. Works with photographers on contract basis only. Offers limited regional exclusivity, guaranteed subject exclusivity (within files). Contracts renew automatically. Statements issued quarterly. Photographers allowed to review account records. Offers one-time rights. Model release required; photo captions required.

How to Contact Send e-mail with new examples of your work as JPEG files.

🕅 🛂 🗏 🖼 STOCK FOUNDRY IMAGES

P.O. Box 78089, Ottawa ON K2E1B1, Canada. (613)258-1551 or (866)644-1644. Fax: (613)258-1551. E-mail: info@stockfoundry.com. Website: www.stockfoundry.com. Estab. 2006. Stock agency. Clients include: advertising agencies, businesses, newspapers, public relations firms, book publishers, audiovisual firms, magazine publishers.

Needs Photos of babies/children/teens, celebrities, couples, multicultural, families, parents, senior citizens, architecture, cities/urban, education, gardening, interiors/decorating, pets, religious, rural, agriculture, business concepts, industry, medicine, military, political, product shots/still life, science, technology/computers, disasters, environmental, landscapes/scenics, wildlife, adventure, automobiles, entertainment, events, food/drink, health/fitness/beauty, hobbies, humor, performing arts, sports, travel. Interested in alternative process, avant garde, documentary, erotic, fashion/ glamour, fine art, historical/vintage, lifestyle, seasonal.

Specs Accepts images in digital format. Send via CD. Save as EPS, JPEG files at 300 dpi. For film and video: .MOV.

Payment & Terms Buys photos/film/video outright. Pays \$25 minimum for all photos, film and videotape. Pays \$250 maximum for all photos, film and videotape. Pays 50% commission. Average price per image (to clients): \$60 minimum for all photos, film and videotape. Negotiates fees below stated minimums. Offers volume discounts to customers. Terms specified in photographer's contracts. Works with photographers on contract basis only. Offers guaranteed subject exclusivity (within files). Contracts renew automatically with additional submissions. "Term lengths are set on each submission from the time new image submissions are received and accepted. There is no formal obligation for photographers to pay for inclusion into catalogs, advertising, etc.; however, we do plan to make this an optional item." Statements issued monthly or in real time online. Payments made monthly. Photographers allowed to review account records in cases of discrepancies only. Informs photographers and allows them to negotiate when a client requests all rights. Negotiates fees below stated minimums. "Volume discounts sometimes apply for preferred customers." Model/property release required. Captions preferred: include actions, location, event, and date (if relevant to the images, such as in the case of vintage collections).

How to Contact E-mail query letter with link to photographer's website. Send query letter with tearsheets, stocklist. Portfolio may be dropped off Monday through Friday. Expects initial submission of 100 images with monthly submission of at least 25 images. Responds only if interested; send nonreturnable samples. Provide résumé to be kept on file. Photo guidelines sheet available online. Market tips sheet is free annually via e-mail to all contributors.

Tips "Submit to us contemporary work that is at once compelling and suitable for advertising. We prefer sets of images that are linked stylistically and by subject matter (better for campaigns). It is acceptable to shoot variations of the same scene (orientation, different angles, with copy space and without, etc.); in fact, we encourage it. Please try to provide us with accurate descriptions, especially as they pertain to specific locations, places, dates, etc. Our wish list for the submission process would be to receive a PDF tearsheet containing small thumbnails of all the high-res images. This would save us time, and speed up the evaluation process."

STOCKMEDIA.NET

1123 Broadway, Suite 1006, New York NY 10010, United States. (212) 463-8300. Fax: (212) 929-6965. E-mail: info@stockmedia.net. Website: www.stockmedia.net. Estab. 1998. Stock photo syndicate. Clients include: photographers, photo agencies, major publishers.

Needs "For photographers and stock photo agencies, we provide software and websites for e-commerce, image licensing, global rights control and fulfillment. We also serve as a conduit, passing top-grade, model-released production stock to foreign agencies."

Specs Uses digital files only.

Payment & Terms Pays 40-60% commission. Works on contract basis only. Offers image exclusive contract only if distribution desired. Contracts renew automatically on annual basis. Statements are automated and displayed online. Payments made monthly. Photographers allowed to review account records to verify sales figures online at website or "upon reasonable notice, during normal business hours." Offers one-time rights. Requests agency promotion rights. Informs photographer and allows them to negotiate when client requests all rights. Model/property release required. Photo captions preferred; include "who, what, where, when, why and how."

How to Contact Send query letter with résumé of credits. Responds "only when photographer is of interest." Photo guidelines sheet available. Tips sheet not distributed.

Tips Has strong preference for experienced photographers. "For distribution, we deal only with top shooters seeking long-term success. If you have not been with a stock photo agency for several years, we would not be the right distribution channel for you."

STOCK OPTIONS

P.O. Box 1048, Fort Davis TX 79734. (432)426-2777. Fax: (432)426-2779. E-mail: stockoptions@ sbcglobal.net. Estab. 1985. Stock photo agency. Member of Picture Archive Council of America (PACA). Has 150,000 photos in files. Clients include: advertising agencies, public relations firms, audiovisual firms, corporations, book/encyclopedia and magazine publishers, newspapers, postcard companies, calendar companies, greeting card companies.

Needs Emphasizes the southern US. Files include Gulf Coast scenics, wildlife, fishing, festivals, food, industry, business, people, etc. Also western folklore and the Southwest.

Specs Uses 35mm, 21/4 × 21/4, 4 × 5 transparencies.

Payment & Terms Pays 50% commission for color photos. Average price per image (to client): \$300-3,000. Works with photographers on contract basis only. Offers nonexclusive contract. Contracts renew automatically with each submission for 5 years from expiration date. When contract ends photographer must renew within 60 days. Charges catalog insertion fee of \$300/ image and marketing fee of \$10/hour. Statements issued upon receipt of payment from client. Payment made immediately. Photographers allowed to review account records to verify sales figures. Offers one-time and electronic media rights. "We will inform photographers for their consent only when a client requests all rights, but we will handle all negotiations." Model/ property release preferred for people, some properties, all models. Photo captions required; include subject and location.

How to Contact Interested in receiving work from full-time commercial photographers. Arrange a personal interview to show portfolio. Send query letter with stock list. Contact by phone and submit 200 sample photos. Tips sheet distributed annually to all photographers.

Tips Wants to see "clean, in-focus, relevant and current materials." Current stock requests include industry, environmental subjects, people in up-beat situations, minorities, food, cityscapes and rural scenics.

STOCKYARD PHOTOS

1410 Hutchins St., Houston TX 77003. (713)520-0898. Fax: (713)227-0399. E-mail: jim@stockyard. com. Website: www.stockyard.com. Estab. 1992. Stock agency. Niche agency specializing in images of Houston and China. Has thousands of photos in files. Clients include: advertising agencies, businesses, newspapers, postcard publishers, public relations firms, book publishers, calendar companies, audiovisual firms, magazine publishers, greeting card companies, real estate firms, interior designers, retail catalogs.

Needs Photos relating to Houston, Texas and the Gulf Coast.

Specs Accepts images in digital format only. To be considered, e-mail URL to photographer's website, showing a sample of 20 images for review.

Payment & Terms Average price per image (to clients): \$250-1,500 for color photos. Offers volume discounts to customers. Photographers can choose not to sell images on discount terms.

■ ■ STSIMAGES STOCK TRANSPARENCY SERVICES

225, Neha Industrial Estate, Off Dattapada Rd., Borivali (East), Mumbai 400 066 India. (91) (222)870-1586. Fax: (91)(222)870-1609. E-mail: info@STSimages.com. Website: www.STSimages. com. Contact: Mr. Pawan Tikku. Estab. 1993. Has over 200,000 photos on website. Clients include: advertising agencies, businesses, postcard publishers, public relations firms, book publishers, calendar companies, freelance web designers, audiovisual firms, magazine publishers, greeting card companies.

Needs Royalty free and rights managed images of babies/children/teens, celebrities, couples, multicultural, families, parents, senior citizens, disasters, environmental, landscapes/scenics, wildlife, architecture, cities/urban, education, gardening, interiors/decorating, pets, religious, rural, adventure, automobiles, entertainment, events, food/drink, health/fitness, hobbies, humor, performing arts, sports, travel, agriculture, business concepts, industry, medicine, military, political, product shots/still life, science, technology/computers. Interested in alternative process, avant garde, documentary, fashion/glamour, fine art, historical/vintage, seasonal. Also needs vector

Specs Accepts images in digital format only. Send via DVD or Direct Upload to website, JPEG files at 300 dpi. Minimum file size 25MB, preferred 50MB or more. Image submissions should be made separately for rights managed and royalty free images.

Payment & Terms Pays 50% commission. Average price per image (to clients): \$20 minimum for b&w or color photos. Enforces minimum prices. Offers to customers. Works with photographers on contract basis only. Offers non-exclusive contract, limited regional exclusivity. Contracts renew automatically with additional submissions for 3 years. Statements issued quarterly. Payments made monthly. Photographers allowed to review account records. Offers royalty-free images as well as one-time rights. Model release required; property release preferred. Photo captions and keyword are mandatory in the File Info area of the image. Include names, description, location.

How to Contact Send e-mail with image thumbnails. Expects minimum initial submission of 200 images with regular submissions of at least some images every month. Responds in 1 month to queries. Ask for photo guidelines by e-mail. Market tips available to regular contributors only. Tips 1) Strict self-editing of images for technical faults. 2) Proper keywording is essential. 3) All images should have the photographer's name in the IPTC(XMP) area. 4) All digital images must contain necessary keywords and caption information within the File Info section of the image file. 5) Send images in both vertical and horizontal formats.

SUGAR DADDY PHOTOS

732½ Alpine St., Los Angeles CA 90012. (626)627-5127. Website: www.sugardaddyphotos.com. Stock agency and picture library. Clients include: advertising agencies, businesses, newspapers, postcard publishers, public relations firms, book publishers, calendar companies, audiovisual firms, magazine publishers, greeting card companies.

Needs Photos of babies/children/teens, celebrities, couples, multicultural, families, parents, senior citizens, architecture, cities/urban, education, gardening, interiors/decorating, pets, religious, rural, agriculture, business concepts, industry, medicine, military, political, product shots/still life, science, technology/computers, disasters, environmental, landscapes/scenics, wildlife, adventure, automobiles, entertainment, events, food/drink, health/fitness/beauty, hobbies, humor, performing arts, sports, travel, exotic locations. Interested in alternative process, avant garde, documentary, erotic, fashion/glamour, fine art, historical/vintage, lifestyle, seasonal.

Specs Uses 35 mm, 21/4 × 21/4, 4 × 5, 8 × 10 transparencies. Accepts images in digital format. Send TIFF or JPEG files at 300 dpi via CD. Buys photos, film and videotape outright; pays \$5-500 for b&w photos; pays \$10-1,000 for color photos; pays \$20-2,000 for film; pays \$30-3,000 for videotape. Pay 40-50% commission. Average price per image (to clients): \$1-150 for photos and videotape. Enforces strict minimum prices. "We have set prices; however, they are subject to change without notice." Photographers can choose not to sell images on discount terms. Works with photographers with or without a contract; negotiable. Offers nonexclusive contract. Statements issued quarterly. Payments made quarterly. Offers one-time rights. Informs photographers and allows them to negotiate when a client requests all rights. Model/property release required. Photo captions required; include location, city, state, country, full description, related keywords, date image was

How to Contact "We at Suggardaddy have added a new store face to be proud of. We are encouraging all new prospects to submit any work from any agencies or person who share a passion towards photography. We will soon be adding other features that will help photographers reach out to the market and potentially sell that 'shot seen around the world.'" E-mail query letter with JPEG samples at 72 dpi. Send query letter with résumé, slides, prints, tearsheets, transparencies. Provide résumé, business card, self-promotion piece to be kept on file. Expects minimum initial submission of 50 images with submissions of at least 50 images every 2

Tips "Please e-mail through our form online before sending samples. We're interested in receiving submissions from new photographers. Arrange your work in categories to view. Clients expect the very best in professional-quality material."

SUPERSTOCK INC.

7660 Centurion Pkwy., Jacksonville FL 32256, (904)565-0066 or (800)828-4545. Fax: (904)641-4480. E-mail: yourfriends@superstock.com. Website: www.superstock.com. International stock photo agency represented in 192 countries. Extensive rights-managed and royalty-free content within 3 unique collections—contemporary, vintage and fine art. Clients include: advertising agencies, businesses, book and magazine publishers, newspapers, greeting card and calendar companies.

Needs "SuperStock is looking for dynamic lifestyle, travel, sports and business imagery, as well as fine art content and vintage images with releases."

Specs Accepts images in digital format only. Digital files must be a minimum of 50MB (up-sized), 300 dpi, 8-bit color, RGB, JPEG format.

Payment & Terms Statements issued monthly to contracted contributors. "Rights offered vary, depending on image quality, type of content, and experience." Informs photographers when client requests all rights. Model release required. Photo captions required.

Tips "Please review our website to see the style and quality of our imagery before submitting."

■ TROPIX PHOTO LIBRARY

44 Woodbines Ave., Kingston-Upon-Thames, Surrey KT1 2AY, United Kingdom. (44)(020)8546-0823. E-mail: photographers@tropix.co.uk. Website: www.tropix.co.uk. Picture library specialist. Has 100,000 photos in files. Clients include: book publishers, magazine publishers, newspapers, government departments, design groups, travel companies, new media.

Needs "Sorry, Tropix is currently closed to new contributing photographers. But any temporary exceptions to this will be posted on our website."

Specs Uses large digital files only, minimum 50MB when sent as TIFF files.

Payment & Terms Pays 40% commission for color photos. Average price per image (to clients): \$118 for b&w and color photos. Offers guaranteed subject exclusivity. Charges cost of returning photographs by insured post, if required. Statements made quarterly with payment. Photographers allowed to have qualified auditor review account records to verify sales figures in the event of a dispute but not as routine procedure. Offers one-time, electronic media and agency promotion rights. Informs photographers when a client requests all rights, but agency handles negotiation. Model release always required. Photo captions required; accurate, detailed data to be supplied in IPTC, electronically, and on paper. "It is essential to follow captioning guidelines available from agency."

How to Contact "E-mail preferred. Send no unsolicited photos or JPEGs, please."

ULLSTEIN BILD

Axel-Springer-Str. 65, Berlin 10888 Germany. +49(0)30 2591 72547. Fax: +49(0)30 2591 73896. E-mail: ramershoven@ullsteinbild.de. Website: www.ullsteinbild.de, Director: Ulrich Ramershoven. Estab. 1900. Stock agency, picture library and news/feature syndicate. Has approximately 12 million photos in files. Clients include: advertising agencies, public relations firms, audiovisual firms, businesses, book publishers, magazine publishers, newspapers, calendar companies, greeting card companies, postcard publishers, TV companies.

Needs Photos of celebrities, couples, multicultural, families, parents, senior citizens, wildlife, disasters, environmental, landscapes/scenics, architecture, cities/urban, education, pets, religious, rural, adventure, automobiles, entertainment, events, health/fitness, hobbies, humor, performing arts, sports, travel, agriculture, buildings, computers, industry, medicine, military, political, portraits, science, technology/computers. Interested in digital, documentary, fashion/glamour, historical/vintage, regional, seasonal. Other specific photo needs: German history.

Specs Accepts images in digital format only. Send via FTP, CD, e-mail as TIFF, JPEG files at minimum 25MB decompressed.

Payment & Terms Pays on commission basis. Works with photographers on contract basis only. Offers nonexclusive contract for 5 years minimum. Statements issued monthly, quarterly, annually. Payments made monthly, quarterly, annually. Photographers allowed to review account records in cases of discrepancies only. Offers one-time rights. Photo captions required; include date, names, events, place.

How to Contact "Please contact Mr. Ulrich Ramershoven (ramershoven@ullsteinbild.de) before sending pictures!"

UNICORN STOCK PHOTOS

524 Second Ave., Holdrege NE 68949. (308)995-4100. Fax: (308)995-4581. E-mail: info@unicornphotos.com. Website: www.unicorn-photos.com. Has over 500,000 photos in files. Clients include: advertising agencies, corporate accounts, textbook publishers, magazine publishers, calendar companies, religious publishers.

Needs Photos of ordinary people of all ages and races doing everyday things at home, school, work and play. Current skylines of all major cities, tourist attractions, historical, wildlife, seasonal/ holiday and religious subjects. "We particularly need images showing two or more races represented in one photo and family scenes with BOTH parents. There is a need for more minority shots including Hispanics, Asians and African-Americans." Also wants babies/children/teens, couples, senior citizens, disasters, landscapes; gardening, pets, rural, adventure, automobiles, events, food/ drink, health/fitness, hobbies, sports, travel, agriculture.

Specs Uses 35mm color slides.

Payment & Terms Works with photographers on contract basis only. Offers nonexclusive contract. Contracts renew automatically with additional submissions for 4 years. Statements issued quarterly. Payments made quarterly. Informs photographers and allows them to negotiate when client requests all rights. Model release preferred; increases sales potential considerably. Photo captions required; include location, ages of people, dates on skylines.

How to Contact Write first for guidelines. "We are looking for professionals who understand this business and will provide a steady supply of top-quality images. At least 500 images are generally required to open a file. Contact us by e-mail."

Tips "We keep in close, personal contact with all our photographers. Our monthly newsletter is a very popular medium for doing this."

VIEWFINDERS STOCK PHOTOGRAPHY

3245 SE Ankeny St., Portland OR 97214. (503)222-5222. Fax: (503)274-7995. E-mail: studio@ viewfindersnw.com. Website: www.viewfindersnw.com. Stock agency. Member of the Picture Archive Council of America (PACA). Has 70,000 photos in files. Clients include: advertising agencies, public relations firms, businesses, book publishers, magazine publishers, design agencies.

Needs All images should come from the Pacific Northwest-Oregon, Washington, Northern California, British Columbia and Idaho. Photos of babies/children/teens, couples, multicultural, families, senior citizens, environmental, landscapes/scenics, architecture, cities/urban, education, gardening, adventure, entertainment, events, health/fitness, performing arts, sports, travel, agriculture, industry, medicine, science, technology/computers, lifestyle.

Specs Prefers to review samples of photographer's work electronically, via photographer's website or online portfolio.

Payment & Terms Pays 50% commission for b&w and color photos. Works with photographers on contract basis only. Offers limited regional exclusivity. Statements issued monthly. Payment made monthly. Photographers allowed to review account records. Model/property release preferred. Photo captions required.

How to Contact "Send us an e-mail and we'll get you started on the submission process."

■ VIREO (VISUAL RESOURCES FOR ORNITHOLOGY)

1900 Benjamin Franklin Pkwy., Philadelphia PA 19103-1195. (215)299-1069. Fax: (215)299-1182. E-mail: vireo@acnatsci.org. Website: http://vireo.acnatsci.org. Picture library. "We specialize in birds only." Has 150,000 photos in files. Clients include: advertising agencies, businesses, book publishers, magazine publishers, newspapers, calendar companies, CD-ROM publishers.

Needs High-quality photographs of birds from around the world with special emphasis on behavior. All photos must be related to birds or ornithology.

Specs Uses digital format primarily. See website for specs.

Payment & Terms Pays 50% commission for b&w and color photos. Average price per image (to clients): \$125. Negotiates fees below stated minimums; "we deal with many small nonprofits as well as commercial clients." Offers volume discounts to customers. Discount sales terms negotiable. Works with photographers on contract basis only. Offers nonexclusive contract. Statements issued semiannually. Payments made semiannually. Offers one-time rights. Model release preferred. Photo captions preferred; include date, location.

How to Contact Read guidelines on website. To show portfolio, photographer should send 10 JPEGs or a link to websites with the images. Follow up with a call. Responds in 1 month to queries.

Tips "Study our website and show us some bird photos we don't have or better than those we have. Write to us describing the types of bird photographs you have, the type of equipment you use, and where you do most of your bird photography. You may also send us a web link to a portfolio of your work. Edit work carefully."

■ WILDLIGHT

P.O. Box 1606, Double Bay, NSW Sydney 1360, Australia. +61 2 9043 3255. E-mail: wild@wildlight. net. Website: www.wildlight.net. Estab. 1985. Picture library specializing in Australian images

Stock Photo Agencies

only. Has 50,000 photos in files. Clients include: advertising agencies, public relations firms, audiovisual firms, businesses, book/encyclopedia publishers, magazine publishers, newspapers, postcard publishers, calendar companies, greeting card companies.

Needs Australian photos of babies/children/teens, couples, multicultural, families, parents, senior citizens, disasters, environmental, landscapes/scenics, wildlife, architecture, cities/urban, education, gardening, interiors/decorating, pets, religious, rural, adventure, entertainment, events, food/drink, health/fitness, hobbies, humor, performing arts, sports, travel, agriculture, business concepts, industry, medicine, military, political, product shots/still life, science, technology/ computers. Interested in documentary, seasonal.

Specs Accepts images in digital format only.

Payment & Terms Pays 40% commission for color photos. Works with photographers on contract basis only. Offers image exclusive contract within Australia. Statements issued quarterly. Payments made quarterly. Offers one-time rights. Model/property release required. Photo captions required.

How to Contact Send CD to show portfolio. Expects minimum initial submission of 100 images with periodic submissions of at least 50 images per quarter. Photo guidelines available by e-mail.

WINDIGO IMAGES

P.O. Box 24828, Edina MN 55424. (952)540-0606. Fax: (952)540-1018. E-mail: info@windigoimages. com. Website: www.windigoimages.com. Stock agency. Has 500,000 photos in files. Also sells fine art prints. Represents 161 photographers. Clients include: advertising agencies, businesses, newspapers, postcard publishers, public relations firms, book publishers, calendar companies, audiovisual firms, magazine publishers, greeting card companies.

Needs "We have a constant need for modern hunting, fishing, camping, hiking and mountain biking images. We seek high-quality images."

Specs Accepts images in digital format. Send via CD, e-mail as JPEG files at 72 dpi for initial consultation.

Payment & Terms Pays 50% commission for color photos. Offers volume discounts to customers; terms specified in photographer's contracts. Works with photographers on contract basis only. Offer's nonexclusive contract. Offers one-time, electronic media and agency promotion rights.

How to Contact Send query letter with résumé, stock list. Provide résumé, business card, selfpromotion piece to be kept on file. Expects minimum initial submission of 100 images. Responds in 1 week.

Tips "Study the market and offer images that can compete in originality, composition, style and quality. Our clients are the best in the business, and we expect no less of our photographers."

Advertising, Design, & Related Markets

dvertising photography is always "commercial" in the sense that it is used to sell a product or service. Assignments from ad agencies and graphic design firms can be some of the most creative, exciting, and lucrative that you'll ever receive.

Prospective clients want to see your most creative work—not necessarily your advertising work. Mary Virginia Swanson, an expert in the field of licensing and marketing fine art photography, says that the portfolio you take to the Museum of Modern Art is also the portfolio that Nike would like to see. Your clients in advertising and design will certainly expect your work to show, at the least, your technical proficiency. They may also expect you to be able to develop a concept or to execute one of their concepts to their satisfaction. Of course, it depends on the client and their needs: Read the tips given in many of the listings on the following pages to learn what a particular client expects.

When you're beginning your career in advertising photography, it is usually best to start close to home. That way, you can make appointments to show your portfolio to art directors. Meeting the photo buyers in person can show them that you are not only a great photographer but that you'll be easy to work with as well.

When you're just starting out, you should also look closely at the agency descriptions at the beginning of each listing. Agencies with smaller annual billings and fewer employees are more likely to work with newcomers. On the flip side, if you have a sizable list of ad and design credits, larger firms may be more receptive to your work and be able to pay what you're worth.

Trade magazines such as HOW, Print, Communication Arts, and Graphis are good places to start when learning about design firms. These magazines not only provide information about how designers operate, but they also explain how creatives use photography. For ad agencies, try Ad-week and Advertising Age. These magazines are more business oriented, but they reveal facts about the top agencies and about specific successful campaigns. (See Publications on page 502 for ordering information.) The website of American Photographic Artists (APA) contains information on business practices and standards for advertising photographers (www.apanational.org).

■ \$\$ ■ AUGUSTUS BARNETT ADVERTISING/DESIGN

P.O. Box 197, Fox Island WA 98333. (253)549-2396. E-mail: charlieb@augustusbarnett.com. Website: www.augustusbarnett.com. Ad agency, design firm. Firm specializes in print, collateral, direct mail, business to business, package design and branding and identity systems. Types of clients: small business, industrial, financial, retail, small business, food & beverage, agriculture.

Needs Works with assignment photographers as needed. Uses photos for consumer and trade requirements. Subjects include: industrial, food-related product photography. Model release required; property release preferred for fine art, vintage cars, boats and documents. Photo captions preferred.

Specs Uses transparencies. Accepts images in digital format. Send via CD, Jaz, Zip, e-mail, FTP as TIFF, EPS, GIF files at 300 dpi minimum.

Making Contact & Terms Call for interview. Keeps samples on file. Responds in 2 weeks. Pays \$600-1,500/day; negotiable. Pay is negotiable. Credit line sometimes given "if the photography is partially donated for a nonprofit organization." Buys one-time and exclusive product rights; negotiable.

■ A \$ BERSON, DEAN, STEVENS INC.

P.O. Box 3997, Westlake Village CA 91359-3997. (877)447-0134. E-mail: contact@bersondeanstevens. com. Website: www.bersondeanstevens.com. Design firm. Number of employees: 3. Firm specializes in annual reports, display design, collateral, packaging, direct mail and video production. Types of clients: industrial, financial, food and retail. Examples of recent clients: Dole Food Company; Charles Schwab & Co., Inc.

Needs Works with 4 photographers/month. Uses photos for billboards, trade magazines, direct mail, P-O-P displays, catalogs, posters, packaging, signage and the web. Subjects include: product shots and food. Reviews stock photos. Model/property release required.

Specs Accepts images in digital format only. Send via CD, DVD as TIFF, EPS, JPEG files at 300 dpi.

Making Contact & Terms Provide résumé, business card, brochure, flier or tearsheets to be kept on file. Works on assignment only. Responds in 1-2 weeks. Payment negotiable. Pays within 30 days after receipt of invoice. Credit line not given. Rights negotiable.

■ \$\$ BOB BOEBERITZ DESIGN

247 Charlotte St., Asheville NC 28801. (828)258-0316. E-mail: bob@bobboeberitzdesign.com. Website: www.bobboeberitzdesign.com. Member of American Advertising Federation—Asheville Chapter, Asheville Freelance Network, Asheville Creative Services Group, National Academy of Recording Arts & Sciences. Graphic design studio. Approximate annual billing: \$100,000. Number of employees: 1. Firm specializes in annual reports, collateral, direct mail, magazine ads, packaging, publication design, signage, websites. Types of clients: management consultants, retail, recording artists, mail-order firms, industrial, nonprofit, restaurants, hotels, book publishers.

Needs Works with 1 freelance photographer "every 6 months or so." Uses photos for consumer and trade magazines, direct mail, brochures, catalogs, posters. Subjects include: babies/children/teens, couples, multicultural, families, parents, senior citizens, environmental, landscapes/scenics, wildlife, architecture, cities/urban, education, pets, rural, adventure, entertainment, events, food/drink, health/fitness/beauty, hobbies, performing arts, sports, travel, business concepts, industry, medicine, product shots/still life, science, technology/computers; some location, some stock photos. Interested in fashion/glamour, seasonal. Model/property release required.

Specs Accepts images in digital format. Send via CD, Zip, floppy disk, e-mail as TIFF, BMP, JPEG, GIF files at 300 dpi. E-mail samples at 72 dpi. No EPS attachments.

Making Contact & Terms Provide résumé, business card, brochure, flier or postcard to be kept on file. Cannot return unsolicited material. Responds "when there is a need." Pays \$75-200 for b&w

photos; \$100-500 for color photos; \$75-150/hour; \$500-1,500/day. Pays on per-job basis. Buys all rights; negotiable.

Tips "Send promotional piece to keep on file. Do not send anything that has to be returned. I usually look for a specific specialty; no photographer is good at everything. I also consider studio space and equipment. Show me something different, unusual, something that sets you apart from any average local photographer. If I'm going out of town for something, it has to be for something I can't get done locally. I keep and file direct mail pieces (especially postcards). I do not keep anything sent by e-mail. If you want me to remember your website, send a postcard."

A \$ BRAGAW PUBLIC RELATIONS SERVICES

800 E. Northwest Hwy., Suite 1040, Palatine IL 60074. (847)934-5580, ext. 111. Fax: (847)934-5596. E-mail: info@bragawpr.com, rbragaw@bragawpr.com. Website: http://bragawpr.com. Member of Publicity Club of Chicago. PR firm. Number of employees: 3. Types of clients: professional service firms, high-tech entrepreneurs.

Needs Uses photos for trade magazines, direct mail, brochures, newspapers, newsletters/news releases. Subjects include: "products and people." Model release preferred. Photo captions preferred.

Specs Uses 3×5 , 5×7 , 8×10 glossy prints.

Making Contact & Terms Provide résumé, business card, brochure, flier or tearshects to be kept on file. Works with freelance photographers on assignment basis only. Payment is negotiated at the time of the assignment. **Pays on receipt of invoice.** Credit line "possible." Buys all rights; negotiable.

Tips "Execute an assignment well, at reasonable costs, with speedy delivery."

■ IA BRAINWORKS DESIGN GROUP

2460 Garden Road, Suite G, Monterey CA 93940. (831)657-0650. Fax: (831)657-0750. E-mail: mail@brainwks.com. Website: www.brainwks.com. Design firm. Approximate annual billing: \$2 million. Number of employees: 8. Firm specializes in publication design and collateral. Types of clients: higher education, technology, medical, and pharmaceutical. Specializing in innovative and visually powerful communications, Brainworks pioneered Emotional Response Communications. This process, which includes photographic and conceptual images, is designed to induce an emotional reaction and connection on the part of the target market. It combines marketing, psychology, and design. Over the years, Brainworks has earned numerous awards.

Needs Works with 4 photographers/month. Uses photographs for direct mail, catalogs and posters. Subjects include: couples, environmental, education, entertainment, performing arts, sports, business concepts, science, technology/computers. Interested in avant garde, documentary. Wants conceptual images. Model release required.

Specs Uses 35mm, 4×5 transparencies. Accepts images in digital format. Send via CD.

Making Contact & Terms Arrange a personal interview to show portfolio. Send unsolicited photos by e-mail for consideration. Submit online. Works with freelancers on assignment only. Keeps samples on file. Cannot return material. Responds in 1 month. Pay negotiable. **Pays on receipt of invoice**. Credit line sometimes given, depending on client. Buys first, one-time and all rights; negotiable.

■ BRIGHT LIGHT VISUAL COMMUNICATIONS

602 Main St., Suite 810, Cincinnati OH 45202. (513)721-2574. Fax: (513)721-3329. E-mail: info@ brightlightusa.com. Website: www.brightlightusa.com. CEO: Linda Spalazzi. Visual communication company. Types of clients: national, regional and local companies in the governmental, educational, industrial and commercial categories. Examples of recent clients: Procter & Gamble; U.S. Grains Council; Convergys.

Needs Model/property release required. Photo captions preferred.

Audiovisual Needs "Hire crews around the world using variety of formats."

Making Contact & Terms Provide résumé, flier and brochure to be kept on file. Call to arrange appointment or send query letter with résumé of credits. Works on assignment only. Pays \$100 minimum/day for grip; payment negotiable based on photographer's previous experience/ reputation and day rate (10 hours). Pays within 30 days of completion of job. Buys all rights.

Tips Sample assignments include camera assistant, gaffer or grip. Wants to see sample reels or samples of still work. Looking for sensitivity to subject matter and lighting. "Show a willingness to work hard. Every client wants us to work smarter and provide quality at a good value."

🕅 🗏 届 💲 🕖 BYNUMS MARKETING AND COMMUNICATIONS. INC.

1501 Reedsdale St., Suite 5003, Pittsburgh PA 15233, (412)471-4332, Fax: (412)471-1383, E-mail: rbynum2124@earthlink.net; russell@bynums.com. Website: www.bynums.com. Ad agency. Number of employees: 8. Firm specializes in annual reports, collateral, direct mail, magazine ads, packaging, publication design, signage. Types of clients: financial, health care, consumer goods, nonprofit.

Needs Works with 1 photographer/month. Uses photos for billboards, brochures, direct mail, newspapers, posters. Subjects include: babies/children/teens, couples, multicultural, families, parents, senior citizens, environmental, wildlife, cities/urban, education, religious, adventure, automobiles, events, food/drink, health/fitness, performing arts, sports, medicine, product shots/ still life, science, technology/computers. Interested in fine art, seasonal, Model/property release required. Photo captions preferred.

Audiovisual Needs Works with 1 videographer and 1 filmmaker/year. Uses slides, film, videotape.

Specs Uses 8 × 10 glossy or matte color and b&w prints; 35mm, 4 × 5 transparencies. Accepts images in digital format. Send via Zip, e-mail as TIFF files.

Making Contact & Terms Send query letter with resume, prints, tearsheets, stock list. Provide business card, self-promotion piece to be kept on file. Responds only if interested, send nonreturnable samples. Pays \$150-300 for b&w and color photos. "Payment may depend on quote and assignment requirements." Buys electronic rights.

■ S\$\$\$ CARMICHAEL LYNCH

110 N. 5th St., Minneapolis MN 55403. (612)334-6000. Fax: (612)334-6090. E-mail: portfolio@ clynch.com. Website: www.clynch.com. Executive Art Producer: Sandy Boss Febbo. Art Producers: Bonnie Brown, Jill Kahn, Jenny Barnes, Andrea Mariash. Member of American Association of Advertising Agencies. Ad agency. Number of employees: 250. Firm specializes in collateral, direct mail, magazine ads, packaging. Types of clients: finance, health care, sports and recreation, beverage, outdoor recreational. Examples of recent clients: Harley-Davidson, Porsche, Northwest Airlines, American Standard.

Needs Uses many photographers/month. Uses photos for billboards, consumer and trade magazines, direct mail, P-O-P displays, brochures, posters, newspapers and other media as needs arise. Subjects include: environmental, landscapes/scenics, architecture, interiors/decorating, rural, adventure, automobiles, travel, product shots/still life. Model/property release required for all visually recognizable subjects.

Specs Uses all print formats. Accepts images in digital format. Send as TIFF, GIF, JPEG files at 72 dpi or higher.

Making Contact & Terms Submit portfolio for review. To show portfolio, call Andrea Mariash. Provide résumé, business card, brochure, flier or tearsheets to be kept on file. Payment negotiable. Pay depends on contract. Buys all, one-time or exclusive product rights, "depending on agreement."

Tips "No 'babes on bikes'! In a portfolio we prefer to see the photographer's most creative work not necessarily ads. Show only your most technically, artistically satisfying work."

■ \$\$ DESIGN2MARKET

1973 O'Toole Way, San Jose CA 95131. (408)232-0440. Fax: (408)232-0443. E-mail: info@ design2marketinc.com. Website: www.design2marketinc.com. Design firm. Number of employees: 5. Firm specializes in publication design, display design, magazine ads, collateral, packaging, direct mail and advertising. Types of clients: industrial, retail, nonprofit and technology. Examples of recent clients: NEC (Tradeshow, promotions), Metropolis Retail (web), California Insurance Careers Program (web, promotions), Silicon Valley Charity Ball (invitation and posters); IDEC Corporation (advertising); City College of San Francisco (advertising); Polycom (packaging).

Needs Works with 6 photographers/month. Uses photos for trade magazines, direct mail, P-O-P displays, catalogs, posters, packaging and advertising. Subjects include: people, computers, equipment. Reviews stock photos. Model/property release required.

Specs Accepts images in digital format. Send via CD as TIFF, EPS, PICT, JPEG files at 300 dpi minimum.

Making Contact & Terms Send unsolicited photos by mail for consideration. Include SASE for return of material. Provide résumé, business card, brochure, flier or tearsheets to be kept on file. Works on assignment and buys stock photos. Payment negotiable. Credit line sometimes given. Buys all rights.

M DYKEMAN ASSOCIATES, INC.

4115 Rawlins St., Dallas TX 75219. (214)528-2991. E-mail: adykeman@airmail.net. Website: www. dykemanassociates.com. Member of Public Relations Society of America. PR, marketing, video production firm. Firm specializes in website creation and promotion, communication plans, media training, collateral, direct marketing. Types of clients: industrial, financial, sports, technology.

Needs Works with 4-5 photographers or videographers. Uses photos for publicity, consumer and trade magazines, direct mail, catalogs, posters, newspapers, signage, websites.

Audiovisual Needs "We produce and direct video. Just need crew with good equipment and people and ability to do their part."

Making Contact & Terms Arrange a personal interview to show portfolio. Provide business card, brochure, flier or tearsheets to be kept on file. Works on assignment only. Cannot return material. Pays \$800-1,200/day; \$250-400/1-2 days. "Currently we work only with photographers who are willing to be part of our trade dollar network. Call if you don't understand this term." **Pays 30 days after receipt of invoice.**

Tips Reviews portfolios with current needs in mind. "If video, we would want to see examples. If for news story, we would need to see photojournalism capabilities."

301 W. Osborn, Phoenix AZ 85013-3997. (800)234-2269. E-mail: clsinfo@central.com. Website: www.farnam.com. **Creative Director:** Leslie Burger. Firm specializes in display design, magazine ads, packaging. Types of clients: retail.

• This company has an in-house ad agency called Charles Duff Advertising.

Needs Works with 2 photographers/month. Uses photos for direct mail, catalogs, consumer magazines, P-O-P displays, posters, AV presentations, trade magazines and brochures. Subject matter includes horses, dogs, cats, birds, farm scenes, ranch scenes, cowboys, cattle, horse shows, landscapes/scenics, gardening. Model release required.

Audiovisual Needs Uses film and videotape. Occasionally works with freelance filmmakers to produce educational horse health films and demonstrations of product use.

Specs Uses 35mm, $2\frac{1}{4} \times 2\frac{1}{4}$, 4×5 transparencies; 16mm and 35mm film and videotape. Accepts images in digital format. Send via CD, Zip.

Making Contact & Terms Send query letter with samples; include SASE for return of material. Provide résumé, business card, brochure, flier or tearsheets to be kept on file. Works with freelance

photographers on assignment basis only. Pays \$50-350 for color photos. Pays on publication. Credit line given whenever possible. Buys one-time rights.

Tips "Send me a number of good, reasonably priced for one-time use photos of dogs, horses or farm scenes. Better yet, send me good-quality dupes I can keep on file for rush use. When the dupes are in the file and I see them regularly, the ones I like stick in my mind and I find myself planning ways to use them. We are looking for original, dramatic work. We especially like to see horses, dogs, cats and cattle captured in artistic scenes or poses. All shots should show off quality animals with good conformation. We rarely use shots if people are shown and prefer animals in natural settings or in barns/stalls."

■ S FLINT COMMUNICATIONS

101 10th St. N. Suite 300, Fargo ND 58102. (701)237-4850. Fax: (701)234-9680. E-mail: gerriL@ flintcom.com, dawnk@flintcom.com. Website: www.flintcom.com. Creative Director: Gerri Lien. Art Director: Dawn Koranda, Ad agency, Approximate annual billing: \$9 million, Number of employees: 30. Firm specializes in display design, direct mail, magazine ads, publication design, signage, annual reports. Types of clients: industrial, financial, agriculture, health care and tourism.

Needs Works with 2-3 photographers/month. Uses photos for direct mail, P-O-P displays, posters and audiovisual. Subjects include: babies/children/teens, couples, parents, senior citizens, architecture, rural, adventure, automobiles, events, food/drink, health/fitness, sports, travel, agriculture, industry, medicine, political, product shots/still life, science, technology, manufacturing, finance, health care, business. Interested in documentary, historical/vintage, seasonal. Reviews stock photos. Model release preferred.

Audiovisual Needs Works with 1-2 filmmakers and 1-2 videographers/month. Uses slides and film.

Specs Uses 35mm, 21/4 × 21/4, 4 × 5 transparencies. Accepts images in digital format. Send via CD, Zip as TIFF, EPS, JPEG files.

Making Contact & Terms Send query letter with stock list. Submit portfolio for review. Provide résumé, business card, brochure, flier or tearsheets to be kept on file. Responds in 1-2 weeks. Pays \$50-150 for b&w photos; \$50-1,500 for color photos; \$50-130/hour; \$400-1,200/day; \$100-2,000/ job. Pays on receipt of invoice. Buys one-time rights.

■ 🖬 \$ GIBSON ADVERTISING

928 Broadwater Ave., Suite 244, Billings MT 59101. (406)248-3555. Fax: (406)839-9006. E-mail: jenna@gibsonad.com. Website: www.gibsonad.com. President: Mike Curtis. Estab. 1984. Ad agency. Number of employees: 2. Types of clients: industrial, financial, retail, food, medical.

Needs Works with 1-3 freelance photographers and 1-2 videographers/month. Uses photos for direct mail, P-O-P displays, catalogs, posters, newspapers, signage, audiovisual. Subjects vary with job. Reviews stock photos. "We would like to see more Western photos." Model release required. Property release preferred.

Audiovisual Needs Uses slides and videotape.

Specs Uses color and b&w prints; 35mm, 2¼ × 2¼, 4 × 5, 8 × 10 transparencies; 16mm, VHS, Betacam videotape; and digital formats.

Making Contact & Terms Send query letter with résumé of credits or samples. Provide résumé, business card, brochure, flier or tearsheets to be kept on file. Works with local freelancers on assignment only. Keeps samples on file. Cannot return material. Responds in 2 weeks. Pays \$75-150/job; \$150-250 for color photo; \$75-150 for b&w photo; \$100-150/hour for video. Pays on receipt of invoice, net 30 days. Credit line sometimes given. Buys one-time and electronic rights. Rights negotiable.

■ GOLD & ASSOCIATES, INC.

6000-C Sawgrass Village Circle, Ponte Vedra Beach FL 32082. (904)285-5669. Fax: (904)285-1579. E-mail: gold@strikegold.com. Website: www.strikegold.com. Creative Director/CEO: Keith Gold. Marketing/design/advertising firm. Approximate annual billing: \$50 million in capitalized billings. Multiple offices throughout Eastern U.S. Firm specializes in health care, publishing, tourism, entertainment industries. Examples of clients: State of Florida; Harcourt; Time-Warner; GEICO; the PGA Tour.

Needs Works with 1-4 photographers/month. Uses photos for print advertising, posters, brochures, direct mail, television spots, packaging. Subjects vary. Reviews stock photos and reels. Tries to buy out images.

Audiovisual Needs Works with 1-2 filmmakers/month. Uses 35mm film; no video.

Specs Uses digital images.

Making Contact & Terms Contact through rep. Provide samples to be kept on file. Works with freelancers from across the U.S. Cannot return material. Only responds to "photographers being used." **Pays 50% on receipt of invoice, 50% on completion**. Credit line given only for original work where the photograph is the primary design element; never for spot or stock photos. Buys all rights worldwide.

■ \$\$ @ GRAFICA

P.O. Box 2758, Poulsbo WA 98370. (360)697-1638. Fax: (360)697-1638. E-mail: graficaeps@aol. com. Website: www.graficaeps.com. Member of Adobe Authorized Imaging Center, Quark Service Alliance, Corel Approved Service Bureau. Design studio and service bureau. Approximate annual billing: \$250,000. Number of employees: 5. Firm specializes in annual reports, magazine ads, direct mail, publication design, collateral design, video graphics-titling. Types of clients: high technology, industrial, retail, publishers, entertainment.

Needs Works with 1-2 photographers/month. Uses photos for annual reports, billboards, consumer and trade magazines, P-O-P displays, catalogs, posters, packaging. Subjects include: babies/children/teens, celebrities, couples, multicultural, families, parents, senior citizens, disasters, environmental, landscapes, scenics, wildlife, architecture, cities/urban, education, gardening, interiors/decorating, pets, religious, rural, adventure, automobiles, entertainment, events, food/drink, health/fitness, hobbies, humor, performing arts, sports, travel, agriculture, business concepts, industry, medicine, military, political, product shots/still life, science, technology/computers. Interested in alternative process, avant garde, documentary, erotic, fashion/glamour, fine art, historical/vintage, seasonal. Model release required; property release preferred.

Specs Uses 35mm, $2\frac{1}{4} \times 2\frac{1}{4}$, 4×5 transparencies. Accepts images in digital format. Send via CD, e-mail as JPEG files.

Making Contact & Terms Send query letter with samples. Provide résumé, business card, brochure, flier or tearsheets to be kept on file. Responds in 1-2 weeks. Pays \$100-1,000 for b&w and color photos. Credit line sometimes given. Buys first, one-time, electronic and all rights; negotiable.

Tips "Send sample sheets (nonreturnable) for our files. We will contact when appropriate project arises."

HALLOWES PRODUCTIONS & ADVERTISING

11260 Regent St., Los Angeles CA 90066-3414. (310)390-4767. Fax: (310)745-1107. E-mail: adjim@aol.com. Website: www.hallowesproductions.com. Creative Director/Producer-Director: Jim Hallowes. Estab. 1984. Creates and produces TV commercials, corporate films and videos, and print and electronic advertising.

Needs Buys 8-10 photos/year. Uses photos for magazines, posters, newspapers and brochures. Reviews stock photos; subjects vary.

Audiovisual Needs Uses film and video for TV commercials and corporate films.

Specs Uses 35mm, 4 × 5 transparencies; 35mm/16mm film; Beta SP videotape; all digital formats.

Making Contact & Terms Send query letter with résumé of credits. "Do not fax unless requested." Keeps samples on file. Responds if interested. Payment negotiable. Pays on usage. Credit line sometimes given, depending upon usage, usually not. Buys first and all rights; rights vary depending on client.

\$\$\$ AMPTON DESIGN GROUP

(610)821-0963. E-mail: wendy@hamptondesigngroup.com. Website: www.hamptondesign group.com. Creative Director: Wendy Ronga. Estab. 1997. Member of Type Director Club, Society of Illustrators, Art Directors Club, Society for Publication Designers, Design firm, Approximate annual billing: \$450,000. Number of employees: 3. Firm specializes in annual reports, magazine and book design, editorial packaging, advertising, collateral, direct mail. Examples of recent clients: Conference for the Aging, Duke University/Templton Foundation (photo shoot/5 images); Religion and Science, UCSB University (9 images for conference brochure).

Needs Works with 2 photographers/month. Uses photos for billboards, brochures, catalogs, consumer magazines, direct mail, newspapers, posters, trade magazines. Subjects include: babies/ children/teens, multicultural, senior citizens, environmental, landscapes/scenics, wildlife, pets, religious, health/fitness/beauty, business concepts, medicine, science. Interested in alternative process, avant garde, fine art, historical/vintage, seasonal. Model/property release required. Photo captions preferred.

Specs Prefers images in digital format. Send via CD as TIFF, EPS, JPEG files at 300 dpi.

Making Contact & Terms Send query letter. Keeps samples on file. Responds only if interested; send nonreturnable samples or web address to see examples. Pays \$150-1,500 for color photos; \$75-1,000 for b&w photos. Pays extra for electronic usage of photos, varies depending on usage. Price is determined by size, how long the image is used and if it is on the home page. Pays on receipt of invoice. Credit line given. Buys one-time rights, all rights, electronic rights; negotiable. **Tips** "Use different angles and perspectives, a new way to view the same old boring subject. Try different films and processes."

BERNARD HODES GROUP

220 East 42nd St., New York NY 10017. (212)999-9687. E-mail: info@hodes.com; ipatrisso@hodes. com. Website: www.hodes.com. Member of Western Art Directors Club, San Francisco Ad Club. Ad agency, design firm. Has over 90 offices and affiliates worldwide; approximately 700 employees. Firm specializes in annual reports, collateral, direct mail, magazine ads, packaging, publication design. Types of clients: industrial, retail, nonprofit.

Needs Works with 1 or more photographers/month. Uses photos for brochures, catalogs, consumer and trade magazines, direct mail. Model release preferred.

Audiovisual Needs Uses slides.

Specs Uses 35mm, 21/4 × 21/4, 4 × 5 transparencies. Accepts images in digital format. Send via CD, SyQuest, Zip, e-mail as TIFF, EPS, JPEG files.

Making Contact & Terms Send query letter with resume. Works with local freelancers only. Provide résumé, business card, self-promotion piece to be kept on file. Pays net 30 days. Buys all rights.

8521 Six Forks Rd., Raleigh NC 27613. (919)848-2400. Fax: (919)845-9845. Website: www. merrellgroup.com. Member of AAAA. Number of employees: 45.

Needs Works with 1-2 photographers/month. Uses photos for consumer and trade magazines, newspapers, collateral, outdoor boards and websites. Purchases stock images. Model/property release required.

Specs Uses b&w prints; 21/4 × 21/4, 4 × 5 transparencies. Accepts images in digital format.

Making Contact & Terms Query on the website form. Provide samples to be kept on file. Work on assignment and buys stock photos. **Pays on receipt of invoice.** Buys one-time and all rights.

■ \$\$\$ ☑ HUTCHINSON ASSOCIATES, INC.

1147 W. Ohio St., Suite 305, Chicago IL 60622-5874. (312)455-9191. Fax: (312)455-9190. E-mail: hutch@hutchinson.com. Website: www.hutchinson.com. Member of American Institute of Graphic Arts. Design firm. Number of employees: 3. Firm specializes in identity development, website development, annual reports, collateral, magazine ads, publication design, marketing brochures. Types of clients: industrial, financial, real estate, retail, publishing, nonprofit and medical. Example of recent client: Cardinal Growth.

Needs Works with 1 photographer/month. Uses photographs for annual reports, brochures, consumer and trade magazines, direct mail, catalogs, websites and posters. Subjects include: still life, real estate. Reviews stock photos.

Specs Accepts images in digital format.

Making Contact & Terms Send query letter with samples. Keeps samples on file. Responds "when the right project comes along." Payment rates depend on the client. Pays within 30-45 days. Credit line sometimes given. Buys one-time, exclusive product and all rights; negotiable.

Tips In samples, "print quality and composition count."

■ IMAGE INTEGRATION

2619 Benvenue Ave. #A, Berkeley CA 94704. (510)841-8524. E-mail: vincesail@aol.com. Firm specializes in material for TV productions and Internet sites. Approximate annual billing: \$100,000. Examples of recent clients: "Ultimate Subscription," Sailing World (30-second spot); "Road to America's Cup," ESPN (stock footage); "Sail With the Best," U.S. Sailing (promotional video).

Needs Works with 1 photographer/month. Reviews stock photos of sailing only. Property release preferred. Photo captions required; include regatta name, regatta location, date.

Audiovisual Needs Works with 1 videographer/month. Uses videotape. Subjects include: sailing only.

Specs Uses 4×5 or larger matte color and b&w prints; 35mm transparencies; 16mm film and Betacam videotape. Prefers images in digital format. Send via e-mail, Zip, CD-ROM (preferred).

Making Contact & Terms Send unsolicited photos of sailing by mail with SASE for consideration. Keeps samples on file. Responds in 2 weeks. Payment depends on distribution. Pays on publication. Credit line sometimes given, depending upon whether any credits included. Buys nonexclusive rights; negotiable.

JUDE STUDIOS

8000 Research Forest, Suite 115-266, The Woodlands TX 77382. (281)364-9366. Fax: (281)364-9529. E-mail: jdollar@judestudios.com. Website: www.judestudios.com. Number of employees: 2. Firm specializes in collateral, direct mail, packaging. Types of clients: nonprofits, builder, retail, destination marketing, event marketing, service. Examples of recent clients: home builder; festivals and events; corporate collateral; various logos; banking.

Needs Works with 1 photographer/month. Uses photos for newsletters, brochures, catalogs, direct mail, trade and trade show graphics. Needs photos of families, active adults, senior citizens, education, pets, business concepts, industry, product shots/still life, technology/computers. Model release required; property release preferred. Photo captions preferred.

Specs Accepts images in digital format. Send via CD as TIFF, EPS, JPEG files at 350 dpi. "Do not e-mail attachments."

Making Contact & Terms Send e-mail with link to website, blog, or portfolio. Provide business card, self-promotion piece to be kept on file. Responds only if interested; send nonreturnable samples. Pays by the project. **Pays on receipt of invoice.**

■ ■ ✓ KINETIC

200 Distillery Commons, Suite 200, Louisville KY 40206. (502)719-9500. Fax: (502)719-9509. E-mail: info@theTechnologyAgency.com. Website: www.thetechnologyagency.com. Types of clients: industrial, financial, fashion, retail and food.

Needs Works with freelance photographers and videographers as needed. Uses photos for audiovisual and print. Model/property release required.

Specs Prefers images in digital format. Send via CD, Jaz, Zip as TIFF files.

Making Contact & Terms Provide résumé, business card, brochure, flier or tearsheets to be kept on file. Works with local freelancers only. Responds only when interested. Payment negotiable. Pays within 30 days. Buys all rights.

A KOCHAN & COMPANY

800 Geyer Ave., St. Louis MO 63104. (314)621-4455. Fax: (314)621-1777. E-mail: bob@ kochanandcompany.com; tucker@kochanandcompany. Website: www.kochanandcompany.com. Member of AAAA, AAF/St. Louis. Ad agency. Number of employees: 10. Firm specializes in brand identity, print & magazine ads, outdoor, direct mail, signage. Example of recent clients: Argosy Casino (billboards/duratrans); Pasta House Co. (menu inserts); Mystique Casino (billboards/print ads).

Needs Uses photos for billboards, brochures, catalogs, direct mail, newspapers, posters, signage. Reviews stock photos. Model/property release required. Photo captions required.

Making Contact & Terms Send query letter with samples, brochure, stock list, tearsheets. To show portfolio, photographer should follow up with call or letter after initial query. Portfolio should include b&w, color, prints, tearsheets, slides, transparencies. Works with freelancers on assignment only. Keeps samples on file. Responds only if interested; send nonreturnable samples. Pays on receipt of invoice. Credit line given. Buys all rights.

■ LIGGETT STASHOWER

1240 Huron Rd., Cleveland OH 44115. (216)373-8290. E-mail: info@liggett.com. Website: www. liggett.com. (Formerly Ligget Stashower Advertising, Inc.) Ad and PR agency. Examples of recent clients: Forest City Management; Ritz-Carlton; Crane Performance Siding; Henkel Consumer Adhesives; TimberTech.

Needs Works with 10 photographers, filmmakers and videographers per month. Uses photos for billboards, websites, consumer and trade magazines, direct mail, P-O-P displays, catalogs, posters, newspapers, signage and audiovisual. Interested in reviewing stock photos/film or video footage. Model/property release required.

Audiovisual Needs Uses film and videotape for commercials.

Specs Uses b&w and color prints (size and finish varies); 21/4 × 21/4, 4 × 5, 8 × 10 transparencies; 16mm film; 1/4-3/4" videotape. Accepts images in digital format.

Making Contact & Terms Send query letter with samples. Provide résumé, business card, brochure, flier or tearsheets to be kept on file. Responds only if interested. Pays according to project. Buys one-time, exclusive product, all rights; negotiable.

■ \$\$ ☑ LINEAR CYCLE PRODUCTIONS

Box 2608, Sepulveda CA 91393-2608. E-mail: lcp@westworld.com. Member of International United Phótographer Publishers, Inc. Ad agency, PR firm. Approximate annual billing: \$5 million. Number of employees: 20. Firm specializes in annual reports, display design, magazine ads, publication design, direct mail, packaging, signage. Types of clients: industrial, commercial, advertising, retail, publishing.

Needs Works with 7-10 photographers/month. Uses photos for billboards, consumer magazines, direct mail, P-O-P displays, posters, newspapers, audiovisual uses. Subjects include: candid photographs. Reviews stock photos, archival. Model/property release required. Photo captions required; include description of subject matter.

Audiovisual Needs Works with 8-12 filmmakers and 8-12 videographers/month. Uses slides and/or film or video for television/motion pictures. Subjects include: archival-humor material.

Specs Uses 8×10 color and b&w prints; 35mm, 8×10 transparencies; 16mm-35mm film; ½", ¾", 1" videotape. Accepts images in digital format. Send via CD, floppy disk, Jaz as TIFF, GIF, JPEG files.

Making Contact & Terms Submit portfolio for review. Send query letter with résumé of credits, stock list. Provide résumé, business card, brochure, flier or tearsheets to be kept on file. Works with local freelancers on assignment and buys stock photos. Responds in 1 month. Pays \$100-500 for b&w photos; \$150-750 for color photos; \$100-1,000 per job. Prices paid depend on position. Pays on publication. Credit line given. Buys one-time rights; negotiable.

Tips "Send a good portfolio with color images. No sloppy pictures or portfolios! The better the portfolio is set up, the better the chances we would consider it, let alone look at it!" Seeing a trend toward "more archival/vintage and a lot of humor pieces."

S\$ LOHRE & ASSOCIATES INC.

126A West 14th St., 2nd Floor, Cincinnati OH 45202-7535. (513)961-1174. Website: www.lohre.com. Art Director: Art Jeffries. Ad agency. Types of clients: industrial.

Needs Uses photos for trade magazines, direct mail, catalogs and prints. Subjects include: machine-industrial themes and various eye-catchers.

Specs Uses high-res digital images.

Making Contact & Terms Send query letter with résumé of credits. Provide business card, brochure, flier or tearsheets to be kept on file.

■ MONDERER DESIGN

2067 Massachusetts Ave., Cambridge MA 02140. (617)661-6125. Fax: (617)661-6126. E-mail: stewart@monderer.com. Website: www.monderer.com. Estab. 1981. Member of AIGA. Design firm. Approximate annual billing: \$1 million. Number of employees: 4. Firm specializes in annual reports, branding, print and collateral, direct response, publication design and packaging, website and interactive design. Types of clients: technology, life science, industrial, financial and educational. Examples of recent clients: Northeastern University brochure (faces, portraits, classroom); Makepeace brochure (real estate, nature, landscape); ads, thermo scientific (metaphorical, conceptual).

Needs Works with 2 photographers/month. Uses photos for advertising, annual reports, catalogs, posters and brochures. Subjects include: environmental, architecture, cities/urban, education, adventure, automobiles, entertainment, events, performing arts, sports, travel, business concepts, industry, medicine, product shots/still life, science, technology/computers, conceptual, site specific, people on location. Interested in alternative process, avant garde, documentary, historical/vintage, seasonal. Model release preferred; property release sometimes required.

Specs Accepts images in digital format. Send via CD as TIFF, EPS files at 300 dpi.

Making Contact & Terms Send unsolicited photos by mail for consideration. Keeps samples on file. Follow up from photographers recommended. Payment negotiable. **Pays on receipt of invoice.** Credit line sometimes given depending upon client. Rights always negotiated depending on use.

■ \$\$ Ø MULLIN/ASHLEY ASSOCIATE

306 Cannon St., Chesteron MD 21620. (410)778-2184. Fax: (410)778-6640. E-mail: mar@ mullinashley.com. Website: www.mullinashley.com. Approximate annual billing: \$2 million. Number of employees: 6. Firm specializes in collateral and interactive media. Types of clients: industrial, business to business, health care. Examples of recent clients: W.L. Gore & Associates, Nevamar of International Paper, Community Hospitals.

Needs Works with 1 photographer/month. Uses photos for brochures and Web. Subjects include: business concepts, industry, product shots/still life, technology. Also needs industrial, business to business, health care on location. Model release required; property release preferred. Photo captions preferred.

Audiovisual Needs Works with 1 videographer/year. Uses for corporate capabilities, brochure, training, videos.

Specs Prefers images in digital format; also uses $2\frac{1}{4} \times 2\frac{1}{4}$, 4×5 transparencies; high-8 video.

Making Contact & Terms Send query letter or e-mail with résumé and digital files. Responds only if interested; send nonreturnable samples. Pays \$500-5,000 for b&w or color photos; depends on the project or assignment. Pays on 30 days receipt of invoice. Credit line sometimes given depending upon assignment.

MYRIAD PRODUCTIONS

P.O. Box 888886, Atlanta GA 30356. (678)417-0041. E-mail: myriad@mindspring.com. Primarily involved with sports productions and events. Types of clients: publishing, nonprofit.

Needs Works with photographers on assignment-only basis. Uses photos for portraits, live-action and studio shots, special effects, advertising, illustrations, brochures, TV and film graphics, theatrical and production stills. Subjects include: celebrities, entertainment, sports. Model/property release required. Photo captions preferred; include names, location, date, description.

Specs Uses 8 × 10 b&w and color prints; 21/4 × 21/4 transparencies. Accepts images in digital format. Send via "Mac-compatible CD or DVD. No floppy disks or Zips!"

Making Contact & Terms Provide brochure, résumé or samples to be kept on file. Send material by mail for consideration. "No telephone or fax inquiries, please!" Cannot return material. Response time "depends on urgency of job or production." Payment negotiable. Credit line sometimes given. Buys all rights.

Tips "We look for an imaginative photographer—one who captures all the subtle nuances. Working with us depends almost entirely on the photographer's skill and creative sensitivity with the subject. All materials submitted will be placed on file and not returned, pending future assignments. Photographers should not send us their only prints, transparencies, etc., for this reason."

S NATIONAL BLACK CHILD DEVELOPMENT INSTITUTE

1313 L St., NW, Suite 110, Washington DC 20005. (202)833-2220. Fax: (202)833-8222. E-mail: moreinfo@nbcdi.org; vdavis@nbcdi.org. Website: www.nbcdi.org. Estab. 1970.

Needs Uses photos in brochures, newsletters, annual reports and annual calendar. Candid action photos of black children and youth. Reviews stock photos. Model release required.

Specs Uses 5 × 7, 8 × 10 color or glossy b&w prints; color slides; b&w contact sheets. Accepts images in digital format. Send via CD.

Making Contact & Terms Send query letter with samples; include SASE for return of material. Pays \$70 for cover; \$20 for inside. Credit line given. Buys one-time rights.

Tips "Candid action photographs of one black child or youth or a small group of children or youths. Color photos selected are used in annual calendar and are placed beside an appropriate poem selected by organization. Therefore, photograph should communicate a message in an indirect way. Black & white photographs are used in quarterly newsletter and reports. Obtain sample of publications published by organization to see the type of photographs selected."

■ M \$\$ NOVUS COMMUNICATIONS

121 E. 24th St., 12th Fl., New York NY 10010. (212)473-1377. Fax: (212)505-3300. E-mail: novuscom@aol.com. Website: www.novuscommunications.com. Integrated creative marketing and communications firm. Number of employees: 5. Firm specializes in multi-channel online and offline advertising, annual reports, publication design, display design, multimedia, packaging, direct mail, signage and website, Internet and DVD development. Types of clients: start ups and developers, industrial, financial, retail, health care, entertainment, nonprofit.

Needs Works with 1 photographer/month. Uses photos for cross marketing campaigns, business-to-business direct mail, digital displays, online and print catalogs, posters, packaging and signage. Subjects include: babies/children/teens, couples, multicultural, families, parents, senior citizens, environmental, landscapes/scenics, wildlife, architecture, cities/urban, education, gardening, interiors/decorating, pets, religious, rural, adventure, automobiles, entertainment, events, food/drink, health/fitness, hobbies, humor, performing arts, sports, travel, agriculture, business concepts, industry, medicine, military, political, product shots/still life, science, technology/computers. Interested in alternative process, avant garde, documentary, fashion/glamour, fine art, historical/vintage, seasonal. Reviews stock photos. Model/property release required. Photo captions preferred. **Audiovisual Needs** Uses film, videotape, DVD.

Specs Accepts images in digital format. Send via Zip, CD as TIFF, JPEG files.

Making Contact & Terms Arrange a personal interview to show portfolio. Works on assignment only. Keeps samples on file. Cannot return material. Responds in 1-2 weeks. Pays \$85-175 for b&w photos; \$175-800 for color photos; \$300-1,000 for digital film; \$175-800 for videotape. Pays upon client's payment. Credit line given. Rights negotiable.

Tips "The marriage of photos and illustrations continues to be trendy. More illustrators and photographers are adding stock usage as part of their business. E-mail with link to website. Send a sample postcard; follow up with phone call. Use low tech marketing."

■ \$ ② POSEY SCHOOL

P.O. Box 254, Northport NY 11768. (631)757-2700. E-mail: EPosey@optonline.net. Website: www. poseyschool.com. Sponsors a school of dance, art, music, drama; regional dance company and acting company. Uses photos for brochures, news releases, newspapers.

Needs Buys 12-15 photos/year; offers 4 assignments/year. Special subject needs include children dancing, ballet, modern dance, jazz/tap (theater dance) and "photos showing class situations in any subjects we offer. Photos must include girls and boys, women and men." Interested in documentary, fine art, historical/vintage. Reviews stock photos. Model release required.

Specs Uses 8 × 10 glossy b&w prints. Accepts images in digital format. Send via CD, e-mail.

Making Contact & Terms "Call us." Responds in 1 week. Pays \$35-50 for most photos, b&w or color. Credit line given if requested. Buys one-time rights; negotiable.

Tips "We are small but interested in quality (professional) work. Capture the joy of dance in a photo of children or adults. Show artists, actors or musicians at work. We prefer informal action photos, not posed pictures. We need photos of *real* dancers dancing. Call first. Be prepared to send photos on request."

QUALLY & COMPANY, INC.

2 E. Oak St., Suite 2903, Chicago IL 60611. (312)280-1898. E-mail: iva@quallycompany.com. Website: www.quallycompany.com. Creative Director: Mike Iva. Ad agency. Types of clients: new product development and launches.

Needs Uses photos for every media. "Subject matter varies, but it must always be a 'quality image' regardless of what it portrays." Model/property release required. Photo captions preferred.

Specs Uses b&w and color prints; 35mm, 4×5 , 8×10 transparencies. Accepts images in digital format.

Making Contact & Terms Send query letter with photocopies, tearsheets. Provide résumé, business card, brochure, flier or tearsheets to be kept on file. Responds only if interested; send nonreturnable samples. Payment negotiable. Pays net 30 days from receipt of invoice. Credit line sometimes given, depending on client's cooperation. Rights purchased depend on circumstances.

QUON DESIGN

543 River Rd., FH NJ 07704-3227. (732)212-9200. Fax: (732)212-9217. E-mail: studio@quondesign.com. Website: www.quondesign.com. Design firm. Firm specializes in corporate identity/logos,

collateral, event promotion, advertising, illustration. Types of clients: industrial, financial, retail, publishers, nonprofit.

Needs Works with 1-3 photographers/year. Uses photos for direct mail, P-O-P displays, packaging, signage. Model/property release preferred. Photo captions required; include company name.

Specs Uses color and b&w digital images.

Making Contact & Terms Submit portfolio for review by mail only. No drop-offs. "Please, do not call office. Contact through mail only." Keeps samples on file. Responds only if interested; send nonreturnable samples. Pays net 30 days. Credit line given when possible. Buys first rights, onetime rights; negotiable.

Tips Mike Ouon says he is using more stock photography and less assignment work.

PATRICK REDMOND DESIGN

P.O. Box 75430-PM, St. Paul MN 55175-0430. (651) 503-4480. E-mail: Redmond@PatrickRedmondDesign. com. Website: www.patrickredmonddesign.com. Design firm. Number of employees: 1. Firm specializes in publication design, book covers, books, packaging, direct mail, posters, branding, logos, trademarks, annual reports, websites, collateral. Types of clients: publishers, financial, retail, advertising, marketing, education, nonprofit, industrial, arts. Examples of recent clients: Flamenco: A Touch of Spain (website, branding, print); The Alonzo Hauser Collection (website launch; print); Experienced Staff, LLC (brand identity consulting). See "portfolio" section of website for examples.

· Books designed by Redmond have won awards from Midwest Independent Publishers Association, Midwest Book Achievement Awards, Publishers Marketing Association Benjamin Franklin Awards.

Needs Uses photos for books and book covers, direct mail, P-O-P displays, catalogs, posters, packaging, annual reports. Subject varies with client—may be editorial, product, how-to, etc. May need custom b&w photos of authors (for books/covers designed by PRD). "Poetry book covers provide unique opportunities for unusual images (but typically have miniscule budgets)." Reviews stock photos; subject matter varies with need. Model/property release required; varies with assignment/project. Photo captions required; include correct spelling and identification of all factual matters regarding images; names, locations, etc. to be used optionally if needed.

Specs Accepts images in digital format; type varies with need, production requirements, budgets. Making Contact & Terms Contact through rep. Arrange a personal interview to show portfolio if requested. "Send query letter with your website address only via brief e-mail text message. Patrick Redmond Design will not reply unless specific photographer may be needed." Works with local freelancers on assignment only. Cannot return material. Payment negotiable. "Client typically pays photographer directly even though PRD may be involved in photo/photographer selection and photo direction." Payment depends on client. Credit line sometimes given depending upon publication style/individual projects. Rights purchased by clients vary with project; negotiable. "Clients typically involved with negotiation of rights directly with photographer. Please include note 'Photographer's Market 2011' in any correspondence (unlikely to open or respond to mail or e-mails which don't include this on envelope or in subject line)."

Tips Needs are "open-vary with project; location work, studio, table-top, product, portraits, travel, etc." Seeing "use of existing stock images when image/price are right for project, and use of black & white photos in low- to mid-budget/price books. Provide URLs and e-mail addresses. Freelance photographers need Web presence in today's market in addition to exposure via direct mail, catalogs, brochures, etc. Do not send any images/files attached to your e-mails. Briefly state/ describe your work in e-mail. Do not send unsolicited print samples or digital files in any format via e-mail, traditional mail or other delivery."

\$\$ TED ROGGEN ADVERTISING AND PUBLIC RELATIONS

101 Westcott St., Unit 306, Houston TX 77007. (713)426-2314. Fax: (713)869-3563. E-mail: sroggen@ aol.com. Website: http://tedroggen-advertising.com. Estab. 1945. Ad agency and PR firm. Number of employees: 3. Firm specializes in magazine ads, direct mail. Types of clients: construction, entertainment, food, finance, publishing, travel.

Needs Buys 25-50 photos/year; offers 50-75 assignments/year. Uses photos for billboards, direct mail, radio, TV, P-O-P displays, brochures, annual reports, PR releases, sales literature and trade magazines. Subjects include adventure, health/fitness, sports, travel, Interested in fashion/glamour. Model release required. Photo captions required.

Specs Uses 5 × 7 glossy or matte b&w or color prints; 4 × 5 transparencies. "Contact sheet OK."

Making Contact & Terms Provide résumé to be kept on file. Pays \$75-250 for b&w photos: \$125-300 for color photos; \$150/hour. Pays on acceptance. Rights negotiable.

ARNOLD SAKS ASSOCIATES

350 E. 81st St., 4th Fl. New York NY 10028. (212)861-4300. Fax: (212)535-2590. E-mail: afiorillo@ saksdesign.com. Website: www.saksdesign.com. Graphic design firm. Number of employees: 6. Approximate annual billing: \$2 million. Types of clients; industrial, financial, legal, pharmaceutical. hospitals. Examples of recent clients: Alcoa; McKinsey; UBS; Wyeth; Xerox; Hospital for Special Surgery.

Needs Works with approximately 10 photographers during busy season. Uses photos for annual reports and corporate brochures. Subjects include corporate situations and portraits. Wants photos of babies/children/teens, couples, multicultural, families, parents, senior citizens, automobiles, health/fitness/beauty, performing arts, sports, business concepts, industry, medicine, product shots/still life, science, technology/computers. Reviews stock photos; subjects vary according to the nature of the annual report. Model release required. Photo captions preferred.

Specs Accepts images in digital format. Send via e-mail as TIFF, EPS, JPEG files.

Making Contact & Terms "Appointments are set up during the spring for summer review on a firstcome only basis. We have a limit of approximately 30 portfolios each season." Call to arrange an appointment. Responds as needed. Payment negotiable, "based on project budgets. Generally we pay \$1,500-2,500/day." Pays on receipt of invoice and payment by client; advances provided. Credit line sometimes given depending upon client specifications. Buys one-time and all rights; negotiable.

Tips "Ideally a photographer should show a corporate book indicating his success with difficult working conditions and establishing an attractive and vital final product. Our company is well known in the design community for doing classic graphic design. We look for solid, conservative, straightforward corporate photography that will enhance these ideals."

JACK SCHECTERSON DEZIGN ASSOCIATES

5316 251 Place, Little Neck NY 11362. (718)225-3536. Fax: (718)423-3478. Design firm. Firm specializes in 2-D and 3-D visual marketing communications via product, package, collateral and graphic design for large and small industrial and consumer product manufacturers. Types of clients: industrial, retail, publishing, consumer product manufacturers.

Needs "Depends on work in-house." Uses photos for packaging, P-O-P displays, corporate graphics, collateral. Reviews stock photos. Model/property release required. Photo captions preferred.

Specs Uses color and b&w prints; 35mm, $2\frac{1}{4} \times 2\frac{1}{4}$, 4×5 , 8×10 transparencies. Accepts images in digital format.

Making Contact & Terms Works with local freelancers on assignment. Responds in 3 weeks. Payment negotiable, "depends upon job." Credit line sometimes given. Buys all rights.

Tips Wants to see creative and unique images. "Contact by mail only. Send SASE for return of samples or leave samples for our files."

\$\$ HENRY SCHMIDT DESIGN

P.O. Box 67204, Portland OR 97268. (503)652-1114. E-mail: hank@hankink.com. Website: www. hankink.com. Design firm. Number of employees: 2. Approximate annual billing: \$160,000. Firm specializes in branding, packaging, P-O-P displays, catalog/sales literature.

Needs Works with 1-2 photographers/month. Uses photos for catalogs and packaging. Subjects include product shots/still life. Interested in fashion/glamour. Model/property release required. Making Contact & Terms Contact via e-mail with samples attached or link to website. Buys all rights.

■ SOUNDLIGHT

5438 Tennessee Ave., New Port Richey FL 34652. (727)842-6788. E-mail: keth@awakeninghealing.com. Website: www.soundlight.org. Estab. 1972. Approximate annual billing: \$150,000. Number of employees: 2. Firm specializes in websites, direct mail, magazine ads, model portfolios, publication design. Types of clients: businesses, astrological and spiritual workshops, books, calendars, fashion, magazines, models, special events, products, nonprofit, websites. Examples of recent clients: Sensual Women of Hawaii (calendars, post cards).

Needs Works with 1 freelance photographer every 7 months. Subjects include: women, celebrities, couples, Goddess, people in activities, landscapes/scenics, animals, religious, adventure, health/ fitness/beauty, humor, alternative medicine, spiritual, travel sites and activities, exotic dance and models (art, glamour, lingerie, nude). Interested in alternative process, avant garde, erotic, fine art. Reviews stock photos, slides, computer images. Model release preferred for models and advertising people. Photo captions preferred; include who, what, where.

Audiovisual Needs Uses freelance photographers for slide sets, multimedia productions, videotapes, websites.

Specs Uses 4 × 6 to 8 × 10 glossy color prints; 35mm color slides. Accepts images in digital format. Send via CD, floppy disk, e-mail as TIFF, GIF, JPEG files at 70-100 dpi.

Making Contact & Terms Send query letter with résumé, stock list. Provide prints, slides, business card, computer disk, CD, contact sheets, self-promotion piece or tearsheets to be kept on file. Works on assignment; sometimes buys stock nude model photos. May not return unsolicited material. Responds in 3 weeks. Pays \$100 maximum for b&w and color photos, \$10-1,800 for videotape; \$10-100/hour; \$50-750/day; \$2,000 maximum/job; sometimes also pays in "trades." Pays on publication. Credit line sometimes given. Buys one-time, all rights; various negotiable rights depending on use.

Tips In portfolios or demos, looks for "unique lighting, style, emotional involvement; beautiful, artistic, sensual, erotic viewpoints." Sees trend toward "manipulated computer images. Send query about what you have to show, to see what we can use at that time."

A SOUTH CAROLINA FILM COMMISSION

1205 Pendleton St., Room 225, Columbia SC 29201. (803)737-0490. Fax: (803)737-3104. E-mail: tclark@scprt.com; danrogers@scprt.com. Website: www.filmsc.com. 1201 Main St., Suite 1600, Columbia SC 29201. Project Manager: Tom Clark. Senior Manager: Dan Rogers. Types of clients: motion picture and television producers.

Needs Works with 8 photographers/month. Uses photos of South Carolina landscapes/architecture to recruit feature films/TV productions. Subjects include: location photos for feature films, TV projects, national commercials, print ads and catalogs.

Specs Accepts images in digital format. Send via CD as JPEG files. Recommended resolution and sizes for digital files: 144-150 dpi; file size: 200kB-1MB; JPEG compression = 10 maximum quality; 1280×1024 resolution (for single photos).

Making Contact & Terms Submit portfolio by mail. Provide résumé, business card, self-promotion piece or tearsheets to be kept on file. Works with local freelancers on assignment only. Does not return unsolicited material. Payment negotiable. Pays per yearly contract, upon completion of assignment. Buys all rights.

Tips "Experience working in the film/video industry is essential. Ability needed to identify and photograph suitable structures or settings to work as a movie location."

S SUN.ERGOS

130 Sunset Way, Priddis AB TOL 1W0, Canada. (403)931-1527. Fax: (403)931-1534. E-mail: waltermoke@sunergos.com. Website: www.sunergos.com. "A unique, professional, two-man company of theater and dance, touring nationally and internationally as cultural ambassadors to urban and rural communities."

Needs Buys 10-30 photos/year; offers 3-5 assignments/year. Uses photos for brochures, newsletters, posters, newspapers, annual reports, magazines, press releases, audiovisual uses, catalogs. Reviews theater and dance stock photos. Property release required for performance photos for media use. Photo captions required; include subject, date, city, performance title.

Audiovisual Needs Uses digital images, slides, film and videotape for media usage, showcases and international conferences. Subjects include performance pieces/showcase materials.

Specs Uses 8×10 , $8\frac{1}{2} \times 11$ color and b&w prints; 35mm, $2\frac{1}{4} \times 2\frac{1}{4}$ transparencies; 16mm film; NTSC/PAL/SECAM videotape.

Making Contact & Terms Arrange a personal interview to show portfolio. Send query letter with résumé of credits. Provide résumé, business card, self-promotion piece or tearsheets to be kept on file. Works on assignment only. Response time depends on project. Pays \$100-150/day; \$150-300/job; \$2.50-10 for color or b&w photos. Pays on usage. Credit line given. Buys all rights.

Tips "You must have experience shooting dance and live theater performances."

■ \$\$\$ MARTIN THOMAS, INC.

42 Riverside Dr., Barrington RI 02806. (401)245-8500. Fax: (866)899-2710. E-mail: contact@ martinthomas.com. Website: www.martinthomas.com. Ad agency, PR firm. Approximate annual billing: \$7 million. Number of employees: 5. Firm specializes in collateral. Types of clients: industrial and business-to-business. Examples of recent clients: NADCA Show Booth, Newspaper 4PM Corp. (color newspaper); Pennzoil-Quaker State "Rescue," PVC Container Corp. (magazine article); "Bausch & Lomb," GLS Corporation (magazine cover); "Soft Bottles," McKechnie (booth graphics); "Perfectly Clear," ICI Acrylics (brochure).

Needs Works with 3-5 photographers/month. Uses photos for trade magazines. Subjects include: location shots of equipment in plants and some studio. Model release required.

Audiovisual Needs Uses videotape for 5- to 7-minute capabilities or instructional videos.

Specs Uses 8×10 color and b&w prints; 35mm, 4×5 transparencies. Accepts images in digital format (call first). Send via CD, e-mail, floppy disk as GIF, JPEG files.

Making Contact & Terms Send stock list. Provide résumé, business card, brochure, flier or tearsheets to be kept on file. Send materials on pricing, experience. "No unsolicited portfolios will be accepted or reviewed." Cannot return material. Pays \$1,000-1,500/day; \$300-900 for b&w photos; \$400-1,000 for color photos. Pays 30 days following receipt of invoice. Buys exclusive product rights; negotiable.

Tips To break in, demonstrate you "can be aggressive, innovative, realistic, and can work within our clients' parameters and budgets. Be responsive; be flexible."

■ M VIDEO I-D TELEPRODUCTIONS

105 Muller Rd., Washington IL 61571. (309)444-4323. E-mail: videoid@videoid.com. Website: www.videoid.com. Number of employees: 10. Types of clients: health, education, industry, service, cable and broadcast.

Needs Works with 2 photographers/month to shoot digital stills, multimedia backgrounds and materials, films and videotapes. Subjects "vary from commercial to industrial—always high quality." Somewhat interested in stock photos/footage. Model release required.

Audiovisual Needs Uses digital stills, videotape, DVD, DVD-ROM, CD-ROM.

Specs Uses digital still extension, Beta SP, HDV and HD. Accepts images in digital format. Send via DVD, CD, e-mail, FTP.

Making Contact & Terms Provide résumé, business card, self-promotion piece or tearsheets to be kept on file. "Also send video sample reel." Include SASE for return of material. Works with freelancers on assignment only. Responds in 3 weeks. Pays \$10-65/hour; \$160-650/day. Usually pays by the job; negotiable. Pays on acceptance. Credit line sometimes given. Buys all rights; negotiable.

Tips "Sample reel—indicate goal for specific pieces. Show good lighting and visualization skills. Show me you can communicate what I need to see, and have a willingness to put out effort to get top quality."

☑ ■ ■ ■ WARNE MARKETING + COMMUNICATIONS

65 Overlea Blvd., Suite 112, Toronto ON M4H 1P1 Canada. (416)927-0881. Fax: (416)927-1676. E-mail: scott@warne.com. Website: www.warne.com. President: Scott Warne. Estab. 1979. Ad agency. Types of clients: business-to-business.

Needs Works with 4 photographers/month. Uses photos for trade magazines, direct mail, Internet, P-O-P displays, catalogs and posters. Subjects include: business concepts, science, technology/ computers, in-plant photography and studio set-ups. Special subject needs include in-plant shots. Model release required.

Audiovisual Needs Uses PowerPoint and videotape.

Specs Uses digital images or transparencies.

Making Contact & Terms Send letter citing related experience plus 2 or 3 samples. Works on assignment only. Cannot return material. Responds in 2 weeks. Pays \$1,000-1,500/day. Pays within 30 days. Buys all rights.

Tips In portfolio/samples, prefers to see industrial subjects and creative styles. "We look for lighting knowledge, composition and imagination."

A S DANA WHITE PRODUCTIONS

2623 29th St., Santa Monica CA 90405. (310)450-9101. F-mail: dwprods@aol.com. Full-service book development and design, video/film production studio. Types of clients: schools and communitybased nonprofit institutions, corporate, government, publishing, marketing/advertising, art galleries. Examples of recent clients: Copper Cauldron Publishing, Toyota Hybrid Synergy: Mobile Experience Tour (video production); Los Angeles County (annual report); Back Forty Feature Films; Southern California Gas Company/South Coast AQMD (clean air environmental film trailers in 300 LA-based motion picture theaters); Glencoe/McGraw-Hill (textbook photography and illustrations, slide shows); Pepperdine University (awards banquet presentations, fund-raising, biographical tribute programs); U.S. Forest Service (training programs); Venice Family Clinic (newsletter photography); Johnson & Higgins (brochure photography). "Stock photography is available through PhotoEdit: www.photoeditinc.com; locate Dana White in list of photographers."

Needs Works with 2-3 photographers/month. Uses photos for catalogs, audiovisual, books. Subjects include: people, products, still life, event documentation, architecture. Interested in reviewing 35mm stock photos by appointment. Model release required for people and companies. "If your portfolio is on flickr.com, please send a link to your images."

Audiovisual Needs Uses all AV formats including scanned and digital images for computer-based multimedia; 35mm slides for multi-image presentations; and medium-format as needed.

Specs Uses color and b&w prints; 35mm, 2½ × 2½ transparencies; digital images (minimum 6mp files).

Making Contact & Terms Arrange a personal interview to show portfolio and samples. "Please do not send originals." Works with freelancers on assignment only. Will assign certain work on spec. Do not submit unsolicited material. Cannot return material. Pays when images are shot to White's satisfaction—never delays until acceptance by client. Pays according to job: \$25-100/hour, up to \$750/day; \$20-50/shot; or fixed fee based upon job complexity and priority of exposure. Hires according to work-for-hire and will share photo credit when possible.

Tips In freelancer's portfolio or demo, wants to see "quality of composition, lighting, saturation, degree of difficulty, and importance of assignment. The trend seems to be toward more video, less AV. Clients are paying less and expecting more. To break in, freelancers should diversify, negotiate, be personable and flexible, go the distance to get and keep the job. Freelancers need to see themselves as hunters who are dependent upon their hunting skills for their livelihood. Don't get stuck in one-dimensional thinking. Think and perform as a team—service that benefits all sectors of the community and process."

■ ○ WORCESTER POLYTECHNIC INSTITUTE

100 Institute Rd., Worcester MA 01609. (508)831-6715. Fax: (508)831-5820. E-mail: charna@wpi. edu. Website: www.wpi.edu. Publishes periodicals; promotional, recruiting and fund-raising printed materials. Photos used in brochures, newsletters, posters, audiovisual presentations, annual reports, catalogs, magazines, press releases, website.

Needs On-campus, comprehensive and specific views of all elements of the WPI experience. **Specs** Prefers images in digital format, but will use 5×7 (minimum) glossy b&w and color prints.

Making Contact & Terms Arrange a personal interview to show portfolio or query with website link. Provide résumé, business card, brochure, flier or tearsheets to be kept on file. "No phone calls." Responds in 6 weeks. Payment negotiable. Credit line given in some publications. Buys one-time or all rights; negotiable.

■ \$\$\$ SPENCER ZAHN & ASSOCIATES

2015 Sansom St., Philadelphia PA 19103. (215)564-5979. Fax: (215)564-6285. E-mail: szahn@erols. com. Website: www.spencerzahn.com. Member of GPCC. Three employees. Specializes in brand and corporate identity, direct mail design, marketing, retail and business to business advertising. Clients: corporations, manufacturers, etc. Firm specializes in direct mail, electronic collateral, print ads.

Needs Works with freelance illustrators and designers. Prefers artists with experience in Macintosh computers. Uses freelancers for design and illustration; direct mail design; and mechanicals. Needs computer-literate freelancers for design, illustration and production. 80% of freelance work demands knowledge of Illustrator, Photoshop, FreeHand and QuarkXPress.

Making Contact & Terms Send query letter with samples. Samples are not filed and are returned by SASE if requested by artist. Responds only if interested. Artist should follow up with call. Portfolio should include final art and printed samples. Buys all rights.

MARKETS

Galleries

he popularity of photography as a collectible art form has improved the market for fine art photographs over the last decade. Collectors now recognize the investment value of prints by Ansel Adams, Irving Penn, and Henri Cartier-Bresson, and therefore frequently turn to galleries for photographs to place in their private collections.

The gallery/fine art market can make money for many photographers. However, unlike commercial and editorial markets, galleries seldom generate quick income for artists. Galleries should be considered venues for important, thought-provoking imagery, rather than markets through which you can make a substantial living.

More than any other market, this area is filled with photographers who are interested in delivering a message. Many photography exhibits focus on one theme by a single artist. Group exhibits feature the work of several artists, and they often explore a theme from many perspectives, though not always. These group exhibits may be juried (i.e., the photographs in the exhibit are selected by a committee of judges who are knowledgeable about photography). Some group exhibits also may include other mediums such as painting, drawing, or sculpture. In any case, galleries want artists who can excite viewers and make them think about important subjects. They, of course, also hope that viewers will buy the photographs shown in their galleries.

As with picture buyers and art directors, gallery directors love to see strong, well-organized portfolios. Limit your portfolio to twenty top-notch images. When putting together your portfolio, focus on one overriding theme. A director wants to be certain you have enough quality work to carry an entire show. After the portfolio review, if the director likes your style, then you might discuss future projects or past work that you've done. Directors who see promise in your work, but don't think you're ready for a solo exhibition, may place your photographs in a group exhibition.

HOW GALLERIES OPERATE

In exchange for brokering images, a gallery often receives a commission of 40–50 percent. They usually exhibit work for a month, sometimes longer, and hold openings to kick off new shows. They also frequently provide pre-exhibition publicity. Some smaller galleries require exhibiting photographers to help with opening night reception expenses. Galleries also may require photographers to appear during the show or opening. Be certain that such policies are put in writing before you allow them to show your work.

Gallery directors who foresee a bright future for you might want exclusive rights to represent your work. This type of arrangement forces buyers to get your images directly from the gallery that represents you. Such contracts are quite common, usually limiting the exclusive rights to specified distances. For example, a gallery in Tulsa, Oklahoma, may have exclusive rights to distribute your work within a 200-mile radius of the gallery. This would allow you to sign similar contracts with galleries outside the 200-mile range.

FIND THE RIGHT FIT

As you search for the perfect gallery, it's important to understand the different types of exhibition spaces and how they operate. The route you choose depends on your needs, the type of work you do, your long-term goals, and the audience you're trying to reach.

- **Retail or commercial galleries.** The goal of the retail gallery is to sell and promote artists while turning a profit. Retail galleries take a commission of 40–50 percent of all sales.
- **Co-op galleries.** Co-ops exist to sell and promote artists' work, but they are run by artists. Members exhibit their own work in exchange for a fee, which covers the gallery's overhead. Some co-ops also take a commission of 20–30 percent to cover expenses. Members share the responsibilities of gallery-sitting, sales, housekeeping, and maintenance.
- **Rental galleries.** The rental gallery makes its profit primarily through renting space to artists and consequently may not take a commission on sales (or will take only a very small commission). Some rental spaces provide publicity for artists, while others do not. Showing in this type of gallery is risky. Rental galleries are sometimes thought of as "vanity galleries," and, consequently, they do not have the credibility other galleries enjoy.
- **Nonprofit galleries.** Nonprofit spaces will provide you with an opportunity to sell work and gain publicity, but will not market your work aggressively, because their goals are not necessarily sales-oriented. Nonprofits normally take a commission of 20–30 percent.
- Museums. Don't approach museums unless you have already exhibited in galleries. The work
 in museums is by established artists and is usually donated by collectors or purchased through
 art dealers.
- **Art consultancies.** Generally, art consultants act as liaisons between fine artists and buyers. Most take a commission on sales (as would a gallery). Some maintain small gallery spaces and show work to clients by appointment.

If you've never exhibited your work in a traditional gallery space before, you may want to start with a less traditional kind of show. Alternative spaces are becoming a viable way to help the public see your work. Try bookstores (even large chains), restaurants, coffee shops, upscale home furnishings stores, and boutiques. The art will help give their business a more pleasant, interesting environment at no cost to them, and you may generate a few fans or even a few sales.

Think carefully about what you take pictures of and what kinds of businesses might benefit from displaying them. If you shoot flowers and other plant life, perhaps you could approach a nursery about hanging your work in their sales office. If you shoot landscapes of exotic locations, maybe a travel agent would like to take you on. Think creatively and don't be afraid to approach a business person with a proposal. Just make sure the final agreement is spelled out in writing so there will be no misunderstandings, especially about who gets what money from sales.

COMPOSING AN ARTIST'S STATEMENT

When you approach a gallery about a solo exhibition, they will usually expect your body of work to be organized around a theme. To present your work and its theme to the public, the gallery will expect you to write an artist's statement, a brief essay about how and why you make photographic images. There are several things to keep in mind when writing your statement: Be brief. Most statements should be 100–300 words long. You shouldn't try to tell your life's story leading up to this moment. Write as you speak. There is no reason to make up complicated motivations for your work if there aren't any. Just be honest about why you shoot the way you do. Stay focused. Limit your thoughts to those that deal directly with the specific exhibit for which you're preparing.

Before you start writing your statement, consider your answers to the following questions: Why do you make photographs (as opposed to using some other medium)? What are your photographs about? What are the subjects in your photographs? What are you trying to communicate through your work?

ADDISON/RIPLEY FINE ART

1670 Wisconsin Ave. NW, Washington DC 20007. (202)338-5180. Fax: (202)338-2341. E-mail: addisonrip@aol.com. Website: www.addisonripleyfineart.com. Art consultancy, for-profit gallery. Approached by 100 artists/year; represents or exhibits 25 artists. Average display time 6 weeks. Gallery open Tuesday through Saturday from 11 to 6. Closed end of summer. Located in Georgetown in a large, open, light-filled gallery space. Overall price range \$500-80,000. Most work sold at \$2,500-10,000.

Exhibits Exhibits works of all media.

Making Contact & Terms Gallery provides insurance, promotion, contract. Accepted work should be framed, mounted, matted.

Submissions Mail portfolio for review. Send query letter with artist's statement, bio, photocopies, résumé, SASE. Responds in 1 month.

Tips "Submit organized, professional-looking materials."

ADIRONDACK LAKES CENTER FOR THE ARTS

Route 28, P.O. Box 205, Blue Mountain Lake NY 12812. (518)352-7715. Fax: (518)352-7333. E-mail: laura@adirondackarts.org; info@adirondackarts.org. Website: www.adironackarts.org. "ALCA is a 501c, nonprofit organization showing national and international work of emerging to established artists. A tourist and second-home market, demographics profile our client as highly educated, moderately affluent, environmentally oriented and well-travelled. In addition to its public programs, the Arts Center also administers the New York State Decentralization Regrant Program for Hamilton County. This program provides grants to local nonprofit organizations to sponsor art and cultural events, including concerts, workshops, and lectures in their own communities. The area served by the Arts Center includes Hamilton County, and parts of Essex, Franklin, Warren, and Herkimer counties. Our intent, with this diversity, is to enrich and unite the entire Adirondacks via the arts. The busy season is June through September."

Exhibits Solo, group and call for entry exhibits of color and b&w work. Sponsors 15-20 exhibits/ year. Average display time 1 month. Overall price range \$100-2,000. Most work sold at \$250.

Making Contact & Terms Consignment gallery, fee structure on request. Payment for sales follows within 30 days of close of exhibit. White mat and black frame required, except under prior agreement. ALCA pays return shipping only or cover work in transit.

Submissions Apply by CD or slides, résumé and bio. Must include SASE for return of materials. Upon acceptance notification, price sheet and artist statement required.

Tips "ALCA offers a residency program, maintains a fully-equipped darkroom with 24 hour access."

AKRON ART MUSEUM

1 S. High St., Akron OH 44308. (330)376-9185. Fax: (330)376-1180. E-mail: mail@akronartmuseum. org, btannenbaum@akronartmuseum.org. Website: www.akronartmuseum.org. **Director of Curatorial Affairs:** Barbara Tannenbaum. The Akron Art Museum re-opened in July 2007 after expanding into a new, larger building.

 Annually awards the Knight Purchase Award to a living artist working with photographic media.

Exhibits To exhibit, photographers must possess "a notable record of exhibitions, inclusion in publications, and/or a role in the historical development of photography. We also feature area photographers (northeast Ohio)." Interested in innovative works by contemporary photographers; any subject matter. Interested in alternative process, documentary, fine art, historical/vintage.

Making Contact & Terms Payment negotiable. Buys photography outright.

Submissions Will review websites and CDs. Send material via e-mail or by mail with SASE if you want materials returned. Responds in 2 months, "depending on our workload."

Tips "Send professional-looking materials with high-quality images, a résumé and an artist's statement. Never send original prints."

ALASKA STATE MUSEUM

395 Whittier St., Juneau AK 99801-1718. (907)465-2901. Fax: (907)465-2976. E-mail: bob.banghart@alaska.gov. Website: www.museums.state.ak.us/asm/asmhome.html. Museum. Approached by 40 artists/year. Sponsors 1 photography exhibit every 2 years. Average display time 10 weeks. Downtown location—3 galleries.

Exhibits Interested in historical and fine art.

Submissions Finds artists through portfolio reviews.

THE ALBUQUERQUE MUSEUM OF ART & HISTORY

2000 Mountain Rd. NW, Albuquerque NM 87104. (505)243-7255. Fax: (505)764-6546. E-mail: tasedillo@cabq.gov. Website: www.cabq.gov/museum. Sponsors 7-10 exhibits/year. Average display time 3-4 months. Gallery open Tuesday through Sunday from 9 to 5. Closed Monday and city holidays.

Exhibits Considers art, historical and documentary photography for exhibition and purchase. Art related to Albuquerque, the state of New Mexico, and the Southwest.

Submissions Submit portfolio of slides, photos, or disk for review. Responds in 2 months.

THE AMERICAN PRINT ALLIANCE

302 Larkspur Turn, Peachtree City GA 30269-2210. E-mail: director@printalliance.org. Website: www.printalliance.org. Nonprofit arts organization with online gallery and exhibitions, travelling exhibitions, and journal publication; Print Bin: a place on website that is like the unframed, shrink-wrapped prints in a bricks-and-mortar gallery's "print bin." Estab. 1992. Approached by hundreds of artists/year; represents dozens of artists/year. "We only exhibit original prints, artists' books and paperworks." Usually sponsors 2 travelling exhibits/year—all prints, paperworks and artists' books; photography within printmaking processes but not as a separate medium. Most exhibits travel for 2 years. Hours depend on the host gallery/museum/arts center. "We travel exhibits throughout the U.S. and occasionally to Canada." Overall price range for Print Bin: \$150-3,200; most work sold at \$300-500.

Exhibits "We accept all styles, genres and subjects; the decisions are made on quality of work." **Making Contact & Terms** Individual subscription: \$32-39. Print Bin is free with subscription. "Subscribers are eligible to enter juried travelling exhibitions but must pay for framing, shipping to and from our office." Gallery provides promotion.

Submissions Subscribe to journal, *Contemporary Impressions* (www.printalliance.org/alliance/al_subform.html), send one slide and signed permission form (www.printalliance.org/gallery/printbin_info.html). Returns slide if requested with SASE. Usually does not respond to queries from non-subscribers. Files slides and permission forms. Finds artists through submissions to the gallery or Print Bin, and especially portfolio reviews at printmakers conferences. "Unfortunately, we don't have the staff for individual portfolio reviews, though we may—and often do—request additional images after seeing one work, often for journal articles. Generally about 100 images are reproduced per year in the journal."

Tips "See the Standard Forms area of our website (www.printalliance.org/library/li_forms.html) for correct labels on slides and much, much more about professional presentation."

AMERICAN SOCIETY OF ARTISTS

P.O. Box 1326, Palatine IL 60078. (847)991-4748 or (312)751-2500. E-mail: asoa@webtv.net. Website: www.americansocietyofartists.org.

Exhibits Members and nonmembers may exhibit. "Our members range from internationally known artists to unknown artists—quality of work is the important factor. We have about 25 shows throughout the year that accept photographic art.

Making Contact & Terms Accepted work should be framed, mounted or matted.

Submissions Send SASE and 4 slides/photos representative of your work, and request membership information and application. See our website for online jury. To jury via e-mail: submit only to:

Asoaartists@aol.com. Accepted work should be framed, mounted or matted. Responds in 2 weeks. Accepted members may participate in lecture and demonstration service. Member publication: *ASA Artisan*.

ARC GALLERY

832 W. Superior St., #204, Chicago IL 60642. (312)733-2787. E-mail: info@arcgallery.com. Website: www.arcgallery.org. Sponsors 5-8 exhibits/year. Average display time 1 month. Overall price range \$100-1,200.

Exhibits All styles considered. Contemporary fine art photography, documentary and journalism. **Making Contact & Terms** Charges no commission, but there is a space rental fee.

Submissions Must send slides, résumé and statement to gallery for review; include SASE. Reviews JPEGs. Responds in 1 month.

Tips Photographers "should have a consistent body of work. Show emerging and experimental work."

ARIZONA STATE UNIVERSITY ART MUSEUM

P.O. Box 872911, 51 E. 10th Ave., Tempe AZ 85287-2911. (480)965-2787. Fax: (480)965-5254. E-mail: susan.ables@asu.edu; Gordon.Knox@asu.edu. Website: asuartmuseum.asu.edu. **Director:** Gordon Knox. Estab. 1950. Has 2 facilities and approximately 8 galleries of 2,500 square feet each; mounts approximately 15 exhibitions/year. Average display time 3-4 months.

Exhibits Only a small number of solo shows are presented, but all proposals are reviewed by curatorial staff.

Making Contact & Terms Accepted work should be framed, mounted, matted.

Submissions Send query letter with résumé, reviews, images of current work and SASE. "Allow several months for a response since we receive many proposals and review monthly."

ARNOLD ART

210 Thames St., Newport RI 02840. E-mail: info@arnoldart.com. Website: www.arnoldart.com. For-profit gallery. Represents or exhibits 40 artists. Average display time 1 month. Gallery open Monday through Saturday from 9:30 to 5:30; Sunday from 12 to 5. Closed Christmas, Thanksgiving, Easter. Art gallery is 17 × 50 ft., open gallery space (3rd floor). Overall price range \$100-35,000. Most work sold at \$300.

Exhibits Marine (sailing), classic yachts, America's Cup, wooden boats, sailing/racing.

Making Contact & Terms Artwork is accepted on consignment, and there is a 45% commission. Gallery provides promotion. Accepted work should be framed.

Submissions E-mail to arrange personal interview to show portfolio.

THE ARSENAL GALLERY

The NYC Dept. of Parks & Recreation, The Arsenal, Room 20, Central Park, New York NY 10065. (212)360-8163. Fax: (212)360-1329. Website: www.nycgovparks.org. Nonprofit gallery. Approached by 100 artists/year; 8-10 exhibits/year. Sponsors 2-3 photography exhibits/year. Average display time 4-6 weeks. Gallery open Monday through Friday from 9 to 5. Closed weekends and holidays. Has 100 linear feet of wall space on the 3rd floor of the Administrative Headquarters of the Parks Department located in Central Park. Overall price range \$100-5,000.

Exhibits Exhibits photos of environmental, landscapes/scenics, wildlife, architecture, cities/urban, adventure, NYC parks. Interested in alternative process, avant garde, documentary, fine art, historical/vintage.

Making Contact & Terms Artwork is accepted on consignment, and there is a 15% commission. Gallery provides promotion.

Submissions Please note: The Arsenal Gallery is no longer accepting proposals for the 2011 exhibition schedule. We received a large volume of high quality submissions this year. Proposals for the 2012 schedule are due by Spring 2011." Mail portfolio for review. Send query letter with artist's

statement, bio, brochure, business card, photocopies, résumé, reviews, SASE. Responds within 6 months, only if interested. Artist should call. Finds artists through word of mouth, portfolio reviews, art exhibits, referrals by other artists.

Tips "Appear organized and professional."

■ ART@NET INTERNATIONAL GALLERY

(359)(2)455187. Fax: (359)(2)512838. E-mail: fedix@astratec.net; Artnetg@yahoo.com. Website: www.designbg.com. For-profit Internet gallery. Estab. 1998. Approached by 100 artists/year; represents or exhibits 20 artists. Sponsors 5 photography exhibits/year. Display time permanent. "Our gallery exists only on the Internet. Each artist has individual 'exhibition space' divided into separate thematic exhibitions along with bio and statement." Overall price range \$150-55,000.

Exhibits Exhibits photos of multicultural, landscapes/scenics, wildlife, architecture, cities/urban, education, adventure, beauty, sports, travel, science, buildings. Interested in avant garde, erotic, fashion/glamour, fine art, seasonal.

Making Contact & Terms Artwork is accepted on consignment; there is a 10% commission and a rental fee for space of \$1/image per month or \$5/image per year. First 6 images are displayed free of rental fee. Gallery provides promotion. Accepted work should be matted.

Submissions "We accept computer scans only; no slides, please. E-mail us attached scans, 900 × 1200 px (300 dpi for prints or 900 dpi for 36mm slides), as JPEG files for IBM computers." E-mail query letter with artist's statement, bio, résumé. Responds in 6 weeks. Finds artists through submissions, portfolio reviews, art exhibits, art fairs, referrals by other artists.

Tips "E-mail us a tightly edited selection of less than 20 scans of your best work. All work must force any person to look over it again and again. Main usage of all works exhibited in our gallery is for limited edition (photos) or original (paintings) wall decoration of offices and homes, so photos must have quality of paintings. We like to see strong artistic sense of mood, composition, light, color and strong graphic impact or expression of emotions. For us, only quality of work is important, so newer, lesser-known artists are welcome."

ARTEFACT/ROBERT PARDO GALLERY

805 Lake Ave., Lake Worth FL 33460. (561)585-2881. E-mail: robertpardogallery@yahoo.com. Approached by 500 artists/year; represents or exhibits 18 artists. Sponsors 3 photography exhibits/year. Average display time 4-5 weeks.

Exhibits Interested in avant garde, fashion/glamour, fine art.

Submissions Arrange personal interview to show portfolio of slides, transparencies. Responds in 1 month.

ARTISTS' COOPERATIVE GALLERY

405 S. 11th St., Omaha NE 68102. (402)342-9617. E-mail: bronzesculptor@yahoo.com. Website: www.artistsco-opgallery.com. Estab. 1974. Sponsors 11 exhibits/year. Average display time 1 month. Gallery sponsors all-member exhibits and outreach exhibits; individual artists sponsor their own small group exhibits throughout the year. Overall price range \$100-500.

Exhibits Fine art photography only. Interested in all types, styles and subject matter.

Making Contact & Terms Charges no commission. Reviews transparencies. Accepted work should be framed work only. "Artist must be willing to work 13 days per year at the gallery. We are a member-owned-and-operated cooperative. Artist must also serve on one committee."

Submissions Send query letter with résumé, SASE. Responds in 2 months.

Tips "Write for membership application. Membership committee screens applicants August 1-15 each year. Responds by September 1. New membership year begins October 1. Members must pay annual fee of \$325. Our community outreach exhibits include local high school photographers and art from local elementary schools."

THE ARTS COMPANY

215 5th Ave., Nashville TN 37219. (615)254-2040. Fax: (615)254-9289. E-mail: art@theartscompany.com. Website: www.theartscompany.com. Art consultancy, for-profit gallery. Sponsors 6-10 photography exhibits/year. Average display time 1 month. Open Tuesday through Saturday from 10 to 5. Located in downtown Nashville, the gallery has 6,000 sq. ft. of contemporary space in a historic building. Overall price range \$10-35,000. Most work sold at \$300-3,000.

Exhibits Exhibits photos of celebrities, architecture, cities/urban, rural, environmental, landscapes/scenics, entertainment, performing arts. Interested in documentary, fine art, historical/vintage.

Making Contact & Terms Artwork is accepted on consignment. Gallery provides insurance, contract. Accepted work should be framed. Requires exclusive representation locally.

Submissions "We prefer an initial info packet via e-mail." Send query letter with artist's statement, bio, brochure, business card, photocopies, résumé, reviews, SASE, CD. Returns material with SASE. Finds artists through word of mouth, art fairs, art exhibits, submissions, referrals by other artists. **Tips** Provide professional images on a CD along with a professional bio, résumé.

ARTS IOWA CITY

114 S. Dubuque St., Iowa City IA 52240. (319)337-7447. E-mail: gallery@artsiowacity.org. Website: www.artsiowacity.org. Nonprofit gallery. Approached by more than 65 artists/year; represents or exhibits more than 30 artists. Average display time 1 month. Mail gallery open limited hours. Several locations open during business hours; satellite galleries at Starbucks Downtown, US Bank, Melrose Meadows, and Englert. Overall price range: \$200-6,000. Most work sold at \$500.

Exhibits Exhibits photos of landscapes/scenics, architecture, cities/urban, rural. Interested in fine art.

Making Contact & Terms Artwork is accepted on consignment, and there is a 20% commission. Gallery provides insurance (in gallery, not during transit to/from gallery), promotion and contract. Accepted work should be framed, mounted and matted. "We represent artists who are members of Arts Iowa City; to be a member, one must pay a membership fee. Most members are from Iowa and surrounding states."

Submissions Call or write to arrange personal interview to show portfolio of photographs, transparencies. No slides; JPEG advisable. Send query letter with artist's statement, bio, brochure, business card, photographs, résumé, reviews, slides, SASE. Responds to queries in 1 month. Finds artists through referrals by other artists, submissions and word of mouth.

Tips "We are a nonprofit gallery with limited staff. Most work is done by volunteers. Artists interested in submitting work should visit our website to gain a better understanding of the services we provide and to obtain membership and show proposal information. Please submit applications according to the guidelines on the website."

ARTS ON DOUGLAS

123 Douglas St., New Smyrna Beach FL 32168. (386)428-1133. Fax: (386)428-5008. E-mail: mail@ artsondouglas.net. Website: www.artsondouglas.net. For-profit gallery. Represents 60 Florida artists in ongoing group exhibits and features 8 artists/year in solo exhibitions. Average display time 1 month. Gallery open Tuesday through Friday from 10 to 5; Saturday from 11 to 3; by appointment. Location has 5,000 sq. ft. of exhibition space. Overall price range varies.

Exhibits Exhibits photos of environmental. Interested in alternative process, documentary, fine art.

Making Contact & Terms Artwork is accepted on consignment, and there is a 50% commission. Gallery provides insurance, promotion. Accepted work should be framed. Requires exclusive representation locally. *Accepts only professional artists from Florida*.

Submissions Call in advance to inquire about submissions/reviews. Send query letter with artist's statement, bio, brochure, résumé, reviews, slides, SASE. Finds artists through referrals by other artists.

ART SOURCE L.A., INC.

2801 Ocean Park Blvd. #7, Santa Monica CA 90405. (310)452-4411. Fax: (310)452-0300. E-mail: info@artsourcela.com; bonniek@artsourcela.com. Website: www.artsourcela.com. Estab. 1980. Overall price range \$300-15,000. Most work sold at \$600.

Exhibits Exhibits photos of multicultural, environmental, landscapes/scenics, wildlife, architecture, cities/urban, gardening, interiors/decorating, rural, automobiles, food/drink, travel, technology/computers. Interested in alternative process, avant garde, fine art, historical/vintage, seasonal. "We do projects worldwide, putting together fine art for corporations, health care, hospitality, government and public space. We use a lot of photography."

Making Contact & Terms Interested in receiving work from emerging and established photographers. Charges 50% commission.

Submissions Prefers digital submissions via e-mail. Send a minimum of 20 JPEGs, photographs or inkjet prints (laser copies not acceptable), clearly labeled with name, title and date of work; plus catalogs, brochures, résumé, price list, SASE. Responds in 2 months maximum.

Tips "Show a consistent body of work, well marked and presented so it may be viewed to see its merits."

ART WITHOUT WALLS, INC.

P.O. Box 341, Sayville NY 11782. (631)567-9418. Fax: (631)567-9418. E-mail: info@artwithoutwalls. net. Website: www.artwithoutwalls.net. Nonprofit gallery. Estab. 1985. Approached by 300 artists/year; represents or exhibits 100 artists. Sponsors 3 photography exhibits/year. Average display time 1 month. Gallery open daily from 9 to 5. Closed December 22 to January 5 and Easter week. Traveling exhibits in various public spaces. Overall price range \$1,000-25,000. Most work sold at \$3,000-5,000. "Price varies—especially if student work."

Exhibits Exhibits photos of multicultural, families, parents, senior citizens, disasters, environmental, landscapes/scenics, wildlife, architecture, cities/urban, education, rural, adventure, events, food/drink, health, performing arts, sports, travel, agriculture, medicine, political, product shots/still life, science, technology/computers. Interested in alternative process, avant garde, documentary, fashion, fine art, historical/vintage, seasonal.

Making Contact & Terms Artwork is accepted on consignment, and there is a 20% commission. Gallery provides promotion, contract. Accepted work should be framed, mounted, matted.

Submissions Mail portfolio for review. Send query letter with artist's statement, brochure, photographs, résumé, reviews, SASE, slides. Responds in 1 month. Finds artists through submissions, portfolio reviews, art exhibits.

Tips "Work should be properly framed with name, year, medium, title, size."

ARTWORKS

20 E. Central Parkway, Cincinnati OH 45202. (513)333-0388. Fax: (513)333-0799. E-mail: tamara@ artworkscincinnati.org. Website: www.artworkscincinnati.org. Alternative space, cooperative gallery, nonprofit gallery, rental gallery. Estab. 2003. Average display time 1.5 months. Open Monday through Friday from 9 to 5. Closed January. Has 1,500 sq. ft of exhibition space in downtown Cincinnati. Overall price range \$200-15,000. Most work sold at \$1,200.

Exhibits Exhibits photos of multicultural, architecture, cities/urban, education, gardening, interiors/decorating, rural, environmental, adventure, performing arts. Interested in alternative process, avant garde, documentary, fashion/glamour, fine art, lifestyle.

Making Contact & Terms Artwork is accepted on consignment, and there is a 30% commission. Gallery provides promotion, contract.

Submissions Call; send images via e-mail; mail portfolio for review; send query letter with résumé, slides, artist's statement, digital slides. Send nonreturnable samples. "We hold on to materials for future exhibition opportunities." Responds to queries in 1 month. Finds artists through word of mouth, art fairs, portfolio reviews, exhibitions, submissions, referrals by other artists.

Tips "ArtWorks is looking for strong artists who are not only talented in terms of their ability to make and create, but who can also professionally present themselves and show a genuine interest in the exhibition of their artwork. We're looking for concise statements that the artists themselves have written about their work as well as a résumé of exhibitions to help back up their written statements. Artists should continue to communicate with us beyond exhibitions and further down the line just to let us know what they're up to and how they've grown."

ATLANTIC GALLERY

135 W. 29th, Suite 601, New York NY 10001. (212)219-3183. E-mail: contact@atlanticgallery.org. Website: www.atlanticgallery.org. Cooperative gallery. Estab. 1974. Approached by 50 artists/year; represents or exhibits 40 artists. Average display time 3 weeks. Gallery open Tuesday through Saturday from 12 to 6. Closed August. Located in Soho. Overall price range \$100-13,000. Most work sold at \$1,500-5,000.

Exhibits Exhibits photos of multicultural, families, environmental, landscapes/scenics, wildlife, architecture, cities/urban, rural, performing arts, travel, product shots/still life, technology/computers. Interested in fine art.

Making Contact & Terms There is a co-op membership fee plus a donation of time. Accepts mostly artists from New York, Connecticut, Massachusetts, New Jersey.

Submissions Call or write to arrange a personal interview to show portfolio of slides. Send artist's statement, bio, brochure, SASE, slides. Responds in 1 month. Views slides monthly. Finds artists through word of mouth, submissions, art exhibits, referrals by other artists.

Tips "Submit an organized folder with slides, bio, and 3 pieces of actual work. If we respond with interest, we then review again."

AXIS GALLERY

50-52 Dobbin St., Brooklyn NY 11222. (212)741-2582. E-mail: info@axisgallery.com. Website: www.axisgallery.com. For-profit gallery. Approached by 40 African artists/year; representative of 30 artists. Located in Williamsburg, 900 sq. ft. Hours during exhibitions: Friday 12-6, Saturday 12-6, Sunday 1-5 and by appointment. Closed during summer. Overall price range \$500-50,000.

Exhibits Interested in alternative process, avant garde, documentary, erotic, fine art, historical/vintage. Also interested in photojournalism, resistance.

Making Contact & Terms Artwork is accepted on consignment, and there is a 50% commission. Gallery provides insurance, promotion, contract. *Accepts only artists from Africa*.

Submissions Send query letter with résumé, reviews, SASE, slides, photographs or CD-ROM. Responds in 3 months. Finds artists through research, recommendations, submissions, portfolio reviews, art exhibits, referrals by other artists.

Tips "Send letter with SASE and materials listed above. Photographers should research galleries first to check if their work fits the gallery program. Avoid bulk mailings."

BALZEKAS MUSEUM OF LITHUANIAN CULTURE ART GALLERY

6500 S. Pulaski Rd., Chicago IL 60629. (773)582-6500. Fax: (773)582-5133. E-mail: info@ balzekasmuseum.org. Website: www.balzekasmuseum.org. Museum, museum retail shop, nonprofit gallery, rental gallery. Estab. 1966. Approached by 20 artists/year. Sponsors 2 photography exhibits/year. Average display time 6 weeks. Gallery open 7 days a week. Closed holidays. Overall price range \$150-6,000. Most work sold at \$545.

Exhibits Exhibits photos of babies/children/teens, celebrities, couples, multicultural, families, parents, senior citizens, disasters, environmental, landscapes/scenics, wildlife, architecture, cities/urban, education, gardening, interiors/decorating, pets, religious, rural, adventure, automobiles, entertainment, events, food/drink, health/fitness, hobbies, humor, performing arts, sports, travel, agriculture, buildings, business concepts, industry, medicine, military, political, product shots/still life, science, technology/computers. Interested in alternative process, avant garde, documentary, erotic, fashion/glamour, fine art, historical/vintage, seasonal.

Making Contact & Terms Artwork is accepted on consignment, and there is a 331/3 % commission. Gallery provides promotion. Accepted work should be framed.

Submissions Write to arrange personal interview to show portfolio. Responds in 2 months. Finds artists through word of mouth, art exhibits, referrals by other artists.

BARRON ARTS CENTER

1 Main St., Woodbridge NJ 07095. (732)634-0413. Fax: (732)634-8633. E-mail: barronarts@twp. woodbridge.nj.us. Website: www.twp.woodbridge.nj.us. **Director:** Cynthia A. Knight. Overall price range \$150-400. Most work sold at \$150.

Making Contact & Terms Charges 20% commission.

Submissions Reviews transparencies but prefers portfolio. Submit portfolio for review; include SASE for return. Responds "depending upon date of review, but generally within a month of receiving materials." COS of photos acceptable for review.

Tips "Make a professional presentation of work with all pieces matted or treated in a like manner. In terms of the market, we tend to hear that there are not enough galleries that will exhibit photography."

N BELIAN ART CENTER

5980 Rochester Rd., Troy MI 48085. (248)828-1001. E-mail: BelianArtCenter@aol.com. Estab. 1985. Sponsors 1-2 exhibits/year. Average display time 3 weeks. Sponsors openings. Average price range \$200-2,000.

Exhibits Looks for originality, capturing the intended mood, perfect copy, mostly original editions. Subjects include landscapes, cities, rural, events, agriculture, buildings, still life.

Making Contact & Terms Charges 40-50% commission. Buys photos outright. Reviews transparencies. Requires exclusive representation locally. Arrange a personal interview to show portfolio. Send query letter with résumé and SASE.

BELL STUDIO, NC.

3428 N. Southport Ave., Chicago IL 60657. (773)281-2172. Fax: (773)281-2415. E-mail: paul@bellstudio.net; bellstudioinc@gmail.com. Website: www.bellstudio.net. **Director:** Paul Therieau. For-profit gallery. Estab. 2001. Approached by 60 artists/year; represents or exhibits 10 artists. Sponsors 3 photography exhibits/year. Average display time 6 weeks. Open all year; Monday through Friday from 12 to 7; weekends from 12 to 5. Located in brick storefront; 750 sq. ft. of exhibition space; high traffic. Overall price range: \$150-3,500. Most work sold at \$600.

Exhibits Interested in alternative process, avant garde, fine art.

Making Contact & Terms Artwork is accepted on consignment, and there is a 50% commission. Gallery provides insurance, promotion, contract. Accepted work should be framed. Requires exclusive representation locally.

Submissions Write to arrange personal interview to show portfolio; include bio and résumé. Responds to queries within 3 months, only if interested. Finds artists through referrals by other artists, submissions, word of mouth.

Tips "Send SASE; type submission letter; include show history, résumé."

■ BENHAM STUDIO GALLERY

P.O. Box 2808, Seattle WA 98101. Website: www.benhamfineart.com. Online gallery. Sponsors 9 exhibits/year. Average display time 6 weeks. Overall price range \$250-9,750. Most work sold at \$650.

Exhibits Exhibits photos of multicultural, environmental, landscapes/scenics, architecture, cities/urban, religious, rural, humor. Interested in alternative process, avant garde, documentary, fine art.

Making Contact & Terms: \\Charges 50% commission.

Submissions: See website for submission guidelines. If you have a website with a portfolio, you can send the URL via e-mail.

BENNETT GALLERIES AND COMPANY

5308 Kingston Pike, Knoxville TN 37919. (865)584-6791. Fax: (865)588-6130. E-mail: info@ bennettgalleries.com. Website: www.bennettgalleries.com. For-profit gallery. Estab. 1985. Represents or exhibits 40 artists/year. Sponsors 1-2 photography exhibits/year. Average display time 1 month. Gallery open Monday through Saturday from 10 to 5:30. Conveniently located a few miles from downtown Knoxville in the Bearden area. The formal art gallery has over 2,000 sq. ft. and 20,000 sq. ft. of additional space. Overall price range \$100-12,000. Most work sold at \$400-600.

Exhibits Exhibits photos of landscapes/scenics, architecture, cities/urban, humor, sports, travel. Interested in alternative process, fine art, historical/vintage.

Making Contact & Terms Artwork is accepted on consignment, and there is a 50% commission. Gallery provides insurance, promotion, contract. Accepted work should be framed. Requires exclusive representation locally.

Submissions Mail portfolio for review. Send query letter with artist's statement, bio, photographs, SASE, CD. Responds within 1 month, only if interested. Finds artists through word of mouth, submissions, art exhibits, referrals by other artists.

Tips "When submitting material to a gallery for review, the package should include information about the artist (neatly written or typed), photographic material, and SASE if you want your materials back."

BONNI BENRUBI GALLERY

41 E. 57th St. #13, New York NY 10022-1908. (212)888-6007. Fax. (212)751-0819. E-mail: Benrubi@BonniBenrubi.com; benrubi@aol.com. Website: www.bonnibenrubi.com. Estab. 1987. Sponsors 7-8 exhibits/year. Average display time 6 weeks. Overall price range \$500-50,000.

Exhibits Interested in 19th- and 20th-century photography, mainly contemporary.

Making Contact & Terms Charges commission. Buys photos outright. Accepted work should be matted. Requires exclusive representation locally. No manipulated work.

Submissions Submit portfolio for review; include SASE. Responds in 2 weeks. "Portfolio review is the first Thursday of every month. Out-of-towners can send slides with SASE, and work will be returned."

MONA BERMAN FINE ARTS

78 Lyon St., New Haven CT 06511. (203)562-4720. E-mail: info@MonaBermanFineArts.com. Website: www.MonaBermanFineArts.com. Sponsors 0-1 exhibit/year. Average display time 1 month. Overall price range \$500-5,000.

• "We are art consultants serving corporations, architects and designers. We also have private clients. We hold very few exhibits; we mainly show work to our clients for consideration and sell a lot of photographs."

Exhibits "Photographers must have been represented by us for over 2 years. Interested in all except figurative, although we do use some portrait work."

Making Contact & Terms Charges 50% commission. "Payment to artist 30 days after receipt of payment from client." Interested in seeing unframed, unmounted, unmatted work only.

Submissions "E-mail digital images or Web links, or send CDs. Inquire by e-mail; no calls, please. Always include retail prices." Materials returned with SASE only. Responds in 1 month.

Tips "Looking for new perspectives, new images, new ideas, excellent print quality, ability to print in *very* large sizes, consistency of vision. Digital prints must be archival. Not interested in Giclee prints."

B.J. SPOKE GALLERY

299 Main St., Huntington NY 11743. (631)549-5106. E-mail: managerbjs@verizon.net. Website: www.bjspokegallery.com. **Contact:** Manager. Member-owned cooperative gallery. Average display time 1 month. Sponsors openings. Overall price range \$300-2,500.

Exhibits Holds national/international juried competitions. Visit website for details. Interested in "all styles and genres, photography as essay, as well as 'beyond' photography."

Making Contact & Terms Charges 30% commission. Photographer sets price.

Submissions Arrange a personal interview to show portfolio. Send query letter with SASE.

BLOUNT-BRIDGERS HOUSE/HOBSON PITTMAN MEMORIAL GALLERY

130 Bridgers St., Tarboro NC 27886. (252)823-4159. Fax: (252)823-6190. E-mail: edgecombearts@ embarqmail.com. Website: www.edgecombearts.org. Museum. Estab. 1982. Approached by 1-2 artists/year; represents or exhibits 6 artists. Sponsors 1 photography exhibit/year. Average display time 6 weeks. Gallery open Monday through Friday from 10 to 4; weekends from 2 to 4. Closed major holidays, Christmas-New Year. Located in historic house in residential area of small town. Gallery is approximately 48 × 20 ft. Overall price range \$250-5,000. Most work sold at \$500.

Exhibits Exhibits photos of landscapes/scenics, wildlife. Interested in fine art, historical/vintage. **Making Contact & Terms** Artwork is accepted on consignment, and there is a 30% commission. Gallery provides insurance, limited promotion. Accepted work should be framed. Accepts artists from the Southeast and Pennsylvania.

Submissions Mail portfolio review. Send query letter with artist's statement, bio, SASE, slides. Responds in 3 months. Finds artists through word of mouth, submissions, art exhibits, referrals by other artists.

BOOK BEAT GALLERY

26010 Greenfield, Oak Park MI 48237. (248) 968-1190. Fax: (248) 968-3102. E-mail: cary@thebookbeat.com. Website: www.thebookbeat.com. Sponsors 6 exhibits/year. Average display time 6-8 weeks. Overall price range \$300-5,000. Most work sold at \$600.

Exhibits "Book Beat is a bookstore specializing in fine art and photography. We have a backroom gallery devoted to photography and folk art. Our inventory includes vintage work from 19th- to 20th-century, rare books, issues of *Camerawork*, and artist books. Book Beat Gallery is looking for courageous and astonishing image makers, high quality digital work is acceptable. Artists are welcome to submit a handwritten or typed proposal for an exhibition, include artist bio, statement, and website, book or CD with sample images. We are especially interested in photographers who have published book works or work with originals in the book format, also those who work in 'dead media' and extinct processes."

Submissions Responds in 6 weeks.

RENA BRANSTEN GALLERY

77 Geary St., San Francisco CA 94108. (415)982-3292. Fax: (415)982-1807. E-mail: info@ renabranstengallery.com, calvert@renabranstengallery.com. Website: www.renabranstengallery.com. For-profit gallery. Approached by 200 artists/year; represents or exhibits 12-15 artists. Average display time 4-5 weeks. Open Tuesday through Friday from 10:30 to 5:30; Saturday from 11 to 5. **Submissions** E-mail JPEG samples at 72 dpi. Finds artists through word of mouth, art exhibits, submissions, art fairs, portfolio reviews, referrals by other artists.

J.J. BROOKINGS GALLERY

330 Commercial St., San Jose CA 95112. (408)287-3311. Fax: (408)287-6705. E-mail: info@ jjbrookings.com. Website: www.jjbrookings.com. Sponsors rotating group exhibits. Sponsors openings. Overall price range \$500-30,000.

Exhibits Interested in photography created with a "painterly eye."

Making Contact & Terms Charges 50% commission.

Submissions Send material by mail for consideration. Responds in 3-5 weeks if interested; immediately if not acceptable.

Tips Wants to see "professional presentation, realistic pricing, numerous quality images. We're interested in whatever the artist thinks will impress us the most. 'Painterly' work is best. No documentary or politically oriented work."

BUSINESS OF ART CENTER

513 Manitou Ave., Manitou Springs CO 80829. (719)685-1861. Fax: (719)685-5276. E-mail: liz@ thebac.org. Website: www.thebac.org. Gallery Curator and Director: Liz Szabo. Nonprofit gallery. Estab. 1988. Sponsors 6 photography exhibits/year. Average display time 1 month. Gallery open Tuesday through Saturday from 11-6 and Sunday 12-5. Overall price range \$50-3,000. Most work sold at \$300.

Exhibits Exhibits photos of environmental, landscapes/scenics, wildlife, gardening, rural, adventure, health/fitness, performing arts, travel. Interested in alternative process, avant garde, documentary, fashion/glamour, fine art.

Making Contact & Terms Artwork is accepted on consignment, and there is a 40% commission. Gallery provides insurance, promotion, contract. Accepted work should be framed.

Submissions Write to arrange a personal interview to show portfolio. Send query letter with artist's statement, bio, slides. Finds artists through word of mouth, submissions, portfolio reviews, art exhibits, referrals by other artists.

THE CAMERA OBSCURA GALLERY

1309 Bannock St., Denver CO 80204. (303)623-4059. Fax: (303)893-4195. E-mail: info@ cameraobscuragallery.com. Website: www.cameraobscuragallery.com. Approached by 350 artists/year; represents or exhibits 20 artists. Sponsors 7 photography exhibits/year. Open Tuesday through Saturday from 10 to 6; Sunday by appointment. Overall price range \$400-20,000. Most work sold at \$600-3,500.

Exhibits Exhibits photos of environmental, landscapes/scenics, wildlife. Interested in fine art.

Making Contact & Terms Charges 50% commission. Write to arrange a personal interview to show portfolio of photographs. Send bio, brochure, résumé, reviews. Finds artists by word of mouth, submissions, portfolio reviews, art exhibits, art fairs, referrals by other artists, reputation.

Tips "To make a professional gallery submission, provide a good representation of your finished work that is of exhibition quality. Slowly but surely we are experiencing a more sophisticated audience. The last few years have shown a tremendous increase in media reporting on photography-related events and personalities, exhibitions, artist profiles and market news."

■ WILLIAM CAMPBELL CONTEMPORARY ART

4935 Byers Ave., Ft. Worth TX 76107. (817)737-9566. Fax: (817)737-5466. E-mail: wcaa@flash.net. Website: www.williamcampbellcontemporaryart.com. **Owner/Director:** William Campbell. Estab. 1974. Sponsors 8-10 exhibits/year. Average display time 5 weeks. Sponsors openings; provides announcements, press releases, installation of work, insurance, cost of exhibition. Overall price range \$300-8,000.

Exhibits "Primarily interested in photography which has been altered or manipulated in some form."

Making Contact & Terms Charges 50% commission. Reviews transparencies. Accepted work should be mounted. Requires exclusive representation within metropolitan area.

Submissions Send CD (preferred) or slides and résumé by mail with SASE. Responds in 1 month.

CAPITOL COMPLEX EXHIBITIONS

500 S. Bronough St., R.A. Gray Bldg., 3rd Floor, Department of State, The Capitol, Tallahassee FL 32399-0250. (850)245-6470. Fax: (850)245-6492. E-mail: sshaughnessy@dos.state.fl.us. Website:

www.florida-arts.org. Average display time 3 months. Overall price range \$200-1,000. Most work sold at \$400.

Exhibits Exhibits photos of babies/children/teens, couples, multicultural, families, parents, senior citizens, landscapes/scenics, wildlife, architecture, cities/urban, gardening, adventure, entertainment, performing arts, agriculture. Interested in avant garde, fine art, historical/vintage. "The Capitol Complex Exhibitions Program is designed to showcase Florida artists and art organizations. Exhibitions are displayed in the Capitol Gallery (22nd floor) and the Cabinet Meeting Room in Florida's capitol. Exhibitions are selected based on quality, diversity of media, and regional representation."

Making Contact & Terms Does not charge commission. Accepted work should be framed. Interested only in Florida artists or arts organizations.

Submissions Download application from website, complete and send with image CD. Responds in 3 weeks.

CENTER FOR CREATIVE PHOTOGRAPHY

University of Arizona, P.O. Box 210103, 1030 North Olive Rd., Tucson AZ 85721-0103. (520)621-7968. Fax: (520)621-9444. E-mail: wolfep@u.library.arizona.edu; oncenter@ccp.library.arizona.edu. Website: www.creativephotography.org. Museum/archive, research center, print study, library, museum retail shop. Estab. 1975. Sponsors 6-8 photography exhibits/year. Average display time 3-4 months. Gallery open Monday through Friday from 9 to 5; weekends from 12 to 5. Closed most holidays. 5,500 sq. ft.

■ THE CENTER FOR FINE ART PHOTOGRAPHY

400 S. College Ave., Fort Collins CO 80524. (970)224-1010. E-mail: contact@c4fap.org. Website: www.c4fap.org. Nonprofit gallery. Approached by 4,500 artists/year; represents or exhibits about 500 artists. Average display time 4-5 weeks. Office open Monday through Friday from 10 to 5; Saturday from 10 to 3. Closed between exhibitions. Consisting of a 1,600-sq.-ft. gallery, adjoining coffee shop, and events space. Overall price range \$180-3,000. Most work sold at \$150-500. "The Center provides and markets to buyers its online gallery of artists' portfolios—Artists' ShowCase Online, available to all members of the Center." Workshops and forums are also offered.

Exhibits Exhibits photos of babies/children/teens, celebrities, couples, multicultural, families, parents, senior citizens, architecture, cities/urban, interiors/decorating, rural, political, environmental, landscapes/scenics, wildlife, performing arts; abstract, experimental work. Interested in alternative process, avant garde, documentary, erotic, fine art. "The Center features fine art photography that incorporates all processes, many styles and subjects."

Making Contact & Terms Art is accepted through either juried calls for entry or from portfolio review. Gallery provides insurance. Accepts only fine art photographic work.

Submissions Work accepted for exhibition via the center's juried calls for entry. Details at website.

Tips "Only signed archival-quality work is seriously considered by art collectors. This includes both traditional and digital prints."

CENTER FOR PHOTOGRAPHIC ART

Sunset Cultural Center, P.O. Box 1100, Carmel CA 93921. (831)625-5181. Fax: (831)625-5199. E-mail: info@photography.org. Website: www.photography.org. Estab. 1988. Nonprofit gallery. Sponsors 7-8 exhibits/year. Average display time 5-7 weeks. Hours: Tuesday-Sunday 1-5.

Exhibits Interested in fine art photography.

Submissions "Currently not accepting unsolicited submissions. Please e-mail the Center and ask to be added to our submissions contact list if you are not a member."

■ CENTER FOR PHOTOGRAPHY AT WOODSTOCK

59 Tinker St., Woodstock NY 12498. (845)679-9957. Fax: (845)679-6337. E-mail: ariel@cpw. org. Website: www.cpw.org. Alternative space, nonprofit arts and education center. Estab. 1977. Approached by more than 500 artists/year. Hosts 10 photography exhibits/year. Average display time 7 weeks. Gallery open all year; Wednesday through Sunday from 12 to 5.

Exhibits Interested in presenting all aspects of contemporary creative photography including digital media, film, video, and installation by emerging and under-recognized artists. "We host 5 group exhibitions and 5 solo exhibitions annually. Group exhibitions are curated by guest jurors, curators, and CPW staff. Solo exhibition artists are selected by CPW staff. Visit the exhibition archives on our website to learn more."

Making Contact & Terms CPW hosts exhibition and opening reception; provides insurance, promotion, a percentage of shipping costs, installation and de-installation, and honorarium for solo exhibition artists who give gallery talks. CPW takes 25% commission on exhibition-related sales. Accepted work should be framed and ready for hanging.

Submissions Send introductory letter with samples, résumé, artist's statement, SASE. Responds in 4 months. Finds artists through word of mouth, art exhibits, open calls, portfolio reviews, referrals by other artists.

Tips "Please send 10-20 digital work samples by mail (include an image script with your name, telephone number, image title, image media, size). Include a current résumé, statement, SASE for return. We are not responsible for unlabeled slides. We DO NOT welcome solicitations to visit websites. We DO advise artists to visit our website and become familiar with our offerings."

CEPA GALLERY

617 Main St., Suite 201, Buffalo NY 14203. (716)856-2717. Fax: (716)270-0184. E-mail: info@ cepagallery.com. Website: www.cepagallery.com. Alternative space, nonprofit gallery. Sponsors 15 photography exhibits/year. Average display time 6-8 weeks. Open Monday through Friday from 10 to 5; Saturday from 12 to 4. Located in the heart of downtown Buffalo's theater district in the historic Market Arcade complex—8 galleries on 3 floors of the building plus public art sites and state-of-the-art imaging facility. Overall price range varies depending on artist and exhibition—all prices set by artist.

Exhibits Exhibits multicultural photos. Interested in alternative process, avant garde, fine art. **Making Contact & Terms** Artwork is accepted on consignment, and there is a 25% commission. Gallery provides insurance, promotion.

Submissions E-mail proposal and digital images or send query letter with artist's statement, bio, résumé, reviews, slides, slide script, SASE. See full guidelines online at: www.cepagallery.org/artist_resources/calls/generalcall.html. Responds in 3 months. Finds artists through word of mouth, submissions, art exhibits, referrals by other artists.

Tips Prefers only photo-related materials. (See additional information in the Center for Exploratory and Perceptual Art listing.)

THE CHAIT GALLERIES DOWNTOWN

218 E. Washington St., Iowa City IA 52240. (319)338-4442. Fax: (319)338-3380. E-mail: info@ thegalleriesdowntown.com. Website: www.thegalleriesdowntown.com. For-profit gallery. Estab. 2003. Approached by 100 artists/year; represents or exhibits 150 artists. Open Monday through Friday from 10 to 6; Saturday from 11 to 5; Sunday by appointment or by chance. Located in a downtown building renovated to its original look of 1882 with 14-ft.-high molded ceiling and original 9-ft. front door. Professional museum lighting and Scamozzi-capped columns complete the elegant gallery. Overall price range: \$50-10,000.

Exhibits Exhibits landscapes, oil and acrylic paintings, sculpture, fused glass wall pieces, jewelry.

Making Contact & Terms Artwork is accepted on consignment, and there is a 50% commission. Gallery provides insurance, promotion and contract. Accepted work should be framed. Requires exclusive representation locally.

Submissions Call; mail portfolio for review. Responds to queries in 2 weeks. Finds artists through art fairs, art exhibits, portfolio reviews and referrals by other artists.

CHAPMAN FRIEDMAN GALLERY

624 W. Main St., Louisville KY 40202. E-mail: friedman@imagesol.com. Website: www. chapmanfriedmangallery.com. For-profit gallery. Approached by 100 or more artists/year; represents or exhibits 25 artists. Sponsors 1 photography exhibit/year. Average display time 1 month. Open Wednesday through Saturday from 10 to 5. Closed August. Located downtown; approximately 3,500 sq. ft. with 15-foot ceilings and white walls. Overall price range: \$75-10,000. Most work sold at more than \$1,000.

Exhibits Exhibits photos of landscapes/scenics, architecture. Interested in alternative process, avant garde, erotic, fine art.

Making Contact & Terms Artwork is accepted on consignment, and there is a 50% commission. Gallery provides insurance, promotion and contract. Accepted work should be framed. Requires exclusive representation locally.

Submissions Send query letter with artist's statement, bio, brochure, photographs, résumé, slides and SASE. Responds to queries within 1 month, only if interested. Finds artists through portfolio reviews and referrals by other artists.

CLAMPART

521-531 W. 25th Street, Ground Floor, New York NY 10001. (646)230-0020. E-mail: portfolioreview@clampart.com. Website: www.clampart.com. For-profit gallery. Approached by 1,200 artists/year; represents or exhibits 15 artists. See portfolio review guidelines at: www.clampart.com/portfolio. html. Sponsors 12 photography exhibits/year. Average display time 6 weeks. Open Tuesday through Saturday from 11 to 6; closed last 2 weeks of August. Located on the ground floor on Main Street in Chelsea. Overall price range: \$300-50,000. Most work sold at \$2,000.

Exhibits Exhibits photos of couples, disasters, environmental, landscapes/scenics, architecture, cities/urban, humor, performing arts, travel, science, technology/computers. Interested in alternative process, avant garde, documentary, erotic, fashion/glamour, fine art, historical/vintage.

Making Contact & Terms Artwork is accepted on consignment, and there is a 50% commission. Gallery provides insurance, promotion and contract. Accepted work should be framed, mounted and matted.

Submissions E-mail query letter with artist's statement, bio and JPEGs. Responds to queries in 2 weeks. Finds artists through portfolio reviews, submissions and referrals by other artists.

Tips "Include a bio and well-written artist's statement. Do not submit work to a gallery that does not handle the general kind of work you produce."

CATHARINE CLARK GALLERY

150 Minna St., Ground Floor, San Francisco CA 9410. (415)399-1439. Fax: (415)543-1338. E-mail: info@cclarkgallery.com. Website: www.cclarkgallery.com. For-profit gallery. Estab. 1991. Approached by 1,000 artists/year; represents or exhibits 28 artists. Sponsors 1-3 photography exhibits/year. Average display time 4-6 weeks. Overall price range \$200-150,000. Most work sold at \$5,000.

Exhibits Interested in alternative process, avant garde. "The work shown tends to be vanguard with respect to medium, concept and process."

Making Contact & Terms Charges 50% commission. Gallery provides insurance, promotion. Accepted work should be ready to hang. Requires exclusive representation locally.

Submissions "Do not call." No unsolicited submissions. Finds artists through word of mouth, art exhibits, art fairs, referrals by other artists and colleagues.

M JOHN CLEARY GALLERY

2635 Colquitt, Houston TX 77098. (713)524-5070. E-mail: info@johnclearygallery.com. Website: www.johnclearygallery.com. Average display time 5 weeks. Open Tuesday through Saturday from 10 to 5 and by appointment. Located in upper Kirby District of Houston, Texas. Overall price range \$500-40,000. Most work sold at \$1,000-2,500.

Exhibits Exhibits photos of babies/children/teens, celebrities, couples, multicultural, families, parents, senior citizens, landscapes/scenics, wildlife, architecture, cities/urban, education, pets, religious, rural, adventure, automobiles, entertainment, events, humor, performing arts, travel, agriculture, industry, military, political, portraits, product shots/still life, science, technology/computers. Interested in alternative process, documentary, fashion/glamour, fine art, historical/vintage.

Making Contact & Terms Artwork is bought outright or accepted on consignment with a 50% commission. Gallery provides insurance, promotion, contract.

Submissions Call to show portfolio of photographs. Finds artists through submissions, art exhibits.

STEPHEN COHEN GALLERY

7358 Beverly Blvd., Los Angeles CA 90036. (323)937-5525. Fax: (323)937-5523. E-mail: info@ stephencohengallery.com. Website: www.stephencohengallery.com. Photography and photo-based art gallery. Represents 40 artists. Sponsors 6 exhibits/year. Average display time 2 months. Open Tuesday through Saturday from 11 to 5. "We are a large, spacious gallery and are flexible in terms of types of shows we can mount." Overall price range \$500-20,000. Most work sold at \$2,000.

Exhibits All styles of photography and photo-based art. "The Gallery has exhibited vintage and contemporary photography and photo-based art from the United States, Europe and South America. The gallery is also able to locate work by photographers not represented by the gallery. As host gallery for Photo LA, Photo San Francisco, Photo NY and Art LA, the gallery has helped to expand the awareness of photography as an art form to be appreciated by the serious collector."

Making Contact & Terms Charges 50% commission. Gallery provides insurance, promotion, contract. Requires exclusive representation locally.

Submissions Mail portfolio for review. Send query letter with artist's statement, bio, brochure, business card, photographs, résumé, reviews, SASE. Responds within 3 months, only if interested. Finds artists through word of mouth, published work.

Tips "Photography is still the best bargain in 20th-century art. There are more people collecting photography now, increasingly sophisticated and knowledgeable people aware of the beauty and variety of the medium."

■ CONTEMPORARY ARTS CENTER

900 Camp St., New Orleans LA 70130. (504)528-3805. Fax: (504)528-3828. E-mail: jking@cacno. org; info@cacno.org. Website: www.cacno.org. Exhibitions Manager: Johnny King. Alternative space, nonprofit gallery. Estab. 1976. Gallery open Thursday through Sunday from 11 to 4. Closed Mardis Gras, Christmas, New Year's Day. Located in the central business district of New Orleans; renovated/converted warehouse.

Exhibits Interested in alternative process, avant garde, fine art. Cutting-edge contemporary preferred.

Submissions Send query letter with bio, SASE, slides or CD. Responds in 4 months. Finds artists through word of mouth, submissions, art exhibits, art fairs, referrals by other artists, professional contacts, art periodicals.

Tips "Submit only 1 slide sheet with proper labels (title, date, media, dimensions) or CD-ROM with the same information."

THE CONTEMPORARY ARTS CENTER (CINCINNATI)

44 E. Sixth St., Cincinnati OH 45202. (513)345-8400. Fax: (513)721-7418. E-mail: jmagoto@ contemporaryartscenter.org;pr@contemporaryartscenter.org. Website: www.ContemporaryArts Center.org. Nonprofit arts center. Sponsors 9 exhibits/year. Average display time 6-12 weeks. Sponsors openings; provides printed invitations, music, refreshments, cash bar.

Exhibits Photographer must be selected by the curator and approved by the board. Exhibits photos of multicultural, disasters, environmental, landscapes/scenics, gardening, technology/computers. Interested in avant garde, innovative photography, fine art.

Making Contact & Terms Photography sometimes sold in gallery. Charges 15% commission. **Submissions** Send guery with résumé, slides, SASE. Responds in 2 months.

CONTEMPORARY ARTS COLLECTIVE

101 East Charleston Blvd., Suite 101, Las Vegas NV (702)382-3886. Fax: (702)598-3886. E-mail: info@lasvegascac.org. Website: www.lasvegascac.org. Nonprofit gallery. Estab. 1989. Sponsors more than 9 exhibits/year. Average display time 1 month. Gallery open Tuesday through Saturday from 12 to 4. Closed Thanksgiving, Christmas, New Year's Day, 1,200 sq. ft. Overall price range \$200-4,000. Most work sold at \$400.

Exhibits Interested in alternative process, avant garde, documentary, fine art.

Making Contact & Terms Artwork is accepted through annual call for proposals of self-curated group shows, and there is a 30% requested donation. Gallery provides insurance, promotion, contract.

Submissions Finds artists through annual call for proposals, membership, word of mouth, submissions, portfolio reviews, art exhibits, art fairs, referrals by other artists and walk-ins. Check website for dates and submission guidelines.

Tips Submitted slides should be "well labeled and properly exposed with correct color balance."

N CORCORAN FINE ARTS LIMITED, INC.

12610 Larchmere Blvd., Cleveland OH 44120. (216)767-0770. Fax: (216)767-0774. E-mail: corcoranfinearts@gmail.com. Website: www.corcoranfinearts.com. Gallery. Estab. 1986. Represents 28 artists.

Exhibits Interested in fine art. Specializes in representing high-quality 19th- and 20th-century

Making Contact & Terms Gallery receives 50% commission. Requires exclusive representation locally.

Submissions For first contact, send a query letter, résumé, bio, slides, photographs, SASE. Responds within 1 month. After initial contact, drop off or mail in appropriate materials for review. Portfolio should include slides, photographs. Finds artists through solicitation.

CORPORATE ART SOURCE/CAS GALLERY

2960-F Zelda Rd., Montgomery AL 36106. (334)271-3772. Fax: (334)271-3772. E-mail: casjb@ mindspring.com. Website: www.casgallery.com. Approached by 100 artists/year; represents or exhibits 50 artists. Sponsors 1 photography exhibit/year. Average display time 6 weeks. Gallery open Monday through Friday from 10 to 5:30; weekends from 11 to 3. Overall price range \$200-20,000. Most work sold at \$1,000.

Exhibits Exhibits photos of landscapes/scenics, architecture, rural. Interested in alternative process, avant garde, fine art, historical/vintage.

Making Contact & Terms Artwork is accepted on consignment, and there is a 50% commission. Gallery provides contract.

Submissions E-mail from the website, or mail portfolio for review. Send query letter. Responds within 6 weeks, only if interested. Finds artists through submissions, portfolio reviews, art exhibits, art fairs, referrals by other artists.

M COURTHOUSE GALLERY, LAKE GEORGE ARTS PROJECT

1 Amherst St., Lake George NY 12845. (518)668-2616. Fax: (518)668-3050. E-mail: mail@ lakegeorgearts.org. Website: www.lakegeorgearts.org. **Gallery Director:** Laura Von Rosk. Nonprofit gallery. Estab. 1986. Approached by more than 200 artists/year; represents or exhibits 10-15 artists. Sponsors 1-2 photography exhibits/year. Average display time 5-6 weeks. Gallery open Tuesday through Friday from 12 to 5; weekends from 12 to 4. Closed mid-December to mid-January. Overall price range \$100-5,000. Most work sold at \$500.

Making Contact & Terms Artwork is accepted on consignment and there is a 25% commission. Gallery provides insurance, promotion, contract. Accepted work should be framed, mounted, matted.

Submissions Mail portfolio for review. Deadline always January 31st. Send query letter with artist's statement, bio, résumé, slides, SASE. Responds in 2 months. Finds artists through word of mouth, submissions, portfolio reviews, art exhibits, art fairs, referrals by other artists.

■ CREALDÈ SCHOOL OF ART

600 St. Andrews Blvd., Winter Park FL 32792. (407)671-1886. Fax: (407)671-0311. E-mail: rickpho@aol.com. Website: www.crealde.org. Open Mon.-Thurs. 9-4; Fri. & Sat. 9-1.

Exhibits "The school's gallery holds 6-7 exhibitions/year, representing artists from regional/national stature in all media.

Making Contact & Terms Anyone who would like to show here may send 20 slides or digital images, résumé, statement and return postage."

CROSSMAN GALLERY

950 W. Main St., Whitewater WI 53190. (262)472-5708. E-mail: flanagam@uww.edu. Website: http://blogs.uss.edu/crossman/. Estab. 1971. Photography is frequently featured in thematic exhibits at the gallery. Average display time 1 month. Overall price range \$250-3,000.

Exhibits "We primarily exhibit artists from the Midwest but do include some from national and international venues. Works by Latino artists are also featured in a regular series at ongoing exhibits." Interested in all types of innovative approaches to photography.

Making Contact & Terms Sponsors openings; provides food, beverage, show announcement, mailing, shipping (partial) and possible visiting artist lecture/demo.

Submissions Submit 10-20 slides or CD, artist's statement, résumé, SASE.

Tips "The Crossman Gallery operates within a university environment. The focus is on exhibits that have the potential to educate viewers about processes and techniques and have interesting thematic content."

■ THE DALLAS CENTER FOR CONTEMPORARY ART

161 Glass Street at Riverfront, Dallas TX 75207. (214)821-2522. Fax: (214)821-9103. E-mail: info@ dallascontemporary.org. Website: www.dallascontemporary.org. **Director:** Peter Doroshenko. Nonprofit gallery. Estab. 1981. Sponsors 1-2 photography exhibits/year. Other exhibits may include photography as well as other mediums. Average display time 6-8 weeks. Gallery open Tuesday through Saturday from 10 to 5.

Exhibits Exhibits a variety of subject matter and styles.

Making Contact & Terms Charges no commission. "Because we are nonprofit, we do not sell artwork. If someone is interested in buying art in the gallery, they get in touch with the artist. The transaction is between the artist and the buyer."

Submissions Reviews slides/CDs. Send material by mail for consideration; include SASE. Responds October 1 annually.

Tips "Memberships available starting at \$50. See our website for info and membership levels."

THE DAYTON ART INSTITUTE

456 Belmonte Park N., Dayton OH 45405-4700. (937)223-5277. Fax: (937)223-3140. E-mail: info@ daytonartinstitute.org. Website: www.daytonartinstitute.org. Museum. Estab. 1919. Galleries open Tuesday through Saturday, 10 to 4; Sunday from noon to 4, Thursdays until 8.

Exhibits Interested in fine art.

DELAWARE CENTER FOR THE CONTEMPORARY ARTS

200 S. Madison St., Wilmington DE 19801. (302)656-6466. Fax: (302)656-6944. E-mail: info@ thedcca.org. Website: www.thedcca.org. Alternative space, museum retail shop, nonprofit gallery. Approached by more than 800 artists/year; exhibits 50 artists. Sponsors 30 total exhibits/year. Average display time 6 weeks. Gallery open Tuesday, Thursday, Friday, and Saturday from 10 to 5; Wednesday and Sunday from 12 to 5. Closed on Monday and major holidays. Seven galleries located along rejuvenated Wilmington riverfront.

Exhibits Interested in alternative process, avant garde.

Making Contact & Terms Gallery provides PR and contract. Accepted work should be framed, mounted, matted. Prefers only contemporary art.

Submissions Send query letter with artist's statement, bio, SASE, 10 digital images. Returns material with SASE. Responds within 6 months. Finds artists through calls for entry, word of mouth, submissions, portfolio reviews, art exhibits, referrals by other artists.

DEMUTH MUSEUM

120 E. King St., Lancaster PA 17602. (717)299-9940. Fax: (717)299-9749. E-mail: information@demuth.org. Website: www.demuth.org. Contact: Gallery Director. Museum. Estab. 1981. Average display time 2 months. Open Tuesday through Saturday from 10 to 4; Sunday from 1 to 4. Located in the home and studio of Modernist artist Charles Demuth (1883-1935). Exhibitions feature the museum's permanent collection of Demuth's works with changing, temporary exhibitions.

DETROIT FOCUS

P.O. Box 843, Royal Oak MI 48068-0843. (248)541-2210. Fax: (248)541-3403. E-mail: michael@sarnacki.com. Website: www.detroitfocus.org. Artist alliance. Approached by 100 artists/year; represents or exhibits 100 artists. Sponsors 1 or more photography exhibit/year.

Exhibits Interested in photojournalism, avant garde, documentary, erotic, fashion/glamour, fine art.

Making Contact & Terms No charge or commission.

Submissions Call or e-mail. Responds in 1 week. Finds artists through word of mouth, submissions, art exhibits, referrals by other artists.

SAMUEL DORSKY MUSEUM OF ART

1 Hawk Dr., 75 S. Manheim Blvd., New Paltz NY 12561. (845)257-3844. Fax: (845)257-3854. E-mail: wallaceb@newpaltz.edu. Website: www.newpaltz.edu/museum. **Curator**: Brian Wallace. Estab. 1964. Sponsors ongoing photography exhibits throughout the year. Average display time 2 months. Museum open Tuesday through Friday from 11 to 5; weekends from 1 to 5. Closed legal and school holidays "and during intersession; check website to confirm your visit."

Exhibits Interested in alternative process, avant garde, documentary, fine art, historical/vintage. **Submissions** Send query letter with bio and SASE. Responds within 3 months, only if interested. Finds artists through art exhibits.

N O DOT FIFTYONE GALLERY

51 NW 36 St., Wynwood Arts District, Miami FL 33127. (305)573-9994. E-mail: dot@dotfiftyone.com. Website: www.dotfiftyone.com. Estab. 2003. Sponsors 6 photography exhibits per year. Average display time: 30 days. Clients include the local community, tourists, and upscale corporate collectors. Art sold for \$1,000-20,000 (avg. \$5,000) with a 50% commission. Prices are set by

the gallery and the artist. Gallery provides insurance, promotion, and contract. Work should be framed, mounted and matted. Will respond within 1 month if interested.

GEORGE EASTMAN HOUSE

900 East Ave., Rochester NY 14607. (585)271-3361. Website: www.eastmanhouse.org. Museum. Estab. 1947. Approached by more than 400 artists/year. Sponsors more than 12 photography exhibits/year. Average display time 3 months. Gallery open Tuesday through Saturday from 10 to 5 (Thursday until 8); Sunday from 1 to 5. Closed Thanksgiving and Christmas. Museum has 7 galleries that host exhibitions, ranging from 50- to 300-print displays.

Exhibits GEH is a museum that exhibits the vast subjects, themes and processes of historical and contemporary photography.

Submissions See website for detailed information: http://eastmanhouse.org/inc/collections/submissions.php. Mail portfolio for review. Send query letter with artist's statement, résumé, SASE, slides, digital prints. Responds in 3 months. Finds artists through word of mouth, art exhibits, referrals by other artists, books, catalogs, conferences, etc.

Tips "Consider as if you are applying for a job. You must have succinct, well-written documents; a well-selected number of visual treats that speak well with written document provided; an easel for reviewer to use."

CATHERINE EDELMAN GALLERY

300 W. Superior St., Lower Level, Chicago IL 60610. (312)266-2350. Fax: (312)266-1967. Website: www.edelmangallery.com. **Director:** Catherine Edelman. Estab. 1987. Sponsors 7 exhibits/year. Average display time 8-10 weeks. Open Tuesday through Saturday from 10 to 5:30. Overall price range \$1,500-25,000.

Exhibits "We exhibit works ranging from traditional photography to mixed media photo-based work."

Making Contact & Terms Charges 50% commission. Requires exclusive representation in the Midwest.

Submissions Policy on the website.

Tips Looks for "consistency, dedication and honesty. Try to not be overly eager and realize that the process of arranging an exhibition takes a long time. The relationship between gallery and photographer is a partnership."

PAUL EDELSTEIN STUDIO AND GALLERY

540 Hawthorne Street, Memphis TN 38112-5029. (901)496-8122. Fax: (901)276-1493. E-mail: henrygrove@yahoo.com. Website: www.askart.com. Shows are presented continually throughout the year. Overall price range: \$300-10,000. Most work sold at \$1,000.

Exhibits Exhibits photos of celebrities, children, multicultural, families. Interested in avant garde, historical/vintage, C-print, dye transfer, ever color, fine art and 20th-century photography "that intrigues the viewer"—figurative still life, landscape, abstract—by upcoming and established photographers.

Making Contact & Terms Charges 50% commission. Buys photos outright. Reviews transparencies. Accepted work should be framed or unframed, mounted or unmounted, matted or unmatted work. There are no size limitations. Submit portfolio for review. Send query letter with samples. Cannot return material. Responds in 3 months.

Tips "Looking for figurative and abstract figurative work."

EMEDIALOFT.ORG

55 Bethune St. #A-629, New York NY 10014-2035. (212)924-4893. E-mail: abc@medialoft.org. Website: www.emedialoft.org. Alternative space. Average display time 3 months. Open by appointment. Located in Greenwich Village, Westbeth Artists' Building. Overall price range \$5-50,000. Most work sold at \$500-2,000. eMediaLoft offers photographic services, and services for photographers,

including digital and film shoots, slides, scans and prints; photo assistants; darkroom processes; retouching and digital manipulation; dry mounting; artists' web pages; catalogues (including catalogue essays); consultation on grant and exhibition preparation (including artists' statements); college application materials and portfolio; curatorials; labels; etc. Consult rates and services page as well as other links listed on the website.

Exhibits Exhibits photos of environmental, landscapes/scenics, humor, performing arts. Interested in alternative process, avant garde, fine art, vintage; pictorial and conceptual photography.

Making Contact & Terms Artwork is accepted on consignment, and there is a 50% commission. Submissions "E-mail 250 words plus 5 JPEGs at 72 dpi (300 pixels on the longest side). Send query letter with anything you like. No SASE—sorry, we can't return anything, although we may keep you on file, but please do not telephone." Responds only if interested.

Tips "Create art from your subconscious, even if it looks like something recognizable; don't illustrate ideas. No political art. Be sincere and probably misunderstood. Be hard to categorize. Show me art that nobody 'gets,' but, please, nothing psychedelic. Don't start your cover letter with 'My name is...' Take a good look at the artists and pages on our website before you send anything."

THOMAS ERBEN GALLERY

526 W. 20th St., New York NY 10011. (212)645-8701. Fax: (212)941-9630. E-mail: info@thomaserben. com. Website: www.thomaserben.com. For-profit gallery. Estab. 1996. Approached by 100 artists/ year; represents or exhibits 15 artists. Average display time 5-6 weeks. Gallery open Tuesday through Saturday from 10 to 6 (Monday through Friday in July). Closed Christmas/New Year's Day and August.

Submissions Mail portfolio for review. Responds in 1 month.

ERNESTO MAYANS GALLERY

601 Canyon Rd., Santa Fe NM 87501. (505)983-8068. E-mail: arte2@aol.com. Website: ernestomayansgallery.com. Director: Ernesto Mayans. Estab. 1977. "We exhibit Photogravures by Unai San Martin; Pigment prints by Pablo Mayans, Silver Gelatin prints by Richard Faller (Vintage Southwest Works) and Johanna Saretzki and Sean McGann (Nudes)."

Making Contact & Terms Please call before submitting. Size limited to 16 × 20 maximum. Arrange a personal interview to show portfolio. Send query by mail with SASE for consideration. Responds in 4 weeks. Charges 50% commission. Consigns. Requires exclusive representation within area.

ETHERTON GALLERY

135 S. 6th Ave., Tucson AZ 85701. (520)624-7370. Fax: (520)792-4569. E-mail: info@ethertongallery. com. Website: www.ethertongallery.com. Retail gallery and art consultancy; Terry Etherton is a certified appraiser of photographs. Specializes in vintage and contemporary photography. Represents 50 + emerging, mid-career and established artists. Exhibited artists include Harry Callahan, Kate Breakey, Manuel Alvarez Bravo, Jack Dykinga, Elliott Erwitt, Danny Lyon, Mark Klett, Alex Webb. Sponsors 4 shows/year. Average display time 8 weeks. Open year round. Located downtown; 3,000 sq. ft. in historic building, 60% of space for special exhibitions; 40% of space for gallery artists. Clientele: 50% private collectors, 25% corporate collectors, 25% museums. Overall price range \$500-50,000; most work sold at \$2,000-5,000. Media: Considers all types of photography, painting, works on paper. Etherton Gallery regularly purchases 19th-century, vintage, and classic photography; occasionally purchases contemporary photography and artwork. Interested in seeing work that is "well-crafted, cutting-edge, contemporary, issue-oriented."

Making Contact & Terms Usually accepts work on consignment (50% commission). Retail price set by gallery and artist. Gallery provides insurance and promotion; shipping costs are shared; Prefers framed artwork.

Submissions Send CD or DVD, resume, reviews, bio; materials not returned without a SASE. No unprepared, incomplete works or unfocused work with too wide a range. Responds in 6 weeks only if interested.

Tips "Become familiar with the style of our gallery and with contemporary art scene in general."

EVENTGALLERY 910ARTS

910 Santa Fe Dr., Denver CO 80204. (303)815-7113. Fax: (303)333-9762. E-mail: info@910arts.com. Website: www.910arts.com. Community outreach gallery and event rental space whose mission is to create an open dialogue between artists and the community by raising awareness of social and environmental issues through creation of art. Average display time 2 months. Located in Denver's art district with 1,200 sq. ft./ 105 linear ft./optional additional 76 linear ft. of marble walls.

Exhibits Interested in fine art.

Making Contact & Terms Artwork is accepted on consignment; there is a 60% commission, or there is a rental fee for space. Gallery provides insurance, promotion, contract. Artwork must be professionally displayed. See website for submission guidelines. Responds to queries as soon as possible. Finds artists through word of mouth, art fairs, portfolio reviews, submissions, referrals by other artists.

EVERSON MUSEUM OF ART

401 Harrison St., Syracuse NY 13202. (315)474-6064. Fax: (315)474-6943. E-mail: everson@ everson.org; smassett@everson.org. Website: www.everson.org. Museum. Approached by many artists/year; represents or exhibits 16-20 artists. Sponsors 2-3 photography exhibits/year. Average display time 3 months. Gallery open Tuesday through Friday from 12 to 5; Saturday from 10 to 5; Sunday from 12 to 5. "The museum features four large galleries with twenty-four foot ceilings, track lighting and oak hardwood, a sculpture court, a children's gallery, a ceramic study center and five smaller gallery spaces."

Exhibits Photos of multicultural, environmental, landscapes/scenics, wildlife. Interested in alternative process, avant garde, documentary, fine art, historical/vintage.

Submissions Send query letter with artist's statement, bio, résumé, reviews, SASE, slides. Finds artists through submissions, portfolio reviews, art exhibits.

■ FAHEY/KLEIN GALLERY

148 N. La Brea Ave., Los Angeles CA 90036. (323)934-2250. Fax: (323)934-4243. E-mail: fkg@ earthlink.net. Website: www.faheykleingallery.com. **Co-Owners:** David Fahey and Ken Devlin. Estab. 1986. For-profit gallery. Approached by 200 artists/year; represents or exhibits 60 artists. Sponsors 10 exhibits/year. Average display time 5-6 weeks. Gallery open Tuesday through Saturday from 10 to 6. Closed on all major holidays. Sponsors openings; provides announcements and serves beverages at reception. Overall price range \$500-500,000. Most work sold at \$2,500. Located in Hollywood; gallery features 2 exhibition spaces with extensive work in back presentation room.

Exhibits Interested in established work; photos of celebrities, landscapes/scenics, wildlife, architecture, entertainment, humor, performing arts, sports. Interested in alternative process, avant garde, documentary, erotic, fashion/glamour, fine art, historical/vintage. Specific photo needs include iconic photographs, Hollywood celebrities, photojournalism, music-related, reportage and still life.

Making Contact & Terms Artwork is accepted on consignment, and the commission is negotiated. Gallery provides insurance, promotion, contract. Accepted work should be unframed, unmounted and unmatted. Requires exclusive representation within metropolitan area. Photographer must be established for a minimum of 5 years; preferably published.

Submissions Prefers website URLs for initial contact, or send material (CD, reproductions, no originals) by mail with SASE for consideration. Responds in 2 months. Finds artists through art fairs, exhibits, portfolio reviews, submissions, word of mouth, referrals by other artists.

Tips "Please be professional and organized. Have a comprehensive sample of innovative work. Interested in seeing mature work with resolved photographic ideas and viewing complete portfolios addressing one idea."

FALKIRK CULTURAL CENTER

P.O. Box 151560, San Rafael CA 94915-1560. (415)485-3328. Fax: (415)485-3404. E-mail: Beth. Goldberg@ci.san-rafael.ca.us. Website: www.falkirkculturalcenter.org. **Curator:** Beth Goldberg. Nonprofit gallery and national historic place (1888 Victorian) converted to multi-use cultural center. Approached by 500 artists /year; exhibits 300 artists. Sponsors 2 photography exhibits/year. Average display time 2 months. Gallery open Monday through Friday from 1 to 5; Saturday from 10 to 1.

Making Contact & Terms Gallery provides insurance.

Submissions Send query letter with artist's statement, bio, slides, résumé. Returns material with SASE. Please prepare a written proposal explaining the exhibition scope and content. Thematic exhibits are encouraged, and shows must include at least three artists. Include slides and/or photo samples of work to be included. Proposals should be delivered to Falkirk or mailed to Exhibition Committee, Falkirk Cultural Center. Finds artists through word of mouth, submissions, portfolio reviews, art exhibits, art fairs, referrals by other artists.

FAVA (FIRELANDS ASSOCIATION FOR THE VISUAL ARTS)

New Union Center for the Arts, 39 S. Main St., 39 S. Main St., Oberlin OH 44074. (440)774-7158. Fax: (440)775-1107. E-mail: favagallery@oberlin.net. Website: www.favagallery.org. Nonprofit gallery. Estab. 1979. Sponsors 1 photography exhibit/year. Average display time 1 month. Gallery open Tuesday through Saturday from 11 to 5; Sunday from 1 to 5. Overall price range \$75-3,000. Most work sold at \$200.

Exhibits Open to all media, including photography. Exhibits a variety of subject matter and styles.

Making Contact & Terms Charges 30% commission. Accepted work should be framed or matted. Sponsors 1 regional juried photo exhibit/year: Six-State Photography, open to residents of Ohio, Kentucky, West Virginia, Pennsylvania, Indiana, Michigan. Deadline for applications: March. Send annual application for 6 invitational shows by mid-December of each year; include 15-20 slides, slide list, résumé.

Submissions Send SASE for Exhibition Opportunity flier or Six-State Photo Show entry form,

Tips "As a nonprofit gallery, we do not represent artists except during the juried show. Present the work in a professional format; the work, frame and/or mounting should be clean, undamaged, and (in cases of more complicated work) well organized."

FREEPORT ARTS CENTER

121 N. Harlem Ave., Freeport IL 61032. Fax: (815)235-6015. E-mail: director@freeportartscenter.org. Website: www.freeportartscenter.org. **Director:** Jennifer Kirker Priest. Estab. 1976. Sponsors 10-12 exhibits/year. Average display time: 2 months.

Exhibits All artists are eligible for solo or group shows. Exhibits photos of multicultural, families, senior citizens, landscapes/scenics, architecture, cities/urban, gardening, rural, performing arts, travel, agriculture. Interested in fine art, historical/vintage.

Making Contact & Terms Charges 30% commission. Accepted work should be framed. **Submissions** Send material by mail with SASE for consideration. Responds in 3 months.

FRESNO ART MUSEUM

2233 N. First St., Fresno CA 93703. (559)441-4221. E-mail: info@fresnoartmuseum.org; rebecca@ fresnoartmuseum.org. Website: www.fresnoartmuseum.org. "Approached by many California artists throughout the year." The Museum highlights 6 areas of artwork: the work of women artists; support of professional mid-career local and California artists; modern masters; ethnographic art; emerging younger artists; and "popular" art. For more information on artist submissions, please call or e-mail us. Over 25 changing exhibitions/year including at least two photography exhibitions. Average display time 8 weeks. Gallery closed mid-August to early September.

Exhibits Focused on Modernist and Contemporary art.

Making Contact & Terms Museum provides insurance. Send letter of inquiry through the mail with artist's statement, résumé, slides for curator to review (20 or more images). Studio visit arranged following review of material. "The Museum shows the work of contemporary California artists; interested in sculpture, the work of mid-career and mature artists working in photography, sculpture, painting, mixed-media, installation work. The Museum also draws exhibitions from its permanent collection."

N Ø 🖪 THE G2 GALLERY

1503 Abbot Kinney Blvd., Venice CA 90291. (310)452-2842. Fax: (310)452-0915. E-mail: info@ theg2gallery.com. Website: www.theg2gallery.com. For-profit gallery exhibiting emerging, mid-career, and established artists. Approached by 100 + artists/year; represents or exhibits 45 artists. Exhibited photography by Robert Glenn Ketchum and Art Wolfe. Average display time 4-6 weeks. Open Tuesday through Saturday from 11-9; Sundays from 11-6. Closed Mondays. "The G2 Gallery is a green art space. The first floor features a gift shop and some additional exhibition space. In 2008, before the gallery opened, the building was renovated to be as eco-friendly as possible. The space is rich in natural light with high ceilings and there are large screen televisions and monitors for exhibition-related media. The G2 Gallery donates all proceeds from art sales (40% of the retail price) to environmental causes and partners with conservation organizations related to exhibition themes." Clients include local community, tourists, upscale. Price range of work: \$300-3,000. Most work sold at \$500.

Exhibits Exhibits photography featuring gardening, environmental, landscapes/scenics, wildlife, alternative process, documentary, fine art, historical/vintage.

Making Contact & Terms Art is accepted on consignment and there is a 60% commission. Retail price of the art is set by the artist. Gallery provides insurance, promotion, and contract. Accepted work should be framed, mounted, matted. Accepts photography only.

Submissions All prospective artists are vetted through a juried application process. Please e-mail info@theg2gallery.com to request an application or download the application from website. Responds in 1-2 weeks. "The G2 Gallery will contact artist with a confirmation that application materials have been received." Accepts only electronic materials. Physical portfolios are not accepted. Finds artists through word of mouth, submissions.

Tips "Preferred applicants have a website with images of their work, inventory list, and pricing. Please do not contact the gallery once we have confirmed that your application has been received."

■ GALLERY 110 COLLECTIVE

110 3rd Ave. S., Seattle WA 98104. (206)624-9336. E-mail: director@gallery110.com. Website: www. gallery110.com. Gallery represents variety of other contemporary media. Open Wednesday through Saturday from 12 to 5. Located in the historic gallery district of Pioneer Square. Overall price range \$125-3,000. Most work sold at \$500-800.

Exhibits Exhibitions include a variety of subject matter including portraits, still life objects, landscape, and narrative scenes. Interested in alternative and experimental process, documentary, fine art.

Making Contact & Terms Yearly active membership with monthly dues, art on consignment. Artwork is bought outright. Gallery provides insurance, promotion, contract (nonexclusive).

Submissions Application for membership occurs once per year in November or as space opens for new members throughout the year. Application requirements and instructions are located on the Gallery 110 website.

Tips "The artist should research the gallery to confirm it is a good fit for their work. The artist should be interested in being an active member, collaborating with other artists and participating in the success of the gallery. The work should challenge the viewer through concept, a high sense of craftsmanship, artistry, and expressed understanding of contemporary art culture and history.

Artists should be emerging or established individuals with a serious focus on their work and participation in the field."

GALLERY 218

207 E. Buffalo St., Suite 218, Milwaukee WI 53202. (414)643-1732. E-mail: director@gallery218.com. Website: www.gallery218.com. Sponsors 12 exhibits/year. Average display time 1 month. Sponsors openings. "If a group show, we make arrangements and all artists contribute. If a solo show, artist provides everything." Overall price range \$150-5,000. Most work sold at \$350.

Exhibits Interested in alternative process, avant garde, abstract, fine art. Membership dues: \$55/ year plus \$55/month rent. Artists help run the gallery. Group and solo shows. Photography is shown alongside fine arts painting, printmaking, sculpture, etc.

Making Contact & Terms Charges 25% commission. There is an entry fee for each month. Fee covers the rent for 1 month. Accepted work must be framed.

Submissions Send SASE for an application. "This is a cooperative space. A fee is required."

Tips "Get involved in the process if the gallery will let you. We require artists to help promote their show so that they learn what and why certain things are required. Have inventory ready. Read and follow instructions on entry forms; be aware of deadlines. Attend openings for shows you are accepted into locally."

■ GALLERY 400

400 S. Peoria St. (MC 034), Chicago IL 60607. (312)996-6114. Fax: (312)355-3444. E-mail: lorelei@uic.edu. Website: www.uic.edu/aa/college/gallery400. Nonprofit gallery. Estab. 1983. Approached by 500 artists/year; exhibits 80 artists. Sponsors 1 photography exhibit/year. Average display time 4-6 weeks. Gallery open Tuesday through Friday from 10 to 6; Saturday from 12 to 6. Clients include local community, students, tourists, and upscale.

Making Contact & Terms Gallery provides insurance and promotion.

Submissions Check info section of website for guidelines. Responds in 5 months. Finds artists through word of mouth, art exhibits, referrals by other artists.

Tips "Check our website for guidelines for proposing an exhibition and follow those proposal guidelines. Please do not e-mail, as we do not respond to e-mails."

M GALLERY LUISOTTI

2525 Michigan Ave., Santa Monica CA 90404. E-mail: rampub@gte.net. Website: www.galleryluisotti. com. For-profit gallery. Estab. 1993. Approached by 80-100 artists/year; represents or exhibits 15 artists. Sponsors 6 photography exhibits/year. Average display time 2 months. Located in Bergamot Station Art Center in Santa Monica. Overall price range \$500-100,000. Most work sold at \$3,000.

Exhibits Exhibits photos of environmental, cities/urban, rural, automobiles, entertainment, science, technology. Interested in avant garde, documentary, erotic, fashion/glamour, fine art, historical/vintage. Other specific subjects/processes: topographic artists from the 1970s; also represents artists who work in photography as well as film, painting or sculpture. Considers installation, mixed media, oil, paper, pen & ink.

Making Contact & Terms Charges 50% commission. Gallery provides insurance, promotion, contract. Requires exclusive representation locally.

Submissions Write to arrange a personal interview to show portfolio of transparencies. Returns material with SASE.

GALLERY NORTH

90 N. Country Rd., Setauket NY 11733. (631)751-2676. Fax: (631)751-0180. E-mail: info@ gallerynorth.org. Website: www.gallerynorth.org. Nonprofit gallery. Estab. 1965. Approached by 200-300 artists/year; represents or exhibits approximately 100 artists. Sponsors 1-2 photography exhibits/year. Average display time 4 weeks. Open Tuesday through Saturday from 10 to 5; Sunday from 12 to 5. Located on the north shore of Long Island in a professional/university community, in

an 1840s house; exhibition space is 1,000 sq. ft. Overall price range \$250-20,000. Most work sold at \$1,500-5,000.

Exhibits Exhibits photos of architecture, cities/urban, environmental, landscapes/scenics, occasionally people. Interested in alternative process, avant garde, fine art.

Making Contact & Terms Artwork is accepted on consignment, and there is a 50% commission. **Submissions** Artists should mail portfolio for review and include artist's statement, bio, résumé, reviews, contact information. "We return all materials with SASE. We file CDs, photographs, slides." Responds to queries within 6 months. Finds artists through word of mouth, art exhibits, submissions, portfolio reviews, referrals by other artists.

Tips "All written material should be typed and clearly written. Slides, CDs and photos should be organized by categories, and no more than 20 images should be submitted."

GALLERY WEST

1213 King St., Alexandria VA 22314. (703)549-6006. E-mail: gallerywest@verizon.net. Website: www.gallery-west.com. Vice President: Wayne Guenther. Cooperative gallery. Estab. 1979. Approached by 30 artists/year; represents or exhibits 25 artists. Average display time 1 month. Gallery open Thursday through Monday from 11 to 5 (January through March) and from 11 to 6 (April through December). The gallery is located in the historic district of Old Town Alexandria, Virginia. Overall price range \$100-3,500. Most work sold at \$500-700.

Exhibits Exhibits photos of babies/children/teens, multicultural, landscapes/scenics, wildlife, architecture, cities/urban, gardening, religious, rural, automobiles, food/drink, travel, product shots/still life. Interested in alternative process, avant garde, documentary, fine art, seasonal.

Making Contact & Terms There is a co-op membership fee plus a donation of time. There is a 25% commission. Gallery provides promotion, contract. Accepted work should be framed.

Submissions Call to show portfolio of slides. Send query letter with artist's statement, bio, SASE, slides. Responds in 1 month. Finds artists through word of mouth, portfolio reviews, art exhibits, referrals by other artists.

Tips "Send high-quality slides."

M GALMAN LEPOW ASSOCIATES, INC.

1879 Old Cuthbert Rd., Unit 12, Cherry Hill NJ 08034. (856)354-0771. Fax: (856)428-7559. E-mail: galmnlepow@aol.com. Website: www.galmanlepowappraisers.com. Estab. 1979.

Submissions Send query letter with résumé and SASE. "Visual imagery of work is helpful." **Tips** "We are corporate art consultants and use photography for our clients."

© GERING & LOPEZ GALLERY

534 W. 22nd St., New York NY 10011. (646)336-7183. E-mail: info@geringlopez.com. Website: www.geringlopez.com. For-profit gallery. Approached by 240 artists/year; represents or exhibits 12 artists. Sponsors 1 photography exhibit/year. Average display time 5 weeks. Gallery open Tuesday through Saturday from 10 to 6.

Exhibits Interested in alternative process, avant garde; digital, computer-based photography.

Making Contact & Terms Artwork is accepted on consignment.

Submissions E-mail with link to website or send postcard with image. Responds within 6 months, only if interested. Finds artists through word of mouth, art exhibits, art fairs, referrals by other artists. *Gering & López Gallery is currently NOT accepting unsolicited submissions.*

Tips "Most important is to research the galleries and only submit to those that are appropriate. Visit websites if you don't have access to galleries."

N GRAND RAPIDS ART MUSEUM

101 Monroe Center, Grand Rapids MI 49503. (616)831-1000. E-mail: cbuckner@artmuseumgr. org. Website: www.gramonline.org. Museum. Estab. 1910. Sponsors 1 photography exhibit/year. Average display time 4 months. Gallery open Tuesday through Sunday from 11 to 6.

Exhibits Interested in fine art, historical/vintage.

ANTON HAARDT GALLERY

2858 Magazine St., New Orleans LA 70115. (504)897-1172. E-mail: antonhaardt@hotmail.com. Website: www.antonart.com. For-profit gallery. Represents or exhibits 25 artists. Overall price range \$500-5,000. Most work sold at \$1,000.

Exhibits Exhibits photos of celebrities. Mainly photographs (portraits of folk artists).

Making Contact & Terms Prefers only artists from the South. Self-taught artists who are original and pure, specifically art created from 1945 to 1980. "I rarely take on new artists, but I am interested in buying estates of deceased artist's work or an entire body of work by artist."

Submissions Send query letter with artist's statement.

Tips "I am only interested in a very short description if the artist has work from early in his or her career."

CARRIE HADDAD GALLERY

622 Warren St., Hudson NY 12534. (518)828-1915. Fax: (518)828-3341. E-mail: carrie. haddad@carriehaddadgallery.com;david.hatfield@carriehaddadgallery.com. Website: www. carriehaddadgallery.com. Owner: Carrie Haddad. Art consultancy, for-profit gallery. Estab. 1990. Approached by 50 artists/year; represents or exhibits 60 artists. Sponsors 8 photography exhibits/year. Average display time 5 weeks. Open Thursday through Monday from 11 to 5. Overall price range \$350-6,000. Most work sold at \$1,000.

Exhibits Exhibits photos of nudes, landscapes/scenics, architecture, pets, rural, product shots/still life.

Making Contact & Terms Artwork is accepted on consignment, and there is a 50% commission. Gallery provides insurance, promotion. Requires exclusive representation locally.

Submissions Send query letter with bio, photocopies, photographs, price list, SASE. Responds in 1 month. Finds artists through word of mouth, submissions, art exhibits, referrals by other artists.

THE HALSTED GALLERY INC.

P.O. Box 130, Bloomfield Hills MI 48303. (248)895-0204. Fax: (248)332-0227. Website: www. halstedgallery.com. **Contact:** Wendy or Thomas Halsted. Estab. 1969. Sponsors 3 exhibits/year. Average display time 2 months. Sponsors openings. Overall price range \$500-25,000.

Exhibits Interested in 19th- and 20th-century photographs.

Submissions Call to arrange a personal interview to show portfolio only. Prefers to see scans. Send no slides or samples. Unframed work only.

Tips This gallery has no limitations on subjects. Wants to see creativity, consistency, depth and emotional work.

JAMES HARRIS GALLERY

312 Second Ave. S., Seattle WA 98104. (206)903-6220. Fax: (206)903-6226. E-mail: mail@jamesharrisgallery.com. Website: www.jamesharrisgallery.com. Approached by 40 artists/year; represents or exhibits 26 artists. Average display time 6 weeks. Open Tuesday through Saturday from 11 to 5.

Exhibits Exhibits photos of landscapes and portraits. Interested in fine art.

Submissions E-mail with JPEG samples at 72 dpi. Send query letter with artist's statement, bio, slides.

WILLIAM HAVU GALLERY

1040 Cherokee St., Denver CO 80204. (303)893-2360. Fax: (303)893-2813. E-mail: info@ williamhavugallery.com. Website: www.williamhavugallery.com. Owner: Bill Havu. Gallery Administrator: Kate Thompson. For-profit gallery. Approached by 120 artists/year; represents or exhibits 50 artists. Sponsors 1 photography exhibit/year. Average display time 6-8 weeks. Gallery

open Tuesday through Friday from 10-6; Saturdays from 11 to 5. Closed Christmas and New Year's Day. Overall price range \$250-15,000. Most work sold at \$1,000-4,000.

Exhibits Exhibits photos of multicultural, landscapes/scenics, religious, rural. Interested in alternative process, documentary, fine art.

Making Contact & Terms Gallery provides insurance, promotion, contract. Accepted work should be framed. Requires exclusive representation locally. *Accepts only artists from Rocky Mountain, Southwestern region*.

Submissions *Not accepting unsolicited submissions.* Mail portfolio for review. Send query letter with artist's statement, bio, brochure, resume, SASE, slides. Responds within 1 month, only if interested. Finds artists through word of mouth, submissions, referrals by other artists.

Tips "Always mail a portfolio packet. We do not accept walk-ins or phone calls to review work. Explore website or visit gallery to make sure work would fit with the gallery's objective. We only frame work with archival quality materials and feel its inclusion in work can 'make' the sale."

HEARST ART GALLERY, SAINT MARY'S COLLEGE

P.O. Box 5110, 1928 Saint Mary's Rd., Moraga CA 94575-5110. (925)631-4379. E-mail: jarmiste@ stmarys-ca.edu. Website: www.stmarys-ca.edu/arts/hearst-art-gallery/.College gallery. Sponsors 1 photography exhibit/year. Gallery open Wednesday through Sunday from 11 to 4:30. Closed major holidays. 1,650 sq. ft. of exhibition space.

Exhibits Exhibits photos of multicultural, landscapes/scenics, religious, travel.

Submissions Send query letter (Attn: Registrar) with artist's statement, bio, résumé, slides, SASE. Finds artists through submissions, art exhibits, art fairs, referrals by other artists.

Ø HEMPHILL

1515 14th St. NW, Suite 300, Washington DC 20005. (202)234-5601. Fax: (202)234-5607. E-mail: gallery@hemphillfinearts.com. Website: www.hemphillfinearts.com. Art consultancy and for-profit gallery. Estab. 1993. Represents or exhibits 30 artists/year. Sponsors 2-3 photography exhibits/year. Sponsors 4-5 photography exhibits/year, and is a member of The Association of International Photography Art Dealers (AIPAD)]. Gallery open Tuesday through Saturday from 10 to 5 and by appointment. Overall price range \$900-300,000.

Exhibits photos of landscapes/scenics, architecture, cities/urban, rural. Interested in alternative process, fine art, historical/vintage.

Submissions Gallery does not accept or review portfolio submissions.

HENRY STREET SETTLEMENT/ABRONS ART CENTER

265 Henry Street, New York NY 10002. (212)766-9200. E-mail: info@henrystreet.org. Website: www.henrystreet.org. Visual Arts Coordinator: Martin Dust. Alternative space, nonprofit gallery, community center. Holds 9 solo photography exhibits/year. Gallery open Monday through Friday from 9 to 6; Saturday and Sunday from 12 to 6. Closed major holidays.

Exhibits Exhibits photos of multicultural, environmental, landscapes/scenics, architecture, cities/urban, rural. Interested in alternative process, avant garde, documentary, fine art, historical/vintage.

Making Contact & Terms Artwork is accepted on consignment, and there is a 20% commission. Gallery provides insurance, space, contract.

Submissions Send query letter with artist's statement, SASE. Finds artists through word of mouth, submissions, referrals by other artists.

HERA EDUCATIONAL FOUNDATION AND ART GALLERY

P.O. Box 336, Wakefield RI 02880. (401)789-1488. E-mail: info@heragallery.org. Website: www. heragallery.org. Cooperative gallery. Estab. 1974. The number of photo exhibits varies each year. Average display time: 6 weeks. Gallery open Wednesday through Friday from 1-5. Closed during the month of January. Sponsors openings; provides refreshments and entertainment or lectures,

demonstrations and symposia for some exhibits. Call for information on exhibitions. Overall price range: \$100-10,000.

Exhibits Interested in all types of innovative contemporary art that explores social and artistic issues. Exhibits photos of disasters, environmental, landscapes/scenics. Interested in fine art.

Making Contact & Terms Charges 25% commission. Works must fit inside a 6'6" × 2'6" door. Photographer must show a portfolio before attaining membership.

Submissions Inquire about membership and shows. Membership guidelines and application available on website or mailed on request.

Tips "Hera exhibits a culturally diverse range of visual and emerging artists. Please follow the application procedure listed in the Membership Guidelines. Applications are welcome at any time of the year."

GERTRUDE HERBERT INSTITUTE OF ART

506 Telfair St., Augusta GA 30901-2310. (706)722-5495. Fax: (706)722-3670. E-mail: ghia@ghia. org. Website: www.ghia.org. Nonprofit gallery. Has 5 solo or group shows annually; exhibits approximately 40 artists annually. Average display time 6-8 weeks. Open Tuesday through Friday from 10 to 5; weekends by appointment only. Closed 1st week in August, and December 17-31. Located in historic 1818 Ware's Folly mansion.

Making Contact & Terms Artwork is accepted on consignment, and there is a 35% commission. **Submissions** Send query letter with artist's statement, bio, brochure, résumé, reviews, slides or CD of work, SASE. Responds to queries in 1-3 months. Finds artists through art exhibits, submissions, referrals by other artists.

EDWYNN HOUK GALLERY

745 Fifth Ave., Suite 407, New York NY 10151. (212)750-7070. Fax: (212)688-4848. E-mail: info@ houkgallery.com; julie@houkgallery.com. Website: www.houkgallery.com. Director: Julie Castellano. For-profit gallery. The gallery is a member of the Art Dealers Association of America and Association of International Photography Art Dealers. The gallery represents the Estates of Ilse Bing, Bill Brandt, Brassaï and Dorothea Lange, and is the representative for such major contemporary photographers as Lynn Davis, Robert Polidori, Joel Meyerowitz, Annie Leibovitz, Elena Dorfman, Elinor Carruci, Lalla Essaydi, Danny Lyon and Elliott Erwitt. Gallery open Tuesday through Saturday from 11 to 6. Closed 3 weeks in August.

Exhibits Exhibits photography.

Tips Specializes in masters of 20th century photography with an emphasis on the 1920s and 1930s and contemporary photography.

HUNTSVILLE MUSEUM OF ART

300 Church St. S., Huntsville AL 35801. (256)535-4350. E-mail: info@hsvmuseum.org. Website: www.hsvmuseum.org. Estab. 1970. Sponsors 1-2 exhibits/year. Average display time 2-3 months. **Exhibits** No specific stylistic or thematic criteria. Interested in alternative process, avant garde, documentary, fine art, historical/vintage.

Making Contact & Terms Buys photos outright. Accepted work may be framed or unframed, mounted or unmounted, matted or unmatted. Must have professional track record and résumé, slides, critical reviews in package (for curatorial review).

Submissions Regional connection strongly preferred. Send material by mail with SASE for consideration.

ICEBOX QUALITY FRAMING & GALLERY

1500 Jackson St. NE, Suite 443, Minneapolis MN 55413. (612)788-1790. E-mail: icebox@bitstream. net. Website: www.iceboxminnesota.com. Exhibition, promotion and sales gallery. Estab. 1988. Represents photographers and fine artists in all media, predominantly photography. "A sole

proprietorship gallery, Icebox sponsors installations and exhibits in the gallery's 1,700-sq.-ft. space in the Minneapolis Arts District." Overall price range \$200-1,500. Most work sold at \$200-800.

Exhibits Exhibits photos of multicultural, environmental, landscapes/scenics, rural, adventure, travel. Interested in alternative process, documentary, erotic, fine art, historical/vintage. Specifically wants "fine art photographs from artists with serious, thought-provoking work."

Making Contact & Terms Charges 50% commission.

Submissions "Send letter of interest telling why and what you would like to exhibit at Icebox. Include only materials that can be kept at the gallery and updated as needed. Check website for more details about entry and gallery history."

Tips "We are experienced with the out-of-town artist's needs."

ILLINOIS STATE MUSEUM CHICAGO GALLERY

100 W. Randolph, Suite 2-100, Chicago IL 60601. (312)814-5322. E-mail: director@museum.state. il.us. Website: www.museum.state.il.us. Estab. 1985. Sponsors 2-3 exhibits/year. Average display time 4 months. Sponsors openings; provides refreshments at reception and sends out announcement cards for exhibitions.

Exhibits Must be an Illinois photographer. Interested in contemporary and historical/vintage, alternative process, fine art.

Submissions Send résumé, artist's statement, 10 slides, SASE. Responds in 6 months.

INDIANAPOLIS ART CENTER

820 E. 67th St., Indianapolis IN 46220. (317)255-2464. Fax: (317)254-0486. E-mail: MWinkelman@ IndplsArtCenter.org; exhibs@indplsartcenter.org. Website: www.indplsartcenter.org. Estab. 1934. Sponsors 1-2 photography exhibits/year. Average display time 8 weeks. Overall price range \$50-5,000. Most work sold at \$500.

Exhibits Interested in alternative process, avant garde, documentary, fine art and "very contemporary work, preferably unusual processes." Prefers artists who live within 250 miles of Indianapolis.

Making Contact & Terms Charges 35% commission. One-person show: \$300 honorarium; 2-person show: \$200 honorarium; 3-person show: \$100 honorarium; plus \$0.32/mile travel stipend (one way). Accepted work should be framed (or other finished-presentation formatted).

Submissions Send minimum of 20 digital images with résumé, reviews, artist's statement and SASE between July 1 and December 31. No wildlife or landscape photography. Interesting color and mixed media work is appreciated.

Tips "We like photography with a very contemporary look that incorporates unusual processes and/or photography with mixed media. Submit excellent images with a full résumé, a recent artist's statement, and reviews of past exhibitions or projects. Please, no glass-mounted slides. Always include a SASE for notification and return of materials, ensuring that correct return postage is on the envelope. Exhibition materials will not be returned. Currently booking 2012."

INDIVIDUAL ARTISTS OF OKLAHOMA

706 W. Sheridan Ave., Oklahoma City OK 73102; P.O. Box 60824, Oklahoma City OK 73146. (405)232-6060. Fax: (405)232-6061. E-mail: stokes@iaogallery.org. Website: www.iaogallery.org. Director: Jeff Stokes. Alternative space. Estab. 1979. Approached by 60 artists/year; represents or exhibits 30 artists. Sponsors 10 photography exhibits/year. Average display time 3-4 weeks. Gallery open Tuesday through Friday from 11 to 4; Saturdays from 1 to 4. Closed August. Gallery is located in downtown art district, 2,300 sq. ft. with 10 ft. ceilings and track lighting. Overall price range \$100-2,000. Most work sold at \$400.

Exhibits Interested in alternative process, avant garde, documentary, fine art, historical/vintage photography. Other specific subjects/processes: contemporary approach to variety of subjects.

Making Contact & Terms Charges 20% commission. Gallery provides insurance, promotion, contract. Accepted work must be framed.

Submissions Mail portfolio for review with artist's statement, bio, photocopies or slides, résumé, SASE. Reviews quarterly. Finds artists through word of mouth, art exhibits, referrals by other artists.

■ INTERNATIONAL CENTER OF PHOTOGRAPHY

1133 Avenue of the Americas, New York NY 10036. (212)857-0000. Fax: (212)768-4688. E-mail: info@icp.org. Website: www.icp.org.

Submissions "Due to the volume of work submitted, we are only able to accept portfolios in the form of 35mm slides or CDs. All slides must be labeled on the front with a name, address, and a mark indicating the top of the slide. Slides should also be accompanied by a list of titles and dates. CDs must be labeled with a name and address. Submissions must be limited to 1 page of up to 20 slides or a CD of no more than 20 images. Portfolios of prints or of more than 20 images will not be accepted. Photographers may also wish to include the following information: cover letter, rèsumè or curriculum vitae, artist's statement and/or project description. ICP can only accept portfolio submissions via mail (or FedEx, etc.). Please include a SASE for the return of materials. ICP cannot return portfolios submitted without return postage."

INTERNATIONAL VISIONS GALLERY

2629 Connecticut Ave. NW, Washington DC 20008. (202)234-5112. Fax: (202)234-4206. E-mail: intvisions@aol.com. Website: www.inter-visions.com. For-profit gallery. Approached by 60 artists/year; represents or exhibits 50 artists. Sponsors 1 photography exhibit/year. Average display time 4-6 weeks. Gallery open Wednesday through Saturday from 11 to 6. Located in the heart of Washington, DC; features 1,000 sq. ft. of exhibition space. Overall price range \$1,000-8,000. Most work sold at \$2,500.

Exhibits Exhibits photos of babies/children/teens, multicultural.

Making Contact & Terms Artwork is accepted on consignment, and there is a 50% commission. Gallery provides insurance, promotion, contract. Accepted work should be framed. Requires exclusive representation locally.

Submissions Call. Send query letter with artist's statement, bio, photocopies, résumé, SASE. Responds in 2 months. Finds artists through word of mouth, art exhibits, referrals by other artists.

JACKSON FINE ART

3115 E. Shadowlawn Ave., Atlanta GA 30305. (404)233-3739. Fax: (404)233-1205. E-mail: malia@jacksonfineart.com; info@jacksonfineart.com. Website: www.jacksonfineart.com. Exhibitions are rotated every 6 weeks. Gallery open Tuesday through Saturday from 10 to 5. Overall price range \$600-500,000. Most work sold at \$5,000.

Exhibits Interested in innovative photography, avant garde, fine art.

Making Contact & Terms Only buys vintage photos outright. Requires exclusive representation locally. Exhibits only nationally known artists and emerging artists who show long term potential. "Photographers must be established, preferably published in books or national art publications. They must also have a strong biography, preferably museum exhibitions, national grants."

Submissions Send JPEG files via e-mail, or CD-ROM by mail with SASE for return. Responds in 3 months, only if interested. Unsolicited original work is not accepted.

M JENKINS GALLERY, ALICE AND WILLIAM

600 St. Andrews Blvd., Winter Park FL 32804. (407)671-1886. Fax: (407)671-0311. E-mail: Rberrie@ Crealde.org. Website: www.Crealde.org. **Director of Photo Department:** Rick Lang.

JHB GALLERY

26 Grove St., Suite 4C, New York NY 10014-5329. (212)255-9286. Fax: (212)229-8998. E-mail: info@ jhbgallery.com. Website: www.jhbgallery.com. Private art dealer and consultant. Gallery open by appointment only. Overall price range \$1,500-40,000. Most work sold at \$2,500-15,000.

Making Contact & Terms Artwork is accepted on consignment, and there is a 50% commission. Gallery provides promotion.

Submissions Accepts online submissions. Send query letter with résumé, CD, slides, artist's statement, reviews, SASE. Finds artists through submissions, portfolio reviews, art exhibits, art fairs, referrals by other curators.

STELLA JONES GALLERY

Place St., 201 St. Charles, New Orleans LA 70170. (504)568-9050. Fax: (504)568-0840. E-mail: jones6941@aol.com. Website: www.stellajonesgallery.com. For-profit gallery. Approached by 40 artists/year; represents or exhibits 45 artists. Sponsors 1 photography exhibit/year. Average display time 6-8 weeks. Gallery open Monday through Friday from 11 to 6; Saturday from 12 to 5. Located on 1st floor of corporate 53-story office building downtown, 1 block from French Quarter. Overall price range \$500-150,000. Most work sold at \$5,000.

Exhibits Exhibits photos of babies/children/teens, multicultural, families, cities/urban, education, religious, rural.

Making Contact & Terms Artwork is accepted on consignment, and there is a 50% commission. Gallery provides insurance, promotion, contract. Accepted work should be framed. Requires exclusive representation locally.

Submissions Call to show portfolio of photographs, slides, transparencies. Mail portfolio for review. Send query letter with artist's statement, bio, brochure, business card, photocopies, photographs, résumé, reviews, slides, SASE. Responds in 1 month. Finds artists through word of mouth, submissions, portfolio reviews, art exhibits, referrals by other artists.

Tips "Photographers should be organized with good visuals."

■ KENT STATE UNIVERSITY SCHOOL OF ART GALLERIES

(330)672-1369. E-mail: haturner@kent.edu. Website: galleries.kent.edu/index.html. Sponsors at least 6 photography exhibits/year. Average display time 4 weeks.

Exhibits Interested in all types, styles and subject matter of photography. Photographer must present quality work.

Making Contact & Terms Photography can be sold in gallery. Charges 40% commission. Buys photography outright.

Submissions Will review transparencies. Write a proposal and send with slides/CD. Send material by mail for consideration; include SASE. Responds "usually in 4 months, but it depends on time submitted."

■ KIRCHMAN GALLERY

P.O. Box 115, 213 N. Nuget St., Johnson City TX 78636. 830-868-9290. E-mail: susan@kirchmangallery. com; warren@kirchmangallery.com. Website: www.kirchmangallery.com. **Owner/Director**: Susan Kirchman. Art consultancy and for-profit gallery. Estab. 2005. Represents or exhibits 25 artists. Average display time 1 month. Sponsors 4 photography exhibits/year. Open Wednesday through Sunday from 11 to 6; any time by appointment. Located across from Johnson City's historic Courthouse Square in the heart of Texas hill country. Overall price range \$250-25,000. Most work sold at \$500-1,000.

Exhibits Exhibits photos of landscapes/scenics. Interested in alternative process, avant garde, fine art.

Making Contact & Terms Artwork is accepted on consignment, and there is a 50% commission.

Submissions Send 20 digital-format examples of your work, along with a resume and artist's statement.

ROBERT KLEIN GALLERY

38 Newbury St., Boston MA 02116. (617)267-7997. Fax: (617)267-5567. E-mail: inquiry@robertkleingallery.com. Website: www.robertkleingallery.com. Sponsors 10 exhibits/year. Average display time 5 weeks. Overall price range \$1,000-200,000.

Exhibits Interested in fashion, documentary, nudes, portraiture, and work that has been fabricated to be photographs.

Making Contact & Terms Charges 50% commission. Buys photos outright. Accepted work should be unframed, unmatted, unmounted. Requires exclusive representation locally. Must be established a minimum of 5 years; preferably published.

Submissions "The Robert Klein Gallery is not accepting any unsolicited submissions. Unsolicited submissions will not be reviewed or returned."

ROBERT KOCH GALLERY

49 Geary St., San Francisco CA 94108. (415)421-0122. Fax: (415)421-6306. E-mail: info@kochgallery. com. Website: www.kochgallery.com. Sponsors 6-8 photography exhibits/year. Average display time 2 months. Gallery open Tuesday through Saturday from 10:30 to 5:30.

Making Contact & Terms Artwork is accepted on consignment. Gallery provides insurance, promotion, contract. Requires West Coast or national representation.

Submissions Finds artists through publications, art exhibits, art fairs, referrals by other artists and curators, collectors, critics.

LA ART ASSOCIATION/GALLERY 825

825 N. La Cienega Blvd., Los Angeles CA 90069. (310)652-8272. Fax: (310)652-9251. E-mail: peter@laaa.org. Website: www.laaa.org. Executive Director: Peter Mays. Artistic Director: Sinead Finnerty-Pyne. Estab. 1925. Sponsors 16 exhibits/year. Average display time 4-5 weeks. Sponsors openings. Overall price range \$200-5,000. Most work sold at \$600.

Exhibits Considers all media and original handpulled prints. Fine art only. No crafts. Most frequently exhibits mixed media, oil/acrylic, and watercolor. Exhibits all styles.

Making Contact & Terms Retail price set by artist. Gallery provides promotion.

Submissions Submit 2 pieces during biannual screening date. Responds immediately following screening. Call for screening dates.

Tips "Bring work produced in the last three years. No commercial work (i.e. portraits or advertisements)."

ELIZABETH LEACH GALLERY

417 NW 9th Ave., Portland OR 97209-3308. (503)224-0521. Fax: (503)224-0844. Website: www. elizabethleach.com. Sponsors 3-4 exhibits/year. Average display time 1 month. "The gallery has extended hours every first Thursday of the month for our openings." Overall price range \$300-5,000.

Exhibits Photographers must meet museum conservation standards. Interested in "high-quality concept and fine craftsmanship."

Making Contact & Terms Charges 50% commission. Accepted work should be framed or unframed, matted. Requires exclusive representation locally.

Submissions Not accepting submissions at this time.

LEEPA-RATTNER MUSEUM OF ART

P.O. Box 1545, 600 Klosterman Rd., Palm Harbor FL 34683. (727)712-5762. E-mail: lrma@spcollege.edu; Whitelaw.lynn@spcollege.edu. Website: www.spcollege.edu/museum. **Director:** R. Lynn

Whitelaw. Museum. Estab. 2002. Open Tuesday through Saturday from 10 to 5; Thursday from 1 to 9; Sunday from 1 to 5. Located on the Tarpon Springs campus of St. Petersburg College.

Exhibits Exhibits photos of babies/children/teens, celebrities, couples, multicultural, families, parents, senior citizens, architecture, cities/urban, education, gardening, interiors/decorating, pets, religious, rural, agriculture, business concepts, industry, medicine, military, political, product shots/still life, science, technology/computers, disasters, environmental, landscapes/scenics, wildlife, adventure, automobiles, entertainment, events, food/drink, health/fitness/beauty, hobbies, humor, performing arts, sports, travel. Interested in alternative process, avant garde, documentary, erotic, fashion/glamour, fine art, historical/vintage, seasonal.

LEHIGH UNIVERSITY ART GALLERIES

420 E. Packer Ave., Bethlehem PA 18015. (610)758-3619. Fax: (610)758-4580. E-mail: rv02@ lehigh.edu. Website: www.luag.org. Sponsors 5-8 exhibits/year. Average display time 6-12 weeks. Sponsors openings.

Exhibits Exhibits fine art/multicultural, Latin American. Interested in all types of works. The photographer should "preferably be an established professional."

Making Contact & Terms Reviews transparencies. Arrange a personal interview to show portfolio. Send query letter with SASE. Responds in 1 month.

Tips "Don't send more than 10 (top) slides, or CD."

DAVID LEONARDIS GALLERY

1346 N. Paulina St., Chicago IL 60622. (773)278-3058. E-mail: david@dlg-gallery.com. Website: www.dlg-gallery.com. For-profit gallery. Approached by 100 artists/year; represents or exhibits 12 artists. Average display time 30 days. Gallery open Tuesday through Saturday from 12 to 7; Sunday from 12 to 6. "One big room, four big walls." Overall price range \$50-5,000. Most work sold at \$500.

Exhibits Exhibits photos of celebrities. Interested in fine art.

Making Contact & Terms Artwork is accepted on consignment, and there is a 50% commission. Gallery provides promotion. Accepted work should be framed.

Submissions E-mail to arrange a personal interview to show portfolio. Mail portfolio for review. Send query letter via e-mail. Responds only if interested. Finds artists through word of mouth, art exhibits, referrals by other artists.

Tips "Artists should be professional and easy to deal with."

LEOPOLD GALLERY

324 W. 63rd St., Kansas City MO 64113. (816)333-3111. Fax: (816)333-3616. E-mail: email@leopoldgallery.com. Website: www.leoppoldgallery.com. For-profit gallery. Approached by 100 + artists/year; represents or exhibits 50 artists/year. Sponsors 1 photography exhibit/year. Average display time 3 weeks. Open Sunday through Saturday from 10 to 6; weekends from 10 to 5. Closed holidays. "We are located in Brookside, a charming retail district built in 1920 with more than 70 shops, restaurants and offices. The gallery has two levels of exhibition space, with the upper level dedicated to artist openings/exhibitions." Overall price range \$50-25,000. Most work sold at \$1,000.

Exhibits Exhibits photos of architecture, cities/urban, rural, environmental, landscapes/scenics, wildlife, entertainment, performing arts. Interested in alternative process, avant garde, documentary, fine art.

Making Contact & Terms Artwork is accepted on consignment; there is a 50% commission. Gallery provides insurance, promotion, contract. Accepted work should be framed, mounted, matted. **Accepts artists from Kansas City area only.** Send query letter with artist's statement, bio, brochure, business card, résumé, reviews, SASE, disc with images. Responds in 2 weeks. Finds artists through word of mouth, art exhibitions, submissions, art fairs, portfolio reviews, referrals by other artists.

Submissions E-mail 5-10 JPEG images of your body of work to email@leopoldgallery.com. Before sending, please scan your e-mail for viruses, as any viral e-mails will be deleted upon receipt. Images should be saved at 72 dpi, approximately 5 x 7 inches in measurement and compressed to level 3 JPEG. Please save for Windows. Or, send e-mail query letter with link to artist's website. Please call if you cannot submit by e-mail due to technological constraints.

■ THE LIGHT FACTORY

E-mail: dkiel@lightfactory.org. Website: www.lightfactory.org. Nonprofit contemporary museum of photography and film. Open Monday through Saturday from 9 to 6; Sunday from 1 to 6.

Exhibits Interested in light-generated media (photography, video, film, digital art). Exhibitions often push the limits of photography as an art form and address political, social or cultural issues.

Making Contact & Terms "Although prices are not listed in the galleries, the artwork is for sale. Artists price their work." Charges 30% commission. Gallery provides insurance. "We do not represent artists, but present changing exhibitions." No permanent collection. Send query letter with résumé, slides/CDs, artist's statement, SASE. Responds in 4 months.

LIMITED EDITIONS & COLLECTIBLES

697 Haddon, Collingswood NJ 08108. (856)869-5228. E-mail: jdl697ltd@juno.com. Website: www. ltdeditions.net. For-profit online gallery. Approached by 24 artists/year; represents or exhibits 70 artists. Sponsors 20 photography exhibits/year. Overall price range \$100-3,000. Most work sold at \$450.

Exhibits Exhibits photos of landscapes/scenics, wildlife, adventure, automobiles, entertainment, events, food/drink, health/fitness/beauty, hobbies, humor, performing arts, sports, travel. Interested in alternative process, documentary, erotic, fashion/glamour, historical/vintage, seasonal.

Making Contact & Terms Artwork is accepted on consignment, and there is a 30% commission. Gallery provides insurance, promotion, contract.

Submissions Call or write to show portfolio. Send query letter with bio, business card, résumé. Responds in 1 month. Finds artists through word of mouth, portfolio reviews, art exhibits, referrals by other artists.

LIMNER GALLERY

123 Warren St., Hudson NY 12534. (518)828-2343. E-mail: thelimner@aol.com. Website: www. slowart.com. Alternative space. Established in Manhattan's East Village. Approached by 200-250 artists/year; represents or exhibits 90-100 artists. Sponsors 2 photography exhibits/year. Average display time 4 weeks. Open Wednesday through Sunday from 11 to 5. Closed January, July-August (weekends only). Located in the art and antiques center of the Hudson Valley. Exhibition space is 1,000 sq. ft.

Exhibits Interested in alternative process, avant garde, documentary, erotic, fine art, historical/vintage.

Submissions. Artists should e-mail a link to their website; or download exhibition application at www.slowart.com/prospectus; or send query letter with artist's statement, bio, brochure or photographs/slides, SASE. Finds artists through submissions.

Tips "Artist's website should be simple and easy to view. Complicated animations and scripted design should be avoided, as it is a distraction and prevents direct viewing of the work. Not all galleries and art buyers have cable modems. The website should either work on a telephone line connection or two versions of the site should be offered—one for telephone, one for cable/high-speed Internet access."

M LIZARDI/HARP GALLERY

P.O. Box 91895, Pasadena CA 91109. (626)791-8123. Fax: (626)791-8887. E-mail: lizardiharp@earthlink.net. Sponsors 3-4 exhibits/year. Average display time 4-6 weeks. Overall price range \$250-1,500. Most work sold at \$500.

Exhibits Primarily interested in the figure. Also exhibits photos of celebrities, couples, religious, performing arts. "Must have more than one portfolio of subject, unique slant and professional manner." Interested in avant garde, erotic, fine art, figurative, nudes, "maybe" manipulated work. documentary and mood landscapes, both b&w and color.

Making Contact & Terms Charges 50% commission. Accepted work should be unframed, unmounted; matted or unmatted.

Submissions Submit portfolio for review. Send query letter by mail résumé, samples, SASE. Responds in 1 month.

Tips Include 20 labeled slides, résumé and artist's statement with submission. "Submit at least 20 images that represent bodies of work. I mix photography of figures, especially nudes, with shows on painting."

LUX CENTER FOR THE ARTS

2601 N. 48th St., Lincoln NE 68504-3632. (402)466-8692. Fax: (402)466-3786. E-mail: info@ luxcenter.org, Website: www.luxcenter.org, Nonprofit gallery. Estab. 1978. Represents or exhibits 60 + artists, Sponsors 3-4 photography exhibits/year. Average display time 1 month. Open Tuesday through Friday from 11 to 5; Saturday from 10 to 5.

Exhibits Exhibits photos of landscapes/scenics. Interested in alternative process, avant garde, fine art.

Making Contact & Terms Artwork is accepted on consignment, and there is a 50% commission. Submissions Mail portfolio for review. Send query letter with artist's statement, bio, slides or digital images on CD, SASE. Finds artists through referrals by other artists and through research. **Tips** "To make your submission professional, you should have high-quality images (either slides or high-res digital images), cover letter, bio, résumé, artist's statement and SASE."

MACALESTER GALLERY

Janet Wallace Fine Arts Center, 1600 Grand Ave., St. Paul MN 55105. (651)696-6416. Fax: (651)696-6266. E-mail: fitz@macalester.edu. Website: www.macalester.edu/gallery. Curator: Gregory Fitz. Nonprofit gallery. Estab. 1964. Approached by 15 artists/year; represents or exhibits 3 artists. Sponsors 1 photography exhibit/year. Average display time 4-5 weeks. Gallery open Monday through Friday from 10 to 4; weekends from 12 to 4. Closed major holidays, summer and school holidays. Located in the core of the Janet Wallace Fine Arts Center on the campus of Macalester College. Gallery is approx. 1,100 sq. ft. and newly renovated. Overall price range: \$200-1,000. Most work sold at \$350.

Exhibits Exhibits photos of multicultural, environmental, landscapes/scenics, architecture, rural. Interested in avant garde, documentary, fine art, historical/vintage.

Making Contact & Terms Gallery provides insurance. Accepted work should be framed, mounted,

Submissions Send query letter with artist's statement, bio, brochure, business card, photocopies, photographs, résumé, reviews, SASE, slides. Responds in 3 weeks. Finds artists through word of mouth, portfolio reviews, referrals by other artists.

Tips "Photographers should present quality slides which are clearly labeled. Include a concise artist's statement. Always include a SASE. No form letters or mass mailings."

MACNIDER ART MUSEUM

303 Second St. SE, Mason City IA 50401. (641)421-3666. Fax: (641)422-9612. E-mail: eblanchard@ masoncity.net; macniderinformation@masoncity.net. Website: www.macniderart.org. Nonprofit gallery. Estab. 1966. Represents or exhibits 1-10 artists. Sponsors 2-5 photography exhibits/year (1 is competitive for the county). Average display time 2 months. Gallery open Tuesday and Thursday from 9 to 9; Wednesday, Friday, Saturday from 9 to 5; Sunday from 1 to 5. Closed Monday. Overall price range \$50-2,500. Most work sold at \$200.

Making Contact & Terms Artwork is accepted on consignment, and there is a 40% commission. Gallery provides insurance, promotion, contract. Accepted work should be framed.

Submissions Mail portfolio for review. Responds within 3 months, only if interested. Finds artists through word of mouth, submissions, portfolio reviews, art exhibits, art fairs, referrals by other artists. Exhibition opportunities: exhibition in galleries, presence in museum shop on consignment or booth at Festival Art Market in June.

THE MAIN STREET GALLERY

105 Main St., P.O. Box 161, Groton NY 13073. (607)898-9010. Fax: (607)898-9010. E-mail: maingal@localnet.com. Website: www.mainstreetgal.com. Exhibits 15 artists. Sponsors 1 photography exhibit/year. Average display time 5-6 weeks. Open Thursday through Saturday from 12 to 6; Sunday from 1 to 5. Closed January and February. Located in the village of Groton in the Finger Lakes Region of New York, 20 minutes from Ithaca; 900 sq. ft. Overall price range: \$120-5,000.

Exhibits Interested in fine art.

Submissions Write to arrange a personal interview to show portfolio of photographs, slides. Send query letter with artist's statement, bio, brochure, photographs, résumé, reviews, slides/CD images, SASE. Responds to queries in 1 month, only if interested. Finds artists through art exhibits, portfolio reviews, referrals by other artists, submissions, word of mouth.

Tips After submitting materials, the artist will set an appointment to talk over work. Artists should send in up-to-date résumé and artist's statement.

MARKEIM ART CENTER

104 Walnut St., Haddonfield NJ 08033. (856)429-8585. E-mail: markeim@verizon.net. Website: www.markeimartcenter.org. Sponsors 10-11 exhibits/year. Average display time 4 weeks. The exhibiting artist is responsible for all details of the opening. Overall price range \$75-1,000. Most work sold at \$350.

Exhibits Interested in all types work. Exhibits photos of babies/children/teens, celebrities, couples, multicultural, families, parents, senior citizens, environmental, landscapes/scenics, wildlife, architecture, cities/urban, education, rural, adventure, automobiles, entertainment, performing arts, sports, travel, agriculture, product shots/still life. Interested in alternative process, avant garde, documentary, fine art, historical/vintage, seasonal.

Making Contact & Terms Charges 30% commission. Accepted work should be framed and wired, ready to hang, mounted or unmounted, matted or unmatted. Artists from New Jersey and Delaware Valley region are preferred. Work must be professional and high quality.

Submissions Send slides by mail or e-mail for consideration. Include SASE, résumé and letter of intent. Responds in 1 month.

Tips "Be patient and flexible with scheduling. Look not only for one-time shows, but for opportunities to develop working relationships with a gallery. Establish yourself locally and market yourself outward."

MARLBORO GALLERY

Prince George's Community College, Marlboro Gallery, 301 Largo Rd., Largo MD 20772-2199. (301)322-0965. Fax: (301)808-0418. E-mail: tberault@pgcc.edu. Website: www.pgcc.edu. Average display time 6 weeks. Overall price range \$50-2,000. Most work sells at \$75-350.

Exhibits We exhibit fine art, photos of celebrities, portraiture, landscapes/scenics, wildlife/adventure, entertainment, events and travel. Also interested in alternative processes, avant garde, fine art. Not interested in commercial work.

Making Contact & Terms "We do not take commission on artwork sold." Accepted work must be framed and suitable for hanging.

Submissions "We are looking for fine art photos; we need 10-20 to make assessment. Reviews are done every 6 months. We prefer to receive submissions February through April." Please send query

letter with résumé, CD with 15 to 20 JPEGs, image list with title, date, media and dimensions, artist statement, bio and SASE. Responds in 1 month.

Tips "Send examples of what you wish to display, and explanations if photos do not meet normal standards (i.e., in focus, experimental subject matter)."

MASUR MUSEUM OF ART

1400 S. Grand St., Monroe LA 71202. (318)329-2237. Fax: (318)329-2847. E-mail: info@ masurmuseum.org. Website: www.masurmuseum.org/. Approached by 500 artists/year; represents or exhibits 150 artists. Sponsors 2 photography exhibits/year. Average display time 2 months. Museum open Tuesday through Friday from 9 to 5; Saturday from 12 to 5. Closed Mondays, between exhibitions and on major holidays. Located in historic home, 3,000 sq. ft. Overall price range \$100-12,000. Most work sold at \$300.

Exhibits Exhibits photos of babies/children/teens, celebrities, environmental, landscapes/scenics. Interested in alternative process, avant garde, documentary, fine art, historical/vintage.

Making Contact & Terms Artwork is accepted on consignment, and there is a 20% commission. Gallery provides insurance, promotion. Accepted work should be framed.

Submissions Send query letter with artist's statement, bio, résumé, reviews, slides, SASE. Responds in 6 months. Finds artists through word of mouth, submissions, art exhibits, referrals by other artists.

MICHELE MATTEL PHOTOGRAPHY

1714 Wilton Place, Los Angeles CA 90028. (323)462-6342. Fax: (323)462-7568. E-mail: michele@ michelemattei.com. Website: http://michelemattei.net/. **Director:** Michele Mattei. Estab. 1974. Stock photo agency. Clients include: book/encyclopedia publishers, magazine publishers, television, film.

Tips "Shots of celebrities and home/family stories are frequently requested." In samples, looking for "high-quality, recognizable personalities and current newsmaking material. We are interested mostly in celebrity photography. Written material on personality or event helps us to distribute material faster and more efficiently."

MCDONOUGH MUSEUM OF ART

525 Wick Ave., One University Plaza, Youngstown OH 44555-1400. (330)941-1400. E-mail: labrothers@ysu.edu. Website: www.fpa.ysu.edu. **Director:** Leslie Brothers. A center for contemporary art, education and community, the museum offers exhibitions in all media, experimental installation, performance, and regional outreach programs to the public. The museum is also the public outreach facility for the Department of Art and supports student and faculty work through exhibitions, collaborations, courses and ongoing discussion. Estab. 1991. **Submissions** Send exhibition proposal.

MESA CONTEMPORARY ARTS AT MESA ARTS CENTER

1 E. Main St., P.O. Box 1466, Mesa AZ 85211-1466. (480)644-6560. E-mail: patty.haberman@mesaartscenter.com. Website: www.mesaartscenter.com. Curator: Patty Haberman. Not-for-profit art space. Estab. 1980.

Exhibits Exhibits photos of babies/children/teens, celebrities, couples, multicultural, families, parents, senior citizens, disasters, environmental, landscapes/scenics, wildlife, architecture, cities/urban, interiors/decorating, rural, adventure, automobiles, entertainment, events, performing arts, travel, industry, political, science, technology/computers. Interested in alternative process, avant garde, documentary, fine art, historical/vintage, seasonal, and contemporary photography.

Making Contact & Terms Charges \$25 entry fee, 25% commission.

Submissions "Please view our online prospectus for further info, or contact Patty Haberman at (480)644-6561."

Tips "We do invitational or national juried exhibits. Submit professional-quality slides."

MICHAEL MURPHY GALLERY M

2701 S. MacDill Ave., Tampa FL 33629. (813)902-1414. Fax: (813)835-5526. Website: www. michaelmurphygallery.com. (formerly Michael Murphy Gallery Inc.) For-profit gallery. Approached by 100 artists/year; exhibits 35 artists. Sponsors 1 photography exhibit/year. Average display time 1 month. Open all year; Monday through Saturday from 10 to 6. Overall price range \$500-15,000. Most work sold at less than \$1,000. "We provide elegant, timeless artwork for our clients' home and office environment as well as unique and classic framing design. We strongly believe in the preservation of art through the latest technology in archival framing."

Exhibits Exhibits photos of babies/children/teens, celebrities, couples, multicultural, families, parents, senior citizens, disasters, environmental, landscapes/scenics, wildlife, architecture, cities/urban, education, gardening, interiors/decorating, pets, religious, rural, agriculture, business concepts, industry, medicine, military, political, product shots/still life, science, technology/computers. Interested in alternative process, avant garde, documentary, erotic, fashion/glamour, fine art, historical/vintage, seasonal.

Making Contact & Terms Artwork is accepted on consignment, and there is a 50% commission. Accepted work should be framed. Requires exclusive representation locally.

Submissions Send query with artist's statement, bio, brochure, business card, photocopies, photographs, résumé, reviews, slides and SASE. Responds to queries in 1 month, only if interested.

R. MICHELSON GALLERIES

132 Main St., Northampton MA 01060. (413)586-3964. Fax: (413)587-9811. E-mail: RM@RMichelson. com. Website: www.RMichelson.com. **Owner and President:** Richard Michelson. Estab. 1976. Sponsors 1 exhibit/year. Average display time 6 weeks. Sponsors openings. Overall price range \$1,200-\$15,000.

Exhibits Interested in contemporary, landscape and/or figure work.

Making Contact & Terms Sometimes buys photos outright. Accepted work can be framed or unframed, mounted or unmounted, matted or unmatted. Requires exclusive representation locally. Not taking on new photographers at this time.

MILL BROOK GALLERY & SCULPTURE GARDEN

236 Hopkinton Rd., Concord NH 03301. (603)226-2046. E-mail: artsculpt@mindspring.com. Website: www.themillbrookgallery.com. Exhibits 70 artists. Sponsors 1 photography exhibit/year. Average display time 6 weeks. Gallery open Tuesday through Sunday from 11 to 5, April 1 to December 24; open by appointment December 25 to March 31. Outdoor juried sculpture exhibit. Three rooms inside for exhibitions, 1,800 sq. ft. Overall price range \$8-30,000. Most work sold at \$500-1,000.

Making Contact & Terms Artwork is accepted on consignment, and there is a 50% commission. Gallery provides insurance, promotion, contract. Accepted work should be framed, matted.

Submissions Write to arrange a personal interview to show portfolio of photographs, slides. Send query letter with artist's statement, bio, photocopies, photographs, résumé, slides, SASE. Responds within 1 month, only if interested. Finds artists through word of mouth, submissions, art exhibits, referrals by other artists.

PETER MILLER GALLERY

118 N. Peoria St., Chicago IL 60607. (312)226-5291. Fax: (312)226-5441. E-mail: director@petermillergallery.com. Website: www.petermillergallery.com. The Peter Miller Gallery exhibits contemporary art by emerging and mid-career artists. The gallery's current direction spans a broad range of contemporary art practice, including photo-based work, sound + video installations as well as painting and sculpture. The current location in Chicago's West Loop Gallery District occupies approximately 1800 square feet on the ground floor. The main exhibition gallery has its

own project space and the office/reception area has two smaller project rooms. Gallery is 2,400 sq. ft. with 10-foot ceilings. Overall price range \$1,000-40,000. Most work sold at \$5,000.

Exhibits Painting, sculpture, photography and new media.

Making Contact & Terms Charges 50% commission. Accepted work can be framed or unframed, mounted or unmounted, matted or unmatted. Requires exclusive representation locally.

Submissions Send CD with minimum of 20 images (no details) from the last 18 months with SASE, or e-mail a link to your website to director@petermillergallery.com.

Tips "We look for work we haven't seen before; i.e., new images and new approaches to the medium."

M MILLS POND HOUSE GALLERY

Smithtown Township Arts Council, 660 Route 25 A, St. James NY 11780. E-mail: Exhibits@Stacarts. org. Website: www.Stacarts.org. Non-profit gallery. Sponsors 9 exhibits/year (1-2 photography). Average display time is 5 weeks. Hours: Monday-Friday 10-5, weekends 12-4. Considers all types of prints, media and styles. Prices set by the artist. Gallery provides insurance and promotion. Work should be framed. Clientele includes the local community.

MOBILE MUSEUM OF ART

4850 Museum Dr., Mobile AL 36608. (251)208-5200. Fax: (251)208-5201. E-mail: director@ MobileMuseumOfArt.com. Website: www.mobilemuseumofart.com. **Director:** Tommy McPherson. Estab. 1964. Sponsors 4 exhibits/year. Average display time 3 months. Sponsors openings; provides light hors d'oeuvres and wine.

Exhibits Open to all types and styles.

Making Contact & Terms Photography sold in gallery. Charges 20% commission. Occasionally buys photos outright. Accepted work should be framed.

Submissions Arrange a personal interview to show portfolio; send material by mail for consideration. Returns material when SASE is provided "unless photographer specifically points out that it's not required."

Tips "We look for personal point of view beyond technical mastery."

MONTEREY MUSEUM OF ART

559 Pacific St., Monterey CA 93940. (831)372-5477. Fax: (831)372-5680. E-mail: info@montereyart. org. Website: www.montereyart.org. Sponsors 3-4 exhibitions/year. Average display time approximately 10 weeks. Open Wednesday through Saturday from 11 to 5; Sunday from 1 to 4.

• 2nd location: 720 Via Miranda, Monterey CA 93940; (831)372-3689.

Exhibits Interested in all subjects.

Making Contact & Terms Accepted work should be framed.

Submissions Send slides by mail for consideration; include SASE. Responds in 1 month.

Tips "Send 20 slides and résumé at any time to the attention of the museum curator."

MULTIPLE EXPOSURES GALLERY

105 N. Union St., #312, Alexandria VA 22314-3217. (703)683-2205. E-mail: multipleexposuresgallery@verizon.net. Website: www.multipleexposuresgallery.com. Cooperative gallery. Estab. 1986. Represents or exhibits 14 artists. Sponsors 12 photography exhibits/year. Average display time 1-2 months. Open daily from 11 to 5. Closed on 5 major holidays throughout the year. Located in Torpedo Factory Art Center; 10-ft. walls with about 40 ft. of running wall space; 1 bin for each artist's matted photos, up to 20 × 24 in size with space for 25 pieces.

Exhibits Exhibits photos of landscapes/scenics, architecture, beauty, cities/urban, religious, rural, adventure, automobiles, events, travel, buildings. Interested in alternative process, documentary, fine art. Other specific subjects/processes: "We have on display roughly 300 images that run the gamut from platinum and older alternative processes through digital capture and output."

Making Contact & Terms There is a co-op membership fee, a time requirement, a rental fee and a 15% commission. Accepted work should be matted. **Accepts only artists from Washington, DC, region.** Accepts only photography. "Membership is by jury of active current members. Membership is limited. Jurying for membership is only done when a space becomes available; on average, 1 member is brought in about every 2 years."

Submissions Send query letter with SASE to arrange a personal interview to show portfolio of photographs, slides. Responds in 2 months. Finds artists through word of mouth, referrals by other artists, ads in local art/photography publications.

Tips "Have a unified portfolio of images mounted and matted to archival standards."

MUSEO DE ARTE DE PONCE

P.O. Box 9027, Ponce PR 00732-9027. (787)848-0505, ext. 231. Fax: (787)841-7309. E-mail: map@museoarteponce.org, aserna@museoarteponce.org. Website: www.museoarteponce.org. Contact: Curatorial Department. Museum. Estab. 1959. Approached by 50 artists/year; mounts 3 exhibitions/year. Museum currently closed until fall 2010. Satellite gallery in Plaza las Americas, San Juan open Monday through Sunday from 12 to 5. Closed New Year's Day, January 6, Good Friday, Thanksgiving and Christmas day.

Exhibits Interested in avant garde, fine art, European and Old Masters.

Submissions Send query letter with artist's statement, résumé, images, reviews, publications. Responds in 3 months. Finds artists through research, art exhibits, studio and gallery visits, word of mouth, referrals by other artists.

MUSEO ITALOAMERICANO

(415)673-2200. Fax: (415)673-2292. E-mail: sfmuseo@sbcglobal.net. Website: www. museoitaloamericano.org. Museum. Estab. 1978. Approached by 80 artists/year; exhibits 15 artists. Sponsors 1 photography exhibit/year (depending on the year). Average display time 2-3 months. Gallery open Tuesday through Sunday from 12 to 4; Monday by appointment. Closed major holidays. Gallery is located in the San Francisco Marina District, with a beautiful view of the Golden Gate Bridge, Sausalito, Tiburon and Alcatraz; 3,500 sq. ft. of exhibition space.

Exhibits Exhibits photos of babies/children/teens, celebrities, couples, multicultural, families, parents, senior citizens, environmental, landscapes/scenics, architecture, cities/urban, education, religious, rural, entertainment, events, food/drink, hobbies, humor, performing arts, sports, travel, product shots/still life. Interested in alternative process, avant garde, documentary, fine art, historical/vintage.

Making Contact & Terms "The museum rarely sells pieces. If it does, it takes 20% of the sale." Museum provides insurance, promotion. Accepted work should be framed, mounted, matted. Accepts only Italian or Italian-American artists.

Submissions Call or write to arrange a personal interview to show portfolio of photographs, slides, catalogs. Send query letter with artist's statement, bio, brochure, photographs, résumé, reviews, slides, SASE. Responds in 2 months. Finds artists through word of mouth, submissions.

Tips "Photographers should have good, quality reproduction of their work with slides, and clarity in writing their statements and résumés. Be concise."

■ MUSEUM OF CONTEMPORARY ART SAN DIEGO

700 Prospect St., La Jolla CA 92037. (858)454-3541. E-mail: jsiman@mcasd.org; info@mcasd.org. Website: www.mcasd.org. Contact: Curatorial Department. Museum. Estab. 1941. Open Monday through Sunday from 11 to 5 (both locations), Thursday until 7 (La Jolla only). Closed Wednesday and during installation (both locations).

Exhibits Exhibits photos of families, architecture, education. Interested in avant garde, documentary, fine art.

Submissions See Artist Proposal Guidelines at www.mcasd.org/information/proposals.asp.

■ MUSEUM OF CONTEMPORARY PHOTOGRAPHY, COLUMBIA COLLEGE CHICAGO

600 S. Michigan Ave., Chicago IL 60605-1996. (312)663-5554. Fax: (312)344-8067. E-mail: RSlemmons@colum.edu. Website: www.mocp.org. **Director:** Rod Slemmons. **Associate Director:** Natasha Egan. Estab. 1984. "We offer our audience a wide range of provocative exhibitions in recognition of photography's roles within the expanded field of imagemaking." Sponsors 6 main exhibits and 4-6 smaller exhibits/year. Average display time 2 months.

Exhibits Exhibits and collects national and international works including portraits, environment, architecture, urban, rural, performance art, political issues, journalism, social documentary, mixed media, video. Primarily interested in experimental work of the past ten years.

Submissions Reviews of portfolios for purchase and/or exhibition held monthly. Submission protocols on website. Respond in 2-3 months. No critical review guaranteed.

Tips "Professional standards apply; only very high-quality work considered."

■ MUSEUM OF PHOTOGRAPHIC ARTS

1649 El Prado, Balboa Park, San Diego CA 92101. (619)238-7559. Fax: (619)238-8777. E-mail: klochko@mopa.org. Website: www.mopa.org. **Curator of Photography:** Carol McCusker. Estab. 1983. Sponsors 12 exhibits/year. Average display time 3 months.

Exhibits Interested in the history of photography, from the 19th century to the present.

Making Contact & Terms "The criteria is simply that the photography be of advanced artistic caliber, relative to other fine art photography. MoPA is a museum and therefore does not sell works in exhibitions." Exhibition schedules planned 2-3 years in advance. Holds a private Members' Opening Reception for each exhibition.

Submissions "For space, time and curatorial reasons, there are few opportunities to present the work of newer, lesser-known photographers." Send a CD, website or JPEGs to curator Curator will respond, and if interested, will request materials for future consideration. Files are kept on contemporary artists of note for future reference. Send return address and postage if you wish your materials returned. Responds in 2 months.

Tips "Exhibitions presented by the museum represent the full range of artistic and journalistic photographic works. There are no specific requirements. The executive director and curator make all decisions on works that will be included in exhibitions. There is an enormous stylistic diversity in the photographic arts. The museum does not place an emphasis on one style or technique over another."

MUSEUM OF PRINTING HISTORY

1324 W. Clay, Houston TX 77019. (713)522-4652. E-mail: akasman@printingmuseum.org. Website: www.printingmuseum.org. **Executive Director:** Ann Kasman. Estab. 1982. Represents or exhibits 4-12 artists. Sponsors 1-12 photography exhibits/year. Average display time 6-16 weeks. Gallery open Tuesday through Saturday from 10 to 5. Closed 4th of July, Thanksgiving, Christmas Eve, Christmas, New Year's Eve/Day. Three rotating exhibit galleries. Overall price range \$10-1,500.

Exhibits Exhibits photos of multicultural, landscapes/scenics, architecture, cities/urban, rural. Interested in alternative process, documentary.

Making Contact & Terms Artwork is accepted on consignment, and there is a 30% commission. Gallery provides insurance. Accepted work should be mounted, matted.

Submissions Write to arrange a personal interview to show portfolio of photographs, slides. Mail portfolio for review. Send query letter with artist's statement, bio, brochure, business card, photocopies, photographs, résumé, reviews, slides, SASE. Responds within 2 months, only if interested. Finds artists through word of mouth, submissions, portfolio reviews, art exhibits, referrals by other artists.

Tips "Check our website for Sunday hours, e-mail addresses and additional info."

MUSEUM OF THE PLAINS INDIAN

P.O. Box 410, Browning MT 59417. (406)338-2230. Fax: (406)338-7404. E-mail: mpi@3rivers.net. Website: www.iacb.doi.gov/museums/museum_plains2.html. Estab. 1941. Open daily from 9 to 4:45 (June-September); Monday through Friday from 10 to 4:30 (October-May). Admission is free of charge October-May. Contact for additional information.

NEVADA MUSEUM OF ART

160 W. Liberty St., Reno NV 89501. Fax: (775)329-1541. E-mail: wolfe@nevadaart.org. Website: www.nevadaart.org. Sponsors 12-15 exhibits/year in various media. Average display time 4-5 months.

Submissions See website for detailed submission instructions. No phone calls, please."

Tips "The Nevada Museum of Art is a private, nonprofit institution dedicated to providing a forum for the presentation of creative ideas through its collections, educational programs, exhibitions and community outreach. We specialize in art addressing the environment and the altered landscape."

NEW GALLERY/THOM ANDRIOLA

2627 Colquitt, Houston TX 77098-2117. (713)520-7053. Fax: (713)520-1145. E-mail: info@ newgallery.net. Website: www.newgallery.net. Director: Thom Andriola. For-profit gallery. Estab. 1979. Represents or exhibits 22 artists/year. Sponsors 1 photography exhibit/year. Average display time 1 month. Open Tuesday through Saturday from 11 to 5.

Making Contact & Terms Artwork is accepted on consignment, and there is a 50% commission. Requires exclusive representation locally.

NEW MEXICO STATE UNIVERSITY ART GALLERY

MSC 3572, NMSU, P.O. Box 30001, Las Cruces NM 88003-8001. (575)646-2545. Fax: (575)646-8036. E-mail: artglry@nmsu.edu; pthayer@nmsu.edu. Website: www.nmsu.edu/~artgal. Director: Preston Thayer. Museum. Estab. 1969. Average display time 2-3 months. Gallery open Tuesday through Saturday from 11 to 4; Saturday and Sunday from 1 to 5. Closed Christmas through New Year's Day and university holidays. See website for summer hours. Located on university campus, 3,900 sq. ft. of exhibit space.

Making Contact & Terms Artwork is accepted on consignment, and there is a 30% commission. Gallery provides insurance, promotion, contract. Accepted work should arrive ready to install. Submissions Send query letter with artist's statement, bio, brochure, résumé, slides, SASE. Responds in 6 months.

NEW ORLEANS MUSEUM OF ART

P.O. Box 19123, New Orleans LA 70179. (504)658-4145. Fax: (504)658-4199. E-mail: dcortez@ noma.org. Website: www.noma.org. Curator of Photography: Diego Cortez. Collection estab. 1973. Sponsors exhibits continuously. Average display time 1-3 months.

Exhibits Interested in all types of photography.

Making Contact & Terms Buys photography outright; payment negotiable. Current budget for purchasing contemporary photography is very small. Sometimes accepts donations from established artists, collectors or dealers.

Submissions Send query letter with color photocopies (preferred) or slides, résumé, SASE. Accepts images in digital format; submit via website. Responds in 3 months.

Tips "Send thought-out images with originality and expertise. Do not send commercial-looking images."

NEXUS/FOUNDATION FOR TODAY'S ART

1400 N. American St., Suite 102, Philadelphia PA 19122. E-mail: info@nexusphiladelphia.org. Website: http://nexusphiladelphia.org. Executive Director: Nick Cassway. Alternative space; cooperative, nonprofit gallery. Estab. 1975. Approached by 40 artists/year; represents or exhibits 20 artists. Sponsors 2 photography exhibits/year. Average display time 1 month. Open Wednesday through Sunday from 12 to 6; closed July and August. Located in Fishtown, Philadelphia; 2 gallery spaces, approximately 750 sq. ft. each. Overall price range: \$75-1,200. Most work sold at \$200-400.

Exhibits Exhibits photos of multicultural, families, environmental, architecture, rural, entertainment, humor, performing arts, industry, political. Interested in alternative process, documentary, fine art.

Submissions Send query letter with artist's statement, bio, photocopies, photographs, slides, SASE. Finds artists through portfolio reviews, referrals by other artists, submissions, and juried reviews 2 times/year. "Please visit our website for submission dates."

Tips "Learn how to write a cohesive artist's statement."

NICOLAYSEN ART MUSEUM & DISCOVERY CENTER

400 E. Collins Dr., Casper WY 82601. (307)235-5247. E-mail: vkulhavy@thenic.org. Website: www. thenic.org. **Acting Director:** Val Kulhavy. **Director of Exhibitions and Programming:** Ben Mitchell. Estab. 1967. Sponsors 10 exhibits/year. Average display time 3-4 months. Sponsors openings. Overall price range \$250-1,500.

Exhibits Work must demonstrate artistic excellence and be appropriate to gallery's schedule. Interested in all subjects and media.

Making Contact & Terms Charges 40% commission.

Submissions Send material by mail for consideration (slides, résumé/CV, proposal); include SASE. Responds in 1 month.

M NICOLET COLLEGE ART GALLERY

(715)365-4556. E-mail: Kralph@Nicoletcollege.edu. Website: www.Nicoletcollege.edu. Gallery Director: Katherine Ralph.

Making Contact & Terms Call or e-mail for further information.

NORTHWEST ART CENTER

500 University Ave. W., Minot ND 58707. (701)858-3264. Fax: (701)858-3894. E-mail: nac@ minotstateu.edu. Website: www.misu.nodak.edu/nac. Sponsors 18-20 exhibits/year, including 2 national juried shows. Average display time 4-6 weeks. Northwest Art Center consists of 2 galleries: Hartnett Hall Gallery and the Library Gallery. Overall price range \$50-2,000. Most work sold at \$800 or less.

Exhibits Interested in alternative process, avant garde, documentary, fine art, historical/vintage. **Making Contact & Terms** Charges 30% commission. Accepted work must be framed.

Submissions Send material by mail with SASE or e-mail for consideration. Responds within 3 months. Prospectus for juried shows available on website.

NORTHWESTERN UNIVERSITY DITTMAR MEMORIAL GALLERY

1999 S. Campus Dr., Evanston IL 60208. (847)491-2348. E-mail: dittmargallery@u.northwestern. edu. Website: www.norris.northwestern.edu/nbsm_dittmar.php. Contact: Gallery Coordinator. Nonprofit gallery. Estab. 1972. Approached by 30 artists/year; represents or exhibits more than 10 artists. Sponsors 1-2 photography exhibits/year. Average display time 6 weeks. Gallery open daily from 10 to 10. Closed December. The gallery is located within the Norris Student Center on the main floor behind the information desk.

Exhibits Exhibits photos of babies/children/teens, couples, multicultural, families, parents, disasters, environmental, landscapes/scenics, wildlife, architecture, cities/urban, education, gardening, adventure, automobiles, entertainment, events, food/drink, health/fitness, hobbies, humor, performing arts, sports, travel. Interested in avant garde, erotic, fashion/glamour, fine art, historical/vintage, seasonal.

Making Contact & Terms Artwork is accepted on consignment, and there is a 20% commission. Gallery provides promotion, contract. Accepted work should be mounted.

Submissions Mail portfolio for review. Send query letter with 10-15 slides, artist's statement, brochure, résumé, reviews. Responds in 3 months. Finds artists through word of mouth, submissions, referrals by other artists.

Tips "Do not send photocopies. Send a typed letter, good photos or color photocopies. Send résumé of past exhibits, or if emerging, a typed statement."

■ THE NOYES MUSEUM OF ART

733 Lily Lake Rd., Oceanville NJ 08231. (609)652-8848. Fax: (609)652-6166. E-mail: info@noyesmuseum.org; mcagno@noyesmuseum.org; dpapadem@noyesmuseum.org. Website: www.noyesmuseum.org. Executive Director: Michael Cagno. Director of Exhibitions: Dorrie Papademetriou. Sponsors 10-12 exhibits/year. Average display time 12 weeks. The Richard Stockton College of New Jersey has entered into collaboration with the Noyes Museum of Art that will benefit students and enthusiasts of the arts, as well as the College, Museum and the entire southern New Jersey region. Stockton will partner with the Noyes Museum and support an expanded array of educational opportunities, events, exhibits and performances at the nearby off-campus facility. Stockton is also home to one of the area's top performing arts centers, and its own art gallery.

Exhibits Interested in alternative process, avant garde, fine art, historical/vintage.

Making Contact & Terms Charges 30% commission. Accepted work must be ready for hanging, preferably framed. Infrequently buys photos for permanent collection.

Submissions Any format OK for initial review. Send material by mail for consideration; include résumé, artist's statement, slide samples or CD.

Tips "Send challenging, cohesive body of work. May include photography and mixed media."

OAKLAND UNIVERSITY ART GALLERY

Oakland University, 2200 N. Squirrel Rd., Rochester MI 48309-4401. (248)370-3005. Website: www.oakland.edu/ouag. Nonprofit gallery. Estab. 1962. Represents 10-25 artists/year. Sponsors 6 exhibits/year. Average display time 4-6 weeks. Open September-May: Tuesday through Sunday from 12 to 5; evenings during special events and theater performances (Wednesday through Friday from 7 through 1st intermission, weekends from 5 through 1st intermission). Closed Monday, holidays and June-August. Located on the campus of Oakland University; exhibition space is approximately 2,350 sq. ft. of floor space, 301-ft. linear wall space, with 10-ft. 7-in. ceiling. The gallery is situated across the hall from the Meadow Brook Theatre. "We do not sell work, but do make available price lists for visitors with contact information noted for inquiries."

Exhibits Considers all styles and all types of prints and media.

Making Contact & Terms Charges no commission. Gallery provides insurance, promotion and contract. Accepted work should be framed, mounted, matted. No restrictions on representation; however, prefers emerging Detroit artists.

Submissions E-mail bio, education, artist's statement and JPEG images. Mail portfolio for review. Send query letter with artist's statement, bio, photocopies, curriculum vitae. Returns material with SASE. Responds to queries in 1-2 months. Finds artists through referrals by other artists, word of mouth, art community, advisory board and other arts organizations.

O.K. HARRIS WORKS OF ART

383 W. Broadway, New York NY 10012. (212)431-3600. Fax: (212)925-4797. E-mail: okharris@okharris.com. Website: www.okharris.com. Sponsors 3-8 exhibits/year. Average display time 1 month. Gallery open Tuesday through Saturday from 10 to 6. Closed August and from December 25 to January 1. Overall price range \$350-3,000.

Exhibits Exhibits photos of cities/urban, events, rural. "The images should be startling or profoundly evocative. No rocks, dunes, weeds or nudes reclining on any of the above or seascapes." Interested in urban and industrial subjects, "cogent photojournalism," documentary.

Making Contact & Terms Charges 50% commission. Accepted work should be matted and framed.

Submissions Appear in person, no appointment. Responds immediately.

Tips "Do not provide a descriptive text."

OPALKA GALLERY

The Sage Colleges, 140 New Scotland Ave., Albany NY 12208. (518)292-7742. E-mail: opalka@ sage.edu. Website: www.sage.edu/opalka. **Director:** Jim Richard Wilson. Nonprofit gallery. Estab. 2002. "The Opalka Gallery replaced Rathbone Gallery, which served The Sage Colleges for 25 years." Approached by 90-120 artists/year; represents or exhibits approximately 24 artists. Average display time 5 weeks. Open Monday through Friday from 10 to 4:30; Monday-Thursday evenings 6-8, Sundays noon-4; June-July 10-4 and by appointment. Open by appointment only between exhibitions and when classes are not in session. Closed July 4. "Located on the Sage Albany campus, The Opalka's primary concentration is on work by professional artists from outside the region. The gallery frequently features multidisciplinary projects and hosts poetry readings, recitals and symposia, often in conjunction with its exhibitions. The 7,400-sq.-ft. facility includes a vaulted gallery and a 75-seat lecture/presentation hall with Internet connectivity." Overall price range \$50-260,000.

Exhibits Interested in fine art.

Making Contact & Terms Artwork is accepted on consignment; there is no commission. "We primarily accept artists from outside our region and those who have ties to The Sage Colleges. We host the local 'Photography Regional' every three years." Requires exclusive representation locally.

Submissions Send query letter with artist's statement, bio, brochure, business card, photocopies, photographs, reviews, slides, SASE; or e-mail pertinent information. Finds artists through word of mouth, art exhibits, submissions, portfolio reviews, referrals by other artists.

Tips "Submit all correspondence in a professional manner. Include any pertinent information with visuals of your work (slides, CD, etc.)."

M OPENING NIGHT GALLERY

2836 Lyndale Ave. S., Minneapolis MN 55408-2108. (612)872-2325. Fax: (612)872-2385. E-mail: deen@onframe-art.com. Website: www.onframe-art.com. Rental gallery. Approached by 40 artists/year; represents or exhibits 15 artists. Sponsors 1 photography exhibit/year. Average display time 6-10 weeks. Gallery open Monday through Friday from 8:30-5; Saturday from 10:30-4. Overall price range \$300-12,000. Most work sold at \$2,500.

Exhibits Exhibits photos of landscapes/scenics, architecture, cities/urban.

Making Contact & Terms Artwork is accepted on consignment, and there is a 50% commission. Gallery provides insurance, promotion, contract. Accepted work should be framed "by our frame shop." Requires exclusive representation locally.

Submissions Mail slides for review. Send query letter with artist's statement, bio, résumé, slides, SASE. Responds in 2 months. Finds artists through word of mouth, submissions, portfolio reviews.

PALO ALTO ART CENTER

1313 Newell Rd., Palo Alto CA 94303. (650)329-2366. Fax: (650)326-6165. E-mail: ArtCenter@cityofpaloalto.org. Website: www.cityofpaloalto.org/artcenter. **Contact:** Exhibitions Dept. Estab. 1971. Average display time 1-3 months. Open Tuesday through Saturday from 10 to 5; Sunday from 1 to 5. Sponsors openings.

Exhibits "Exhibit needs vary according to curatorial context." Seeks "imagery unique to individual artist. No standard policy. Photography may be integrated in group exhibits." Interested in alternative process, avant garde, fine art; emphasis on art of the Bay Area.

Submissions Send slides/CD, bio, artist's statement, SASE.

PARKLAND ART GALLERY

2400 W. Bradley Ave., Champaign IL 61821. (217)351-2485. Fax: (217)373-3899. E-mail: lcostello@ parkland.edu. Website: www.parkland.edu/gallery. Nonprofit gallery. Approached by 130 artists/ year; represents or exhibits 8 artists. Average display time 4-6 weeks. Open Monday-Friday 10-3: Monday-Thursday 6-8; open Saturday 12-2 (fall and spring semesters). Summer: open Monday-Thursday 10-3; Monday-Wednesday 6-8. Parkland Art Gallery at Parkland College seeks exhibition proposals in all genres of contemporary approaches to art making by single artists, collaborative groups, or curators. Parkland Art Gallery is a professionally designed gallery devoted primarily to education through contemporary art. Parkland Art Gallery hosts 8 exhibitions per year including two student exhibitions, one Art & Design Faculty Show, and a Biennial Watercolor Invitational that alternates with a National Ceramics Invitational. Other shows vary depending on applications and the vision of the Art Gallery Advisory Board. Exhibits are scheduled on a four- to six-week rotation. Closed college and official holidays. Overall price range \$100-5,000. Most work sold at \$300.

Exhibits Interested in alternative process, avant garde, documentary, fine art, historical/vintage. Making Contact & Terms Gallery provides insurance, promotion. Accepted work should be

Submissions Send 20 slides or a CD containing 20 images; an identifying list with titles, sizes, dates, and media; a resume; an artist statement; and a SASE (if necessary) to attention of the Director, Parkland Art Gallery, Parkland College. Only complete proposal packages including all information listed on the Proposal Guidelines will be reviewed. Responds in 4 months. Finds artists through word of mouth, portfolio reviews, art exhibits, referrals by other artists. Call for entry.

LEONARD PEARLSTEIN GALLERY

Drexel University, 33rd and Market Streets, Philadelphia PA 19104. (215)895-2548. Fax: (215)895-4917. E-mail: gallery@drexel.edu. Website: www.drexel.edu/academics/comad/gallery. Contact: Filiz O'Brien. Nonprofit gallery. Estab. 1986. Sponsors 8 total exhibits/year; 1 or 2 photography exhibits/year. Average display time 1 month. Open Monday through Friday from 11 to 5. Closed during summer.

Making Contact & Terms Artwork is bought outright. Gallery takes 20% commission. Gallery provides insurance, promotion. Accepted work should be framed, mounted, matted. "We will not pay transport fees."

Submissions Write to arrange a personal interview to show portfolio. Send query letter with artist's statement, bio, résumé, SASE. Returns material with SASE. Responds by February, only if interested. Finds artists through referrals by other artists, academic instructors.

PETERS VALLEY CRAFT CENTER

19 Kuhn Rd., Layton NJ 07851. (973)948-5202. Fax: (973)948-0011. E-mail: store@petersvalley.org. Website: www.petersvalley.org. Nonprofit gallery and store. Approached by about 100 artists/year; represents about 350 artists. Average display time 1 month in gallery; varies for store items. Open year round; call for hours. Located in northwestern New Jersey in Delaware Water Gap National Recreation Area; 2 floors, approximately 3,000 sq. ft. Overall price range \$5-3,000. Most work sold at \$100-300.

Exhibits Considers all media and all types of prints. Also exhibits non-referential, mixed media, collage and sculpture.

Making Contact & Terms Artwork is accepted on consignment, and there is a 60% commission to artist. "Retail price set by the gallery in conjunction with artist." Gallery provides insurance and promotion. Accepted work should be framed, mounted and matted.

Submissions Submissions reviewed in March. Send query letter with artist's statement, bio, résumé and images (slides or CD of JPEGs). Returns material with SASE. Responds in 2 months. Finds artists through submissions, art exhibits, art fairs, referrals by other artists.

Tips "Submissions must be neat and well-organized throughout."

PHILLIPS GALLERY

444 East 200 S., Salt Lake City UT 84111. (801)364-8284. Fax: (801)364-8293. E-mail: meri@ phillips-gallery.com. Website: www.phillips-gallery.com. Commercial gallery. We represent artists working in a variety of media including painting, drawing, sculpture, photography, ceramics, printmaking, jewelry, and mixed media. Our artists, many of whom have been with us for 37 years, are primarily from Utah or the surrounding area. Phillips Gallery also represents national and international artists who have an association with Utah. You will discover a full range of subject matter from traditional to contemporary. Average display time 4 weeks. Sponsors openings; provides refreshments, advertisement, and half of mailing costs. Overall price range \$300-2,000. Most work sold at \$600.

Exhibits Accepts all types and styles.

Making Contact & Terms Charges 50% commission. Accepted work should be matted. Requires exclusive representation locally. **Photographers must have Utah connection.** Must be actively pursuing photography.

Submissions Submit portfolio for review; include SASE. Responds in 2 weeks.

PHOENIX GALLERY

210 11th Ave. at 25th St., Suite 902, New York NY 10001. (212)226-8711. Fax: (212)343-7303. E-mail: info@phoenix-gallery.com. Website: www.phoenix-gallery.com. Sponsors 10-12 exhibits/year. Average display time 1 month. Overall price range \$100-10,000. Most work sold at \$3,000-8,000.

Exhibits "The gallery is an artist-run nonprofit organization; an artist has to be a member in order to exhibit in the gallery. There are 3 types of membership: active, inactive and associate." Interested in all media; alternative process, documentary, fine art.

Making Contact & Terms Charges 25% commission.

Submissions Artists wishing to be considered for membership must submit an application form, slides and résumé. Call, e-mail or download membership application from website.

PHOTOGRAPHIC RESOURCE CENTER

832 Commonwealth Ave., Boston MA 02215. (617)975-0600. Fax: (617)975-0606. E-mail: info@ prcboston.org. Website: www.prcboston.org. "The PRC is a nonprofit arts organization founded to facilitate the study and dissemination of information relating to photography." Average display time 6 weeks. Open Tuesday, Wednesday and Friday from 10 to 6; Saturday and Sunday from 12 to 5; Thursday from 10 to 8. Closed major holidays. Located in the heart of Boston University. Gallery brings in nationally recognized artists to lecture to large audiences and host workshops on photography.

Exhibits Interested in contemporary and historical photography and mixed-media work incorporating photography.

Submissions Unsolicited submissions discouraged. Send query e-mail with address for web portfolio. Finds artists through word of mouth, art exhibits, portfolio reviews.

Tips "Present a cohesive body of work. Don't expect immediate results; your work gets more interesting as it evolves over time."

PHOTOGRAPHY ART

107 Myers Ave., Beckley WV 25801. (304)252-4060 or (304)575-6491. Fax: (304)252-4060 (call before faxing). E-mail: bruceburgin@photographyart.com. Website: www.photographyart.com. Owner: Bruce Burgin. Internet rental gallery. Estab. 2003. "Each artist deals directly with his/her customers. I do not charge commissions and do not keep records of sales."

Exhibits Exhibits photos of landscapes/scenics, wildlife. Interested in fine art.

Making Contact & Terms There is a rental fee for space. The rental fee covers 1 year. The standard gallery is \$360 to exhibit 40 images with biographical and contact info for 1 year. No commission charged for sales. Artist deals directly with customers and receives 100% of any sale. Gallery provides promotion.

Submissions Internet sign-up. No portfolio required.

Tips "An artist should have high-quality digital scans. The digital images should be cropped to remove any unnecessary background or frames, and sized according to the instructions provided with their Internet gallery. I recommend the artist add captions and anecdotes to the images in their gallery. This will give a visitor to your gallery a personal connection to you and your work."

THE PHOTOMEDIA CENTER

P.O. Box 8518, Erie PA 16505. (617)990-7867. E-mail: info@photomediacenter.org. Website: www. photomediacenter.org. Nonprofit gallery. Estab. 2004. Sponsors 12 "new" photography exhibits/ year. "Previously featured exhibits are archived online. We offer many opportunities for artists, including sales, networking, creative collaboration and promotional resources; maintain an information board and slide registry for members; and hold an open annual juried show in the summer."

Exhibits Interested in alternative process, avant garde, documentary, fine art.

Making Contact & Terms Artwork is accepted on consignment, and there is a 25% commission. Gallery provides promotion. Prefers only artists working in photographic, digital and new media. **Submissions** "We have a general portfolio review call in the fall for the following year's exhibition schedule. If after December 31, send query letter with artist's statement, bio, résumé, slides, SASE." Responds in 2-6 months. Finds artists through word of mouth, submissions, portfolio reviews, art exhibits, referrals by other artists.

Tips "We are looking for artists who have excellent technical skills, a strong sense of voice and cohesive body of work. Pay careful attention to our guidelines for submissions on our website. Label everything. Must include a SASE for reply."

PIERRO GALLERY OF SOUTH ORANGE

Baird Center, 5 Mead St., South Orange NJ 07079. (973)378-7754. Fax: (973)378-7833. E-mail: pierrogallery@southorange.org. Website: www.pierrogallery.org. **Gallery Director:** Judy Wukitsch. Nonprofit gallery. Estab. 1994. Approached by 75-185 artists/year; represents or exhibits 25-50 artists. Average display time 7 weeks. Open Friday-Sunday 1-4; by appointment. Closed mid-December through mid-January and during August. Overall price range \$100-10,000. Most work sold at \$800.

Exhibits Interested in fine art, "which can be inclusive of any subject matter."

Making Contact & Terms Artwork is accepted on consignment, and there is a 15% commission. Gallery provides insurance, promotion, contract. Accepted work should be framed.

Submissions Mail portfolio for review; 3 portfolio reviews/year: January, June, October. Send query letter with artist's statement, résumé, slides. Responds in 2 months from review date. Finds artists through word of mouth, submissions, portfolio reviews, referrals by other artists.

POLK MUSEUM OF ART

800 E. Palmetto St., Lakeland FL 33801-5529. (863)688-7743. Fax: (863)688-2611. E-mail: info@ PolkMuseumofArt.org. Website: www.polkmuseumofart.org. Museum. Approached by 75 artists/year; represents or exhibits 3 artists. Sponsors 1-3 photography exhibits/year. Galleries open Tuesday through Saturday from 10-5; Sunday from 1-5. Closed major holidays. Four different galleries of various sizes and configurations.

Exhibits Interested in alternative process, avant garde, documentary, fine art, historical/vintage. **Making Contact & Terms** Museum provides insurance, promotion, contract. Accepted work should be framed.

Submissions Mail portfolio for review. Send query letter with artist's statement, bio, résumé, slides or CD, SASE.

THE PRINT CENTER

1614 Latimer St., Philadelphia PA 19103. (215)735-6090. Fax: (215)735-5511. E-mail: info@ printcenter.org. Website: www.printcenter.org. Nonprofit gallery and Gallery Store. Estab. 1915. Represents over 75 artists from around the world in Gallery Store. Sponsors 5 photography exhibits/year. Average display time 2 months. Open all year Tuesday-Saturday 11-5:30. Closed Christmas to New Year's. Three galleries. Overall price range \$15-15,000. Most work sold at \$200.

Exhibits Exhibits contemporary prints and photographs of all processes. Accepts original artwork only—no reproductions.

Making Contact & Terms Accepts artwork on consignment (50% commission). Gallery provides insurance, promotion, contract. Artists must be printmakers or photographers.

Submissions Must be member to submit work. Member's work is reviewed by Curator and Gallery Store Manager. See website for membership application. Finds artists through submissions, art exhibits, and membership.

PUCKER GALLERY

171 Newbury St., Boston MA 02116. (617)267-9473. Fax: (617)424-9759. E-mail: contactus@puckergallery.com. Website: www.puckergallery.com. For-profit gallery. Pucker Gallery is always willing to review artist's slides and submissions. Approached by 100 artists/year; represents or exhibits 50 artists. Sponsors 2 photography exhibits/year. Average display time 1 month. Gallery open Monday-Saturday 10-5:30; Sunday 10:30-5. Five floors of exhibition space. Overall price range \$500-75,000.

Exhibits Exhibits photos of multicultural, environmental, landscapes/scenics, architecture, cities/urban, religious, rural. Interested in fine art, abstracts, seasonal.

Making Contact & Terms Gallery provides promotion.

Submissions Send query letter with artist's statement, bio, slides/CD, SASE. "We do not accept e-mail submissions nor do we visit artists' websites." Finds artists through submissions, referrals by other artists.

PUMP HOUSE CENTER FOR THE ARTS

P.O. Box 1613, Chillicothe OH 45601. (740)772-5783. Fax: (740)772-5783. E-mail: info@ pumphouseartgallery.com. Website: www.pumphouseartgallery.com. Nonprofit gallery. Estab. 1991. Approached by 6 artists/year; represents or exhibits more than 50 artists. Average display time 6 weeks. Gallery open Tuesday-Friday from 11-4; weekends from 1-4. Closed Monday and major holidays. Overall price range \$150-600. Most work sold at \$300. Facility is also available for rent (business meetings, reunions, weddings, receptions or rehearsals, etc.).

Exhibits Exhibits photos of landscapes/scenics, wildlife, architecture, gardening, travel, agriculture. Interested in fine art, historical/vintage.

Making Contact & Terms Artwork is accepted on consignment, and there is a 30% commission. Gallery provides insurance, promotion. Accepted work should be framed, matted, wired for hanging. Call or stop in to show portfolio of photographs, slides. Send query letter with bio, photographs, slides, SASE. Responds in 1 month. Finds artists through word of mouth, submissions, portfolio reviews, art exhibits, art fairs, referrals by other artists.

Tips "All artwork must be original designs, framed, ready to hang (wired—no sawtooth hangers)."

QUEENS COLLEGE ART CENTER

Benjamin S. Rosenthal Library, Queens College, Flushing NY 11367-1597. (718)997-3770. E-mail: artcenter@qc.cuny.edu. Website: www.qcpages.qc.cuny.edu/art_library/artcenter.html. Average display time approximately 6-7 weeks. Overall price range \$200-600.

Exhibits Open to all types, styles, subject matter; decisive factor is quality.

Making Contact & Terms Charges 40% commission. Accepted work can be framed or unframed, mounted or unmounted, matted or unmatted. Sponsors openings. Photographer is responsible for providing/arranging refreshments and cleanup.

Submissions Send query letter with résumé, samples and SASE. Responds after May annual review.

MARCIA RAFELMAN FINE ARTS

10 Clarendon Ave., Toronto ON M4V 1H9, Canada. (416)920-4468. Fax: (416)968-6715. E-mail: info@mrfinearts.com. Website: www.mrfinearts.com. Gallery Director: Meghan Richardson. Semi-private gallery. Average display time 1 month. Gallery is centrally located in Toronto; 2,000 sq. ft. on 2 floors. Overall price range \$800-25,000. Most work sold at \$1,500.

Exhibits Exhibits photos of environmental, landscapes. Interested in alternative process, documentary, fine art, historical/vintage.

Making Contact & Terms Charges 50% commission. Gallery provides insurance, promotion, contract. Requires exclusive representation locally.

Submissions Mail (must include SASE) or e-mail portfolio (preferred) for review; include bio, photographs, reviews. Responds only if interested. Finds artists through word of mouth, submissions, art fairs, referrals by other artists.

Tips "We only accept work that is archival."

THE RALLS COLLECTION INC.

1516 31st St. NW, Washington DC 20007. (202)342-1754. Fax: (202)341-0141. Website: www. rallscollection.com. For-profit gallery. Estab. 1991. Approached by 125 artists/year; represents or exhibits 60 artists. Sponsors 7 photography exhibits/year. Average display time 1 month. Gallery open Tuesday-Saturday 11-4 and by appointment. Closed Thanksgiving, Christmas. Overall price range \$1,500-50,000. Most work sold at \$2,500-15,000.

Exhibits Exhibits photos of babies/children/teens, celebrities, parents, landscapes/scenics, architecture, cities/urban, gardening, interiors/decorating, pets, rural, entertainment, health/fitness, hobbies, performing arts, sports, travel, product shots/still life. Interested in alternative process, avant garde, documentary, fashion/glamour, fine art, historical/vintage.

Making Contact & Terms Artwork is accepted on consignment, and there is a 50% commission. Gallery provides insurance, promotion, contract. Accepted work should be framed, matted. Requires exclusive representation locally. Accepts only artists from America.

Submissions Mail portfolio for review. Send query letter with artist's statement, bio, brochure, business card, photocopies, photographs, résumé, reviews, slides, SASE. Responds in 2 months. Finds artists through word of mouth, submissions, portfolio reviews, art exhibits, art fairs, referrals by other artists.

■ ROCHESTER CONTEMPORARY

137 East Ave., Rochester NY 14604. (585)461-2222. Fax: (585)461-2223. E-mail: lizz@ rochestercontemporary.org, info@rochestercontemporary.org. Website: www.rochestercontemporary.org. Contact: Elizabeth Switzer, programming director. Estab. 1977. Sponsors 10-12 exhibits/year. Average display time 4-6 weeks. Gallery open Wednesday-Friday 1-6; weekends 1-5. Overall price range \$100-500.

Making Contact & Terms Charges 25% commission.

Submissions Send slides/CD, letter of inquiry, résumé and statement. Responds in 3 months.

M ROCKPORT CENTER FOR THE ARTS

902 Navigation Circle, Rockport TX 78382. (361)729-5519. E-mail: Info@Rockportartcenter.com. Website: www.Rockportartcenter.com.

Making Contact & Terms Call or e-mail for more information.

THE ROTUNDA GALLERY

33 Clinton St., Brooklyn NY 11201. (718)875-4047. E-mail: jtaylor@bricartsmedia.org. Website: www.briconline.org/rotunda. Nonprofit gallery. Estab. 1981. Average display time 6 weeks. Open Tuesday-Saturday 12-6.

Exhibits Interested in contemporary works.

Making Contact & Terms Gallery provides photographer's contact information to prospective buyers. Shows are limited by walls that are 22 feet high.

Submissions Send material by mail for consideration; include SASE. "View our website for guidelines and Artist Registry form."

SAN DIEGO ART INSTITUTE'S MUSEUM OF THE LIVING ARTIST

1439 El Prado, San Diego CA 92101. (619)236-0011. Fax: (619)236-1974. E-mail: admin@sandiego-art.org. Website: www.sandiego-art.org. Executive Director: Timothy J. Field. Administrative Director: Kerstin Robers. Art Director: K.D. Benton. Nonprofit gallery. Represents or exhibits 500 member artists. Overall price range \$50-3,000. Most work sold at \$700.

Exhibits Photos of babies/children/teens, couples, multicultural, families, parents, senior citizens, disasters, environmental, landscapes/scenics, wildlife, architecture, cities/urban, education, gardening, pets, rural, adventure, entertainment, events, food/drink, health/fitness/beauty, hobbies, humor, performing arts, sports, travel, agriculture, political, product shots/still life, science, technology. Interested in alternative process, avant garde, documentary, erotic, fine art, historical/vintage, seasonal.

Making Contact & Terms Artwork is accepted on consignment, and there is a 40% commission. Membership fee: \$125. Accepted work should be framed. Work must be carried in by hand for each monthly show except for annual international show, JPEG online submission.

Submissions Membership not required for submission in monthly juried shows, but fee required. Artists interested in membership should request membership packet. Finds artists through referrals by other artists.

Tips "All work submitted must go through jury process for each monthly exhibition. Work must be framed in professional manner. No glass; Plexiglas or acrylic only."

WILLIAM & FLORENCE SCHMIDT ART CENTER

Southwestern Illinois College, 2500 Carlyle Ave., 2500 Carlyle Ave., Belleville IL 62221. (618) 641-5143. E-mail: libby.reuter@swic.edu. Website: www.schmidtart.swic.edu. Executive Director: Libby Reuter. Nonprofit gallery. Estab. 2002. Sponsors 3-4 photography exhibits/year. Average display time 6-8 weeks. Open Tuesday through Saturday from 11 to 5 (to 8 on Thursday). Closed during college holidays.

Exhibits Interested in fine art and historical/vintage photography.

Submissions Mail portfolio for review. Send query letter with artist's statement, bio and slides. Finds artists through art fairs and exhibits, portfolio reviews, referrals by other artists, submissions and word of mouth.

■ SCHMIDT/DEAN SPRUCE

1710 Samson St., Philadelphia PA 19103. (215)569-9433. Fax: (215)569-9434. E-mail: schmidtdean@netzero.com. Website: www.schmidtdean.com. For-profit gallery. Houses eclectic art. Sponsors 4 photography exhibits/year. Average display time 6 weeks. Gallery open Tuesday through Saturday from 10:30 to 6. August hours are Tuesday-Friday 10:30-6. Overall price range \$1,000-70,000.

Exhibits Interested in alternative process, documentary, fine art.

Making Contact & Terms Charges 50% commission. Gallery provides insurance, promotion. Accepted work should be framed, mounted, matted. Requires exclusive representation locally.

Submissions Call/write to arrange a personal interview to show portfolio of slides or CD. Send query letter with SASE. "Send 10 to 15 slides or digital images on CD and a résumé that gives a sense of your working history. Include a SASE."

■ SECOND STREET GALLERY

115 Second St. SE, Charlottesville VA 22902. (434)977-7284. Fax: (434)979-9793. E-mail: director@secondstreetgallery.org. Website: www.secondstreetgallery.org. Executive Director: Rebecca Schoenthal. Estab. 1973. Sponsors approximately 2 photography exhibits/year. Average display time 1 month. Open Tuesday through Saturday from 11 to 6; 1st Friday of every month from 6 to 8, with Artist Talk at 6:30. Overall price range \$300-2,000.

Making Contact & Terms Charges 30% commission.

Submissions Reviews slides/CDs in fall; \$15 processing fee. Submit 10 slides or a CD for review; include artist statement, cover letter, bio/résumé, and most importantly, a SASE. Responds in 2 months.

Tips Looks for work that is "cutting edge, innovative, unexpected."

SOHO MYRIAD

1250 B. Menlo Dr., Atlanta GA 30318. (404)351-5656. Fax: (404)351-8284. E-mail: info@sohomyriad.com. Website: www.sohomyriad.com. Art consulting firm and for-profit gallery. Estab. 1997. Represents and/or exhibits over 2,000 artists. Sponsors 1 photography exhibit/year. Average display time: 2 months. Overall price range \$500-20,000. Most work sold at \$500-5,000.

Exhibits Exhibits photos of landscapes/scenics, architecture, floral/botanical and abstracts. Interested in alternative process, avant garde, fine art, historical/vintage.

Making Contact & Terms Artwork is accepted on consignment, and there is a 50% commission. Gallery provides insurance.

SOUTH DAKOTA ART MUSEUM

South Dakota State University, Box 2250, Brookings SD 57007. (605)688-5423 or (866)805-7590. Fax: (605)688-4445. E-mail: John.Rychtarik@sdstate.edu. Website: www.SouthDakotaArtMuseum. com. Museum. Sponsors 1-2 photography exhibits/year. Average display time 4 months. Gallery open Monday through Friday from 10 to 5; Saturday from 10 to 4; Sunday from 12 to 4. Closed state holidays. Seven galleries offer 26,000 sq. ft. of exhibition space. Overall price range \$200-6,000. Most work sold at \$500.

Exhibits Interested in alternative process, documentary, fine art.

Making Contact & Terms Artwork is accepted on consignment, and there is a 30% commission. Gallery provides insurance, promotion. Accepted work should be framed.

Submissions Send query letter with artist's statement, bio, résumé, slides, SASE. Responds within 3 months, only if interested. Finds artists through word of mouth, portfolio reviews, art exhibits, referrals by other artists.

SOUTHSIDE GALLERY

150 Courthouse Square, Oxford MS 38655. (662)234-9090. E-mail: southside@southsideartgallery.com. Website: www.southsideartgallery.com. For-profit gallery. Average display time 4 weeks. Gallery open Tuesday through Saturday from 10 to 6; Sunday from 12 to 5. Overall price range \$300-20,000. Most work sold at \$425.

Exhibits Exhibits photos of landscapes/scenics, architecture, cities/urban, rural, entertainment, events, performing arts, sports, travel, agriculture, political. Interested in avant garde, fine art.

Making Contact & Terms Artwork is accepted on consignment, and there is a 55% commission. Gallery provides promotion. Accepted work should be framed.

Submissions Mail between 10 and 25 slides that reflect current work with SASE for review. CDs are also accepted with images in JPEG or TIFF format. Include artist statement, biography, and resume. Responds within 4-6 months. Finds artists through submissions.

SRO PHOTO GALLERY AT LANDMARK ARTS

School of Art, Texas Tech University, Box 42081, Lubbock TX 79409-2081. (806)742-1947. Fax: (806)742-1971. E-mail: srophotogallery.art@ttu.edu. Website: www.landmarkarts.org. Nonprofit gallery. Hosts an annual competition to fill 8 solo photography exhibition slots each year. Average display time 4 weeks. Open Monday through Friday from 8 to 5; Saturday from 10 to 5; Sunday from 12 to 4. Closed university holidays.

Exhibits Interested in art utilizing photographic processes.

Making Contact & Terms "Exhibits are for scholarly purposes. Gallery will provide artist's contact information to potential buyers." Gallery provides insurance, promotion, contract. Accepted work should be matted.

Submissions Exhibitions are determined by juried process. See website for details (under Call for Entries). Deadline for applications is end of March.

THE STATE MUSEUM OF PENNSYLVANIA

300 North St., Harrisburg PA 17120-0024. (717)783-9904. Fax: (717)783-4558. E-mail: nstevens@ state.pa.us. Website: www.statemuseumpa.org. Current Fine Arts Gallery opened in 1993. Number of exhibits varies. Average display time 2 months. Overall price range \$50-3,000.

Exhibits Fine art photography is a new area of endeavor for The State Museum, both collecting and exhibiting. Interested in works produced with experimental techniques.

Making Contact & Terms Work is sold in gallery, but not actively. Connects artists with interested buyers. No commission. Accepted work should be framed.

■ STATE OF THE ART

120 W. State St., Ithaca NY 14850. (607)277-1626. E-mail: gallery@soag.org. Website: www.soag. org. Cooperative gallery. Sponsors 1 photography exhibit/year. Average display time 1 month. Gallery open Wednesday through Friday from 12 to 6; weekends from 12 to 5. Located in downtown Ithaca, 2 rooms about 1,100 sq. ft. Overall price range \$100-6,000. Most work sold at \$200-500.

Exhibits Exhibits photos in all media and subjects. Interested in alternative process, avant garde, fine art, computer-assisted photographic processes.

Making Contact & Terms There is a co-op membership fee plus a donation of time. There is a 10% commission for members, 30% for nonmembers. Gallery provides promotion, contract. Accepted work must be ready to hang. Write for membership application.

Tips Other exhibit opportunity: Annual Juried Photo Show in March. Application available on website in January.

STATE STREET GALLERY

1804 State St., La Crosse WI 54601. (608)782-0101. E-mail: ssg1804@yahoo.com. Website: www. statestreetartgallery.com. Wholesale, retail and trade gallery. Approached by 15 artists/year; exhibits 12-14 artists/quarter in gallery. Average display time 4-6 months. State Street Gallery hours are 10:00 am to 4:00 pm Tuesday, Thursday & Friday, 11:00 am to 5:00 pm Wednesday, and Saturday 10:00 am to 2:00 pm. Located across from the University of Wisconsin/La Crosse. Overall price range \$50-12,000. Most work sold at \$500-1,200 and above.

Exhibits Exhibits photos of environmental, landscapes/scenics, architecture, cities/urban, gardening, rural, travel, medicine.

Making Contact & Terms Artwork is accepted on consignment, and there is a 40% commission. Gallery provides insurance, promotion, contract. Accepted work should be framed, matted.

Submissions Call or mail portfolio for review. Send query letter with artist's statement, photographs, slides, SASE. Responds in 1 month. Finds artists through word of mouth, art exhibits, art fairs, referrals by other artists.

Tlps "Be organized, professional in presentation, flexible."

STEVENSON UNIVERSITY ART GALLERY

Exhibitions, 1525 Greenspring Valley Rd., Stevenson MD 21153. (443)334-2163. Fax: (410)486-3552. E-mail: exhibitions@stevenson.edu. Website: www.stevenson.edu/explore/gallery/index. asp. College/university gallery. Sponsors at least 2 photography exhibits/year. Average display time 6 weeks. Gallery open Monday, Tuesday, Thursday, Friday from 11 to 5; Wednesday from 11 to 8; Saturday from 1 to 4. "Two beautiful spaces." "Since its 1997 inaugural season, the Stevenson University Art Gallery has presented a dynamic series of substantive exhibitions in diverse media and has achieved the reputation as a significant venue for regional artists and collectors. The museum quality space was designed to support the Baltimore arts community, provide greater opportunities for artists, and be integral to the educational experience of Stevenson students. Our Exhibitions Program offers a series of 7 shows per year in a variety of media including paintings, prints, sculpture and photography."

Exhibits Interested in alternative process, avant garde, documentary, fine art, historical/vintage. "We are looking for artwork of substance by artists from the mid-Atlantic region."

Making Contact & Terms "We facilitate inquiries directly to the artist." Gallery provides insurance. *Accepts artists from mid-Atlantic states only; emphasis on Baltimore artists.*

Submissions Write to show portfolio of slides. Send artist's statement, bio, résumé, reviews, slides, SASE. Responds in 3 months. Finds artists through word of mouth, submissions, portfolio reviews, referrals by other artists.

Tips "Be clear, concise. Have good representation of your images."

☑ □ STORE AND SALLY D. FRANCISCO GALLERY AT PETERS VALLEY CRAFT CENTER, THE

19 Kuhn Rd., Layton NJ 07851. (973)948-5202. Fax: (973)948-0011. E-mail: Store@Petersvalley.org. Website: www.Petersvalley.org. **Store and Gallery Manager:** Brienne Rosner.

SYNCHRONICITY FINE ARTS

106 W. 13th St., New York NY 10011. (646)230-8199. Fax: (646)230-8198. E-mail: synchspa@ bestweb.net. Website: www.synchronicityspace.com. Nonprofit gallery. Approached by hundreds of artists/year; represents or exhibits over 60 artists. Sponsors 2-3 photography exhibits/year. Gallery open Tuesday through Saturday from 12 to 6. Closed 2 weeks in August. Overall price range \$1,500-20,000. Most work sold at \$3,000.

Exhibits Exhibits photos of multicultural, environmental, landscapes/scenics, architecture, cities/urban, education, rural, events, agriculture, industry, medicine, political. Interested in avant garde, documentary, fine art, historical/vintage.

Making Contact & Terms Gallery provides insurance, promotion, contract. Accepted work should be framed, mounted, matted.

Submissions Submissions may be made via electronic or e-mail as JPEG small files as well as the other means. Write to arrange a personal interview to show portfolio of photographs, transparencies, slides. Send query letter with photocopies, SASE, photographs, slides, résumé. Responds in 3 weeks. Finds artists through art exhibits, submissions, portfolio reviews, referrals by other artists.

LILLIAN & COLEMAN TAUBE MUSEUM OF ART

2 N. Main St., Minot ND 58703. (701)838-4445. E-mail: taube@ndak.net. Website: www. taubemuseum.org. Established nonprofit organization. Sponsors 1-2 photography exhibits/year. Average display time 4-6 weeks. Museum is located in a renovated historic landmark building with room to show 2 exhibits simultaneously. Overall price range \$15-225. Most work sold at \$40-100. **Exhibits** Exhibits photos of babies/children/teens, couples, multicultural, families, parents, senior citizens, disasters, landscapes/scenics, wildlife, beauty, rural, travel, agriculture, buildings, military, portraits. Interested in avant garde, fine art.

Making Contact & Terms Charges 30% commission for members; 40% for nonmembers. Sponsors openings.

Submissions Submit portfolio along with a minimum of 6 examples of work in slide format for review. Responds in 3 months.

Tips "Wildlife, landscapes and floral pieces seem to be the trend in North Dakota. We get many slides to review for our photography exhibits each year. We also appreciate figurative, unusual and creative photography work. Do not send postcard photos."

M THE JOSEPH SAXTON GALLERY OF PHOTOGRAPHY

520 Cleveland Ave. NW, Canton OH 44702. E-mail: gallery@joseph.saxton.com. Website: www. josephsaxton.com. A premier photography gallery with nearly 7,000 sq. ft. of display space, more than 160 master photographers represented, and over 200 pieces on display. Upscale clients. 20% of sales are to corporate collectors (2011 projection). Overall price range of work sold is from \$500-20,000. Most work sold at \$1,500. Approached by 150 artists/year; represents or exhibits 4-6 artists. Exhibited artists include: Steve McCurry, photography; Art Wolfe, photography. Average display time 2-3 months. Open Wednesday through Saturday from 12 to 5 pm; open all year.

Exhibits Most frequent exhibit styles: color field, expressionism, surrealism, followed by painterly abstraction, conceptualism, impressionism, postmodernism, minimalism, primitivism realism, geometric abstraction. Considers all genres. Exhibits people: celebrities, multicultural, families; Home & Garden: architecture, cities/urban, religious, rural; Business & Technology: agriculture, industry, military, political, product shots/still life; Outdoors: disasters, environmental, landscapes/scenics, wildlife; Recreation: adventure, automobiles, entertainment, events, performing arts, sports, travel; Style: alternative process, avant garde, documentary, fashion/glamour, fine art, historical/vintage, lifestyle, seasonal.

Making Contact & Terms Artwork is accepted on consignment and there is a 50% commission. Retail price of the art set by the artist. Gallery provides insurance, promotion, contract. Requires exclusive representation locally. Also offers a limited contract. Model release and property release are preferred.

Submissions Accepted work should be framed. E-mail query letter with link to artists's website. Responds only if interested within 2 weeks. Returns material with SASE. Finds artists through word of mouth, portfolio reviews, referrals by other artists, our annual Canton Luminaries Photography Competition.

Tips "We prefer to see work that was created as a cohesive body which exhibits a personal style or technique.

NATALIE AND JAMES THOMPSON ART GALLERY

School of Art & Design, San José State University, San José CA 95192-0089. (408)924-4723. Fax: (408)924-4326. E-mail: jfh@cruzio.com. Website: www.sjsu.edu. Nonprofit gallery. Approached by 100 artists/year. Sponsors 1-2 photography exhibits/year. Average display time 1 month. Gallery open M, W, Th, F 11-4; T 11-4 and 6-7:30.

Exhibits "We are open to all genres, aesthetics and techniques."

Making Contact & Terms "Works are not generally for sale." Gallery provides insurance, promotion. Accepted work should be framed and/or ready to hang.

Submissions Send query letter with artist's statement, bio, résumé, reviews, slides, SASE. Responds as soon as possible. Finds artists through word of mouth, submissions, portfolio reviews, art exhibits, art fairs, referrals by other artists.

■ THROCKMORTON FINE ART

145 E. 57th St., 3rd Floor, New York NY 10022. (212)223-1059. Fax: (212)223-1937. E-mail: spencer@throckmorton-nyc.com; Info@throckmorton-nyc.com. Website: www.throckmorton-nyc.com. For-profit gallery. Estab. 1993. Approached by 50 artists/year; represents or exhibits 20 artists. Sponsors 5 photography exhibits/year. Average display time 2 months. Overall price range \$1,000-10,000. Most work sold at \$2,500.

Exhibits Exhibits photos of babies/children/teens, landscapes/scenics, architecture, cities/urban, rural. Interested in erotic, fine art, historical/vintage, Latin American photography.

Making Contact & Terms Charges 50% commission. Gallery provides insurance, promotion. **Submissions** Write to arrange a personal interview to show portfolio of photographs/slides/CD, or send query letter with artist's statement, bio, photocopies, slides, CD, SASE. Responds in 3 weeks. Finds artists through word of mouth, portfolio reviews.

Tips "Present your work nice and clean."

TOUCHSTONE GALLERY

901 New York Ave., NW, Washington DC 20004-2217. (202) 347-2787. E-mail: info@touchstonegallery. com. Website: www.TouchstoneGallery.com. Cooperative rental gallery. Estab. 1976. Approached by 240 artists/year; represents or exhibits 35 artists. Sponsors 3 photography exhibits/year. Average display time 1 month. Open Wednesday through Friday from 11 to 5; weekends from 12 to 5. Closed Christmas through New Year's Day. Located in downtown Washington, DC, on gallery row. Large main gallery with several additional exhibition areas; high ceilings. Overall price range: \$100-2,500. Most artwork sold at \$600.

Exhibits Exhibits photos of landscapes/scenics, architecture, cities/urban, rural, automobiles. Interested in alternative process, avant garde, documentary, erotic, fine art, historical/vintage.

Making Contact & Terms There is a co-op membership fee plus a donation of time. There is a 40% commission. There is a rental fee for space. The rental fee covers 1 month. Gallery provides contract. Accepted work should be framed and matted.

Submissions Call to arrange personal interview to show portfolio. Responds to queries in 1 month. Finds artists through referrals by other artists and word of mouth.

Tips "Visit website first. Read new member prospectus on the front page. Call with additional questions. Do not 'drop in' with slides or art. Do not show everything you do. Show 10-25 images that are cohesive in subject, style and presentation."

■ UCR/CALIFORNIA MUSEUM OF PHOTOGRAPHY

University of California, 3824 Main St., Riverside CA 92501. (951)784-3686. Fax: (951)827-4797. Website: www.cmp.ucr.edu. **Contact:** Director. Sponsors 10-15 exhibits/year. Average display time 8-14 weeks. Open Tuesday through Saturday from 12 to 5. Located in a renovated 23,000-sq.-ft. building. "It is the largest exhibition space devoted to photography in the West."

Exhibits Interested in technology/computers, alternative process, avant garde, documentary, fine art, historical/vintage.

Making Contact & Terms Curatorial committee reviews CDs, slides and/or matted or unmatted work. Photographer must have "highest-quality work."

Submissions Send query letter with résumé, SASE. Accepts images in digital format; send via CD, Zip.

Tips "This museum attempts to balance exhibitions among historical, technological, contemporary, etc. We do not sell photos but provide photographers with exposure. The museum is always interested in newer, lesser-known photographers who are producing interesting work. We're especially interested in work relevant to underserved communities. We can show only a small percent of what we see in a year."

UNI GALLERY OF ART

University of Northern Iowa, 104 Kamerick Art Bldg, Cedar Falls IA 50614-0362. (319)273-6134. Fax: (319)273-7333. E-mail: galleryofart@uni.edu. Website: www.uni.edu/artdept/gallery. Sponsors 9 exhibits/year. Average display time 1 month. Approximately 5,000 sq. ft. of space and 424 ft. of usable wall space.

Exhibits Interested in all styles of high-quality contemporary art works.

Making Contact & Terms "We do not sell work."

Submissions Please provide a cover letter and proposal as well as an artist's statement, CV (curriculum vitae), and samples. Send material by mail for consideration or submit portfolio for review; include SASE for return of material. Response time varies.

UNION STREET GALLERY

1527 Otto Blvd., Chicago Heights IL 60411. (708)754-2601. E-mail: unionstreetart@sbcglobal.net. Website: www.unionstreetgallery.org. Nonprofit gallery. Represents or exhibits more than 100 artists. "We offer group invitations and juried shows every year." Average display time 6 weeks. Gallery open Wednesday through Saturday from 12 to 4; 2nd Friday of every month from 6 to 9. Overall price range \$30-3,000. Most work sold at \$300-600.

Submissions Finds artists through submissions, referrals by other artists, juried exhibits at the gallery. "To receive prospectus for all juried events, call, write or e-mail to be added to our mailing list. Prospectus also available on website. Artists interested in studio space or solo/group exhibitions should contact the gallery to request information packets."

UNIVERSITY ART GALLERY IN THE D.W. WILLIAMS ART CENTER

P.O. Box 30001, Las Cruces NM 88003. (575)646-2545 or (575)646-5423. Fax: (575)646-8036. E-mail: artglry@nmsu.edu. Website: www.nmsu.edu/ ~ artgal. Estab. 1973. Sponsors 1 exhibit/ year. Average display time 2 months. Overall price range \$300-2,500.

Making Contact & Terms Buys photos outright.

Submissions Arrange a personal interview to show portfolio. Submit portfolio for review. Send query letter with samples. Send material by mail with SASE by end of October for consideration. Responds in 3 months.

Tips Looks for "quality fine art photography. The gallery does mostly curated, thematic exhibitions. Very few one-person exhibitions."

UNIVERSITY OF KENTUCKY ART MUSEUM

Rose St. and Euclid Ave., Lexington KY 40506-0241. (859)257-5716. Fax: (859)323-1994. E-mail: janie.welker@uky.edu. Website: www.uky.edu/artmuseum. Museum.

Exhibits Annual photography lecture series and exhibits.

Submissions Prefers e-mail query with digital images. Responds in 6 months.

UNIVERSITY OF RICHMOND MUSEUMS

28 Westhampton Way, Richmond VA 23173. (804)289-8276. Fax: (804)287-1894. E-mail: rwaller@richmond.edu. Website: http://museums.richmond.edu. "University Museums comprises Joel and Lila Harnett Museum of Art, Joel and Lila Harnett Print Study Center, and Lora Robins Gallery of Design from Nature." Sponsors 18-20 exhibits/year. Average display time 8-10 weeks.

Exhibits Interested in all subjects.

Making Contact & Terms Charges 10% commission. Work must be framed for exhibition.

Submissions Send query letter with résumé, samples. Send material by mail for consideration. Responds in 1 month.

Tips "If possible, submit material that can be left on file and fits standard letter file. We are a nonprofit university museum interested in presenting contemporary art as well as historical exhibitions."

■ UNTITLED [ARTSPACE]

1 NE 3rd St., Oklahoma City OK 73103. (405)815-9995. Fax: (405)813-2070. E-mail: info@ artspaceatuntitled.org. Website: www.1ne3.org. Alternative space, nonprofit gallery. Estab. 2003. Average display time 6-8 weeks. Open Tuesday, Wednesday, Thursday from 11 to 6; Friday from 11 to 8; Saturday from 11 to 4. "Located in a reclaimed industrial space abandoned by decades of urban flight. Damaged in the 1995 Murrah Federal Building bombing, Untitled [[ArtSpace]] has emerged as a force for creative thought. As part of the Deep Deuce historic district in downtown Oklahoma

City, Untitled [[ArtSpace]] brings together visual arts, performance, music, film, design and architecture. Our mission is to stimulate creative thought and new ideas through contemporary art. We are committed to providing access to quality exhibitions, educational programs, performances, publications, and to engaging the community in collaborative outreach efforts." Most work sold at \$750.

Making Contact & Terms Artwork is accepted on consignment, and there is a 50% commission. **Submissions** Mail portfolio for review. Send query letter with artist's statement, bio, résumé, slides, or CD of images. Prefers 10-15 images on a CD. Include SASE for return of materials or permission to file the portfolio. Reviews occur twice annually, in January and July. Finds artists through submissions, portfolio reviews. Responds to queries within 1 week, only if interested.

Tips "Review our previous programming to evaluate if your work is along the lines of our mission. Take the time to type and proof all written submissions. Make sure your best work is represented in the images you choose to show. Nothing takes away from the review like poorly scanned or photographed work."

UPSTREAM GALLERY

26 Main St., Dobbs Ferry NY 10522. (914)674-8548. E-mail: upstreamgallery26@gmail.com. Website: www.upstreamgallery.com. Represents or exhibits 22 artists. Sponsors 1 invitational/juried photography exhibit/year. Average display time 1 month. Open all year; Thursday through Sunday from 12:30 to 5:30. Closed July and August (but an appointment can be made by calling 914-375-1693). "We have 2 store fronts, approximately 15 × 30 sq. ft. each." Overall price range: \$300-2,000.

Exhibits only fine art. Accepts all subject matters and genres for jurying.

Making Contact & Terms There is a co-op membership fee plus a donation of time. There is a 20% commission. Gallery provides insurance. Accepted work should be framed, mounted and matted. **Submissions** Write to arrange a personal interview to show portfolio of photographs and slides. Send query letter with artist's statement, bio, brochure, business card, photographs, résumé, reviews, slides and SASE. Responds to queries within 2 months, only if interested. Finds artists through referrals by other artists and submissions.

UPSTREAM PEOPLE GALLERY

5607 Howard St., Omaha NE 68106. (402)991-4741. E-mail: shows@upstreampeoplegallery.com. Website: www.upstreampeoplegallery.com. For-profit Internet gallery. Approached by approximately 13,000 artists/year; represents or exhibits 1,300 artists. Sponsors 4-6 photography exhibits/year. Average display time 1 or more years online. Virtual gallery open 24 hours daily. Overall price range \$100-125,000. Most work sold at approximately \$300.

Exhibits Exhibits photos of babies/children/teens, couples, multicultural, families, parents, senior citizens, disasters, environmental, landscapes/scenics, wildlife, gardening, interiors/decorating, pets, religious, adventure, automobiles, events, health/fitness/beauty, humor, performing arts, sports, travel, agriculture, military, political, product shots/still life, technology/computers. Interested in alternative process, avant garde, documentary, fine art, historical/vintage, seasonal.

Making Contact & Terms Artwork is accepted on consignment, and there is no commission if the

Making Contact & Terms Artwork is accepted on consignment, and there is no commission if the artists sells; there is a 20% commission if the gallery sells. There is an entry fee for space; covers 1 or more years.

Submissions Mail or e-mail portfolio of slides/CDs/JPEGs/TIFFs for review. Send images, query letter with brief artist's statement, optional bio and personal photograph. Responds to queries in 1 week. Finds artists through art exhibits, portfolio reviews, referrals by other artists, submissions, word of mouth, Internet.

URBAN INSTITUTE FOR CONTEMPORARY ARTS

2 West Fulton St., Grand Rapids MI 49503. (616)454-7000. Fax: (616)459-9395. E-mail: jteunis@uica.org. Website: www.uica.org. Alternative space and nonprofit gallery. Estab. 1977. Approached'

by 250 artists/year; represents or exhibits 20 artists. Sponsors 3-4 photography exhibits/year. Average display time 6 weeks. Gallery open Tuesday through Saturday from 12 to 10; Sunday from 12 to 7.

Exhibits Most frequently exhibits mixed media, avant garde, and nontraditional work. Style of exhibits are conceptual and postmodern.

Submissions Please check our website for gallery descriptions and how to apply. Artists should visit the website, go to Exhibitions-Apply for a Show and follow the instructions. UICA exhibits artists through submissions.

VIRIDIAN ARTISTS, INC.

530 W. 25th St., #407, New York NY 10001. (212)414-4040. Fax: (212)414-4040. Website: www. viridianartists.com. **Director:** Barbara Neski. Estab. 1968. Sponsors 11 exhibits/year. Average display time 4 weeks. Overall price range \$175-10,000. Most work sold at \$1,500.

Exhibits Interested in eclectic work in all fine art media including photography, installation, painting, mixed media and sculpture. Interested in alternative process, avant garde, fine art.

Making Contact & Terms Charges 30% commission.

Submissions Will review transparencies and CDs only if submitted as part of membership application for representation with SASE. Request information for representation via phone or e-mail or check website.

Tips "Opportunities for photographers in galleries are improving. Broad range of styles being shown in galleries. Photography is getting a large audience that is seemingly appreciative of technical and aesthetic abilities of the individual artists. Present a portfolio (regardless of format) that expresses a clear artistic and aesthetic focus that is unique, individual, and technically outstanding."

■ VISUAL ARTS CENTER OF NORTHWEST FLORIDA

19 E. Fourth St., Panama City FL 32401. (850)769-4451. E-mail: vacexhibitions@knology.net. Website: www.vac.org.cn. Contact: Exhibition Manager. Estab. 1988. Approached by 20 artists/year; represents local and national artists. Sponsors 1-2 photography exhibits/year. Average display time 6 weeks. Open Monday, Wednesday and Friday from 10 to 4; Tuesday and Thursday from 10 to 8; Saturday from 1 to 5. Closed major holidays. The Center features a large gallery (200 running ft.) upstairs and a smaller gallery (80 running ft.) downstairs. Overall price range \$50-1,500.

Exhibits Exhibits photos of all subject matter, including babies/children/teens, couples, families, parents, senior citizens, environmental, landscapes/scenics, wildlife, architecture, product shots/still life. Interested in alternative process, avant garde, documentary, fashion/glamour, fine art, historical/vintage, seasonal, digital, underwater.

Making Contact & Terms Artwork is accepted on consignment, and there is a 30% commission. Gallery provides promotion, contract, insurance. Accepted work must be framed, mounted, matted.

Submissions Send query letter with artist's statement, bio, résumé, SASE, 10-12 slides or images on CD. Responds within 4 months. Finds artists through word of mouth, submissions, art exhibits.

VISUAL ARTS GALLERY

Univ. of Alabama. Dept. of Art & Art History, 1530 Third Ave. S., Birmingham AL 35294-1260. (205)934-0815. Fax: (205)975-2836. E-mail: blevine@uab.edu. Website: www.uab.edu/art/gallery/vag.html. Nonprofit university gallery. Sponsors 1-3 photography exhibits/year. Average display time 3-4 weeks. Gallery open Monday through Thursday from 11 to 6; Friday from 11 to 5; Saturday from 1-5. Closed major holidays and last 2 weeks of December. Located on 1st floor of Humanities Building: 2 rooms with a total of 2,000 sq. ft. and 222 running ft.

Exhibits Exhibits photos of multicultural. Interested in alternative process, avant garde, fine art, historical/vintage.

Making Contact & Terms Gallery provides insurance, promotion. Accepted work should be framed.

Submissions Does not accept unsolicited exhibition proposals. Write to arrange a personal interview to show portfolio of slides. Send query letter with artist's statement, bio, brochure, photographs, résumé, reviews, slides, SASE.

THE WAILOA CENTER GALLERY

P.O. Box 936, Hilo HI 96721. (808)933-0416. Fax: (808)933-0417. E-mail: wailoa@yahoo.com. Sponsors 24 exhibits/year. Average display time 1 month.

Exhibits Photos must be submitted to director for approval. "All entries accepted must meet professional standards outlined in our pre-entry forms."

Making Contact & Terms Gallery receives 10% "donation" on works sold. No fee for exhibiting. Accepted work should be framed. "Photos must also be fully fitted for hanging. Expenses involved in shipping, insurance, invitations and reception, etc., are the responsibility of the exhibitor."

Submissions Submit portfolio for review. Send query letter with résumé of credits, samples, SASE. Responds in 3 weeks.

Tips "The Wailoa Center Gallery is operated by the State of Hawaii, Department of Land and Natural Resources. We are unique in that there are no costs to the artist to exhibit here as far as rental or commissions are concerned. We welcome artists from anywhere in the world who would like to show their works in Hawaii. Wailoa Center is booked 2-3 years in advance. The gallery is also a visitor information center with thousands of people from all over the world visiting."

WASHINGTON COUNTY MUSEUM OF FINE ARTS

P.O. Box 423, Hagerstown MD 21741. (301)739-5727. Fax: (301)745-3741. E-mail: info@wcmfa.org. Website: www.wcmfa.org. Approached by 30 artists/year. Sponsors 1 juried photography exhibit/year. Average display time 6-8 weeks. Museum open Tuesday through Friday from 9 to 5; Saturday from 9 to 4; Sunday from 1 to 5. Closed legal holidays. Overall price range \$50-7,000.

Exhibits Exhibits photos of babies/children/teens, celebrities, couples, multicultural, families, parents, senior citizens, disasters, environmental, landscapes/scenics, wildlife, architecture, cities/urban, education, gardening, interiors/decorating, pets, religious, rural, adventure, automobiles, entertainment, events, food/drink, health/fitness/beauty, hobbies, humor, performing arts, sports, travel, agriculture, business concepts, industry, medicine, military, political, product shots/still life, science, technology/computers. Interested in alternative process, avant garde, documentary, fashion/glamour, fine art, historical/vintage, seasonal.

Making Contact & Terms Museum handles sale of works, if applicable, with 40% commission. Accepted work shall not be framed.

Submissions Write to show portfolio of photographs, slides. Mail portfolio for review. Responds in 1 month. Finds artists through word of mouth, portfolio reviews, art exhibits, referrals by other artists.

Tips "We sponsor an annual juried competition in photography. Entry forms are available in the fall of each year. Send name and address to be placed on list."

WEINSTEIN GALLERY

908 West 46th St., Minneapolis MN 55419. (612)822-1722. Fax: (612)822-1745. E-mail: weingall@aol.com. Website: www.weinstein-gallery.com. **Director**: Leslie Hammons. For-profit gallery. Estab. 1996. Approached by hundreds of artists/year; represents or exhibits 12 artists. Average display time 6 weeks. Open Tuesday through Saturday from 12 to 5. Overall price range \$4,000-250,000.

Exhibits Interested in fine art. Most frequently exhibits contemporary photography.

Submissions "We do not accept unsolicited submissions."

WISCONSIN UNION GALLERIES

800 Langdon St., Room 507, Madison WI 53706-1495. (608)262-7592. Fax: (608)262-8862. E-mail: schmoldt@wisc.edu; art@union.wisc/edu. Website: union.wisc.edu/art. **Contact:** Robin Schmoldt. Nonprofit gallery. Estab. 1928. Approached by 100 artists/year; represents or exhibits 20

artists. Average display time 6 weeks. Open Monday through Sunday from 10 to 8. Closed during winter break and when gallery exhibitions turn over. "See our website at www.union.wisc.edu/art/submit.html to find out more about the galleries' features."

· Robin Schmoldt

Exhibits Interested in fine art. "Photography exhibitions vary based on the artist proposals submitted."

Making Contact & Terms All sales through gallery during exhibition only.

Submissions Current submission guidelines available at www.union.wisc.edu/art/submit.html. Finds artists through art fairs, art exhibits, referrals by other artists, submissions, word of mouth.

WOMEN & THEIR WORK ART SPACE

1710 Lavaca St., Austin TX 78701. (512)477-1064. Fax: (512)477-1090. E-mail: info@ womenandtheirwork.org. Website: www.womenandtheirwork.org. Alternative space, nonprofit gallery. Estab. 1978. Approached by more than 400 artists/year; represents or exhibits 6 solo and 1 juried show/year. Sponsors 1-2 photography exhibits/year. Average display time 5 weeks. Gallery open Monday through Friday from 9 to 6; Saturday from 12 to 5. Closed December 24 through January 2, and other major holidays. Exhibition space is 2,000 sq. ft. Overall price range \$500-5,000. Most work sold at \$800-1,000.

Exhibits Interested in contemporary, alternative process, avant garde, fine art.

Making Contact & Terms "We select artists through a juried process and pay them to exhibit. We take 25% commission if something is sold." Gallery provides insurance, promotion, contract. Accepted work should be framed, mounted, matted. **Texas women only in solo shows.** "All other artists, male or female, in curated show. Online Artist Slide Registry on website."

Submissions Finds artists through nomination by art professional.

Tips "Provide quality images, typed résumé and a clear statement of artistic intent."

WORLD FINE ART GALLERY

511 W. 25th St., Suite 803, New York NY 10001-5501. (646)336-1677. Fax: (646)336-8644. E-mail: info@worldfineart.com; wfagallery@gmail.com. Website: www.worldfineart.com. Cooperative gallery. Estab. 1992. Approached by 1,500 artists/year; represents or exhibits 50 artists. Average display time 1 month. Open Tuesday through Saturday from 12 to 6. Closed August. Located in Chelsea, NY; 1,000 sq. ft. Overall price range: \$500-5,000. Most work sold at \$1,500.

Exhibits Exhibits photos of landscapes/scenics, gardening. Interested in fine art.

Making Contact & Terms There is a rental fee for space. The rental fee covers 1 month or 1 year. Gallery provides insurance, promotion and contract. Accepted work should be framed; must be considered suitable for exhibition.

Submissions Write to arrange a personal interview to show portfolio, or e-mail JPEG images. Responds to queries in 1 week. Finds artists through the Internet.

Tips "Have a website available for review."

YESHIVA UNIVERSITY MUSEUM

15 W. 16th St., New York NY 10011. (212)294-8330. Fax: (212)294-8335. E-mail: info@yum.cjh.org. Website: www.yumuseum.org. Estab. 1973. Sponsors 6-8 exhibits/year; at least 1 photography exhibit/year. Average display time 4-6 months. The museum occupies 4 galleries and several exhibition arcades. All galleries are handicapped accessible.

Exhibits Seeks "individual or group exhibits focusing on Jewish themes and interests; exhibition-ready work essential."

Making Contact & Terms Accepts images in digital format. Send CD and accompanying text with SASE for return. Send color slide portfolio of 10-12 slides or photos, exhibition proposal, résumé with SASE for consideration. Reviews take place 3 times/year.

Tips "We exhibit contemporary art and photography based on Jewish themes. We look for excellent quality, individuality, and work that reveals a connection to Jewish identity and/or spirituality."

MIKHAIL ZAKIN GALLERY

561 Piermont Rd., Demarest NJ 07627. (201)767-7160. Fax: (201)767-0497. E-mail: info@tasoc. org; gallery@tasoc.org. Website: www.tasoc.org. Gallery Director: Rachael Faillace. Nonprofit gallery associated with the Art School at Old Church. Estab. 1974. "10-exhibition season includes contemporary, emerging, and established regional artists, NJ Annual Small Works show, student and faculty group exhibitions, among others." Gallery hours: 9:30 am to 5:00 pm Monday-Friday. Call for weekend and evening hours. Exhibitions are mainly curated by invitation. However, unsolicited materials are reviewed and will be returned with the inclusion of a SASE. The gallery does not review artist websites, e-mail attachments or portfolios in the presence of the artist. "Please follow the submission guidelines on our website."

Exhibits All styles and genres are considered.

Making Contact & Terms Charges 35% commission fee on all gallery sales. Gallery provides promotion and contract. Accepted work should be framed, mounted.

Submissions Guidelines are available on gallery's website. Small Works prospectus is available online. Mainly finds artists through referrals by other artists and artist registries.

Tips "Follow guidelines available online."

ZENITH GALLERY

P.O. Box 55295, Washington DC 20040. (202)783-2963. Fax: (202)783-0050. E-mail: art@zenithgallery.com. Website: www.zenithgallery.com. For-profit gallery. Open by appointment. Curates shows throughout Chevy Chase Pavilion at 5533 Wisconsin Avenue in Chevy Chase, DC. Open Monday-Saturday, 10-8, Sunday 11-6, and also operates a gallery on Level 2, open Saturdays, 10-6 and by appointment. Curates The Gallery at 1111 Pennsylvania Ave., NW, Washington DC, open Monday-Friday, 8-7, Saturday-Sunday by appointment. Overall price range: \$500-15,000.

Exhibits Exhibits photos of landscapes/scenics and other. Interested in avant garde, fine art.

Submissions Mail portfolio for review. Send query letter with artist's statement, bio, brochure, business card, résumé, reviews, photocopies, photographs, slides, CD, SASE. Responds to queries within 1 year, only if interested. Finds artists through art fairs and exhibits, portfolio reviews, referrals by other artists, submissions and word of mouth.

Art Fairs

ow would you like to sell your art from New York to California, showcasing it to thousands of eager art collectors? Art fairs (also called art festivals or art shows) are not only a good source of income for artists but an opportunity to see how people react to their work. If you like to travel, enjoy meeting people, and can do your own matting and framing, this could be a great market for you.

Many outdoor fairs occur during the spring, summer, and fall months to take advantage of warmer temperatures. However, depending on the region, temperatures could be hot and humid, and not all that pleasant! And, of course, there is always the chance of rain. Indoor art fairs held in November and December are popular because they capitalize on the holiday shopping season.

To start selling at art fairs, you will need an inventory of work—some framed, some unframed. Even if customers do not buy the framed paintings or prints, having some framed work displayed in your booth will give buyers an idea of how your work looks framed, which could spur sales of your unframed prints. The most successful art fair exhibitors try to show a range of sizes and prices for customers to choose from.

When looking at the art fairs listed in this section, first consider local shows and shows in your neighboring cities and states. Once you find a show you'd like to enter, visit its website or contact the appropriate person for a more detailed prospectus. A prospectus is an application that will offer additional information not provided in the art fair's listing.

Ideally, most of your prints should be matted and stored in protective wraps or bags so that customers can look through your inventory without damaging prints and mats. You will also need a canopy or tent to protect yourself and your wares from the elements as well as some bins in which to store the prints. A display wall will allow you to show off your best framed prints. Generally, artists will have 100 square feet of space in which to set up their tents and canopies. Most listings will specify the dimensions of the exhibition space for each artist.

If you see the icon before a listing in this section, it means that the art fair is a juried event. In other words, there is a selection process artists must go through to be admitted into the fair. Many art fairs have quotas for the categories of exhibitors. For example, one art fair may accept the mediums of photography, sculpture, painting, metal work, and jewelry. Once each category fills with qualified exhibitors, no more will be admitted to the show that year. The jurying process also ensures that the artists who sell their work at the fair meet the sponsor's criteria for quality. So, overall, a juried art fair is good for artists because it means they will be exhibiting their work along with other artists of equal caliber.

Be aware there are fees associated with entering art fairs. Most fairs have an application fee or a space fee, or sometimes both. The space fee is essentially a rental fee for the space your booth will occupy for the art fair's duration. These fees can vary greatly from show to show, so be sure to check this information in each listing before you apply to any art fair.

Most art fair sponsors want to exhibit only work that is handmade by the artist, no matter what medium. Unfortunately, some people try to sell work that they purchased elsewhere as their own original artwork. In the art fair trade, this is known as "buy/sell." It is an undesirable situation because it tends to bring down the quality of the whole show. Some listings will make a point to say "no buy/sell" or "no manufactured work."

For more information on art fairs, pick up a copy of *Sunshine Artist* (www.sunshineartist.com) or *Art Calendar* (www.artcalendar.com), and consult online sources such as www.artfairsource.com.

39TH ANNUAL ARTS & CRAFTS FAIR

Pend Oreille Arts Council, P.O. Box 1694, Sandpoint ID 83864. (208)263-6139. E-mail: art@ sandpoint.net. Website: www.ArtinSandpoint.org. Estab. 1978. Arts & crafts show held annually, second week in August. Outdoors. Accepts photography and all handmade, noncommercial works. Juried by 8-member jury. Number of exhibitors: 120. Public attendance: 5,000. Free to public. Artists should apply by sending in application, available in February. Deadline for entry: May 1. Application fee: \$15. Space fee: \$175-250, no commission taken. Exhibition space: 10×10 ft. or 10×15 ft. For more information, artists should e-mail, visit website, Facebook, call or send SASE.

49TH ARTS EXPERIENCE

P.O. Box 1326, Palatine IL 60078. (312)751-2500, (847)991-4748. Fax: (847)221-5853. E-mail: asoa@ webtv.net. Website: www.americansocietyofartists.org. Fine arts & crafts show held in summer. Outdoors. Accepts photography, paintings, graphics, sculpture, quilting, woodworking, fiber art, hand-crafted candles, glass works, jewelry and more. Juried by 4 slides/photo representative of work being exhibited; 1 photo of display set-up, #10 SASE, résumé with show listings helpful. Number of exhibitors: 50. Free to public. Artists should apply by submitting jury material and indicate you are interested in this particular show. If you wish to jury online please see our website and follow directions given there. To jury via e-mail: submit only at Asoaartists@aol.com. When you pass the jury, you will receive jury approval number and application you requested. Deadline for entry: 2 months prior to show or earlier if space is filled. Space fee: to be announced. Exhibition space: 100 sq. ft. for single space; other sizes are available. For more information, artists should send SASE to submit jury material.

• Event held in Chicago, Illinois.

Tips "Remember that at work in your studio, you are an artist. When you are at a show, you are a business person selling your work."

A DAY IN TOWNE

Boalsburg Memorial Day Committee, 117 E. Boal Ave., Boalsburg PA 16827. (814)466-6311; (814)466-9266. E-mail: office@boalmuseum.com. Website: www.boalmuseum.com/memorialday. village.htm. Estab. May 1980. Arts & crafts show held annually the last Monday in May/Memorial Day weekend. Outdoors. Accepts photography, country fabric & wood, wool knit, soap, jewelry, dried flowers, pottery, blown glass. Vendor must make own work. Number of exhibitors: 125-135. Public attendance: 20,000. Artists should apply by writing an inquiry letter and sending 2-3 photos; 1 of booth and 2 of the craft. Deadline for entry: January 1-February 1. Space fee: \$60. Exhibition space: 10×15 ft.

Tips "Please do not send fees until you receive an official contract. Have a neat booth and nice smile. Have fair prices—if too high, product will not sell here."

AFFAIRE IN THE GARDENS ART SHOW

Greystone Park, 501 Doheny Rd., Beverly Hills CA 90210-2921. (310)285-6836. E-mail: kmclean@beverlyhills.org. Website: www.beverlyhills.org/attractions/affaire. Estab. 1973. Fine arts & crafts

show held biannually 3rd weekend in May and 3rd weekend in October. Outdoors. Accepts photography, painting, sculpture, ceramics, jewelry, digital media. Juried. Awards/prizes: 1st Place in category, cash awards, Best in Show cash award; Mayor's Purchase Award in October show. Number of exhibitors: 225. Public attendance: 30,000-40,000. Free to public. Deadline for entry: end of February, May show; end of July, October show. For more information, artists should e-mail, visit website, call or send SASE.

Tips "Art fairs tend to be commercially oriented. It usually pays off to think in somewhat commercial terms—what does the public usually buy? Personally, I like risky and unusual art, but the artists who produce esoteric art sometimes go hungry! Be nice and have a clean presentation."

AKRON ARTS EXPO

220 S. Balch St., Akron OH 44302. (330)375-2836. Fax: (330)375-2883. E-mail: readni@ci.akron. oh.us. Website: www.akronartsexpo.org. Fine art & craft show held annually in late July (4th weekend). Outdoors. Accepts photography. Juried by 5 jurors from the art community brought in to select the artists." See website for application information. Awards/prizes: ribbon & cash awards. Number of exhibitors: 165. Public attendance: 35,000. Free to public. Deadline for entry: March 31. Space fee: \$200. Exhibition space: 15 × 15 ft. Average gross sales for a typical exhibitor varies. For more information, artists should e-mail, call, or visit website.

Tips "No application fee. Apply with digital and slides. Make sure you send in slides that are in good condition and show your work properly. If you wish to send a sample, this is helpful as well. Make sure you fill out the application correctly." See website for updated information.

ALLEN PARK ARTS & CRAFTS STREET FAIR

16850 Southfield Rd., Allen Park MI 48101-2599. (313)928-1370. Fax: (313)382-7946. Website: www. cityofallenpark.org/visitors-street-fair.php. **Contact:** Allen Park Festivities Commission. Estab. 1981. Arts & crafts show held annually the 1st Friday and Saturday in August. Outdoors. Accepts photography, sculpture, ceramics, jewelry, glass, wood, prints, drawings, paintings. Juried by 3 photos of work. Number of exhibitors: 400. Free to the public. Artists should apply by requesting an application form by December 31 of the previous year. Application fee: \$5. Space fee: \$100. Exhibition space: 10×10 ft. For more information, artists should call.

ALLENTOWN ART FESTIVAL

PO Box 1566, Buffalo NY 14205. (716)881-4269. Fax: (716)881-4269. E-mail: allentownartfestival@ verizon.net. Website: www.allentownartfestival.com. **President:** Mary Myszkiewicz. Estab. 1958. Fine arts & crafts show held annually 2nd full weekend in June. Outdoors. Accepts photography, painting, watercolor, drawing, graphics, sculpture, mixed media, clay, glass, acrylic, jewelry, creative craft (hard/soft). Slides juried by hired professionals that change yearly. Awards/prizes: 40 cash prizes; Best of Show. Number of exhibitors: 450. Public attendance: 300,000. Free to public. Artists should apply by downloading application from website. Deadline for entry: January 31. Exhibition space: 13 × 10 ft. For more information, artists should e-mail, visit website, call or send SASE.

Tips "Artists must have attractive booth and interact with the public."

AMISH ACRES ARTS & CRAFTS FESTIVAL

1600 W Market St., Nappanee IN 46550. (574)773-4188 or (800)800-4942. E-mail: amishacres@ amishacres.com. Website: www.amishacres.com. Estab. 1962. Arts & crafts show held annually first weekend in August. Outdoors. Accepts photography, crafts, floral, folk, jewelry, oil, acrylic, sculpture, textiles, watercolors, wearable, wood. Juried by 5 images, either 35mm slides or e-mailed digital images. Awards/prizes: Cash including Best of Show and \$1,500 Purchase Prizes. Number of exhibitors: 350. Public attendance: 60,000. Children under 12 free. Artists should apply by sending SASE or printing application from website. Deadline for entry: April 1. Exhibition space:

from 120-300 sq. ft. Average gross sales/exhibitor: \$7,000. For more information, artists should e-mail, visit website, call or send SASE.

Tips "Create a vibrant, open display that beckons to passing customers. Interact with potential buyers. Sell the romance of the purchase."

ANACORTES ARTS FESTIVAL

505 "O" Ave., Anacortes WA 98221. (360)293-6211. Fax: 360-299-0722. E-mail: staff@ anacortesartsfestival.com. Website: www.anacortesartsfestival.com. Fine arts & crafts show held annually 1st full weekend in August. Accepts photography, painting, drawings, prints, ceramics, fiber art, paper art, glass, jewelry, sculpture, yard art, woodworking. Juried by projecting 3 images on a large screen. Works are evaluated on originality, quality and marketability. Each applicant must provide 3 high-quality digital images or slides—2 of the product and 1 of the booth display. Awards/prizes: more than \$4,000 in prizes. Number of exhibitors: 250. Artists should apply by visiting website for online submission or by mail. Deadline for entry: early March. For more information, artists should see website.

ANN ARBOR'S SOUTH UNIVERSITY ART FAIR

118 N. 4th Ave., Ann Arbor MI 48104. (734)662.3382. Fax: (734)662.0339. E-mail: info@theguild. org. Website: www.theguild.org/art_fair_summer.html. Estab. 1960. Fine arts & crafts show held annually 3rd Wednesday through Saturday in July. Outdoors. Accepts photography, clay, drawing, digital, fiber, jewelry, metal, painting, sculpture, wood. Juried. Awards/prizes: \$3,000. Number of exhibitors: 190. Public attendance: 750,000. Free to public. Deadline for entry: January. Exhibition space: 10×10 to 20×10 ft. Average gross sales/exhibitor: \$7,000. For more information artists should e-mail, visit website or call.

Tips "Research the market, use a mailing list, advertise in *Art Fair Guide* (150,000 circulation)."

ANN ARBOR STREET ART FAIR

721 E. Huron, Ste. 200, Ann Arbor MI 48104. (734)994-5260. Fax: (734)994-0504. E-mail: production@artfair.org. Website: www.artfair.org. Fine arts & crafts show held annually 3rd Saturday in July. Outdoors. Accepts photography, fiber, glass, digital art, jewelry, metals, 2D and 3D mixed media, sculpture, clay, painting, drawing, printmaking, pastels, wood. Juried based on originality, creativity, technique, craftsmanship and production. Awards/prizes: cash prizes for outstanding work in any media. Number of exhibitors: 175. Public attendance: 500,000. Free to the public. Artists should apply through www.zapplication.org. Deadline for entry: January. Application fee: \$40. Space fee: \$650. Exhibition space: 10 × 12 ft. Average gross sales/exhibitor: \$7,000. For more information, artists should e-mail, visit website, call.

ANNUAL ALTON ARTS & CRAFTS EXPRESSIONS

P.O. Box 1326, Palatine IL 60078. (312)751-2500. Fax: (847)221-5853. E-mail: asoa@webtv.net. Website: www.americansocietyofartists.org. Fine arts & crafts show held annually indoors in spring and fall, usually March and September. Accepts quilting, fabric crafts, artwear, photography, sculpture, jewelry, glass works, woodworking and more. Juried by 4 slides or photos of your work and 1 slide or photo of your display; SASE (No. 10); a resume or show listing is helpful. "See our website for online jury information." Number of exhibitors: 50. Free to the public. Artists should apply by submitting jury materials. If you want to jury via internet see our website and follow directions given there. To jury via e-mail submit to: Asoartists@aol.com. If juried in, you will receive a jury/approval number. Deadline for entry: 2 months prior to show or earlier if spaces fill. Space fee: \$125. Exhibition space: approximately 100 sq. ft for single space; other sizes available. For more information, artists should send SASE, submit jury material.

• Event held in Alton, Illinois.

Tips "Remember that when you are at work in your studio, you are an artist. But when you are at a show, you are a business person selling your work."

ANNUAL ARTS & CRAFTS ADVENTURE

P.O. Box 1326, Palatine IL 60078. (312)751-2500. Fax: (847)221-5853. E-mail: asoa@webtv.net. Website: www.americansocietyofartists.org. Fine arts & crafts show held annually in early May and mid-September. Outdoors. Accepts photography, pottery, paintings, sculpture, glass, wood, woodcarving, and more. Juried by 4 slides or photos of work and 1 slide or photo of display; SASE (No. 10); a résumé or show listing is helpful. See our website for online jury. To jury via e-mail: submit only to: Asoaartists@aol.com. Number of exhibitors: 75. Free to the public. Artists should apply by submitting jury materials. If juried in, you will receive a jury/approval number. Deadline for entry: 2 months prior to show or earlier if spaces fill. Space fee: \$80. Exhibition space: approximately 100 sq. ft. for single space; other sizes available. For more information, artists should send SASE, submit jury material.

• Event held in Park Ridge, Illinois.

Tips "Remember that when you are at work in your studio, you are an artist. But when you are at a show, you are a business person selling your work."

ANNUAL ARTS ADVENTURE

P.O. Box 1326, Palatine IL 60078. (312)571-2500. Fax: (847)221-5853. E-mail: asoa@webtv.net. Website: www.americansocietyofartists.org. American Society of Artists. Fine arts & crafts show held annually the end of July. Event held in Chicago, Illinois. Outdoors. Accepts photography, paintings, pottery, sculpture, Jewelry and more. Juried. Send 4 slides or photos of your work and 1 slide or photo of your display; SASE (No. 10); a resume or show listing is helpful. See our website for online jury. To jury via e-mail: submit only at Asoaartists@aol.com. Number of exhibitors: 50. Free to the public. Artists should apply by submitting jury materials. If juried in, you will receive a jury/approval number. Deadline for entry: 2 months prior to show or earlier if spaces fill. Entry fee: \$135. Exhibition space: approximately 100 sq. ft. for single space; other sizes available. For more information, artists should send SASE, submit jury material.

• Event held in Chicago, Illinois.

Tips "Remember that when you are at work in your studio, you are an artist. But when you are at a show, you are a business person selling your work."

ANNUAL EDENS ART FAIR

P.O. Box 1326, Palatine IL 60078. (312)2500. Fax: (847)5853. E-mail: asoa@webtv.net. Website: www.americansocietyofartists.com. American Society of Artists. Estab. 1995 (after renovation of location; held many years prior to renovation). Fine arts & fine selected crafts show held annually in mid-July. Outdoors. Accepts photography, paintings, sculpture, glass works, jewelry and more. Juried. Send 4 slides or photos of your work and 1 slide or photo of your display; SASE (No. 10); a resume or show listing is helpful. Number of exhibitors: 50. Free to the public. Artists should apply by submitting jury materials. If you wish to jury online please see our website and follow directions given. To jury via e-mail: E-mail jury submissions accepted only at: Asoaartists@aol.com. If juried in, you will receive a jury/approval number. Deadline for entry: 2 months prior to show or earlier if spaces fill. Entry fee: \$145. Exhibition space: approximately 100 sq. ft. for single space; other sizes available. For more information, artists should send SASE, submit jury material.

Event held in Wilmette, Illinois.

Tips "Remember that when you are at work in your studio, you are an artist. But when you are at a show, you are a business person selling your work."

ANNUAL HYDE PARK ARTS & CRAFTS ADVENTURE

P.O. Box 1326, Palatine IL 60078. (312)751-2500, (847)991-4748. Fax: (847)21-5853. E-mail: asoa@ webtv.net. Website: www.americansocietyofartists.org. Arts & crafts show held once a year in late September. Outdoors. Accepts photography, paintings, glass, wood, fiber arts, hand-crafted candles, quilts, sculpture and more. Juried by 4 slides or photos of work and 1 slide or photo

of display; SASE (No. 10); a résumé or show listing is helpful. Number of exhibitors: 50. Free to the public. Artists should apply by submitting jury materials. To jury via e-mail: submit only to: Asoaartists@aol.com. If juried in, you will receive a jury/approval number. See website for jurying online. Deadline for entry: 2 months prior to show or earlier if spaces fill. Entry fee: \$155. Exhibition space: approximately 100 sq. ft. for single space; other sizes are available. For more information, artists should send SASE, submit jury material.

• Event held in Chicago, Illinois.

Tips "Remember that when you are at work in your studio, you are an artist. But when you are at a show, you are a business person selling your work."

ANNUAL OAK PARK AVENUE-LAKE ARTS & CRAFTS SHOW

P.O. Box 1326, Palatine IL 60078. (312)751-2500, (847)991-4748. Fax: (847)221-5853. E-mail: asoa@ webtv.net. Website: www.americansocietyofartists.org. Fine arts & crafts show held annually in mid-August. Outdoors. Accepts photography, paintings, graphics, sculpture, glass, wood, paper, fiber arts, mosaics and more. Juried by 4 slides or photos of work and 1 slide or photo of display; SASE (No. 10); a resume or show listing is helpful. Number of exhibitors: 150. Free to the public. Artists should apply by submitting jury materials. If you want to jury online please see our website and follow directions given there. To jury via e-mail: submissions accepted only at: Asoaartists@ aol.com. If juried in, you will receive a jury/approval number. Deadline for entry: 2 months prior to show or earlier if spaces fill. Entry fee: \$170. Exhibition space: approximately 100 sq. ft. for single space; other sizes available. For more information, artists should send SASE, submit jury material.

· Event held in Oak Park, Illinois.

Tips "Remember that when you are at work in your studio, you are an artist. But when you are at a show, you are a business person selling your work."

APPLE ANNIE CRAFTS & ARTS SHOW

4905 Roswell Rd., Marietta GA 30062. (770)552-6400, ext. 6110. Fax: (770)552-6420. E-mail: appleannie@st-ann.org. Website: www.st-ann.org/apple_annie.php. Estab. 1981. Arts & crafts show held annually the 1st weekend in December. Indoors. Accepts photography, woodworking, ceramics, pottery, painting, fabrics, glass. Juried. Number of exhibitors: 135. Public attendance: 5,000. Artists should apply by visiting website to print an application form, or call to have one sent to them. Deadline: March 31. Application fee: \$10, nonrefundable. Exhibition space: 72 sq. ft. For more information, artists should e-mail, visit website, call.

Tips "Have an open, welcoming booth and be accessible and friendly to customers."

M ART FAIR ON THE COURTHOUSE LAWN

P.O. Box 795, Rhinelander WI 54501. (715)365-7464. E-mail: info@rhinelanderchamber.com. Website: www.rhinelanderchamber.com. Contact: Events Coordinator. Estab. 1985. Arts & crafts show held annually in June. Outdoors. Accepts photography, handmade crafts. Number of exhibitors: 150. Public attendance: 3,000. Free to the public. For more information, artists should e-mail, call.

Tips "We accept only items handmade by the exhibitor."

ART FESTIVAL BETH-EL

400 S. Pasadena Ave., St. Petersburg FL 33707. (727)347-6136. Fax: (727)343-8982. E-mail: administrator@templebeth-el.com. Website: www.templebeth-el.com. Estab. 1972. Fine arts & crafts show held annually the last weekend in January. Indoors. Accepts photography, painting, jewelry, sculpture, woodworking. Juried by special committee on-site or through slides. Awards/prizes: \$7,500 prize money; \$100,000 Purchase Award. Number of exhibitors: 150-175. Public attendance: 8,000-10,000. Free to the public. Artists should apply by application with photos or

slides; show is invitational. Deadline for entry: September. For more information, artists should call.

Tips "Don't crowd display panels with artwork. Make sure your prices are on your pictures. Speak to customers about your work."

ART IN THE PARK FALL FOLIAGE FESTIVAL

16 S. Main St., Rutland VT 05701. (802)775-0356. Fax: (802)773-4401. E-mail: beyondmarketing@yahoo.com. Website: www.chaffeeartcenter.org. Event Coordinator: Sherri Birkheimer Rooker. Estab. 1961. Fine arts & crafts show held annually in October. Accepts fine art, photography, clay, fiber, floral, glass, art, specialty foods, wood, jewelry, handmade soaps, lampshades, baskets, etc. Juried by a panel of 10-15 judges who perform a blind review of slide submissions. Number of exhibitors: 130. Public attendance: 8,000. Public admission: voluntary donation. Artists should submit a CD of three photos of work and one of booth (photos upon pre-approval). Deadline for entry: on-going but to receive discount for doing both shows, must apply by May 31; \$25 late fee after that date. Space fee: \$190-\$340. For more information, artists should e-mail, visit website, or call.

Tips "Have a good presentation and variety, if possible (in pricing also), to appeal to a large group of people."

ART IN THE PARK

PO Box 1540, Thomasville GA 31799. (229)227-7020. Fax: (229)227-3320. E-mail: roseshowfest @rose.net, felicia@thomasville.org. Website: www.downtownthomasville.com. Arts in the park (an event of Thomasville's Rose Show and Festival) is a one-day arts & crafts show held annually in April. 2011 date: April 23, 10-4. Outdoors. Accepts photography, handcrafted items, oils, acrylics, woodworking, stained glass, other varieties. Juried by a selection committee. Number of exhibitors: 60. Public attendance: 2,500. Free to public. Artists should apply by application. Deadline for entry: February 1. Space fee: \$75, varies by year. Exhibition space: 20 × 20 ft. For more information, artists should e-mail or call.

Tips "Most important, be friendly to the public and have an attractive booth display."

ART IN THE PARK (MI)

8707 Forest Ct., Halmich Park, Warren MI 48093. (586)795-5471. E-mail: wildart@wowway.com. Website: www.warrenfinearts.org. Fine arts & crafts show held annually 2nd weekend in July. Indoors and outdoors. Accepts photography, sculpture, basketry, pottery, stained glass. Juried. Awards/prizes; monetary awards. Number of exhibitors: 70. Public attendance: 7,500. Free to public. Deadline for entry: May 16. Jury fee: \$20. Space fee: \$125/outdoor; \$135/indoor. Exhibition space: 12×12 ft./tent; 12×10 ft./atrium. For more information, artists should e-mail, visit website or send SASE.

ART IN THE PARK (SIERRA VISTA)

P.O. Box 247, Sierra Vista AZ 85636-0247. (520) 803-1511. E-mail: dragnfly@theriver.com. Website: www.artintheparksierravista.com. **Contact:** Vendor Committee. Estab. 1972. Oldest longest running Arts & Crafts fair in S. AZ. Fine arts & crafts show held annually 1st full weekend in October. Outdoors. Accepts photography, all fine arts and crafts created by vendor. No resale retail strictly applied. Juried by Huachaca Art Association Board. Artists submit 3-5 photos. Returnable with SASE, Number of exhibitors: 240. Public attendance: 15,000. Free to public. Artists should apply by downloading the application www.artintheparksierravista.com. Deadline for entry: postmarked by June 27. Last minute/late entries always considered. No application fee. Space fee: \$175, includes jury fee. Exhibition space: 15 × 30 ft. Some electrical. Some RV space available at \$15.00 per night. For more information, artists should read website info or e-mail, call or send SASE.

ART IN THE PARK SUMMER FESTIVAL

16 South Main St., Rutland VT 05701. (802)775-8836. Fax: (802)773-0672. E-mail: beyondmarketing@yahoo.com. Website: chaffeartcenter.org. Fine arts and crafts show held outdoors annually in August. 2011 dates: August 13 and 14. Accepts fine art, photography, clay, fiber, floral, glass, art, specialty foods, wood, jewelry, handmade soaps, lampshades, baskets, etc. Juried by a panel of 10-15 judges who perform a blind review of slide submissions. Number of exhibitors: 130. Public attendance: 8,000. Public admission: voluntary donation. Artists should submit a CD with three photos of work and one of booth (photos upon pre-approval). Deadline for entry: on-going but to receive discount for doing both shows, must apply by March 31; \$25 late fee after that date. Space fee: \$190-\$340. For more information, artists should e-mail, visit website, or call.

Tips "Have a good presentation, variety if possible (in price ranges, too) to appeal to a large group of people."

ART IN THE PARK

1 Gypsy Hill Park, Staunton VA 24401. (540)885-2028. E-mail: info@saartcenter.org. Website: www.saartcenter.org. Fine arts & crafts show held annually 3rd Saturday in May. Outdoors. Accepts photography, oil, watercolor, pastel, acrylic, clay, porcelain, pottery, glass, wood, metal, almost anything as long as it is handmade fine art/craft. Juried by submitting 4 photos or slides that are representative of the work to be sold. Award/prizes: Grand Winner. Number of exhibitors: 100. Public attendance: 3,000-4,000. Free to public. Artists should apply by sending in application. Application fee: \$15. Space fee: \$75/members; \$100/nonmembers. Exhibition space: 10×10 ft. For more information, artists should e-mail or call.

AN ARTS & CRAFTS AFFAIR, AUTUMN & SPRING TOURS

P.O. Box 184, Boys Town NE 68010. (402)331-2889. Fax: (402)445-9177. E-mail: hpifestivals@cox. net. Website: www.hpifestivals.com. **Contact:** Huffman Productions. Estab. 1983. An arts & crafts show that tours different cities and states. The Autumn Festival tours annually October-November; Spring Festival tours annually in April. Artists should visit website to see list of states and schedule. Indoors. Accepts photography, pottery, stained glass, jewelry, clothing, wood, baskets. All artwork must be handcrafted by the actual artist exhibiting at the show. Juried by sending in 2 photos of work and 1 of display. Awards/prizes: 4 \$30 show gift certificates; \$50, \$100 and \$150 certificates off future booth fees. Number of exhibitors: 300-500 depending on location. Public attendance: 15,000-35,000. Public admission: \$7-8/adults; \$6-7/seniors; 10 & under, free. Artists should apply by calling to request an application. Deadline for entry: varies for date and location. Space fee: \$400-650. Exhibition space: 8 × 11 ft. up to 8 × 22 ft. For more information, artists should e-mail, visit website, call or send SASE.

Tips "Have a nice display, make sure business name is visible, dress professionally, have different price points, and be willing to talk to your customers."

☑ SIMSBURY WOMAN'S CLUB 42nd ARTS & CRAFTS FESTIVAL

P.O. Box 903, Simsbury Ct., Hartford CT 06070. 860-658-4735; 860-651-0788. E-mail: simsburywomansclub@hotmail.com. Juried arts & crafts show held annually 2nd weekend after Labor Day. Outdoors rain or shine. Accepts fine art, photography, pottery, clothing & accessories, jewelry, toys, wood objects, floral arrangements. Applicants should submit 4 photos or JPEGs - 1 of display setup and 3 of work. Number of exhibitors: over 100. Public attendance: 5,000 to 10,000. Free to public. Deadline for early bird entry: May 31. Final deadline July 31. Space fee: \$150-165. Exhibition space: 11-15 ft. frontage.

ART'S ALIVE

4001 Coastal Highway, Ocean City MD 21842-2247. (410)250-0125. Fax: (410)250-5409. Website: www.ococean.com. Fine art show held annually in mid-June. Outdoors. Accepts photography,

ceramics, drawing, fiber, furniture, glass, printmaking, jewelry, mixed media, painting, sculpture, fine wood. Juried. Awards/prizes: \$5,250 in cash prizes. Number of exhibitors: 110. Public attendance: 10,000. Free to pubic. Artists should apply by downloading application from website or call. Deadline for entry: February 28. Space fee: \$200. Jury Fee: \$25. Exhibition space: 10x10 ft. For more information, artists should e-mail, visit website, call or send SASE. **Tips** "Apply early."

ARTS IN THE PARK

302 2nd Ave. East, Kalispell MT 59901. (406)755-5268. E-mail: information@hockadaymuseum. org. Website: www.hockadaymuseum.org. Estab. 1968. Fine arts & crafts show held annually 4th weekend in July. Outdoors. Accepts photography, jewelry, clothing, paintings, pottery, glass, wood, furniture, baskets. Juried by a panel of 5 members. Artwork is evaluated for quality, creativity and originality. Jurors attempt to achieve a balance of mediums in the show. Number of exhibitors: 100. Public attendance: 10,000. Artists should apply by completing the application form, and mailing entry fee, a SASE and a CD containing 5 images in JPEG format; 4 images of work and 1 of booth. Exhibition space: 10×10 ft- 10×20 ft. For more information artists should e-mail, visit website or call.

ARTS ON FOOT

1250 H St., NW, Suite 1000, Washington DC 20005. (202)638-3232. E-mail: artsonfoot@downtowndc. org. Website: www.artsonfoot.org. Fine arts & crafts show held annually in September. Outdoors. Accepts photography, painting, sculpture, fiber art, furniture, glass, jewelry, leather. Juried by 5 color images of the artwork. Send images as 35mm slides, TIFF or JPEG files on CD or DVD. Also include artist's résumé and SASE for return of materials. Free to the public. Deadline for entry: July. Exhibition space: 10 × 10 ft. For more information, artists should call, e-mail, visit website.

ARTS ON THE GREEN

P.O. Box 752, LaGrange KY 40031. (502)222-3822. Fax: (502)222-3823. E-mail: aogdir@aaooc.org; info@oldhamcountyarts.org. Fine arts & crafts show held annually 1st weekend in June. Outdoors. Accepts photography, painting, clay, sculpture, metal, wood, fabric, glass, jewelry. Juried by a panel. Awards/prizes: cash prizes for Best of Show and category awards. Number of exhibitors: 100. Public attendance: 7,500. Free to the public. Artists should apply online or call. Deadline for entry: March 15. Jury fee: \$15. Space fee: \$125. Electricity fee: \$15. Exhibition space: 12 × 12 ft. For more information, artists should e-mail, visit website, call.

Tips "Make potential customers feel welcome in your space. Don't overcrowd your work. Smile!"

M C ARTSPLOSURE

313 S. Blount St., #200B, Raleigh NC 27601. (919)832-8699. Fax: (919)832-0890. E-mail: Info@ Artsplosure.org. Website: www.Artsplosure.org. **Operations Manager:** Dylan Morris. Estab. 1979. Annual outdoor art/craft fair held the third weekend of May. Accepts ceramics, glass, fiber art, jewelry, metal, painting, photography, wood, 2D and 3D artwork. Juried event. Six award given, totaling \$3,500 cash. 170 exhibitors per event, 75,000 in attendance. Free admission to the public. Applications available in October, deadline is January 15. Application fee: \$30. Space fee: \$225 for 12 × 12 ft. Average sales: \$2,500. For more information visit website or send an e-mail.

Tips "Professional quality photos of work submitted for jurying are preferred, as well as a well executed professional booth photo. Keep artist statements concise and relevant."

AUTUMN FESTIVAL, AN ARTS & CRAFTS AFFAIR

Huffman Productions, P.O. Box 184, Boys Town NE 68010. (402)331-2889. Fax: (402)445-9177. E-mail: hpifestivals@cox.net. Website: www.hpifestivals.com. Fine arts & craft show held annually in October. Indoors. Accepts photography, pottery, stained glass, jewelry, clothing, furniture, paintings, baskets, etc. All must be handcrafted by the exhibitor. Juried by 2 photos of work

and 1 of display. Awards/prizes: \$420 total cash awards. Number of exhibitors: 400. Public attendance: 20,000. Public admission: \$6-8. See brochure online. Artists should apply by calling for an application or downloading one online. Deadline: Until a category is juried full. Space fee: \$600. Exhibition space: 8 × 11 ft. ("We provide pipe and drape plus 500 watts of power.") For more information, artists should e-mail, visit website, call, send SASE.

Tips "Make sure to send good, crisp photos that show your current work and display. This gives you the best chance with jurying in a show."

AVON FINE ART & WINE AFFAIRE

(480)837-5637. Fax: (480)837-2355. Website: www.thunderbirdartists.com. Estab. 1993. Fine arts & crafts show and wine tasting held annually in mid-July. Outdoors. Accepts photography, painting, mixed media, bronze, metal, copper, stone, stained glass, clay, wood, paper, baskets, jewelry, scratchboard. Juried by 4 slides of work and 1 slide of booth. Number of exhibitors: 150. Public attendance: 3,000-6,000. Free to public. Artists should apply by sending application, fees, 4 slides of work, 1 slide of booth and 2 SASEs. Exhibition space: 10 × 10 ft.-10 × 30 ft. For more information, artists should visit website.

BLACK SWAMP ARTS FESTIVAL

P.O. Box 532, Bowling Green OH 43402. (419)354-2723. E-mail: info@blackswamparts.org. Website: www.blackswamparts.org. "The Black Swamp Arts Festival (BSAF) connects art and the community by presenting an annual arts festival and by promoting the arts in the Bowling Green community."

Tips "Offer a range of prices, from \$5 to \$500."

BRICK STREET MARKET

E-mail: info@zionsvilleart.org. Website: www.zionsvilleart.org. Fine art, antique & craft show held annually the Saturday after Mother's Day. Outdoors. In collaboration with area merchants, this annual event is held on the Main Street Gallery District in the Historic Village of Zionsville, Indiana. Please submit up to 3 JPEG images. All mediums are welcome. Artists are encouraged to perform demonstrations of their work and talk with visitors during the event. No tents are required although artists must supply display equipment. Accepts photography, arts, crafts, antiques, apparel. Juried by sending 5 pictures. Number of exhibitors: 150-160. Public attendance: 3,000-4,000. Free to public. Artists should apply by requesting application. Space fee: \$145. Exhibition space: 10×8 ft. For more information, artists should send an e-mail.

Tips "Display is very important. Make it look good."

CAIN PARK ARTS FESTIVAL

40 Severance Circle, Cleveland Heights OH 44118-9988. (216)291-3669. Fax: (216)291-3705. E-mail: jhoffman@clvhts.com; ksenia@clvhts.com. Website: www.cainpark.com. Contact: Ksenia Roshchakovsky, PR. Fine arts & crafts show held annually 2nd full week in July. Outdoors. Accepts photography, painting, clay, sculpture, wood, jewelry, leather, glass, ceramics, clothes and other fiber, paper, block printing. Juried by a panel of professional artists; submit 5 slides. Awards/prizes: cash prizes of \$750, \$500 and \$250; also Judges' Selection, Director's Choice and Artists' Award. Number of exhibitors: 155. Public attendance: 60,000. Free to the public. Artists should apply by requesting an application by mail, visiting website to download application or by calling. Deadline for entry: March 1. Application fee: \$25. Space fee: \$350. Exhibition space: 10 × 10 ft. Average gross sales/exhibitor: \$4,000. For more information, artists should e-mail, visit website, or call.

Tips "Have an attractive booth to display your work. Have a variety of prices. Be available to answer questions about your work."

CALABASAS FINE ARTS FESTIVAL

100 Civic Center Way, Calabasas CA 91302. (818)224-1657 ext. 270. E-mail: artscouncil@cityofcalabasas.com. Website: www.calabasasartscouncil.com. Estab. 1997. Fine arts & crafts show held annually in late April/early May. Outdoors. Accepts photography, painting, sculpture, jewelry, mixed media. Juried. Number of exhibitors: 250. Public attendance: 10,000 + . Free to public; parking: \$5. For more information, artists should visit website or e-mail.

☑ CEDARHURST CRAFT FAIR

P.O. Box 923, Richview Rd., Mt. Vernon IL 62864. (618)242-1236, ext. 234. Fax: (618)242-9530. E-mail: linda@cedarhurst.org. Website: www.cedarhurst.org. Arts & crafts show held annually in September. Outdoors. Accepts photography, paper, glass, metal, clay, wood, leather, jewelry, fiber, baskets, 2D art. Juried. Awards/prizes: Best of each category. Number of exhibitors: 125. Public attendance: 12,000. Public admission: \$5. Artists should apply by filling out application form. Deadline for entry: March. Application fee: \$25. Space fee: \$280. Exhibition space: 10×15 ft. For more information, artists should e-mail, visit website.

CENTERVILLE/WASHINGTON TOWNSHIP AMERICANA FESTIVAL

P.O. Box 41794, Centerville OH 45441-0794. (937)433-5898. Fax: (937)433-5898. E-mail: americanafestival@sbcglobal.net. Website: www.americanafestival.org. Estab. 1972. Arts & crafts show held annually on the Fourth of July except when the 4th falls on a Sunday, when the festival is held on Monday the 5th. Festival includes entertainment, parade, food, car show and other activities. Accepts photography and all mediums. "No factory-made items accepted." Awards/prizes: 1st Place; 2nd Place; 3rd Place; certificates and ribbons for most attractive displays. Number of exhibitors: 275-300. Public attendance: 70,000. Free to the public. Artists should send SASE for application form. "Main Street is usually full by early June." Space fee: \$50. Exhibition space: 12 × 10 ft. For more information, artists should e-mail, visit website, call.

Tips "Artists should have moderately priced items; bring business cards; and have an eye-catching display."

M CHARDON SQUARE ARTS FESTIVAL

(440)564-9096. **Chairman:** Jan Gipson. Estab. 1980. Fine arts & crafts show held annually in August. Outdoors. Accepts photography, pottery, weaving, wood, paintings, jewelry. Juried. Number of exhibitors: 105. Public attendance: 3,000. Free to public. Artists should apply by calling for application. Exhibition space: 10×10 ft. For more information, artists should call.

Tips "Make your booth attractive; be friendly and offer quality work."

M CHATSWORTH CRANBERRY FESTIVAL

P.O. Box 286, Chatsworth NJ 08019. (609)726-9237. Fax: (609)726-1459. E-mail: lgiamalis@ aol.com. Website: www.cranfest.org. Estab. 1983. Arts & crafts show held annually in October. Outdoors. Accepts photography. Juried. Number of exhibitors: 200. Public attendance: 75,000-100,000. Free to public. Artists should apply by sending SASE to above address. Exhibition space: 15 × 15 ft. For more information, artists should visit website.

CHRISTMAS AND EASTER CRAFT SHOWS

Memorial Hall York Expo Center, York PA 17402. (717)764-1155, ext. 1243. Fax: (717)252-4708. E-mail: jolene.kirsch@cumulus.com. Website: www.warm103.com. Christmas (mid-December) and Easter arts & crafts shows held annually. Accepts photography and handmade crafts. Number of exhibitors: 100. Public attendance: 3,000. Public admission: \$3. Artists should apply on the website or through the mail. Space fee: \$95. Exhibition space: 10×10 ft. Average gross sales/exhibitor: \$1,000-2,000.

CHRISTMAS CRAFT SHOW

Craft Show, Cumus Radio, 5989 Susquehanna Plaza Dr., York PA 17406-8910. (717)764-1155, ext. 1367. Fax: (717)252-4708. E-mail: jolene.kirsch@cumulus.com. Website: www.warm103.com. Arts & crafts show held annually in early December. Indoors. Accepts photography and all hand crafts. Number of exhibitors: 250. Public attendance: 3,000. Public admission: \$3. Artists should apply by visiting website or calling or mailing for an entry form. Space fee: \$95. Exhibition space: 10×10 ft. Average gross sales/exhibitor: \$1,000-\$2,000. For more information, artists should e-mail, visit website or call.

CHUN CAPITOL HILL PEOPLE'S FAIR

1290 Williams St., Denver CO 80218. (303)830-1651. Fax: (303)830-1782. E-mail: andreafurness@ chundenver.org; nicoleanderson@chundenver.org. Website: www.peoplesfair.com; www. chundenver.org. Arts & crafts show held annually 1st weekend in June. Outdoors. Accepts photography, ceramics, jewelry, paintings, wearable art, glass, sculpture, wood, paper, fiber, children's items, and more. Juried by professional artisans representing a variety of mediums and selected members of fair management. The jury process is based on originality, quality and expression. Awards/prizes: Best of Show. Number of exhibitors: 300. Public attendance: 250,000. Free to public. Artists should apply by downloading application from website. Deadline for entry: March. Application fee: \$35. Space fee: \$300. Exhibition space: 10 × 10 ft. For more information, artists should e-mail, visit website or call.

CHURCH STREET ART & CRAFT SHOW

P.O. Box 1409, 9 S. Main St., Waynesville NC 28786. (828)456-3517. E-mail: downtownwaynesville@ charter.net. Website: www.downtownwaynesville.com. Estab. 1983. Fine arts & crafts show held annually 2nd Saturday in October. Outdoors. Accepts photography, paintings, fiber, pottery, wood, jewelry. Juried by committee: submit 4 slides or photos of work and 1 of booth display. Number of exhibitors: 100. Public attendance: 15,000-18,000. Free to public. Exhibition space: 10 × 12 ft.-12 × 20 ft. For more information and application, see website.

Tips Recommends "quality in work and display."

CITY OF FAIRFAX FALL FESTIVAL

4401 Sideburn Rd., Fairfax VA 22030. (703)385-7949. Fax: (703)246-6321. E-mail: lherman@ fairfaxva.gov; ParksRec@fairfaxva.gov. **Special Events Coordinator**: Leslie Herman. Estab. 1975. Arts & crafts show held annually 2nd Saturday in October. Outdoors. Accepts photography, jewelry, glass, pottery, clay, wood, mixed media. Juried by a panel of 5 independent jurors. Number of exhibitors: 500. Public attendance: 25,000. Artists should apply by contacting Leslie Herman for an application. Deadline for entry: March. Application fee: \$10. Space fee: \$150. Exhibition space: 10 × 10 ft. For more information, artists should e-mail.

Tips "Be on-site during the event. Smile. Price according to what the market will bear."

CITY OF FAIRFAX HOLIDAY CRAFT SHOW

10455 Armstrong St., Fairfax VA 22030. (703)385-7949. Fax: (703)246-6321. E-mail: ParksRec@ fairfaxva.gov; leslie.herman@fairfaxva.gov. Website: www.fairfaxva.gov. **Special Events Coordinator:** Leslie Herman. Estab. 1985. Arts & crafts show held annually 3rd weekend in November. Indoors. Accepts photography, jewelry, glass, pottery, clay, wood, mixed media. Juried by a panel of 5 independent jurors. Number of exhibitors: 247. Public attendance: 10,000. Public admission: \$5 for age 18 an older. \$8 for two day pass. Artists should apply by contacting Leslie Herman for an application. Deadline for entry: March. Application fee: \$10. Space fee: 10×6 ft.: \$185; 11×9 ft.: \$235; 10×10 ft.: \$260. For more information, artists should e-mail. Currently full. **Tips** "Be on-site during the event. Smile. Price according to what the market will bear."

CODORUS SUMMER BLAST

5989 Susquehanna Plaza Dr., York PA 17406. (717)764-1155, ext. 1367. E-mail: jolene.kirsch. cumulus.com. Website: www.warm103.com. Estab. 2000. Arts & crafts show held annually in late June. Accepts photography and all crafts. Number of exhibitors: 50. Public attendance: 15,000. Free to the public. Artists should apply on website or through the mail. Exhibition space: 20×20 ft. Average gross sales/exhibitor: \$1,000-2,000. For more information, artists should e-mail, visit website or call.

• York Craft Shows also sponsors Christmas Craft Show in mid-December. See listing for this event in this section.

☑ COLORSCAPE CHENANGO ARTS FESTIVAL

P.O. Box 624, Norwich NY 13815. (607)336-3378. E-mail: info@colorscape.org. Website: www. colorscape.org. Fine arts & crafts show held annually the weekend after Labor Day. Outdoors. Accepts photography and all types of mediums. Juried. Awards/prizes: \$5,000. Number of exhibitors: 85-90. Public attendance: 14,000-16,000. Free to public. Deadline for entry: March. Application fee: \$15/jury fee. Space fee: \$175. Exhibition space: 12 × 12 ft. For more information, artists should e-mail, visit website, call or send SASE.

Tips "Interact with your audience. Talk to them about your work and how it is created. People like to be involved in the art they buy and are more likely to buy if you involve them."

CONYERS CHERRY BLOSSOM FESTIVAL

1184 Scott St., Conyers GA 30012. (770)929-4270. E-mail: harriet.gattis@conyersga.com. Website: www.conyerscherryblossomfest.com. Estab. 1981. Arts & crafts show held annually in late March. Outdoors. Accepts photography, paintings. Juried. Number of exhibitors: 300. Public attendance: 40,000. Free to public. Exhibition space: 10×10 ft. For more information, artists should e-mail, visit website or call.

M COUNTRY ARTS & CRAFTS FAIR

PO Box 12, Germantown WI 53022. (262)255-1812. Fax: (262)255-9033. Website: www. germantownchamber.org. Estab. 1975. Arts & crafts show held annually in September. Indoors and outdoors. Limited indoor space; unlimited outdoor booths. Accepts photography, jewelry, clothing, country crafts. Number of exhibitors: 70. Public attendance: 500-600. Free to the public. Artists should e-mail for an application and state permit. Exhibition space: 10×10 ft. and 15×15 ft. For more information, artists should e-mail, call or send SASE.

CRAFT FAIR AT THE BAY

38 Charles St., Rochester NH 03867. (603)332-2616. Fax: (603) 332-8413. E-mail: info@ castleberryfairs.com. Website: www.castleberryfairs.com. Estab. 1988. Arts & crafts show held annually in July in Alton Bay, New Hampshire. Outdoors. Accepts photography and all other. mediums. Juried by photo, slide or sample. Number of exhibitors: 85. Public attendance: 7,500. Free to the public. Artists should apply by downloading application from website. Deadline for entry: until full. Exhibition space: 100 sq. ft. Average gross sales/exhibitor: "Generally, this is considered an 'excellent' show, so I would guess most exhibitors sell ten times their booth fee, or in this case, at least \$2,500 in sales." For more information, artists should visit website.

Tips "Do not bring a book; do not bring a chair. Smile and make eye contact with everyone who enters your booth. Have them sign your guest book; get their e-mail address so you can let them know when you are in the area again. And, finally, make the sale—they are at the fair to shop, after all."

CRAFTS AT RHINEBECK

6550 Springbrook Ave., Rhinebeck NY 12572. (845)876-4001. Fax: (845)876-4003. E-mail: vimperati@dutchessfair.com. Website: www.craftsatrhinebeck.com. **Event Coordinator:** Vicki

Imperati. Estab. 1981. Fine arts & crafts show held biannually in late June and early October, Indoors and outdoors. Accepts photography, fine art, ceramics, wood, mixed media, leather, glass, metal, fiber, jewelry. Juried by 3 slides of work and 1 of booth display. Number of exhibitors: 350. Public attendance: 25,000. Public admission: \$7. Artists should apply by calling for application or downloading application from website. Deadline for entry: February 1. Application fee: \$20. Space fee: \$300-730. Exhibition space: inside: 10×10 ft. and 10×20 ft.; outside: 15×15 ft. For more information, artists should e-mail, visit website or call.

Tips "Presentation of work within your booth is very important. Be approachable and inviting."

M CRAFTWESTPORT

P.O. Box 28, Woodstock NY 12498. (845)331-7484. Fax: (845)331-7484. E-mail: crafts@artrider.com. Website: www.artrider.com. Fine craft and art show held annually in mid-November. Indoors. Accepts photography, wearable and nonwearable fiber, metal and nonmetal jewelry, clay, leather, wood, glass, painting, drawing, prints, mixed media. Juried by 5 images of work and 1 of booth, viewed sequentially. Number of exhibitors: 160. Public attendance: 5,000. Public admission: \$9. Artists should apply by downloading application from www.artrider.com or can apply online at www.zapplication. org. Deadline for entry: July 1. Application fee: \$45. Space fee: \$545. Exhibition space: 10×10 . For more information, artists should e-mail, visit website, call.

CUNEO GARDENS ART FESTIVAL

3417 R.F.D., Long Grove IL 60047. E-mail: dwevents@comcast.net. Website: www.dwevents.org. Contact: D & W Events, Inc. Estab. 2005. Fine arts & crafts show held outdoors in May. Accepts photography, fiber, oil, acrylic, watercolor, mixed media, jewelry, sculpture, metal, paper, painting. Juried by 3 jurors. Awards/prizes: Best of Show; First Place and awards of excellence. Number of exhibitors: 75. Public attendance: 10,000. Free to public. Artists should apply by downloading application from website, e-mail or call. Exhibition space: 100 sq. ft. For more information, artists should e-mail, visit website, call.

Tips "Artists should display professionally and attractively, and interact positively with everyone."

DEERFIELD FINE ARTS FESTIVAL

3417 R.F.D., Long Grove IL 60047. E-mail: dwevents@comcast.net. Website: www.dwevents.org. Contact: D & W Events, Inc. Estab. 2000. Fine arts & crafts show held annually in early June. Outdoors. Accepts photography, fiber, oil, acrylic, watercolor, mixed media, jewelry, sculpture, metal, paper, painting. Juried by 3 jurors. Awards/prizes: Best of Show; First Place, awards of excellence. Number of exhibitors: 150. Public attendance: 35,000. Free to public. Artists should apply by downloading application from website, e-mail or call. Exhibition space: 100 sq. ft. For more information artists should e-mail, visit website, call.

Tips "Artists should display professionally and attractively, and interact positively with everyone."

DELAWARE ARTS FESTIVAL

P.O. Box 589, Delaware OH 43015. (740)363-2695. E-mail: info@delawareartsfestival.org. Website: www.delawareartsfestival.org. Fine arts & crafts show held annually the Saturday and Sunday after Mother's Day. Outdoors. Accepts photography; all mediums, but no buy/sell. Juried by committee members who are also artists. Awards/prizes: Ribbons, cash awards, free booth for the following year. Number of exhibitors: 160. Public attendance: 25,000. Free to the public. Submit three (3) slides or photographs that best represent your work. Your work will be juried in accordance with our guidelines. Photos will be returned only if you provide a SASE. Artists should apply by visiting website for application. Application fee: \$10, payable to the Delaware Arts Festival. Space fee: \$125. Exhibition Space: 120 sq. ft. For more information, artists should e-mail or visit website.

Tips "Have high-quality, original stuff. Engage the public. Applications will be screened according to originality, technique, craftsmanship and design. The Delaware Arts Festival, Inc., will exercise the right to reject items during the show that are not the quality of the media submitted with the applications. No commercial buy and resell merchandise permitted. Set up a good booth."

DOWNTOWN FESTIVAL & ART SHOW

P.O. Box 490, Gainesville FL 32602. (352)393-8536. Fax: (352)334-2249. E-mail: Piperlr@ Cityofgainesville.org. Website: www.Gvlculturalaffairs.org. Events Coordinator: Linda Piper. Estab. 1981. Fine arts & crafts show held annually in November. Outdoors. Accepts photography, wood, ceramic, fiber, glass, and all mediums. Juried by 3 slides of artwork and 1 slide of booth. Awards/prizes: \$14,000 in Cash Awards; \$5,000 in Purchase Awards. Number of exhibitors: 250. Public attendance: 100,000. Free to the public. Artists should apply by mailing 4 slides. Deadline for entry. May. Space fee: \$215, competitive, \$95 noncompetitive. Exhibition space: 12 × 12 ft. Average gross sales/exhibitor: \$6,000. For more information, artists should e-mail, visit website, call.

Tips "Submit the highest-quality slides possible. A proper booth slide is so important."

☑ EDWARDS FINE ART & SCULPTURE FESTIVAL

15648 N. Eagles Nest Dr., Fountain Hills AZ 85268-1418. (480)837-5637. Fax: (480)837-2355. E-mail: info@thunderbirdartists.com. Website: www.thunderbirdartists.com. 11th Annual. Fine arts & sculpture show held annually in late July. Outdoors. Accepts photography, painting, drawing, graphics, fiber sculpture, mixed media, bronze, metal, copper, stone, stained glass, clay, wood, baskets, jewelry. Juried by 4 slides of work and 1 slide of booth presentation. Number of exhibitors: 80. Public attendance: 3,000-6,000. Free to public. Artists should apply by sending application, fees, 4 slides of work, 1 slide of booth labeled and 2 SASE. Deadline for entry: ASAP. Application fee: \$30. Space fee: \$400. Exhibition space: 10 × 10 ft. For more information, artists should visit website.

ELMWOOD AVENUE FESTIVAL OF THE ARTS, INC.

P.O. Box 786, Buffalo NY 14213. (716)830-2484. E-mail: directoreafa@aol.com. Website: www. elmwoodartfest.org. Estab. 2000. Arts & crafts show held annually in late August, the weekend before Labor Day weekend. Outdoors. Accepts photography, metal, fiber, ceramics, glass, wood, jewelry, basketry, 2D media. Juried. Awards/prizes: to be determined. Number of exhibitors: 170. Public attendance: 80,000-120,000. Free to the public. Artists should apply by e-mailing their contact information or by downloading application from website. Deadline for entry: April. Exhibition space: 150 sq. ft. Average gross sales/exhibitor: \$3,000. For more information, artists should e-mail, visit website, call, send SASE.

Tips "Make sure your display is well designed, with clean lines that highlight your work. Have a variety of price points—even wealthy people don't always want to spend \$500 at a booth where they may like the work."

EVERGREEN ARTS FESTIVAL

PO Box 3931, Evergreen CO 80437-3931. (303)679-1609. E-mail: info@evergreenartists.org. Website: www.evergreenartists.org/Shows_Festivals.htm. Fine arts show held annually the last weekend in August. Outdoors in Historic Grove Venue, next to Hiwan Homestead. Accepts both 2D and 3D media, including photography, fiber, oil, acrylic, pottery, jewelry, mixed media, ceramics, wood, watercolor. Juried event with juror(s) that change yearly. Artists should submit a CD with 4 views of work and 1 of booth display by digital photograph high resolution. Awards/prizes: Best of Show; 1st, 2nd, 3rd Places in each category. Number of exhibitors: approximately 96. Public attendance: 3,000-6,000. Free to public. Deadline for entry: April 15. Application fee: \$25. Space fee: \$350, and space is limited. Exhibition space: 10 x 10 ft. Submissions on Zapplication begin in February and jurying completed in early May. For more information, artists should call or send SASE.

Tips "Have a variety of work. It is difficult to sell only high-ticket items."

FAIRE ON THE SQUARE

117 W. Goodwin St., Prescott AZ 86303, United States. (928)445-2000 or (800)266-7534. E-mail: chamber@prescott.org. Website: www.prescott.org. Estab. 1985. Arts & crafts show held annually Labor Day weekend. Outdoors. Accepts photography, ceramics, painting, sculpture, clothing, woodworking, metal art, glass, floral, home décor. No resale. Juried. "Photos of work and artist creating work are required." Number of exhibitors: 170. Public attendance: 10,000-12,000. Free to public. Application can be printed from website or obtained by phone request. Deadline: spaces are sold until show is full. Exhibition space; 10X15 ft. For more information, artist should e-mail, visit website or call.

A FAIR IN THE PARK

906 Yew St., Pittsburgh PA 15224. (412)370-0695. E-mail: info@craftsmensguild.org. Website: www.craftsmensguild.org. **Director:** Katie Horowitz. Estab. 1969. Contemporary fine arts & crafts show held annually the weekend after Labor Day outdoors. Accepts photography, clay, fiber, jewelry, metal, mixed media, wood, glass, 2D visual arts. Juried. Awards/prizes: 1 Best of Show and 4 Craftsmen's Guild Awards. Number of exhibitors: 115. Public attendance: 25,000 + . Free to public. Artists should apply by sending application with jury fee, booth fee and 5 digital images. Deadline for entry: May 1. Exhibition space: 11 × 12 ft. Average gross sales/exhibitor: \$1,000 and up. For more information artists should e-mail, visit website or call.

Tips "It is very important for artists to present their work to the public, to concentrate on the business aspect of their artist career. They will find that they can build a strong customer/collector base by exhibiting their work and by educating the public about their artistic process and passion for creativity."

FALL FEST IN THE PARK

Estab. 1981. Arts & crafts show held annually in mid-October. Outdoors. Accepts photography, ceramics, painting, sculpture, clothing, woodworking, metal art, glass, floral, home décor. "No resale." Juried." Photos of work and artist creating work are required." Number of exhibitors: 150. Public attendance: 6,000-7,000. Free to public. Application can be printed from website or obtained by phone request. Deadline: Spaces are sold until show is full. Exhibition space; 10 × 15 ft. For more information, artists should e-mail, visit website or call.

☑ FALL FESTIVAL OF ART AT QUEENY PARK

P.O. Box 31265, St. Louis MO 63131. (314)889-0433. E-mail: Info@gslaa.org. Website: www.gslaa. org. Estab. 1976. Fine arts & crafts show held annually Labor Day weekend at Queeny Park. Indoors. Accepts photography, all fine art and fine craft categories. Juried by 5 jurors; 5 slides shown simultaneously. Awards/prizes: 3 levels, ribbons, \$4,000 + total prizes. Number of exhibitors: 130. Public attendance: 2,000-4,000. Artists should apply by entrance form on website. Deadline for entry: late May, see website for specific date. Exhibition space: 80 sq. ft. For more information, artists should e-mail or visit website.

Tips "Excellent, professional slides; neat, interesting booth. But most important—exciting, vibrant, eye-catching art work."

FALL FINE ART & CRAFTS AT BROOKDALE PARK

12 Galaxy Court, Hillsborough NJ 08844. (908)874-5247. Fax: (908)874-7098. E-mail: info@ rosesquared.com. Website: www.rosesquared.com. Location: Montclair, NJ. Estab.1997. Fine arts & craft show held annually in mid-October. Outdoors. Accepts photography and all other mediums. Juried. Number of exhibitors: 180. Public attendance: 14,000. Free to the public. Artists should apply by downloading application from website or call for application. Deadline: 1 month before show date. Application fee: \$25. Space fee: \$330. Exhibition space: 120 sq. ft. For more information, artists should e-mail, visit website, call.

Tips "Create a professional booth that is comfortable for the customer to enter. Be informative, friendly and outgoing. People come to meet the artist."

☑ FARGO'S DOWNTOWN STREET FAIR

203 4th St., Fargo ND 58102. (701)241-1570; (701)451-9062. Fax: (701)241-8275. E-mail: steph@ fmdowntown.com. Website: www.fmdowntown.com. Fine arts & crafts show held annually in July (see website for dates). Outdoors. Accepts photography, ceramics, glass, fiber, textile, jewelry, metal, paint, print/drawing, sculpture, 3D mixed media, wood. Juried by a team of artists from the Fargo-Moorehead area. Awards/prizes: Best of Show and best in each medium. Number of exhibitors: 300. Public attendance: 130,000-150,000. Free to pubic. Artists should apply online or by mail. Deadline for entry: February 18. Space fee: \$275/booth; \$50/corner. Exhibition space: 10 × 10 ft. For more information, artists should e-mail, visit website or call.

FAUST FINE ARTS & FOLK FESTIVAL

Greensfelder Recreation Complex, 15185 Olive St., St. Louis MO 63017. (314)615-8482. E-mail: toconnell@stlouisco.com. Website: www.stlouisco.com/parks. Fine arts & crafts show held biannually in May and September. Outdoors. Accepts photography, oil, acrylic, clay, fiber, sculpture, watercolor, jewelry, wood, floral, baskets, prints, drawing, mixed media, folk art. Juried by a committee. Awards/prizes: \$100. Number of exhibitors: 90-100. Public attendance: 5,000. Public admission: Public admission: \$2 for the May show: \$5 for the Sept. show—includes free hayrides and free carousel rides. Deadline for entry: March, spring show; July, fall show. Application fee: \$15. Space fee: \$75. Exhibition space: 10 × 10 ft. For more information, artists should call.

FERNDALE ART SHOW

E-mail: markloeb@aol.com. Website: www.michiganartshow.com. **President:** Mark Loeb. Estab. 2004. Fine arts & crafts show held annually in September. Outdoors. Accepts photography and all fine art and craft mediums; emphasis on fun, funky work. Juried by 3 independent jurors. Awards/prizes: Purchase Awards and Merit Awards. Number of exhibitors: 90. Public attendance: 30,000. Free to the public. Application is available in March. Deadline for entry: July. For more information, artists should e-mail.

Tips "Enthusiasm. Keep a mailing list. Develop collectors."

FESTIVAL IN THE PARK

1409 East Blvd., Charlotte NC 28203. (704)338-1060. E-mail: festival@festivalinthepark.org. Website: www.festivalinthepark.org. Fine arts & crafts show held annually 3rd Thursday after Labor Day. Outdoors. Accepts photography, decorative and wearable crafts, drawing and graphics, fiber and leather, jewelry, mixed media, painting, metal, sculpture, wood. Juried by slides or photographs. Awards/prizes: \$4,000 in cash awards. Number of exhibitors: 150. Public attendance: 100,000. Free to the public. Artists should apply by visiting website for application. Application fee: \$35. Space fee: \$350. Exhibition space: 10 × 10 ft. For more information, artists should e-mail, visit website, call.

FILLMORE JAZZ FESTIVAL

P.O. Box 11017, San Rafael CA 94915. (800)310-6563. Fax: (415)456-6436. Estab. 1984. Fine arts & crafts show and jazz festival held annually 1st weekend of July in San Francisco, between Jackson & Eddy Streets. Outdoors. Accepts photography, ceramics, glass, jewelry, paintings, sculpture, metal clay, wood, clothing. Juried by prescreened panel. Number of exhibitors: 250. Public attendance: 90,000. Free to public. Deadline for entry: ongoing. Exhibition space: 8 × 10 ft. or 10 × 10 ft. Average gross sales/exhibitor: \$800-11,000. For more information, artists should visit website or call.

FINE ART & CRAFTS AT ANDERSON PARK

12 Galaxy Ct., Hillsborough NJ 08844. (908)874-5247. Fax: (908)874-7098. E-mail: info@ rosesquared.com. Website: www.rosesquared.com. Estab. 1984. Location: Upper Montclair, NJ. Fine arts & craft show held annually in mid-September. Outdoors. Accepts photography and all other mediums. Juried. Number of exhibitors: 190. Public attendance: 16,000. Free to the public. Artists should apply by downloading application from website or call for application. Deadline: 1 month before show date. Application fee: \$25. Space fee: \$330. Exhibition space: 120 sq. ft. For more information, artists should e-mail, visit website, call.

Tips "Create a professional booth that is comfortable for the customer to enter. Be informative, friendly and outgoing. People come to meet the artist."

I FINE ART & CRAFTS FAIR AT VERONA PARK

12 Galaxy Ct., Hillsborough NJ 08844. (908)874-5247. Fax: (908)874-7098. E-mail: info@ rosesquared.com. Website: www.rosesquared.com. Estab.1986. Location: Verona, NJ. Fine arts & craft show held annually in May. Outdoors. Accepts photography and all other mediums. Juried. Number of exhibitors: 140. Public attendance: 14,000. Free to the public. Artists should apply by downloading application from website or call for application. Deadline: 1 month before show date. Application fee: \$25. Space fee: \$330. Exhibition space: 120 sq. ft. For more information, artists should e-mail, visit website, call.

Tips "Create a professional booth that is comfortable for the customer to enter. Be informative, friendly and outgoing. People come to meet the artist."

FOOTHILLS CRAFTS FAIR

2753 Lynn Rd. #A, Tryon NC 28782-7870. (828)859-7427. E-mail: info@blueridgebbqfestival.com. Website: www.BlueRidgeBBQFestival.com. Fine arts & crafts show and Blue Ridge BBQ Festival/Championship held annually 2nd Friday and Saturday in June. Outdoors. Accepts photography, arts and handcrafts by artist only; nothing manufactured or imported. Juried. Number of exhibitors: 50. Public attendance: 25,000 +. Public admission: \$8; 12 and under free. Artists should apply by downloading application from website or sending personal information to e-mail or mailing address. See website for deadline for entry. Jury fee: \$25 nonrefundable. Space fee: \$150. Exhibition space: 10×10 ft. For more information, artists should visit website.

Tips "Have an attractive booth, unique items, and reasonable prices."

FORD CITY HERITAGE DAYS

P.O. Box 205, Ford City PA 16226-0205. (724)763-1617. Fax: (724)763-1763. E-mail: fcheritagedays@ gmail.com. Estab. 1980. Arts & crafts show held annually on the Fourth of July. Outdoors. Accepts photography, any handmade craft. Juried by state. Awards/prizes: 1st & 2nd place plaques for best entries. Public attendance: 35,000-50,000. Free to public. Artists should apply by requesting an application by e-mail or telephone. Deadline for entry: April 15. Application fee: \$200. Space fee included with application fee. Exhibition space: 12 × 17 ft. For more information, artists should e-mail, call or send SASE.

Tips "Show runs for six days. Have quality product, be able to stay for length of show, and have enough product."

FOREST HILLS FESTIVAL OF THE ARTS

P.O. Box 477, Smithtown NY 11787. (631)724-5966. Fax: (631)724-5967. E-mail: Showtiques@aol. com. Website: www.showtiques.com. Estab. 2001. Fine arts & crafts show held annually in May/June. Outdoors. Accepts photography, all arts & crafts made by the exhibitor. Juried. Number of exhibitors: 300. Public attendance: 175,000. Free to public. Deadline for entry: until full. Exhibition space: 10×10 ft. For more information, artists should visit website or call.

FOURTH AVENUE SPRING STREET FAIR

434 E. 9th Street, Tucson AZ 85705. (520)624-5004 or (800)933-2477. Fax: (520)624-5933. Website: www.fourthavenue.org. Estab. 1970. Arts & crafts fair held annually in March. Outdoors. Accepts photography, drawing, painting, sculpture, arts and crafts. Juried by 5 jurors. Awards/prizes: Best of Show. Number of exhibitors: 400. Public attendance: 300,000. Free to the public. Artists should apply by completing the online application. Exhibition space: 10×10 ft. Average gross sales/exhibitor: \$3,000. For more information, artists should e-mail, visit website, call, send SASE.

FOURTH AVENUE WINTER STREET FAIR

434 E. 9th Street, Tucson AZ 85705. (520)624-5004 or (800)933-2477. Fax: (520)624-5933. Website: www.fourthavenue.org. Estab. 1970. Arts & crafts fair held annually in December. Outdoors. Accepts photography, drawing, painting, sculpture, arts and crafts. Juried by 5 jurors. Awards/prizes: Best of Show. Number of exhibitors: 400. Public attendance: 300,000. Free to the public. Artists should apply by completing the online application. Deadline for entry: September. Exhibition space: 10×10 ft. Average gross sales/exhibitor: \$3,000. For more information, artists should e-mail, visit website, call, send SASE.

FOURTH OF JULY STREET FAIR and AUTUMN FEST IN THE PARK

501 Poli St., #226, Ventura CA 93002. (805)654-7749. Fax: (805)648-1030. Website: www. venturastreetfair.com. Fine arts & crafts show held annually in July and September. Outdoors. Accepts photography. Juried by a panel of 3 artists who specialize in various mediums; photos of work required. Number of exhibitors: 75-300. Public attendance: 1,000-50,000. Free to public. Artists should apply by downloading application from website or call to request application. Space fee: \$100-175. Exhibition space: 10 × 10 ft. For more information, artists should e-mail, visit website or call.

Tips "Be friendly, outgoing; know the area for pricing."

FOURTH STREET FESTIVAL FOR THE ARTS & CRAFTS

P.O. Box 1257, Bloomington IN 47402. (812)335-3814. E-mail: info@4thstreet.org. Website: www.4thstreet.org. Estab. 1976. Fine arts & crafts show held annually Labor Day weekend. Outdoors. Accepts photography, clay, glass, fiber, jewelry, painting, graphic, mixed media, wood. Juried by a 4-member panel. Awards/prizes: Best of Show, 1st, 2nd, 3rd in 2D and 3D. Number of exhibitors: 105. Public attendance: 25,000. Free to public. Artists should apply by sending requests by mail, e-mail or download application from website. Exhibition space: 10×10 ft. Average gross sales/exhibitor: \$2,700. For more information, artists should e-mail, visit website, call or send for information with SASE.

Tips "Be professional."

FRANKFORT ART FAIR

P.O. Box 566, Frankfort MI 49635. (231)352-7251. Fax: (231)352-6750. E-mail: fcofc@frankfort-elberta.com. Website: www.frankfort-elberta.com. Executive Director: Joanne Bartley. Fine Art Fair held annually in August. Outdoors. Accepts photography, clay, glass, jewelry, textiles, wood, drawing/graphic arts, painting, sculpture, baskets, mixed media. Juried by three photos of work, one photo of booth display and one photo of work in progress. Prior exhibitors are not automatically accepted. No buy/sell allowed. Artists should apply by downloading application from website, e-mailing or calling. Deadline for entry: May 1. Jury fee: \$15. Space fee: \$105 for Friday and Saturday. Exhibition space: 12 × 12 ft. For more information, artists should e-mail, see website.

M FREDERICK FESTIVAL OF THE ARTS

15 W. Patrick St., Frederick MD 21701. (301)662-4190. Fax: (301)663-3084. E-mail: areese@ frederickartscouncil.org. Website: www.Frederickarts.org. Marketing & Development Director:

Apple Reese. "Juried two-day fine art and fine craft regional festival and multidisciplined celebration of the arts. Offerings include over 120 professional artists from over 20 states, two stages of musical performances, children's crafts and activities, artist demonstrations, as well as interactive Classical theater performances."

Tips "Pricing is key. People like to feel like they are getting a deal."

GARRISON ART CENTER FINE ART & CRAFT FAIR

23 Garrison's Landing, P.O. Box 4, Garrison NY 10524. (845)424-3960. E-mail: info@ garrisonartcenter.org. Website: www.garrisonartcenter.org. Fine arts & crafts show held annually 3rd weekend in August. Outdoors. Accepts all mediums. Juried by a committee of artists and community members. Number of exhibitors: 100. Public attendance: 10,000. Artists should call for application form or download from website. Deadline for entry: April. Exhibition space: 10 × 10 ft. For more information, artists should e-mail, visit website, call, send SASE.

Tips "Have an inviting booth and be pleasant and accessible. Don't hide behind your product-engage the audience."

GERMANTOWN FESTIVAL

PO Box 381741, Germantown TN 38183. (901)757-9212. E-mail: gtownfestival@aol.com. Website: www.germantownfest.com. Arts & crafts show held annually the weekend after Labor Day. Outdoors. Accepts photography, all arts & crafts mediums. Number of exhibitors: 400 + . Public attendance: 65,000. Free to public. Artists should apply by sending applications by mail. Deadline for entry: until filled. Application/space fee: \$190-240. Exhibition space: 10×10 ft. For more information, artists should e-mail, call or send SASE.

Tips "Display and promote to the public. Price attractively."

☑ GLOUCESTER WATERFRONT FESTIVAL

38 Charles St., Rochester NH 03867. (603)332-2616. E-mail: terrym@worldpath.net. Website: www. castleberryfairs.com. Arts & crafts show held 3rd weekend in August in Gloucester, MA. Outdoors on Hough Avenue; two days, 9 am-6 pm. Accepts photography and all other mediums. Juried by photo, slide or sample. Number of exhibitors: 225. Public attendance: 50,000. Free to the public. Artists should apply by downloading application from website. Deadline for entry: until full. Space fee: \$375. Exhibition space: 100 sq. ft. Average gross sales/exhibitor: "Generally, this is considered an 'excellent' show, so I would guess most exhibitors sell ten times their booth fee, or in this case, at least \$3,500 in sales." For more information, artists should visit website.

Tips "Do not bring a book; do not bring a chair. Smile and make eye contact with everyone who enters your booth. Have them sign your guest book; get their e-mail address so you can let them know when you are in the area again. And, finally, make the sale-they are at the fair to shop, after all."

GOLD RUSH DAYS

P.O. Box 774, Dahlonega GA 30533. (706)864-7247. E-mail: festival@dahlonegajaycees.com. Website: www.dahlonegajaycees.com. Arts & crafts show held annually the 3rd full week in October. Accepts photography, paintings and homemade, handcrafted items. No digitally originated art work. Outdoors. Number of exhibitors: 300. Public attendance: 200,000. Free to the public. Artists should apply online under "Gold Rush," or send SASE to request application. Deadline: March. Exhibition space: 10×10 ft. Artists should e-mail, visit website for more information.

Tips "Talk to other artists who have done other shows and festivals. Get tips and advice from those in the same line of work."

GOOD OLD SUMMERTIME ART FAIR

P.O. Box 1753, Kenosha WI 53141. (262)654-0065. E-mail: KenoshaArtAssoc@yahoo.com. Website: www.kenoartassoc.tripod.com/events.html. Estab. 1975. Fine arts show held annually the 1st Sunday

in June. Outdoors. Accepts photography, paintings, drawings, mosaics, ceramics, pottery, sculpture, wood, stained glass. Juried by a panel. Photos or slides required with application. Number of exhibitors: 100. Public attendance: 3,000. Free to public. Artists should apply by completing application form, and including fees and SASE. Deadline for entry: April 1. Exhibition space: 12 × 12 ft. For more information, artists should e-mail, visit website or send SASE.

Tips "Have a professional display, and be friendly."

GRADD ARTS & CRAFTS FESTIVAL

3860 US Hwy 60 W., Owensboro KY 42301. (270)926-4433. Fax: (270)684-0714. E-mail: bethgoetz@gradd.com. Website: www.gradd.com. Festival Coordinator: Beth Goetz. Estab. 1972. Arts & crafts show held annually 1st full weekend in October. Outdoors. Accepts photography taken by crafter only. Number of exhibitors: 180-200. Public attendance: 15,000 + . Artists should apply by calling to be put on mailing list. Exhibition space: 10 × 12 ft. For more information, artists should e-mail, visit website or call.

Tips "Be sure that only hand-crafted items are sold. No buy/sell items will be allowed."

GRAND FESTIVAL OF THE ARTS & CRAFTS

PO Box 429, Grand Lake CO 80447-0429. (970)627-3372. Fax: (970)627-8007. E-mail: glinfo@grandlakechamber.com. Website: www.grandlakechamber.com. Festival Coordinator: Betty Murray. Fine arts & crafts show held annually in June & September. Outdoors. Accepts photography, jewelry, leather, mixed media, painting, paper, sculpture, wearable art. Juried by chamber committee. Awards/prizes: Best in Show and People's Choice. Number of exhibitors: 60-75. Public attendance: 1,000 + . Free to public. Artists should apply by submitting slides or photos. Deadline for cntry: June 1 & September 1. Application fee: \$175, includes space fee and business license. Exhibition space: 10 × 10 ft. For more information, artists should e-mail or call.

M GREAT LAKES ART FAIR

46100 Grand River Ave., Novi MI 48374. (248)348-5600. Fax: (248)347-7720. E-mail: info@ greatlakesartfair.com. Website: www.greatlakesartfair.com. Contact: Kristina Jones. Estab. 2009. Held twice per year. Accepts paintings, sculptures, metal and fiber work, jewelry, 2D and 3D art, ceramics, and glass. Cash prizes are given. Number of exhibitors: 150-200. Public attendance: 12,000-15,000. Application fee: \$30. Space fee: \$400. Exhibition space: 10 × 12 ft.

GREAT NECK STREET FAIR

P.O. Box 477, Smithtown NY 11787. (631)724-5966. Fax: (631)724-5967. E-mail: Showtiques@ aol.com. Website: www.showtiques.com. Estab. 1978. Fine arts & crafts show held annually in May. Outdoors. Accepts photography, all arts & crafts made by the exhibitor. Juried. Number of exhibitors: 250. Public attendance: 50,000. Free to public. Deadline for entry: until full. Exhibition space: 10×10 ft. For more information, artists should e-mail, visit website or call.

GREENWICH VILLAGE ART FAIR

711 N. Main St., Rockford IL 61103. (815)972-2870 (815)968-2787. Fax: (815)316-2179. E-mail: ldennis@rockfordartmuseum.org. Website: www.rockfordartmuseum.org. Contact: Nancy. Estab. 1948. Fine arts & crafts show held annually in September. Outdoors. To prepare for our application in 2011, please review the 2010 Prospectus. Our application will open late October and close early January. Download prospectus to apply. Accepts photography and all mediums. Juried by a panel of artists and committee. Awards/prizes: Best of Show and Best of Categories. Number of exhibitors: 120. Public attendance: 7,000. Artists should apply by mail or locating prospectus on the website. Deadline for entry: April 30. Exhibition space: 10 × 10 ft. For more information, artists should e-mail, visit website or call.

M GUILFORD CRAFT EXPO

P.O. box 28, Woodstock NY 12498. (845)331-7900. E-mail: crafts@artrider.com. Website: http://guilfordartcenter.org; www.artrider.com. Fine art & craft show held annually in mid-July. Outdoors. Accepts photography, wearable and nonwearable fiber, metal and nonmetal jewelry, clay, leather, wood, glass, painting, drawing, prints, mixed media. Juried by 5 images of work and 1 of booth, viewed sequentially. Number of exhibitors: 180. Public attendance: 14,000. Public admission: \$7. Artists should apply by downloading application from www.artrider.com or can apply online at www.zapplication.org. Deadline for entry: January 1. Application fee: \$45. Space fee: \$630-655. Exhibition space: 10 × 10 ft. For more information, artists should e-mail, visit website, call.

GUNSTOCK SUMMER FESTIVAL

38 Charles St., Rochester NH 03867. (603)332-2616. Fax: (603)332-8413. E-mail: info@castle berryfairs.com. Website: www.castleberryfairs.com. Estab. 1971. Arts & crafts show held annually in July. Indoors and outdoors. Accepts photography and all other mediums. Juried by photo, slide or sample. Number of exhibitors: 100. Public attendance: 10,000. Free to the public. Artists should apply by downloading application from website. Deadline for entry: until full. Exhibition space: 100 sq. ft. For more information, artists should visit website.

• Event held in Gilford, NH.

Tips "Do not bring a book; do not bring a chair. Smile and make eye contact with everyone who enters your booth. Have them sign your guest book; get their e-mail address so you can let them know when you are in the area again. And, finally, make the sale-they are at the fair to shop, after all."

HIGHLAND MAPLE FESTIVAL

(540)468-2550. Fax: (540)468-2551. E-mail: info@highlandcounty.org. Website: www. highlandcounty.org. Estab. 1958. Fine arts & crafts show held annually the 2nd and 3rd weekends in March. Indoors and outdoors. Accepts photography, pottery, weaving, jewelry, painting, wood crafts, furniture. Juried by 3 photos or slides. Number of exhibitors: 150. Public attendance: 35,000-50,000. "Vendors accepted until show is full." Exhibition space: 10 × 10 ft. For more information, artists should e-mail, visit website, call.

Tips "Have quality work and good salesmanship."

HIGHLANDS ART LEAGUE'S ANNUAL FINE ARTS & CRAFTS FESTIVAL

1989 Lakeview Dr., Sebring FL 33870. (863)385-5312. Fax: 863-385-5336. E-mail: director@ highlandsartleague.org. **Festival Director:** Martile Blackman. Estab. 1966. Fine arts & crafts show held annually 2nd weekend in November. Outdoors. Accepts photography, pottery, painting, jewelry, fabric. Juried based on quality of work. Awards/prizes: monetary awards up to \$1,500 and Purchase Awards. Number of exhibitors: 100 + . Public attendance: more than 15,000. Free to the public. Artists should apply by calling or visiting website for application form. Deadline for entry: October. Exhibition space: 10 × 14 ft. Artists should e-mail for more information.

HINSDALE FINE ARTS FESTIVAL

22 E. First St., Hinsdale IL 60521. (630)323-3952. Fax: (630)323-3953. E-mail: info@hinsdalechamber. com. Website: www.hinsdalechamber.com. Fine arts show held annually in mid-June. Outdoors (in beautiful park setting). Accepts photography, ceramics, painting, sculpture, fiber arts, mixed media, jewelry. Juried by 3 slides. Awards/prizes: Best in Show, Presidents Award and 1st, 2nd and 3rd Place in 2-dimensional and 3-dimensional categories. Number of exhibitors: 140. Public attendance: 2,000-3,000. Free to public. Artists should apply by mailing or downloading application from website. Deadline for entry: First week in March. Application fee: \$25. Space fee: \$250. Exhibition space: 10×10 ft. For more information, artists should e-mail or visit website.

Tips "Original artwork sold by artist."

HOLIDAY ARTS & CRAFTS SHOW

60 Ida Lee Dr., Leesburg VA 20176. (703)777-1368. Fax: (703)737-7165. E-mail: Ifountain@leesburgva. gov. Website: www.leesburgva.gov. Arts & crafts show held annually 1st weekend in December. Indoors. Accepts photography, jewelry, pottery, baskets, clothing, accessories. Juried. Number of exhibitors: 95. Public attendance: 2,500. Free to public. Artists should apply by downloading application from website. Deadline for entry: August 31. Space fee: \$100-150. Exhibition space: 10 × 7 ft. and 10 × 10 ft. For more information, artists should e-mail or visit website.

HOLIDAY CRAFTS AT MORRISTOWN

P.O. Box 28, Woodstock NY 12498. (845)31-7900. Fax: (845)31-7484. E-mail: crafts@artrider.com. Website: www.craftsatmorristown.com. Fine arts & crafts show held annually in early December. Indoors. Accepts photography, wearable and nonwearable fiber, metal and nonmetal jewelry, clay, leather, wood, glass, painting, drawing, prints, mixed media. Juried by 5 images of work and 1 of booth, viewed sequentially. Number of exhibitors: 150. Public attendance: 5,000. Public admission: \$7. Artists should apply by downloading application from www.artrider.com or can apply online at www.zapplication.org. Deadline for entry: July 1. Application fee: \$45. Space fee: \$495. Exhibition space: 10×10 . For more information, artists should e-mail, visit website, call.

HOLLY ARTS & CRAFTS FESTIVAL

P.O. Box 2122, Pinehurst NC 28370. (910)295-7462. E-mail: sbharrison@earthlink.net. Website: www.pinehurstbusinessguild.com. Contact: Susan Harrison. Estab. 1978. Arts & crafts show held annually 3rd Saturday in October. Outdoors. Accepts quality photography, arts, and crafts. Juried based on uniqueness, quality of product, and overall display. Awards/prizes: plaque given to Best in Show. Number of exhibitors: 200. Public attendance: 7,000. Free to the public. Artists should apply by filling out application form. Deadline for entry: March. Space fee: \$75. Exhibition space: 10×10 ft. For more information, artists should e-mail, visit website, call, send SASE. Applications accepted after deadline if available space.

HOME, CONDO AND GARDEN ART & CRAFT FAIR

P.O. Box 486, Ocean City MD 21843. (410)213-8090. Fax: (410)213-8092. E-mail: oceanpromotions@ beachin.net. Website: www.oceanpromotions.info. **Assistant Promoter:** Mike Starr. Estab. 1984. Fine arts & crafts show held annually in March. Indoors. Accepts photography, carvings, pottery, ceramics, glass work, floral, watercolor, sculpture, prints, oils, pen & ink. Number of exhibitors: 125. Public attendance: 12,000. Public admission: \$7/adults; \$6/seniors & students; 13 and under free. Artists should apply by e-mailing request for info and application. Deadline for entry: Until full. Space fee: \$250. Exhibition space: 8 × 12 ft. For more information, artists should e-mail, visit website or call.

HOME DECORATING & REMODELING SHOW

P.O. Box 230699, Las Vegas NV 89105-0699. (702)450-7984; (800)343-8344. Fax: 702)451-7305. E-mail: spvandy@cox.net. Website: www.nashvillehomeshow.com. Estab. 1983. Home show held annually in September. Indoors. Accepts photography, sculpture, watercolor, oils, mixed media, pottery. Awards/prizes: Outstanding Booth Award. Number of exhibitors: 300-350. Public attendance: 25,000. Public admission: \$8. Artists should apply by calling. Marketing is directed to middle and above income brackets. Deadline for entry: open until filled. Space fee: \$900 + . Exhibition space: 9×10 ft. or complement of 9×10 ft. For more information, artists should call.

HOT SPRINGS ARTS & CRAFTS FAIR

Garland County Fairgrounds, Higdon Ferry Rd., Hot Springs AR 71912. (501)623-9592. E-mail: sephpipkin@aol.com. Website: www.hotspringsartsandcraftsfair.com. Fine arts & crafts show held annually the 1st full weekend in October. Indoors and outdoors. Accepts photography and varied

mediums ranging from heritage, crafts, jewelry, furniture. Juried by a committee of 12 crafter & artist volunteers. Number of exhibitors: 350+. Public attendance: 50,000+. Free to public. Deadline for entry: August. Single space fee: \$100. Exhibition space: 10 × 10 ft. Double space fee: \$200 (10×20 ft.). For more information, artists should e-mail or call.

M STAN HYWET HALL & GARDENS WONDERFUL WORLD OF OHIO MART

714 N. Portage Path, Akron OH 44303. (330)836-5533 or (888)836-5533. E-mail: info@StanHywet. org. Website: www.stanhywet.org. Estab. 1966. Arts & crafts show held annually 1st full weekend in October. Outdoors. Accepts photography and all mediums. Juried 2 Saturdays in January and via mail application. Awards/prizes: Best Booth Display. Number of exhibitors: 115. Public attendance: 15,000-20,000. Exhibition space: 10 × 10 ft. For more information, artists should visit website or call.

INDIAN WELLS ARTS FESTIVAL

78-200 Miles Ave, Indian Wells CA 92210. (760)346-0042. Fax: (760)346-0042. E-mail: Info@ Indianwellsartsfestival.com. Website: www.Indianwellsartsfestival.com. Producer: Dianne Funk. "A premier fine arts festival attracting thousands annually. The brings a splash of color to the beautiful grass concourse of the Indian Wells Tennis Garden. This spectacular venue transforms into an artisan village featuring 200 judged and juried artists and hundreds of pieces of one-of-akind artwork available for sale. Watch glass blowing, monumental rock sculpting, wood carving, pottery Wheel Demonstrations, Weaving and Mural Painting. Glass, Bead-making and Canvas Stretching demonstrations. Wine tasting, gourmet market, children's activities, entertainment and refreshment add to the festival atmosphere." See website for information and an application.

Tips "Have a professional display of work. Be approachable and engage in conversation. Don't give up—people sometimes need to see you a couple of times before they buy."

☑ INTERNATIONAL FOLK FESTIVAL

201 Hay St., Fayetteville NC 28302. (910)323-1776. Fax: (910)323-1727. E-mail: kelvinc@ theartscouncil.com, admin@theartscouncil.com; ashleyh@theartscouncil.com. Website: www. theartscouncil.com. Director of Special Events: Kelvin Culbreth. Special Events Coordinator: Ashley Hunt. Estab. 1978. Fine arts & crafts show held annually the last weekend in September. Outdoors. Accepts photography, painting of all mediums, pottery, woodworking, sculptures of all mediums. "Work must be original." Juried. Awards/prizes: \$1,000 in cash prizes. Number of exhibitors: 120 + . Public attendance: 85,000-100,000 over two days. Free to public. Artists should apply on the website. Deadline for entry: September 1. Application fee: \$75; includes space fee. Exhibition space: 10 × 10 ft. For more information, artists should e-mail or visit website.

Tips "Have reasonable prices."

ISLE OF EIGHT FLAGS SHRIMP FESTIVAL

18 N. Second St., Fernandina Beach FL 32034. (904)271-7020. Fax: (904)261-1074. E-mail: mailbox@ islandart.org. Website: www.islandart.org. Fine arts & crafts show and community celebration held annually the 1st weekend in May. Outdoors. Accepts photography and all mediums. Juried. Awards/prizes: \$9,700 in cash prizes. Number of exhibitors: 300. Public attendance: 150,000. Free to public. Artists should apply by downloading application from website. Deadline for entry: January 1. Application fee: \$30. Space fee: \$200. Exhibition space: 10 × 12 ft. Average gross sales/exhibitor: \$1,500 + . For more information, artists should visit website.

Tips "Quality product and attractive display."

JOHNS HOPKINS UNIVERSITY SPRING FAIR

3400 N Charles St., Mattin Ste. 210, Baltimore MD 21218. (410)513-7692. Fax: (410)516-6185. E-mail: springfair@gmail.com. Website: www.jhuspringfair.com. Fine arts & crafts, campus-wide, festival held annually in April. Outdoors. Accepts photography and all mediums. Juried. Number of exhibitors: 80. Public attendance: 20,000 + . Free to public. Artists should apply via website. Deadline for entry: March 1. Application fee: \$200. Space fee: \$200. Exhibition space: 10×10 ft. For more information, artists should e-mail, visit website or call.

Tips "Artists should have fun displays, good prices, good variety and quality pieces."

JUBILEE FESTIVAL

29750 Larry Dee Cawyer Dr., P. O. Drawer 310, Daphne AL 36526. (251)621-8222. Fax: (251)621-8001. E-mail: office@eschamber.com. Website: www.eschamber.com. Estab. 1952. Fine arts & crafts show held in September. Outdoors. Accepts photography and fine arts and crafts. Juried. Awards/prizes: ribbons and cash prizes. Number of exhibitors: 258. Public attendance: 200,000. Free to the public. Exhibition space: 10×10 ft.

• Event held in Olde Towne of Daphne, AL. For more information, artists should e-mail, call, see website.

KETNER'S MILL COUNTY ARTS FAIR

P.O. Box 322, Lookout Mountain TN 37350. (423)267-5702. E-mail: contact@ketnersmill.org. Website: www.ketnersmill.org. Event Coordinator: Barbara Skeen. Estab. 1977. Arts & crafts show held annually the 3rd weekend in October. Outdoors. Accepts photography, painting, prints, dolls, fiber arts, baskets, folk art, wood crafts, jewelry, musical instruments, sculpture, pottery, glass. Juried. Number of exhibitors: 150. Number of attendees: 10,000/day, depending on weather. Artists should call or send SASE to request a prospectus/application. Exhibition space: 15 × 15 ft. Average gross sales/exhibitor: \$1,500.

Tips "Display your best and most expensive work, framed. But also have smaller unframed items to sell. Never underestimate a show: Someone may come forward and buy a large item."

KIA ART FAIR (KALAMAZOO INSTITUTE OF ARTS)

314 S. Park St., Kalamazoo MI 49007. (269)349-7775. Fax: (269)349-9313. E-mail: museum@ kiarts.org. Estab. 1951. Fine arts & crafts show held annually the 1st Friday and Saturday in June. Outdoors. Accepts photography, prints, pastels, drawings, paintings, mixed media, ceramics (functional and nonfunctional), sculpture/metalsmithing, wood, fiber, jewelry, glass, leather. Juried by no fewer than 3 and no more than 5 art professionals chosen for their experience and expertise. See prospectus for more details. Number of exhibitors: 200. Public attendance: 40,000-50,000. Free to the public. Artists should apply by filling out application form and submitting 3 digital images of their art and 1 digital image of booth display. Exhibition space: 10 × 12 ft. Height should not exceed 10 ft. in order to clear the trees in the park. For more information, artists should e-mail, visit website, call.

N N KINGS MOUNTAIN ART FAIR

13106 Skyline Blvd., Woodside CA 94062. (650)851-2710. E-mail: Kmafsecty@Aol.com. Website: www.Kingsmountainartfair.org. **Administrative Assistant:** Carrie German. Est. 1963. Fine arts & crafts show held annually Labor Day weekend. Fund-raiser for volunteer fire dept. Accepts photography, ceramics, clothing, 2D, painting, glass, jewelry, leather, sculpture, textile/fiber, wood. Juried. Number of exhibitors: 138. Public attendance: 10,000. Free to public. Deadline for entry: January 30. Application fee: \$10. Space fee: \$100 plus 15%. Exhibition space: 10×10 ft. Average gross sales/exhibitor: \$3,500. For more information, artists should e-mail, visit website, call or send SASE.

Tips "Read and follow the instructions. Keep an open mind and be flexible."

KRASL ART FAIR ON THE BLUFF

707 Lake Blvd., St. Joseph MI 49085. (269)983-0271. Fax: (269)983-0275. E-mail: info1@krasl. org. Website: www.krasl.org. Fine arts & crafts show held annually in July. Outdoors. Accepts photography, painting, digital art, drawing, pastels, wearable and nonwearable fiber art, glass,

jewelry, sculpture, printmaking, metals and woods. Number of exhibitors: 216. Number of attendees: more than 70,000. Free to public. Application fee: \$30. Applications will be available on line through www.zapplication.com. Deadline for entry: approximately mid-January. There is on-site jurying the same day of the fair; approximately 50% are invited back without having to pay the \$30 application fee. Space fee: \$250. Exhibition space: 15×15 ft. or \$275 for 20×20 ft. (limited). Average gross sales/exhibitor: \$3,000. For more information, artists should e-mail or visit website.

Tips "Be willing to talk to people in your booth. You are your own best asset!"

☑ LAKE CITY ARTS & CRAFTS FESTIVAL

P.O. Box 876, Lake City CO 81235. E-mail: info@lakecityarts.org. Website: www.lakecityarts.org. Estab. 1975. Fine arts/arts & craft show held annually 3rd Tuesday in July. One-day event. Outdoors. Accepts photography, jewelry, metal work, woodworking, painting, handmade items. Juried by 3-5 undisclosed jurors. Prize: Winners are entered in a drawing for a free booth space in the following year's show. Number of Exhibitors: 85. Public Attendance: 500. Free to the public. Exhibition space: 12 × 12 ft. Average gross sales/exhibitor: \$500-\$1,000. For more information, artists should visit website.

Tips "Repeat vendors draw repeat customers. People like to see their favorite vendors each year or every other year. If you come every year, have new things as well as your best-selling products."

LEEPER PARK ART FAIR

22180 Sundancer Ct., Villa 504, Estero FL 33928. (239)495-1783. E-mail: Studio266@aol.com. Website: www.leeperparkartfair.org. **Director:** Judy Ladd. Estab. 1967. Fine arts & crafts show held annually in June. Indoors. Accepts photography and all areas of fine art. Juried by slides. Awards/prizes: \$3,500. Number of exhibitors: 120. Public attendance: 10,000. Free to public. Artists should apply by submitting application along with fees. Deadline for entry: March 1. Exhibition space: 12 × 12 ft. Average gross sales/exhibitor: \$5,000. For more information, artists should e-mail or send SASE.

Tips "Make sure your booth display is well presented and, when applying, slides are top notch!"

II LES CHENEAUX FESTIVAL OF ARTS

P.O. Box 301, Cedarville MI 49719. (906)484-2821. Fax: (906)484-6107. Fine arts & crafts show held annually 2nd Saturday in August. Outdoors. Accepts photography and all other media; original work and design only; no kits or commercially manufactured goods. Juried by a committee of 10. Submit 4 slides (3 of the artwork; 1 of booth display). Awards/prizes: monetary prizes for excellent and original work. Number of exhibitors: 70. Public attendance: 8,000. Public admission: \$7. Artists should fill out application form to apply. Deadline for entry: April 1. Application fee: \$65. Exhibition space: 10×10 ft. Average gross sales/exhibitor: \$5-\$500. For more information, artists should call, send SASE.

□ LIBERTY ARTS SQUARED

P.O. Box 302, Liberty MO 64069. E-mail: Staff@Libertyartssquared.org. Website: www. Libertyartssquared.org. Estab. 2010. Outdoor fine art & craft show held annually. Accepts all mediums. Awards/prizes: cash totaling \$4,000. No admission fee for the public, free parking. Application fee: \$25. Space fee: \$75. Exhibition space: 10 × 10 ft. For more information e-mail or visit website.

□ LILAC FESTIVAL ARTS & CRAFTS SHOW

E-mail: lilacfestival@gmail.com. Website: www.lilacfestival.com. Estab. 1985. Arts & crafts show held annually in May. Outdoors. Accepts photography, painting, ceramics, woodworking, metal sculpture, fiber. Juried by a panel. Number of exhibitors: 150. Public attendance: 25,000. Free

to public. Exhibition space: 10×10 ft. For more information, artists should visit website or send SASE.

☑ LOMPOC FLOWER FESTIVAL

119 Cypress, Lompoc CA 93436. (805)737-1129. E-mail: web@willeyweb.com. Website: www. lompocvalleyartassociation.com. Show held annually last week in June. Festival event includes a parade, food booths, entertainment, beer garden and commercial center, which is not located near arts & crafts area. Outdoors. Accepts photography, fine art, woodworking, pottery, stained glass, fine jewelry. Juried by 5 members of the Lompoc Valley Art Association. Vendor must submit 5 photos of their craft and a description on how to make the craft. Free to public. Artists should apply by calling the contact person for application or download application from website. Deadline for entry: May 1. Application fee: \$200, plus insurance. Exhibition space: 12 × 16 ft. For more information, artists should visit website, call the gallery or send SASE.

Tips "Artists should have prices that are under \$100 to succeed."

N LUTZ ARTS & CRAFTS FESTIVAL

(813)949-7060. **Contact:** Shirley Simmons. Estab. 1979. Fine arts & crafts show held annually in December. Outdoors. Accepts photography, sculpture. Juried. Directors make final decision. Number of exhibitors: 250. Public attendance: 35,000. Free to public. Deadline for entry: September 1 of each year or until category is filled. Exhibition space: 12 × 12 ft. For more information, artists should call or send SASE.

Tips "Have varied price range."

M MADISON CHAUTAUQUA FESTIVAL OF ART

601 W. First St., Madison IN 47250, USA. (812)265-6100. Fax: (812)273-3694. E-mail: georgie@ madisonchautauqua.com. Website: www.Madisonchautauqua.com. Coordinator: Georgie Kelly. Estab. 1901. "Enjoy this juried fine arts & crafts show featuring painting, sculpture, stained glass, textiles, pottery and more amid the tree-lined streets of Madison's Historic District. Stop by the riverfront FoodFest for delicious treats. Relax and listen to the live performances on the Lanier Mansion lawn, on the riverfront, and enjoy strolling performers." Will be held Sept. 24-25, 2011. See website information and an application.

MAIN AVENUE ARTS FESTIVAL

802 E. Second Ave., Durango CO 81301. (970)259-2606. Fax: (970)259-6571. E-mail: info@durangoarts.org. Website: www.durangoarts.org. Estab. 1993. Fine arts & crafts show held annually 2nd full weekend in August. Outdoors. Accepts photography and all mediums. Juried. Number of exhibitors: 100. Public attendance: 8,000. Free to public. Exhibition space: 10 × 10 ft. For more information, artists should e-mail, visit website or send SASE.

MASON ARTS FESTIVAL

P.O. Box 381, Mason OH 45040. (513)309-8585. E-mail: masonarts@gmail.com. Website: www. masonarts.org. **Executive Director:** Meredith Raffel. Fine arts & crafts show held annually in September. Indoors and outdoors. Accepts photography, graphics, printmaking, mixed media; painting and drawing; ceramics, metal sculpture; fiber, glass, jewelry, wood, leather. Juried. Awards/prizes: \$3,000 + . Number of exhibitors: 75-100. Public attendance: 3,000-5,000. Free to the public. Artists should apply by visiting website for application, e-mailing or calling. Deadline for entry: June. Exhibition space: 12 × 12 ft.; artist must provide 10 × 10 ft. pop-up tent.

• City Gallery show is held indoors; these artists are not permitted to participate outdoors and vice versa. City Gallery is a juried show featuring approximately 30-50 artists who may show up to 2 pieces.

Tips "Photographers are required to disclose both their creative and printing processes. If digital manipulation is part of the composition, please indicate."

MEMORIAL WEEKEND ARTS & CRAFTS FESTIVAL

38 Charles St., Rochester NH 03867. (603)332-2616. Fax: (603) 332-8413. E-mail: $\inf o @$ castleberryfairs.com. Website: www.castleberryfairs.com. Estab. 1989. Arts & crafts show held annually on Memorial Day weekend. Outdoors. Accepts photography and all other mediums. Juried by photo, slide or sample. Number of exhibitors: 85. Public attendance: 7,500. Free to the public. Artists should apply by downloading application from website. Deadline for entry: until full. Exhibition space: 10×10 ft. Average gross sales/exhibitor: "Generally, this is considered an 'excellent' show, so I would guess most exhibitors sell ten times their booth fee, or in this case, at least \$3,000 in sales." For more information, artists should visit website.

• Event held in Meredith, NH.

Tips "Do not bring a book; do not bring a chair. Smile and make eye contact with everyone who enters your booth. Have them sign your guest book; get their e-mail address so you can let them know when you are in the area again. And, finally, make the sale-they are at the fair to shop, after all."

MICHIGAN STATE UNIVERSITY HOLIDAY ARTS & CRAFTS SHOW

319 MSU Union, East Lansing MI 48824. (517)355-3354. E-mail: ab@hfs.msu.edu. Website: www. uabevents.com. Estab. 1963. Arts & crafts show held annually 1st weekend in December. Indoors. Accepts photography, basketry, candles, ceramics, clothing, sculpture, soaps, drawings, floral, fibers, glass, jewelry, metals, painting, graphics, pottery, wood. Juried by a panel of judges using the photographs submitted by each vendor to eliminate commercial products. They will evaluate on quality, creativity and crowd appeal. Number of exhibitors: 220. Public attendance: 15,000. Free to public. Artists should apply online. Exhibition space: 8 × 5 ft. For more information, artists should visit website or call.

MICHIGAN STATE UNIVERSITY SPRING ARTS & CRAFTS SHOW

322 MSU Union, East Lansing MI 48824. (517)355-3354. Fax: (517)432-2448. E-mail: uab@hfs. msu.edu; artsandcrafts@uabevents.com. Website: www.uabevents.com. Assistant Manager: Kate Lake. Arts & crafts show held annually the weekend before Memorial Day Weekend in mid-May in conjunction with the East Lansing Art Festival. Free to the public. Outdoors. Accepts photography, basketry, candles, ceramics, clothing, sculpture, soaps, drawings, floral, fibers, glass, jewelry, metals, painting, graphics, pottery, wood. Juried by a panel of judges using the photographs submitted by each vendor to eliminate commercial products. They will evaluate on quality, creativity and crowd appeal. Number of exhibitors: 329. Public attendance: 60,000. Free to public. Artists can apply online beginning in February. Online applications will be accepted until show is filled. Application fee: \$240. Exhibition space: 10 × 10 ft. For more information, artists should visit website or call.

MID-MISSOURI ARTISTS CHRISTMAS ARTS & CRAFTS SALE

P.O. Box 116, Warrensburg MO 64093. (660)747-6092. E-mail: rlimback@iland.net. Holiday arts & crafts show held annually in November. Indoors. Accepts photography and all original arts and crafts. Juried by 3 good-quality color photos (2 of the artwork, 1 of the display). Number of exhibitors: 50. Public attendance: 1,200. Free to the public. Artists should apply by e-mailing or calling for an application form. Deadline for entry: November 1. Space fee: \$50. Exhibition space: 10×10 ft. For more information, artists should e-mail or call.

Tips "Items under \$100 are most popular."

MONTAUK POINT LIONS CLUB

(631)668-5300. Estab. 1970. Arts & crafts show held annually Labor Day weekend. Outdoors. Accepts photography, arts & crafts. Number of exhibitors: 100. Public attendance: 1,000. Free to public. Exhibition space: 10×10 ft. For more information, artists should call.

MOUNTAIN STATE FOREST FESTIVAL

P.O. Box 388, 101 Lough St., Elkins WV 26241. (304)636-1824. Fax: (304)636-4020. E-mail: msff@forestfestival.com; pkeller@forestfestival.com. **Executive Secretary:** Renee Heckel. Estab. 1930. Arts, crafts & photography show held annually in early October. Accepts photography and homemade crafts. Awards/prizes: cash awards for photography only. Number of exhibitors: 50. Public attendance: 50,000. Free to the public. Artists should apply by requesting an application form. Application fee: \$100. Exhibition space: 10 × 10 ft. For more information, artists should visit website, call.

MOUNT GRETNA OUTDOOR ART SHOW

P.O. Box 637, Mount Gretna PA 17064. (717)964-3270. Fax: (717)964-3054. E-mail: mtgretnaart@comcast.net. Website: www.mtgretnaarts.com. Fine arts & crafts show held annually 3rd full weekend in August. Outdoors. Accepts photography, oils, acrylics, watercolors, mixed media, jewelry, wood, paper, graphics, sculpture, leather, clay/porcelain. Juried by 4 professional artists who assign each applicant a numeric score. The highest scores in each medium are accepted. Awards/prizes: Judges' Choice Awards: 30 artists are invited to return the following year, jury exempt; the top 10 are given a monetary award of \$250. Number of exhibitors: 250. Public attendance: 15,000-19,000. Public admission: \$8; children under 12 free. Artists should apply via www.zapplication.org. Deadline for entry: April 1. Application fee: \$25 jury fee. Space fee: \$300-350. Exhibition space: 10 × 12 ft. For more information, artists should e-mail, visit website, call.

NAPA WINE & CRAFTS FAIRE

1310 Napa Town Center, Napa CA 94559. (707)257-0322. E-mail: info@napadowntown.com. Website: www.napadowntown.com. Wine and crafts show held annually in September. Outdoors. Accepts photography, jewelry, clothing, woodworking, glass, dolls, candles and soaps, garden art. Juried based on quality, uniqueness, and overall craft mix of applicants. Number of exhibitors: over 200. Public attendance: 20,000-30,000. Artists should apply by contacting the event coordinator. Application forms are available on website. Exhibition space: 10 × 10 ft. For more information, artists should e-mail, visit website or call.

Tips "Electricity is available, but limited. There is a \$40 processing fee for cancellations."

NEW ENGLAND ARTS & CRAFTS FESTIVAL

38 Charles St., Rochester NH03867. (603)322-2616. Fax: (603)332-8413. E-mail: $\inf @$ castleberryfairs. com. Website: www.castleberryfairs.com. Estab. 1988. Arts & crafts show held annually on Labor Day weekend. Indoors and outdoors. Accepts photography and all other mediums. Juried by photo, slide or sample. Number of exhibitors: 250. Public attendance: 25,000. Artists should apply by downloading application from website. Deadline for entry: until full. Exhibition space: 10×10 ft. Average gross sales/exhibitor: "Generally, this is considered an 'excellent' show, so I would guess most exhibitors sell ten times their booth fee, or in this case, at least \$3,500 in sales." For more information, artists should visit website.

Event held in Topsfield, MA.

Tips "Do not bring a book; do not bring a chair. Smile and make eye contact with everyone who enters your booth. Have them sign your guest book; get their e-mail address so you can let them know when you are in the area again. And, finally, make the sale—they are at the fair to shop, after all."

NEW ENGLAND CRAFT & SPECIALTY FOOD FAIR

38 Charles St., Rochester NH 03867. (603)332-2616. Fax: (603) 332-8413. E-mail: info@ castleberryfairs.com. Website: www.castleberryfairs.com. Estab. 1995. Arts & crafts show held annually on Veteran's Day weekend. Indoors. Accepts photography and all other mediums. Juried by photo, slide or sample. Number of exhibitors: 200. Public attendance: 15,000. Artists should apply by downloading application from website. Deadline for entry: until full. Exhibition space:

10 × 10 ft. Average gross sales/exhibitor: "Generally, this is considered an 'excellent' show, so I would guess most exhibitors sell ten times their booth fee, or in this case, at least \$3,000 in sales." For more information, artists should visit website.

• Event held in Salem, NH.

Tips "Do not bring a book; do not bring a chair. Smile and make eye contact with everyone who enters your booth. Have them sign your guest book; get their e-mail address so you can let them know when you are in the area again. And, finally, make the sale—they are at the fair to shop, after all."

NEW MEXICO ARTS & CRAFTS FAIR

5500 San Mateo NE, Ste. 106, Albuquerque NM 87109. (505)884-9043. Fax: (505)884-9084. E-mail: info@nmartsandcraftsfair.org. Website: www.nmartsandcraftsfair.org. Estab. 1962. Fine arts & craft show held annually in June. Indoors and outdoors. Accepts photography, ceramics, fiber, digital art, drawing, jewelry—precious and nonprecious, printmaking, sculpture, wood, mixed media. Only New Mexico residents 18 years and older are eligible. Additional details for 2011 to be announced; see website for more details.

M NEW ORLEANS JAZZ & HERITAGE FESTIVAL PRESENTED BY SHELL

336 Camp St., Ste. 250, New Orleans LA 70130. (504)410-4100. Fax: (504)410-4122. Website: www. Nojazzfest.com.

Tips Call or mail for more information.

NEW SMYRNA BEACH ART FIESTA

210 Sams Ave., New Smyrna Beach FL 32168. (386)424-2175. Fax: (386)424-2177. E-mail: kshelton@cityofnsb.com. Website: www.cityofnsb.com. Arts & crafts show held annually the last full weekend in February. Outdoors. Accepts photography, oil, acrylics, pastel, drawings, graphics, sculpture, crafts, watercolor. Awards/prizes: \$15,000 prize money; \$1,600/category; Best of Show. Number of exhibitors: 250. Public attendance: 14,000. Free to public. Artists should apply by calling to get on mailing list. Applications are always mailed out the day before Thanksgiving. Deadline for entry: until full. Application/space fee: \$150 plus tax. Exhibition space: 10 × 10 ft. For more information, artists should call.

NEW WORLD FESTIVAL OF THE ARTS

P.O. Box 246, Manteo NC 27954. (252)473-2133. Fax: (252)473-2135. Estab. 1963. Fine arts &crafts show held annually in August. Outdoors. Juried. Accepts photography, watercolor, oil, mixed media, drawing printmaking, graphics, pastel, ceramic, sculpture, fiber, handwoven wearable art, wood, glass, hand-crafted jewelry, metalsmithing, leather. "No commercial molds or kids will be accepted. All work must be signed by the artist." Juror reviews slides to select participants; then selects winners on the 1st day of exhibit. Awards/prizes: cash awards totaling \$3,000. Number of exhibitors: 80. Public attendance: 4,500-5000. Free to pubic. Artists should apply by sending for application. Deadline for entry: June 10. Exhibition space: 10 × 10 ft. For more information, artists should call.

NORTH CONGREGATIONAL PEACH & CRAFT FAIR

17 Church St., New Hartford CT 06057. (860)379-2466. Arts & crafts show held annually in mid-August. Outdoors on the Green at Pine Meadow. Accepts photography, most arts and crafts. Number of exhibitors: 50. Public attendance: 500-2,000. Free to public. Artists should call for application form. Deadline for entry: August. Application fee: \$60. Exhibition space: 11 × 11 ft.

Tips "Be prepared for all kinds of weather."

OFFICIAL TEXAS STATE ARTS & CRAFTS FAIR

4000 Riverside Dr., Kerrville TX 78028. (830)896-5711. Fax: (830)896-5569. E-mail: fair@tacef.org; debbie@tacef.org. Website: www.tacef.org.

Tips "Market and advertise."

ORCHARD LAKE FINE ART SHOW

P.O. Box 79, Milford MI 48381-0079. (248)684-2613. Fax: (248)684-0195. Website: www.hotworks. org. E-mail: Info@Hotworks.org. **Show Director:** Patty Narozny. Estab. 2003. Fine arts & crafts show held annually late July. Next show: July 29-31, 2011. Outdoors. Accepts photography, clay, glass, fiber, wood, jewelry, painting, prints, drawing, sculpture, metal, multimedia. Artist applications available via www.zapplication.com, Juried Art Services, or via "manual" application. Awards: \$2,500 in prizes: \$1,000 Best of Show; two \$500 Purchase Awards; and five \$100 Awards of Excellence. Admission: \$5; 12 & under free; free parking. Deadline March 1, 2011. Space size 10×10 ft.; 10×15 ft. or 10×20 ft. For more information, call or e-mail.

Tips "Be attentive to your customers. Do not ignore anyone."

PANOPLY ARTS FESTIVAL, PRESENTED BY THE ARTS COUNCIL, INC.

700 Monroe Street SW, Ste. 2, Huntsville AL 35801. (256)519-2787. E-mail: tac@panoply.org. Website: www.panoply.org. Estab. 1982. Fine arts show held annually the last weekend in April. Also features music and dance. Outdoors. Accepts photography, painting, sculpture, drawing, printmaking, mixed media, glass, fiber. Juried by a panel of judges chosen for their in-depth knowledge and experience in multiple mediums, and who jury from slides or disks in January. During the festival 1 judge awards various prizes. Number of exhibitors: 60-80. Public attendance: 140,000 + . Artists should e-mail, call or write for an application form, or check online through November 1. Deadline for entry: January. Exhibition space: 10 × 10 ft. Average gross sales/exhibitor: \$2,500. For more information, artists should e-mail.

PARADISE CITY ARTS FESTIVALS

30 Industrial Dr. E., Northampton MA 01060-2351. (800)511-9725. Fax: (413)587-0966. E-mail: artist@paradisecityarts.com. Website: www.paradisecityarts.com. Five fine arts & crafts shows held annually in March, April, May, October and November. Indoors. Accepts photography, all original art and fine craft media. Juried by 5 slides or digital images of work and an independent board of jury advisors. Number of exhibitors: 150-275. Public attendance: 5,000-20,000. Public admission: \$12. Artists should apply by submitting name and address to be added to mailing list or print application from website. Deadline for entry: September 9. Application fee: \$30-45. Space fee: \$650-1,500. Exhibition space: 8 × 10 ft.; 10 × 20 ft. For more information, artists should e-mail, visit website or call.

PATTERSON APRICOT FIESTA

P.O. Box 442, Patterson CA 95363. (209)892-3118. Fax: (209)892-3388. E-mail: patterson_apricot_fiesta@hotmail.com. Website: www.apricotfiesta.com. **Chairperson:** Sandra Stobb. Estab. 1984. Arts & crafts show held annually in May/June. Outdoors. Accepts photography, oils, leather, various handcrafts. Juried by type of product; number of artists already accepted; returning artists get priority. Number of exhibitors: 140-150. Public attendance: 30,000. Free to the public. Deadline for entry: approximately April 15. Application fee/space fee: \$225/craft - \$325/commercial. Exhibition space: 12 × 12 ft. For more information, artists should call, send SASE.

Tips "Please get your applications in early!"

PETERS VALLEY ANNUAL CRAFT FAIR

19 Kuhn Rd., Layton NJ 07851. (973)948-5200 ext. 203. Fax: (973)948-0011. E-mail: craftfair@petersvalley.org. Website: www.petersvalley.org. Estab. 1970. Arts & crafts show held annually

in late September. Indoors. Accepts photography, ceramics, fiber, glass, basketry, metal, jewelry, sculpture, printmaking, paper book art, drawing, painting. Juried. Awards/prizes: cash awards. Number of exhibitors: 185. Public attendance: 7,000-8,000. Public admission: \$8. Artists should apply at www.zapplication.org. Deadline for entry: June 1. Application fee: \$35. Space fee: \$395. Exhibition space: 10x10 ft. Average gross sales/exhibitor: \$2,000-5,000. For more information artists should e-mail, visit website, or call.

· Event held at the Sussex County Fair Grounds in Augusta, NJ.

M PRAIRIE ARTS FESTIVAL

201 Schaumburg Ct., Schaumburg IL 60193. (847)923-3605. Fax: (847)923-2458. E-mail: Rbenvenuti@Ci.schaumburg.il.us. Website: www.Prairiecenter.org. **Special Events Coordinator:** Roxane Benvenuti. Held May 28-29, 2011. "With thousands of patrons in attendance, an ad in the program is a great way to get your business noticed. Rates are reasonable, and an ad in the program gives you access to a select regional market. Download an ad form here. Sponsorship opportunities are also available."

Tips "Submit your best work for the jury since these images are selling your work."

PUNGO STRAWBERRY FESTIVAL

P.O. Box 6158, Virginia Beach VA 23456. (757)721-6001. Fax: (757)721-9335. E-mail: pungofestival@aol.com. Website: www.pungostrawberryfestival.info. Arts & crafts show held annually on Memorial Day Weekend. Outdoors. Accepts photography and all media. Number of exhibitors: 60. Public attendance: 120,000. Free to Public; \$5 parking fee. Artists should apply by calling for application or downloading a copy from the website and mail in. Deadline for entry: March 1; applications accepted from that point until all spaces are full. Notice of acceptance or denial by April 5. Application fee: \$50 refundable deposit. Space fee: \$175. Exhibition space: 10×10 ft. For more information, artists should e-mail, visit website or call.

N O PYRAMID HILL ANNUAL ART FAIR

1673 Hamilton Cleves Rd., Hamilton OH 45013. (513)868-8336. Fax: (513)868-3585. E-mail: Pyramid@Pyramidhill.org. Website: www.pyramidhill.org. Art fair held the last Saturday and Sunday of September. Call, e-mail or visit website for more information.

Tips "Make items affordable! Quality work at affordable prices will produce profit."

QUAKER ARTS FESTIVAL

P.O. Box 202, Orchard Park NJ 14127. (716)667-2787. E-mail: opjaycees@aol.com. Website: www. opjaycees.com. Estab. 1961. Fine arts & crafts show held annually in September. Outdoors. Accepts photography, painting, graphics, sculpture, crafts. Juried by 4 panelists during event. Awards/prizes: over \$10,000 total cash prizes. Number of exhibitors: 330. Public attendance: 75,000. Free to the public. Artists should apply by sending SASE. Deadline for entry: August. Exhibition space: 10 × 12 ft. For more information, artists should call, send SASE.

Tips "Have an inviting booth and be pleasant and accessible. Don't hide behind your product—engage the audience."

RATTLESNAKE ROUNDUP

P.O. Box 292, Claxton GA 30417. (912)739-3820. Fax: (912)739-0507. Website: www. claxtonevanschamber.com. **Event Coordinator:** Nickole L. Holland. Arts & crafts show held annually 2nd weekend in March. Outdoors. Accepts photography and various mediums. Number of exhibitors: 150-200. Public attendance: 15,000-20,000. Public admission: \$5/age 6 and up. Artists should apply by filling out an application. Click on the "Registration Tab" located on the Rattlesnake Roundup home page. Deadline for entry: March 1. Space fee: \$90. Exhibition space: 10×16 ft. For more information, artists should e-mail, visit website or call.

Tips "Your display is a major factor in whether people will stop to browse when passing by. Offer a variety."

RILEY FESTIVAL

312 E. Main St., #C, Greenfield IN 46140. (317)462-2141. Fax: (317)467-1449. E-mail: info@ rileyfestival.com. Website: www.rileyfestival.com. Contact: Sarah Kesterson, public relations. Estab. 1970. Fine arts & crafts show held in early October. Outdoors. Accepts photography, fine arts, home arts, quilts. Juried. Awards/prizes: small monetary awards and ribbons. Number of exhibitors: 450. Public attendance: 75,000. Free to public. Artists should apply by downloading application on website. Deadline for entry: September 15. Space fee: \$185. Exhibition space: 10 × 10 ft. For more information, artists should visit website.

Tips "Keep arts priced for middle-class viewers."

RIVERBANK CHEESE & WINE EXPOSITION

6618 Third St., Riverbank CA 95367-2317. (209)863-9600. Fax: (209)863-9601. E-mail: events@ riverbankcheeseandwine.org. Website: www.riverbankcheeseandwine.org. Contact: Chris Elswick. Estab. 1977. Arts & crafts show and food show held annually 2nd weekend in October. Outdoors. Accepts photography, other mediums depends on the product. Juried by pictures and information about the artists. Number of exhibitors: 250. Public attendance: 60,000. Free to public. Artists should apply by calling and requesting an application. Applications available on our website. Deadline for entry: September 1. Space fee: \$345/arts & crafts; \$465/commercial. Exhibition space: 12 × 12 ft. For more information, artists should e-mail, visit website, call or send SASE.

Tips "Make sure your display is pleasing to the eye."

RIVERFRONT MARKET

P.O. Box 565, Selma AL 36702-0565. (334)874 6683. E-mail: info@selmaalabama.com. Website: www.selmaalabama.com. Arts & crafts show held annually the 2nd Saturday in October. Outdoors. Accepts photography, painting, sculpture. Number of exhibitors: 200. Public attendance: 8,000. Public admission: \$2. Artists should apply by calling or mailing to request application. Deadline for entry: September 1. Space fee: \$40; limited covered space available at \$60. Exhibition space: 10×10 ft. For more information, artists should call.

Tips Market held October 15, 2011

ROYAL OAK OUTDOOR ART FAIR

(248)246-3180. E-mail: artfair@ci.royal-oak.mi.us. Website: www.ci.royal-oak.mi.us. **Contact**: recreation office staff. Events & Membership. Estab. 1970. Fine arts & crafts show held annually in July. Outdoors. Accepts photography, collage, jewelry, clay, drawing, painting, glass, wood, metal, leather, soft sculpture. Juried. Number of exhibitors: 110. Public attendance: 25,000. Free to pubic. Artists should apply with application form and 3 slides of current work. Exhibition space: 15 × 15 ft. For more information, artists should e-mail or call.

Tips "Be sure to label your slides on the front with name, size of work and 'top'."

SACO SIDEWALK ART FESTIVAL

P.O. Box 336, 12 1/2 Pepperell Square, Ste. 2A, Saco ME 04072. (207)286-3546. E-mail: sacospirit@hotmail.com. Website: www.sacospirit.com.

Tips "Offer a variety of pieces priced at various levels."

SANDY SPRINGS FESTIVAL

6110 Bluestone Rd., Sandy Springs GA 30328. (404)851-9111. Fax: (404)851-9807. E-mail: info@ sandyspringsfestival.org. Website: www.sandyspringsfestival.com. Fine arts & crafts show held annually in mid-September. Outdoors. Accepts photography, painting, sculpture, jewelry, furniture, clothing. Juried by area professionals and nonprofessionals who are passionate about art. Awards/

prizes: change annually; usually cash with additional prizes. Number of exhibitors: 100 + . Public attendance: 20,000. Public admission: \$5. Artists should apply via application on website. Application fee: \$10 (\$35 for late registration). Space fee: \$150. Exhibition space: 10×10 ft. Average gross sales/exhibitor: \$1,000. For more information, artists should visit website. There may be changes in the information shown here.

Tips "Most of the purchases made at Sandy Springs Festival are priced under \$100. The look of the booth and its general attractiveness are very important, especially to those who might not 'know' art."

SANTA CALI GON DAYS FESTIVAL

210 W. Truman Rd., Independence MO 64050. (816)252-4745. E-mail: tsingleton@ independencechamber.org. Website: www.santacaligon.com. Estab. 1973. Market vendors show held annually Labor Day weekend. Outdoors. Accepts photography, all other mediums. Juried by committee. Number of exhibitors: 240. Public attendance: 225,000. Free to public. Artists should apply by requesting application. Application requirements include completed application, application fee, 4 photos of product/art and 1 photo of display. Exhibition space: 8 × 8 ft. to 10 × 10 ft. For more information, artists should e-mail, visit website or call.

M SAUSALITO ART FESTIVAL

P.O. Box 10, Sausalito CA 94966. (415)332-3555. Fax: (415)331-1340. E-mail: apply@ sausalitoartfestival.org. Website: www.sausalitoartfestival.org. Estab. 1952. Fine arts & crafts show held annually Labor Day weekend. Outdoors. Accepts painting, photography, 2D and 3D mixed media, ceramics, drawing, fiber, functional art, glass, jewelry, printmaking, sculpture, watercolor, woodwork. Juried. Jurors are elected by their peers from the previous year's show (1 from each category). They meet for a weekend at the end of March and give scores of 1, 2, 3, 4 or 5 to each applicant (5 being the highest). Number of exhibitors: 270. Public attendance: 40,000. Artists should apply by visiting website for instructions and application. Applications are through Juried Art Services. Deadline for entry: March. Exhibition space: 100 or 200 sq. ft. Average gross sales/exhibitor: \$14,000. For more information, artists should visit website.

SCOTTSDALE ARTS FESTIVAL

7380 E. 2nd St., Scottsdale AZ 85251. (480)874-2787. Fax: 480-874-4699. Website: www. scottsdaleartsfestival.org. Estab. 1970. Fine arts & crafts show held annually in March. Outdoors. Accepts photography, jewelry, ceramics, sculpture, metal, glass, drawings, fiber, paintings, printmaking, mixed media, wood. Juried. Awards/prizes: 1st, 2nd, 3rd Places in each category and Best of Show. Number of exhibitors: 200. Public attendance: 40,000. Public admission: \$7. Artists should apply through www.zapplication.org. Deadline for entry: October. Exhibition space: 10×10 ft. For more information, artists should visit website.

SIDEWALK ART MART

Downtown Helena, Inc., 225 Cruse Ave., Ste. B, Helena MT 59601. (406)447-1535. Fax: (406)447-1533. E-mail: hlnabid@mt.net. Website: www.downtownhelena.com. Arts, crafts and music festival held annually in June. Outdoors. Accepts photography. No restrictions except to display appropriate work for all ages. Number of exhibitors: 50 +. Public attendance: 5,000. Free to public. Artists should apply by visiting website to download application. Space fee: \$100-125. Exhibition space: 10×10 ft. For more information, artists should e-mail, visit website or call.

Tips "Greet people walking by and have an eye-catching product in front of booth. We have found that high-end artists or expensively priced art booths that had business cards with e-mail or website information, received many contacts after the festival."

SIERRA MADRE WISTARIA FESTIVAL

37 Auburn Ave., Ste. 1, Sierra Madre CA 91024. (626)355-5111. Fax: (626)306-1150. E-mail: info@ sierramadrechamber.com. Website: www.SierraMadrechamber.com. Estab. 100 years ago. Fine arts, crafts and garden show held annually in March. Outdoors. Accepts photography, anything handcrafted. Juried. Craft vendors send in application and photos to be juried. Most appropriate are selected. Number of exhibitors: 175. Public attendance: 12,000. Free to public. Artists should apply by sending completed and signed application, 3-5 photographs of their work, application fee, license application, space fee and 2 SASEs. Deadline for entry: December 31. Application fee: \$25. Public Safety Fee (non-refundable): \$25. Space fee: \$175 and a city license fee of \$31. Exhibition space: 10×10 ft. For more information, artists should e-mail, visit website or call. Applications can be found on Chamber website.

Tips "Have a clear and simple application. Be nice."

N SKOKIE ART GUILD'S 49TH ANNUAL ART FAIR

5211 W. Oakton, Skokie IL 60076. (847)677-8163. E-mail: Skokieart@aol.com. Website: Skokieartguild.org. **Art Fair Chairperson:** B. Willerman. Outdoor fine art/craft show open to all artists. Held on second weekend of July. Awards/prizes: Guild awards, a Mayor's award, and community business gift certificates are rallied. Exhibition fee: \$150. Exhibition space: 10 × 10 ft. Application deadline May 20, 2011.

☑ SMITHVILLE FIDDLERS' JAMBOREE AND CRAFT FESTIVAL

P.O. Box 83, Smithville TN 37166. (615)597-8500. E-mail: jfuson@smithvillejamboree.com. Website: www.smithvillejamboree.com. Estab. 1971. Arts & crafts show held annually the weekend nearest the Fourth of July. Indoors. Juried by photos and personally talking with crafters. Awards/prizes: ribbons and free booth for following year for Best of Show, Best of Appalachian Craft, Best Display, Best New Comer. Number of exhibitors: 235. Public attendance: 130,000. Free to public. Artists should apply by requesting application by phone or letter. Exhibition space: 12 × 12 ft. Average gross sales/exhibitors: \$1,200 + . For more information, artists should call.

SOLANO AVENUE STROLL

1563 Solano Ave., #PMB 101, Berkeley CA 94707. (510)527-5358. E-mail: SAA@solanoavenueassn. org. Website: www.solanoave.org. Estab. 1974. Fine arts & crafts show held annually 2nd Sunday in September. Outdoors. Accepts photography and all other mediums. Juried by board of directors. Number of exhibitors: 140 spaces for crafts; 600 spaces total. Public attendance: 300,000. Free to the public. Artists should apply online after April 1, or send SASE. Exhibition space: 10 × 10 ft. For more information, artists should e-mail, visit website, send SASE.

Tips "Artists should have a clean presentation; small-ticket items as well as large-ticket items; great customer service; enjoy themselves."

M SOUTHWEST ARTS FESTIVAL AT THE EMPIRE POLO CLUB

82921 Indio Blvd., Indio CA92201 (760)347-0676. Fax: (763)3476069. E-mail: Swaf@Indiochamber. org. Website: www.southwestartsfest.com. "Featuring over 275 acclaimed artists showing traditional, contemporary and abstract fine works of art and quality crafts, the festival is a major, internationally recognized cultural event and was attended by nearly 10,000 people in 2010. The features a wide selection of clay, crafts, drawings, glass work, jewelry, metal works, paintings, photographs, printmaking, sculpture and textiles." Application fee: \$50 before August 31; \$65 after that. Easy check-in and check-out procedures with safe and secure access to festival grounds for set-up and breakdown. Advance set-up for artists with special requirements (very large art requiring the use of cranes, forklifts, etc., or artists with special needs.). Artist parking is free. Disabled artist parking is available. Apply online.

SPRING CRAFTS AT LYNDHURST

P.O. Box 28, Woodstock NY 12498. (845)331-7900. Fax: (845)331-7484. E-mail: crafts@artrider.com. Website: www.craftsatlyndhurst.com. Fine arts & crafts show held annually in early May. Outdoors. Accepts photography, wearable and nonwearable fiber, metal and nonmetal jewelry, clay, leather, wood, glass, painting, drawing, prints, mixed media. Juried by 5 images of work and 1 of booth, viewed sequentially. Number of exhibitors: 250. Public attendance: 14,000. Public admission: \$10. Artists should apply by downloading application from www.artrider.com or can apply online at www.zapplication.org. Deadline for entry: January 1. Application fee: \$45. Space fee: \$745-845. Exhibition space: 10×10 ft. For more information, artists should e-mail, visit website, call.

SPRING CRAFTS AT MORRISTOWN

P.O. Box 28, Woodstock NY 12498. (845)331-7900. Fax: (845)331-7484. E-mail: crafts@artrider.com. Website: www.craftsatmorristown.com. Fine arts & crafts show held annually at the end of March or beginning of April. Indoors. Accepts photography, wearable and nonwearable fiber, metal and nonmetal jewelry, clay, leather, wood, glass, painting, drawing, prints, mixed media. Juried by 5 images of work and 1 of booth, viewed sequentially. Number of exhibitors: 150. Public attendance: 5,000. Public admission: \$7. Artists should apply by downloading application from www.artrider.com or apply online at www.zapplication.org. Deadline for entry: January 1. Application fee: \$45. Space fee: \$475. Exhibition space: 10×10 ft. For more information, artists should e-mail, visit website, call.

SPRINGFEST

P.O. Box 1604, Southern Pines NC 28388. (910)315-6508. E-mail: spba@earthlink.net. Website: www.southernpines.biz. Arts & crafts show held annually last Saturday in April. Outdoors. Accepts photography and crafts. "We host over 160 vendors from all around North Carolina and the country. Enjoy beautiful artwork and crafts including paintings, jewelry, metal art, photography, woodwork, designs from nature, and other amazing creations. Event is held in conjunction with Tour de Moore, an annual bicycle race in Moore County, and is co-sponsored by the Town of Southern Pines." Public attendance: 8,000. Free to the public. See deadline online for entry sometime in March. Space fee: \$75. Exhibition space: 10×12 ft. For more information, artists should e-mail, visit website, call, send SASE. Application online.

SPRING FINE ART & CRAFTS AT BROOKDALE PARK IN MONTCLAIR, NJ

12 Galaxy Court, Montclair NJ (908)874-5247. Fax: (908)874-7098. E-mail: info@rosesquared.com. Website: www.rosesquared.com. Estab.1988. Fine arts & craft show held annually in mid-June Father's Day weekend. Outdoors. Accepts photography and all other mediums. Juried. Number of exhibitors: 180. Public attendance: 16,000. Free to the public. Artists should apply by downloading application from website or call for application. Deadline: 1 month before show date. Application fee: \$25. Space fee: \$340. Exhibition space: 120 sq. ft. For more information, artists should e-mail, visit website, call.

Tips "Create a professional booth that is comfortable for the customer to enter. Be informative, friendly and outgoing. People come to meet the artist."

ST. CHARLES FINE ART SHOW

213 Walnut St., St. Charles IL 60174. (630)513-5386. E-mail: david@dtown.org; jennifer@dtown. org. Website: www.dtown.org/events/fine_art_show.asp. Fine art fair held annually in late May. Outdoors. Accepts photography, painting, sculpture, glass, ceramics, jewelry, nonwearable fiber art. Juried by committee: submit 4 slides of art and 1 slide of booth/display. Awards/prizes: Cash awards of \$3,500 awarded in several categories. Purchase Award Program: \$14,000 of art has been purchased through this program since its inception in 2005. Number of exhibitors: 100. Free to the public. Artists should apply by downloading application from website or call for application.

Deadline for entry: February. Jury fee: \$25. Space fee: \$200. Exhibition space: 12×12 ft. The 2011 Application will be available in September 2010. For more information, artists should e-mail, visit website, call.

STEPPIN' OUT

P.O. Box 233, Blacksburg VA 24063. (540)951-0454. E-mail: dmob@downtownblacksburg.com. Website: www.downtownblacksburg.com. Arts & crafts show held annually 1st Friday and Saturday in August. Outdoors. Accepts photography, pottery, painting, drawing, fiber arts, jewelry, general crafts. Number of exhibitors: 170. Public attendance: 45,000. Free to public. Artists should apply by e-mailing, calling or by downloading application on website. Space fee: \$150. For more information, artists should e-mail, visit website or call.

Tips "Visit shows and consider the booth aesthetic-what appeals to you. Put the time, thought, energy and money into your booth to draw people in to see your work."

ST. GEORGE ART FESTIVAL

86 S. Main St., George UT 84770. (435)627-4500. E-mail: leisure@sgcity.org. Website: www.sgcity.org/artfestival/. Estab. 1979. Fine arts & crafts show held annually Easter weekend in either March or April. Outdoors. Accepts photography, painting, wood, jewelry, ceramics, sculpture, drawing, 3D mixed media, glass. Juried from slides. Awards/prizes: \$5,000 Purchase Awards. Art pieces selected will be placed in the city's permanent collections. Number of exhibitors: 110. Public attendance: 20,000/day. Free to public. Artists should apply by completing application form, nonrefundable application fee, slides or digital format of 4 current works in each category and 1 of booth, and SASE. Deadline for entry: January. Exhibition space: 10 × 11 ft. For more information, artists should e-mail.

Tips "Artists should have more than 50% originals. Have quality booths and set-up to display art in best possible manner. Be outgoing and friendly with buyers."

☑ STILLWATER ARTS & HERITAGE FESTIVAL

P.O. Box 1449, Stillwater OK 74074. (405)533-8539. Fax: (405)533-3097. E-mail: jnovak@stillwater. org. Fine arts & crafts show held annually in April. Outdoors. Accepts photography, oil, acrylic, watercolor and multimedia paintings, pottery, pastel work, fiber arts, jewelry, sculpture, glass art. Juried by a committee of 3-5 jurors. Awards are based on entry acceptance on quality, distribution, and various media entries. Awards/prizes: Best of Show, \$500; 1st Place, \$200; 2nd Place, \$150 and 3rd Place, \$100. Number of exhibitors: 80. Public attendance: 7,500-10,000. Free to public. Artists should apply by calling for an application to be mailed or e-mailed. Deadline for entry: early February. Application fee: \$80. Exhibition space: 10×10 ft. Average gross sales/exhibitor: \$700. For more information, artists should call.

ST. JAMES COURT ART SHOW

P.O. Box 3804, Louisville KY 40201. (502)635-1842. Fax: (502)635-1296. E-mail: mesrock@ stjamescourtartshow.com. Website: www.stjamesartshow.com. Estab. 1957. Annual fine arts & crafts show held the first full weekend in October. Accepts photography; has 16 medium categories. Juried in April; there is also a street jury held during the art show. Awards/prizes: Best of Show-3 places; \$7,500 total prize money. Number of exhibitors: 300. Public attendance: 275,000. Free to the public. Artists should apply by visiting website and printing out an application or via www. zapplication.org. Deadline for entry in 2011 show: March 31, 2011. Application fee: \$30. Space fee: \$500. Exhibition space: 10×12 ft. For more information, artists should e-mail or visit website. **Tips** "Have a variety of price points. Don't sit in the back of the booth and expect sales."

STOCKLEY GARDENS FALL ARTS FESTIVAL

801 Boush St., Ste. 302, Norfolk VA 23510. (757)625-6161. Fax: (757)625-7775. E-mail: skaplan@hope-house.org. Website: www.hope-house.org. **Development Coordinator:** Stephanie Kaplan.

Estab. 1984. Fine arts & crafts show held annually 3rd weekend in October. Outdoors. Accepts photography and all major fine art mediums. Juried. Number of exhibitors: 150. Public attendance: 30,000. Free to the public. Artists should apply by submitting application, jury and booth fees, 5 slides. Deadline for entry: July. Exhibition space: 10×10 ft. For more information, artists should e-mail, visit website, call.

☑ STONE ARCH FESTIVAL OF THE ARTS

(763)438-9978. E-mail: mplsriverfront@msn.com. Manager: Sara Collins. Estab. 1994. Fine arts & crafts show and culinary arts show held annually Father's Day weekend. Outdoors. Accepts photography, painting, ceramics, jewelry, fiber, printmaking, wood, metal. Juried by committee. Awards/prizes: free booth the following year; \$100 cash prize. Number of exhibitors: 230. Public attendance: 80,000. Free to public. Artists should apply by application found on website or through www.zapplication.org. Deadline for entry: March 15. Exhibition space: 10 × 10 ft. For more information, artists should call or e-mail.

Tips "Have an attractive display and variety of prices."

ST. PATRICK'S DAY CRAFT SALE & FALL CRAFT SALE

P.O. Box 267, Maple Lake MN 55358-2331. (612)270-8586. E-mail: rbpamoco@lakedalelink.net. Website: www.maplelakechamber.com. Contact: Irene Hudek. Arts & crafts show held biannually in March and early November. Indoors. Number of exhibitors: 40-50. Public attendance: 300-600. Free to public. Artists should apply by requesting an application. Deadline for entry: 1 month-2 weeks before the event. Exhibition space: 10×10 ft. For more information, artists should send SASE.

Tips "Don't charge an arm and a leg for the items. Don't over crowd your items. Be helpful, but not pushy."

M STRAWBERRY FESTIVAL

(406)294-5060. Fax: (406)294-5061. E-mail: mikaly@downtownbillings.com. Website: www. strawberryfun.com. Estab. 1991. Fine arts & crafts show held annually 2nd Saturday in June. Outdoors. Accepts photography. Juried. Public attendance: 15,000. Free to public. Artists should apply by application available on the website. Deadline for entry: April. Exhibition space: 12×12 ft. For more information, artists should visit website.

SUMMER ARTS & CRAFTS FESTIVAL

38 Charles St., Rochester NH 03867. (603)332-2616. Fax: (603)332-8413. E-mail: info@ castleberryfairs.com. Website: www.castleberryfairs.com. Estab. 1992. Arts & crafts show held annually 2nd weekend in August. Outdoors. Accepts photography and all other mediums. Juried by photo, slide or sample. Number of exhibitors: 100. Public attendance: 7,500. Free to the public. Artists should apply by downloading application from website. Exhibition space: 10×10 ft. For more information, artists should visit website.

• Event held in Lincoln, NH.

Tips "Do not bring a book; do not bring a chair. Smile and make eye contact with everyone who enters your booth. Have them sign your guest book; get their e-mail address so you can let them know when you are in the area again. And, finally, make the sale-they are at the fair to shop, after all."

SUMMERFAIR

7850 Five Mile Road, Cincinnati OH 45230. (513)531-0050. Fax: (513)531-0377. E-mail: exhibitors@ summerfair.org. Website: www.summerfair.org. Fine arts & crafts show held annually the weekend after Memorial Day. Outdoors. Accepts photography, ceramics, drawing/printmaking, fiber/leather, glass, jewelry, painting, sculpture/metal, wood and 2D/3D Mixed Media. Juried by a panel of judges selected by Summerfair, including artists and art educators with expertise in the categories

offered at Summerfair. Submit application with 5 digital images (no booth image) through www. zapplication.com. Awards/prizes: \$10,000 in cash awards. Number of exhibitors: 300. Public attendance: 20,000. Public admission: \$10. Deadline: February. Application fee: \$30. Space fee: \$375, single space; \$750, double space; \$75 canopy fee (optional-exhibitors can rent a canopy for all days of the fair.). Exhibition space: 10×10 ft. for single space; 10×20 ft. for double space. For more information, artists should e-mail, visit website, call.

SUN FEST, INC.

P.O. Box 2404, Bartlesville OK 74005. (918)331-0456. Fax: (918)331-3217. E-mail: wcfd90@ sbcglobal.net. Website: www.bartlesvillesunfest.org. Estab. 1982. Fine arts & crafts show held annually in early June. Outdoors. Accepts photography, painting and other arts and crafts. Juried. Awards/prizes: \$2,000; Best of Show receives free booth rental for the following year. Number of exhibitors: 95-100. Number of attendees: 25,000-30,000. Free to the public. Artists should apply by e-mailing or calling for an entry form, or visit website. Exhibition space: 10 × 10 ft. For more information, artists should e-mail, call or visit website.

SYRACUSE ARTS & CRAFTS FESTIVAL

572 South Salina St., Syracuse NY 13202. (315)422-8284. Fax: (315)471-4503. E-mail: mail@downtownsyracuse.com. Website: www.syracuseartsandcraftsfestival.com. Estab. 1970. Fine arts & crafts show held annually in July. Outdoors. Accepts photography, ceramics, fabric/fiber, glass, jewelry, leather, metal, wood, computer art, drawing, printmaking, painting. Juried by 4 independent jurors. Jurors review 4 slides of work and 1 slide of booth display. Number of exhibitors: 170. Public attendance: 50,000. Free to public. Artists should apply by calling for application or downloading from website. Exhibition space: 10 × 10 ft. For more information, artists should e-mail, visit website or call.

M TARPON SPRINGS FINE ARTS FESTIVAL

11 E. Orange St., Tarpon Springs FL 34689. (727)937-6109. Fax: (727)937-2879. E-mail: scottie@ tarponspringschamber.org. Website: www.tarponspringschamber.com. Fine arts & crafts show held annually in April. Outdoors. Accepts photography, acrylic, oil, ceramics, fiber, glass, graphics, drawings, pastels, jewelry, leather, metal, mixed media, sculpture, watercolor, wood. Juried by CD. Awards/prizes: cash and ribbons. Number of exhibitors: 250. Public attendance: 20,000. Public admission: \$2; free 12 and under. Artists should apply by submitting signed application, CD, slides, fees and SASE. Deadline for entry: mid-November. Jury fee: \$25. Space fee: \$200. Exhibition space: 10×12 ft. For more information artists should e-mail, call or send SASE.

Tips "Produce good CDs for jurors."

M THREE RIVERS ARTS FESTIVAL

803 Liberty Ave., Pittsburgh PA 15222. (412)471-3191. Fax: (412)471-6917. Website: www. Artsfestival.net. Contact: Sonja Sweterlitsch. Estab. 1960. "Three Rivers Arts Festival has presented, during its vast and varied history, more than 10,000 visual and performing artists and entertained millions of residents and visitors. In its 50th anniversary year, Three Rivers Arts Festival today faces a new turning point in its history as a division of The Pittsburgh Cultural Trust, further advancing the shared mission of each organization to foster economic development through the arts and to enhance the quality of life in the region." 2011 applications due February 19.

TUBAC FESTIVAL OF THE ARTS

P.O. Box 1866, Tubac AZ 85646. (52)398-2704. Fax: (520)398-1704. E-mail: assistance@tubacaz. com. Website: www.tubacaz.com. Fine arts & crafts show held annually in early February. Next date: February 9-13, 2011. Outdoors. Accepts photography and considers all fine arts & crafts. Juried. A 7-member panel reviews digital images and artist statement. Jury process is blind—applicants' names are withheld from the jurors. Number of exhibitors: 170. Public attendance: 65,000. Free to

the public; parking: \$6. Applications for the 2011 festival posted on website. Application fee: \$30. Space fee: \$575 for 10×10 ft. space. For more information, artists should e-mail, visit website, call, send SASE.

☑ TULIP FESTIVAL STREET FAIR

P.O. Box 1801, Mt. Vernon WA 98273. (360)336-3801. E-mail: edmvdt@gmail.com. Website: www. mountvernondowntown.org. **Contact:** Executive Director. Estab. 1984. Arts & crafts show held annually 3rd weekend in April. Outdoors. Accepts photography and original artists' work only. No manufactured work. Juried by a board. Jury fee: \$10 with application and prospectus. Number of exhibitors: 215-220. Public attendance: 30,000-35,000. Free to public. Artists should apply by calling or e-mailing. Deadline for entry: January 30. Application fee: \$10. Space fee: \$300. Exhibition space: 10×10 ft. Average gross sales/exhibitor: \$2,500-4,000. For more information, artists should e-mail, visit website, call or send SASE.

Tips "Keep records of your street fair attendance and sales for your résumé. Network with other artists about which street fairs are better to return to or apply for."

TULSA INTERNATIONAL MAYFEST

321 S. Boston #101, Tulsa OK 74152. (918)517-3518. Fax: (918)587-7721. E-mail: comments@ tulsamayfest.org. Website: www.tulsamayfest.org. Fine arts & crafts show annually held in May. Outdoors. Accepts photography, clay, leather/fiber, mixed media, drawing, pastels, graphics, printmaking, jewelry, glass, metal, wood, painting. Juried by a blind jurying process. Artists should apply online at www.zapplication.org and submit 4 photos of work and 1 of booth set-up. Awards/prizes: Best in Category and Best in Show. Number of exhibitors: 120. Public attendance: 350,000. Free to public. Artists should apply by downloading application in the fall. Deadline for entry: January 2011. Application fee: \$35. Space fee: \$300. Exhibition space: 10 × 10 ft. For more information, artists should e-mail or visit website.

UPTOWN ART FAIR

1406 West Lake St., Lower Level C, Minneapolis MN 55408. (612)823-4581. Fax: (612)823-3158. E-mail: maude@uptownminneapolis.com; info@uptownminneapolis.com. Website: www. uptownminneapolis.com. Fine arts & crafts show held annually 1st full weekend in August. Outdoors. Accepts photography, painting, printmaking, drawing, 2D and 3D mixed media, ceramics, fiber, sculpture, jewelry, wood. Juried by 4 images of artwork and 1 of booth display. Awards/prizes: Best in Show in each category; Best Artist. Number of exhibitors: 350. Public attendance: 375,000. Free to the public. The Uptown Art Fair uses www.zapplication.com. Each artist must submit 5 images of his or her work. All artwork must be in a high-quality digital format. Five highly qualified artists, instructors, and critics handpick Uptown Art Fair exhibitors after previewing projections of the images on 8-foot screens. The identities of the artists remain anonymous during the entire review process- all submitted images must be free of signatures, headshots or other identifying marks. Three rounds of scoring determine the final selection and waitlist for the show. Artists will be notified shortly after of their acceptance. For additional information, see the links on website. Deadline for entry: March. Application fee: \$30. Space fee: \$450, 10 × 10 ft.; \$900 10 × 20 ft. For more information, artists should call or visit website.

A VICTORIAN CHAUTAUQUA

P.O. Box 606, Jeffersonville IN 47131. (812)283-3728 or (888)472-0606. Fax: (812)283-6049. E-mail: hsmsteam@aol.com. Website: www.steamboatmuseum.org. Estab. 1993. Fine arts & crafts show held annually 3rd weekend in May. Outdoors. Accepts photography, all mediums. Juried by a committee of 5. Number of exhibitors: 80. Public attendance: 3,000. Exhibition space: 12 × 12 ft. For more information, artists should e-mail or call.

VIRGINIA CHRISTMAS SHOW

P.O. Box 305, Chase City VA 23924. (804)253-6284. Fax: (800)253-6285. E-mail: vashowsinc@ comcast.net. Website: www.vashowsinc.com. Holiday arts & crafts show held annually in November. Indoors. Accepts photography and other arts and crafts. Juried by 3 slides of artwork and 1 of display. Attendance: 30,000. Admission: \$7. Artists should apply by calling or e-mailing for application or downloading application from our website. Artists should apply by writing or e-mailing for an application. Space fee: \$435. Exhibition space: 10×10 ft. (or multiples thereof). Included are booth curtains, 24-hour security in the show exhibit area, signage, a complimentary listing in the show directory and an extensive multi-media advertising campaign—radio, television, billboards, direct mail, magazines and newspapers. Set-up is always easy-organized and convenient. The building is climate-controlled and many RVs may park on the premises for a nominal fee.

 Event held in the Showplace Exhibition Center, 3000 Mechanicsville Turnpike Richmond, VA 23223.

Tips "If possible, attend the shows before you apply. 24th Annual Virginia Spring Show is March 11-13, 2011. Corner space is additional \$75 (if any are available). Requirements same as above."

VIRGINIA SPRING SHOW

11050 Branch Rd., Glen Allen VA 23059. (804)253-6284. Fax: (804)253-6285. E-mail: vashowsinc@ comcast.net. Website: www.vashowsinc.com. Arts & crafts show held annually 2nd weekend in March. 2011 dates: March 11-13. Accepts photography and other arts and crafts. Juried by 3 slides of artwork and 1 of display. Awards/prizes: Best Display. Number of exhibitors: 300. Public attendance: 20,000. Public admission: \$7. Exhibitor application is online at website. Artists can also apply by writing or e-mailing for an application. Space fee: \$335. Exhibition space: 10×10 ft. For more information, artists should e-mail or contact us through our website.

 Event held in the Showplace Exhibition Center, 3000 Mechanicsville Turnpike Richmond, VA 23223.

Tips "If possible, attend the show before you apply."

WASHINGTON SQUARE OUTDOOR ART EXHIBIT

P.O. Box 1045; New York NY 10276. (212)982-6255. Fax: (212)982-6256. E-mail: jrm.wsoae@gmail.com. Website: www.washingtonsquareoutdoorartexhibit.org. Estab. 1931. Fine arts & crafts show held semiannually Memorial Day weekend and the following weekend in May/early June and Labor Day weekend and following weekend in September. Outdoors. Accepts photography, oil, watercolor, graphics, mixed media, sculpture, crafts. Juried by submitting 5 slides of work and 1 of booth. Awards/prizes: certificates, ribbons and cash prizes. Number of exhibitors: 200. Public attendance: 200,000. Free to public. Artists should apply by sending a SASE or downloading application from website. Deadline for entry: March, Spring Show; July, Fall Show. Exhibition space: 10 × 5 ft. For more information, artists should call or send SASE.

Tips "Price work sensibly."

WELCOME TO MY WORLD PHOTOGRAPHY COMPETITION

529 Beachview Dr., St. Simons Island GA 31522. (912)638-8770. E-mail: glynnart@bellsouth.net. Website: www.glynnart.org. Estab. 1991. Seasonal photography competition annually held in July. Indoors. Accepts only photography. Juried. Awards/prizes: 1st, 2nd, 3rd in each category. Number of exhibitors: 50. Artists should apply by visiting website. Deadline for entry: June. For more information, artists should e-mail, visit website or call.

WESTMORELAND ART NATIONALS

252 Twin Lakes Rd., Latrobe PA 15650-3554. (724)834-7474. E-mail: info@artsandheritage.com. Website: www.artsandheritage.com. Executive Director: Diana Morreo. Estab. 1975. Fine arts & crafts show held annually in July. Photography displays are indoors. Accepts photography,

all mediums. 2 jurors review images. Awards/prizes: \$7,000 in prizes. Number of exhibitors: 100. Public attendance: 155,000. Free to public. WAN exhibits shown at Westmoreland County Community College early June and Westmoreland Arts & Heritage Festival July 1-4. Artists should apply by downloading application from website. Application fee: \$25/craft show vendors; \$35/art nationals exhibitors. Space fee: \$400. Vendor/exhibition space: 10 × 10 ft. For more information, artists should visit website or call.

WHITEFISH ARTS FESTIVAL

P.O. Box 131, Whitefish MT 59937. Website: www.whitefishartsfestival.org. Estab. 1979. Fine arts & crafts show held annually 1st full weekend in July. Outdoors. Accepts photography, pottery, jewelry, sculpture, paintings, woodworking. Juried. Art must be original and handcrafted. Work is evaluated for creativity, quality and originality. Awards/prizes: Best of Show awarded half-price booth fee for following year with no application fee. Number of exhibitors: 100. Public attendance: 3,000. Free to public. Exhibition space: 10 × 10 ft. For more information, artists should visit website.

Tips Recommends "variety of price range, professional display, early application for special requests."

WHITE OAK CRAFTS FAIR

1424 John Bragg Hwy, Woodbury TN 37190. (615) 563-2787 or (800)235-9073. E-mail: donald@ artscenterofcc.com. Website: www.artscenterofcc.com. Estab. 1985. Arts & crafts show held annually in September. Outdoors. Accepts photography; all handmade crafts, traditional and contemporary. Must be handcrafted displaying "excellence in concept and technique." Juried by committee. Send 3 slides or photos. Awards/prizes: more than \$1,000. Number of exhibitors: 80. Public attendance: 6,000. Free to public. Applications can be downloaded from website. For more information, artists should e-mail or call.

WILD WIND FOLK ART & CRAFT FESTIVAL

P.O. Box 719, Long Lake NY 12847. (814)723-0707 or (518)624-6404. E-mail: wildwindcraftshow@yahoo.com. Website: www.wildwindfestival.com. **Directors:** Liz Allen or Carol Jilk. Estab. 1979. Fine arts & traditional crafts show held annually the weekend after Labor Day. Barn locations and outdoors. Accepts photography, paintings, pottery, jewelry, traditional crafts, prints, stained glass. Juried by promoters. Three photos or slides of work plus one of booth, if available. Number of exhibitors: 140. Public attendance: 8,000. Artists should apply by visiting website and filling out application request, calling or sending a written request.

• Event held at the Warren County Fairgrounds in Pittsfield, PA.

WILMETTE FESTIVAL OF FINE ARTS

P.O. Box 902, Wilmette IL 60091. (847)256-2080. E-mail: wilmetteartsguild@gmail.com. Website: www.wilmetteartsguild.org. Estab. 1992. Fine arts & crafts show held annually in September. Outdoors. Accepts photography, paintings, prints, jewelry, sculpture, ceramics, and any other appropriate media; no wearable. Juried by a committee of 6-8 artists and art teachers. Number of exhibitors: 100. Public attendance: 4,000. Free to the public. Deadline for entry: April. Exhibition space: 12×12 ft. For more information, artists should e-mail, visit website, call, send SASE.

Tips "Maintain a well-planned, professional appearance in booth and person. Greet viewers when they visit the booth. Offer printed bio with photos of your work. Invite family, friends and acquaintances."

WINNEBAGOLAND ART FAIR

South Park Avenue/ South Park, Oshkosh WI 54902. E-mail: oshkoshfaa@gmail.com. Estab. 1957. Fine arts show held annually the second Sunday in June. Outdoors. Accepts photography, watercolor, oils & acrylics, 3D large, 3D small, drawing, pastels, mixed media. Artwork must be the original

Art Fairs

work of the artist in concept and execution. Juried. Applicants send in photographs to be reviewed. Awards/prizes: monetary awards, Purchase, Merit and Best of Show awards. Number of exhibitors: 125-160. Public attendance: 5,000-8,000. Free to public. Deadline for entry: Previous exhibitors due March 15. New Exhibitors due March 31. \$25 late entry fee after March 31. Application fee: \$90, but may increase next year. Exhibition space: 20×20 ft. For more information, artists should e-mail oshkoshfaa@gmail.com or see website www.oshkoshfinearts.org. The updated entry form will be added to the website around Jan1.

Tips "Artists should send clear, uncluttered photos of their current work which they intend to show in their booth as well as a photo of their booth setup."

WYANDOTTE STREET ART FAIR

3131 Biddle Ave., Wyandotte MI 48192. (734)324-4502. Fax: (734)324-7296. E-mail: info@wyan. org. Website: www.wyandottestreetartfair.org. **Special Event Coordinator**: Heather Thiede. Estab. 1961. Fine arts & crafts show held annually 2nd week in July. Outdoors. Accepts photography, 2D mixed media, 3D mixed media, painting, pottery, basketry, sculpture, fiber, leather, digital cartoons, clothing, stitchery, metal, glass, wood, toys, prints, drawing. Juried. Awards/prizes: Best New Artist: \$500; Best Booth Design Award: \$500; Best of Show: \$1,200. Number of exhibitors: 300. Public attendance: 200,000. Free to the public. Artists may apply online or request application. Deadline for entry: February. Application fee: \$20 jury fee. Space fee: \$225/single space; \$450/double space. Exhibition space: 10 × 10 ft. Average gross sales/exhibitor: \$2,000-\$4,000. For more information, artists should e-mail, visit website, call, send SASE.

MARKETS

Contests

hether you're a seasoned veteran or a newcomer still cutting your teeth, you should consider entering contests to see how your work compares to that of other photographers. The contests in this section range in scope from tiny juried county fairs to massive international competitions. When possible, we've included entry fees and other pertinent information in our limited space. Contact sponsors for entry forms and more details.

Once you receive rules and entry forms, pay particular attention to the sections describing rights. Some sponsors retain all rights to winning entries or even *submitted* images. Be wary of these. While you can benefit from the publicity and awards connected with winning prestigious competitions, you shouldn't unknowingly forfeit copyright. Granting limited rights for publicity is reasonable, but you should never assign rights of any kind without adequate financial compensation or a written agreement. If such terms are not stated in contest rules, ask sponsors for clarification.

If you're satisfied with the contest's copyright rules, check with contest officials to see what types of images won in previous years. By scrutinizing former winners, you might notice a trend in judging that could help when choosing your entries. If you can't view the images, ask what styles and subject matters have been popular.

ALEXIA COMPETITION

Syracuse University Newhouse School, 215 University Place, Syracuse NY 13244-2100. E-mail: dcsuther@syr.edu. Website: www.alexiafoundation.org. **Contact:** David Sutherland. Annual contest. Provides financial ability for students to study photojournalism in England, and for professionals to produce a photo project promoting world peace and cultural understanding. Students win cash grants plus scholarships to study photojournalism at Syracuse University in London. A professional wins \$15,000 cash grant. Deadline: January 14, 2011. Photographers should e-mail or see website for more information.

ANNUAL COLLEGE PHOTOGRAPHY CONTEST

Serbin Communications, 813 Reddick St., Santa Barbara CA 93103. (805)963-0439 or (800)876-6425. Fax: (805)965-0296. E-mail: admin@serbin.com. Website: www.pfmagazine.com. Managing Editor: Julie Simpson. Annual student contest; runs September thru mid-November. Sponsored by *Photographer's Forum Magazine* and Nikon. Winners and finalists have their photos published in the hardcover book *The Best of College Photography*. See website for entry form.

ANNUAL EXHIBITION OF PHOTOGRAPHY

San Diego County Fair Entry Office, 2260 Jimmy Durante Blvd., Del Mar CA 92014. (858)792-4207. E-mail: entry@sdfair.com. Website: www.sdfair.com/entry. Contact: Entry Office. Sponsor: San Diego County Fair (22nd District Agricultural Association). Annual event for still photos/prints. This year, the Photography, Photojournalism and Digital Arts competitions have merged into one competition. Guidelines have been standardized and summarized into one competition information document. Some divisions have combined styles (photography and digital art), there are some new classes, and some have been omitted. There are new guidelines for mounting and matting, so be sure to read the complete competition prospectus. This is a juried competition open to individual photographers. Entry information is posted on the website as it becomes available in February and March. Pre-registration deadline: April/May. Access the dates and specifications for entry on website. Entry form can be submitted online.

ANNUAL JURIED PHOTOGRAPHY EXHIBITION

395 Kings Hwy., Moorestown NJ 08057. (856)235-6488 or (800)387-5226. Fax: (856)235-6624. E-mail: create@perkinscenter.org. Website: www.perkinscenter.org. Entry fee: \$8/entry; up to 3 entries. Regional juried photography exhibition. Works from the exhibition are considered for inclusion in the permanent collection of the Philadelphia Museum of Art and the Woodmere Art Museum. Past jurors include Merry Foresta, former curator of photography at the Smithsonian American Art Museum; Katherine Ware, curator of photographs at the Philadelphia Museum of Art; and photographers Emmett Gowin, Ruth Thorne-Thomsen, Matthew Pillsbury, and Vik Muniz. All work must be framed with wiring in back and hand-delivered to Perkins Center. Prospectus must be downloaded from the Perkins site.

☐ ANNUAL SPRING PHOTOGRAPHY CONTEST

Serbin Communications, 813 Reddick St., Santa Barbara CA 93103. (805)963-0439 or (800)876-6425. Fax: (805)965-0496. E-mail: admin@serbin.com. Website: www.pfmagazine.com. Annual amateur contest, runs January thru mid-May. Sponsored by *Photographer's Forum Magazine*. Winners and finalists have their photos published in the hardcover book, *Best of Photography*. See website for entry form.

ARC AWARDS

500 Executive Blvd., Ossining-on-Hudson NY 10562. (914)923-9400. Fax: (914)923-9484. E-mail: info@mercommawards.com. Website: www.mercommawards.com. Entry fee: \$185-290. Annual contest. The International ARC Awards, celebrating its 24th year, is the "Academy Awards of Annual Reports", according to the financial media. It is now the largest international competition honoring

excellence in annual reports. The competition is open to corporations, small companies, government agencies, non-profit organizations, and associations, as well as agencies and individuals involved in producing annual reports. The purpose of the contest is to honor outstanding achievement in annual reports. Major category for annual report photography—covers and interiors. "Best of Show" receives a personalized trophy. Grand Award winners receive personalized award plaques. Gold, silver, bronze and finalists receive a personalized award certificate. Every entrant receives complete judge score sheets and comments. **2010 deadline has passed. See deadline for 2011 online later in the year.** Photographers should see website, write, call or e-mail for more information.

ARTIST FELLOWSHIP GRANTS

c/o Oregon Arts Commission, 775 Summer St. NE, Salem OR 97301-1280. (503)986-0082. Fax: (503)986-0260. E-mail: oregon.artscomm@state.or.us. Website: www.oregonartscommission.org. A highly competitive juried grant process offering \$3,000 in cash awards to Oregon visual artists, in odd-numbered years.

ARTIST FELLOWSHIPS/VIRGINIA COMMISSION FOR THE ARTS

223 Governor St., Richmond VA 23219-2010. (804)225-3132. Fax: (804)225-4327. E-mail: arts@ arts.virginia.gov. Website: www.arts.virginia.gov. Applications accepted in alternating years. The purpose of the Artist Fellowship program is to encourage significant development in the work of individual artists, to support the realization of specific artistic ideas, and to recognize the central contribution professional artists make to the creative environment of Virginia. Grant amounts: \$5,000. Emerging and established artists are eligible. Open only to photographers who are legal residents of Virginia and at least 18 years of age. Applications are available in July. See Guidelines for Funding and application forms on the website or write for more information.

ARTSLINK PROJECTS

435 Hudson St., 8th Floor, New York NY 10014. (212)643-1985. Fax: (212)643-1996. E-mail: info@ cecartslink.org. Website: www.cecartslink.org. Biennial travel grants. ArtsLink Projects accepts applications from individual artists, curators and nonprofit arts organizations who intend to undertake projects in Central and Eastern Europe, Russia, Central Asia, and the Caucasus. Open to advanced photographers. January deadline. Photographers should e-mail or call for more information.

ATLANTA PHOTOJOURNALISM SEMINAR CONTEST

PMB 301, 541 Tenth St. NW, Atlanta GA 30318-5713. (404)982-9359. E-mail: contest@photojournalism.org. Website: www.photojournalism.org. Annual contest. This is an all-digital contest with several different categories (all related to news and photojournalism). Photographs may have been originally shot on film or with a digital camera, but the entries must be submitted in digital form. Photographs do not have to be published to qualify. No slide or print entries are accepted. Video frame grabs are not eligible. Rules are very specific. See website for official rules. More than \$5,000 in prizes, including \$1,000 and Nikon camera gear for Best Portfolio. Open to all skill levels. November deadline.

BANFF MOUNTAIN PHOTOGRAPHY COMPETITION

Box 1020, 107 Tunnel Mountain Dr., Banff AB T1L 1H5, Canada. (403)762-6347. Fax: (403)762-6277. E-mail: BanffMountainPhotos@banffcentre.ca. Website: www.BanffMountainFestivals.ca. Contact: Competition Coordinator. Annual contest. Maximum of 3 images (digital) in each of 5 categories: Mountain Landscape, Mountain Adventure, Mountain Flora/Fauna, Mountain Culture, and Mountain Environment. Entry form and regulations available on website. Approximately \$5,000 in cash and prizes to be awarded. Open to all skill levels. Photographers should write, e-mail or fax for more information.

COLLEGE PHOTOGRAPHER OF THE YEAR

101B Lee Hills Hall, Columbia MO 65211-1370. (573)884-2188. E-mail: info@cpoy.org. Website: www.cpoy.org. Annual contest to recognize excellent photography by currently enrolled college students. Portfolio winner receives a plaque, cash and camera products. Other category winners receive cash and camera products. Open to beginning and intermediate photographers. Fall deadline. Photographers should see website for more information.

CURATOR'S CHOICE AWARDS

P.O. Box 2483, Santa Fe NM 87504. (505)984-8353. E-mail: programs@visitcenter.org. Website: www.visitcenter.org. Executive Director: Laura Pressley. Cost: \$25/members \$35/non-members. Annual contest. Center's Choice Awards are in three different categories with different jurors and prizes. "You can submit to one, two or all categories. Our jurors are some of the most important and influential people in the business. Photographers are invited to submit their most compelling images. Open to all skill levels." Prizes include exhibition and more. Photographers should see submissions guidelines at: centeryourcareer.org/programs.cfm?p=CompetitionGuidelines

Center, the organization that sponsors this competition, was formerly known as The Santa Fe
Center for Photography. "Get a second opinion on your edit and your artist statement. Be very
clear in your concepts and execution. Look at the work of your contemporaries and work that
preceded yours. If it resembles others it will be too 'familiar' and not as potent to the national
and international community. So keep going, keep working, until its ripe, until it's mainly your
voice, your vision that others see."

DANCE ON CAMERA FESTIVAL

48 W. 21st St., #907, New York NY 10010. (212)727-0764. E-mail: info@dancefilms.org. Website: www.dancefilms.org. Sponsored by Dance Films Association, Inc. The oldest annual dance-festival competition in the world for films and videotapes on all aspects of dance. Next event: January 28-February 1, 2011. Co-presented by the Film Society of Lincoln Center in New York City; also tours internationally. Entry forms available on website.

DIRECT ART MAGAZINE PUBLICATION COMPETITION

123 Warren St., Hudson NY 12534. (845)688-7129. E-mail: slowart@aol.com. Website: www.slowart.com. **Director:** Tim Slowinski. Entry fee: \$35. Annual contest. National magazine publication of new and emerging art in all medias. Cover and feature article awards. Open to all skill levels. Deadline: March 31. Photographers should send SASE for more information. SlowArt Productions presents the annual group thematic exhibition, *A Show of Heads*. The exhibition will be held at the Limner Gallery. Open to all artists working in any media, this exhibition will include all interpretations and portrayals of the human head, from the traditional to the abstract and conceptual. All visions of the The Head, including partial and multiple heads, will be reviewed and considered. Eligibility: *A Show of Heads* is open to all artists, national and international, working in all media. All forms of art are eligible. Entrants must be 18 years of age or older to apply. 96" maximum for wall hung work, 72" for free-standing sculpture.

ME ENERGY GALLERY ART CALL

E-mail: info@energygallery.com. Website: www.energygallery.com. Entry fee: \$35 for 5 images; additional images \$10 each. Energy Gallery is an arts organization operated by professional artists, art instructors and curators for promoting emerging and established artists globally. Energy Gallery is a virtual gallery as well as a physical gallery that organizes exhibitions at art galleries, trade shows and public institutions. A jury selects artworks for the online exhibition at Energy Gallery's website for a period of 3 months and archived in Energy Gallery's website permanently. Selected artists also qualify to participate in Energy Gallery's annual exhibit. Photographers should visit website for submission form and more information. Deadline: August 30.

INFOCUS

Palm Beach Photographic Centre, 415 Clematis St., West Palm Beach FL 33401. (561)276-9797. Fax: (561)276-1932. E-mail: cs@workshop.org. Website: www.workshop.org. CEO: Fatima NeJame. Cost: \$25 nonrefundable entry fee. Annual contest. Awards: Best of Show, \$950. Merit awards of free tuition for a PBPC photography workshop of choice. Open to members of the Palm Beach Photographic Centre. Interested parties can obtain an individual membership for \$95. Photographers should write or call for more information.

LAKE CHAMPLAIN MARITIME MUSEUM'S ANNUAL JURIED PHOTOGRAPHY EXHIBIT

4472 Basin Harbor Rd., Vergennes VT 05491. (802)475-2022. E-mail: eloiseb@lcmm.org. Website: www.lcmm.org. Contact: Eloise Beil. Annual exhibition, Lake Champlain Through the Lens, images of Lake Champlain. "Amateur and professional photographers are invited to submit framed prints in color or black & white. Professional photographers will judge and comment on the work." Call for entries begins in June, photograph delivery in August, on view September and October. Photographers should call, e-mail, or visit website for registration form.

LARSON GALLERY JURIED BIENNUAL PHOTOGRAPHY EXHIBITION

Yakima Valley Comm. College, P.O. Box 22520, Yakima WA 98907. (509)574-4875. Fax: (509)574-6826. E-mail: gallery@yvcc.edu. Website: www.larsongallery.org. **Assistant Gallery Director:** Denise Olsen. Cost: \$12/entry (limit 4 entries). National juried competition with approximately Awards: \$3,500 in prize money. Held odd years in April. First jurying held in February. Photographers should write, fax, e-mail or visit the website for prospectus.

LOS ANGELES CENTER FOR DIGITAL JURIED COMPETITION

107 W. Fifth St., Los Angeles CA 90013. (323)646-9427. E-mail: lacda@lacda.com, rexbruce@lacda.com. Website: www.lacda.com. LACDA is dedicated to the propagation of all forms of digital art, supporting local, international, emerging and established artists in our gallery. Its juried competition is open to digital artists around the world. It also sponsors other competitions throughout the year. Photographers should visit website, e-mail, call for more information. Entry fee: \$30.

MERCURY AWARDS

500 Executive Blvd., Ossining-on-Hudson NY 10562. (914)923-9400. Fax: (914)923-9484. E-mail: rwitt@mercommawards.com. Website: www.mercommawards.com. President: Ms. Reni L. Witt. Entry fee: \$190-250/entry (depending on category). Annual contest. The purpose of the contest is to honor outstanding achievement in public relations and corporate communications. Major category for photography, including ads, brochures, magazines, etc. Awards: Best of Show receives a personalized trophy; Grand Award winners receive award plaques (personalized); Gold, silver, bronze and finalists receive a personalized award certificate. All nominators receive complete judge score sheets and evaluation comments. November 11 deadline. Photographers should write, call or e-mail for more information.

MYRON THE CAMERA BUG

c/o Educational Dept., 2106 Hoffnagle St., Philadelphia PA 19152-2409. E-mail: cambug8480@aol. com. Website: www.shutterbugstv.com. **Director:** Len Friedman. Open to all photography students and educators. Photographers should e-mail for details and/or questions.

NEW YORK STATE FAIR PHOTOGRAPHY COMPETITION AND SHOW

581 State Fair Blvd., Syracuse NY 13209. (315)487-7711, ext. 1264 or 12. Website: www.nysfair. org. All entry forms must be completed to include name, address, social security number and return mailing or pick-up information. Entry fees must be included with forms. All works must be received at the Harriet May Mills Art & Home Center by August 14. If mailing, August 13.

Culinary entries are received the day of the specific culinary competition. Only one form per person, per department will be accepted. You may enter on-line with a credit card at www.nysfair. org/competitions.

THE GORDON PARKS PHOTOGRAPHY COMPETITION

Fort Scott Community College, 2108 S. Horton, Fort Scott KS 66701-3140. (620)223-2700. Fax: (620)223-6530. E-mail: photocontest@fortscott.edu. Website: www.fortscott.edu. Contact: Jill Warford. The Annual Gordon Parks Photography Competition is in tribute to Fort Scott, KS, native Gordon Parks. This competition is open to anyone. Photographs submitted should have been taken within the last five years. "Freedom," was the theme of all of his work, Parks said. "Not allowing anyone to set boundaries, cutting loose the imagination and then making the new horizons." Each photographer may submit up to 4 photographs which will be judged as an individual entry. Each photo entry is \$15. Awards: \$500 first place; \$350 second place; \$200 third place; up to three Honorable Mentions will receive \$50 each. See complete details and access entry forms online.

PHOTOGRAPHY NOW

Center for Photography at Woodstock, 59 Tinker St., Woodstock NY 12498. (845)679-9957. Fax: (845)679-6337. E-mail: info@cpw.org. Website: www.cpw.org. **Program Associate:** Akemi Hiatt. 2 annual contests: 1 for exhibitions, 1 for publication. Juried annually by renowned photographers, critics, museum and gallery curators. Deadlines vary. General submission is ongoing. Photographers must call or write for guidelines.

■ THE PHOTO REVIEW ANNUAL PHOTOGRAPHY COMPETITION

140 E. Richardson Ave., Ste. 301, Langhorne PA 19047. (215)891-0214. E-mail: info@photoreview. org. Website: www.photoreview.org. Editor: Stephen Perloff. Cost: \$30 for up to 3 images; \$5 each for up to 3 additional images. National annual contest. All types of photographs are eligible—b&w, color, nonsilver, computer-manipulated, etc. Submit prints (unmatted, unframed, 16 × 20 in. or smaller), or images on CD. All entries must be labeled. Awards include SilverFast HDR Studio digital camera RAW conversion software from LaserSoft Imaging (\$499), a \$270 gift certificate from Lensbabies for a Composer lens or other items on the Lensbaby.com webstore, a \$250 gift certificate from Calumet Photographic, a 24 × 50 in. role of Museo Silver Rag (\$240), a 20 × 24 in. silver gelatin fiber print from Digital Silver Imaging (\$215), camera bags from Lowepro, and \$250 in cash prizes. All winners reproduced in summer issue of *Photo Review* magazine and prizewinners exhibited at photography gallery of the University of Arts/Philadelphia. Open to all skill levels. May 15 deadline. Photographers should send SASE or see website for more information.

PHOTOSPIVA

222 W. Third St., Joplin MO 64801. (417)623-0183. Fax: (417)623-3805. E-mail: jmueller@spivaarts. org. Website: www.spivaarts.org; www.photospiva.org. **Director:** Jo Mueller. Annual national fine art photography competition. Awards: over \$2,000 cash. Open to all photographers in the U.S. and its territories; any photographic process welcome. Enter online. See website for updates on deadlines and exhibition dates.

PICTURES OF THE YEAR INTERNATIONAL

315 Reynolds Journalism Institute, Columbia MO 65211. (573)884-2188. E-mail: info@poyi.org. Website: www.poyi.org. Cost: \$50/entrant. Annual contest to reward and recognize excellence in photojournalism, sponsored by the Missouri School of Journalism and the Donald W. Reynolds Journalism Institute. Awards: over \$20,000 in cash and products. Open to all skill levels. January deadline. Photographers should write, call or e-mail for more information.

The Missouri School of Journalism also sponsors College Photographer of the Year. See website
for details.

RHODE ISLAND STATE COUNCIL ON THE ARTS FELLOWSHIPS

One Capitol Hill, 3rd Floor, Providence RI 02908. (401)222-3880. Fax: (401)222-3018. E-mail: Cristina@arts.ri.gov. Website: www.arts.ri.gov. RI residents only. Cost: free. Annual contest "to encourage the creative development of Rhode Island artists by enabling them to set aside time to pursue their work and achieve specific career goals." Awards \$5,000 fellowship; \$1,000 merit award. Open to advanced photographers. April 1 deadline. Photographers should go to www.arts. ri.gov/grants/guidelines/fellow.php for more information.

W. EUGENE SMITH MEMORIAL FUND, INC.

International Center of Photography, 1133 Avenue of the Americas, New York NY 10036. (212)857-0038. Fax: (212)768-4688. Website: www.smithfund.org. Annual contest. Promotes humanistic traditions of W. Eugene Smith. Every year it recognizes a photographer who has demonstrated an exemplary commitment to documenting the human condition in the spirit of Smith's concerned photography and dedicated compassion. The intention of this grant has never been to find photographers who replicate Smith's particular preoccupations or his photographic style. It has been, and continues to be, to find worthy recipients who in their own way will explore and report upon aspects of the contemporary world that are of significant importance. The grant is given to allow photographers to escape from the increasingly formulaic demands of the mass media. The photography, as it should, will evolve. Applicants should include a written proposal that is concise, journalistically realizable, visually translatable, and humanistically driven, and a résumé of educational and professional qualifications. Additionally, applicants must demonstrate evidence of their photographic ability and submit between 20 and 40 images. The Fund's preferred method of submission is low-resolution JPEGs on a CD or DVD (no RAW or TIFF files). However, for those applicants who do not have access to digital technology, the fund will accept between 20-40 traditional or digital work prints instead, provided they are no larger than 18 × 24 cms or 8 × 10 inches (see submission guidelines on our website). Grant of \$30,000; secondary grant of \$5,000. Open to photographers with a project in the tradition of W. Eugene Smith. Photographers should send SASE (60¢) for application information.

TAYLOR COUNTY FAIR PHOTO CONTEST

The Taylor County Photography Club, P.O. Box 613, Grafton WV 26354-0613. (304)265-5405. E-mail: hsw123@comcast.net. **President:** Harry S. White, Jr. Cost: \$3/print (maximum of 10). Annual juried contest (nationally judged) held in July/August during the May observance of Memorial Day in Grafton. Color and b&w; all subject matter. All prints must be mounted or matted, with a minimum overall size of 8×10 in. and maximum overall size of 16×20 in. No framed prints or slides. No signed prints or mats. All prints must be identified on the back as follows: name, address, phone number, title, and entry number of print (e.g., 1 of 6). All entries must be delivered in a reusable container. Entrant's name, address and number of prints must appear on the outside of the container. Open to amateur photographers only. Six award categories.

THE MOBIUS AWARDS FOR ADVERTISING

713 S. Pacific Coast Hwy., Ste. A, Redondo Beach CA 90277-4233. (310)540-0959. Fax: (310)316-8905. E-mail: kristengluckman@mobiusawards.com. Website: www.mobiusawards.com. Executive Director: Kristen Gluckman. Twitter: MobiusAwards; Facebook: MobiusAwards; Skype: MobiusAwards. Annual international awards competition founded in 1971 for TV, cinema/inflight and radio commercials, print, outdoor, new media, direct, online, mixed media campaigns and package design. Student & spec work welcome. Deadline, October 1. Late entries accepted. "Entries are judged by an international jury on their effectiveness and creativity. Mobius Awards reflects the most current trends in the advertising industry by updating the competition regularly, such as adding new media types and categories. We are dedicated to consistently providing a fair competition with integrity."

UNLIMITED EDITIONS INTERNATIONAL JURIED PHOTOGRAPHY COMPETITIONS

c/o Competition Chairman, 319 E. Shay Circle, P.O. Box 1509, Hendersonville NC 28791. (828)692-4638. E-mail: UltdEditionsIntl@aol.com. President and Owner: Gregory Hugh Leng. Sponsors juried photography competitions several times yearly offering cash, award certificates and prizes. Photography accepted from amateurs and professionals. Open to all skill levels and ages. Prizes awarded in different categories or divisions such as commercial, portraiture, journalism, landscape, digital imaging, and retouching. We accept formats in print film, transparencies and digital images. Black and white, color, and digital imaging CDs or DVDs may be submitted for consideration. Prints and large transparencies may be in mats, no frames. All entries must be delivered in a reusable container with prepaid postage to insure photography is returned. Unlimited Editions International also offers the unique opportunity to purchase photography from those photographers who wish to sell their work. All images submitted in competition remain the property of the photographer/entrants unless an offer to purchase their work is accepted by the photographer. All photographers must send SASE (\$.92 USA and \$2.25 international) for entry forms, contest dates, and detailed information on how to participate in our International juried photography competitions.

YOUR BEST SHOT

E-mail: yourbestshot@bonniercorp.com. Website: www.popphoto.com. Monthly contest; submit up to 5 entries/month. Submit digital photographs: 50-75KB recommended, 1000KB maximum, JPEG format only; if accepted for publication, an image file size of at least 9MB (uncompressed) will be required. Each file should be named with your full name. Multiple entries should be named with your full name followed by consecutive numbers. "If your photo is selected for first place you will receive \$300; \$200 for second place; \$100 for third place; and \$50 for honorable mention. And your photo will be published in *Popular Photography* magazine and may be showcased in a gallery on the Pop Photo website. Include your name, address, phone number, and e-mail address. Also, any technical information you can supply about the photo—camera, lens, settings, film, software, and printer. Submitting a composite? Tell us! If you win and we need more material, we will contact you."

MARKETS

Photo Representatives

any photographers are good at promoting themselves and seeking out new clients, and they actually enjoy that part of the business. Other photographers are not comfortable promoting themselves and would rather dedicate their time and energy solely to producing their photographs. Regardless of which camp you're in, you may need a photo rep.

Finding the rep who is right for you is vitally important. Think of your relationship with a rep as a partnership. Your goals should mesh. Treat your search for a rep much as you would your search for a client. Try to understand the rep's business, who they already represent, etc., before you approach them. Show you've done your homework.

When you sign with a photo rep, you basically hire someone to get your portfolio in front of art directors, make cold calls in search of new clients, and develop promotional ideas to market your talents. The main goal is to find assignment work for you with corporations, advertising firms, or design studios. And, unlike stock agencies or galleries, a photo rep is interested in marketing your talents rather than your images.

Most reps charge a 20- to 30-percent commission. They handle more than one photographer at a time, usually making certain that each shooter specializes in a different area. For example, a rep may have contracts to promote three different photographers—one who handles product shots, another who shoots interiors, and a third who photographs food.

DO YOU NEED A REP?

Before you decide to seek out a photo representative, consider these questions:

- Do you already have enough work, but want to expand your client base?
- Are you motivated to maximize your profits? Remember that a rep is interested in working with photographers who can do what is necessary to expand their businesses.
- Do you have a tightly edited portfolio with pieces showing the kind of work you want to do?
- Are you willing to do what it takes to help the rep promote you, including having a budget to help pay for self-promotional materials?
- Do you have a clear idea of where you want your career to go, but need assistance in getting there?
- Do you have a specialty or a unique style that makes you stand out?

If you answered yes to most of these questions, perhaps you would profit from the expertise of a rep. If you feel you are not ready for a rep or that you don't need one, but you still want some help, you might consider a consultation with an expert in marketing and/or self-promotion.

As you search for a rep, there are numerous points to consider. First, how established is the rep you plan to approach? Established reps have an edge over newcomers in that they know the territory. They've built up contacts in ad agencies, magazines, and elsewhere. This is essential

since most art directors and picture editors do not stay in their positions for long periods of time. Therefore, established reps will have an easier time helping you penetrate new markets.

If you decide to go with a new rep, consider paying an advance against commission in order to help the rep financially during an equitable trial period. Usually it takes a year to see returns on portfolio reviews and other marketing efforts, and a rep who is relying on income from sales might go hungry if he doesn't have a base income from which to live.

Whatever you agree upon, always have a written contract. Handshake deals won't cut it. You must know the tasks that each of you is required to complete, and having your roles discussed in a contract will guarantee there are no misunderstandings. For example, spell out in your contract what happens with clients that you had before hiring the rep. Most photographers refuse to pay commissions for these "house" accounts, unless the rep handles them completely and continues to bring in new clients.

Also, it's likely that some costs, such as promotional fees, will be shared. For example, photographers often pay 75 percent of any advertising fees (such as sourcebook ads and direct mail pieces).

If you want to know more about a specific rep, or how reps operate, contact the Society of Photographers and Artists Representatives, 60 E. 42nd St., Suite 1166, New York NY 10165, (212) 779-7464, www.spar.org. SPAR sponsors educational programs and maintains a code of ethics to which all members must adhere.

ACHARD & ASSOCIATES

611 Broadway, Ste. 803, New York NY 10012. (212)614-0962. Fax: (212)254-9751. E-mail: philippe@pachard.com. Website: www.p-achard.com; www.achardimages.com. Commercial photography representative, Estab. 1990, Represents 12 photographers, Agency specializes in fashion, portraiture, interiors and still life. Markets include advertising agencies, editorial/magazines, direct mail firms, corporate/client direct, design firms, publishing/books.

Handles Photography only.

Terms Rep receives 25% commission. Exclusive area representation required. For promotional purposes, talent must provide images and money. Advertises in Le Book.

How to Contact Send portfolio. Responds only if interested within 1 week. Portfolios may be dropped off every day. To show portfolio, photographer should follow up with a call.

Tips Finds new talent through recommendations from other artists, magazines. "Be original.".

ROBERT BACALL REPRESENTATIVES INC.

4 Springwood Dr., Princeton Junction NJ 08550. (212)695-1729. Fax: (212)695-1739. E-mail: rob@ bacall.com. Website: www.bacall.com. Contact: Robert Bacall. Commercial photography and artist representative. Represents 12 photographers. Agency specializes in digital, food, still life, fashion, beauty, kids, corporate, environmental, portrait, lifestyle, location, landscape. Markets include advertising agencies, corporations/clients direct, design firms, editorial/magazines, publishing/ books, sales/promotion firms.

Terms Rep receives 30% commission. Exclusive area representation required. For promotional purposes, talent must provide portfolios, cases, tearsheets, prints, etc. Advertises in Creative Black Book, Workbook, Le Book, Alternative Pick, PDN-Photoserve, At-Edge.

How to Contact Send query letter/e-mail, direct mail flier/brochure. Responds only if interested. After initial contact, drop off or mail materials for review.

Tips "Seek representation when you feel your portfolio is unique and can bring in new business." Also offering consulting services to photographers that are not represented but are looking to improve their business potential.

MARIANNE CAMPBELL ASSOCIATES

(415)433-0353. Fax: (415)433-0351. E-mail: marianne@mariannecampbell.com; quinci@ mariannecampbell.com; nyc@mariannecampbell.com. Website: www.MarianneCampbell.com. Contact: Marianne Campbell. Commercial photography representative. Member of APA, SPAR, Western Art Directors Club. Represents 6 photographers. Markets include advertising agencies, corporations/clients direct, design firms, editorial/magazines.

Handles Photography.

Terms Negotiated individually with each photographer.

How to Contact Send printed samples of work. Responds in 2 weeks, only if interested.

Tips Obtains new talent through recommendations from art directors and designers and outstanding promotional materials.

MARGE CASEY & ASSOCIATES

20 W. 22nd St., #1605, New York NY 10010. (212)929-3757. E-mail: info@margecasey.com. Website: www.margecasey.com. Represents photographers. Staff includes Elliot Abelson, production coordinator/partner; Patrick Casey, sales associate/photo agent/partner; Marge Casey, sales associate/photo agent/partner. Agency specializes in representing commercial photographers. Markets include advertising agencies, corporate/client direct, design firms, editorial/magazines, direct mail firms

Handles Photography.

How to Contact Send brochure, promo cards. Responds only if interested. Portfolios may be dropped off Monday through Friday. To show portfolio, photographer should follow up with call. Rep will contact photographer for portfolio review if interested.

Tips Finds new talent through submission, recommendations from other artists.

RANDY COLE REPRESENTS. LLC

115 W. 30th St., Ste. 404, New York NY 10001. (212)760-1212. Fax: (212)760-1199. E-mail: randy@ randycole.com. Website: www.randycole.com. Commercial photography representative. Member of SPAR. Represents 10 photographers. Staff includes an assistant. Markets include advertising agencies, editorial companies and magazines, corporate clients, design firms, publishers and entertainment and music companies.

Handles Photography.

Terms Rep receives commission on the creative fees; dependent upon specific negotiation. Advertises in At Edge, Archive and Le Book, as well as online creative directories i.e. Workbook and Photoserve, etc.

How to Contact Send e-mail or promo piece and follow up with call. Portfolios may be dropped off; set up appointment.

Tips Finds new talent through submissions and referrals.

CONSULTANT/PHOTOGRAPHER'S REPRESENTATIVE

11977 Kiowa Ave., Los Angeles CA 90049-6119. E-mail: rhoni@phototherapists.com. Website: www. phototherapists.com. Contact: Rhoni Epstein. Commercial and fine art photography consultants. Expert in imagery/portfolio development, design, branding/ marketing and business plans. "We show you how to differentiate yourself from the myriad other photographers. Customized portfolios, marketing programs, branding materials and website design are developed to be compatible with you and your photography. Your imagery will be focused and tell memorable stories that will last in the viewer's mind long after your portfolio has been seen. We'll guide you to recognize and embrace your own personal style, which will fulfill you and your market." Rhoni Epstein is a photography panel moderator, portfolio reviewer, lecturer and contest judge.

How to Contact Via e-mail.

Tips "Consulting with a knowledgeable and well-respected industry insider is a valuable way to get focused and advance your career in a creative and cost-efficient manner. Always be true to your own personal vision! When researching a representative's agency, research their photographers to understand if they prefer to rep similar styles or experts in a specific area. Remain persistent and enthusiastic; there is always a market for creative and talented people."

M CRISTOPHER LAPP PHOTOGRAPHY

1211 Sunset Plaza Dr., Ste. 413, Los Angeles CA 90069. (310)612-0040. Fax: (310)943-3793. E-mail: cristopherlapp@yahoo.com. Website: www.cristopherlapp.com. Estab. 1994. Specializes in canvas transfers, fine art prints, hand-pulled originals, limited edition, monoprints, monotypes, offset reproduction, unlimited edition, posters.

Handles Posner Fine Art, Gilanyi Inc, Jordan Designs.

Terms Keeps samples on file.

How to Contact Send an e-mail inquiries.

LINDA DE MORETA REPRESENTS

1511 Union St., Alameda CA 94501. (510)769-1421. Fax: (510)892-2955. E-mail: linda@lindareps. com. Website: www.lindareps.com. Contact: Linda de Moreta. Commercial photography and illustration representative. Estab. 1988. Member of Graphic Artists Guild. Represents 1 photographer and 10 illustrators. Markets include advertising agencies, design firms, corporations/client direct, editorial/magazines, paper products/greeting cards, publishing/books, sales/promotion firms.

Handles Photography, illustration, lettering.

Terms Exclusive representation requirements and commission arrangements vary. Advertising costs are handled by individual agreement. Materials for promotional purposes vary with each artist. Advertises in Workbook, Directory of Illustration.

How to Contact E-mail or send direct mail flier/brochure. "Please do not send original art. Include SASE for any items you wish returned." Responds to any inquiry in which there is an interest. Portfolios are individually developed for each artist.

Tips Obtains new talent primarily through client and artist referrals, some solicitation. "I look for a personal vision and style of photography, and exceptional creativity combined with professionalism, maturity, and commitment to career advancement."

FRANCOISE DUBOIS/DUBOIS REPRESENTS

305 Newbury Lane, Newbury Park CA 91320. (805)376-9738. Fax: (805)376-9738. E-mail: fd@ francoisedubois.com. Website: www.francoisedubois.com. Owner: Françoise Dubois. Commercial photography representative and creative and marketing consultant. Represents 3 photographers. Staff includes Andrew Bernstein (sports and sports celebrities), Michel Dubois (still life/people) and Michael Baciu (photo impressionism). Agency specializes in commercial photography for advertising, editorial, creative, marketing consulting. Markets include advertising agencies, corporations/clients direct, design firms, editorial/magazines, publishing/books, sales/promotion firms.

Handles Photography.

Terms Rep receives 25% commission. Charges FedEx expenses (if not paid by advertising agency or other potential client). Exclusive area representation required. Advertising costs are paid by talent. For promotional purposes, talent must provide "3 portfolios, advertising in national sourcebook, and 3 or 4 direct mail pieces per year. All must carry my name and number."

How to Contact Not looking at portfolios at this time. Send e-mail with link to site.

Tips "Do not look for a rep if your target market is too small a niche. Do not look for a rep if you're not somewhat established. Hire a consultant to help you design a consistent and unique portfolio and marketing strategy, and to make sure your strengths are made evident and you remain focused."

MICHAEL GINSBURG & ASSOCIATES, INC.

345 East 94th St., #10F, New York NY 10128. (212)369-3594. Fax: (212)679-3495. E-mail: mg@ michaelginsburg.com. Website: www.michaelginsburg.com. Contact: Michael Ginsburg. Commercial photography representative. Estab. 1978. Represents 9 photographers. Agency specializes in advertising and editorial photographers. Markets include advertising agencies, corporations/clients direct, design firms, editorial/magazines, sales/promotion firms.

Handles Photography.

Terms Rep receives 30% commission. Charges for messenger costs, FedEx expenses. Exclusive area representation required. Advertising costs are paid 100 percent by talent. For promotional purposes, talent must provide a minimum of 5 portfolios—direct mail pieces 2 times per year—and at least 1 sourcebook per year. Advertises in Workbook, source books and online source books.

How to Contact Send query letter, direct mail flier/brochure, or e-mail. Responds only if interested within 2 weeks. After initial contact, call for appointment to show portfolio of tearsheets, slides, photographs.

Tips Obtains new talent through personal referrals and solicitation.

TOM GOODMAN INC.

2061 Lombard St., Philadelphia PA 19146. (215)545-1738. E-mail: tom@tomgoodman.com. Website: www.tomgoodman.com. Contact: Tom Goodman. Commercial photography and commercial illustration representative. Estab. 1986. Represents 4 photographers. Agency specializes in commercial photography, electronic imaging. Markets include advertising agencies, corporations/ client direct, design firms, editorial/magazines, publishing/books, direct mail firms, sales/ promotion firms.

Handles Photography, electronic imaging.

Terms For promotional purposes, talent must provide original film, files or tearsheets. Requires direct mail campaigns. Optional: sourcebooks. Advertises in Creative Black Book.

How to Contact Send query letter with direct mail flier/brochure.

CAROL GUENZI AGENTS, INC.

865 Delaware, Denver CO 80204-4533. (303)820-2599 or (800)417-5120. Fax: (303)820-2598. E-mail: art@artagent.com. Website: www.artagent.com. Contact: Carol Guenzi. Commercial illustration, photography, new media, film/animation representative. Member of Art Directors Club of Denver, AIGA and ASMP. Represents 30 illustrators, 8 photographers, 6 computer multimedia designers, 3 copywriters, 2 film/video production companies. Agency specializes in a "worldwide selection of talent in all areas of visual communications." Markets include advertising agencies, corporations/ clients direct, design firms, editorial/magazine, paper products/greeting cards, sales/promotions firms.

Handles Illustration, photography, new media, film and animation. Looking for unique styles and applications and digital imaging.

Terms Rep receives 25-30% commission. Exclusive area representation required. Advertising costs are split: 70-75% paid by talent; 25-30% paid by representative. For promotional purposes, talent must provide "promotional material after 6 months, some restrictions on portfolios." Advertises in Directory of Illustration and Workbook.

How to Contact E-mail JPEGs or send direct mail piece, tearsheets. Responds in 2-3 weeks, only if interested. After initial contact, call or e-mail for appointment or to drop off or ship materials for review. Portfolio should include tearsheets, prints, samples and a list of current clients.

Tips Obtains new talent through solicitation, art directors' referrals and active pursuit by individual. "Show your strongest style and have at least 12 samples of that style before introducing all your capabilities. Be prepared to add additional work to your portfolio to help round out your style. We do a large percentage of computer manipulation and accessing on network. All our portfolios are both electronic and prints."

PAT HACKETT/ARTIST REPRESENTATIVE

7014 N. Mercer Way, Mercer Island WA 98040. (206)447-1600. E-mail: pat@pathackett.com. Website: www.pathackett.com. Commercial illustration and photography representative. Estab. 1979. Member of Graphic Artists Guild. Represents 12 illustrators and 1 photographer. Markets include advertising agencies, corporations/client direct, design firms, editorial/magazines.

Handles Illustration, photography.

Terms Rep receives 25-33% commission. Exclusive area representation required. No geographic restrictions. Advertising costs are split: 75% paid by talent; 25% paid by representative. For promotional purposes, talent must provide "standardized portfolio, i.e., all pieces within the book are the same format." Advertises in Showcase and Workbook (www.portfolios.com and www. theispot.com).

How to Contact Send direct mail flier/brochure or e-mail. Responds within 3 weeks if interested.

JG + A

(323)464-2492. Fax: (323)465-7013. E-mail: info@igaonline.com. Website: www.jgaonline.com. Commercial photography representative. Estab. 1985. Member of APA. Represents 12 photographers. Staff includes Dominique Cole (sales rep) and Sherwin Taghdiri (sales rep). Agency specializes in photography. Markets include advertising agencies, design firms.

Handles Photography.

Terms Rep receives 25% commission. Charges shipping expenses. Exclusive representation required. No geographic restrictions. Advertising costs are paid by talent. For promotional purposes, talent must provide promos, advertising and a quality portfolio. Advertises in various source books. How to Contact Send direct mail flier/brochure.

TRICIA JOYCE INC.

79 Chambers St., New York NY 10007. (212)962-0728. E-mail: info@triciajoyce.com, Website: www.triciajoyce.com. Contact: Tricia Joyce, Amy Fraher. Commercial photography representative. Represents photographers and stylists. Agency specializes in fashion, advertising, lifestyle, still life, travel, cosmetics/beauty, interiors, portraiture. Markets include advertising agencies, corporations/ clients direct, design firms, editorial/magazines and sales/promotion firms.

Handles Photography, stylists, hair and makeup artists, and fine art.

Terms Agent receives 25% commission for photography; 20% for stylists, 50% for stock.

How to Contact Send query letter, résumé, direct mail flier/brochure and photocopies. Responds only if interested. After initial contact, "wait to hear—please don't call."

N KORMAN + COMPANY

(212)402-2450. Fax: (212)504-9588. E-mail: contact@kormanandcompany.com. Website: www. kormanandcompany.com. Commercial photography representative. Markets include advertising agencies, corporations/clients direct, editorial/magazines, publishing/books, music, celebrities.

Handles Photography.

Terms Rep receives 25-30% commission or hourly consultation.

How to Contact Send promo by e-mail with link to website. Do not attach large files. Responds in 1 month if interested.

Tips "Research before seeking." Obtains new talent through "recommendations, seeing somebody's work out in the market and liking it. Be prepared to discuss your short-term and long-term goals and how you think a rep can help you achieve them."

JOAN KRAMER AND ASSOCIATES, INC.

10490 Wilshire Blvd., Ste. 1701, Los Angeles CA 90024. (310)446-1866. Fax: (310)446-1856. Contact: Joan Kramer. Commercial photography representative and stock photo agency. Member of SPAR, ASMP, PACA. Represents 45 photographers. Agency specializes in model-released lifestyle. Markets

include advertising agencies, design firms, publishing/books, sales/promotion firms, producers of TV commercials.

Handles Photography.

Terms Rep receives 50% commission. Advertising costs are split: 50% paid by talent; 50% paid by representative. Advertises in Creative Black Book and Workbook.

How to Contact Send a query letter. Responds only if interested.

Tips Obtains new talent through recommendations from others.

LEE + LOU PRODUCTIONS INC.

8522 National Blvd., #104, Culver City CA 90232. (310)287-1542. Fax: (310)287-1814. E-mail: leelou@earthlink.net. Website: www.leelou.com. Contact: Lee Pisarski: Commercial illustration and photography representative, digital and traditional photo retouching, Estab. 1981. Represents 2 retouchers, 5 photographers, 5 film directors, 2 visual effects company, 1CGI company. Specializes in automotive. Markets include advertising agencies.

Handles Photography, commercial film, CGI, visual effects.

Terms Rep receives 25% commission. Charges for shipping, entertainment. Exclusive area representation required. Advertising costs are paid by talent. For promotional purposes, talent must provide direct mail advertising material. Advertises in Creative Black Book, Workbook and Single Image, Shoot, Boards.

How to Contact Send direct mail flier/brochure, tearsheets. Responds in 1 week. After initial contact, call for appointment to show portfolio of photographs.

Tips Obtains new talent through recommendations from others, some solicitation.

THE BRUCE LEVIN GROUP

305 Seventh Ave., Ste. 1101, New York NY 10001. (212)627-2281. Fax: (212)627-0095. E-mail: brucelevin@mac.com. Website: www.brucelevingroup.com. President: Bruce Levin. Commercial photography representative. Estab. 1983. Member of SPAR and ASMP. Represents 10 photographers. Agency specializes in advertising, editorial and catalog; heavy emphasis on fashion, lifestyle and computer graphics.

Handles Photography.

Terms Rep receives 25% commission. Exclusive area representation required. Advertising costs are paid by talent. Advertises in Workbook and other sourcebooks.

How to Contact Send brochure, photos; call. Portfolios may be dropped off every Monday through Friday.

Tips Obtains new talent through recommendations, research, word of mouth, solicitation.

MASLOV AGENT INTERNATIONAL

879 Florida St., San Francisco CA 94110. (415)641-4376. Fax: (415)695-0921. E-mail: maslov@ maslov.com. Website: maslov.com. Member of APA. Represents 9 photographers. Markets include advertising agencies, corporations/clients direct, design firms, editorial/magazines, paper products/ greeting cards, publishing/books, private collections.

Handles Photography. Looking for "original work not derivative of other artists. Artist must have developed style."

Terms Rep receives 25% commission. Exclusive US national representation required. Advertising costs split varies. For promotional purposes, talent must provide 3-4 direct mail pieces/year. Advertises in Archive, Workbook and At Edge.

How to Contact Send query letter, direct mail flier/brochure, tearsheets. Do not send original work. Responds in 2-3 weeks, only if interested. After initial contact, call to schedule an appointment, or drop off or mail materials for review.

Tips Obtains new talent through suggestions from art buyers and recommendations from designers, art directors, other agents, sourcebooks and industry magazines. "We prefer to follow our own leads rather than receive unsolicited promotions and inquiries. It's best to have represented yourself for several years to know your strengths and be realistic about your marketplace. The same is true of having experience with direct mail pieces, developing client lists, and having a system of follow up. We want our talent to have experience with all this so they can properly value our contribution to their growth and success—otherwise that 25% becomes a burden and point of resentment. Enter your best work into competitions such as Communication Arts and Graphis photo annuals. Create a distinctive promotion mailer if your concepts and executions are strong."

JUDITH MCGRATH

P.O. Box 133, 23W040 Army Trail Rd., Wayne IL 60184. (630)762-8451. Fax: 630-524-9126. E-mail: judy@judymcgrath.net. Website: www.judymcgrath.net. Commercial photography representative. Represents photographers. Markets include advertising agencies, corporate/client direct, design firms, editorial/magazines, paper products/greeting cards, publishing/books, direct mail firms.

Handles Photography.

Terms Rep receives 25% commission. Exclusive area representation required. Advertising costs paid by talent. Advertises in Workbook.

How to Contact Send query letter, bio, tearsheets, photocopies. Rep will contact photographer for portfolio review if interested.

MUNRO GOODMAN ARTISTS REPRESENTATIVES

630 N. State St., #2109, Chicago IL 60610. (312)335-8925. E-mail: steve@munrocampagna.com. Website: www.munrocampagna.com. President: Steve Munro. Commercial photography and illustration representative. Estab. 1987. Member of SPAR, CAR (Chicago Artist Representatives). Represents 4 photographers, 30 illustrators. Markets include advertising agencies, corporations/ clients direct, design firms, publishing/books.

Handles Illustration, photography.

Terms Rep receives 25% commission. Exclusive area representation required. Advertising costs are split: 75% paid by talent; 25% paid by representative. For promotional purposes, talent must provide 2 portfolios, leave-behinds, several promos. Advertises in Workbook, other sourcebooks.

How to Contact Send query letter, bio, tearsheets, SASE. Responds within 2 weeks, only if interested. After initial contact, write to schedule an appointment.

Tips Obtains new talent through recommendations, periodicals. "Do a little homework and target appropriate rep. Try to get a referral from an art buyer or art director."

PHOTOKUNST

725 Argyle Ave., Friday Harbor WA 98250. (360)378-1028. Fax: (360)370-5061. Website: www. photokunst.com. Principal: Barbara Cox. Consulting and marketing of photography archives and fine art photography, nationally and internationally. "Accepting select number of photographers on our website. Works with artists on licensing, curating and traveling gallery and museum exhibitions; Agent for photo books."

Handles Emphasis on cause oriented photography, photojournalism, documentary and ethnographic photography. Vintage and contemporary photography.

Terms Charges for consultation, hourly/daily rate; for representation, website fee and percentage of sales and licensing.

How to Contact Send website information. Responds in 2 months.

Tips Finds new talent through submissions, recommendations from other artists, publications, art fairs, portfolio reviews. "In order to be placed in major galleries, a book or catalog must be either in place or in serious planning stage."

MARIA PISCOPO

2973 Harbor Blvd., #341, Costa Mesa CA 92626-3912. (714) 356-4260. Fax: (888)713-0705. E-mail: maria@mpiscopo.com. Website: www.mpiscopo.com. Contact: Maria Piscopo. Commercial photography representative. Estab. 1978. Member of SPAR, Women in Photography, Society of Illustrative Photographers. Markets include advertising agencies, design firms, corporations.

Handles Photography. Looking for "unique, unusual styles; established photographers only."

Terms Rep receives 25% commission. Exclusive area representation required. No geographic restrictions. Advertising costs are split: 50% paid by talent; 50% paid by representative. For promotional purposes, talent must have a website and provide 3 traveling portfolios, leave-behinds and at least 6 new promo pieces per year. Plans web, advertising and direct mail campaigns.

How to Contact Send query letter and samples via PDF to maria@mpiscopo.com. Responds within 2 weeks, only if interested.

Tips Obtains new talent through personal referral and photo magazine articles. "Do lots of research. Be very businesslike, organized, professional and follow the above instructions!"

ALYSSA PIZER

13121 Garden Land Rd., Los Angeles CA 90049. (310)440-3930. Fax: (310)440-3830. E-mail: alyssapizer@earthlink.net. Website: www.alyssapizer.com. Member of APCA. Represents 10 photographers. Agency specializes in fashion, beauty and lifestyle (catalog, image campaign, department store, beauty and lifestyle awards). Markets include advertising agencies, corporations/clients direct, design firms, editorial/magazines.

Handles Photography. Established photographers only.

Terms Rep receives 25% commission. Photographer pays for FedEx and messenger charges. Talent pays 100% of advertising costs. For promotional purposes, talent must provide 10 portfolios, leavebehinds and quarterly promotional pieces.

How to Contact Send query letter or direct mail flier/brochure or e-mail website address. Responds in a couple of days. After initial contact, call to schedule an appointment or drop off or mail materials for review.

Tips Obtains new talent through recommendations from clients.

THE ROLAND GROUP, INC.

4948 St. Elmo Ave., Ste. 201, Bethesda MD 20814. (301)718-7955. Fax: (301)718-7958. E-mail: info@ therolandgroup.com. Website: www.therolandgroup.com. Contact: Rochel Roland. Commercial photography and illustration representatives and brokers. Member of SPAR, Art Directors Club and Ad Club. Represents 300 photographers, 10 illustrators. Markets include advertising agencies, corporations/clients direct, design firms and sales/promotion firms.

Handles Illustration, photography.

Terms Agent receives 35% commission. For promotional purposes, talent must provide transparencies, slides, tearsheets and a digital portfolio.

How to Contact Go online to query about a project. Responds only if interested. There is no talent recruitment at this time.

Tips "The Roland Group provides the NPN Worldwide Service, a global network of advertising and corporate photographers." (See separate listing online at website.)

VICKI SANDER/FOLIO FORUMS

48 Gramercy Park N., New York NY 10010. (212)420-1333. E-mail: vicki@vickisander.com. Website: www.vickisander.com. Commercial photography representative. Estab. 1985. Member of SPAR, The One Club for Art and Copy, The New York Art Directors Club. Represents photographers. Markets include advertising agencies, corporate/client direct, design firms, editorial/magazines, paper products/greeting cards. "Folio Forums is a company that promotes photographers by presenting portfolios at agency conference rooms in catered breakfast reviews. Accepting submissions for consideration on a monthly basis."

Handles Photography, fine art. Looking for lifestyle, fashion, food.

Terms Rep receives 30% commission. Exclusive representation required. Advertising costs are paid by talent. For promotional purposes, talent must provide direct mail and sourcebook advertising. Advertises in Workbook.

How to Contact Send tearsheets. Responds in 1 month. To show portfolio, photographer should follow up with a call and/or letter after initial query.

Tips Finds new talent through recommendation from other artists, referrals. Have a portfolio put together and have promo cards to leave behind, as well as mailing out to rep prior to appointment.

M WALTER SCHUPFER MANAGEMENT CORPORATION

413 W. 14th St., 4th Floor, New York NY 10014. (212)366-4675. Fax: (212)255-9726. Website: www. wschupfer.com. President: Walter Schupfer. Commercial photography representative. Estab. 1996. Represents photographers, stylists, designers. Staff includes producers, art department, syndication. Agency specializes in photography. Markets include advertising agencies, corporate/client direct, design firms, editorial/magazines, record labels, galleries.

Handles Photography, design, stylists, make-up artists, specializing in complete creative management.

Terms Charges for messenger service. Exclusive area representation required. For promotional purposes, talent must provide several commercial and editorial portfolios. Advertises in Le Book. **How to Contact** Send promo cards, "then give us a call." To show portfolio, photographer should follow up with call.

Tips Finds new talent through submissions, recommendations from other artists. "Do research to see if your work fits our agency."

TM ENTERPRISES

P.O. Box 18644, Beverly Hills CA 90210. E-mail: tmarques1@hotmail.com. Contact: Tony Marques. Commercial photography representative and photography broker. Member of Beverly Hills Chamber of Commerce. Represents 50 photographers. Agency specializes in photography of women only: high fashion, swimsuit, lingerie, glamour and fine (good taste) Playboy-style pictures, erotic. Markets include advertising agencies, corporations/clients direct, editorial/magazines, paper products/greeting cards, publishing/books, sales/promotion firms, medical magazines. Handles Photography.

Terms Rep receives 50% commission. Advertising costs are paid by representative. "We promote the standard material the photographer has available, unless our clients request something else." Advertises in Europe, South and Central America, and magazines not known in the U.S.

How to Contact Send everything available. Responds in 2 days. After initial contact, drop off or mail appropriate materials for review. Portfolio should include slides, photographs, transparencies, printed work.

Tips Obtains new talent through worldwide famous fashion shows in Paris, Rome, London and Tokyo; by participating in well-known international beauty contests; recommendations from others. "Send your material clean and organized. Do not borrow other photographers' work in order to get representation. Always protect yourself by copyrighting your material. Get releases from everybody who is in the picture (or who owns something in the picture)."

DOUG TRUPPE

121 E. 31st St., New York NY 10016. (212)685-1223. E-mail: doug@dougtruppe.com. Website: www. dougtruppe.com. Artist Representative: Doug Truppe. Commercial photography representative. Member of SPAR, Art Directors Club. Represents 8 photographers. Agency specializes in lifestyle, food, still life, portrait and children's photography. Markets include advertising agencies, corporate, design firms, editorial/magazines, publishing/books, direct mail firms.

Handles Photography. "Always looking for great commercial work." Established, working photographers only.

Terms Rep receives 25% commission. Exclusive area representation required. Advertising costs are paid by talent. For promotional purposes, talent must provide directory ad (at least 1 directory per year), direct mail promo cards every 3 months, website. Advertises in Workbook.

How to Contact Send e-mail with website address. Responds within 1 month, only if interested. To show portfolio, photographer should follow up with call.

Tips Finds artists through recommendations from other artists, source books, art buyers. "Please be willing to show some new work every 6 months. Have 4-6 portfolios available for representative, Have website and be willing to do direct mail every 3 months. Be professional and organized."

THE WILEY GROUP

1535 Green St., Ste. 301, San Francisco CA 94123. (415)441-3055. Fax: (415)520-0999. E-mail: info@ thewileygroup.com. Website: www.thewileygroup.com. Owner: David Wiley. Commercial artist representative. Established "as an artist agency that promotes and sells the work of illustrators for commercial use worldwide. We has over 25 years of experience in the industry, and extensive knowledge about the usage, pricing, and marketing of commercial art. Currently represents 13 illustrators. The artists' work ranges from traditional to digital. The agency services accounts in advertising, design, and publishing as well as corporate accounts." Clients include Disney, Coca Cola, Smithsonian, Microsoft, Nike, Oracle, Google, Random House, Eli Lilly Pharmaceuticals, National Geographic, Super Bowl XLII, FedEx, Nestle Corp., and Apple Computers.

Terms Rep receives 25% commission with a bonus structure. No geographical restriction. Artist pays 75% of sourcebook ads, postcard/tearsheet mailings. Agent will reimburse artist for 25% of costs. Each year the artists are promoted using online agencies, monthly postcard mailings, and weekly eMailers from Adbase.com.

How to Contact For first contact, e-mail URL and one visual image representing your style. If interested, agent will e-mail or call back to discuss representation.

Tips "The bottom line is that a good agent will get you more work at better rates of pay."

MARKETS

Workshops & Photo Tours

aking a photography workshop or photo tour is one of the best ways to improve your photographic skills. There is no substitute for the hands-on experience and one-on-one instruction you can receive at a workshop. Besides, where else can you go and spend several days with people who share your passion for photography?

Photography is headed in a new direction. Digital imaging is here to stay and is becoming part of every photographer's life. Even if you haven't invested a lot of money into digital cameras, computers or software, you should understand what you're up against if you plan to succeed as a professional photographer. Taking a digital imaging workshop can help you on your way.

Outdoor and nature photography are perennial workshop favorites. Creativity is another popular workshop topic. You'll also find highly specialized workshops, such as underwater photography. Many photo tours specialize in a specific location and the great photo opportunities that location affords.

As you peruse these pages, take a good look at the quality of workshops and the skill level of photographers the sponsors want to attract. It is important to know if a workshop is for beginners, advanced amateurs, or professionals. Information from a workshop organizer can help you make that determination.

These workshop listings contain only the basic information needed to make contact with sponsors, and a brief description of the styles or media covered in the programs. We also include information on costs when possible. Write, call, or e-mail the workshop/photo tour sponsors for complete information. Most have websites with extensive information about their programs, when they're offered, and how much they cost.

A workshop or photo tour can be whatever the photographer wishes—a holiday from the normal working routine, or an exciting introduction to new skills and perspectives on the craft. Whatever you desire, you're sure to find in these pages a workshop or tour that fulfills your expectation's.

EDDIE ADAMS WORKSHOP

540 East 11th St., New York NY 10009. E-mail: info@eddieadamsworkshop.com. Website: www. eddieadams.com. Work Shop Producer: Mirjam Evers. Annual tuition-free photojournalism workshop. The Eddie Adams Workshop brings together 100 promising young photographers with over 150 of the most influential picture journalists, picture editors, managing editors and writers from prestigious organizations such as the Associated Press, CNN, The White House, Life, National Geographic, Newsweek, Time, Parade, Entertainment Weekly, Sports Illustrated, The New York Times, The Los Angeles Times and The Washington Post. Pulitzer-prize winning photographer Eddie Adams created this program to allow young photographers to learn from experienced professionals about the story-telling power and social importance of photography. Participants are divided into 10 teams, each headed by a photographer, editor, producer, or multimedia person. Daily editing and critiquing help each student to hone skills and learn about the visual, technical, and emotional components of creating strong journalistic images. Open to photography students and professional photographers with 3 years or less of experience. Photographers should e-mail for more information.

AERIAL AND CREATIVE PHOTOGRAPHY WORKSHOPS

Hangar 23, Box 470455, San Francisco CA 94147. (415)771-2555. Website: www.aerialarchives.com. Aerial and creative photography workshops in unique locations from helicopters, light planes and balloons.

ALASKA'S SEAWOLF ADVENTURES

P.O. Box 312, Gustavus AK 99826. (907)957-1438. E-mail: kimber@seawolfadventures.net. Website: www.seawolf-adventures.com. "Photograph glaciers, whales, bears, wolves, incredible scenics, etc., while using the Seawolf, a 97-foot, 12-passenger expedition ship, as your base camp in the Glacier Bay area."

ANCHELL PHOTOGRAPHY WORKSHOPS

1127 Broadway NE, Salem OR 97301. (503)375-2163. Fax: (503)588-4003. E-mail: steve@steveanchell. com; sanchell@ctelco.net. Website: www.anchellworkshops.com. Contact: Steve Anchell. Cost: \$250-2,500. Film or digital, group or private workshops held throughout the year, including largeformat, 35mm, studio lighting, figure, darkroom, both color and b&w. Open to all skill levels. Photographers should write, call or e-mail for more information.

ANDERSON RANCH ARTS CENTER

P.O. Box 5598, Snowmass Village CO 81615. (970)923-3181. Fax: (970)923-3871. E-mail: info@ andersonranch.org. Website: www.andersonranch.org. Digital media and photography workshops featuring distinguished artists and educators from around the world. Classes range from traditional silver and alternative photographic processes to digital formats and use of the computer as a tool for time-based and interactive works of art. Program is diversifying into video, animation, sound and installations.

ANDY LONG'S FIRST LIGHT PHOTOGRAPHY WORKSHOP TOURS

P.O. Box 2123, Castle Rock CO 80104. (303)601-2828, Castle Rock CO 80101. (303)601-2828. E-mail: andy@firstlighttours.com. Website: www.firstlighttours.com. Owner: Andy Long. Cost: \$1,095-4,395, depending on tour; hotels, meals and ground transportation included. Tours cover a variety of locations and topics, including Penguins of Falkland Islands, Alaskan northern lights, Florida, south Texas birds, Glacier National Park, Iceland, Maine coast, eagles of southwest Alaska, Alaskan northern lights, Florida, south Texas birds, Mt. Rainier National Park, Colorado wildflowers, Alaska bears, and more. See website for more information on locations, dates and prices. Open to all skill levels. Photographers should call, e-mail, see website for more information.

N ANIMALS OF MONTANA, INC.

(406)686-4224. Fax: (406)686-4224. E-mail: animals@animalsofmontana.com. Website: www. animalsofmontana.com. See website for pricing information. Held annually. Workshops held year round. "Whether you're a professional photographer or amateur or just looking for a Montana Wildlife experience, grab your camera and leave the rest to us! Please visit our tour page for a complete listing of our tours." Open to all skill levels. Photographers should call, e-mail, see website for more information.

ARIZONA HIGHWAYS PHOTO WORKSHOPS

2039 W. Lewis Ave., Phoenix AZ 85009. (888)790-7042. Fax: (602)256-2873. E-mail: friends@ friendsofazhighways.com. Website: www.friendsofazhighways.com. Sales and Customer Service Manager: Laura Montoya. Offers photo adventures to the American West's most spectacular locations with top professional photographers whose work routinely appears in Arizona Highways magazine.

ARROWMONT SCHOOL OF ARTS AND CRAFTS

556 Parkway, Gatlinburg TN 37738. (865)436-5860. Fax: (865)430-4101. E-mail: info@arrowmont.org. Website: www.arrowmont.org. Offers weekend, 1- and 2-week spring, summer and fall workshops in photography, drawing, painting, clay, metals/enamels, kiln glass, fibers, surface design, wood turning and furniture. Residencies, studio assistantships, work-study, and scholarships are available. See individual course descriptions for pricing.

ART NEW ENGLAND SUMMER WORKSHOPS @ BENNINGTON VT

621 Huntington Avenue, Boston MA 02115. (617)879-7200. Fax: (617)879-7171. E-mail: ce@massart. edu. Website: www.massartplus.org. Art New England Coordinator: Nancy McCarthy. Weeklong workshops in August, run by Massachusetts College of Art. Areas of concentration include b&w, alternative processes, digital printing and many more. Photographers should call, e-mail or see website for more information.

ART OF NATURE PHOTOGRAPHY WORKSHOPS

211 Kirkland Ave., Ste. 503, Kirkland WA 98033-6408. (425)968-2884. E-mail: charles@ charlesneedlephoto.com. Website: www.charlesneedlephoto.com. Founder/Instructor: Charles Needle. Cost: \$125-3,500 depending on the workshop; U.S. and international locations such as Monet's Garden (France); Keukenhof Gardens (Holland), and Gardens of England; includes personalized one-on-one field and classroom instruction and supportive image evaluations. Emphasis on creative camera techniques in the field and digital darkroom, allowing students to express "the art of nature" with unique personal vision. Topics include creative macro, flower/garden photography, multipleexposure impressionism, intimate landscapes and scenics, dynamic composition and lighting, etc. Open to all skill levels. Photographers should call, e-mail, see website for more information.

ART WORKSHOPS IN GUATEMALA

4758 Lyndale Ave. S., Minneapolis MN 55419-5304. (612)825-0747. Fax: (612)825-6637. E-mail: info@artguat.org; fourre@artguat.org. Website: www.artguat.org. Director: Liza Fourre. Cost: \$1,945; includes tuition, lodging, breakfast, ground transport. Annual workshops held in Antigua, Guatemala. Workshops include Adventure Travel Photo with Steve Northup, Portraiture/ Photographing the Soul of Indigenous Guatemala with Nance Ackerman, Photography/Capturing Guatemala's Light and Contrasts with David Wells, Travel Photography/Indigenous Peoples, and Spirit of Place with Doug Beasley.

BACHMANN TOUR OVERDRIVE

P.O. Box 950833, Lake Mary FL 32746. (407)333-9988. E-mail: Bill@Billbachmann.com. Website: www.Billbachmann.com. Owner: Bill Bachmann. "Bill Bachmann shares his knowledge and adventures with small groups several times a year. Past trips have been to China, Tibet, South Africa, Antarctica, India, Nepal, Australia, New Zealand, New Guinea, Greece, Vietnam, Laos, Cambodia, Malaysia, Singapore, Guatemala, Honduras, Greece and Cuba. Future trips will be back to Cuba, Antarctica, Eastern Canada, Italy, Eastern Europe, Peru, Argentina, Brazil and many other destinations. Programs are designed for adventure travelers who love photography and want to learn stock photography from a top stock photographer." Open to all skill levels.

NOELLA BALLENGER & ASSOCIATES PHOTO WORKSHOPS

P.O. Box 457, La Canada CA 91012. (818)954-0933. Fax: (818)954-0910. E-mail: Noella1B@aol. com. Website: www.noellaballenger.com. Contact: Noella Ballenger. Travel and nature workshops/ tours, West Coast locations. Individual instruction in small groups emphasizes visual awareness, composition, and problem-solving in the field. All formats and levels of expertise welcome. Also offers online photo classes and articles at www.apogeephoto.com.

FRANK BALTHIS PHOTOGRAPHY WORKSHOPS

P.O. Box 255, Davenport CA 95017. (831)426-8205. E-mail: frankbalthis@yahoo.com. Website: pa.photoshelter.com/c/frankbalthis. Photographer/Owner: Frank S. Balthis. Cost depends on the length of program and travel costs. "Workshops emphasize natural history, wildlife and travel photography, often providing opportunities to photograph marine mammals." Worldwide locations range from Baja California to Alaska. Frank Balthis runs a stock photo business and is the publisher of the Nature's Design line of cards and other publications.

BETTERPHOTO.COM ONLINE PHOTOGRAPHY COURSES

16544 NE 79th St., Redmond WA 98052. (888)927-9992. Fax: (425)881-0309. E-mail: celia@ betterphoto.com. Website: www.betterphoto.com. Sales Manager: Celia Burkhart. Cost: Online courses including personal critiques from professional photographers cost \$198-348 for 4- and 8-week sessions. BetterPhoto.com is the worldwide leader in online photography education, offering an approachable resource for photographers who want to improve their skills, share their photos, and learn more about the art and technique of photography. BetterPhoto offers over 100 photography courses that are taught by top professional photographers. Courses begin the 1st Wednesday of every month. Courses range in skill level from beginner to advanced and consist of inspiring weekly lessons and personal feedback on students' photos from the instructors. "We provide websites for photographers, photo sharing solutions, free online newsletters, lively Q&A and photo discussions, a monthly contest, helpful articles and online photography courses." Open to all skill levels.

BIRDS AS ART/INSTRUCTIONAL PHOTO-TOURS

P.O. Box 7245, 4041 Granada Dr., Indian Lake Estates FL 33855. (863)692-0906. E-mail: birdsasart@ verizon.net. Website: www.birdsasart.com. Instructor: Arthur Morris. Cost: varies, approximately \$300/day. The tours, which visit the top bird photography hot spots in North America, feature evening in-classroom lectures, breakfast and lunch, in-the-field instruction, 6 or more hours of photography, and most importantly, easily approachable yet free and wild subjects.

BLUE PLANET PHOTOGRAPHY WORKSHOPS AND TOURS

(208)466-9340. Website: www.blueplanetphoto.com. Cost: varies depending on type and length of workshop (\$250-5,000; average: \$1,900). Award-winning professional photographer and former wildlife biologist Mike Shipman conducts small group workshops/tours emphasizing individual expression and "vision-finding" by breaking the barriers to creative vision. Workshops held in beautiful locations away from crowds and the more-often-photographed sites. Some workshops are semi-adventure-travel style, using alternative transportation such as hot air balloons, horseback, llama, and camping in remote areas. Group feedback sessions, digital presentations and film processing whenever possible. Workshops and tours held in western U.S., Alaska, Canada and overseas. On-site transportation and lodging during workshop usually included; meals included on some trips. Specific fees, optional activities and gear list outlined in tour materials. Digital photographers welcome. Workshops and tours range from 2 to 12 days, sometimes longer; average is 9 days. Custom tours and workshops available upon request. Open to all skill levels. Photographers should write, call, e-mail or see website for more information.

N BLUE RIDGE WORKSHOPS

4831 Keswick Court, Montclair VA 22025. E-mail: blueridgews@mac.com. Website: www. blueridgeworkshops.com. Contact: Elliot Stern, owner/photographer.

NANCY BROWN HANDS-ON WORKSHOPS

381 Mohawk Lane, Boca Raton FL 33487. (561)988-8992. Fax: (561)988-1791. E-mail: nbrown50@ bellsouth.net. Website: www.nancybrown.com. Contact: Nancy Brown. Cost: \$2,000. Offers oneon-one intensive workshops all year long in studio and on location in Florida. You work with Nancy, the models and the crew to create your images. Photographers should call, fax, e-mail or see website for more information.

BURREN COLLEGE OF ART WORKSHOPS

(353)65-7077200. Fax: (353)65-7077201. E-mail: anna@burrencollege.ie. Website: www.burren college.ie. Resident Artist: Anne McKeown, "These workshops present unique opportunities to capture the qualities of Ireland's western landscape. The flora, prehistoric tombs, ancient abbeys and castles that abound in the Burren provide an unending wealth of subjects in an ever-changing light." Participants will explore the technical as well as creative range of possibilities offered on the average digital SLR camera. Suitable for beginners as well as intermediate students, the courses involve a mixture of both fieldwork and instruction in the digital darkroom. Maximum of 10 participants. Photographers should e-mail for more information or go to website.

CALIFORNIA PHOTOGRAPHIC WORKSHOPS

2500 N. Texas St., Fairfield CA 94533. (888)422-6606. E-mail: cpwschool@sbcglobal.net. Website: www.cpwschool.com. Contact: James Inks. 3 and 5 day workshops in professional photography.

◯ CAMARGO FOUNDATION VISUAL ARTS FELLOWSHIP

1, Avenue Jermini, Cassis 13260, France. E-mail: apply@camargofoundation.org. Website: www. camargofoundation.org. Applications Coordinator: Emily Roberts. Residencies awarded to visual artists, creative writers, composers, and academics. Artists may work on a specific project, develop a body of work, etc. Fellows must live on-site at foundation headquarters for the duration of the Fellowship, Self-catering accommodation provided, stipend of \$1,500 available. Open to advanced photographers. See website for deadline. Photographers should visit website to apply.

JOHN C. CAMPBELL FOLK SCHOOL

One Folk School Rd., Brasstown NC 28902. (828)837.2775 or (800)365-5724. Fax: (828)837.8637. Website: www.folkschool.org. The Folk School offers weekend and weeklong courses in photography year-round. "Please call for free catalog."

THE CENTER FOR FINE ART PHOTOGRAPHY

400 N. College Ave., Fort Collins CO 80524. (907)224-1010. E-mail: contact@c4fap.org. Website: www. c4fap.org/workshops_intro.asp. Executive Director: Hamidah Glasgow. Cost: varies depending on workshop, \$10-400. Offers workshops and forums by photographers who have skills in the subject they present, including Photoshop; photography basics with film and digital; studio lighting. Open to all skill levels. Photographers should write, call, see website for more information.

CENTER FOR PHOTOGRAPHY AT WOODSTOCK

59 Tinker St., Woodstock NY 12498. (845)679-9957. Fax: (845)679-6337. E-mail: info@cpw.org. Website: www.cpw.org. Executive Director: Ariel Shanberg. A not-for-profit arts and education organization dedicated to contemporary creative photography. Programs in education, exhibition, publication, and services for artists. This includes year-round exhibitions, summer/fall Woodstock Photography Workshop and Lecture Series, artist residencies, PHOTOGRAPHY Quarterly magazine, annual call for entries, permanent print collection, slide registry, library, darkroom, fellowship, membership, portfolio review, film/video screenings, internships, gallery talks and more.

N CHICAGO PHOTO SAFARIS

9171 Raven Crest Ln., Byron IL 61010. (815)222-2824. E-mail: Info@Chicagophotosafaris.com. Website: www.Chigagophotosafaris.com. **Owner:** Gary Gullet. Costs \$79-22,700. Held annually. "Local workshops are held daily in convenient locations in Chicago. These are 'hands-on' workshops with participants learning creative camera controls and concepts of photography. There are also regional, national and worldwide safaris for the more adventurous. Extreme photography opportunities include mountain climbing and scuba diving, all in great photographic venues. Check the website for details." Open to photographers of all skill levels.

CATHY CHURCH PERSONAL UNDERWATER PHOTOGRAPHY COURSES

P.O. Box 479, GT, Grand Cayman KY1 1106, Cayman Islands. (345)949-7415; (607)330-3504 (U.S. callers). Fax: (345)949-9770; (607)330-3509 (U.S.). E-mail: cathy@cathychurch.com. Website: www.cathychurch.com. Contact: Cathy Church. Cost: \$125/hour with Cathy Church; \$60/hour with staff. Hotel/dive package available at Sunset House Hotel. Private and group lessons available for all levels throughout the year; classroom and shore diving can be arranged. Lessons available for professional photographers expanding to underwater work. Photographers should e-mail for more information.

CLICKERS & FLICKERS PHOTOGRAPHY NETWORK—LECTURES & WORKSHOPS

P.O. Box 60508, Pasadena CA 91116-6508. (310)457-6130. E-mail: dawnhope@clickersandflickers. com; photographer@clickersandflickers.com. Website: www.clickersandflickers.com. Organizer: Dawn Hope Stevens. Cost: depends on particular event. Monthly networking dinners with outstanding guest speakers (many award winners, including the Pulitzer Prize), events and free activities for members. "Clickers & Flickers Photography Network, Inc., was created to provide people with an interest and passion for photography (cinematography, filmmaking, image making) the opportunity to meet others with similar interests for networking and camaraderie. It creates an environment in which photography issues, styles, techniques, enjoyment and appreciation can be discussed and viewed as well as experienced with people from many fields and levels of expertise (beginners, students, amateur, hobbyist, or professionals, gallery owners and museum curators). We publish a bimonthly color magazine listing thousands of activities for photographers and lovers of images." Most of its content is not on our website for a reason. Membership and magazine subscriptions help support this organization. Clickers & Flickers Photography Network, Inc., is a 21-year-old professional photography network association that promotes information and offers promotional marketing opportunities for photographers, cinematographers, individuals, organizations, businesses, and events. "C&F also provides referrals for photographers. Our membership includes photographers, videographers, and cinematographers who are skilled in the following types of photography: outdoor and nature, wedding, headshots, fine art, sports, events, products, news, glamour, fashion, macro, commercial, landscape, advertising, architectural, wildlife, candid, photojournalism, marquis gothic—fetish, aerial and underwater; using the following types of equipment: motion picture cameras (Imax, 70mm, 65mm, 35mm, 16mm, 8mm), steadicam systems, video, high-definition, digital, still photography—large format, medium format and 35mm." Open to all skill levels. Photographers should call or e-mail for more information.

COMMUNITY DARKROOM

713 Monroe Ave., Rochester NY 14607. (585)244-1730. E-mail: gcae@geneseearts.org. Website: www. geneseearts.org. "We offer 30 different photography and digital classes for all ages on a quarterly basis utilizing digital and vintage processes. Classes include 35mm and digital camera techniques; black & white darkroom techniques; composition; studio lighting and available light; Photoshop, Dreamweaver, InDesign, and Illustrator; wet plate collodion, cyanotype, salt printing, liquid emulsion, and gum biochromate, and many special topics including nature, sports, architecture, night photography, photojournalism, and portraiture."

CONE EDITIONS WORKSHOPS

P.O. Box 51, East Topsham VT 05076. (802)439-5751, ext. 101. E-mail: cathy@cone-editions.com. Website: www.cone-editions.com. Cost: varies per workshop. See website for details on workshop dates and prices. Workshops in Piezography b&w digital printing, digital cameras. Open to all skill levels. Photographers should call, e-mail, see website for more information.

THE CORTONA CENTER OF PHOTOGRAPHY, ITALY

(404)876-6341. E-mail: allen@cortonacenter.com. Website: www.cortonacenter.com. Robin Davis and Allen Matthews lead a personal, small-group photography workshop in the ancient city of Cortona, Italy, centrally located in Tuscany, once the heart of the Renaissance. Dramatic landscapes; Etruscan relics; Roman, Medieval and Renaissance architecture; and the wonderful and photogenic people of Tuscany await. Photographers should write, e-mail or see website for more information.

CORY PHOTOGRAPHY WORKSHOPS

P.O. Box 42, Signal Mountain TN 37377. (423)886-1004. E-mail: tompatcory@aol.com. Website: www.tomandpatcory.com. Contact: Tom or Pat Cory. Small workshops/field trips (8-12 maximum participants) with some formal instruction, but mostly one-on-one instruction in the field. "Since we tailor this instruction to each individual's interests, our workshops are suitable for all experience levels. Participants are welcome to use film or digital cameras or even video. Our emphasis is on nature and travel photography. We spend the majority of our time in the field, exploring our location. Cost and length vary by workshop. Many of our workshop fees include single-occupancy lodging, and some also include home-cooked meals and snacks. We offer special prices for 2 people sharing the same room, and, in some cases, special non-participant prices. Workshop locations vary from year to year but include the Eastern Sierra of California, Colorado and Arches National Park, Olympic National Park, Acadia National Park, the Upper Peninsula of Michigan, Death Valley National Park, Smoky Mountain National Park, and Glacier National Park. We offer international workshops in Ireland, Scotland, Provence, Brittany, Tuscany, New Zealand, Newfoundland, Wales, Iceland, Morocco, Costa Rica and Panama. We also offer a number of short workshops throughout the year in and around Chattanooga, Tennessee-individual instruction and custom-designed workshops for groups." Photographers should write, call, e-mail or see website for more information.

CREALDÉ SCHOOL OF ART

600 St. Andrews Blvd., Winter Park FL 32792. (407)671-1886. E-mail: pschreyer@crealde.org; rickpho@aol.com. Website: www.crealde.org. Director of Photography: Rick Lang. Executive Director: Peter Schreyer. Cost: Membership fee begins at \$35/individual. Offers classes covering traditional and digital photography; b&w darkroom techniques; landscape, portrait, documentary, travel, wildlife and abstract photography; and educational tours.

CREATIVE ARTS WORKSHOP

80 Audubon St., New Haven CT 06511. (203)562-4927. E-mail: hshapiro8@aol.com. Website: www. creativeartsworkshop.org. Photography Department Head: Harold Shapiro. Offers exciting classes and advanced workshops. Digital and traditional b&w darkroom.

BRUCE DALE PHOTOGRAPHIC WORKSHOPS

E-mail: bruce@brucedale.com. Website: www.brucedale.com. Bruce teaches throughout the world. Send an e-mail or visit his website for current information on his workshops and lectures.

🖾 🖬 DAWSON COLLEGE CENTRE FOR TRAINING AND DEVELOPMENT

4001 de Maisonneuve Blvd. W., Ste. 2G.1, Montreal QC H3Z 3G4, Canada. (514)933-0047. Fax: (514)937-3832. E-mail: ctd@dawsoncollege.qc.ca. Website: www.dawsoncollege.qc.ca/ciait. Workshop subjects include imaging arts and technologies, computer animation, photography, digital imaging, desktop publishing, multimedia, and web publishing and design. See website for course and workshop information.

THE JULIA DEAN PHOTO WORKSHOPS

801 Ocean Front Walk, Studio 8, Venice CA 90291. (310)392-0909. Fax: (310)664-0809. E-mail: julia@juliadean.com, workshops@juliadean.com. Website: www.juliadean.com. General Manager: Brandon Gannon. The Julia Dean Photo Workshops (JDPW) is a practical education school of photography devoted to advancing the skills and increasing the personal enrichment of photographers of all experience levels and ages. Photography workshops of all kinds held throughout the year, including alternative and fine art, photography & digital camera fundamentals, lighting & portraiture, specialized photography, Photoshop and printing, photo safaris, and travel workshops. Open to all skill levels. Photographers should call, e-mail or see website for more information.

CYNTHIA DELANEY PHOTO WORKSHOPS

168 Maple St., Elko NV 89801. (775)753-5833. Fax: (775)753-5833. E-mail: cynthia@cynthiadelaney. com. Website: www.cynthiadelaney.com. Contact: Cynthia Delaney. "In addition to her photography classes, Cynthia offers outdoor photography workshops held in many outstanding locations. It is our hope to bring photographers to new and unusual places where inspiration comes naturally. Costa Rica: Eye of the Beholder (January 15-22, 2011): Enjoy the peacefulness of this lovely Central American country while gaining a full understanding of outdoor photography. The workshop offers several day trips, lectures at our stunning hotel, and a group critique. This is one of my all time favorite destinations. E-mail for specific itinerary. Price \$2,150. \$500.00 Deposit for Costa Rica holds your place. Early Bird Special: save \$100; \$2,050 pay in full."

DIGITAL WILDLIFE PHOTOGRAPHY FIELD SCHOOL

P.O. Box 236, S. Wellfleet MA 02663. (508)349-2615. E-mail: mlowe@massaudubon.org. Website: www.massaudubon.org/wellfleetbay. **Education Coordinator:** Melissa Lowe. Cost: \$325-350. Four-day course on Cape Cod focusing on wildlife photography using digital technology. Course covers fundamentals of shooting wildlife in a natural setting and an introduction to editing images using photoshop. Taught by Shawn Carey and Eric Smith. Sponsored by Massachusetts Audubon Society.

M DRAMATIC LIGHT NATURE PHOTOGRAPHY WORKSHOPS

2292 Shiprock Rd., Grand Junction CO 81503. E-mail: josephklange@aol.com or joe.lange@dramaticlightphoto.com. Website: www.dramaticlightphoto.com. Cost: \$1,295-1,695 for North American (6-day) workshops; includes motel, transportation, continental breakfast and instruction in the field and classroom. Maximum workshop size: 10 participants. Specializing in the American West. Schedule and registration available online. E-mail for further information.

ELOQUENT LIGHT PHOTOGRAPHY WORKSHOPS

903 W. Alameda St., No 115, Santa Fe NM 87501. (505)983-2934. E-mail: cindylane@eloquentlight.com. Website: www.eloquentlight.com. Managing Director: Cindy Lane. Eco-Photography Workshops inspired by the history, character and beauty of the American Southwest. Award-winning photographer Craig Varjabedian has designed workshops that capture not only the subjects, but also

to explore themes that underscore the collective story of the many cultures that have been drawn to the state over the centuries. Eloquent Light delivers an authentic experience that is both aesthetically and environmentally-sensitive, and, as Managing Director Cindy Lane describes it, "our objective is to honor the sense that what you take away will be given back; a spin on the old adage 'to take only photographs and leave only footprints." Varjabedian's unique methods attract participants from all over the country, drawn by a reputation for offering much more than a photo tour but rather an immersive symbiosis between person and environment that allows the photographer to articulate an individual "voice" in a world overwhelmed with digital images. Participants visit ranches and climb ladders at ancient cliff dwellings. They share stories with ranchers or watch cowboys roping calves, working at sunset when New Mexico's spectacular light makes the mountains glow. These rare opportunities are packaged with expert instruction, field trips, classroom feedback, small group sizes, individual attention and a supportive and fun learning environment, with a range of weeklong workshops to choose from. Due to popular demand, weekend workshops has been added to the yearly schedule. Varjabedian's teaching methods transform the student from the casual shooter into an active observer of the scene and its elements, participating in the stewardship of the land and forming a relationship with the landscape in order to make expressive photographs of it. Eloquent Light's staff integrates instruction with hands-on experience to expand each participant's sense of self and the world, using a style of education that is both contextual and experiential, engaging both head and heart in the process. Whether roaming Georgia O'Keeffe country, exploring Bandelier's caves, or interacting with "Ranchers, Ramblers & Renegades," students are captivated by the magical process that the workshops offer. "Bit by bit, I learned that in photography, technique is only a means to an end. Now what I want is to communicate, to put on film the emotion I felt at a certain place and time, to express what excited me about a place or the people there," said participant Anne Guidry. Varjabedian brings a masters' degree in Fine Art Photography and over 30 years of awards, publications, and teaching; providing rare opportunities for participants to photograph the real characters, back roads and vistas of New Mexico while polishing their own techniques to capture an authentic experience that transcends vacation images or clichéd themes of the Southwest.

JOE ENGLANDER PHOTOGRAPHY WORKSHOPS & TOURS

P.O. Box 1261, Manchaca TX 78652. (512)922-8686. E-mail: info@englander-workshops.com. Website: www.englander-workshops.com. Contact: Joe Englander. Cost: \$275-8,000. Instruction in beautiful locations throughout the world, all formats and media, color/b&w/digital, photoshop instruction. Locations include Europe, Asia with special emphasis on Bhutan and the Himalayas and the U.S. See website for more information.

EUROPA PHOTOGENICA PHOTO TOURS TO EUROPE

3920 W. 231st Place, Torrance CA 90505. (310)378-2821. Fax: (310)378-2821. E-mail: fraphoto@ aol.com. Website: www.francephotogenique.com. Owner: Barbara Van Zanten-Stolarski. (Formerly France Photogenique/Europa Photogenica Photo Tours to Europe.) Cost: \$2,700-3,900; includes some meals, transportation, hotel accommodation. Tuition provided for beginners/intermediate and advanced level. Workshops held in spring (3-5) and fall (1-3). Five- to eleven-day photo tours of the most beautiful regions of Europe. Shoot landscapes, villages, churches, cathedrals, vineyards, outdoor markets, cafes and people in Paris, Provence, southwest France, England, Italy, Greece, etc. Tours change every year. Open to all skill levels. Photographers should call or e-mail for more information.

EXPOSURE36 PHOTOGRAPHY

805 SE 176th Place, Portland OR 97233. (866)368-6736. E-mail: workshop@exposure36.com. Website: www.exposure36.com. Cost: varies, depending on workshop. Open to all skill levels. Workshops offered at prime locations in the U.S. and Canada, including Yosemite, Smoky Mountains, Bryce Canyon, the Oregon coast. Also offers classes on the basics of photography in Portland, Oregon (through the Experimental College or Mt. Hood Community College) and Seattle, Washington (through the Experimental College of the University of Washington). Photographers should write, call, e-mail, see website for more information.

FINDING & KEEPING CLIENTS

2973 Harbor Blvd., Ste. 341, Costa Mesa CA 92626-3912. (714) 356-4260. Fax: (888)713-0705. E-mail: maria@mpiscopo.com. Website: www.mpiscopo.com. Instructor: Maria Piscopo. "How to find new photo assignment clients and get paid what you're worth! See website for schedule or send query via e-mail." Maria Piscopo is the author of The Photographer's Guide to Marketing & Self Promotion (Allworth Press).

FINE ARTS WORK CENTER

24 Pearl St., Provincetown MA 02657. (508)487-9960, ext. 103. Fax: (508)487-8873. E-mail: workshops@fawc.org, Website: www.fawc.org. Summer Program Director: Dorothy Antczak. Cost: \$700/week, \$675/week (housing). Faculty includes Constantine Manos, David Graham, Amy Arbus, Marian Roth, Gabe Greenburg, Joanne Dugan, David Hilliard, and Connie Imboden. Write, call or e-mail for more information.

FIRST LIGHT PHOTOGRAPHIC WORKSHOPS AND SAFARIS

10 Roslyn, Islip Terrace NY 11752. (631)581-0400. Website: www.firstlightphotography.com. President: Bill Rudock. Photo workshops and photo safaris for all skill levels held on Long Island, NY, and specializing in national parks, domestic and international; also presents workshops for portrait and wedding photographers. "We will personally teach you through our Workshops & Safaris, the techniques necessary to go from "taking pictures" to "creating" those unique, magical images while experiencing some of life's greatest adventures." Contact through website e-mail form.

FOCUS ADVENTURES

P.O. Box 771640, Steamboat Springs CO 80477. (970)879-2244. E-mail: karen@focusadventures. com. Website: www.focusadventures.com. Owner: Karen Gordon Schulman. Photo workshops and tours emphasize photography and the creative spirit and self-discovery through photography. Summer photo workshops in Steamboat Springs, Colorado and at Focus Ranch, a private guest ranch in NW Colorado. Customized private and small-group lessons available year-round. International photo tours run with Strabo Photo Tour Collection to various destinations including Ecuador, Bali, Morocco, Barcelona, and Western Ireland.

FOTOFUSION

415 Clematis St., West Palm Beach FL 33401. (561)276-9797. Fax: (561)276-9132. E-mail: cs@ workshop.org. Website: www.fotofusion.org. America's foremost festival of photography and digital imaging is held each January. Learn from more than 90 master photographers, picture editors, picture agencies, gallery directors, and technical experts, over 5 days of field trips, seminars, lectures and Adobe Photoshop workshops. Open to all skill levels, interested in nature, landscape, documentary, portraiture, photojournalism, digital, fine art, commercial, etc. Photographers should write, call or e-mail for more information.

GALÁPAGOS TRAVEL

783 Rio Del Mar Blvd., Ste. 49, Aptos CA 95003. (831)689-9192 or (800)969-9014. E-mail: info@ galapagostravel.com. Website: www.galapagostravel.com. Cost: \$5,200; includes lodging and most meals. Landscape and wildlife photography tour of the islands with an emphasis on natural history. Spend either 11 or 15 days aboard the yacht in Galápagos, plus three nights in a first-class hotel in Ouito, Ecuador. See website for additional information.

☑ GALLANT/FREEMAN PATTERSON PHOTO WORKSHOPS

Shamper's Cove Limited, 3487 Route 845, Long Reach NB E5S 1X4, Canada. (506)763-2189, Fax: (506)763-2035. E-mail: freepatt@nbnet.nb.ca. Website: www.freemanpatterson.com. All workshops are for anybody interested in photography and visual design, from the novice to the experienced amateur or professional. "Our experience has consistently been that a mixed group functions best and learns the most." For more information, including how to prepare, cost and registration, see website.

GERLACH NATURE PHOTOGRAPHY WORKSHOPS & TOURS

P.O. Box 642, Ashton ID 83420. (208)652-4444. E-mail: michele@gerlachnaturephoto.com. Website: www.gerlachnaturephotocom. Office Manager: Michele Smith. Costs vary. Professional nature photographers John and Barbara Gerlach conduct intensive field workshops in the beautiful Upper Peninsula of Michigan in August and during October's fall color period. They lead a photo safari to the best game parks in Kenya in January. They also lead winter photo tours of Yellowstone National Park and conduct high-speed flash hummingbird photo workshops in British Columbia in late May and early June. Barbara and John work for an outfitter a couple weeks a year leading photo tours into The Yellowstone Back Country and Lee Metcalf Wilderness with the use of horses. This is a wonderful way to experience Yellowstone. They conduct an inspirational one-day seminar on how to shoot beautiful nature images in major cities each year. Their two highly rated books, Digital Nature Photography-The Art and the Science, and Digital Landscape Photography have helped thousands master the art of nature photography. Photographers should visit their website for more information.

GLOBAL PRESERVATION PROJECTS

P.O. Box 30866, Santa Barbara CA 93130. (805)682-3398 or (805)455-2790. E-mail: timorse@aol.com. Website: www.globalpreservationprojects.com. Director: Thomas I. Morse. Offers photographic workshops and expeditions promoting the preservation of environmental and historic treasures. Produces international photographic exhibitions and publications. GPP workshops & expeditions include the ghost town of Bodie, CA; Digital Basics for Photographers held in Santa Barbara, CA; expeditions to Arches and Canyonlands; Durango Fall and Winter, Big Sur; Slot Canyons; White Sands; Death Valley and many other places. GPP has also introduced, by request, Bucket List tours with small groups to places you would like to see and photograph before you die. GPP uses a 34-ft. motor home with state-of-the art digital imaging and printer systems for participants use. Photographers should call, e-mail or see website for more information.

GOLDEN GATE SCHOOL OF PROFESSIONAL PHOTOGRAPHY

P.O. Box F, San Mateo CA 94402-0018. (650)548-0889. E-mail: goldengateschool@vahoo.com. Website: www.goldengateschool.org. Director: Martha Bruce. Offers 1-3 day workshops in traditional and digital photography for professional and aspiring photographers in the San Francisco Bay Area.

ROB GOLDMAN CREATIVE PHOTOGRAPHY WORKSHOPS

Huntington NY (631)424-1650. Fax: (631)424-1650. E-mail: rob@rgoldman.com. Website: www. rgoldman.com. **Photographer:** Rob Goldman. Cost varies depending on type and length of workshop. 1-on-1 customized photography lessons for all levels, plus intensive workshops held 3-5 times/year. Purpose is artistic and personal growth for photographers. Open to all skill levels. Photographers should call or e-mail for more information.

HALLMARK INSTITUTE OF PHOTOGRAPHY

P.O. Box 308, Turners Falls MA 01376. (413)863-2478. E-mail: info@hallmark.edu. Website: www. hallmark.edu. Director of Admissions: Lindsay O'Neil. President: George J. Rosa III. Tuition: \$49,600. Offers an intensive 10-month resident program teaching the technical, artistic and business aspects of traditional and digital professional photography for the career-minded individual.

JOHN HART PORTRAIT SEMINARS

344 W. 72nd St., New York NY 10023. (212)873-6585. E-mail: johnharth@aol.com; johnhartstudio1@ mac.com. Website: www.johnhartpics.com.

HAWAII PHOTO SEMINARS

P.O. Box 280, Kualapuu, Molokai HI 96757. (808)567-6430. E-mail: hui@aloha.net. Website: www. huiho.org. Contact: Rik Cooke. Cost: \$2,175; includes lodging, meals and ground transportation. Seven-day landscape photography workshop for beginners to advanced photographers. Workshops taught by 2 National Geographic photographers.

HAWAII PHOTO TOURS, DIGITAL INFRARED, DIGITAL PHOTOGRAPHY. PHOTOSHOP, POLAROID & FUJI TRANSFER WORKSHOPS. PRIVATE TOURS & INSTRUCTION SESSIONS

P.O. Box 335, Honaunau HA 96726. (808)328-2162. E-mail: kcarr@kathleencarr.com. Website: www. kathleencarr.com; www.kathleentcarr.com. Contact: Kathleen T. Carr. \$85-750/day plus materials. Carr, author of Polaroid Transfers and Polaroid Manipulations (Amphoto Books), and To Honor the Earth, offers her expertise in photography and photoshop for photographers of all skill levels. Programs last 1-7 days in Hawaii and other locales.

HEART OF NATURE PHOTOGRAPHY WORKSHOPS

P.O. Box 1645, Honokaa HI 96727. (808)345-7179. E-mail: info@heartofnature.net. Website: www.heartofnature.net. Contact: Robert Frutos. Cost: \$385-2,695, depending on workshop/tours. "Photograph nature in the magnificent wonder of Hawaii, capture compelling and dynamic images that convey the beauty and spirit of the islands." E-mail or see website for more information.

HORIZONS: ARTISTIC TRAVEL

P.O. Box 634, Leverett MA 01054. (413)367-9200. Fax: (413)367-9522. E-mail: horizons@horizonsart.com. Website: www.horizons-art.com. Director: Jane Sinauer. One-of-a-kind small-group travel adventures: 1 and 2-week programs in the American Southwest, Mexico, Ecuador, Peru, Burma, Laos, Vietnam, Cambodia, Southern Africa, Morocco, Northern India.

INFINITY WORKSHOPS

P.O. Box 27555, Seattle WA 98165. (206)367-6864. Fax: (206)367-8102. E-mail: mark@ infinityworkshops.com. Website: www.infinityworkshops.com. Director: Mark Griffith. Cost: \$850. Lodging and food are not included in any workshop fee. Location workshops on the Oregon coast and Southern Utah. Open to all digital and film users, color or black and white. Call, e-mail, or see website for information.

IN FOCUS WITH MICHELE BURGESS

20741 Catamaran Lane, Huntington Beach CA 92646. (714)536-6104. E-mail: maburg5820@aol.com. Website: www.infocustravel.com. President: Michele Burgess. Cost: \$4,500-8,000. Offers overseas tours to photogenic areas with expert photography consultation at a leisurely pace and in small groups (maximum group size: 20).

INTERNATIONAL EXPEDITIONS

One Environs Park, Helena AL 35080. (800)633-4734 (US/Canada). Fax: (205)428-1714. E-mail: nature@ietravel.com. Website: www.ietravel.com. Photo Tour Coordinator: Charlie Weaver. Includes scheduled ground transportation; extensive pre-travel information; services of experienced English-speaking local guides; daily educational briefings; all excursions, entrance fees and permits; all accommodations; meals as specified in the respective itineraries; transfer and luggage handling when taking group flights. Guided nature expeditions all over the world: Amazon, Costa Rica, Machu Picchu, Galapagos, Laos & Vietnam, Borneo, Kenya, Patagonia and many more. Open to all skill levels. Photographers should write, call, e-mail, see website for more information.

JIVIDEN'S "NATURALLY WILD" PHOTO ADVENTURES

P.O. Box 333, Chillicothe OH 45601. (800)866-8655 or (740)774-6243. Fax: (740)774-2272 (call first). E-mail: mail@imagesunique.com. Website: www.naturallywild.net. Contact: Jerry or Barbara Jividen. Cost: \$149 and up depending on length and location. Workshops held throughout the year; please inquire. All workshops and photo tours feature comprehensive instruction, technical advice, pro tips and hands on photography. Many workshops include lodging, meals, ground transportation, special permits and special guest rates. Group sizes are small for more personal assistance and are normally led by 2 photography guides/certified instructors. Subject emphasis is on photographing nature, wildlife and natural history. Supporting emphasis is on proper techniques, composition, exposure, lens and accessory use. Workshops range from 1-7 days in a variety of diverse North American locations. Open to all skill levels. Free information available upon request. Free quarterly journal by e-mail upon request. Photographers should write, call or e-mail for more information.

JORDAHL PHOTO WORKSHOPS

P.O. Box 3998, Hayward CA 94540. (510)785-7707. E-mail: kate@jordahlphoto.com. Website: www. jordahlphoto.com. Directors: Kate or Geir Jordahl. Cost: \$150-700. Intensive 1- to 5-day workshops dedicated to inspiring creativity and community among artists through critique, field sessions and exhibitions.

ART KETCHUM HANDS-ON PHOTOGRAPHIC MODEL WORKSHOPS

3540 Seagate Way, Oceanside CA 92056. (773)551-8751. E-mail: artketchum@sbcglobal.net. Website: www.artketchum.com. Contact: Art Ketchum. Art Ketchum's extensive lighting and posing workshops allow the participant to learn and build a super portfolio of images in the workshop. Cost of the 5-hour workshop is \$125; check website or call for more info.

LIGHT PHOTOGRAPHIC WORKSHOPS

1062 Los Osos Valley Rd., Los Osos CA 93402. (805)528-7385. Fax: (888)254-6211. E-mail: info@ lightworkshops.com. Website: www.lightworkshops.com. Offers small groups. "New focus on digital tools to optimize photography, make the most of your images and improve your photography skills at the premier digital imaging school on the West Coast."

THE LIGHT FACTORY

Spirit Square, Ste. 211, 345 N. College St., Charlotte NC 28202. (704)333-9755. E-mail: dkiel@@ lightfactory.org; julietteMontauk-Smith@lightfactory.org; info@lightfactory.org. Website: www. lightfactory.org. Chief Curator: Dennis Kiel. The Light Factory is "a nonprofit arts center dedicated to exhibition and education programs promoting the power of photography and film." Classes are offered throughout the year in SLR and digital photography and filmmaking.

LLEWELLYN PHOTOGRAPHY WORKSHOPS & FIELD TOURS, PETER

645 Rollo Rd., Gabriola BC VOR 1X3, Canada. (250)247-9109. E-mail: peter@peterllewellyn.com. Website: www.peterllewellyn.com. Cost varies. "All workshops and field trips feature small groups, maximum 6 for workshops and 12 for field trips to allow maximum personal attention. Workshops include basic Photoshop skills, digital photography and digital workflow. Field trips are designed to provide maximum photographic opportunities to participants with the assistance of a professional photographer. Trips include several South American destinations, including Brazil, Guatemala, and Peru, and various venues in Canada and U.S." Open to all skill levels. For further information, e-mail or see website.

C.C. LOCKWOOD WILDLIFE PHOTOGRAPHY WORKSHOP

P.O. Box 14876, Baton Rouge LA 70898. (225)769-4766. Fax: (225)767-3726. E-mail: cactusclyd@aol. com. Website: www.cclockwood.com. Photographer: C.C. Lockwood. Cost: Lake Martin Spoonbill Rookery, \$800; Atchafalaya Swamp, \$290; Eagle Expo \$195; Grand Canyon, \$2,650; Alaska \$6,000; Lake Charles Marsh Birds \$1,000. Workshop at Lake Martin is 3 days plus side trip into Atchafalaya, February and April. Each April and October, C.C. conducts a 2-day Atchafalaya Basin Swamp Wildlife Workshop. It includes lecture, canoe trip into the swamp, and critique session. Every other year, C.C. does a 7-day winter wildlife workshop in August. "Eagle Expo is a lecture and 1/2 day field trip to see nesting bald eagles near Houma, LA. Grand Canyon is a 7-day raft trip in August. At Lake Clark we work on Brown Bears and Landscapes around the Lake Clark and Katmai areas. Near Lake Charles, LA we visit a rookery and stay at a first class hunting camp."

LONG ISLAND PHOTO WORKSHOP

E-mail: jerry@jsmallphoto.com; info@ismallphoto.com. Website: (516)221-4058. liphotoworkshop.com. Director: Jerry Small. Annual 4-day workshop covering professional wedding, portrait, and digital photography and photographic skills. Open to all skill levels.

THE MACDOWELL COLONY

100 High St., Peterborough NH 03458. (603)924-3886. Fax: (603)924-9142. E-mail: admissions@ macdowellcolony.org. Website: www.macdowellcolony.org. Founded in 1907 to provide creative artists with uninterrupted time and seclusion to work and enjoy the experience of living in a community of gifted artists. Residencies of up to 8 weeks for writers, playwrights, composers, film/video makers, visual artists, architects and interdisciplinary artists. Artists in residence receive room, board and exclusive use of a studio. Average length of residency is 5 weeks. Ability to pay for residency is not a factor. There are no residency fees. Limited funds available for travel reimbursement and artist grants based on need. Application deadlines: January 15: summer (June-September); April 15: fall/winter (October-January); September 15: winter/spring (February-May). Photographers should see website for application and guidelines. Questions should be directed to the admissions director.

MAINE MEDIA WORKSHOPS

70 Camden St., P.O. Box 200, Rockport ME 04856. (207)236-8581 or (877)577-7700. Fax: (207)236-2558. E-mail: info@theworkshops.com. Website: www.mainemedia.edu. "Maine Media Workshops is a non-profit educational organization offering year-round workshops for photographers, filmmakers and media artists. Students from across the country and around the world attend courses at all levels, from absolute beginner and serious amateur to working professional; also high school and college students. Professional certificate and low-residency MFA degree programs are available through Maine Media College."

WILLIAM MANNING PHOTOGRAPHY

6396 Birchdale Ct., Cincinnati OH 45230. (513)624-8148. E-mail: williammanning@fuse.net. Website: www.williammanning.com. Digital photography workshops worldwide with emphasis on travel, nature, and architecture. Offers small group tours. Four programs worldwide, with emphasis on landscapes, wildlife and culture. Please see website for locations, schedule and fees.

JOE & MARY ANN MCDONALD WILDLIFE PHOTOGRAPHY WORKSHOPS AND **TOURS**

73 Loht Rd., McClure PA 17841-9340. (717)543-6423. Fax: (717)543-6423. E-mail: info@hoothollow. com. Website: www.hoothollow.com. Owner: Joe McDonald. Cost: \$1,200-8,500. Offers small groups, quality instruction with emphasis on nature and wildlife photography.

MENTOR SERIES WORLDWIDE PHOTO TREKS

2 Park Ave, 9th Floor, New York NY 10016. (888)676-6468; (212)779-5473. Fax: (212)376-7057. E-mail: michelle.cast@bonniercorp.com; erica.johnson@bonniercorp.com. Website: www.mentorseries. com. Director of Special Events: Michelle Cast. Workshops that build not only your skill as a photographer but your sense of the world around you. Enjoy many days of photo activities led by world-renowned professional shooters, all experienced and charismatic photographers who will offer in-the-field advice, lectures, slide shows and reviews. "The chance of getting good photos is high because we have invested in getting great teachers and permits for private access to some cool places. Some of our upcoming destinations include New York City, Egypt, Puerto Rico, Vietnam, California, Botswana, Santa Fe, Fiji, Montana, Switzerland." Open to all skill levels. Photographers should call, e-mail or see website for more information. See terms and conditions on website at: archive.popphoto.com/mentor-series-aboutus/.

MEXICO PHOTOGRAPHY WORKSHOPS

Otter Creek Photography, Hendricks WV 26271. (304)478-3586. E-mail: OtterCreekPhotography@ yahoo.com. Instructor: John Warner. Cost: \$1,400. Intensive weeklong, hands-on workshops held throughout the year in the most visually rich regions of Mexico. Photograph snow-capped volcanoes, thundering waterfalls, pre-Columbian ruins, botanical gardens, fascinating people, markets and colonial churches in jungle, mountain, desert and alpine environments.

MID-ATLANTIC REGIONAL SCHOOL OF PHOTOGRAPHY

(888)267-MARS. E-mail: adele@marsschool.com. Website: www.photoschools.com, Cost: \$1,150 (all-inclusive). The 2011 trip will be the 15th annual voyage for discovery. Scheduled for May 1-May 6, 2011. Covers many aspects of professional photography from digital to portrait to wedding. Open to photographers of all skill levels. See website for further detail.

MIDWEST PHOTOGRAPHIC WORKSHOPS

28830 W. Eight Mile Rd., Farmington Hills MI 48336. (248)471-7299. E-mail: officemanager@mpw. com. Owner: Bryce Denison. Cost: varies per workshop. "One-day weekend and weeklong photo workshops, small group sizes and hands-on shooting seminars by professional photographers/ instructors on topics such as portraiture, landscapes, nudes, digital, nature, weddings, product advertising and photojournalism. We offer Landscape/nature workshops to Italy, Alaska, Maine, Florida, California, and Canada."

MISSOURI PHOTOJOURNALISM WORKSHOP

E-mail: reesd@missouri.edu. Website: www.mophotoworkshop.org. Contact: photojournalism department. Workshop for photojournalists. Participants learn the fundamentals of documentary photo research, shooting, and editing. Held in a different Missouri town each year.

MOUNTAIN WORKSHOPS

Western Kentucky University, 1906 College Heights, MMTH 131, Bowling Green KY 42101-1070. (502)745-6292. E-mail: mountainworkshops@wku.edu; kurt.fattic@wku.edu. Website: www. mountainworkshops.org. Workshop Coordinator: Jim Bye. Cost: Photojournalism and Picture editing: \$595 plus expenses, Multimedia: \$750 plus expenses. Annual documentary photojournalism workshop held in October. Open to intermediate and advanced shooters. The online application for the 2011 Mountains Workshops is available at www.mountainworkshops.org/. Click the "APPLY" button. Tuition: Photojournalism or Picture Editing Workshop Tuition: \$595 prior to Sept. 15, \$650 after Sept. 15; Multimedia Workshop Tuition: \$750 prior to Sept. 15, \$805 after Sept. 15; Cancellation prior to August 15: 100% refund. Cancellation August 16 to Oct 5: \$100 penalty. Cancellation after Oct. 5: NO refunds issued.

NATURAL HABITAT ADVENTURES

833 W. South Boulder Rd., Louisville CO 80027. (303)449-3711 or (800)543-8917. Fax: (303)449-3712. E-mail: info@nathab.com. Website: www.nathab.com. Cost: \$2,195-20,000; includes lodging, meals, ground transportation and expert expedition leaders. Guided photo tours for wildlife photographers. Tours last 5-27 days. Destinations include North America, Latin America, Canada, the Arctic, Galápagos Islands, Africa, the Pacific and Antarctica.

NATURAL TAPESTRIES

1208 St. Rt. 18, Aliquippa PA 15001. (724)495-7493. Fax: (724)495-7370. E-mail: nancyrotenberg@ aol.com. Website: www.naturaltapestries.com. Photographer: Nancy Rotenberg. Cost: varies by workshop. For 2011, we will be traveling to Mexico, Guatemala, Oregon Coast, Callaway Gardens, Ireland, Zion, New Hampshire, and Alaska. Open to all skill levels. Photographers should e-mail or check website for more information.

NATURE PHOTOGRAPHY WORKSHOPS, GREAT SMOKY MOUNTAINS INSTITUTE AT TREMONT

9275 Tremont Rd., Townsend TN 37882. (865)448-9732, ext. 24. Fax: (865)448-9250. E-mail: mail@ gsmit.org. Website: www.gsmit.org. Contact: Registrar. Workshop instructors: Bill Lea, Will Clay and others. Cost: \$611. Offers workshops April 15-18, 2011 and October 21-24, 2011 emphasizing the use of natural light in creating quality scenic, wildflower and wildlife images.

NEVERSINK PHOTO WORKSHOP

P.O. Box 641, Woodbourne NY 12788. (212)929-0009. E-mail: lou@loujawitz@mac.com; louisjawitz@mac.com. Website: www.neversinkphotoworkshop.com. Owner: Louis Jawitz. Offers weekend workshops (both private and group) in digital and film, teaching scenic, travel, macro, location and stock photography during the last 2 weeks of July in the Catskill Mountains. See website for more information.

N NEW ENGLAND SCHOOL OF PHOTOGRAPHY

537 Commonwealth Ave., Boston MA 02215. (617)437-1868 or (800)676-3767. E-mail: info@nesop. com. Website: www.nesop.com. Instruction in professional and creative photography in the form of workshops or a professional photography program.

NEW JERSEY HERITAGE PHOTOGRAPHY WORKSHOPS

124 Diamond Hill Rd., Berkeley Heights NJ 07922. (908)790-8820. E-mail: nancyori@comcast.net. Website: www.nancyoriphotography.com. Director: Nancy Ori. Cost: \$295-450. Workshops held every spring. Nancy Ori, well-known instructor, freelance photographer and fine art exhibitor of landscape and architecture photography, teaches how to use available light and proper metering techniques to document the man-made and natural environments of Cape May. A variety of film and digital workshops taught by guest instructors are available each year and are open to all skill levels, especially beginners. Topics include hand coloring of photographs, creative camera techniques with Polaroid materials, intermediate and advanced digital, landscape and architecture with alternative cameras, environmental portraits with lighting techniques, street photography; as well as pastel, watercolor and oil painting workshops. All workshops include an historic walking tour of town, location shooting or painting, demonstrations and critiques.

NEW JERSEY MEDIA CENTER LLC WORKSHOPS AND PRIVATE TUTORING

124 Diamond Hill Rd., Berkeley Heights NJ 07922. (908)790-8820. E-mail: nancyori@comcast.net. Website: www.nancyoriworkshops.com. Contact: Nancy Ori. 1. Tuscany Photography Workshop by Nancy Ori. Explore the Tuscan countryside, cities and small villages, with emphasis on architecture, documentary, portrait and landscape photography. The group will venture in non-tourist areas. Cost: call for this year's price; includes tuition, accommodations at a private estate, breakfasts

and some dinners. Open to all skill levels. Next workshop will be in October of 2012. 2. Private Photography and Darkroom Tutoring with Nancy Ori in Berkeley Heights, New Jersey. This unique and personalized approach to learning photography is designed for the beginning or intermediate student who wants to expand his/her understanding of the craft and work more creatively with the camera, develop a portfolio, create an exhibit or learn darkroom techniques. The goal is to refine individual style while exploring the skills necessary to make expressive photographs. The content will be tailored to individual needs and interests. Cost: \$350 for a total of 8 hours; \$450 for the darkroom sessions or \$50 per hour. 3. Capturing the Light of the Southwest, a painting, sketching and photography workshop with Nancy Ori and a different painting instructor each year, held every other year in October, (October 2012) will focus on the natural landscape and man-made structures of the area around Santa Fe and Taos. Participants can be at any level in their media. All will be encouraged to produce a substantial body of work worthy of portfolio or gallery presentation. Features special evening guest lecturers from the photography and painting community in the Santa Fe area. Artists should e-mail for more information. 4. Cape May Photography Workshops are held annually in April and May. Also, a variety of subjects such as photojournalism, environmental portraiture, landscape, alternative cameras, Polaroid techniques, creative digital techniques, onlocation wedding photography, large-format, and how to photograph birds in the landscape are offered by several well-known East-Coast instructors. Open to all skill levels. Includes critiques, demonstrations, location shooting of Victorian architecture, gardens, seascapes, and, in some cases, models in either film or digital. E-mail for dates, fees and more information. Workshops are either 3 or 4 days. 5: Costa Rica in February 2012.

NIKON SCHOOL DIGITAL SLR PHOTOGRAPHY

1300 Walt Whitman Rd., Melville NY 11747. (631)547-8666. Fax: (631)547-0309. E-mail: ecoburn@ nikon.net. Website: www.nikonschool.com. Operations Manager: Ellen Coburn. Weekend seminars traveling to 30 major U.S. cities; lunch is included; no camera equipment is required. Intro to Digital SLR Photography, \$129; for those new to digital SLR photography or those coming back after many years away. Expect a good understanding of the basics of photography, terminology, techniques and solutions for specific challenges allowing you to unleash your creative potential. NEXT STEPS, \$159; for experienced digital SLR photographers and those comfortable with the basics of digital photography and key camera controls. Take your digital photography to a higher level creatively and technically.

NORTHERN EXPOSURES

4917 Evergreen Way #383, Everett WA 98203. (425)341-4981 or (425)347-7650. Fax: (425)347-7650. E-mail: abenteuerbc@yahoo.com. Director: Linda Moore. Cost: \$450-1,200 for 3- to 8-day workshops (U.S. and Canada); \$200-450/day for tours in Canada. Offers 3- to 8-day intermediate to advanced nature photography workshops in several locations in Pacific Northwest and western Canada; spectacular settings including coast, alpine, badlands, desert and rain forest. Also, 1- to 2-week Canadian Wildlife and Wildlands Photo Adventures and nature photo tours to extraordinary remote wildlands of British Columbia, Alberta, Saskatchewan, and Yukon.

NYU TISCH SCHOOL OF THE ARTS

721 Broadway, 8th Floor, New York NY 10003. (212)998-1930. E-mail: photo.tsoa@nyu.edu. Website: www.photo.tisch.nyu.edu. Contact: Dept. of Photography and Imaging. Summer classes offered for credit and noncredit covering digital imaging, career development, basic to advanced photography, darkroom techniques, photojournalism, and human rights & photography. Open to all skill levels.

OREGON COLLEGE OF ART AND CRAFT

8245 SW Barnes Rd., Portland OR 97225. (503)297-5544 or (800)390-0632. Fax: (503)297-9651. E-mail: admissions@ocac.edu. Website: www.ocac.edu. Offers workshops and classes in photography throughout the year: b&w, color, alternative processes, studio lighting, digital imaging. Also offers MFA in photography. For schedule information, call or visit website.

STEVE OUTRAM'S TRAVEL PHOTOGRAPHY WORKSHOPS

D. Katsifarakis St., Galatas, Chania 73100 Crete, Greece. E-mail: mail@steveoutram.com. Website: www.steveoutram.com. Workshop Photographer: Steve Outram. Brazil: 13 days every March and October. Western Crete: 9 days in the Venetian town of Chania, every May and October. Lesvos: 14 days on Greece's 3rd-largest island, every October. Istanbul: 7 days in one of the worlds most visually exciting cities, every Oct. Slovenia: 11 days exploring the charming towns of Ljubjana and Piran, every June. Zanzibar: 14 days on this fascinating Indian Ocean island, every February and September. Learn how to take more than just picture postcard-type images on your travels. Workshops are limited to 8 people.

PACIFIC NORTHWEST ART SCHOOL/PHOTOGRAPHY

15 NW Birch St., Coupeville WA 98239. (360)678-3396. Fax: (877)678-3396. E-mail: info@ pacificnorthwestartschool.org. Website: www.pacificnorthwestartschool.org. Contact: Registrar. Cost: varies. "Join us for workshops taught by a well known faculty offering on site (beautiful Whidbey Island) and on location classes." Topics are new and varied every year.

PALM BEACH PHOTOGRAPHIC CENTRE

415 Clematis St., West Palm Beach FL 33401. (561)253-2600. E-mail: cs@workshop.org. Website: www.workshop.org. Cost: \$75-1,100 depending on class. The center is an innovative learning facility offering 1- to 5-day seminars in photography and digital imaging year round. Also offered are travel workshops to cultural destinations such as South Africa, Bhutan, Myanmar, Peru, and India. Emphasis is on photographing the indigenous cultures of each country. Also hosts the annual Fotofusion event (see separate listing in this section). Photographers should call for details.

RALPH PAONESSA PHOTOGRAPHY WORKSHOPS

509 W. Ward Ave., Ste. B-108, Ridgecrest CA 93555-2542. (800)527-3455. E-mail: ralph@rpphoto.com. Website: www.rpphoto.com. Cost: starting at \$1,895; includes 1 week or more of lodging, meals and ground transport. Various workshops repeated annually. Nature, bird and landscape trips to the Eastern Sierra, Death Valley, Falkland Islands, Alaska, Costa Rica, Ecuador, and many other locations. Open to all skill levels. Photographers should write, call or e-mail for more information.

PETERS VALLEY CRAFT CENTER

19 Kuhn Rd., Layton NJ 07851. (973)948-5200. Fax: (973)948-0011. E-mail: info@petersvalley.org. Website: www.petersvalley.org. Offers workshops May, June, July, August and September; 3-6 days long. Offers instruction by talented photographers in a wide range of photographic disciplines—from daguerrotypes to digital and everything in between. Also offers classes in blacksmithing/metals, ceramics, fibers, fine metals, weaving and woodworking. Located in northwest New Jersey in the Delaware Water Gap National Recreation Area, 70 miles west of New York City. Photographers should call for catalog or visit website or more information.

PHOTO EXPLORER TOURS

2506 Country Village, Ann Arbor MI 48103-6500. (800)315-4462 or (734)996-1440. E-mail: decoxphoto@aol.com. Website: www.photoexplorertours.com. **Director:** Dennis Cox. Cost: \$3,195; all-inclusive: Photographic explorations of China, southern Africa, India, Turkey, Indonesia, Morocco, Burma, Iceland, Croatia, Bhutan, and Vietnam. "Founded in 1981 as China Photo Workshop Tours by award-winning travel photographer and China specialist Dennis Cox, Photo Explorer Tours has expanded its tours program since 1996. Working directly with carefully selected tour companies at each destination who understand the special needs of photographers, we keep our groups small, usually from 5 to 16 photographers, to ensure maximum flexibility for both

planned and spontaneous photo opportunities." On most tours, individual instruction is available from professional photographer leading tour. Open to all skill levels. Photographers should write, call or e-mail for more information.

PHOTOGRAPHERS' FORMULARY

P.O. Box 950, 7079 Hwy 83 N, Condon MT 59826-0950. (800)922-5255. Fax: (406)754-2896. E-mail: lynnw@blackfoot.net; formulary@blackfoot.net. Website: www.photoformulary.com. Workshop Program Director: Lynn Wilson. Photographers' Formulary workshops include a wide variety of alternative processes, and many focus on the traditional darkroom. Located in Montana's Swan Valley, some of the best wilderness lands in the Rocky Mountains. See website for details on costs and lodging. Open to all skill levels.

PHOTOGRAPHIC ARTS WORKSHOPS

P.O. Box 1791, Granite Falls WA 98252. (360)691-4105. Fax: (360)691-4105. E-mail: barnbaum@aol. com. Website: www.barnbaum.com. Contact: Bruce Barnbaum. Offers a wide range of workshops across the U.S., Latin America and Europe. Instructors include masters of both traditional and digital imagery. Workshops feature instruction in the understanding and use of light, composition, exposure, development, printing, photographic goals and philosophy. All workshops include reviews of student portfolios. Sessions are intense but highly enjoyable, held in field, darkroom and classroom with outstanding photographer/instructors. Ratio of students to instructors is always 8:1 or fewer, with detailed attention to problems students want solved. All camera formats, color and b&w. Go to the application page at the link on the website, print it out, fill it in, and send it via snail mail. The deposit for each workshop is \$150, except the Escalante backpack, which is \$200. Final payment is requested 5 weeks prior to the start of the workshop. The deposit is non-refundable. If a workshop is cancelled for any reason, your deposit will be returned in full.

PHOTOGRAPHIC CENTER NORTHWEST

900 12th Ave., Seattle WA 98122. (206)720-7222. E-mail: pcnw@pcnw.org; jbrandicke@pcnw. org. Website: www.pcnw.org. Executive Director: Annie Van Avery. Day and evening classes and workshops in fine art photography (b&w, color, digital) for photographers of all skill levels; accredited certificate program.

PHOTOGRAPHY AT THE SUMMIT: JACKSON HOLE

R. Clarkson & Assoc., 1099 18th St., Ste. 1840, Denver CO 80202. (303)295-7770 or (800)745-3211. Fax: (303)295-7771. E-mail: bwilhelm@richclarkson.com. Website: www.photographyatthesummit. com. Administrator: Brett Wilhelm. Annual workshops held in spring (May) and fall (October). Weeklong workshops with top journalistic, nature and illustrative photographers and editors. See website for more information.

PHOTOGRAPHY IN PROVENCE

La Chambre Claire, Rue du Buis, Ansouis 84240, France. E-mail: andrew.squires@photographyprovence.com. Website: www.photographie.-provence.com. Contact: Mr. Andrew Squires, M.A. Cost: £540-620; accommodations can be arranged for you. Workshops May to October. Theme: What to Photograph and Why? Designed for people who are looking for a subject and an approach they can call their own. Explore photography of the real world, the universe of human imagination, or simply let yourself discover what touches you. Explore Provence and photograph on location. Possibility to extend your stay and explore Provence if arranged in advance. Open to all skill levels. Photographers should send SASE, call or e-mail for more information.

N PHOTO WALKING TOURS

422 ½ Carnation Ave., Corona del Mar CA 92625. (888)9PHOTO9 (974-6869). Fax: (888)974-6869. E-mail: Ralph@Ralphvelasco.com. Website: www.photowalkingtours.com. Founder/Lead Instructor: Ralph Velasco. "Photo Walking Tours are designed to provide a unique opportunity for hands-on experience with a professional photography instructor. Learn to 'see like a photographer,' develop skills that will allow you to readily notice and take advantage of more and better photo opportunities and begin to 'think outside the camera!'" Includes: "Local (Southern California), domestic (Chicago) and international photo tours with award-winning photography instructor, international tour guide and author Ralph Velasco. Tours concentrate on various locations throughout Southern California including Orange County (Newport Beach, Corona del Mar, Crystal Cove, Long Beach, Laguna Beach, the Mission San Juan Capistrano), San Diego County (Balboa Park, Old Town San Diego, Point Loma, La Jolla Cove, downtown, Sand Diego by Train) and Los Angeles/Pasadena (Santa Monica Pier, Walt Disney Concert Hall, downtown, The Huntington, San Gabriel Mission. Other parts of California include Temecula, The Flower Fields of Carlsbad, Catalina Island, Joshua Tree National Park, Death Valley, San Francisco, California Coast. International destinations include Cuba, Eastern Europe, Egypt, Spain, the Rhine River and much more. Other destinations are being added all the time." Next tours are: Egypt, November 2010; Cuba, April 2011; Chicago, May 2011. Many more will follow.

PHOTO WORKSHOPS BY COMMERCIAL PHOTOGRAPHER SEAN ARBABI

508 Old Farm Rd., Danville CA 94526-4134. (925)855-8060. Fax: (925)855-8060. E-mail: workshops@ seanarbabi.com. Website: www.seanarbabi.com/workshops.html. Photographer/Instructor: Sean Arbabi. Cost: \$85-3,000 for workshops only; some meals, lodging included - airfare and other services may be included, depending on workshop. Online and seasonal workshops held in spring, summer, fall, winter. Taught around the world via online, and in locations including Digital Photo Academy, Betterphoto.com, Point Reves Field Seminars, Santa Fe Photographic Workshops, as well as locations around the U.S. Sean Arbabi teaches through computer presentations, software demonstrations, slide shows, field shoots and hands-on instruction. All levels of workshops are offered from beginner to advanced; subjects include exposure, digital photography, composition, technical aspects of photography, lighting, fine-tuning your personal vision, utilizing equipment, a philosophical approach to the art, as well as how to run a photography business.

PRAGUE SUMMER SEMINARS

Division of International Education, 2000 Lakeshore Dr., ED 128, Metropolitan College, University of New Orleans, New Orleans LA 70148. (504)280-6388. E-mail: prague@uno.edu. Website: www. unostudyabroad.com/prague.htm. **Program Director**: Mary I. Hicks. Cost: \$4,295; includes lodging. Challenging seminars, studio visits, excursions within Prague; field trips to Vienna, Austria, and Brno, Moravia; film and lecture series. Open to beginners and intermediate photographers. Photographers should call, e-mail or see website for more information.

PROFESSIONAL PHOTOGRAPHER'S SOCIETY OF NEW YORK STATE PHOTO WORKSHOPS

2175 Stuyvesant St., Niskayuna NY 12309. (518)377-5935. E-mail: tmack1@nycap.rr.com; linda@ ppsnysworkshop.com. Website: www.ppsnysworkshop.com. Director: Tom Mack. Cost: \$775 or \$875. Weeklong, specialized, hands-on workshops for professional photographers in July.

B PYRENEES EXPOSURES

12 Rue du Fenouille, Vernet-les-Bains 66820, France. E-mail: explorerimages@yahoo.com. Website: www.Pyreneesexposures.com. Director: Martin N. Johansen. Cost: varies by workshop; starts at \$125 for tuition; housing and meals extra. Workshops held year-round. Offers 1- to 5-day workshops and photo expeditions in the French- and Spanish Pyrenees, including the Andorra, with emphasis on landscapes, wildlife and culture. Workshops and tours are limited to small groups. Open to all skill levels. Photographers should e-mail or see website for more information.

2 QUETICO PHOTO TOURS

P.O. Box 593, Atikokan ON POT 1C0, Canada. (807)597-2621. E-mail: idstradiotto@canoemail. com. Website: www.nwconx.net/~jdstradi. Owner/Operator/Instructor: John Stradiotto. Cost: \$750 U.S.; food and accommodation provided. Annual workshop/conference. Tours depart every Monday morning, during July and August. "Nature photography skills, portrait photography, and telephoto work will be undertaken during a gentle wilderness tour from a cottage base camp. Guests additionally enjoy the benefits of fine outdoor food. We provide the support necessary for photographers to focus on observing nature and developing their abilities."

JEFFREY RICH WILDLIFE PHOTOGRAPHY TOURS

P.O. Box 66, Millville CA 96062. (530)547-3480. E-mail: jrich@jeffrichphoto.com. Website: www. jeffrichphoto.com. Contact: Jeffrey Rich. Leading wildlife photo tours in Alaska and western U.S.: bald eagles, whales, birds, Montana babies and predators, Brazil's Pantanal, Borneo, and Japan's winter wildlife. Photographers should call or e-mail for brochure.

ROCKY MOUNTAIN FIELD SEMINARS

1895 Fall River Rd., Estes Park CO 80517. (970)586-3262. E-mail: fieldseminars@rmna.org. Website: www.rmna.org. Rachel Balduzzi, Field Seminar Director and NGF Manager. Contact: Seminar Coordinator. Cost: \$85-200. Daylong and weekend seminars covering photographic techniques for wildlife and scenics in Rocky Mountain National Park. Professional instructors include David Halpern, W. Perry Conway, Don Mammoser, Glenn Randall, Allan Northcutt and Lee Kline. Call or e-mail for a free seminar catalog listing over 50 seminars.

ROCKY MOUNTAIN SCHOOL OF PHOTOGRAPHY

216 N. Higgins, Missoula MT 59802. (406)543.0171 or (800)394-7677. Fax: (406)721-9133. E-mail: workshops@rmsp.com. Website: www.rmsp.com. Cost: \$90-7,000. "RMSP offers three types of photography programs: Career Training, Workshops and Weckend events. There are varied learning opportunities for students according to their individual goals and educational needs. In a noncompetitive learning environment we strive to instill confidence, foster creativity and build technical skills."

SANTA FE PHOTOGRAPHIC WORKSHOPS

P.O. Box 9916, Santa Fe NM 87504. (505)983-1400. Fax: (505)989-8604. E-mail: info@ santafeworkshops.com. Website: www.santafeworkshops.com. Cost: \$850-1,150 for tuition; lab fees, housing and meals extra; package prices for workshops in Mexico start at \$2,250 and include ground transportation, most meals and accommodations. Over 120 weeklong workshops encompassing all levels of photography and more than 35 digital lab workshops and 12 weeklong workshops in Mexico—all led by top professional photographers. The Workshops campus is located near the historic center of Santa Fe. Call or e-mail to request a free catalog.

SELLING YOUR PHOTOGRAPHY

2973 Harbor Blvd., #341, Costa Mesa CA 92626-3912. (714) 356-4260. E-mail: maria@mpiscopo. com. Website: www.mpiscopo.com. Contact: Maria Piscopo. Cost: \$25-100. One-day workshops cover techniques for marketing and selling photography services. Open to photographers of all skill levels. See website for dates and locations. Maria Piscopo is the author of Photographer's Guide to Marketing & Self-Promotion, 4th edition (Allworth Press).

SELLPHOTOS.COM

Pine Lake Farm, 1910 35th Rd., Oscepla WI 54020. (715)248-3800, ext. 21. Fax: (715)248-3800. E-mail: psi2@photosource.com, info@photosource.com. Website: www.sellphotos.com, www. photosource.com. Contact: Rohn Engh. Offers half-day workshops in major cities. Marketing critique of attendees' slides follows seminar.

JOHN SEXTON PHOTOGRAPHY WORKSHOPS

P.O. Box 30, Carmel Valley CA 93924. (831)659-3130. Fax: (831)659-5509. E-mail: info@johnsexton. com. Website: www.johnsexton.com. Director: John Sexton. Administrative Assistant: Laura Bayless. Cost: \$800-900. Offers a selection of intensive workshops with master photographers in scenic locations throughout the U.S. All workshops offer a combination of instruction in the aesthetic and technical considerations involved in making expressive black and white prints.

SHENANDOAH PHOTOGRAPHIC WORKSHOPS

P.O. Box 54, Sperryville VA 22740. (540)937-5555. Director: Frederick Figall. Three-day to 1-week photo workshops in the Virginia Blue Ridge foothills, held in summer and fall. Weekend workshops held year round in Washington, D.C., area. Prefers contact by phone.

THE SHOWCASE SCHOOL OF PHOTOGRAPHY

1135 Sheridan Road, Atlanta GA 30324. 404-965-2205. E-mail: staff@theshowcaseschool.com. Website: www.theshowcaseschool.com. Cost: \$30-330 depending on class. Offers photography classes to the general public, including beginning digital camera, people photography, nature photography and Adobe Photoshop. Open to beginner and intermediate amateur photographers. Photographers should see website for more information.

SINGING SANDS WORKSHOPS

(519)800-2099. E-mail: donmartelca@yahoo.ca. Website: www.singingsandsworkshops.com. Film shooters welcome. Semiannual workshops held in June and October. Creative photo techniques in the rugged coastline of Georgian Bay and the flats of Lake Huron, taught by Don Martel and James Sidney. Open to all skill levels. Photographers should send SASE, call, e-mail or see website for more information.

M SMOKY MOUNTAIN LEARNING CENTER

414 Whittier School Rd., Whittier NC 28789. (828)736-8450. E-mail: info@mountainlearning.com. Website: www.mountainlearning.com. Offers workshops on portraiture and wedding photography, Photoshop and Painter. Open to all skill levels. Photographers should write, call, see website for more information.

SOUTHEAST PHOTO ADVENTURE SERIES WORKSHOPS

1143 Blakeway St., Daniel Island SC 29492. (843) 377-8652. E-mail: images@peterfinger.com. Website: www.peterfinger.com. President: Peter Finger. Cost: ranges from \$150 for a weekend to \$895 for a weeklong workshop. Offers over 20 weekend and weeklong photo workshops, held in various locations. Workshops planned include Charleston, Savannah, Carolina Coast, Outer Banks, and the Islands of Georgia. "Group instruction from dawn till dusk." Write for additional information.

SOUTH SHORE ART CENTER

119 Ripley Rd., Cohasset MA 02025. (781)383-2787. Fax: (781)383-2964. E-mail: info@ssac. org. Website: www.ssac.org. Offers workshops and classes in introductory and advanced digital photography, landscape photography, travel photography, portrait photography, and darkroom. Photographers should call, e-mail, or visit website for more information.

SPORTS PHOTOGRAPHY WORKSHOP: COLORADO SPRINGS, CO

R. Clarkson & Assoc., 1099 18th St., Ste. 1840, Denver CO 80202. (303)295-7770 or (800)745-3211. Fax: (303)295-7771. E-mail: bwilhelm@richclarkson.com. Website: www.sportsphotographyworkshop. com. Administrator: Brett Wilhelm. Annual workshop held in June. Weeklong workshop in sports photography at the U.S. Olympic Training Center with Sports Illustrated and Associated Press photographers and editors. See website for more information.

SUMMIT PHOTOGRAPHIC WORKSHOPS

P.O. Box 67459, Scotts Valley CA 95067. (831)440-0124. E-mail: b-and-k@pacbell.net. Website: www. summitphotographic.com. Owner: Barbara Brundege. Cost: \$99-200 for workshops; \$1,500-6,000 for tours. Offers several workshops per year, including nature and landscape photography; wildlife photography classes; photo tours from 5 days to 3 weeks. Open to all skill levels. Photographers should see website for more information.

M SUPERIOR/GUNFLINT PHOTOGRAPHY WORKSHOPS

P.O. Box 19286, Minneapolis MN 55419. (612)824-2999. E-mail: lk@laynekennedy.com. Website: www.lavnekennedv.com. Director: Lavne Kennedv. Lodging and meals for North Shore session are paid for by participants. Offers wilderness adventure photo workshops 3 times/year. Winter session includes driving your own dogsled team in northeastern Minnesota. Summer sessions include kayaking/camping trip in the Apostle Islands with first and last nights in lodges, and a new session along Minnesota's North Shore, at the famed North House Folk School, covering Lake Superior's north shore. All trips professionally guided. Workshops stress how to shoot effective and marketable magazine photos in a story-telling format. Write for details on session dates.

SYNERGISTIC VISIONS WORKSHOPS

2435 E. Piazza Ct., Grand Junction CO 81506. (970)245-6700. Fax: (970)245-6700. E-mail: steve@ synvis.com. Website: www.synvis.com. Director: Steve Traudt. Offers a variety of digital photography and Photoshop classes at various venues in Grand Junction, Moab, Ouray, and others. "Steve is also available to present day-long photo seminars to your group." Visit website for more information.

M TEXAS SCHOOL OF PROFESSIONAL PHOTOGRAPHY

P.O. Box 1120, Caldwell TX 77836. (979)272-5200. Fax: (979)272-5201. E-mail: don@texas school.org. Website: texasschool.org/index.html. Director: Don Dickson. Cost: varies. Twenty-five different classes offered, including portrait, wedding, marketing, background painting and video.

THE WORKSHOPS & BOB KORN IMAGING

46 Main St., P.O. Box 1687, Orleans MA 02653. (508)255-5202. E-mail: bob@bobkornimaging.com. Website: www.bobkornimaging.com. Director: Bob Korn. Cost: \$175-645. Photography workshops for the digital photographer. All skill levels. Workshops run year-round. Photographers should call, e-mail or see website for more information.

TOM MURPHY PHOTOGRAPHY

402 S. Fifth, Livingston MT 59047. (406)222-2986 or (406)222-2302. E-mail: tom@tmurphywild. com. Website: www.tmurphywild.com. President: Tom Murphy. Offers programs in wildlife and landscape photography in Yellowstone National Park and special destinations.

TRAVEL IMAGES

P.O. Box 2434, Eagle ID 83616. (800)325-8320. E-mail: phototours@travelimages.com. Website: www.travelimages.com. Owner/Guide: John Baker. Small-group photo tours. Locations include U.S, Canada, Wales, Scotland, Ireland, England, New Zealand, Tasmania, Galapagos Islands, Machu Picchu, Patagonia, Provence, Tuscany, Cinque Terre, Venice, Austria, Switzerland, Germany, and Greece.

JOSEPH VAN OS PHOTO SAFARIS, INC.

P.O. Box 655, Vashon Island WA 98070. Fax: (206)463-5484. E-mail: info@photosafaris.com. Website: www.photosafaris.com. Director: Joseph Van Os. Offers over 50 different photo tours and workshops worldwide.

VIRGINIA CENTER FOR THE CREATIVE ARTS

154 San Angelo Dr., Amherst VA 24521. (434)946-7236. Fax: (434)946-7239. E-mail: vcca@vcca. com. Website: www.vcca.com. Director of Artists' Services: Sheila Gulley Pleasants. The Virginia Center for the Creative Arts (VCCA) is an international working retreat for writers, visual artists and composers. Located on 450 acres in the foothills of the Blue Ridge Mountains in central Virginia, VCCA provides residential fellowships ranging from 2 weeks to 2 months. VCCA can accommodate 25 fellows at a time and provides separate working and living quarters and all meals. There is one fully equipped black-and-white darkroom at VCCA. Artists provide their own materials. Cost: "There is no fee to attend, but a daily contribution of \$45-90 is suggested." VCCA application and work samples required. Photographers should call or see website for more information. Application deadlines are January 15, May 15, and September 15 each year.

VISION QUEST PHOTO WORKSHOPS CENTER

2370 Hendon Ave., St. Paul MN 55108-1453. (651)644-1400. Fax: (651)644-2122. E-mail: info@ douglasbeasley.com. Website: www.beasleyphotography.com. Director: Doug Beasley. Cost: \$495-2,495; often includes food and lodging. Annual workshops held February through November. Handson photo workshops that emphasize content, vision and creativity over technique or gimmicks. Workshops are held in a variety of locations such as The Badlands of South Dakota, Wisconsin, New Mexico, Maine, New York, Oregon, Hawaii, Ireland, China, Japan, Africa, and Guatemala. Open to all skill levels. Photographers should call or e-mail for more information.

VISUAL ARTISTRY & FIELD MENTORSHIP PHOTOGRAPHY WORKSHOP SERIES

P.O. Box 963, Eldersburg MD 21784. (410)552-4664. Fax: (410)552-3332. E-mail: tony@tonysweet. com; susan@tonysweet.com. Website: tonysweet.com. Contact: Tony Sweet or Susan Milestone. Cost: \$1,000-\$1750 for instruction; all other costs are the responsibility of participant. Five-day workshops, limit 8-10 participants. Formats: Digital preferred; 35mm film; xpan. Extensive personal attention and instructional slide shows. Post-workshop support and image critiques for 6 months after the workshop (for an additional fee). Frequent attendees discounts and inclement weather discounts on subsequent workshops. Dealer discounts available from major vendors. "The emphasis is to create in the participant a greater awareness of composition, subject selection, and artistic rendering of the natural world using the raw materials of nature: color, form and line." Open to intermediate and advanced photographers.

WILDLIFE PHOTOGRAPHY WORKSHOPS AND LECTURES

138 Millbrook Rd., Blairstown NJ 07825. (908)362-6616. E-mail: rue@rue.com. Website: www.rue. com; www.rueimages.com. Contact: Len Rue, Jr. Taught by Len Rue, Jr., who has over 35 years experience in outdoor photography by shooting photographic stock for the publishing industry. Also leads tours and teaches photography.

WILD WINGS PHOTO ADVENTURES

2035 Buchanan Rd., Manning SC 29102. (803)473-3414. E-mail: doug@totallyoutdoorsimaging. www.douggardner.com; www.totallyoutdoorsimaging.com/workshops.html. Photographer: Doug Gardner. Cost: \$200-\$450 (some adventures include meals and lodging). Annual workshops held various times throughout the year in North and South Carolina: Waterfowl (Ducks, Snow Geese, Tundra Swan), Osprey & Swamp Critters. "The purpose of Wild Wings Photo Adventures is to offer one on one instruction and great opportunities to photograph 'wild' animals up close. Students will learn valuable techniques in the field with internationally recognized wildlife photographer Doug Gardner. The biggest change to this adventure is the addition of the wild horses. I have recently teamed up with Jared Lloyd who brings to the table an unbelievable knowledge of the geology and history of the Outer Banks and ability to find these elusive wild horses. Jared was literally raised with these beautiful creatures and he knows how to get you in position for spectacular images. Be sure to view the all new TV series, 'Wild Photo Adventures' online at: www. wildphotoadventures.com."

ROBERT WINSLOW PHOTO, INC.

P.O. Box 334, Durango CO 81302-0334. (970)259-4143. E-mail: rwinslow@mydurango.net. Website: www.agpix.com/robertwinslow. Cost: varies depending on workshop or tour. "We arrange and lead custom wildlife and natural history photo tours to East Africa and other destinations around the world."

WOODSTOCK PHOTOGRAPHY WORKSHOPS

59 Tinker St., Woodstock NY 12498. (845)679-9957. E-mail: info@cpw.org. Website: www.cpw. org. Contact: Lindsay Stern. Cost: \$120-625. Offers annual lectures and workshops in all topics in photography from June through October. Faculty includes numerous top professionals in fine art, documentary and commercial photography. Topics include still life, landscape, portraiture, lighting, alternative processes and digital. Offers 1-, 2- and 4-day events. Free catalog available by request.

WORKING WITH ARTISTS

(303)837-1341. E-mail: info@workingwithartists.org. Website: www.workingwithartists.org. Cost: varies, depending on workshop, \$100-1,000. Offers workshops on Photoshop, digital, alternative process, portraiture, landscape, creativity, studio lighting and more. Travels with Artists Workshops are held in Bali; Tuscany, Italy; San Miquel de Allende, Mexico; Spain. Open to all skill levels. They also have a gallery with changing juried photo exhibits. Photographers should call, e-mail, see website for more information.

THE HELENE WURLITZER FOUNDATION OF NEW MEXICO

P.O. Box 1891, Taos NM 87571. (575)758-2413. Fax: (575)758-2559. E-mail: hwf@taosnet.com. Website: www.wurlitzerfouridation.org. Executive Director: Michael A. Knight. The foundation offers residencies to artists in the creative fields-visual, literary and music composition. There are three thirteen week sessions from mid-January through November annually. Application deadline: January 18 for following year. For application, request by e-mail or visit website to download.

YADDO .

(518)584-0746. Fax: (518)584-1312. E-mail: chwait@yaddo.org; Lleduc@yaddo.org. Website: www. yaddo.org. Program Director: Candace Wait. Two seasons: large season is mid-May through August; small season is late September-May (stays from 2 weeks to 2 months; average stay is 5 weeks). Accepts 230 artists/year. Average attendance: Accommodates approximately 35 artists in large season. Those qualified for invitations to Yaddo are highly qualified writers, visual artists (including photographers), composers, choreographers, performance artists and film and video artists who are working at the professional level in their fields. Artists who wish to work collaboratively are encouraged to apply. An abiding principle at Yaddo is that applications for residencies are judged on the quality of the artists' work and professional promise. Site includes four small lakes, a rose garden, woodland, swimming pool, tennis courts. There is a nonrefundable application fee of \$40, payable by credit card. Two letters of recommendation are requested. Applications are considered by the Admissions Committee and invitations are issued by March 15 (deadline: January 1) and October 1 (deadline: August 1). Information available on website. Accepts inquiries by e-mail, fax, SASE, phone. As of the January 1, 2011 application deadline, Yaddo will be accepting applications in all disciplines through the online application portal: Yaddo.slideroom.com. Work samples (images, video, documents, audio), individual application information, professional résumés and letters of recommendation will all be uploaded electronically. The application fee will be \$40 (payable by credit card) for all disciplines. Further information will be provided.

YELLOWSTONE ASSOCIATION INSTITUTE

P.O. Box 117, Yellowstone National Park WY 82190. (406)848-2400. Fax: (406)848-2847. E-mail: Registrar@yellowstoneassociation.org. Website: www.YellowstoneAssociation.org. Offers workshops in nature and wildlife photography during the summer, fall and winter. Custom courses can be arranged. Photographers should see website for more information.

YOSEMITE OUTDOOR ADVENTURES

P.O. Box 230, El Portal CA 95318. (209)379-2646. Fax: (209)379-2486. E-mail: info@yosemite conservancy.org. Website: www.yosemite.org. Cost: \$200 and up. Offers small (8-15 people) workshops in Yosemite National Park in outdoor field photography and natural history year-round. Photographers should see website for more information.

M @ ZORBA PHOTO WORKSHOPS

15 Thermopilon Str., Analipsi Thessaloniki 54248, Greece. +30 6944 257125. E-mail: angelouphotography@gmail.com. Website: www.zorbaphotoworkshops.com. **Owner/Instructor:** John Angelou. Cost: Please check website for information about pricing. Workshop held annually. Next workshop is held summer 2011. Workshops focus on landscape photography, the introduction of the human form into the landscape, creation of fashionable and conceptual images, and post-production. Open to all skill levels. E-mail or see website for more information.

RESOURCES

Stock Photography Portals

These sites market and distribute images from multiple agencies and photographers.

AGPix www.agpix.com
Alamy www.alamy.com
Digital Railroad www.digitalrailroad.net
Find a Photographer www.asmp.org/find-a-photographer
Independent Photography Network (IPNStock) www.ipnstock.com
PhotoServe www.pdnonline.com/pdn/photoserve/index.jsp
PhotoSource International www.photosource.com
Shutterpoint Photography www.shutterpoint.com
Veer www.veer.com
Workbook Stock www.workbook.com

RESOURCES

Portfolio Review Events

ortfolio review events provide photographers the opportunity to show their work to a variety of photo buyers, including photo editors, publishers, art directors, gallery representatives, curators, and collectors.

Art Director's Club, International Annual Awards Exhibition, New York City, www.adcglobal.org
Atlanta Celebrates Photography, held annually in October, Atlanta GA, www.acpinfo.org

Center for Photography at Woodstock, New York City, www.cpw.org

Festival of Light International Directory of Photography Festivals, an international collaboration of more than twenty photography festivals, www.festivaloflight.net

Fotofest, March, Houston TX, www.fotofest.org. Biennial—held in even-numbered years.

Fotofusion, January, Delray Beach FL, www.fotofusion.org

North American Nature Photographers Association, annual summit held in January. Location varies. www.nanpa.org

Photo LA, January, Los Angeles CA, www.photola.com

Photo Miami, held annually in December, Miami FL, http://fotomarketart.com

Photo San Francisco, July, San Francisco CA, www.photosanfrancisco.net

Photolucida, March, Portland OR, www.photolucida.org. Biennial—held in odd-numbered years.

The Print Center, events held throughout the year, Philadelphia PA, www.printcenter.org

Review Santa Fe, July, Santa Fe NM, http://visitcenter.org. The only juried portfolio review event.

Rhubarb-Rhubarb, July, Birmingham UK, www.rhubarb-rhubarb.net

Society for Photographic Education National Conference, March, different location each year, www.spenational.org

RESOURCES

Grants

State, Provincial, & Regional

rts councils in the United States and Canada provide assistance to artists (including photographers) in the form of fellowships or grants. These grants can be substantial and confer prestige upon recipients; however, only state or province residents are eligible. Because deadlines and available support vary annually, query first (with a SASE) or check websites for guidelines.

UNITED STATES ARTS AGENCIES

- **Alabama State Council on the Arts,** 201 Monroe St., Montgomery, AL 36130-1800. (334) 242-4076. E-mail: staff@arts.alabama.gov. Website: www.arts.state.al.us.
- Alaska State Council on the Arts, 161 S. Klevin St., Suite 102, Anchorage, AK 99508-1506. (907) 269-6610 or (888) 278-7424. E-mail: aksca.info@alaska.gov. Website: www.eed.state.ak.us/aksca.
- **Arizona Commission on the Arts,** 417 W. Roosevelt St., Phoenix, AZ 85003-1326. (602) 771-6501. E-mail: info@azarts.gov. Website: www.azarts.gov.
- **Arkansas Arts Council**, 1500 Tower Bldg., 323 Center St., Little Rock, AR 72201-2606. (501) 324-9766. E-mail: info@arkansasarts.com. Website: www.arkansasarts.org.
- California Arts Council, 1300 I St., Suite 930, Sacramento, CA 95814. (916) 322-6555 or (800) 201-6201. E-mail: info@caartscouncil.com. Website: www.cac.ca.gov.
- **Colorado Creative Industries**, 1625 Broadway, Suite 2700, Denver, CO/80202. (303) 892-3802. E-mail: online form. Website: www.coloarts.state.co.us.
- **Connecticut Commission on Culture & Tourism,** One Constitution Plaza, 2nd floor, Hartford, CT 06103. (860) 256-2800. Website: www.cultureandtourism.org.
- **Delaware Division of the Arts,** Carvel State Office Bldg., 4th Floor, 820 N. French St., Wilmington, DE 19801. (302) 577-8278 (New Castle County) or (302) 739-5304 (Kent or Sussex Counties). E-mail: delarts@state.de.us. Website: www.artsdel.org.
- **District of Columbia Commission on the Arts & Humanities**, 1371 Harvard St. NW, Washington, DC 20009. (202) 724-5613. E-mail: cah@dc.gov. Website: www.dcarts.dc.gov.
- **Florida Division of Cultural Affairs**, R.A. Gray Building, 3rd Floor, 500 S. Bronough St., Tallahassee, FL 32399-0250. (850) 245-6470. E-mail: info@florida-arts.org. Website: www.florida-arts.org.
- **Georgia Council for the Arts**, 260 14th St. NW, Atlanta, GA 30318-5360. (404) 685-2787. E-mail: gaarts@gaarts.org. Website: www.gaarts.org.
- Guam Council on the Arts & Humanities, P.O. Box 2950, Hagatna, GU 96932. (671) 475-2781/2782/3661. E-mail: info@caha.guam.gov. Website: www.guamcaha.org.

- **Hawai'i State Foundation on Culture & the Arts,** 250 S. Hotel St., 2nd Floor, Honolulu, HI 96813. (808) 586-0300. E-mail: vivien.lee@hawaii.gov. Website: www.state.hi.us/sfca.
- **Idaho Commission on the Arts,** P.O. Box 83720, Boise, ID 83720-0008. (208) 334-2119 or (800) 278-3863. E-mail: info@arts.idaho.gov. Website: www.arts.idaho.gov.
- Illinois Arts Council, James R. Thompson Center, 100 W. Randolph, Suite 10-500, Chicago, IL 60601-3230. (312) 814-6750 or (800) 237-6994. E-mail: iac.info@illinois.gov. Website: www.arts. illinois.gov.
- **Indiana Arts Commission**, 100 N. Senate Ave., Room N505, Indianapolis, IN 46204. (317) 232-1268. E-mail: IndianaArtsCommission@iac.in.gov. Website: www.in.gov/arts.
- **lowa Arts Council**, 600 E. Locust, Des Moines, IA 50319-0290. (515) 242-6194. Website: www. iowaartscouncil.org.
- **Kansas Arts Commission**, 700 SW Jackson, Suite 1004, Topeka, KS 66603-3774. (785) 296-3335 or (866) 433-0688. E-mail: kac@arts.ks.gov. Website: http://arts.ks.gov.
- **Kentucky Arts Council**, Capital Plaza Tower, 21st Floor, 500 Mero St., Frankfort, KY 40601-1987. (502) 564-3757 or (888) 833-2787. E-mail: kyarts@ky.gov. Website: www.artscouncil.ky.gov.
- **Louisiana Division of the Arts,** P.O. Box 44247, Baton Rouge, LA 70804-4247. (225) 342-8180. E-mail: arts@crt.state.la.us. Website: www.crt.state.la.us/arts.
- Maine Arts Commission, 193 State St., 25 State House Station, Augusta, ME 04333-0025. (207) 287-2724. E-mail: MaineArts.info@maine.gov. Website: http://mainearts.maine.gov.
- **Maryland State Arts Council**, 175 W. Ostend St., Suite E, Baltimore, MD 21230. (410) 767-6555. E-mail: msac@msac.org. Website: www.msac.org.
- **Massachusetts Cultural Council**, 10 St. James Ave., 3rd Floor, Boston, MA 02116-3803. (617) 727-3668. E-mail: mcc@art.state.ma.us. Website: www.massculturalcouncil.org.
- **Michigan Council for Arts & Cultural Affairs**, 300 N. Washington Square, Lansing, MI 48913. (517) 241-4011. E-mail: artsinfo@michigan.org. Website: www.themedc.org/Arts.
- Minnesota State Arts Board, Park Square Court, Suite 200, 400 Sibley St., St. Paul, MN 55101-1928. (651) 215-1600 or (800) 866-2787. E-mail: msab@arts.state.mn.us. Website: www.arts. state.mn.us.
- **Mississippi Arts Commission,** 501 N. West St., Suite 1101A, Woolfolk Bldg., Jackson, MS 39201. (601) 359-6030 or (800) 582-2233. Website: www.arts.state.ms.us.
- Missouri Arts Council, 815 Olive St., Suite 16, St. Louis, MO 63101-1503. (314)340-6845 or (866)407-4752. E-mail: moarts@ded.mo.gov. Website: www.missouriartscouncil.org.
- **Montana Arts Council**, P.O. Box 202201, Helena, MT 59620-2201. (406) 444-6430. E-mail: mac@ mt.gov. Website: http://art.mt.gov.
- National Assembly of State Arts Agencies, 1029 Vermont Ave. NW, 2nd Floor, Washington, DC 20005. (202) 347-6352. E-mail: nasaa@nasaa-arts.org. Website: www.nasaa-arts.org.
- **Nebraska Arts Council**, 1004 Farnam St., Burlington Bldg., Plaza Level, Omaha, NE 68102. (402) 595-2122 or (800) 341-4067. Website: www.nebraskaartscouncil.org.
- **Nevada Arts Council,** 716 N. Carson St., Suite A, Carson City, NV 89701. (775) 687-6680. E-mail: online form. Website: http://nac.nevadaculture.org.
- **New Hampshire State Council on the Arts,** 21/2 Beacon St., Suite 225, Concord, NH 03301-4447. (603) 271-3584 or (800) 735-2964. Website: www.nh.gov/nharts.
- **New Jersey State Council on the Arts,** 225 W. State St., 4th floor, P.O. Box 306, Trenton, NJ 08625. (609) 292-6130. E-mail: online form. Website: www.njartscouncil.org.
- **New Mexico Arts, Dept. of Cultural Affairs,** P.O. Box 1450, Santa Fe, NM 87504-1450. (505) 827-6490 or (800) 879-4278. Website: www.nmarts.org.
- **New York State Council on the Arts,** 175 Varick St., New York, NY 10014. (212) 627-4455 or (800) 895-9838. Website: www.nysca.org.

- North Carolina Arts Council, 109 East Jones St., Cultural Resources Building, Raleigh, NC 27601. (919) 807-6500. E-mail: ncarts@ncdcr.gov. Website: www.ncarts.org.
- North Dakota Council on the Arts, 1600 E. Century Ave., Suite 6, Bismarck, ND 58503-0649. (701)328-7590. E-mail: comserv@nd.gov. Website: www.state.nd.us/arts.
- Ohio Arts Council, 727 E. Main St., Columbus, OH 43205-1796. (614) 466-2613. Website: www. oac.state.oh.us.
- Oklahoma Arts Council, Jim Thorpe Building, 2101 N. Lincoln Blvd., Suite 640, Oklahoma City, OK 73152-2001. (405) 521-2931. E-mail: okarts@arts.ok.gov. Website: www.arts.state.ok.us.
- **Oregon Arts Commission**, 775 Summer St. NE, Suite 200, Salem, OR 97301-1280. (503) 986-0082. E-mail: oregon.artscomm@state.or.us. Website: www.oregonartscommission.org.
- **Pennsylvania Council on the Arts**, 216 Finance Bldg., Harrisburg, PA 17120. (717) 787-6883. Website: www.pacouncilonthearts.org.
- Institute of Puerto Rican Culture, P.O. Box 9024184, San Juan, PR 00902-4184. (787) 724-0700. E-mail: webicp@icp.gobierno.pr. Website: www.icp.gobierno.pr.
- Rhode Island State Council on the Arts, One Capitol Hill, Third Floor, Providence, RI 02908. (401) 222-3880. E-mail: info@arts.ri.gov. Website: www.arts.ri.gov.
- American Samoa Council on Culture, P.O. Box 1995, Pago Pago, AS 96799. (684) 633-4347. E-mail: amssc@prel.org. Website: www.prel.org/programs/pcahe/ptg/terr-asamoa1.html.
- **South Carolina Arts Commission**, 1800 Gervais St., Columbia, SC 29201. (803) 734-8696. E-mail: info@arts.state.sc.us. Website: www.southcarolinaarts.com.
- **South Dakota Arts Council**, 711 E. Wells Ave., Pierre, SD 57501-3369. (605) 773-3301. E-mail: sdac@state.sd.us. Website: www.artscouncil.sd.gov.
- Tennessee Arts Commission, 401 Charlotte Ave., Nashville, TN 37243-0780. (615) 741-1701. Website: www.arts.state.tn.us.
- **Texas Commission on the Arts**, E.O. Thompson Office Building, 920 Colorado, Suite 501, Austin, TX 78701. (512) 463-5535. E-mail: front.desk@arts.state.tx.us. Website: www.arts.state.tx.us.
- **Utah Arts Council**, 617 E. South Temple, Salt Lake City, UT 84102-1177. (801) 236-7555. Website: http://arts.utah.gov.
- **Vermont Arts Council**, 136 State St., Montpelier, VT 05633-6001. (802) 828-3291. E-mail: online form. Website: www.vermontartscouncil.org.
- **Virgin Islands Council on the Arts**, 5070 Norre Gade, St. Thomas, VI 00802-6876. (340)774-5984. Website: http://vicouncilonarts.org.
- **Virginia Commission for the Arts**, Lewis House, 223 Governor St., 2nd Floor, Richmond, VA 23219. (804) 225-3132. E-mail: arts@arts.virginia.gov. Website: www.arts.state.va.us.
- Washington State Arts Commission, 711 Capitol Way S., Suite 600, P.O. Box 42675, Olympia, WA 98504-2675. (360) 753-3860. E-mail: info@arts.wa.gov. Website: www.arts.wa.gov.
- **West Virginia Commission on the Arts,** The Cultural Center, Capitol Complex, 1900 Kanawha Blvd. E., Charleston, WV 25305-0300. (304) 558-0220. Website: www.wvculture.org/arts.
- **Wisconsin Arts Board**, 101 E. Wilson St., 1st Floor, Madison, WI 53702. (608) 266-0190. E-mail: artsboard@wisconsin.gov. Website: http://artsboard.wisconsin.gov.
- **Wyoming Arts Council**, 2320 Capitol Ave., Cheyenne, WY 82002. (307) 777-7742. E-mail: online form. Website: http://wyoarts.state.wy.us.

CANADIAN PROVINCES ARTS AGENCIES

- Alberta Foundation for the Arts, 10708 105 Ave., Edmonton, AB T5H 0A1. (780) 427-9968: Website: www.affta.ab.ca.
- British Columbia Arts Council, P.O. Box 9819, Stn. Prov. Govt., Victoria, BC V8W 9W3. (250) 356-1718. E-mail: BCArtsCouncil@gov.bc.ca. Website: www.bcartscouncil.ca.

- **The Canada Council for the Arts,** 350 Albert St., P.O. Box 1047, Ottawa, ON K1P 5V8. (613) 566-4414 or (800) 263-5588 (within Canada). E-mail: online form. Website: www.canadacouncil. ca.
- Manitoba Arts Council, 525-93 Lombard Ave., Winnipeg, MB R3B 3B1. (204) 945-2237 or (866) 994-2787 (within Manitoba). E-mail: info@artscouncil.mb.ca. Website: www.artscouncil.mb.ca.
- **New Brunswick Arts Board (NBAB)**, 61 Carleton St., Fredericton, NB E3B 3T2. (506) 444-4444 or (866) 460-2787. E-mail: online form. Website: www.artsnb.ca.
- **Newfoundland & Labrador Arts Council,** P.O. Box 98, St. John's, NL A1C 5H5. (709) 726-2212 or (866) 726-2212 (within Newfoundland). E-mail: nlacmail@nfld.net. Website: www.nlac.nf.ca.
- Nova Scotia Department of Tourism, Culture, and Heritage, Culture Division, World Trade Center, 6th floor, 1800 Argyle St., P.O. Box 456, Halifax, NS B3J 2R5. (902) 424-4510. E-mail: culture@gov.ns.ca. Website: www.gov.ns.ca/tch.
- Ontario Arts Council, 151 Bloor St. W., 5th Floor, Toronto, ON M5S 1T6. (416) 961-1660 or (800) 387-0058 (within Ontario). E-mail: info@arts.on.ca. Website: www.arts.on.ca.
- **Prince Edward Island Council of the Arts**, 115 Richmond St., Charlottetown, PE C1A 1H7. (902) 368-4410 or (888) 734-2784. E-mail: info@peica.ca. Website: www.peiartscouncil.com.
- Québec Council for Arts & Literature, 79 boul. René-Lévesque Est, 3e étage, Québec, QC G1R 5N5. (418) 643-1707 or (800) 897-1707. E-mail: info@calq.gouv.qc.ca. Website: www.calq.gouv.qc.ca.
- **The Saskatchewan Arts Board**, 1355 Broad St., Regina, SK S4P 7V1. (306) 787-4056 or (800) 667-7526 (within Saskatchewan). E-mail: info@artsboard.sk.ca. Website: www.artsboard.sk.ca.
- Yukon Arts Section, Cultural Services Branch, Dept. of Tourism & Culture, Government of Yukon, Box 2703, Whitehorse, YT Y1A 2C6. (867) 667-8589 or (800) 661-0408 (within Yukon). E-mail: arts@gov.yk.ca. Website: www.tc.gov.yk.ca/138.html.

REGIONAL GRANTS & AWARDS

The following opportunities are arranged by state since most of them grant money to artists in a particular geographic region. Because deadlines vary annually, check websites or call for the most up-to-date information.

California

- **Flintridge Foundation Awards for Visual Artists**, 1040 Lincoln Ave., Suite 100, Pasadena, CA 91103. (626) 449-0839 or (800) 303-2139. Fax: (626) 585-0011. Website: www.flintridge.org. For artists in California, Oregon, and Washington only.
- **James D. Phelan Art Awards,** Kala Art Institute, Don Porcella, 1060 Heinz Ave., Berkeley, CA 94710. (510)549-2977. Website: www.kala.org. For artists born in California only.

Connecticut

Martha Boschen Porter Fund, Inc., 145 White Hallow Rd., Sharon, CT 06064. For artists in northwestern Connecticut, western Massachusetts, and adjacent areas of New York (except New York City).

Idaho

Betty Bowen Memorial Award, c/o Seattle Art Museum, 100 University St., Seattle, WA 98101. (206)654-3131. E-mail: bettybowen@seattleartmuseum.org. Website: www.seattleartmuseum.org/bettybowen/. For artists in Washington, Oregon and Idaho only.

Illinois

Illinois Arts Council, Individual Artists Support Initiative, James R. Thompson Center, 100 W. Randolph, Suite 10-500, Chicago, IL 60601. (312)814-6750. Website: www.arts.illinois.gov/grants-programs/funding-programs/individual-artist-support. For Illinois artists only.

Kentucky

Kentucky Foundation for Women Grants Program, 1215 Heyburn Bldg., 332 W. Broadway, Louisville, KY 40202. (502) 562-0045 or (866) 654-7564. E-mail: info@kfw.org. Website: www.kfw.org/grants.html. For female artists living in Kentucky only.

Massachusetts

See Martha Boschen Porter Fund, Inc., under Connecticut.

Minnesota

McKnight Artist Fellowships for Photogographers, University of Minnesota Dept. of Art, Regis Center for Art, E-201, 405 21st Ave. S., Minneapolis, MN 55455. (612) 626-9640. E-mail: info@mnartists.org. Website: www.mcknightphoto.umn.edu. For Minnesota artists only.

New York

- **A.I.R. Gallery Fellowship Program,** 111 Front St., #228, Brooklyn, NY 11201. (212) 255-6651. E-mail: info@airgallery.org. Website: www.airgallery.org. For female artists from New York City metro area only.
- Arts & Cultural Council for Greater Rochester, 277 N. Goodman St., Rochester, NY 14607. (585) 473-4000. Website: www.artsrochester.org.
- Constance Saltonstall Foundation for the Arts Grants and Fellowships, 435 Ellis Hollow Creek Rd., Ithaca, NY 14850 (include SASE). (607) 539-3146. E-mail: artscolony@saltonstall.org. Website: www.saltonstall.org. For artists in the central and western counties of New York.
- New York Foundation for the Arts: Artists' Fellowships, 20 Jay St., 7th floor, Brooklyn, NY 11201. (212) 366-6900. E-mail: fellowships@nyfa.org. Website: www.nyfa.org. For New York artists only.

Oregon

See Flintridge Foundation Awards for Visual Artists, under California.

Pennsylvania

Leeway Foundation—Philadelphia, Pennsylvania Region, The Philadelphia Building, 1315 Walnut St., Suite 832, Philadelphia, PA 19107. (215) 545-4078. E-mail: online form. Website: www.leeway.org. For female artists in Philadelphia only.

Texas

Individual Artist Grant Program—Houston, Texas, Houston Arts Alliance, 3201 Allen Pkwy., Suite 250, Houston, TX 77019-1800. (713) 527-9330. E-mail: online form. Website: www.houstonart-salliance.com. For Houston artists only.

Washington

See Flintridge Foundation Awards for Visual Artists, under California.

Professional Organizations

- **American Photographic Artists, National,** P.O. Box 725146, Atlanta, GA 31139. (800) 272-6264, ext. 12. E-mail: membership@apanational.com. Website: www.apanational.com
- **American Photographic Artists, Atlanta**, 2221-D Peachtree Rd. NE, Suite #553, Atlanta, GA 30309. (888) 889-7190, ext. 50. E-mail: director@apaatlanta.com. Website: www.apaatlanta.com
- American Photographic Artists, Los Angeles, 9190 W. Olympic Blvd., #212, Beverly Hills, CA, 90212. (323) 933-1631. E-mail: director@apa-la.org. Website: http://midwest.apanational.com
- American Photographic Artists, Midwest, 28 E. Jackson, Bldg. #10-A855, Chicago, IL 60604. (877) 890-7375. E-mail: apamidwest@gmail.com. Website: www.apamidwest.com
- American Photographic Artists, New York, 27 W. 20th St., Suite 601, New York, NY 10011. (212) 807-0399. Fax: (212) 727-8120. E-mail: jocelyn@apany.com. Website: www.apany.com
- American Photographic Artists, San Diego, P.O. Box 84321, San Diego, CA 92138. (619) 417-2150. E-mail: webmaster@apasd.org. Website: http://sandiego.apanational.com
- American Photographic Artists, San Francisco, 560 Fourth St., San Francisco, CA 94107. (415) 882-9780. Fax: (415) 882-9781. E-mail: info@apasf.com. Website: http://sanfrancisco.apanational.com
- **American Society of Media Photographers (ASMP)**, 150 N. Second St., Philadelphia, PA 19106. (215) 451-2767. Fax: (215) 451-0880. Website: www.asmp.org
- American Society of Picture Professionals (ASPP), 117 S. St. Asaph St., Alexandria, VA 22314. (703) 299-0219. Fax: (703) 299-9910. Website: www.aspp.com
- **The Association of Photographers**, 81 Leonard St., London EC2A 4QS, United Kingdom. (44) (020) 7739-6669. Fax: (44) (020) 7739-8707. E-mail: general@aophoto.co.uk. Website: www.the-aop.org
- **British Association of Picture Libraries and Agencies**, 59 Tranquil Vale, Blackheath, London SE3 OBS, United Kingdom. (44) (020) 7713-1780. Fax: (44) (020) 8852-7211. E-mail: online form. Website: www.bapla.org.uk
- British Institute of Professional Photography (BIPP), 1 Prebendal Ct., Oxford Rd., Aylesbury, Bucks HP19 8EY, United Kingdom. (44) (012) 9671-8530. Fax: (44) (012) 9633-6367. E-mail: membership@bipp.com. Website: www.bipp.com
- **Canadian Association of Journalists**, 1106 Wellington St, Box 36030, Ottawa, ON K1Y 4V3 Canada. (613) 526-8061. Fax: (613) 521-3904. E-mail: online form. Website: www.caj.ca
- Canadian Association of Photographers & Illustrators in Communications, 720 Spadina Ave., Suite 202, Toronto, ON M5S 2T9, Canada. (416) 462-3677 or (888) 252-2742. Fax: (416) 929-5256. E-mail: administration@capic.org. Website: www.capic.org

- Canadian Association for Photographic Art, Box 357, Logan Lake, BC V0K 1W0, Canada. (604) 855-4848. Fax: (604) 855-4824. E-mail: capa@capacanada.ca. Website: www.capacanada.ca
- The Center for Photography at Woodstock (CPW), 59 Tinker St., Woodstock, NY 12498. (845) 679-9957. Fax: (845) 679-6337. E-mail: info@cpw.org. Website: www.cpw.org
- Evidence Photographers International Council, Inc. (EPIC), 229 Peachtree St. NE, Suite 2200, Atlanta, GA 30303. (866) 868-3742. Fax: (404) 614-6406. E-mail: csc@evidencephotographers. com. Website: www.epic-photo.org
- International Association of Panoramic Photographers, 9207 Warriors Creek, San Antonio, TX 78230. (210) 748-0800. E-mail: bryan@snowprophoto.com. Website: www.panoramicassociation org
- International Center of Photography (ICP), 1133 Avenue of the Americas at 43rd St., New York, NY 10036. (212) 857-0000. E-mail: membership@icp.org. Website: www.icp.org
- The Light Factory (TLF), 345 N. College St., Charlotte, NC 28202. (704) 333-9755. E-mail: info@ lightfactory.org. Website: www.lightfactory.org
- National Association of Photoshop Professionals (NAPP), 333 Douglas Rd. E., Oldsmar, FL 34677. (813) 433-5005 or (800) 738-8513. Fax: (813) 433-5015. Website: www.photoshopuser.com
- National Press Photographers Association (NPPA), 3200 Croasdaile Dr., Suite 306, Durham, NC 27705. (919) 383-7246. Fax: (919) 383-7261. E-mail: members@nppa.org. Website: www.nppa.
- North American Nature Photography Association (NANPA), 10200 W. 44th Ave., Suite 304, Wheat Ridge, CO 80033-2840. (303) 422-8527. Fax: (303) 422-8894. E-mail: info@nanpa.org. Website: www.nanpa.org
- Photo Marketing Association International, 3000 Picture Place, Jackson, MI 49201. (517) 788-8100. Fax: (517) 788-8371. E-mail: PMA_Information_Central@pmai.org. Website: www.pmai.org
- Photographic Society of America (PSA), 3000 United Founders Blvd., Suite 103, Oklahoma Citv. OK 73112-3940. (405) 843-1437. Fax: (405) 843-1438. E-mail: hq@psa-photo.org. Website: www. psa-photo.org
- Picture Archive Council of America (PACA), 23046 Avenida de la Carlota, Suite 600, Leguna Hills, CA 92653-1537. (714) 815-8427. Fax: (949) 282-5066. E-mail: pacnews@pacoffice.org. Website: www.pacaoffice.org
- Professional Photographers of America (PPA), 229 Peachtree St. NE, Suite 2200, Atlanta, GA 30303. (404) 522-8600 or (800) 786-6277. Fax: (404) 614-6400. E-mail: csc@ppa.com. Website: www.ppa.com
- Professional Photographers of Canada (PPOC), 209 Light St., Woodstock, ON N4S 6H6 Canada. (519) 537-2555 or (888) 643-7762. Fax: (888) 831-4036. Website: www.ppoc.ca
- The Royal Photographic Society, Fenton House, 122 Wells Rd., Bath BA2 3AH United Kingdom. (44) (012) 2532-5733. E-mail: reception@rps.org. Website: www.rps.org
- Society for Photographic Education, 2530 Superior Ave., #403, Cleveland, OH 44114. (216) 622-2733. Fax: (216) 622-2712. E-mail: membership@spenational.org. Website: www.spenational. org
- Society of Photographers and Artists Representatives (SPAR), 60 E. 42nd St., Suite 1166, New York, NY 10165. E-mail: info@spar.org. Website: www.spar.org
- Volunteer Lawyers for the Arts, 1 E. 53rd St., 6th Floor, New York, NY 10022. (212) 319-2787, ext. 1. Fax: (212) 752-6575. Website: www.vlany.org
- Wedding & Portrait Photographers International (WPPI), 6059 Bristol Pkwy., Suite 100, Culver City, CA 90230. (310) 846-4770. Fax: (310) 846-5995. Website: www.wppionline.com
- White House News Photographers' Association (WHNPA), 7119 Ben Franklin Station, Washington, DC 20044-7119. E-mail: online form. Website: www.whnpa.org

Publications

PERIODICALS

Advertising Age: www.adage.com

Weekly magazine covering marketing, media and advertising.

Adweek: www.adweek.com

Weekly magazine covering advertising agencies.

American Photo: www.popphoto.com

Monthly magazine emphasizing the craft and philosophy of photography.

Art Calendar: www.artcalendar.com

Monthly magazine listing galleries reviewing portfolios, juried shows, percent-for-art programs, scholarships, and art colonies.

ASMP Bulletin: www.asmp.org

Newsletter of the American Society of Media Photographers published five times/year. Subscription with membership.

Communication Arts: www.commarts.com

Trade journal for visual communications.

Editor & Publisher: www.editorandpublisher.com

Monthly magazine covering latest developments in journalism and newspaper production. Publishes an annual directory issue listing syndicates and another directory listing newspapers.

Folio: www.foliomag.com

Monthly magazine featuring trends in magazine circulation, production, and editorial.

Graphis: www.graphis.com

Magazine for the visual arts.

HOW: www.howdesign.com

Bimonthly magazine for the design industry.

News Photographer: www.nppa.org

Monthly news tabloid published by the National Press Photographers Association. Subscription with membership.

Outdoor Photographer: www.outdoorphotographer.com

Monthly magazine emphasizing equipment and techniques for shooting in outdoor conditions.

Photo District News: www.pdnonline.com

Monthly magazine for the professional photographer.

Photosource International: www.photosource.com

This company publishes several helpful newsletters, including *PhotoLetter*, *PhotoDaily*, and *PhotoStockNotes*.

Popular Photography & Imaging: www.popphoto.com

Monthly magazine specializing in technical information for photography.

Print: www.printmag.com

Bimonthly magazine focusing on creative trends and technological advances in illustration, design, photography, and printing.

Professional Photographer: www.ppmag.com

Professional Photographers of America's monthly magazine emphasizing technique and equipment for working photographers.

Publishers Weekly: www.publishersweekly.com

Weekly magazine covering industry trends and news in book publishing; includes book reviews and interviews.

Rangefinder: www.rangefindermag.com

Monthly magazine covering photography technique, products, and business practices.

Selling Stock: www.selling-stock.com

Newsletter for stock photographers; includes coverage of trends in business practices such as pricing and contract terms.

Shutterbug: www.shutterbug.net

Monthly magazine of photography news and equipment reviews.

BOOKS & DIRECTORIES

Adweek Agency Directory, VNU Business Publications. Annual directory of advertising agencies in the U.S.

Adweek Brand Directory, VNU Business Publications. Directory listing top 2,000 brands, ranked by media spending.

ASMP Copyright Guide for Photographers, American Society of Media Photographers.

ASMP Professional Business Practices in Photography, 7th **Edition,** American Society of Media Photographers. Handbook covering all aspects of running a photography business.

Bacon's Media Directories, Cision. Contains information on all daily and community newspapers in the U.S. and Canada, and 24,000 trade and consumer magazines, newsletters, and journals.

The Big Picture: The Professional Photographer's Guide to Rights, Rates & Negotiation, by Lou Jacobs, Writer's Digest Books, F + W Media, Inc. Essential information on understanding contracts, copyrights, pricing, licensing and negotiation.

Business and Legal Forms for Photographers, 4th Edition, by Tad Crawford, Allworth Press. Negotiation book with thirty-four forms for photographers.

The Business of Photography: Principles and Practices, by Mary Virginia Swanson, available through her Website (www.mvswanson.com) or by emailing Lisa@mvswanson.com.

The Business of Studio Photography, Third Edition, by Edward R. Lilley, Allworth Press. A complete guide to starting and running a successful photography studio.

Children's Writers & Illustrator's Market, Writer's Digest Books, F+W Media, Inc. Annual directory including photo needs of book publishers, magazines and multimedia producers in the children's publishing industry.

Color Confidence: The Digital Photographer's Guide to Color Management, by Tim Grey, Sybex.

Color Management for Photographers: Hands-On Techniques for Photoshop Users, by Andrew Rodney, Focal Press.

Creative Careers in Photography: Making a Living With or Without a Camera, by Michal Heron, Allworth Press.

Digital Stock Photography: How to Shoot and Sell, by Michal Heron, Allworth Press.

How to Succeed in Commercial Photography: Insights from a Leading Consultant, by Selina Maitreya, Allworth Press.

How to Grow as a Photographer: Reinventing Your Career, by Tony Luna, Allworth Press.

LA 411, 411 Publishing. Music industry guide, including record labels.

Legal Guide for the Visual Artist, 4th Edition, by Tad Crawford, Allworth Press. The author, an attorney, offers legal advice for artists and includes forms dealing with copyright, sales, taxes, etc.

Licensing Photography, by Richard Weisgrau and Victor Perlman, Allworth Press.

Literary Market Place, Information Today. Directory that lists book publishers and other book publishing industry contacts.

O'Dwyer's Directory of Public Relations Firms, J.R. O'Dwyer Company, available through website (www.odwyerpr.com). Annual directory listing public relations firms, indexed by specialties.

Photo Portfolio Success, by John Kaplan, Writer's Digest Books, F+W Media, Inc.

The Photographer's Guide to Marketing & Self-Promotion, 4th Edition, by Maria Piscopo, Allworth Press. Marketing guide for photographers.

Photographer's Market Guide to Building Your Photography Business, Second Edition, by Vic Orenstein, Writer's Digest Books, F+W Media, Inc. Practical advice for running a profitable photography business.

Pricing Photography: The Complete Guide to Assignment & Stock Prices, by Michal Heron and David MacTavish, Allworth Press.

The Professional Photographer's Legal Handbook, by Nancy Wolff, Allworth Press.

Real World Color Management: Industrial-Strength Production Techniques, Second Edition, by Bruce Fraser, Chris Murphy, and Fred Bunting, Peachpit Press.

Sell & Resell Your Photos, 5th Edition, by Rohn Engh, Writer's Digest Books, F+W Media, Inc. Revised edition of the classic volume on marketing your own stock.

Selling Your Photography: How to Make Money in New and Traditional Markets, by Richard Weisgrau, Allworth Press.

Shooting & Selling Your Photos, by Jim Zuckerman, Writer's Digest Books, F+W Media, Inc.

Songwriter's Market, Writer's Digest Books, F+W Media, Inc. Annual directory listing record labels.

Standard Rate and Data Service (SRDS), Kantar Media. Directory listing magazines and their advertising rates.

Starting Your Career as a Freelance Photographer, by Tad Crawford, Allworth Press.

Workbook, Scott & Daughter Publishing. Numerous resources for the graphic arts industry.

Writer's Market, Writer's Digest Books, F+W Media, Inc. Annual directory listing markets for freelance writers. Many listings include photo needs and payment rates.

RESOURCES

Websites

PHOTOGRAPHY BUSINESS

The Alternative Pick www.altpick.com
Black Book www.blackbook.com
Copyright Website www.benedict.com
EP: Editorial Photographers www.editorialphoto.com
MacTribe www.mactribe.com
ShootSmarter.com www.shootsmarter.com
Small Business Administration www.sba.gov

MAGAZINE AND BOOK PUBLISHING

American Journalism Review's News Links www.ajr.org Bookwire www.bookwire.com

STOCK PHOTOGRAPHY

Global Photographers Search www.photographers.com
PhotoSource International www.photosource.com
Stock Photo Price Calculator www.photographersindex.com/stockprice.htm
Selling Stock www.selling-stock.com
Stock Artists Alliance www.stockartistsalliance.org
The STOCKPHOTO Network www.stockphoto.net

ADVERTISING PHOTOGRAPHY

Advertising Age www.adage.com

Adweek, Mediaweek and Brandweek www.adweek.com

Communication Arts Magazine www.commarts.com

FINE ART PHOTOGRAPHY

The Art List www.theartlist.com
Art Support www.art-support.com
Art DEADLINES List www.artdeadlineslist.com
Photography in New York International www.photography-guide.com
Mary Virginia Swanson www.mvswanson.com

PHOTOJOURNALISM

The Digital Journalist www.digitaljournalist.org

Foto8 www.foto8.com

National Press Photographers Association www.nppa.org

MAGAZINES

Afterimage www.vsw.org

Aperture www.aperture.org

Art Calendar www.artcalendar.com

Black and White Photography www.bandwmag.com

Blind Spot www.blindspot.com

British Journal of Photography www.bjphoto.co.uk

Lens Work www.lenswork.com

Photo District News www.pdnonline.com

Photograph Magazine www.photography-guide.com

The Photo Review, The Photography Collector, and The Photographic Art Market Magazines www.photoreview.org

Shots Magazine www.shotsmag.com

View Camera www.viewcamera.com

E-ZINES

The following publications exist online only. Some offer opportunities for photographers to post their personal work.

Apogee Photo www.apogeephoto.com

American Photo Magazine www.popphoto.com

American Photography Museum www.photographymuseum.com

Art in Context www.artincontext.org

Art Business News www.artbusinessnews.com

Art Support www.art-support.com

Artist Register http://artistsregister.com

Digital Journalist www.digitaljournalist.org

En Foco www.enfoco.org

Fotophile www.fotophile.com

Handheld Magazine www.handheldmagazine.com/index.html

Musarium www.musarium.com

Fabfotos www.fabfotos.com

Foto8 www.foto8.com

One World Journeys www.oneworldjourneys.com

PhotoArts www.photoarts.com

Pixel Press www.pixelpress.org

Photo Imaging Information Council www.takegreatpictures.com

Photo Links www.photolinks.com

Online Photo Workshops www.photoworkshop.com

Picture Projects www.pictureprojects.com

Sight Photo www.sightphoto.com

Zone Zero www.zonezero.com

TECHNICAL

About.com www.photography.about.com
BetterPhoto.com® http://betterphoto.com
Photo.net www.photo.net
PhotoflexLightingSchool® www.photoflexlightingschool.com
The Pixel Foundry www.thepixelfoundry.com
Shoot Smarter www.shootsmarter.com
Wilhelm Imaging Research www.wilhelm-research.com

March 1980 and Carlot March 1980 and Carlot

Web Photo School www.webphotoschool.com

HOW TO

Adobe Tutorials www.adobe.com.designcenter

Digital Photographers www.digitalphotographers.net

Digital Photography Review www.dpreview.com

Fred Miranda www.fredmiranda.com/forum/index.php
Imaging Resource www.imaging-resource.com
Lone Star Digital www.lonestardigital.com

The National Association of Photoshop Professionals www.photoshopuser.com
Photography Review www.photographyreview.com

Steve's Digicams www.steves-digicams.com

Glossary

Absolute-released images. Any images for which signed model or property releases are on file and immediately available. For working with stock photo agencies that deal with advertising agencies, corporations and other commercial clients, such images are absolutely necessary to sell usage of images. Also see Model release, Property release.

Acceptance (payment on). The buyer pays for certain rights to publish a picture at the time it is accepted, prior to its publication.

Agency promotion rights. Stock agencies request these rights in order to reproduce a photographer's images in promotional materials such as catalogs, brochures and advertising.

Agent. A person who calls on potential buyers to present and sell existing work or obtain assignments for a client. A commission is usually charged. Such a person may also be called a *photographer's rep*.

All rights. A form of rights often confused with work for hire. Identical to a buyout, this typically applies when the client buys all rights or claim to ownership of copyright, usually for a lump sum payment. This entitles the client to unlimited, exclusive usage and usually with no further compensation to the creator. Unlike work for hire, the transfer of copyright is not permanent. A time limit can be negotiated, or the copyright ownership can run to the maximum of 35 years.

Alternative Processes. Printing processes that do not depend on the sensitivity of silver to form an image. These processes include cyanotype and platinum printing.

Archival. The storage and display of photographic negatives and prints in materials that are harmless to them and prevent fading and deterioration.

Artist's statement. A short essay, no more than a paragraph or two, describing a photographer's mission and creative process. Most galleries require photographers to provide an artist's statement.

Assign (designated recipient). A third-party person or business to which a client assigns or designates ownership of copyrights that the client purchased originally from a creator such as a photographer. This term commonly appears on model and property releases.

Assignment. A definite OK to take photos for a specific client with mutual understanding as to the provisions and terms involved.

Assignment of copyright, rights. The photographer transfers claim to ownership of copyright over to another party in a written contract signed by both parties.

Audiovisual (AV). Materials such as filmstrips, motion pictures and overhead transparencies which use audio backup for visual material.

Automatic renewal clause. In contracts with stock photo agencies, this clause works on the concept that every time the photographer delivers an image, the contract is automatically renewed for a specified number of years. The drawback is that a photographer can be bound by the con-

tract terms beyond the contract's termination and be blocked from marketing the same images to other clients for an extended period of time.

Avant garde. Photography that is innovative in form, style or subject matter.

Biannual. Occurring twice a year. Also see Semiannual.

Biennial. Occurring once every two years.

Bimonthly. Occurring once every two months.

Bio. A sentence or brief paragraph about a photographer's life and work, sometimes published along with photos.

Biweekly. Occurring once every two weeks.

Blurb. Written material appearing on a magazine's cover describing its contents.

Buyout. A form of work for hire where the client buys all rights or claim to ownership of copyright, usually for a lump sum payment. Also see All rights, Work for hire.

Caption. The words printed with a photo (usually directly beneath it), describing the scene or action.

CCD. Charged Coupled Device. A type of light detection device, made up of pixels, that generates an electrical signal in direct relation to how much light strikes the sensor.

CD-ROM. Compact disc read-only memory; non-erasable electronic medium used for digitized image and document storage and retrieval on computers.

Chrome. A color transparency, usually called a slide.

Cibachrome. A photo printing process that produces fade-resistant color prints directly from color slides.

Clips. See Tearsheet.

CMYK. Cyan, magenta, yellow and black—refers to four-color process printing.

Color Correction. Adjusting an image to compensate for digital input and output characteristics.

Commission. The fee (usually a percentage of the total price received for a picture) charged by a photo agency, agent or gallery for finding a buyer and attending to the details of billing, collecting, etc.

Composition. The visual arrangement of all elements in a photograph.

Compression. The process of reducing the size of a digital file, usually through software. This speeds processing, transmission times and reduces storage requirements.

Consumer publications. Magazines sold on newsstands and by subscription that cover information of general interest to the public, as opposed to trade magazines, which cover information specific to a particular trade or profession. See Trade magazine.

Contact Sheet. A sheet of negative-size images made by placing negatives in direct contact with the printing paper during exposure. They are used to view an entire roll of film on one piece of paper.

Contributor's copies. Copies of the issue of a magazine sent to photographers in which their work

Copyright. The exclusive legal right to reproduce, publish and sell the matter and form of an artistic work.

Cover letter. A brief business letter introducing a photographer to a potential buyer. A cover letter may be used to sell stock images or solicit a portfolio review. Do not confuse cover letter with query letter.

C-print. Any enlargement printed from a negative.

Credit line. The byline of a photographer or organization that appears below or beside a published photo.

Cutline. See Caption.

Day rate. A minimum fee that many photographers charge for a day's work, whether a full day is spent on a shoot or not. Some photographers offer a half-day rate for projects involving up to a half-day of work.

Demo(s). A sample reel of film or sample videocassette that includes excerpts of a filmmaker's or videographer's production work for clients.

Density. The blackness of an image area on a negative or print. On a negative, the denser the black, the less light that can pass through.

Digital Camera. A filmless camera system that converts an image into a digital signal or file.

DPI. Dots per inch. The unit of measure used to describe the resolution of image files, scanners and output devices. How many pixels a device can produce in one inch.

Electronic Submission. A submission made by modem or on computer disk, CD-ROM or other removable media.

Emulsion. The light-sensitive layer of film or photographic paper.

Enlargement. An image that is larger than its negative, made by projecting the image of the negative onto sensitized paper.

Exclusive property rights. A type of exclusive rights in which the client owns the physical image, such as a print, slide, film reel or videotape. A good example is when a portrait is shot for a person to keep, while the photographer retains the copyright.

Exclusive rights. A type of rights in which the client purchases exclusive usage of the image for a negotiated time period, such as one, three or five years. May also be permanent. Also see All rights, Work for hire.

Fee-plus basis. An arrangement whereby a photographer is given a certain fee for an assignment—plus reimbursement for travel costs, model fees, props and other related expenses incurred in completing the assignment.

File Format. The particular way digital information is recorded. Common formats are TIFF and JPEG.

First rights. The photographer gives the purchaser the right to reproduce the work for the first time. The photographer agrees not to permit any publication of the work for a specified amount of time.

Format. The size or shape of a negative or print.

Four-color printing, four-color process. A printing process in which four primary printing inks are run in four separate passes on the press to create the visual effect of a full-color photo, as in magazines, posters and various other print media. Four separate negatives of the color photo—shot through filters—are placed identically (stripped) and exposed onto printing plates, and the images are printed from the plates in four ink colors.

GIF. Graphics Interchange Format. A graphics file format common to the Internet.

Glossy. Printing paper with a great deal of surface sheen. The opposite of matte.

Hard Copy. Any kind of printed output, as opposed to display on a monitor.

Honorarium. Token payment—small amount of money and/or a credit line and copies of the publication.

Image Resolution. An indication of the amount of detail an image holds. Usually expressed as the dimension of the image in pixels and the color depth each pixel has. Example: a 640X480, 24-bit image has higher resolution than a 640X480, 16-bit image.

IRC. International Reply Coupon. IRCs are used with self-addressed envelopes instead of stamps when submitting material to buyers located outside a photographer's home country.

JPEG. Joint Photographic Experts Group. One of the more common digital compression methods that reduces file size without a great loss of detail.

Licensing/Leasing. A term used in reference to the repeated selling of one-time rights to a photo. **Manuscript.** A typewritten document to be published in a magazine or book.

Matte. Printing paper with a dull, nonreflective surface. The opposite of glossy.

. Model release. Written permission to use a person's photo in publications or for commercial use.

Multi-image. A type of slide show that uses more than one projector to create greater visual impact with the subject. In more sophisticated multi-image shows, the projectors can be programmed to run by computer for split-second timing and animated effects.

Multimedia. A generic term used by advertising, public relations and audiovisual firms to describe productions using more than one medium together—such as slides and full-motion, color video-to create a variety of visual effects.

News release. See Press release.

No right of reversion. A term in business contracts that specifies once a photographer sells the copyright to an image, a claim of ownership is surrendered. This may be unenforceable, though, in light of the 1989 Supreme Court decision on copyright law. Also see All rights, Work for

On spec. Abbreviation for "on speculation." Also see Speculation.

One-time rights. The photographer sells the right to use a photo one time only in any medium. The rights transfer back to the photographer on request after the photo's use.

Page rate. An arrangement in which a photographer is paid at a standard rate per page in a publication.

Photo CD. A trademarked, Eastman Kodak-designed digital storage system for photographic images

PICT. The saving format for bit-mapped and object-oriented images.

Picture Library. See Stock photo agency.

Pixels. The individual light-sensitive elements that make up a CCD array. Pixels respond in a linear fashion. Doubling the light intensity doubles the electrical output of the pixel.

Point-of-purchase, point-of-sale (P-O-P, P-O-S). A term used in the advertising industry to describe in-store marketing displays that promote a product. Typically, these highly-illustrated displays are placed near checkout lanes or counters, and offer tear-off discount coupons or trial samples of the product.

Portfolio. A group of photographs assembled to demonstrate a photographer's talent and abilities, often presented to buyers.

PPI. Pixels per inch. Often used interchangeably with DPI, PPI refers to the number of pixels per inch in an image. See DPI.

Press release. A form of publicity announcement that public relations agencies and corporate communications staff people send out to newspapers and TV stations to generate news coverage. Usually this is sent with accompanying photos or videotape materials.

Property release. Written permission to use a photo of private property or public or government facilities in publications or for commercial use.

Public domain. A photograph whose copyright term has expired is considered to be "in the public domain" and can be used for any purpose without payment.

Publication (payment on). The buyer does not pay for rights to publish a photo until it is actually published, as opposed to payment on acceptance.

Query. A letter of inquiry to a potential buyer soliciting interest in a possible photo assignment.

Rep. Trade jargon for sales representative. Also see Agent.

Resolution. The particular pixel density of an image, or the number of dots per inch a device is capable of recognizing or reproducing.

Resume. A short written account of one's career, qualifications and accomplishments.

Royalty. A percentage payment made to a photographer/filmmaker for each copy of work sold.

R-print. Any enlargement made from a transparency.

SAE. Self-addressed envelope.

SASE. Self-addressed, stamped envelope. (Most buyers require a SASE if a photographer wishes unused photos returned to him, especially unsolicited materials.)

Self-assignment. Any project photographers shoot to show their abilities to prospective clients. This can be used by beginning photographers who want to build a portfolio or by photographers wanting to make a transition into a new market.

Self-promotion piece. A printed piece photographers use for advertising and promoting their businesses. These pieces generally use one or more examples of the photographer's best work, and are professionally designed and printed to make the best impression.

Semiannual. Occurring twice a year. Also see Biannual.

Semigloss. A paper surface with a texture between glossy and matte, but closer to glossy.

Semimonthly. Occurring twice a month.

Serial rights. The photographer sells the right to use a photo in a periodical. Rights usually transfer back to the photographer on request after the photo's use.

Simultaneous submissions. Submission of the same photo or group of photos to more than one potential buyer at the same time.

Speculation. The photographer takes photos with no assurance that the buyer will either purchase them or reimburse expenses in any way, as opposed to taking photos on assignment.

Stock photo agency. A business that maintains a large collection of photos it makes available to a variety of clients such as advertising agencies, calendar firms and periodicals. Agencies usually retain 40-60 percent of the sales price they collect, and remit the balance to the photographers whose photo rights they've sold.

Stock photography. Primarily the selling of reprint rights to existing photographs rather than shooting on assignment for a client. Some stock photos are sold outright, but most are rented for a limited time period. Individuals can market and sell stock images to individual clients from their personal inventory, or stock photo agencies can market photographers' work for them. Many stock agencies hire photographers to shoot new work on assignment, which then becomes the inventory of the stock agency.

Subsidiary agent. In stock photography, this is a stock photo agency that handles marketing of stock images for a primary stock agency in certain US or foreign markets. These are usually affiliated with the primary agency by a contractual agreement rather than by direct ownership, as in the case of an agency that has its own branch offices.

SVHS. Abbreviation for Super VHS. Videotape that is a step above regular VHS tape. The number of lines of resolution in a SVHS picture is greater, thereby producing a sharper picture.

Tabloid. A newspaper about half the page size of an ordinary newspaper that contains many photos and news in condensed form.

Tearsheet. An actual sample of a published work from a publication.

TIFF. Tagged Image File Format. A common bitmap image format developed by Aldus.

Trade magazine. A publication devoted strictly to the interests of readers involved in a specific trade or profession, such as beekeepers, pilots or manicurists, and generally available only by subscription.

Transparency. Color film with a positive image, also referred to as a slide.

Unlimited use. A type of rights in which the client has total control over both how and how many times an image will be used. Also see All rights, Exclusive rights, Work for hire.

Unsolicited submission. A photograph or photographs sent through the mail that a buyer did not specifically ask to see.

Work for hire. Any work that is assigned by an employer who becomes the owner of the copyright. Stock images cannot be purchased under work-for-hire terms.

World rights. A type of rights in which the client buys usage of an image in the international marketplace. Also see All rights.

Worldwide exclusive rights. A form of world rights in which the client buys exclusive usage of an image in the international marketplace. Also see All rights.

Geographic Index

Alabama

Alabama Living 69
Civitan Magazine 181
Commercial Carrier Journal 182
Corporate Art Source/CAS Gallery 358
Huntsville Museum of Art 370
International Expeditions 478
Mobile Museum of Art 381
Panoply Arts Festival, Presented by the Arts
Council, Inc. 435
Riverfront Market 437
Visual Arts Gallery 401

Alaska

Accent Alaska/Ken Graham Agency 255 Alaska 69 Alaska's Seawolf Adventures 468 Alaska State Museum 344 Alaska Stock Images 259 Mushing.com Magazine 121

Arizona

Arizona Highways Photo Workshops 469
Arizona State University Art Museum 345
Arizona Wildlife Views 74
Art in the Park (Sierra Vista) 411
Center for Creative Photography 354
DRK Photo 276
Edwards Fine Art & Sculpture Festival 419
Etherton Gallery 362
Farnam Companies, Inc. 326
Fourth Avenue Spring Street Fair 423
Fourth Avenue Winter Street Fair 423

Mesa Contemporary Arts at Mesa Arts Center 379

Museum of Northern Arizona 227

Native Peoples Magazine 123

Scottsdale Arts Festival 438

Tubac Festival of the Arts 443

Zolan Company, LLC, The 250

Arkansas

Hot Springs Arts & Crafts Fair 427 New Leaf Press, Inc. 228

California

Action Publishing 211

Aerial and Creative Photography Workshops 468 Aerial Archives 257 Affaire in the Gardens Art Show 406 After Five 68 AGStockUSA Inc. 258 All About Kids Publishing 211 American Fitness 71 American Sports Network 161 Annual Exhibition of Photography 449 Annual Spring Photography Contest 449 Aguarium Fish International 74 Art Source L.A., Inc. 348 Asian Enterprise Magazine 175 Automated Builder 176 Auto Restorer 75 Ballenger & Associates Photo Workshops, Noella 470 Balthis Photography Workshops, Frank 470 Bentley Publishing Group 240

Berson, Dean, Stevens Inc. 323 Biological Photo Service and Terraphotographics 268 Boxoffice Magazine 179 Brainworks Design Group 324 Bransten Gallery, Rena 352 Brookings Gallery, J.J. 352 Calabasas Fine Arts Festival 415 . California Photographic Workshops 471 California Views/Mr. Pat Hathaway Historical Photo Collection 270 Campbell Associates, Marianne 458 Cat Fancy 83 Center for Photographic Art 354 Centerstream Publication 215 Centric Corporation 242 Clark Gallery, Catharine 356 Cleis Press 215 Clickers & Flickers Photography Network--Lectures & Workshops 472 Cohen Gallery, Stephen 357 CONSULTANT/Photographer's Representative Continental Newstime 90 Convergence 91 Creative With Words Publications (CWW) 218 Cycle California! Magazine 92 Cycle World Magazine 92 Dean Photo Workshops, The Julia 474 De Moreta Represents, Linda 459 Design2Market 326 Dog Fancy 94 Dubois, Francoise/Dubois Represents 459 Entrepreneur 96 Europa Photogenica Photo Tours to Europe 475 Fahey/Klein Gallery 363 Falkirk Cultural Center 364 Fillmore Jazz Festival 421 Finding & Keeping Clients 476 FireRescue Magazine 186 Flaunt Magazine 99 Fourth of July Street Fair and Autumn Fest in the Park 423 Fresno Art Museum 364

Gallery Luisotti 366

Galápagos Travel 476

Global Preservation Projects 477

Golden Gate School of Professional Photography 477 Golf Tips 103 Government Technology 187 Hallowes Productions & Advertising 328 Hearst Art Gallery, Saint Mary's College 369 Highways 107 Image Integration 330 Impact Photographics 244 In Focus with Michele Burgess 478 Instinct Magazine 111 In The Wind 111 Jeroboam 291 JG + A 461 Jillson & Roberts 245 Jordahl Photo Workshops 479 Journal of Psychoactive Drugs 190 Key Curriculum Press 224 Kimball Stock 291 Kings Mountain Art Fair 429 Koch Gallery, Robert 374 Korman + Company 461 Kramer and Associates, Inc., Joan 292, 461 LA Art Association/Gallery 825 374 Lee + Lou Productions Inc. 462 LIGHT Photographic Workshops 479 Linear Cycle Productions 331 Lizardi/Harp Gallery 376 Log Newspaper, The 165 Lompoc Flower Festival 431 Lonely Planet Images 293 Los Angeles Center for Digital Juried Competition 452 Maslov Agent International 462 Mattei Photography, Michele 379 MGW Newsmagazine 119 Mobius Awards for Advertising, The 454 Monterey Museum of Art 381 MPTV (a/k/a Motion Picture and Television Photo Archive) 296 Museo ItaloAmericano 382 Museum of Contemporary Art San Diego 382 Museum of Photographic Arts 383 Nailpro 192 Nails Magazine 193 Napa Wine & Crafts Faire 433 National Masters News 165

National Notary, The 193

Palo Alto Art Center 387

Paonessa Photography Workshops, Ralph 484
Paper Products Design 246
Patterson Apricot Fiesta 435
Pet Product News 195
PhotoEdit 304
Photographer's Forum Magazine 133

Pilot Getaways 195 Piscopo, Maria 463 Pizer, Alyssa 464 Police Magazine 197

Rangefinder 200

Rich Wildlife Photography Tours, Jeffrey 487 Riverbank Cheese & Wine Exposition 437 San Diego Art Institute's Museum of the Living

Artist 393

School Transportation News 203.

Sea 142

Selling Your Photography 487 Sexton Photography Workshops, John 488

Sierra Madre Wistaria Festival 439

Solano Avenue Stroll 439 Specialty Travel Index 205

Specialty Travel Index 20 SportsCar 146 Still Media 314 Sugar Daddy Photos 317

Summit Photographic Workshops 489

Surfing Magazine 148

Thompson Art Gallery, Natalie and James 397

Tikkun 150

TM Enterprises 465 Track & Field News 151

Trailer Boats Magazine 152

Travelworld International Magazine 153

Tricycle Press 234

UCR/California Museum of Photography 398

Ventura County Reporter 168 White Productions, Dana 339

Wiley Group, The 466

Wilshire Book Company 237

Wines & Vines 208

Yosemite Outdoor Adventures 492

Colorado

Anderson Ranch Arts Center 468 Avon Fine Art & Wine Affaire 414 Blue Sky Publishing 240 Brewers Association 214 Business of Art Center 353 Camera Obscura Gallery, The 353 Center for Fine Art Photography, The 354, 471 Chun Capitol Hill People's Fair 416

Current, Inc. 243

Drake Magazine, The 95

Dramatic Light Nature Photography Workshops 474

EventGallery 910Arts 363

Evergreen Arts Festival 419

Focus Adventures 476

Grand Festival of the Arts & Crafts 425

Guenzi Agents, Inc., Carol 460

Havu Gallery, William 368

Healing Lifestyles & Spas Magazine 106

Lake City Arts & Crafts Festival 430

Long's First Light Photography Workshop

Tours, Andy 468

Main Avenue Arts Festival 431

Mountain Living 121

Natural Habitat Adventures 482

Outside Imagery 300

Photography at the Summit 485

Racquetball Magazine 137

Rocky Mountain Field Seminars 487

Sports Photography Workshop 488

Surgical Technologist, The 205

Synergistic Visions Workshops 489

Trail Runner 152

VeloNews 168

Winslow Photo, Inc., Robert 491

Working With Artists 491

Connecticut

Berman Fine Arts, Mona 351

Beverage Dynamics 178

Bon Artique.com/Art Resources Int., Ltd. 241

CEA Advisor 180

Chatham Press 215

Creative Arts Workshop 473

E/The Environmental Magazine 97

New York Graphic Society Publishing Group

246

North Congregational Peach & Craft Fair 434 Simsbury Woman's Club 42nd Arts & Crafts

Festival 412

Tide-Mark Press 249

Woodshop News 209

Delaware

Delaware Center for the Contemporary Arts 360

Mitchell Lane Publishers, Inc. 227 Reading Today 200

District of Columbia

Addison/Ripley Fine Art 343
American Forests Magazine 71
Animal Sheltering 173
Arts on Foot 413
Catholic News Service 272
Children's Defense Fund 162
Chronicle of Philanthropy, The 181

Company Magazine 88

Conscience 90 Hemphill 369

International Visions Gallery 372

ITE Journal 189

Landscape Architecture 191

National Black Child Development Institute 333

National Geographic 122 National Parks Magazine 123

Public Power 199

Ralls Collection Inc., The 392

Remodeling 202 Scrap 204

Smithsonian Magazine 145 Touchstone Gallery 398 Washington Blade, The 168

Zenith Gallery 404

Florida

Art Festival Beth-el 410
Art Licensing International Inc. 265
Artefact/Robert Pardo Gallery 346
Arts on Douglas 347
Bachmann Tour Overdrive 469
Birds as Art/Instructional Photo-Tours 470
Brown Hands-On Workshops, Nancy 471
Capitol Complex Exhibitions 353
Caribbean Travel & Life 82
Charisma Magazine 83
CrealdË School of Art 359, 473
FOTOAGENT.COM/FOTOCONCEPT, INC 282
Fotofusion 476
Ft. Myers Magazine 100

Gold & Associates, Inc. 328 Highlands Art League's Annual Fine Arts & Crafts Festival 426 InFocus 452

International Photo News 288 Isle of Eight Flags Shrimp Festival 428 Leepa-Rattner Museum of Art 374

Lutz Arts & Crafts Festival 431

Marlin 118

Michael Murphy Gallery M 380 Motor Boating Magazine 120 New Smyrna Beach Art Fiesta 434

Nicolas-Hays, Inc. 228 Onboard Media 128 Out of the Blue 300

Palm Beach Photographic Centre 484

Polk Museum of Art 390 Recommend Magazine 200 Relay Magazine 202 Salt Water Sportsman 141

Skydiving 144
Soundlight 337
Southern Boating 145
Sport Fishing 146
Stack & Associates Inc. T

Stack & Associates, Inc., Tom 313

Stickman Review 147

Strang Communications Company 233

Sun 166

Superstock Inc. 318

Gold Rush Days 424

Tarpon Springs Fine Arts Festival 443 Visual Arts Center of Northwest Florida 401 WaterSki 157

Georgia

American Print Alliance 344
Apple Annie Crafts & Arts Show 410
Aquarius 161
Art in the Park (GA) 411
Atlanta Homes & Lifestyles 75
Atlanta Photojournalism Seminar Contest 450
Conyers Cherry Blossom Festival 417
Cortona Center of Photography, Italy, The 473
Deljou Art Group 243
Display Design Ideas 184
Forest Landowner 186
Fulton County Daily Report 163
Game & Fish Magazines 101

Herbert Institute of Art, Gertrude 370
Jackson Fine Art 372
KNOWAtlanta 115
Myriad Productions 333
North American Whitetail Magazine 124
Professional Photographer 198
Rattlesnake Roundup 436
Sandy Springs Festival 437
Showcase School of Photography, The 488
Soho Myriad 394
SouthComm Publishing Company, Inc. 145
Welcome to My World Photography
Competition 445

Hawaii

Hawaii Photo Seminars 478
Hawaii Photo Tours, Digital Infrared, Digital
Photography, Photoshop, Polaroid & Fuji
Transfer Workshops. Private Tours &
Instruction Sessions 478
Heart of Nature Photography Workshops 478
Pacific Stock/Printscapes.com 301
Photo Resource Hawaii 307
Wailoa Center Gallery, The 402

Idaho

39th Annual Arts & Crafts Fair 406
Appaloosa Journal 174
Artwerks Stock Photography 265
Blue Planet Photography Workshops and Tours 470
Gerlach Nature Photography Workshops & Tours 477
Travel Images 489

Illinois

Show 410

49th Arts Experience 406
AAP News 171
American Bar Association Journal 172
American Bee Journal 173
American Society of Artists, Inc. 344
Annual Alton Arts & Crafts Expressions 408
Annual Arts Adventure 409
Annual Arts & Crafts Adventure 409
Annual Edens Art Fair 409
Annual Hyde Park Arts & Crafts Adventure
409
Annual Oak Park Avenue-Lake Arts & Crafts

A.R.C. Gallery 345 Balzekas Museum of Lithuanian Culture Art Gallery 349 Beef Today 178 Bragaw Public Relations Services 324 Cedarhurst Craft Fair 415 Chef 180 Collectible Automobile 87 Complete Woman 89 Cuneo Gardens Art Festival 418 Deerfield Fine Arts Festival 418 Down Beat Magazine 95 Edelman Gallery, Catherine 361 Electrical Apparatus 184 Elks Magazine, The 96 El Restaurante Mexicano 185 Fire Chief 185 Freeport Arts Center 364 Gallant Greetings Corp. 244 Gallery 400 366 Grain Journal 187 Greenwich Village Art Fair 425 Hinsdale Fine Arts Festival 426 HOLT McDougal 222 Human Kinetics Publishers 222 Hutchinson Associates, Inc. 330 IGA Grocergram 189 Illinois State Museum Chicago Gallery 371 Lakeland Boating Magazine 115 Leonardis Gallery, David 375 Liturgy Training Publications 225 Loyola Magazine 117 Luckypix 294 Lutheran, The 118 Marketing & Technology Group 192 McGrath, Judith 463 McGraw-Hill 226 Miller Gallery, Peter 380 Munro Goodman Artists Representatives 463 Museum of Contemporary Photography, Columbia College Chicago 383 Northwestern University Dittmar Memorial Gallery 385 Panoramic Images 303 Parkland Art Gallery 388 Pix International 308 Planning 196 Playboy 134 Produce Merchandising 198

Oually & Company, Inc. 334 Recycled Paper Greetings, Inc. 247 Rockford Review 138 Rotarian, The 139 Schmidt Art Center, William & Florence 393 SpeciaLiving 146 St. Charles Fine Art Show 440 Tyndale House Publishers 234 Union Street Gallery 399 Video I-D, Inc. 338 Waveland Press, Inc. 235 Wilmette Festival of Fine Arts 446

Indiana

Amish Acres Arts & Crafts Festival 407 Brick Street Market 414 Fourth Street Festival for the Arts & Crafts 423 Indianapolis Art Center 371 Indianapolis Monthly 110 Kiwanis Magazine 114 Muzzle Blasts 122 Phi Delta Kappan 133 Riley Festival 437 Victorian Chautauqua, A 444

lowa

Arts Iowa City 347 Chait Galleries Downtown, The 355 Iowan Magazine, The 112 Judicature 190 MacNider Art Museum 377 Rural Heritage 140 UNI Gallery of Art 398

Kansas Capper's 162

College PreView Magazine 88 Greyhound Review, The 188 Grit Magazine 104 Kansas! 113 Parks Photography Competition, The Gordon 453

Kentucky

Arts on the Green 413 Chapman Friedman Gallery 356 Gradd Arts & Crafts Festival 425

Veterinary Economics 207

Horse Illustrated 109 Kentucky Monthly 114 Mountain Workshops 481 St. James Court Art Show 441 Thoroughbred Times 206 University of Kentucky Art Museum 399

Louisiana

Contemporary Arts Center 357 DDB Stock Photography, LLC 274 Haardt Gallery, Anton 368 Jones Gallery, Stella 373 Lockwood Wildlife Photography Workshop, C.C. 480

Masur Museum of Art 379 New Orleans Museum of Art 384 Prague Summer Seminars 486 THEMA 149

Maine

Aurora Photos 266 Borealis Press, The 241 Flv Rod & Reel 99 Maine Media Workshops 480 Saco Sidewalk Art Festival 437

Maryland

AOPA Pilot 174 Avionics Magazine 177 Chesapeake Bay Magazine 84 Childhood Education 181 German Life Magazine 102 Girls Life Magazine/GirlsLife.com 102 Gryphon House 221 Home, Condo and Garden Art & Craft Fair 427 Insight Magazine 111 Johns Hopkins University Spring Fair 428 Journal of Adventist Education 190 Lacrosse Magazine 115 Marlboro Gallery 378 Mullin/Ashley Associate 332 Naval History 193 Outdoor America 129 Proceedings 198 ProStar Publications Inc. 231 Roland Group Inc., The 464 Stevenson University Art Gallery 396 Stock Connection, Inc. 314

Visual Artistry & Field Mentorship Photography Workshop Series 490 Washington County Museum of Fine Arts 402

Massachussets

Allyn & Bacon Publishers 212 AMC Outdoors 70 Anthro-Photo File 262 Appalachian Mountain Club Books 212 Art New England Summer Workshops @ Bennington VT 469 Bentley Publishers 213 Catholic Library World 180 Conari Press 215 Digital Wildlife Photography Field School 474 Fine Arts Work Center 476 Focal Press 220 Gloucester Waterfront Festival 424 Hallmark Institute of Photography 477 Horizons 478 Klein Gallery, Robert 374 Michelson Galleries, R. 380 Monderer Design 332 New England Arts & Crafts Festival 433 New England School of Photography 482 NFPA Journal 194 Pakn Treger 131 Paradise City Arts Festivals 435 Photographic Resource Center 389 Positive Images (Stock Photography & Gallery 61) 309 Pucker Gallery 391

Michigan

Rigby Education 231

Sportslight Photo 312

Design Design, Inc. 243

South Shore Art Center 488

Sail Magazine 140

Allen Park Arts & Crafts Street Fair 407 American Power Boat Association 173 Ann Arbor Street Art Fair 408 Art in the Park (MI) 411 Automotive News 176 Belian Art Center 350 Book Beat Gallery 352 Community Observer 88

The Workshops & Bob Korn Imaging 489

Worcester Polytechnic Institute 340

Detroit Focus 360 Freefall Review 100 Grand Rapids Art Museum 367 Grand Rapids Business Journal 164 Grand Rapids Family Magazine 103 Grand Rapids Magazine 104 Halsted Gallery Inc., The 368 Illogical Muse 110 KIA Art Fair (Kalamazoo Institute of Arts) 429 Krasl Art Fair on the Bluff 429 Les Cheneaux Festival of Arts 430 Lucent Books 225 Michigan Out-of-Doors 119 Michigan State University Holiday Arts & Crafts Show 432 Michigan State University Spring Arts & Crafts Show 432 Midwest Photographic Workshops 481 Nova Media Inc. 246 Oakland University Art Gallery 386 Orchard Lake Fine Art Show 435 Photo Explorer Tours 484 Prakken Publications, Inc. 230 Urban Institute for Contemporary Arts 400

Minnesota

Voyageur Press 235

Art Workshops in Guatemala 469 Capstone Press 214 Carmichael-Lynch, Inc. 325 Creative Company, The 217 Creative Editions 217 Geosynthetics 187 İcebox Quality Framing & Gallery 370 Lake Superior Magazine 116 Lerner Publishing Group, Inc. 224 Macalester Gallery 377 Milkweed Editions 227 Minnesota Golfer 120 Opening Night Gallery 387 Redmond Design, Patrick 335 Shots 144 Stone Arch Festival of the Arts 442 St. Patrick's Day Craft Sale & Fall Craft Sale Superior/Gunflint Photography Workshops 489 Uptown Art Fair 444 Vision Quest Photo Workshops Center 490 Windigo Images 321 WRITERS' Journal 209

Mississippi

Bridge Bulletin, The 80 Clarion-Ledger, The 163 Southside Gallery 394

Missouri

Dairy Today 183
Faust Fine Arts & Folk Festival 421
Hereford World 188
Kochan & Company 331
Leopold Gallery 375
Mid-Missouri Artists Christmas Arts & Crafts Sale 432
Missouri Photojournalism Workshop 481
Photospiva 453
Pictures of the Year International 453
Santa Cali Gon Days Festival 438
Sharing the Victory 143
Ziti Cards 250

College Photographer of the Year 451

Montana

Adventure Cyclist 67
Animals of Montana, Inc. 469
Arts in the Park 413
Farcountry Press 220
Museum of the Plains Indian 384
Photographers' Formulary 485
Rocky Mountain School of Photography 487
Sidewalk Art Mart 438
Strawberry Festival 442
Tom Murphy Photography 489
Whitefish Arts Festival 446

Nebraska

Artists' Cooperative Gallery 346
Arts & Crafts Affair, Autumn & Spring Tours,
An 412
Autumn Festival, An Arts & Crafts Affair 413
Lux Center for the Arts 377
Unicorn Stock Photos 319
Upstream People Gallery 400
Woodmen Living 157

Nevada

Casino Journal 179
Comstock Cards 242
Contemporary Arts Collective 358
Delaney Photo Workshops, Cynthia 474
Home Decorating & Remodeling Show 427
Nevada Museum of Art 384
Rugby Magazine 139

New Hampshire

Business NH Magazine 179
Calliope 80
Cobblestone 87
Concord Litho 242
Craft Fair at the Bay 417
Gunstock Summer Festival 426
Hearth and Home 188
Living Free 116
MacDowell Colony, The 480
Memorial Weekend Arts & Crafts Festival 432
Mill Brook Gallery & Sculpture Garden 380
New England Craft & Specialty Food Fair 433
Summer Arts & Crafts Festival 442
Tree Care Industry 207
Yankee Magazine 159

New Jersey

Annual Juried Photography Exhibition 449 Bacall Representatives Inc., Robert 457 Barron Arts Center 350 Bartender Magazine 177 Bergman Collection, The 268 Chatsworth Cranberry Festival 415 Contemporary Bride Magazine 90 Creative Homeowner 217 Down The Shore Publishing Corp. 218 Fall Fine Art & Crafts at Brookdale Park 420 Fine Art & Crafts at Anderson Park 422 Fine Art & Crafts Fair at Verona Park 422 Fire Engineering 186 Galman Lepow Associates, Inc. 367 Limited Editions & Collectibles 376 Markeim Art Center 378 Mid-Atlantic Regional School of Photography 481 Mira 296 Modernart Editions 245

New Jersey Heritage Photography Workshops 482

New Jersey Media Center LLC Workshops and Private Tutoring 482

Noyes Museum of Art, The 386

Paulist Press 230

Pediatric Annals 194

Peters Valley Annual Craft Fair 435

Peters Valley Craft Center 388, 484

Pierro Gallery of South Orange 390

PI Magazine 195

Princeton Alumni Weekly 136

Quaker Arts Festival 436

Quick Frozen Foods International 199

Quon Design 334

RIG 248

Spencer Gifts, LLC 248

Spring Fine Art & Crafts at Brookdale Park in Montclair, NJ 440

Up and Under 155

Wildlife Photography Workshops & Lectures

Zakin Gallery, Mikhail 404

New Mexico

Albuquerque Museum of Art & History, The 344

American Archaeology 70

Curator's Choice Awards 451

Eloquent Light Photography Workshops 474

Journal of Asian Martial Arts 113

Mayans Gallery, Ernesto 362

New Mexico Arts & Crafts Fair 434

New Mexico Magazine 124

New Mexico State University Art Gallery 384

Painet Inc. 302

Santa Fe Photographic Workshops 487

University Art Gallery in the D.W. Williams Art

Center 399

Wurlitzer Foundation of New Mexico, The Helene 491

New York

911 Pictures 255

ABA Banking Journal 171

Achard & Associates 457

Adams Workshop, Eddie 468

Adirondack Lakes Center for the Arts 343

African American Golfer's Digest 67

Alexia Competition 449

Allentown Art Festival 407

American Museum of Natural History Library, Photographic Collection 260

American Turf Monthly 72

Animals Animals/Earth Scenes 261

Aperture 74

ARC Awards 449

Arsenal Gallery, The 345

Art Resource 265

ArtsLink Projects 450

Art Without Walls, Inc. 348

Athletic Management 176

Atlantic Gallery 349

Avanti Press Inc. 240

Axis Gallery 349

Bedford/St. Martin's 213

Benrubi Gallery, Bonni 351

Bridgeman Art Library, The 269

Bristol Gift Co., Inc. 241

Casey & Associates, Marge 458

Center for Photography at Woodstock 355, 472

CEPA Gallery 355

Chronogram 86

City Limits 86

Clampart 356

Cleaning & Maintenance Management

Magazine 182

Cole Represents, LLC, Randy 458

Colorscape Chenango Arts Festival 417

Community Darkroom 473

Conde Nast Traveller 89

Corbis 273

Courthouse Gallery, Lake George Arts Project

359

Crabtree Publishing Company 216

Crafts at Rhinebeck 417

CraftWestport 418

Dance on Camera Festival 451

Design Conceptions (Joel Gordon

Photography) 275

Direct Art Magazine Publication Competition

451

DK Stock, Inc. 276

DM News 184

Dodo Graphics Inc. 243

Dorsky Museum of Art, Samuel 360

Eastman House, George 361

Elmwood Avenue Festival of the Arts, Inc. 419

eMediaLoft.org 361

Erben Gallery, Thomas 362

eStock Photo, LLC 279

Everson Museum of Art 363

Ewing Galloway Inc. 279

Fellowship 98

First Light Photographic Workshops and

Safaris 476

Forest Hills Festival of the Arts 422

Fort Ross Inc. 220

Fortune 99

Fundamental Photographs 284

Garrison Art Center Fine Art & Craft Fair 424

Gering and Lopez Gallery 367

Ginsburg & Associates, Inc., Michael 460

Goldman Creative Photography Workshops,

Rob 477

Great Neck Street Fair 425

Guideposts 104

Guilford Craft Expo 426

Guitar World 105

Hadassah Magazine 105

Haddad Gallery, Carrie 368

Hard Hat News 164

Harper's Magazine 106

Hart Portrait Seminars, John 478

Henry Street Settlement/Abrons Art Center

369

Hodes Group, Bernard 329

Houk Gallery, Edwynn 370

Hyperion Books for Children 223

IEEE Spectrum 189

Image Works, The 287

Intercontinental Greetings LTD. 244

International Center of Photography 372

Jewish Action 112

JHB Gallery 373

Joyce Inc., Tricia 461

Juvenile Diabetes Research Foundation

International 113

Kashrus Magazine 114

Korman + Company 461

Layla Productions, Inc. 224

Levin Group, The Bruce 462

Lilac Festival Arts & Crafts Show 430

Limner Gallery 376

Long Island Photo Workshop 480

Main Street Gallery, The 378

McGaw Graphics, Inc. 245

Medical File Inc., The 295

Mentor Series Worldwide Photo Treks 481

Mercury Awards 452

Metrosource Magazine 119

Montauk Point Lions Club 432

Music Sales Group 228

Na'amat Woman 122

Neversink Photo Workshop 482

Newsweek 124

New York State Fair Photography Competition

and Show 452

New York Times Magazine 165

New York Times on the Web, The 165

Nikon School Digital SLR Photography 483

Norton and Company, W.W. 229

NOVUS 333

NYU Tisch School of the Arts 483

O.K. Harris Works of Art 386

Omni-Photo Communications 298

ONE 128

Opalka Gallery 387

Outdoor Life Magazine 130

Owen Publishers, Inc., Richard C. 229

Phoenix Gallery 389

Photography Now 453

Photolibrary Group 305

Photo Researchers, Inc. 306

Poets & Writers Magazine 135

Popular Photography & Imaging 135

Posev School 334

POZ Magazine 136

Professional Photographer's Society of New

York State Photo Workshops 486

Queens College Art Center 391

Reform Judaism 138

Registered Rep 201

Rochester Contemporary 392

Rolling Stone 139

Rotunda Gallery, The 393

Saks Associates, Arnold 336

Sander, Vicki/Folio Forums 464

Schecterson Dezign Associates, Jack 336

Scholastic Library Publishing 232

Scholastic Magazines 142

School Guide Publications 233

Schupfer Management Corporation, Walter

Security Dealer & Integrator 204

Seventeen Magazine 143

Smith Memorial Fund, Inc., W. Eugene 454 Sovfoto/Eastfoto, Inc. 312 spoke gallery, b.i. 352 Spring Crafts at Morristown 440 State of the Art 395 StockMedia.net 316 Synchronicity Fine Arts 396 Syracuse Arts & Crafts Festival 443 Syracuse New Times 167 Throckmorton Fine Art 397 **TIME 150** Tobacco International 206 TRACE Magazine 151 Travel + Leisure 153 Truppe, Doug 465 TV Guide 154 Upstream Gallery 400 Vintage Books 234 Viridian Artists, Inc. 401 Washington Square Outdoor Art Exhibit 445 Wild Wind Folk Art & Craft Festival 446 Wine Enthusiast Magazine 158 Woman Engineer 208 Woodstock Photography Workshops 491 World Fine Art Gallery 403 Yeshiva University Museum 403 Your Best Shot 455

North Carolina

Aerial Photography Services 211 AKM Images, Inc. 258 BedTimes 177 Blount-Bridgers House/Hobson Pittman Memorial Gallery 352 Boeberitz Design, Bob 323 Campbell Folk School, John C. 471 Church Street Art & Craft Show 416 Festival in the Park 421 Foothills Crafts Fair 422 Holly Arts & Crafts Festival 427 Howard, Merrell and Partners, Inc. 329 International Folk Festival 428 Light Factory, The 376, 479 North Carolina Literary Review 125 Novastock 297 **QSR** 199 Smoky Mountain Learning Center 488 Springfest 440

Sun, The 147 Today's Photographer 207 Unlimited Editions International Juried Photography Competitions 455

North Dakota

Fargo's Downtown Street Fair 421
Flint Communications 327
Horizons Magazine 108
Northwest Art Center 385
Taube Museum of Art, Lillian & Coleman 396

Ohio

Aftermarket Business World 171 Akron Art Museum 343 Akron Arts Expo 407 American School Health Association 212 Bird Watcher's Digest 77 Black Swamp Arts Festival 414 Bright Light Visual Communications 324 Cain Park Arts Festival 414 Centerville/Washington Township Americana Festival 415 Chardon Square Arts Festival 415 Cleveland Magazine 87 Contemporary Arts Center (Cincinnati), The 358 Corcoran Fine Arts Limited, Inc. 358 CropLife 183 Dayton Art Institute, The 360 Delaware Arts Festival 418 Family Motor Coaching 98 FAVA (Firelands Association for the Visual Arts) 364 F+W Media 219 Hoof Beats 108 Hywet Hall & Gardens Wonderful World of Ohio Mart, Stan 428 Image Finders, The 286 Jividen's 479 Kent State University School of Art Galleries Liggett Stashower 331 Lohre & Associates Inc. 332 Manning Photography, William 480 Mason Arts Festival 431 McDonough Museum of Art 379 My Foodservice News 192 Plastics News 196

Plastics Technology 197
Pump House Center for the Arts 391
Restaurant Hospitality 202
Saxton Gallery of Photography, The Joseph 397
Summerfair 442
Water Well Journal 207
Whiskey Island Magazine 158
Writer's Digest 158

Oklahoma

Individual Artists of Oklahoma 371
Oklahoma Today 127
Persimmon Hill Magazine 132
Stillwater Arts & Heritage Festival 441
Sun Fest, Inc. 443
Tulsa International Mayfest 444
Untitled [ArtSpace] 399

Oregon

540 Rider 67
Anchell Photography Workshops 468
Artist Fellowship Grants 450
Bear Deluxe Magazine, The 77
Catholic Sentinel 162
exposure36 Photography 475
Leach Gallery, Elizabeth 374
Northwest Travel Magazine 126
Oregon Coast Magazine 129
Oregon College of Art and Craft 483
Schmidt Design, Henry 336
Viewfinders Stock Photography 320
Youth Runner Magazine 159

Pennsylvania

American Stock Photography 260
Automotive Cooling Journal 176
Bowhunter 79
Bynums Marketing and Communications, Inc. 325
Camerique Inc. International 271
Christmas and Easter Craft Shows 415
Christmas Craft Show 416
Codorus Summer Blast 417
Convenience Store Decisions 182
Day in Towne, A 406
Demuth Museum 360
Fair in the Park, A 420

Ford City Heritage Days 422 Goodman Inc., Tom 460 Hampton Design Group 329 Heilman Photography, Inc., Grant 285 Herald Press 222 Lehigh University Art Galleries 375 McDonald Wildlife Photography Workshops and Tours, Joe & Mary Ann 480 Myron the Camera Bug 452 Natural Tapestries 482 Nexus/Foundation for Today's Art 384 Pearlstein Gallery, Leonard 388 Pennsylvania Game News 132 Pennsylvania Magazine 132 Photomedia Center, The 390 Photo Network 306 Photo Review Annual Photography Competition, The 453 Police and Security News 197 Print Center, The 391 Robertstock / ClassicStock 310 Running Press Book Publishers 232 Schmidt/Dean Spruce 393 State Museum of Pennsylvania, The 395 VIREO (Visual Resources for Ornithology) 320 Westmoreland Art Nationals 445 Women's Health Group 237 Zahn & Associates, Spencer 340

Rhode Island

Arnold Art 345
Cruising World 92
Envision 278
Hera Educational Foundation and Art Gallery 369
Rhode Island Monthly 138
Rhode Island State Council on the Arts
Fellowships 454

South Carolina

Sandlapper Magazine 141
South Carolina Film Commission 337
Southeast Photo Adventure Series Workshops 488
Turkey Country 154
Wild Wings Photo Adventures 490

South Dakota

Dakota Outdoors 93

South Dakota Art Museum 394 Watertown Public Opinion 168

Tennessee

Arrowmont School of Arts and Crafts 469 Arts Company, The 347 Bennett Galleries and Company 351 Chess Life 84 Chess Life for Kids 85 Cory Photography Workshops 473 Cotton Grower Magazine 183 Ducks Unlimited Magazine 95 Edelstein Studio and Gallery, Paul 361 Germantown Festival 424 Ideals Magazine 109 Ketner's Mill County Arts Fair 429 Nature Photography Workshops, Great Smoky Mountains Institute at Tremont 482 Now & Then 127 Smithville Fiddlers' Jamboree and Craft Festival 439

Texas

Campbell Contemporary Art, William 353 Cleary Gallery, John 357 Dallas Center for Contemporary Art, The 359 Dockery House Publishing, Inc. 218 Dykeman Associates, Inc. 326 Englander Photography Workshops & Tours, Joe 475 Jude Studios 330 Kirchman Gallery 373 Museum of Printing History 383 New Gallery/Thom Andriola 384 Official Texas State Arts & Crafts Fair 435 Roggen Advertising and Public Relations, Ted 335 RTOHQ 203 SRO Photo Gallery at Landmark Arts 395 Stockyard Photos 317 Streetpeople's Weekly News 166 Texas Gardener Magazine 148 Texas Highways 148 Texas Monthly 149 Texas Realtor Magazine 206 Texas School of Professional Photography 489 Tide Magazine 149 Women & Their Work Art Space 403

Utah

Advanced Graphics 239 Classical Singer 182 Phillips Gallery 389 Portfolio Graphics, Inc. 247 St. George Art Festival 441

Vermont

Art in the Park Fall Foliage Festival 411
Art in the Park Summer Festival 412
Cone Editions Workshops 473
Countryman Press, The 216
Hunger Mountain 109
Inner Traditions/Bear & Company 223
Lake Champlain Maritime Museum's Annual
Juried Photography Exhibit 452
Northern Woodlands 125
Russian Life Magazine 140
Toward Freedom 151
Vermont Life 155
Vermont Magazine 156

Virginia

Air Line Pilot 172 American Gardener, The 72 American Hunter 72 Animal Trails 73 Archaeology 161 Art in the Park (VA) 412 Artist Fellowships/Virginia Commission for the Arts 450 Baseball 76 Blue Ridge Country 78 Bridal Guides Magazine 79 Chronicle of the Horse, The 85 City of Fairfax Fall Festival 416 City of Fairfax Holiday Craft Show 416 Dale Photographic Workshops, Bruce 474 Dance 93 ESL Teacher Today 185 Gallery West 367 Ghost Town 102 Holiday Arts & Crafts Show 427 Log Home Living 117 Multiple Exposures Gallery 381 Nature Friend 123 Photo Agora 304 Pungo Strawberry Festival 436

Ranger Rick 137 Revolutionary War Tracks 138 School Administrator, The 203 Second Street Gallery 394 Shenandoah Photographic Workshops 488 Shooting Sports USA 143 Steppin' Out 441 Techniques 205 Textile Rental Magazine 206 University of Richmond Museums 399 Virginia Center for the Creative Arts 490 Virginia Christmas Show 445 Virginia Spring Show 445

Washington

AIM 68 Anacortes Arts Festival 408 Art of Nature Photography Workshops 469 ArtVisions, 239 Barnett Advertising/Design, Augustus 323 Benham Studio Gallery 350 BetterPhoto.com Online Photography Courses 470 Blend Images 269 Canoe & Kayak 82 Foodpix 282 Gallery 110 Collective 365 Getty Images (WA) 285 Grafica 328 Hackett, Pat/Artist Representative 461 Hancock House Publishers 221 Home Education Magazine 108 Infinity Workshops 478 James Harris Gallery 368 Larson Gallery Juried Biennual Photography Exhibition 452 Northern Exposures 483 OnRequest Images 299 PACIFIC NORTHWEST ART SCHOOL/ PHOTOGRAPHY 484 Paddler Magazine 131 Photographic Arts Workshops 485

Photographic Center Northwest 485

Seattle Homes & Lifestyles 142

Photokunst 463

Tulip Festival Street Fair 444 Van Os Photo Safaris, Inc., Joseph 489 Washington Trails 156

West Virginia

Appalachian Trail Journeys, 74 AppaLight 262 Mexico Photography Workshops 481 Mountain State Forest Festival 433 Photography Art 389 Taylor County Fair Photo Contest 454

Wisconsin

Anchor News 73 AQUA Magazine 175 Art Fair on the Courthouse Lawn 410 Astronomy 75 Athletic Business 175 BizTimes Milwaukee 178 Charlton Photos, Inc. 272 Country Arts & Crafts Fair 417 Country Woman 91 Crossman Gallery 359 Deer & Deer Hunting 93 Finescale Modeler 98 Gallery 218 366 Good Old Summertime Art Fair 424 Progressive, The 137 Referee 201 Sailing Magazine 118 sellphotos.com 487 State Street Gallery 395 Trails Media Group 250 Turkey & Turkey Hunting 154 Weinstein Gallery 402 Willow Creek Press 236 Winnebagoland Art Fair 446 Wisconsin Architect 208 Wisconsin Union Galleries 402

Wyoming

Nicolaysen Art Museum & Discovery Center 385 Yellowstone Association Institute 492

International Index

Argentina

Comesana Agencia de Prensa/Banco Fotográfico, Eduardo 273 Fotoscopio 283

Australia

Ant Photo Library 262 Auscape International 267 DW Stock Picture Library (DWSPL) 277 Lonely Planet Images 293

Belgium

Isopix 289

Brazil

Opção Brasil Imagens 300

British West Indies

Times of the Islands 150

Canada

Alternatives Journal 70
Art in Motion 239
Banff Mountain Photography Competition 450
BC Outdoors 76
Blackflash 78
Boston Mills Press 214
Briarpatch 79
Canada Lutheran 81
Canadian Guernsey Journal 179
Canadian Homes & Cottages 81
Canadian Organic Grower, The 81
Chirp Magazine 85

Devlopment 474 Dogs in Canada 95 ECW Press 219 Energy Gallery Art Call 451 Event 97 First Light Associated Photographers 281 Gallant/Freeman Patterson Photo Workshops 477 Georgia Straight 101 Gospel Herald 103 Guernica Editions, Inc. 221 Hamilton Magazine 105 Lawyers Weekly, The 164 Magenta Publishing for the Arts 226 Manitoba Teacher, The 191 Manufacturing Automation & Advanced Manufacturing 191 Masterfile 294 MAXX Images, Inc. 294 Meetings & Incentive Travel 192 Megapress Images 295 Outdoor Canada Magazine 129 OWL Magazine 130 Oxygen 130 Pacific Yachting Magazine 131 Photo Life 133 PI Creative Art 247 Ponkawonka Inc. 308 Prairie Journal, The 136 Ouetico Photo Tours 487 Rafelman Fine Arts, Marcia 392 Singing Sands Workshops 488

Stock Foundry Images 315

Dawson College Centre for Training and

subTERRAIN Magazine 147
Sun.Ergos 338
Teldon 248
Toronto Sun Publishing 167
Up Here 155
Visitor's Choice Magazine 234
Warne Marketing & Communications 339
WaveLength Magazine 157
Weigl Educational Publishers Limited 236
Western Producer, The 169

Cayman Islands

Church Personal Underwater Photography Courses, Cathy 472

Ecuador

Archivo Criollo 263

France

BSIP 270

Camargo Foundation Visual Arts Fellowship 471 Photography in Provence 485

Photography in Provence 48 Pyrenees Exposures 486

Germany

A+E 256

Foto-Press Timmermann 283 Images.de Digital Photo GmbH 287 Okapia K.G. 298 StockFood GmbH (The Food Image Agency) 314 Ullstein Bild 319

Greece

Outram's Travel Photography Workshops, Steve 484 Zorba Photo Workshops 492

Hong Kong

Argus Photo, Ltd. (APL) 263 Photolife Corporation Ltd. 305

India

Dinodia Photo Library 275 Stock Transparency Services/STSimages 317

Ireland

Burren College of Art Workshops 471 Irish Image Collection, The 289 Irish Picture Library, The 289

Israel

Land of the Bible Photo Archive 268

Italy

Cortona Center of Photography, Italy, The 473 I.C.P. International Colour Press 286

Japan

Aflo Foto Agency 257 amanaimages inc. 260 PLANS, Ltd. (Photo Libraries and News Services) 308

Netherlands

Lineair Fotoarchief, B.V. 293

New Zealand

Focus New Zealand Photo Library Ltd. 282 PhotoSource International 307

Norway

Creative Stock Images 274

Singapore

Asia Images Group 266 OnAsia 299

Spain

Age Fotostock 258

United Kingdom

Ace Stock Limited 256
Ancient Art & Architecture Collection, Ltd.,
The 261
Andes Press Agency 261
ArkReligion.com 264
Art Directors & Trip Photo Library 264
Bird Watching Magazine 78
Camera Press Ltd. 270
Capital Pictures 271
Church of England Newspaper, The 163
Cody Images 273
Digital Photo 94

Ecoscene 278 E & E Picture Library 277 Empics 278 EOS Magazine 96 Famous Pictures & Features Agency 280 Flight Collection, The 281 France Magazine 100 Geoslides & Geo Aerial Photography 284 Heritage Railway Magazine 107 Hutchison Picture Library 285 Jayawardene Travel Photo Library 290 Latitude Stock 292 Lonely Planet Images 293 Medical On Line Ltd. 295 Motoring & Leisure 121 Music & Arts Pictures at Lebrecht 297

NewDesign Magazine 194 Oxford Scientific (OSF) 301 Papilio Natural History Library 303 Pilot Magazine 134 Pitcher Photo Library, Sylvia 307 Planet 134 Quarto Publishing Plc. 231 Railphotolibrary.com 310 Santoro Graphics Ltd. 248 Science Photo Library, Ltd. 311 Skyscan Photolibrary 311 Sunday Post, The 167 Traveller Magazine & Publishing 153 Triumph World 153 Tropix Photo Library 318 World Tobacco 209

Subject Index

Adventure

Accent Alaska/Ken Graham Agency 255

Ace Stock Limited 256

Adirondack Lakes Center for the Arts 343

Aflo Foto Agency 257

After Five 68

Age Fotostock 258

Alaska Stock Images 259

amanaimages inc. 260

AMC Outdoors 70

American Fitness 71

American Power Boat Association 173

American Print Alliance 344

Animals of Montana, Inc. 469

AOPA Pilot 174

Appalachian Mountain Club Books 212

AppaLight 262

Aquarius 161

Archaeology 161

Archivo Criollo 263

Arsenal Gallery, The 345

Art Directors & Trip Photo Library 264

Art@Net International Gallery 346

Art Without Walls, Inc. 348

Aurora Photos 266

Balzekas Museum of Lithuanian Culture Art

Gallery 349

Bear Deluxe Magazine, The 77

Blue Ridge Country 78

Boeberitz Design, Bob 323

Bon Artique.com/Art Resources Int., Ltd. 241

Borealis Press, The 241

Bowhunter 79

Bridal Guides Magazine 79

Business of Art Center 353

Bynums Marketing and Communications, Inc.

325

Canoe & Kayak 82

Capitol Complex Exhibitions 353

Carmichael-Lynch, Inc. 325

Chirp Magazine 85

Cleary Gallery, John 357

Cleveland Magazine 87

Comesana Agencia de Prensa/Banco

Fotográfico, Eduardo 273

Continental Newstime 90

Creative Company, The 217

Creative Stock Images 274

Cycle California! Magazine 92

DDB Stock Photography, LLC 274

Dinodia Photo Library 275

DK Stock, Inc. 276

Dodo Graphics Inc. 243

Elks Magazine, The 96

ESL Teacher Today 185

Flint Communications 327

Focus New Zealand Photo Library Ltd. 282

Foto-Press Timmermann 283

Fotoscopio 283

Geoslides & Geo Aerial Photography 284

Ghost Town 102

Grafica 328

Healing Lifestyles & Spas Magazine 106

Horizons Magazine 108

Icebox Quality Framing & Gallery 370

Immigrant Ancestors 110

Inmagine RF & RM Image Submissions (IRIS)

288

In The Wind 111 Jeroboam 291

Kramer and Associates, Inc., Joan 292

Latitude Stock 292

Leepa-Rattner Museum of Art 374 Limited Editions & Collectibles 376

Lineair Fotoarchief, B.V. 293

Markeim Art Center 378

Marlboro Gallery 378

Megapress Images 295

Mesa Contemporary Arts at Mesa Arts Center 379

Metrosource Magazine 119

Monderer Design 332

Multiple Exposures Gallery 381

Mushing.com Magazine 121

Northern Woodlands 125

Northwestern University Dittmar Memorial

Gallery 385

Novastock 297

NOVUS 333

Now & Then 127

Okapia K.G. 298

Oklahoma Today 127

OnAsia 299

OnRequest Images 299

Outside Imagery 300

Owen Publishers, Inc., Richard C. 229

OWL Magazine 130

Pacific Stock/Printscapes.com 301

Pacific Yachting Magazine 131

Paddler Magazine 131

Painet Inc. 302

Panoramic Images 303

Persimmon Hill Magazine 132

Photo Network 306

PhotoSource International 307

Pilot Getaways 195

Portfolio Graphics, Inc. 247

Quarto Publishing Plc. 231

Ranger Rick 137

Revolutionary War Tracks 138

Rigby Education 231

Roggen Advertising and Public Relations, Ted

335

Sailing Magazine 118

Sail Magazine 140

Salt Water Sportsman 141

San Diego Art Institute's Museum of the Living Artist 393

Sandlapper Magazine 141

Scholastic Library Publishing 232

Soundlight 337

SouthComm Publishing Company, Inc. 145

Sportslight Photo 312

Stock Foundry Images 315

Stock Transparency Services/STSimages 317

Sugar Daddy Photos 317

Teldon 248

Tide-Mark Press 249

Times of the Islands 150

Trail Runner 152

Tropix Photo Library 318

Tyndale House Publishers 234

Ullstein Bild 319

Unicorn Stock Photos 319

Up Here 155

Upstream People Gallery 400

Viewfinders 320

Washington County Museum of Fine Arts 402

Washington Trails 156

WaveLength Magazine 157

Agriculture

Accent Alaska/Ken Graham Agency 255

Aflo Foto Agency 257

Age Fotostock 258

AGStockUSA Inc. 258

AKM Images, Inc. 258

Alabama Living 69

amanaimages inc. 260

American Print Alliance 344

Andes Press Agency 261

Animals Animals/Earth Scenes 261

Animal Trails 73

AppaLight 262

Archaeology 161

Art Directors & Trip Photo Library 264

Art Without Walls, Inc. 348

Aurora Photos 266

Balzekas Museum of Lithuanian Culture Art

Gallery 349

Baseball 76

Beef Today 178

Belian Art Center 350

Biological Photo Service and

Terraphotographics 268

Brewers Association 214 Bridal Guides Magazine 79

California Views/Mr. Pat Hathaway Historical

Photo Collection 270

Canadian Guernsey Journal 179 Canadian Organic Grower, The 81 Capitol Complex Exhibitions 353

Charlton Photos, Inc. 272 Cleary Gallery, John 357

Cobblestone 87

Comesana Agencia de Prensa/Banco

Fotográfico, Eduardo 273 Continental Newstime 90 Cotton Grower Magazine 183

Creative Company, The 217

Creative Homeowner 217

Creative Stock Images 274

CropLife 183
Dairy Today 183
Dance 93

DDB Stock Photography, LLC 274

Dinodia Photo Library 275

DK Stock, Inc. 276 Dodo Graphics Inc. 243

DW Stock Picture Library (DWSPL) 277

Ecoscene 278 Envision 278

ESL Teacher Today 185 Flint Communications 327

Focus New Zealand Photo Library Ltd. 282

Fotoscopio 283 Freefall Review 100 Freeport Arts Center 364 Fundamental Photographs 284

Geoslides & Geo Aerial Photography 284

Ghost Town 102 Grafica 328 Grain Journal 187 Grit Magazine 104

Heilman Photography, Inc., Grant 285

Hereford World 188 Horizons Magazine 108 Hutchison Picture Library 285 Image Finders, The 286

Images.de Digital Photo GmbH 287

Immigrant Ancestors 110

Isopix 289 Jeroboam 291

Kramer and Associates, Inc., Joan 292

. Latitude Stock 292

Leepa-Rattner Museum of Art 374 Lerner Publishing Group, Inc. 224

Lineair Fotoarchief, B.V. 293 Markeim Art Center 378

Medical File Inc., The 295 Michael Murphy Gallery M 380

Museum of Contemporary Photography, Columbia College Chicago 383

National Geographic 122 Northern Woodlands 125

NOVUS 333 Now & Then 127 Okapia K.G. 298

Omni-Photo Communications 298

OnAsia 299

OnRequest Images 299 Outside Imagery 300 Oxford Scientific (OSF) 301 Pacific Stock/Printscapes.com 301

Painet Inc. 302 Photo Agora 304 Photo Network 306

Planet 134 Planning 196

Plastics Technology 197
Portfolio Graphics, Inc. 247
Produce Merchandising 198

Pump House Center for the Arts 391 Quick Frozen Foods International 199 Revolutionary War Tracks 138

Rural Heritage 140

San Diego Art Institute's Museum of the Living Artist 393

Sandlapper Magazine 141 Scholastic Library Publishing 232

SouthComm Publishing Company, Inc. 145

Southside Gallery 394

StockFood GmbH (The Food Image Agency)

314

Stock Foundry Images 315

Stock Transparency Services/STSimages 317

Sugar Daddy Photos 317

Sun, The 147

Synchronicity Fine Arts 396

Taube Museum of Art, Lillian & Coleman 396

Tobacco International 206 Tropix Photo Library 318

Ullstein Bild 319

Unicorn Stock Photos 319
Upstream People Gallery 400
Vermont Life 155
Viewfinders 320
Voyageur Press 235
Washington County Museum of Fine Arts 402
Waveland Press, Inc. 235
Weigl Educational Publishers Limited 236
Western Producer, The 169
World Tobacco 209

Alternative Process

Ace Stock Limited 256 Adirondack Lakes Center for the Arts 343 Aflo Foto Agency 257 Akron Art Museum 343 Alaska Stock Images 259 American Fitness 71 American Print Alliance 344 Animal Trails 73 Archaeology 161 Archivo Criollo 263 Arsenal Gallery, The 345 Art Directors & Trip Photo Library 264 Art in Motion 239 Arts on Douglas 347 Art Source L.A., Inc. 348 Art Without Walls, Inc. 348 Avionics Magazine 177 Axis Gallery 349 Balzekas Museum of Lithuanian Culture Art Gallery 349 Baseball 76 Bell Studio 350 Benham Studio Gallery 350 Bennett Galleries and Company 351 Bentley Publishing Group 240 Blackflash 78 Bon Artique.com/Art Resources Int., Ltd. 241 Book Beat Gallery 352 Brewers Association 214 Bridal Guides Magazine 79 Business of Art Center 353 Center for Fine Art Photography, The 354 CEPA Gallery 355 Chapman Friedman Gallery 356 Chronogram 86

Clampart 356

Cleary Gallery, John 357 Contemporary Arts Center 357 Contemporary Arts Center (Cincinnati), The 358 Contemporary Arts Collective 358 Corporate Art Source/CAS Gallery 358 Creative Stock Images 274 Dance 93 Delaware Center for the Contemporary Arts 360 Dinodia Photo Library 275 Dodo Graphics Inc. 243 Dorsky Museum of Art, Samuel 360 Eastman House, George 361 Edelstein Studio and Gallery, Paul 361 eMediaLoft.org 361 ESL Teacher Today 185 Event 97 Everson Museum of Art 363 Fahey/Klein Gallery 363 Fort Ross Inc. 220 Ft. Myers Magazine 100 Gallant Greetings Corp. 244 Gallery 110 Collective 365 Gallery 218 366 Gallery North 366 Gallery West 367 Gering and Lopez Gallery 367 Ghost Town 102 Golf Tips 103 Grafica 328 Grand Rapids Magazine 104 Hampton Design Group 329 Harper's Magazine 106 Havu Gallery, William 368 Hemphill 369 Henry Street Settlement/Abrons Art Center 369 Houk Gallery, Edwynn 370 Huntsville Museum of Art 370 Icebox Quality Framing & Gallery 370 Illinois State Museum Chicago Gallery 371 Immigrant Ancestors 110 Indianapolis Art Center 371 Individual Artists of Oklahoma 371 Irish Picture Library, The 289 Isopix 289 Jackson Fine Art 372

Clark Gallery, Catharine 356

Journal of Asian Martial Arts 113 Kramer and Associates, Inc., Joan 292 LA Art Association/Gallery 825 374 Leepa-Rattner Museum of Art 374

Leopold Gallery 375 Light Factory, The 376

Limited Editions & Collectibles 376

Limner Gallery 376 Markeim Art Center 378 Marlboro Gallery 378

Masur Museum of Art 379

Mesa Contemporary Arts at Mesa Arts Center 379

Michael Murphy Gallery M 380

Miller Gallery, Peter 380

Monderer Design 332

Multiple Exposures Gallery 381

Museo ItaloAmericano 382

Museum of Contemporary Photography, Columbia College Chicago 383

Museum of Printing History 383

New York Times on the Web, The 165

Nexus/Foundation for Today's Art 384

Northwest Art Center 385

NOVUS 333

Noyes Museum of Art, The 386

Painet Inc. 302

Palo Alto Art Center 387

Panoramic Images 303

Parkland Art Gallery 388

Peters Valley Craft Center 388

Phoenix Gallery 389

Photographic Resource Center 389

Photolibrary Group 305

Photomedia Center, The 390

PI Creative Art 247

Polk Museum of Art 390

Popular Photography & Imaging 135

Portfolio Graphics, Inc. 247

Prairie Journal, The 136

Rafelman Fine Arts, Marcia 392

Ralls Collection Inc., The 392

Recycled Paper Greetings, Inc. 247

Revolutionary War Tracks 138

Rockford Review 138

Rolling Stone 139

San Diego Art Institute's Museum of the Living Artist 393

Schmidt/Dean Spruce 393

Scholastic Library Publishing 232

Shots 144

Soho Myriad 394

Soundlight 337

South Dakota Art Museum 394

State Museum of Pennsylvania, The 395

State of the Art 395

Stevenson University Art Gallery 396

Stickman Review 147

Stock Foundry Images 315

Stock Transparency Services/STSimages 317

Streetpeople's Weekly News 166

subTERRAIN Magazine 147

Sugar Daddy Photos 317

Sun, The 147

Syracuse New Times 167

Touchstone Gallery 398

UCR/California Museum of Photography 398

Upstream People Gallery 400

Viewfinders 320

Viridian Artists, Inc. 401

Visual Arts Center of Northwest Florida 401

Visual Arts Gallery 401

Washington County Museum of Fine Arts 402

Whiskey Island Magazine 158

Women & Their Work Art Space 403

Zakin Gallery, Mikhail 404

Anthology/Annual/Best Of

A.R.C. Gallery 345

Architecture

Adirondack Lakes Center for the Arts 343

Aflo Foto Agency 257

Age Fotostock 258

amanaimages inc. 260

American Print Alliance 344

Ancient Art & Architecture Collection, Ltd.,

The 261

Andes Press Agency 261

Animal Trails 73

Archaeology 161

Archivo Criollo 263

Arsenal Gallery, The 345

Mischar Ganery, The 345

Art Directors & Trip Photo Library 264

Art@Net International Gallery 346

Art Resource 265

Arts Company, The 347

Arts Iowa City 347
Art Source L.A., Inc. 348
Art Without Walls, Inc. 348
Asian Enterprise Magazine 175
Atlanta Homes & Lifestyles 75
Atlantic Callery 349

Atlantic Gallery 349 Aurora Photos 266 Automated Builder 176

Balzekas Museum of Lithuanian Culture Art

Gallery 349

Belian Art Center 350 Benham Studio Gallery 350

Bennett Galleries and Company 351

Bentley Publishing Group 240 Boeberitz Design, Bob 323

Bon Artique.com/Art Resources Int., Ltd. 241

Bridal Guides Magazine 79

Calliope 80

Canadian Homes & Cottages 81 Capitol Complex Exhibitions 353 Carmichael-Lynch, Inc. 325

Center for Fine Art Photography, The 354

Chapman Friedman Gallery 356

Chatham Press 215 Clampart 356

Cleary Gallery, John 357 Cleveland Magazine 87 Cobblestone 87

Continental Newstime 90

Corporate Art Source/CAS Gallery 358

Countryman Press, The 216 Creative Company, The 217 Creative Homeowner 217 Creative Stock Images 274

Dance 93

DDB Stock Photography, LLC 274

Dinodia Photo Library 275 Display Design Ideas 184 Dodo Graphics Inc. 243 E & E Picture Library 277 Fahey/Klein Gallery 363 Flaunt Magazine 99

Flint Communications 327 Focus New Zealand Photo Library Ltd. 282

Fotoscopio 283
Freefall Review 100
Freeport Arts Center 364
Ft. Myers Magazine 100
Gallery North 366

Gallery West 367

Geoslides & Geo Aerial Photography 284

Ghost Town 102 Grafica 328

Guernica Editions, Inc. 221 Haddad Gallery, Carrie 368

Hemphill 369

Henry Street Settlement/Abrons Art Center 369

Hutchinson Associates, Inc. 330 Hutchison Picture Library 285

Illogical Muse 110 Image Finders, The 286 Iowan Magazine, The 112 Key Curriculum Press 224

Kramer and Associates, Inc., Joan 292 Land of the Bible Photo Archive 268

Landscape Architecture 191

Latitude Stock 292

Leepa-Rattner Museum of Art 374 Lehigh University Art Galleries 375

Leopold Gallery 375 Log Home Living 117 Macalester Gallery 377 Markeim Art Center 378

Mattei Photography, Michele 379

McGaw Graphics, Inc. 245

Mesa Contemporary Arts at Mesa Arts Center 379

Metrosource Magazine 119 Michael Murphy Gallery M 380

Monderer Design 332 Mountain Living 121

Multiple Exposures Gallery 381 Museo ItaloAmericano 382

Museum of Contemporary Art San Diego 382

Museum of Contemporary Photography, Columbia College Chicago 383

Museum of Printing History 383

Na'amat Woman 122 Nails Magazine 193 National Geographic 122 New Mexico Magazine 124

New York Times on the Web, The 165 Nexus/Foundation for Today's Art 384 Northwestern University Dittmar Memorial

Gallery 385 NOVUS 333 Now & Then 127 Omni-Photo Communications 298

OnAsia 299

OnRequest Images 299

Opening Night Gallery 387

Owen Publishers, Inc., Richard C. 229

Painet Inc. 302

Panoramic Images 303

Paper Products Design 246

Persimmon Hill Magazine 132

Photo Network 306

PhotoSource International 307

PI Creative Art 247

Planning 196

Portfolio Graphics, Inc. 247

Pucker Gallery 391

Pump House Center for the Arts 391

Ouarto Publishing Plc. 231

Ralls Collection Inc., The 392

Relay Magazine 202

Remodeling 202

Rhode Island Monthly 138

RIG 248

Running Press Book Publishers 232

San Diego Art Institute's Museum of the Living

Artist 393

Sandlapper Magazine 141

Schmidt Art Center, William & Florence 393

Scholastic Library Publishing 232

Seattle Homes & Lifestyles 142

Soho Myriad 394

South Carolina Film Commission 337

SouthComm Publishing Company, Inc. 145

Southside Gallery 394

State Street Gallery 395

Stock Foundry Images 315

Stock Transparency Services/STSimages 317

Sugar Daddy Photos 317

Synchronicity Fine Arts 396

Taube Museum of Art, Lillian & Coleman 396

Teldon 248

Texas Realtor Magazine 206

Throckmorton Fine Art 397

Tide-Mark Press 249

Times of the Islands 150

Touchstone Gallery 398

Ullstein Bild 319

Up and Under 155

Vermont Magazine 156

Viewfinders 320

Visitor's Choice Magazine 234

Visual Arts Center of Northwest Florida 401

Washington County Museum of Fine Arts 402

Weigl Educational Publishers Limited 236

White Productions, Dana 339

Wisconsin Architect 208

Woodshop News 209

Automobiles

Ace Stock Limited 256

Adirondack Lakes Center for the Arts 343

Aflo Foto Agency 257

After Five 68

Aftermarket Business World 171

Age Fotostock 258

amanaimages inc. 260

American Print Alliance 344

Art Directors & Trip Photo Library 264

Art Source L.A., Inc. 348

Art Without Walls, Inc. 348

Automotive Cooling Journal 176

Automotive News 176

Auto Restorer 75

Balzekas Museum of Lithuanian Culture Art

Gallery 349

Barnett Advertising/Design, Augustus 323

Bentley Publishers 213

Bynums Marketing and Communications, Inc.

California Views/Mr. Pat Hathaway Historical

Photo Collection 270

Capstone Press 214

Carmichael-Lynch, Inc. 325

Chatham Press 215

Cleary Gallery, John 357

Cody Images 273

Collectible Automobile 87

Creative Company, The 217

Creative Stock Images 274

Dinodia Photo Library 275

Dodo Graphics Inc. 243

Finescale Modeler 98

Flint Communications 327

Fotoscopio 283

Gallant Greetings Corp. 244

Gallery Luisotti 366

Gallery West 367

Grafica 328

Highways 107

Image Finders, The 286
ITE Journal 189
Kramer and Associates, Inc., Joan 292
Leepa-Rattner Museum of Art 374
Limited Editions & Collectibles 376
Markeim Art Center 378
Megapress Images 295
Mesa Contemporary Arts at Meşa Arts Center 379

Monderer Design 332
Motoring & Leisure 121
Multiple Exposures Gallery 381

New York Times on the Web, The 165 Northwestern University Dittmar Memorial Gallery 385

NOVUS 333

Owen Publishers, Inc., Richard C. 229

Painet Inc. 302
Panoramic Images 303
Photo Network 306

Planning 196
Portfolio Graphics, Inc. 247
Saks Associates, Arnold 336
Scholastic Library Publishing 232
School Transportation News 203
SouthComm Publishing Company, Inc. 145

SportsCar 146

Stack & Associates, Inc., Tom 313

Stock Foundry Images 315

Stock Transparency Services/STSimages 317

Sugar Daddy Photos 317 Tide-Mark Press 249 Touchstone Gallery 398 Triumph World 153 Ullstein Bild 319 Unicorn Stock Photos 319 Upstream People Gallery 400

Washington County Museum of Fine Arts 402

Zahn & Associates, Spencer 340

Avant Garde

Ace Stock Limited 256
Adirondack Lakes Center for the Arts 343
Aflo Foto Agency 257
Age Fotostock 258
Alaska Stock Images 259
American Print Alliance 344
Animal Trails 73
Archaeology 161

Arsenal Gallery, The 345
Art Directors & Trip Photo Library 264
Artefact/Robert Pardo Gallery 346
Art@Net International Gallery 346
Art Source L.A., Inc. 348
Art Without Walls, Inc. 348
Avionics Magazine 177
Axis Gallery 349
Balzelas Museum of Lithuanian Culture

Balzekas Museum of Lithuanian Culture Art Gallery 349

Baseball 76 Bell Studio 350

Benham Studio Gallery 350 Bentley Publishing Group 240

Blackflash 78

Brainworks Design Group 324 Bridal Guides Magazine 79 Business of Art Center 353 Capitol Complex Exhibitions 353

Center for Fine Art Photography, The 354

CEPA Gallery 355

Chapman Friedman Gallery 356

Chatham Press, 215 Chronogram 86 Clampart 356

Clark Gallery, Catharine 356 Contemporary Arts Center 357

Contemporary Arts Center (Cincinnati), The 358

Contemporary Arts Collective 358 Corporate Art Source/CAS Gallery 358 Creative Stock Images 274

Dance 93

Delaware Center for the Contemporary Arts

Detroit Focus 360 Dinodia Photo Library 275 Dodo Graphics Inc. 243

Dorsky Museum of Art, Samuel 360 Edelstein Studio and Gallery, Paul 361

eMediaLoft.org 361 ESL Teacher Today 185

Event 97

Everson Museum of Art 363 Fahey/Klein Gallery 363 Flaunt Magazine 99 Freefall Review 100 Ft. Myers Magazine 100

Gallant Greetings Corp. 244

Gallery 218 366 Gallery Luisotti 366 Gallery North 366

Gallery West 367

Gering and Lopez Gallery 367

Ghost Town 102

Grafica 328

Hampton Design Group 329

Harper's Magazine 106

Henry Street Settlement/Abrons Art Center 369

Houk Gallery, Edwynn 370 Hunger Mountain 109

Huntsville Museum of Art 370

Illogical Muse 110

Immigrant Ancestors 110

Indianapolis Art Center 371

International Photo News 288

Isopix 289

Jackson Fine Art 372

Journal of Asian Martial Arts 113

Journal of Psychoactive Drugs 190 .

Kramer and Associates, Inc., Joan 292

LA Aft Association/Gallery 825 374

Leepa-Rattner Museum of Art 374

Leopold Gallery 375

Light Factory, The 376 Limner Gallery 376

Lizardi/Harp Gallery 376

Macalester Gallery 377

Markeim Art Center 378

Marlboro Gallery 378

Masur Museum of Art 379

Mesa Contemporary Arts at Mesa Arts Center 379

Michael Murphy Gallery M 380

Monderer Design 332

Museo De Arte De Ponce 382

Museo ItaloAmericano 382

Museum of Contemporary Art San Diego 382

Museum of Contemporary Photography, Columbia College Chicago 383

New York Times on the Web, The 165

Northwest Art Center 385

Northwestern University Dittmar Memorial Gallery 385

NOVUS 333

Noyes Museum of Art, The 386

OnAsia 299

Painet Inc. 302

Palo Alto Art Center 387

Panoramic Images 303

Paper Products Design 246

Parkland Art Gallery 388

Photographic Resource Center 389

Photomedia Center, The 390

PI Creative Art 247

Polk Museum of Art 390

Ponkawonka Inc. 308

Popular Photography & Imaging 135

Portfolio Graphics, Inc. 247

Ralls Collection Inc., The 392

Revolutionary War Tracks 138

Rolling Stone 139

San Diego Art Institute's Museum of the Living

Artist 393

Scholastic Library Publishing 232

Soho Myriad 394

Soundlight 337

Southside Gallery 394

State of the Art 395

Stevenson University Art Gallery 396

Stickman Review 147

Stock Foundry Images 315

Stock Transparency Services/STSimages 317

Sugar Daddy Photos 317

Synchronicity Fine Arts 396

Taube Museum of Art, Lillian & Coleman 396

Touchstone Gallery 398

UCR/California Museum of Photography 398

Up and Under 155

Upstream People Gallery 400

Urban Institute for Contemporary Arts 400

Viewfinders 320

Viridian Artists, Inc. 401

Visual Arts Center of Northwest Florida 401

Visual Arts Gallery 401

Washington County Museum of Fine Arts 402

Whiskey Island Magazine 158

Women & Their Work Art Space 403

Zakin Gallery, Mikhail 404

Zenith Gallery 404

Babies/Children/Teens

AAP News 171

Accent Alaska/Ken Graham Agency 255

Ace Stock Limited 256

Adirondack Lakes Center for the Arts 343

Advanced Graphics 239 Aflo Foto Agency 257

Age Fotostock 258 Alabama Living 69

Alaska 69

Alaska Stock Images 259 Allyn & Bacon Publishers 212

amanaimages inc. 260

American Fitness 71

American Print Alliance 344

American School Health Association 212

AppaLight 262 Archaeology 161

Argus Photo, Ltd. (APL) 263

Art Directors & Trip Photo Library 264

Asia Images Group 266 Aurora Photos 266 Avanti Press Inc. 240

Balzekas Museum of Lithuanian Culture Art

Gallery 349 Baseball 76

Blend Images 269
Blue Ridge Country 78
Boeberitz Design, Bob 323
Borealis Press, The 241
Bridal Guides Magazine 79

Bynums Marketing and Communications, Inc.

325

Canada Lutheran 81

Capitol Complex Exhibitions 353 Catholic News Service 272

Center for Fine Art Photography, The 354

Chess Life for Kids 85 Childhood Education 181 Children's Defense Fund 162

Chirp Magazine 85
City Limits 86
Civitan Magazine 181
Cleary Gallery, John 357
Cleveland Magazine 87

Cobblestone 87

Comesana Agencia de Prensa/Banco

Fotográfico, Eduardo 273

Concord Litho 242

Crabtree Publishing Company 216

Creative Stock Images 274

Current, Inc. 243

Dance 93

DDB Stock Photography, LLC 274

Design Conceptions (Joel Gordon

Photography) 275

Dinodia Photo Library 275

DK Stock, Inc. 276 Dodo Graphics Inc. 243

DW Stock Picture Library (DWSPL) 277 Edelstein Studio and Gallery, Paul 361

ESL Teacher Today 185 Farcountry Press 220 Fellowship 98

Flint Communications 327

Focus New Zealand Photo Library Ltd. 282

Foto-Press Timmermann 283

Fotoscopio 283 Freefall Review 100 Gallery West 367 Ghost Town 102

Girls Life Magazine/GirlsLife.com 102

Gospel Herald 103 Grafica 328

Grand Rapids Family Magazine 103

Gryphon House 221

Hampton Design Group 329

Herald Press 222

Home Education Magazine 108

Howard, Merrell and Partners, Inc. 329

Human Kinetics Publishers 222 Hutchison Picture Library 285

Ideals Magazine 109 Illogical Muse 110 Image Finders, The 286

Images.de Digital Photo GmbH 287

Immigrant Ancestors 110

Inmagine RF & RM Image Submissions (IRIS) 288

Inner Traditions/Bear & Company 223

Insight Magazine 111

Intercontinental Greetings LTD. 244
International Visions Gallery 372

Isopix 289 Jeroboam 291 Jillson & Robert

Jillson & Roberts 245 Jones Gallery, Stella 373

Journal of Adventist Education 190 Juvenile Diabetes Research Foundation

International 113 Kashrus Magazine 114

Kashrus Magazine 114 Key Curriculum Press 224 Kiwanis Magazine 114

Kramer and Associates, Inc., Joan 292

Leepa-Rattner Museum of Art 374

Lerner Publishing Group, Inc. 224

Lightwave 292

Lucent Books 225

Luckypix 294

Lutheran, The 118

Manitoba Teacher, The 191

Markeim Art Center 378

Masur Museum of Art 379

MAXX Images, Inc. 294

Medical On Line Ltd. 295

Megapress Images 295

Mesa Contemporary Arts at Mesa Arts Center

379

Michael Murphy Gallery M 380

Multiple Exposures Gallery 381

Museo ItaloAmericano 382

Museum of Contemporary Photography, Columbia College Chicago 383

Na'amat Woman 122

National Black Child Development Institute

333

Native Peoples Magazine 123

Northwestern University Dittmar Memorial

Gallery 385

Nova Media Inc. 246

Novastock 297

NOVUS 333

Okapia K.G. 298

Omni-Photo Communications 298

OnAsia 299

ONE 128

OnRequest Images 299

Opcao Brasil Imagens 300

Outside Imagery 300

Owen Publishers, Inc., Richard C. 229

OWL Magazine 130

Pacific Stock/Printscapes.com 301

Painet Inc. 302

Pakn Treger 131

Paper Products Design 246

Pediatric Annals 194

Photo Agora 304

PhotoEdit 304

Photo Network 306

Photo Researchers, Inc. 306

PhotoSource International 307

Portfolio Graphics, Inc. 247

Posey School 334

Ralls Collection Inc., The 392

Ranger Rick 137

Reading Today 200

Recycled Paper Greetings, Inc. 247

Revolutionary War Tracks 138

Rigby Education 231

Saks Associates, Arnold 336

San Diego Art Institute's Museum of the Living

Artist 393

Sandlapper Magazine 141

Santoro Graphics Ltd. 248

Scholastic Library Publishing 232

Scholastic Magazines 142

School Administrator, The 203

School Guide Publications 233

School Transportation News 203

Smithville Fiddlers' Jamboree and Craft

Festival 439

Soundlight 337

SouthComm Publishing Company, Inc. 145

Spencer Gifts, LLC 248

Stock Foundry Images 315

Stock Transparency Services/STSimages 317

Strang Communications Company 233

Streetpeople's Weekly News 166

Sugar Daddy Photos 317

Sun. The 147

Taube Museum of Art, Lillian & Coleman 396

Teldon 248

Throckmorton Fine Art 397

Tricycle Press 234

Tyndale House Publishers 234

Unicorn Stock Photos 319

Upstream People Gallery 400

Viewfinders 320

Visitor's Choice Magazine 234

Visual Arts Center of Northwest Florida 401

Washington County Museum of Fine Arts 402

Whiskey Island Magazine 158

Women's Health Group 237

Youth Runner Magazine 159

Zakin Gallery, Mikhail 404

Zolan Company, LLC, The 250

Business Concepts

ABA Banking Journal 171

Accent Alaska/Ken Graham Agency 255

Ace Stock Limited 256 Aflo Foto Agency 257 Age Fotostock 258

Allyn & Bacon Publishers 212

amanaimages inc. 260

American Bar Association Journal 172

American Print Alliance 344 Andes Press Agency 261

AppaLight 262

Art Directors & Trip Photo Library 264 Artwerks Stock Photography 265 Asian Enterprise Magazine 175 Automotive Cooling Journal 176

Automotive News 176

Avionics Magazine 177

Balzekas Museum of Lithuanian Culture Art

Gallery 349

Bedford/St. Martin's 213 Beverage Dynamics 178 BizTimes Milwaukee 178

Blend Images 269

Boeberitz Design, Bob 323 Brainworks Design Group 324 Brewers Association 214 Business NH Magazine 179

Chef 180

Cleveland Magazine 87
College PreView Magazine 88
Comesana Agencia de Prensa/Banco
Fotográfico, Eduardo 273

Complete Woman 89 Concord Litho 242

Convenience Store Decisions 182

Creative Stock Images 274

Dairy Today 183

DDB Stock Photography, LLC 274

Dinodia Photo Library 275 DK Stock, Inc. 276

Dodo Graphics Inc. 243

Entrepreneur 96 eStock Photo, LLC 279 Ewing Galloway Inc. 279

First Light Associated Photographers 281

Flint Communications 327

Focus New Zealand Photo Library Ltd. 282

Fortune 99

Foto-Press Timmermann 283

Fotoscopio 283

Fundamental Photographs 284

Geosynthetics 187 Grafica 328

Grand Rapids Business Journal 164

Hampton Design Group 329

IEEE Spectrum 189
Image Finders, The 286

Images.de Digital Photo GmbH 287

Image Works, The 287

Inmagine RF & RM Image Submissions (IRIS)

288 Isopix 289

Jude Studios 330

Kiwanis Magazine 114

KNOWAtlanta 115

Kramer and Associates, Inc., Joan 292 Leepa-Rattner Museum of Art 374

Lineair Fotoarchief, B.V. 293 Lohre & Associates Inc. 332

Luckypix 294

Marketing & Technology Group 192

MAXX Images, Inc. 294 McGraw-Hill 226

Meetings & Incentive Travel 192

Megapress Images 295

Michael Murphy Gallery M 380

Monderer Design 332

Mullin/Ashley Associate 332

Novastock 297 NOVUS 333 OnAsia 299

OnRequest Images 299

Pacific Stock/Printscapes.com 301

Painet Inc. 302

Panoramic Images 303

Photolife Corporation Ltd. 305

Photo Network 306

PhotoSource International 307 Plastics Technology 197

Portfolio Graphics, Inc. 247

Purestock 309 OSR 199

Registered Rep 201

Restaurant Hospitality 202

Rotarian, The 139

RTOHO 203

Saks Associates, Arnold 336 Sandlapper Magazine 141

Scholastic Library Publishing 232

Scrap 204

SouthComm Publishing Company, Inc. 145 Still Media 314 Stock Connection, Inc. 314 Stock Foundry Images 315 Stock Transparency Services/STSimages 317

Sugar Daddy Photos 317 Superstock Inc. 318

Texas Realtor Magazine 206 Textile Rental Magazine 206 Vermont Magazine 156 Veterinary Economics 207

Warne Marketing & Communications 339 Washington County Museum of Fine Arts 402

Writer's Digest 158

Celebrities

Adirondack Lakes Center for the Arts 343

Advanced Graphics 239 Aflo Foto Agency 257 Age Fotostock 258

AIM 68

Allyn & Bacon Publishers 212 amanaimages inc. 260

American Fitness 71

American Print Alliance 344 American Turf Monthly 72

Aquarius 161 Archaeology 161 Arts Company, The 347 Art Without Walls, Inc. 348

Aurora Photos 266

Balzekas Museum of Lithuanian Culture Art Gallery 349

Baseball 76 Briarpatch 79

Bridal Guides Magazine 79 Camera Press Ltd. 270

Camerique Inc. International 271

Capital Pictures 271

Center for Fine Art Photography, The 354

Centric Corporation 242 Chess Life for Kids 85 Cleary Gallery, John 357 Cleveland Magazine 87

Comesana Agencia de Prensa/Banco Fotográfico, Eduardo 273

Complete Woman 89 Continental Newstime 90 Creative Company, The 217 Dance 93

Dinodia Photo Library 275

DK Stock, Inc. 276 Dodo Graphics Inc. 243 Down Beat Magazine 95

ECW Press 219

Edelstein Studio and Gallery, Paul 361

Fahey/Klein Gallery 363

Famous Pictures & Features Agency 280

Fotoscopio 283 Ft. Myers Magazine 100 Georgia Straight 101 Ghost Town 102

Flaunt Magazine 99

Girls Life Magazine/GirlsLife.com 102

Government Technology 187

Grafica 328

Grand Rapids Magazine 104 Haardt Gallery, Anton 368

Howard, Merrell and Partners, Inc. 329

Instinct Magazine 111

International Photo News 288

In The Wind 111 Isopix 289

Kentucky Monthly 114

Kramer and Associates, Inc., Joan 292 Leepa-Rattner Museum of Art 374 Leonardis Gallery, David 375 Lerner Publishing Group, Inc. 224

Lizardi/Harp Gallery 376

Lucent Books 225 Markeim Art Center 378 Marlboro Gallery 378 Masur Museum of Art 379 Mattei Photography, Michele 379

McGaw Graphics, Inc. 245

Megapress Images 295

Mesa Contemporary Arts at Mesa Arts Center

Metrosource Magazine 119 MGW Newsmagazine 119 Michael Murphy Gallery M 380 Mitchell Lane Publishers, Inc. 227

MPTV (a/k/a Motion Picture and Television

Photo Archive) 296 Museo ItaloAmericano 382

Museum of Contemporary Photography, Columbia College Chicago 383 Music & Arts Pictures at Lebrecht 297

Music Sales Group 228 My Foodservice News 192 Myriad Productions 333 Nails Magazine 193 Native Peoples Magazine 123 New York Times on the Web, The 165 Nova Media Inc. 246 Oxvgen 130 Painet Inc. 302 Persimmon Hill Magazine 132 PhotoSource International 307 Pitcher Photo Library, Sylvia 307 Pix International 308 Playboy 134 Portfolio Graphics, Inc. 247 Ralls Collection Inc., The 392 Rockford Review 138 Rolling Stone 139 Sandlapper Magazine 141 Scholastic Library Publishing 232 Seventeen Magazine 143 Soundlight 337 SouthComm Publishing Company, Inc. 145 SportsCar 146 Stock Foundry Images 315 Stock Transparency Services/STSimages 317 Streetpeople's Weekly News 166 Sugar Daddy Photos 317 Sun 166 Texas Monthly 149 Toronto Sun Publishing 167 TRACE Magazine 151 TV Guide 154 Ullstein Bild 319 Washington County Museum of Fine Arts 402 Weigl Educational Publishers Limited 236

Christian

Woodshop News 209

American School Health Association 212 Human Kinetics Publishers 222 Women's Health Group 237

Cities/Urban

911 Pictures 255 Accent Alaska/Ken Graham Agency 255 Aflo Foto Agency 257 Age Fotostock 258 **AIM 68** AKM Images, Inc. 258 Alaska Stock Images 259 amanaimages inc. 260 American Fitness 71 American Print Alliance 344 Andes Press Agency 261 Animal Trails 73 AppaLight 262 Archaeology 161 Archivo Criollo 263 Arsenal Gallery, The 345 Art Directors & Trip Photo Library 264 Art@Net International Gallery 346 Arts Company, The 347 Arts Iowa City 347 Art Source L.A., Inc. 348 Art Without Walls, Inc. 348 Asian Enterprise Magazine 175 Atlantic Gallery 349 Aurora Photos 266 Balzekas Museum of Lithuanian Culture Art Gallery 349 Bedford/St. Martin's 213 Belian Art Center 350 Benham Studio Gallery 350 Bennett Galleries and Company 351 Bentley Publishing Group 240 BizTimes Milwaukee 178 Boeberitz Design, Bob 323 Bon Artique.com/Art Resources Int., Ltd. 241 Bridal Guides Magazine 79 Bynums Marketing and Communications, Inc. 325 Capitol Complex Exhibitions 353 Center for Fine Art Photography, The 354 Chatham Press 215 City Limits 86 Clampart 356 Cleary Gallery, John 357 Cobblestone 87 Continental Newstime 90 Creative Company, The 217 Creative Stock Images 274 Dance 93

DDB Stock Photography, LLC 274

Dinodia Photo Library 275

Dodo Graphics Inc. 243

ESL Teacher Today 185

Farcountry Press 220 Flaunt Magazine 99

Focus New Zealand Photo Library Ltd. 282

Foto-Press Timmermann 283

Fotoscopio 283 France Magazine 100 Freefall Review 100 Freeport Arts Center 364 Gallery Luisotti 366

Gallery North 366 Gallery West 367 Ghost Town 102 Grafica 328

Hadassah Magazine 105

Hemphill 369

Henry Street Settlement/Abrons Art Center

Horizons Magazine 108 Hutchison Picture Library 285

Illogical Muse 110

Immigrant Ancestors 110 Instinct Magazine 111 ITE Journal 189

James Harris Gallery 368

Jeroboam 291

Jones Gallery, Stella 373 Key Curriculum Press 224

KNOWAtlanta 115

Kramer and Associates, Inc., Joan 292

Landscape Architecture 191

Latitude Stock 292

Leepa-Rattner Museum of Art 374

Leopold Gallery 375

Lerner Publishing Group, Inc. 224

Lineair Fotoarchief, B.V. 293

Luckypix 294 Lutheran, The 118 Markeim Art Center 378

Mattei Photography, Michele 379 Meetings & Incentive Travel 192

Mesa Contemporary Arts at Mesa Arts Center 379

Michael Murphy Gallery M 380

Modernart Editions 245 Monderer Design 332 Motoring & Leisure 121

Multiple Exposures Gallery 381 Museo ItaloAmericano 382

Museum of Contemporary Photography, Columbia College Chicago 383

Museum of Printing History 383

My Foodservice News 192

New York Times on the Web, The 165 Northwestern University Dittmar Memorial

Gallery 385 NOVUS 333 Now & Then 127

O.K. Harris Works of Art 386

Omni-Photo Communications 298

OnAsia 299

Opening Night Gallery 387

Owen Publishers, Inc., Richard C. 229

Painet Inc. 302

Panoramic Images 303 Photo Agora 304 Photo Network 306

PhotoSource International 307

PI Creative Art 247 Planning 196

Portfolio Graphics, Inc. 247

Positive Images (Stock Photography & Gallery 61) 309

Pucker Gallery 391

Ralls Collection Inc., The 392 Recommend Magazine 200 Relay Magazine 202 Remodeling 202

Revolutionary War Tracks 138

Rigby Education 231

Running Press Book Publishers 232

San Diego Art Institute's Museum of the Living Artist 393

Sandlapper Magazine 141

Scholastic Library Publishing 232 South Carolina Film Commission 337 SouthComm Publishing Company, Inc. 145

Southside Gallery 394 State Street Gallery 395 Stock Foundry Images 315

Stock Transparency Services/STSimages 317

Streetpeople's Weekly News 166

Sugar Daddy Photos 317

Sun, The 147

Synchronicity Fine Arts 396

Teldon 248

Throckmorton Fine Art 397 Touchstone Gallery 398

Tropix Photo Library 318
Tyndale House Publishers 234
Ullstein Bild 319

Ulistelli bild 519

Unicorn Stock Photos 319

Up and Under 155 Viewfinders 320

Voyageur Press 235

Washington County Museum of Fine Arts 402

Waveland Press, Inc. 235

Weigl Educational Publishers Limited 236

Whiskey Island Magazine 158 Zakin Gallery, Mikhail 404

Couples

Accent Alaska/Ken Graham Agency 255

Ace Stock Limited 256

Adirondack Lakes Center for the Arts 343

Advanced Graphics 239
Aflo Foto Agency 257
Age Estaglary 259

Age Fotostock 258

Alaska 69

Alaska Stock Images 259 Allyn & Bacon Publishers 212

amanaimages inc. 260 American Fitness 71

American Print Alliance 344

AOPA Pilot 174 AppaLight 262 Archaeology 161

Argus Photo, Ltd. (APL) 263

Art Directors & Trip Photo Library 264

Asia Images Group 266 Aurora Photos 266 Avanti Press Inc. 240

Balzekas Museum of Lithuanian Culture Art

Gallery 349
Baseball 76
Blend Images 269
Blue Ridge Country 78
Boeberitz Design, Bob 323
Borealis Press, The 241

Brainworks Design Group 324

Bridal Guides Magazine 79

Business NH Magazine 179

Bynums Marketing and Communications, Inc. 325

Canada Lutheran 81

Capitol Complex Exhibitions 353

Caribbean Travel & Life 82

Center for Fine Art Photography, The 354

Clampart 356

Cleary Gallery, John 357 Cleveland Magazine 87

Comesana Agencia de Prensa/Banco

Fotográfico, Eduardo 273

Complete Woman 89

Creative Stock Images 274

Dance 93

DDB Stock Photography, LLC 274

Design Conceptions (Joel Gordon

Photography) 275

Dinodia Photo Library 275

DK Stock, Inc. 276 Dodo Graphics Inc. 243 Family Motor Coaching 98 Farcountry Press 220

Flint Communications 327

Focus New Zealand Photo Library Ltd. 282

Fort Ross Inc. 220

Foto-Press Timmermann 283

Fotoscopio 283 Freefall Review 100 Ghost Town 102 Grafica 328 Herald Press 222

Highways 107

Howard, Merrell and Partners, Inc. 329

Hutchison Picture Library 285

Illogical Muse 110 Image Finders, The 286

Images.de Digital Photo GmbH 287

Inmagine RF & RM Image Submissions (IRIS)

288

Instinct Magazine 111 In The Wind 111

Isopix 289

Jeroboam 291

Key Curriculum Press 224

Kramer and Associates, Inc., Joan 292 Leepa-Rattner Museum of Art 374

Lizardi/Harp Gallery 376

Lutheran, The 118

Markeim Art Center 378

MAXX Images, Inc. 294 Megapress Images 295

Mesa Contemporary Arts at Mesa Arts Center

379

MGW Newsmagazine 119

Michael Murphy Gallery M 380

Motoring & Leisure 121

Mountain Living 121

Multiple Exposures Gallery 381

Museo ItaloAmericano 382

Museum of Contemporary Photography, Columbia College Chicago 383

Native Peoples Magazine 123

Northwestern University Dittmar Memorial

Gallery 385 Novastock 297

NOVUS 333

Okapia K.G. 298

Omni-Photo Communications 298

Opcao Brasil Imagens 300

Outside Imagery 300

Pacific Stock/Printscapes.com 301

Painet Inc. 302 Pakn Treger 131

Persimmon Hill Magazine 132

Photo Agora 304 PhotoEdit 304

Photo Network 306

Photo Researchers, Inc. 306 PhotoSource International 307 Portfolio Graphics, Inc. 247 Saks Associates, Arnold 336

San Diego Art Institute's Museum of the Living

Artist 393 Sandlapper Magazine 141

Santoro Graphics Ltd. 248 Scholastic Library Publishing 232

Soundlight 337

SouthComm Publishing Company, Inc. 145

Spencer Gifts, LLC 248 Stock Foundry Images 315

Stock Transparency Services/STSimages 317

Streetpeople's Weekly News 166

Sugar Daddy Photos 317

Sun, The 147

Taube Museum of Art, Lillian & Coleman 396

Teldon 248

Tyndale House Publishers 234

Ullstein Bild 319

Unicorn Stock Photos 319 Upstream People Gallery 400

Viewfinders 320

Visitor's Choice Magazine 234

Washington County Museum of Fine Arts 402

Women's Health Group 237

Cultures/Communities various

Annual Spring Photography Contest 449 Prague Summer Seminars 486 Pyrenees Exposures 486

Disasters

911 Pictures 255

Accent Alaska/Ken Graham Agency 255 Adirondack Lakes Center for the Arts 343

Aflo Foto Agency 257

Age Fotostock 258

Allyn & Bacon Publishers 212

amanaimages inc. 260

American Print Alliance 344

Andes Press Agency 261

Animals Animals/Earth Scenes 261

AppaLight 262 Archaeology 161

Art Directors & Trip Photo Library 264

Artwerks Stock Photography 265

Art Without Walls, Inc. 348

Aurora Photos 266

Balzekas Museum of Lithuanian Culture Art

Gallery 349

Biological Photo Service and Terraphotographics 268

California Views/Mr. Pat Hathaway Historical

Photo Collection 270

Civitan Magazine 181

Clampart 356

Comesana Agencia de Prensa/Banco

Fotográfico, Eduardo 273

Contemporary Arts Center (Cincinnati), The 358

Continental Newstime 90

Creative Company, The 217

Creative Stock Images 274

Dinodia Photo Library 275

Dodo Graphics Inc. 243

ESL Teacher Today 185

Fellowship 98

Fire Chief 185

Fire Engineering 186

FireRescue Magazine 186

Fotoscopio 283

Fundamental Photographs 284

Gallery 110 Collective 365

Geoslides & Geo Aerial Photography 284

Ghost Town 102

Government Technology 187

Grafica 328

Hera Educational Foundation and Art Gallery

369

Hutchison Picture Library 285

Illogical Muse 110

Immigrant Ancestors 110

Isopix 289

Jeroboam 291

Kramer and Associates, Inc., Joan 292

Leepa-Rattner Museum of Art 374

Lerner Publishing Group, Inc. 224

Lineair Fotoarchief, B.V. 293

Lucent Books 225

Lutheran, The 118

Medical On Line Ltd. 295

Megapress Images 295

Mesa Contemporary Arts at Mesa Arts Center 379

Michael Murphy Gallery M 380

New York Times on the Web, The 165

Northwestern University Dittmar Memorial

Gallery 385

Novastock 297

Now & Then 127

OnAsia 299

Oxford Scientific (OSF) 301

Painet Inc. 302

Photo Agora 304

Photo Network 306

PhotoSource International 307

Portfolio Graphics, Inc. 247

Relay Magazine 202

Revolutionary War Tracks 138

San Diego Art Institute's Museum of the Living

Artist 393

Scholastic Library Publishing 232

Stock Foundry Images 315

Stock Transparency Services/STSimages 317

Sugar Daddy Photos 317

Taube Museum of Art, Lillian & Coleman 396

Toronto Sun Publishing 167

Ullstein Bild 319

Unicorn Stock Photos 319

Upstream People Gallery 400

Washington County Museum of Fine Arts 402

Waveland Press, Inc. 235

Weigl Educational Publishers Limited 236 Whiskey Island Magazine 158

Documentary

911 Pictures 255

AAP News 171

Ace Stock Limited 256

Adirondack Lakes Center for the Arts 343

Aflo Foto Agency 257

Age Fotostock 258

AIM 68

Akron Art Museum 343

Alaska Stock Images 259

Albuquerque Museum of Art & History, The

344

amanaimages inc. 260

American Power Boat Association 173

American Print Alliance 344

Animal Trails 73

AOPA Pilot 174

AppaLight 262

A.R.C. Gallery 345

Archaeology 161

Archivo Criollo 263

Arsenal Gallery, The 345

Art Directors & Trip Photo Library 264

Arts Company, The 347

Arts on Douglas 347

Artwerks Stock Photography 265

Art Without Walls, Inc. 348

Axis Gallery 349

Balzekas Museum of Lithuanian Culture Art

Gallery 349

Baseball 76

Bedford/St. Martin's 213

Benham Studio Gallery 350

BizTimes Milwaukee 178

Borealis Press, The 241

Brainworks Design Group 324

Briarpatch 79

Bridal Guides Magazine 79

Business of Art Center 353

California Views/Mr. Pat Hathaway Historical

Photo Collection 270

Camera Press Ltd. 270

Center for Fine Art Photography, The 354

Chatham Press 215

Chess Life 84

Chirp Magazine 85

City Limits 86 Clampart 356

Clarion-Ledger, The 163 Cleary Gallery, John 357 Cleveland Magazine 87

Comesana Agencia de Prensa/Banco Fotográfico, Eduardo 273

Contemporary Arts Collective 358

Continental Newstime 90 Creative Editions 217 Creative Stock Images 274

Dance 93

Design Conceptions (Joel Gordon

Photography) 275 Detroit Focus 360

Dinodia Photo Library 275

Dodo Graphics Inc. 243

Dorsky Museum of Art, Samuel 360

E & E Picture Library 277 ESL Teacher Today 185

Event 97

Everson Museum of Art 363 Fahey/Klein Gallery 363

Fire Chief 185
Fire Engineering 186
FireRescue Magazine 186
Flint Communications 327

Fotoscopio 283

Ft. Myers Magazine 100
Gallery 110 Collective 365
Callery Luisetti 366

Gallery Luisotti 366 Gallery West 367

Geoslides & Geo Aerial Photography 284

Ghost Town 102 Golf Tips 103 Grafica 328

Grand Rapids Magazine 104 Harper's Magazine 106 Havu Gallery, William 368

Henry Street Settlement/Abrons Art Center

369

Houk Gallery, Edwynn 370 Hunger Mountain 109

Huntsville Museum of Art 370 Hutchison Picture Library 285

Icebox Quality Framing & Gallery 370

Image Works, The 287 Immigrant Ancestors 110 Indianapolis Art Center 371
Indianapolis Monthly 110

Individual Artists of Oklahoma 371

Isopix 289 Jeroboam 291 Jewish Action 112

Journal of Asian Martial Arts 113 Key Curriculum Press 224 Klein Gallery, Robert 374

Kramer and Associates, Inc., Joan 292 Land of the Bible Photo Archive 268 Leepa-Rattner Museum of Art 374

Leopold Gallery 375

Limited Editions & Collectibles 376

Limner Gallery 376
Lizardi/Harp Gallery 376
Lucent Books 225
Macalester Gallery 377
Markeim Art Center 378
Masur Museum of Art 379

Mesa Contemporary Arts at Mesa Arts Center

379

MGW Newsmagazine 119 Michael Murphy Gallery M 380

Monderer Design 332

Multiple Exposures Gallery 381 Museo ItaloAmericano 382

Museum of Contemporary Art San Diego 382 Museum of Contemporary Photography,

Columbia College Chicago 383

Museum of Printing History 383

Na'amat Woman 122 National Geographic 122

Newsweek 124

New York Times on the Web, The 165 Nexus/Foundation for Today's Art 384

NFPA Journal 194

Northwest Art Center 385 Nova Media Inc. 246

NOVUS 333

Now & Then 127 O.K. Harris Works of Art 386

OnAsia 299 ONE 128

Owen Publishers, Inc., Richard C. 229

OWL Magazine 130 Painet Inc. 302 Panoramic Images 303 Parkland Art Gallery 388 Persimmon Hill Magazine 132

Phoenix Gallery 389

Photomedia Center, The 390

PLANS, Ltd. (Photo Libraries and News

Services) 308

Polk Museum of Art 390

Ponkawonka Inc. 308

Portfolio Graphics, Inc. 247

Posey School 334

Progressive, The 137

Rafelman Fine Arts, Marcia 392

Ralls Collection Inc., The 392

Revolutionary War Tracks 138

Rhode Island Monthly 138

Rolling Stone 139

Russian Life Magazine 140

San Diego Art Institute's Museum of the Living

Artist 393

Schmidt/Dean Spruce 393

Scholastic Library Publishing 232

School Administrator, The 203

Smithsonian Magazine 145

SouthComm Publishing Company, Inc. 145

South Dakota Art Museum 394

Stack & Associates, Inc., Tom 313

Stevenson University Art Gallery 396

Stickman Review 147

Stock Foundry Images 315

Stock Transparency Services/STSimages 317

Streetpeople's Weekly News 166

Sugar Daddy Photos 317

Sun 166

Sun, The 147

Synchronicity Fine Arts 396

Tikkun 150

TIME 150

Touchstone Gallery 398

UCR/California Museum of Photography 398

Ullstein Bild 319

Up Here 155

Upstream People Gallery 400

Vermont Life 155

Viewfinders 320

Visual Arts Center of Northwest Florida 401

Washington County Museum of Fine Arts 402

Watertown Public Opinion 168

Western Producer, The 169

Whiskey Island Magazine 158

Woodshop News 209

Zakin Gallery, Mikhail 404

Education

Adirondack Lakes Center for the Arts 343

Aflo Foto Agency 257

Age Fotostock 258

AIM 68

Allyn & Bacon Publishers 212

amanaimages inc. 260

American Print Alliance 344

Andes Press Agency 261

AppaLight 262

Archaeology 161

Art Directors & Trip Photo Library 264

Art@Net International Gallery 346

Art Without Walls, Inc. 348

Asian Enterprise Magazine 175

Aurora Photos 266

Balzekas Museum of Lithuanian Culture Art

Gallery 349

Bedford/St. Martin's 213

Boeberitz Design, Bob 323

Brainworks Design Group 324

Bynums Marketing and Communications, Inc.

325

CEA Advisor 180

Childhood Education 181

Children's Defense Fund 162

Cleary Gallery, John 357

Cleveland Magazine 87

College PreView Magazine 88

Comesana Agencia de Prensa/Banco

Fotográfico, Eduardo 273

Creative Stock Images 274

DDB Stock Photography, LLC 274

Dinodia Photo Library 275

DK Stock, Inc. 276

Dodo Graphics Inc. 243

ESL Teacher Today 185

Ewing Galloway Inc. 279

Farcountry Press 220

Focus New Zealand Photo Library Ltd. 282

Ghost Town 102

Grafica 328

Grand Rapids Family Magazine 103

Gryphon House 221

HOLT McDougal 222

Home Education Magazine 108

Human Kinetics Publishers 222

Hutchison Picture Library 285

Image Works, The 287

Immigrant Ancestors 110

Inmagine RF & RM Image Submissions (IRIS)

288

Isopix 289

Jeroboam 291

Jones Gallery, Stella 373

Journal of Adventist Education 190

Jude Studios 330

Key Curriculum Press 224

Kiwanis Magazine 114

Kramer and Associates, Inc., Joan 292

Leepa-Rattner Museum of Art 374

Lerner Publishing Group, Inc. 224

Lineair Fotoarchief, B.V. 293

Lucent Books 225

Lutheran, The 118

Manitoba Teacher, The 191

Markeim Art Center 378

Michael Murphy Gallery M 380

Monderer Design 332

Museo ItaloAmericano 382

Museum of Contemporary Art San Diego 382

New Leaf Press, Inc. 228

Northwestern University Dittmar Memorial

Gallery 385

Nova Media Inc. 246

NOVUS 333

UnAsia 299

ONE 128

OnRequest Images 299

Owen Publishers, Inc., Richard C. 229

Painet Inc. 302

Pakn Treger 131

Phi Delta Kappan 133

Photo Agora 304

Photo Network 306

PhotoSource International 307

Portfolio Graphics, Inc. 247

Prakken Publications, Inc. 230

Princeton Alumni Weekly 136

Purestock 309

Reading Today 200

Revolutionary War Tracks 138

Rigby Education 231

San Diego Art Institute's Museum of the Living

Artist 393

Sandlapper Magazine 141

Scholastic Library Publishing 232

Scholastic Magazines 142

School Administrator, The 203

School Transportation News 203

SouthComm Publishing Company, Inc. 145

Stock Foundry Images 315

Stock Transparency Services/STSimages 317

Streetpeople's Weekly News 166

Sugar Daddy Photos 317

Sun, The 147

Synchronicity Fine Arts 396

Techniques 205

Tropix Photo Library 318

Ullstein Bild 319

Video I-D, Inc. 338

Viewfinders 320

Washington County Museum of Fine Arts 402

Waveland Press, Inc. 235

Wisconsin Union Galleries 402

Worcester Polytechnic Institute 340

Writer's Digest 158

Entertainment

Adirondack Lakes Center for the Arts 343

Aflo Foto Agency 257

After Five 68

Age Fotostock 258

AKM Images, Inc. 258

amanaimages inc. 260

American Fitness 71

American Print Alliance 344

Aquarius 161

Art Directors & Trip Photo Library 264

Arts Company, The 347

Art Without Walls, Inc. 348

Balzekas Museum of Lithuanian Culture Art

Gallery 349

Boeberitz Design, Bob 323

Boxoffice Magazine 179

Brainworks Design Group 324

Bridal Guides Magazine 79

Business NH Magazine 179

Camera Press Ltd. 270

Camera Fress Ltd. 270

Capitol Complex Exhibitions 353

Caribbean Travel & Life 82

Cleary Gallery, John 357

Cleveland Magazine 87

Comesana Agencia de Prensa/Banco

Fotográfico, Eduardo 273

Continental Newstime 90

Creative Company, The 217

Creative Stock Images 274

DDB Stock Photography, LLC 274

Dinodia Photo Library 275

DK Stock, Inc. 276

Dodo Graphics Inc. 243

Empics 278

Fahey/Klein Gallery 363

Famous Pictures & Features Agency 280

Flaunt Magazine 99

Foto-Press Timmermann 283

Fotoscopio 283

Ft. Myers Magazine 100

Gallery Luisotti 366

Georgia Straight 101

Girls Life Magazine/GirlsLife.com 102

Grafica 328

Hamilton Magazine 105

Horizons Magazine 108

Images.de Digital Photo GmbH 287

Instinct Magazine 111

International Photo News 288

Iowan Magazine, The 112

Kentucky Monthly 114

Kramer and Associates, Inc., Joan 292

Leepa-Rattner Museum of Art 374

Leopold Gallery 375

Limited Editions & Collectibles 376

Marlboro Gallery 378

Mesa Contemporary Arts at Mesa Arts Center

379

MGW Newsmagazine 119

Mitchell Lane Publishers, Inc. 227

Monderer Design 332

Museo ItaloAmericano 382

Myriad Productions 333

Native Peoples Magazine 123

New York Times on the Web, The 165

Nexus/Foundation for Today's Art 384

Northwestern University Dittmar Memorial

Gallery 385

Nova Media Inc. 246

NOVUS 333

Omni-Photo Communications 298

Painet Inc. 302

Persimmon Hill Magazine 132

PhotoSource International 307

Pitcher Photo Library, Sylvia 307

Pix International 308

Portfolio Graphics, Inc. 247

Ralls Collection Inc., The 392

RIG 248

Rolling Stone 139

San Diego Art Institute's Museum of the Living

Artist 393

Scholastic Library Publishing 232

Seattle Homes & Lifestyles 142

Seventeen Magazine 143

SouthComm Publishing Company, Inc. 145

Southside Gallery 394

Stock Foundry Images 315

Stock Transparency Services/STSimages 317

Sugar Daddy Photos 317

Tide-Mark Press 249

TV Guide 154

Tyndale House Publishers 234

Ullstein Bild 319

Viewfinders 320

Visitor's Choice Magazine 234

Washington Blade, The 168

Washington County Museum of Fine Arts 402

Environmental

Accent Alaska/Ken Graham Agency 255

Ace Stock Limited 256

Adirondack Lakes Center for the Arts 343

Aflo Foto Agency 257

Age Fotostock 258

AGStockUSA Inc. 258

Alabama Living 69

Alaska Stock Images 259

All About Kids Publishing 211

Alternatives Journal 70

amanaimages inc. 260

AMC Outdoors 70

American Forests Magazine 71

American Print Alliance 344

Andes Press Agency 261

Animals Animals/Earth Scenes 261

Animal Trails 73

Anthro-Photo File 262

AppaLight 262

Aquarius 161

Archaeology 161

Archivo Criollo 263

Arizona Wildlife Views 74

Arsenal Gallery, The 345

Art Directors & Trip Photo Library 264

Arts Company, The 347

Arts on Douglas 347

Art Source L.A., Inc. 348

Art Without Walls, Inc. 348

Asian Enterprise Magazine 175

Atlantic Gallery 349 Aurora Photos 266

Auscape International 267

Balzekas Museum of Lithuanian Culture Art

Gallery 349

Baseball 76

Bear Deluxe Magazine, The 77

Beef Today 178

Benham Studio Gallery 350

Biological Photo Service and

Terraphotographics 268

Boeberitz Design, Bob 323

Brainworks Design Group 324

Briarpatch 79

Bridal Guides Magazine 79

Bristol Gift Co., Inc. 241

BSIP 270

Business of Art Center 353

Bynums Marketing and Communications, Inc.

325

Camera Obscura Gallery, The 353

Canoe & Kayak 82

Capstone Press 214

Carmichael-Lynch, Inc. 325

Center for Fine Art Photography, The 354

Centric Corporation 242

Chirp Magazine 85

Chronicle of Philanthropy, The 181

Civitan Magazine 181

Clampart 356

Cleveland Magazine 87

Comesana Agencia de Prensa/Banco

Fotográfico, Eduardo 273

Contemporary Arts Center (Cincinnati), The

358

Continental Newstime 90

Countryman Press, The 216

Creative Company, The 217

Creative Homeowner 217

Creative Stock Images 274

Dairy Today 183

Dance 93

DDB Stock Photography, LLC 274

Dinodia Photo Library 275

Dodo Graphics Inc. 243

Down The Shore Publishing Corp. 218

DRK Photo 276

Ecoscene 278

ESL Teacher Today 185

E/The Environmental Magazine 97

Everson Museum of Art 363

Fellowship 98

Focus New Zealand Photo Library Ltd. 282

Forest Landowner 186

Fotoscopio 283

Ft. Myers Magazine 100

Fundamental Photographs 284

Gallery North 366

Game & Fish Magazines 101

Geoslides & Geo Aerial Photography 284

Ghost Town 102

Government Technology 187

Grafica 328

Grit Magazine 104

Guideposts 104

Hampton Design Group 329

Harper's Magazine 106

Healing Lifestyles & Spas Magazine 106

Henry Street Settlement/Abrons Art Center

Hera Educational Foundation and Art Gallery

369

Herald Press 222

Hutchison Picture Library 285

Icebox Quality Framing & Gallery 370

Images.de Digital Photo GmbH 287

Image Works, The 287

Immigrant Ancestors 110

Inmagine RF & RM Image Submissions (IRIS)

288

Inner Traditions/Bear & Company 223

Iowan Magazine, The 112

Isopix 289

Jeroboam 291

Juvenile Diabetes Research Foundation

International 113

Kashrus Magazine 114

Key Curriculum Press 224

Kramer and Associates, Inc., Joan 292

Latitude Stock 292

Leepa-Rattner Museum of Art 374

Leopold Gallery 375 Lerner Publishing Group, Inc. 224

Lineair Fotoarchief, B.V. 293

Lucent Books 225

Markeim Art Center 378 Masur Museum of Art 379

Mattei Photography, Michele 379

McGaw Graphics, Inc. 245

Meetings & Incentive Travel 192

Megapress Images 295

Mesa Contemporary Arts at Mesa Arts Center

Michael Murphy Gallery M 380 Michigan Out-of-Doors 119

Milkweed Editions 227

Monderer Design 332

Museo ItaloAmericano 382

Museum of Contemporary Photography, Columbia College Chicago 383

National Geographic 122

National Parks Magazine 123

New York Times on the Web, The 165

Nexus/Foundation for Today's Art 384

Northern Woodlands 125

Northwestern University Dittmar Memorial

Gallery 385

Novastock 297 NOVUS 333

Now & Then 127

Omni-Photo Communications 298

OnAsia 299

Onboard Media 128

OnRequest Images 299

Outdoor America 129

Outside Imagery 300

Owen Publishers, Inc., Richard C. 229

OWL Magazine 130

Oxford Scientific (OSF) 301

Pacific Stock/Printscapes.com 301

Painet Inc. 302

Panoramic Images 303

Photo Agora 304

Photo Network 306

PhotoSource International 307

Planet 134

Planning 196

Portfolio Graphics, Inc. 247

Positive Images (Stock Photography & Gallery

61) 309

Progressive, The 137

Pucker Gallery 391

Quarto Publishing Plc. 231

Rafelman Fine Arts, Marcia 392

Ranger Rick 137

Revolutionary War Tracks 138

Rigby Education 231

Salt Water Sportsman 141

San Diego Art Institute's Museum of the Living Artist 393

Sandlapper Magazine 141

Scholastic Library Publishing 232

Scrap 204

SouthComm Publishing Company, Inc. 145

Stack & Associates, Inc., Tom 313

State Street Gallery 395

Still Media 314

Stock Foundry Images 315

Stock Transparency Services/STSimages 317

Sugar Daddy Photos 317

Sun, The 147

Synchronicity Fine Arts 396

Tide Magazine 149

Times of the Islands 150

Toward Freedom 151

Trails Media Group 250

Tree Care Industry 207

Tropix Photo Library 318

Ullstein Bild 319

Up Here 155

Upstream People Gallery 400

Vermont Life 155

Viewfinders 320

Voyageur Press 235

Washington County Museum of Fine Arts 402

Washington Trails 156

Water Well Journal 207

Waveland Press, Inc. 235

Weigl Educational Publishers Limited 236

Western Producer, The 169

Whiskey Island Magazine 158

Erotic

Aflo Foto Agency 257

Age Fotostock 258

amanaimages inc. 260

American Print Alliance 344

Art@Net International Gallery 346

Axis Gallery 349

Balzekas Museum of Lithuanian Culture Art Gallery 349

Center for Fine Art Photography, The 354

Chapman Friedman Gallery 356

Clampart 356

Cleis Press 215

Comstock Cards 242

Creative Stock Images 274

Detroit Focus 360

Dinodia Photo Library 275 Dodo Graphics Inc. 243

Fahey/Klein Gallery 363

Foto-Press Timmermann 283

Gallery Luisotti 366

Grafica 328

Haddad Gallery, Carrie 368

Icebox Quality Framing & Gallery 370

Illogical Muse 110

In The Wind 111

Klein Gallery, Robert 374

Kramer and Associates, Inc., Joan 292

Leepa-Rattner Museum of Art 374

Limited Editions & Collectibles 376

Limner Gallery 376

Lizardi/Harp Gallery 376

Metrosource Magazine 119

Michael Murphy Gallery M 380

Northwestern University Dittmar Memorial

Gallery 385

Nova Media Inc. 246

Painet Inc. 302

Playboy 134

Portfolio Graphics, Inc. 247

Roggen Advertising and Public Relations, Ted 335

San Diego Art Institute's Museum of the Living Artist 393

Scholastic Library Publishing 232

Soundlight 337

Stickman Review 147

Stock Foundry Images 315

Sugar Daddy Photos 317

Throckmorton Fine Art 397

TM Enterprises 465

Touchstone Gallery 398

Events

Accent Alaska/Ken Graham Agency 255

Adirondack Lakes Center for the Arts 343

Aflo Foto Agency 257

After Five 68

Age Fotostock 258

amanaimages inc. 260

American Fitness 71

American Power Boat Association 173

American Print Alliance 344

American Turf Monthly 72

AppaLight 262

Appaloosa Journal 174

Aquarius 161

Archaeology 161

Art Directors & Trip Photo Library 264

Artwerks Stock Photography 265

Art Without Walls, Inc. 348

Athletic Management 176

Aurora Photos 266

Balzekas Museum of Lithuanian Culture Art

Gallery 349

BedTimes 177

Belian Art Center 350

Boeberitz Design, Bob 323

Borealis Press, The 241

Bridal Guides Magazine 79

Rynums Marketing and Communications, Inc.

325

Camera Press Ltd. 270

Canada Lutheran 81

Capper's 162

Capstone Press 214

Caribbean Travel & Life 82

Catholic News Service 272

Chess Life 84

Chess Life for Kids 85

Chirp Magazine 85

Chronicle of the Horse, The 85

City Limits 86

Cleary Gallery, John 357

Cleveland Magazine 87

Comesana Agencia de Prensa/Banco

Fotográfico, Eduardo 273

Contemporary Bride Magazine 90

Continental Newstime 90

Crabtree Publishing Company 216

Creative Stock Images 274

Cycle California! Magazine 92

DDB Stock Photography, LLC 274

Design Conceptions (Joel Gordon Photography) 275

Detroit Focus 360

Dinodia Photo Library 275

Dodo Graphics Inc. 243

ECW Press 219

E & E Picture Library 277

ESL Teacher Today 185

Famous Pictures & Features Agency 280

Flint Communications 327

Focus New Zealand Photo Library Ltd. 282

Freefall Review 100

Ft. Myers Magazine 100

Georgia Straight 101

Ghost Town 102

Grafica 328

Guernica Editions, Inc. 221

Horizons Magazine 108

Human Kinetics Publishers 222

Images.de Digital Photo GmbH 287

Immigrant Ancestors 110

Inmagine RF & RM Image Submissions (IRIS)

International Photo News 288

In The Wind 111

Iowan Magazine, The 112

Isopix 289

Jude Studios 330

Juvenile Diabetes Research Foundation

International 113

KNOWAtlanta 115

Kramer and Associates, Inc., Joan 292

Latitude Stock 292

Lawyers Weekly, The 164

Leepa-Rattner Museum of Art 374

Limited Editions & Collectibles 376

Lutheran, The 118

Marlboro Gallery 378

Meetings & Incentive Travel 192

Mesa Contemporary Arts at Mesa Arts Center

379

MGW Newsmagazine 119

Monderer Design 332

Motoring & Leisure 121

Multiple Exposures Gallery 381

Museo ItaloAmericano 382

Native Peoples Magazine 123

New Mexico Magazine 124

New York Times on the Web, The 165

Northwestern University Dittmar Memorial

Gallery 385

NOVUS 333

O.K. Harris Works of Art 386

OWL Magazine 130

Painet Inc. 302

Persimmon Hill Magazine 132

Pet Product News 195

Portfolio Graphics, Inc. 247

Revolutionary War Tracks 138

Rhode Island Monthly 138

Rolling Stone 139

Sail Magazine 140

San Diego Art Institute's Museum of the Living

Artist 393

Sandlapper Magazine 141

Scholastic Library Publishing 232

Scholastic Magazines 142

Seattle Homes & Lifestyles 142

SouthComm Publishing Company, Inc. 145

Southside Gallery 394

SportsCar 146

Sportslight Photo 312

Still Media 314

Stock Foundry Images 315

Stock Transparency Services/STSimages 317

Streetpeople's Weekly News 166

Sugar Daddy Photos 317

Synchronicity Fine Arts 396

Tide-Mark Press 249

Ullstein Bild 319

Unicorn Stock Photos 319

Upstream People Gallery 400

Viewfinders 320

Visitor's Choice Magazine 234

Washington Blade, The 168

Washington County Museum of Fine Arts 402

Weigl Educational Publishers Limited 236

White Productions, Dana 339

Families

AAP News 171

Accent Alaska/Ken Graham Agency 255

Ace Stock Limited 256

Adirondack Lakes Center for the Arts 343

Advanced Graphics 239

Aflo Foto Agency 257

Age Fotostock 258

Alaska Stock Images 259

Allyn & Bacon Publishers 212

amanaimages inc. 260 American Fitness 71

American Print Alliance 344

AppaLight 262 Archaeology 161

Argus Photo, Ltd. (APL) 263

Art Directors & Trip Photo Library 264

Art Without Walls, Inc. 348 Asia Images Group 266 Atlantic Gallery 349 Aurora Photos 266

Balzekas Museum of Lithuanian Culture Art

Gallery 349 Baseball 76 BC Outdoors 76 Blend Images 269

Blue Ridge Country 78 Boeberitz Design, Bob 323

Borealis Press, The 241 Bridal Guides Magazine 79 Business NH Magazine 179

Bynums Marketing and Communications, Inc. 325

Canada Lutheran 81

Capitol Complex Exhibitions 353

Caribbean Travel & Life 82 Catholic News Service 272

Center for Fine Art Photography, The 354

Chess Life for Kids 85

Children's Defense Fund 162

City Limits 86

Civitan Magazine 181 Cleary Gallery, John 357 Cleveland Magazine 87

Comesana Agencia de Prensa/Banco Fotográfico, Eduardo 273

Concord Litho 242

Creative Stock Images 274

Dance 93

DDB Stock Photography, LLC 274 Design Conceptions (Joel Gordon

Photography) 275 Dinodia Photo Library 275

DK Stock, Inc. 276 Dodo Graphics Inc. 243

DW Stock Picture Library (DWSPL) 277

Edelstein Studio and Gallery, Paul 361

Elks Magazine, The 96

ESL Teacher Today 185 Family Motor Coaching 98

Farcountry Press 220

Focus New Zealand Photo Library Ltd. 282

Foto-Press Timmermann 283

Fotoscopio 283

Freeport Arts Center 364

Ghost Town 102 Gospel Herald 103 Grafica 328

Grand Rapids Family Magazine 103

Grand Rapids Magazine 104

Herald Press 222

Home Education Magazine 108

Howard, Merrell and Partners, Inc. 329

Human Kinetics Publishers 222 Hutchison Picture Library 285

Illogical Muse 110 Image Finders, The 286

Images.de Digital Photo GmbH 287

Image Works, The 287 Immigrant Ancestors 110

Inmagine RF & RM Image Submissions (IRIS) 288

Inner Traditions/Bear & Company 223

Isopix 289 Jeroboam 291

Jones Gallery, Stella 373

Jude Studios 330

Juvenile Diabetes Research Foundation

International 113 Key Curriculum Press 224 Kiwanis Magazine 114

Kramer and Associates, Inc., Joan 292 Leepa-Rattner Museum of Art 374 Lerner Publishing Group, Inc. 224 Liturgy Training Publications 225

Living Free 116

Luckypix 294 Lutheran, The 118

Markeim Art Center 378 MAXX Images, Inc. 294

Megapress Images 295

Mesa Contemporary Arts at Mesa Arts Center 379

Michael Murphy Gallery M 380

Motoring & Leisure 121

Museo ItaloAmericano 382

Museum of Contemporary Art San Diego 382

Museum of Contemporary Photography, Columbia College Chicago 383

Na'amat Woman 122

Native Peoples Magazine 123

Nexus/Foundation for Today's Art 384

Northwestern University Dittmar Memorial

Gallery 385

Nova Media Inc. 246

Novastock 297

NOVUS 333

Okapia K.G. 298

Omni-Photo Communications 298

OnAsia 299

ONE 128

OnRequest Images 299

Opcao Brasil Imagens 300

Outside Imagery 300

Owen Publishers, Inc., Richard C. 229

Pacific Stock/Printscapes.com 301

Painet Inc. 302

Pakn Treger 131

Pediatric Annals 194

Persimmon Hill Magazine 132

Photo Agora 304

PhotoEdit 304

Photo Network 306

PhotoSource International 307

Ponkawonka Inc. 308

Portfolio Graphics, Inc. 247

Reading Today 200

Revolutionary War Tracks 138

Rhode Island Monthly 138

Rigby Education 231

Saks Associates, Arnold 336

San Diego Art Institute's Museum of the Living

Artist 393

Sandlapper Magazine 141

Scholastic Library Publishing 232

Sea 142

SouthComm Publishing Company, Inc. 145

Stock Foundry Images 315

Stock Transparency Services/STSimages 317

Strang Communications Company 233

Streetpeople's Weekly News 166

Sugar Daddy Photos 317

Sun, The 147

Taube Museum of Art, Lillian & Coleman 396

Teldon 248

Tyndale House Publishers 234

Ullstein Bild 319

Unicorn Stock Photos 319

Upstream People Gallery 400

Viewfinders 320

Visitor's Choice Magazine 234

Visual Arts Center of Northwest Florida 401

Washington County Museum of Fine Arts 402

Washington Trails 156

Western Producer, The 169

Women's Health Group 237

Woodmen Living 157

Fashion/Glamour

Ace Stock Limited 256

Adirondack Lakes Center for the Arts 343

Aflo Foto Agency 257

Age Fotostock 258

amanaimages inc. 260

American Fitness 71

American Print Alliance 344

Animal Trails 73

Archaeology 161

Artefact/Robert Pardo Gallery 346

Art@Net International Gallery 346

Art Without Walls, Inc. 348

Balzekas Museum of Lithuanian Culture Art

Gallery 349

Boeberitz Design, Bob 323

Bridal Guides Magazine 79

Business of Art Center 353

Camera Press Ltd. 270

Capital Pictures 271

Chatham Press 215

Chronogram 86

Clampart 356

Clarion-Ledger, The 163

Cleary Gallery, John 357

Cleveland Magazine 87

Complete Woman 89

Contemporary Bride Magazine 90

Creative Stock Images 274

Dance 93

Detroit Focus 360

Dinodia Photo Library 275

Dodo Graphics Inc. 243

ESL Teacher Today 185

Fahey/Klein Gallery 363

Fort Ross Inc. 220

Ft. Myers Magazine 100 Gallery Luisotti 366 Ghost Town 102 Girls Life Magazine/GirlsLife.com 102 Golf Tips 103 Grafica 328 Grand Rapids Magazine 104 Hamilton Magazine 105 Image Finders, The 286 Immigrant Ancestors 110 Inmagine RF & RM Image Submissions (IRIS)

288 Instinct Magazine 111 International Photo News 288

Isopix 289

Klein Gallery, Robert 374

Kramer and Associates, Inc., Joan 292

Leepa-Rattner Museum of Art 374

Levin Group, The Bruce 462

Limited Editions & Collectibles 376

Metrosource Magazine 119 MGW Newsmagazine 119

Michael Murphy Gallery M 380 Museum of Contemporary Photography, Columbia College Chicago 383

Nailpro 192

New York Times on the Web, The 165 Northwestern University Dittmar Memorial Gallery 385

Nova Media Inc. 246

NOVUS 333 OnAsia 299 Painet Inc. 302

Paper Products Design 246

Photo Life 133 Playboy 134

Portfolio Graphics, Inc. 247 Quarto Publishing Plc. 231 Ralls Collection Inc., The 392 Revolutionary War Tracks 138

Roggen Advertising and Public Relations, Ted 335

Rolling Stone 139 Schmidt Design, Henry 336

Scholastic Library Publishing 232

Seventeen Magazine 143

Soundlight 337

SouthComm Publishing Company, Inc. 145

Spencer Gifts, LLC 248

Stock Foundry Images 315 Stock Transparency Services/STSimages 317 Sugar Daddy Photos 317 Toronto Sun Publishing 167 TRACE Magazine 151 Ullstein Bild 319 Visual Arts Center of Northwest Florida 401 Washington County Museum of Fine Arts 402

Fine Art

Bell Studio 350

Benham Studio Gallery 350

Adirondack Lakes Center for the Arts 343 Aflo Foto Agency 257 Age Futostock 258 Akron Art Museum 343 Alaska State Museum 344 Albuquerque Museum of Art & History, The Allyn & Bacon Publishers 212 amanaimages inc. 260 American Print Alliance 344 Ancient Art & Architecture Collection, Ltd., The 261 Animal Trails 73 Aperture 74 Archaeology 161 Archivo Criollo 263 Arsenal Gallery, The 345 Artefact/Robert Pardo Gallery 346 Art in Motion 239 Art in the Park Summer Festival 412 Artists' Cooperative Gallery 346 Art Licensing International Inc. 265 Art@Net International Gallery 346 Art Resource 265 Arts Company, The 347 Arts Iowa City 347 Arts on Douglas 347 Art Source L.A., Inc. 348 Artwerks Stock Photography 265 Art Without Walls, Inc. 348 Atlantic Gallery 349 Axis Gallery 349 Balzekas Museum of Lithuanian Culture Art Gallery 349 Barnett Advertising/Design, Augustus 323 Baseball 76 Bedford/St. Martin's 213

Bennett Galleries and Company 351 Bentley Publishing Group 240

Blackflash 78

Blount-Bridgers House/Hobson Pittman

Memorial Gallery 352 Blue Sky Publishing 240

Bon Artique.com/Art Resources Int., Ltd. 241

Book Beat Gallery 352 Brewers Association 214 Bridal Guides Magazine 79 Bridgeman Art Library, The 269

Business of Art Center 353

Bynums Marketing and Communications, Inc.

Camera Obscura Gallery, The 353 Capitol Complex Exhibitions 353

Center for Fine Art Photography, The 354

Center for Photographic Art 354

CEPA Gallery 355

Chait Galleries Downtown, The 355

Chapman Friedman Gallery 356

Chatham Press 215 Chronogram 86 Clampart 356

Cleary Gallery, John 357

Cobblestone 87

Comesana Agencia de Prensa/Banco

Fotográfico, Eduardo 273 Concord Litho 242

Contemporary Arts Center 357

Contemporary Arts Center (Cincinnati), The 358

Contemporary Arts Collective 358 Corcoran Fine Arts Limited, Inc. 358 Corporate Art Source/CAS Gallery 358

CraftWestport 418

Creative Stock Images 274

Current, Inc. 243

Dance 93

Dayton Art Institute, The 360

Demuth Museum 360

Design Conceptions (Joel Gordon

Photography) 275 Detroit Focus 360

Dinodia Photo Library 275

Dodo Graphics Inc. 243

Dorsky Museum of Art, Samuel 360

Eastman House, George 361

Edelstein Studio and Gallery, Paul 361

E & E Picture Library 277

eMediaLoft.org 361 ESL Teacher Today 185

Event 97

EventGallery 910Arts 363 Everson Museum of Art 363

Fahey/Klein Gallery 363

Fellowship 98

Foto-Press Timmermann 283

Fotoscopio 283 Freefall Review 100 Freeport Arts Center 364 Fresno Art Museum 364 Ft. Myers Magazine 100 Gallant Greetings Corp. 244

Gallery 110 Collective 365 Gallery 218 366 Gallery Luisotti 366 Gallery North 366 Gallery West 367 Ghost Town 102

Grafica 328

Grand Rapids Art Museum 367 Grand Rapids Magazine 104

Guideposts 104

Guilford Craft Expo 426 Hampton Design Group 329 Harper's Magazine 106 Havu Gallery, William 368

Hemphill 369

Henry Street Settlement/Abrons Art Center

Hera Educational Foundation and Art Gallery 369

Houk Gallery, Edwynn 370 Hunger Mountain 109

Huntsville Museum of Art 370

Icebox Quality Framing & Gallery 370 Illinois State Museum Chicago Gallery 371

Image Finders, The 286 Image Works, The 287 Immigrant Ancestors 110 Indianapolis Art Center 371

Individual Artists of Oklahoma 371 Inner Traditions/Bear & Company 223

Irish Picture Library, The 289

Isopix 289

Jackson Fine Art 372 James Harris Gallery 368 Journal of Asian Martial Arts 113

Judicature 190

Key Curriculum Press 224

Kiwanis Magazine 114

Kramer and Associates, Inc., Joan 292

LA Art Association/Gallery 825 374

Land of the Bible Photo Archive 268

Leepa-Rattner Museum of Art 374

Lehigh University Art Galleries 375

Leonardis Gallery, David 375

Leopold Gallery 375

Light Factory, The 376

Limner Gallery 376

Liturgy Training Publications 225

Lizardi/Harp Gallery 376

Lutheran, The 118

Macalester Gallery 377

Main Street Gallery, The 378

Markeim Art Center 378

Marlboro Gallery 378

Masur Museum of Art 379

McGaw Graphics, Inc. 245

Mesa Contemporary Arts at Mesa Arts Center 379

Michael Murphy Gallery M 380

Miller Gallery, Peter 380

Modernart Editions 245

Multiple Exposures Gallery 381

Museo De Arte De Ponce 382

Museo ItaloAmericano 382

Museum of Contemporary Art San Diego 382

Museum of Contemporary Photography, Columbia College Chicago 383

usia e Anta Diatanna at Labo

Music & Arts Pictures at Lebrecht 297

Na'amat Woman 122

Native Peoples Magazine 123

Nevada Museum of Art 384

New York Times on the Web, The 165

Nexus/Foundation for Today's Art 384

Northwest Art Center 385

Northwestern University Dittmar Memorial

Gallery 385

Nova Media Inc. 246

NOVUS 333

Now & Then 127

Noyes Museum of Art, The 386

Opalka Gallery 387

Painet Inc. 302

Palo Alto Art Center 387

Panoramic Images 303

Paper Products Design 246

Parkland Art Gallery 388

Persimmon Hill Magazine 132

Peters Valley Craft Center 388

Phoenix Gallery 389

Photographic Resource Center 389

Photography Art 389

Photo Life 133

Photomedia Center, The 390

PI Creative Art 247

Pierro Gallery of South Orange 390

Planet 134

PLANS, Ltd. (Photo Libraries and News

Services) 308

Polk Museum of Art 390

Popular Photography & Imaging 135

Portfolio Graphics, Inc. 247

Posey School 334

Positive Images (Stock Photography & Gallery

61) 309

Prairie Journal, The 136

Pucker Gallery 391

Pump House Center for the Arts 391

Ouarto Publishing Plc. 231

Rafelman Fine Arts, Marcia 392

Ralls Collection Inc., The 392

Recycled Paper Greetings, Inc. 247

Revolutionary War Tracks 138

Running Press Book Publishers 232

Russian Life Magazine 140

San Diego Art Institute's Museum of the Living

Artist 393

Santoro Graphics Ltd. 248

Schmidt Art Center, William & Florence 393

Schmidt/Dean Spruce 393

Scholastic Library Publishing 232

Scholastic Magazines 142

Seattle Homes & Lifestyles 142

Shots 144

Soho Myriad 394

Soundlight 337

South Dakota Art Museum 394

Southside Gallery 394

SRO Photo Gallery at Landmark Arts 395

State Museum of Pennsylvania, The 395

State of the Art 395

Stevenson University Art Gallery 396

Stickman Review 147

Stock Foundry Images 315 Stock Transparency Service

Stock Transparency Services/STSimages 317 Streetpeople's Weekly News 166

subTERRAIN Magazine 147

Sugar Daddy Photos 317

Sun, The 147

Synchronicity Fine Arts 396

Syracuse New Times 167

Taube Museum of Art, Lillian & Coleman 396

Throckmorton Fine Art 397

Tide-Mark Press 249

Touchstone Gallery 398

UCR/California Museum of Photography 398

University Art Gallery in the D.W. Williams Art

Center 399

Untitled [ArtSpace] 399

Up and Under 155

Upstream Gallery 400

Upstream People Gallery 400

Urban Institute for Contemporary Arts 400

Viridian Artists, Inc. 401

Visual Arts Center of Northwest Florida 401

Visual Arts Gallery 401

Voyageur Press 235

Washington County Museum of Fine Arts 402

Waveland Press, Inc. 235

Weinstein Gallery 402

Whiskey Island Magazine 158

Wisconsin Union Galleries 402

Women & Their Work Art Space 403

World Fine Art Gallery 403

Zakin Gallery, Mikhail 404

Zenith Gallery 404

Food/Drink

Ace Stock Limited 256

Adirondack Lakes Center for the Arts 343

Aflo Foto Agency 257

Age Fotostock 258

amanaimages inc. 260

American Fitness 71

American Print Alliance 344

American Society of Artists, Inc. 344

Archaeology 161

Art Directors & Trip Photo Library 264

Art Source L.A., Inc. 348

Artwerks Stock Photography 265

Art Without Walls, Inc. 348

Atlanta Homes & Lifestyles 75

Balzekas Museum of Lithuanian Culture Art Gallery 349

Barnett Advertising/Design, Augustus 323

Bartender Magazine 177

Bentley Publishing Group 240

Berson, Dean, Stevens Inc. 323

Beverage Dynamics 178

Boeberitz Design, Bob 323

Brewers Association 214

Bridal Guides Magazine 79

BSIP 270

Business NH Magazine 179

Bynums Marketing and Communications, Inc.

325

Camera Press Ltd. 270

Caribbean Travel & Life 82

Chatham Press 215

Chef 180

Clarion-Ledger, The 163

Cleveland Magazine 87

Convenience Store Decisions 182

Creative Stock Images 274

DDB Stock Photography, LLC 274

Dinodia Photo Library 275

Dockery House Publishing, Inc. 218

Dodo Graphics Inc. 243

E & E Picture Library 277

El Restaurante Mexicano 185

Envision 278

ESL Teacher Today 185

Flint Communications 327

Foodpix 282

Ft. Myers Magazine 100

Gallery West 367

Ghost Town 102

Grafica 328

Hamilton Magazine 105

Healing Lifestyles & Spas Magazine 106

Human Kinetics Publishers 222

IGA Grocergram 189

Image Finders, The 286

Images.de Digital Photo GmbH 287

Immigrant Ancestors 110

Inmagine RF & RM Image Submissions (IRIS)

288

Isopix 289

Juvenile Diabetes Research Foundation

International 113

Kashrus Magazine 114

Kramer and Associates, Inc., Joan 292

Latitude Stock 292

Leepa-Rattner Museum of Art 374

Limited Editions & Collectibles 376

Marketing & Technology Group 192

Medical File Inc., The 295

Meetings & Incentive Travel 192

Megapress Images 295

Metrosource Magazine 119

MGW Newsmagazine 119.

Motoring & Leisure 121

Museo ItaloAmericano 382

My Foodservice News 192

New York Times on the Web, The 165

Northwestern University Dittmar Memorial

Gallery 385 NOVUS 333

Omni-Photo Communications 298

OnAsia 299

OnRequest Images 299

Pacific Stock/Printscapes.com 301

Painet Inc. 302

Paper Products Design 246

Photolife Corporation Ltd. 305

Photo Network 306

PhotoSource International 307

Playboy 134

Portfolio Graphics, Inc. 247

OSR 199

Quarto Publishing Plc. 231

Quick Frozen Foods International 199

Restaurant Hospitality 202

Revolutionary War Tracks 138

Rhode Island Monthly 138

Running Press Book Publishers 232

San Diego Art Institute's Museum of the Living

Artist 393

Sandlapper Magazine 141

Scholastic Library Publishing 232

Seattle Homes & Lifestyles 142

SouthComm Publishing Company, Inc. 145

StockFood GmbH (The Food Image Agency)

314

Stock Foundry Images 315

Stock Transparency Services/STSimages 317

Streetpeople's Weekly News 166

Sugar Daddy Photos 317

Tide-Mark Press 249

Travelworld International Magazine 153

Unicorn Stock Photos 319

Vermont Magazine 156

Washington County Museum of Fine Arts 402

Wine Enthusiast Magazine 158

Women's Health Group 237

Gardening

Adirondack Lakes Center for the Arts 343

Aflo Foto Agency 257

Age Fotostock 258

AKM Images, Inc. 258

Alabama Living 69

amanaimages inc. 260

American Gardener, The 72

American Print Alliance 344

Animal Trails 73

AppaLight 262

Archaeology 161

Argus Photo, Ltd. (APL) 263

Art Directors & Trip Photo Library 264

Art Source L.A., Inc. 348

Art Without Walls, Inc. 348

Atlanta Homes & Lifestyles 75

Balzekas Museum of Lithuanian Culture Art

Gallery 349

Bentley Publishing Group 240

Bird Watching Magazine 78

Bon Artique.com/Art Resources Int., Ltd. 241

Bridal Guides Magazine 79

Business of Art Center 353

Canadian Organic Grower, The 81

Capitol Complex Exhibitions 353

Carmichael-Lynch, Inc. 325

Chatham Press 215

Cleveland Magazine 87

Concord Litho 242

Contemporary Arts Center (Cincinnati), The

358

Countryman Press, The 216

Creative Company, The 217

Creative Homeowner 217

Creative Stock Images 274

Current, Inc. 243

Dance 93

Dinodia Photo Library 275

Dodo Graphics Inc. 243

DW Stock Picture Library (DWSPL) 277

Ecoscene 278

Farnam Companies, Inc. 326

Freefall Review 100

Freeport Arts Center 364

Ft. Myers Magazine 100

Gallant Greetings Corp. 244

Gallery West 367

Ghost Town 102

Grafica 328

Grit Magazine 104

Hearth and Home 188

Heilman Photography, Inc., Grant 285

Hutchison Picture Library 285

Ideals Magazine 109

Illogical Muse 110

Image Finders, The 286

Jeroboam 291

Kramer and Associates, Inc., Joan 292

Landscape Architecture 191

Latitude Stock 292

Layla Productions, Inc. 224

Leepa-Rattner Museum of Art 374

Medical File Inc., The 295

Megapress Images 295

Michael Murphy Gallery M 380

Modernart Editions 245

Motoring & Leisure 121

Mountain Living 121

New York Times on the Web, The 165

Northwestern University Dittmar Memorial

Gallery 385

NOVUS 333

Okapia K.G. 298

Oxford Scientific (OSF) 301

Painet Inc. 302

Panoramic Images 303

Paper Products Design 246

Photo Agora 304

Photo Network 306

PhotoSource International 307

Portfolio Graphics, Inc. 247

Positive Images (Stock Photography & Gallery

61) 309

Pump House Center for the Arts 391

Quarto Publishing Plc. 231

Ralls Collection Inc., The 392

Running Press Book Publishers 232

San Diego Art Institute's Museum of the Living

Artist 393

Sandlapper Magazine 141

Scholastic Library Publishing 232

Seattle Homes & Lifestyles 142

SouthComm Publishing Company, Inc. 145

State Street Gallery 395

StockFood GmbH (The Food Image Agency)

314

Stock Foundry Images 315

Stock Transparency Services/STSimages 317

Sugar Daddy Photos 317

Teldon 248

Texas Gardener Magazine 148

Tide-Mark Press 249

Tree Care Industry 207

Tyndale House Publishers 234

Unicorn Stock Photos 319

Upstream People Gallery 400

Vermont Life 155

Viewfinders 320

Voyageur Press 235

Washington County Museum of Fine Arts 402

Western Producer, The 169

Willow Creek Press 236

World Fine Art Gallery 403

Yankee Magazine 159

Health/Fitness/Beauty

AAP News 171

Accent Alaska/Ken Graham Agency 255

Ace Stock Limited 256

Adirondack Lakes Center for the Arts 343

Aflo Foto Agency 257

After Five 68

Age Fotostock 258

Allyn & Bacon Publishers 212

amanaimages inc. 260

AMC Outdoors 70

American Fitness 71

American Print Alliance 344

AppaLight 262

Aguarius 161

Argus Photo, Ltd. (APL) 263

Art Directors & Trip Photo Library 264

Art@Net International Gallery 346

Art Without Walls, Inc. 348

Asia Images Group 266

Athletic Business 175

Auscape International 267

Balzekas Museum of Lithuanian Culture Art

Gallery 349

Bergman Collection, The 268 Boeberitz Design, Bob 323

Bon Artique.com/Art Resources Int., Ltd. 241

Bridal Guides Magazine 79

BSIP 270

Business NH Magazine 179 Business of Art Center 353

Bynums Marketing and Communications, Inc. 325

Camera Press Ltd. 270 Chatham Press 215

Children's Defense Fund 162

Cleveland Magazine 87

Comesana Agencia de Prensa/Banco

Fotográfico, Eduardo 273

Complete Woman 89 Creative Company, The 217

Creative Stock Images 274

Cycle California! Magazine 92

DDB Stock Photography, LLC 274 Design Conceptions (Joel Gordon

Photography) 275 Dinodia Photo Library 275

DK Stock, Inc. 276

Dockery House Publishing, Inc. 218

Dodo Graphics Inc. 243

DW Stock Picture Library (DWSPL) 277

Ecoscene 278

Ewing Galloway Inc. 279 Flint Communications 327

Focus New Zealand Photo Library Ltd. 282

Foto-Press Timmermann 283

Fotoscopio 283

Ft. Myers Magazine 100

Girls Life Magazine/GirlsLife.com 102

Golf Tips 103 Grafica 328

Grand Rapids Magazine 104 Hamilton Magazine 105

Hampton Design Group 329

Healing Lifestyles & Spas Magazine 106

Human Kinetics Publishers 222 Hutchison Picture Library 285 Images.de Digital Photo GmbH 287

Image Works, The 287

Inmagine RF & RM Image Submissions (IRIS) 288

Instinct Magazine 111

International Photo News 288

Isopix 289 Jeroboam 291

Journal of Adventist Education 190 Journal of Asian Martial Arts 113 Juvenile Diabetes Research Foundation

International 113

Key Curriculum Press 224

Kramer and Associates, Inc., Joan 292

Latitude Stock 292

Leepa-Rattner Museum of Art 374 Limited Editions & Collectibles 376 Mattei Photography, Michele 379 Medical File Inc. The 205

Medical File Inc., The 295
Medical On Line Ltd. 295
Megapress Images 295
Metrosource Magazine 119
MGW Newsmagazine 119
Motoring & Leisure 121

Mullin/Ashley Associate 332 Multiple Exposures Gallery 381

Nailpro 192

New York Times on the Web, The 165 Northwestern University Dittmar Memorial

Gallery 385 Nova Media Inc. 246 Novastock 297 NOVUS 333

Okapia K.G. 298 Omni-Photo Communications 298

OnAsia 299

OnRequest Images 299 Opcao Brasil Imagens 300 Outside Imagery 300

Oxygen 130

Pacific Stock/Printscapes.com 301

Painet Inc. 302
Panoramic Images 303
Photo Agora 304
Photo Network 306
Portfolio Craphics Inc.

Portfolio Graphics, Inc. 247

Positive Images (Stock Photography & Gallery 61) 309

Quarto Publishing Plc. 231 Ralls Collection Inc., The 392

Roggen Advertising and Public Relations, Ted 335

Saks Associates, Arnold 336

San Diego Art Institute's Museum of the Living Artist 393 Sandlapper Magazine 141 Scholastic Library Publishing 232

Seventeen Magazine 143

Soundlight 337

SouthComm Publishing Company, Inc. 145

Sportslight Photo 312

StockFood GmbH (The Food Image Agency)

314

Stock Foundry Images 315

Stock Transparency Services/STSimages 317

Streetpeople's Weekly News 166

Sugar Daddy Photos 317

Sun 166

Tide-Mark Press 249

Toronto Sun Publishing 167

Trail Runner 152

Tropix Photo Library 318

Ullstein Bild 319

Unicorn Stock Photos 319

Upstream People Gallery 400

Video I-D, Inc. 338

Viewfinders 320

Washington County Museum of Fine Arts 402

Waveland Press, Inc. 235

Women's Health Group 237

Woodmen Living 157

Historical/Vintage

Adirondack Lakes Center for the Arts 343

Aflo Foto Agency 257

African American Golfer's Digest 67

Age Fotostock 258

Akron Art Museum 343

Alaska State Museum 344

Alaska Stock Images 259

Albuquerque Museum of Art & History, The

344

All About Kids Publishing 211

Allyn & Bacon Publishers 212

amanaimages inc. 260

American Power Boat Association 173

American Print Alliance 344

Anchor News 73

Ancient Art & Architecture Collection, Ltd.,

The 261

Animal Trails 73

Archaeology 161

Archivo Criollo 263

Arsenal Gallery, The 345

Art Directors & Trip Photo Library 264

Art in Motion 239

Arts Company, The 347

Art Source L.A., Inc. 348

Artwerks Stock Photography 265

Art Without Walls, Inc. 348

Axis Gallery 349

Balzekas Museum of Lithuanian Culture Art

Gallery 349

Barnett Advertising/Design, Augustus 323

Baseball 76

Bedford/St. Martin's 213

Bennett Galleries and Company 351

Bentley Publishing Group 240

Blount-Bridgers House/Hobson Pittman

Memorial Gallery 352

Blue Ridge Country 78

Book Beat Gallery 352

Borealis Press, The 241

Brewers Association 214

Bridal Guides Magazine 79

California Views/Mr. Pat Hathaway Historical

Photo Collection 270

Calliope 80

Capitol Complex Exhibitions 353

Chatham Press 215

Chronogram 86

Clampart 356

Cleary Gallery, John 357

Cobblestone 87

Cody Images 273

Collectible Automobile 87

Comesana Agencia de Prensa/Banco

Fotográfico, Eduardo 273

Concord Litho 242

Continental Newstime 90

Corporate Art Source/CAS Gallery 358

Countryman Press, The 216

Crabtree Publishing Company 216

Creative Stock Images 274

Dance 93

Dinodia Photo Library 275

DK Stock, Inc. 276

Dodo Graphics Inc. 243

Dorsky Museum of Art, Samuel 360

Eastman House, George 361

Edelstein Studio and Gallery, Paul 361

E & E Picture Library 277

ESL Teacher Today 185

Etherton Gallery 362 Everson Museum of Art 363 Fahey/Klein Gallery 363 Farcountry Press 220

Flint Communications 327

Fotoscopio 283
Freefall Review 100
Freeport Arts Center 364
Ft. Myers Magazine 100
Gallery Luisotti 366

Geoslides & Geo Aerial Photography 284

Ghost Town 102 Grafica 328

Grand Rapids Art Museum 367 Hampton Design Group 329 Harper's Magazine 106

Hemphill 369

Henry Street Settlement/Abrons Art Center 369

Heritage Railway Magazine 107 Horizons Magazine 108

Houk Gallery, Edwynn 370 Huntsville Museum of Art 370

Icebox Quality Framing & Gallery 370
Illinois State Museum Chicago Gallery 371

Illogical Muse 110 Image Works, The 287 Immigrant Ancestors 110

Individual Artists of Oklahoma 371 Inner Traditions/Bear & Company 223

In The Wind 111

Iowan Magazine, The 112 Irish Picture Library, The 289

Isopix 289 ITE Journal 189 Jeroboam 291

Journal of Asian Martial Arts 113

Judicature 190

Kramer and Associates, Inc., Joan 292 Land of the Bible Photo Archive 268 Leepa-Rattner Museum of Art 374

Light Factory, The 376

Limited Editions & Collectibles 376

Limner Gallery 376

Linear Cycle Productions 331 Log Newspaper, The 165 Lucent Books 225

Macalester Gallery 377 Markeim Art Center 378 Masur Museum of Art 379 McGaw Graphics, Inc. 245

Mesa Contemporary Arts at Mesa Arts Center

379

Michael Murphy Gallery M 380 Mitchell Lane Publishers, Inc. 227

Monderer Design 332 Motoring & Leisure 121

MPTV (a/k/a Motion Picture and Television

Photo Archive) 296 Museo ItaloAmericano 382

Music & Arts Pictures at Lebrecht 297

My Foodservice News 192 Na'amat Woman 122 Nails Magazine 193

National Parks Magazine 123

Naval History 193 Northern Woodlands 125 Northwest Art Center 385

Northwestern University Dittmar Memorial

Gallery 385 Nova Media Inc. 246 NOVIIS 333

NOVUS 333 Now & Then 127

Noyes Museum of Art, The 386

OnAsia 299

Outdoor Life Magazine 130 Pacific Yachting Magazine 131

Painet Inc. 302

Pakn Treger 131

Panoramic Images 303

Paper Products Design 246

Parkland Art Gallery 388

Persimmon Hill Magazine 132

Photographic Resource Center 389

PI Creative Art 247

Planet 134 Planning 196

PLANS, Ltd. (Photo Libraries and News

Services) 308

Polk Museum of Art 390 Ponkawonka Inc. 308

Popular Photography & Imaging 135

Portfolio Graphics, Inc. 247

Posey School 334

Prakken Publications, Inc. 230 ProStar Publications Inc. 231 Pump House Center for the Arts 391

Quarto Publishing Plc. 231

Rafelman Fine Arts, Marcia 392 Railphotolibrary.com 310 Ralls Collection Inc., The 392 Recycled Paper Greetings, Inc. 247 Revolutionary War Tracks 138 Running Press Book Publishers 232 Russian Life Magazine 140 San Diego Art Institute's Museum of the Living Artist 393 Sandlapper Magazine 141 Santoro Graphics Ltd. 248 Schmidt Art Center, William & Florence 393 Scholastic Library Publishing 232 Scholastic Magazines 142 School Transportation News 203 Soho Myriad 394 SouthComm Publishing Company, Inc. 145 Sovfoto/Eastfoto, Inc. 312 Stevenson University Art Gallery 396 Stock Foundry Images 315 Stock Transparency Services/STSimages 317 Streetpeople's Weekly News 166 Sugar Daddy Photos 317 Synchronicity Fine Arts 396 Throckmorton Fine Art 397 Tide-Mark Press 249 Times of the Islands 150 Touchstone Gallery 398

UCR/California Museum of Photography 398 Ullstein Bild 319 Unicorn Stock Photos 319 Up and Under 155 Upstream People Gallery 400 Visual Arts Center of Northwest Florida 401 Visual Arts Gallery 401 Voyageur Press 235

Waveland Press, Inc. 235 Weigl Educational Publishers Limited 236

Washington County Museum of Fine Arts 402

Woodmen Living 157

Hobbies

Accent Alaska/Ken Graham Agency 255 Ace Stock Limited 256 Adirondack Lakes Center for the Arts 343 Aflo Foto Agency 257 African American Golfer's Digest 67 After Five 68

Age Fotostock 258 amanaimages inc. 260 American Bee Journal 173 American Fitness 71 American Hunter 72 American Print Alliance 344 AppaLight 262 Appaloosa Journal 174 Art Directors & Trip Photo Library 264 Artwerks Stock Photography 265 Art Without Walls, Inc. 348 Auto Restorer 75 Balzekas Museum of Lithuanian Culture Art Gallery 349 Bird Watching Magazine 78 Boeberitz Design, Bob 323 Borealis Press, The 241 Bowhunter 79 Brewers Association 214 Capstone Press 214 Chess Life 84 Chirp Magazine 85 Cleveland Magazine 87 Country Woman 91 Creative Company, The 217 Creative Stock Images 274 DDB Stock Photography, LLC 274 Dinodia Photo Library 275 DK Stock, Inc. 276 Dodo Graphics Inc. 243 Family Motor Coaching 98 Finescale Modeler 98 Flv Rod & Reel 99 Focus New Zealand Photo Library Ltd. 282 Foto-Press Timmermann 283 Fotoscopio 283 F+W Media 219 Game & Fish Magazines 101 Grafica 328 Grit Magazine 104 Guitar World 105 Heritage Railway Magazine 107 Horizons Magazine 108

Image Integration 330 Images.de Digital Photo GmbH 287

Inmagine RF & RM Image Submissions (IRIS) 288

Isopix 289

Kramer and Associates, Inc., Joan 292

Latitude Stock 292 Leepa-Rattner Museum of Art 374 Lerner Publishing Group, Inc. 224 Limited Editions & Collectibles 376

Marlin 118

Motor Boating Magazine 120

Motoring & Leisure 121

Museo ItaloAmericano 382

Mushing.com Magazine 121

Muzzle Blasts 122

New York Times on the Web, The 165 Northwestern University Dittmar Memorial

Gallery 385 NOVUS 333

OWL Magazine 130

Painet Inc. 302

Pennsylvania Game News 132 Persimmon Hill Magazine 132

Photo Network 306

PhotoSource International 307

PI Creative Art 247

Portfolio Graphics, Inc. 247 Quarto Publishing Plc. 231

Ralls Collection Inc., The 392

Rigby Education 231

Running Press Book Publishers 232

San Diego Art Institute's Museum of the Living Artist 393

Sandlapper Magazine 141

Scholastic Library Publishing 232

Shooting Sports USA 143

SouthComm Publishing Company, Inc. 145

Stock Foundry Images 315

Stock Transparency Services/STSimages 317

Streetpeople's Weekly News 166

Sugar Daddy Photos 317 Surfing Magazine 148

Texas Gardener Magazine 148

Tide-Mark Press 249

Trailer Boats Magazine 152

Turkey & Turkey Hunting 154

Ullstein Bild 319

Unicorn Stock Photos 319

Voyageur Press 235

Washington County Museum of Fine Arts 402

Washington Trails 156

WaterSki 157

WaveLength Magazine 157

Writer's Digest 158

Humor

Accent Alaska/Ken Graham Agency 255

Ace Stock Limited 256

Adirondack Lakes Center for the Arts 343

Aflo Foto Agency 257

After Five 68

Age Fotostock 258

Alabama Living 69

amanaimages inc. 260

American Fitness 71

American Print Alliance 344

AppaLight 262

Art Directors & Trip Photo Library 264

Art Without Walls, Inc. 348

Avanti Press Inc. 240

Balzekas Museum of Lithuanian Culture Art

Gallery 349

Benham Studio Gallery 350

Bennett Galleries and Company 351

Borealis Press, The 241

Brewers Association 214

Camera Press Ltd. 270

Centric Corporation 242

Chess Life for Kids 85

Chirp Magazine 85

Clampart 356

Cleary Gallery, John 357

Cleveland Magazine 87

Comesana Agencia de Prensa/Banco

Fotográfico, Eduardo 273

Comstock Cards 242

Creative Stock Images 274

Current, Inc. 243

Design Design, Inc. 243

Dinodia Photo Library 275

DK Stock, Inc. 276

Dodo Graphics Inc. 243

eMediaLoft.org 361

Fahey/Klein Gallery 363

Fellowship 98

F+W Media 219

Gallant Greetings Corp. 244

Grafica 328

Grand Rapids Magazine 104

Indianapolis Monthly 110

Instinct Magazine 111

Isopix 289

Jeroboam 291

Kashrus Magazine 114

Kramer and Associates, Inc., Joan 292

Leepa-Rattner Museum of Art 374

Limited Editions & Collectibles 376

Linear Cycle Productions 331

Luckypix 294

Museo ItaloAmericano 382

Museum of Contemporary Photography,

Columbia College Chicago 383

Nexus/Foundation for Today's Art 384

Northwestern University Dittmar Memorial

Gallery 385 NOVUS 333

OWL Magazine 130

Painet Inc. 302

Pakn Treger 131

Paper Products Design 246

Photo Network 306

Police Magazine 197

Portfolio Graphics, Inc. 247

Recycled Paper Greetings, Inc. 247

RIG 248

Sail Magazine 140

San Diego Art Institute's Museum of the Living

Artist 393

Santoro Graphics Ltd. 248

Scholastic Library Publishing 232

School Transportation News 203

Soundlight 337

Stock Foundry Images 315

Stock Transparency Services/STSimages 317

Streetpeople's Weekly News 166

Sugar Daddy Photos 317

Sun 166

Tide-Mark Press 249

Ullstein Bild 319

Upstream People Gallery 400

Vermont Life 155

Voyageur Press 235

Washington County Museum of Fine Arts 402

Woodmen Living 157

Industry

Accent Alaska/Ken Graham Agency 255

Ace Stock Limited 256

Aflo Foto Agency 257

Age Fotostock 258

Alabama Living 69

Alaska Stock Images 259

amanaimages inc. 260

American Print Alliance 344

Andes Press Agency 261

AOPA Pilot 174

AppaLight 262

Art Directors & Trip Photo Library 264

Artwerks Stock Photography 265

Aurora Photos 266

Automated Builder 176

Avionics Magazine 177

Balzekas Museum of Lithuanian Culture Art

Gallery 349

Barnett Advertising/Design, Augustus 323

Boeberitz Design, Bob 323

Brewers Association 214

Business NH Magazine 179

Cleary Gallery, John 357

Cleveland Magazine 87

Cobblestone 87

Comesana Agencia de Prensa/Banco

Fotográfico, Eduardo 273

Continental Newstime 90

Creative Company, The 217

Creative Stock Images 274

Dinodia Photo Library 275

DK Stock, Inc. 276

Dodo Graphics Inc. 243

DW Stock Picture Library (DWSPL) 277

Ecoscene 278

Electrical Apparatus 184

Elks Magazine, The 96

Ewing Galloway Inc. 279

Flint Communications 327

Fillit Collinations 327

Focus New Zealand Photo Library Ltd. 282

FOTOAGENT.COM/FOTOCONCEPT, INC 282

Foto-Press Timmermann 283

Fotoscopio 283

Fundamental Photographs 284

Geoslides & Geo Aerial Photography 284

Geosynthetics 187

Grafica 328

Grain Journal 187

Grand Rapids Business Journal 164

Horizons Magazine 108

Hutchison Picture Library 285

IEEE Spectrum 189

Image Finders, The 286

Images.de Digital Photo GmbH 287

Image Works, The 287

Inmagine RF & RM Image Submissions (IRIS) 288

Isopix 289

ITE Journal 189

Jeroboam 291

Jude Studios 330

Kramer and Associates, Inc., Joan 292

Leepa-Rattner Museum of Art 374

Lerner Publishing Group, Inc. 224

Lineair Fotoarchief, B.V. 293

Lohre & Associates Inc. 332

Manufacturing Automation & Advanced

Manufacturing 191

Marketing & Technology Group 192

McGraw-Hill 226

Mesa Contemporary Arts at Mesa Arts Center 379

Michael Murphy Gallery M 380

Monderer Design 332

Mullin/Ashley Associate 332

Naval History 193

New York Times on the Web, The 165

Nexus/Foundation for Today's Art 384

NOVUS 333

Okapia K.G. 298

O.K. Harris Works of Art 386

Omni-Photo Communications 298

OnAsia 299

OnRequest Images 299

Opcao Brasil Imagens 300

Oxford Scientific (OSF) 301

Pacific Stock/Printscapes.com 301

Painet Inc. 302

Panoramic Images 303

Pet Product News 195

Photo Agora 304

Photo Network 306

PhotoSource International 307

Planet 134

Plastics Technology 197

Popular Photography & Imaging 135

Portfolio Graphics, Inc. 247

Prakken Publications, Inc. 230

Proceedings 198

Professional Photographer 198

Purestock 309

Quick Frozen Foods International 199

Relay Magazine 202

Saks Associates, Arnold 336

Sandlapper Magazine 141

Scholastic Library Publishing 232

Scrap 204

SouthComm Publishing Company, Inc. 145

Stack & Associates, Inc., Tom 313

Still Media 314

Stock Foundry Images 315

Stock Transparency Services/STSimages 317

Sugar Daddy Photos 317

Synchronicity Fine Arts 396

Textile Rental Magazine 206

Tropix Photo Library 318

Ullstein Bild 319

Video I-D, Inc. 338

Viewfinders 320

Warne Marketing & Communications 339

Washington County Museum of Fine Arts 402

Water Well Journal 207

Weigl Educational Publishers Limited 236

Wines & Vines 208

Wisconsin Architect 208

Woman Engineer 208

Woodshop News 209

Interiors/Decorating

Adirondack Lakes Center for the Arts 343

Aflo Foto Agency 257

Age Fotostock 258

amanaimages inc. 260

American Print Alliance 344

Animal Trails 73

Archaeology 161

Argus Photo, Ltd. (APL) 263

Art Directors & Trip Photo Library 264

Art Source L.A., Inc. 348

Art Without Walls, Inc. 348

Atlanta Homes & Lifestyles 75

Balzekas Museum of Lithuanian Culture Art

Gallery 349

Bentley Publishing Group 240

Beverage Dynamics 178

Bon Artique.com/Art Resources Int., Ltd. 241

Bridal Guides Magazine 79

Camera Press Ltd. 270

Canadian Homes & Cottages 81

Caribbean Travel & Life 82

Carmichael-Lynch, Inc. 325

Center for Fine Art Photography, The 354

Cleveland Magazine 87 Country Woman 91 Creative Homeowner 217 Creative Stock Images 274 Dance 93 Dinodia Photo Library 275 Display Design Ideas 184

Dockery House Publishing, Inc. 218

Dodo Graphics Inc. 243 Fotoscopio 283 Freefall Review 100 Ft. Myers Magazine 100

Ghost Town 102 Grafica 328

Hutchinson Associates, Inc. 330 Hutchison Picture Library 285

Ideals Magazine 109 Kashrus Magazine 114

Kramer and Associates, Inc., Joan 292 Leepa-Rattner Museum of Art 374

Log Home Living 117

Meetings & Incentive Travel 192

Mesa Contemporary Arts at Mesa Arts Center 379

Metrosource Magazine 119 Michael Murphy Gallery M 380

Mountain Living 121

Nailpro 192

Nails Magazine 193

New York Times on the Web, The 165

NOVUS 333 OnAsia 299

OnRequest Images 299

Painet Inc. 302

Panoramic Images 303

Persimmon Hill Magazine 132

Photo Network 306

PhotoSource International 307 Portfolio Graphics, Inc. 247 Quarto Publishing Plc. 231 Ralls Collection Inc., The 392

Remodeling 202

Rhode Island Monthly 138

Running Press Book Publishers 232

Sandlapper Magazine 141

Scholastic Library Publishing 232 Seattle Homes & Lifestyles 142

SouthComm Publishing Company, Inc. 145

StockFood GmbH (The Food Image Agency) 314

Stock Foundry Images 315

Stock Transparency Services/STSimages 317

Sugar Daddy Photos 317

Teldon 248

Tide-Mark Press 249

Upstream People Gallery 400

Washington County Museum of Fine Arts 402

Woodshop News 209

Yankee Magazine 159

Landscapes/Scenics

Accent Alaska/Ken Graham Agency 255

Ace Stock Limited 256

Adirondack Lakes Center for the Arts 343

A+E 256

Aerial Photography Services 211

Aflo Foto Agency 257

After Five 68

Age Fotostock 258

AKM Images, Inc. 258

Alabama Living 69

Alaska Stock Images 259

Albuquerque Museum of Art & History, The 344

amanaimages inc. 260

AMC Outdoors 70

American Forests Magazine 71

American Gardener, The 72 American Print Alliance 344

Andes Press Agency 261

Animals Animals/Earth Scenes 261

Animal Trails 73

Ant Photo Library 262

Appalachian Mountain Club Books 212

Appalachian Trail Journeys 74

AppaLight 262

Appaloosa Journal 174

Archaeology 161

Archivo Criollo 263

Arizona Wildlife Views 74

Arsenal Gallery, The 345

Art Directors & Trip Photo Library 264 Art@Net International Gallery 346

Arts Iowa City 347

Art Source L.A., Inc. 348

Artwerks Stock Photography 265

Art Without Walls, Inc. 348

Atlantic Gallery 349 Aurora Photos 266

Auscape International 267

Balzekas Museum of Lithuanian Culture Art Gallery 349

Baseball 76

Bear Deluxe Magazine, The 77

Beef Today 178

Belian Art Center 350

Benham Studio Gallery 350

Bennett Galleries and Company 351

Biological Photo Service and Terraphotographics 268

Bird Watching Magazine 78

Blount-Bridgers House/Hobson Pittman

Memorial Gallery 352
Blue Ridge Country 78
Blue Sky Publishing 240

Boeberitz Design, Bob 323

Bon Artique.com/Art Resources Int., Ltd. 241

Bowhunter 79

Bridal Guides Magazine 79 Bristol Gift Co., Inc. 241

BSIP 270

California Views/Mr. Pat Hathaway Historical Photo Collection 270

Camera Obscura Gallery, The 353 Camerique Inc. International 271 Canadian Homes & Cottages 81

Canoe & Kayak 82

Capitol Complex Exhibitions 353

Capper's 162
Capstone Press 214
Caribbean Travel & Life 82
Carmichael-Lynch, Inc. 325

Center for Fine Art Photography, The 354

Centric Corporation 242

Chait Galleries Downtown, The 355 Chapman Friedman Gallery 356

Civitan Magazine 181

Clampart 356 Cleary Gallery, John 357

Cleveland Magazine 87

Cobblestone 87

Comesana Agencia de Prensa/Banco Fotográfico, Eduardo 273

Concord Litho 242

Contemporary Arts Center (Cincinnati), The 358

Corporate Art Source/CAS Gallery 358

Countryman Press, The 216

Country Woman 91

Crealdè School of Art 473

Creative Company, The 217

Creative Homeowner 217

Creative Stock Images 274

Current, Inc. 243

Dairy Today 183

Dakota Outdoors 93

Dance 93

DDB Stock Photography, LLC 274

Deljou Art Group 243 Dinodia Photo Library 275

Dockery House Publishing, Inc. 218

Dodo Graphics Inc. 243

Down The Shore Publishing Corp. 218

DRK Photo 276

Ducks Unlimited Magazine 95

Edelstein Studio and Gallery, Paul 361

eMediaLoft.org 361 ESL Teacher Today 185

E/The Environmental Magazine 97

Event 97

Everson Museum of Art 363
Fahey/Klein Gallery 363
Family Motor Coaching 98
Farcountry Press 220
Farnam Companies, Inc. 326

Fellowship 98 Fly Rod & Reel 99

Focus New Zealand Photo Library Ltd. 282

Forest Landowner 186 Foto-Press Timmermann 283

Fotoscopio 283

Freeport Arts Center 364 Ft. Myers Magazine 100 Gallant Greetings Corp. 244

Gallery West 367

Game & Fish Magazines 101

Geoslides & Geo Aerial Photography 284

Ghost Town 102 Gospel Herald 103

Grafica 328

Grand Rapids Magazine 104

Grit Magazine 104 Guideposts 104 Haddad Gallery, Čarrie 368 Hampton Design Group 329 Hancock House Publishers 221 Havu Gallery, William 368

Healing Lifestyles & Spas Magazine 106 Hearst Art Gallery, Saint Mary's College 369

Heilman Photography, Inc., Grant 285

Hemphill 369

Henry Street Settlement/Abrons Art Center 369

Hera Educational Foundation and Art Gallery 369

Highways 107

Horizons Magazine 108

Howard, Merrell and Partners, Inc. 329

Hutchison Picture Library 285

Icebox Quality Framing & Gallery 370

Ideals Magazine 109 Illogical Muse 110 Image Finders, The 286

Immigrant Ancestors 110
Impact Photographics 244

Inmagine RF & RM Image Submissions (IRIS) 288

Inner Traditions/Bear & Company 223

In The Wind 111

Iowan Magazine, The 112

Isopix 289

ITE Journal 189 Jewish Action 112

Kansas! 113

Kashrus Magazine 114 Kentucky Monthly 114 Key Curriculum Press 224

Kimball Stock 291 Kiwanis Magazine 114

Kramer and Associates, Inc., Joan 292

Lakeland Boating Magazine 115 Lake Superior Magazine 116

Land of the Bible Photo Archive 268

Landscape Architecture 191

Latitude Stock 292

Leepa-Rattner Museum of Art 374 Lehigh University Art Galleries 375

Leopold Gallery 375

Lerner Publishing Group, Inc. 224 Limited Editions & Collectibles 376

Lineair Fotoarchief, B.V. 293 Lizardi/Harp Gallery 376 Lutheran, The 118

Macalester Gallery 377

Markeim Art Center 378 Marlboro Gallery 378

Marlin 118

Masur Museum of Art 379 McGaw Graphics, Inc. 245

Meetings & Incentive Travel 192

Megapress Images 295

Mesa Contemporary Arts at Mesa Arts Center 379

Michael Murphy Gallery M 380 Michelson Galleries, R. 380 Michigan Out-of-Doors 119

Milkweed Editions 227

Modernart Editions 245 Motoring & Leisure 121

Multiple Exposures Gallery 381

Museo ItaloAmericano 382

Museum of Contemporary Photography, Columbia College Chicago 383

Museum of Printing History 383

Na'amat Woman 122

National Geographic 122

National Parks Magazine 123

Nevada Museum of Art 384

New Leaf Press, Inc. 228

New Mexico Magazine 124

New York Times on the Web, The 165

Nicolas-Hays, Inc. 228 Northern Woodlands 125

Northwestern University Dittmar Memorial

Gallery 385

Northwest Travel Magazine 126

Nova Media Inc. 246

NOVUS 333

Now & Then 127

Oklahoma Today 127

OnAsia 299

Onboard Media 128 OnRequest Images 299

Opening Night Gallery 387 Oregon Coast Magazine 129

Outdoor America 129

Outside Imagery 300

Owen Publishers, Inc., Richard C. 229

Oxford Scientific (OSF) 301

Pacific Stock/Printscapes.com 301 Pacific Yachting Magazine 131 Paddler Magazine 131

Painet Inc. 302

Panoramic Images 303

Pennsylvania Magazine 132

Persimmon Hill Magazine 132

Photo Agora 304

Photography Art 389

Photo Life 133

PhotoSource International 307

PI Creative Art 247

Planning 196

Portfolio Graphics, Inc. 247

Positive Images (Stock Photography & Gallery

61) 309

ProStar Publications Inc. 231

Pucker Gallery 391

Pump House Center for the Arts 391

Rafelman Fine Arts, Marcia 392

Ralls Collection Inc., The 392

Recommend Magazine 200

Recommend Wagazine 200

Recycled Paper Greetings, Inc. 247

Revolutionary War Tracks 138

Rhode Island Monthly 138

Rigby Education 231

Rockford Review 138

Running Press Book Publishers 232

Sail Magazine 140

Salt Water Sportsman 141

San Diego Art Institute's Museum of the Living

Artist 393

Sandlapper Magazine 141

Schmidt Art Center, William & Florence 393

Scholastic Library Publishing 232

Sea 142

Soho Myriad 394

Soundlight 337

South Carolina Film Commission 337

SouthComm Publishing Company, Inc. 145

Southside Gallery 394

Sportslight Photo 312

Stack & Associates, Inc., Tom 313

State Street Gallery 395

Stock Connection, Inc. 314

Stock Foundry Images 315

Stock Transparency Services/STSimages 317

Sugar Daddy Photos 317

Sun, The 147

Surfing Magazine 148

Synchronicity Fine Arts 396

Taube Museum of Art, Lillian & Coleman 396

Teldon 248

Texas Highways 148

Throckmorton Fine Art 397

Tide Magazine 149

Tide-Mark Press 249

Times of the Islands 150

Touchstone Gallery 398

Trailer Boats Magazine 152

Trail Runner 152

Trails Media Group 250

Tree Care Industry 207

Tropix Photo Library 318

Tyndale House Publishers 234

Ullstein Bild 319

Unicorn Stock Photos 319

Up and Under 155

Up Here 155

Upstream People Gallery 400

Vermont Life 155

Vermont Magazine 156

Viewfinders 320

Visitor's Choice Magazine 234

Visual Arts Center of Northwest Florida 401

Voyageur Press 235

Washington County Museum of Fine Arts 402

Washington Trails 156

WaveLength Magazine 157

Weigl Educational Publishers Limited 236

Western Producer, The 169.

Whiskey Island Magazine 158

Willow Creek Press 236

World Fine Art Gallery 403

WRITERS' Journal 209

With Elico Souther 20

Yankee Magazine 159

Zakin Gallery, Mikhail 404

Zenith Gallery 404

Lifestyle

Aflo Foto Agency 257

African American Golfer's Digest 67

Age Fotostock 258

Alaska 69

Appalachian Mountain Club Books 212

Appalachian Trail Journeys 74

AppaLight 262

Argus Photo, Ltd. (APL) 263

Artwerks Stock Photography, 265

Asia Images Group 266 Atlanta Homes & Lifestyles 75 Auscape International 267 BC Outdoors 76 Blend Images 269 Blue Ridge Country 78 Camera Press Ltd. 270 Capper's 162 Caribbean Travel & Life 82 Catholic News Service 272 Charisma Magazine 83 Chesapeake Bay Magazine 84 Creative Stock Images 274 DK Stock, Inc. 276 Dockery House Publishing, Inc. 218 DW Stock Picture Library (DWSPL) 277 Envision 278 eStock Photo, LLC 279 Ewing Galloway Inc. 279 Flaunt Magazine 99 Foodpix 282 Foto-Press Timmermann 283 Girls Life Magazine/GirlsLife.com 102 Grand Rapids Family Magazine 103 Grand Rapids Magazine 104 Hadassah Magazine 105 Hamilton Magazine 105 Highways 107 Indianapolis Monthly 110 Inmagine RF & RM Image Submissions (IRIS) 288 Insight Magazine 111 In The Wind 111 Jewish Action 112 Kansas! 113 Kimball Stock 291 Kramer and Associates, Inc., Joan 292 Leepa-Rattner Museum of Art 374 Mattei Photography, Michele 379 MAXX Images, Inc. 294 Medical On Line Ltd. 295 MGW Newsmagazine 119 Mountain Living 121 Novastock 297

Now & Then 127

OnRequest Images 299

Photolibrary Group 305

Outside Imagery 300 Painet Inc. 302

Photolife Corporation Ltd. 305 Portfolio Graphics, Inc. 247 Positive Images (Stock Photography & Gallery 61) 309 Princeton Alumni Weekly 136 Purestock 309 Rhode Island Monthly 138 Running Press Book Publishers 232 Santoro Graphics Ltd. 248 Scholastic Library Publishing 232 Seventeen Magazine 143 SouthComm Publishing Company, Inc. 145 Southern Boating 145 Spencer Gifts, LLC 248 Stock Foundry Images 315 Sugar Daddy Photos 317 Superstock Inc. 318 TRACE Magazine 151 Vermont Life 155 Viewfinders 320 Visitor's Choice Magazine 234 Washington Blade, The 168 Washington Trails 156 Wine Enthusiast Magazine 158 Woodmen Living 157 Medicine

BSIP 270

AAP News 171 Accent Alaska/Ken Graham Agency 255 Ace Stock Limited 256 Aflo Foto Agency 257 Age Fotostock 258 amanaimages inc. 260 American Fitness 71 American Print Alliance 344 AppaLight 262 Aquarius 161 Archaeology 161 Art Directors & Trip Photo Library 264 Art Without Walls, Inc. 348 Auscape International 267 Balzekas Museum of Lithuanian Culture Art Gallery 349 Bergman Collection, The 268 Biological Photo Service and Terraphotographics 268 Boeberitz Design, Bob 323

Bynums Marketing and Communications, Inc. 325

Cleveland Magazine 87 College PreView Magazine 88

Comesana Agencia de Prensa/Banco

Fotográfico, Eduardo .273

Continental Newstime 90

Creative Company, The 217

Creative Stock Images 274

Design Conceptions (Joel Gordon

Photography) 275

Dinodia Photo Library 275

DK Stock, Inc. 276

Dodo Graphics Inc. 243

Ecoscene 278

ESL Teacher Today 185

Ewing Galloway Inc. 279

FireRescue Magazine 186

Flint Communications 327

FOTOAGENT.COM/FOTOCONCEPT, INC 282

Foto-Press Timmermann 283

Freefall Review 100

Ft. Myers Magazine 100

Fundamental Photographs 284

Geoslides & Geo Aerial Photography 284

Ghost Town 102

Grafica 328

Hampton Design Group 329

Human Kinetics Publishers 222

Hutchinson Associates, Inc. 330

Hutchison Picture Library 285

IEEE Spectrum 189

Image Finders, The 286

Images.de Digital Photo GmbH 287

Image Works, The 287

Immigrant Ancestors 110

Inmagine RF & RM Image Submissions (IRIS) 288

Inner Traditions/Bear & Company 223

Isopix 289

Jeroboam 291

Journal of Psychoactive Drugs 190

Juvenile Diabetes Research Foundation

International 113

Kiwanis Magazine 114

KNOWAtlanta 115

Kramer and Associates, Inc., Joan 292

Leepa-Rattner Museum of Art 374

Medical File Inc., The 295

Medical On Line Ltd. 295

Megapress Images 295

Michael Murphy Gallery M 380

Monderer Design 332

Mullin/Ashley Associate 332

Museum of Contemporary Photography,

Columbia College Chicago 383

New York Times on the Web, The 165

NOVUS 333

Okapia K.G. 298

Omni-Photo Communications 298

OnAsia 299

Opcao Brasil Imagens 300

Oxford Scientific (OSF) 301

Painet Inc. 302

Panoramic Images 303

Pediatric Annals 194

Photo Agora 304

Photolife Corporation Ltd. 305

Photo Network 306

Photo Researchers, Inc. 306

PhotoSource International 307

Portfolio Graphics, Inc. 247

Purestock 309

Revolutionary War Tracks 138

Saks Associates, Arnold 336

Sandlapper Magazine 141

Scholastic Library Publishing 232

Science Photo Library, Ltd. 311

Soundlight 337

SouthComm Publishing Company, Inc. 145

State Street Gallery 395

Stock Foundry Images 315

Stock Transparency Services/STSimages 317

Sugar Daddy Photos 317

Sun 166

Surgical Technologist, The 205

Synchronicity Fine Arts 396

Tropix Photo Library 318

Ullstein Bild 319

Veterinary Economics 207

Viewfinders 320

Washington County Museum of Fine Arts 402

Weigl Educational Publishers Limited 236

Membership/Subscription

Schmidt/Dean Spruce 393

Military

Accent Alaska/Ken Graham Agency 255

Aflo Foto Agency 257

Age Fotostock 258

amanaimages inc. 260

American Print Alliance 344

Anchor News 73

AppaLight 262

Archaeology 161

Art Directors & Trip Photo Library 264

Asian Enterprise Magazine 175

Aurora Photos 266

Balzekas Museum of Lithuanian Culture Art

Gallery 349

California Views/Mr. Pat Hathaway Historical

Photo Collection 270

Capstone Press 214

Cleary Gallery, John 357

Cobblestone 87

Cody Images 273

College PreView Magazine 88

Continental Newstime 90

Creative Company, The 217

Creative Stock Images 274

DDB Stock Photography, LLC 274

Dinodia Photo Library 275

DK Stock, Inc. 276

Dodo Graphics Inc. 243

ESL Teacher Today 185

Geoslides & Geo Aerial Photography 284

Ghost Town 102

Grafica 328

Human Kinetics Publishers 222

Hutchison Picture Library 285

IEEE Spectrum 189

Immigrant Ancestors 110

Jeroboam 291

Kramer and Associates, Inc., Joan 292

Leepa-Rattner Museum of Art 374

Michael Murphy Gallery M 380

Naval History 193

New York Times on the Web, The 165

Nova Media Inc. 246

Novastock 297

NOVUS 333

OnAsia 299

Painet Inc. 302

Panoramic Images 303

Photo Network 306

Portfolio Graphics, Inc. 247

Proceedings 198

Revolutionary War Tracks 138

Sandlapper Magazine 141

Scholastic Library Publishing 232

SouthComm Publishing Company, Inc. 145

Stock Foundry Images 315

Stock Transparency Services/STSimages 317

Sugar Daddy Photos 317

Taube Museum of Art, Lillian & Coleman 396

Toward Freedom 151

Ullstein Bild 319

Upstream People Gallery 400

Washington County Museum of Fine Arts 402

Multicultural

AAP News 171

Accent Alaska/Ken Graham Agency 255

Ace Stock Limited 256

Adirondack Lakes Center for the Arts 343

Advanced Graphics 239

Aflo Foto Agency 257

Age Fotostock 258

AIM 68

AKM Images, Inc. 258

Alaska Stock Images 259 .

All About Kids Publishing 211

Allyn & Bacon Publishers 212

amanaimages inc. 260

American Fitness 71

American Print Alliance 344

Andes Press Agency 261

AppaLight 262

Aquarius 161

Archaeology 161

Archivo Criollo 263

memvo chono 205

Argus Photo, Ltd. (APL) 263

Art Directors & Trip Photo Library 264

Art@Net International Gallery 346

Art Source L.A., Inc. 348

Art Without Walls, Inc. 348

Asian Enterprise Magazine 175

Atlantic Gallery 349

Aurora Photos 266

Balzekas Museum of Lithuanian Culture Art

Gallery 349

Baseball 76

Bedford/St. Martin's 213 Benham Studio Gallery 350

Blend Images 269

Boeberitz Design, Bob 323

Briarpatch 79

Bridal Guides Magazine 79

Bynums Marketing and Communications, Inc. 325

Capitol Complex Exhibitions 353

Capstone Press 214

Caribbean Travel & Life 82

Center for Fine Art Photography, The 354

CEPA Gallery 355 Chess Life for Kids 85 Childhood Education 181 Children's Defense Fund 162

Chirp Magazine 85 Civitan Magazine 181 Cleary Gallery, John 357 Cleveland Magazine 87

Cobblestone 87

College PreView Magazine 88

Concord Litho 242 Conscience 90

Contemporary Arts Center (Cincinnati), The 358

Continental Newstime 90

Convergence 91

Crabtree Publishing Company 216

Creative Stock Images 274 Crossman Gallery 359

Dance 93

DDB Stock Photography, LLC 274

Dinodia Photo Library 275

DK Stock, Inc. 276 Dodo Graphics Inc. 243

DW Stock Picture Library (DWSPL) 277

Ecoscene 278

Edelstein Studio and Gallery, Paul 361

E & E Picture Library 277

Envision 278

ESL Teacher Today 185 Everson Museum of Art 363 Ewing Galloway Inc. 279

Fellowship 98

Focus New Zealand Photo Library Ltd. 282

Fotoscopio 283

Freeport Arts Center 364

Ghost Town 102

Grafica 328

Gryphon House 221

Hampton Design Group 329

Havu Gallery, William 368

Healing Lifestyles & Spas Magazine 106

Hearst Art Gallery, Saint Mary's College 369

Henry Street Settlement/Abrons Art Center 369

Herald Press 222

Home Education Magazine 108

Howard, Merrell and Partners, Inc. 329

Human Kinetics Publishers 222

Hutchison Picture Library 285

Hyperion Books for Children 223

Icebox Quality Framing & Gallery 370

Image Finders, The 286

Images.de Digital Photo GmbH 287

Immigrant Ancestors 110

Inmagine RF & RM Image Submissions (IRIS)

Inner Traditions/Bear & Company 223

International Visions Gallery 372

Jayawardene Travel Photo Library 290

Jeroboam 291

Jones Gallery, Stella 373

Journal of Adventist Education 190

Key Curriculum Press 224

Kiwanis Magazine 114

Kramer and Associates, Inc., Joan 292 Land of the Bible Photo Archive 268

Latitude Stock 292

Leepa-Rattner Museum of Art 374

Lehigh University Art Galleries 375

Lerner Publishing Group, Inc. 224

Liturgy Training Publications 225

Luckypix 294

Lutheran, The 118

Macalester Gallery 377

Markeim Art Center 378

Mesa Contemporary Arts at Mesa Arts Center 379

MGW Newsmagazine 119

Michael Murphy Gallery M 380

Milkweed Editions 227

Mitchell Lane Publishers, Inc. 227

Multiple Exposures Gallery 381

Museo ItaloAmericano 382

Museum of Contemporary Photography, Columbia College Chicago 383 Museum of Printing History 383

National Black Child Development Institute

333

National Geographic 122

Native Peoples Magazine 123

Nexus/Foundation for Today's Art 384

Northwestern University Dittmar Memorial

Gallery 385

Nova Media Inc. 246

Novastock 297

NOVUS 333

O.K. Harris Works of Art 386

Omni-Photo Communications 298

OnAsia 299

ONE 128

OnRequest Images 299

Outside Imagery 300

Owen Publishers, Inc., Richard C. 229

OWL Magazine 130

Pacific Stock/Printscapes.com 301

Painet Inc. 302

Photo Agora 304

PhotoEdit 304

Photo Network 306

PhotoSource International 307

PLANS, Ltd. (Photo Libraries and News

Services) 308

Portfolio Graphics, Inc. 247

Pucker Gallery 391

Quarto Publishing Plc. 231

Ranger Rick 137

Reading Today 200

Revolutionary War Tracks 138

Rigby Education 231

Saks Associates, Arnold 336

San Diego Art Institute's Museum of the Living

Artist 393

Sandlapper Magazine 141

Scholastic Library Publishing 232

Scholastic Magazines 142

School Administrator, The 203

Seventeen Magazine 143

SouthComm Publishing Company, Inc. 145

Sovfoto/Eastfoto, Inc. 312

Still Media 314

Stock Foundry Images 315

Stock Transparency Services/STSimages 317

Streetpeople's Weekly News 166

Sugar Daddy Photos 317

Sun, The 147

Synchronicity Fine Arts 396

Taube Museum of Art, Lillian & Coleman 396

Teldon 248

Tikkun 150

Tricycle Press 234

Tropix Photo Library 318

Tyndale House Publishers 234

Ullstein Bild 319

Unicorn Stock Photos 319

Upstream People Gallery 400

Viewfinders 320

Visual Arts Gallery 401

Washington County Museum of Fine Arts 402

Waveland Press, Inc. 235

Weigl Educational Publishers Limited 236

Whiskey Island Magazine 158

Women's Health Group 237

Zakin Gallery, Mikhail 404

Parents

Accent Alaska/Ken Graham Agency 255

Ace Stock Limited 256

Adirondack Lakes Center for the Arts 343

Advanced Graphics 239

Aflo Foto Agency 257

Age Fotostock 258

Alaska 69

Alaska Stock Images 259

Allyn & Bacon Publishers 212

amanaimages inc. 260

American Fitness 71

American Print Alliance 344

AppaLight 262

Archaeology 161

Argus Photo, Ltd. (APL) 263

Art Directors & Trip Photo Library 264

Art Without Walls, Inc. 348

Asia Images Group 266

Atlantic Gallery 349

Aurora Photos 266

Balzekas Museum of Lithuanian Culture Art

Gallery 349

Baseball 76

Blend Images 269

Blue Ridge Country 78

Boeberitz Design, Bob 323

Borealis Press, The 241

Bridal Guides Magazine 79.

Bynums Marketing and Communications, Inc. 325

Canada Lutheran 81

Capitol Complex Exhibitions 353

Center for Fine Art Photography, The 354

City Limits 86

Cleary Gallery, John 357 Cleveland Magazine 87

Comesana Agencia de Prensa/Banco

Fotográfico, Eduardo 273

Creative Stock Images 274

Dance 93

DDB Stock Photography, LLC 274

Design Conceptions (Joel Gordon

Photography) 275

Dinodia Photo Library 275

DK Stock, Inc. 276

Dodo Graphics Inc. 243

DW Stock Picture Library (DWSPL) 277

ESL Teacher Today 185 Farcountry Press 220 Flint Communications 327

Focus New Zealand Photo Library Ltd. 282

Foto-Press Timmermann 283

Ghost Town 102 Gospel Herald 103 Grafica 328

Home Education Magazine 108

Howard, Merrell and Partners, Inc. 329

Hutchison Picture Library 285

Illogical Muse 110

Images.de Digital Photo GmbH 287

Immigrant Ancestors 110

Inmagine RF & RM Image Submissions (IRIS)

Inner Traditions/Bear & Company 223

Isopix 289 Jeroboam 291

Journal of Adventist Education 190

Key Curriculum Press 224 Kiwanis Magazine 114

Kramer and Associates, Inc., Joan 292 Leepa-Rattner Museum of Art 374

Lutheran, The 118 Markeim Art Center 378 MAXX Images, Inc. 294 Megapress Images 295

Mesa Contemporary Arts at Mesa Arts Center 379

Michael Murphy Gallery M 380

Motoring & Leisure 121

Museo De Arte De Ponce 382

Museo ItaloAmericano 382

Museum of Contemporary Photography,

Columbia College Chicago 383

Na'amat Woman 122

Native Peoples Magazine 123

Northwestern University Dittmar Memorial

Gallery 385 Novastock 297 NOVUS 333 Okapia K.G. 298 OnAsia 299

OnRequest Images 299

Opcao Brasil Imagens 300

Pacific Stock/Printscapes.com 301

Painet Inc. 302 Pakn Treger 131 Photo Agora 304 Photo Network 306

PhotoSource International 307 Portfolio Graphics, Inc. 247 Ralls Collection Inc., The 392

Reading Today 200

Revolutionary War Tracks 138

Rigby Education 231

Saks Associates, Arnold 336

San Diego Art Institute's Museum of the Living

Artist 393

Sandlapper Magazine 141

Scholastic Library Publishing 232

School Administrator, The 203

Sea 142

SouthComm Publishing Company, Inc. 145

Stock Foundry Images 315

Stock Transparency Services/STSimages 317

Streetpeople's Weekly News 166

Sugar Daddy Photos 317

Sun, The 147

Taube Museum of Art, Lillian & Coleman 396

Teldon 248

Tyndale House Publishers 234

Ullstein Bild 319

Unicorn Stock Photos 319 Upstream People Gallery 400

Visitor's Choice Magazine 234

Visual Arts Center of Northwest Florida 401 Washington County Museum of Fine Arts 402 Women's Health Group 237

Performing Arts

Accent Alaska/Ken Graham Agency 255 Adirondack Lakes Center for the Arts 343

Aflo Foto Agency 257

After Five 68

Age Fotostock 258

amanaimages inc. 260

American Fitness 71

American Print Alliance 344

Animal Trails 73

Aquarius 161

Art Directors & Trip Photo Library 264

Artwerks Stock Photography 265

Art Without Walls, Inc. 348

Atlantic Gallery 349

Balzekas Museum of Lithuanian Culture Art

Gallery 349

Bedford/St. Martin's 213

Boeberitz Design, Bob 323

Brainworks Design Group 324

Bridal Guides Magazine 79

Business NH Magazine 179

Business of Art Center 353

Bynums Marketing and Communications, Inc.

325

Camera Press Ltd. 270

Capitol Complex Exhibitions 353

Center for Fine Art Photography, The 354

Clampart 356

Classical Singer 182

Cleary Gallery, John 357

Cleveland Magazine 87

Comesana Agencia de Prensa/Banco

Fotográfico, Eduardo 273

Continental Newstime 90

Creative Stock Images 274

Dance 93

DDB Stock Photography, LLC 274

Dinodia Photo Library 275

DK Stock, Inc. 276

Dodo Graphics Inc. 243

Down Beat Magazine 95

ECW Press 219

eMediaLoft.org 361

Fahey/Klein Gallery 363

Famous Pictures & Features Agency 280

Flaunt Magazine 99

Focus New Zealand Photo Library Ltd. 282

Freefall Review 100

Freeport Arts Center 364

Ft. Myers Magazine 100

Grafica 328

Guitar World 105

Hamilton Magazine 105

Horizons Magazine 108

Human Kinetics Publishers 222

Illogical Muse 110

International Photo News 288

Iowan Magazine, The 112

Jeroboam 291

Key Curriculum Press 224

KNOWAtlanta 115

Kramer and Associates, Inc., Joan 292

Leepa-Rattner Museum of Art 374

Leopold Gallery 375

Limited Editions & Collectibles 376

Lizardi/Harp Gallery 376

Markeim Art Center 378

Mesa Contemporary Arts at Mesa Arts Center

Mitchell Lane Publishers, Inc. 227

Monderer Design 332

Museo ItaloAmericano 382

Museum of Contemporary Photography,

Columbia College Chicago 383

Music & Arts Pictures at Lebrecht 297

Music Sales Group 228

Native Peoples Magazine 123

New York Times on the Web, The 165

Nexus/Foundation for Today's Art 384

Northwestern University Dittmar Memorial

Gallery 385

NOVUS 333

Now & Then 127

Oklahoma Today 127

OnAsia 299

Painet Inc. 302

PhotoSource International 307

Pitcher Photo Library, Sylvia 307

Pix International 308

Planet 134

Portfolio Graphics, Inc. 247

Posey School 334

Quarto Publishing Plc. 231

Ralls Collection Inc., The 392 Rhode Island Monthly 138 Rolling Stone 139 Running Press Book Publishers 232 Saks Associates, Arnold 336 San Diego Art Institute's Museum of the Living Artist 393 Sandlapper Magazine 141 Scholastic Library Publishing 232 Soundlight 337 SouthComm Publishing Company, Inc. 145 Southside Gallery 394 Stock Foundry Images 315 Stock Transparency Services/STSimages 317 Sugar Daddy Photos 317 Sun.Ergos 338 Syracuse New Times 167 Tide-Mark Press 249 Tricycle Press 234 Ullstein Bild 319 Up Here 155 Upstream People Gallery 400

Washington County Museum of Fine Arts 402

Weigl Educational Publishers Limited 236

Pets

Viewfinders 320

Accent Alaska/Ken Graham Agency 255 Ace Stock Limited 256 Adirondack Lakes Center for the Arts 343 A+E 256 Aflo Foto Agency 257 Age Fotostock 258 Alaska Stock Images 259 amanaimages inc. 260 American Print Alliance 344 Animals Animals/Earth Scenes 261 Animal Sheltering 173 Animal Trails 73 AppaLight 262 Appaloosa Journal 174 Aguarium Fish International 74 Archaeology 161 Art Directors & Trip Photo Library 264 Art Without Walls, Inc. 348 Auscape International 267 Avanti Press Inc. 240 Balzekas Museum of Lithuanian Culture Art Gallery 349

Boeberitz Design, Bob 323 Bridal Guides Magazine 79 Capstone Press 214 Cat Fancy 83 Charlton Photos, Inc. 272 Cleary Gallery, John 357 Concord Litho 242 Creative Company, The 217 Creative Stock Images 274 Current, Inc. 243 Dance 93 Dinodia Photo Library 275 Dodo Graphics Inc. 243 Dog Fancy 94 Dogs in Canada 95 DW Stock Picture Library (DWSPL) 277 Farnam Companies, Inc. 326 Fotoscopio 283 Gallant Greetings Corp. 244 Ghost Town 102 Grafica 328 Grit Magazine 104 Haddad Gallery, Carrie 3.68 Hampton Design Group 329 Heilman Photography, Inc., Grant 285 Horse Illustrated 109 Ideals Magazine 109 Illogical Muse 110 Image Finders, The 286 Intercontinental Greetings LTD. 244 Jeroboam 291 Jillson & Roberts 245 Jude Studios 330 Kimball Stock 291 Kramer and Associates, Inc., Joan 292 Leepa-Rattner Museum of Art 374 Lerner Publishing Group, Inc. 224 Megapress Images 295 Michael Murphy Gallery M 380 Mushing.com Magazine 121 NOVUS 333 Okapia K.G. 298 OnRequest Images 299 Owen Publishers, Inc., Richard C. 229 Oxford Scientific (OSF) 301 Painet Inc. 302 Paper Products Design 246

Pet Product News 195

Photo Agora 304 Photo Network 306 Portfolio Graphics, Inc. 247

Positive Images (Stock Photography & Gallery 61) 309

Quarto Publishing Plc. 231 Ralls Collection Inc., The 392 Recycled Paper Greetings, Inc. 247

Rigby Education 231

San Diego Art Institute's Museum of the Living Artist 393

Sandlapper Magazine 141 Santoro Graphics Ltd. 248 Scholastic Library Publishing 232

Soundlight 337

SouthComm Publishing Company, Inc. 145

Stock Foundry Images 315

Stock Transparency Services/STSimages 317

Streetpeople's Weekly News 166

Sugar Daddy Photos 317

Sun 166

Tide-Mark Press 249 Ullstein Bild 319

Unicorn Stock Photos 319

Upstream People Gallery 400

Washington County Museum of Fine Arts 402

Whiskey Island Magazine 158

Willow Creek Press 236

Zolan Company, LLC, The 250

Political

Aflo Foto Agency 257 Age Fotostock 258

AIM 68

amanaimages inc. 260

American Print Alliance 344

Andes Press Agency 261

AppaLight 262

Archaeology 161

Art Directors & Trip Photo Library 264

Art Without Walls, Inc. 348

Asian Enterprise Magazine 175

Aurora Photos 266

Balzekas Museum of Lithuanian Culture Art

Gallery 349

Bear Deluxe Magazine, The 77

Bedford/St. Martin's 213

Briarpatch 79

Camera Press Ltd. 270

Capital Pictures 271

Catholic News Service 272

Catholic Sentinel 162

Center for Fine Art Photography, The 354

Church of England Newspaper, The 163

City Limits 86

Cleary Gallery, John 357

Cleveland Magazine 87

Comesana Agencia de Prensa/Banco

Fotográfico, Eduardo 273

Continental Newstime 90

Creative Stock Images 274

DDB Stock Photography, LLC 274

Dinodia Photo Library 275

DK Stock, Inc. 276

Dodo Graphics Inc. 243

ESL Teacher Today 185

E/The Environmental Magazine 97

Fellowship 98

Flint Communications 327

Geoslides & Geo Aerial Photography 284

Ghost Town 102

Government Technology 187

Grafica 328

Harper's Magazine 106

Hutchison Picture Library 285

Image Finders, The 286

Images.de Digital Photo GmbH 287

Immigrant Ancestors 110

International Photo News 288

Jeroboam 291

Judicature 190

Kramer and Associates, Inc., Joan 292

Leepa-Rattner Museum of Art 374

Lerner Publishing Group, Inc. 224

Light Factory, The 376

Lineair Fotoarchief, B.V. 293

Mesa Contemporary Arts at Mesa Arts Center

MGW Newsmagazine 119

Michael Murphy Gallery M 380

Museum of Contemporary Photography,

Columbia College Chicago 383

Naval History 193

New York Times on the Web, The 165

Nexus/Foundation for Today's Art 384

Nova Media Inc. 246

NOVUS 333

Now & Then 127

OnAsia 299 Painet Inc. 302 Photo Network 306

Planet 134

Portfolio Graphics, Inc. 247

Proceedings 198 Progressive, The 137 Reform Judaism 138

Revolutionary War Tracks 138

Rolling Stone 139

San Diego Art Institute's Museum of the Living Artist 393

Scholastic Library Publishing 232

SouthComm Publishing Company, Inc. 145

Southside Gallery 394 Stock Foundry Images 315

Stock Transparency Services/STSimages 317

Streetpeople's Weekly News 166

Sugar Daddy Photos 317

Sun, The 147

Synchronicity Fine Arts 396

Tikkun 150 **TIME 150**

Toward Freedom 151 Ullstein Bild 319

Upstream People Gallery 400

Washington County Museum of Fine Arts 402

Waveland Press, Inc. 235

Weigl Educational Publishers Limited 236

Whiskey Island Magazine 158 Zakin Gallery, Mikhail 404

Product Shots/Still Life

Accent Alaska/Ken Graham Agency 255

Ace Stock Limited 256 Aflo Foto Agency 257

Aftermarket Business World 171

Age Fotostock 258 amanaimages inc. 260 American Fitness 71

American Print Alliance 344

Animal Trails 73 Archaeology 161

Art Directors & Trip Photo Library 264

Artwerks Stock Photography 265 Art Without Walls, Inc. 348

Atlanta Homes & Lifestyles 75

Atlantic Gallery 349

Balzekas Museum of Lithuanian Culture Art Gallery 349

Barnett Advertising/Design, Augustus 323

Bedford/St. Martin's 213

BedTimes 177

Belian Art Center 350

Berson, Dean, Stevens Inc. 323

Beverage Dynamics 178

Boeberitz Design, Bob 323

Bragaw Public Relations Services 324

Brewers Association 214

Bristol Gift Co., Inc. 241

Bynums Marketing and Communications, Inc. 325

Caribbean Travel & Life 82 Carmichael-Lynch, Inc. 325

Chef 180

Cleary Gallery, John 357 Cleveland Magazine 87

Convenience Store Decisions 182

Creative Homeowner 217 Creative Stock Images 274

Current, Inc. 243

Dance 93

Dinodia Photo Library 275

DM News 184

Dodo Graphics Inc. 243

Edelstein Studio and Callery, Paul 361

Entrepreneur 96 Envision 278

ESL Teacher Today 185

Event 97

Fahey/Klein Gallery 363 Flint Communications 327

Fotoscopio 283 Freefall Review 100 Ft. Myers Magazine 100 Gallant Greetings Corp. 244

Gallery West 367

Geoslides & Geo Aerial Photography 284

Ghost Town 102 Grafica 328

Haddad Gallery, Carrie 368

Healing Lifestyles & Spas Magazine 106

Hearth and Home 188

Human Kinetics Publishers 222 Hutchinson Associates, Inc. 330

Ideals Magazine 109 IEEE Spectrum 189

IGA Grocergram 189 Immigrant Ancestors 110

Intercontinental Greetings LTD. 244

Jude Studios 330

Juvenile Diabetes Research Foundation International 113

Kashrus Magazine 114

Kramer and Associates, Inc., Joan 292

Leepa-Rattner Museum of Art 374

Levin Group, The Bruce 462

Markeim Art Center 378

Marketing & Technology Group 192

McGaw Graphics, Inc. 245

Medical File Inc., The 295

Megapress Images 295

Metrosource Magazine 119

Michael Murphy Gallery M 380

Modernart Editions 245

Monderer Design 332

Mullin/Ashley Associate 332

Museo ItaloAmericano 382

My Foodservice News 192

Nails Magazine 193

NewDesign Magazine 194

New York Times on the Web, The 165

NOVUS 333

Painet Inc. 302

Pet Product News 195

PhotoSource International 307

Pilot Getaways 195

Popular Photography & Imaging 135

Portfolio Graphics, Inc. 247

Positive Images (Stock Photography & Gallery

61) 309

QSR 199

Quarto Publishing Plc. 231

Quick Frozen Foods International 199

Ralls Collection Inc., The 392

Restaurant Hospitality 202

Revolutionary War Tracks 138

Saks Associates, Arnold 336

San Diego Art Institute's Museum of the Living

Artist 393

Sandlapper Magazine 141

Schmidt Design, Henry 336

Scholastic Library Publishing 232

SouthComm Publishing Company, Inc. 145

Stock Foundry Images 315

Stock Transparency Services/STSimages 317

Sugar Daddy Photos 317

Upstream People Gallery 400

Vermont Life 155

Vermont Magazine 156

Visual Arts Center of Northwest Florida 401

Warne Marketing & Communications 339

Washington County Museum of Fine Arts 402

WaveLength Magazine 157

White Productions, Dana 339

Woodshop News 209

World Tobacco 209

Writer's Digest 158

Zahn & Associates, Spencer 340

Zakin Gallery, Mikhail 404

Regional

Gallery West 367

Religions various

Macalester Gallery 377

Religious

Accent Alaska/Ken Graham Agency 255

Adirondack Lakes Center for the Arts 343

Aflo Foto Agency 257

Age Fotostock 258

AKM Images, Inc. 258

amanaimages inc. 260

American Print Alliance 344

Ancient Art & Architecture Collection, Ltd.,

The 261

Andes Press Agency 261

Animal Trails 73

AppaLight 262

Aquarius 161

Archaeology 161

Archivo Criollo 263

ArkReligion.com 264

Art Directors & Trip Photo Library 264

Balzekas Museum of Lithuanian Culture Art

Gallery 349

Benham Studio Gallery 350

Bridal Guides Magazine 79

Bristol Gift Co., Inc. 241

Bynums Marketing and Communications, Inc.

325

Canada Lutheran 81

Catholic News Service 272

Catholic Sentinel 162

Charisma Magazine 83

Church of England Newspaper, The 163

Civitan Magazine 181 Cleary Gallery, John 357

Company Magazine 88

Concord Litho 242 Conscience 90

Creative Stock Images 274

Dance 93

DDB Stock Photography, LLC 274

Dinodia Photo Library 275 Dodo Graphics Inc. 243 E & E Picture Library 277

ESL Teacher Today 185

Fellowship 98 Fotoscopio 283

Gallant Greetings Corp. 244

Gallery West 367 Ghost Town 102 Gospel Herald 103

Grafica 328 Guideposts 104

Hadassah Magazine 105 Hampton Design Group 329 Havu Gallery, William 368

Hearst Art Gallery, Saint Mary's College 369

Herald Press 222

Hutchison Picture Library 285

Illogical Muse 110

Immigrant Ancestors 110

Inner Traditions/Bear & Company 223

Insight Magazine 111

Isopix 289 Jeroboam 291 Jewish Action 112

Jones Gallery, Stella 373

Journal of Adventist Education 190

Kashrus Magazine 114

Kramer and Associates, Inc., Joan 292 Land of the Bible Photo Archive 268

Latitude Stock 292

Leepa-Rattner Museum of Art 374

Lineair Fotoarchief, B.V. 293

Liturgy Training Publications 225

Lizardi/Harp Gallery 376

Lutheran, The 118

Megapress Images 295

Michael Murphy Gallery M 380

Multiple Exposures Gallery 381

Museo ItaloAmericano 382

Na'amat Woman 122

New Leaf Press, Inc. 228

Nova Media Inc. 246

NOVUS 333

Omni-Photo Communications 298

OnAsia 299 ONE 128

Painet Inc. 302 Pakn Treger 131

Paulist Press 230

Photo Agora 304 Photo Network 306

Ponkawonka Inc. 308

Portfolio Graphics, Inc. 247

Pucker Gallery 391

Quarto Publishing Plc. 231

Reform Judaism 138

Revolutionary War Tracks 138 Sandlapper Magazine 141

Scholastic Library Publishing 232

Soundlight 337

SouthComm Publishing Company, Inc. 145

Stock Foundry Images 315

Stock Transparency Services/STSimages 317

Streetpeople's Weekly News 166

Sugar Daddy Photos 317

Sun. The 147

Tide-Mark Press 249 Tropix Photo Library 318

Tyndale House Publishers 234

Ullstein Bild 319

Unicorn Stock Photos 319 Upstream People Gallery 400

Washington County Museum of Fine Arts 402

Waveland Press, Inc. 235

Weigl Educational Publishers Limited 236

Whiskey Island Magazine 158

Rural

Accent Alaska/Ken Graham Agency 255 Adirondack Lakes Center for the Arts 343

Aflo Foto Agency 257

After Five 68

Age Fotostock 258

AKM Images, Inc. 258

Alabama Living 69

amanaimages inc. 260 American Fitness 71

American Print Alliance 344 Andes Press Agency 261

Animal Trails 73

Ant Photo Library 262

AppaLight 262

Archaeology 161 Archivo Criollo 263

Art Directors & Trip Photo Library 264

Arts Iowa City 347 Art Source L.A., Inc. 348

Art Without Walls, Inc. 348

Atlantic Gallery 349
Aurora Photos 266

Balzekas Museum of Lithuanian Culture Art

Gallery 349 Beef Today 178

Belian Art Center 350

Benham Studio Gallery 350 Bentley Publishing Group 240

Boeberitz Design, Bob 323

Bon Artique.com/Art Resources Int., Ltd. 241

Bridal Guides Magazine 79 Business NH Magazine 179 Business of Art Center 353

California Views/Mr. Pat Hathaway Historical

Photo Collection 270

Capstone Press 214 Carmichael-Lynch, Inc. 325

Center for Fine Art Photography, The 354

Cleary Gallery, John 357 Concord Litho 242

Corporate Art Source/CAS Gallery 358

Countryman Press, The 216

Country Woman 91

Creative Company, The 217 Creative Homeowner 217 Creative Stock Images 274

Current, Inc. 243

Dance 93

DDB Stock Photography, LLC 274

Dinodia Photo Library 275 Dodo Graphics Inc. 243

DW Stock Picture Library (DWSPL) 277

Ecoscene 278

ESL Teacher Today 185 Farnam Companies, Inc. 326 Flint Communications 327 Focus New Zealand Photo Library Ltd. 282

France Magazine 100
Freefall Review 100
Freeport Arts Center 364
Gallery 110 Collective 365
Gallery Luisotti 366
Gallery West 367

Geoslides & Geo Aerial Photography 284

Ghost Town 102 Grafica 328 Grit Magazine 104

Haddad Gallery, Carrie 368 Havu Gallery, William 368

Heilman Photography, Inc., Grant 285

Hemphill 369

Henry Street Settlement/Abrons Art Center

369

Horizons Magazine 108 Hutchison Picture Library 285 Icebox Quality Framing & Gallery 370

Illogical Muse 110
Immigrant Ancestors 110

Iowan Magazine, The 112 ITE Journal 189 Jeroboam 291

Jones Gallery, Stella 373

Kansas! 113

Kashrus Magazine 114 Key Curriculum Press 224

Kramer and Associates, Inc., Joan 292

Latitude Stock 292

Leepa-Rattner Museum of Art 374 Lehigh University Art Galleries 375

Leopold Gallery 375

Lerner Publishing Group, Inc. 224

Macalester Gallery 377 Markeim Art Center 378 McGaw Graphics, Inc. 245

Mesa Contemporary Arts at Mesa Arts Center

379

Michael Murphy Gallery M 380 Multiple Exposures Gallery 381 Museo ItaloAmericano 382

Museum of Contemporary Photography, Columbia College Chicago 383

Museum of Printing History 383

Nexus/Foundation for Today's Art 384 Northern Woodlands 125

Nova Media Inc. 246

Novastock 297 NOVUS 333 Now & Then 127

O.K. Harris Works of Art 386

Omni-Photo Communications 298

OnAsia 299

OnRequest Images 299 Outside Imagery 300

Oxford Scientific (OSF) 301

Painet Inc. 302

Panoramic Images 303

Persimmon Hill Magazine 132

Photo Agora 304

Photo Network 306 PI Creative Art 247

Pitcher Photo Library, Sylvia 307

Portfolio Graphics, Inc. 247

Pucker Gallery 391

Ralls Collection Inc., The 392 Revolutionary War Tracks 138

Running Press Book Publishers 232

Rural Heritage 140

San Diego Art Institute's Museum of the Living Artist 393

Sandlapper Magazine 141

Scholastic Library Publishing 232

SouthComm Publishing Company, Inc. 145

Southside Gallery 394 State Street Gallery 395 Stock Foundry Images 315

Stock Transparency Services/STSimages 317

Streetpeople's Weekly News 166

Sugar Daddy Photos 317

Sun, The 147

Synchronicity Fine Arts 396

Taube Museum of Art, Lillian & Coleman 396

Teldon 248

Throckmorton Fine Art 397

Touchstone Gallery 398

Tyndale House Publishers 234

Ullstein Bild 319

Unicorn Stock Photos 319

Up and Under 155

Vermont Life 155

Vovageur Press 235

Washington County Museum of Fine Arts 402

Waveland Press, Inc. 235

Weigl Educational Publishers Limited 236

Western Producer, The 169

Whiskey Island Magazine 158 WRITERS' Journal 209

Zakin Gallery, Mikhail 404

Zolan Company, LLC, The 250

Science

Accent Alaska/Ken Graham Agency 255

Ace Stock Limited 256

Aflo Foto Agency 257

Age Fotostock 258

Allyn & Bacon Publishers 212

amanaimages inc. 260

American Fitness 71

American Print Alliance 344

Anthro-Photo File 262

AppaLight 262

Archaeology 161

Art Directors & Trip Photo Library 264

Art@Net International Gallery 346

Artwerks Stock Photography 265

Art Without Walls, Inc. 348

Asia Images Group 266

Astronomy 75

Aurora Photos 266

Balzekas Museum of Lithuanian Culture Art

Gallery 349

Bergman Collection, The 268

Biological Photo Service and

Terraphotographics 268

Boeberitz Design, Bob 323

Brainworks Design Group 324

Brewers Association 214

BSIP 270

Business NH Magazine 179

Bynums Marketing and Communications, Inc.

325

Camera Press Ltd. 270

Chatham Press 215

Clampart 356

Cleary Gallery, John 357

College PreView Magazine 88

Comesana Agencia de Prensa/Banco

Fotográfico, Eduardo 273

Continental Newstime 90

Creative Company, The 217

Creative Stock Images 274

DDB Stock Photography, LLC 274

Design Conceptions (Joel Gordon

Photography) 275

Dinodia Photo Library 275

DK Stock, Inc. 276

Dodo Graphics Inc. 243

Ecoscene 278

ESL Teacher Today 185

Flint Communications 327

Focus New Zealand Photo Library Ltd. 282

Freefall Review 100

Fundamental Photographs 284

Gallery Luisotti 366

Geoslides & Geo Aerial Photography 284

Ghost Town 102

Grafica 328

Hampton Design Group 329

Heilman Photography, Inc., Grant 285

HOLT McDougal 222

Hutchison Picture Library 285

IEEE Spectrum 189

Images.de Digital Photo GmbH 287

Immigrant Ancestors 110

Isopix 289

Jeroboam 291

Juvenile Diabetes Research Foundation

International 113

Key Curriculum Press 224

Kiwanis Magazine 114

Kramer and Associates, Inc., Joan 292

Leepa-Rattner Museum of Art 374

Lerner Publishing Group, Inc. 224

Lineair Fotoarchief, B.V. 293

Manufacturing Automation & Advanced

Manufacturing 191

Mattei Photography, Michele 379

Medical File Inc., The 295

Medical On Line Ltd. 295

Megapress Images 295

Mesa Contemporary Arts at Mesa Arts Center

379

Michael Murphy Gallery M 380

Mitchell Lane Publishers, Inc. 227

Monderer Design 332

Museum of Contemporary Photography,

Columbia College Chicago 383

Museum of Northern Arizona 227

New York Times on the Web, The 165

Northern Woodlands 125

Novastock 297

NOVUS 333

Okapia K.G. 298

OnAsia 299

OnRequest Images 299

Owen Publishers, Inc., Richard C. 229

OWL Magazine 130

Oxford Scientific (OSF) 301

Painet Inc. 302

Panoramic Images 303

Photo Agora 304

Photo Network 306

Photo Researchers, Inc. 306

PhotoSource International 307

Planet 134

Plastics Technology 197

Portfolio Graphics, Inc. 247

Quarto Publishing Plc. 231

Ranger Rick 137

Revolutionary War Tracks 138

Saks Associates, Arnold 336

San Diego Art Institute's Museum of the Living

Artist 393

Sandlapper Magazine 141

Scholastic Library Publishing 232

Scholastic Magazines 142

Science Photo Library, Ltd. 311

Soundlight 337

SouthComm Publishing Company, Inc. 145

Stack & Associates, Inc., Tom 313

Stock Foundry Images 315

Stock Transparency Services/STSimages 317

Sugar Daddy Photos 317

Tricycle Press 234

Ullstein Bild 319

Viewfinders 320

Warne Marketing & Communications 339

Washington County Museum of Fine Arts 402

Water Well Journal 207

Weigl Educational Publishers Limited 236

Western Producer, The 169

Whiskey Island Magazine 158

Seasonal

Accent Alaska/Ken Graham Agency 255

Ace Stock Limited 256

Adirondack Lakes Center for the Arts 343

Advanced Graphics 239

Aerial Photography Services 211

Aflo Foto Agency 257

Age Fotostock 258

Alaska Stock Images 259 amanaimages inc. 260 American Bee Journal 173 American Fitness 71 American Print Alliance 344

Animal Trails 73 AppaLight 262 Appaloosa Journal 174

Archaeology 161

Art Directors & Trip Photo Library 264 Art@Net International Gallery 346

Art Source L.A., Inc. 348 Art Without Walls, Inc. 348 Avanti Press Inc. 240

Balzekas Museum of Lithuanian Culture Art Gallery 349

Baseball 76

Blue Ridge Country 78 Blue Sky Publishing 240 Boeberitz Design, Bob 323 Borealis Press, The 241 Bridal Guides Magazine 79 Bristol Gift Co., Inc. 241

Bynums Marketing and Communications, Inc. 325

Canada Lutheran 81 Capper's 162 Capstone Press 214 Caribbean Travel & Life 82 Catholic Sentinel 162 Centric Corporation 242 Chirp Magazine 85 Cleveland Magazine 87

Comstock Cards 242 Concord Litho 242 Conscience 90

Continental Newstime 90 Countryman Press, The 216

Country Woman 91

Creative Stock Images 274

Current, Inc. 243 Dance 93

Design Design, Inc. 243 Dinodia Photo Library 275 Dodo Graphics Inc. 243

Down The Shore Publishing Corp. 218

E & E Picture Library 277 ESL Teacher Today 185

Event 97

Farcountry Press 220 Flint Communications 327

Focus New Zealand Photo Library Ltd. 282

Foto-Press Timmermann 283 Gallant Greetings Corp. 244

Gallery West 367 Ghost Town 102 Gospel Herald 103 Grafica 328 Grit Magazine 104

Hampton Design Group 329

Heilman Photography, Inc., Grant 285

Horizons Magazine 108 Hunger Mountain 109

Hutchison Picture Library 285

Ideals Magazine 109 Illogical Muse 110 Image Finders, The 286 Immigrant Ancestors 110 Impact Photographics 244 Indianapolis Monthly 110

Intercontinental Greetings LTD. 244

Iowan Magazine, The 112

Isopix 289 Jeroboam 291 Jillson & Roberts 245 Kansas! 113

Kashrus Magazine 114 Kimball Stock 291

Kramer and Associates, Inc., Joan 292 Leepa-Rattner Museum of Art 374 Limited Editions & Collectibles 376

Lutheran, The 118 Markeim Art Center 378

Mesa Contemporary Arts at Mesa Arts Center

Metrosource Magazine 119 Michael Murphy Gallery M 380 Michigan Out-of-Doors 119 Modernart Editions 245 Monderer Design 332 Motoring & Leisure 121 Mushing.com Magazine 121

Na'amat Woman 122

Northern Woodlands 125

Northwestern University Dittmar Memorial

Gallery 385

Northwest Travel Magazine 126

Nova Media Inc. 246

NOVUS 333 OnAsia 299

OnRequest Images 299

OWL Magazine 130 Oxford Scientific (OSF) 301

Pacific Yachting Magazine 131

Painet Inc. 302

Panoramic Images 303

Paper Products Design 246

Persimmon Hill Magazine 132

Pet Product News 195

PhotoSource International 307

PI Creative Art 247

Portfolio Graphics, Inc. 247

Pucker Gallery 391

Recycled Paper Greetings, Inc. 247

Revolutionary War Tracks 138

Rhode Island Monthly 138

Running Press Book Publishers 232

San Diego Art Institute's Museum of the Living

Artist 393

Sandlapper Magazine 141

Scholastic Library Publishing 232

Seattle Homes & Lifestyles 142

SouthComm Publishing Company, Inc. 145

Stock Foundry Images 315

Stock Transparency Services/STSimages 317

Streetpeople's Weekly News 166

Sugar Daddy Photos 317

Syracuse New Times 167

Texas Highways 148

Trails Media Group 250

Ullstein Bild 319

Unicorn Stock Photos 319

Up Here 155

Upstream People Gallery 400

Vermont Life 155

Visual Arts Center of Northwest Florida 401

Voyageur Press 235

Washington County Museum of Fine Arts 402

Weigl Educational Publishers Limited 236

Whiskey Island Magazine 158

Zolan Company, LLC, The 250

Senior Citizens

Accent Alaska/Ken Graham Agency 255

Ace Stock Limited 256

Adirondack Lakes Center for the Arts 343

Advanced Graphics 239

Aflo Foto Agency 257

Age Fotostock 258

Alaska 69

Alaska Stock Images 259

Allyn & Bacon Publishers 212

amanaimages inc. 260

American Fitness 71

American Print Alliance 344

Andes Press Agency 261

AppaLight 262

Art Directors & Trip Photo Library 264

Art Without Walls, Inc. 348

Asia Images Group 266

Asian Enterprise Magazine 175

Aurora Photos 266

Balzekas Museum of Lithuanian Culture Art

Gallery 349

Blend Images 269

Blue Ridge Country 78

Boeberitz Design, Bob 323

Borealis Press, The 241

Bynums Marketing and Communications, Inc.

325

Canada Lutheran 81

Capitol Complex Exhibitions 353

Catholic News Service 272

Center for Fine Art Photography, The 354

Chess Life for Kids 85

City Limits 86

Cleary Gallery, John 357

Cleveland Magazine 87

Creative Stock Images 274

Dance 93

DDB Stock Photography, LLC 274

Design Conceptions (Joel Gordon

Photography) 275

Dinodia Photo Library 275

DK Stock, Inc. 276

Dockery House Publishing, Inc. 218

Dodo Graphics Inc. 243

DW Stock Picture Library (DWSPL) 277

Family Motor Coaching 98

Farcountry Press 220

Flint Communications 327

Focus New Zealand Photo Library Ltd. 282

Foto-Press Timmermann 283

Fotoscopio 283

Freefall Review 100

Freeport Arts Center 364

Grafica 328

Hampton Design Group 329

Herald Press 222

Highways 107

Home Education Magazine 108

Howard, Merrell and Partners, Inc. 329

Hutchison Picture Library 285

Illogical Muse 110

Image Finders, The 286

Images.de Digital Photo GmbH 287

Isopix 289

Jeroboam 291

Jude Studios 330

Key Curriculum Press 224

Kiwanis Magazine 114

Kramer and Associates, Inc., Joan 292

Leepa-Rattner Museum of Art 374

Living Free 116

Lutheran, The 118

Markeim Art Center 378

MAXX Images, Inc. 294

Medical On Line Ltd. 295

Megapress Images 295

Mesa Contemporary Arts at Mesa Arts Center 379

Michael Murphy Gallery M 380

Museo ItaloAmericano 382

Museum of Contemporary Photography,

Columbia College Chicago 383

Na'amat Woman 122

Native Peoples Magazine 123

Novastock 297

NOVUS 333

Okapia K.G. 298

Omni-Photo Communications 298

Outside Imagery 300

Pacific Stock/Printscapes.com 301

Painet Inc. 302

Photo Agora 304

PhotoEdit 304

Photo Network 306

Photo Researchers, Inc. 306

PhotoSource International 307

Portfolio Graphics, Inc. 247

Saks Associates, Arnold 336

San Diego Art Institute's Museum of the Living

Artist 393

Sandlapper Magazine 141

Santoro Graphics Ltd. 248

Scholastic Library Publishing 232

SouthComm Publishing Company, Inc. 145

Stock Foundry Images 315

Stock Transparency Services/STSimages 317

Strang Communications Company 233

Streetpeople's Weekly News 166

Sugar Daddy Photos 317

Sun, The 147

Taube Museum of Art, Lillian & Coleman 396

Teldon 248

Tyndale House Publishers 234

Ullstein Bild 319

Unicorn Stock Photos 319

Upstream People Gallery 400

Viewfinders 320

Visitor's Choice Magazine 234

Visual Arts Center of Northwest Florida 401

Washington County Museum of Fine Arts 402

Women's Health Group 237

Spirituality/Inspirational

Sportslight Photo 312

Sports

540 Rider 67

AAP News 171

Accent Alaska/Ken Graham Agency 255

Ace Stock Limited 256

Adirondack Lakes Center for the Arts 343

Adventure Cyclist 67

Aflo Foto Agency 257

African American Golfer's Digest 67

After Five 68

Age Fotostock 258

amanaimages inc. 260

AMC Outdoors 70

American Fitness 71

American Hunter 72

American Power Boat Association 173

American Print Alliance 344

American Sports Network 161

American Turf Monthly 72

Appalachian Mountain Club Books 212

Appaloosa Journal 174

Archaeology 161

Argus Photo, Ltd. (APL) 263

Arizona Wildlife Views 74

Art Directors & Trip Photo Library 264

Art@Net International Gallery 346

Artwerks Stock Photography 265

Art Without Walls, Inc. 348

Athletic Business 175

Athletic Management 176

Aurora Photos 266

Balzekas Museum of Lithuanian Culture Art

Gallery 349

Baseball 76

BC Outdoors 76

Bennett Galleries and Company 351

Boeberitz Design, Bob 323

Bon Artique.com/Art Resources Int., Ltd. 241

Bowhunter 79

Brainworks Design Group 324

Bynums Marketing and Communications, Inc.

325

Camera Press Ltd. 270

Canoe & Kayak 82

Capstone Press 214

Caribbean Travel & Life 82

Chronicle of the Horse, The 85

Clarion-Ledger, The 163

Cleveland Magazine 87

Continental Newstime 90

Countryman Press, The 216

Crabtree Publishing Company 216

Creative Company, The 217

Creative Stock Images 274

Cruising World 92

Cycle California! Magazine 92

Dakota Outdoors 93

Deer & Deer Hunting 93

Dinodia Photo Library 275

DK Stock, Inc. 276

Dodo Graphics Inc. 243

Drake Magazine, The 95

ECW Press 219

Elks Magazine, The 96

Empics 278

ESL Teacher Today 185

Fahey/Klein Gallery 363

Flint Communications 327

Fly Rod & Reel 99

Focus New Zealand Photo Library Ltd. 282

Fotoscopio 283

Ft. Myers Magazine 100

Gallant Greetings Corp. 244

Gallery 110 Collective 365

Game & Fish Magazines 101

Ghost Town 102

Golf Tips 103

Grafica 328

Grand Rapids Magazine 104

Guideposts 104

Horse Illustrated 109

Human Kinetics Publishers 222

Image Finders, The 286

Image Integration 330

Immigrant Ancestors 110

Inmagine RF & RM Image Submissions (IRIS)

288

Jeroboam 291

Jillson & Roberts 245

Journal of Asian Martial Arts 113

Kansas! 113

Kev Curriculum Press 224

Kramer and Associates, Inc., Joan 292

Lacrosse Magazine 115

Latitude Stock 292

Leepa-Rattner Museum of Art 374

Lerner Publishing Group, Inc. 224

Limited Editions & Collectibles 376

Log Newspaper, The 165 Markeim Art Center 378

Marlin 118

Megapress Images 295

Michigan Out-of-Doors 119

Minnesota Golfer 120

Mitchell Lane Publishers, Inc. 227

Modernart Editions 245

Monderer Design 332

Motoring & Leisure 121

Museo ItaloAmericano 382

Widseo Haiorimericano 302

Mushing.com Magazine 121

Muzzle Blasts 122

Myriad Productions 333

National Masters News 165

New York Times on the Web, The 165

North American Whitetail Magazine 124

Northwestern University Dittmar Memorial

Gallery 385

NOVUS 333

Oklahoma Today 127

Omni-Photo Communications 298

OnAsia 299

Opcao Brasil Imagens 300 Outdoor Canada Magazine 129 Outdoor Life Magazine 130 Outside Imagery 300

Owen Publishers, Inc., Richard C. 229

OWL Magazine 130 Oxford Scientific (OSF) 301 Pacific Stock/Printscapes.com 301 Pacific Yachting Magazine 131 Paddler Magazine 131

Painet Inc. 302

Panoramic Images 303

Photolife Corporation Ltd. 305

Photo Network 306

PhotoSource International 307

PI Creative Art 247

Planet 134

Portfolio Graphics, Inc. 247 ProStar Publications Inc. 231

Purestock 309

Quarto Publishing Plc. 231 Racquetball Magazine 137 Ralls Collection Inc., The 392

Referee 201

Revolutionary War Tracks 138

Rigby Education 231

Roggen Advertising and Public Relations, Ted 335

Rugby Magazine 139 Sailing Magazine 118 Sail Magazine 140 Saks Associates, Arnold 336

Salt Water Sportsman 141

San Diego Art Institute's Museum of the Living Artist 393

Sandlapper Magazine 141

Scholastic Library Publishing 232

Sharing the Victory 143

Shooting Sports USA 143

Skydiving 144

Skyscan Photolibrary 311

SouthComm Publishing Company, Inc. 145

Southern Boating 145 Southside Gallery 394 Sport Fishing 146 SportsCar 146 Sportslight Photo 312

Still Media 314

Stock Connection, Inc. 314

Stock Foundry Images 315

StockMedia.net 316

Stock Transparency Services/STSimages 317

Sugar Daddy Photos 317

Sun 166

Sunday Post, The 167 Superstock Inc. 318

Surfing Magazine 148

Teldon 248

Texas Monthly 149

Tide-Mark Press 249

Times of the Islands 150

Toronto Sun Publishing 167

Track & Field News 151

Trailer Boats Magazine 152

Trail Runner 152

Turkey & Turkey Hunting 154

Ullstein Bild 319

Unicorn Stock Photos 319

Upstream People Gallery 400

VeloNews 168

Vermont Life 155

Vermont Magazine 156

Viewfinders 320

Visitor's Choice Magazine 234

Washington Blade, The 168

Washington County Museum of Fine Arts 402

Washington Trails 156

WaterSki 157

WaveLength Magazine 157

Willow Creek Press 236

Windigo Images 321

Women's Health Group 237

Youth Runner Magazine 159

Zolan Company, LLC, The 250

Students

A+E 256

Ant Photo Library 262

Center for Creative Photography 354

Edelstein Studio and Gallery, Paul 361

Famous Pictures & Features Agency 280 I.C.P. International Colour Press 286

Latitude Stock 292

PhotoSource International 307

Science Photo Library, Ltd. 311

Technology/Computers

ABA Banking Journal 171

Accent Alaska/Ken Graham Agency 255

Ace Stock Limited 256

Aflo Foto Agency 257

Age Fotostock 258

Allyn & Bacon Publishers 212

amanaimages inc. 260

American Print Alliance 344

AOPA Pilot 174

AppaLight 262

Aquarius 161

Archaeology 161

Art Directors & Trip Photo Library 264

Art Source L.A., Inc. 348

Artwerks Stock Photography 265

Art Without Walls, Inc. 348

Asia Images Group 266

Asian Enterprise Magazine 175

Atlantic Gallery 349

Aurora Photos 266

Avionics Magazine 177

Balzekas Museum of Lithuanian Culture Art

Gallery 349

Bedford/St. Martin's 213

Bentley Publishers 213

Bergman Collection, The 268

Biological Photo Service and

Terraphotographics 268

Boeberitz Design, Bob 323

Brainworks Design Group 324

Business NH Magazine 179

Bynums Marketing and Communications, Inc.

325

Clampart 356

Cleary Gallery, John 357

Cleveland Magazine 87

Cody Images 273

College PreView Magazine 88

Comesana Agencia de Prensa/Banco

Fotográfico, Eduardo 273

Contemporary Arts Center (Cincinnati), The

358

Continental Newstime 90

Creative Company, The 217

Creative Stock Images 274

DDB Stock Photography, LLC 274

Design2Market 326

Design Conceptions (Joel Gordon

Photography) 275

Dinodia Photo Library 275

DK Stock, Inc. 276

Dodo Graphics Inc. 243

Electrical Apparatus 184

Elks Magazine, The 96

Entrepreneur 96

ESL Teacher Today 185

Ewing Galloway Inc. 279

Flint Communications 327

Focus New Zealand Photo Library Ltd. 282

Foto-Press Timmermann 283

Fotoscopio '283

Fundamental Photographs 284

Gallery Luisotti 366

Geoslides & Geo Aerial Photography 284

Geosynthetics 187

Ghost Town 102

Government Technology 187

Grafica 328

Heilman Photography, Inc., Grant 285

Hutchinson Associates, Inc. 330

Hutchison Picture Library 285

IEEE Spectrum 189

Image Finders, The 286

Images.de Digital Photo GmbH 287

Image Works, The 287

Immigrant Ancestors 110

Isopix 289

ITE Journal 189

Jeroboam 291

Journal of Adventist Education 190

Journal of Psychoactive Drugs 190

Jude Studios 330

Kashrus Magazine 114

Key Curriculum Press 224

Kiwanis Magazine 114

KNOWAtlanta 115

Kramer and Associates, Inc., Joan 292

Leepa-Rattner Museum of Art 374

Lerner Publishing Group, Inc. 224

Lineair Fotoarchief, B.V. 293

Manufacturing Automation & Advanced

Manufacturing 191

Mattei Photography, Michele 379

McGraw-Hill 226

Medical File Inc., The 295

Meetings & Incentive Travel 192

Mesa Contemporary Arts at Mesa Arts Center 379

Michael Murphy Gallery M 380 .

Monderer Design 332

Motoring & Leisure 121

Mullin/Ashley Associate 332

Museum of Contemporary Photography,

Columbia College Chicago 383

NewDesign Magazine 194

New York Times on the Web, The 165

Nova Media Inc. 246

Novastock 297

NOVUS 333

Okapia K.G. 298

OnAsia 299

OnRequest Images 299

OWL Magazine 130

Oxford Scientific (OSF) 301

Painet Inc. 302

Panoramic Images 303

Photo Agora 304

Photo Network 306

PhotoSource International 307

PI Magazine 195

Plastics News 196

Plastics Technology 197

Police Magazine 197

Popular Photography & Imaging 135

Portfolio Graphics, Inc. 247

Prakken Publications, Inc. 230

Professional Photographer 198

Quarto Publishing Plc. 231

Revolutionary War Tracks 138

Saks Associates, Arnold 336

San Diego Art Institute's Museum of the Living

Artist 393

Sandlapper Magazine 141

Scholastic Library Publishing 232

Science Photo Library, Ltd. 311

Scrap 204

SouthComm Publishing Company, Inc. 145

SportsCar 146

Stack & Associates, Inc., Tom 313

Stock Foundry Images 315

Stock Transparency Services/STSimages 317

Streetpeople's Weekly News 166

Sugar Daddy Photos 317

Tropix Photo Library 318

UCR/California Museum of Photography 398

Ullstein Bild 319

Upstream People Gallery 400

Viewfinders 320

Warne Marketing & Communications 339

Washington County Museum of Fine Arts 402

Waveland Press, Inc. 235

Weigl Educational Publishers Limited 236

Whiskey Island Magazine 158

Worcester Polytechnic Institute 340

Themes

Individual Artists of Oklahoma 371

Travel

AAP News 171

Accent Alaska/Ken Graham Agency 255

Ace Stock Limited 256

Adirondack Lakes Center for the Arts 343

Aflo Foto Agency 257

African American Golfer's Digest 67

After Five 68

Age Fotostock 258

AKM Images, Inc. 258

Alaska Stock Images 259

amanaimages inc. 260

AMC Outdoors 70

American Fitness 71

American Print Alliance 344

Ancient Art & Architecture Collection, Ltd.,

The 261

Andes Press Agency 261

Animals Animals/Earth Scenes 261

AOPA Pilot 174

AppaLight 262

Aquarius 161

Archaeology 161

Archivo Criollo 263

Arizona Wildlife Views 74

Art Directors & Trip Photo Library 264

Art@Net International Gallery 346

Art Source L.A., Inc. 348

Artwerks Stock Photography 265

Art Without Walls, Inc. 348

Asian Enterprise Magazine 175

Atlantic Gallery 349

Aurora Photos 266

Avionics Magazine 177

Balzekas Museum of Lithuanian Culture Art Gallery 349

Bennett Galleries and Company 351 Bentley Publishing Group 240 Bird Watching Magazine 78 Blue Ridge Country 78

Boeberitz Design, Bob 323 Bridal Guides Magazine 79 Business NH Magazine 179 Business of Art Center 353

California Views/Mr. Pat Hathaway Historical

Photo Collection 270 Camera Press Ltd. 270 Canoe & Kayak 82 Capstone Press 214

Caribbean Travel & Life 82 Carmichael-Lynch, Inc. 325

Civitan Magazine 181 Clampart 356

Cleary Gallery, John 357 Cleveland Magazine 87

Comesana Agencia de Prensa/Banco

Fotográfico, Eduardo 273 Contemporary Bride Magazine 90

Continental Newstime 90 Countryman Press, The 216 CrealdE School of Art 473 Creative Company, The 217 Creative Stock Images 274

Cruising World 92

DDB Stock Photography, LLC 274 Dinodia Photo Library 275

DK Stock, Inc. 276

Dockery House Publishing, Inc. 218

Dodo Graphics Inc. 243

Down The Shore Publishing Corp. 218 DW Stock Picture Library (DWSPL) 277

ECW Press 219

ESL Teacher Today 185 eStock Photo, LLC 279

Event 97

Family Motor Coaching 98 Flint Communications 327

Focus New Zealand Photo Library Ltd. 282 FOTOAGENT.COM/FOTOCONCEPT, INC 282

Foto-Press Timmermann 283

Fotoscopio 283 France Magazine 100 Freeport Arts Center 364 Ft. Myers Magazine 100 Gallant Greetings Corp. 244

Gallery West 367

Geoslides & Geo Aerial Photography 284

Ghost Town 102 Golf Tips 103 Grafica 328

Grand Rapids Magazine 104 Hadassah Magazine 105

Healing Lifestyles & Spas Magazine 106 Hearst Art Gallery, Saint Mary's College 369

Highways 107

Horizons Magazine 108 Hutchison Picture Library 285

Icebox Quality Framing & Gallery 370

Image Finders, The 286

Images.de Digital Photo GmbH 287

Immigrant Ancestors 110 Impact Photographics 244

Inmagine RF & RM Image Submissions (IRIS) 288

Instinct Magazine 111

International Photo News 288

In The Wind 111

Iowan Magazine, The 112

ITE Journal 189

Jayawardene Travel Photo Library 290

Jeroboam 291 Jewish Action 112 Kansas! 113

Kashrus Magazine 114

Kramer and Associates, Inc., Joan 292

Lake Superior Magazine 116

Land of the Bible Photo Archive 268

Latitude Stock 292

Leepa-Rattner Museum of Art 374 Limited Editions & Collectibles 376 Lineair Fotoarchief, B.V. 293

Living Free 116

Lonely Planet Images 293

Luckypix 294

Markeim Art Center 378 Marlboro Gallery 378

Meetings & Incentive Travel 192

Megapress Images 295

Mesa Contemporary Arts at Mesa Arts Center

Metrosource Magazine 119 MGW Newsmagazine 119 Monderer Design 332 Motoring & Leisure 121

Multiple Exposures Gallery 381 Museo ItaloAmericano 382 My Foodservice News 192

Na'amat Woman 122

Native Peoples Magazine 123

New York Times on the Web, The 165

Northern Woodlands 125

Northwestern University Dittmar Memorial

Gallery 385

Northwest Travel Magazine 126

Novastock 297 NOVUS 333 Now & Then 127 Okapia K.G. 298 Oklahoma Today 127

Omni-Photo Communications 298

OnAsia 299

OnRequest Images 299 Outside Imagery 300

Owen Publishers, Inc., Richard C. 229

Oxford Scientific (OSF) 301 Pacific Stock/Printscapes.com 301

Painet Inc. 302
Panoramic Images 303
Paper Products Design 246
Pennsylvania Magazine 132
Persimmon Hill Magazine 132

Photo Agora 304

Photolife Corporation Ltd. 305

Photo Network 306

Photo Researchers, Inc. 306 PhotoSource International 307

PI Creative Art 247 Pilot Getaways 195 Playboy 134

Ponkawonka Inc. 308 Portfolio Graphics, Inc. 247

Positive Images (Stock Photography & Gallery

61) 309

ProStar Publications Inc. 231

Pump House Center for the Arts 391

Quarto Publishing Plc. 231 Ralls Collection Inc., The 392 Recommend Magazine 200 Revolutionary War Tracks 138

RIG 248

Roggen Advertising and Public Relations, Ted 335

Running Press Book Publishers 232

Sailing Magazine 118 Sail Magazine 140 Salt Water Sportsman 141

San Diego Art Institute's Museum of the Living

Artist 393

Sandlapper Magazine 141

Scholastic Library Publishing 232

Sea 142

Soundlight 337

SouthComm Publishing Company, Inc. 145

Southern Boating 145 Southside Gallery 394 Specialty Travel Index 205 State Street Gallery 395 Still Media 314

Stock Foundry Images 315

Stock Transparency Services/STSimages 317

Sugar Daddy Photos 317

Sun, The 147 Superstock Inc. 318 Surfing Magazine 148

Taube Museum of Art, Lillian & Coleman 396

Teldon 248

Texas Highways 148
Texas Monthly 149
Tide-Mark Press 249
Times of the Islands 150
Trailer Boats Magazine 152

Trail Runner 152 Travel + Leisure 153

Traveller Magazine & Publishing 153
Travelworld International Magazine 153

Tropix Photo Library 318

Ullstein Bild 319

Unicorn Stock Photos 319 Upstream People Gallery 400

Vermont Life 155 Vermont Magazine 156 Viewfinders 320 Voyageur Press 235

Washington County Museum of Fine Arts 402

WaterSki 157

Wine Enthusiast Magazine 158 Women's Health Group 237 WRITERS' Journal 209 Zakin Gallery, Mikhail 404

Wildlife

Accent Alaska/Ken Graham Agency 255

Ace Stock Limited 256

Adirondack Lakes Center for the Arts 343

Advanced Graphics 239

Aflo Foto Agency 257

After Five 68

Age Fotostock 258

AGStockUSA Inc. 258

AKM Images, Inc. 258

Alabama Living 69

Alaska Stock Images 259

All About Kids Publishing 211

Alternatives Journal 70

amanaimages inc. 260

AMC Outdoors 70

American Forests Magazine 71

American Hunter 72

American Print Alliance 344

Animals Animals/Earth Scenes 261

Animal Sheltering 173

Animals of Montana, Inc. 469

Animal Trails 73

Anthro-Photo File 262

Ant Photo Library 262

Appalachian Trail Journeys 74

AppaLight 262

Aguarium Fish International 74

Archaeology 161

Archivo Criollo 263

Arizona Wildlife Views 74

Arsenal Gallery, The 345

Art Directors & Trip Photo Library 264

Art@Net International Gallery 346

Art Source L.A., Inc. 348

Artwerks Stock Photography 265

Art Without Walls, Inc. 348

Atlantic Gallery 349

Aurora Photos 266

Auscape International 267

Balzekas Museum of Lithuanian Culture Art

Gallery 349

Baseball 76

BC Outdoors 76

Bear Deluxe Magazine, The 77

Biological Photo Service and

Terraphotographics 268

Bird Watcher's Digest 77

Bird Watching Magazine 78

Blount-Bridgers House/Hobson Pittman

Memorial Gallery 352

Blue Ridge Country 78

Blue Sky Publishing 240

Boeberitz Design, Bob 323

Bon Artique.com/Art Resources Int., Ltd. 241

Bowhunter 79

Bridal Guides Magazine 79

BSIP 270

Business of Art Center 353

Bynums Marketing and Communications, Inc.

Camera Obscura Gallery, The 353

Capitol Complex Exhibitions 353

Capstone Press 214

Caribbean Travel & Life 82

Center for Fine Art Photography, The 354

Centric Corporation 242

Chirp Magazine 85

Cleary Gallery, John 357

Comesana Agencia de Prensa/Banco

Fotográfico, Eduardo 273

Continental Newstime 90

Countryman Press, The 216

Crabtree Publishing Company 216

Crealdè School of Art 473

Creative Company, The 217

Creative Stock Images 274

Current, Inc. 243

Dakota Outdoors 93

Dance 93

DDB Stock Photography, LLC 274

Deer & Deer Hunting 93

Deliou Art Group 243

Dinodia Photo Library 275

Dodo Graphics Inc. 243

DRK Photo 276

Ducks Unlimited Magazine 95

DW Stock Picture Library (DWSPL) 277

Ecoscene 278

ESL Teacher Today 185

E/The Environmental Magazine 97

Everson Museum of Art 363

Fahey/Klein Gallery 363

Farcountry Press 220

Farnam Companies, Inc. 326

Fellowship 98

Fly Rod & Reel 99

Forest Landowner 186

Fotoscopio 283

Ft. Myers Magazine 100 Gallant Greetings Corp. 244

Gallery West 367

Game & Fish Magazines 101

Geoslides & Geo Aerial Photography 284

Ghost Town 102 Gospel Herald 103

Grafica 328

Grand Rapids Magazine 104

Grit Magazine 104

Hampton Design Group 329 Hancock House Publishers 221

Heilman Photography, Inc., Grant 285

Hereford World 188
Horizons Magazine 108
Horse Illustrated 109
Illogical Muse 110
Image Finders, The 286
Image Works, The 287
Immigrant Ancestors 110
Impact Photographics 244

Intercontinental Greetings LTD. 244

Iowan Magazine, The 112

Isopix 289 Kansas! 113

Kentucky Monthly 114 Key Curriculum Press 224

Kimball Stock 291

Kramer and Associates, Inc., Joan 292

Lake Superior Magazine 116

Latitude Stock 292

Leepa-Rattner Museum of Art 374

Leopold Gallery 375

Lerner Publishing Group, Inc. 224 Limited Editions & Collectibles 376

Lineair Fotoarchief, B.V. 293 Lucent Books 225

Markeim Art Center 378 Marlboro Gallery 378

Marlin 118

McGaw Graphics, Inc. 245 Megapress Images 295

Mesa Contemporary Arts at Mesa Arts Center 379

Michael Murphy Gallery M 380 Michigan Out-of-Doors 119 Milkweed Editions 227 Motoring & Leisure 121 Mushing.com Magazine 121

Muzzle Blasts 122

National Geographic 122 National Parks Magazine 123

Nature Friend 123

New York Times on the Web, The 165 North American Whitetail Magazine 124

Northern Woodlands 125

Northwestern University Dittmar Memorial

Gallery 385 Novastock 297 NOVUS 333

Omni-Photo Communications 298

OnAsia 299

Opcao Brasil Imagens 300 Outdoor America 129

Outdoor Canada Magazine 129 Outdoor Life Magazine 130

Outside Imagery 300

Owen Publishers, Inc., Richard C. 229

OWL Magazine 130 Oxford Scientific (OSF) 301 Pacific Stock/Printscapes.com 301

Painet Inc. 302

Panoramic Images 303

Papilio Natural History Library 303 Pennsylvania Game News 132 Pennsylvania Magazine 132 Persimmon Hill Magazine 132

Pet Product News 195 Photo Agora 304 Photography Art 389 Photo Life 133

Photolife Corporation Ltd. 305

Photo Network 306 Photo Researchers, Inc. 306 PhotoSource International 307 Portfolio Graphics, Inc. 247

Positive Images (Stock Photography & Gallery 61) 309

ProStar Publications Inc. 231 Pump House Center for the Arts 391 Quarto Publishing Plc. 231

Ranger Rick 137

Recommend Magazine 200 Recycled Paper Greetings, Inc. 247 Revolutionary War Tracks 138 Rigby Education 231 Running Press Book Publishers 232

Rural Heritage 140

Salt Water Sportsman 141

San Diego Art Institute's Museum of the Living

Artist 393

Sandlapper Magazine 141

Scholastic Library Publishing 232

Soundlight 337

SouthComm Publishing Company, Inc. 145

Stack & Associates, Inc., Tom 313

Stock Connection, Inc. 314

Stock Foundry Images 315

Stock Transparency Services/STSimages 317

Sugar Daddy Photos 317

Taube Museum of Art, Lillian & Coleman 396

Teldon 248

Tide Magazine 149

Tide-Mark Press 249

Times of the Islands 150

Trails Media Group 250

Traveller Magazine & Publishing 153

Tricycle Press 234

Tropix Photo Library 318

Turkey Country 154

Turkey & Turkey Hunting 154

Ullstein Bild 319

Unicorn Stock Photos 319

Up Here 155

Upstream People Gallery 400

Vermont Life 155

Vermont Magazine 156

VIREO (Visual Resources for Ornithology) 320

Visual Arts Center of Northwest Florida 401

Voyageur Press 235

Washington County Museum of Fine Arts 402

Washington Trails 156

Weigl Educational Publishers Limited 236

Whiskey Island Magazine 158

Willow Creek Press 236

WRITERS' Journal 209

Yankee Magazine 159

Zakin Gallery, Mikhail 404

General Index

39th Annual Arts & Crafts Fair 406 49th Arts Experience 406 540 Rider 67 911 Pictures 255

A

AAP News 171 ABA Banking Journal 171 A cappella Zoo 67 Accent Alaska/Ken Graham Agency 255 Ace Stock Limited 256 Achard & Associates 457 Acropolis Books, Inc. 211 Action Publishing 211 Adams Workshop, Eddie 468 Addison/Ripley Fine Art 343 Adirondack Lakes Center for the Arts 343 Adventure Cyclist 67 A+E 256 Aerial and Creative Photography Workshops 468 Aerial Archives 257 Aerial Photography Services 211 Affaire in the Gardens Art Show 406 Aflo Foto Agency 257 African American Golfer's Digest 67 African Pilot 68 After Five 68 Aftermarket Business World 171 Age Fotostock 258 AGStockUSA Inc. 258 AIM 68 Air Line Pilot 172 AKM Images, Inc. 258

Akron Art Museum 343 Akron Arts Expo 407 Alabama Living 69 Alarm Magazine 69 Alaska 69 Alaska's Seawolf Adventures 468 Alaska State Museum 344 Alaska Stock Images 259 Albuquerque Museum of Art & History, The Alexia Competition 449 All About Kids Publishing 211 Allen Park Arts & Crafts Street Fair 407 Allentown Art Festival 407 Allyn & Bacon Publishers 212 Alternatives Journal 70 amanaimages inc. 260 AMC Outdoors 70 American Archaeology 70 American Bar Association Journal 172 American Bee Journal 173 American Fitness 71 American Forests Magazine 71 American Gardener, The 72 American Hunter 72 American Museum of Natural History Library, Photographic Collection 260 American Power Boat Association 173 American Print Alliance 344 American School Health Association 212 American Society of Artists, Inc. 344 American Sports Network 161 American Stock Photography 260

American Turf Monthly 72

Amish Acres Arts & Crafts Festival 407 Anacortes Arts Festival 408 Anchell Photography Workshops 468 Anchor News 73 Ancient Art & Architecture Collection, Ltd., The 261 Anderson Ranch Arts Center 468 Andes Press Agency 261 Animals Animals/Earth Scenes 261 Animal Sheltering 173 Animals of Montana, Inc. 469 Animal Trails 73 Ann Arbor's South University Art Fair 408 Ann Arbor Street Art Fair 408 Annual Alton Arts & Crafts Expressions 408 Annual Arts Adventure 409 Annual Arts & Crafts Adventure 409 Annual College Photography Contest 449 Annual Edens Art Fair 409 Annual Exhibition of Photography 449 Annual Hyde Park Arts & Crafts Adventure Annual Juried Photography Exhibition 449 Annual Oak Park Avenue-Lake Arts & Crafts Show 410 Annual Spring Photography Contest 449 Anthro-Photo File 262 Ant Photo Library 262 Anvil Press 212 AOPA Pilot 174 Aperture 74 Appalachian Mountain Club Books 212 Appalachian Trail Journeys 74 AppaLight 262 Appaloosa Journal 174 Apple Annie Crafts & Arts Show 410 AQUA Magazine 175 Aquarium Fish International 74 Aquarius 161 ARC Awards 449 A.R.C. Gallery .345 Archaeology 161 Archivo Criollo 263 Argus Photo, Ltd. (APL) 263 Arizona Highways Photo Workshops 469 Arizona State University Art Museum 345

Arizona Wildlife Views 74

ArkReligion.com 264

Arnold Art 345

Arrowmont School of Arts and Crafts 469 Arsenal Gallery, The 345 Art Directors & Trip Photo Library 264 Artefact/Robert Pardo Gallery 346 Art Fair on the Courthouse Lawn 410 Art Festival Beth-el 410 Art in the Park Fall Foliage Festival 411 Art in the Park (GA) 411 Art in the Park (MI) 411 Art in the Park (Sierra Vista) 411 Art in the Park Summer Festival 412 Art in the Park (VA) 412 Artist Fellowship Grants 450 Artist Fellowships/Virginia Commission for the Arts 450 Artists' Cooperative Gallery 346 Art Licensing International Inc. 265 Art@Net International Gallery 346 Art New England Summer Workshops @ Bennington VT 469 Art of Nature Photography Workshops 469 Art Resource 265 Art's Alive 412 Arts Company, The 347 Arts & Crafts Affair, Autumn & Spring Tours, An 412 Arts in the Park 413 Arts Iowa City 347 ArtsLink Projects 450 Arts on Douglas 347 Arts on Foot 413 Arts on the Green 413 Art Source L.A., Inc. 348 Artsplosure ñ The Raleigh Arts Festival 413 Artwerks Stock Photography 265 Art Without Walls, Inc. 348 Art Workshops in Guatemala 469 Asia Images Group 266 Asian Enterprise Magazine 175 Astronomy 75 Athletic Business 175 Athletic Management 176 Atlanta Homes & Lifestyles 75 Atlanta Photojournalism Seminar Contest 450 Atlantic Gallery 349 Aurora Photos 266 Auscape International 267 Author Pictures at Lebrecht 267 Automated Builder 176

Automotive Cooling Journal 176 Automotive News 176 Auto Restorer 75 Autumn Festival, An Arts & Crafts Affair 413 Avionics Magazine 177 Avon Fine Art & Wine Affaire 414 Axis Gallery 349

В

Bacall Representatives Inc., Robert 457 Bachmann Tour Overdrive 469 Ballenger & Associates Photo Workshops, Noella 470 Balthis Photography Workshops, Frank 470 Balzekas Museum of Lithuanian Culture Art Gallery 349 Banff Mountain Photography Competition 450 Barbour Publishing, Inc. 212 Barnett Advertising/Design, Augustus 323 Barron Arts Center 350 Bartender Magazine 177 Baseball 76 BC Outdoors 76 Bear Deluxe Magazine, The 77 BearManor Media 213 Bedford/St. Martin's 213 BedTimes 177 Beef Today 178 Belian Art Center 350 Bellingham Review 77 Benham Studio Gallery 350 Bennett Galleries and Company 351 Benrubi Gallery, Bonni 351 Bentley Publishers 213 Bergman Collection, The 268 Berman Fine Arts, Mona 351 Berson, Dean, Stevens Inc. 323 BetterPhoto.com Online Photography Courses

470 Beverage Dynamics 178 Biological Photo Service and Terraphotographics 268 Birds as Art/Instructional Photo-Tours 470 Bird Watcher's Digest 77 Bird Watching Magazine 78 BizTimes Milwaukee 178 Blackflash 78 Black Swamp Arts Festival 414 Blend Images 269

Blount-Bridgers House/Hobson Pittman Memorial Gallery 352 Blue Planet Photography Workshops and Tours Blue Ridge Country 78 Blue Ridge Workshops 471 Boeberitz Design, Bob 323 Book Beat Gallery 352 Boston Mills Press 214 Bowhunter 79 Boxoffice Magazine 179 Bragaw Public Relations Services 324 Brainworks Design Group 324 Bransten Gallery, Rena 352 Brewers Association 214 Briarpatch 79 Brick Street Market 414 Bridal Guides Magazine 79 Bridge Bulletin, The 80 Bridgeman Art Library, The 269 Bright Light Visual Communications 324 Brookings Gallery, J.J. 352 Brown Hands-On Workshops, Nancy 471 BSIP 270 Burren College of Art Workshops 471 Business NH Magazine 179 Business of Art Center 353 Bynums Marketing and Communications, Inc.

Cain Park Arts Festival 414 Calabasas Fine Arts Festival 415 California Photographic Workshops 471 California Views/Mr. Pat Hathaway Historical Photo Collection 270 Calliope 80 Camargo Foundation Visual Arts Fellowship 471 Camera Obscura Gallery, The 353 Camera Press Ltd. 270 Camerique Inc. International 271 Campbell Associates, Marianne 458 Campbell Contemporary Art, William 353 Campbell Folk School, John C. 471 Canada Lutheran 81 Canadian Guernsey Journal 179 Canadian Homes & Cottages 81 Canadian Organic Grower, The 81

Canoe & Kayak 82 Capital Pictures 271

Capitol Complex Exhibitions 353

Capper's 162 Capstone Press 214 Caribbean Travel & Life 82

Carmichael-Lynch, Inc. 325

Casey & Associates, Marge 458

Casino Journal 179

Cat Fancy 83

Catholic Library World 180 Catholic News Service 272 Catholic Sentinel 162

CEA Advisor 180

Cedarhurst Craft Fair 415

Center for Creative Photography 354

Center for Fine Art Photography, The 354, 471

Center for Photographic Art 354

Center for Photography at Woodstock 355, 472

Centerstream Publication 215

Centerville/Washington Township Americana

Festival 415 CEPA Gallery 355

Chait Galleries Downtown, The 355

Chapman Friedman Gallery 356 Chardon Square Arts Festival 415

Charlsma Magazine 83 Charlton Photos, Inc. 272 Chatham Press 215

Chatsworth Cranberry Festival 415

Chef 180

Chesapeake Bay Magazine 84

Chesapeake

Chess Life 84

Chess Life for Kids 85 Chicago Photo Safaris 472

Childhood Education 181

Children's Defense Fund 162

Chirp Magazine 85

Christmas and Easter Craft Shows 415

Christmas Craft Show 416

Chronicle of Philanthropy, The 181

Chronicle of the Horse, The 85

Chronogram 86

Chun Capitol Hill People's Fair 416

Church of England Newspaper, The 163

Church Personal Underwater Photography

Courses, Cathy 472

Church Street Art & Craft Show 416

City Limits 86

City of Fairfax Fall Festival 416

City of Fairfax Holiday Craft Show 416

Civitan Magazine 181

Clampart 356

Clarion-Ledger, The 163

Clark Gallery, Catharine 356

Classical Singer 182

Cleaning & Maintenance Management

Magazine 182

Cleary Gallery, John 357

Cleis Press 215

Cleveland Magazine 87

Clickers & Flickers Photography Network--

Lectures & Workshops 472

Cobblestone 87

Codorus Summer Blast 417

Cody Images 273

Cohen Gallery, Stephen 357

Cole Represents, LLC, Randy 458

Collectible Automobile 87

College Photographer of the Year 451

College PreView Magazine 88

Colorscape Chenango Arts Festival 417

Comesana Agencia de Prensa/Banco

Fotográfico, Eduardo 273

Commercial Carrier Journal 182

Community Darkroom 473

Community Observer 88

Company Magazine 88

Complete Woman 89

Complete woman 69

Conari Press 215

Conde Nast Traveller 89

Cone Editions Workshops 473

Conscience 90

CONSULTANT/Photographer's Representative

458

Contemporary Arts Center 357

Contemporary Arts Center (Cincinnati), The

358

Contemporary Arts Collective 358

Contemporary Bride Magazine 90

Continental Newstime 90

Convenience Store Decisions 182

Convergence 91

Convers Cherry Blossom Festival 417

Corbis 273

Corcoran Fine Arts Limited, Inc. 358

Corporate Art Source/CAS Gallery 358

Cortona Center of Photography, Italy, The 473

Cory Photography Workshops 473 Cotton Grower Magazine 183 Country Arts & Crafts Fair 417

Countryman Press, The 216

Country Woman 91

Courthouse Gallery, Lake George Arts Project 326

Crabtree Publishing Company 216

Craft Fair at the Bay 417

Crafts at Rhinebeck 417

CraftWestport 418

Crealdè School of Art 473

CrealdE School of Art 359

Creative Arts Workshop 473

Creative Company, The 217

Creative Editions 217

Creative Homeowner 217

Creative Stock Images 274

Creative With Words Publications (CWW) 218

Cristopher Lapp Photography 459

CropLife 183

Crossman Gallery 359

Cruising World 92

Cuneo Gardens Art Festival 418

Curator's Choice Awards 451

Cycle California! Magazine 92

Cycle World Magazine 92

D

Dairy Today 183

Dakota Outdoors 93

Dale Photographic Workshops, Bruce 474

Dallas Center for Contemporary Art, The 359

Dance 93

Dance on Camera Festival 451

Dawson College Centre for Training and

Devlopment 474

Day in Towne, A 406

Dayton Art Institute, The 360

DDB Stock Photography, LLC 274

Dean Photo Workshops, The Julia 474

Deer & Deer Hunting 93

Deerfield Fine Arts Festival 418

Delaney Photo Workshops, Cynthia 474

Delaware Arts Festival 418

Delaware Center for the Contemporary Arts

360

De Moreta Represents, Linda 459

Demuth Museum 360

General Index 607

otions (Joel Gordon

Dn 275

tion Competition

Display Dexaphy Field School 474
DK Stock DK Stock, Inc. 2

DM News 184

Dockery House Publiship

Dog Fancy 94

Dogs in Canada 95

Dorsky Museum of Art, Samuel 360

Dot Fiftyone Gallery 360

Down Beat Magazine 95

Down The Shore Publishing Corp. 218

Downtown Festival & Art Show 419

Drake Magazine, The 95

Dramatic Light Nature Photography Workshops 474

DRK Photo 276

Dubois, Francoise/Dubois Represents 459

Ducks Unlimited Magazine 95

DW Stock Picture Library (DWSPL) 277

Dykeman Associates, Inc. 326

E

Eastman House, George 361

Ecoscene 278

ECW Press 219

Edelman Gallery, Catherine 361

Edelstein Studio and Gallery, Paul 361

Edwards Fine Art & Sculpture Festival 419

E & E Picture Library 277

Electrical Apparatus 184

Elks Magazine, The 96

Elmwood Avenue Festival of the Arts, Inc. 419

Eloquent Light Photography Workshops 474

El Restaurante Mexicano 185

eMediaLoft.org 361

Empics 278

Energy Gallery Art Call 451

Englander Photography Workshops & Tours,

Joe 475

Entrepreneur 96

Envision 278

F

Safaris 476

Flashlight Press 220

608 General Index aunt Magazine 99 Flight Collection, The 281 EOS Magazine 96 Flint Communications 327 Equipment Journal Fly Rod & Reel 99 Erben Gallery, Thoo Focal Press 220 Ernesto Mayans C Focus Adventures 476 ESL Teacher Tor Focus New Zealand Photo Library Ltd. 282 eStock Photo, Tours to Europe Foodpix 282 E/The Envir Foothills Crafts Fair 422 Etherton G Ford City Heritage Days 422 Europa PI Forest Hills Festival of the Arts 422 475 Arts 363 Forest Landowner 186 Event, Festival 419 Fort Ross Inc. 220 Evenseum of Art 363 Fort Ross Inc. International Rights 221 Evalloway Inc. 279 Fortune 99 sure36 Photography 475 FOTOAGENT.COM/FOTOCONCEPT, INC 282 Fotofusion 476 Foto-Press Timmermann 283 Fotoscopio 283 Fahey/Klein Gallery 363 Fourth Avenue Spring Street Fair 423 Faire on the Square 420 Fourth Avenue Winter Street Fair 423 Fair in the Park, A 420 Fourth of July Street Fair and Autumn Fest in Falkirk Cultural Center 364 the Park 423 Fall Fest in the Park 420 Fourth Street Festival for the Arts & Crafts 423 Fall Festival of Art at Queeny Park 420 France Magazine 100 Fall Fine Art & Crafts at Brookdale Park 420 Frankfort Art Fair 423 Family Motor Coaching 98 Frederick Festival of the Arts 423 Famous Pictures & Features Agency 280 Freefall Review 100 Farcountry Press 220 Freeport Arts Center 364 Fargo's Downtown Street Fair 421 Freshly Baked Fiction 100 Farnam Companies, Inc. 326 Fresno Art Museum 364 Faust Fine Arts & Folk Festival 421 Ft. Myers Magazine 100 FAVA (Firelands Association for the Visual Fulton County Daily Report 163 Arts) 364 Fundamental Photographs 284 Fellowship 98 F+W Media 219 Ferndale Art Show 421 Festival in the Park 421 Fillmore Jazz Festival 421 G2 Gallery, The 365 Finding & Keeping Clients 476 Gallant/Freeman Patterson Photo Workshops Fine Art & Crafts at Anderson Park 422 477 Fine Art & Crafts Fair at Verona Park 422 Gallery 110 Collective 365 Fine Arts Work Center 476 Gallery 218 366 Finescale Modeler 98 Gallery 400 366 Fire Chief 185 Gallery Luisotti 366 Fire Engineering 186 Gallery North 366 FireRescue Magazine 186 Gallery West 367 First Light Associated Photographers 281 Galman Lepow Associates, Inc. 367 First Light Photographic Workshops and

Gal pagos Travel 476

Game & Fish Magazines 101

Hackett, Pat/Artist Representative 461 Garrison Art Center Fine Art & Craft Fair 424 Hadassah Magazine 105 Georgia Straight 101 Haddad Gallery, Carrie 368 Geoslides & Geo Aerial Photography 284 Hallmark Institute of Photography 477 Geosynthetics 187 Hallowes Productions & Advertising 328 Gering and Lopez Gallery 367 Gerlach Nature Photography Workshops & Halsted Gallery Inc., The 368 Hamilton Magazine 105 Tours 477 Hampton Design Group 329 German Life Magazine 102 Germantown Festival 424 Hancock House Publishers 221 Hard Hat News 164 Getty Images (WA) 285 HarperCollins Children's Books / HarperCollins Ghost Town 102 Ginsburg & Associates, Inc., Michael 460 Publishers 222 Girls Life Magazine/GirlsLife.com 102 Harper's Magazine 106 Global Preservation Projects 477 Hart Portrait Seminars, John 478 Gloucester Waterfront Festival 424 Havu Gallery, William 368. Gold & Associates, Inc. 328 Hawaii Photo Seminars 478 Golden Gate School of Professional Hawaii Photo Tours, Digital Infrared, Digital Photography, Photoshop, Polaroid & Fuji Photography 477 Transfer Workshops. Private Tours & Goldman Creative Photography Workshops, Rob 477 Instruction Sessions 478 Healing Lifestyles & Spas Magazine 106 Gold Rush Days 424 Hearst Art Gallery, Saint Mary's College 369 Golf Tips 103 Goodman Inc., Tom 460 Hearth and Home 188 Good Old Summertime Art Fair 424 HeartLand Boating 107 Heart of Nature Photography Workshops 478 Gospel Herald 103 Government Technology 187 Heilman Photography, Inc., Grant 285 Gradd Arts & Crafts Festival 425 Hemphill 369 Grafica 328 Henry Street Settlement/Abrons Art Center Grain Journal 187 Grand Festival of the Arts & Crafts 425 Hera Educational Foundation and Art Gallery 369 Grand Rapids Art Museum 367 Herald Press 222 Grand Rapids Business Journal 164 Herbert Institute of Art, Gertrude 370 Grand Rapids Family Magazine 103 Hereford World 188 Grand Rapids Magazine 104 Heritage Railway Magazine 107 Great Lakes Art Fair 425 Highland Maple Festival 426 Great Neck Street Fair 425 Highlands Art League's Annual Fine Arts & Greenwich Village Art Fair 425 Crafts Festival 426 Greyhound Review, The 188 Highways 107 Grit Magazine 104 Hinsdale Fine Arts Festival 426 Gryphon House 221 Hodes Group, Bernard 329 Guenzi Agents, Inc., Carol 460 Guernica Editions, Inc. 221 Holiday Arts & Crafts Show 427 Holiday Crafts at Morristown 427 Guideposts 104 Holly Arts & Crafts Festival 427 Guilford Craft Expo 426 Guitar World 105 **HOLT McDougal** 222 Gunstock Summer Festival 426 Home, Condo and Garden Art & Craft Fair 427 Home Decorating & Remodeling Show 427

Home Education Magazine 108

Hoof Beats 108

H

Haardt Gallery, Anton 368

Automotive Cooling Journal 176 Automotive News 176 Auto Restorer 75 Autumn Festival, An Arts & Crafts Affair 413 Avionics Magazine 177 Avon Fine Art & Wine Affaire 414 Axis Gallery 349

B

Bacall Representatives Inc., Robert 457 Bachmann Tour Overdrive 469 Ballenger & Associates Photo Workshops, Noella 470 Balthis Photography Workshops, Frank 470 Balzekas Museum of Lithuanian Culture Art Gallery 349 Banff Mountain Photography Competition 450 Barbour Publishing, Inc. 212 Barnett Advertising/Design, Augustus 323 Barron Arts Center 350 Bartender Magazine 177 Baseball 76 BC Outdoors 76 Bear Deluxe Magazine, The 77 BearManor Media 213 Bedford/St. Martin's 213 BedTimes 177 Beef Today 178 Belian Art Center 350 Bellingham Review 77 Benham Studio Gallery 350 Bennett Galleries and Company 351 Benrubi Gallery, Bonni 351 Bentley Publishers 213 Bergman Collection, The 268 Berman Fine Arts, Mona 351 Berson, Dean, Stevens Inc. 323 BetterPhoto.com Online Photography Courses 470

Beverage Dynamics 178
Biological Photo Service and
Terraphotographics 268
Birds as Art/Instructional Photo-Tours 470
Bird Watcher's Digest 77
Bird Watching Magazine 78
BizTimes Milwaukee 178
Blackflash 78
Black Swamp Arts Festival 414
Blend Images 269

Blount-Bridgers House/Hobson Pittman Memorial Gallery 352 Blue Planet Photography Workshops and Tours Blue Ridge Country 78 Blue Ridge Workshops 471 Boeberitz Design, Bob 323 Book Beat Gallery 352 Boston Mills Press 214 Bowhunter 79 Boxoffice Magazine 179 Bragaw Public Relations Services 324 Brainworks Design Group 324 Bransten Gallery, Rena 352 Brewers Association 214 Briarpatch 79 Brick Street Market 414 Bridal Guides Magazine 79 Bridge Bulletin, The 80 Bridgeman Art Library, The 269 Bright Light Visual Communications 324 Brookings Gallery, J.J. 352 Brown Hands-On Workshops, Nancy 471 **BSIP 270** Burren College of Art Workshops 471 Business NH Magazine 179 Business of Art Center 353 Bynums Marketing and Communications, Inc.

C

Cain Park Arts Festival 414 Calabasas Fine Arts Festival 415 California Photographic Workshops 471 California Views/Mr. Pat Hathaway Historical Photo Collection 270 Calliope 80 Camargo Foundation Visual Arts Fellowship 471 Camera Obscura Gallery, The 353 Camera Press Ltd. 270 Camerique Inc. International 271 Campbell Associates, Marianne 458 Campbell Contemporary Art, William 353 Campbell Folk School, John C. 471 Canada Lutheran 81 Canadian Guernsey Journal 179 Canadian Homes & Cottages 81 Canadian Organic Grower, The 81

Canoe & Kayak 82 Capital Pictures 271

Capitol Complex Exhibitions 353

Capper's 162.
Capstone Press 214
Caribbean Travel & Life 82
Carmichael-Lynch, Inc. 325
Casey & Associates, Marge 458

Casino Journal 179

Cat Fancy 83

Catholic Library World 180 Catholic News Service 272

Catholic Sentinel 162 CEA Advisor 180

Cedarhurst Craft Fair 415

Center for Creative Photography 354

Center for Fine Art Photography, The 354, 471

Center for Photographic Art 354

Center for Photography at Woodstock 355, 472

Centerstream Publication 215

Centerville/Washington Township Americana

Festival 415 CEPA Gallery 355

Chait Galleries Downtown, The 355

Chapman Friedman Gallery 356 Chardon Square Arts Festival 415

Charisma Magazine 83 Charlton Photos, Inc. 272

Chatham Press 215

Chatsworth Cranberry Festival 415

Chef 180

Chesapeake Bay Magazine 84

Chess Life 84

Chess Life for Kids 85 Chicago Photo Safaris 472

Childhood Education 181

Children's Defense Fund 162

Chirp Magazine 85

Christmas and Easter Craft Shows 415

Christmas Craft Show 416

Chronicle of Philanthropy, The 181

Chronicle of the Horse, The 85

Chronogram 86

Chun Capitol Hill People's Fair 416

Church of England Newspaper, The 163

Church Personal Underwater Photography

Courses, Cathy 472

Church Street Art & Craft Show 416

City Limits 86

City of Fairfax Fall Festival 416

City of Fairfax Holiday Craft Show 416

Civitan Magazine 181

Clampart 356

Clarion-Ledger, The 163

Clark Gallery, Catharine 356

Classical Singer 182

Cleaning & Maintenance Management

Magazine 182

Cleary Gallery, John 357

Cleis Press 215

Cleveland Magazine 87

Clickers & Flickers Photography Network--

Lectures & Workshops 472

Cobblestone 87

Codorus Summer Blast 417

Cody Images 273

Cohen Gallery, Stephen 357

Cole Represents, LLC, Randy 458

Collectible Automobile 87

College Photographer of the Year 451

College PreView Magazine 88

Colorscape Chenango Arts Festival 417

Comesana Agencia de Prensa/Banco

Fotográfico, Eduardo 273

Commercial Carrier Journal 182

Community Darkroom 473

Community Observer 88

Company Magazine 88

Complete Woman 89

Conari Press 215

Conde Nast Traveller 89

Cone Editions Workshops 473

Conscience 90

CONSULTANT/Photographer's Representative

458

Contemporary Arts Center 357

Contemporary Arts Center (Cincinnati), The

358

Contemporary Arts Collective 358

Contemporary Bride Magazine 90

Continental Newstime 90

Convenience Store Decisions 182

Convergence 91

Conyers Cherry Blossom Festival 417

Corbis 273

Corcoran Fine Arts Limited, Inc. 358

Corporate Art Source/CAS Gallery 358

Cortona Center of Photography, Italy, The 473

Cory Photography Workshops 473
Cotton Grower Magazine 183
Country Arts & Crafts Fair 417
Countryman Press, The 216
Country Woman 91
Courthouse Gallery, Lake George Arts Project 359
Crabtree Publishing Company 216
Craft Fair at the Bay 417
Crafts at Rhinebeck 417
CraftWestport 418
CrealdÈ School of Art 473
CrealdÈ School of Art 359
Creative Arts Workshop 473

Creative Company, The 217
Creative Editions 217
Creative Homeowner 217
Creative Stock Images 274
Creative With Words Publications (CWW) 218

Cristopher Lapp Photography 459
CropLife 183
Crossman Gallery 359

Cruising World 92 Cuneo Gardens Art Festival 418 Curator's Choice Awards 451 Cycle California! Magazine 92 Cycle World Magazine 92

Dairy Today 183 Dakota Outdoors 93 Dale Photographic Workshops, Bruce 474 Dallas Center for Contemporary Art, The 359 Dance 93 Dance on Camera Festival 451 Dawson College Centre for Training and Devlopment 474 Day in Towne, A 406 Dayton Art Institute, The 360 DDB Stock Photography, LLC 274 Dean Photo Workshops, The Julia 474 Deer & Deer Hunting 93 Deerfield Fine Arts Festival 418 Delaney Photo Workshops, Cynthia 474 Delaware Arts Festival 418 Delaware Center for the Contemporary Arts De Moreta Represents, Linda 459

Demuth Museum 360

Design2Market 326 Design Conceptions (Joel Gordon Photography) 275 Detroit Focus 360 Digital Photo 94 Digital Wildlife Photography Field School 474 Dinodia Photo Library 275 Direct Art Magazine Publication Competition Display Design Ideas 184 DK Stock, Inc. 276 DM News 184 Dockery House Publishing, Inc. 218 Dog Fancy 94 Dogs in Canada 95 Dorsky Museum of Art, Samuel 360 Dot Fiftyone Gallery 360 Down Beat Magazine 95 Down The Shore Publishing Corp. 218 Downtown Festival & Art Show 419 Drake Magazine, The 95 Dramatic Light Nature Photography Workshops 474 DRK Photo 276 Dubois, Francoise/Dubois Represents 459 Ducks Unlimited Magazine 95 DW Stock Picture Library (DWSPL) 277 Dykeman Associates, Inc. 326

F

Eastman House, George 361 Ecoscene 278 ECW Press 219 Edelman Gallery, Catherine 361 Edelstein Studio and Gallery, Paul 361 Edwards Fine Art & Sculpture Festival 419 E & E Picture Library 277 Electrical Apparatus 184 Elks Magazine, The 96 Elmwood Avenue Festival of the Arts, Inc. 419 Eloquent Light Photography Workshops 474 El Restaurante Mexicano 185 eMediaLoft.org 361 Empics 278 Energy Gallery Art Call 451 Englander Photography Workshops & Tours, Joe 475 Entrepreneur 96 Envision 278

EOS Magazine 96
Equipment Journal 163
Erben Gallery, Thomas 362
Ernesto Mayans Gallery 362
ESL Teacher Today 185
eStock Photo, LLC 279
E/The Environmental Magazine 97
Etherton Gallery 362
Europa Photogenica Photo Tours to Europe 475
Event 97
Event Callery 910 Arts, 363

Event 97
EventGallery 910Arts 363
Evergreen Arts Festival 419
Everson Museum of Art 363
Ewing Galloway Inc. 279
exposure36 Photography 475

Fahey/Klein Gallery 363

F

Faire on the Square 420 Fair in the Park, A 420 Falkirk Cultural Center 364 Fall Fest in the Park 420 Fall Festival of Art at Queeny Park 420 Fall Fine Art & Crafts at Brookdale Park 420 Family Motor Coaching 98 Famous Pictures & Features Agency 280 Farcountry Press 220 Fargo's Downtown Street Fair 421 Farnam Companies, Inc. 326 Faust Fine Arts & Folk Festival 421 FAVA (Firelands Association for the Visual Arts) 364 Fellowship 98 Ferndale Art Show 421 Festival in the Park 421 Fillmore Jazz Festival 421 Finding & Keeping Clients 476 Fine Art & Crafts at Anderson Park 422 Fine Art & Crafts Fair at Verona Park 422 Fine Arts Work Center 476 Finescale Modeler 98 Fire Chief 185 Fire Engineering 186 FireRescue Magazine 186 First Light Associated Photographers 281 First Light Photographic Workshops and Safaris 476 Flashlight Press 220

Flaunt Magazine 99 Flight Collection, The 281 Flint Communications 327 Fly Rod & Reel 99 Focal Press 220 Focus Adventures 476 Focus New Zealand Photo Library Ltd. 282 Foodpix 282 Foothills Crafts Fair 422 Ford City Heritage Days 422 Forest Hills Festival of the Arts 422 Forest Landowner 186 Fort Ross Inc. 220 Fort Ross Inc. International Rights 221 Fortune 99 FOTOAGENT.COM/FOTOCONCEPT, INC 282 Fotofusion 476 Foto-Press Timmermann 283 Fotoscopio 283 Fourth Avenue Spring Street Fair 423 Fourth Avenue Winter Street Fair 423 Fourth of July Street Fair and Autumn Fest in the Park 423 Fourth Street Festival for the Arts & Crafts 423 France Magazine 100 Frankfort Art Fair 423 Frederick Festival of the Arts 423 Freefall Review 100 Freeport Arts Center 364 Freshly Baked Fiction 100 Fresno Art Museum 364 Ft. Myers Magazine 100 Fulton County Daily Report 163 Fundamental Photographs 284 F+W Media 219

G
G2 Gallery, The 365
Gallant/Freeman Patterson Photo Workshops 477
Gallery 110 Collective 365
Gallery 218 366
Gallery 400 366
Gallery Luisotti 366
Gallery North 366
Gallery West 367
Galman Lepow Associates, Inc. 367
Gal pagos Travel 476

Game & Fish Magazines 101

Garrison Art Center Fine Art & Craft Fair 424 Georgia Straight 101 Geoslides & Geo Aerial Photography 284 Geosynthetics 187 Gering and Lopez Gallery 367 Gerlach Nature Photography Workshops & Tours 477 German Life Magazine 102 Germantown Festival 424 Getty Images (WA) 285 Ghost Town 102 Ginsburg & Associates, Inc., Michael 460 Girls Life Magazine/GirlsLife.com 102 Global Preservation Projects 477 Gloucester Waterfront Festival 424 Gold & Associates, Inc. 328 Golden Gate School of Professional Photography 477 Goldman Creative Photography Workshops, Rob 477 Gold Rush Days 424 Golf Tips 103 Goodman Inc., Tom 460 Good Old Summertime Art Fair 424 Gospel Herald 103 Government Technology 187 Gradd Arts & Crafts Festival 425 Grafica 328 Grain Journal 187 Grand Festival of the Arts & Crafts 425 Grand Rapids Art Museum 367 Grand Rapids Business Journal 164 Grand Rapids Family Magazine 103 Grand Rapids Magazine 104 Great Lakes Art Fair 425 Great Neck Street Fair 425 Greenwich Village Art Fair 425 Greyhound Review, The 188 Grit Magazine 104 Gryphon House 221 Guenzi Agents, Inc., Carol 460 Guernica Editions, Inc. 221 Guideposts 104 Guilford Craft Expo 426

H

Haardt Gallery, Anton 368

Gunstock Summer Festival 426

Guitar World 105

Hackett, Pat/Artist Representative 461 Hadassah Magazine 105 Haddad Gallery, Carrie 368 Hallmark Institute of Photography 477 Hallowes Productions & Advertising 328 Halsted Gallery Inc., The 368 Hamilton Magazine 105 Hampton Design Group 329 Hancock House Publishers 221 Hard Hat News 164 HarperCollins Children's Books / HarperCollins Publishers 222 Harper's Magazine 106 Hart Portrait Seminars, John 478 Havu Gallery, William 368 Hawaii Photo Seminars 478 Hawaii Photo Tours, Digital Infrared, Digital Photography, Photoshop, Polaroid & Fuji Transfer Workshops. Private Tours & Instruction Sessions 478 Healing Lifestyles & Spas Magazine 106

Healing Lifestyles & Spas Magazine 106 Hearst Art Gallery, Saint Mary's College 369 Hearth and Home 188 HeartLand Boating 107 Heart of Nature Photography Workshops 478

Heilman Photography, Inc., Grant 285 Hemphill 369

Hempini 309

Henry Street Settlement/Abrons Art Center 369

Hera Educational Foundation and Art Gallery 369

Herald Press 222

Herbert Institute of Art, Gertrude 370

Hereford World 188

Heritage Railway Magazine 107

Highland Maple Festival 426

Highlands Art League's Annual Fine Arts & Crafts Festival 426

Highways 107

Hinsdale Fine Arts Festival 426 Hodes Group, Bernard 329 Holiday Arts & Crafts Show 427

Holiday Crafts at Morristown 427

Holly Arts & Crafts Festival 427

HOLT McDougal 222

Home, Condo and Garden Art & Craft Fair 427 Home Decorating & Remodeling Show 427

Home Education Magazine 108

Hoof Beats 108

Horizons 478 Horizons Magazine 108 Horse Illustrated 109 Hot Springs Arts & Crafts Fair 427 Houk Gallery, Edwynn 370 Howard, Merrell and Partners, Inc. 329 Human Kinetics Publishers 222 Hunger Mountain 109 Huntsville Museum of Art 370 Hutchinson Associates, Inc. 330 Hutchison Picture Library 285 Hyperion Books for Children 223 Hywet Hall & Gardens Wonderful World of Ohio Mart, Stan 428

Icebox Quality Framing & Gallery 370 I.C.P. International Colour Press 286 Ideals Magazine 109 IEEE Spectrum 189 IGA Grocergram 189 Illinois State Museum Chicago Gallery 371 Illogical Muse 110 Image Finders, The 286 Image Integration 330 Images.de Digital Photo GmbH 287 Image Works, The 287 Immedium 223 **Immigrant Ancestors** 110 Indianapolis Art Center 371 Indianapolis Monthly 110 Indian Wells Arts Festival 428 Individual Artists of Oklahoma 371 Infinity Workshops 478 InFocus 452 In Focus with Michele Burgess 478 Inmagine RF & RM Image Submissions (IRIS)

Inner Traditions/Bear & Company 223 Insight Magazine 111 Instinct Magazine 111 International Center of Photography 372 International Expeditions 478 International Folk Festival 428 International Photo News 288 International Visions Gallery 372

In The Wind 111 Iowan Magazine, The 112 Irish Image Collection, The 289 Irish Picture Library, The 289 Isle of Eight Flags Shrimp Festival 428 Isopix 289 ITE Journal 189

Jackson Fine Art 372 James Harris Gallery 368 Jayawardene Travel Photo Library 290 Jenkins Gallery, Alice and William 372 Jeroboam 291 Jewish Action 112 JG + A 461 JHB Gallery 373 Jividen's 479 Johns Hopkins University Spring Fair 428 Jones Gallery, Stella 373 Jordahl Photo Workshops 479 Journal of Adventist Education 190 Journal of Asian Martial Arts 113 Journal of Psychoactive Drugs 190 Joyce Inc., Tricia 461 Jubilee Festival 429 Jude Studios 330 Judicature 190 Juvenile Diabetes Research Foundation International 113

K

Kansas! Magazine 113 Kashrus Magazine 114 Kent State University School of Art Galleries 373 Kentucky Monthly 114 Ketchum Hands-On Photographic Model Workshops, Art 479 Ketner's Mill County Arts Fair 429 Key Curriculum Press 224 KIA Art Fair (Kalamazoo Institute of Arts) 429 Kimball Stock 291 Kings Mountain Art Fair 429 Kirchman Gallery 373 Kiwanis Magazine 114 Klein Gallery, Robert 374 KNOWAtlanta 115 Kochan & Company 331 Koch Gallery, Robert 374 Korman + Company 461 Kramer and Associates, Inc., Joan 292, 461

Krasl Art Fair on the Bluff 429

L

LA Art Association/Gallery 825 374

Lacrosse Magazine 115

Lake Champlain Maritime Museum's Annual

Juried Photography Exhibit 452

Lake City Arts & Crafts Festival 430

Lakeland Boating Magazine 115

Lake Superior Magazine 116

Land of the Bible Photo Archive 268

Landscape Architecture 191

Larson Gallery Juried Biennual Photography

Exhibition 452

Latitude Stock 292

Lawyers Weekly, The 164

Layla Productions, Inc. 224

Leach Gallery, Elizabeth 374

Lee + Lou Productions Inc. 462

Leepa-Rattner Museum of Art 374

Leeper Park Art Fair 430

Lehigh University Art Galleries 375

Leonardis Gallery, David 375

Leopold Gallery 375

Lerner Publishing Group, Inc. 224

Les Cheneaux Festival of Arts 430

Levin Group, The Bruce 462

Liberty Arts Squared 430

Liggett Stashower 331

Light Factory, The 376, 479

LIGHT Photographic Workshops 479

Lilac Festival Arts & Crafts Show 430

Limited Editions & Collectibles 376

Limner Gallery 376

Lineair Fotoarchief, B.V. 293

Linear Cycle Productions 331

Liturgy Training Publications 225

Living Free 116

Lizardi/Harp Gallery 376

Llewellyn Photography Workshops & Field

Tours, Peter 479

Lockwood Wildlife Photography Workshop,

C.C. 480

Log Home Living 117

Log Newspaper, The 165

Lohre & Associates Inc. 332

Lompoc Flower Festival 431

Lonely Planet Images 293

Long Island Photo Workshop 480

Long's First Light Photography Workshop

Tours, Andy 468

Los Angeles Center for Digital Juried

Competition 452

Loyola Magazine 117

Lucent Books 225

Luckypix 294

Lullwater Review 117

Lutheran, The 118

Lutz Arts & Crafts Festival 431

Lux Center for the Arts 377

M

Macalester Gallery 377

MacDowell Colony, The 480

MacNider Art Museum 377

Madison Chautauqua Festival of Art 431

Magenta Publishing for the Arts 226

Magical Child 226

Main Avenue Arts Festival 431

Maine Media Workshops 480

Main Street Gallery, The 378

Manitoba Teacher, The 191

Manning Photography, William 480

Manufacturing Automation & Advanced

Manufacturing 191

Markeim Art Center 378

Marketing & Technology Group 192

Marlboro Gallery 378

Marlin 118

Maslov Agent International 462

Mason Arts Festival 431

Masterfile 294

Masur Museum of Art 379

Mattei Photography, Michele 379

MAXX Images, Inc. 294

McDonald Wildlife Photography Workshops

and Tours, Joe & Mary Ann 480

McDonough Museum of Art 379

McGrath, Judith 463

McGraw-Hill 226

Meadowbrook Press 226

Medical File Inc., The 295

Medical On Line Ltd. 295

Meetings & Incentive Travel 192

Megapress Images 295

Memorial Weekend Arts & Crafts Festival 432

Mentor Series Worldwide Photo Treks 481

Mercury Awards 452

Mesa Contemporary Arts at Mesa Arts Center 379

Metrosource Magazine 119

Mexico Photography Workshops 481

MGW Newsmagazine 119

Michael Murphy Gallery M 380

Michelson Galleries, R. 380

Michigan Out-of-Doors 119

Michigan State University Holiday Arts &

Crafts Show 432

Michigan State University Spring Arts & Crafts Show 432

Mid-Atlantic Regional School of Photography

Mid-Missouri Artists Christmas Arts & Crafts Sale 432

Midwest Photographic Workshops 481

Milkweed Editions 227

Mill Brook Gallery & Sculpture Garden 380

Miller Gallery, Peter 380

Mills Pond House Gallery 381

Minnesota Golfer 120

Mira 296

Missouri Photojournalism Workshop 481

Mitchell Lane Publishers, Inc. 227

Mobile Museum of Art 381

Mobius Awards for Advertising, The 454

Monderer Design 332

Mondial 227

Montauk Point Lions Club 432

Monterey Museum of Art 381

Morpheus Tales Publishing 227

Mother Jones 120

Motor Boating Magazine 120

Motoring & Leisure 121

Mountain Living 121

Mountain State Forest Festival 433

Mountain Workshops 481

Mount Gretna Outdoor Art Show 433

MPTV (a/k/a Motion Picture and Television

Photo Archive) 296

Mullin/Ashley Associate 332

Multiple Exposures Gallery 381

Munro Goodman Artists Representatives 463

Museo De Arte De Ponce 382

Museo ItaloAmericano 382

Museum of Contemporary Art San Diego 382

Museum of Contemporary Photography,

Columbia College Chicago 383

Museum of Northern Arizona 227

Museum of Photographic Arts 383

Museum of Printing History 383

Museum of the Plains Indian 384

Mushing.com Magazine 121

Music & Arts Pictures at Lebrecht 297

Music Sales Group 228

Muzzle Blasts 122

My Foodservice News 192

Myriad Productions 333

Myron the Camera Bug 452

Na'amat Woman 122

Nailpro 192

Nails Magazine 193

Napa Wine & Crafts Faire 433

National Black Child Development Institute

National Geographic 122

National Masters News 165

National Notary, The 193

National Parks Magazine 123

Native Peoples Magazine 123

Natural Habitat Adventures 482

Natural Tapestries 482

Nature Friend 123

Nature Photography Workshops, Great Smoky

Mountains Institute at Tremont 482

Naval History 193

Nevada Museum of Art 384

Neversink Photo Workshop 482

NewDesign Magazine 194

New England Arts & Crafts Festival 433

New England Craft & Specialty Food Fair 433

New England School of Photography 482

New Gallery/Thom Andriola 384

New Jersey Heritage Photography Workshops

New Jersey Media Center LLC Workshops and Private Tutoring 482

New Leaf Press, Inc. 228

New Mexico Arts & Crafts Fair 434

New Mexico Magazine 124

New Mexico State University Art Gallery 384

New Orleans Jazz & Heritage Festival

Presented by Shell 434

New Orleans Museum of Art 384

New Smyrna Beach Art Fiesta 434

New World Festival of the Arts 434 New York State Fair Photography Competition

and Show 452 New York Times Magazine 165

New York Times on the Web, The 165

Nexus/Foundation for Today's Art 384

NFPA Journal 194

Nicolas-Hays, Inc. 228

Nicolaysen Art Museum & Discovery Center 385

Nicolet College Art Gallery 385

Nikon School Digital SLR Photography 483

North American Whitetail Magazine 124

North Carolina Literary Review 125

North Congregational Peach & Craft Fair 434

Northern Exposures 483

Northern Woodlands 125

Northwest Art Center 385

Northwestern University Dittmar Memorial Gallery 385

Northwest Travel Magazine 126

Norton and Company, W.W. 229

Notre Dame Magazine 126

Novastock 297

NOVUS 333

Now & Then 127

Noyes Museum of Art, The 386

NYU Tisch School of the Arts 483

0

Oakland University Art Gallery 386

OCEAN Magazine 127

Official Texas State Arts & Crafts Fair 435

Okapia K.G. 298

O.K. Harris Works of Art 386

Oklahoma Today 127

Omni-Photo Communications 298

OnAsia 299

Onboard Media 128

ONE 128

OnRequest Images 299

Opalka Gallery 387

Opcao Brasil Imagens 300

Opening Night Gallery 387

Orchard Lake Fine Art Show 435

Oregon Coast Magazine 129

Oregon College of Art and Craft 483

Outdoor America 129

Outdoor Canada Magazine 129

Outdoor Life Magazine 130

Out of the Blue 300

Outram's Travel Photography Workshops,

Steve 484

Outside Imagery 300

Owen Publishers, Inc., Richard C. '229

OWL Magazine 130

Oxford Scientific (OSF) 301

Oxygen 130

P

PACIFIC NORTHWEST ART SCHOOL/ PHOTOGRAPHY 484

Pacific Stock/Printscapes.com 301

Pacific Yachting Magazine 131

Paddler Magazine 131

radulei Wagazilie 13

Painet Inc. 302

Pakn Treger 131

Palm Beach Photographic Centre 484

Palo Alto Art Center 387

Panoply Arts Festival, Presented by the Arts

Council, Inc. 435

Panoramic Images 303

Paonessa Photography Workshops, Ralph 484

Papilio Natural History Library 303

Paradise City Arts Festivals 435

Parkland Art Gallery 388

Parks Photography Competition, The Gordon 453

Patterson Apricot Fiesta 435

Paulist Press 230

Pearlstein Gallery, Leonard 388

Pediatric Annals 194

Pelican Publishing Co. 230

Pennsylvania Game News 132

Pennsylvania Magazine 132

Persimmon Hill Magazine 132

Peters Valley Annual Craft Fair 435

Peters Valley Craft Center 388, 484

Pet Product News 195

Phi Delta Kappan 133

Phillips Gallery 389

Phoenix Gallery 389

Photo Agora 304

PhotoEdit 304

Photo Explorer Tours 484

Photographers' Formulary 485

Photographer's Forum Magazine 133

Photographic Arts Workshops 485 Photographic Center Northwest 485 Photographic Resource Center 389 Photography Art 389 Photography at the Summit 485 Photography in Provence 485 Photography Now 453 Photokunst 463 Photolibrary Group 305 Photo Life 133 Photolife Corporation Ltd. 305 Photomedia Center, The 390 Photo Network 306 Photo Researchers, Inc. 306 Photo Resource Hawaii 307 Photo Review Annual Photography Competition, The 453 PhotoSource International 307 Photospiva 453 PhotoWalkingTours 485 Photo Workshops by Commercial Photographer Sean Arbabi 486 Pictures of the Year International 453 Pierro Gallery of South Orange 390 Pilot Getaways 195 Pilot Magazine 134 PI Magazine 195 Piscopo, Maria 463 Pitcher Photo Library, Sylvia 307 Pix International 308 Pizer, Alvssa 464 Planet 134 Planning 196 PLANS, Ltd. (Photo Libraries and News Services) 308 Plastics News 196 Plastics Technology 197 Playboy 134 Poets & Writers Magazine 135 Police and Security News 197 Police Magazine 197 Polk Museum of Art 390 Ponkawonka Inc. 308 Popular Photography & Imaging 135 Posev School 334 Positive Images (Stock Photography & Gallery 61) 309 POZ Magazine 136

Prague Summer Seminars 486

Prairie Arts Festival 436 Prairie Journal, The 136 Prairie Messenger 136 Prakken Publications, Inc. 230 Princeton Alumni Weekly 136 Print Center, The 391 Proceedings 198 Produce Merchandising 198 Professional Photographer 198 Professional Photographer's Society of New York State Photo Workshops 486 Progressive, The 137 ProStar Publications Inc. 231 Public Power 199 Pucker Gallery 391 Pump House Center for the Arts 391 Pungo Strawberry Festival 436 Purestock 309 Pyramid Hill Annual Art Fair 436 Pyrenees Exposures 486

Q

QSR 199
Quaker Arts Festival 436
Qually & Company, Inc. 334
Quarto Publishing Plc. 231
Queens College Art Center 391
Quetico Photo Tours 487
Quick Frozen Foods International 199
Quon, Mike/Designation Inc. 334

R

Racquetball Magazine 137 Rafelman Fine Arts, Marcia 392 Railphotolibrary.com 310 Ralls Collection Inc., The 392 Rangefinder 200 Ranger Rick 137 Rattlesnake Roundup 436 Reading Today 200 Recommend Magazine 200 Redmond Design, Patrick 335 Referee 201 Reform Judaism 138 Registered Rep 201 Relay Magazine 202 Remodeling 202 Restaurant Hospitality 202

Revolutionary War Tracks 138 Rhode Island Monthly 138 Rhode Island State Council on the Arts Fellowships 454 Rich Wildlife Photography Tours, Jeffrey 487 Rigby Education 231 Riley Festival 437 Riverbank Cheese & Wine Exposition 437 Riverfront Market 437 Robertstock / ClassicStock 310 Rochester Contemporary 392 Rockford Review 138 Rockport Center for the Arts 392 Rocky Mountain Field Seminars 487 Rocky Mountain School of Photography 487 Roggen Advertising and Public Relations, Ted 335

Roland Group Inc., The 464
Rolling Stone 139
Rotarian, The 139
Rotunda Gallery, The 393
Royal Oak Outdoor Art Fair 437
RTOHQ 203
Rugby Magazine 139
Running Press Book Publishers 232.
Rural Heritage 140
Russian Life Magazine 140

S

Saco Sidewalk Art Festival 437 Sailing Magazine 118 Sail Magazine 140 Saks Associates, Arnold 336 Salt Water Sportsman 141 Sander, Vicki/Folio Forums 464 San Diego Art Institute's Museum of the Living Artist 393 Sandlapper Magazine 141 Sandy Springs Festival 437 Santa Cali Gon Days Festival 438 Santa Fe Photographic Workshops 487 Sausalito Art Festival 438 Saxton Gallery of Photography, The Joseph Schecterson Dezign Associates, Jack 336 Schmidt Art Center, William & Florence 393 Schmidt/Dean Spruce 393 Schmidt Design, Henry 336

Scholastic Library Publishing 232

Scholastic Magazines 142 School Administrator, The 203 School Guide Publications 233 School Transportation News 203 Schupfer Management Corporation, Walter Science Photo Library, Ltd. 311 Scottsdale Arts Festival 438 Scrap 204 Sea 142 Seattle Homes & Lifestyles 142 Second Street Gallery 394 Security Dealer & Integrator 204 Selling Your Photography 487 sellphotos.com 487 Seventeen Magazine 143 Sexton Photography Workshops, John 488 Sharing the Victory 143 Shenandoah Photographic Workshops 488 Shooting Sports USA 143 Shots 144 Showcase School of Photography, The 488 Sidewalk Art Mart 438 Sierra 144 Sierra Madre Wistaria Festival 439 Simsbury Woman's Club 42nd Arts & Crafts Festival 412 Singing Sands Workshops 488 Skipping Stones 144 Skokie Art Guild's 49th Annual Art Fair 439 Skydiving 144 Skyscan Photolibrary 311 Smith Memorial Fund, Inc., W. Eugene 454 Smithsonian Magazine 145 Smithville Fiddlers' Jamboree and Craft Festival 439 Smoky Mountain Learning Center 488 Soho Myriad 394 Solano Avenue Stroll 439 Soundlight 337 South Carolina Film Commission 337 SouthComm Publishing Company, Inc. 145 South Dakota Art Museum 394 Southeast Photo Adventure Series Workshops 488 Southern Boating 145 South Shore Art Center 488 Southside Gallery 394

Southwest Arts Festival at the Empire Polo Club 439

Sovfoto/Eastfoto, Inc. 312

SpeciaLiving 146

Specialty Travel Index 205

spoke gallery, b.j. 352

Sport Fishing 146

SportsCar 146

Sportslight Photo 312

Sports Photography Workshop 488

Spring Crafts at Lyndhurst 440

Spring Crafts at Morristown 440

Springfest 440

Spring Fine Art & Crafts at Brookdale Park in

Montclair, NJ 440

SRO Photo Gallery at Landmark Arts 395

Stack & Associates, Inc., Tom 313

State Museum of Pennsylvania, The 395

State of the Art 395

State Street Gallery 395

St. Charles Fine Art Show 440

Steppin' Out 441

Stevenson University Art Gallery 396

St. George Art Festival 441

Stickman Review 147

Still Media 314

Stillwater Arts & Heritage Festival 441

St. James Court Art Show 441

Stock Connection, Inc. 314

StockFood GmbH (The Food Image Agency)

314

Stock Foundry Images 315

Stockley Gardens Fall Arts Festival 441

StockMedia.net 316

Stock Transparency Services/STSimages 317

Stockvard Photos 317

Stone Arch Festival of the Arts 442

Store and Sally D. Francisco Gallery at Peters

Valley Craft Center, The 396

St. Patrick's Day Craft Sale & Fall Craft Sale

442

Strang Communications Company 233

Strawberry Festival 442

Streetpeople's Weekly News 166

subTERRAIN Magazine 147

Sugar Daddy Photos 317

Summer Arts & Crafts Festival 442

Summerfair 442

Summit Photographic Workshops 489

Sun 166

Sunday Post, The 167

Sun.Ergos 338

Sun Fest, Inc. 443

Sun, The 147

Superior/Gunflint Photography Workshops

489

Superstock Inc. 318

Surfing Magazine 148

Surgical Technologist, The 205

Synchronicity Fine Arts 396

Synergistic Visions Workshops 489

Syracuse Arts & Crafts Festival 443

Syracuse New Times 167

T

Tarpon Springs Fine Arts Festival 443

Taube Museum of Art, Lillian & Coleman 396

Taylor County Fair Photo Contest 454

Techniques 205

Texas Gardener Magazine 148

Texas Highways 148

Texas Monthly 149

Texas Realtor Magazine 206

Texas School of Professional Photography 489

Textile Rental Magazine 206

THEMA 149

The Workshops & Bob Korn Imaging 489

Thompson Art Gallery, Natalie and James 397

Thoroughbred Times 206

Three Rivers Arts Festival 443

Throckmorton Fine Art 397

Tide Magazine 149

Tightrope Books 233

Tikkun 150

Tilbury House 233

TIME 150

Times of the Islands 150

TM Enterprises 465

Tobacco International 206

Today's Photographer 207

Tom Murphy Photography 489

Torah Aura Productions 233

Toronto Sun Publishing 167

Touchstone Gallery 398

Toward Freedom 151

TRACE Magazine 151

Track & Field News 151

Trailer Boats Magazine 152 Trail Runner 152 Travel Images 489 Travel + Leisure 153 Traveller Magazine & Publishing 153 Travelworld International Magazine 153 Tree Care Industry 207 Tricycle Press 234 Triumph World 153 Tropix Photo Library 318 Truppe, Doug 465 Tubac Festival of the Arts 443 Tulip Festival Street Fair 444 Tulsa International Mayfest 444 Turkey Country 154 Turkey & Turkey Hunting 154 TV Guide 154 Tyndale House Publishers 234

U

UCR/California Museum of Photography 398 Ullstein Bild 319 Unicorn Stock Photos 319 UNI Gallery of Art 398 Union Street Gallery 399 University Art Gallery in the D.W. Williams Art Center 399 University of Kentucky Art Museum 399 University of Richmond Museums 399 Unlimited Editions International Juried Photography Competitions 455 Untitled [ArtSpace] 399 Up and Under 155 Up Here 155 Upstream Gallery 400 Upstream People Gallery 400 Uptown Art Fair 444 Urban Institute for Contemporary Arts 400

V

Van Os Photo Safaris, Inc., Joseph 489
VeloNews 168
Ventura County Reporter 168
Vermont Life 155
Vermont Magazine 156
Versal 156
Veterinary Economics 207
Victorian Chautauqua, A 444

Video I-D, Inc. 338
Viewfinders 320
Vintage Books 234
VIREO (Visual Resources for Ornithology) 320
Virginia Center for the Creative Arts 490
Virginia Christmas Show 445
Virginia Spring Show 445
Viridian Artists, Inc. 401
Vision Quest Photo Workshops Center 490
Visitor's Choice Magazine 234
Visual Artistry & Field Mentorship
Photography Workshop Series 490
Visual Arts Center of Northwest Florida 401
Visual Arts Gallery 401
Voyageur Press 235

W

Wailoa Center Gallery, The 402 Warne Marketing & Communications 339 Washington Blade, The 168 Washington County Museum of Fine Arts 402 Washington Square Outdoor Art Exhibit 445 Washington Trails 156 WaterSki 157 Watertown Public Opinion 168 Water Well Journal 207 Waveland Press, Inc. 235 WaveLength Magazine 157 Weigl Educational Publishers Limited 236 Weinstein Gallery 402 Welcome to My World Photography Competition 445 Western Producer, The 169 Westmoreland Art Nationals 445 Whiskey Island Magazine 158 Whitefish Arts Festival 446 White Oak Crafts Fair 446 White Productions, Dana 339 Wildlife Photography Workshops & Lectures 490 Wild Wind Folk Art & Craft Festival 446 Wild Wings Photo Adventures 490 Wiley Group, The 466 Willow Creek Press 236 Wilmette Festival of Fine Arts 446 Wilshire Book Company 237 Windigo Images 321 Wine Enthusiast Magazine 158 Wines & Vines 208

Winnebagoland Art Fair 446 Winslow Photo, Inc., Robert 491 Wisconsin Architect 208 Wisconsin Union Galleries 402 Woman Engineer 208 Women's Health Group 237 Women & Their Work Art Space 403 Woodmen Living 157 Woodshop News 209 Woodstock Photography Workshops 491 Worcester Polytechnic Institute 340 Working With Artists 491 World Fine Art Gallery 403 World Tobacco 209 Writer's Digest 158 WRITERS' Journal 209 Wurlitzer Foundation of New Mexico, The Helene 491

. Wyandotte Street Art Fair 447

Y

Yaddo 491 Yankee Magazine 159 Yellowstone Association Institute 492 Yeshiva University Museum 403 Yosemite Outdoor Adventures 492 Your Best Shot 455 Youth Runner Magazine 159

Z

Zahn & Associates, Spencer 340 Zakin Gallery, Mikhail 404 Zenith Gallery 404 Zorba Photo Workshops 492